Photography
in America

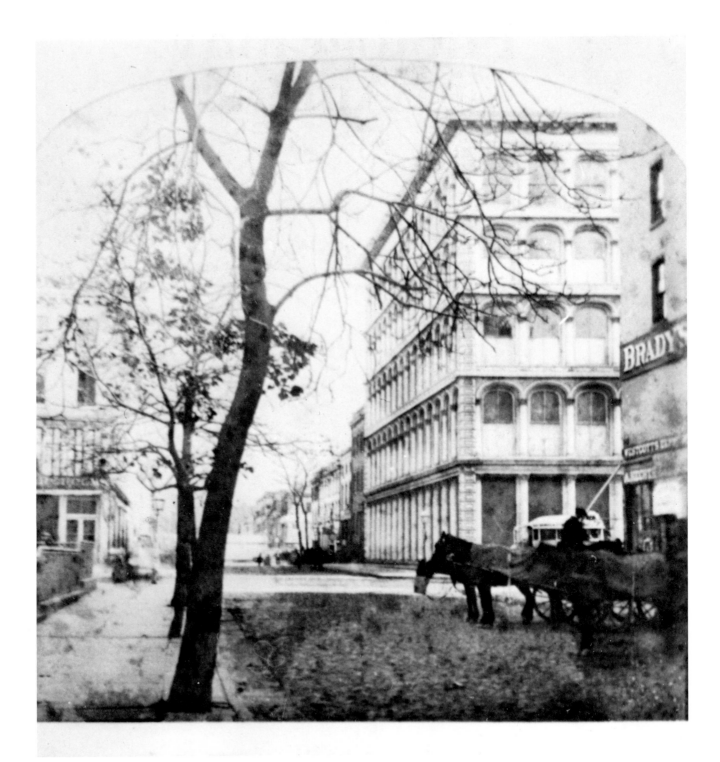

View of Broadway from Tenth Street, New York, showing the northern side of the building, right, which housed Mathew Brady's photographic gallery from 1860 to 1873.

Photography in America
The Formative Years
1839–1900

William Welling

University of New Mexico Press
Albuquerque

Library of Congress Cataloging-in-Publication Data

Welling, William.
 Photography in America.

 Reprint. Originally published, New York : Crowell, c1978.
 Bibliography: p.
 Includes index.
 1. Photography—United States—History—19th century. I. Title.
[TR23.W44 1987] 770′.973 86-24899
ISBN 0-8263-0953-4 (pbk.)

ACKNOWLEDGEMENTS

To Marian Carson for her consummate energy and interest in helping me research the most extensive private collections of early photographs and photographic literature covering Philadelphia's pioneering role in the birth and early development of American photography, and for her gracious help in opening other doors in Philadelphia and Baltimore to prime sources of rare photographic material.

To George R. Rinhart, who has once again provided invaluable assistance in drawing upon the contents of his enormous photographic collection, and who readily put at my disposal his entire library of nineteenth-century photographic journals and books, which I believe to be now the largest such privately held collection in the United States.

To Gene Collerd, for his abiding help in unearthing antique cameras and rare, unpublished photographs from a fabulous collection, and in appreciation, too, of his craftsmanship in reproducing most of the illustrations loaned for reproduction.

To Allan and Hilary Weiner, R. Bruce Duncan, J. Randall Plummer, Samuel Wagstaff, Bradford Bachrach, Richard Russack, Pearl Korn, Paul F. Walter, Janet and Lewis Lehr, David Steinmann, Lou Marcus, and Robert Lansdale, each of whom undertook to copy images from their personal collections for use in these pages; and to Timothy Beard, Arnold Crane, Mrs. Roy Douglass, William Kaland, Fred Lightfoot, Jerome Sprung, and Harvey Zucker, who kindly made key items from their collections available for reproduction; and to Howard Bendix and Philip Kaplan for providing leads to other important sources of information or illustrations.

To these dedicated men and women at more than a dozen libraries and institutions, who have assisted me with original research or provided valued materials on a timely basis: Mrs. Helen Reid, manuscript librarian for the McKeldin Library at the University of Maryland, College Park, who with Dr. Robert L. Beare, the assistant director for collections at McKeldin, initiated a chain reaction of referrals which proved to be the most important of this entire undertaking; Dr. Michael McMahon and Harvey S. S. Miller at the Franklin Institute, who gave freely of their time and made it possible for me to photograph key items among the Institute's archives; Edda Schwartz of the Institute's research staff, whose original research was extremely beneficial; Barbara Bond, executive director, and Dr. Josephine Chapin at the Dyer-Yorke Library and Museum in Saco, Maine; Dean John C. Sprille and Anne Van Camp at the University of Cincinnati; Dr. John Patton at the Cincinnati Historical Society; Mrs. Susan Childress and Sarah M. Lowery at the Cincinnati Art Museum; John B. Griggs, librarian at the Lloyd Library and Museum in Cincinnati; Anthony Raimo, director of the library at the University of Maryland, Baltimore County; David Haberstich at the Smithsonian Institution Museum of History and Technology; Richard Wright of the Onondaga (New York) Historical Association; Suzanne H. Gallup at the University of California Bancroft Library; Thomas Greenslade at Kenyon College; Mrs. Hildegarde L. Watson, director of the Rochester Historical Society; Chuck Kelly at the Library of Congress Prints and Photographs Division; and the librarians at the Library of Congress, New York Public Library, and International Museum of Photography at George Eastman House.

To Hugh Rawson, the "captain" of this W.W. literary voyage and a prime motivator of what Winthrop Knowlton has justly termed "the lively and distinguished program which characterizes the Crowell imprint"; and to Cynthia Kirk, for her able assistance in editing.

To my brother, Lindsay H. Welling, Jr., finally, an "amateur" photographer with a distinctly professional touch and a helping hand in moments of need; and to those stalwarts—Richard W. Strehle, James W. Bowers, and Annette Sorrentino—whose personal help in compiling documentation has been of incalculable value.

PREFACE

Photography's formative years in America followed a pattern very similar to the American experience in art. Many who took up photography after 1839 had been house, sign, or carriage painters, or practitioners of another craft. Some, like their contemporaries in folk artistry, traveled the backroads of America as itinerant photographers; and even those in the big cities tended to work in isolation until well after the Civil War. Employees of metropolitan galleries were customarily enjoined to secrecy about their work, and as one of them said later, "the darkroom was as exclusive as a Free Mason's Lodge." Not surprisingly, they were slow in establishing fraternal organizations, which were organized first in Paris and London. Even the editors of American photographic journals had difficulty obtaining contributions, while those who did submit articles usually hid their identities, simply giving their initials or writing as a "friend."

Early American photographers, like early American painters, excelled in portraiture. During the 1840s, no photographic portraits abroad surpassed those made in New York by Mathew Brady, Jeremiah Gurney, and others, or in Boston by Albert Southworth and Josiah Hawes. In the 1850s, two Philadelphia photographers, John J. Mayall and Warren Thompson, established notable reputations as portrait photographers in London and Paris, respectively. At the great Crystal Palace Exhibition held in London in 1851, three Americans (Brady among them) captured top awards in photography, principally for portraiture.

American landscape photography developed slowly, just as landscape painting in America lagged behind oil portraiture. England and Europe boasted numerous distinguished landscape photographers in the 1840s and 1850s, but there were no counterparts in the United States. Not until after the flourishing of the Hudson River art school did an American landscape photography school emerge, its cameras focusing on the scenic wonders of California and other western states. In 1873, a gold medal for landscape photography was finally awarded, for the first time, to an American entry at an international exposition in Vienna.

Until the 1880s, the major new photographic processes, picture styles, and even equipment continued to originate in England, or on the continent. There were, of course, exceptions, such as the merchandising (in Philadelphia) of the Magic Lantern as an early slide projector; and the invention (in Baltimore) of the solar camera, which could make the first practical enlargements. But even in the realm of color photography, the extent of scientific research conducted in the United States never matched that performed in London, Paris, and Berlin. Except for the pioneering work of the New York optician Charles C. Harrison, the fineries of lens manufacture also remained strictly within the province of Europeans. But the dawn of photography's modern era near the turn of the century found the United States in a better position for technical innovation, or for exploiting what might be invented elsewhere. American ingenuity was becoming translated into vast new business enterprises, and under the auspices of one such duke of American capitalism—George Eastman—the long-sought dry negative process, perfected in England, was applied to rollable celluloid film, boxed in a hand camera (which no longer required a tripod), and made available—cheaply—to an entire new generation of amateur photographers. Once the domain of professionals, photography quickly became a handmaiden for *all* people.

During the nineteenth century, only one attempt was made to publish a history of photography in America. This was *The Camera and the Pencil,* by M. A. Root (Philadelphia, 1864; reprinted by the Helios Press, Putney, Vt., 1971). In the present century, only one attempt, again, has been made prior to this to provide a comprehensive history of the medium's formative years in America. This was *Photography and the American Scene,* by Robert Taft (New York, Macmillan, 1938; reprinted by Dover Publications, New York, 1964). The problem has been that not only are there few museums devoted to photography, but that no single library or institution has managed to acquire a fully comprehensive collection of nineteenth-century photographic journals, private papers, biographical material, and other literature pertaining to the medium. Talk with any scholar or curator in the photography field and he or she will tell you how much there is still to be learned, unraveled, or pieced together from additional isolated data—much of

it still in private hands, or otherwise still to be unearthed by researchers at public libraries, historical societies, and the like.

In these pages I have endeavored to give a new perspective on photography's formative years, particularly on the early workings with negative processes, photoengraving, the origins of amateur practice, motion picture camera development, and the birth of American art photography. In these pages, too, will be found a number of names which have not heretofore figured prominently in historical studies, but whose careers and accomplishments merit the attention which they are given here. The names include: John Locke, John Johnson, Victor Piard, J. DeWitt Brinckerhoff, Ezekiel Hawkins, J. Milton Sanders, Charles Seely, David Woodward, Charles Ehrmann, Frank Rowell, George B. Coale, Jex Bardwell, Arthur H. Elliott, Henry J. Newton, Thomas C. Roche, David Bachrach, Jr., Ernest Edwards, John Calvin Moss, Alfred Clements, Charles Francis Jenkins, Louis A. A. Le Prince, John Lawrence Breese, and George Bain.

Photography's formative years—in America as well as elsewhere—will continue to provide an exciting challenge for researchers for years to come. Occasionally, one hears that the private papers or photographs of a particular pioneer survive in private hands, unseen by scholars. While I have been privileged to be given access to a number of major private collections in preparing this book, I hope that its publication will encourage the making available of other unpublished information or photographs, or the donation of such valued material to the Library of Congress, or to such other institutions as will, in future, place only a modest premium on its use or reproduction by serious students and writers.

<div align="right">William Welling</div>

CONTENTS

Contents

x

Photography
in America

PROLOGUE

THE FOUNDING FATHERS

As early as the sixteenth century, scientists had constructed a primitive form of "darkroom" which contained a small hole in one wall through which the sun's rays projected the inverted image of the view outside onto the opposite wall of the room. This "room" was the first version of what came to be known over the next several centuries as the *camera obscura*. The smaller the hole, the sharper was the image projected on the opposite wall. Various forms of lenses were inserted in the aperture, which served to brighten the reflected image. Knowledge of the optical principle involved in this phenomenon dates back to the times of Aristotle, and the camera obscura was first used as an aid in drawing by Giovanni Batista (1538–1615).

In the eighteenth century, the portable reflex camera obscura was developed. This was the precursor of the box camera, and was placed on the market principally for sale to artists. The device (shown right) threw an observed image (of a person, object, or view) onto an internal mirror at a 45-degree angle, and the mirror, in turn, projected the image onto a piece of ground glass at the top of the box where it could be conveniently viewed. This enabled the artist to study an image which he desired to paint at close range; or, if he preferred, he could trace the image for later use by placing a piece of translucent paper over the glass. In time, these camera obscuras were equipped with achromatic lenses, which bring the visual and nonvisible light rays (possessing radiant energy) to the same point of focus. With an achromatic lens, camera obscura viewers could visually focus the lens on the intended image, and the image observed on the viewing glass would appear equally sharp.

Thus, by the 1700s, an early form of camera was in wide use, but its images could only be observed while the device was being used, and were never "trapped."

In 1725, scientists learned that the sun's rays could be utilized to darken silver salts (a procedure upon which photography would later depend). They found, too, that the darkening was caused not by the heat from the sun, but by the light. Silhouettes of objects, or of a person's head, placed directly between the sun's rays and a screen or other surface "sensitized" with silver nitrate could be "captured" on the sensitized surface as soon as the rays darkened the surface around the reflected image. But then the silhouette itself would darken upon exposure to light.

By the end of the eighteenth century, experiments were begun to find a means not only of securing but "fixing" the images of the camera obscura on paper, or on other surfaces coated with light-sensitive nitrate of silver, chloride of silver, or other substances. The ultimate success of these efforts can be credited principally to the separate undertakings of these five men:

THOMAS WEDGEWOOD (1771–1805) Fourth son of the noted English potter Josiah Wedgewood, Thomas Wedgewood experimented first with a camera obscura, then by directly superimposing leaves, wings of insects, paintings-on-

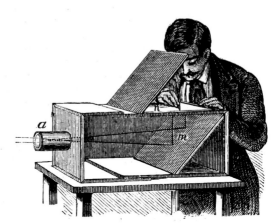

A portable camera obscura. The mirror reflects the image to the viewing glass.

glass, etc., on sensitized paper on white leather, and exposing them to light. He also obtained silhouettes by casting the shadow of a figure upon his treated surfaces—but the result was always the same; all of his copied images had to be kept in a dark place to prevent their fading and ultimate complete disappearance from exposure to light. Sir Humphrey Davy, a close friend of Wedgewood's and professor of chemistry at the Royal Institution, concluded in a report published in 1802: "Nothing but a method of preventing the unshaded parts of the delineation from being coloured [darkened] by exposure to the day is wanting, to render the process as useful as it is elegant." [1] Three years later, Wedgewood—who suffered from an illness his doctors could never identify—was dead at age thirty-four. Today, he is remembered as the first to secure photographic images, albeit temporarily.

JOSEPH NICEPHORE NIÉPCE (1765–1833) Niépce was a country gentleman who managed to save a portion of the family fortune after the French Revolution, and experimented at his estate near Châlon-sur-Sâone. He secured images on paper, partially "fixed" with nitric acid, which could be viewed in daylight, but evidently only for a short time.

His first success resulted from spreading a thin layer of light-sensitive bitumen of Judea (an asphalt used in engraving and lithography) on a glass plate, and exposing the plate, together with an engraving superimposed on it, to light for several hours. The bitumen beneath the white parts of the engraving hardened, while that beneath the dark lines remained soluble, and could be washed away with a solvent. The result was a permanently copied image, and technically the world's first photo-engraving (a specimen which, unfortunately, was later dropped and broken by a clumsy admirer).

In 1826, Niépce produced a series of photo-engraving

plates on pewter, and in 1826 or 1827 exposed a pewter plate of size 8 inches by 6½ inches (sensitized with bitumen) in a camera obscura and after an eight-hour exposure secured what is now recognized to be the world's first photograph obtained with a camera. The picture is of a pigeon house and barn adjacent to the Niépce home. Niépce called his pictures "heliographs," and prints from some of his photo-engraving plates were pulled as late as 1864 and 1869. In 1829, Niépce formed a partnership with Louis Jacques Mande Daguerre to continue photography experiments jointly, but in 1833 he died of a stroke.[2]

LOUIS JACQUES MANDE DAGUERRE (1787–1851) Painter, scenic designer, and proprietor of the Diorama (a theater without actors in Paris, where enormous paintings were exhibited under changing light effects to paying audiences), this Frenchman lacked a knowledge of physics or chemistry, yet was actively engaged in trying to secure permanent images with a camera obscura before entering into partnership in 1829 with Niépce. The latter had experimented with iodized plates (both pewter and silver-coated metal plates) before his death in 1833, but Daguerre alone perfected the finally adopted method of sensitizing the silver plates with the fumes of iodine. This was accomplished by placing the silvered side of the plate over a box containing particles of iodine. The iodine fumes, after heating, produced light-sensitive silver iodide when they came into contact with the silver.

In 1835, he also found a means of bringing out, or "developing" the unseen, or latent images secured on his plates by subjecting the plates after exposure to mercury vapor. The "fixing" of his secured images was accomplished with common salt. For a description of an early American Daguerre-type camera, see page 12.

In 1837 and 1838, Daguerre attempted to sell, or interest subscribers in his "daguerreotype" invention, but then the director of the Paris Observatory, Francois Arago, stepped into the picture. Recognizing its immense potential, Arago decided to use his influence to have France purchase Daguerre's invention and make it available to the entire world. This he accomplished by shepherding a bill through the French Chamber of Deputies which provided a pension both for Daguerre and Niépce's son, Isadore Niépce. Arago also appeared before the French Academy of Sciences (on January 7, 1839) and, after the passage of his bill, before a joint session of the Sciences Academy and the French Institute of Fine Arts (on August 19), to announce the details of the daguerreotype process. In his first talk, he was careful to point out that Daguerre's process could not produce pictures in color. "There are only white, black and grey tones representing light, shade and half-tones," he explained. "In M. Daguerre's camera obscura, light itself reproduces the forms and properties of external objects with almost mathematical precision; but while the photometric proportions of the various white, black and grey tones are exactly preserved, red, yellow, green, etc. are represented by half-tones, for the method produces drawings and not pictures in colour." Within a year, manuals covering the daguerreotype process were published in eight languages, and in thirty-two separate editions. The process was a no-negative one, but for nearly two decades it was to serve as the world's principal mode of photography.[3]

W. H. FOX TALBOT (1800–1877) Unaware of Daguerre's activities, this member of the English landed gentry, and Fellow of the Royal Society, experimented with photography at his country estate near Bath, and by 1835 had succeeded in securing images (in reverse) on ordinary writing paper, which he sensitized with silver chloride. Next, he put a reversed image in contact with another sensitized sheet and found he could obtain a re-reversed image on the second sheet (providing a picture the way it would be seen by the naked eye). The sheet with the reversed image was a form of negative, since it had served the purpose of making the re-reversed image, a second positive. In this way, Talbot in effect was the first to use a negative-positive mode in making a photograph. But because he was preoccupied with research in other scientific fields, he had made no formal report of his discoveries before word of Daguerre's discovery came from Paris.

Word of the new French process spread quickly to other countries. Immediately upon hearing it, Talbot put together specimens of his work—items which he called "photogenic drawings"—and both his own formal announcement and that of Daguerre's were made at an evening meeting of the Royal Institution on January 25, 1839. Six days later, a detailed description of Talbot's experiments was read to members of the Royal Society by the Society's secretary. But like Daguerre, Talbot had really not found a solution to the permanent "fixing" of pictures obtained with a camera. He bathed his images in a strong solution of sodium chlo-

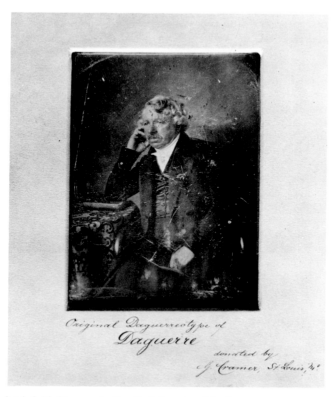

Original Daguerreotype of Daguerre

donated by G. Cramer, St Louis, Mo.

Louis J. M. Daguerre (1787–1851), inventor of the daguerreotype process, from a daguerreotype by Charles Meade of Albany, New York, taken in 1849. After 1852, brothers Charles and Henry Meade operated a photography studio in New York City.

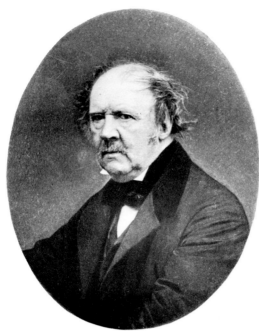

W. H. Fox Talbot (1800–1877), inventor of the calotype process.

of photography, and devoted much of his time to the study of the effects of light on organic and inorganic substances. In 1819, he had discovered a new acid from which a group of salts could be derived, and when word of Daguerre's announcement reached him, he went to work in his laboratory 19 miles west of London and a week later (January 29, 1839) perfected a method of using one of the new salts—hyposulphite of soda—as an improved means of "fixing" a daguerreotype image on a silver-coated metal plate. Thus, Herschel is given the credit for discovering the "hypo" used to the present day in every photographic darkroom.[5]

HIPPOLYTE BAYARD (1801–1887) Holder of a modest position in the French government, Bayard began experiments somewhat different from Talbot's as early as 1837. In May 1839, he exhibited pictures secured on paper to the physicist Jean Baptiste Biot and to Arago, who considered Bayard's work a threat to the government's negotiations with Daguerre, and arranged for a subsidy to prolong Bayard's experiments for a period of another year.[6] The historian W. Jerome Harrison, a Fellow of the Royal Geological Society and an officer of the Birmingham Photographic Society, gave this description of Bayard's process in 1895:

> Bayard's process was that he prepared a surface of chloride of silver on paper by means of a 2 per cent solution of chloride of ammonium, with subsequent drying followed by sensitizing upon a bath of a 10 per cent solution of nitrate of silver. The paper was then exposed to light until it became black all over, after which it was washed in several changes of water, and preserved in a portfolio until required for use. To sensitize it, a 4 per cent solution of iodide of potassium was applied, and the paper exposed in the camera. Iodine was liberated wherever the light acted, and, entering into combination with the silver, formed an image in iodide of silver; this was dissolved in the fixing solution, which consisted of diluted ammonia. In this way a positive on paper, with its sides reversed, was produced in the camera.[7]

ride, which made the unexposed, or imaged portion of the sensitized paper, relatively insensitive to light, but this was "stabilizing" rather than "fixing" the pictures permanently.[4]

SIR JOHN HERSCHEL (1792–1871) A renowned mathematician, chemist, astronomer, and past president of the Royal Society in 1839, Herschel appears to have been more interested in photochemistry than in inventing a practical process

THE CLIMATE FOR TECHNOLOGY IN AMERICA: 1800–1839

There were few attempts, as we shall see, to experiment with some primitive form of photography in America prior to 1839, principally because there were few men of science in the classical sense to be found in the new country. While American inventiveness became a recognized national trait after the turn of the century, it was directed primarily at solving problems of transportation, and in bringing the Industrial Revolution to the American scene. Such purely scientific research as there was in this period concerned itself less with adding to the body of technical knowledge than with merely keeping up with rapid scientific advances taking place across the Atlantic.

America had produced two outstanding men of science prior to the American Revolution, the foremost among them being Benjamin Franklin. But Franklin lived in England or France much of the time after he passed the age of fifty. The other early technical giant was Massachusetts-born Benjamin Thompson (later Count Rumford), who became a Tory in 1776 (at age twenty-three) and thereafter lived an illustrious life abroad. Thompson became a Bavarian diplo-

mat, military strategist (greatly admired by Napoleon), Royal Scientist to King George III, founder of Britain's Royal Institution, and, in 1791, a count of the Holy Roman Empire. He not only exhibited Yankee ingenuity in numerous inventions (a drip coffeepot; the basic design for the modern fireplace and flue) but also contributed substantially to the fundamental knowledge on which his own and later technical advances of others were based.

The first American scientific society was organized in 1743 as the American Philosophical Society, with Franklin as secretary. College chairs in chemistry were not established until after the Revolution, the earliest being professorships at Harvard and Princeton. Institutional instruction in chemistry, at the outset of the nineteenth century, was almost exclusively confined to medical schools. The traditional college curriculum, at most colleges and universities, was heavily weighted toward literary pursuits and the study of classical languages. In 1828, the president of Union College in Schenectady, Eliphalet Nott, "cut loose" from this rigid curriculum structure and organized a "scien-

tific course'' which he said was designed to fit young men for "practical life." One of Nott's students, Charles A. Seely, an 1847 graduate, founded (in 1855) the *American Journal of Photography*, and went on to obtain nineteen United States patents for improvements in photographic processes.

The first chair in chemistry at Yale was established in 1802 and filled by Benjamin Silliman (1779–1864), who founded the *American Journal of Science and the Arts* sixteen years later. Although the Franklin Institute had been established at Philadelphia in 1823, the American Association for the Advancement of Science and the Smithsonian Institution were not established until 1846. Even as late as 1850, when Josiah Parsons Cooke, Jr., assumed the chair of Erving Professor of Chemistry at Harvard, he found the Chemical Department of the college to be nearly extinct, and his first years have been described as "a constant struggle to re-establish the chemical teaching . . . and to raise chemistry to a position of equality with the so-called humanities, which up to that time had held undisputed possession of the college course.''[8]

America had a number of technical giants early in the nineteenth century, among them Silliman and Thomas Cooper (chemistry), Joseph Henry (electricity), Nathaniel Bowditch (navigation), James Dwight Dana (geology), Gotthilf Muhlenberg (botany), and William Redfield (meteorology). But many, like Cooke, achieved their positions of prominence with only fragmentary schooling. The noted Philadelphia chemist and inventor Dr. Robert Hare (1781–1858), for example, learned chemistry by independent study and helped run his family's brewery while functioning at the same time as professor of natural philosophy at the University of Pennsylvania Medical School. In 1818, Hare was named professor of chemistry at the medical school, where his lecture hall was considered "perhaps the best equipped in the United States'' at that time.[9]

One of Hare's students, and evidently the man whose experiments most closely paralleled those of photography's founding fathers in Europe, was John William Draper. Born in England, Draper studied chemistry at the University of London for several years, then came to America in 1832. He was graduated from the University of Pennsylvania Medical School in 1836, and the same year took a position as professor of chemistry and natural philosophy at Hampden-Sidney College in Virginia. His experiments in photochemistry and photography during the period 1836–1839 are recounted in this (excerpted) reminiscence, published in 1858:

For years before either Daguerre or Talbot had published anything on the subject, I had been in the habit of using sensitive paper for investigations of this kind. It was thus as you will find by looking into the Journal of the Franklin Institute for 1837, that I had examined the impressions of the solar spectrum, proved the interference of the chemical rays, investigated the action of moonlight and of flames, either common or colored, red or green, and also the effects of yellow and blue solutions, and other absorbing media. You will notice that in these experiments I was using the preparations of bromine, about which so much has of late been said. The difficulty at this time was to fix the impressions. I had long known what had been done in the copying of objects by Wedgewood and Davy, had amused myself with repeating some of their experiments, and had even unsuccessfully tried the use of hyposulphite of soda, having learnt its properties in relation to the chloride of silver from

Herschel's experiments, but abandoned it because I found it removed the black as well as the white parts. This want of success was probably owing to my having used too strong a solution, and kept the paper in it too long. . . When Mr. Talbot's experiments appeared in the spring of 1839, they, of course, interested me greatly, as having been at work on the action of light for so many years. I repeated what he published and varied it. This was whilst I was professor at Hampden Sidney College in Virginia, and before anything had been published by Daguerre. . .

It was during my repetitions of Mr. Talbot's experiments that I recognized the practical value of the experiments I had made in 1835, and published in 1837 respecting the chemical focus of a non achromatic lens, and saw that the camera must be shortened in order to obtain a sharp picture. It is the experiment of passing a cone of light through a known aperture on sensitive paper. It was from considering the difficulty of getting an impression from colored surfaces as red or green, that I saw the necessity of enlarging the aperture of the lens, and diminishing its focus, so as to have the image as bright as possible; for it was plain that in no other way landscapes could be taken or silhouettes replaced by portraits. And when I had failed altogether in these particulars, I knew it was owing to insufficient sensitiveness in the bromine paper, and waited anxiously for the divulging of Daguerre's process, respecting which statements were beginning to be made in the newspapers.[10]

A report that an Indiana youth experimented with photography as early as 1828 is contained in the first chapter of *The History and Practice of the Art of Photography*, by Henry Hunt Snelling, published in 1849. The youth, James M. Wattles, was using a camera obscura while studying under the Parisian artist Charles Le Seur at the New Harmony School in Indiana, according to Snelling. The latter also states in his book that Wattles' parents "laughed at him" and "bade him attend to his studies and let such moonshine thoughts alone." Snelling gives this account of the experiments in Wattles' own words:

" I first dipped a quarter sheet of thin white writing paper in a weak solution of caustic (as I then called it) and dried it in an empty box, to keep it in the dark; when dry, I placed it in the camera and watched it with great patience for nearly half an hour, without producing any visible result; evidently from the solution being to weak. I then soaked the same piece of paper in a solution of common potash, and then again in caustic water a little stronger than the first, and when dry placed it in the camera. In about forty-five minutes I plainly percieved the effect, in the gradual darkening of various parts of the view, which was the old stone fort in the rear of the school garden, with the trees, fence, &c. I then became convinced of the practicability of producing beautiful solar pictures in this way; but, alas! my picture vanished and with it, all—no not *all*—my hopes. With renewed determination I began again by studying the nature of the preparation, and came to the conclusion, that if I could destroy the part not acted upon by the light without injuring that which was so acted upon, I could save my pictures. I then made a strong solution of sal. soda I had in the house, and soaked my paper in it, and then washed it off in hot water, which perfectly fixed the view upon the paper. This paper was very poor with thick spots, more absorbent than other parts, and consequently made dark shades in the picture where they should not have been; but it was enough to convince me that I had succeeded, and that at some future time, when I had the means and a more extensive knowledge of chemistry, I could apply myself to it again. I have done so since, at various times, with perfect success; but in every instance laboring under adverse circumstances.''[11]

SOLITARY BEGINNINGS

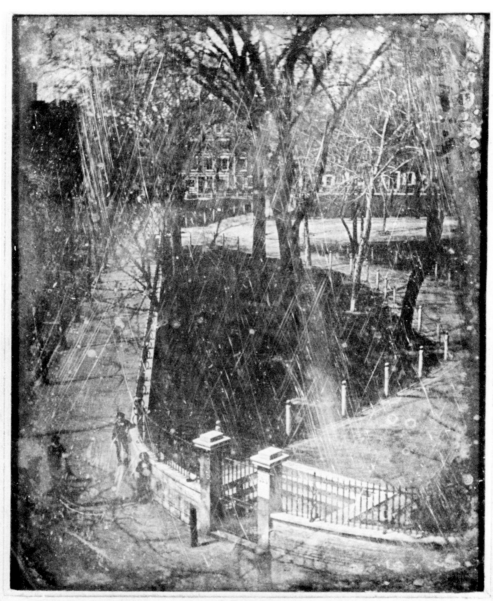

South West gate leading into Independance Square Philada

Philadelphia, New York, and Boston were the prime centers where the first practice of daguerreotype photography took place in the United States. Outdoor daguerreotype views were made in New York in 1839, but the specimens are not known to be extant. Although the date of the early daguerreotype made of Independence Square (above) is not known, the image was acquired by its present owner from descendants of the Philadelphia naturalist and artist Titian Ramsey Peale (1799–1885). Titian Peale was named an official of the Philadelphia Museum in 1821, but during the years 1838–1842 he accompanied the American naval officer Charles Wilkes on the latter's historic scientific exploration of the South Seas and Antarctic Ocean. Scratch marks which appear on the image surface are probably the result of a mistaken attempt made in subsequent years to clean the surface of silvered metal plate with a cloth.

THE YOUNG DAGUERREANS
1839

It is probable that news of Daguerre's invention was published in American as well as European newspapers and journals in the first three months of 1839, but the earliest limited description of the process was sent by S. F. B. Morse to his brothers in New York after Morse had met with Daguerre in Paris on March 7 and 8. Morse's brothers were publishers of the *New York Observer,* a religious weekly with wide readership, and Morse's letter appeared in the May 18 issue.

> A few days ago I addressed a note to M. Daguerre requesting, as a stranger, the favor to see his results, and inviting him in turn to see my Telegraph. I was politely invited to see them under these circumstances, for he had determined not to show them again, until the Chambers had passed definitely on a proposition for the Government to purchase the secret of the discovery, and make it public. The day before yesterday, the 7th, I called on M. Daguerre, at his rooms in the Diorama, to see these admirable results. They are produced on a metallic surface, the principal pieces about 7 inches by 5, and they resemble aquatint engravings, for they are in simple chiaro-oscuro, and not in colors. But the exquisite minuteness of the delineation cannot be conceived. No painting or engraving ever approached it. For example: In a view up the street, a distant sign would be perceived, and the eye could just discern that there were lines of letters upon it, but so minute as not to be read with the naked eye. By the assistance of a powerful lens, which magnified 50 times, applied to the delineation, every letter was clearly and distinctly legible, and so also were the minutest breaks and lines in the walls of the buildings, and the pavements of the street. The effect of the lens upon the picture was in great degree like that of the telescope in nature.
>
> Objects moving are not impressed. The Boulevard, so constantly filled with a moving throng of pedestrians and carriages, was perfectly solitary, except for an individual who was having his boots shined. His feet were compelled, of course, to be stationary for some time, one being on the box of the boot-black and the other on the ground. Consequently, his boots and legs are well defined, but he is without body or head because these were in motion.[12]

Talbot, meanwhile, having been spurred to action by Daguerre's first announcement in January, disclosed the details of his primitive paper process immediately, and these were published in American journals as early as April.[13] The American academic community appears to have been first to respond. At some point in the spring of 1839, two Harvard students, Edward Everett Hale (later a noted clergyman and author) and Samuel Longfellow (brother of the poet) "repeated Talbot's experiments at once," using a small camera obscura and a common lens to secure a photographic image of a bust of Apollo, which reposed in a window of Harvard Hall.[14] In Cincinnati, John Locke, professor of chemistry and pharmacy at the Medical College of Ohio, exhibited specimens of photogenic drawings in a bookstore. The *Observer* picked up the story from a local Cincinnati newspaper and published it in the same issue in which Morse's letter appeared:

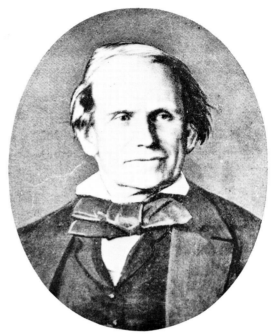

John Locke (1792–1856), possibly the first American to exhibit photographs to the public, which he made with Talbot's primitive "photogenic drawing" method. The son of the founder of Locke Mills, Maine, Locke left home in 1815 when his father opposed further scientific education. He attended Benjamin Silliman's lectures at Yale and became his laboratory assistant for a year. From 1816 to 1818 he studied medicine with doctors at Keene, New Hampshire, and in 1819 published his *Outlines of Botany* containing over two hundred illustrations, all drawn and engraved by himself. Because he felt that New England was dominated by religious intolerance, he moved west to Cincinnati where in 1822 he founded an academy for women. In 1835, he was appointed professor of chemistry and pharmacy at the Medical College of Ohio, a position he held until three years before his death.

> Some experiments on the subject of photogenic drawing have been made by Prof. Locke of the Medical College of Ohio, and with entire success. He prepared paper chemically for this purpose, and placed it under some astronomical diagrams, which were then exposed to the sun's rays. The new picture was in a few minutes formed and removed, and a process used by which the figures were permanently fixed. The specimens which the Doctor has left in our hands are in every respect satisfactory. They look as though they had been carefully engraven. The difficulty or mystery connected with the matter is to retain the picture which the light has formed on the paper. This has been overcome, and the curious may satisfy themselves with what success, by examining a few small specimens which we have left at Mr. Flash's book store.[15]

The *Observer* article reporting on Locke's experiments appeared under the heading "American Daguerroscope," which was indicative of the confusion in the public mind at this time between the French and British inventions. With the benefit of hindsight, it is now easy to see why photog-

SOME INITIAL THOUGHTS
ON THE EFFECTS OF
THE DAGUERREOTYPE ON ART

Thomas Cole wrote a friend in 1840: "You would be led to suppose that the poor craft of painting was knocked in the head by this new machinery for making Nature take her own likeness, and we [artists] nothing to do but give up the ghost." But he said he felt that "the art of painting is creative, as well as an imitative art, and is in no danger of being superseded by any mechanical contrivance." One might have thought he "ghosted" this (excerpted) commentary, published in *The Corsair* on April 13, 1839:

> Here, in truth, is a discovery launched upon the world, that must make a revolution in art. It is impossible, at first view, not to be amused at the sundry whimsical views the coming changes present. But, to speak more seriously, in what way, in what degree, will art be affected by by it ! Art is of two kinds, or more properly speaking, has two walks, the imaginative and the imitative ; the latter may, indeed, greatly assist the former, but, in the *strictly* imitative, imagination may not enter but to do mischief. They may be considered therefore, as the two only proper walks. It must be evident that the higher, the imaginative, cannot immediately be affected by the new discovery—it is not tangible to its power—the poetry of the mind cannot be submitted to this material process ; but there is a point of view in which it may be highly detrimental to genius, which, being but a power over materials, must collect with pains and labor, and acquire a *facility* of drawing. Now, it is manifest that, if the artist can lay up a store of objects without the (at first very tedious) process of correct drawing, both his mind and his hand will fail him ; the mind will not readily supply what it does not know practically and familiarly, and the hand must be crippled when brought to execute what it has not previously supplied as a sketch. Who will make elaborate drawings from statues or from life, if he can be supplied in a more perfect, a more true manner, and in the space of a few minutes, either with the most simple or the most complicated forms ! How very few will apply themselves to a drudgery, the benefits of which are to be so remote, as an ultimate improvement, and will forego for that hope, which genius may be most inclined to doubt, immediate possession ! But if genius could really be schooled to severe discipline, the new discovery, by new and most accurate forms, might greatly aid conception. If this view be correct, we may have fewer artists ; but those few, who will "spurn delights and live laborious days," will arrive at an eminence which no modern, and possibly no ancient master has reached.
>
> But, in the merely imitative walk, and that chiefly for scientific purposes, draughts of machinery and objects of natural history, the practice of art, as it now exists, will be nearly annihilated—it will be chiefly confined to the coloring representations made by the new instruments—for it is not presumed that color will be produced by the new process.
>
> Ye animal painters, go no more to the Zoologicals to stare the lions out of countenance—they do not want your countenace any more. The day is come for every beast to be his own portrait painter. "None but himself shall be his parallel." Every garden will publish its own *Botanical Magazine*. The true "Forget me not" will banish all others from the earth. Talk no more of "holding the mirror up to nature"—she will hold it up to herself, and present you with a copy of her countenance for a penny. What would you say to looking in a mirror and having the image fastened ! ! As one looks sometimes, it is really quite frightful to think of it ; but such a thing is possible—nay, it is probable—no, it is certain. What will become of the poor thieves, when they shall see handed in as evidence against them their own portraits, taken by the room in which they stole, and in the very act of stealing ! What wonderful discoveries is this wonderful discovery destined to discover ! The telescope is rather an unfair tell-tale ; but now every thing and every body may have to encounter his double every where, most inconveniently, and thus every one become his own caricaturist. Any one may walk about with his patent sketch-book—set it to work—and see in a few moments what is doing behind his back ! Poor Murphy outdone !—the weather must be its own almanack—the waters keep their own tide-tables. What confusion will there be in autograph signs manual ! How difficult to prove the representation a forgery, if nobody has a hand in it ! ! [16]

raphy took off in the direction of Daguerre's rather than Talbot's invention. The British government never took the same action as did the French to purchase Talbot's rights and donate them, freely, to the world at large. Immediately, manuals on Daguerre's process were published in eight languages, while no detailed information of schematic drawings covering the workings of Talbot's method appeared in either scientific or general news publications. Suitable chemical means for developing the latent image of a "photogenic drawing" were also not forthcoming until the fall of 1840, and Talbot's improved calotype process (also known as the Talbotype process) was not perfected and patented until February 8, 1841. (See page 31.) No promoter of Talbot's invention traveled the American lecture circuit either, as did Daguerre's agent, Francois Gouraud, who came to New York in November 1839 to hold exhibits and lectures first in New York City and soon thereafter in Boston.

Thus, while Talbot worked in seclusion at his English country estate endeavoring to further perfect his paper process, the "new art" of daguerreotyping spread like the wave of a new fashion on the continent, and to the United States. Daguerre, meanwhile, also took out a patent in England for the daguerreotype just prior to his government's purchase of the rights to the process. Perhaps because of his new friendship with Morse (or because there wasn't time), he made no attempt to patent the daguerreotype in America. This meant that there were no restrictions on its practice or further development in the United States, while at the same time the patent secured in Great Britain retarded its early practice there. A Frenchman, Antoine Claudet, who lived in London but had learned the daguerreotype process directly from Daguerre, purchased the English rights, and for a short time was the sole practitioner in the United Kingdom.

From the evidence which presently exists, New York, Philadelphia, and Boston were the principal scenes of action during the first year of the daguerreotype practice in the United States. Having been the first to provide American readers with a personal report on Daguerre's invention, Morse was among the first to take up its practice upon his return to New York. But as late as November 19, he dispatched a letter to Daguerre stating that he had been experimenting "with indifferent success," and promising the Frenchman that he would be favored with the first specimen that was "in any degree perfect." [17]

Morse's first camera was made by George W. Prosch, a manufacturer of scientific instruments who later was among the first to advertise commercially available cameras (his first advertisement appeared March 28, 1840). Forty-three years after the event, Prosch's brother, A. Prosch, published a reminiscence (see right) describing how the Morse camera was made, and how a Daguerre manual was brought to Morse by D. W. Seager, and was translated and used by Morse to aid in the equipment construction. One of Morse's first pictures, according to Prosch's account, was a daguerreotype of the New York City Hall.

A year after A. Prosch's reminiscence was published (in 1882), another reminiscence appeared looking back forty-four years to these same events. This was written by a Brooklyn, New York, resident, George E. West, [18] who recalled that in 1839 he represented the Rutgers Female Institute located at the time in the same building with George

Prosch (No. 142 Nassau Street), and that he, too, recalled Seager's having brought a Daguerre manual to Morse. "I was in his [George Prosch's] shop almost every day," West stated in his account. West also said Morse's City Hall daguerreotype was "the first daguerreotype of still life taken in this country," adding that it was taken in October 1839. But, as we shall see, this statement was in error, Seager having publicly exhibited a daguerreotype view earlier.

To further confuse the issue, Morse himself recollected later in life (in 1855) that his first successful daguerreotype was not of City Hall, but of the Unitarian Church adjacent to what is now New York University. Whenever it was taken, *The Corsair* reported on February 22, 1840, that a daguerreotype view of City Hall taken by Morse was on exhibit "in Chamber Street," adding: "We never saw anything in the shape of an engraving so beautiful."

Morse did not remember Seager's correct name in 1855; however, it was Seager who was first to publicly exhibit a daguerreotype. The *New York Morning Herald,* on September 30, 1839, reported viewing a daguerreotype taken three days earlier by Seager of St. Paul's Church (the edifice which stands to the present day at Broadway and Fulton streets). Although it subsequently disappeared, along with its maker (Morse indicated in 1855 that Seager had gone to Mexico), the Seager daguerreotype is generally regarded as the earliest produced and exhibited in the United States, for which documentation exists.

Having exhibited his daguerreotype, Seager announced in the press that he would hold a lecture on the daguerreotype process on Saturday evening, October 5, at the Stuyvesant Institute in New York City. It is quite possible that a twenty-six-year-old man of scientific bent, John Johnson, a native of Saco, Maine, attended this lecture. For, on the following day, or on Monday, October 7, Johnson brought a description of the process to his business partner, Alexander S. Wolcott, thirty-five, a manufacturer of instruments and dental equipment at 52 First Street. While Wolcott set about sketching a design he had in mind for a camera different from Daguerre's, Johnson went out and purchased the necessary materials for its construction and use (see next page). Quietly, the pair then proceeded on that same day to build the prototype of America's first patented camera. It was thereupon used by Wolcott, after several trials, to secure a daguerreotype profile of Johnson on a plate only ⅜th-inch square. This was, in all probability, the first successful photograph of a human being secured in the United States, although it, too, appears to have been lost. However, Samuel D. Humphrey, editor of *Humphrey's Journal,* disclosed to his readers on July 15, 1855, that the daguerreotype was then in his possession, and that he planned to send it to Europe, "that some of our friends as well as admirers of the art, may see it for themselves." [19]

Despite his letter to Daguerre of November 19, saying he was experimenting "with indifferent success," Morse claimed in 1855 that he had taken daguerreotypes of his daughter, both singly and in groups of her friends in September or early October 1839.[20] One of these specimens he sent to Marcus A. Root, who reproduced it as an engraving in *The Camera and the Pencil,* published in 1864. Root said he found the eyes of the sitters (in this case two) "tolerably

A DAGUERRE MANUAL THROWN ABOARD SHIP FOR NEW YORK

This reminiscence was published in 1882 by A. Prosch, whose brother, in 1839, made the first daguerreotype camera used by Samuel F. B. Morse.

EARLY in the fall of 1839 a gentleman by the name of Seger, and by birth an Englishman, but a resident of this city, had been on a visit to Europe, and returning to this country in one of our London packets just prior to the successful establishment of steam navigation, had the good fortune to make a quick voyage.

On leaving the London dock a friend of his having just received from Paris one of the French pamphlets giving a complete description of the process of making pictures known as daguerreotypes threw the pamphlet from the dock to the ship, as the ship had already cast off. Upon Mr. Seger's arrival in New York, having a personal acquaintance with him, he at once sought Professor Morse. As the Professor was an artist by profession at that time, and also President of the Academy of Design, and naturally one who would not alone be interested in any new method of picture taking but also to receive early information of such process, therefore pamphlet in hand Mr. Seger sought him.

At the corner of Nassau and Beekman streets, in the structure known as the Morse buildings, Prof. Morse was lodging, and experimenting, also, with his telegraph. My brother, George W. Prosch, also had a workshop in the basement of the same building, he being a skilled mechanic in scientific instruments. Prof. Morse, much excited, one day came to my brother with the pamphlet spoken of, wishing him to quit other work at once and give immediate attention to this new discovery. My brother being equally interested in all new scientific discoveries did not require much urging, and the result was, Prof. Morse acting as translator, the first apparatus was completed in a very few days, made exactly after the French description. I think not a week elapsed after the reception of th pamphlet in this country before the first picture was made by my brother, with the assistance of Prof. Morse, Dr. James R. Chilton supplying the chemicals. One of the first pictures made was the City Hall, direct from the shop door at that time. There was an iron fence around the park, and hacks lined the curb stone waiting for custom. There upon the picture was the coachman sleeping on his box on the carriage, horses and carriage complete with view of City Hall, the horses standing so quietly that they, too, appeared almost like coachmen asleep This was the first picture of a living object taken, without doubt. It attracted a great deal of attention, and was hung with some others out by the door so that the passers-by could see them.[21]

DAGUERREOTYPE PORTRAIT

John Johnson's account (published in 1846) of the taking of his daguerreotype likeness by A. S. Wolcott, his business partner, on October 6, 1839.

On the morning of the 6th day of October, 1839, I took to A. Wolcott's residence a full description of Daguerre's discovery, he being at the time engaged in the department of Mechanical Dentistry on some work requiring his immediate attention, the work being promised at 2, P. M., that day; having, therefore, no opportunity to read the description for himself, (a thing he was accustomed to do at all times, when investigating any subject,) I read to him the paper, and proposed to him that if he would plan for a Camera, (a matter he was fully acquainted with, both theoretically and practically,) I would obtain the materials as specified by Daguerre. This being agreed tó, I departed for the purpose, and on my return to his shop, he handed me the sketch of a Camera box, without at all explaining in what manner the lens was to be mounted. This I also undertook to procure. After 2, P. M., he had more leisure, when he proceeded to complete the Camera, introducing for that purpose a reflector in the back of the box, and also to affix a plate holder on the inside, with a slide to obtain the focus on the plate, prepared after the manner of Daguerre. While Mr. Wolcott was engaged with the Camera, I busied myself in polishing the silver plate, or rather silver plated copper, but ere reaching the end preparatory to iodizing, I found I had nearly, or quite removed the silver surface from off the plate, and that being the best piece of silver plated copper to be found, the first remedy at hand, that suggested itself, was a burnisher, and a few strips were quickly burnished and polished. Meantime, the Camera being finished, Mr. Wolcott, after reading for himself Daguerre's method of iodizing, prepared two plates, and placing them in the Camera, guessed at the required time they should remain exposed to the action of the light; after mercurializing each in turn, and removing the iodized surface with a solution of common salt, two successful impressions were obtained, each *unlike the other!* Considerable surprise was excited by this result; for each plate was managed precisely like the other. On referring to Daguerre, no explanation was found for this strange result; time, however, revealed to us that one picture was positive, and the other negative. On this subject I shall have much to say during the progress of the work. Investigating the cause of this difference, occupied the remainder of that day. However, another attempt was resolved upon, and the instruments, plates, etc., prepared, and taken up into an attic room, in a position most favorable for light. Having duly arranged the Camera, I *sat* for five minutes, and the result was a profile miniature, (a miniature in reality,) on a plate not quite three-eighths of an inch square. Thus, with much deliberation and study, passed the *first* day in Daguerreotype— little dreaming or knowing into what a labyrinth such a beginning was hastening us. [22]

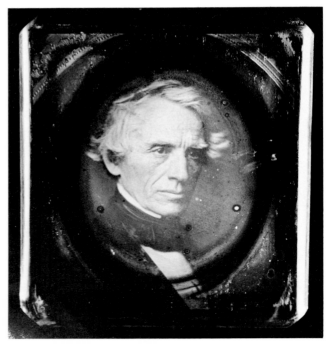

Samuel F. B. Morse (1791–1872), from an unpublished daguerreotype.

well defined'' on the original plate, even though he ''presumed'' that the eyes of the two girls had been both opened and closed during what Morse said had been a 10- to 20-minute exposure. It seems likely that if Morse had failed to exhibit daguerreotype specimens at the same time as Seager (the end of September), this and other portraits of his daughter and her friends were taken sometime later.

Prof. John W. Draper, meanwhile, had left Hampton-Sidney to assume a professorship at New York City University (now New York University) on September 28, 1838. In 1839, he, too, took up the ''new art,'' recalling in later years that he succeeded ''with no other difficulty than the imperfection of the silver plating in copying brick buildings, a church, and other objects seen from my laboratory window.'' None of these specimens, however, is extant. Draper afterwards tried portraiture, at first using a lens of 5 inches diameter (and a 7-inch focal length) and dusting the faces of his sitters with flour. But he soon found that the makeup was unnecessary. He also experimented for a time with lenses of other size. ''The first portrait I obtained last December,'' he wrote in an article published in July 1840, ''was with a common spectacle glass, only an inch in diameter, arranged at the end of a cigar box.'' Draper is also on record as saying that it was ''about this time'' (when he experimented with the spectacle glass) that he became acquainted with Morse, after which the pair took portraits on the rooftop of the University.[23]

The problem, in 1839, was that Daguerre's process was ''still an undeveloped mystery,'' according to Montgomery P. Simons, later a prominent Virginia photographer. ''For some cause or other,'' he said, ''the published accounts of it received were not clear nor definite, and as a matter of course, those who took hold of it in its early stages had a good deal to contend with, being obliged to fill in and work

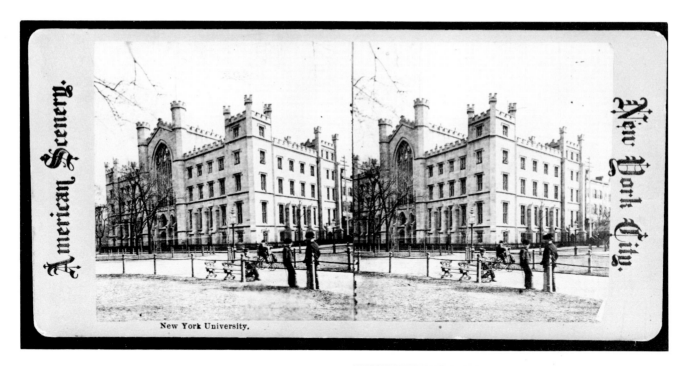

New York University.

up a picture (so to speak) from indistinct outlines."[24] Morse, Draper, and Wolcott all made different cameras, or had them constructed under their personal supervision. Others who did the same were Joseph Saxton, a curator at the United States Mint; Robert Cornelius, inventor, metalworker, and son of the founder of Cornelius & Sons of Philadelphia, largest American manufacturer (in the 1870s) of gas fixtures; and Prof. Paul Beck Goddard, an associate of Dr. Robert Hare at the University of Pennsylvania. Saxton was first, in Philadelphia, to experiment with the daguerreotype process. He fixed an ordinary sunglass in a cigar box, perfected a makeshift coating box and mercury bath, and on October 16, 1839, from a window in the Mint, secured a view of the Philadelphia Arsenal and cupola of the Central High School. This somewhat indistinct photograph, taken on a burnished piece of silver 1¼ x 2 inches, is the earliest known American-made daguerreotype image to survive to modern times. Saxton also secured a second image from the Mint.[25]

Robert Cornelius, in later years, recounted in these words how he began a brief career in the daguerreotype art (1839–1842), which started with a request for assistance from Saxton:

He [Saxton] was anxious to continue the experiment, and called upon me, and showed his experiment [the daguerreotype made on October 16], and explained to me the manner of doing it, and desired me to prepare some plated metal (copper coated with silver). Very soon afterwards I made in the factory a tin box (and boxes according to Saxton's description), and bought from McAllister . . . a lens about two inches in diameter, such as was used for opera purposes (called achromatic). With these instruments I made the first likeness of myself, and another one of some of my children, in the open yard of my dwelling, sunlight bright upon us."[26]

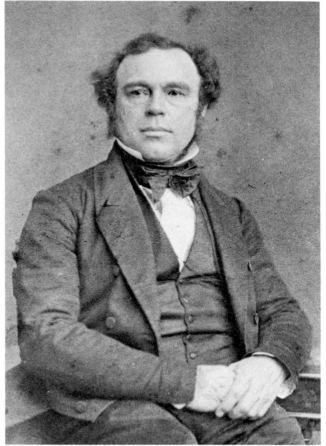

Prof. John W. Draper, shown above in an early paper photograph made by J. DeWitt Brinckerhoff, opened a daguerreotype portrait studio with Samuel F. B. Morse in 1840 atop the New York University building (also shown above) which then stood at Washington Square East and Waverly Place.

1839

11

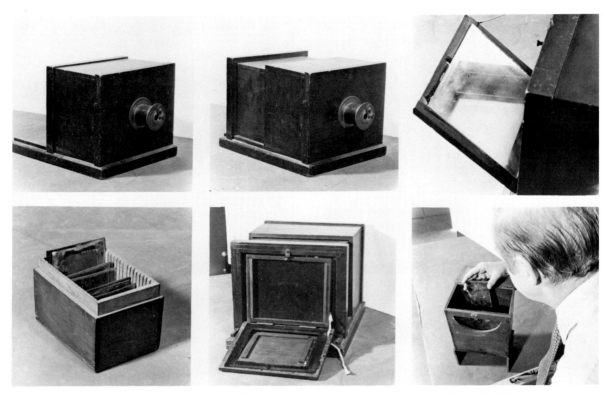

Apparatus owned by Dr. Paul Beck Goddard, Assistant to the Professor of Chemistry, University of Pennsylvania (now part of the permanent collection of the Franklin Institute).

AN EARLY AMERICAN-MADE DAGUERREOTYPE CAMERA

CAMERA, shown in Figures 1 and 2, is of the sliding-box variety (for portability), and is made of white pine blackened within and without. Its dimensions are 10 inches high by 12 inches wide. Interior measures 14 inches when camera is fully extended. Sliding tube protrudes from front of camera, and is protected by a brass cap having an orifice of $9/16$ inches (controlled by a brass shutter). Achromatic lens, 2 inches in diameter, is set in back of tube.

REAR VIEW MIRROR, shown extended, 3, on a hinged chain at a 45-degree angle from back of camera, is removable and allows easy checking of focus. Image seen on mirror is reflected by camera's ground glass, which is of same size as the mirror ($4\frac{1}{2}$ x 6 inches). Mirror is unhooked and removed after focusing.

PLATES used in camera are shown in portable box, 4. Each measures $4\frac{1}{4}$ x $6\frac{1}{4}$ inches. Although the exact nature of plates first used by Goddard (and manufactured at the Cornelius & Sons factory) is not recorded, standard daguerreotype plates were soon used with the camera. Plates were made of copper, silvered on one side. Silvered side was first cleaned with rotton

stone, then brought to a high polish with a buffer. Great care was exercised to avoid the appearance of lines on the silvered surface.

EXPOSURE was made by removing mirror and ground glass from the back of camera, 5, and substituting a plateholder containing the sensitized image plate. Early exposures with daguerreotype cameras lasted as long as 10 to 20 minutes. Goddard's first portrait was taken in sunshine, reportedly in three minutes with this camera. Exposures by early 1840, achieved by "accelerating" imaging action on plates with the aid of bromine, were down to as little as from 10 to 60 seconds.

FUMING of exposed plate with mercury vapor, after its removal from camera, was accomplished by inserting plate in a special fuming box, 6. Spirit lamp placed beneath box heated mercury. Glass covering on side of box allowed viewing of plates during fuming, and their subsequent removal at the desired moment in "development" process. Iodine, bromine, and mercury used with apparatus were kept in glass-stoppered bottles which could be fitted into the fuming box for convenience of storage.[27]

1839

12

The Cornelius self-portrait (see next page) was in all probability made in November, or just before December 6, 1839, when the director of the United States Mint, Dr. Robert M. Patterson, exhibited a daguerreotype made by Cornelius at a meeting of the American Philosophical Society (unfortunately, the minutes of the meeting do not identify the subject of the image exhibited).[28]

These specimens by Saxton and Cornelius attracted widespread interest in Philadelphia scientific circles, and among the first to become interested in the daguerreotype process was Dr. Goddard. He and Cornelius soon became close working partners, although no formal business association was then established. Both soon ordered similar cameras of unique design (see illustration, left), which were constructed by Joachim Bishop, an assistant to Dr. Hare and the maker of the latter's research and demonstration apparatus. By December, too, Goddard had secured his first successful daguerreotype likeness—of Aaron D. Chaloner, a university student who reportedly posed in the sunshine for three minutes.[29]

By December, too, Goddard had also found the chemical means of treating a sensitized daguerreotype plate just before use in such a way as to substantially shorten the length of time required for an exposure. In this discovery, he was assisted both by Dr. Hare and Dr. Martin Boyé, another associate at the University of Pennsylvania.[30] As long as it

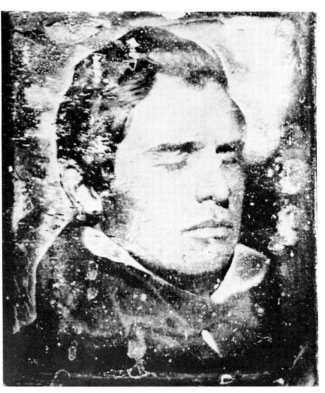

Henry Fitz, Jr. (1808–1863), pioneer American telescope maker and a co-worker with Alexander Wolcott and John Johnson in launching the first American photography studio in New York City. Image, with eyes closed because of the need for several minutes' exposure time, is on a daguerreotype plate of size 1½ x 1¾ inches, and may have been made in November 1839, when Fitz is reported by his son to have made his first daguerreotype portrait, and when an improved reflector was provided by Fitz for Wolcott's first patented American camera. Experiments by the trio were suspended in December 1839, hence the Fitz likeness may have been made in January 1840, or thereafter. Fitz died in his New York home twenty-three years later after being struck by a falling chandelier.

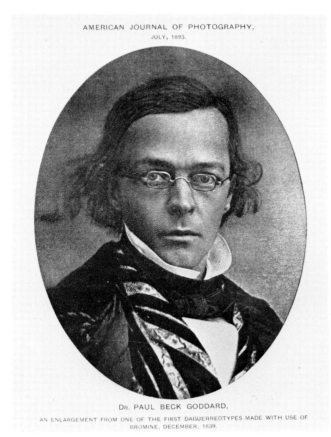

AMERICAN JOURNAL OF PHOTOGRAPHY,
JULY, 1893.

DR. PAUL BECK GODDARD,
AN ENLARGEMENT FROM ONE OF THE FIRST DAGUERREOTYPES MADE WITH USE OF BROMINE, DECEMBER, 1839.

Dr. Paul Beck Goddard, an associate of the noted Philadelphia chemist and inventor Prof. Robert Hare of the University of Pennsylvania.

was necessary to count minutes instead of seconds for every camera exposure, it was difficult to view the "new art" as applicable to portraiture. When he took the additional step of subjecting a plate already sensitized with iodine to the vapor of bromine (Daguerre's process only called for sensitizing with the slow-acting iodine), Goddard found he could accelerate the securing of an image during plate exposure in the camera. The use of bromine as an "accelerator" in daguerreotype practice evidently remained a Philadelphia secret for a year or more, although John Johnson and a British technician, John F. Goddard (no relation to the Philadelphia chemist), experimented with it in 1840, and a Wolcott "quickstuff" accelerating formula was on the market by 1841. Additional chemical techniques and other methods cutting exposure time were also put into practice by gifted practitioners in the 1850s.

The team of Wolcott and Johnson in New York, meanwhile, continued with their efforts to perfect a patentable "mirror" camera—one that would use a reflector rather than a lens. They felt, with some justification at this early stage in photography, that a reflector could focus more light on the image plate than a lens of any type then available.

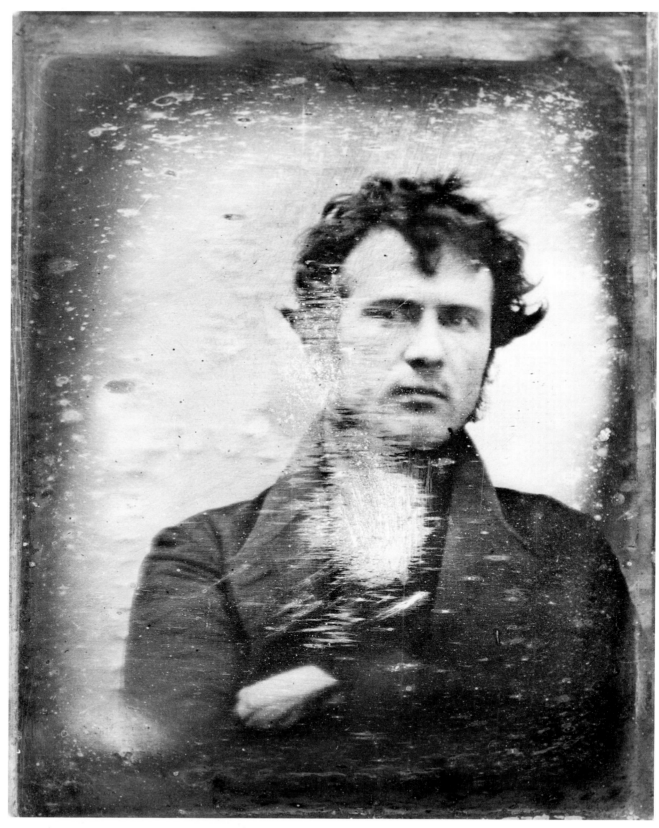

1839

14

Robert Cornelius self-portrait made by jumping in front of a daguerreotype camera in the yard of his Philadelphia home, probably in November 1839. Daguerreotype, from which this illustration has been copied, measures 2¾ x 3¼ inches, and is believed to be the earliest surviving photograph of a human being.

The decision was made to utilize a telescope reflector of 8 inches diameter, whose inner concave surface could reflect and focus light at a point (the focal point) eight inches away. By grinding the reflector's curved surface, the focal length (the distance between the reflector and the focal point) could be increased to 12 inches, which would make it possible to use image plates 2 x 2½ inches in size—still small, but larger than the tiny ⅜th-inch plate used for the first Johnson portrait. The grinding of the reflector was a time-consuming process, and one which Prof. Draper, at the time, didn't think could be done. At this point (late October or early November), Henry Fitz, Jr., thirty-one, a locksmith and later a world-renowned telescope maker (who had previously been associated in business with Wolcott), showed up on the scene. The trio thereupon divided their work—Wolcott attended to his mechanical dentistry business; Johnson set about trying to procure and properly finish good image plates; and Fitz completed the job of grinding and polishing the new reflector (later he said he also constructed the camera). Trials were begun with the camera and new reflector in November, when Fitz possibly made the self-portrait, left (for an illustration of the Wolcott studio and camera system, see page 13). But then Johnson became ill, and further trials were suspended for nearly four weeks, or until January 1840.[31]

Prof. Morse misspelled Daguerre's process when he dispatched his letter from Paris to the *New York Observer* in March 1839. The public, too, evidently found it a tongue twister. Abraham Bogardus, an early practitioner and later first president of a national photographic association, recalled the matter at a dinner meeting late in the nineteenth century:

I remember when the newspapers first announced that a French chemist named Daguerre had, after long experimenting, succeeded in fixing the image shown in the camera obscura on a chemically prepared plate. I remember some of the comments made on the great discovery. One writer said it would probably do away with oil painting. I remember the difficulty the public had in spelling and pronouncing that hard name Daguerreotype—Da-gu-erreotype, Dag-u-erreotype, and the vulgar Daug-re-o-type, and finally the Dog-type. I remember the public estimate of the "dark room;" they thought the operator conducted some hocus-pocus affair in there. "Say, now, Bogardus, what do you do in there, do you say something over it?" I remember when a prominent merchant who had had a daguerreotype taken was asked how it was done. He said you sat and looked in the glass (lens) until you "grinned yourself on the plate."[32]

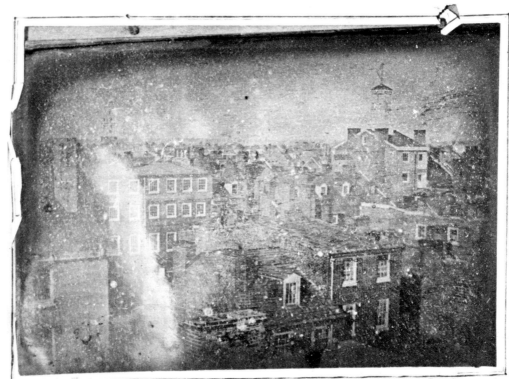

Heliograph L.... P. P. Goddard

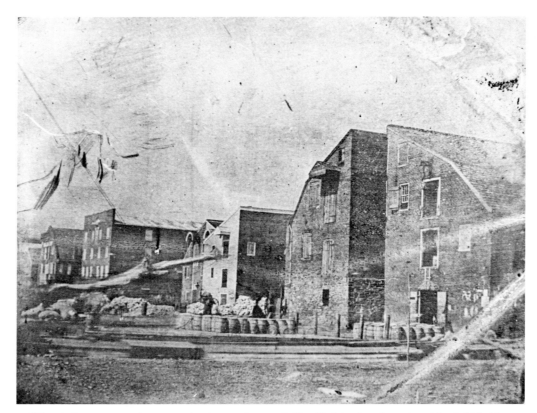

Although daguerreotype views were taken by experimenters in New York in 1839, these views taken in Philadelphia are among the earliest extant in the United States. Top view, taken by Dr. Paul B. Goddard, is now in the Franklin Institute. Bottom view is a photographic print copied later in the nineteenth century of a daguerreotype view, now lost, made around 1840 by a Philadelphia dentist, Dr. J. E. Parker.

1840

The United States entered its third year of a severe economic depression in 1840, and both the novelty of the "new art" and the fact that only a small outlay of money was required to begin its practice attracted many people to the new daguerreotype invention. In New York, the team of Alexander S. Wolcott and John Johnson lost no time in exploiting their opportunities. Men such as George W. Prosch, maker of S. F. B. Morse's first camera, placed a line of American-made cameras on the market in March which were somewhat improved from Daguerre's original equipment. But Wolcott and Johnson worked diligently, and secretly, to perfect their camera of different design, which became the first to be patented in the United States (on May 8) and in Great Britain (on June 13).

In their trials the previous October, Wolcott had decided to substitute a concave reflecting mirror (inside the camera) for the refracting lens called for in a standard Daguerre camera. The mirror was positioned such that it reflected a greater amount of light on the image plate than was brought to bear by a Daguerre camera lens. While this resulted in accelerating an exposure, the area of focus was small, restricting plate size to 2 x 2½ inches. If larger pictures were wanted, Wolcott maintained, photographers could always copy the originals on plates of larger size.

Americans were not scenery conscious at this time (as they became later), and perhaps for this reason—and also because most early daguerreotypes were small—daguerreotype cameras were little used to take city, landscape, or architectural views. In Europe it was otherwise; cameras of the Daguerre variety were employed immediately to secure daguerreotype views in many lands. The most notable example was the taking of views by various photographers in France, Italy, Spain, Greece, Egypt, Nubia, Palestine, and Syria under the direction of a Parisian optician, Noël M. P. Lerebours. Although some 1,200 daguerreotypes were secured by Lerebours, only a small portion were used to make copperplate engravings for illustrations of *Excursions Daguerriennes*, a two-volume work published during the years 1841–43. Books illustrated with lithographs made from daguerreotypes were also published in Paris, and in Poland, in 1840.

The earliest American daguerreotype views extant (other than Saxton's view from the U.S. Mint) appear to be those made in Philadelphia in 1839, or early 1840, by Dr. Paul B. Goddard and Dr. J. E. Parker, a dental surgeon. Parker, as well as Goddard, is said to have used bromine as an accelerator for plate exposure.[33] Views made in Boston and New England in April 1840 by Dr. Samuel Bemis, another dentist, have also survived. In addition to Bemis, Edward Everett Hale also is known to have made daguerreotype views early in 1840 in Boston (of a church which he later headed). Both men evidently purchased their cameras from Daguerre's agent, Francois Gouraud, who held a private viewing of daguerreotypes brought with him from France at the Masonic Temple in Boston on March 6. Bemis bought his camera on April 15, and four days later secured a view of King's Chapel in Boston. The view was taken late in the afternoon when the air was dry and it was unseasonably cold. It took Bemis 25 minutes to iodize his plate (he was not privy to Goddard's bromine discovery) and 40 minutes to make the exposure. After that, he later made a series of additional views in Boston and New Hampshire, all of which have survived to modern times. Bemis was fifty-one when he secured these images, and ninety-two when he died in Boston in 1881.[34] The safe-keeping of these pioneer American landscapes can be attributed to his longevity and the precise manner in which he kept records. Bemis' success, in 1840, was also clearly a case of the student outperforming his teacher. For of Gouraud's first Boston lecture on the daguerreotype process, another student, Albert H. Southworth, had this to say:

> His illustrative experiment resulted in his producing a dimmed and foggy plate instead of the architectural details of buildings, and the definite lines and forms of street objects. It happened to be a misty day attended with both snow and rain. The Professor appeared highly elated, and exhibited his picture with great apparent satisfaction, that he had it in his power to copy the very mist and smoke of the atmosphere in a stormy day. Many a photographer has often wished for some natural phenomenon that might serve as a pretext for attributing to some apparent cause the faults of imperfectly understood chemical combinations, or partially polished plates.[35]

In New York, John Johnson had recovered from his "illness" by January (possibly the injurious effects of daguerreotype chemicals on his health, which caused him to abandon daguerreotyping in 1843), and the trio—Wolcott, Johnson, and Fitz—again resumed their experiments. From a historical standpoint, one of the most telling comments Johnson makes in this subsequent (1846) account of this period in their activity (January–March) is the statement that most of the portraits secured—like the first one of Johnson himself—were profiles:

> Up to January 1st, 1840, all experiments had been tried on an economical scale, and the apparatus then made was unfit for public exhibition; we resolved to make the instruments as perfect as possible while they were in progress of manufacture. Experiments were made upon mediums for protecting the eyes from the direct light of the sun, and also upon the best form and material for a background to the likenesses. The length of time required for a "sitting" even with the reflecting apparatus was such as to render the operation any thing but pleasant. Expedients were ever ready in the hands of Wolcott: blue glass was tried, and abandoned in consequence of being at that time unable to procure a piece of uniform density and surface; afterwards a series of *thin* muslin screens secured to wire frames were prepared as a substitute for blue glass. The objections

to these screens, however, were serious, inasmuch as a multiplication of them became necessary to lessen the intensity of the light sufficiently for due protection to the eyes, without which, the likenesses other than profiles were very unpleasant to look upon.— Most of the portraits, then, of necessity were profiles, formed upon backgrounds, the lighter parts relieved upon black, and the darker parts upon light ground; the background proper being of light colored material with black velvet so disposed upon the light

ground, this being placed *sufficiently* far from the sitter, to produce harmony of effect when viewed in the field of the camera. Other difficulties presented themselves seriously to the working of the Discovery of Daguerre, to portrait taking—one of which was the necessity for a constant and nearly horizontal light, that the shaded portions of the portrait should not be too hard, and yet at the same time be sufficiently well developed without the "high light" of the picture becoming overdone, solarized or destroyed. In almost all the early specimens of the Daguerreotype, extremes of light and shade presented themselves much to the annoyance of the early operators, and seriously objectionable were such portraits. To overcome this difficulty, Mr. Wolcott mounted with suitable joints upon the top of his camera a large looking-glass or plane reflector, in such a manner that the light of the sun, (as a strong light, was absolutely necessary,) when falling upon the glass could be directed upon the person in an almost horizontal direction. [37]

Before New York was aware of what they were up to, Wolcott and Johnson sent Johnson's father, William S. Johnson, to London on February 3 to try to arrange for the patenting of the mirror camera in England. Johnson, Sr., arrived at the end of the month "with a few likenesses," according to one British writer, and was put in touch with an English coal merchant and patent speculator, Richard Beard. The pair immediately entered into an agreement looking to an English patent, but, according to John Johnson, the move was opposed by Daguerre's agent in London, who threatened suit. This opposition was withdrawn, however, upon agreement to pay Daguerre 120 pounds annually for the right to employ the mirror camera and to use "all pertaining to the daguerrean art, chemically" in the United Kingdom. As for the financial arrangement with Beard, he paid the Americans 200 pounds and expenses for one half of the invention, and a year after issuance of the British patent (on June 13) paid another 7,000 pounds for the other half. [38]

From John Johnson, meanwhile, we have confirmation (hard to find elsewhere) that a number of now-prominent names, principally in New York and Philadelphia, were engaged in taking daguerreotype portraits and views in the early months of 1840:

From time to time reports reached us from various sources of the success of others, and specimens of landscapes, etc., were exhibited at Dr. James R. Chilton's Laboratory, in Broadway, much to the gratification of the numerous visitors and anxious expectants for this most wonderful discovery. Dr. Chilton, Professor J. J. Mapes, Professor J. W. Draper, Professor S. F. B. Morse, all of this city. Mr. Cornelius, Dr. Goddard and others of Philadelphia. Mr. Southworth, Professor Plumbe, and numerous others were early in the field; all, however, using the same description of camera as that of Daguerre, with modification for light, either by enlargment of lens and aperture for light, or by shortening the focal distance. [39]

Among the first to learn the daguerreotype practice from Morse was Joseph Pennell (not known to be a kin of the famous etcher), who graduated from Bowdoin College on

September 4, 1839. His former schoolmate, Albert S. Southworth, joined Pennell in New York, probably in January 1840. In 1870, Southworth recalled the event:

Thirty years ago last winter I found Mr. Joseph Pennell, of Brunswick, Maine, assisting Professor Morse in the Professor's own building on Nassau street. Mr. Pennell had a few months previously graduated at Bowdoin College in his native town. He had gone to New York for the purpose of procuring pecuniary assistance by some employment of his leisure hours. He had been my former school and room-mate, and had written to me to visit New York and learn respecting the new art. He invited me also to join him as an associate in business for the purpose of making likenesses. He introduced me to Professor Morse, and from him we received all the information and instruction he was able to give upon the subject. Little was then known except that a polished silver surface of plate, coated with the vapor of iodine in the dark, and exposed in the camera obscura for a certain time, and then played over fumes of mercury, would develop a picture in light and shade, the shaded parts being the black polished surface of the plate, and the lights made out by the mercury chalked upon and adhering to it. I do not remember that Professor Morse had then made any likenesses. Very clear, distinct views of Brooklyn in the distance and the roofs in the foreground, taken from the top of the buildings in Nassau street, were upon his table. I do remember the coil of telegraph wire, miles in length, wound upon a cylinder, with which he was experimenting, and which he had prepared to carry over to the New Jersey side, and extend for the purpose of testing the practicability of communicating between distant points by electricity, and the use of his alphabet of dots and marks.[40]

Only a few friends were apprised of Wolcott's and Johnson's progress prior to February, and one of these, a Mr. Kells (a mystery man in the partners' operation) was the first to divulge the news at a meeting of the Mechanics' Institute in which he drew on a blackboard "the whole as contrived by Mr. Wolcott." This gave publicity to the invention, and led immediately to sittings by Morse, Mapes, Dr. Chilton, and others. Morse, according to Johnson, proposed at this time that Wolcott join with him in a daguerreotype business (an invitation which Wolcott evidently declined).[41]

On March 4, the New York *Sun* announced that Wolcott was securing likenesses in sittings lasting 3 to 5 minutes, and said that the miniatures produced were being packaged in cases and sold for $3 apiece. Shortly thereafter, Wolcott moved his operation to the Granite Building at Broadway and Chambers Street, devising a unique studio lighting system (see illustration right) which soon became a showplace. Robert Cornelius reportedly came up from Philadelphia to see it in April, and George Prosch and others, according to Johnson, adopted its reflecting arrangement for their own practice.

While the successful use of bromine as an accelerator for plate exposure appears to have remained a Philadelphia secret during most, or all, of 1840, Johnson said (in 1846) that Morse "and others" were "acquainted with the use of bromine" in 1840, and that Wolcott had even asked Dr. Chilton to prepare a small quantity for his own experimental use. But he "did not succeed very well with it," having "invariably used too much in combination with iodine" for successful results.[42]

Cornelius, aided by the technical expertise of his silent partner (Dr. Goddard), fared somewhat better. According

FIRST PATENTED AMERICAN CAMERA AND STUDIO LIGHTING SYSTEM

Alexander S. Wolcott's "mirror" camera, shown here, is now in the Smithsonian Institution. No lens was in front. Light entered the opening at the front of the box and was reflected by an 8-inch diameter concave mirror onto an image plate measuring 2 x 2½ inches. Studio window sashes were removed and two reflecting mirrors were extended outside the building to deflect sunlight directly at the sitter. The light passed through a plate-glass contrivance (on easel) containing a liquid blue vitriol solution, which muted its intensity. A headrest and background screen are shown behind sitter.[43]

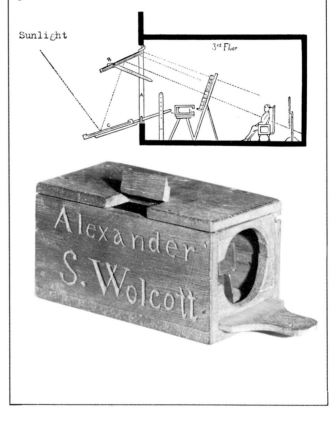

to historian Marcus A. Root, who learned the trade from Cornelius, the latter soon began procuring (indoors) "fair impressions, even without reflectors, in from 10 to 60 seconds."[44]

Another of what Johnson termed the "innumerable obstacles" to the rapid advance of the daguerreotype art was an inability to procure good image plates. Manufacturers at that time were reluctant to prepare silver-plated copper with *pure* silver—with the result that when one attempted to polish such plated metal as could be obtained, the plate would become cloudy or colored in spots (caused by the surface exhibiting more or less alloy, depending on whether more or less silver was removed in the polishing). Johnson stated the problem more fully in these words:

ENTER EDWARD ANTHONY

An 1838 graduate of Columbia (in a class of twenty), Edward Anthony learned photography from Samuel F. B. Morse, but gave up the practice in 1847 to found a supplies business whose name, E. & H. T. Anthony & Co., became world famous after the Civil War. The following remarks, excerpted from an 1883 speech at a photography dinner, relate all that is known of his early years:

> My first acquaintance with photography was by the announcement of the discovery by Daguerre, and on seeing the samples brought from Paris by M. Gouraud, which were exhibited in the building on the cor. of Chambers St. and B'way, N.Y. City.
>
> I immediately became an enthusiastic amateur, and set about manufacturing an apparatus to take daguerreotypes. This I did at large expense, the camera, lens and all costing a sum total of twenty five cents. This will show one point of contrast between the old and new, when we consider that lenses are now constructed for the apparatus costing $500 and $600, and cameras worth over $100. With this crude instrument I amused myself by taking pictures out of the back windows.
>
> In the following season I joined my brother as civil engineer in the construction of the Croton Aqueduct. We there got up a better camera, using the front lens of the levelling instrument. We not only took landscapes, but tried our hand at portraits. We had our axeman sit on a chair against the side of the white house in the bright sun with his eyes closed, and in thirty minutes got a portrait which was considered a great wonder. [45]

Croton Aqueduct, spanning New York's East River, about 1865.

explain more clearly, it was the practice of most silver platers to use an alloy for silver-plating. In the reduction of the ingot, to sheet metal, annealing has to be resorted to, and acid pickles to remove oxides, &c. The number of times the plated metal is exposed to heat and acid in its reduction to the required thickness, produces a *surface of pure silver*. The most of this surface is, however, so rough as to be with difficulty polished, without in *places* removing entirely this pellicle of pure metal, and exposing a polished surface of the alloy used in plating. Whenever such metal was used, very unsightly stains or spots frequently disfigured the portraits. The portrait or portion of it, developed upon the *pure* silver, being much lighter or whiter than that developed upon the alloy; it therefore appeared that the purer the silver the more sensitive the plate became. [46]

Morse and Draper, once in partnership together, ordered French-made plates; and Prosch, in his first advertisement for commercially available cameras, specified Corduan, Perkins & Co. as his supplier. Not content with these sources, Johnson contacted the Scovill Manufacturing Company in Waterbury, Connecticut, and asked them to provide a roll of silver-plated metal capped with pure silver. This marked Scovill's entry into the photography field, the company in later years becoming a supplier second only to the house of Anthony. But on this initial project, Scovill provided an item which, while "a good article," nevertheless was too costly, according to Johnson. "Soon after this," he said, "some samples of English-plated metal of very superior quality came into our possession, and relieved us from the toil of making and plating one plate at a time." [47]

Southworth and Pennell, meanwhile, at some point in the spring or summer of 1840, established a daguerreotype business at Cabotville, near Boston. "We had the sympathy and substantial assistance of the Messrs. Ames, Chase [probably the pioneer Boston photographer, Lorenzo P. Chase], and Bemis," Southworth recalled later, "and began our business of daguerreotyping on a capital of less than fifty dollars." To obtain "more rapid action by increased light" (for their exposures), the pair fabricated a large lens weighing 55 pounds, which had a diameter of 13 inches and a focal length of 30 inches. But their efforts proved unsuccessful, and by the spring of 1841 they were "deeply in debt," and "often unable to take our letters from the Post Office." Their entire expenses for a week were sometimes as low as 75 cents! [48]

John Plumbe, the first man to advocate building a railroad linking the East with the West, also opened a Boston daguerreotype studio in 1840—the first of a chain of galleries he was soon to establish in other major cities.

As soon as the Wolcott camera patent was awarded (on May 8), Henry Fitz, Jr., headed for Baltimore to establish that city's first daguerreotype business, and Wolcott went to Washington, D.C., where he was evidently instrumental in helping John G. Stevenson open a gallery there on June 30

in "Mrs. Cummings' rooms" on Pennsylvania Avenue, a short distance from the U.S. Capitol building. Five days prior to this, he sent a letter to Johnson in New York, which is among few Wolcott letters or other documents extant. In it he imparts a small insight into the workings of the Wolcott-Johnson business just prior to concentration (in 1841) of their principal attention on the London operation:

Washington, June 25 1840.

Friend John— 1 forgot in my last to mention how you should direct your letters—you must send them by Harnden's Express Line to Baltimore, directed to *John G. Stevenson, care of William Hawkins, Baltimore,* and send the receipt you get for the package to Wm. Hawkins at Harrison & Co., requesting him to get the package and forward it to John G. Stevenson at Washington Send me a lot of the gilt frames; Mr. Stevenson has only about five dozen of the cases so if you have any to spare *send;* no glasses on hand but those I brought with me. If you have bought another lot of thermometers send two or three, we have none at present, but will have to buy at a high price; send a few sheets of filtering paper to manufacture distilled water with. How shall I direct my letters to you? I am *busy busy* BUSY, don't think I can be ready before Monday. How many customers has your advertisement brought to your rooms, and how many V's have they left with you? When Mr. Kells finishes the two lens he has on hand, he may, if you think proper, make two more of the same curves and of as large diameter as ¾ glass will allow. Mr. Stevenson intends when he leaves here to go to Baltimore, where he cannot use the reflector.

Yours &c.,
A. S. Wolcott [49]

According to a seemingly reliable account published many years later, Morse and Draper opened what was described as a "primitive gallery" atop the New York City University building in April—not the previous December, as Draper has indicated. Morse, according to this account, "supplied the artistic element, whilst Draper attended to the scientific manipulation." The "gallery" consisted of an old room, used as a workshop, and a hastily constructed shed with a glass roof for operating quarters. But it appears to have been an instant success, and during the summer vacation period, the pair evidently made portraits of New York's political and social elite (while Johnson, as we have just seen, resorted to advertising for customers). The portraits were taken only on bright, sunshiny days, however, the darker days being used to teach the art to others. Exposures required 5 to 7 minutes, even in the sunshine. [50]

In August, Morse went to his thirtieth class reunion at Yale, taking his daguerreotype apparatus with him. The assembling of graduates for class reunions that far advanced from the original date of graduation was considered unusual, and the *New York Observer* gave prominent notice to the August 18 event, concluding in its article:

This meeting was perpetuated in a manner altogether unprecedented by Prof. Morse of the University of this city, who took a *daguerreotype view* of the whole class. Arranging them side by side, he has, by the power of this wonderful art, transferred the perfect likeness of each individual to his plate, so that he has now in his possession the invaluable treasure of the image of his classmates, from whom he has been separated thirty years, and who will probably never be assembled in this world again. The likenesses are so natural that individuals not connected with the class recognize their acquaintances on the plate, without the least hesitation. How valuable would such a momento of early friendship be to every class, on leaving college for the busy scenes of life. [51]

A prominent gathering of men (totaling eighteen) it was, too. Besides Morse (who must have stepped into position during the exposure), the group included Connecticut gov-

The use of bromine as an accelerator for daguerreotype plate exposures may account for the greater sharpness and quality of the portrait (top) of J. H. F. Sachse, who was the first to pose for Robert Cornelius when the latter opened his Philadelphia gallery in 1840. Discovery of the importance of the bromine accelerator is credited to Dr. Paul B. Goddard, a silent partner in Cornelius' gallery. Portrait of an unidentified man, bottom, was made by Henry Fitz, Jr., on a piece of solid silver. He did not use bromine prior to May 1840, and is not known to have used the accelerator when he opened a gallery of his own in Baltimore shortly thereafter (which he operated until 1844).

1840

21

AN AMERICAN PHOTOGENIC DRAWING

Possibly the earliest surviving American photographs on paper are a set contained in a personal album at the Franklin Institute, from which the example above has been selected. The photographs are primitive forms of the calotype process, and were made of plants and shells by seventeen-year-old M. Carey Lea before being exhibited by his father, Isaac Lea, at a meeting of the American Philosophical Society in Philadelphia on February 6, 1840.[52]

ernor William Wolcott Ellsworth; his brother, Henry Leavitt Ellsworth, U.S. Commissioner of Patents; Abraham B. Hasbrouck, newly elected president of Rutgers College; Prof. Chauncey Goodrich, of Yale; and Ethan Allen Andrews, a renowned Latin scholar and former professor of ancient languages at the University of North Carolina.

And where has this, and all of the other daguerreotypes, taken by Morse, Draper, Wolcott, Seager, et al., gone? One explanation lies in the fact that the first specimens were inordinately delicate, being composed of an amalgam of silver and mercury, which could be removed from the surface of the plate by the merest touch. Not until the latter part of 1840 was a toning of gold applied to daguerreotypes (a process invented in France which came to be known as "gilding," and which was subsequently adopted univer-

sally). The toning not only improved the appearance of an image but it also rendered it less fragile. Another explanation may be that glass covers were not early adopted as protectors, allowing images to be easily damaged or destroyed. Morse, too, sent at least one plate to Root for use in making an engraving, and may have disposed of others in like fashion (the images ultimately becoming lost, or destroyed). The minutes of a meeting of the American Photographical Society in New York, on February 10, 1862, reveal interestingly enough that John Johnson had in his possession at that late date "about one thousand" daguerreotypes made prior to introduction of the gilding process. "Of these a majority are in perfect preservation," Prof. Draper, president of the society, stated in his annual address read at the meeting. "Where change has occurred it appears as a film of deposited matter, which commonly commences to form at the mat," Draper said. "It has been observed that ungilded daguerreotypes fade sooner if kept in a warm place, this being perhaps due to the vaporization of the mercury of the amalgam constituting the lights."[53]

Some early plates were also simply discarded as not worth keeping at the time. One man who said he posed for eight minutes at Wolcott's studio in February 1840 furnished his own solid silver plate, which was used to make his likeness. "After plates became plenty and cheap," he told the *American Journal of Photography* in 1861, "I considered the metal worth more than the portrait and sold it. I regret very much that I did not preserve it."[54]

The state of the art in daguerreotype portraiture, as of December 1840, was best summarized by W. H. Goode, a former assistant to Draper who by then had transferred to the Medical College in New Haven. His principal findings were these:

● Pictures of the largest size—eight inches by six—are taken with the French achromatic lenses, perfect throughout; the parts within the shade are brought into view, distant objects are perfectly delineated. A common spectacle lens, an inch in diameter, of fourteen inches focal length, adjusted by means of a sliding tube, into one end of a cigar box, answers very well to take small pictures . . . this apparatus . . . recommends itself by its cheapness—costing about 25 cents.

● Plates for daguerreotype purposes are either of American manufacture, or they are imported from France. American plates are exceedingly imperfect. The silver abounds with perforations, which appear as black dots in the pictures; it also assumes a yellow instead of a white coat in burning.

● The possibility of obtaining impressions on an iodized surface in any kind of weather has been amply demonstrated. Generally, however, to obtain proofs successfully, a dry atmosphere, a pure white light, and a clear blue sky, are required. Attempts made to obtain them the day after one of rain—when snow is melting rapidly—or when the sun's light is of a yellowish tint, will generally be fruitless. The proofs taken with the light of a yellowish cast are frequently black.

● The camera operation is usually completed in from 1 minute to 2½ minutes; portraits, however, have been obtained in 10 seconds.[55]

1841

In October 1840, John Johnson left New York to join his father at the Beard studio in London. There was a considerable delay before the studio's official opening, due to the continued experimentation with chemical techniques for accelerating camera exposures. Beard had hired an assistant in midsummer, John Frederick Goddard (no kin of the Philadelphia chemist), who had been serving as a lecturer on optics and natural philosophy (a nineteenth-century term for scientific pursuits) at the Adelaide Gallery. After John Johnson's arrival, both he and Goddard devoted a great part of their time to these experiments. Both used the same mirror camera—Johnson at first continuing experiments begun in New York with nitro-muriatic acid (a solution which he found "reacted and formed a peculiar chloride of iodine . . . preferable to simple iodine"), then experimenting with chloride of iodine directly. John Goddard, on his part, discovered "a rather valuable combination of chemicals," according to Johnson, which consisted of a mixture of iodine, bromine, iodus, and iodic acid. A proper combination of these solutions "gave an action (on the daguerreotype plate) somewhat more sensitive than chloride of iodine."[56]

On February 12, 1841, John Goddard used his new formula to take a daguerreotype of Johnson's father, which was accomplished on a rainy day in a matter of 2 minutes and a few seconds. The same day, Goddard also took a self-portrait, and on the sixteenth, a portrait of his own father. On the eighteenth, he exhibited these specimens at a meeting of the Royal Society (among those present being Sir Charles Wheatstone, who the previous year had appeared before the same body to demonstrate the principle of binocular vision and a primitive stereoscope illustrating the new principle). Because bromine was to become such an essential factor in daguerreotype portraiture, Goddard's description of the chemical reaction resulting from a combination of bromine and iodine (published two months before the Royal Society meeting) is informative:

> If iodine and bromine are placed together in equal porportions, they instantly combine and form a new compound, the bright, scaly crystals of the former dissolving, and the new substance crystallizing in dark microscopic crystals of a beautiful arborescent appearance. These are exceedingly volatile, more so than iodine alone, the vapor attacking the silver surface in a similar manner, and so delicately sensitive are the plates, when properly prepared, that the faintest light acts readily on them, even in the dull, cloudy days of November, with a London atmosphere, if not too foggy.[57]

In keeping with a policy of the Royal Society to acquire deposits of sealed packets covering data on technical advances, Goddard submitted a packet covering the results of his experiments on March 2, 1841 (a report which, when opened twenty-three years later, revealed that he had used a more elaborate formula than the one published in December 1840). But Johnson still felt that the "high lights" in Goddard's specimens would become "solarized, or overdone" more frequently than was the case with portraits secured

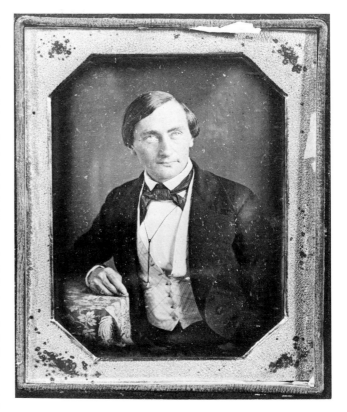

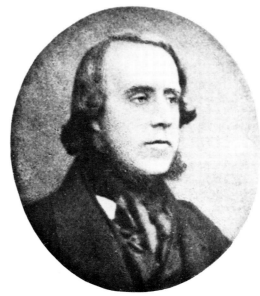

Prof. Martin Boyé (top) of the University of Pennsylvania is credited with first suggesting to his colleague, Dr. Paul B. Goddard, the possible value of using bromine to accelerate daguerreotype plate exposures, which Goddard thereupon adopted and perfected chemically in December 1839. In February 1841, John F. Goddard (bottom), no kin of the Philadelphian, perfected a similar method independently at the Richard Beard Gallery in London. Bromine was used by daguerreotype photographers universally thereafter.

2ND U.S. PATENT IN PHOTOGRAPHY

Patent was assigned to John Johnson on December 14, 1841, for a method of polishing the silvered metal plates on which exposures were made in daguerreotype cameras. He described his pioneering work in this 1846 statement:

> Having it now in our power to obtain good plated metal, a more rapid mode of polishing than that recommended by Daguerre, was attempted as follows:—
>
> This metal was cut to the desired size, and having a pair of "hand rolls" at hand, each plate with its silvered side placed next to the highly polished surface of a steel die, were passed and re-passed through the rolls many times, by which process a very smooth perfect surface was obtained. The plates were then annealed, and a number of plates thus prepared were fastened to the bottom of a box a few inches deep, a foot wide, and eighteen inches long; this box was placed upon a table, and attached to a rod, connected to the face plate of a lathe, a few inches from its centre, so as to give the box a reciprocating motion. A quantity of emery was now strewn over the plates, and the lathe set in motion. The action produced was a friction or rubbing of the emery over the surface of the plates. When continued for some time, a grayish polish was the result. Linseed when used in the same manner gave us better hope of success, and the next step resorted to, was to build a wheel and suspend it after the manner of a grindstone. The plates being secured to the inner side of the wheel or case, and as this case revolved, the seeds would constantly keep to the lower level, and their sliding over the surface of the plates, would polish or burnish their surfaces. This, with the former was soon abandoned; rounded shots of silver placed in the same wheel were found not to perform the polishing so well as linseed. Buff-wheels of leather with rotten stone and oil proved to be far superior to all other contrivances; and subsequently, at the suggestion of Professor Draper, velvet was used in lieu of buff leather, and soon superceded all other substances, both for lathe and hand buffs, and I would add for the benefit of new beginners, that those who are familiar with its use, prefer cotton velvet. The only requisite necessary, is that the buffs made of cotton velvet should be kept *dry* and *warm*.[61]

with chloride of iodine "applied as one coating" to a daguerreotype plate. In July, Wolcott arrived from New York. According to Johnson, he proceeded to experiment with a combination of iodine, bromine, and chlorine, achieving "more or less success." But the difficulty of exactly combining the three elements—such as "to produce a certainty of result with harmony of effect"—was the work of many months, "the slightest modification requiring a long series of practical experiments, a single change consuming, frequently, an entire day in instituting comparisons, etc., etc."[59]

However extensive these experiments may have been, it was still necessary to count minutes instead of seconds in making a camera exposure. By March 23, the date of the Beard studio's official opening, it was still not possible to secure a daguerreotype portrait in the 10 to 60 seconds reportedly accomplished by Robert Cornelius a year earlier in Philadelphia. Cornelius' success was due to the efforts of the University of Pennsylvania chemist Dr. Paul B. Goddard, aided by a number of colleagues. It appears that one of these, Prof. Martin Boyé, proposed a combination of bromine and iodine in definite proportions, and that the successful "Philadelphia method" for plate acceleration was ultimately worked out by an "interchange of ideas" between Goddard, Joseph Saxton (of the U.S. Mint), and Prof. William G. Mason, an accomplished engraver.[60] The exact formula was said to have been published later, but one of the best recorded descriptions of what was involved—a so-called third step in sensitization, presumably introduced by the Philadelphia experimenters—is to be found in this excerpt from an article published in Philadelphia around the time of photography's centennial in 1939:

> Sensitization was effected by first placing the polished (daguerreotype) plate, in a holder, inside a box filled with iodine vapor. From this box the plate was transferred to another, similar in construction, containing the vapor of bromine. The plate was then returned to the iodine box to complete the sensitization. This last step was necessary to prevent the finished daguerreotype from having a bluish tone in the whites. Some of the earliest daguerreotypes made with the use of bromine, and before this third step in sensitization was discovered, are in the collection of the Historical Society of Pennsylvania. These were undoubtedly made by either Professor Goddard or Professor Boyé of the University of Pennsylvania. . . . Shortening the time in the first insertion in the iodine box increased the sensitivity, but made for thinness which was not adapted for portraiture, although suited to views.[61]

John Johnson was awarded the second American patent in the field of photography (see description, left) for a method of polishing daguerreotype plates before use. While at the Beard studio in London, he also supervised the manufacture and polishing of plates at a factory in Birmingham. On his part, Wolcott attended to the manufacture of mirror cameras at a factory in London. Branch portrait galleries were established by Beard in Liverpool (September), Southampton (October), Brighton (November), and Manchester (also in November). Johnson evidently handled the Liverpool and Southampton openings, but returned to the United States in October prior to the openings in Brighton and Manchester in order to marry a boyhood sweetheart in his native Saco, Maine.[62]

By September, Beard's chief rival, Antoine Claudet, was making daguerreotype portraits at the Adelaide Gallery, using a Daguerre style rather than a mirror-type camera. *The Spectator,* after viewing both operations, decided London's best portrait photographs were being made at the Beard studio (see next page). But this acclaim was to be short-lived. Cameras without lenses (i.e. the mirror camera) were not the real answer to photography's needs. This was to come in the form of the first true camera lens, which had been designed and constructed in Austria during 1840. Strangely, this all-important invention was ready by the time the Beard-Claudet rivalry first began, but was not properly brought to the world's attention until 1843 (see page 39).

When Wolcott went to London in July, M. D. Van Loan took over his New York studio, and on July 19 placed an advertisement in the New York *Tribune* in which he stated that likenesses could be taken "from 7 A.M. till sundown, in any kind of weather—clear, cloudy or rainy." Other ads in a similar vein soon began to appear. A. Page advertised that he could take likenesses in any kind of weather "in a few seconds."[63] Despite these claims, reality was usually a different story. The noted Rochester daguerreotypist of the 1850s, Edward T. Whitney, recalled in later years this opinion of the first specimen he ever saw:

> I was visiting a friend in Newark who showed me a daguerreotype case with what looked like a plate of polished steel in it, and stating at the time that it was his likeness. I looked and looked. Finally, by many turns and twists, I caught the shadow. The likeness was good but perfectly black. It was taken by Seth Boyden, the great inventor. I afterward sat for him in his observatory at Newark; the time of the sitting was 15 minutes; results—some black dots on a white vest, but no likeness.[64]

Montgomery P. Simons, another veteran looking back to his early daguerreotype days, summed it up this way:

> Ah! those were the days of trials and many tryings of contingencies, of slow iodine, slow cameras and consequently long sittings, when an artist might very easily have taken his dinner whilst his sitter was sweating out a picture in the sun. This, then, should have been called *long* as well as *"high"* art. Few were able to sit long enough to be "taken off" quietly, and fewer still could go through the mysterious operation without receiving a bunged eye or having some other feature knocked into a condition not the most flattering to be handed down as one's facsimile.[65]

The story is told that a young assistant working with Robert Cornelius in Philadelphia was bribed to tell his employer's method of using bromine as an accelerator in 1841, and that he subsequently worked for several weeks in New York divulging the entire secret. Just when this took place is not recorded, but in all probability during or before the summer. For as early as October 2, George Prosch, the first to supply cameras in New York, began advertising the commercial availability of a French brand of bromine to the trade. This suggests that bromine was by then generally accepted as a principal chemical, along with iodine, for successful daguerreotype portraiture. Yet the record also shows that in the latter part of 1841, Prof. Draper, working with Frederick Augustus Porter Barnard, later president of Co-

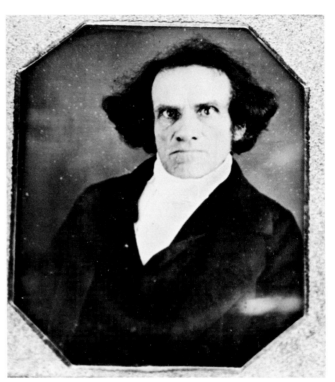

This daguerreotype of an unidentified man is typical of many an icy stare adopted by sitters during long camera exposures in the early daguerreotype years.

lumbia College, was conducting experiments with chlorine for plate acceleration use.[66]

George Prosch's "warranted good" French bromine may have attracted many customers in 1841, but this is how E. T. Whitney characterized its early general use:

> Bromine at first caused much trouble by flashing over the plate and fogging the image. To overcome this we constructed a glass box with a glass fan in it, the place under the coating box having a hole in the bottom, covered by a slide. When the bromine was wanted, the slide was drawn, and the fan was then used to draw up a small portion of the vapors into the coating box. By closing the slide we had just enough stored to coat one plate. But this troublesome and uncertain remedy was overcome when it was found that lime would hold the bromine and give off the fumes slowly. Before this we experimented with "closed doors" each morning before admitting sitters, and often after admitting them, thinking all was right, would discover that we had to dismiss them with excuses about the weather, etc. Thus, through much tribulation, we at last emerged under a clear sky; but complete success was not attained until we galvanized the plates with pure silver before buffing.[67]

Galvanizing—a method of electrically charging a plate before exposure—was tested as early as the summer of 1841 by Daguerre in Paris, but without success. Whitney's cousin in St. Louis, T. R. Whitney, began experiments of a similar nature after observing the effects of thunderstorms on camera exposures:

> In the year 1841, while practicing the art in St. Louis, Mo., I was at times, during the summer, much troubled with the electric influence of the atmosphere, especially

MIRROR CAMERA SHINES IN LONDON DAGUERREOTYPE RIVALRY

Richard Beard's portrait gallery atop the Polytechnic Institute and Antoine Claudet's studio at the Adelaide Gallery were the only two photographic portrait galleries in London when this article in *The Spectator* appeared on September 4, 1841:

PHOTOGRAPHIC MINIATURES.

INVITED lately by M. CLAUDET to witness his method of taking Photographic Miniatures, in operation at the Adelaide Gallery, we had an opportunity of ascertaining in what consists the difference between it and that of Mr. BEARD at the Polytechnic Institution, and of comparing the results of each. As the sun-limned portraits are become very popular, on account of the quickness and cheapness of the process and the force and minute fidelity of the resemblances, though they are unflattering to disagreeableness, an explanation of the two methods may be interesting.

To render the Daguerreotype applicable to the purpose of portraiture, it was necessary to accelerate the action of light on the plate; for rapid as was the formation of the image, even five minutes was too long for any sitter to remain perfectly still. This has been accomplished by various modifications of the chemical preparation of the plate, which it is needless to specify: suffice it to say, that the diminution of time required to form the image is in the ratio of seconds to minutes. The process of Mr. BEARD is the quicker of the two; but as M. CLAUDET takes two different views of the face at once in two cameras, and Mr. BEARD two in succession in the same, the time required to produce a couple of miniatures is about equal in both cases.

The principal difference, and that which affects the likeness, is the means of transmitting the image formed by the pencils of light on to the plate. M. CLAUDET accomplishes this by refraction, Mr. BEARD by reflection,—that is, M. CLAUDET, following the practice of DAGUERRE, transmits the rays of light radiating from the face of the sitter through a plano-convex lens; while Mr. BEARD avails himself of the improvement of an American optician, of which he has purchased the patent, and reflects the image on to the plate by a concave mirror. The distortion of the image in the refracting medium is less in amount than that of the reflector, and of the opposite kind,—that is, the image transmitted by the convex lens is larger in the centre and smaller at the circumference; while that of the concave reflector is smaller in the centre and larger at the circumference: though the deviation in either case is so slight, owing to the smallness of the surface affected by the rays of light, that it is almost incalculable. But the image transmitted through the lens is reversed laterally,—that is, the left side of the face appears to be the right in the miniature, and *vice versa*; so that if a sitter had the right eye closed the left would be closed in the miniature, and a person taken in the act of writing would appear to be left-handed. This reversal of the lineaments has an injurious effect on the likeness; much more so than the slight deviation from actual proportion in those taken by the reflector. M. CLAUDET has a process of fixing the portrait which is peculiar to himself; but that adopted by Mr. BEARD has not been known to fail, as far as we can learn, though we have seen miniatures exposed to the light for several months without changing: the process of gilding them, however, effectually secures the plate from the influence of climate, and any but violent injury.

On an attentive comparison of the two, we are bound to say that the Photographic Miniatures taken at the Polytechnic Institution by Mr. BEARD's process are superior to those taken by M. CLAUDET at the Adelaide Gallery, in fidelity of resemblance, delicacy of marking, and clearness of effect; in a word, they are more pleasing and artistical: the shadows are denser and the lineaments less defined in those produced by M. CLAUDET; though these objections are less important than the reversal of the countenance and figure.

At the Adelaide Gallery we saw two or three cancelled miniatures of persons who had very red faces, which looked black and heavy; from which we infer that the redness of the lips contributes to give to the mouth the dark tint that, added to the strong shadow between and below the lips, makes this feature look larger and coarser than in life, at least in the instance of persons with full and prominent lips. The

Cruikshank's *Omnibus* published this illustration of Richard Beard's London daguerreotype studio some years after it was opened on March 23, 1841. Two of Alexander Wolcott's American-made mirror cameras can be seen on the shelf pointed at the sitter. An assistant on the stepladder times an exposure, while another, right, appears to be burnishing the silvered surface of a daguerreotype plate prior to its use in the camera for another portrait. The laboratory can be seen through the opened door.

grave look and formal attitude commonly assumed by the sitters, being faithfully reflected in the miniature portrait, the sombre effect of the strong shadows and colourless lights of the photograph is increased to an unpleasing degree of sternness, occasionally amounting to a repulsiveness, and sometimes even falsifying the likeness: an animated expression, therefore, is essential to the production of a pleasing portrait, and the most vivacious countenances appear to the best advantage. In every case, however, the want of brilliancy in the eyes, and the strong shadows beneath the nose and about the mouth, cause the physical peculiarities of form to predominate in an exaggerated degree. The apparatus used to steady the head gives a fixed and constrained air to the sitter; and it would be well if this could be dispensed with, that persons might assume their habitual posture and be at ease. The great pains taken to place the sitter and to satisfy the parties with the likeness, by taking fresh ones if the first is defective, indicates a praiseworthy willingness to please. The photographs may best be copied through a powerful lens, not only for the sake of enlarging their size, but for bringing out the details of form and lightening the intense shadows: the mere addition of colour to the copy will effect a marvellous improvement, and may, perhaps, render a fresh portrait painted from the sitter unnecessary: the photograph alone will satisfy but in few instances.

QUICKSTUFF

By the end of 1841, ready-made chemicals, called "quick-stuff" in the trade, were placed on the market for use in accelerating camera exposures. Among the best known, both in the United States and in England, was a formula bearing Alexander S. Wolcott's name. Eleven years after its introduction, *Humphrey's Journal* termed it "one of the first and most valuable sensitives introduced to facilitate the operator in forming an image by the camera," adding that "probably no chemical before the Daguerreotype public has so often been counterfeited as this." The *Journal*'s further comments and publication of the formula follows:

WOLCOTT'S MIXTURE

Woolcott's Mixture was one of the first and most valuable sensitive introduced to facilitate the operator of forming an image by the camera. This compound has been known to our operators under different names, as *Van Loan's* Quick, and *Mayall's* Quick, probably no chemical before the Daguerreotype public has been so often counterfeited as this.

Through the kindness of Mr. J. JOHNSON, the former partner of Mr. Woolcott, we are enabled to give the *true* receipt for preparing the mixture known and used as *Woolcott's*.

> One part of Bromine,
> Eight parts of Nitric Acid,
> Sixteen parts of Muriatic Acid,
> About 100 parts of Water.

The above should be allowed to stand several days, and a few *drops* can be put into the coating box, containing, if a half size box about three ounces of pure water, the strength of the mixture is soon gone, and it requires frequent renewal.

The impressions successfully produced by this combination are exceedingly brilliant, but it requires an operator of certainty and much skill to use it, from the fact of the volatile agents employed.

We have a half ounce bottle hermetically sealed, which is filled with Woolcott's mixture, made in 1841. [68]

A FATHER PHOTOGRAPHS HIS SON

Horace Finley, age four, posed outdoors for 4 minutes while his father, Marshall Finley, a teacher, made this daguerreotype in 1841. Marshall Finley had never seen a camera or a lens when he decided to construct his own camera and his own lens arrangement, purchasing all materials locally. His first daguerreotype was of the family barn, but the first "good" image was of Horace. In 1842, the Finleys moved to Canandaigua, New York, where Marshall Finley co-authored, with Samuel D. Humphrey (in 1849) *A System of Photography,* one of the first books on photography published in the United States. The book was printed on the press of the local newspaper. Until his death in 1893, Marshall Finley was among the most prominent of upstate New York photographers, and was named president of the town of Canandaigua in 1872 and 1873. Horace Finley also became a noted photographer, the Finley gallery name carrying on well into the twentieth century. [69]

on the approach of a thunder-storm. At such times I found the coating of my plates much more sensitive than when the atmosphere was comparatively free from the electric fluid, and the effect was so irregular that no calculation could counteract the difficulty. This satisfied me that electricity was in some measure an important agent in the chemical process, and it occurred to me that the element might be turned to advantage. I determined, therefore, to enter on a series of experiments to test my theory. Finding it impossible to obtain an electric machine, and unwilling to abandon the examination, it occurred to me, that the galvanic influence might answer the same purpose. I therefore proceeded to make a galvanic battery in the following simple manner. I obtained a piece of zinc about two inches long, one inch wide, and an eighth of an inch thick. On this I soldered a narrow strip of copper, about six inches long, the soldered end laid on one side of the zinc, and extending its whole length. The battery was completed by placing the zinc in a glass tumbler, two-thirds full of dilute sulphuric acid, strong enough to produce a free action of the metals. The upper end of the copper slip extending

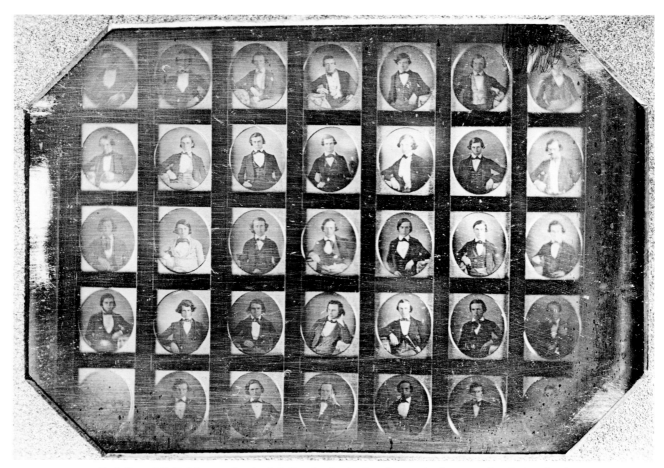

Prof. Samuel F. B. Morse made what is believed to be the first photograph of a group of graduates when he daguerreotyped the Yale class of 1810 at its thirtieth reunion in New Haven, Connecticut, on August 18, 1840. The illustration above is an enlargement of a group of thirty-five daguerreotype images, each only one-half-inch square, presumably of students whose names and institution remain unknown. Images could be tiny originals (possibly made with a Wolcott mirror camera) or tiny copies of larger daguerreotype portraits made to fit the actual frame size of 3¼ x 4¼ inches.

above the tumbler was sharpened to a point, and bent a little over the glass.

The method of using, was thus :—After preparing the plate in the usual manner and placing it in the camera, in such manner as to expose the back of the plate to view, the battery was prepared by placing the zinc in the acid, and as soon as the galvanic fluid began to traverse (as could be known by the effervessence of the acid, operating on the zinc and copper) the cap of the camera was removed, and the plate exposed to the sitter ; at the same instant the point of the battery was brought quickly against the back of the plate, and the cap replaced instantly. If the plate is exposed more than an instant after the contact, the picture will generally be found solarized. By this process I have taken pictures of persons in the act of walking, and in taking the pictures of infants and young children I found it very useful. [69]

1841

28 Prof. Draper's duties at New York City University prevented him from continuing to work with Morse, probably

after the conclusion of the summer vacation period, and the latter, in his own words, "was left to pursue the artistic results of the process, as more in accordance with my profession." Actually, Morse was in a state of near poverty—waiting for congressional action (which came in 1843 with some lobbying by his classmate, Henry Ellsworth, the Commissioner of Patents), funding an experimental telegraphic line between Baltimore and Washington. David Hunter Strother, the noted magazine illustrator of the 1850s and a breveted brigadier general and consul general in Mexico after the Civil War, recalls Morse's plight in a reminiscence published in Morse's official biography. "I engaged to become Morse's pupil and, subsequently, went down to New York and found him in a room in University Place. He had three other pupils, and I soon found that our Professor had very little patronage. I paid my fifty dollars; that settled for one quarter's instruction. Morse was a faithful teacher, and he took as much interest in our progress as—more, indeed, than—we did ourselves. But he was very poor. I remember that when my second quarter's pay was due, my remittance from home did not come as expected, and one

day the Professor came in and said, very courteously, 'Well, Strother, my boy, how are we off for money?'

" 'Why, Professor,' I answered, 'I am sorry to say I have been disappointed, but expect a remittance next week.'

" 'Next week!' he repeated sadly, 'I shall be dead by that time.'

" 'Dead, sir?'

" 'Yes, dead by starvation!'

"I was distressed and astonished. I said hurriedly, 'Would ten dollars be of any service?'

" 'Ten dollars would save my life; that is all it would do.'

"I paid the money, all that I had, and we dined together. It was a modest meal but good, and after he had finished, he said, 'This is my first meal in 24 hours. Strother, don't be an artist. It means beggary. Your life depends upon people who know nothing of your art and care nothing for you. A house dog lives better, and the very sensitiveness that stimulates an artist to work, keeps him alive to suffering.' "[71]

Morse's influence on American daguerreotype portraiture was nevertheless sizeable. From him, many of the most illustrious early photographers not only learned their trade but more importantly were given the rudiments of the traditional art form as it applies—in oil as well as photographic portraiture—to lighting, proportions, subject posing, facial expression, and the like.

But at the same time, the concurrent advent of the traveling salesman, whose wagons meandered over the highways and byways of the land, provided an unschooled medium for the spread of the "new art" to rural as well as urban communities. Advertisements by itinerant daguerreans began to appear in contemporary newspapers of this period, in many cases short-lived—due, usually, to an unfavorable response to their "art" by local citizenry. A Mr. Salisbury, for example, placed an ad in a Chicago newspaper in March 1842, making him possibly the first photographer to operate in that city; but within two weeks the advertising ceased, and Mr. Salisbury disappeared into oblivion.[72]

AN EARLY CALOTYPE VIEW MADE IN BOSTON

The earliest surviving American photographs made by the calotype process patented in 1841 by inventor W. H. F. Talbot may be a set of views made in Boston in 1842 by fifteen-year-old Josiah Parsons Cooke, later head of the chemistry department at Harvard. The view above from this collection shows a portion of the Boston Museum, left, and the Old Merchants Building, center. It is possible that Cooke made the photograph after reading of a further technical improvement in Talbot's process published in February 1842 by a fellow Bostonian, twenty-two-year-old William F. Channing.

1842

Methods of coloring daguerreotypes were introduced in 1842, and the public evidently responded to the novelty with much the same enthusiasm which greeted the arrival of genuine color photography in the present century.

The first coloring patent (the third patent awarded in the photographic field) was awarded March 28, 1842, to two Lowell, Massachusetts, operators, Benjamin R. Stevens and Lemuel Morse. It specified application of a transparent protective varnish over the image, after which the plate could be hand-colored with paints. A second patent, awarded the following October 22 to Daniel Davis, Jr., of Boston, called for gilding the plate by fixing deposits of transparent colors (applied to selected areas of the image) with the aid of a galvanic battery. Both methods were probably widely used, but in the case of the Davis patent, many photographers used a spirit lamp instead of a battery to heat the rear of the plate in those portions where evaporation of a gilding solution (applied to the face of the plate) was wanted. The Davis patent was assigned to John Plumbe, Jr., shortly after its award, and by 1843 Plumbe was advertising the capability of producing colored daguerreotypes at a chain of galleries he had established by then in Boston, Albany, Saratoga Springs, New York, Philadelphia, and Baltimore.[73]

An apparently momentary interest in paper photography occurred at this time in Boston. The previous year (on February 8, 1841) Talbot patented an improved paper photography process in England, which came to be known, interchangeably, as the "calotype" or "Talbotype" process. In his original invention, that of making photogenic drawings, the paper negative was left exposed in the camera until the image became visible on it. In the calotype process, the negative paper was exposed in the camera, then removed while still blank, the image being developed chemically thereafter.

As early as February 1842, William F. Channing, twenty-two, son of the noted Boston clergyman and author, published a method of simplifying the preparation and treatment of the paper both before and after its exposure in the camera. The English responded admirably, one authority citing Channing as "the first to publish any method by which the calotype process could be simplified." Channing, on his part, felt that "there is no science which is now advancing so rapidly as photography," and modestly stated that he expected "these processes" which he had proposed "will soon undoubtedly be superseded."

Possibly Channing collaborated with, or served as an inspiration for, another young Bostonian, Josiah Parsons Cooke, fifteen, who produced in 1842 the first of a series of calotypes which today are the earliest such American specimens extant. Cooke was obsessed with chemistry and was an early version of the proverbial American youth puttering at home with a chemistry set (which of course did not exist at that time). As a boy, he even attended a series of Lowell Lectures by the elder Benjamin Silliman. In 1850, he began an illustrious career as head of the chemistry department at Harvard. But in 1842–44, he made a series of calotype views in Boston, the first being a view taking in portions of the Boston City Hall and the Boston Museum, then adjacent to it. Photography was not to become his vocation, hence these photographs merely exemplify one phase of his scientific endeavors during his younger years.

The Channing and Cooke exploits appear to have been nothing more than two straws in the wind.[74] Talbot's patent, as we shall see, exerted a restrictive influence on the practice of the calotype at the very moment when practice of the daguerreotype was beginning to assume sizeable proportions. The most outstanding calotypes produced anywhere in the 1840s were those made in Scotland (where the patent did not apply) by David O. Hill and Robert Adamson. But a full appreciation of the Hill-Adamson works did not capture the world's attention until their "rediscovery" in the 1890s. An American patent for Talbot's process was secured in 1847, but to no avail. American photographers showed no real interest in its practice until the 1850s when all attempts by Talbot to patent his own and other paper photography processes were voided, and a French modification of his process was adopted by a number of American photographers.

Despite the problems of lengthy exposures and poor lenses, the camera was taken into the field on at least three American exploratory missions in this early period. There is some confusion as to its application on two excursions to the Yucatan made in the fall of 1839, and again in the autumn of 1841 by John Lloyd Stephens, the noted travel writer, and Frederick Catherwood, archaeologist, surveyor, architect, and illustrator. Stephens was a sponsor of D. W. Seager's lecture on the daguerreotype process held in New York on October 5, 1839, but was not present for the occasion, having departed for the Yucatan with Catherwood just two days previously. In his first book on the 1839–40 explorations of lost Mayan stone cities on the Mexican peninsula, Stephens implied that a daguerreotype camera had *not* been taken along. On the second trip, which lasted from the autumn of 1841 to June 17, 1842, Stephens and Catherwood (accompanied this time by Dr. Samuel Cabot of Boston) *did* take a daguerreotype apparatus with them, although Stephens reported in his second book that Catherwood was dissatisfied with the results obtained with the camera.[75]

But these reports by Stephens are at variance with a reminiscence published much later in the nineteenth century by the distinguished photojournalist Henry Hunt Snelling. Snelling was admittedly seventy-one years old and blind when his account was published, but it is nevertheless a straightforward, rather factual report of his evidently successful efforts to help Catherwood make his camera more effective for operation in the intense heat, and "yellow atmosphere" prevalent in the Yucatan. To begin with, before meeting Catherwood, Snelling said he had been experimenting with blue glass for camera nozzles (which were the tubes containing camera lenses) at "Mathew Brady's gallery" in New York—which is equally evocative, since

LABNAH

GATEWAY AT LABNA

Edward Anthony reportedly made successful daguerreotype photographs on a government survey in 1841, but John Lloyd Stephens, Frederick Catherwood, and Dr. Samuel Cabot reportedly had little success trying to make daguerreotypes of the ruins of the stone Mayan cities on the Yucatán peninsula in 1842. A pyramidal mound, top, among the ruins of Labná, which Stephens described as the most interesting of all ruins encountered, was drawn by Catherwood while Stephens and Cabot spent an entire day trying to photograph it with their daguerreotype apparatus. ''Our best view,'' Stephens said, ''was obtained in the afternoon, when the edifice was in shade, but so broken and confused were the ornaments that a distinct representation could not be made even with the Daguerreotype, and the only way to make out all the details was near approach by means of a ladder.'' An arched gateway (bottom illustration) was situated a few hundred feet from the mound.[76]

Brady is not known to have operated a "gallery" prior to 1843. Then Snelling recalled Catherwood's entry into the picture in these words:

> It was just after these experiments that Mr. Catherwood, who had been to Central America with Mr. Stephens, the traveler and author, to obtain views of the ancient ruins in that country, returned to New York unsuccessful with his camera. He said the heat was so great, and the atmosphere so yellow, that he could not make the chemicals work, and every attempt at a picture was a failure. We told him that we thought we could remedy the evil. As he was going to return to Yucatan with his artist's materials immediately, we induced him to bring his camera to us and have it fitted with blue glass. On his return from this second trip, he informed us that it was effectual, and he brought home many daguerreotypes.[77]

Even more strange is Stephens' statement in his first book (covering the 1839–40 expedition) that daguerreotype instruments "had not reached this country at the time of embarkation." But if Stephens was a sponsor of the Seager lecture, he must have been familiar with the early experiments of the other sponsors, namely Morse and Dr. Chilton, all having begun before the first departure to the Yucatan. Then, too, why would a blind seventy-one-year-old man, in looking back to his more impressionable years (Snelling was between twenty and twenty-four at that time), recall that a celebrity (Catherwood) had come to see him *twice,* the first time to complain about his camera on one trip to the Yucatan, and the second time to report that all had gone well on a second trip? Unfortunately, we shall probably never know the answer to this particular riddle. For if Catherwood did in fact return with "many daguerreotypes," they were subsequently lost and may have perished along with Catherwood when he was lost at sea with all his belongings in the sinking of the S.S. *Arctic* on September 27, 1854.[78]

The great American "Pathfinder," John Charles Frémont, evidently was unsuccessful with a daguerreotype apparatus which he took with him on *his* first western expedition, begun in 1842. Having failed to obtain results, he neglected to mention in his official report of the trip that he had taken the equipment with him in the first place. The world had to wait an entire century before learning of Frémont's abortive photography exploits from the diary of the German illustrator and cartographer Charles Preuss, who accompanied him. Preuss's diary remained in the Preuss family through successive generations down to 1954, when it was translated and published in the United States. Preuss was highly critical of Frémont, and gave these unflattering accounts of the progress of the expedition, thirteen and sixteen days, respectively, after leaving Fort Laramie:

> *August 2:* Yesterday afternoon and this morning Frémont set up his daguerreotype to photograph the rocks; he spoiled five plates that way. Not a thing was to be seen on them. That's the way it often is with these Americans. They know everything, they can do everything, and when they are put to the test, they fail miserably. Last night a few horses became restless. When we walked up with a lantern, we were told that Indians are nearby. Frémont wasted the morning with his machine. Now, after we have ridden about ten miles and pitched camp, we see smoke rising in the mountains opposite us, about six miles dis-

Col. John C. Fremont

tant. Here that can mean nothing else but Indians. We shall therefore have to be on guard again. We shall probably not be at ease again until we see the Missouri before our eyes.

> *August 5:* . . . Frémont is roaming through the mountains collecting rocks and keeping us waiting for lunch. I am hungry as a wolf. That fellow knows nothing about mineralogy or botany. Yet he collects every trifle in order to have it interpreted later in Washington and to brag about it in his report. . . . Today he said the air up here is too thin; that is the reason his daguerreotype was a failure. Old boy, you don't understand the thing, that is it.[79]

The most successful early operator in the field was clearly Edward Anthony. Following his first trials at the Croton Aqueduct, Anthony took lessons in daguerreotyping from Morse during his spare hours. Before the aqueduct was completed, Anthony's former instructor at Columbia, Prof. James Renwick, invited him to obtain a complete daguerreotype apparatus and accompany him on a government mission to survey the northeast boundary of the United States, the exact location of which had become a matter of dispute between the United States and Great Britain. Few records exist profiling Anthony's career and activities, but at an 1883 field-day excursion by members of the Photographic Section of the American Institute to Brighton Beach, he gave this brief account of the trip with Renwick:

> In the year 1841 I went as a surveyor on the Northeastern boundary survey, about the location of which there was then a dispute with Great Britain. The boundary was described as running along the *highlands* between the rivers emptying into the

THE STORY OF A FAMOUS ENGRAVING

Victor Piard, shown left in a photograph which he took of him-
self in 1857, served as principal operator for Anthony, Ed-
wards & Co. when the latter firm set up business in Washing-
ton, D.C., in 1842. Among his first assignments was the taking
of daguerreotype portraits of members of Congress which were
later used to compose the celebrated engraving of the United
States Senate chamber, shown above, commemorating Henry
Clay's farewell address on March 31, 1842. Although the
plates in this instance may have been destroyed after use by the
engravers (a common occurrence at the time), all of the daguer-
reotype portraits made and retained by the Anthony firm in
Washington were included in Anthony's National Daguerreo-
type Miniature Gallery in New York City, which was destroyed
by fire in 1852. Piard's role in early Washington portraiture is
little known, and appears only to have been recorded once in
contemporary photographic literature. He remained with Anth-
ony until the latter gave up photography for the supplies busi-
ness in 1847, after which he became associated with Alexander
Beckers in New York City. In the 1850s, Piard went into the
grocery business for a while, but returned to photography
when, in his own words, he accepted "a more agreeable posi-
tion before the nitrate bath in the establishment of C. D. Frede-
ricks."[80]

7.—VICTOR PIARD, ESQ.

Negative by Bishop—H. H. Snelling, Print.

Atlantic Ocean and those emptying into the St. Lawrence. On the land claimed by the United States, Great Britain asserted there were no highlands. Professor Renwick requested me to take a daguerreotype apparatus on the survey, and take views of the highlands, which would place their existence beyond dispute. I did so, and though the facilities for making views in the wilderness were very poor at that time, yet I succeeded in taking a number of the objects required, which were copied in water colors, and deposited in the archives of the State Department at Washington.[81]

The "dispute" between England and the United States, which stemmed from the provisions of a 1783 treaty, were resolved by the Webster-Asburton Treaty signed by the foreign ministers of both countries (Daniel Webster and Lord Asburton) on August 9, 1842. Anthony's daguerreotypes evidently settled the question as to the existence of the "highlands," for the agreement refers to them in Article I of the treaty.

The financial depression then in full swing in the United States made it difficult for a young civil engineer to obtain work, and this was probably a factor in Anthony's decision, after the boundary survey, to establish a daguerreotype business, Anthony, Edwards & Co., with a partner, J. M. Edwards. Also, it is possible that Anthony's services may have been called upon in the discussions held in Washington by Webster and Asburton from June 13 to the signing of the treaty on August 9. In any event, something determined Anthony to establish his business in Washington at some point in 1842, and for a base of operation he was given use of the Senate Military Affairs committee room—interestingly enough, a committee headed by Missouri senator Thomas Hart Benton, the principal Senate opponent of the Webster-Asburton Treaty.[82]

Although he later returned to the United States Senate in 1849, Henry Clay gave his famous farewell address there on March 31, 1842, and it appears that one of the first things

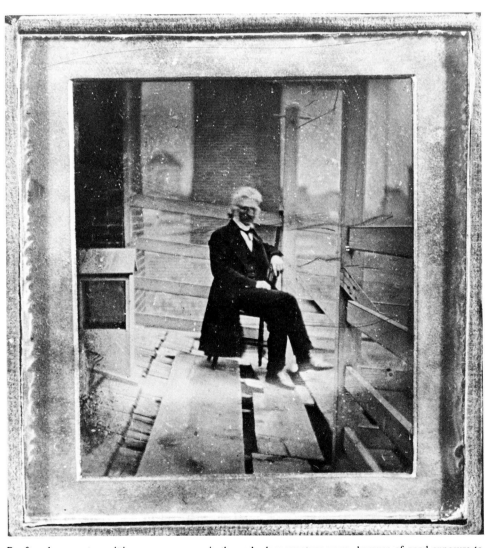

Rooftop daguerreotype sittings were common in the early daguerreotype years, because of good exposure to sunlight, but such daguerreotypes today are extremely rare. Illustration above is from a daguerreotype of the Philadelphian, John McAllister, Jr.

Anthony, Edwards & Co. set out to accomplish was the taking of daguerreotype likenesses of all the members of Congress present on that occasion, the purpose being to have the plates copied by engravers and composed into a single large mezzotint engraving depicting the historic scene (see page 34). What is less known about this undertaking is that Anthony brought with him to Washington as his "principal operator" a young daguerrean by the name of Victor Piard, who assisted in taking the portraits for the Clay speech engraving, and remained with the Anthony firm, in total obscurity, until Anthony entered the supplies business some five years later. In 1852, the vast majority of Anthony's personal collection of daguerreotypes made in Washington at this time were destroyed in a fire. Nevertheless, the Chicago Historical Society, which owns a sizeable collection of daguerreotypes of men prominent in Washington in the 1840s, believes that some of the specimens in the society's collection, including possibly one of Anthony's patron, Sen. Thomas Benton, are copies made by the Anthony firm for their sitters. But such attribution can only apply to plates which it can be accurately determined were secured in the period 1842–47 (Anthony gave up his daguerreotype business to enter the supplies business in 1847). Perhaps the only daguerreotype ever positively attributed to the Anthony firm was a portrait made by Anthony's partner, J. M. Edwards, of Secretary of the Navy Thomas W. Gilmer just a few days before Gilmer was killed (on February 28, 1844) in an explosion aboard the USS *Princeton*.[83]

Things continued to go well, meanwhile, for the Americans in London—A. S. Wolcott and John Johnson. During the first year of operation, the Beard studio was heavily patronized. "In the waiting rooms," according to an account published years later, "you would see, awaiting their turn to enter the blue glass roofed room, the nobility and beauty of England, accommodating each other as well as the limited space would allow, during hours of tedious delay." In 1842, Beard opened two additional studios in London. He also established the practice of selling the rights to his businesses in the counties outside London, and on November 9, 1842, he assigned to Johnson the exclusive rights to all daguerreotype business in the counties of Lancashire, Cheshire, and Derbyshire. A biographical sketch of Johnson published in 1896 states that while in England (Johnson was in Manchester at least in the early part of 1843), he took pictures of the Royal Family, including the Prince of Wales (later King Edward VII, born in 1841). But a more recent record reveals that the first picture of the Prince was taken March 6, 1842, by William Constable, proprietor of Beard's Brighton gallery. Nevertheless, it is probable that Johnson photographed a number of England's nobility. A daguerreotype of Lady Byron, according to Johnson's biographical sketch, was still in the hands of his survivors twenty-five years after his death.[84]

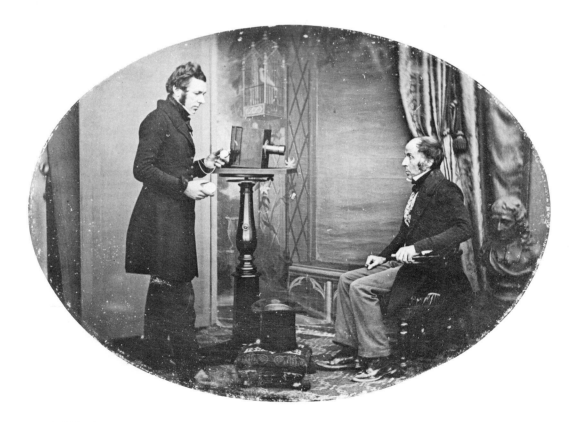

At Richard Beard's Westminster gallery (opened March 29, 1842), Jabez Hogg uses a new sliding-box daguerreotype camera to photograph "Mr. Johnson" (probably William S. Johnson, father of John Johnson). Possibly the earliest surviving photograph of a photographer at work, the image was reproduced as an engraving in the *Illustrated London News* on August 19, 1843.

1843

Many early advances in photography emanated from the researches of Sir John Herschel, who freely published his findings without any apparent desire to claim or to patent this or that discovery from his rather large bag of tricks. First, he had given the photographic world its "hypo" universally used to "fix" prints in a darkroom; in February 1840, he disclosed that bromide of silver was far more light-sensitive than any other silver salt, and this provided the basis for bottling various formulas of "quickstuff" used throughout the daguerrean era. Herschel also disclosed, in 1840, that he had been experimenting with photography on glass, and that he had even made positive prints from glass negatives.

No doubt this set a number of minds working, among the first of whom was Alexander Wolcott. Wolcott was still in London in the early part of 1843, where he and Johnson patented (in March) an apparatus intended for use in making enlargements from the mirror camera's small images—producing the enlargements on larger daguerreotype plates, or on sensitized paper. But at the same time, Wolcott began experimenting with a camera which was designed to secure an image on a hemispherical piece of transparent glass. If this could be done, the glass plate could be used in a magic lantern to project the image on a screen. Johnson, meanwhile, was in Manchester, presiding over his three-county domain for daguerreotype operation. The pair evidently conducted experiments separately, but corresponded frequently by mail. Then, unfortunately, at some point in 1843, Wolcott became ill with a terminal disease. He returned to the United States the same year and died on November 10, 1844, at Stamford, Connecticut, in his fortieth year.[85]

Much of the Wolcott-Johnson correspondence in this period was given to Prof. Charles A. Seely, editor of the *American Journal of Photography,* in 1860. Seely said at that time that he intended organizing and publishing the material, but never did. He did, however, publish two of Wolcott's letters which, unfortunately, were written in a somewhat rambling manner, making the precise nature of his experiments unclear. For his part, Johnson never published or shed any further light on the pair's work. However, in a letter to Johnson dated February 20, 1843, Wolcott made the following statement:

> The easiest plan that occurred to me was to follow some known process, Talbot's for instance (which was the one I tried); previously, however, coating the glass with some substance which, like paper, would absorb the fluids; the thing that first occurred to me was the white of egg, and that by heating it after it was spread on the glass, it would coagulate and thereby become insoluble. The difficulty seems to be that although it is insoluble, it is mechanically disturbed by the fluids, and that therefore it is exceedingly difficult, if not impossible, to preserve an even coating throughout the operation.[86]

The white of an egg is known as albumen. In experimenting with this substance, Wolcott anticipated, by seven years, its use as a sensitizer for photography's first glass negative process. He also indicated, in his February 20 letter, that he had been studying Herschel's published reports, but his remark to Johnson that "for some reason or other I cannot do anything by Herschel's plan, with the ammonia citrate of iron," gives us no clue as to precisely how he was endeavoring to benefit from Herschel's research. Wolcott also told Johnson that he had gone to the "Enrolment Office" in order to "see Talbot's claim," and followed this with a jumbled series of "extracts" from the claim which he said he hoped "might suggest something useful to your mind."

In November 1861, Johnson donated the camera used by Wolcott in 1843 to the Photographical Section of the American Institute. Prof. Seely, who was present on the occasion, is recorded in the minutes as having stated that Wolcott and Johnson had "nearly succeeded in perfecting the albumen process," and added: "Had the letters of Mr. Wolcott been published at the time they were written, Messrs. Wolcott and Johnson would have been everywhere recognized as the inventors of many devices which are used at the present day."[87] Prof. Draper, in his annual report as president of the society in 1861, concurred: "It appears," he said, "that evidence is in existence that Messrs. Wolcott and Johnson had at that time nearly succeeded in perfecting the albumen process."[88]

Wolcott's obituary states that "the disease which terminated his life was contracted by too close application to some extremely valuable improvements in the manufacture of cotton." In the biographical sketch of Johnson published in 1896, the statement is made that Johnson "invented several improvements in cotton machinery" while in England, "for which he received medals." Johnson never discussed or published anything on these experiments in later years, but one is left wondering why they became involved with cotton. In 1846, gun-cotton (an explosive substance consisting of cotton mixed with nitric and sulphuric acids) was mixed with ether and alcohol to make collodion. In the late 1840s, collodion was used to treat wounds, but then, in the 1850s, it was adopted universally as a sensitizer for preparing photographic negatives.

Despite Wolcott's patented means of enlarging the small daguerreotypes made with the mirror camera, the impending demise of this type of equipment became evident, if it had not done so earlier, in May 1843, when Claudet exhibited daguerreotypes of large size produced with a new camera and a new type of lens. This was the Petzval lens—the first true camera lens—which had been perfected two years earlier, but was slow in reaching the market. Initially, all lenses used in daguerreotype cameras were single lenses, constructed originally for telescopes or microscopes—or were ordinary spectacle lenses of the type used by Prof. Draper in a cigar box. Achromatic lenses were adopted early (making the focus seen with the eye coincident with the focusing on the plate of the sun's invisible or "actinic" rays), but the angle of these lenses was small (at most a few degrees), and did not insure a sharp image over the entire

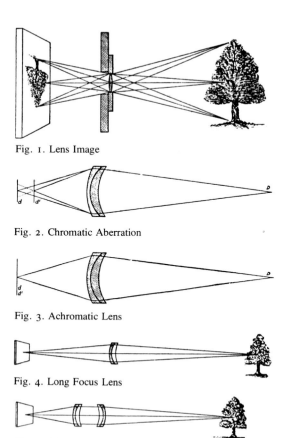

Fig. 1. Lens Image

Fig. 2. Chromatic Aberration

Fig. 3. Achromatic Lens

Fig. 4. Long Focus Lens

Fig. 5. Short Focus Lens

THE FUNDAMENTALS OF EARLY LENS DESIGN

Beginning with the Petzval lens, camera lenses quickly took on a variety of design configurations. Basically, the glass of a lens bends the rays of light, which proceed from a point in the object being photographed until they reach the lens, after which they are bent by the lens until they meet once again in a point (called the focal point) on the focusing glass or image plate. Fig. 1 illustrates how this is true of all points of a subject tree. The distance from the lens to the place where the rays come again to a point depends on the strength of the lens in bending the rays, and this distance is called the focal length.

The focal point at which the visible rays of light come together on the viewing glass or image plate is not the same for the actinic or nonvisible light rays. Thus, the rays of visible and actinic light proceeding from point D in Fig. 2 are brought to differing focal points (d and d¹) unless this chromatic aberration is corrected by the lens itself. This is accomplished in the achromatic lens (Fig. 3), wherein two pieces of glass of differing refractive powers (once having been ground "positive," or thicker in the middle than at the edges, the other having been ground "negative," or thinner in the middle) are united. Two of the surfaces of each of the two glasses are given a similar curvature, making it possible to cement the glasses together. In the achromatic lens, the visual and actinic rays are thus brought to the same point when the camera is focused.

Lenses having a longer focal length rely upon the back lens cell only for bending light rays and bringing them into focus (as in Fig. 4). A shorter focus lens (Fig. 5) utilizes both front and back lens cells, bending the rays to a much greater extent and bringing them into focus in a much shorter distance. [89]

plate. Straight lines would appear curved; circles when seen at the edge of the plate would appear oval and ill-defined. Achromatic lenses also could not focus enough light on the plate fast enough to achieve the wanted reduction in exposure time.[90]

Immediately after the daguerreotype invention, a Viennese optician, Josef Max Petzval, began the tedious work of designing a photographic doublet some twenty times faster-acting than the lenses used in Daguerre's camera, and having an aperture corresponding in today's nomenclature to f/3.6. First, Petzval (who had flunked mathematics as a student, but kept up studies on his own) made use of optical data on all known kinds of glass tabulated in 1811 by Friedrich Voigtlander, son of the founder (in 1756) of the Voigtlander optical firm, also in Vienna. On the basis of this data, he calculated the curvatures and internal distances

A VIENNESE CONNECTION

The early arrival in the United States of this novel, spyglasslike camera, containing the new Petzval portrait lens, resulted from a close family tie between the manufacturer, Voigtlander & Sons in Vienna, and the bothers William and Frederick Langenheim in Philadelphia. The all-metal camera was easily taken apart for traveling, but square daguerreotype plates had to be cut to fit its cylindrical frame. Low temperature of metal also necessitated longer exposures.

Petzval lens

required to make a doublet of low achromatism and spherical aberration. The task was an enormous one, and such calculations today are handled by a computer; in Petzval's case, the Archduke Ludwig came to his rescue with two officers and eight soldiers of the Austrian Bombadier Corps, all skilled in mathematical computation. Petzval's lens consisted of an achromatic cemented pair backed by an achromatic air-spaced pair. Voigtlander produced a wooden camera of conventional design to house the new lens, together with a spyglass style, all-metal camera of unconventional design. The spyglass camera was not widely adopted, but the Petzval lens became the standard for most cameras and was exported all over the world. By 1862, Voigtlander had produced the ten thousandth Petzval lens, and it continued its popularity throughout the nineteenth century.[91]

The first Voigtlander cameras were available in the United States as early as January 1843. This resulted from the fact that Peter Friedrich Voigtlander, third son of a founder of the firm, had been a classmate of the eldest of the two Philadelphia photography pioneers, William and his brother Frederick Langenheim (both natives of Brunswick, Germany), and had married one of the brothers' two sisters. Alexander Beckers, later a prominent New York photographer and builder of stereoscopes, recalled that one of the spyglass instruments "and a kind of hiding-place for a darkroom" greeted him when he joined the brothers as an assistant in 1843 in their first rooms in the Merchants' Exchange in Philadelphia. Beckers said the camera had been sent to William Langenheim by young Voigtlander "as a present,

with supplies and instructions, but also the warning not to try daguerreotyping unless he had courage enough to try five hundred times more after failing with the first hundred pictures. William Langenheim, a lawyer, did not have the courage,'' Beckers added, "but his brother Fred had, and succeeded so well that he was offered six hundred dollars for that odd camera.''[92]

M. P. Simons felt that the exclusive agentry for the Voigtlander cameras gave Frederick Langenheim "quite a start and a decided advantage over his contemporaries. I at once saw that he was getting ahead of me fast, much faster than suited my youthful aspirations; so one day I took it into my head to make him a professional visit to ascertain if possible the cause of his great success, for up to that time, I must admit, I was not aware of there being any difference whatever in the quality of lenses. I found Mr. L. quite busy making better pictures, and in much shorter sittings, with his quarter-size Voigtlander than I was able to do with my half-size Plumbe.'' This referred, in all probability, to a camera manufactured by J. H. Plumbe. On a second visit, Simons found Langenheim "without sitters, though as busy as ever in that mysterious 'No admissions' room, finishing up his day's work and preparing for the next. This suited me very well, as it gave me a fine opportunity to scrutinize more carefully his little lens without being in anybody's way. There were quite a large number of these tubes and lenses of the different sizes, as they are usually gotten up, lying about on shelves and tables waiting for lucky purchasers. But the one Mr. L. himself used interested me the

1843

most of all; it was a tube lens and camera-box combined, done up in brass and reminded one of a small telescope— the only one of this description I have ever seen—and, although it appears, not a *success,* it was to my notion a perfect beauty from head to foot, and I fell dead in love with it at first sight. No child ever looked with more covetous eyes at toys in the shop windows than I did at this unique, brass-clad camera."[93]

Although it is not known how widely the spyglass camera was used after its introduction by the Langenheims, M. P. Simons was one operator who dug up the money and bought one. But "necessity soon introduced a square camera, with square plates and holders" at the Langenheim gallery, according to Beckers. "In the summer of 1843 the first dozen of small Voigtlander objectives . . . were imported. Soon after, four larger ones, for 6 x 8 pictures, arrived."

When the first daguerreotype was exhibited in New York in September 1839, it was contained in an expensive moroccan leather case of the type which was used previously to house miniature paintings. While many of the first specimens made at the Beard and Claudet galleries were placed in pinchbeck cases, or in black papier-mâché frames similar to those used for silhouettes, the custom quickly began, both in the United States and in England, of adopting the

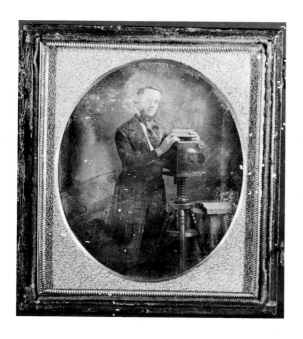

GHOSTLY PIONEERS

The directories of major United States cities contained few names of daguerreotype photographers in 1843, yet reports like those opposite reveal that there may have been more activity in this early period than has been fully recorded. The unknown daguerreotypist, above, could have operated for only a fleeting moment, or this could be an early likeness of numerous later photographers of note, of whom no early likeness—and in some cases no likeness at all—is known to exist. No identified daguerreotype likeness of any of photography's early "big names," with few exceptions, is known to be extant. Only the Boston firm, Southworth & Hawes, left a record of their work in sizeable form. No collections by Morse, Draper, Anthony, Brady, Gurney, the Langenheims, Plumbe, and numerous others who maintained large operations have survived—all having disappeared with their sitters, or, as in the case of the Anthony collection, been destroyed in fires.

COMPETITION FOR ANTHONY IN WASHINGTON, D.C.

A photographer who appears to have escaped notice up until the present time placed the following advertisement in a Washington, D.C., daily on June 23, 1843, and repeated it in same or shortened form twenty-one times in 1843 and twice in 1844. The ad appeared on the front page on December 4, 1843, the day of the opening of the 28th Congress.

DAGUERREOTYPE: Daguerreotype Portraits and Miniatures, copies of paintings and statuary, views of buildings, landscapes, etc. by L. T. WARNER at the Washington Photographic Rooms, corner of Pennsylvania Avenue and C Street, a few doors west of Brown's Hotel.

Likenesses taken on plates, from breastpin size to 8 inches square, and full length groups from 2 to 20 persons.

The natural colors given to pictures by various processes, including those of Thsenring, Lechi, Lerebour, and Dr. Page; also Electrotype copies of Daguerreotype pictures.

Instructions in the above; also in Magneto electric and Galvanic gilding and silvering, according to the processes of Elkington, Roulz and Fitzeau.

Daguerreotype apparatus of the first quality for sale, at prices varying from $25 to $100. Also Electro-magnetic, Magneto-electric, Thermo-electric, Galvanic and Electrotype apparatus of the most approved construction.

Chemicals and all materials of the best quality for Daguerreotyping, Electrotyping and gilding and silvering constantly on hand.

Rooms open from 8 o'clock till 7 o'clock P.M. The public are respectfully invited to call and examine specimens and witness the manner of taking pictures.

L. T. Warner[94]

moroccan leather case for framing daguerreotype images. Then, in 1843, a Boston case maker, William Shew, conceived the idea of producing wooden cases of cheaper design which could be covered with embossed paper. This marked the beginning of a sizeable new industry wherein millions of cases were produced in a variety of materials and shapes.

There were an estimated 500 to 600 different embossed designs applied to wooden cases, and some 800 motifs to the plastic cases introduced in 1854. Cases were also made of papier-mâché, papier-mâché inlaid with mother-of-pearl, tortoise shell, and silk. The vast majority of the cases were manufactured in New York, Philadelphia, Boston, and half a dozen cities and towns in Connecticut. The reason for this proliferation of manufacturers lies in the fact that neither Shew nor the largest of the manufacturers, the Scovill Manufacturing Company in Waterbury, Connecticut, obtained patents for their designs. Nature motifs predominated in the early case designs, following the widespread artistic interest in nature created during the period 1827–38 by publication of John J. Audubon's monumental *Birds of America,* which contained a thousand life-size figures of some 500 different species.

Although it went unrecognized at the time, the manufacture of plastic cases for daguerreotypes marked the beginning of thermoplastic molding in the United States. The cases were made of a plastic material consisting of shellac and excelsior, ground wood or sawdust, and a black or brown coloring—all of which was hot-pressed in dies or molds of the chosen design. Thick image cases made to resemble a book were produced, the edges of the case usually gilt-painted to resemble the pages of a book. Among the embossed and plastic case design motifs are two of Washington monuments, one in Washington, D.C. (a design later abandoned when the monument was reconfigured prior to completion of the structure in 1884), and one in Richmond. Strangely, no case design of the first Washington monument, built in Baltimore in 1824, is known to exist.[95]

At this early stage of photography the daguerreotype camera was not used for social documentation purposes, as cameras in the hands of Jacob Riis and Lewis Hine were

DAGUERREOTYPISTS AND BEGGARS ARE MONEYMAKERS IN NEW YORK

This humorous item appeared on February 24, 1843, in a Washington, D.C., newspaper. It was sent by a New York correspondent four days earlier:

I presume you would like to know who makes money in New York in these Jeremiad times. I can hear but two classes—the *beggars* and the *takers of likenesses by daguerreotype.* It's an old contradiction in human nature (very likely the basis of the parable of the camel and the needle's eye) that we give more as we have less to give; and with the late twin increase of poverty and pity, the beggars of New York have correspondingly increased. . . . *Daguerreotyping,* which is now done for a dollar and a half, is the next most profitable vocation. It will soon be difficult to find man or woman who has not his likeness done by the sun (Apollo fecit) as it was, before the *rain* of portrait painters, to find one without a profile cut in black. A Frenchman has opened a shop in Fulton street for the sale of apparatuses for daguerreotyping, so that any pedlar can take up the trade. Some beginnings have been made in copying in colors, and one man has altered his sign to *''photographer.''* Should an improvement be made hereafter by which an artist could correct the variations made by the imperfectness of the perspective and the convexity of the lens (for these daguerreotypes are very incorrect after all), the immortality of this generation is as sure, at least, as the duration of the metallic plate.[96]

later in the century. In 1841, Dorothea Dix, for example, began visiting jails and almshouses in Massachusetts, and delivered a scathing report to the Massachusetts Legislature in January 1843, which produced a profound sensation and call for reforms. This was an early instance in which the exposure of inhuman social conditions prompted official remedial action. But no cameras recorded what Miss Dix witnessed.[97]

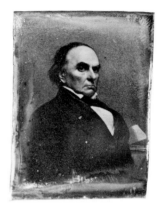

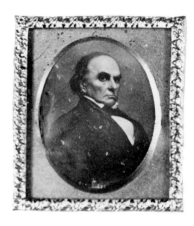 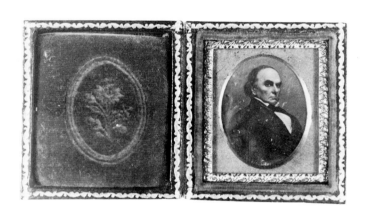

THE ELEMENTS OF A DAGUERREOTYPE PORTRAIT

Looking every bit like the original, this copy daguerreotype of Daniel Webster (probably made after his death in 1852 from a daguerreotype made in the 1840s) is secured on a silvered copper plate (1), which was exposed in the camera without the use of a negative. A sheet-brass mat (2) and glass cover of same size (not shown) are placed over the image and secured in a thin, pliable gold-plated protective border (3) which wraps around these elements (4). The completed daguerreotype is then placed in the right-hand side of a paper-covered plastic miniature case (5), the interior left-hand side of which is lined with velvet-covered cardboard. Many cases made after 1855 were of plastic.

Louis J. M. Daguerre made many of his daguerreotypes on plates measuring approximately 6½ x 8½ inches, which was larger than the 2¾ x 3¼ size which became the most prevalent for the millions of daguerreotypes made after a general standardization of plate holder sizes. The daguerreotype plate of Webster, above, measures 1½ x 1¾ inches, which was a size frequently used in making copy daguerreotypes. The nomenclature adopted for the various plate sizes was as follows:

Ninth plate	1½ x 1¾ inches	Half plate	4½ x 5½ inches
Sixth plate	2 x 2½ inches	Whole plate	6½ x 8½ inches
Quarter plate	2¾ x 3¼ inches	Double whole plate	8½ x 13 inches

1844

42

1844

Experiments with glass as a negative base for photography were begun in 1844 in Boston. John A. Whipple, twenty-two, a supplier of chemicals for daguerreotype use, gave up his business at this time because of the ill effects of the chemicals on his health, and formed a partnership in a daguerrean studio with Albert Litch. Strangely, Whipple did not experiment with Litch (who became associated with Jeremiah Gurney in New York after 1846, then went to England in 1853), but chose to work, instead, with another friend, William B. Jones, during the pair's leisure hours. At first, they began "trying the different processes then published (principally Talbot's calotype process), devising means to improve upon them." But when they made positive prints from a paper negative, they found that they could not prevent the fibers of the negative paper from being copied in the prints, which Whipple felt marred their beauty (there would be later schools of thought in photography which thought quite the contrary).

"Knowing that the basis of the whole thing was the connection of nitrate, and iodide of silver with organic matter, the idea naturally suggested itself, why could not an even film of some kind be laid upon mica and glass, and the negative impression be taken upon that, thus avoiding the great evil of copying the texture of the paper," Whipple thought. Having come to this conclusion, the pair tried their first "film"—milk. But this proved unsuccessful. "Not being able to operate to our mind with the milk, various other substances of a gelatinouus and albuminous nature were tried: but none operated so well as albumen from the hen's egg," according to Whipple. "It would hold the desired quantity of iodide of silver, and dry smooth, and would withstand the action of the hyposulphite of soda solution—two very important points gained—but in pictures made with it, there was a want of harmony, of light and shade; the deep shades and high lights coming in masses, the half tints being most wholly wanting, so that for practical purposes it was very difficult." Whipple and Jones nevertheless continued experimenting with albumen, evidently for quite an extended period of time, unaware that similar experiments begun about the same time, or shortly afterwards, would catch them napping in another four years, much as Daguerre's invention had caught Talbot by surprise in January 1839.[98]

Talbot, meanwhile, endeavored to make up for lost time in promoting the calotype process. First, he established his Reading Talbotype Establishment outside of London, where a large number of "Talbotype Photogenic Drawings" were

The cased miniature oil portrait, such as the one (above) of Ann Bolton by Edward Greene Malbone (1777–1807), the noted artist from Newport, Rhode Island, provided the style copied by daguerreans for casing their photographic portraits.

produced, but sold with only moderate success. Then, in June 1844, he commenced publishing (in six installments) *The Pencil of Nature,* the world's first book illustrated with original photographs (of architecture, sculpture, botanical specimens, and other assorted themes). "It must be understood," he explained in the prospectus, "that the plates of the work offered to the public are the pictures themselves, obtained by the action of light, and no engravings in imitation of them . . ." A thousand prints—two hundred each from five negatives—were supplied for the first installment of the book, which was issued in a limited edition of about two hundred. Ultimately, a total of twenty-four negatives were used to make the thousands of prints required to complete the six installments, the last of which came off the press in April 1846. All prints were exposed to sunlight in racks in the back yard of the Reading establishment. Exposures in each case took from minutes to hours, depending upon the intensity of sunlight at a given time. Patrons for this monumental work were solicited in the United States, as well as in England and on the continent. The *Living Age* reprinted in New York a review published by *The Spectator* in London, which said in part:

> The images of the calotype are only inferior to those of the daguerreotype in this respect—the definition of form is not so sharp, nor are the shadows so pure and transparent. By looking through a magnifying glass at a daguerreotype plate, details imperceptible to the naked eye become visible in the shaded parts; not so with the calotype drawings—they do not bear looking

into. This arises chiefly from the rough texture and unequal substance of the paper; which cannot, of course, present such a delicate image as the finely polished surface of a silvered plate.

In 1845, Talbot undertook a second publishing venture, *Sun Pictures in Scotland.* This was a book without text, sold in a limited edition of only 118 copies. Twenty-three negatives of scenes connected with the life and writings of Sir Walter Scott were used to print a total of 2,714 photographs at the Reading factory. But the prices for these publishing ventures were high, and delays developed in deliveries. In addition, the stability of the prints was considered unsatisfactory in many instances. Talbot also had high hopes that his process would be adopted (under license) for portraiture, but a studio opened in London in 1847 proved a failure. Only in Scotland was the calotype a resounding success in portraiture. There the process was practiced in all its forms by Hill and Adamson from 1843 to 1847, and their works can still be found today at auctions or in the hands of dealers.[99]

By 1844, daguerreotype portrait galleries were becoming more plentiful in New York. Doggett's New York City Directory for 1843–44 lists Mathew Brady as a jewel case maker, then in 1844–45 as a jewel, surgical, and miniature case maker at 187 Broadway; and as a daguerrean operator at 207 Broadway, with an entrance at 162 Fulton Street. Before opening his first gallery, Brady worked as a clerk at the A. T. Stewart dry goods firm. But upon becoming a photographer, his notoriety was immediate. He captured

THE FIRST BRADY GALLERY

From 1844 to 1853, Mathew Brady operated his first photographic gallery (top) in New York at this Broadway and Fulton Street location, opposite St. Paul's Chapel where Washington had worshiped half a century earlier. The Brady gallery is not visible in this view (bottom) taken from a similar vantage point. The Low footbridge in the foreground was built in 1866 at the request of merchants on one side of Broadway, then torn down in 1868 after protests from those on the *opposite* side.

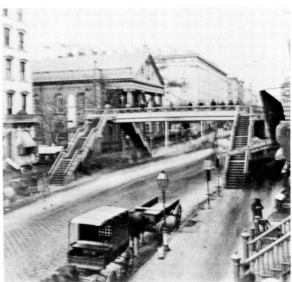

1844

45

Daguerreotypes were placed in oval silver frames of the type used for miniature portraits in oil (top), and were applied to all forms of jewelry. Depicted above are likenesses in a watch case (center) and breast brooch (bottom), which also contains decoration of strands of hair on the exterior.

first honors for daguerreotype portraiture at the annual fair of the American Institute in 1844 (the Institute's first industrial fair was in 1828), while his principal rival, Jeremiah Gurney, and the Boston operator John Plumbe, Jr., were awarded other prizes.

Although he was officially in the photography business by 1844, it is still questionable as to when the famous Civil War photographer actually began to take daguerreotypes commercially. H. H. Snelling, as we have already seen, recalled experimenting in "Brady's Gallery" at the time of the two Yucatan expeditions by Stephens and Catherwood. Possibly, this could have been an early studio of the celebrated portrait painter, William Page (1811–1885), who befriended Brady in the late 1830s and introduced him to Morse in 1839 or 1840. Page maintained a gallery in New York from about 1833 to 1843 (when Brady was possibly his roommate), then relocated in Boston during the years 1843–47. Brady's birthdate (1823 or 1824) and place of birth (Wales or upstate New York) have never been determined precisely, and one Brady historian has termed the years 1841–43 in Brady's life as "shadowy." Still another source puts Brady and a water-colorist, James S. Brown (who became a photographer with his own gallery after first working for Brady), as working together as early as 1842 in New York, combining their respective talents.[100]

When another New York photographer and plate maker, Edward White, bought a large Voigtlander camera from the Langenheims in Philadelphia in the spring of 1844, Alexander Beckers was evidently induced to leave the Langenheims' employ in order to join White in New York. But by December, he went into business for himself "when it became impossible to make a picture in his [White's] operating room on account of the extreme cold" [White would not allow a fire to burn in his gallery overnight]. Beckers recalled that besides Brady, Gurney, and Plumbe, the other principal daguerreans in New York at this time were Edward Anthony, J. M. Edwards, Howard Chilton, Augustus Morand, Samuel Van Loan, Nathan G. Burgess, Henry Insley, and others he identified only as Brush, Weston, and Artho. Two others also then in business in New York were Martin M. Lawrence and George Prosch. Beckers later said he had made "the first large daguerreotypes" in New York while associated with White, and had made a view of the Croton Aqueduct in the spring of 1845, before the construction scaffolding was removed. "By taking out-of-doors views I discovered that the plates increased in sensitiveness with the time between preparation and exposure," Beckers said of these early daguerreotype views. By 1848, he had succeeded in obtaining a "sharp picture of a procession in motion."[101]

1845

It was in 1845 that the term "manifest destiny," which presumed a divine sanction for American growth across the continent, first appeared in an expansionist magazine edited by John L. O'Sullivan.[102] Prompted by foreign opposition to the annexation of Texas, the phrase applied equally well to the 1845 dispute with Great Britain over the joint occupation (since 1818) of Oregon, which President Polk flatly declared was United States territory in his first annual message to Congress on December 2.

The feeling that a Divine Providence had great things in store for the "free development" of the nation's "yearly multiplying millions" evidently had its effect on young Mathew Brady. "From the first," he said of his goal in life, "I regarded myself as under obligation to my country to preserve the faces of its historic men and mothers." He "loved men of achievment," and he set out to make daguerreotype likenesses of all the great and famous—first at his New York gallery, then at a second gallery opened in Washington in 1847. Brady has been described as shy and a tireless worker whose poor eyesight grew weaker in this period when the lenses in his glasses grew thicker and thicker.

Reportedly, he took "thousands" of daguerreotypes in the first few years of his business. Possibly, many of the gallery's early daguerreotypes were finished in colors, since an 1893 profile of the water-colorist James S. Brown, who was Brady's helper prior to 1848, makes the statement in looking back to the Brady years that "Brown's eye for color in the coating process made fine, strong, vigorous daguerreotypes." By the 1850s, Brady was to become the principal source for supplying daguerreotype portraits copied as engravings and published in *Harper's, Leslie's,* and other illustrated weeklies. During all of the nineteenth century, the term "Photograph by Brady" was never matched in the public's eye by the works of any other American photographer.[103]

Aside from isolated undertakings (such as Lerebours' feat in securing daguerreotype views of various European architectural and scenic wonders), cameras were little used in the 1840s to record scenic views anywhere. No photographs are known to have been taken, for example, of the first wave of migrations across the American continent to Oregon and the Far West. One exception occurred, however, when Frederick Langenheim journeyed to Niagara Falls in the spring or summer of 1845 and made a primitive form of a panoramic view of the falls by securing five daguerreotypes which he mounted side by side in a single frame. Returning to Philadelphia, he copied these views in eight sets, and in December he sent one set each to President Polk; Queen Victoria; Daguerre; the kings of Prussia, Saxon, and Württemberg; and the Duke of Brunswig. The five views taken of Niagara Falls did not exactly coincide with one another; however, this was accomplished in a similar feat the following year by Friedrich von Martens, who secured a panoramic view of Paris with a camera of unique design in which the lens was moved horizontally through an angle of more than 150 degrees, the picture being secured on a curved daguerreotype plate.[104]

Daguerreotype portraiture, meanwhile, was not practiced with any marked success at all in Daguerre's homeland prior to this time. Historian Marcus Root tells the story of Nathan G. Burgess' visit to Paris in 1840, where he met one of the "artisans" who had constructed Daguerre's first apparatus (presumably Michel Chevreul or Alphonse Giroux). Burgess, the "artisan," and another unidentified man tried making daguerreotype portraits and views in Paris, but without success. As strange as it sounds, a nineteenth-century version of "an American in Paris" was among the first to produce noteworthy daguerreotype portraits in Paris. This was Warren Thompson of Philadelphia—another pioneer American photographer who leaves a tantalizingly illustrious but elusive trail in the recorded pages of photographic history. Thompson is said by Root to have been the second Philadelphian (after Cornelius) to successfully take daguerreotype portraits—presumably with a mastery of plate acceleration techniques learned from Dr. Paul God-

The westward migration of covered wagons across the American continent began in the early 1840s, increasing from a thousand vehicles a year heading for Oregon in 1843 to three thousand by 1845.

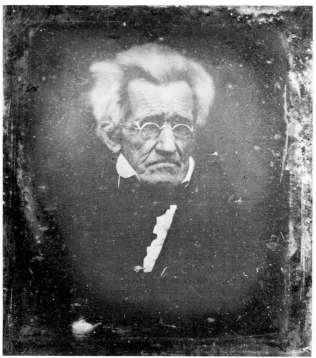

Fig. 1

Fig. 2

PHOTOGRAPHERS PAY HOMAGE TO A NATIONAL PATRIOT

As the spirit of "manifest destiny" spread throughout the land, so it seemed an appropriate time to pay homage to one of America's most venerable patriots, who had helped to make it all possible. Thus, one of the great photographic undertakings of 1845 was the effort by a number of daguerreans—possibly including Brady—to procure a likeness of former President Andrew Jackson, who was by this time approaching the end of his life in failing health at The Hermitage, his planation home outside of Nashville.

Although all of the portraits above were made of Old Hickory in the spring of 1845, the photographer of only one can be determined with assurance. This is Fig. 2, reproduced from a half-plate daguerreotype profile in a private collection which is still secured in its original case, on the back of which is written in a contemporary hand: "Daguerreotype of Genl. Andrew Jackson in possession of the late Judge John K. Kane. Taken by Langenheim at The Hermitage a short time before the death of the General." The photographer was therefore either Frederick or William Langenheim of Philadelphia. Fig. 1, which has been reproduced from a sixth-plate daguerreotype donated by A. Conger Goodyear to the International Museum of Photography at George Eastman House, is attributed by museum officials to a Nashville photographer, Dan Adams. Figures 3 and 4 are clearly similar to one another, but Fig. 4 gives the appearance of being a retouched version of Fig. 3. The latter has been reproduced from an 1897 article in *McClure's* in which Charles H. Hart, an authority at that time on historical portraiture, describes the original as a daguerreotype of only size 1⅛ x ¾ inches, made by Dan Adams and owned at that time (1897) by Col. Andrew Jackson of Cincinnati. Fig. 4 is from a wet-plate negative at the National Archives attributed to Brady, and said to have been made from a daguerreotype. But the daguerreotype itself is not in the Archives and remains unidentified. It would seem that the daguerreotype represented in Fig. 3 (or another copy of the same image) served as the original from which the retouched wet-plate negative by Brady (Fig. 4)

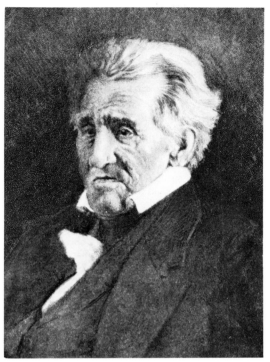

Fig. 3

Fig. 4

was made in later years. The question therefore remains: Who made the original daguerreotype attributed by Hart to Dan Adams, and represented in Fig. 3? The late Prof. Robert Taft, in his *Photography and the American Scene,* is of the opinion that the *McClure's* image attributed to Adams was actually a copy of an original, since small copies of this nature were frequently made of larger daguerreotype portraits. The *McClure's* image could therefore be attributed to Adams, or to another photographer, such as Brady or Edward Anthony. There is considerable likelihood that the original was, in fact, made by Anthony, who is reported to have journeyed from New York to The Hermitage in 1845 for the express purpose of daguerreotyping Jackson. Two issues of the *Democratic Review* in 1845, and another in 1846, carried engravings of a Jackson likeness similar to the daguerreotype in Fig. 3, and these engravings were said to have been made from a daguerreotype by Anthony, Edwards & Co. In the *McClure's* article, Hart quotes Jackson's granddaughter, Mrs. Rachel Jackson, as having ''a vivid recollection of the arrangement for taking this likeness,'' but she does not state that it was Adams who came to The Hermitage for this important sitting. She does, however, refer to ''old plates of some earlier daguerreotypes [of Jackson], but they are entirely faded out.'' As for Mathew Brady, we have only the statement he made to a reporter in 1891: ''I sent to The Hermitage and had Andrew Jackson taken barely in time to save his aged lineaments to posterity.'' Brady was, of course, unaware of the existence of the Langenheim portrait, and whom he ''sent'' or whether he went to Nashville himself remains unknown. But Brady and Anthony frequently collaborated in daguerreotype undertakings, and possibly it was Anthony whom he ''sent.'' If the Fig. 3 daguerreotype attributed to Adams was copied from an Anthony original, it is possible that the original was lost in the 1852 fire which destroyed Anthony's National Daguerreotype Miniature Gallery in New York City after it had been sold to D. E. Gavit. Only one daguerreotype, a portrait of former President John Quincy Adams, was retrieved from the rubble of that holocaust.[105]

THE LANGENHEIM BROTHERS

Frederick (top) and William Langenheim came separately to the United States from Germany in the 1830s, and later rendez-voused in Philadelphia. But before that, William fought in the Texas war of independence and helped recapture the Alamo after the massacre of 1836. The brothers are credited with being first to introduce German-made cameras equipped with Petzval portrait lenses in the United States, and their Philadelphia gallery became one of the nation's foremost after 1843. After 1850, they would become the principal American pioneers both in the new field of stereophotography and in the application of photography to audience slide viewing with magic lanterns. Their attempts to license American photographers in the use of Fox Talbot's calotype process in 1848–49, however, would prove unsuccessful.

dard. On May 12, 1843, he was awarded the fifth patent in American photography for a daguerreotype coloring process—a patent which he sold the same year to Montgomery P. Simons. His subsequent distinguished career in Paris began modestly in 1845:

Thompson came to Paris without being able to speak a single word of French. He merely had a letter of introduction from the Russian Consul in New York to the Vice-Consul, Iwanow, in Paris. The latter turned the American over to Levitzky,* who received him cavalierly, supposing him to be a mere amateur. He was soon disabused when Thompson produced his specimens. They proved far better than anything which had so far been seen in Europe. Neither Paris, Vienna, nor Rome could produce such results. Levitzky, then one of the leading daguerreotype artists in Paris, writes: "They were not mere daguerreotypes, they were works of art." Here was strength, relief, artistic lighting, softness of shadows, with a wealth of halftones. All specimens were half-plates. This in itself was a revelation, as thus far in Paris nothing larger than quarter-plates had been used. Thompson at once opened a studio in a large building in Boulevard Poissonier, Maison du pont de fer. The studio contained two stories, with three large rooms, having large windows. So superior were Thompson's results, that, notwithstanding the competition of native operators, his sitters averaged 30–40 a day.[106]

Contrasting with this tour de force in Paris, we find that an Ohio blacksmith-turned-daguerrean was successfully playing Yankee tricks on Yankees in Boston at this same time. John W. Bear was called the "Buckeye Blacksmith" (for his native state, Ohio) all during his life, which included much politiking on behalf of various national political campaigns (and an occasional political appointment when his candidates won). According to his autobiography, which he published privately, in 1873, his on-again-off-again career in photography began after the defeat of Henry Clay in the presidential election of 1844:

As soon as the election was over and I had got a little rested, I concluded to leave the West and go East where I thought there was a better chance to get a start in life than in the West; I therefore went to Philadelphia where some of my old Whig friends assisted me with funds to learn and start the daguerrotype business. I started my business in Philadelphia, but owing to its being a new thing I did not succeed as well as I expected, so I packed up in the Spring of 1845 and went to Boston, believing that if ever I got a start in life again it must be among the Yankees; accordingly I opened up in Boston where I had but one or two oppositions to contend with; I hung out my sign and at the end of the first month I found I had made a failure; I could not get the people to come into my place; I saw plainly that I must burst up or use some other plan to attract the attention of the people; we were charging three dollars for a small picture in a morocco case which was considered very high. So I concluded to reduce the price, and in order to attract attention to the price, I concluded to play a Yankee trick on the Yankees. I got up a large placard on each side of a frame that I fixed on the top of a pole ten feet high and hired a boy to stand at the corner of Court and Hanover Sts., the most popular corner in the city, and hold this pole so that all the passers-by could see it, (from five to seven in the evening when thousands passed on their way home from work.) The people of the country had just

began to talk about a war with Mexico; this subject was in everybody's mouth, I took advantage of this and had my placard headed in large letters: "War with Mexico, (then under that) or not (in small letters) J. W. Bear will furnish beautiful daguerreotypes at No. 17 Hanover street, colored, true to life, in fine morocco cases for one dollar and a half, with a premium to the first setter every morning." This was all that I had on my large placard.

I stood a short distance off to see the effect it would have; it had the desired effect, for the people came running from every direction to see what that war news meant; after reading the whole bill they would go away laughing, saying, "that it was the best dodge of the season."

The bait took like hot pancakes, for next morning early when I got to my rooms I found a score or more waiting ready to enlist as they said for one of my cheap pictures. I gave a premium of fifty cents to the first one that came every morning, (this hurried them up.)

The result of my experiment was: that rich and poor, high and low, all flocked around me, and many of them said that I must be a Yankee for none but a Yankee could ever have got up such a good dodge as I had to get custom, and many of them offered to assist me with means to increase my business, and I have no doubt had I have stayed there that I should have been a rich man to-day, for the Yankees are the best people I have ever seen to help a stranger along in business who is willing to help himself, and I would here advise every young man who wishes to make a good start in the world to make that start among the Yankees. [107]

With all these activities—in New York, Nashville, Paris, and Boston—the daguerreotype process was still "very difficult and uncertain" in the eyes of the London photographer Antoine Claudet. "So many conditions are requisite to a successful operation that, indeed, it might be said that failure is the rule, and success the exception," he said in a progress report on the state of the art, published in the summer of 1845 in the *Journal of the Franklin Institute*. First, there was the problem of light itself:

> This renders the task most delicate and arduous. The operator has constantly to overcome new difficulties, and the greatest is, perhaps, the want of power to appreciate the amount of operating rays existing at every moment. No photometer can be constructed; for the acting rays are not always in the same ratio to the intensity of light. It is true that, if it were possible to measure the comparative quantity of blue, yellow, and red lights, at all times, then it would be of considerable assistance in judging of the amount of photogenic light. But even this test would not be sufficient, for the acting rays are not strictly identical with the blue rays. Still, to be able to ascertain that there were no yellow or red vapors in the atmosphere, making, as it were, screens of those colors between the sun and the object, would be, no doubt, an important assistance.
>
> It is to the influence of these vapors that the difference found by operators in various climates is due, which difference seemed at first irrational, but which can now easily be explained.
>
> When the daguerreotype was first discovered, it was expected that southern climates would be more favorable than northern for the process, and that, in countries, where the sun constantly shines, the operation would be considerably shorter. This has not been proved to be the fact, and the following reason may be given for such an apparent anomaly. Light is more intense in the northern latitudes up to a certain degree, on account of its being reflected in all directions by the clouds disseminated in the atmosphere; whilst in the drier climates the open sky, instead of reflecting light, absorbs a great quantity of it. Of course, in speaking of clouds, it cannot be meant that a completely covered sky is more favorable than a sky without any clouds, for in this case the sun is entirely obscured. But still there are days when, although the disk of the sun is not seen from

Antoine Claudet (1797–1867), circa 1865.

> any part of the horizon, the thin clouds allow a much more considerable quantity of photogenic rays to be diffused and retained in the lower strata of the atmosphere than when there are no clouds, and that by some imperceptible vapors the light has a yellow or red tint.

Today, our cameras are equipped with devices which automatically cope with differentials in lighting, as it is cast upon each and every subject of a camera exposure. It is difficult to realize that different atmospheres and even the response of different prople to long exposure to light had an important effect on the success or failure of daguerreotype portraiture. Claudet explained the matter in these words:

> There is a curious fact which would seem to corroborate the argument in favor of greater intensity of light in northern climates. It is known that, by a provision of nature, all races of men are constitutionally adapted to the climates in which they are destined to live, that the inhabitants of the tropics can bear a much higher temperature than the inhabitants of the north. May it not be the same for light? The eyes of the inhabitants of the cloudy and snowy countries are adapted to bear a stronger light than those living in the south. In the course of my daguerreotype experience, I have observed that there is a comparatively greater number of Englishmen than of Frenchmen, Spaniards, and Indians, capable of sitting for their portraits in a strong light, without being much incommoded. If this fact is correct, such a provision of nature would prove that generally light is more intense in the northern climates, and that it decreases gradually towards the equator.
>
> It was first expected that the climate of England, and countries similarly situated, would be unsuitable to the daguerreotype operation; nevertheless, it has turned out that this is one of the most favorable climates for the practice of the process. [108]

* Sergej L. Levitzky (1819–1898).

1845

51

WASHINGTON IN THE POLK ADMINISTRATION

1846

52

These half-plate daguerreotypes (each 4½ x 5½ inches) are two of the earliest-known photographs of Washington, D.C., found with several others at a California flea market in 1972. The views of the U.S. Capitol building (top) and the White House (bottom) are attributed to John Plumbe, Jr., and are believed to be examples from a series which Plumbe advertised for sale in 1846.

1846

With the new availability of improved cameras and lenses, the practice of photographing the great and famous became more commonplace. The *Christian Watchman* observed that "already, the daguerreotypes of the most important public characters adorn the saloons of noted artists." John K. Plumbe, Jr., became the third photographer—along with the Anthony firm and L. T. Warner—to establish a major gallery in Washington, and by March 1846, President Polk and former President John Quincy Adams had posed before his cameras. Perhaps because Edward Anthony was given the use of a congressional committee room to conduct his private photographic business, Plumbe also endeavored, before locating in Washington, to secure a committee room for himself through a political connection of his brother's; but whether or not he managed that is not known. His gallery, in any event, was established on Pennsylvania Avenue.

On January 29, a Washington newspaper reported that Plumbe was setting out to take daguerreotype views of "all the public buildings" in the city, something no one else before him is known to have attempted. The account also stated that Plumbe intended to dispose of copies of these photographs "either in sets, or singly." Twenty-two days later, another Washington newspaper reported that views of the U.S. Capitol, Patent Office, and other buildings "embellish" the walls of the Plumbe gallery, and were the subject of "universal commendation."[109] But like the daguerreotype views known to have been taken by various photographers in New York and elsewhere, Plumbe's daguerreotypes of Washington buildings were soon heard of no more. If there were sets made and sold, they were subsequently discarded or lost by their owners, or by successive generations—until, one hundred and twenty-six years later, a set turned up (in 1972) at a flea market in Alameda, California. When photographic copies of these specimens were sent to the Library of Congress for confirmation of their identification, "excitement ran high in the [Prints and Photographs] division, for, after an examination of the images," according to a division official, "it was felt that five of the views undoubtedly were those referred to in the 1846 newspaper story and would, therefore, have the distinction of being the earliest surviving photographic record of the nation's capitol."[110] A sixth daguerreotype found at the 1972 flea market is of the Battle Monument in Baltimore (constructed in 1815). This indicates that if it was taken by Plumbe, as presumed, he evidently made an attempt to secure daguerreotype views in other cities.

Plumbe appeared to be doing well at his New York gallery (at Broadway and Murray streets) as in Washington. A New York newspaper reported being shown a daguerreotype early in March of former president Martin Van Buren, which was described as being "nearly twice the size of the usual miniatures."[111] Nevertheless, within a year, for reasons none of his biographers has made clear, Plumbe found himself in financial difficulty and sold *all* of his photographic establishments (in Washington, New York, Boston,

THE FURTHER EXPLOITS OF THE "BUCKEYE BLACKSMITH"

I stayed in Boston until the winter set in, and then concluded that the climate was too cold for me and that I had better go South.

The first place I stopped at was Wilmington, Del., where I stayed a few weeks, but done but little business, owing, I suppose, to its being a new thing it did not take with the people. I very soon saw that it was no go at that place, so I pulled up stakes and went to Annapolis, Md., where I opened up in the Court House with an excellent light for the business. I had no sooner hung out my sign than the people began to crowd around me, and for five or six weeks I done a most excellent business; I took in over five hundred dollars in less than two months, then when all that wished pictures had been supplied I packed up and went to Alexandria, Va.

I opened up in a fine room and went to the printer to get some bills printed, when he frankly told me, that he would charge me five dollars for them and that I would never get it back for pictures in that city, for said he, "daguerrotypes are played out here, there are three men at it here already that can't make their rent, and they are citizens, so it is no use for a stranger to try it." All right, said I, "print my bills, I will try it a few days and see what I can do."

I changed my bills from what I had intended to put up; in place of putting the price at two dollars I concluded to play a Yankee trick on them, so I got up the following bill:

Only $1.50 for the best daguerrotype ever seen in Alexandria, put up in fine morocco cases; colored true to life and warranted not to fade at —— Washington street, (adding below,) how many have lost a father, a mother, a sister, a brother, or an innocent little prattling child, and have not even a shadow to look upon after the separation; some little toy or trifling article are often kept for years and cherished as a token of remembrance. How more valuable would be one of the Buckeye Blacksmith's beautiful pictures of the loved and lost.

Reader you could not do a better thing now, while your mind is on the subject, than to take a stroll to the Buckeye's Place, you may have reason in future years to feel thankful for these gentle hints from a stranger:

For think not these Portraits by the sunlight made,
Though shades they are, will like a shadow fade;
No, when this lip of flesh in dust shall lie,
And death's gray film o'erspreads the beaming eyes,
These life like pictures mocking at decay,
Will still be fresh and vivid as to day.

A call is respectfully solicited. I hung out my sign at 12 o'clock, went to my dinner and returned at 1, and found a dozen or more looking at my pictures. "Are you the gentleman that makes these pictures," said a pretty young lady to me. I told her I was. "Will you make me as pretty a picture as this (pointing to one in my frame) for a dollar and a half?" "oh, yes, and prettier too, for you are a better looking young lady than the one that set for that picture," said I. This raised a great laugh among the crowd; we went in, and I not only took her picture but nine others, thus before night I had taken in fifteen dollars. I went to the printer that night and told him what I had done, "that I had taken fifteen dollars the first day and intended to take in fifteen hundred before I left," he said, he hoped that I would but doubted it. The next day I was full from morning till night with the fashion and beauty of the city, and so I continued from day to day, until finally the families of all three of the other operators came to me to get pictures, for none of these operators knew how to take good pictures and had quit the business as soon as I got under way.[112]

PHOTOGRAPHY DOCUMENTS FIRST SURGERY UNDER ETHER

Of all medical advances, none was more revolutionary than the discovery of anesthetics; without a way of preventing pain no real advances in surgery would ever have been possible. On October 16, 1846, in the first such experiment, surgeon John C. Warren operated on a patient's neck tumor while Dr. William T. G. Morton applied ether as an anesthetic at Massachusetts General Hospital. The half-plate daguerreotype, above, is a reenactment of this historic scene. Dr. Warren was again present (facing camera with hands on the patient's thigh), but Dr. Morton was not. In his place, Freeman J. Bumpstead, acting as a stand-in, holds ether cloth. A substitute was also used for this photograph to play the role of the patient, Gilbert Abbott, on whom the operation was originally performed. Although the date of this reenactment of the 1846 operation is not known, it may have been as early as November 1847, when Dr. Warren and ten other prominent Bostonians—among them Oliver Wendell Holmes and Nathaniel Bowditch—petitioned Congress to reward Dr. Morton for the ether anesthesia discovery. Or the reenactment photograph may have been taken as late as the fall of 1856, when Boston and New York hospitals took up a collection for the financially troubled Morton, aided by the poet Longfellow. This daguerreotype is believed to be the original taken of the reenactment, and at least one copy daguerreotype is known to be extant. The scene is possibly the earliest documentary photograph taken in the United States.[113]

EMERSON AND CARLYLE EXCHANGE DAGUERREOTYPES

Ralph Waldo Emerson was eminently happy with a daguerreotype sent to him by his friend, Thomas Carlyle, in 1846, but neither Emerson nor Carlyle were happy with Emerson's results secured in Boston. On May 14, the latter wrote Carlyle:

> I was in Boston the other day, and went to the best daguerreotypist, but though I brought home three transcripts of my face, the housemates voted them rueful, supremely ridiculous. I must sit again; or, as true Elizabeth Hoar said, I must not sit again, not being of the right complexion which Daguerre and iodine delight in.

On May 31, Emerson again wrote Carlyle that he had brought home "three shadows not agreeable to my own eyes," which his wife dubbed "slanderous." But he decided to send one to Carlyle anyway. The latter responded thus on July 17:

> . . . the photograph after some days of loitering at the Liverpool Custom-House, came safe to hand. Many thanks to you for this punctuality: this poor shadow, it is all you could do at present in that matter! But it must not rest there, no. This image is altogether unsatisfying, illusive, and even in some measure tragical to me! First of all, it is a bad photograph, no eyes discernable, at least one of the eyes not, except in rare favorable lights: then, alas, Time itself and Oblivion must have been busy. I could not at first, nor can I yet with perfect decisiveness bring out any feature completely recalling to me the old Emerson, that lighted us from the Blue, at Craigenputtock, long ago—eheu! Here is a genial, smiling, energetic face, full of sunny strenth, intelligence, integrity, good humor; but it lies imprisoned in baleful shades, as of the Valley of Death; seems smiling on me as if in mockery. Doesn't know me, friend? I am dead, thou seeist, and distant, and forever hidden from thee; I belong already to the Eternities, and thou recognizest me not! On the whole, it is the strangest feeling that I have:—and practically the thing will be, that you get us by the earliest opportunity some living pictorial sketch, chalk-drawing or the like, from a trustworthy hand; and send it hither to represent you. Out of the two I shall compile for myself a likeness by degrees: but as for the present, we cannot put up with it at all; my wife and me, and to sundry other parties far and near that have interest in it, there is no satisfaction in this.[114]

During the last dozen years of his life, Emerson suffered from a failing mind and loss of memory. But near the end when he saw a picture of Carlyle, he is reported to have whispered: "That is that man, my man."

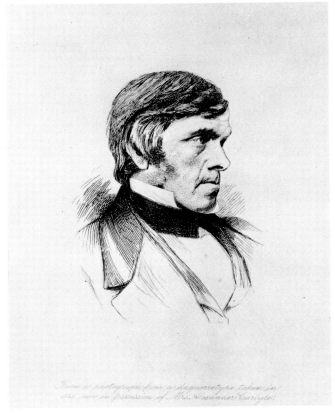

The carte-de-visite-style photograph of Ralph Waldo Emerson (left) which is mounted on a card size 2½ x 4 inches, was made in the early 1860s. The photograph of Carlyle (right) was copied from an 1846 daguerreotype of the English essayist and historian. No daguerreotype of Emerson made in 1846, or a copy photograph made from such a specimen, is known to have survived to modern times.

Baltimore, Philadelphia, Saratoga, Louisville, New Orleans, Dubuque, and St. Louis) to employees. After this his activities became as "shadowy" as had been those of Brady four years earlier. He returned first to his former home in Dubuque, then in 1849 went to California where he again endeavored to promote his scheme for an east-west railroad which would follow a southern route across the continent. But the government decided on a northern route. At some point after 1854, Plumbe returned once again to Dubuque where, in 1857, he committed suicide. He was only forty-eight years old.[115]

A more happy tale is to be found in the life of Plumbe's contemporary, John J. E. Mayall, of Philadelphia. Mayall, who may have been born in England, decided in 1846 (at age thirty-six) to sell his photographic gallery to Marcus Root, and in the summer he left the United States to join Antoine Claudet in London. Within a year, he established his own business there, known as the "American Daguerreotype Institution," which flourished immediately. Mayall had studied under Professors Goddard and Boyé at the University of Pennsylvania, and this training served him well. He became noted for making unusually large daguerreotypes admired for their superior polish and clarity. As the years passed, he became recognized as one of England's foremost Victorian photographers, and his photographs of Queen Victoria after 1860 are now ranked as the finest.

Mayall lived to the age of ninety-one, serving at one time as mayor of Brighton.[116]

The lot of the rural or small-city photographer was still a difficult one for most, although the novel approach to his businesses in various cities continued to be beneficial to the "Buckeye Blacksmith" (see page 53). There were two photographers in Elmira, New York, during the period 1846–47, for example, but neither lasted more than a matter of weeks—their "shadow pictures" having been not well received by the local citizenry. An itinerant woman photographer, Sarah Holcomb (who had been a student of Albert Southworth's in Boston) lacked the "Buckeye Blacksmith's" competitive nature, and when she journeyed to Manchester, New Hampshire, in the winter of 1846, she did not stay when she found that there was already another photographer there. A combination of bad weather and the absence of any competition at Claremont, New Hampshire, made her decide to stop there, but then she found her chemicals had frozen. She wrote Southworth that her bottle of bromide had burst and that "I can do nothing till I get more."[117]

Abraham Bogardus, twenty-four, a farmer's son from Dutchess County, New York, decided at this time to become a photographer and spent two weeks in September learning the trade from George Prosch in New York. In later years he recalled:

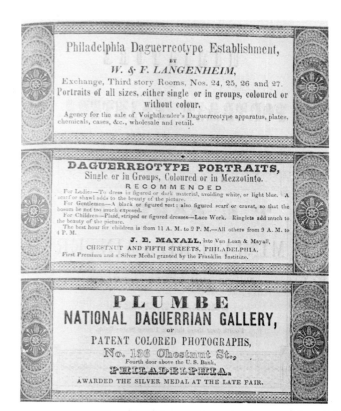

The page of daguerreotype advertisements (above left) is from the *Mercantile Directory* of Philadelphia for 1846. John J. E. Mayall (above right) sold his gallery to Marcus A. Root the same year and went to England to become an assistant to Antoine Claudet. Within a year he established an "American Daguerreotype Institution," and soon became one of England's most prominent portrait photographers of the Victorian era. After becoming mayor of Brighton, he died there in 1901 at the age of ninety-one.

William C. Bouck (left), governor of New York from 1843 to 1845, exhibits what the *Christian Watchman* considered a "literary weakness" by posing for this daguerreotype surrounded by his books. An unidentified man, (right), posing with his musical instrument, exhibits what the *Watchman* considered a "musical weakness."

"THERE IS A PECULIAR AND IRRESISTIBLE CONNECTION BETWEEN ONE'S WEAKNESSES AND HIS DAGUERREOTYPE . . ."

The *Christian Watchman,* in the spring of 1846, foresaw unlimited possibilities for the daguerrean art, and expressed the belief that it was "slowly accomplishing a great revolution in the morals of portrait painting." The problem had simply been, the magazine contended, that the flattery of portrait painters was "notorious." But now, these "abuses of the brush" could "happily" be corrected by the new photographic art:

Daguerreotypes properly regarded, are the indices of human character. Lavater judged of men by their physiognomies; and in a voluminous treatise has developed the principles by which he was guided. The photograph, we consider to be the grand climacteric of the science. Lord Chesterfield assures his son that everybody has a weak point, which if you are fortunate enough to touch or irritate delivers him into your power at once. It has been said that the inhalation of exhilarating gas is a powerful artificial agent for disclosing these weaknesses of human nature. In reality, however, the sitting for a daguerreotype, far surpasses all other expedients. There is a peculiar and irresistible connection between one's weaknesses and his daguerreotype; and the latter as naturally attracts the former as the magnet the needle, or toasted cheese, the rat.

There is a *literary weakness.* Persons afflicted with this mania are usually taken with a pile of books around them—or with the fore-finger gracefully interposed between the leaves of a half-closed volume, as if they consented to the interruption of their studies solely to gratify posterity with a view of their scholarlike countenances—or in a student's cap and morning robe, with the head resting on the hand, profoundly meditating on—nothing. Thus a young woman whose leisure hours are exclusively devoted to the restoration of dilapidated male habiliments, appears in her daguerreotype to be intensely absorbed in the perusal of a large octavo. What renders the phenomenon the more remarkable is, that the book was upside down, which necessarily implies the possession of a peculiar mental power.—There is the *musical* weakness which forces a great variety of suffering, inoffensive flutes, guitars, and pianos, to be brought forward in the company of their cruel and persecuting masters and mistresses. One young lady, whose ear had been pronounced utterly incapable of detecting discords, sat with a sheet of Beethoven's most difficult compositions, in her delicate dexter hand. Some amusing caricatures are produced by those who attempt to assume a look which they have not. Timid men, at the critical juncture, summon up a look of stern fierceness, and savage natures borrow an expression of gentle meekness. People appear dignified, haughty, mild, condescending, humorous, and grave, in their daguerreotypes, who manifestly never appeared so anywhere else. Jewelry is generally deemed indispensable to a good likeness. Extraordinarily broad rings—gold chains of ponderous weight and magnitude, sustaining dropsical headed gold pencils, or very yellow-faced gold watches, with a very small segment of their circumference concealed under the belt—bracelets, clasps, and brooches—all of these. in their respective places, attract attention, and impress the spectator with a dazzling conception of the immense and untold riches of those favored beings whose duplicate daguerreotypes he is permitted to behold.[118]

I paid fifty dollars for instructions and a complete set of apparatus, consisting of a quarter-size camera and stand with three legs, two coating boxes, a mercury bath, a hand buff, a clamp head-rest to attach to a chair, and a clasp to hold the plate while being buffed. With this outfit I commenced business.

To have a daguerreotype taken was the ambition of every aspiring man. It was a great event to most sitters. A black suit, a white vest and thumb in the armhole of the vest, the other hand holding an open book—an attitude of spirit and importance—was considered just the thing.

A sitting required from *forty seconds* to *four minutes*. At that date we all worked by side lights; there was but one skylight in the city, and that was in the granite building on the corner of Broadway and Chambers Street. The light was some six or seven flights up stairs from the street, and was made to revolve, so as to keep the back of the sitter towards the sun. Soon after this most of the fraternity built skylights; then the work improved, sittings being made in much shorter time, and much better effects of light and shade were produced. [119]

The fall of 1846 was a "trying and discouraging" period for Bogardus, and sometimes he managed to take only two pictures in an entire week. But sixteen years later he was still operating at the same location (Barclay and Greenwich streets), and he continued to expand his business with marked success. In 1871, he was named first president of the National Photographic Association of the United States.

One of the things which evidently caused John A. Whipple to delay, or to temporarily abandon his experimentation with glass negatives, was his early (and evidently success-ful) efforts to obtain daguerreotypes of images seen through a microscope. His experiments, which were presumably the earliest in microphotography, were described in an undated letter which he addressed to H. H. Snelling:

"Friend Snelling * * * * * * * In 1846, it was suggested to me by the Rev. S. Adams, of this city, that it might be possible to daguerreotype the image of the microscope; he was in possession of a fine 'Oberhausen,' which he loaned me for the trial. By removing the lenses from the camera and substituting the microscope in its place and adjusting the object properly for seeing with the naked eye, a clear but very faint image was found projected on the ground glass, the light being so weak that it was hardly possible to focus it. But doing that as well as I could, and submitting a plate to its action, giving it an exposure of one and a half hours, then marvelously long, great was my astonishment and delight when lifting the plate to take a peep, I saw a clear and distinct image there, thus demonstrating the possibility of indelibly fixing the forms of nature now invisible by our unaided vision. The object tried was the mandible of a small spider, so small that it could only be discerned as a mere speck by the naked eye; it was magnified on the plate to cover three-fourths of an inch surface, and every part was reproduced in bold relief, showing its little comb-like appurtenances to perfection, equally as well as represented to the eye in the instrument; the only defect in this first proof was a small light spot exactly in the middle of the plate, which we found was caused by a prism used in the microscope to reflect the image at right angles. On removing that the next proof was without a blemish. My next experience was with test object scales of the tepizum; and truly they were a test for daguerreotyping. I could do every part well enough but the cross-strings, which are only brought out with instruments of the very best manufacture; when so high a power is used as is here necessary a great loss of light is experienced, requiring an exposure of many hours, which every one acquainted with daguerreotyping knows is not favorable to fine results. I succeeded in doing them with the finest instrument as well as a second rate one would show them to the eye. I find a much better way for ordinary purposes, instead of a microscope with eye pieces, is to use simply a double or treble achromatic of a combined focus, of from one-fourth to one inch in length, according to the character of the object, and the extent desirable to magnify; a section of woody fibre, for making an eighth of an inch in diameter, an image of which it would be desirable to impress on a plate five inches in diameter, I should use a lens of about half an inch focus, and all that is to be done to it is to have these little lenses set in the brass plate, which will screw into the camera when the daguerreotype lenses unscrews, then support the slip of wood to be magnified half an inch before the lens on a little slide prepared to hold it, that can be made to move backwards and forwards a quarter of an inch or so, thereby pointing the camera towards the rim, and having the wood just in the focus of the small lens, a beautiful distinct magnified image of it will be seen on the ground glass of the camera, in size just in proportion as the camera box is lengthened or shortened, and the wood supports on the stand moved nearer to or farther from the lens.

" The brilliancy is greatly increased if the sunlight is condensed upon the object by means of a lens, one about two inches in diameter, and three or four inches focus answers the purpose well, always being careful not to exactly focus the sunlight upon the object; if so it would be singed by the heat. [120]

1847

A Cincinnati daguerrean scooped the world in the summer of 1847 by making a positive photograph on a piece of glass, using collodion as his sensitizer—but nobody talked about it until nearly a dozen years later. The photographer was Ezekiel Hawkins, one of three artist sons of a minister of the Gospel. A privately printed book on Ohio taverns (published in 1937) now appears to be the only source of information on the Hawkins family, but it gives no indication as to the three brothers' place of birth. Ezekiel ("Zeke") was said to be working as a window-shade painter in Baltimore in 1806; Steubenville, Ohio, in 1811; Wheeling, Virginia (now West Virginia), in 1829; and Cincinnati in 1843. He also tried landscape and portrait painting, and "indulged" in Shakespearean drama before "becoming famous for his perfecting of the daguerrean art."[121]

The historian Marcus Root says that the daguerreotype practice was introduced in Cincinnati by Thomas Faris in 1841, and that Faris was the first to use bromine as a plate accelerator there. But a Cincinnati newspaper stated in 1852 that Ezekiel Hawkins was first to introduce the daguerreotype art in that city. Hawkins is listed for the first time in a Cincinnati directory in 1844, and the listing given reads "H. & Faris" after Hawkins' name.[122]

Like many of photography's "firsts," the invention of the glass negative process using collodion has been contested. An English sculptor, Frederick Scott Archer (1813–1857) is generally credited with the invention, and he published his method in a British chemical journal in March 1851. The noted French calotypist Gustave Le Gray (1820–1862) has also been credited with suggesting collodion for photography use, but he did not propose or publish a method for its adoption before Archer did. A third claim was made twenty years after Archer's premature death in 1857. Robert J. Bingham, who had been a laboratory assistant at the Royal Institution prior to 1850, and partner of Warren Thompson in Paris after 1859, claimed on his deathbed (in 1870) that he had assisted Archer in the latter's darkroom, and that he, not Archer, was the one who actually perfected the method published by Archer. Bingham is not known to have contested Archer's publication or subsequent recognition for the invention prior to the deathbed statement, which he made to the English photographer and author Thomas Sutton. Then Sutton waited another five years before he published Bingham's claim.[123]

Ezekiel Hawkins seems never to have tried to perfect a workable collodion method based on the one he used to produce his pioneering photograph, nor did he publish anything concerning this endeavor, or assert any claim when he later achieved notoriety in the photography world (in 1852) for being one of the first in the United States to make paper photographic prints from glass negatives. The first word of Hawkins' 1847 feat was contained in what the theatrical world would label a "throwaway line" at the end of an article which appeared in the fourth American edition of a standard English chemistry textbook published in 1857. The editor of the American edition was Dr. J. Milton Sanders,

who was no slouch in the world of chemistry. Sanders experimented in Dr. Michael Faraday's laboratory at the Royal Institution, and served for a time as professor of chemistry at the London Adelaide Gallery. He was twice professor of chemistry at the Eclectic Medical Institute in Cincinnati (from 1851–52, and again from 1856–58), and held similar posts at eclectic medical institutes in New York and Philadelphia. Sanders was evidently acquainted with Hawkins, and by his own account had proposed to Hawkins that he try using collodion in his photographic work, which Hawkins thereupon proceeded to do. Ten years later, Sanders mentioned Hawkins' successful experiment in a two-sentence attribution in his chemistry textbook, and this caught the eye of Charles A. Seely, editor of *The American Journal of Photography,* who at the time was also a manufacturer of photographic chemicals. Seely queried Sanders on the matter, and the latter responded with the only recorded description of Hawkins' feat (see correspondence, next page). Sanders never provided the additional details promised, but became after that an infrequent contributor to Seely's journal.[124]

Collodion, when it came into use in the 1850s, could be used to make a glass negative (from which positive prints could be made on paper or another surface), or to make a positive image on glass or other surface (from which no prints could be made). Different chemical conditions were called for to produce either one or the other result. In Hawkins' case, he produced a positive image on glass—technically an ambrotype, which may well have been the first ambrotype produced anywhere. The image would appear to be a negative when the glass was examined by itself, but became a positive photograph when Hawkins painted the back of the glass with black paint. The identical set of circumstances can be observed by examining the elements of any ambrotype (see page 110). No Cincinnati institutions today appear to possess any records or photographs by, or pertaining to, Hawkins, and the whereabouts of his 1847 ambrotype is unknown. It may have been lost in an 1851 fire which started next door at the Cincinnati museum building and destroyed Hawkins' gallery.[125]

It appears that the thought of using collodion for photography may have occurred to a number of people at the time. Dr. Charles S. Rand, of Philadelphia, for example, reportedly suggested the use of collodion to the Langenheims in 1848, and the Langenheims reportedly conducted experiments with it, but were unsuccessful. The Langenheims were more interested in calotype photography at this point, and in 1849 William Langenheim met with Talbot in England to secure (for the price of $6,000) the exclusive American rights to the calotype process, which had been given an American patent on June 26, 1847.[126] American photographers, however, showed no interest at this time in making photographs with paper negatives. There were, in fact, few practitioners of the calotype process anywhere, although increased interest was shown in Europe after 1847 when a Frenchman, Louis Blanquart-Evrard, perfected an

COLLODION IS USED TO MAKE A PHOTOGRAPH
ON GLASS IN CINCINNATI

Just as the first recorded American photograph on paper appears to have been made in Cincinnati in May 1839 by Prof. John Locke at the Medical College of Ohio, so it appears that the first recorded American photograph on glass was made there in the summer of 1847 by Ezekiel Hawkins. The correspondence below indicates that Hawkins was assisted by Prof. Joseph Locke, which in all likelihood was the same Prof. John Locke who in 1847 was still in his post at the Medical College.

<div align="center">New York, August 26th, 1858.</div>

DR. J. MILTON SANDERS—DEAR SIR,—In your American edition of Gregory's Chemistry, on page 59 I find the following : "The first collodion picture that we have any account of, was taken at Cincinnati. in 1847, by Mr. E. C. Hawkins, assisted by the writer. If others were taken previous to that time, we have no knowledge of it." This is the first intimation to myself that the origin of the present beautiful methods of the photographic art may be claimed for America. Is it not justice to Mr. Hawkins and yourself, that the facts regarding that early experiment should be known by the photographic public ?

Will you have the goodness to furnish for publication in the American Journal of Photography a history of the picture alluded to, with as much detail as convenient.

<div align="center">I am with great respect,</div>

<div align="right">Yours truly,</div>

J. MILTON SANDERS, M.D., L.L.D CHARLS A. SEEELY.

<div align="center">New York, August 27th, 1858.</div>

MR. CHARLES A. SEELY—DEAR SIR,—Your letter of the 26th inst. is received, in which you request a detailed account of the discovery of collodion as an article for pictures mentioned in my edition of Gregory's Chemistry.

After a lapse of eleven years, it cannot be expected that the mind could retain all the details you desire ; still I remember the principal incidents connected with the discovery. They may interest you, and perhaps substantiate the fact, that the first collodion picture was taken in this country. It was while in a conversation in the Summer of 1847, with Mr. E. C. Hawkins of Cincinnati that the first idea of using collodion was suggested. Mr. Hawkins had been experimenting upon paper pictures, (the colotype I believe) but could not get paper fine and thin enough for the purpose. He remarked that if a paper could be got sufficiently fine and thin, that paper negatives could be made which would print positives that would rival the finest engravings. I had that day, in Dr. Kent's drug store, been experimenting upon the preparation of collodion for medicinal purposes, and this previous occupation suggested collodion to my mind. Collodion after all, I thought, was nothing else than paper held in solution, and I suggested its use. Glass was then naturally suggested for the purpose of retaining the paper, and Mr. Hawkins, with

Dr. J. Milton Sanders (above) was probably serving as head of the chemistry department of the Eclectic Medical Institute in New York at the time of this correspondence. His American edition of *Gregory's Chemistry*, published in Britain, was a standard American college textbook.

his characteristic zeal and perseverance, commenced his work. If I am not mistaken, Prof. Joseph Locke assisted him in the preparation of the first picture. Their surprise was great when besides a negative picture, as they anticipated, they got a positive one, which was painted upon the back with black paint, and mounted. That picture still exists, or did a short time ago, and even in these days of beautiful ambrotypes, is a pretty picture. I would here state that I do not claim any of the credit of producing the first collodion picture, but to EZEKIEL C. HAWKINS of Cincinnati, belongs the credit of having made the first picture upon collodion. In a future communication, either by Mr. Hawkins (if I can prevail upon him to forego his usual modesty,) or by myself, you will get more details upon this interesting subject.

<div align="right">Respectfully,</div>

<div align="right">J. MILTON SANDERS.[127]</div>

improved means of preparing the paper negative. The greatest impetus to calotype practice—both in the United States as well as in Europe—proved to be yet another improvement in negative preparation published by Gustave Le Gray in December 1851 (see page 91).

At this time, meanwhile, the number of daguerreotype photographers—at least in the New York area—began to increase "somewhat faster than the demand" for their photographs, according to H. H. Snelling. These operators depended heavily on apparatus and appliances imported from France, and the prices for these items were high because the French, as Snelling expressed it, "were not disposed to calculate on very large sales or rapid increase" in business in the American market. The Messrs. William and William H. Lewis (father and son), formerly machinists in New York, had begun operating a retail establishment for daguerreotype materials in Chatham Square around 1843, and by 1847 had become a prime New York source for cameras and other supplies. In the summer of 1846, too, the Scovill Manufacturing Company had opened a New York retail outlet, serving as a major supplier of daguerreotype plates, mats, and cases.[128] Then, at some point in 1847, Edward Anthony, at age twenty-nine, gave up his daguerreotype business and also entered the supplies field. Snelling, who became his general manager, recalled the effect on his competitors:

> Up to this time the manufacture and sale of daguerreotype apparatus and appliances was confined to two or three firms, who considered themselves, quite justly to all appearances, to supply the demand, and when Mr. Edward Anthony . . . joined their ranks, many doubts were expressed as to the wisdom of the act; "there were too many in the business already." It proved, however, to be a "new departure" in the right direction, and added an impetus to the entire business of making daguerreotypes that photography has not yet got over, and, probably never will, judging by the events as they pass. Like all such business apprehensions, the fears of the other stock dealers were groundless. Mr. Anthony's methods of doing business not only built up his own but materially improved theirs. At first he was not disposed to become a manufacturer, but it was soon evident that nothing less would suit the daguerreans. One branch of manufacture after another was added to his business until it assumed the largest proportions, and his goods were sought after wherever the daguerreotype was made.[129]

One of Anthony's first moves was to import French-made daguerreotype plates in such vast quantities as to be able to substantially reduce the prices he could quote to his customers. By this time, Scovill had gone heavily into plate manufacture, having been unable to produce such articles at low price only seven years earlier. Albert Southworth's former partner, Joseph Pennell, had joined Scovill and wrote Southworth in the winter of 1848 that Scovill was then producing daguerreotype plates at the rate of 1,000 a day.[130] But the French plates continued to be in large demand. They were high-quality items, and daguerreans appreciated the fact that this quality was reflected in most instances by the appearance, on the edges of the plate, of an officially stamped hallmark indicating the numerical ratio of the thickness of the silver plating to that of the (copper) base metal.

Daguerrean operators—particularly itinerant photog-

"WE WERE NOW MASTERS OF THE CHEMICALS"
From a reminiscence by Abraham Bogardus

The years 1847 and 1848 saw some elegant pictures made. Gurney, Lawrence, Anthony, Edwards & Clark, Brady, Inslee, Becker, Prosch, Plumb, Whitehurst, Lewis, the speaker, and others, made work that beat the *world*. The daguerreotypes made in Europe did not compare with the *Yankee work !*

We were now masters of the chemicals, and produced pictures with certainty, and the time of sitting was reduced to *ten* and *twenty seconds*. One of our greatest difficulties was to get the plate clean enough to be sensitive in damp weather—the buff used in polishing being filled with rouge, this would attract the dampness; and if the buff was damp a good impression could not be obtained. Many dryers were made and patented to keep the buff dry in any weather. One introduced by Mr. Lewis I found effective.

Thousands of the pictures made at this time are still in existence and are as good as ever. I have some now in my possession that are as good as the day they were made. Sometimes they were covered by a film from the action of the air. This could be removed by the application of hyposulphite of soda or cyanide of potash; one or both properly used will clean them instantly.

In making the daguerreotype we went from the wet to the dry process. At first the bromine was used in liquid form; afterwards, we used it dry, being absorbed by dry lime. And also the iodine was at first covered with water to prevent its evaporating too fast; afterwards we used it dry.

The smell of turpentine in the building rendered it impossible to get an impression. I remember while the building I occupied was being painted outside, the windows being open, I was compelled to stop work until the odor of the turpentine was gone.

I shall always remember with pleasure the good old daguerreotype.

No glass to clean and albumenize; no black fingers; few or no re-sittings; no retouching; no proofs to show for his grandmother, and his sisters, and his cousins, and his aunts to find fault with; no waiting for sunshine to print with; no paper to blister, and no promising of the pictures next week if the weather was good. The picture was gilded, finished and cased while the lady was putting on her bonnet; delivered, put in her pocket, and you had the money in your pocket.

I have yet to see the picture made with a camera equal to the daguerreotype. Yet that process, like the photograph now, required great care in manipulation, and only by experience could you make good work.

It was a rarity to hear any person say, "It does not look like me." It was a known certainty that the impression on the plate was a copy of the sitter. There was no disputing the fact. Yet I remember a man saying to me one day, "my picture looks like the *Devil*." I told him I had never seen that personage and could not say as to the resemblance, but sometimes a likeness ran all through families.[131]

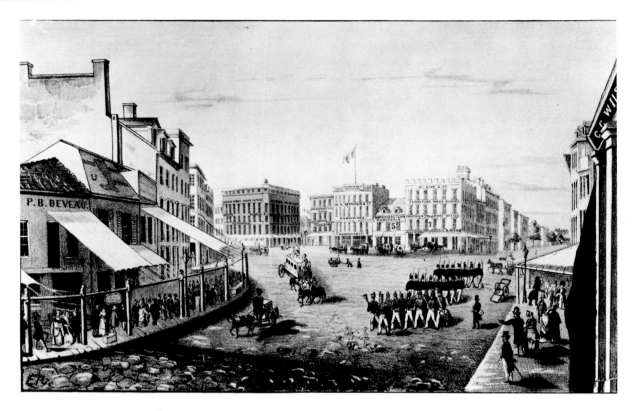

Chatham Square, a "melting pot" of New York City at the time this lithograph was made by N. Currier about 1847, now borders on the city's Chinatown. The four-story building recessed the farthest in the background (see detail below) carries the sign "Daguerreotype Room," which may have been the Chatham Square headquarters of William and William H. Lewis, the city's prime source of cameras and other photographic supplies. By April 1852, the Lewises also opened a daguerreotype manufactory six miles south of Newburgh, New York (see page 93).

raphers or those operating in smaller communities—began at this time to style themselves as "professors." One of the most colorful descriptions of what a "professor" was like is to be found in the autobiography of the noted nineteenth-century Cleveland photographer James F. Ryder, whose career began in 1847 in Ithaca, New York:

The new business of likeness-taking was admitted to be a genteel calling, enveloped in a haze of mystery and a smattering of science. The dark room where the plates were prepared was dignified by some of the more pretentious as the laboratory. A "No Admittance" door, always carefully closed by "the professor" on entering or emerging, naturally impressed the uninitiated as something out of the usual, and when he came out carrying a little holder to his sitter and from it drawing a thin slide, revealing from under it the likeness just taken, it was no unreasonable stretch of credulity to recognize in the man something of a scientist and a professor.

In the fall of 1847 I met the professor who was to lead me into the mysteries of daguerreotypy. I had been three years the boy behind the press, pushing the inking roller over the pages of "forms" in a book printing office, with a vague idea of following the Ben Franklin route, when I met Professor Brightly, a newcomer to our village, a daguerreotype man. He encouraged my visits to his rooms, and I naturally became interested in the new and mysterious work. Professor Brightly was a tall man of rather striking appearance. His silk hat had been much brushed and was shiny. He wore glasses, his hair was heavy, stiff, and, especially in front, stood straight up. At the sides it was trained behind his ears, at the back it covered his coat collar. His eyes were gray and keen, which evidently pleased him. He had a big forehead, bigger up and down than across. He wore a large gray shawl, heavily folded, such as was worn by men fifty years ago as a shoulder covering and as a substitute for an overcoat. His trousers bagged at the knees and were too short by a couple of inches. He always wore rubbers.

He had taught cross-roads school in the country, had a smattering knowledge of, and lectured upon, phrenology and biology. The new art of daguerreotypy attracted his attention and had been gathered in as another force with which to do battle in the struggle for fame and dollars. His habit of brushing with his hand the already stiff front hair in an upward direction rather emphasized its standing and his dignity. . . .

The professor was anxious for my progress and helped me all he could. He encouraged me, praised my work as promising and satisfactory, assured me I was surprisingly good for a beginner, and told me it would be greatly helpful for me to work out the difficulties alone, rather than depend upon him. The fact was, I asked too many questions, many of which he could not answer.

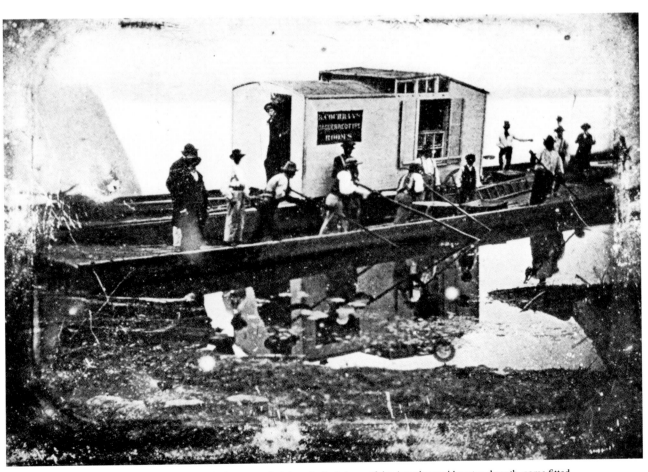

Daguerreotype galleries on flatboats traveled the principal rivers of the American midwest and south, some fitted with skylights and reception rooms. This daguerreotype, made about 1847, is of a small gallery which traveled a tributary of the Ohio River.[132]

In the first few years most practitioners were plodding in the dark, something like "the blind leading the blind." There was no literature bearing upon the subject beyond the mere statement of routine description, no sure road yet opened to successful work. "Professors" were more plentiful than intelligent teachers. In our work repeated trial was the rule—we would try and try again without knowing the cause of failure. Many a day did I work blindly and almost hopelessly, pitying my outraged sitters, and pitying myself in my despair and helplessness. The weak excuses and explanations I made to cover my ignorance were many. The lies I told, if recorded, would make a big book which I would dislike to see opened. *"You moved!"* headed the list. "You looked too serious!" "You did not keep still!" "You winked too often!" These and other fabrications to show the necessity for another sitting were made with great efforts at cheerfulness, but the communings with my inner self in the dark room while preparing the next plate would hardly bear the light, and were best left in the dark. After three months practice I had gained confidence and some skill. The professor could and did trust me with his business when on occasion he went out to arrange for and deliver lectures in the neighboring villages. These lecture outings were productive of advantage to the business in daguerreotypes. He made acquaintances who came in for likenesses and in turn the picture business played into the hands of the lecture field. We were not accused of driving "a trust" or "a combine," but photography, phrenology, and biology were all handled from our headquarters at 137 Owego street, over J. M. Heggies' harness store, Ithaca, New York. It was no uncommon thing to find watch repairers, dentists, and other styles of business folk to carry daguerreotypy "on the side." I have known blacksmiths and cobblers to double up with it, so it was possible to have a horse shod, your boots tapped, a tooth pulled or a likeness taken by the same man; verily, a man—a daguerreotype man, in his time, played many parts.[133]

1848

In 1848, just before reaching the age of seventy-one, Henry Clay made a final try for the presidency, but was bypassed for the Whig party nomination by the Mexican War hero Gen. Zachary Taylor. Clay's preconvention tour took him to Baltimore, Philadelphia, and New York, and according to one of his biographers, "there was no end to the hand-shaking and cheers." [134] In New York, the festivities lasted several days. Marcus Root photographed Clay after his arrival in Philadelphia, and the mayor, the sheriff of the county, and a party of well-wishers accompanied Clay to Root's studio for the picture-taking event. Root evidently made daguerreotypes of the statesman while engaged in conversation, and he later recalled the visit in these words:

"The mayor, turning to Mr. Clay, said, 'Mr. Root desires us to continue talking, as he wishes to daguerreotype your *thoughts;* to catch, if possible, your very smiles.'

" 'Smiles!' exclaimed Mr. Clay,—'I can give him *frowns,* if he wants *them*'; upon which he smiled, while his face was radiant with intelligence as well. And in twenty seconds three good portraits were taken at once; the plates were removed from the instruments and four fresh ones got ready. In a few seconds more, Mr. Clay the while conversing pleasantly with his friends, all else was prepared, and then his likeness again was daguerreotyped by four cameras at once; all representing him, as we *then* saw him engaged in conversation, mentally aroused, and wearing a cheerful, intellectual and noble expression of countenance. Thus

eleven portraits were taken in but thirteen minutes—with such success, too, that Mr. Clay remarked, after inspecting them: 'Mr. Root, I consider these as decidedly the best and most satisfactory likenesses that I have ever had taken, and I have had many.' These words as he left in my register with his autograph." [135]

If Clay was photographed in Philadelphia in this precampaign period, he was presumably daguerreotyped in New York and possibly in other cities visited. It was becoming commonplace for daguerreans to produce daguerreotype copies of their own, or others' specimens, and today there are four identical daguerreotypes of Clay in museum collections which are attributable to at least three different makers—Southworth and Hawes, Brady, and Martin M. Lawrence. One Philadelphia photographer, Frederick De-Bourg Richards, offered copy daguerreotypes of the Swedish singer Jenny Lind, in 1851, which were available in a variety of sizes. But the vast majority of copy daguerrotypes made of particular celebrities in the daguerrean era have not survived; the existence of the four identical Clay plates is the exception rather than the rule. [136]

In Boston, John A. Whipple had become dissatisfied with the amount of labor expended in mechanical operations at his gallery, so he decided to buy a steam engine and apply its power to plate polishing and other branches of his business (see advertisement, reproduced on pg. 67). The engine was particularly helpful in preparing large plates, according

Nancy Southworth (left) and Josiah Johnson Hawes (right) were married in 1849, about a year before these daguerreotypes were made, presumably by her brother, Albert Sands Southworth, Hawes's partner from 1843 to 1861. The firm of Southworth & Hawes daguerreotyped all of the major figures during New England's great flowering in literature, statesmanship, and the arts. After 1861, Hawes alone made the principal surviving record of buildings and urban living in Boston during the 1860s and 1870s. Active to the end of his life, Hawes died in 1901 at age ninety-four. His wife preceded him by six years. [137]

WHIPPLE'S DAGUERREOTYPES
BY STEAM.

 After much patient experimenting I have finally succeeded in applying, with more uniform results and certainty, Steam power to do all the mechanical parts of Daguerreotyping, and conse- quently am enabled to furnish my cus- tomers with

BETTER MINIATURES IN LESS TIME
THAN FORMERLY, ESPECIALLY

BEAUTIFUL LIKENESSES OF LITTLE CHILDREN,

Which I will warrant to make satisfactory to parents,

If they will call upon me between the hours of 11 and 2, when the sky is clear.

I HEREBY EXTEND AN INVITATION TO ALL,
WHETHER THEY WISH TO OBTAIN LIKENESSES OR NOT,

To call and examine my large collection of Daguerreotype Portraits, and see the operation of the Miniature Steam Engine.

JOHN A. WHIPPLE.

TWO SILVER MEDALS FOR THE BEST PICTURES & PLATES.

MESSRS. SOUTHWORTH & HAWES,

THE ONLY FIRST PREMIUM

Daguerreotype
ROOMS,

ARE AT 5½ TREMONT ROW,

BOSTON.

The attention of all persons interested in procuring

DAGUERREOTYPE LIKENESSES

Of themselves or friends, or copies from Portraits, Miniatures, Paintings, Engravings, or Statuary, is particular- ly invited to our specimens.

For seven years we have taken copies of every description, *without reversing* them ; also from Life when desired.

We have in attendance two Ladies, and Females can have assistance in arranging their dress and drapery, and con- sult them as to colors most appropriate and harmonious for the Daguerreotype process.

Our arrangements are such that we take miniatures of children and adults instantly, and of DECEASED persons, either at our rooms or at private residences. We take great pains to have Miniatures of deceased persons agreeable and satisfactory, and they are often so natural as to seem, even to Artists, in a quiet sleep.

In style of execution and picturesque effect — in boldness of character and beauty of expression — in variety of size and delicacy of lights and shadows, we shall aim at the highest perfection possible.

Photographs painted in the very best manner if required. Cameras which will not reverse pictures, and every variety of Apparatus, Chemicals, and Materials, furnished and warranted.

Assisted by MRS. & MISS SOUTHWORTH, they will sustain their well-earned reputation. No CHEAP work done. Plates PERFECTLY polished. They neither use steam, humbug by false pretences, nor wear laurels won by competitors.

PHOTOGRAPHING THE DEAD: A PECULIARLY AMERICAN CUSTOM

Soon after daguerreotype photographers appeared in rural towns and cities, the custom began of taking daguerreotypes of the dead, particularly of children. It was strictly an American phenomenon, and became a lucrative source of income for those who specialized in its practice. In the 1850s, photographic supply houses offered framing mats in black, and cases of sentimental design as regular stock items. This experience of James F. Ryder occurred before he settled in Cleveland in 1850:

AWAY back in '48 I found myself in a little village in Central New York, where a camera had never been seen or used before, and to the citizens of that quiet place it was as good as a brass band.

The prominent lady of the place, whose husband was merchant and post-master, welcomed me to her house, gave me her parlor (the finest in the village), for operating room, rent free, and glad to have me at that—board, two dollars per week, payable in daguerreotypes.

My little frame of specimens was hung upon the picket fence beside the gate, my clip headrest screwed to the back of a common chair, and the business of "securing the shadow ere the substance fade" (see handbills), was declared opened.

The people came in throngs, the dollars rolled in right merrily; no business in town equalled mine.

The good lady of the house was the possessor of a large cluster breastpin, which was kindly loaned to every female sitter that came, to the mutual satisfaction of lady owner and lady sitter; a great help to me as well, proving a capital point for aiming my focus.

After the day's work was done a saunter across the bridge and through the narrow path of the meadow, where was the pleasant odor of clover and the glad ripple of the brook, was my pleasure and my habit. The home-coming farmer gave me friendly greeting. The boy with torn hat and trousers rolled half way to the knee, as he fetches the cows from pasture, hails me with: "Take my likeness, mister?" The country lasses, shy and sweet, give a modest bow as they meet the "likeness man."

I was regarded with respect and supposed to be a prosperous young fellow. All were friendly and genial—save one.

The blacksmith, a heavy, burly man, the muscular terror of the village, disapproved of me. Said I was a lazy dog, too lazy to do honest hard work and was humbugging and swindling the people of their hard earnings. He, for one, was ready to help drive me out of the village.

The greater my success the more bitter his spleen, and in the abundance of his candor denounced me to my face as a humbug too lazy to earn an honest living. He said he wouldn't allow me to take his dog; that I ought to be ashamed of robbing poor people. Other uncomplimentary things, he said, which were hard to bear, but in view of his heavy muscle and my tender years, I did not attempt to resent.

Well, I left that quiet town and brawny blacksmith one day and moved to another town a few miles distant.

Example of a sixth-plate size daguerreotype of a dead person.

A week later I was surprised at a visit from him. He had driven over to the new place to find me. He had a crazed manner which I did not understand and which filled me with terror.

He demanded that I put my machine in his wagon and go with him straight at once. I asked why he desired it and what was the matter. Then the powerful man, with heaving chest, burst into a passion of weeping quite uncontrollable. When he subsided sufficiently to speak he grasped my hands, and through heavy weeping, broken out afresh, told me his little boy had been drowned in the mill race and I must go and take his likness.

"A fellow-feeling makes us wondrous kind." My sympathy for the poor fellow developed a tenderness for him in his wild bereavement which seemed to bring me closer to him than any friend I had made in the village.

To describe his gratitude and kindness to me after that is beyond my ability to do. [138]

"BUCKEYE BLACKSMITH" CONSTRUCTS A MOBILE DAGUERREOTYPE "SALOON"

After the campaign of '48 was over I concluded to go to work again at my business, but by this time every little town in the country had a daguerrotype saloon in it and the large places had two or more men running opposition in them. Every fellow who could raise a few dollars would get up a small outfit, mostly almost worthless, and put out into some country town and stick up his cards and pretend he knew more about the business than any man living, when at the same time all that he knew and his tools in the bargain were not worth ten dollars. Almost every town I went to I found one or two and sometimes more of these fellows blowing their own trumpets, and as soon as I would open up and commence business they would generally put the price of their pictures down to about half what I charged in order to burst me up, but I generally made them leave, and that very soon after I got under way.

The greatest difficulty I had to encounter with these men, was the want of a suitable room with the right kind of light to make good pictures with, they being there before me, would generally get the best places to be had, and I would have to take an inferior place to compete with them, but having more knowledge of the business than they had, and the best instruments in the country, I could always put them to flight.

I saw very plainly, that there was something wanting. I knew what kind of light I required to do good work with, and this light I could not get in country towns. There being a little Yankee in me, I set to work to build me a house adapted exactly to the business, with a large, splendid sky-light, made in such a manner, that I could, by taking off a few screws, take it all apart in small compartments and load it on a car or big wagon and move it to any place I might wish to, where, with the aid of two men, in three hours I could put it up, ready for work. It was three times as large as those saloons which were built on wheels years after that, and far superior; those saloons were too small and were never adapted to the business, consequently I never had one.

As soon as I got my house done I had no more trouble with opposition. My sky-light made such fine even shades over the face, everybody said they were just the thing they wanted, and everybody admired my enterprise in getting up such a novel plan of doing good work, and they fully rewarded me for my outlay and skill. I would go into a town, get a vacant lot whereever I could, get two or three men to help me, and have my house all ready for business before any person knew what was going on. The first thing they would know about my being there would be when they read my bill, which I would have thrown into every house as well as all over the country around. I put up my bills thus:

The great crowd you see moving from morning till twilight
Are enquiring the way to the Buckeye's great sky-light,
To have a daguerrotype view of their faces
Put up for a dollar, in the very best cases.

A call is respectfully solicited—saloon on——lot —— &c.

This saloon as I called it was a decided success, for in it I did the best work I had ever done, and wherever I went, I did a very nice business. I continued to travel about through Pennsylvania, from town to town, from the time of Taylor's election until the Spring of 1852, when another political campaign was about to open, but as yet nobody knew who were to be the candidates.[139]

to a contemporary account, and "with the steam he brings out his pictures, heats his rooms in winter, and cools them in summer by means of an ingeniously constructed fan." Whipple's action may have been prompted by the adoption of steam power by lithographers. P. S. Duval of Philadelphia, for example, installed steam power to run most of his presses, thereby making it possible to produce lithographs more cheaply, and at a faster rate. But Whipple's competitors, Southworth and Hawes, stated in their advertisements on the same pages with Whipple that they "neither use steam, humbug by false pretenses, nor wear laurels won by competitors."[140]

But with all his experimenting with glass negatives, microphotography, and steam power, Whipple and his partner on the side, Jones, failed to get on with the job of perfecting an albumen negative process, and were caught napping when Abel Niépce de Saint-Victor, a cousin of Daguerre's former partner, published a method in Paris (on June 12, 1848). The experiments by Whipple and Jones had been carried on, in Whipple's own words, "with the greatest secrecy, known to only a few of our most intimate friends, which I am now convinced [he was speaking in 1853] was very bad policy." Niépce de Saint-Victor's discovery, he said, "dashed all our hopes to the ground for foreign countries." The pair immediately filed a caveat with the U.S. Patent Office, conducted further experiments during the time period allowed by this filing, then applied for a patent which was granted in 1850 after a long delay.[141]

Niépce de Saint-Victor's process called for coating a glass plate with albumen containing a few drops of a solution of iodide of potassium. The plate was sensitized in a silver nitrate bath and could be exposed in the camera while moist (for quicker exposures), or after drying. The process had built-in drawbacks, since exposures with moist plates were irksome, and those made with a dried plate required from five to fifteen minutes' time.[142] Whipple's process was similar, but included addition of pure liquid honey to the albumen coating. Neither process ultimately was considered suitable for portraiture, but both were used by photographers on both sides of the Atlantic to make architectural and landscape views.

Strangely, the revolutions which swept Europe in 1848 had a direct effect on the early development of both the French and American albumen processes. In France, rioters who brought an end to King Louis Philippe's eighteen-year reign, entered Niépce de Saint-Victor's laboratory and destroyed all his valuables, leaving no trace of the work he had accomplished. This put an end to further progress for the time being, and delayed the adoption of the French process.[143] The revolutions in Germany the same year caused a wave of immigration to the United States by many well-educated Germans, who settled principally in New York, Baltimore, Cincinnati, St. Louis, and Milwaukee. One such immigrant was twenty-six-year-old Carl August Theodor Ehrmann, who as a student at the University of Berlin, had participated in guerilla warfare in Schleswig-Holstein, in the revolt of Silesian weavers, and in street warfare in Dresden. When Ehrmann settled in Philadelphia around 1850, he contributed immeasurably to the improvement and widespread adoption of the American process (see page 98).[144]

1849

The gold rush years gave photography a shot in the arm. Business increased to such an extent, particularly at eastern galleries, that operators were able to reduce prices to a lower level of about $2.50, which was thereafter maintained by most of the better galleries to the end of the daguerrean era.

Photographers in 1849 suddenly found themselves busy taking daguerreotypes of prospective miners about to leave for California, and also of their loved ones who would be left behind. "On steamer days," Abraham Bogardus recalled, "the gallery would be filled with miners in rough suits carrying their mining tools and a pair of pistols in the belt. We made several sittings before he left the chair and usually sold them all." The number of miners who made the journey by steamer or sailing vessel via the Isthmus of Panama (a 60-mile, malaria-ridden strip of land and waterways) totaled 6,489 in 1849, rising to 24,231 in 1852. The steamers also made the journey to San Francisco via Cape Horn, a route which took from six to nine months' travel time under crowded shipboard conditions.[145]

The cameras in most general use in the United States at this time, according to Henry Hunt Snelling, were Voigtlander models of the box, as opposed to the telescope variety. Because of the absence of photography manuals or books on photography practice during the 1840s, it is not now possible to determine with any degree of assuredness just how long the original Daguerre-style daguerreotype camera (as copied by the Goddard camera) or Alexander Wolcott's mirror style camera remained in widespread use. Beginning in 1843, Voigtlander began supplying the American market with a new box-style daguerreotype camera, as well as the Petzval portrait lens. By 1849, Edward Anthony was supplying cameras which Snelling said were "fully equal to the German, and for which Voigtlander instruments have been refused in exchange by the purchaser." But Snelling functioned as Edward Anthony's general manager, as well as the first chronicler of American photography, and the presumption must be made that other American manufacturers besides Anthony supplied cameras similar to the new Voigtlander design. The illustration on page 69 is of what Snelling characterized as "the ordinary camera box" in vogue in 1849. Whether it was a Voigtlander camera or an American version of the same style, is not known. But by 1849 there were several other firms—newly formed, in most cases—which could have been the manufacturer, including W. and W. H. Lewis, and Charles C. Harrison, all of New York City.

In 1849, Snelling published *The History and Practice of the Art of Photography,* which he characterized as the "first bound book on photography issued from the press in this country." The book had a rapid sale and passed through four editions of 1,000 copies each.[146] "The extensive manufacture of the most approved cameras, both in Europe and this country, obviates all necessity for any one attempting to construct one for their own use," Snelling stated in this publication. "Lenses are now made so perfect by some ar-

AN ORDINARY CIRCA 1849 DAGUERREOTYPE CAMERA

The camera was a dark box (*a*) having a tube with an achromatic lens (*b*) which formed the image seen (inverted laterally) upon a ground glass spectrum (*g*). Within the camera, a slide was used to regulate focusing, and the ground glass was inserted at one end of the slide. The cap (*c*) covered the lens until the silvered copper plate was placed in holder (*e*), covered with a dark slide (*f*) and inserted in the camera, taking the place of the ground glass spectrum, which was withdrawn. Lids (*d,d*) were closed after removing the slide (*f*). Camera boxes varied in size to suit the tube, and were termed medium, half, or whole, depending on the plate size intended for use.[147]

tisans that what is called the 'quick working camera' will take a picture in one second, while the ordinary cameras require from eight to sixty." Snelling also had some recommendations to make with respect to lenses used:

The diameter and focal length of a lens must depend in a great measure on the distance of the object, and also on the superficies of the plate or paper to be covered. For portraits one of 1½ inches diameter, and from 4½ to 5½ inches for focus may be used; but for distant views, one from 2 inches to 3 inches diameter, and from 8 to 12 inches focal length will answer much better. For single lenses, the aperture in front should be placed at a distance from it, corresponding to the diameter, and of a size not more than one third of the same. A variety of moveable diaphragms or caps, to cover the aperture in front, are very useful, as the intensity of the light may be modified by them and more or less distinctness and clearness of delineation obtained. These caps always come with Voigtlander instruments and should be secured by the purchaser.[148]

By the time his book was published, there were about nine dealers in the supply of photographic apparatus and materials. They were: Edward Anthony, Scovill Manufacturing Company, and William and W. H. Lewis all in New York; Benjamin French and John Sawyer in Boston; Myron Shew, and Dobbs and Birmingham in Philadelphia; and Peter Smith in Cincinnati. In 1851, Smith offered a line of cameras made by Charles C. Harrison, of New York, for taking quarter, half, whole, and Mammoth plate daguerreotypes. He also offered "quick-working" cameras of the type described by Snelling. Mammoth plates used in the

GOLD RUSH

Few daguerreotypes exist today of the covered wagons which traversed the American prairies during the 1840s. This half-plate specimen of an unidentified group was made about 1849, when an estimated thirty thousand wagons took the northern route from St. Louis through the Rocky Mountains to California. A southern route, also marked out before the gold rush, went via Sante Fe and the Arizona desert to southern California. Caravans averaged twenty-six wagons, each drawn by five yoke of oxen, or a span of ten mules. The 2,000-mile trek (over either route) could be covered in a hundred days, although delays were not infrequent. Eastern daguerreotype galleries, meanwhile, were crowded with prospective miners at this time having their pictures taken to leave behind with their kin. But these daguerreotypes are also now extremely rare. The man in the sixth-plate size daguerreotype (left) is unidentified. Few of those who flocked to California were experienced miners, but some of those who were first to arrive averaged between $300 and $500 a day for weeks on end, while there were reports of a few lucky diggers who made as much as $5,000 in a single day.[149]

1849

"THE MOST HOMELY FACES MAKE THE HANDSOMEST PICTURES"

In a revised edition of his 1849 book *The History and Practice of the Art of Photography*, Henry Hunt Snelling used the above two illustrations of President Zachary Taylor as evidence that "there are many points to be observed in placing the head in a position to be the most effective." The pose of Taylor at the left, he maintained, "represents him in a very unfavorable position," while the one at the right "shows him as he really is, when animated and graceful."

Snelling carefully refrained from drawing any analogies, but said: "I have noticed that in a majority of instances, the most homely faces make the handsomest pictures; this is a fact that will be duly appreciated by all, and will undoutedly lead to the query why it is so?, and I answer that it is mainly owing to the fact that ugly faces have more strongly marked outlines than those that are beautiful; the image produced therefore by the camera possesses greater contrast in light and shade, which while they give a greater depth of tone and a more pleasing effect, do not betray the defects." Stating that he was "not aware that any one else had made these observations," Snelling offered the following suggestions in posing:

In Daguerreotyping, I should, as a general thing, adopt the following rules, although in some instances I should possibly have to deviate.

A full round face, with large mouth, small eyes and nose, I should make what is called a half face, that is, where the whole of one side, and a *very small* portion of the other is seen, being but a slight remove from the profile likeness.

Of a moderately full face, with aquiline nose and handsome mouth and eyes, I would make a three-quarter picture, wherein all the features of one portion of the face would be visible, and about one-fourth of the other.

A face in which the features were a little more prominent, a three-quarter view would be preferable.

And one in which the lines are very strongly marked, and bordering upon projecting angles, I should decidedly make a full front view.

Always endeavor to throw life into the expression of your sitter's face by animate conversation, or a pleasant and polished witticism, avoiding all approach to the broad grin.

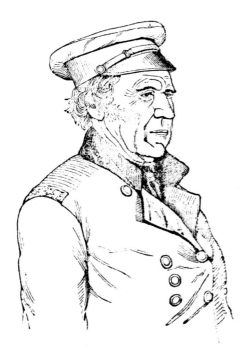

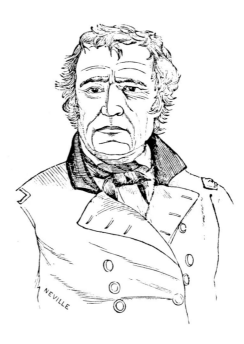

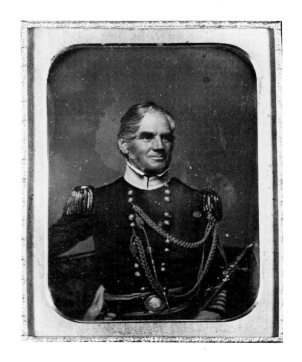

CHOLERA VICTIM
GEN. WILLIAM JENKINS WORTH
(1794–1849)

Cameras were evidently too busy recording the faces of miners to be focused on the streets, or in dingy rooms of tenements in such cities as New York, Cincinnati, and St. Louis where the worst effects of an epidemic of blue cholera broke out in 1849. One who succumbed was the Mexican War hero Gen. William Jenkins Worth, whose unpublished daguerreotype likeness, left, was made shortly before his death on May 7, 1849, while commanding United States troops in Texas. At one point, the death rate in New York reached between two hundred and three hundred persons *daily,* while the epidemic was also particularly severe in many infant cities of the West, which were crowded with transients. There were no American illustrated weeklies in 1849, and the plague appears not to have been recorded visually in the daily press, where the use of illustrations was decreasing rather than increasing at the time.

Gen. Worth's death removed what some observers considered a potential contender for the American presidency. Worth was known as the Murat of the American army, because his dashing manner and dress conjured up memories of Joachim Murat, king of Naples and a brother-in-law of Napoleon Bonaparte. Worth's Mexican War superiors, Zachary Taylor and Winfield Scott, figured prominently in later political history, as did such other generals and junior officers in the Mexican War as Franklin Pierce, Ulysses Grant, and George McClellan.[153]

larger cameras ranged in size up to as much as 13½ x 17½ inches. Such specimens sold for $50, the plates alone costing nearly $10 before use.[151]

And who were the big names in photography at the end of the medium's first decade as later recalled by Snelling? Mathew Brady, Jeremiah Gurney, J. R. Clark (Anthony's partner after J. M. Edwards), Augustus H. Morand, Abraham Bogardus, Gabriel Harrison, Alexander Beckers, Martin M. Lawrence, Jesse M. Whitehurst—all of New York; Frederick DeBourg Richards, of Philadelphia; James F. Ryder, of Cleveland; George S. Cook, of Charleston, South Carolina; John Fitzgibbons, of St. Louis; Alexander Hesler, of Galena, Illinois; George Barnard, of Syracuse; D. D. T. Davie, of Utica, New York; and James Landy, of Cincinnati. If Snelling had thought about the matter at greater length, he would presumably have included: John A. Whipple, Albert Southworth, and Josiah Hawes, of Boston; Marcus and Samuel Root, and A. A. Turner, in New York; Edward T. Whitney, in Rochester; Thomas Faris, Ezekiel C. Hawkins and Charles Fontayne, in Cincinnati.[152]

This was the year the Langenheims attempted to interest the American photographic community in Talbot's process, after William Langenheim returned from a visit with Talbot in England where he had concluded an agreement for exclusive rights to Talbot's American calotype patent on May 11.

But, as indicated earlier, there were no takers. At the same time, the Langenheims also developed a modification of Niépce de Saint-Victor's albumen negative process, which the brothers managed to patent on November 19, 1850.[154] Precisely when they began their experiments with glass negatives—paralleling Whipple's experiments in Boston—does not appear to be recorded. The Langenheim patent applied to positive pictures on glass obtained with albumenized glass negatives, and to these positives they gave the name "Hyalotypes." Whipple's 1850 patent applied to positive pictures secured on paper from glass negatives sensitized with a different albumenizing formula, containing pure liquid honey. These prints were termed "Crystalotypes." The Langenheims exhibited both their Hyalotypes and Talbotypes at the annual fair of the Franklin Institute in Philadelphia in 1849, but the top photographic award went to the Cincinnati photographers Charles Fontayne and William Porter for a daguerreotype panorama of the Cincinnati waterfront, taken the previous September. Porter had learned the daguerreotype business in Philadelphia and had secured a panorama of that city (consisting of seven plates framed together) on May 28, 1848. The Cincinnati panorama, which he took with Fontayne, consisted of eight wholeplates framed in a custom-made mahogany display case. The panorama was also displayed in 1849 at the Maryland Institute, where it again took top honors.[155]

1850

The first rumblings of civil disunion were heard in 1850 as three ailing elder statesmen—Clay, Webster, and Calhoun—debated for eight months in the United States Senate over antislavery legislation, and the role which slavery was to play in the creation or admittance to the Union of several new western states, among them California. While this drama was taking place in Washington, the great El Dorado in California began to take on sizeable proportions. San Francisco had grown from a town of 812 people (in March 1848) to a city of 25,000 by 1850, and along with the incessant influx of gold diggers and adventurers, there came, individually, a small band of photographers. Their names were: S. S. McIntyre (from where, unknown); William J. Shew (the Boston daguerreotype case maker); Isaiah W. Taber (from New Bedford, Massachusetts); J. Wesley Jones (from where, also unknown); Fred Coombs (from Chicago); Henry W. Bradley (from Wilmington, South Carolina); William H. Rulofson (from Newfoundland); and Robert Vance (from New York City). In the hands of these daguerreans, the outdoor use of the daguerreotype camera flourished—if only for a period of a few years—as it never did elsewhere in the country.

Robert Vance and J. Wesley Jones were the most prolific of the group, but unfortunately their photographs have been lost. Vance was among the earliest to arrive, and appears to have begun making dagurreotypes as early as 1849. Only because a record exists of more than three hundred photographs he took and exhibited in New York in the fall of 1851 is it possible to surmise the extent of his activities, and where he was and when.[156]

Among the Vance collection was a daguerreotype panorama of Panama, and daguerreotypes made in Acapulco (Vance called it Acupulco), one showing the hills in back of the city with the steamers *Panama* and *Sea Bird* at anchor in the bay. These would seem to suggest that Vance had traveled to California via the Isthmus of Panama, as William Shew had done. (Shew took the steamer *Tennessee* via the Isthmus route, and sent his daguerreotype wagon on a clipper ship via Cape Horn.) Vance may have made the trip on either the *Panama* or *Sea Bird,* photographing the two vessels during a stopover at Acapulco. But the collection also includes daguerreotype views made in the Chilean seaport of Valparaiso, and a daguerreotype of a cathedral in Cuzco, the former capital of the Inca empire in southern Peru. If these photographs were made by Vance on his initial trip to California, it would suggest that he traveled via Cape Horn.

Still another possible explanation seems more plausible. In August 1849, Isaiah Taber journeyed to San Francisco from his native New Bedford, Massachusetts, on the clipper *Friendship* via Cape Horn. In April 1850, with a group of friends, he chartered a bark, the *Hebe,* on which the party sailed to Valparaiso on a unique seafaring venture. The voyagers purchased flintlock muskets at Valparaiso, then sailed to the island of Marquesas (south of what is now Hawaii) to exchange the muskets for a thousand hogs. By November 1850, the *Hebe* was back in San Francisco, the

hogs being offered in a market where pork was selling for as much as a dollar a pound.[157] It is likely that Vance had become acquainted with Taber in San Francisco, and quite possible that he made his South American daguerreotypes on the *Hebe* voyage.

That Vance began making daguerreotypes in the San Francisco area as early as 1849 is suggested by the fact that two of the identified views in his collection were made in Hangtown, the early mining community which derived its name from a hanging which took place there in 1849. A number of daguerreotypes were also made in Placerville, the name to which Hangtown was later changed.

None of his photographs, however, can be said definitely to have been made between April and October, or November 1850 (when the *Hebe* was away on its voyage), but a major series was made in San Francisco before and after what Vance described only as the "May" and "June" fires. San Francisco was ravaged by fires in December 1849, and again in May, June and September 1850, but the most disastrous of its early conflagrations occurred on May 4, 1851. Since Vance's exhibition of his photographs took place in New York only four months later, it seems logical to conclude that his designations "May" and "June" applied to 1851, as opposed to 1850 fires in San Francisco.

Six of the daguerreotypes were made in Portsmouth Square before and after the "May" and "June" fires, and while another was made of Kearney Street on election day (the date being unspecified), Vance appears not to have recorded the celebration in Portsmouth Square which took place on October 18, 1850, when news reached San Francisco of California's admission to the Union. This is further indication that he may have been away at that time.

The catalog of Vance's daguerreotypes (page 77), which is all that remains, establishes him as among the first to use the camera for a large-scale documentary undertaking. He made plates of John Sutter at his famous mill; views of miners and mining activities in all of the principal towns—Coloma, Sonora, Yuba City, Makelame, Nevada City, Marysville, etc.—and of the principal supply centers, Stockton to the north, Sacramento to the south; views along the Stanislaus and Feather rivers; and views of streamers and waterfront scenes. His numerous views of a Spanish mission three miles south of San Francisco were strictly documentary in purpose. "This mission, Dolores, now time-worn and crumbling to ruins, was a proud and influential religious establishment of the days of the Jesuits, founded more than a century ago," he said. He also photographed in Benicia, possibly including the two-story building then in mud flats (now a museum) which housed the first meetings of the California Legislature in 1853–54. When he made his photographs in Benicia and Martinez, which today are connected by a freeway and toll bridge spanning Carquinez Strait, he remarked: "This place is a port of entry, and [is] destined to be a place of first importance as a commercial city."

Vance left California for New York, possibly as early as

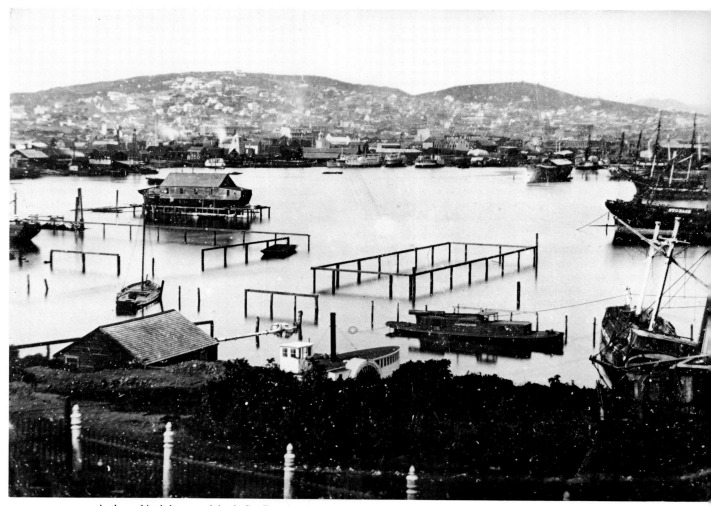

As the multitude began arriving in San Francisco for the gold rush, frigates soon clogged the city's inner harbor. The scene above is from only two plates of a panorama of five whole-plate daguerreotypes taken about 1852 by William Shew, a Boston daguerreotype case maker who was among those who headed west in 1851. An estimated thirty-six thousand immigrants landed in these and other ships in 1850, and the harbor had become a forest of masts when six hundred abandoned vessels were counted a year before Shew's panorama was taken.

June 1851. He secured space on the second floor of 349 Broadway (above the gallery of Jesse Whitehurst, newly arrived from Washington), opened a formal exhibition of his works at the end of September and put together a finely printed catalogue to announce the event. H. H. Snelling gave him a rave review in a photographic journal which he had just recently established, but there is no evidence that it was duplicated in the general press. In any event, the exhibition was a total failure, and in January or February 1852, Vance returned to San Francisco to reestablish his daguerreotype business there. For about a year, the California photographs were exhibited at Jeremiah Gurney's gallery, then Snelling, in February 1853, announced that he was authorized to sell the collection at a greatly reduced price: It had cost Vance $3,000 to make his photographs, and another $700 to frame them in gilded rosewood. Snelling offered to sell the collection for $1,500, or in smaller increments at a price of about $7.50 a daguerreotype.[158]

It is difficult to think of another occasion when such a large, timely, and interesting collection of photographs (in keeping with the popular tastes and interests of the period) was ever presented at a public exhibition. Snelling was also incredulous at the lack of interest in the daguerreotypes. The attention which the world was giving California, he said, was "never before equalled in the annals of history. To such a pitch has public curiosity been excited," he added, "that the smallest item of news in regard to this newly discovered El Dorado is eagerly seized upon." Perhaps so, but no eagerness was evidenced to *purchase* the California views. The collection was finally bought in July 1853 by John H. Fitzgibbons, the last recorded owner. Fitzgibbons twice sold his St. Louis gallery, the first time in 1861 when he moved to Mississippi (where he was captured by Union troops and sent to a prisoner of war camp in Cuba), and again in 1877 when he retired. Vance's collection could have been acquired at either time, and could,

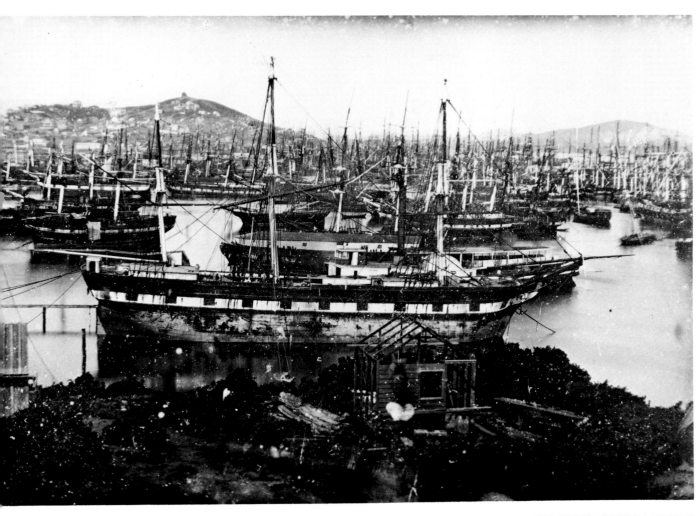

therefore—like the previously lost Plumbe daguerreotypes of Washington—still be found.[159]

Also missing are the 1,500 daguerreotypes which J. Wesley Jones claimed he had taken, beginning in the summer of 1851, in California and on the prairies and Rocky Mountains. Jones also came east to New York, but to lecture and exhibit sketches and paintings made from his daguerreotypes. This he did in New York and in other eastern cities in the winter of 1853–54. Then, in March 1854, his paintings were sold in a lottery. Jones reportedly lived in Melrose, Massachusetts, after coming east from California, but today there appears to be no record of what became of his daguerreotypes or his paintings. Some of his sketches, and the notes for his lectures, however, were acquired by the California Historical Society.[160]

Daguerreotype views of San Francisco and mining activities exist in small numbers in institutional and private hands, but the photographer, in most instances, is un-

Isaiah W. Taber

1850

75

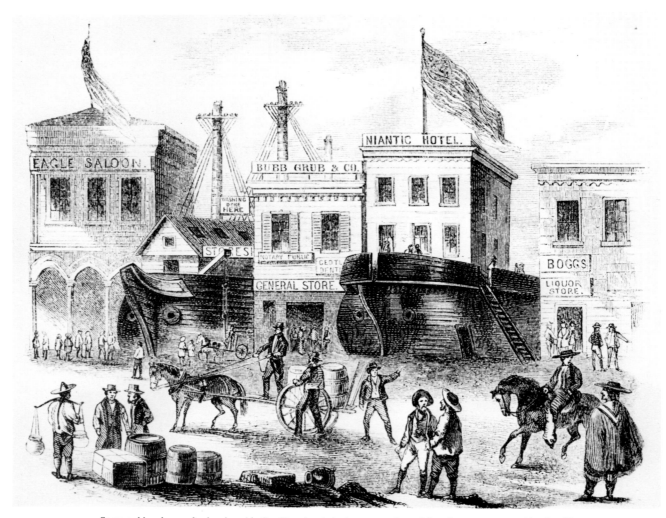

Some gold rush vessels abandoned in San Francisco's harbor were salvaged for other purposes, as this 1849 N. Currier lithograph reveals. But as building lots become more costly at the bay's edge downtown, room was made for more lots simply by dumping landfill around the remainder of the abandoned armada.

known. Six daguerreotype panoramas of San Francisco are extant, for example, but only the five whole-plates panorama taken about 1852 by William Shew (see previous pages) is identified as to maker. The International Museum of Photography in Rochester possesses a daguerreotype view of Montgomery Street in San Francisco, said to have been taken in 1850 by Fred Coombs. In July 1851, Samuel D. Humphrey, editor of the then newly founded *Daguerreian Journal* (later *Humphrey's Journal*), disclosed to his readers that S. S. McIntyre had sent him a panorama of San Francisco consisting of five half-plates. Humphrey also said that McIntyre had been burned out of his gallery (presumably the May 1851 fire), and that he (Humphrey) was prepared to supply copies of McIntyre's original at no charge for his services. William Shew's daguerreotype wagon was scorched in a San Francisco fire, and he was later burned out of a gallery which he had established after civic authori-

ties banned his use of the wagon in Portsmouth Square.[161]

With the national focus centered on gold-digging in California and the great Senate debates in Washington, little attention was given to the birth of the world's first photographic journal in New York, or the perfection in Philadelphia of the first photographic slides which could be projected on a screen by a magic lantern.

Samuel D. Humphrey, about whom virtually nothing is now known, started the *Daguerreian Journal* (the title being spelled differently from the term "daguerrean" used at the same time) on November 1, 1850. Humphrey was probably a native of Canandaigua, New York, where he was active as a daguerrean in 1849 and printed, on the local newspaper press, his first photography book in conjunction with Marshall Finley.

In the first issue of the *Daguerreian Journal*, Humphrey prepared photography's first "Who's Who" listing (right),

Unless or until they are someday found, this catalog is all that remains, giving us a partial listing of some three hundred daguerreotypes by Robert Vance which documented the people, activities, towns, and numerous fires in the bay area during the early gold rush years.

which omitted a number of operators such as Southworth and Hawes, the Langenheim brothers, Abraham Bogardus, Alexander Beckers, Victor Piard, Edward T. Whitney and Alexander Hesler whose names today are prominent in the annals of photographic history. Humphrey also mispelled Mathew Brady's first name, a common error to the present day. In his first issue, Humphrey also counted seventy-one daguerreotype rooms in New York City which were run by 127 people (proprietors, operators, eleven ladies and forty-six boys). The fact that the 1850 national census tabulated only 938 males over the age of fifteen as daguerreotype practitioners can be attributed to the variety of occupations which a daguerrean then followed. If a man or woman did not give daguerreotyping as a principal occupation, that person was tabulated under a different heading.

In Philadelphia, the Langenheims found little interest in their Hyalotypes, when offered simply in the form of posi-

PHOTOGRAPHY'S FIRST "WHO'S WHO"

An incomplete listing published in the first issue of the first photographic journal, the *Daguerreian Journal*.

DAGUERREIAN ARTISTS' REGISTER.

Adams, George, Worcester, Mass.
Brady, Matthew B., No. 205 Broadway, N. Y.
Burges, Nathan G., No. 187 Broadway, New York.
Baker, F. S., Baltimore, Md.
Broadbent, Samuel, Wilmington, Md.
Barnes, C., Mobile, Ala.
Brown, H. S., Milwaukie, Wis.
Collins, David, Chesnut Street, Philadelphia, Pa.
Cooley, O. H. Springfield, Mass.
Clark Brothers, No. 551 Broadway, N. Y. 128 Genesee Street, Utica, Franklin Building, Syracuse, New York, and Tremont Row, Boston, Mass.
Cook, George S., Charleston, S. C.
Coombs, F., San Francisco, Cal.
Cary, P. M., Savannah, Ga.
Dodge, E. S., Augusta, Ga.
Davie, D. D. T., Utica, N. Y.
Dobyns, T. J., New Orleans, La and Vicksburg, Miss., and Louisville, Ky.
Evans, O. B. Main Street, Buffalo, New York.
Finley, M., Canandaigua, Ontario Co., N. Y.
Fitzgibbon, J. H., St. Louis, Mo.
Faris, ———— Corner Fourth and Walnut Street, Cincinnati, Ohio.
Gurney, Jeremiah, No. 189 Broadway, N. Y.
Gavit, Daniel E., 480 Broadway, Albany, N. Y.
Gay, C H., New London, Ct.
Hough & Anthony, Pittsburg, Alleghany Co., Pa.
Hale, L. H., 109 Washington street, Boston, Mass.
Hawkins, E. C., Corner of Fifth and Walnut Street, Cincinnatti, Ohio.
Johnson, Charles E, Cleaveland, Ohio.
Jacobs, ———— New Orleans, La.
Johnston, D. B., Utica, N. Y.
Johnson, George H., Sacramento, Cal.
Kelsey, C. C., Chicago, Ill.
Lawrence, Martin M., No. 203 Broadway, N. Y.
Lewis, W. and W. H., No. 142 Chatham Street, New York.
Long, H. H., St. Louis, Mo.
Long, D., St. Louis, Mo.
L'Homdieu, Charles, Charleston, S. C.
Meade Brother, No. 233 Broadway, New York, and Exchange Albany, N. Y.
Martin, J. H., Detroit, Mich.
Moissenet, F., New Orleans, La.
Moulthroup, M., New Haven, Ct.
Manchester & Brother, Providence, and Newport, R. I.
Mc Donald, D., Main Street, Buffalo, New York.
Peck, Samuel, New Haven, Ct.
Root, M. A. & S., No. 363 Broadway, New York, and 140 Chesnut Street, Philadelphia, Pa.
Sissons, N. E., No. 496 Broadway, Albany, N. Y.
Shew, Jacob, Chesnut Street, Philadelphia, Pa.
Thompson, S. J., No. 57 State Street, Albany New York.
Tomlinson, William A., Troy, New York.
Van Alsten, A., Worcester, Mass.
Walker, Samuel L., Poughkeepsie, N. Y.
Westcott, C P., Watertown, Jefferson Co., N. Y.
Wood, R. L., Macon, Ga.
Whipple, John A., Washington Street, Boston, Mass.
Whitehurst, J. H., Norfolk and Richmond, Va., and Baltimore, Md. 162

1850

The "Hyalotype" glass slide of the U.S. Mint at Philadelphia (above) is from Frederick and William Langenheim's first series of 126 different slides prepared in 1850 for magic lantern viewing. Series included portraits of celebrities and views taken in Philadelphia, Washington, and New York.

tive pictures on glass, and they turned their attention to manufacturing Hyalotypes in the form of glass slides suitable for use with the magic lantern. Previously, this device was used to project hand-painted slides only, which were prepared by applying transparent oil colors to the slides. The method used by the Langenheims to make their first slides (see example above) involved use of a thick piece of glass bearing the image, which was covered by a second piece of glass, the two plates being bound together with the same gummed paper used to bind daguerreotype plates together with their covers. Thus assembled, the bound plates were placed in a wooden frame, the front of which had a circular opening while the back was hollowed out in rectangular shape to hold the slide in much the same fashion as any modern picture frame holds a picture (with nails secured on the back side). The slides were toned a golden brown, a distinguishing characteristic of the few such Langenheim slides which are to be found today anywhere.

To launch this latest of a number of ventures begun by the

Langenheims in this period (1848–1850), they made a series of 126 slides of prominent personages (President Zachary Taylor, ex-President Martin Van Buren, Henry Clay, and John J. Audubon among others) and views taken in Philadelphia, New York, and Washington, which could be sold individually or as an entire group for magic lantern viewing. The brothers also prepared a circular and sent collections to various people for promotional purposes. One recipient was Robert Hunt, editor of the *Art-Journal* in London and author of an early book on photography, *Researches on Light*. Hunt expressed himself as greatly "excited" with the Hyalotype slides sent to him, and published portions of the Langenheim circular, few, if any, copies of which are to be found today:

The new magic lantern pictures on glass, being produced by the action of light alone on a prepared glass plate, by means of the camera obscura, must throw the old style of magic lantern slides into the shade, and supersede them at once, on account of the greater accuracy of the smallest details which are drawn and

1850

78

fixed on glass from nature, by the camera obscura, with a fidelity truly astonishing. By magnifying these new slides through the magic lantern, the representation is nature itself again, omitting all defects and incorrectness in the drawing which can never be avoided in painting a picture on the small scale required for the old slides. To be able to perceive fully the great accuracy with which nature is copied in these small pictures, it is absolutely necessary that they should be examined through a magnifying glass. In minuteness of detail, as well as in general effect, they surpass even the daguerreotype impression, as the light passing through the picture gives a better effect in the deep, yet transparent shadows.''[163]

The Langenheims exhibited their Hyalotypes—both the lantern slides and the glass positives—at the London Crystal Palace Exhibition, the first international exhibit of technology by the industries of all nations, where they were received as ''a pleasing application'' of the photographic art.

They were not, of course, recognized immediately for what they were—the forerunners of lecture slides for business, educational, and home use, and an important first step toward motion picture projection.

In 1850, Richard Beard was declared bankrupt in London after a protracted series of litigations against infringers of his rights to the British daguerreotype patent. While this did not prevent him from continued prominence in the British photographic world, his litigation problems had repercussions on his former American partner, John Johnson. After 1843, Johnson took up plumbing and gas fitting in New York because of the ill effects on his health from continued working with daguerreotype chemicals. At the same time, he also became for a time a correspondent for the *Scientific American*. He evidently also continued to derive revenue from the rights to daguerreotype practice which had been assigned to him by Beard (in 1842) for the counties of Lan-

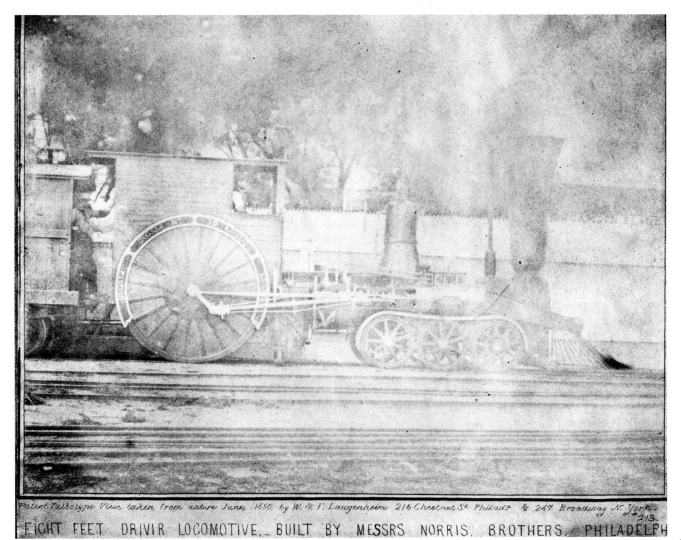

Patent Talbotype View, taken from nature June 1850 by W. & F. Langenheim 216 Chestnut St. Philad.a & 247 Broadway N. York.

EIGHT FEET DRIVIR LOCOMOTIVE, BUILT BY MESSRS NORRIS. BROTHERS, PHILADELPH

This faded calotype paper photograph of a Norris brothers locomotive was made in 1850 by the Langenheims, who were unsuccessful in trying to introduce Talbot's process in the United States. Gustave Le Gray's improved calotype process, introduced in the United States in 1851, would attract greater interest.

Although uncommon, daguerreotype cameras were made in large size after 1850 to accommodate large plates (and occasionally small children!). In 1851, S. D. Humphrey reported having seen Southworth & Hawes daguerreotypes in size 13½ x 16½ inches.

cashire, Cheshire, and Derbyshire. Just how long this source of revenue continued is not recorded; however on June 29, 1850, Johnson inserted the following notice in the *Manchester Guardian:*

CAUTION—PHOTOGRAPHY. Whereas several persons in the counties of Lancashire, Cheshire and Derbyshire, have been and are infringing upon the patent rights granted in and by certain letters patent, bearing date the 14th day of March 1842, Assigned and Granted unto RICHARD BEARD, Esquire, of the city of London, by whom the sole and exclusive right and privilege of using and exercising the Daguerreotype invention in the taking of likenesses, or other representations, in the said counties of Lancashire, Cheshire and Derbyshire, was on the 9th day of November, 1842, Granted and Assigned unto JOHN JOHNSON, Esquire, of the city of New York in America. Notice is hereby given, that the validity of the said letters patent has been fully established by the Judgment of the Court of Common Pleas at Westminster, and that the proceedings will be taken against all persons in the said counties now or hereafter infringing upon the said several letters patent, by using the said invention without having a license and authority for that purpose. And notice is also given, that the only establishment licensed to practice photography under such letters patent in the borough of Manchester and its vicinity, is the Photographic and Daguerreotype Portrait Gallery, in the Exchange Arcade, Manchester. Persons desirous of obtaining licenses to use and exercise the said Daguerreotype inventions in the said counties, may learn the terms upon which licenses can be obtained upon application to MR. NEILD, 5 Marsden Street, Manchester, solicitor for the said John Johnson. Manchester, June 1850.[164]

1851

American photographers took top honors at the world's first exhibition of the industry of all nations, held in 1851 at the newly constructed Crystal Palace in London. Looking back to this time from the vantage point of later years, the English photographer and writer John Werge felt there was a definite reason for American superiority in daguerreotype practice: "All employed the best mechanical means for cleaning and polishing their plates, and it was this that enabled the Americans to produce more brilliant pictures than we did. Many people used to say that it was the climate, but it was nothing of the kind." American-made daguerreotypes, Werge said, "were all of fine quality and free from the 'buff lines' so noticeable in English work of that period."[165]

But both European and American daguerreans were by this time demonstrating an ability to prepare their chemicals and to use the daguerreotype camera in such a way as to obtain early examples of "instantaneous" photographs—the term used throughout the nineteenth century for results which today would be called "candid" photographs. Through a combination of unique plate preparation techniques, favorable weather, and lighting conditions, certain photographers managed to reduce exposures to one second—the time it would take a facile operator to remove and replace a lens cap—and, with small, fast-acting cameras, to a fraction of a second. Most early instantaneous results were novelties, and many were small pictures made from a high vantage point to minimize whatever movement was "stopped" and recorded in the image. Hippolyte Macaire, of Le Havre, could get as much as 100 francs apiece for daguerreotypes he made in 1851 of people, horses, and carriages in motion, and of seascapes with waves, and steamships with smoke coming out of their funnels. But few instantaneous daguerreotypes of this period are to be found today, and in most cases the movement recorded was probably coming towards, or going away from, the camera, as opposed to taking place laterally.[166]

Alexander Beckers and Alexander Hesler appear to have arrived at a similar conclusion about the same time with respect to a means of enhancing the sensitiveness of a daguerreotype plate, but it was many years before either of them talked about it, or published any details of their experiments (which, in fact, Beckers never did). All Beckers ever said (recorded in 1889) was that "by taking outdoor views I discovered that the plates increased in sensitiveness with the time between the preparation and exposure." He evidently put this discovery to good use, for in 1864 Marcus Root said Beckers had made instantaneous views in Broadway in 1851 "wherein all moving objects were clearly and beautifully delineated on a silver plate." Hesler waited thirty-eight years before revealing his "secret," which also involved use of a primitive camera shutter mechanism:

In the early summer of 1851 I made a series of views for "Harpers' Traveler's Guide" of all the towns between Galena and St. Paul that were then

NEW YORK

Copy of Instantaneous Daguerreotype, 1851.

The English photographer-historian John Werge visited the United States for the first time between June 1853 and October 1854. His second visit lasted from April 1860 to August 1861. This daguerreotype was either made by himself or by an American photographer, and taken with him back to England. Reproduced some thirty-six years later in Werge's *Evolution of Photography,* the illustration ranks as possibly the earliest surviving photograph of a New York harbor scene. Werge abandoned the daguerreotype process in 1857.[167]

settled on the Mississippi, from the pilot-house of the steamer "Nominee" while under full headway, that were just as sharp as if taken from a fixed point. The pictures were taken on what we then called a half Daguerreotype plate.

I had constructed a drop-shutter, the first and only one I had ever seen or heard of—had it made at a tin-shop—and practically the same as is now in use. In the drop I made a slit half an inch wide, and extending entirely across the diameter of the lens. The drop was accelerated in its fall by a stout rubber spring. The lens was a "C C Harrison" single view. When the boat was far enough away so that all the village was embraced in the plate it was at once put in place and the shutter released, the plate put away in a light-tight box, and not developed until I got back to Galena.

How did I get the rapidity? Simply by having a pure silver surface exposed to the right proportion of the fumes of iodine and bromine. And here was the secret. *Coating the plates two or three weeks* beforehand and keeping in light and airtight boxes ! The longer they were kept the more rapid they became ! When properly prepared, the time was reduced from minutes to seconds !

HESLER DAGUERREOTYPE INSPIRES "HIAWATHA"

About the same time that Robert Vance was making his dageurreotype views of gold mining activities and urban life in the San Francisco area, Alexander Hesler, of Galena, Illinois, was photographing the upper Mississippi River, Fort Snelling, and the falls of St. Anthony. Later, when glass negative processes came into general use, Hesler copied many of his daguerreotypes, making what are classed as "salt prints"—the earliest form of photograph on plain salted paper, similar in appearance to a calotype, but made with a glass, as opposed to a paper negative. The original from which the photograph (left) has been reproduced is a Hesler salt print copied from an 1851 daguerreotype of the falls of Minnehaha. Another daguerreotype made at the same time by Hesler was given to Henry Wadsworth Longfellow, inspiring "Hiawatha," the idealized love story based upon the poetic legends of the Indians which Longfellow wrote in 1855.

Later a photographer of Lincoln, Hesler was feted shortly before his death in 1895, and on that occasion this description was given of the role played by his daguerreotype in the writing of "Hiawatha":

Alexander Hesler, from an 1858 salt print.

"It has been made the subject of much comment among artists and poets that it was Mr. Hesler who was principally responsible for the inspiration which induced Henry W. Longfellow to write 'Hiawatha.' The incident became known at a dinner in this city, attended by old-time photographers at which anecdotes were discussed, as well as choice morsels and cigars.

"It seems that Mr. Hesler, armed with his picture-taking paraphernalia, wandered into the northwest in search of Nature's beautiful retreats. This was in 1851, and in August of that year, he tramped over the present site of Minneapolis. There was no sign of a city at that time. Coming upon the falls of Minnehaha, he took several views of the 'natural poem.' While arranging his pictures, he was accosted by a man who said his name was George Sumner. The latter purchased two pictures of Minnehaha to take to his home in the East, remarking that he would retain one and give the other to his brother Charles.

"The incident had nearly been forgotten by Mr. Hesler when it was revived in a startling manner. He received an elegantly bound volume of a work by Longfellow, and the principal poem was 'Hiawatha.' On the flyleaf was the poet's signature and the legend, 'With the author's compliments.' Hesler was puzzled to account for the poet's solicitude, and almost a year after the receipt of the book he met George Sumner, who explained the mystery.

"It seems that the daguerreotype had got into Longfellow's possession and taking it with him into the woods, he got his inspiration, as he said, from the pretty view, and wrote 'Hiawatha.' Mr. Sumner said that it was a good thing for the poet that it was the counterfeit of Minnehaha Falls, not the real article, that the poet gazed upon for his inspiration, otherwise there would have been no 'Hiawatha' written." 168

Romanticized painting of Minnehaha and her Indian lover, Hiawatha, showing falls in the rear.

The plates could be exposed and developed at any future time. Many, both in and out of the profession, wondered at the soft and delicate detail both in shadow and high light, and roundness of the portraits I exhibited at the Crystal Palace in 1853, and tried in vain to equal.

None of the pictures had received over five seconds' exposure! Hence their lifelike pose and expression.

Rapid or short exposures were also obtained by charging the plates with electricity generated by giving the plate for the last finish a brisk rubbing on a white silk-plush buff; but this was only effectual in a dry, warm atmosphere. When thus treated I could get rapid plates about one-sixth the usual time, but unless the temperature and atmosphere was right the exposure was only retarded, so I had to abandon that as very uncertain.[169]

Other experimenters resorted to other methods or devices. F. A. P. Barnard, while professor of mathematics at the University of Alabama in the early 1840s reportedly had made instantaneous daguerreotypes with chlorine even before the advent of bromine and the various "quickstuff" formulas. Still another experimenter was James Cady, of New York. This account of his instantaneous experiments, about 1851–52, was given at a meeting of the New York Mechanics' Club in 1858:

Mr. J. Cady had made daguerreotypes of the ferry boats in motion, so that all parts were as distinct as if taken at rest. The paddles of the wheel, and even drops of water in the air were faithfully depicted. He had frequently made good pictures of stages in motion on Broadway, and men in the act of walking. The pictures were made with what was called Cyrus' Magic Buff. He was one of the very few who succeeded with it. The greatest difficulty at first was in shutting off the light quick enough.[170]

Separate attempts at fraternal organization were initiated this year, but they were not destined to be successful. The first was the New York State Daguerrean Association (organized initially as the New York State Photographic Asso-

THE ABORTIVE FIRST STEPS TOWARD FRATERNAL ORGANIZATION

DATE	NEW YORK STATE DAGUERREAN ASSOCIATION Organized initially as the New York State Photographic Assoc.	AMERICAN DAGUERRE ASSOCIATION Organized initially as the American Heliographic Assoc.
July 12 1851 Syracuse	Edward T. Whitney of Rochester named chairman; preamble and resolutions adopted calling for the burying forever of "all feelings of envy and jealousy which has heretofore existed"; "fair compensation" for the "best miniatures" not made by the "many imposters (which) are flooding our country with caricatures" at low price; call for a national convention at Utica November 20.	
July 15 1851 New York		Jeremiah Gurney named chairman, Samuel D. Humphrey secretary of meeting to form an association and prepare a constitution.
July 17 1851 New York		Augustus Morand, Martin M. Lawrence, Alexander Beckers, and others named to draft bylaws; M. M. Lawrence elected president; vice presidents named included: Gurney, John H. Fitzgibbons (St. Louis), Albert Southworth (Boston), Samuel Van Loan (Philadelphia), T. J. Dobyns (New Orleans), Thomas Faris (Cincinnati); constitution adopted calling for "a higher standard of taste" in photography, and "more friendly intimacy" among photographers. Association boasted 131 *elected* members.
August 5 1851 New York		Committee appointed to contact Daguerre's widow expressing sympathy at Daguerre's death July 10.
August 20 1851 Utica	Augustus Morand appointed chairman of convention, then president of the association. A new constitution adopted, prescribed membership only for those "who will agree not to take pictures at a disreputably low price"; confirmation of new members to be by two-thirds vote of members; call for another convention in New York in November, with invitation to members of American Daguerre Association to join.	

ciation), which was composed of photographers from New York City and environs, whose names for the most part are not well known today. The setting of a floor for daguerreotype prices was a principal factor in leading to the establishment of this group, which held an organizational meeting on July 12 in Syracuse.

A second organization, the American Daguerre Association (initially called the American Heliographic Association), was founded three days later by a group of prominent New York, Boston, Philadelphia, Cincinnati, St. Louis, and New Orleans photographers. The A.D.A. reported at a second meeting (July 17) that it had an *elected* membership of 131. A higher standard of "taste" in photography was the principal stated purpose of this group. Martin M. Lawrence, one of the three Americans who were to take top honors in photography at the Crystal Palace exhibition, was chosen president of the A.D.A.

There was an immediate antipathy to the A.D.A., and the first man to express his misgivings was none other than Gabriel Harrison, Lawrence's chief operator. Perhaps there was bad blood between the two, for Harrison was operating his own gallery in Brooklyn by 1852, and in 1853 said that he—not Lawrence—had taken all of the daguerreotypes which Lawrence exhibited at the Crystal Palace exhibition. Harrison's attack against the A.D.A. was delivered at a meeting of New York and Brooklyn photographers which gathered at Brady's gallery to "respond" to the Daguerrean association's call for a convention at Utica just twelve days later (on November 20). Brady was not present, having sailed for Europe with his wife the previous month. Harrison did not specifically name the A.D.A. in his speech at this gathering, but it was the A.D.A. to which he eluded when he delivered these remarks:

> Now, gentlemen, I come not here for the purpose of finding fault with any particular individual in the profession; but, certain it is, that lately, a *Secret Society* has been formed in this city, I must call it a Secret Society, from the notorious fact, that not more than a dozen or two knotted and gendered for it in a corner, elected its President, and even appointed its foreign Plenipotentiaries, and most inapplicably christened it a National Institution. Three out of the dozen originators, are not practical Daguerreotypists, and one of the three holds the high and responsible office of Secretary. I respectfully ask if this is not unprecedented in the history of the formation of National Institutions. All this was done without a single notice through the medium of the press calling together even the Daguerreans of the city, let alone from all parts of the Union, and at this moment, after they have had some eight or ten meetings, there is in this city some of the brightest stars the profession can boast of still uninvited, and even operators, the first that took up the art after the immortal Daguerre's discovery, the men who have been scorched over the furnace of the art, the identical men, too, that have by their *taste*, their

Gabriel Harrison (1818–1902) was more prominent in acting and literary circles than in the world of photography. Having learned daguerreotyping from John Plumbe, Jr., he worked alone and as a chief operator for other daguerreans, including Martin M. Lawrence during 1849–52, when Lawrence won top awards at the London 1851 Crystal Palace Exhibition for daguerreotype portraits made at his New York gallery. Harrison opened a second gallery of his own in Brooklyn, New York, in 1852.

patience, and their *genius.* elevated these men in the eyes of the public, and placed their mysterious art on the high and proud pinacles it now rests upon.

Gentlemen, I must be emphatic, and tell these partialists I cannot, *will not sanction* any such *work* as this. If we are to have a society for the good of *all,* why not invite all to come in? Why not invite the fifty cent man as well as the dollar or two dollar man? Let the corner stone of the institution be democratic. With such we will have union! Union is strength! and with strength we must prosper. Therefore let us here to night respond to these men of *Syracuse,* who were the first to move in the matter, and who have, in a noble and democratic manner invited every Daguerrean to come to their Convention at Utica on the 20th day of August, and there, in a proper manner, form a National Institution.[173]

Despite Harrison's misgivings, there were men whose feet could be found in both camps. Augustus Morand, a New York photographer of some note, served as a member of the committee which drafted the bylaws of the A.D.A., then was elected president of the Daguerrean association. S. D. Humphrey was named secretary of the A.D.A., then an honorary member of the Daguerrean body. Whatever his sentiments before attending the August 20 convention in Utica, Harrison along with J. P. Weston, another photographer from the New York-Brooklyn group, were elected trustees of the Daguerrean association. Snelling also joined Humphrey as an honorary member. The association held several meetings in New York in November, first at Brady's gallery then at Anthony's headquarters, but the principal action centered on the reputed discovery of a color daguerreotype process claimed by an upstate New York photographer, Levi Hill. The Daguerrean group named a committee to look into the matter, which consisted of Harrison, Morand, D. D. T. Davie, J. M. Clark (Anthony's former daguerrean partner), and W. A. Tomlinson. This committee spent the night of November 13 in Westkill, New York (where Hill resided), and most of the following day, after which it issued a devastating report, stating that it had "found no evidence to satisfy them that any person had seen any picture colored by any process, new to the scientific world, at the hands of Mr. Hill. On the contrary, they are of the opinion that the pictures in colors which have been exhibited by Mr. Hill are mere transfers of colored prints, and that they have been in no case transfers of copies from nature." The whole thing, the committee concluded, was a "delusion." But this was not the end of the affair. Samuel F. B. Morse, Jeremiah Gurney, Marcus Root, John A. Whipple, and a number of other men of equal prominence in the photography world visited Hill in 1852—all attesting to the apparent achievement by Hill of securing daguerreotypes in color. Even a Senate committee, after looking into the matter in 1853, produced a report which, although inconclusive, nevertheless tended to be favorably inclined towards Hill's claims.[174]

While the first signs of a fraternal spirit had emerged, both the Daguerrean Association and the A.D.A. were gone from the scene within another year. The "fraternity" was, in effect, still factionalized; the signs on the darkroom doors still read "no admittance." It would be another twenty years, for example, before such a book could be published as *Secrets of the Dark Chambers,*[175] revealing the practices and methods of operating in the galleries of such prominent men as Gurney, Bogardus, and Charles deForest Fredericks. In an October issue of his *Photographic Art-Journal,* Snelling drew attention to yet a third new fraternal group. He was critical of the "selfish and demeaning sentiments" which had given birth to the A.D.A., but, in this short essay, he put the problems and challenges of fraternal organization in proper perspective:

Our Daguerrean artists have truly awakened to the necessity of forming protective and mutual benefit associations. Besides the New York State Daguerrean Association, and the American Daguerre Association, another has been organized in

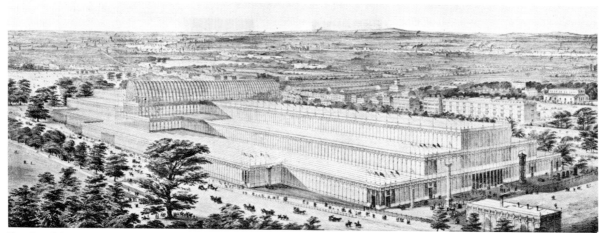

Exterior of the London Crystal Palace, scene of the first great world's fair.

AMERICANS TAKE ALL DAGUERREOTYPE AWARDS
AT CRYSTAL PALACE EXHIBITION

"In daguerreotypes we beat the world!" So exclaimed Horace Greely after a jury awarded the three prizes for daguerreotypes exhibited to Martin M. Lawrence, Mathew Brady, and John A. Whipple. Lawrence received the top award for a series of portraits termed "remarkable for clear definition." The jury noted that the two large portraits of size 12½ x 10½ inches were "throughout, pefectly in focus." Brady received a prize medal for forty-eight uncolored daguerreotypes, but the jury also said: "The artist, having placed implicit reliance upon his knowledge of photographic science, has neglected to avail himself of the resources of art" (apparently a reference to the custom, introduced by Claudet, of placing painted backgrounds behind the sitter). Whipple also was awarded a prize medal for a daguerreotype of the moon taken through a telescope at Harvard University. The *Illustrated London News* felt that the American display was "super-excellent," and that it atoned for "the disrespect with which they have treated all other nations, in having applied for so large a space, and yet at last having left their space comparatively unfilled."[176]

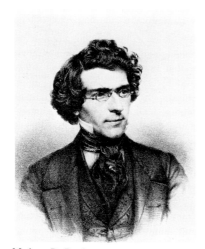

Mathew B. Brady

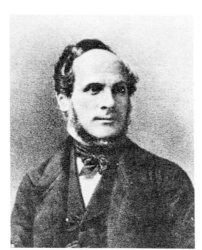

Martin M. Lawrence

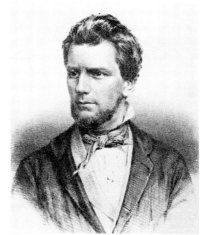

John A. Whipple

1851

A PHOTOGRAPHIC SUPPLIES BUSINESS TAKES SHAPE

In his fourth year of business, Edward Anthony placed an advertisement (below) in the *Daguerreian Journal*. The Anthony name was now without a peer in photographic supplies, and long after his death a merger between the Anthony firm and the Scovill Manufacturing Company would create a new trademark, "Ansco," which survives to the present day. H. H. Snelling, Anthony's manager, began publishing a competitive journal, the *Photographic Art-Journal*, in January 1851 and in its second issue Snelling touted certain foreign-made chemicals such as German bromine and English iodine (see listings below) as being superior to American-made counterparts. The best "golds", he said, were those made by Dr. James R. Chilton, Nathan G. Burgess (both of New York), and D. D. T. Davie of Utica.

ANTHONY'S
NATIONAL DAGUERREIAN DEPOT,
203 & 205 BROADWAY, NEW YORK.

DAGUERREOTYPE GOODS ONLY.

The attention of Dealers and Daguerreotypists is respectfully requested to my assortments of Apparatus and Materials, which will be found to be very extensive and complete.

DAGUERREOTYPE PLATES.

The celebrated Crescent Brand Plate, exclusively of my own importation, stamped with my name, and warranted.
The Sun 40th Plate, (guaranteed to be 40th.) Star 40th Plate. French Plates, 20th and 30th. (quality guaranteed.) Scovill Plates, of all sizes and qualities. French Galvanized Plates.
All the plates of my importation are carefully examined in Paris by an EXPERIENCED agent, practically acquainted with the manufacture of plates, and all that are VISIBLY imperfect, are rejected and returned to the manufacturer. The great number I import, enables me to sell a GENUINE ARTICLE at a low rate.

CASES.

[Exclusively of my own manufacture.]
1-15 size, 1-9 size, 1-6 size, 1-4 size, 1-2 size, 2-3 size, 4-4 size, of every style and quality. Papier Mache or Pearl Inlaid Cases of every size and style. *My Papier Mache work will be found to be superior to any in the market.* Turkey Morocco Bookcases. Snap Cases of various styles.
Cases manufactured to suit the taste of any customer, or adapted to any particular Gallery, the name being beautifully embossed on the cushion without extra charge, except for the die.

CASEMAKERS' MATERIALS.

Heavy leather for embossing. Thin leather for binding. Crimson silk for cushions. Silk velvet, ruby and maroon, of different qualities. Cotton velvet, crimson. Patent velvet, silk finished, crimson. Satin, maroon. Varnish, of superior quality. Hooks. Clasps, for book-cases, &c., &c. Embossing done at moderate rates.

PLATE GLASS

Of the very best quality, cut to order, of any size, for cases or show frames, and furnished by the quantity to dealers, in original packages as imported. Also, Half white German Glass, in original packages or cut. Green English Glass, by the gross.

METALLIC MATTINGS,

Burnished and fire gilt, of all sizes and styles, for cases or frames, all of my own manufacture, and superior in color and beauty of finish to any in the market.

ROSEWOOD AND BLACK WALNUT FRAMES

Of all sizes, made in a durable manner, and fitted in a style to do justice to a good specimen of Daguerreian art.

Fancy Frames, of various styles, of French manufacture.

PRESERVERS.

1-9 size, 1-6 size, 1-4 size, 1-2 size, of a new and beautiful style of chasing.

APPARATUS.

Cameras of Voightlander, Harrison, Roach, and Lewis' make; also Coating Boxes, Mercury Baths, Plate Vices, &c., &c., comprising every thing required for the successful prosecution of the art.

HARRISON'S PATENT BUFFING WHEEL.
LEWIS' BUFFING WHEELS.
NEW STYLE PLATE BENDER.
Neat simple, and effectual, Price, $1,50.

CHEMICALS.

Iodine, best English resublimed. Chloride of Iodine. Bromine, pure German; do. American. Chloride of Gold, of the best makers. Salt of Gold or Hyposulphite of Gold. Distilled Mercury. Rotton Stone, of all the various makers. Rouge, best French; do. American. Photogine. Hyposulphite of Soda, best French; do. do. American. Cyanide of Potassium. Dry Quickstuff, Anthony's Anhydrous. Roach's Triple Compound of Bromine. Chloride of Bromine. Fluoride of Bromine. Oxide of Silver. Gallic Acid. Crystallizable Acetic Acid. Bromide of Potassium. Nitrate of Silver. Muriate of Potash. Chloride of Calcium. Succinic Acid. Hydrofluoric Acid. Drying Powder. Pure liquid Ammonia. Iodide of Lime, a new and valuable preparation for iodizing the plate.

Those desiring to commence the practice of Daguerreotyping, fitted out with everything necessary for their success at moderate cost.
LOCKETS, Gold or Gilt, of all sizes and styles, oval, round, single or double, open or hunting.
GOODS CAN BE FORWARDED to any town in the United States or Canada (provided said town have connection by Express with New York) and the money collected on delivery of the goods. Persons will do well, when in places that have no such connection, to have what they order forwarded to the nearest express town.
TERMS—Cash. No allowance for breakage after goods have left the City.
I have been compelled to adopt the rule of not sending lists of prices, because it only injures such country dealers as buy of me. But all who send *orders for goods* may depend upon getting them at my regular New York prices.

E. ANTHONY,
Importer and Manufacturer of Daguerreian Materials.

308 Broadway, New York.

N.B.—Good journeymen Case-Makers wanted to whom steady employment will be given.

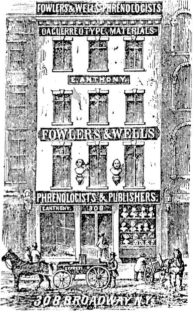

This building, which once stood at 308 Broadway in New York, was not only Edward Anthony's first headquarters but that of the American Phrenology movement, the pseudoscience which divided the human brain into separate sections of differing mental faculties, holding that the development of each faculty could be judged by the shape of the skull over it. During the 1850s, phrenology took on all the aspects of a religion as well as a science. Karl Marx reportedly judged the mental qualities of others from the shape of their heads. Walt Whitman published his phrenology chart five times, including it in an 1855 edition of *The Leaves of Grass* published at the Fowlers & Wells headquarters depicted in this illustration. But Mark Twain remained skeptical, satirizing the "bumpologists" in his literary works after a phrenology "reading" given him when he appeared under an assumed name held that he lacked a sense of humor. Phrenology "readings" were even provided by mail (at a cost of $4), provided the customer sent in a "good" daguerreotype—a "three-quarter pose" being preferred.[177]

the city of New York, essentially different from the two named, under the title of the American Photographic Institute. This society is in principle, both a protective and collegiate institution. It already numbers thirty-seven members, with Mr. J. M. Clark, of the city of New York, for its president, and Mr. Dorat and Mr. Harrison, for recording and corresponding secretaries. It has a fine chemical apparatus, and an embryo library. Several lectures have already been given to its members by Dr. Dorat and Mr. Holt, upon the combination of chemicals used in the art. This institution is certainly deserving the attention of Daguerreans throughout the country, and we sincerely wish it all the prosperity its members can desire.

The American Daguerre Association still holds its weekly meetings, we believe, but its proceedings are so studiously kept a profound secret from us, that we are deprived of the pleasure of speaking of it as we wish. Since its organization, we understand that several important changes have been made in the constitution, by-laws, and officers, making it less objectionable than at first. We trust to see it soon completely eradicated of the most unwarrantable selfish and demeaning sentiments which gave it birth ; and we have every reason to trust so from the more elevated minds which have attached themselves to it since its first organization. We have no reason to fear for the result at present.

There is, however, we think, too much stress and importance put upon the pecuniary measures of this movement, both in the State and City Society, to the exclusion of more important considerations. Instead of the improvement of the mind, and the practical manipulary processes being discussed as of paramount importance, the question of "what shall be the price of pictures?" is most eagerly and persever-

ingly discussed by nine-tenths of the members of the art....

There is too great a disposition on the part of the most influential operators to lose sight of the fact that others besides Daguerre are equally entitled to lasting honors as discoverers of the beautiful art of Heliography, as well as to exclude every branch of the art except the Daguerreotype, from consideration. Under the present organizations, none can be admitted who do not practice the daguerreotype, consequently all those connected with the other branches, such as the calotype and the photogenic, are forcibly excluded. It is also unjust to the other great minds, Niepce of France, and Talbot of England, to imply by such proceedings that to Daguerre alone are we indebted for the great discovery. We have no objection that the latter gentleman's name should be given to some of the Heliographic societies formed, but to assert, in so doing, that to him alone is due the honor, is decidedly wrong. He was undoubtedly the first to practically perfect the art, but sufficient data is given to prove conclusively that its first principles were the discovery of M. Niepce. He should, therefore, receive a due portion of the honor at the hands of Americans. Our principal objection, however, to Daguerre's name being exclusively given to our Photographic societies, is that it makes them too exclusive and isolated.

We trust that the National Convention, to be held in New York city on the 12th of November, will take these facts into serious consideration, and before they fix upon a name for the National Society, debate the subject well....

The paper photographists are now increasing almost as rapidly as the Daguerreotypists, and they are equally entitled to the benefits of these societies. They should not, therefore, be excluded.[178]

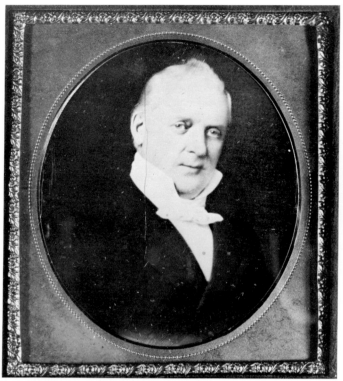

Copy daguerreotype of James Buchanan, made from an original taken circa 1851.

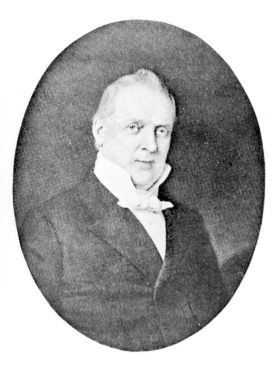

Miniature painting of Buchanan made by J. Henry Brown in March 1851.

A DAGUERREOTYPE SERVES AS "SITTER" FOR PORTRAIT OF A FUTURE PRESIDENT

Copy daguerreotypes were used quite extensively by artists in the 1840s and 1850s for portraiture, particularly in painting portraits of the famous. The copy daguerreotype of James Buchanan (left), found at an antiques show in the early 1970s, is the youngest known likeness taken from life of the fifteenth president, and is similar to, or the one actually used by artist J. Henry Brown to paint the miniature portrait (right), completed in 1851 when Buchanan was between stints as Secretary of State and Ambassador to Great Britain.

"Copying pictures," the Owego, New York, photographer George N. Barnard said in 1852, "has become a large share of the daguerrean business." But there were tricks to this trade, as in others, which Barnard described in these words: "The chief dificulties in making copies has been that the copy is produced in a much lower tone—that is, the lights and shades are much weaker—and that, in the copy, the lines are not so sharp and distinct as in the original. The freshness and brilliancy of a fine tone daguerreotype I fear can never be imparted to the copy, but we can produce one as clear, distinct and strong as the original; further than this cannot be expected of us. In my process I use a whole size camera with an aperture in the diaphragm about the size of a dime, and I place the picture to be copied directly in the sunshine, by which all the reflections will certainly be avoided—because the direct light is stronger than the reflected lights. Reducing the size of the aperture in the diaphragm produces the sharpness and distinctness of the original, and in aid to this, and to obtain the same strength of light and shade, I use a smaller quantity of bromine in the preparation of the plates. Others may have adopted this process, but I believe that it is not generally known." [179]

PERFECTING NEGATIVE PROCESSES
1852

This was photography's watershed year. The profession was now dividing itself three ways—between continued use of silvered metal plates to make daguerreotypes; the never widespread use of paper negatives to make calotypes; and the adoption of glass negatives (prepared with albumen or collodion) to make newer forms of photographic prints. S. D. Humphrey felt that the daguerreotype would continue to be the dominant medium "while the patent right of Mr. Talbot exists." He also said that Talbot's process was, "comparatively speaking, almost neglected." He also felt that "many objections might be argued" against universal adoption of glass negatives, because "the nature of the material will always be an insuperable obstacle to its general use."[180] Snelling, too, thought (in July 1852) that it "might be many months, perhaps years" before the daguerreotype was superseded, but by the end of the year he had changed his tune:

> Hitherto the photographists of this country have confined themselves exclusively to the practice of their art upon the silvered plate, but, if we are to judge from the constantly increasing demand for photogenic paper and paper chemicals—it will not be long before photography upon paper will be as extensively practiced as the daguerrean art. The beautiful results obtained by the Messrs. Whipple and Black, of Boston, have undoubtedly contributed to enhance the interest in the paper processes. These gentlemen have produced proofs upon paper far excelling any of those coming from either English or French manipulators. We consider them superior, because they come from their hands in a finished state, fine in tone and softness, excellent in color, and almost perfect in outline, soundness and perspective, without the aid of the brush, which cannot be said of the European photographs, they being more or less retouched.[181]

Snelling also drew attention this year to the improvements on paper processes made in France by such men as Louis Blanquart-Evrard, Gustave Le Gray, and others. As a result, he said that many French operators "have thrown entirely aside the metallic plate," and that the same could be said of England, "notwithstanding the shackles thrown around the art by Talbot's patents."

Helmut Gernsheim has termed the years 1852–57 "the golden period of the paper negative" in Europe.[182] So, too, there was a mild flourishing of the calotype practice in the United States, utilizing principally the newer French mode introduced in 1851 by Le Gray. Among the earliest practitioners was a Frenchman, Victor Prevost, who had studied art with Le Gray and Roger Fenton in the studio of Paul Delaroche in Paris, then came to the United States in 1848. There is no record of his work in the period 1848–51, but in the latter year Prevost made at least one recorded calotype view in New York, the first of a series made by the Le Gray method in the period 1853–54. But in 1853, Prevost returned to Paris, possibly to master the new process which his friend Le Gray had published after Prevost had gone to the United States. The *Daguerreian Journal*, meanwhile, commented on a number of occasions during 1851 on calotype activities by others in New York. One notice cited C. J. Muller, who used a method he had originated while living in India, and which the *Journal* said "resembles somewhat the Talbotype." Another notice described prints made by J. P. Weston, a trustee of the New York State Daguerrean Association, as "some of the best calotypes we have seen." A lady by the name of Madam Weinert Beckman exhibited such a fine collection of calotypes made with waxed paper negatives that J. DeWitt Brinckerhoff decided, after viewing her prints, to quit his association of several years with camera maker Charles C. Harrison and establish a photography business of his own. This was probably as early as 1852, as Brinckerhoff was one of the first American photographers to take up the collodion process after his friend, John J. E. Mayall, sent him Archer's formula before it was published in the United States. In Chicago, Polycarpus von Schneidau, a Swedish immigrant who learned the daguerreotype process from Brady in 1848, also practiced Talbot's calotype method, and in 1854 made a Talbotype of Abraham Lincoln which is the second earliest known photograph of Lincoln.[184]

But the calotype lost out in competition with the daguerreotype when John Charles Frémont, the noted American explorer, made a decision between the two methods for

LE GRAY PROCESS

Gustave Le Gray (1820–1862), a French painter, took up Talbot's process in 1848, then modified the process in 1851. By using thinner paper impregnated with wax, he could achieve paper negatives of almost glasslike transparency, yet sturdy enough for in-camera use. Talbot's paper was thicker; it had to be, to withstand the many and frequent washings required in print making. One British writer said of the Le Gray process: "It imparts a horny character to the paper, making the thinnest very strong, without increasing its thickness; it may even be washed, soaked, and re-washed for several days if required without the slightest fear of injury. And secondly, the paper so prepared can be kept after it is made sensitive and ready for the camera, without deterioration for from ten to fourteen days; while that prepared by the Talbot process can only be kept for about as many hours." Waxing was accomplished with a moderately hot iron passed with one hand over the unprepared paper, the other hand following with a block of pure wax. As the iron heated the paper, it absorbed the wax and became saturated with it. The Le Gray process could obtain sharper positive images on paper than could be obtained with the thicker, more fibrous paper negatives of the Talbot method. For exposures, Prof. John Towler, in his *Silver Sunbeam,* said that the time would vary according to temperature and brilliancy of light, but that "2–3 minutes in a good light will in general be sufficient; in ordinary light on an average from 10 to 15 minutes will be required." Photographs printed from finely prepared wax paper negatives are hard to distinguish, in terms of clarity, from prints made from glass negatives of the same period.[183]

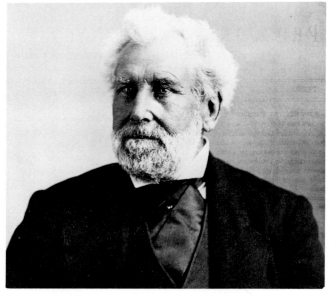

Only the faded photograph (top) of Victor Prevost and the 1881 photograph (below) of J. DeWitt Brinckerhoff survive to tell us what two of America's pioneers in the making of paper photographic prints looked like. Prevost made the earliest known American calotype photographs, using Gustave Le Gray's waxed paper negatives. Brinckerhoff was possibly the first professional American photographer to take up the practice of the collodion glass negative process. Both operated in New York City.

field work on an expedition begun in the fall of 1853 to survey a southern route for the proposed transcontinental railroad. Frémont first engaged S. N. Carvalho, an artist and daguerreotypist then residing in Baltimore, to accompany him, then asked a second photographer known only as "Mr. Bomar," who worked Le Gray's method, to join the expedition in St. Louis. After getting as far as Westport, Missouri, Frémont asked both men to prepare specimens of their work so that he could choose between them. Carvalho's later report of the contest stated: "In half an hour from the time the word was given, my daguerreotype was made; but the photograph [Carvalho's term for Bomar's calotype] could not be seen until next day, as it had to remain in water all night, which was absolutely necessary to develop it." Bomar naturally lost out, but it would appear that he engaged in an unnecessary amount of washing—required, perhaps for Talbotypes, but not for the Le Gray process.[185]

While the Langenheim brothers endeavored, unsuccessfully, to promote the practice of Talbot's process in the American fraternity, several other men took the lead in adopting other means of making photographs on paper, using either Le Gray's process or glass negatives. Among the first of these was Dr. Charles M. Cresson of Philadelphia. According to Marcus Root, who supplied the cotton Cresson used to prepare collodion negatives, Cresson mixed "iodine, bromine and sundry other substances"—all suggested by James (probably John) Price Wetherill of the family of noted scientists—to make his negatives. Cresson himself later said that he used bromine to make collodion negatives in the period spanning April 15 to May 20, 1852, and that he made pictures thereafter of "the most eminent business men and members of the bar of Philadelphia." A chemist, Dr. Cresson had practiced photography—principally as an amateur—since 1845. While he did not go into the business of making collodion photographs, and there is some question as to just how good his photographs were, nevertheless he did one very important thing at this time: he communicated the nature of his experiments—principally the way he used bromine—to James A. Cutting of Boston, who was then preparing to apply for an American patent for the collodion process. Cresson's action was in response to queries from Cutting, who may have read of Cresson's exploits in the May 20 issue of the *Journal of the Franklin Institute*. Sixteen years later, this brief communication between Cresson and Cutting would be spotlighted as the highlight of testimony gathered by American photographers to support their claims in the greatest of their nineteenth-century patent wars.[186]

Other early leaders in perfecting methods of securing photographs on paper were: John A. Whipple, inventor of "crystalotype" photographic prints (made initially by his patented albumen negative process; later by the collodion method); Victor Prevost, whose calotype views of New York City and environs made in 1853–54 are today the earliest surviving photographs of the city; Ezekiel Hawkins, inventor of "solograph" photographic prints (which won awards in Cincinnati before Whipple's crystalotypes did at the American Institute Fair of 1853); and J. DeWitt Brinckerhoff, who adopted, and was among the first to teach, the collodion process.

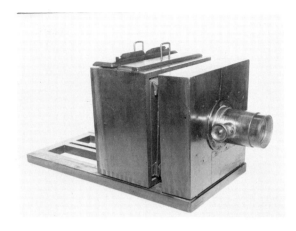

Ezekiel Hawkins, the pioneer American experimenter with collodion photography, was making his solograph photographs on paper at least by October 1852. The advertisement (above), which appeared in the 1851–52 *Cincinnati Directory*, gives no hint as to the style or nature of his solographs, however. Available evidence suggests that they were made with albumenized glass negatives in the early 1850s, and with collodion negatives thereafter. Although Hawkins' colored solograph portraits as well as his daguerreotype portraits and glass portraits having an enameled appearance were universally admired, none are known to survive in institutional hands.

Records do not seem to exist which will tell us precisely when Whipple abandoned and sold the rights to the albumen negative process which he had invented and patented in 1850, but we do know that the Whipple and Black studio was using the collodion method to make crystalotypes as early as the summer of 1853.[187] Whipple's process did not, however, die with his abandonment of it; on the contrary, there is evidence that it was practiced fairly extensively in the United States and spread to England and the continent through the efforts of the Philadelphia firm McClees and Germon (see page 98). It is unfortunate, too, that records do not appear to exist on Hawkins' methods. The Cincinnati Directory for 1850–51 carries a Hawkins advertisement for his "Apollo" daguerreotype rooms (which were destroyed by a fire in August or September 1851), while that of 1851–52 lists him at a new address with the title of his gallery changed to read: "Daguerreotype and Solograph Gallery." A Cincinnati newspaper, on October 6, described his solographs only as "taken on paper instead of the silver plate."

In 1852, Hawkins was awarded a silver medal for the solographs he exhibited at the twelfth annual exhibition of the Ohio Mechanics' Institute. In 1854, he exhibited paper prints at the American Institute fair in New York which a critic, writing in Snelling's *Photographic Art-Journal*, said were "not to be compared to Whipple's; the process is entirely different and do not show them to the same advantage." The critic also gave Hawkins (by then in his fifties) a pat on the head: "We hope that Mr. Hawkins will persevere and try and do better the next time." One clue as to Hawkins' methods is to be found in an isolated statement made in a communication from a Col. John R. Johnson to Snelling's journal, which appeared in November 1857. It said that Hawkins was "one of the first in the Union to use the albumen process—now he uses the collodion." Possibly Hawkins used the French, as opposed to Whipple's albumen process for his early solographs; possibly, too, he used the collodion method he had first tried in 1847.[188] Whatever his methods were, Hawkins was, in Humphrey's view, every bit the pioneer that Whipple was. On December 1, 1852, Humphrey proposed that the two get together for the benefit of the entire profession:

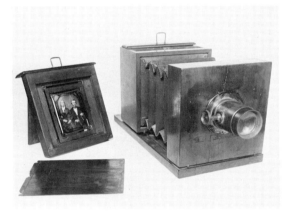

BELLOWS CAMERA

On November 11, 1851, William Lewis and two sons, William H. and Henry J. Lewis, were awarded a patent for the first commercially produced camera having an accordionlike bellows, which made the camera collapsible and at the same time helpful for copying work. A later version of the camera (similar to the original) is shown in closed condition (top) and opened (bottom). The box was held opened at any desired distance with the aid of a thumbscrew. Although the patent specifications show the plate holder as loading from the side, most known models (including the camera above) loaded the plate holder through a panel on the top of the rear (sliding) camera section. The Lewis firm was located in Chatham Square in New York in the late 1840s and evidently remained there at least until the 1870s. But by April 1852, the firm had also established a manufactory at New Windsor, New York (near Newburgh), which became known as "Daguerreville." *Humphrey's Journal* described the company at that time as "the largest manufacturers of daguerreotype apparatus in the world." The business included the manufacture of cameras, camera stands, chemical boxes, chemical baths, headrests, etc., all of which were stocked in what the *Journal* described as the firm's "extensive warehouse" in New York (presumably at the Chatham Square location).[189]

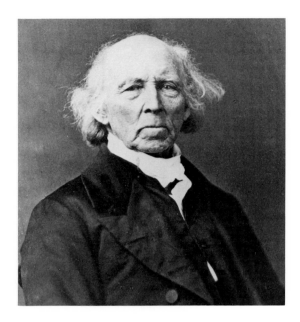

DAGUERREAN ASSOCIATION
GETS SCIENTIFIC FLAVOR

At its December 7, 1852, meeting, the New York State Daguerrean Association elected several scientific men to honorary membership, among them Prof. Chester Dewey (1784–1867) (above), who had been named first professor of chemistry and natural sciences at the founding of the University of Rochester in 1850. Dewey, a nationally known botanist, had previously served as principal of the high school in Rochester (afterwards known as the Collegiate Institute), where for several years his laboratory assistant was Charles A. Seely, founder (in 1852) of the *American Journal of Photography*. In 1839, when he was thirteen, Seely borrowed apparatus from Dewey to conduct his first experiments in photography.[190]

Whipple of Boston is still progressing in his paper and glass experimenting. Probably no two daguerreotypists do a greater amount of valuable service for the profession than this gentleman and Mr. Hawkins of Cincinnati. We are sorry to learn from one of these gentlemen, that he is not in correspondence with the other, for by their united exertions, good would result. Mr. Whipple—Mr. Hawkins—now you are acquainted, go on. You are both liberal minded men, and in union there is strength.[191]

Three years later, Snelling sounded equally impressed, but he could not find Hawkins when he called on him in October 1855:

We called twice on Mr. Hawkins but did not see him, and as he had recently removed into his present establishment and appeared to be still unsettled, we had little opportunity of judging of his work. With the exception of a few daguerreotypes we saw nothing of which we can give a decidedly favorable opinion. We are sorry we did not see him, for he appears to stand high in public estimates, and we should have been pleased to have seen those results upon which his fame rests.[192]

P. C. Duchochois, another of Prevost's Parisian acquaintances who came to the United States in 1853, formed a partnership with Prevost in a gallery on Broadway north of Houston Street. There, according to Duchochois, Prevost "introduced the wax paper process in this country, and he and I together the albumen and collodion processes."[193] Presumably the albumen process was Niépce de Saint-Victor's. But it is questionable whether their practice of the collodion process preceded Brinckerhoff's, whose receipt of Archer's formula from Mayall in London must have occurred prior to Duchochois' arrival in New York in 1853. The two photographs by Brinckerhoff used as illustrations in this book (pages 11 and 108) can be dated approximately 1851–53, based on the known ages of the two subjects at the time the photographs were made. A profile of Brinckerhoff, published in 1881, said he was "among the first to exhibit, along with his daguerreotypes, proofs of photographs on paper made from collodion negatives, which led to his being employed in giving instructions to many daguerreotypists, who were flocking to the city for the purpose of acquiring a knowledge of the new art."[194]

Chemicals used in daguerreotyping, meanwhile, were taking their toll. Claudet warned of the "deleterious effects" of mercury vapors, and on May 1, 1852, this announcement appeared in *Humphrey's Journal:*

> ☞ A WARNING TO ALL.—Mr. GURNEY, of this city, has been confined to his bed by his system being charged with *mercury*—he has suffered the most acute pain, and been unable to move his limbs; his legs and arms have been swollen to nearly double the ordinary size, and his situation has been of the most perilous nature. We have known several instances of effects produced by mercury, but never before to such an extent. No operator can observe too much caution in being exposed to the vapors of this metal.
>
> Frequently the question is asked "if there is not danger in operating in the Daguerreotype." We must say that the chief, if not the only danger, is in being so much exposed to the *mercury*. Many will say that its effect can be avoided by placing a flange with pipe conducting the vapor off, this plan is not complete in itself, as the metal in contact with the colder air is condensed and falls back, falling about the bath, and the consequence is, particularly in a close room, the atmosphere is charged, it is inhaled and in other ways penetrates the system. Few indeed are the instances where any marked influences have been given, but is it better not to have a *mercury room* very close.[195]

"For some time past," Claudet said almost a year later, "several operators have, to my knowledge, been obliged by advice of their physicians, to abandon daguerreotyping at least until they should become completely restored."[197]

Polycarpus von Schneidau, the Chicago daguerreotypist who is best remembered for taking the second earliest known likeness of Abraham Lincoln in 1854, became poisoned from his chemicals shortly thereafter and engaged in a long but losing war with death, which led him to return to Europe with his daughter in 1856 to seek medical help there. But in 1859 he gave up hope and returned to Chicago, a paralyzed man, where he died a few months later.[197]

Tantalizing evidence that the daguerreotype camera may have been used more extensively in landscape photography than is generally acknowledged today is to be found in a book which was published in 1852 in London (with an American edition) by the English authority Robert Hunt. Hunt's *Photography* gives this brief mention of what must have been a vast exploratory undertaking with a daguerreotype camera:

H. Whittemore, a gentleman who has traveled over most of the South, as well as North America, has probably made the most valuable collection of views ever produced in this country. His collection presents a map of paramount interest. I saw a single view of the falls of Niagara, which surpassed anything of the kind that has ever been presented before me; the harmony of the tone, the exquisite mellowness and faithful delineations, were unsurpassed, while the whole effect presented a charm rarely attending a daguerreotype view. Mr. W. produced his views with a common mirror reflector.[198]

Whittemore's camera suggests an enlarged variation of Wolcott's earlier mirror camera, which was confined to small images. Hunt said he was familiar with Robert Vance's large collection of views, but as they were of a single state only, he felt they were of less "general interest" than Whittemore's. And who was H. Whittemore? Evidently another "ghost" in American photographic history. His photographs are not known to have survived, and information about him is meager. In the same issue of *Humphrey's Journal* that told of Gurney's illness, we learn that "H. Whittemore [is] doing a fine business in South America." Seven months later, we learn he is in New York "much engaged in the stereoscope line." Humphrey then added this rejoinder: "Mr. W. is heartily welcome, but we fear that the great difference in customers of the two countries will not tend to increase his happiness with us."[199]

A move was afoot in the spring of 1852 to organize a national photographic society in the United States (such an organization was formed in England in January 1853), but the only brief mention of it appears at the end of an article by Snelling on a similar theme in which he expressed regret "that those who have the subject in charge are so dilatory in their movements." Snelling identified those in charge as a "committee" consisting of the two presidents of the two existing fraternal organizations, Augustus Morand and Martin M. Lawrence, and Henry Meade. Nothing further, however, was heard from this committee. Snelling's voice, as was so frequently the case during his journalistic career, was a lone cry in the wilderness where it concerned the need for true fraternal association among American photographers. It would not happen while he remained actively on

A COSTLY FIRE

On February 7, 1852, a fire destroyed the National Daguerrean Gallery in New York which had housed the collection of daguerreotypes made by Edward Anthony's firm in Washington in the early 1840s. Only a daguerreotype of ex-President John Quincy Adams was saved from the rubble. *Humphrey's Journal* gave this description of the tragedy:

There is not such another collection of the likenesses of our old Statesmen and distinguished individuals; and numbers of the subjects have long since departed from this world leaving no duplicate Daguerreotypes of themselves. At a time this was the most flourishing establishment of the kind in America. It was established about the first of the year 1843, under the management of Messrs. Anthony, Edwards & Chilton. Mr. Chilton, however, remained in the concern but a short time, and it was Anthony, Edwards & Co. Another change, it was Anthony, Clark & Co. Up to this time the greatest endeavors were made to obtain likenesses of the most distinguished citizens of America. We give one, as a single instance, of the exertions made by the enterprising proprietors to gather in this collection the great men of the world.—Mr. Anthony went from this city to the residence of *Gen. Andrew Jackson*, for the purpose of securing a likeness of the old hero before his death. Thus we see no expense of time or money was spared to accomplish the grand object. After the establishment had flourished for some time under the care of Anthony, Clark & Co., Mr. J. R. Clark, assumed the responsibility of the concern. Mr. Clarke remained here but a short time after, disposed of his interest to Mr. E. White; and although we feel that the gallery did not improve to any great extent under Mr. W., yet we cannot say that it depreciated in interest. This gentleman remained here two years and sold to W. & F. Langenhimes, who made some valuable additions to the collection by their fine *Talbotypes, Hyaliotypes, or Pictures on Plate Glass*, and a number of well executed *pictures on ivory*.

We have followed the progress of the successive changes in this establishment up to about a year since, when Mr. Gavit purchased the entire gallery, and it has been his misfortune to loose it as before stated. There was no insurance, consequently the loss fell heavily upon the proprietor.[200]

the scene, but at no time did anyone hit the nail so squarely on the head as he did in this analysis of the drawbacks to new improvements or inventions caused by the secretiveness of individual operators, and the vast "humbug" mentality which seemed to pervade the ranks:

None dispute the superiority of American daguerreotypes over those of all other countries, but all are astonished that among so many excellent practical daguerreotypists as we possess in this country, none have made themselves a name as the discoverers of some improvement worthy of more than a passing notice.

There is not an improvement now in use among our artists at the present day, that enables them thus to excel, that did not first eminate from some European daguerrean, and that European a scientific man. The process of gilding, the use of chloride of iodine, bromine, and even the dry quick were first applied to the art either in France or England.

The various methods of making the latter pursued by our daguerreans cannot be called inventions; they are mere modifications of the invention and are actually better only so far as they enable the lime to hold more permanently the bromine which it absorbs, for the same difficulties occur in their use which were prevalent before their adoption.

And why is it that Americans do not add to their reputation as inventors as well as manipulators in the art? The answer is given in the remarks made to us a very short time since by one of our most succesful artists.

"Daguerreans in this country are not a scientific set of men; they are merely imitators not researches."

This is, unfortunately too true. So many take it up only to use and abuse it that our really scientific men are actually ashamed to attempt experiments in it, or have it known that they are in any way engaged in it, for fear of being considered daguerreotypists.

There are, notwithstanding, many more engaged in the art who are its ornaments, and who command the respect of all classes; but these too are deterred from making researches into its secret principles, or when they do and are successful, are deterred from making their discoveries public—to use the language of one of them—"because there are so many knaves who are constantly practising upon the credulity of the more simple that an announcement of a discovery by any connected with the art in this country is synonymous with "humbug" and that it is as much as a daguerreans reputation is worth to father an invention." In short it appears to be considered, now, by the daguerrean community, that discoveries and rascality go together.

Now, what is the remedy for this state of affairs? We answer, well organized Photographic Associations, both National and State. From these associations can emanate all inventions and discoveries impressed with the seal of truth, and the designing men who suck so assiduously at the bunghole of credulity—to use a homely expression—will be deprived of their occupation, while the talented and simple minded but honest artists will be protected in their inventions, and secured against imposition.

We, therefore, beseech our artists to foster and sustain the NEW YORK STATE DAGUERREAN ASSOCIATION, as the only means through which to elevate the character of, and beget respect for, the art. [201]

1852

96

1853

Until 1853, American photography remained free of any major attempts to control or license the various facets of its practice. The Langenheim brothers, busy with experimentation in stereophotography and perfection of their "Hyalotypes" for magic lantern slides, made no attempt, for example, to assert broader claims for Talbot's patent in the United States, such as Talbot himself was proceeding to do in England. In Boston, John A. Whipple initiated then abandoned a controversial scheme to channel the production of crystalotype photographs through a "joint stock company" which was to consist of a limited number of dues-paying subscribers—a plan which was sanctioned by S. F. B. Morse and Edward Anthony, but was attacked as "worse than the Talbot monopoly" by *Humphrey's Journal*. "Now what would be the result of such a company?" Humphrey asked. "Would it not have a tendency to build up a monopoly, and drive our worthy and enterprising operators from the field of honorable competition, by presenting a barrier to intimidate many from taking hold of *any process?*"

But worried as he was about a monopoly, Humphrey had no idea what was in store for the profession when he published this brief notice on October 1:

> Cutting and Rehn are giving instruction in taking paper pictures in this city. Of their process we know nothing.[202]

The item referred to James A. Cutting of Boston, and Isaac Rehn of Philadelphia. Within a year, Cutting and Rehn would be awarded a United States patent which would give them, in effect, a monopoly on the entire practice of collodion photography in the United States. Talbot endeavored to do the same through extension of his calotype patent in Britain. But within two years, his battle would be lost; while in America, the war with Cutting and his agents would drag on for fourteen years.

There appears to have been a general confusion at this time as to what processes were being tried in the various paper photography experiments at a number of galleries. The previous year, Humphrey, for example, had made the comment that a Dr. Canfield of Pennsylvania, Whipple in Boston, and a Mr. Holt of New York were making "very fine calotypes." In Whipple's case, of course, he was making crystalotypes, not calotypes. Again, when Jeremiah Gurney referred to his paper prints as "Mezzographs," Humphrey remarked: "How much easier it would be to say calotypes." For a time, the word *calotype* was probably applied by many others to any and all methods of securing a photograph on paper—whether from a paper negative (i.e. the calotype method) or from a glass negative (albumen or collodion).

Humphrey's attack on the joint stock company plan was made in April. On June 15 he reported in his journal that Whipple "disclaims all connection with the great scheme of the *paper monopoly concern*," and said Whipple planned to dispose of his crystalotype process "at such prices as to be within the reach of almost everyone." Actually, Whipple

JOINT STOCK COMPANY PROPOSAL

H. H. Snelling published this description of Whipple's proposal for channeling production of crystalotypes through an organization having a limited number of dues-paying subscribers, and said "we cordially recommend his plan to our readers."

The Stock of the Company will be represented by 100 shares at $250 each—it will go into operation as a Manufacturing, rather than a Patent Right Company.; that is, its object will be to manufacture pictures, and dispose of the same by means of Agents, rather than to sell rights to individuals to manufacture their own. The object of this is, to control the manufacture in order that the character and prices of the pictures issued may be sustained, and also enable the Company to make exclusive contracts with parties for special purposes; it is also intended that no parties shall be engaged in the manufacture or sale of Crystalotypes except Stockholders.

The holding of one share by a Photographist will entitle him to the dividends on the same—the agency for the Public Pictures of the Company, and the privilege of having his customer's daguerreotype copied—but a knowledge of the process, instruction in the same, and the right to practise the art, will involve the purchase and holding of a second share by the same person, together with the giving of bonds neither to teach the Art or impart the secret to others,—in other words, the charge to any one party, for the right to execute pictures for their retail customers, will be $500.

As the company will provide, upon an extensive scale, everything necessary to produce good pictures at the lowest possible cost, it must, as a general rule, be for the interest of all photographists to send their daguerreotype to the company's manufactory to be copied in preference to being at the expense of a full right—the sale of the published pictures of the company (public men, views, &c.) and of their customer's crystalotypes will give a good business of itself, while the dividends upon the shares held will in time pay for them.

The number of shares will be but one hundred; and it is proposed that the operatives, Trustees, &c., shall all be stockholders, and there is already a call for crystalotypists to go abroad on account of pictorial magazines; and as there is a large extent of territory to cover, the sale of rights must necessarily be limited to one in each place, immediate application should be made by those who desire to secure them.

The following gentlemen have been named as Trustees :—

CALEB S. WOODHULL, }
S. F. B. MORSE, } Trustees.
ED'W. ANTHONY. } [203]

WHIPPLE'S PROCESS

During the 1850s, the collodion "wet-plate" photography process, then in its infancy, was given more competition than has perhaps been recognized by the albumen negative process patented in 1850 by John A. Whipple and his partner, W. B. Jones. Although numerous collodion process methods were published, Whipple's never was, and about 1853 he sold the rights to James E. McClees for Philadelphia for $250. The process was further perfected by the McClees firm (McClees & Germon), principally through the efforts of an employee, Charles Ehrmann (who later headed the Chautauqua University School of Photography at Chautauqua, New York). In 1855, McClees won a premium at a photography exhibition in Paris for a panoramic view of Niagara Falls made by Whipple's process on five plates, each 16 x 22 inches; and after that, through the McClees firm, the process spread to Europe as well as the United States. In 1856, a Liverpool photographic journal observed: "Whipple's process seems to be in great favor with the Liverpool photographers." In 1858, the first full-scale photography manual published in the United States for amateurs devoted itself principally to the merits of Whipple's process for outdoor use. In 1885, Ehrmann gave what may be the only recorded description in a lecture to members of the photographic section of the American Institute:

> The process is similar to Nièpce's, but greatly modified and improved. I will describe it to you in all its details as far as my memory serves me:
>
> | Iodide of potassium | 3 drams |
> | Bromide of potassium | 30 grains |
> | Chloride of sodium | 10 grains |
>
> were dissolved in 2 ounces of water and added to a mixture of 8 ounces of albumen, from which the germ had been carefully removed, and 7 ounces of pure liquid honey.
>
> Crystallized honey never answered as well when directly taken from the comb. In course of time the proportion of bromide was increased, by which a more rapid action was believed to take place. The addition of the chloride served to give better details in foliage when taking landscapes. . . .
>
> The mixture is beaten into a stiff froth, allowed to settle, and strained through flannel. The plates are coated in a similar manner as with collodion, but as with albumen a sudden evaporation does not take place; by returning the liquid from edge to edge repeatedly, or by spinning the plate around, a perfectly even coating can be effected. The plate is then laid down flat, another one coated, and so forth, until the required number is on hand. The plates having been coated have first become sticky in the meantime and are ready to be dried.
>
> We used to dry over an alcohol lamp, repeating the operation three to four times, or until the film, when still warm, did not adhere to the finger when touched.
>
> The most difficult and also the most important part was silvering the plate, so that the film comes from the bath without having been injured. The bath:
>
> | Nitrate of silver | 6 ounces |
> | Acetic acid No. 8 | from 6 to 8 ounces |
> | Water | 60 ounces |
>
> previously iodized, as we do with a bath for collodion plates. The dried plate, yet warm, somewhat higher than the temperature of the bath, is now dipped for about one minute, during which time it is constantly moved about. After the plate is taken from the bath it is slightly washed if to be used immediately; if to be kept for future use (the plates keep well for six or eight weeks), a more perfect washing is necessary, in fact, all the silver should be washed away. Many difficulties arose at times when plates were sensitized; the film washed off in flakes; not acid enough in the bath; the plate too cold, or the glass not clean. The film cracked all over the plate in forms of lines of different thicknesses when the plate is too hot, or blistered and puckered when a crystalline honey is used, *or the glass is not*

Charles Ehrmann, circa 1890. He was given a salary raise and a new suit of clothes after perfecting improvements in Whipple's process at the McClees firm in Philadelphia, about 1853.

> *clean.* Air bubbles made comet-like spots; dust on the plate, pinholes; in fact, troubles arose as we have seen in all processes afterwards. After the plate had been washed it was ready for exposure; when still wet it worked much quicker than when dry. At the time the process was in use daguerreotypy was at its height, and a daguerreotype could be made much more rapid than an albumen negative. When a paper photograph was wanted we made a daguerreotype first, and copied it, reversing the original. For reproductions, for out-door work, for photographing inanimate objects, the process, although slow, worked well.
>
> The developing of crystallotype plates is not easier or more difficult than with other processes. Gallic acid in saturated solution, occasionally increasing the strength with an alcoholic solution and a trace of nitrate of silver, developed a correctly exposed plate in a short time. With over or under exposures, however, a careful watching of the development for two hours and more was often necessary. We regulated the process then by weakening or strengthening the gallic acid solution and adding more or less silver to it. As we developed upon those level stands used for gilding daguerreotypes, we often applied the flames of an alcoholic lamp to accelerate the process in parts holding back. We fixed in hypo. With our little knowledge, and less experience, and from the fact that these plates do not resemble in appearance either emulsion or collodion plates, being semi-transparent, we actually at first did not know whether a plate was fixed or not. We took it for granted that five minutes were sufficient.
>
> The greatest blunders were committed with washing the plates; had we done so properly no doubt our negatives would have kept for thirty years, which, however, they did not. Although it does not properly belong here, let me describe how we printed them. We salted the plain paper, silvered with ammonia nitrate, and fixed with plain hypo, saturated with chloride of silver, gold, and before that chloride of platinum came later. Washing the prints left a great deal to desire.
>
> In course of time the process was improved and we made pictures quite rapidly, fluorides, even cyanides were added, and the proportions altered, till finally it had to succumb to collodion.[204]

told Snelling a week later that a Mr. Brigham had been trying to make arrangements to form the stock company, but that he had "failed to comply with my terms within the time specified." Four months later, Whipple issued the following announcement, which appeared in *Humphrey's Journal:*

> Having now so far perfected my crystalotype process as to render it eminently practical for a great variety of purposes, I am now prepared to dispose of it to Daguerreotypists and others who may wish to practice (with the exception of New England and Philadelphia) for the sum of fifty dollars for a right, and fifty more for instructions. In fixing upon a price for this I have wished to consult the interest of the art, and daguerreotypists generally, as well as my own, and I take this method of putting it before the public so as to remunerate myself in some measure for the large outlay of time and money it has cost me, and hope it will meet the wishes of all.[205]

The rights to the practice of the crystalotype in New England were sold to Marcus Ormsbee, and a year later Humphrey reported that Ormsbee "was in a strife with Whipple to excel him in producing the finest crystalotypes." Full rights to the practice in Philadelphia were sold to James E. McClees for $250.[206]

At this point, the young German immigrant, Carl, now "Charles," Ehrmann, who had arrived in Philadelphia sometime after fleeing Germany in 1848, came into the picture. Having acquired the rights to Whipple's process, McClees and his partner, W. L. Germon, immediately experienced difficulty in making crystalotypes, and evidently imparted this fact to Ehrmann, who was a prescription clerk in their local drugstore. Years later Ehrmann recounted his introduction to McClees, the nature of the problems the firm was having, and what he did to help solve them:

> "I met McClees, was introduced to him, and he asked me if I knew anything about chemistry. I answered modestly, yes, to some extent. Then Mr. McClees spoke to me about coming to his photographic department to undertake to make pictures by the Whipple process. The greatest difficulty that all my predecessors and my employers had in the preparation of albumen plates was, that they could not coat the glass plate uniformly, and here came to my rescue an experience that I' had gained with working in a pharmaceutical laboratory, viz.: In order to prepare for the market citrate of iron and ammonia, we coated large glass plates with a solution of the substance reduced to a certain concentration, and when dried scraped that off. The coating of a plate with albumen mixture appeared to me at once to be analogous to that of coating a glass plate with the iron solution, and when I first took hold of the matter I was perfectly successful. We had clean plates, uniformly coated, and they developed evenly all over. The albumen plates did not work with sufficient rapidity to take portraits directly, but in order to circumvent this difficulty, we took daguerreotypes first, of the person that wanted a talbotype, or a photograph, and copied that afterward upon an albumen plate. At one time there came a big order for six quarter size

The crystalotype rated equal billing with the daguerreotype among photographic processes used at the McClees & Germon firm in Philadelphia, as this circa 1854 advertising leaflet reveals. Lesser known today (because of the scarcity of their identified works), James E. McClees and Washington L. Germon enjoyed a prominence in Philadelphia equal to that of their Boston contemporaries, Albert S. Southworth and Josiah J. Hawes.

daguerreotypes to be enlarged to 11 x 14 size, to be colored and framed, which amounted to several hundred dollars. The following Sunday I went to the atelier and undertook the job on my own responsibility. I was successful with my first attempt, with the second, with the third, and up to the last. I printed from my negatives good prints in our estimation then, and Mr. McClees, when he saw my work, was so highly delighted with the result, that he raised my salary—which was originally $5 a week—to $15, and gave me a new suit of clothes and a hat.

"The albumen honey process was not accepted as readily as might have been expected, although extremely fine work had been done upon plates of that description. As the photographic business proper was not extensive

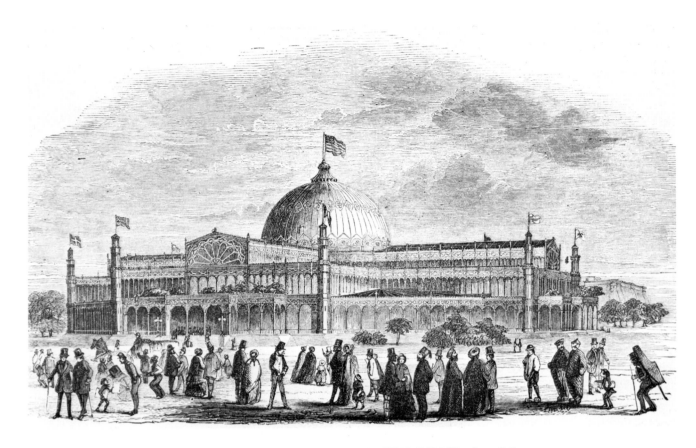

THE SAGA OF THE NEW YORK CRYSTAL PALACE, 1853–1858

Inspired by the Crystal Palace in London, the New York Crystal Palace was built for America's first World's Fair in 1853, and was officially opened by President Franklin Pierce on July 14 of that year. It stood in what is now Bryant Park, adjacent to the massive Croton Reservoir (partially shown in background) which was replaced after 1900 by the present New York Public Library. Daguerreotypes predominated in the photography competi-

enough to employ one man constantly, I was often relegated to the daguerreotype room. I learned daguerreotyping so that I was able to make a good daguerreotype, and if I had the opportunity to do so, could do it at the present day.[207]

Whipple's sale of crystalotype rights to McClees probably took place in the summer of 1853 (based on the fact that Whipple's offer to sell the process to others outside of Philadelphia and New England was made in September). Ehrmann's improvements were presumably made in the fall, as the McClees & Germon firm was awarded a premium for both the colored crystalotypes and Talbotypes which they exhibited at the annual fair of the Franklin Institute, held in December.[208]

It appears, too, that Whipple took up the collodion process probably at the time he determined to abandon organizing the joint stock company (May or June). Whipple's activities were not recorded in American photographic literature; however, the English photographer and writer

John Werge visited Boston in June 1853 and left this account which reveals that by that time the crystalotype had gone collodion:

At Mr. Whipple's gallery, in Washington Street, a dual photography was carried on, for he made both Daguerreotypes and what he called "crystallotypes," which were simply plain silver prints obtained from collodion negatives. Mr. Whipple was the first American photographer who saw the great commercial advantages of the collodion process over the Daguerreotype, and he grafted it on the elder branch of photography almost as soon as it was introduced. Indeed, Mr. Whipple's establishment may be considered the very cradle of American photography as far as collodion negatives and silver prints are concerned, for he was the very first to take hold of it with spirit, and as early as 1853 he was doing a large business in photographs, and teaching the art to others. Although I had taken collodion negatives in England with Mawson's collodion in 1852, I paid Mr. Whipple fifty dollars to be shown how he made his collodion, silver bath, developer, printing, &c., &c., for which purpose he handed me over to his active and intelligent assistant and newly-made partner, Mr. Black.[209]

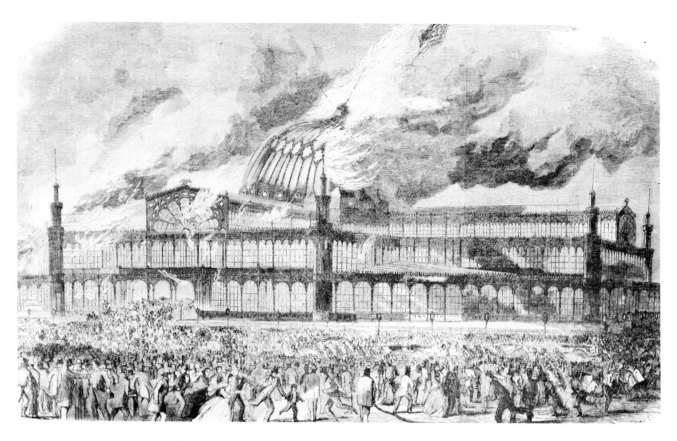

tion at the 1853 fair, as in previous years, but for the first time the top award was captured for photographs made on paper from glass negatives. These were crystalotype prints made from albumen glass negatives by the patentee of the process John A. Whipple, of Boston. Reputedly fireproof, the New York Palace was constructed of glass and iron, but contained wood and other combustible materials in the interior. On October 5, 1858, it caught fire and was destroyed in fifteen minutes' time, burying in its ruins the rich collection of the American Institute Fair of that year. No photographs of the Palace are known to exist.

Despite all of the new activity in paper photography, the daguerreotype continued to be "the fashion" in portraiture. During the summer of 1853, the New York *Tribune* counted "upward of a hundred daguerrean establishments" in New York and Brooklyn, "giving direct employment to about 250 men, women and boys." With respect to the country as a whole, the paper said "it is estimated that there cannot be less than three million daguerreotypes taken annually."[210] Probably for about the last time, the daguerreotype camera was used to record views in New York City which were then copied as engravings and used to illustrate an article, "New York Daguerreotyped," published in *Putnam's Monthly Magazine* in February. Once again the question can be asked, What happened to the daguerreotypes? The answer, probably, was that they were left with the engravers to be later destroyed or discarded. Up until this time, lithography served as the principal medium for recording city and landscape views sold to the public, or used for book or magazine illustration. But competition was on the way; in 1855, for example, McClees and Germon made large photo-

graphic prints of a whole series of Philadelphia's most prominent buildings and favorite scenes, which were made available commercially.[211]

Frederick DeBourg Richards, in a review of the December Franklin Institute fair, said he was "sorry to say" that "a couple of the 25-cent fraternity" had placed exhibits at the event. This was the first year, apparently, that these "cheap workers," as Bogardus termed them, appeared on the scene in force. Probably as the size of their number grew, there was a corresponding decline in attempts to counteract their commercial viability. The New York State Daguerrean Association, which had been organized principally by photographers interested in maintaining a higher price level, had a membership of only sixty by the summer of 1853, only a quarter of which had paid their dues. Marcelia Barnes, of Salem, New York, was the sole person who showed up at a Daguerrean association meeting set at Utica in October. Bogardus evidently took "the 25-cent fraternity," as Richards called them, in his stride:

DAGUERREOTYPE SHOPPING

The unidentified man above appears to have patronized two Boston studios on the same day, paying 25 cents for one ninth-plate likeness, and presumably 25 cents for the other. Both were kept with the respective photographer's card behind each image.

I once had a hearty laugh in visiting a 25-cent gallery. The ninth size picture was made and inserted in a cheap case for that sum. Sitters paid their money at the desk and received a numbered check. In the skylights the operator and assistant stood one at the camera and the other at the head rest; and that interesting accessory was jammed against the head of No. 13 as soon as he touched the chair, the plate exposed, and he was ordered to step out and number 14 called. The so-called picture was delivered to him in the next room, and if he had any complaints to make he was told to buy another ticket and go through again. [212]

But Alexander Hesler felt there was more to low-price pictures than just quackery; in fact, he thought it was a good thing for the future of photography:

As I look upon it, there is a great responsibility resting upon the leading members of the art, and if they would see the art improve, they must put their shoulders to the work. But, some will say, "I do work to sell all the pictures I can, and make all the money I can, and this is my duty. I paid for learning what I know and if others get it they must pay me, and besides, if I give all my experience and research to others, they will stand an equal chance with me and may get some of my business." Ah!, this is the sticking point, and the very feeling that keeps the art down, and that has brought so much shame and reproach upon it.

It is not the dollar, or fifty-cent, or 25-cent pictures that have done it, for there will be quacks in all professions, do what you may, and, I think in this case, the low-price pictures have done much good in many ways. It has brought the art and its influence within the reach of all classes, and thousands and tens of thousands have had daguerreotypes taken at the low prices that would never have thought of it at higher prices, and what has been the result? When a person has got a low price picture and worth only the first price of the material used in its manufacture, this person compares with others better and worth something. Now, will he be satisfied with the poor one, when he can get a better at a higher price? Certainly not, his taste for the beautiful is aroused and he will not be satisfied until he has the best the art will give him, cost what it may . . .[213]

1854

"Stereoscopic pictures are sold in Paris and London by the thousands, and it is time they were better appreciated in America." So wrote Henry Meade to H. H. Snelling, while traveling in Europe in the summer of 1854.[214] Photography's great nineteenth-century bonanza had begun in Europe, but it would be another four years before the double-image picture craze would strike the United States.

A small lenticular stereoscope for convenient viewing of stereoscopic pictures had been invented as early as 1849 by Sir David Brewster. It was a small box in which two similar photographs, mounted side by side, could be viewed (magnified) through a pair of eye pieces. The device attracted considerable attention at the 1851 Crystal Palace exhibition, and largely as a result of Queen Victoria's interest in it, nearly a quarter of a million of the stereoscopes were sold in the ensuing months. At this time, too, patented daguerreotype miniature cases were on the market—one manufactured in Philadelphia by John F. Mascher, another produced in London by Antoine Claudet—which contained folding eyepieces for viewing two similar images placed opposite one another in the two folds of the case.

There are few records which give any indication of the extent to which stereoscopic photographs were produced in the United States during the period 1850–54. One man who appears to have played a major role was Otis T. Peters, about whom little is now known. According to Snelling, Peters introduced the stereoscope in New York just prior to October 1852, after which Brady, Gurney, and Beckers & Piard followed by offering the same or similar type of product three to four weeks later. Peters died February 10, 1862, at the age of fifty-two, and from an obituary by Prof. Charles Seely, published in his *American Journal of Photography,* we are given this additional, albeit small, bit of information:

> As soon as the stereoscope was brought to this country, Mr. Peters took it up as a specialty. His gallery at 394 Broadway, previous to 1856, was the headquarters of the business for many years; it was the only place where stereoscopic portraits were correctly made. Mr. Peters also made most of the stereo-daguerreotypes which were sold by opticians about the country or exhibited as philosophical curiosities.

Peters lacked "business tact and ambition," according to Seely, and but for the want of these "might have been eminently successful." He retired from his photographic business about 1856, and thereafter engaged in a variety of manufacturing "speculations" in which he was "only moderately successful." At the time of his death he was manufacturing hoop skirts.[215]

When a Detroit newspaper editor examined paired daguerreotype images through a stereoscope in George P. Henson's gallery in January 1853, he thought that "this curious instrument" was so great that Congress should appropriate funds for a national gallery of some sort where people could view portraits of American heroes and statesmen by stereoscopic means.[216] But it was "the great encouragement this special kind of pictures had found in Europe" that prompted the Langenheim brothers to be the first to undertake large-scale production of stereoscopic photographs. In a letter to Snelling dated September 19, Frederick Langenheim said he was "confident that the American public will patronize this branch of the Photographic Art, in a similar degree as the European public, as soon as the results are brought before them in a presentable shape, and at reasonable prices." Langenheim also said he thought American photographers "have not paid the attention to the subject it richly deserves."[217] By the end of the year, the Langenheims were making both glass stereographs (another version of their hyalotype glass photographs) and card stereographs.

Prior to this time, all stereoscopic pictures on glass had been imported from Europe, principally from France. But over the next several years the Langenheims enjoyed moderate success with their American-made glass specimens. What form of stereoscope was adopted for viewing them does not appear to be recorded, but presumably it was of the lenticular variety. That the means of viewing may have been a drawback to sales of the glass slides can be surmised from the experience encountered by Beckers and Piard when exhibiting the first three dozen slides sent by the Langenheims to their New York gallery. Twelve were broken at the exhibit, causing Beckers to toy with ideas for the design of a new type of stereoscope which would "show and secure the pictures against breakage." Within four years he secured a patent for a revolving stereoscope design, and in 1858 he abandoned his photography business in order to manufacture stereoscopes exclusively.[218]

In 1854, the London Stereoscopic Company was established to market Sir David Brewster's lenticular stereoscope and card stereographs (mostly of views secured by company photographers, not only in England but in other European countries and, after 1858, in the United States). This marked the real beginning of the stereophotography revolution. By 1858, when the card stereograph "took on" in the United States, the British concern had already compiled a stock of over 100,000 different views of famous buildings and scenic points of interest all over Great Britain, on the continent, and in the Middle East.

Up until this time, stereoscopic pictures could be secured either with two single-lens cameras positioned a few feet apart from one another, and both pointed in the direction of the object (or person) being photographed, or with one single-lens camera equipped with a rear sliding plate holder which allowed the subject to be photographed twice, the resultant images appearing side by side. During the period 1854–60, the single-lens camera was gradually replaced by the binocular, or twin-lens, camera, which made it possible to take two pictures of the same object simultaneously. The distance between the double lenses of these new cameras was about the same as that between the pupils of the eyes (or about 2½ inches). The lenses were of short focus, which

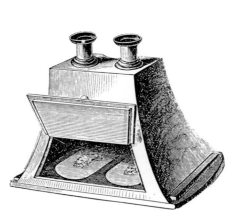
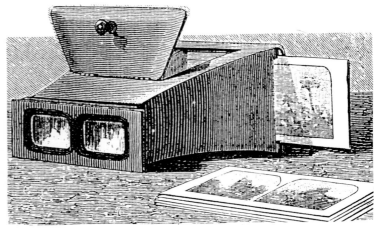

In 1849, Sir David Brewster (1781–1868), the English scientist and inventor, developed a lenticular stereoscope for viewing magnified images of two similar illustrations side by side. At first unsuccessful, the Brewster device was modified by a Parisian optician to include a lid which could be opened for improved lighting of the images. This model (above left) was placed on the market in 1851 and sold rapidly. A simplified Brewster stereoscope, minus the eyepieces (above right), was introduced later after the market for card stereographs took on sizeable proportions.[219]

gave sharp pictures at almost open aperture, and this, combined with the use of faster-acting collodion negatives, made it possible to make exposures in as little as half a second. Thus, the world's first truly "instantaneous," or candid, photographs soon began to appear in card stereograph form.[220]

The first binocular camera appeared in Great Britain in 1852, but its developer, John Benjamin Dancer, did not place it in full production for several years. A French model, developed by A. Quinet of Paris, appeared in 1853, and in 1854, Silas A. Holmes, of New York, patented a double camera which could make simultaneous exposures on two separate plate holders. Holmes's patent specified use of the camera for stereophotógraphy and "other purposes," but it was used principally for the latter.

Talbot's endeavors to extend his calotype patent to the practice of collodion photography, meanwhile, delayed widespread adoption of paper photography not only in England but to some extent in the United States as well. In May, Brewster and Herschel signed affidavits in Talbot's behalf, and after these were printed in full in *Humphrey's Journal*, Humphrey disclosed that there was "some little excitement among our photographers in regard to the Talbot patent," adding: "We may not look for a full advancement of photography in America while things are in this state." But while the storm clouds of a long American patent war gathered on the horizon, Talbot's claims were challenged in the British press, then were rebuffed entirely by a British court in December. "The decision settles the question in this country as well as in England," Snelling said after the court victory, "and we hope our readers will no longer pay attention to the threats of speculators, but enter boldly and energetically into the photographic processes. No court in this country will attempt to enforce the patent here (it still had several months to run) after the decision we now record, and we expect to see a very decided progress made

in all the paper and glass processes during the present [1855] year."[221]

One of the myriad problems encountered in adopting a paper photography process was the simple determination of what paper, among the variety offered, was most suitable for a photographer's particular purpose. Photographic paper was supplied principally by four English manufacturers (Turner, Whatman, Nash, and Towgood), and three French suppliers (Canson Brothers, Marion, and Lacroix). For waxed-paper process work, for example, Gustave Le Gray recommended thin Whatman paper (slightly glazed) for portraiture, but a thicker version for use in making views of landscapes and monuments.[222] Humphrey was particularly unhappy with Turner's paper, but at the same time said he felt that none of the manufacturers was giving photography the attention it deserved:

There is great difficulty in procuring good paper of Turner's make; he having lately undertaken a contract for Government in making paper for the new stamps, the manufacture of paper for photographic purposes has been to him of little importance. In fact, this observation—of the little importance of photographic compared to other papers—applies to all our great paper makers, who have it in their power to make a suitable article. . . . All manufacturers, in order to please the eye, use bleaching materials, which deteriorate the paper chemically. They should be thoroughly impressed with the truth, that color is of little consequence. A bad colored paper is of no importance; it is the extraneous substances in the paper itself which do the mischief.[223]

A British correspondent expressed himself as equally disenchanted with the Turner paper two months later: "For every sheet that has turned out well," he said, "at least half a dozen have proved useless from spottiness, and some sheets do not take the iodizing solution evenly, from an apparent want of uniformity in the texture of the paper."[224]

Philip Henry Delamotte, a London Stereoscopic Company photographer and author, whose book, *The Practice of*

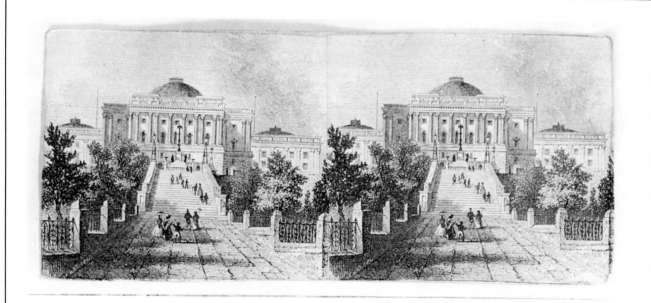

CARD STEREOGRAPHS

The first stereoscopes, such as Sir David Brewster's lenticular model (left), were used for viewing artist renderings, engravings, etc., before actual photographic prints were substituted on the card mounts. The stereoview (above) was probably prepared by cutting out two similar illustrations from two of the same issues of a newspaper or journal (cira 1850–54). These were pasted side by side on the same mount for viewing stereoscopically. In 1854, Frederick and William Langenheim introduced the first major American card stereograph series with copyrighted photographs, entitled "American Stereoscopic Views," taken on a journey from Philadelphia along the southern route of the Reading, Catawissa, Williamsport, and Elmira Railroad to Niagara Falls. More than twenty subscribers backed the photographic venture, then signed an advertisement published in the Philadelphia *Public Ledger* (in December 1855) certifying as to their complete satisfaction with the results. The example (below) from the Langenheim series is of the interior of a covered bridge which traversed the Niagara River at the time.

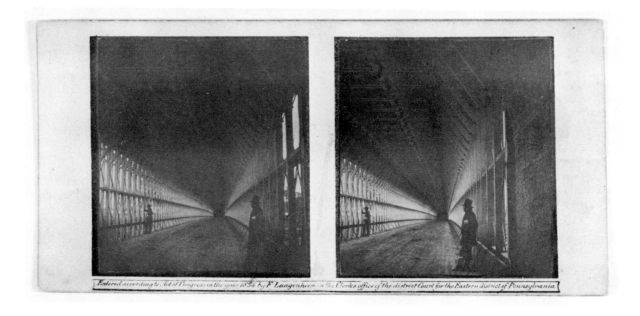

1854

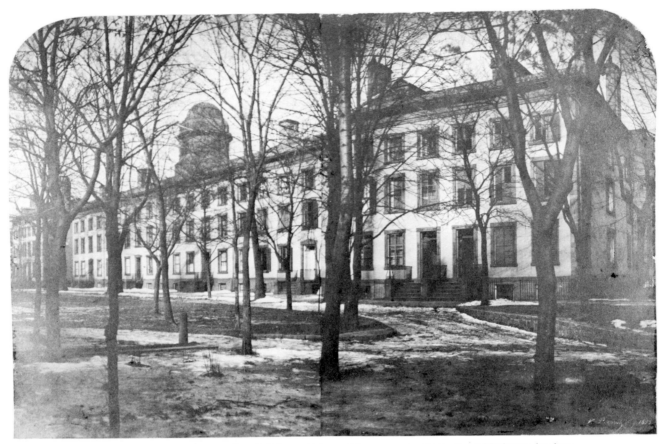

This view of the Columbia College building, which stood from 1790 to 1857 in lower Manhattan, has been reproduced from one of several calotypes of the building made by Victor Prevost in the period 1854–55. Prevost used waxed paper negatives (the Le Gray calotype process) to make photographs in New York, and today his are the earliest known photographs of the city to survive.

Photography (Humphrey defined "Photography" as meaning paper and glass processes), was published in an American edition in 1854, identified these differences between the quality of the English and French papers:

> The difference in their quality appears to consist in this—the English papers are hard and dense, owing to their being sized with gelatine, or resin soap, consequently the sensitive preparation does not so readily penetrate its substance, but remains more on the surface; they are, therefore, best fitted for positive proofs. The French papers on the contrary are generally sized with starch, with which iodine enters eagerly into combination; they are usually thinner and lighter, and consequently better adapted for negatives; but both English and French papers are prepared for positives and negatives; and the photographer can select either without any reserve; only with this precaution, let him avoid using different papers as much as possible, for the difference in their manufacture causes them to be equally affected under the same treatment. If bought of an honorable dealer in apparatus, etc., there is little fear of an unsuitable material being offered for sale. All the success of manipulation may rest upon the quality of the paper.[225]

1854 Snelling thought "the superiority of paper photographs as illustrations, the rapidity with which they can be multiplied, their distinctness, and the great number of purposes to which they are applicable must cause them, in a great measure, to supersede the daguerreotype; and not only daguerreotypes, but lithographs."

Seventeen years later, when he reread these remarks, he considered them so much hogwash. Paper photographs made in 1854 were "a poor, miserable, deformed infant," he said. He characterized them further in these unflattering words:

> Take the landscape—not a negative could be shown that was not faulty in every particular. The defects of the lenses produced aberration in every part of the picture; not a line nor an object true to nature or art, and everything that had life was marred by a want of distinctness in outline, while the foliage was more or less characterized by fuzziness, more resembling tufts of cottonwood than leaves.
>
> The print, of course, partook of all these defects and exhibited many more peculiar to itself; its general characteristics being want of clearness, no uniformity of detail, no softness, no delicate contrasts of light and shade. It reminded one of the first attempts at lithography, or mezzotint engraving, and the crude drawings of the savage.
>
> Portraiture was still worse—masses of muddy shadows and dusky middle tints, and chalky highlights—the eyes looking like two whortleberries in a bowl of milk.[226]

Snelling was referring, of course, to American-made photographic prints of this period; but as early as 1850, a new photographic paper became available in Europe which, although slow in being adopted by American photographers, gave prints of greater luster and life. This was albumen paper, introduced in France by Blanquart-Evrard. Once again egg white was used as a coating for paper, as it was already being used as a coating for glass negatives. The albumen (mixed with the conventional "salting" solution) filled the pores of the paper, causing pictures printed on it to appear more *on* the surface, as opposed to *sunken into* the paper, which was a characteristic of prints secured on plain paper. The photographic literature of this period does not record to what extent albumen paper was adopted by American photographers in the 1850s, but few American-made prints of this period will be found today on albumen paper; and at least one authority, John Werge, has asserted that up to 1860, American photographic prints "were all on plain paper." There were problems enough, it seems, in working the new albumen or collodion negative processes—each man separately perfecting his own particular methods and procedures—without taking on the additional complications (and costs) involved in preparing albumenized paper. Few modes for preparing albumen paper were published in American journals at all, and those that were were taken from foreign publications.[227]

In such a time of secrecy and "no admittance" signs on photographers' darkrooms, it was perhaps easier for James A. Cutting to obtain the several patents he did in July 1854, covering, first, a *particular* method of making ambrotype photographs, but more importantly the use of bromide of potassium *in combination with collodion* to prepare collodion negatives. The use of bromine was a technique previously known and used on both sides of the Atlantic, but documenting the proof was another matter. The Commissioner of Patents found certain early references, but Cutting—benefiting from the total absence of any other protesting voices—convinced him otherwise. Fourteen years later, another Commissioner of Patents would admit that the patent should never have been granted in the first place. When the full text of the patent was published in *Humphrey's Journal,* there were no voices of protest raised—probably because there had never been a patent problem in the United States before and the fragmented nature of the photographic profession caused few to take the matter very seriously. The protests would come later, but in the meantime, Humphrey candidly sized up the situation—and even named names—in this essay criticizing both the "secrecy" of American operators, and the propensity for some to "appropriate" foreign processes for domestic license:

> **We do not mean to be understood as being opposed to a strife for the greatest perfection in practice, for we look upon a desire to excel as a most worthy ambition. What we would complain of is, a number of our American photographers are in the habit of taking European experiments and appropriating their results to their own personal benefit, and not even giving in return an acknowledgment. There is no wonder that the foreigner looks upon us as being "a selfish, grasping people."**

ALBUMEN PAPER

Invented in 1850, albumen paper was little used in the United States prior to 1860. This procedure for making it, suggested by a British photographer, George Shadbolt, was published in Snelling's journal in New York in December 1853:

> *To prepare the Albumen* —Take the white of *one* egg ; this dissolve in one ounce of distilled water, two grains of chloride of sodium (common salt,) and two grains of *grape* sugar ; mix with the egg, whip the whole to a froth, and allow it to stand until it again liquifies. The object of this operation is to thoroughly incorporate the ingredients, and render the whole as homogeneous as possible.
>
> A variety in the resulting tone is produced by using ten grains of sugar of milk instead of the grape sugar.
>
> The albumen mixture is then laid on to the paper by means of a flat camel's hair brush, about three inches broad, the mixture being first poured into a cheese plate, or other flat vessel, and all froth and bubbles carefully removed from the surface. Four longitudinal strokes with such a brush, if properly done, will cover the whole half-sheet of paper with an even thin film ; but in case there are any lines formed, the brush may be passed very lightly over it again in a direction at right angles to the preceding. The papers should then be allowed to remain on a perfectly level surface until nearly dry, when they may be suspended for a few minutes before the fire, to complete the operation. In this condition the gloss is but moderate, and as is generally used; but if, after the first drying before the fire, the papers are again subjected to precisely the same process, the negative paper will shine like polished glass. That is coated again with the albumenizing mixture, and dried as before.
>
> One egg, with the ounce of water, &c., is enough to cover five half-sheets with two layers, or five whole sheets with one.
>
> I rarely iron my papers, I do not find any advantage therein, because the moment the silver solution is applied the albumen becomes coagulated, and I cannot discover the slightest difference in the final result, except that when the papers are ironed I sometimes find flaws and spots occur from some carelessness in the ironing process.
>
> If the albumenized paper is intended to be kept for any *long* time before use, the ironing may be useful as a protection against moisture, provided the *iron be sufficiently hot ;* but the temperature ought to be considerable.[228]

1854

Charles C. Harrison, circa 1852. From an early collodion photograph by J. DeWitt Brinckerhoff.

NEW YORK RAILROAD DEPOT AND PHOTOGRAPHIC SUPPLIES CENTER

This massive railroad depot and manufacturing center stood until at least the 1880s in what is now the complex of city, state, and federal court buildings in lower Manhattan. Edward Anthony's manufacturing operations were housed in the section to the left, while those of Charles C. Harrison, shown left, occupied one of the upper stories to the right. Harrison "commenced in a small way," according to S. D. Humphrey, "being limited in means and convenience, and having to plod his course through—to him—an unexplored field." But by 1854, he was America's foremost camera manufacturer. His role as the country's most noted early photographic optician also began at this time. In 1855, H. H. Snelling said Harrison had devised a means "to test the achromalicity of each lens, separately or in combination, so that the chemical and visual foci are rendered coincident to a certainty. He is also engaged on, and will shortly perfect, a new View Camera of short focus and enlarged field, which is something all have wished for but none has been able to obtain." A new addition to the New York camera manufacturing scene in 1854 was the firm of brass manufacturers, Holmes, Booth and Hayden, headed by John C. Booth, Israel Holmes, and Henry Hayden. Humphrey said the firm could be "justly considered as vieing for the palm of superiority" with Harrison's manufactory.[229]

Every person has a just right to expect the credit of a process which' originated in his own hands; and it is not in the least surprising, that specimens produced by mere practitioners, and sent forth to the world, should be held in disrepute, particularly when from those who have never published the process employed in their production.

We are well aware that it is said " We are compelled to keep *our process* a secret, or every one else would benefit by it : or, "We have paid for a *right*, and it will not do to let any one know how we work." Now, this is speaking highly for the honor of the profession at large. You plainly imply that it is composed of scamps, and admit a great inefficiency in our country's laws. You have a process which is patented, and have *bought* a *right*, and yet the rascality of the profession of which *you* are a member, prevents you from giving publicity to the very article you may legally control. Poor, deluded mortals! divest yourselves of fear, and describe to the world the manipulations you employ, and even though they may bear close resemblance to, or exactly correspond with those of another, you, by your liberality, will be entitled to credit, at least for an honorable frankness; and those European experimentalists to whom *you* owe the very first hint for your process, will look upon you with respect, and not cast aside your productions as the result of *their studies*, which have been pirated from themselves and appropriated solely to purposes of satisfying a morbid propensity for gain.

Let a Daguerreotype operator visit WHIPPLE's, GURNEY's, McCLEES & GERMON's, or LAWRENCE's establishment, and tell either of these gentlemen that *he* has "something new," and can do so and so, by which "*he* has done such great things, in the village in which *he* has operated," yet show nothing better than they or their neighbors are every day producing—would they not consider this boaster a conceited mountebank? We greatly dislike these secret processes, consequently we do not hold in deep reverence those who proclaim they have great improvements, and at the same time withhold them.

We cannot possibly see what objection our friends WHIPPLE and CUTTING can have to giving their process, since they are willing to guarantee its *security* to others, by right of a patent. Come, gentlemen, don't be incredulous! First try the profession, before you fear.

There is a gentleman in Cincinnati (Ohio), who has promised us some hints upon the paper process. Come, friend HAWKINS, you are just the man, and only need the start. No one can say more of the difficulties of the process than you, who have battled your way to eminence, through every variety of mishap. [230]



Fig. 1

Fig. 2

Fig. 3

Fig. 4

ELEMENTS OF AN AMBROTYPE MADE BY
PATENTED CUTTING METHOD

In July 1854, James A. Cutting of Boston was awarded a patent for securing and packaging positive photographic images on glass in the manner depicted above. Called "ambrotypes" (but only in America), the positive image secured on a glass plate (Fig. 1) resembled a negative, but would appear as a positive (Fig. 2) when the plate was given a coat of varnish or black backing on the reverse side. Cutting's *particular* mode of packaging called for using balsam of fir (used in cementing lenses together) to seal a second piece of glass of the same size to the rear of the image plate, thus protecting the image thereafter against infiltration of air or moisture, or against damage in handling. An oval brass mat (Fig. 3) contains Cutting patent identification at bottom (magnified in insert). Completed ambrotype, with ornate protector rim (Fig. 4), is ready for placement in a miniature case of wooden or plastic design.[231]

1855

Because the daguerreotype remained in vogue for portraiture, and this constituted a large portion of gallery business everywhere, many photographers turned to what might be called a detour at this stage of collodion photography. This was the ambrotype, frequently referred to today as a daguerreotype on glass. Ambrotypes looked like daguerreotypes, but they were made by a slight variation of the collodion process. Above all, they were less costly to make than a daguerreotype. Ezekiel Hawkins had made an ambrotype in 1847, when he first experimented with the collodion process and produced a photograph on glass. The word "ambrotype" had not been coined at that time, nor was it used by James A. Cutting when he secured a patent for a *particular* mode of making an ambrotype in July 1854. The first ambrotypes exhibited in the United States (in December 1854) were actually described as daguerreotypes on glass. The term was coined early in 1855 by Marcus A. Root, who derived the name from a Greek word signifying "imperishable."[232] But in England, where this type of photograph had been made by Archer at the same time he introduced the collodion process, the term "collodion positive" remained in use. This, in effect, was how an ambrotype was made; a weaker solution of collodion was used, and after the plate was exposed in the camera it could not be used as a negative after that to make prints on paper or other surfaces. Like the daguerreotype, it remained as a one-of-a-kind image—on a glass plate, instead of on a silvered copper plate.

Cutting's patent came to be known fairly quickly, however, as the "ambrotype patent," and it might have become the object of a second prolonged patent war on the American photographic scene were it not for the fact that the ambrotype was short-lived, suffering a similar fate as the daguerreotype when a combination of events (the stereophotography revolution; the invention of the carte de visite form of portrait photograph; multitube cameras; etc.) signaled a mass exodus just before the Civil War to the collodion method of paper photography.

Ambrotypes were fitted into the same miniature cases used for daguerreotypes. Images resembled glass negatives until the plates were given a backing of some form (black or dark varnish; black paper or cardboard). Then they would assume the appearance of a positive picture (see illustration opposite). Probably because of the existence of the Cutting patent (and his subsequent court actions taken against certain photographers), ambrotypes were made in a variety of ways. Cutting's method was among the best, in that it called for hermetically sealing together the image plate (image side) and a second piece of glass of the same size, which would serve as a permanent cover. The ambrotype of an elderly man (opposite page) was made by the Cutting method. Many ambrotypes were made more simply, using just one piece of glass with the image side painted over with a varnish or paint. The specimen shown on page 112 serves as an example, but since the varnish has deteriorated the photograph requires additional backing (the black piece of paper shown in the center) in order for it to exhibit some semblance of its original appearance. Some ambrotypes were also made without any suitable protective coating, or covering for the image, and in the case of such specimens the image can literally be wiped off the glass with a finger or cloth.

Cutting's basis for pricing, as of July 1855, was $100 a license for one photographer to make ambrotypes by the Cutting method in an area of approximately five thousand inhabitants. "Of course, some modification is necessary in large cities and among people who do not appreciate the fine arts," Cutting's agent, W. R. Howes, of Mattapoisett, Massachusetts, declared in a letter to George N. Barnard in Syracuse. "The disposal of your county is in my hands at present," he told Barnard, adding: "From what we have been able to learn of Onondaga County, we think it worth $800." Whether Barnard purchased a license on these terms is not known.[233]

Cutting's patent specified balsam of fir as the sealing compound for the two glass plates, but Montgomery P. Simons, operating in Richmond, found a way to get around this which he communicated to Snelling on November 11:

. . . if you will get Mr. Cutting's claim from the patent office reports, 1854 (I have one before me), you will find that *two glasses can be used,* and cemented together with *any varnish* except balsam of fir; I use two glasses and cement them together with a varnish which I think has many advantages over the patented balsam; it is not so sticky and unpleasant to use, it dries quicker and the tone which it imparts to the picture is quite as good.[234]

Ambrotypes reportedly were not widely made by the more prominent photographic galleries, but they were made to some extent by most—even in whole-plate size at Brady's gallery. The better made specimens were greatly admired, as witness these comments by Marcus A. Root after visiting the Whipple and Black gallery in Boston:

The ambrotype patent being reserved exclusively by J. A. Cutting & Co. of Boston, others have had little encouragement to experiment in this beautiful style of heliographic portraiture. Yet I saw, taken by Mr. Black, a specimen likeness of a gentleman, which in delicacy and beauty, was not only vastly superior to the finest daguerreotypes, but was what an enthusiastic virtuoso would pronounce "a miracle of art." In truth, all enthusiastic daguerrotypists who succeed in producing good photographic ambrotype portraits by the collodion process, will probably loose—for a time at least—much of their attachment to the daguerreotype process: so much more pleasing, and easily handled by the skillful artist is the former than the latter. And here I would earnestly urge on Messrs. Cutting & Co. the propriety of rendering to all *located* daguerreotypists who may desire to make these pictures, the *right* of so doing, at rates so moderate as to inflict upon them no injustice—offering the same to *all,* and permitting the most skillful to "lead the field."[235]

But most of the major galleries were beginning by this time to concentrate heavily on using the collodion process to make photographs on paper. Brady, Gurney, Lawrence, and others in New York were now using it commercially, prompting the New York *Tribune* to declare in March that the process was "coming into vogue as a means for taking

INFERIOR GRADE AMBROTYPE

Photographers made ambrotypes in a number of different ways to get around paying Cutting a license to use his process. Here, the image secured to the rear of the glass plate (above left) has flaked away, but with the backing of black paper (above) appears more positively, as at left. Varnish or black paint backing on the original was inferior, and no second glass of the same size for added backing and sturdiness was used.

portraits.'' Hesler adopted it in Chicago in 1855, as did I. B. Webster in Louisville and John H. Fitzgibbons in St. Louis. Root was particularly laudatory of collodion portraits, both small and life size, which A. A. Turner from Brady's gallery exhibited at a Franklin Institute fair early in 1855.

Root also praised the collodion prints exhibited at the same fair by McClees & Germon, but once again Charles Ehrmann recorded how difficult it was to work the collodion method at the start. According to Ehrmann, a Philadelphia acquaintance, Ed Thilgman, had visited Archer in Edinburgh in 1852 and had returned with a six-ounce bottle of collodion and a twelve-ounce bottle of developer, containing pyrogallic acid and hyposulphite of soda. As Ehrmann then recalled:

> Mr. Thilgman handed these new materials to me. I tried them; my associate John C. Parke did the same; Mr. McClees, Mr. Germon, my old chum William Bell, and many others, and we all came to the one conclusion—that this stuff called collodion could not be possibly used for making pictures. We went back to our albumen and practiced it as much as possible. At last a man from Boston, James Cutting, took out a patent for bromized collodion. He sold his patent right and left in every direction, and photographic pictures upon collodion were then made. I give him the credit of having made the collodion process practical, but more credit belongs to Isaac Rehn of Philadelphia.[236]

Ehrmann also said a collodion operator became ''a big man'' at this time. The pay ranged from $40 to $70 a week, ''with a percentage attached each year, and we all lived in clover.'' According to Ehrmann, McClees & Germon printed their collodion pictures principally on plain silvered Rives or Steinbach paper.

While the process had come into use as the ''collodion process,'' a new term gradually became synonymous in usage, and is perhaps better known today. This is the term ''wet-plate process,'' which evolved quite naturally from the photographer's need to keep his collodion glass negatives continuously moist (with wet collodion) from the moment the plate was sensitized in its bath through exposure in the camera, and subsequent negative development. As Humphrey would later say: ''In taking collodion pictures it is always advisable for the sitter to be arranged before the glass is taken from the bath; this will save time and there will be less liability of the collodion drying.'' While this was not an undue hindrance to gallery practice, this requirement made it necessary for a photographer to transport to the field with him all of the chemicals and paraphernalia required to sensitize, expose, and develop a plate when taking photographs out-of-doors. Understandably this led to continuing efforts—achieved in the 1880s—to perfect a dry-plate method equally suitable for *all* forms of photography, such as only the collodion process was during its lifetime.

As early as 1852, cameras had been given the capability of moveable focus with the introduction of the accordionlike bellows camera that year, and in 1854 the noted French photographer Eugene Disderi devised a way of repositioning the plate inside a camera in order to allow multiple exposures to be made on the one plate. Either with or without the knowledge of Disderi's invention, Albert S. Southworth, in April 1855, patented a sliding plate-holder device

Plastic ''union'' cases for housing daguerreotype and ambrotype photographs were introduced in 1854, marking the beginning of thermoplastic molding in the United States (a feat which went unheralded at the time). Approximately eight hundred different design motifs on plastic cases are said to have been made, featuring scenes derived from classical paintings and etchings, or reflecting the popular taste for themes of nature, history, patriotism, and religion. The scenes of a clipper ship and fort (top) and a seated Liberty (bottom) were made between 1858 and 1860 at Northampton, Massachusetts, by Littlefield, Parsons & Co. The case with the nautical motif (middle) is by an unknown maker.

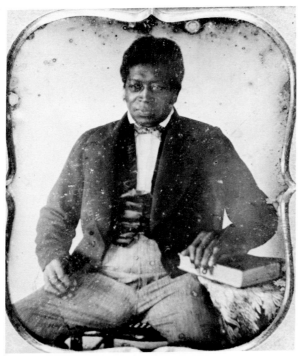

Robert Morris, from a daguerreotype, circa 1855.

Mrs. Robert Morris, from a daguerreotype, circa 1855.

Morris home, circa 1870s.

Morris home, 1976.

FROM SLAVERY TO LANDOWNER

The illustrations on this page tell the success story of a New Jersey slave, Robert Morris (1790–1878), who was freed in 1828, the year Andrew Jackson became president, and the year the minstrel character "Jim Crow" was introduced in Louisville, Kentucky. Morris was freed by a landowner, Simon van Duyne, whose modest stone house still stands in what is now Pine Brook, New Jersey. From his meager savings, Morris began purchasing lots from other members of the van Duyne family, and records which have been handed down through several generations reveal the following purchases:

Seller	Acres	Year	Price
John van Duyne	2+	1829	$35
James van Duyne	5+	1851	$26.70
Daniel van Duyne	4	1853	$120

After winning his freedom, Morris continued to till the land for the van Duyne family and built a home not far from the Simon van Duyne homestead. Here, his wife engaged in weaving, and many of her embroideries will still be found in the van Duyne house. Like the latter, the Morris house still stands today. A granddaughter is shown standing in front of the house (at left, center) and the house as it looks today is pictured beneath. After Morris' death in 1878, the house was later willed back into the van Duyne family.[237]

1855

114

which was designed to accomplish the same purpose. Like Silas Holmes's "double camera" patented the previous year, the Southworth invention was also intended to be applicable to taking stereoscopic pictures "upon the same or different plates with one camera." But neither the Holmes nor the Southworth inventions are known to have been applied to any great extent to stereophotography. Instead, these mechanisms served immediately to increase the number of daguerreotype or collodion photographs which a photographer could obtain with a single exposure at one sitting. Describing his invention, Southworth said it "consists of a peculiarly arranged frame in which the plate-holder is permitted to slide, by which means I am enabled to take four daguerreotypes on one plate and at one sitting, different portions of the plate being brought successively opposite an opening in the frame, the opening remaining stationary in the axis of the camera while the plate-holder and plate are moved." By the same token, four images could be secured on a single collodion negative plate, after which the plate was developed in the usual manner and the four [similar] images on the paper print were cut apart and mounted separately. No doubt, the Southworth invention made a significant contribution to the tabulated 403,626 daguerreotypes taken throughout the state of Massachusetts this year.[238]

Silas Holmes, whose negatives today comprise an important element of the nineteenth-century photographs owned by the New York Historical Society, was dubbed the "machine daguerreotypist" by Snelling because of the number of daguerreotypes he could produce with his own particular invention. Humphrey noted in January that six hundred of Holmes's "two-at-once" daguerreotypes could be turned out daily at his "picture factory" for prices ranging from twenty-five cents to $5 a dozen. A month later, Humphrey said Holmes had further enlarged his gallery with the addition of a wholesale department, and was advertising the taking of daguerreotype portraits at $20 a hundred. When the gallery was put up for sale at the end of the year, Snelling said Holmes had "made a fortune there in four years," and had even won a medal for "machine pictures" at the annual fair of the American Institute in 1855.[239]

Daguerreotyping continued to be a $50,000-a-year business at this time in such cities as Philadelphia and St. Louis. But in the case of St. Louis, volume appears to have been heavier at only sixteen galleries there, as compared to the reported seventy galleries in Philadelphia.

Two Boston photographers, George Silsbee and Samuel Masury, tried making daguerreotypes by artificial light, but their experiments ended in a mishap. While attempting to make a daguerreotype by gaslight, the chemicals exploded, shattering the front of their building on busy Washington Street, and causing Silsbee to lose an eye. Masury suffered a broken leg.

In 1855, Buffalo was the scene of possibly the first recorded use of the daguerreotype for law enforcement. The police there were looking for a "rogue" by the name of Lewis Fredel, and sent a daguerreotype likeness of Fredel to Boston where they evidently thought he had gone. But *Ballou's* magazine, which reported the incident, did not state whether the image was helpful in apprehending the fugitive.[240]

THE FIRST "BOHEMIANS"

Although the camera did not capture the group of young rebels known as "the Bohemians" which scandalized polite society in New York in the late 1850s, their unconventional dress, irreverent literary fervor, and "seductive ways" (*The New York Times*'s description for what it considered their moral menace) could be observed at the far end of Charlie Pfaff's cellar restaurant beneath Broadway a few doors north of Bleeker Street. Walt Whitman was a member of the group, and the photograph of him above, made from a circa 1855 daguerreotype (probably by Gabriel Harrison), reveals the Jovian-looking man with the steel-blue eyes as he appeared at the time of publication of his *Leaves of Grass*. His companions at Pfaff's were the poets Ada Clare, Edmund Clarence Stedman, and Thomas Bailey Aldrich, and literary figures such as Fitz-James O'Brien and the editors of the notorious *Saturday Press*. But by the end of the Civil War, all were gone, or departed to other, and for the most part, more "respectable" walks of life.[241]

Fig. 1

Fig. 2

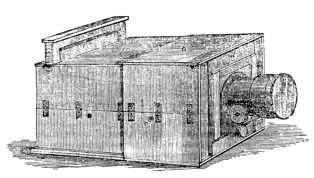

Fig. 3

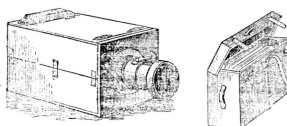

Fig. 4

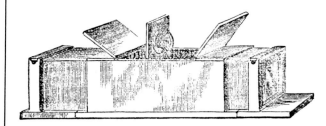

Fig. 5

CAMERA STYLES, CIRCA 1856

Catalogues or other literature on American-made cameras available in the 1850s are today nonexistent. In the summer of 1856, *Humphrey's Journal* published these drawings of cameras offered by a British concern:

EXPANDING CAMERAS: The larger of two versions (Fig. 1) came in two portions, one sliding within the other. It allowed use of either a portrait or view lens, and the back portion held a plate holder on which could be placed a sensitized daguerreotype or glass plate, or paper negative. Figure 2 illustrates a similar but smaller and more portable expanding camera. The tail board was hinged so it could be turned up to give added protection to the plate holder.

FOLDING CAMERAS: The larger of two versions (Fig. 3) included the facilities of adjustment possessed by an expanding camera, but could be dismantled by folding the sides and back flat on the camera's base for packing in a compact manner with separate plate holders, lens, and interior dividers. Figure 4 illustrates a folding camera whose front and sides could be lifted from their grooves and the body of the camera folded together by hinges for packing with plate holders, lens, etc., in a traveler's leather case.

COPYING CAMERA: Daguerreotypes or photographs on paper or other opaque surfaces could be placed in a good light a short distance from the open end (left) of the camera shown in Fig. 5 for copying. A slide holding the lens was placed in a center-section groove, and a focusing glass was placed in the plate holder (right). Focusing was accomplished by moving the right-hand (expanding) body of camera inwards or outwards from center portion. When focusing was completed, a sensitized plate was substituted in the plate holder, after which the copy photograph could be secured. The nearer the lens was placed to the plate holder, the further the camera itself had to be removed from the original, and the smaller the copy photograph would be. The reverse was the case in making larger copies.

STEREOSCOPIC CAMERA: Figure 6 shows an ordinary view camera equipped with a rear sliding plate holder, which gave it the ability to make two images of the same scene on the one plate. After making the first picture, the camera was moved to a second location, two, four, or six feet to the right or left, depending on the distance of the camera from the scene.[242]

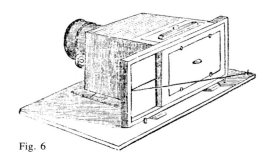

Fig. 6

1856

An obscure professor of chemistry and natural philosophy (physics) at Kenyon College in Ohio patented the great American tintype on February 19, 1856, apologizing afterwards for the necessity to extract a small fee ($20) for its practice. This was Hamilton L. Smith, who graduated from Yale in 1839, the year the daguerreotype process was introduced, and who for a time shared directorship of the Yale Observatory before becoming (in 1853) one of a faculty of seven for a student body of sixty-five at Kenyon College. At first the new pictures were called "melainotypes," then "ferrotypes" (by a rival manufacturer of the iron plates used), but the world knows them as tintypes.

The tintype is an offshoot, in a sense, of both the daguerreotype and the ambrotype. Like the former, a tintype image was secured on a metal plate exposed in the camera, but the metal used was iron instead of copper, and the iron plate was lacquered with a black japan varnish instead of coated with silver. The tintype plate, like the ambrotype glass plate, was sensitized with collodion. With the new sliding-plate camera mechanisms just introduced by Southworth and Holmes, it was possible to expose four images on a plate which, after the plate's development, could be cut apart with a pair of tin shears. Later, when multilens cameras came into use, up to a dozen, or even thirty-six tiny "gem" tintype images could be secured on a single plate.

As soon as it was granted, Smith assigned the rights to his patent to an associate at Kenyon, Peter Neff (then calling himself Peter Neff, Jr.), and Neff's father, William Neff. The younger Neff had worked with Smith on his invention and had persuaded Smith to apply for the patent, which, by his own account, he prosecuted before the Commissioner of Patents. The patent covered the production of tintype photographs, but not the manufacture of materials for them (which left room for the rival manufacture of "ferrotype" plates). William Neff died in November 1856, leaving his rights and all the manufacturing responsibilities to his son. As this account by Peter Neff reveals, it was no easy matter to produce sheets of iron that would be thin enough for commercial use:

> My first experiments toward making it of commercial value were made in rooms over my father's stable, on West Sixth Street, near Cutter Street, Cincinnati, Ohio. The many difficulties in obtaining sheet iron thin enough to suit for my plates were insurmountable, and plainishing them did not remove its roughness, but in the summer of 1856, with my father's security, Phelphs, Dodge & Co., imported for me several tons of Tagers Iron. This was among the earliest if not the first importation of these sheets. I built a factory for japanning plates at 239 West Third Street, Cincinnati, with rooms for operating and teaching their manipulation and uses, and the preparation by compounding chemicals. It was slow and difficult work introducing this new process, being everywhere met with opposition from daguerreotype dealers, but succeeded by sending out teachers to instruct daguerreotype operators. My factory was destroyed by fire in the summer of 1857, and I then built at Middletown, Conn., and James O. Smith had charge of them and the work. My office was with James O. Smith in Fulton Street, New York.[243]

A tintype portrait of a youth in uniform. Photographs of youths or military personnel in uniform, taken prior to 1860, are uncommon today.

In the midst of building his first manufactory, Neff prepared and distributed—gratuituously—some four thousand copies of a fifty-three-page pamphlet, *The Melainotype Process, Complete*. But having originated in the Midwest, instead of in New York or in Europe where most new photographic processes had previously originated, the tintype was not adopted across the country as soon as it might otherwise have been. The ambrotype eclipsed the daguerreotype in the years 1856–57, but the tintype never eclipsed either. It did, however, outlast them both, and also outlasted the wet-plate process itself, accommodating itself equally well to dry-plate photography after the 1880s. It never achieved social status, but the simplicity and novelty of the process—and the low cost of its pictures—assured it a long life.

A variety of camera styles (see illustration, left) were now to be had on the market, but to the brothers A. S. and A. H. Heath, manufacturers of chemicals in New York, there was still no "perfect" camera in their eyes which had yet been devised. In reality, cameras in the emerging wet-plate era would become both larger and smaller, and would be produced to meet narrower demands. The Heaths nevertheless drew attention to the drawbacks of the existing equipment of the period, and were among the first to call for a breed of camera that, in their words, would "give large-size pictures distinct in all parts; command a most intense light; and be equally adaptable for portraits or for landscape and architectural work:"

> Up to the present time, the problem of fulfilling all these conditions equally has not been solved; indeed one excludes the other. If the picture is to be large, or of equal clearness and distinctness in all parts, even to the border, and equally so for near objects as for those farther off, the focal distance must be proportionately longer, and the aperture through which the luminous rays enter must be smaller. The necessary consequence of this mode of construction is that the apparatus does not command a sufficiently intense light to answer the purpose of taking portraits with it. On the other hand, if the focal distance is less-

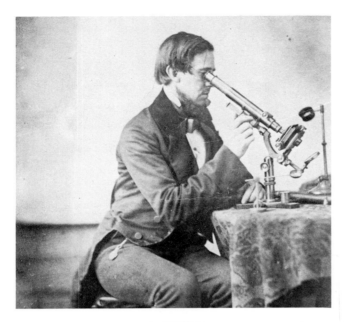

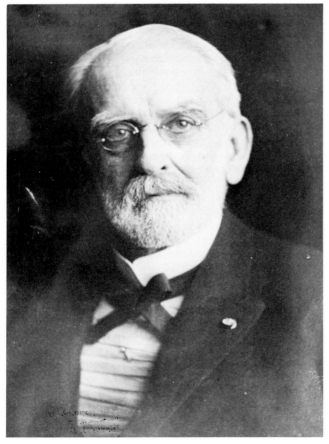

Tintype inventor Hamilton L. Smith (top) shared directorship of the Yale Observatory in the 1840s before being named professor of chemistry and natural philosophy (physics) at Kenyon College, Gambier, Ohio, in 1853. His co-worker at the time of the tintype patent award (1856) was Peter Neff (bottom), who attended Yale for a year in 1845 and later transferred to Kenyon, where he graduated in 1849. Neff was studying for the ministry while working with Smith in 1853–54, and continued the association after assuming the ministry of Christ Church, Yellow Springs, Ohio, in 1855.

1856

118

ened, and the aperture enlarged (with the best suited to the purpose), the apparatus will then command a greater amount of light, and will accordingly be better adapted for the taking of portraits. But it will be found that this has been achieved only at the expense of the size of the picture, and of the desired correct delineation, and equal clearness and distinctness in all parts. An apparatus so constructed is therefore but imperfectly adapted for taking views of landscapes or of architectural objects; and although small views may, if need be, be taken with it, by placing screens before it to reduce the aperture, the productions so obtained are very inferior to the views taken with an apparatus of greater focal distance and smaller aperture. This applies more especially to pictures taken on paper; since from the unequal texture of that material, the minute details of the object delineated will necessarily grow indistinct and confined, or even vanish altogether if the surface acted upon is too restricted to reflect these details on a sufficiently large scale.[244]

Although Prof. Smith found it personally "galling" to have to exact a fee for the practice of tintyping (to reimburse his expenses over several years), James A. Cutting suffered from no such qualms and began a prolonged series of litigations in January 1856, aimed at curbing the practice of those whom he felt violated the dictates of his ambrotype and bromide patents. His first thrust was against M. P. Simons in Richmond, but to no avail, as Simons explained in this letter to Snelling:

"I wrote you some time ago that I was making ambrotypes and cementing them between two glasses, and at the same time told you that I had not been foolish enough to pay for a patent right. Since then I received a notice from Gibbs, one of Mr. Cutting's victims, informing me that he would, through his lawyer, apply for an injunction on the following Tuesday. I heeded him not, but continued to make ambrotypes, as usual. Tuesday came, and Mr. Gibbs was not ready, and, for the same reasons, it was put off again and again, until I was not willing to have it delayed any farther, and last Thursday it was argued at length before the Judge of the U.S. Court. His bill desired to restrain me from making ambrotypes and cementing them between two glasses. My answer was, that there was nothing new or novel in the patent, and, if the patent was good, that I did not use balsam, and, therefore, did not infringe his rights. You will be pleased to learn that the judge, after having it in consideration for several days, decided in my favor, by refusing to grant the injunction. What will these patent men say to this? It is laughable to read their advertisements—"Rights for sale to respectable operators"—meaning any one who would be willing to pay through the nose for them."[245]

Other litigations commenced in 1857, including a suit (handled by Cutting's New York agent, W. A. Tomlinson) against a group of New Yorkers, among them Abraham Bogardus, Nathan G. Burgess, Battelle & Grey, and Lewis & Hall. This case was also thrown out of court, however, on the grounds that the name "ambrotype" was not included in the Cutting patent. Robert Vance purchased the ambrotype rights for the state of California, and in October he placed an advertisement in a San Francisco newspaper which stated: "I hereby denounce all Pictures taken on Glass in this city or state, and called Ambrotypes, as BOGUS, and a fraud upon the public, being a miserable imitation of the genuine article." A rival photographer, J. M. Ford, placed an advertisement on the same day in the same newspaper in which he said the "Patent Ambrotypes" were "worthless trash." He gave these reasons:

Proprietor Vance stands in center, third from the right, surrounded by, left to right: Ira G. French, gallery operator; Milton M. Miller, photographer; George H. Foster, clerk (seated); P. A. Davis, bookkeeper; and John Hammersmith, operator.

THE ROBERT H. VANCE "PREMIUM DAGUERREOTYPE GALLERY" IN SAN FRANCISCO

Having left his celebrated daguerreotype views of California behind in New York, Vance opened a gallery in San Francisco in 1852. After winning the First Premium for his photographs at the state fair in 1854, he opened an enlarged "Premium Gallery," followed by other branches in Sacramento and San Jose. The San Francisco gallery boasted fourteen rooms, a billiard parlor, a ladies' boudoir, and a skylight containing 500 feet of glass. Vance made "many threats of prosecution . . . against his brother artists for alleged infringements" on his rights to the Cutting ambrotype patent, but is not known to have filed any suits. He sold his business in 1861, drifted into oblivion, and died in New York in 1876.[246]

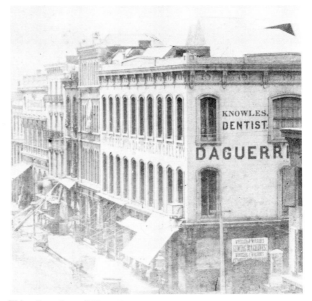

This 1859 view of Vance's "Premium Gallery" was among the first series of card stereographs published by Edward Anthony.

LAST SEEN AT THE ENGRAVERS

Commodore Matthew Perry took an artist, William Heine, and a daguerreotypist, E. Brown, with him on his 1852–53 expedition to Japan. Heine's lithograph (above) from Perry's three-volume *Narrative of Expedition of American Squadron to China Seas and Japan* (Washington, D.C., 1856) depicts Brown at work with his camera on an island in Okinawa. Several scores of the illustrations in Perry's report were based on Brown's daguerreotypes, but the photographs may have perished in a fire at the P. S. Duval lithographic firm in Philadelphia on April 11, 1856, which destroyed the government-supplied lithographic stones and illustrations made from the stones at the Duval plant.

The daguerreotypes made by S. N. Carvalho on the 1853 Frémont western expedition, together with copy photographic prints made by Brady in the winter of 1855–56 in New York also have been lost. The photographs were used to make oil paintings and engravings on wood in a special studio set up near a large bay window in the Frémont home. These were passed on to other "artist-engravers of the best school," and a book on the expedition was scheduled to be published (then was later cancelled) by George Childs of Philadelphia. The materials for the book survived an 1881 warehouse fire, according to Mrs Frémont.[247]

In the so-called Patent Ambrotypes the pictures are sealed with Balsam, which constantly oozes out, and soon leaves the pictures covered with blisters. . . . By the improved method of putting up Ambrotypes, the cement is entirely done away with, and the picture is covered with an enamel which instantly dries and becomes as hard as the glass itself. This is the improvement, and the pictures are called IMPROVED AMBROTYPES throughout the United States and honest operators make no others.[248]

Were daguerreotypes subject to fading? Prof. Draper said he thought they would if they were left in a warm place, such as on the top of a mantlepiece. He had seen specimens "almost obliterated" in this manner. But Humphrey argued that the daguerreotype was the only type of photograph that could be "finished" on the basis of "scientific principles," and the only type that could be "secured from the oxydizing influence of adulterated atmosphere." But the problem of fading photographic prints was another matter, and in 1855 a committee of photographers was formed in London to determine if the problem could be remedied. Its report, published in *Humphrey's Journal* on January 1, listed the principal causes (enumerated at right), but concluded that no set of procedures adopted for making prints would insure their "permanency." For the remainder of the nineteenth century efforts would be made by the best technical minds—principally in England and on the continent—to devise so-called permanent modes of photographic printing. But as there would never be a universally accepted "perfect" camera able to do all things for all users, so there would be advantages and drawbacks to every "permanant" process devised for making photographic prints.[249]

The collodion process provided the first stimulus for amateur photography, which flourished for a time in England and in Europe, then subsided somewhat as "the stains of inky darkness upon the hands and clothes soon earned for the infant science the appellation of the 'black art.' "[250]

A "second birth of photography" in England began as soon as Talbot's patent claims were thrown out of court, according to the *Art-Journal* in London. "Since then our opticians have found no rest for mind or body, our camera makers have been inundated with orders—and Photographic chemists have sprung up one after another and continue to increase, till the unconscious public wonder and are amazed. The *Illustrated London News* gives learned criticism as incomprehensible as they are long . . ."[251]

On October 28, 1856, a Baltimore businessman, George B. Coale, addressed a letter to *Humphrey's Journal* which may be characterized today as the first sound of the trumpet for amateur practice in the United States.

Dear Sir,—I desire, through you and your Journal, to urge upon the professional Photographists throughout the country, and especially upon the Manufacturers and Dealers in Stock and instruments, to make some exertion to encourage the *amateur* practice of the Art in this country. In Europe, the Amateurs far outnumber the Professors; and there is no exaggeration in saying, that the perfections attained in many branches of the Art are more than half attributable to the animated enthusiasm with which the former class have devoted to it leisure, wealth and chemical science. Here the Art has been exclusively left in the hands of the takers of likenesses—and what has America contributed to it beyond some mere mechanical improvements and perhaps some simplifications in manipulation? Mr. Whipple's Albumen Process is all, or nearly all, that can be claimed for us. I would not be understood as implying by these remarks any *reproach* to the body of Professors. It is not to be expected that they should abstract from their active business, time and means, which it wholly needs to make it a profitable calling. But I would suggest to each one who takes the trouble to read this communication, that there is doubtless within the circle of his acquaintance more than one person whom he can stimulate to take up the practice of the Art as an accomplishment and amusement of his leisure; and such a one, if gifted with taste, will be led by the fascinations of the Art into paths of experiment and

investigation, in which he will gather what will more than repay his professional friend for setting him in the way.

The Manufacturers and Dealers in Photographic Stock have more in their power; and from establishments that boast of selling to the amount of a million a year, surely something may reasonably be asked. At present *no one facility* exists for the Amateur. He must find out by costly experiments what he really needs, and then, at unreasonable cost, have especially made articles adapted to his purposes, or, at great risk of mistakes, undertake to import them from England or France. In your large New York establishments, not an article is to be found except such as are needed for likenesses—not even a cheap stand that could *be brought to a level*: and, I am sorry to add, not the least disposition to go one step in advance of the present state of the market; to supply articles that might and surely would *create* a demand. I searched in vain for a portable field camera and stand, and finally had to have one made *after* a design furnished by my friend and neighbor Mr. D——, who has been working his way through the same difficulties that I have experienced, and who, with myself, constitute our "Photographic Society" thus far. This camera is compact and light; all bellows except the front and bottom, and could be furnished as low at a price (according to Mr. Townsend) as the common "Bellows Box," *if made in any number*. To make a single one cost about 30 per cent. more. I cite this single fact as illustration of the difficulty an Amateur has to contend with at every step.

Now, as the readiest means of advancing the end I wish to see attained, will not one of your large Manufacturing Companies, or if not they, then some Importing house connected with the Arts—Williams & Stephens or Goupil for example—import a judicious selection from the full English or French catalogues of apparatus? I note, in Thornthwaite's list, complete outfits for the Photographic Excursionist, at prices ranging from $15 to $250 and upwards; "packed in a convenient case," &c., &c. I do not think that one of these cases would be exhibited here a long time without a purchaser. The very examination of such an arrangement of apparatus is as good as a Manual of Instruction.

It is about two months since I commenced the practice of Whipple's albumen process, (undoubtedly the branch for Amateurs), and already, with the application of only such leisure as a pretty active business affords, I have obtained a facility that yields me the greatest delight, and at every step of progress the fascinations of the Art increase. I can prepare half a dozen plates in an hour after tea—carry out three of these in the early morning before business hours, with the certainty of returning with three good pictures; a short time after tea suffices to develope them. I can prepare a few sheets of paper any morning before breakfast and let my negatives print themselves in my office window while I am attending to my business; I then carry them home carefully wrapped up and give them to my fixing and coloring bath in the afternoon or evening. 253

PRINT FADING

A committee of London photographers examined Talbotypes and plain paper prints up to ten years old; also albumen paper prints, and prints colored with a salt of gold, or fixed with "old hypo." The report, published on January 1, 1856, listed these causes of fading:

Causes of Fading.

The most common cause of fading has been the presence of hyposulphite of soda, left in the paper from imperfect washing after fixing.

The committee think it right to state, that they have been unable to find any test to be relied upon, which can be used to detect a minute portion of hyposulphite of soda, in the presence of the other substances which are obtained by boiling photographs in distilled water and evaporating to dryness; yet they have no doubt of the truth of the above statement, from the history given of the mode of washing adopted.

The continued action of sulphureted hydrogen and water will rapidly destroy every kind of photograph; and as there are traces of this gas at all times present in the atmosphere, and occasionally in a London atmosphere very evident traces, it appears reasonable to suppose that what is effected rapidly in the laboratory with a strong solution of the gas, will take place also slowly but surely in the presence of moisture, by the action of the very minute portion in the atmosphere.

The committee find that there is no known method of producing pictures which will remain unaltered under the continued action of moisture and the atmosphere in London.

They also find that pictures may be exposed to dry sulphureted hydrogen gas for some time with comparatively little alteration, and that pictures in the coloration of which gold has been used, are acted upon by the gas, whether dry or in solution, less rapidly than any others.

They also find that some pictures which have remained unaltered for years, kept in dry places, have rapidly faded when exposed to a moist atmosphere. Hence it appears that the most ordinary cause of fading, may be traced to the presence of sulphur, the source of which may be intrinsic from hyposulphite left in the print, or extrinsic from the atmosphere, and in either case the action is much more rapid in the presence of moisture. 252

Fig. 1. David Woodward's enlarger.

Fig. 2. Alphonse Liébert's enlarger.

SOLAR CAMERAS

In the early 1850s, photographers began making enlargements with cameras which used reflectors and a copying lens to pass the sun's rays through a negative onto larger sheets of sensitized paper. In 1857, David A. Woodward, a professor of fine arts at the Maryland Institute in Baltimore, patented the first "solar camera" (Fig. 1), which used a plano-convex lens, B, to condense and focus the sun's rays from an inclined mirror, A, through a negative, C, to the copying lens, E. The focus was made to coincide exactly with the optical center of the copying lens, with the result that an enlargement could be made totally from powerfully focused sunlight, and not by any other points of the copying lens subject to spherical aberration. The English photographer and editor Thomas Sutton, after seeing an enlarged print of a Baltimore civic building made with a Woodward camera, said the definition was as good as if the print had been made directly from a same-size negative. A solar camera which could be operated unattended in the open air (principally on rooftops) was patented by David Shrive of Philadelphia in 1859, and another of similar design (Fig. 2) was exhibited by Alphonse Liébert at an 1864 Vienna photographic fair. The Liébert camera, which was manufactured in Philadelphia after that, could make photographs of size 17¾ x 23¼ inches from a carte-de-visite-size negative in from 45 to 70 minutes. It passed sunlight through a condenser at the camera's top to a copying lens, which projected the image with the required degree of amplification onto sensitized photographic paper at the camera's bottom.[254]

1857

The year 1857 appears to have been a milestone year for photographers in making large-size photographs. Henry Hunt Snelling in New York and the Whipple and Black studio in Boston gained notoriety at the outset of the year for making prints as large as 18 x 22 inches without resort to enlargement. In Paris, the Philadelphian Warren Thompson fitted his studio with a 12-foot-long, bellows-style camera which could be moved backwards or forwards on a pair of railroad tracks to bring the subject to be copied into the proper focus of a lens 3 feet long and 13 inches in diameter.[255] But the year's most important invention (patented on February 24) was a new "solar camera" developed by David A. Woodward, a professor of fine arts at the Maryland Institute in Baltimore. This device collected the sun's rays with the aid of a reflector and focused them powerfully through a condenser and copying lens onto a conventional-size negative, amplifying and projecting the negative after that onto a large sensitized sheet of photographic paper. But since it was impossible to use a solar camera in the absence of sunshine (and because the enlarging process itself was time consuming), the instrument never became an adjunct of every photographer's studio. Instead, the process of making enlargements with solar cameras became in time the province of a specialized new breed of "solar printers" (see page 192).

Prof. Woodward is not known to have experimented in photography previously, and said the idea for his camera originated from his desire to make enlarged copies of photographs on canvas in order to be able to paint portraits over them. He had his detractors, however, among them Charles Seely, who co-invented a "Megascopic" solar camera which did not use a condenser. Stating that he considered the Woodward patent "of little moment," Seely contended that, "with a lens of nine inches diameter [the Woodward camera was supplied with condensers of either nine or five inches diameter], refractory metals may be melted, and ordinary combustibles readily ignited." Further, he asked: "Who has not heard of solar camera boxes being set on fire and other damage done? Who would long trust a valuable camera tube in such a heat? Accidents from fire may be prevented, but the injury to the tube is certain."[256]

But while the *Scientific American* praised Seely's camera design, Woodward obtained a continuing series of patent renewals for his camera in the 1860s and 1870s, and his invention sparked development of other new cameras with condensers which could be operated unattended on rooftops. In 1859 he traveled to Europe to promote his camera, and after giving a demonstration to Antoine Claudet in London, the latter termed Woodward's camera "one of the most important improvements introduced into the art of photography." The Austrian court photographer came to London to see what it was all about, and subsequently adopted the use of the camera himself. Woodward also visited Thompson and his partner, Robert Bingham, in Paris, selling them the rights to his patent for France and Belgium for 5,000 francs. Woodward followed one of the customs of the time in providing only his customers with information as to his suggested mode of solar printing, with the predictable result that others published their particular methods of operating a Woodward camera—methods which did not always meet with the inventor's approval. In June 1859, however, Woodward wrote to Snelling giving this scant bit of information:

> I am constantly using one of the large size Solar Cameras, with plain salted paper, or with that which is albumenized. The longest period of time consumed seldom exceeds one hour of good sunlight, and often not more than 45 minutes for a life-size print, and much less for a cabinet. It must be understood that this is in the production of prints not to be retouched or afterwards painted. By a much more sensitive process the time of exposure can be reduced to from 3 to 5 minutes. The latter process is intended generally for pictures that are afterwards to be painted.[257]

The first American photography manuals covering the practice of the collodion "wet-plate" process appeared this year. These included Humphrey's *Practical Manual of the Collodion Process,* published in New York, and the Charles Waldack and P. Neff manual, *Treatise of Photography on Collodion,* published in Cincinnati. Snelling also published two American editions of T. F. Hardwich's *Manual of Photographic Chemistry* (originally published in London), which included the collodion process. Wet-plate photography allowed of many formulas for preparing the collodion, most of them mixing an iodide (of potassium or cadmium) with the viscous collodion; others, a combination of bromide with the iodide. A method using iodide of potassium is described in the brief excerpt (see page 130) which relates the steps a photographer afterwards took to prepare a collodion negative. No committee of American experts appears ever to have been formed to sanction a particular mode or series of modes for collodion practice; however, in 1859 such a committee was appointed by the Royal Society in London. This committee thereafter gave its approval to Hardwich's methods among several other modes favorably reported by individual committee members.[258]

Negatives prepared with collodion were more sensitive and more stable than those prepared with albumen (requiring seconds instead of minutes for an exposure), and this proved to be a boon for making large-size photographs. Snelling, for example, in offering a size 18 x 22 salt print of the Equestrian Washington Monument in New York's Union Square to his readers free of charge, asserted: "This offer has never before been made in the publishing line. A year ago it would have been considered a piece of madness." Another who began making large-size photographs at this time was James Landy of New York, later prominent in Cincinnati. His first series were views of size 14 x 17 of all the points of interest on the Hudson River made historic by Washington Irving and Nathaniel Parker Willis. He followed these with views of similar size of Niagara Falls and Washington, D.C. England's largest publisher of English and foreign views, Francis Frith, did some of his finest early

This view of the Equestrian Washington Monument in New York's Union Square has been reproduced from a salt print which was bought at a New York auction in 1952. It was probably made by H. H. Snelling, who offered similar photographs of the monument and Union Square scene in size 18 x 22 inches to the readers of his *Photographic & Fine Arts Journal* in January 1857, free of charge. The palatial homes depicted to the right and the building in the rear have long since been torn down, and the monument itself has been relocated in the park to the left. At the time the view was made, the Vanderbilts were building new mansions "uptown" at Thirty-fourth Street (twenty blocks north), and the Astors maintained a country estate near what is now East Eighty-eighth Street and the East River. The year 1857 was something of a turning point in photography from the standpoint of the ability of photographers to make large prints. Mathew Brady and Jeremiah Gurney, for example, entered into their first competition to make enlarged prints with the aid of solar cameras for display at the 1857 American Institute Fair in New York. New cameras were also becoming available, able to handle mammoth-size negative plates. John Whipple and J. W. Black sent photographic portraits of size 18 x 22 inches to Snelling in January 1857, which were said to have been made from life by a camera. At about the same time, James Landy made a series of views of size 14 x 17 inches of scenes along the Hudson River which had been popularized in the writings of Washington Irving and M. P. Willis.

1857

124

COLLODION PROCESS

This capsule explanation has been taken from one of the first American manuals on collodion photography, published in 1857. Exposures by this time ranged from three to thirty seconds, depending on light conditions. Good judgment in timing would prevent grayish pictures (from too long an exposure), or overly positive pictures (from too short an exposure).

What is generally known as "Iodized Collodion," is a gun cotton solution, in which has been dissolved a certain quantity of an iodide or a bromide: the iodide of potassium for instance. If a glass or melainotype plate be coated with this iodized Collodion, and after being "set" by the evaporation of the greater part of the ether, be then dipped into a solution of nitrate of silver, the iodide of potassium and nitrate of silver will decompose each other and produce *iodide of silver*, which will be retained on the plate by the fibers of the collodion. In this state, the film will present a blue, white, or creamy opaque appearance, according to the quantity of iodide of potassium dissolved in the plain collodion. This operation must be done in a dark room by the light of a candle. If we now expose this plate in the camera, the iodide of silver will be impressed by the rays of light, strongly in the clear parts, to a smaller extent in the darker. If we examine the plate at this moment, we find it to have the same appearance as before, presenting no trace of an image. To bring the image out, we have to submit the plate to the action of certain compounds called developers. In the Daguerreotype process, the developer is the vapor of mercury; in the collodion process, it is a solution of protosulphate of iron or of pyrogallic acid in water. If, then, we pour one of these developers on the plate, the image will make its appearance in a short time, presenting the most intensity in those places where the light was the strongest. This image is formed by metallic silver in fine powder retained on the plate by the film of collodion. At this period of the operation, we have thus on the plate metallic silver, and iodide of silver that has not been reduced by the subsequent action of the light and the developer. That which remains to be done is to take away this iodide of silver by dissolving it in a solution of cyanide of potassium, or of hyposulphite of soda. [259]

work in Egypt, Nubia, Palestine, and Syria in the latter half of the 1850s, and this description of his handling of the large negatives at his Reigate printing establishment, recalled later by Hardwich, is indicative of the "dexterity" which collodion operators had to develop in working with large negatives at this time:

> Frith had at that time a photographic omnibus replete with every convenience. His plates were so large that when I first saw him developing a negative it looked to me like a man balancing the top of a small table on his fingers and pouring a jug of water over it. I was anxious to see whether he would ever get the developer back again into the vessel without spilling; but this feat he accomplished with much dexterity.

In New York, Mathew Brady and Jeremiah Gurney were first to enter into a competition to make large-size prints by the collodion process for exhibition at the 1857 annual fair of the American Institute. The prints were costly to make, and each man went about making them by a different mode, as this excerpt from a later reminiscence by E. T. Whitney reveals:

> The first year that the solar camera was introduced there was great rivalry between Brady and Gurney as to who should make the largest and best solar print for the American Institute fair. Unknown to each other, both were working in different ways to accomplish the object. Fortunately, I happened to be in New York at this time, and went from one gallery to the other to witness the operation at the same time keeping the secret. Brady prepared his paper for a life-size group of three. He floated his paper in an immense tank of gutta percha, 7 feet long by 5 feet wide, on a "silver wave" that cost $100.00. Gurney spread his silver on the paper with wads of cotton. His subject was a life-size figure of a lady. Brady's group took the prize. [260]

H. H. Snelling severed his association with Edward Anthony in January 1857 and began devoting full time to publishing the *Photographic and Fine Art Journal* (the new name for his journal adopted in January 1854). He also commenced making, himself, all of the prints (usually from negatives supplied by others) which were prepared in quantity and inserted by hand in all copies of each issue mailed to his subscribers. He soon found that "different papers require different treatment even with the same formulae. The same degree of intensity in printing on Marion and Canson papers," he observed, for example, "produce entirely different results. In the latter, the shadows dissolve out—in the toning bath—more readily and require closer watching; while in the former they are slow in changing, and are rather inclined to become milky and opaque instead of clear and transparent in the same length of time." These problems possibly account for the difference in sharpness or luster of individual prints to be found in the relatively small number of copies of the *Photographic and Fine Art Journal* which have survived to modern times.

Another bugaboo was the varnish applied to the glass negative after it was "fixed" in its hypo, washed, and dried. Snelling found that it would wear off, and the collodion would sometimes blister. J. W. Black encountered similar problems in Boston, and wrote Snelling that he found that this happened when the glass was not perfectly clear. He also observed that the negative film would sometimes detach itself from the glass, even before varnishing,

Photographic services at tourist resorts in the United States probably date from 1853 when a man known today only as "Mr. Babbitt" was granted a monopoly to take daguerreotypes of tourists visiting Niagara Falls. By 1857, the ambrotype was widely adopted as a cheaper mode of taking photographs of tourists, and while the specimen shown above may be an ambrotype taken by Babbitt, it is similar to an ambrotype by S. Davis owned by the International Museum at Rochester, New York, which shows tourists posing in the same or a similar carriage at Niagara Falls.

"in the dark parts of the picture where the light has had but *little* accession." This allowed portions of the picture to contract and expand, and when the negative was used to make prints under varying weather conditions—hot, cold, damp, or dry—the picture would actually split off from the glass. Black said he had found that "some varieties of collodion are much more liable to this kind of accident than others," but he did not specify the varieties to which he alluded. He did, however, specify a homemade recipe for making a tough varnish which was not susceptible to scratching, and when applied to a "good" collodion film on the glass, would adhere permanently. "I have never had a single picture crack up or darken by exposure," he said, adding that he had used some negatives to make as many as five hundred prints, and that many were at least three to four years old.[261]

Ellicott's Mills, Md.

THE CARD STEREOGRAPH COMES INTO VOGUE

A series of ''American Stereoscopic Views,'' issued in 1858 by the Philadelphia photographers Frederick and William Langenheim, signaled the beginning of the card stereograph bonanza in the United States. The Langenheims began importing foreign-made views, and were joined in competition by Edward Anthony, D. Appleton & Company, and George Stacey, all of New York. The view of Ellicott's Mills (above) bears the Langenheim name on the face of the card, which is characteristic of this early series. Ellicott's Mills was the principal industry in what is now Ellicott City, located four miles west of Baltimore. An unknown number of other photographers sold small numbers of card stereographs at this time, and such views are now quite rare. The Beckel brothers of Lockport, New York, secured the view of New York's City Hall (below) before a fire, which was touched off at the ceremonies of the Atlantic cable laying in 1858, destroyed both the clock tower and the circular cupola behind it. In the rebuilt tower, as it stands today, the clocks are no longer contained in the dome, but will be found in the windows beneath the dome.

1858

On August 1, 1858, the following notice appeared in the "Editorial Miscellany" columns of Seely's *American Journal of Photography:*

> Stereoscopes are at last coming into vogue with us, and we are actually getting up a taste for them. This may be somewhat owing to the price, since they can be bought for $1.50 a dozen. It were strange indeed if many parlors were without them; what is better adapted to enlarge the attention of a visitor whilst temporarily delayed, waiting for the appearance of the lady of the house? What a better interlude during an evening party than to fill up a pause with a glance at a fine steroscopic view? Certainly, nothing better displays the beauties and marvels of the Photographic Art. . . . It is a good sign that the taste has commenced in the right direction—Landscapes, Architecture and Composition.[262]

The start of photography's great nineteenth-century bonanza was at hand. Never before had pictures been taken on such a vast scale to be sold commercially by the number. Paired photographs made by the daguerreotype, ambrotype, and calotype processes had enjoyed only limited sales up to this time, and even the card-mounted stereoviews of Pennsylvania and upstate New York scenery sold by the Langenhiems in 1854 are now extremely rare items. But the series of "American Stereoscopic Views" (see illustration, left) which the Langenheims issued in 1858 started the ball rolling. Within a year, Edward Anthony placed a set of 175 different stock views on the market, and was joined in competition by two other New York publishers, D. Appleton & Company and George Stacey. In 1859, too, the English photographer William England made a series, "America in the Stereoscope," for the London Stereoscopic Company, which were the first views of American scenery and architecture to be published abroad commercially. Among the first card stereographs placed on the market were such items as a Langenheim stereoview of the construction of the dome on the U.S. Capitol building in Washington, D.C.; an Anthony series of the yacht regatta in New York on July 4, 1859; a series of views of the steamship *Great Eastern* by Stacey; a train crossing the bridge over the Niagara River, and Blondin walking a tightrope over the Niagara Falls by William England.

The card stereograph revolution was by this time farther advanced across the Atlantic. The London Stereoscopic Company already boasted a stock of one hundred thousand commercially available titles. In 1857, Francis Frith had made two series of a hundred stereoscopic views in Egypt and the Holy Land, which, after they were published by Negretti and Zambra, prompted the London *Times* to comment editorially that the views were "the first serious and worthy effort that has been made to develop the educational uses of the stereoscope in an artistic, geographical and historic point of view."[263] By 1858, card views of many of the architectural gems of Paris had been recorded for stereoscopic viewing by Theodorine d'Harcourt.

Although it is not known how many, there were other photographers besides the Langenheims and the New York

Alexander Beckers patented a stereoscope in 1857 which allowed hand rotation and viewing of card stereographs in sequence, and the device shown above is a later version of this basic design. Stereoscopes soon became available in a variety of configurations as the card stereograph boom increased. Table-model versions of the type above could hold up to three hundred cards mounted in blades, which could be viewed through the eyepiece by rotating a knob or handle on the side of the device. Beckers gave up his photography business in order to become a manufacturer of stereoscopes.

publishers who began making stereoscopic views in this early period. The Beckel brothers of Lockport, New York, for example, secured what may be one of the earliest surviving photographs of New York's City Hall (see illustration, left). The stereoview was taken at some point prior to 1858 when the original clock tower (now replaced) was destroyed by fire. In September 1858, Seely's journal gave this brief report on P. C. Duchochois' stereophotography activity:

> Our correspondent Mr. P. C. Duchochois has returned from a very successful photographic tour in New Jersey and Staten Island. His stereoscopic pictures as photographs are among the most perfect we have ever seen. . . . Few are aware of the beautiful natural scenery we have almost in our midst. We believe American views will soon be in demand, and that people will be convinced that every branch of photography is as thoroughly understood here as abroad.[264]

Many of the earliest American card stereographs which have survived are of a quality equal to those which came later; yet H. H. Snelling, writing in December 1858, said the majority of American-made cards, as well as those im-

ported from France, "are perfect failures—abortions—and if continued on sale to the public must eventually produce for them disgust in the public mind. They indicate that the makers of them consider it only necessary to plant their camera stand, point their double tube box at an object, secure two pictures on the same glass or paper slide, and put them into market, and all necessary work is done." Snelling said he felt that "no true artist" would use a double tube or stereoscopic camera because he considered the results from a single camera positioned twice for the same view "more perfect in every respect." He also doubted that it would be possible to produce a pair of lenses for a stereoscopic camera "so completely identical as to give pictures precisely alike and at the proper angle."

N. G. Burgess, author of *The Photograph Manual* (originally published as *The Photograph and Ambrotype Manual* in 1855), felt that a camera with a single lens was better for still life, statutory, or architectural photographs, but that a stereoscopic camera was needed for "instantaneous" views capturing people or objects in motion. Otherwise, the peo-

ple or objects in motion would appear differently on the two slides obtained, or might even be out of the picture entirely in one case or the other.[265]

Having called attention to the needs of people who wanted to take up photography as an amateur practice, George B. Coale published a *Manual of Photography* in 1858 through the firm of J. B. Lippincott & Company in Philadelphia. This appears to be the earliest manual prepared in the United States for the amateur market. In it, Coale devoted a considerable number of pages to Whipple's albumen process, which he said "appears to surpass Collodion in the capability of rendering depth and transparency of shadow, and details in shadow contrasted with high light." He said further:

> It is, under the names of "Whipple's Process," and "The American Process," largely practiced in England, and affords, perhaps, above all others, the greatest attractions to the amateur. No other is more capable of being practiced in hours of leisure occurring at uncertain periods. Plates properly prepared retain their virtue for a long time unimpaired; the tourist is encumbered with only his camera, a box of plates, and exposure frame, and a dark bag in which the plates may be adjusted to the frame, and afterwards returned to the box; the development after exposure is the work of leisure hours that may be waited for without hazard to the result of the labor undergone. For landscape Photography it is especially adapted; extreme distance and all the gradations of distance being rendered with wonderful fidelity and beauty.

The best plates for amateur practice, Coale maintained, were the "French full" size measuring 8½ x 6½ inches, which he said were almost universally used by English and French amateurs, and were easy to manipulate and more portable than plates only a few inches larger. French and German window glass was preferable to American window glass, he said, because the latter was "too brittle to be always relied on." Coale still regretted, as he did when he wrote to *Humphrey's Journal* in 1856, "that so little of the apparatus adopted peculiarly to the amateur practice of Photography is supplied, as yet, by the manufacturers of the United States," but he recommended Anthony's portable field camera and Harrison's landscape lenses. With regard to the advisability of using either plain or albumenized paper for print making, he offered these comments:

> The first point upon which judgment and taste are to be exercised is in the choice between plain and Albumenized papers. Landscapes upon plain paper possess more of the characteristics of fine drawings in India Ink or Neutral Tint. They appear to be preferred by the English amateurs, who regard them as more artistic and expressive. Prints upon paper which has received a fine coating of Albumen surpass them in sharpness of details, and in brilliancy of color. They present a highly glazed surface, and are ascertained to be more permanent than prints on plain paper. The Photographers of France and Italy appear to use it almost exclusively. Of all the various kinds of paper offered for sale in this country, the Saxony Paper (papier Saxe) will be found the most invariably good in quality and free from defects. It gives the best results when used plain, and is also excellent for Albumenizing. It is procured in sheets measuring 17½ x 22½ inches, cutting into six pieces of the size adapted for our negatives, with a small margin. The papers of Marion and Canson are good in quality, but the writer has never seen in the Photographic Depots a sheet of either plain or Albumenized French

1858

130

Published in 1858 by J. P. Lippincott of Philadelphia, this manual by Baltimorean George B. Coale is possibly the first American photography manual aimed at the amateur, as opposed to the professional photographer.

paper, which was *entirely* free from belmish. All that comes to this country seems to have been picked over. Occasionally a small lot of Albumenized paper of superior quality is specially imported.

As an alternative to the use of Whipple's process, Coale said Le Gray's waxed-paper process also "offers great attractions to the amateur," although it was "inferior to Whipple's process in sharpness of detail and in rendering of distant objects," and required "a tedious length of exposure." But he cited these advantages:

> It is admirably adapted to large masses. Buildings, Rocks, Trees without foliage, with details of foreground. It also has the advantage of greater portability; a portfolio of paper being substituted for the box of plates, and an adjustment to the camera for the exposure frame. With the exception of waxing the paper, an operation which requires care with some skill and experience, the details of the manipulation are so simple and mechanical, as scarcely to admit of failure, except through carelessness and uncleanliness. It requires also a smaller amount of chemicals and laboratory apparatus than any of the previously named methods.[266]

D. D. T. Davie was another advocate of Whipple's process. He was one of the few American photographers to publish his thoughts and methods of operating during the 1850s, and he authored several copyrighted articles which appeared in Snelling's journal in 1857. With respect to the albumen negative process, Davie said its advantages lay in the fact that any number of negative plates could be prepared at one time and then developed after use at the photographer's convenience; that the views secured by the process were unquestionably sharper and exhibited "well defined outlines"; and that because of the hardness of the albumen film on the glass plate, it could scarcely be scratched even with the point of a knife.[267]

Coale's statement that the developing agent "most commonly used" in bringing out the image of a glass negative in the darkroom was photosulphate of iron is at variance with one made by Edwin Musgrave some eight years later in Seely's journal. In 1858, according to Musgrave, "pyrogallic acid was considered to be the only correct developer for negatives, the iron developer being only considered suitable for glass positives." The reason for the switch to the iron developer, he said, was that pyrogallic acid had a tendency to produce excessive hardness and a loss of delicate detail in pictures so developed unless it was very skillfully used. But in the 1850s, intensity was what was wanted, according to Musgrave. "Unless the sky in a landscape negative was as black as your hat, the negative was considered to be inferior; and various plans, such as painting out with black varnish, were resorted to, to produce white paper skies, without which no landscape photograph was considered perfect." In any event, when John Werge went looking for some pyrogallic acid during his visit to the United States in 1860–61, the only place he could find any was in Anthony's store stowed away with a "Not Wanted" sign on it.[268]

Coale also maintained in his manual that cyanide of potassium was as universally used as hyposulphite of soda in the final darkroom operation in which an image was rendered permanent. But the cyanide of potassium was evidently injurious to the photographer's health, as this report by Franklin B. Gage in December 1858 reveals:

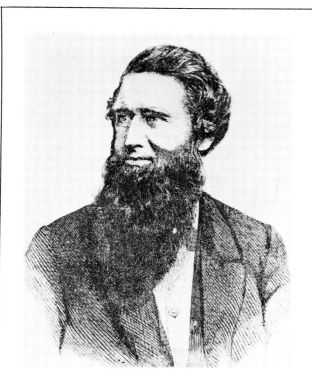

JEREMIAH GURNEY

For years, Jeremiah Gurney (above) and Mathew Brady vied with each other for top honors at photographic contests, and in their promotional feats. When Gurney moved further uptown in the fall of 1858, Seely published a description of the new gallery, from which this has been excerpted:

> Photography has become so great an institution in this City that it builds "marble halls" for itself. GURNEY has just opened, at No. 707 Broadway, a sort of Photographic palace which he has erected for the purposes of his business, and with a special view to its requirements. Discarding the practice of sending customers up three or four flights of stairs to an operating room which the sun can get at, he receives them in the ground-floor—shows them his pictures, cases and so forth, takes their orders and passes them forward to his main gallery, on the floor above, from which they enter upon a ladies dressing room on one side, and an operating room on the other. This latter apartment is provided with side-lights and roof-lights, so that in the event of his having a customer more "wrinkly" than usual—in which case the roof-lights, are insufficient—GURNEY usually smoothes down the creases with the side-light, and somewhat rejuvenates him by the process. When the operating rooms below are full, which would seem to be a common occurrence at this establishment, there are others on the next floor, which are, however, mainly devoted to the artists, who are there, in great force, to finish the photographs. These are taken of all sizes, from the "locket minature" to the "life," sometimes containing only the face, at others giving the bust also, and not uncommonly the whole form, of the size of life.
>
> Of the various "types" which are more or less advertised, GURNEY confines his operations to the Daguerreotype and the Photograph. He objects to the Ambrotype on the ground that it is not durable, which is another proof of the way in which even Doctors will disagree, since BRADY declares the Ambrotype to be the most durable picture made.[269]

URBAN PHOTOGRAPHY

In 1855, James McClees began making large photographs of historic and new buildings in Philadelphia, which he then sold to the general public in competition with prints made by lithographers or engravers. But the practice was little repeated elsewhere in the 1850s, and the size 16¾ x 14¾-inch albumen print made probably the same year (1855) of the Maryland Steam Sugar Refinery in Baltimore (right) was probably secured not for public sale,

Having had my attention called to this matter by sudden and unaccountable inflammation of the throat and mouth, accompanied with dizziness and great difficulty of breathing, I instituted a series of experiments and inquiries to ascertain if the sickness was caused by this chemical. After my recovery I laid the potassium aside for four weeks, using hyposulphite of soda instead. Having occasion to make a picture extremely white, I tried the cyanide of potassium for fixing the impression. Although not exposed more than one minute of time to the weak fumes, I felt an immediate return to the symptoms of the dizziness and inflammation. One subsequent trial, three weeks after, produced the same effect; and I have since fully resolved not to use it at all in future. I then commenced making inquiries of other operators; and, out of twenty, I found five who had been extremely sick with the same description of disease. Ten more, of the twenty, had felt the symptoms I describe; the other five did not know whether they had experienced any bad effects from its use, as they had not been long in the business, and never had thought about it.

On one occasion a lady accidentally got a silver stain on her finger, and I gave her a lump of the potassium to remove it with. The fumes produced such instantaneous and extreme prostration that she had to be carried from the room. I have been accustomed to fix my pictures where my customers could watch the operation as a matter of curiosity, and I recollect many instances where they spoke of *feeling queer* from the effect of the fumes. 270

Despite earlier experimentation by others, James A. Cutting and his Boston partner, Lodwick H. Bradford, were the first to secure a U.S. patent for a photolithography process on March 16, 1858. Joseph Dixon, a perennial inventor in many fields, had been somewhat successful as early as 1840 when he coated a stone with bichromate of potash, exposed the stone in a camera (as he was then doing with daguerreotype plates), and secured a rudimentary form of photolithographic printing plate. He did not continue with these experiments, however, and waited until 1854 to publish an article concerning them in *Scientific American*. The Duval lithographic printing company in Philadelphia had also conducted photolithography experiments in 1857, indicating "probabilities of success" in future.

but as an aid in making engravings of the refinery. Several engravings have survived, and the one left is reproduced in an 1873 history of Baltimore. The photograph of the refinery, which was found in a Cockeysville, Maryland, antiques store in 1972, is probably one of several made from different vantage points, since the engraving was drawn from a different angle. To a public used to colorful lithographs or doctored engravings of their buildings and monuments, the somewhat duller appearance of a photograph (whether a salt print or a glossier albumen print) caused them to be valued less highly, with the result that few pictorial records exist today of American metropolitan centers prior to the Civil War.[271]

Humphrey was ecstatic over the new discovery, but failed to describe it very clearly. Snelling described it in these words:

This particular process for transferring the photograph to stone is the joint invention of Messrs. Cutting and Bradford. The impressions here given are taken direct from the stone, without any retouching, the transfer to the stone being made from a glass negative in the same way as other positive prints. The impression so obtained is afterwards prepared so as to take the lithographic ink, and the prints are taken off the press in the same manner as any other lithograph. The advantages, both to art and business, of this method of executing pictures, are very numerous. . . . Specimens of photo-lithography have been occasionally shown, which were very fair; but the processes were not sufficiently developed to produce the perfection required by art. This process . . . may be considered a decided step forward in this branch of art.[272]

Only the *American Journal of Photography* reacted negatively to the invention. Henry Garbanati, writing in the journal, described it as "scarcely an improvement, but by being more generally known by being patented, than Mr. Dixon's mode, simply answers the purpose of placing this branch of the art in exclusive hands." Garbanati also indicated that the patent award was as much a reflection of the inadequacies of the U.S. Patent Office as it would be a new bone of contention for the photographic community:

The practice of the Commissioners granting to almost all who apply, patents for the products of other mens' brains, because of some trifling, and perhaps, valueless variation, is

HOBNOBBING WITH THE FACES OF CELEBRITIES—AT BRADY'S GALLERY

Noting that "no feeling is more common everywhere than a desire to see great or famous people," a *New York Times* reporter went to study their faces at a photographic gallery.

It is not, however, always possible to see many great men together, but as it is quite easy to see their portraits, which answer the purpose almost as well as the originals, we went to Brady's gallery in Broadway a few days ago, expressly to pass an hour in an inspection of the features of the numerous people of note whom Brady keeps "hung up" in photograph. We found the amusement agreeable. It is pleasant, after reading what Senator [John P.] Hale [of New Hampshire] said, to look at the features of the man who said it. When we hear that Senator [James M.] Mason [of Virginia] has been pitching into Senator [William] Seward [of New York], it is agreeable to inspect the features, in a state of placidity, of the two belligerents. So also, when we learn that the President [James Buchanan] has been doing something tricky and evasive, it is not bad to have one's surprise immediately removed by a glance at the corresponding expression of features in the portrait of that venerable man. For the President is there—at Brady's—and almost opposite to the master stands the man, in the person of James Gordon Bennett, whose pleasant features excite in the portrait, the same sensations of doubt suggested by the inspection of the original, as to the actual direction of his visual orbs. Our affectionate Brother [Horace] Greeley is also there, the malicious photographer having placed him side by side with his affectionate Brother Bennett, just mentioned. Brother [Henry J.] Raymond [publisher of the *New York Times*] is also in the collection, and faithfully rendered to the last hair of his moustache. We sought in vain for Brother [James W.] Webb [publisher of the New York *Enquirer*], who begins to appear in plaster with great frequency as a sign for image makers in the side streets; he shines not at Brady's. The most striking picture now in the gallery is that of John C. Calhoun, a half-length portrait, photographed, life-size, from a daguerreotype miniature, and finished in oil. It is a beautiful piece of work, and wonderfully life-like. The ragged, wiry character of the face, marking nervous energy—the overhanging brow and broad intellectual development,—all mark Calhoun at a glance. We found, also, Mr. Speaker [James L.] Orr—a right proper, staid sort of gentleman, with an expression of countenance speaking loudly of red tape. Then we have the high and mighty General Lewis Cass, Secretary of State, etc., etc., with that peculiar "shut-up" case of countenance, which belongs to the high and mighty diplomatist. Mr. [John C.] Breckinridge, the Vice President, occupies a prominent place in the gallery—a gentlemanly but rather disputive face, with a nose somewhat of the Edwin Forrest [the actor] pattern. . . . Gov. [Henry] Wise [of Virginia] is also present in photography, with the decidedly *prononcé* face belonging to the Calhoun class—and near him is our beloved President, sunk into his chair—James Buchanan, with the "buck" forehead thrust forward, and his eyes a long way behind, peering at you from ambush as though it is not a delight to the old gentleman to look anybody in the face—the features expressing a strange mixture of obtuse stolidity and sharp cunning. . . . The great financiers are represented by Erastus Corning, two of the Messrs. Brown, of Wall Street, and Cornelius Vanderbilt—commonly called by persons who desire to impress you with their intimacy with the great, "Kurnele Vanderbilt"—whose portrait, by the way, is one of the best-looking in the gallery; there is an air of aristocracy about the face which does not altogether accord with the "Kurnele's" beginnings, but there is also a shrewdness which is quite in keeping with the little trifle of $50,000 a month which the Commodore is said to receive as a bonus for not running his Nicaragua steamers.[273]

1858

134

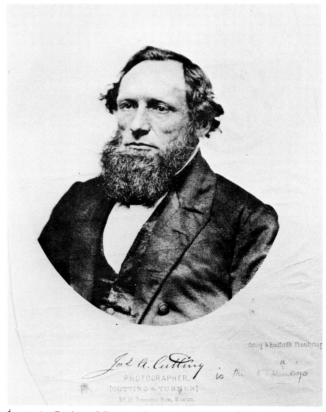

James A. Cutting of Boston, the great adversary of American photographers in the period from 1854 to a year following his death in an insane asylum in 1867, is pictured above in the five-hundredth impression of a photolithograph made in 1858 at the time he received the first U.S. patent with co-inventor Lodwick H. Bradford for an American photolithography process. Photolithography was little used after this, however, for reproduction of human likenesses in books, magazines, or newspapers.

becoming of so serious a matter, that it almost necessitates a "Vigilance Committee" to examine into the various claims No branch of industry has suffered more than the photographic, and it is really worthy of consideration whether its members should not subscribe to a general fund for mutual protection in keeping open all the various channels of improvement in the art.

Messrs. Cutting and Bradford, in applying for a patent for the simple use of sugar and soap in photo-lithography, either must have carefully eschewed all publications detailing the progress of their art. not to have known that the same results were obtained both here and in Europe before their claims, or, anxious to originate something themselves, have plodded over the well beaten track, and taken a vast deal of trouble to arrive at the point they might have started from ; nevertheless as they have claimed, on the use of the sugar and soap alone, it would appear as if they were cognizant of the previous success of photo lithography. 274

It appears that there may have been some connection between Cutting and the Duval firm in Philadelphia. The five-hundredth impression of the lithographic likeness of Cutting (shown above) turned up in the estate of James F. Queen, who served as Duval's chief artist. But an exhaustive study of lithography in Philadelphia in the nineteenth century has failed to uncover evidence that Duval engaged in photolithography to any extent. Nor is it known to what extent it was practiced by Cutting and Bradford. But in 1872, five years after Cutting's death, Bradford and Cutting's estate administrator obtained an extension of the 1858 patent.[275]

1859

In the spring of 1858, Edward Anthony told a meeting of the Mechanics' Club in New York that he doubted the practicability of forming a photographic society, then being talked about, because the "practical operators," he felt, had tried on several occasions to unite, but "there was no harmony." Amateurs, he said, could not spare the time.[276] Nevertheless, on February 22, 1859, about forty invitations were sent out to a list of "photographic amateurs" to participate in the organizational meeting of such a society which would be held four days later at the American Institute. The invitations were signed by eight men: Charles A. Seely, Henry H. Snelling, Joseph Dixon, P. C. Duchochois, Lewis M. Rutherford (the noted astrophysicist and early experimenter in astronomical photography), Alex H. Everett, John Campbell, and Benjamin T. Hedrick.

The organizational meeting was held, as scheduled, and a number of speeches were delivered citing the existence of a growing number of European societies and the need to make the American society "popular"; the importance of encouraging and making more popular the study of chemistry; and the opportunity to enlist membership among amateur photographers "of education and leisure," who seek further knowledge and instruction in the photographic art. A. W. Whipple of Brooklyn was named chairman at the organizational meeting, and committees were appointed to draw up a constitution and a set of bylaws.

Two additional organizational meetings were held in March at the newly completed Cooper Institute, after arrangements were made with the inventor and philanthropist Peter Cooper to hold these and subsequent meetings there.

At a March 26 meeting the new society was formally constituted as the American Photographical Society, and a slate of officers was elected which included Prof. John W. Draper as president; Lewis M. Rutherford, Dr. Robert Ogden Doremus and Henry H. Shieffelin as vice presidents; John Johnson as treasurer; and A. W. Whipple and Isaiah Deck, respectively, corresponding and recording secretaries.

How it all happened is not recorded, but for the first time an interest in the practice and furtherance of photography had brought together some of the medium's earliest pioneers—men such as Draper, Johnson, Snelling, and Dixon; scientific men, such as Rutherford, Samuel D. Tillman (professor of science and mechanics at the American Institute), Amasa G. Holcomb and Henry Fitz, Jr. (foremost American manufacturers of telescopes), and Robert MacFarlane (editor of the *Scientific American*); and a group of men who could be characterized as some of the foremost business, professional, and social leaders of the day. Dr. Doremus was professor of chemistry and physics at the College of the City of New York (later a vice president of the institution until his retirement in 1903), and was later a founder of the New York Philharmonic. Among others who signed the constitution were Robert L. Pell, president of the American Institute; Mendes Cohen, superintendent of the Hudson River Railroad, and later a trustee of the Peabody Institute in Baltimore and president of the American Society of Civil Engineers; James A. Roosevelt, founder of a New York banking firm, a director of the Delaware and Hudson Railroad, president of Roosevelt Hospital, and uncle of future President Theodore Roosevelt; Leopold Eidlitz, leading exponent of the "Gothic" revival style then popular in American architecture, and designer of such buildings as the Brooklyn Academy of Music and the State Capitol at Albany; and Cornelius Grinnell and Henry H. Shieffelin, the bearers of two of the oldest names in New York society. It is strange that the existence and activities of this society have remained so obscure, and that biographies of Prof. Draper, for example, fail to record that he was the founding president of the society, while recording his founding presidency of the American Chemical Society seventeen years later.

In Snelling's view, the existence of the new society would "prove to the world that we are not the mere mechanics in the business that we are deemed by many Europeans." Seely noted that "many scientific men were more or less engaged in Photography, and that it was only necessary for them to give expression to their views and labors through a society of this kind to place the art here in a position equally as elevated as in Europe." He also observed that not only were "the first scientific minds of the age" engaging in photography investigations in Europe but that "it had got to be quite fashionable, even the Queen of England devoting some of her leisure hours to its study and practice."[277]

The number of active photographers among the signees was not high. Those with distinguished careers (past or present) included Draper, James R. Chilton, Johnson, Fitz, Dixon, Burgess, Duchochois, Cady, Pike, and a newcomer, Napoleon Sarony. By June, membership in the society rose to a hundred, but in October, Seely noted in his journal that few other so-called practical photographers—just as Anthony, himself absent, had forecast a year earlier—had joined the body. In fact, Seely felt they would be "more out of place" in the society "than in any other spot they could find."[278]

The American Photographical Society not only survived but became the principal counterpart to similar bodies in a number of British and European cities. It continued to grow both in membership and stature, and in the 1870s it became the Photographic Section of the American Institute. Throughout its entire existence, it provided a major forum for the exchange of ideas, and the report of, or testing of, new discoveries in the photographic field.

The practice began at the society's first meeting on February 26, at which Duchochois presented a technical paper covering an entirely new mode of preparing more sensitive albumen glass negatives. At the society's third meeting, Samuel Wallin disclosed that another signer, Charles B. Boyle, had developed a commercially acceptable method of making photographs in wood, and that he (Wallin) had successfully applied the method to engraving. Two other pho-

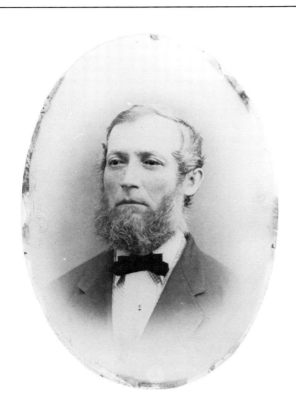

IVORYTYPES

In 1855, John J. E. Mayall patented a method in England for printing photographic images on artificial ivory sensitized either with albumen or collodion (after which the photograph was hand-colored). F. A. Wenderoth, of Philadelphia, invented a method described later by Marcus Root as a photograph which was colored and sealed upon plate glass. Wenderoth gave no description of his process at the time he exhibited specimens at a fair of the Franklin Insitute, but in a letter to H. H. Snelling, dated May 3, 1859, he said he had sold the process for $250 each to Jeremiah Gurney and C. D. Fredericks in New York.

Other modes of making an ivorytype followed the "Grecian printing" process whereby the hand coloring was applied to the backs of pictures secured on transparent paper or glass. A popular version was one using two superimposed prints on paper. The front print was made on transparent paper, and coloring was applied to the back of this print. The second, or back-side print, was made on ordinary photographic paper and coloring was applied to its face. The two prints were then sealed together.

In the ivorytype specimen shown on this page the portrait has been secured on the back of a piece of thin oval glass (top left) to which coloring was applied to the eyes, cheeks, and tie. A second piece of oval glass of the same size (top right) was placed behind the first, allowing skin coloring applied to the back of the rear glass to flesh out the otherwise transparent facial features on the front glass. Black coloring on the rear glass also darkened the subject's hair and clothing. At right, you see the result when the two pieces of glass are sealed together.[279]

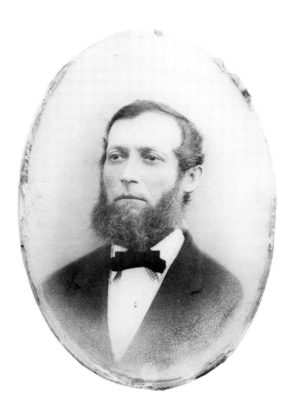

tographers who had earlier developed methods of using photography to make woodcuts were J. DeWitt Brinckerhoff and George N. Barnard (who exhibited pictures on box-wood at the 1857 American Institute fair). Most of the society's ninth meeting (on October 11) was devoted to a wide-ranging discussion of the problem and causes of faded photographs (a discussion which also alluded to evidence of daguerreotype fading, and possible methods of restoring faded daguerreotypes). Members used their new forum during 1859 to exhibit new advances in photolithography, improved enlarging and focusing apparatus, and even a French-made photograph on varnished cloth procured in France by Mendes Cohen.

The society elected to honorary membership such men as Nathaniel F. Moore, ex-president of Columbia University and an early amateur photographer; and T. Frederick Hardwich, the noted British photographer and professor of photographic chemistry at King's College, London. Dr. J. Milton Sanders joined the society in August, and George B. Coale became a corresponding member from Baltimore in July. There was much talk of establishing a museum of photography under the auspices of the society, and a committee composed of Johnson, Deck, and Hedrick was named to consult with Peter Cooper on the possibility of its establishment at the Cooper Institute. This scheme came to naught, however, when Cooper made the proviso that any museum established at the Institute would have to remain at the Institute thereafter. Proposals would continue to be made over the coming years, but no such museum would be established in New York for over a hundred years.

Among the more interesting demonstrations was a preview of a new electrical technique for instantly lighting a series of gas burners. The event took place on August 8, 1859, in the main hall of the Cooper Institute where there were 156 gas burners by Humphrey's count, and 168 by Seely's. Humphrey gave this description of the feat:

After this [previous discussion] the members received an invitation from Mr. Wilson to examine an arrangement he had in the large hall of the Institute to light the 156 gas burners at once by means of an electric spark. After finding their way with some trouble along the dark stairs to the darker hall, the company was agreeably surprised with a sudden brilliant illumination of all the lights; a thin copper wire is conducted from one burner to the other, and so arranged that a little spark, one-sixteenth of an inch long, will fly over to the orifice of each burner, as soon as the gas is turned on. The electricity used is the secondary current of Ruhmkort's induction apparatus, with the improvement of Ritchie of Boston.[280]

The electric current and sparks were of particular interest to photographers, Humphrey said, "as their light is one of the best to obtain impressions from in the night." Several years earlier, he said, Brady had made some large negatives in the Academy of Music at midnight, using the light of electric sparks. Six months after this demonstration, Abraham Lincoln came to the same hall to deliver his famous Cooper Institute speech which he later said was a major factor in his election to the presidency in 1860. On the occasion of his speech, it was said that in the quiet of some moments, the only sound competing with Lincoln's voice was the steady sizzle of the burning gaslights.

THE SIGNERS

The sixty-two names affixed to the constitution of the American Photographical Society, adopted March 26, 1859.[281]

PETER COOPER,
JOHN CAMPBELL,
WILLIAM CAMPBELL,
HENRY FITZ,
ISAAC FITZ,
ISAIAH DECK,
CHARLES A. SEELY,
A. W. WHIPPLE,
P. H. VANDERWEYDE,
HENRY GARBANATI,
B. S. HEDRICK,
THOMAS D. STETSON,
LEWIS M. RUTHERFORD,
P. C. DUCHOCHOIS,
ALEX. BENJAMIN,
M. HASKELL,
O. J WALLIS,
JOHN JOHNSON,
SAMUEL D. TILLMAN,
H. H. SNELLING,
JOHN C. LORD,
PHILIP BOILEAU JONES,
JOHN W. HADFIELD,
N. GRIFFING,
ROBT. L. PELL,
N. G. BURGESS,
GEO. A. JONES,
WM. H. BUTLER,
CHAS. WAGER HULL,
F. W. GEISSENHAINER, JR.,
NICHOLAS PIKE,

JNO. W. DRAPER,
A. G. HOLCOMB,
LEVI REUBEN,
HENRY DRAPER,
CHARLES HADFIELD,
R. OGDEN DOREMUS,
BERN L. BUDD,
HENRY H. SHIEFFELIN,
CHARLES A. JOY,
A. H. EVERETT,
AUGS. WETMORE, JR.,
EDWD. PRIME, JR.,
CORNELIUS GRINNELL,
J. A. ROOSEVELT,
H. MEIGS,
LEOP. EIDLITZ,
JAMES R. CHILTON,
J. B. WANDESFORDE,
JOSEPH P. PIRSSON,
WILLIAM CHURTON,
JOSEPH DIXON,
ALFRED PELL, JR.,
ROBERT MACFARLANE,
WILLIAM GIBSON,
F. H. HARDCASTLE,
MENDES COHEN,
N. SARONY,
SAML. WALLIN,
CYRUS MASON,
JAMES CADY,
CHARLES B. BOYLE.

1859

137

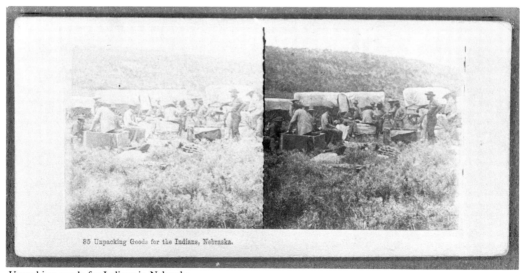

Unpacking goods for Indians in Nebraska.

Ford on the Little Blue River in Nebraska.

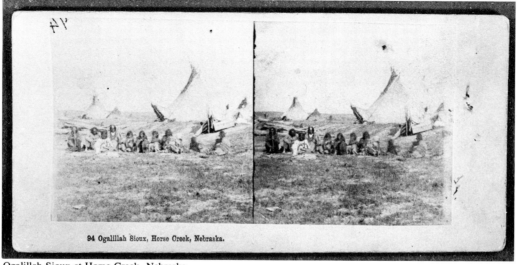

Ogalillah Sioux at Horse Creek, Nebraska.

ALBERT BIERSTADT SKETCHES,
MAKES STEREOVIEWS IN THE FAR WEST

A few daguerreotypes survive of the earliest government expeditions in the West, but the three illustrations (left) are from the first series of stereoviews made on an expedition in the summer of 1859 by Col. Frederick W. Lander, which had the purpose of relocating certain portions of a wagon route to the Pacific. The views are by Albert Bierstadt, earliest of the "Rocky Mountain School" of picturesque genre painters of the Far West.

Albert Bierstadt and his two brothers, Charles and Edward, were born near Düsseldorf in Germany, but grew up in New Bedford, Massachusetts. Albert early exhibited an avocation for painting, and in 1853 (at age twenty-three) he returned to Europe and studied art in Düsseldorf and Rome. During his stay in Europe, it is probable that he learned stereophotography from other artists who were then beginning its practice. In 1857, after his return to America, he explored the White Mountains in New Hampshire with a camera. Then, with S. F. Frost of Boston, he joined the Lander expedition to make sketches and photographs at his own expense. From somewhere in the Rocky Mountains, on July 10, he sent a letter to *The Crayon* which told briefly of his photographic exploits:

> We have taken many stereoscopic views, but not so many of mountain scenery as I could wish, owing to various obstacles attached to the process, but still a goodly number. We have a great many Indian subjects. We were quite fortunate in getting them, the natives not being very willing to have the brass tube of the camera pointed at them. Of course they were astonished when we showed them pictures they did not sit for; and the best we have taken have been obtained without the knowledge of the parties, which is, in fact, the best way to take any portrait. When I am making studies in color, the Indians seem much pleased to look on and see me work; they have an idea that I am some strange medicine-man. They behave very well, never crowding upon me or standing in my way, for many of them do not like to be painted, and fancy that if they stand before me their likenesses will be secured.

Bierstadt presumably traveled in his own wagon, heavily laden with glass negatives, darkroom materials, at least one camera, and artist's supplies. He went only as far as what is now Wyoming, then returned to New Bedford with an estimated one hundred to two hundred stereoscopic negatives to make paintings from his sketches by a method he had mastered in Germany. All three brothers thereupon formed a photography business, and in 1860 issued a sales catalogue offering fifty-two western views in glass and card stereograph form. The views were numbered, with gaps, from 53 to 136, suggesting that the negatives of missing photographs were not up to commercial standards. But it is possible that these were later published separately. In 1861, for example, *The Crayon* drew

Albert Bierstadt, circa 1870.

attention to publication by the Bierstadts of Albert's earlier views taken in the White Mountains.

In 1866, the Bierstadts sold their business, and during the 1870s, a castle-studio with thirty-five rooms which Albert built overlooking the Hudson River at Irvington, New York, became an American showplace, and he himself became a national celebrity. But then the castle burned in 1882, and in 1889 Bierstadt's work was passed over for the first time for an exhibit that year in Paris. After that he became a has-been, and at his death in 1902 he was all but bankrupt.[282]

"INSTANTANEOUS" STEREOVIEWS

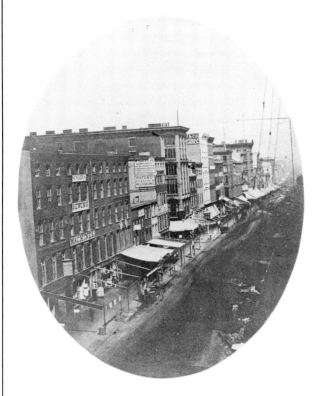

Until 1857, when George Washington Wilson made card stereographs of people and carriages in motion on Princess Street in Edinburgh, views of city streets were customarily barren of human activity, as in the view of Broadway (left) printed by Snelling from a negative by L. E. Walker. Early in the summer of 1859, Edward Anthony issued his first series of "instantaneous" card stereographs, and sent several specimens to the editor of the *Photographic Notes* in London. "One of these views," Anthony said, "was taken as you will perceive when it was *raining,* and the *drenched* appearance of the sidewalks and carriage way is admirably developed in the stereoscope [reproduced below]. The sharpness of the moving figures is sufficient evidence of the quickness with which it was taken. The development occupied but one or two minutes."

In response to Anthony's request to know how his pictures compared with "instantaneous" views taken in Europe, the editor of the *Notes* printed this reply:

> The noble street is represented thronged with carriages and foot passengers. All is life and motion. The trotting omnibus horses are caught with two feet off the ground,—boys are running,—men walking, driving, riding, carrying weights,—ladies sweeping the dirty pavement with their long dresses, or brailing up their crinoline and displaying their pretty ankles as they trip over the crossings, exactly as they do in Europe. . . . There is very little snow upon the tops of the omnibuses . . . and a little black sticking plaster in places, but at the same time a great deal of good halftone. In particular, the picture taken in the rain has a charming effect . . . we can only say we know of no pictures, save two or three of Mr. Wilson's best, which could be put in comparison . . .[283]

THE "WET-PLATE" ERA

The revolution in portrait photography, brought on by the carte de visite, together with the bonanza already underway in stereophotography, enhanced the supplies business for ready-made chemicals to fulfill the needs of photographers less schooled in chemistry and more concerned with speed of output.

CARD PHOTOGRAPHY REVOLUTION
1860

The *carte de visite,* or "visiting card," style of photograph was universally adopted for photographic portraiture in 1860. As its nomenclature suggests, the style originated in Paris, then spread to London and New York. Like the card stereograph, it could be made cheaply in small or large numbers, and for the first time, likenesses of the world's celebrities could be reproduced and sold commercially on a vast scale. The style was never used to any great extent for making outdoor views, but more full-length portraits were made by this method than had been previously attempted with either the daguerreotype or ambrotype processes. Carte de visite photographs customarily measured 2½ x 4 inches and were mounted on cards providing a small border around the sides and top of the picture, leaving room beneath the print for the photographer's logo. To N. G. Burgess, cartes de visite were a consequence of stereoscopic photographs, not an original conception. "They are in reality stereoscopes, only not viewed in pairs—for every card picture can be so arranged as to produce the stereoscopic effect, as most of them are taken with two sets of lenses."[284]

Silas Holmes, inventor of the "double camera," was, naturally enough, among the first to adopt the new style. As early as January 7, 1860, he began advertising that he could make "the London style" portraits for as little as $1 for twenty-five copies. But this was evidently unrealistic, and the going price soon established itself at a higher level of $1 for four copies, which occurred after the introduction of a new breed of cameras with four or more tubes, each able to take its own picture at the same time on one negative plate in the camera. One exposure would produce four separate but similar images on the one plate (or up to eight if the camera was equipped with a moveable plate holder). When printed, the images could be separated and mounted individually, providing a set of similar card photographs (see illustration, page 144).

The arrival of the carte de visite vogue was timely, and probably had more than a little to do with boosting the candidacy, and ultimately the election, of Lincoln in the 1860 presidential campaign. On the morning of his Cooper Union speech, February 27, 1860, Mathew Brady took an ordinary collodion negative of Lincoln which was later reproduced in carte de visite form, helping make the Illinois rail splitter known throughout the country. Once he was nominated, Lincoln was photographed in Chicago by Alexander Hesler on June 3, and more than one hundred thousand copies of four poses from this sitting were distributed in the campaign.

As Lincoln was being nominated in Chicago, Queen Victoria began the custom of putting cartes de visite taken of herself and the royal family (by John J. E. Mayall) into a new style of photograph album designed specifically to house card photographs. This immediately sparked yet another new vogue; people everywhere began putting cartes de visite not only of their family and friends but also of celebrities into what became known as the "family album." Fifteen U.S. patents were issued for designs of carte de

This example of a carte de visite photograph, reproduced in actual size, was made by C. D. Fredericks of his adversary, W. A. Tomlinson, the New York photographer and agent of James A. Cutting, holder of the "bromide" patent for collodion practice. In January 1860, Tomlinson brought suit against Fredericks to compel him to obtain a Cutting license for collodion practice. But the case was later taken out of Tomlinson's hands and was never fully prosecuted.

visite albums in the period 1861–65, most of them featuring recessed pockets in each leaf into which the card photographs could be inserted.[285]

While photography began to take massive new strides through the mediums of the carte de visite and card stereograph, legal skirmishes were stepped up by the forces of James A. Cutting against the New York photographic community. Cutting's agent for New York City and environs, William A. Tomlinson, had lost the first of these skirmishes

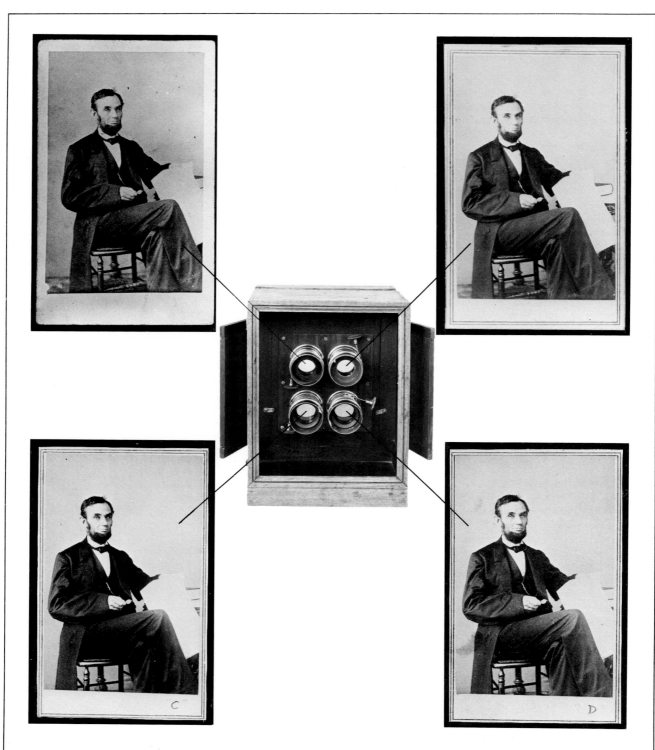

FOUR PRINTS FROM A SINGLE NEGATIVE

The carte de visite revolution brought with it a new style camera equipped with four or more tubes, each able to take its own picture on a portion of one glass negative plate. A contact print from one negative in a four-lens camera yielded four pictures on a single sheet of photographic paper. These were then cut apart and mounted individually to provide four similar but slightly varied carte de visite poses. This 1863 series by Alexander Gardner of Abraham Lincoln has been reassembled by Lincoln historian Lloyd Ostendorff.

in 1857 when a suit brought against Abraham Bogardus for violation of Cutting's ambrotype patent was thrown out of court (see page 118). Next, Tomlinson instituted a suit against Bogardus over the bromide patent, this time obtaining a judgment against Bogardus which the latter, under the press of business, settled out of court early in 1859.

The rumblings of discontent among photographers over the Cutting matter continued, fanned by the editorial fires of both Seely and Snelling. Humphrey chose to retire at this time (with good riddance, in Seely's view), and was never heard from again. In March 1859, Seely printed a sampling of letters received from various photographers—most of them opposing the Cutting patents—and three months later Snelling printed a factual review of discoveries and events prior to 1854 which indicated quite clearly that the patents had been wrongfully granted.

After the Bogardus settlement, Tomlinson moved again—against C. D. Fredericks—and for the first time, on February 3, 1860, a large group of photographers convened at the Cooper Institute to determine a course of resistance to Tomlinson and aid to Fredericks. Committees were appointed to solicit a subscription of funds to aid Fredericks' cause, and to contact photographers in other cities. Interestingly enough, men such as Bogardus, Charles C. Harrison, and Henry T. Anthony (brother of Edward, and partner in the newly renamed firm E. & H. T. Anthony & Company), who took no active part in the American Photographic Society, felt strongly enough about this issue to participate in the meetings at the Cooper Institute.

Successive meetings were held on the Fredericks case, and on February 24 a fund of about $500 had been raised. But the Fredericks case was never resolved. It became expensive for the Cutting forces, and its prosecution was passed from the hands of Tomlinson to those of Thomas H. Hubbard, who "knew how things were done in Yankee Land," as one observer later expressed it. "He approached the enemy; found it weak in pocket; made an offer, and the case, upon settlement, was very mysteriously allowed . . . to go by default." Thus, as the guns of the Civil War began firing, the skirmishes in the Cutting patent war were, for the time being, halted.[286]

There was a widespread interest at this time in instantaneous photography, as witness the card stereograph series issued by Anthony, and other series made across the Atlantic. On May 14, the subject became a matter of prolonged discussion at a monthly meeting of the Photographical Society when George Barnard appeared before the body with a series of waterfront views taken in Havana. The light was stronger than usual, and the collodion he had used was a little more sensitive; but that little difference, Barnard said, was very important in obtaining the results which he exhibited. W. S. Kuhns marveled at the Barnes prints because, while he could achieve "whites and blacks" in instantaneous photographs with any collodion, he could never achieve the "intermediate shadows" wanted. In the Barnard specimens, he noted, the stones on Moreau Castle could be distinguished even in the shade. Barnard estimated that his exposures had been made in as little as a fortieth of a second, but this was challenged by Lewis M. Rutherford. On the basis of his experiments with astronomical clocks and chronometers, as well as in estimating time by the

Mathew Brady's February 27, 1860, portrait of Lincoln was reproduced in tintype form to serve as a campaign medal measuring a half-inch in diameter (top) in the 1860 presidential election. A similar medal was made of a likeness of vice presidential candidate Hannibal Hamlin (bottom), a Maine Democrat turned Republican who was defeated for renomination four years later by Andrew Johnson.

chronograph, Rutherford said he doubted that the exposures could have been made in less than a fifth of a second.

Seely, who was also present at the discussion, referred to the many so-called instantaneous collodion mixtures being offered, but said these were not reliable because there were so many "little conditions" that determined a particular formula's sensitiveness. "Ether and alcohol today might be very different from what they were last week. A man however skillful he might be could not make gun cotton twice the same. There might be uniformity in the iodides and bromides, but there were complications when you tried to mix them with the unknown ether and the unknown gun cotton, and tried to put them in the ever-changing bath."

The discussion touched on two other important aspects of instantaneous photography, namely, the choice of camera used and, as Rutherford expressed it, "a good process of making the picture strong after you had got it." A year previously, Thomas Sutton had stated that "it is impossible in the present state of the photographic process to take in-

EARLY VIEWS OF THE FIRST MONUMENT TO GEORGE WASHINGTON

On July 4, 1815, in the presence of an estimated twenty thousand people, the cornerstone of the first monument to George Washington was laid in a cleared woodland area in front of the Baltimore home of Charles Howard, son of the Revolutionary war patriot John Eager Howard. The monument's architect, Robert Carey Long, sketched the scene (above) after the monument was finally completed, following construction delays, in 1829. The earliest known photograph of the monument taken from the same vantage point is the quarter-plate ambrotype (left) made about 1860, and found in an antiques store in 1972. By 1860, the monument had become the focal point of Baltimore's Mount Vernon Square. The chimneys of the Howard home can still be seen above the treetops to the rear of the monument, while at the extreme right is a corner of the famed Peabody Institute, whose walls were standing in 1860, although the Institute did not open its doors until several years later. Francis Scott Key, who composed the United States' national anthem in 1814, died in the Howard home in 1843. The Howard home was demolished in 1870 to make way for a Methodist church, and the railings shown ringing the park area in front of the monument were removed in 1877. Of the three wagons shown in the foreground of the photograph, possibly one contained the photographer's nitrate bath and other developing chemicals; for, as N. G. Burgess pointed out in his *Ambrotype Manual* (published in 1855), it was necessary to have the bath nearby when making outdoor views, since "as little time as possible should intervene after the impression is given before the developer is applied." [287]

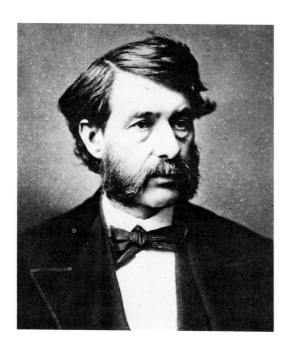

GEORGE N. BARNARD

Barnard's was among the longest but now least-known careers in early American photography. He began in Oswego, New York, in 1847, then moved to Syracuse. In 1853 he served as secretary of the New York State Daguerrean Association, and in 1857 perfected a method of using photography to make woodcuts, for which he was awarded a prize at the American Institute. In February 1861, he joined Mathew Brady's Washington, D.C., gallery where he helped photograph Lincoln's inauguration and made many of the earliest carte de visite photographs of the nation's political leaders and military personnel. When Gen. Sherman left Nashville in 1864, Barnard went along as official photographer for the Military Division of Mississippi, and his large photographs made on this campaign are among the rarest and most famous of the Civil War period. In the 1870s he worked in Chicago and in South Carolina, then returned to New York State where he helped George Eastman get started in business. Barnard and Eastman were elected members of the Rochester Photographic Association on the same evening in 1884. There are no details of his last eighteen years. He died in Onondaga, New York, on February 4, 1902.[288]

stantaneous pictures with a view lens and small stop.'' Sutton also said that the use of a portrait lens with full aperture presented yet another ''optical difficulty,'' in that it was not possible to get the sides of a picture into the same focus with that of the center of the picture. Rutherford echoed these sentiments at the Photographical Society meeting. It was important ''to have a camera which, with a large aperture gave a reasonable degree of distinctness in the different parts of the field,'' but that ''here was required a reconciliation of contradictions, because depth of focus really meant no focus at all. A camera which was microscopically sharp on any one point could not be so in regard to objects on any other plane. It was then by sacrificing a little of the sharpness in all parts of the picture, yet still retaining sharpness enough on the whole, that the best results were obtained.''

Instantaneous pictures, Rutherford also pointed out, were ''scarcely more than positives at first and required to be brought up.'' With this Seely was in total agreement. Earlier, he had expressed the matter in his journal in these words:

> The practice of short exposures has brought out the various methods of strengthening negatives by redeveloping and otherwise. The necessary opacity required for a negative is obtained with difficulty, after a short exposure, without recourse to reinforcement. Many photographers will be surprised to find with what a short exposure they can make a good negative, by carefully managing the development and strengthening.

One aspect of the subject not specifically covered at the Photographical Society meeting was the effect of a certain chemical which photographers used at this time in their nitrate baths, Edwin Musgrave touched on this matter some six years later in Seely's journal:

> In 1858, empirical mixtures and secret processes for the purpose of taking instantaneous pictures by the wet process were abundant. Experience has taught us, since that time, that the conditions requisite to produce pictures instantaneously are—absolute purity of chemicals and a condition of perfect balance between the collodion, bath, and developer, combined with tact and dexterious manipulation. The view as to the condition of the nitrate bath were also unsatisfactory at that time, acetic acid being recommended in preference to nitric acid for acidifying the nitrate solution; and there is no doubt that most of the excessive chalkiness of a great number of pictures taken at that period was due to the formation of acetates in the nitrate bath, as well as the accumulation of organic matter.[289]

1861

Along with the carte de visite and four lens cameras used to make them, the so-called multiplying camera came into vogue at this time. There were several versions of this type of camera, evidently, but the most famous was a camera developed by Simon Wing of Waterville, Maine, which Wing, together with Marcus Ormsbee of Boston, sold as the "Ormsbee & Wing Tri-Patent Multiplying Camera," beginning in the summer of 1861.

The four-tube device was equipped with a plate holder which could accept 616 negative images, each a half-inch square, on an area measuring 11 x 14 inches. To secure these images, the operator made a single half-second exposure (using all four tubes) on a corner of the plate, then sequenced the plate in one direction or the other by half an inch and made another half-second exposure, repeating the operation until the entire 11 x 14-inch area was fully covered. All 616 images could be obtained on the one plate in about five minutes, according to Wing, and a single print from the 11 x 14 negative could be made in a matter of about two minutes. By exposing ten plates in this manner at one sitting, Wing said, it was possible to obtain as many as 184,800 half-inch-square photographs in one hour.[290]

Today, we have only Wing's word that his camera could, in practice, produce this many pictures in one hour; however, within a year, the camera was reported to be making a considerable stir both in New York and Boston. *Humphrey's Journal* reported in August 1862, for example, that Ormsbee had opened rooms at 411 Broadway where the

camera was being used to make daguerreotypes, ambrotypes, and tintypes, as well as cartes de visite. This account by the editor (presumably Prof. John Towler, who had taken over the magazine's editorship the previous month) suggests that the invention had an explosive effect on photographic portraiture, much as Silas Holmes's double camera had had a decade earlier:

> We are told that some operators, with only one small room, have netted sixty and seventy dollars per day, or eight hundred dollars per month, by using this new Camera. The second size of the Patent Camera will copy and make from the face more than thirty different styles of pictures. We hear of parties who have recently started in business having leased rooms and hired apparatus, and commenced receiving ten, fifteen, and twenty dollars per day.. . . . With his wonderful multiplying camera he is now executing the vignette carte de visite photographs at the low price of one dollar and fifty cents per dozen, mounted on the finest quality of cards. He sells one card vignette of three dozen, without mounting, at two dollars; for another size, sixty-four on card, his price is only one dollar and fifty cents; duplicate cards, one dollar. Houses of Representatives, schools, churches, choirs, military companies, or assemblies of any kind, can obtain likenesses of a superior quality, by this new process, at as low a price as two dollars per hundred, each person, or ten dollars per thousand. He defies all competition as to price and quality unless by the use of the tri-patent camera.
>
> At Boston Mr. Ormsbee one day made sixty-four photographs of the Chaplain of the House of Representatives on one plate; the next day his rooms were full of Representatives, and the next following a committee called to arrange for 30,000 pictures. He has some of these card prints on exhibition at 411 Broadway, where all are invited to call and examine. [291]

One August Semmendinger, of 144 Elizabeth Street, New York City, appears to have secured an earlier patent for a multiplying camera, but this was not recorded in any

The first product-style photograph of a camera to be published in an American photographic journal appears to have been this illustration of the front (left), side (center), and rear (right) views of Simon Wing's four-tube camera, which could accept 616 negative images, each a half-inch square, within an area measuring 11 x 14 inches on a negative plate of size 12 x 15 inches. The illustration is an enlargement of an actual photograph of size 1¾ x ⅝ inches which was pasted into all copies of the July 1, 1861, issue of the *American Journal of Photography*. In the lower part of all three views is a drawer for storage of articles or materials used with the camera.

The Wing camera depicted in the carte de visite photograph (above) exhibits a protruding plate holder, which would be sequenced in one direction or the other for purposes of securing multiple exposures on a single 11 x 14-inch image plate. The patent for the moveable plate holder was assigned to Simon Wing by inventor Albert S. Southworth (see page 113).

defend my right. . . . My right to make and sell these boxes is a clear one, and I shall make and sell these boxes hereafter and shall warrant their use without a license. If you think that you are in a position to nullify my patent, commence your proceedings at once. I would prefer to see action on your part rather than your idle threats, as I shall then have an opportunity of showing to what extent you are an infringer on my patent, and also who was the real original inventor of shifting or sliding a plain plateholder on a camera-box.[292]

During or after the Civil War, Ormsbee moved his New York studio to 350 Bowery, south of the Cooper Institute, where his greatest volume of business appears to have been in making limited numbers of tintypes and cartes de visite for individual customers at low cost. Among his more popular orders were those calling for eight ferrotypes (tintypes) in carte de visite size for fifty cents; and eighteen vignetted cartes de visite in medallion size ($1\frac{1}{2}$ x $2\frac{5}{6}$ inches), also for fifty cents. "His box," *Humphrey's Journal* contended in the winter of 1867, "is an institution, and make no mistake."

By February 1, 1861, Seely could report in his journal that "card photographs in New York are now in the height of fashion. In several of the leading galleries it makes the chief business, and in one so great is the demand that the actual work is at least a week behind the orders; the patrons make their applications and appointments a week in advance. Each photograph is multiplied by the dozen, so that it appears that photographs may soon become as common as newspapers, and we trust as useful." As to the manufacturers of cases, mats, and preservers for daguerreotypes and ambrotypes, Seely reported on January 1, 1862, "Their occupation is gone."[293]

While phasing out this supplies business, E. & H. T. Anthony & Co. received a boost in the carte de visite business from two major sources. First, because business came virtually to a standstill in the South, the Charleston photographer (and former manager of Brady's gallery in 1851) George Cook sold a large amount of carte de visite negatives to the Anthonys, who thereupon made prints from them at the rate of a thousand a day. Secondly, because business at Brady's Washington, D.C., gallery was booming with sittings of Washington officialdom and soldiers (particularly following Lincoln's call for troops), Alexander Gardner, the gallery manager, approached the Anthonys with a plan to supply the firm with carte de visite negatives which the Anthonys could mass-produce and distribute from New York—the Brady and Anthony establishments both sharing in the profits from sales.[294]

There were only four photographers in the federal government at this time—one each in the Navy and Treasury departments; and at the Capitol Extension and Patent offices—and on June 10 Charles Seely proposed at a meeting of the American Photographical Society in New York that the society contact the War Department to discuss "the application of photography to military purposes." This was agreed to and a committee comprised of Seely, John Johnson, and a Mr. Babcock was named to follow through on the proposal. But nothing came of this effort, and later in the year Mathew Brady took steps on his own to organize a war photography operation for which he would receive lasting fame.[295]

of the journals until eight years later. Evidently Semmendinger's camera afforded enough competition to prompt Ormsbee to try to halt his sales. In response, Semmendinger sent Ormsbee a blistering letter, which was published in *Humphrey's Journal:*

Mr. Marcus Ormsbee: Sir: In the month of July, 1861, you and Mr. Wing from Boston called on me and informed me about a re-issue of a patent for multiplying pictures, stating at the same time that it would not interfere with my patent. I told you that I had procured a patent for the same purpose, February 21, 1860, and that before that time no Multiplying Camera-Box was known or used except those made by myself. Ever since (now over eight years) I have openly and publicly made and sold the boxes thus patented by me. Now some weeks ago, you requested me to stop making said boxes, a request which I of course utterly disregarded, and I then declared that I would

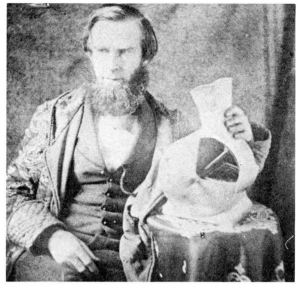

PRIMITIVE DEVICE MAKES
MOTION PICTURES,
USING CARD STEREOGRAPHS

On February 5, 1861, Coleman Sellers, thirty-four (above, right), professor of mechanics at the Franklin Institute School and supervisor of drafting at his father's machine tool factory in Philadelphia, patented the *Kinematoscope* device shown in both pictures above. Sellers was an avid amateur photographer, but his interests lay principally in mechanical engineering. The object of his patent, he said, was simply ''to exhibit stereoscopic pictures as to make them represent objects in motion, such as the revolving wheels of machinery.'' He harbored no thoughts of becoming the inventor of motion pictures. To prepare pictures for his rotating wheel device, he posed his two sons, Coleman, Jr., and Horace, and photographed related stages of action with a stereoscopic camera in a series of timed exposures (shown at left). These captured Coleman, Jr., in the throes of hammering a nail into a box, and Horace rocking gently in a small rocking chair beside him. Next, he made card stereographs and placed these on the surfaces of the series of paddle wheels comprising the drum of the *Kinematoscope*. Each photograph could be secured in a slot in the steel rim around the drum. By turning a knob (as in the photograph at top, left, showing the device as it appears today in the archives of the Franklin Institute), the viewer sequences the pictures and captures the illusion of motion, the one boy hammering and the other rocking. Because the stereographs are secured in their respective slots, the viewer receives only an instantaneous glimpse of each photograph before the appearance of the next one to follow. This provides movement which is intermittent rather than continuous, and prevents the appearance of blurring (a principle which became basic to all motion picture cameras developed in later years). Sellers made no effort to commercialize the *Kinematoscope,* and concentrated most of his energies on new machine tool inventions. In later years, he managed an organization which for the first time transmitted electrical power from Niagara Falls.[296]

FIRST AMATEUR CLUB

Henry T. Anthony, aided by two New Yorkers, F. F. Thompson and Charles Wagner Hull, organized an Amateur Photographic Exchange Club with headquarters in New York in November 1861. The club functioned until September 1863, when both Anthony and Hull were drafted into the Union forces. Membership was purposefully kept small, and each member was required to send every other member at least one stereoscopic photographic print six times a year at prescribed intervals. Members of the club included:

 H. T. Anthony, New York
 C. W. Hull, New York
 L. M. Rutherford, New York
 August Wetmore, New York
 F. F. Thompson, New York
 J. H. Haight and Mr. Masterton, of the Anthony firm, New York
 E. L. Cottenet, Dobbs' Ferry, New York
 George B. Coale, Baltimore
 Robert Shriver, Cumberland, Maryland
 Constant Guillou, Philadelphia
 S. Fisher Corlies, Philadelphia
 Prof. Fairman Rogers, Philadelphia
 Coleman Sellers, Philadelphia
 Dickerson Sargent, Philadelphia
 Frederick Graff, Philadelphia
 F. T. Fassitt, Philadelphia
 E. Borda, Schuylkill County, Pennsylvania
 Prof. E. Emerson, Troy University, Troy, New York
 Charles F. Himes, Troy, New York
 Henry Bedlow, Newport, Rhode Island
 Titian R. Peale, U.S. Patent Office, Washington, D.C.

The club reportedly issued seven issues of *The Amateur Photographic Print,* which was prepared by Thompson with contributions from members. Oliver Wendell Holmes declined membership in the club, but in later years Coleman Sellers reported that he had sent pictures to Holmes on April 2, 1862, and that the latter had sent him at that time "a fine stereoscopic picture of a large ball of rock crystal from Japan, in and on the surface of which can be seen the reflection of the objects in the room." [297]

THE GLOBE LENS

The crowning achievement of Charles C. Harrison's career was his development of the wide-angle *Globe* camera lens about four years before his premature death in 1864. It was imitated in Europe, and Prof. John Towler described it in the *Silver Sunbeam* as "all that can be desired for field work; it comprehends a larger angle than almost any other lens, and produces an irreproachable picture." Lewis Rutherford described it in these words at an American Photographical Society meeting on January 14, 1861:

Mr. C. C. Harrison has for a considerable time been engaged in perfecting a lens which appears to be a novelty in construction and its properties. He has already completed three grades: first, for stereo views with a focal length of 2½ inches and a flat field 5 inches in diameter; second, a view lens with 5½ inches focal length and a field 10 inches in diameter; third, a 12-inch focus and a field of 24 inches. Thus the angular aperture is double what has hitherto been achieved. The plan of the lens is this: the two lenses of the combination are symmetrical and are so mounted in the tube that their outer surface shall form a part of the surface of the opposite segments of the same sphere. These outside curves subtend an angle of about 180 degrees, and thus the combination is brought within a convenient length. A small stop is placed midway between the two lenses, and at the center of the sphere. The lenses being symmetrical, either end of the tube may be turned to the view. The trials with these lenses show that they give a flat field and a more perfect rendering of straight lines than any other lens. [298]

Up to this time, the principal camera lenses made for landscape and architectural use had originated in Europe. These included a Voigtlander lens whose mathematical design calculations had been completed by Petzval as early as 1840; the first aplanat (a lens free from spherical aberration, a defect caused by a lens's curved surface) introduced in 1857; a panoramic lens introduced by Thomas Sutton in 1860, which could cover a field of 120 degrees (but only on a curved plate); and a triple achromatic lens introduced in 1861 by John H. Dallmeyer.

At some point in (or before) 1860, Charles C. Harrison, the self-trained optician and New York camera manufacturer, together with a partner, J. Schnitzer, introduced the *Globe* lens, which became one of the most famous nineteenth-century American-made camera lenses. The lens covered a field of 90 degrees with an aperture which, in today's nomenclature, would be defined as f/30. At a meeting of the American Photographical Society held on January 14, 1861, Rutherford said the *Globe* gave a more perfect rendering of straight lines than previous view lenses, adding that Petzval "does not claim as much for his *Orthoscopic* lens, although he professes in that to have exhausted the subject." Seely was skeptical of the configuration chosen for the *Globe* design (see illustration, above), and pointed out

1861

152

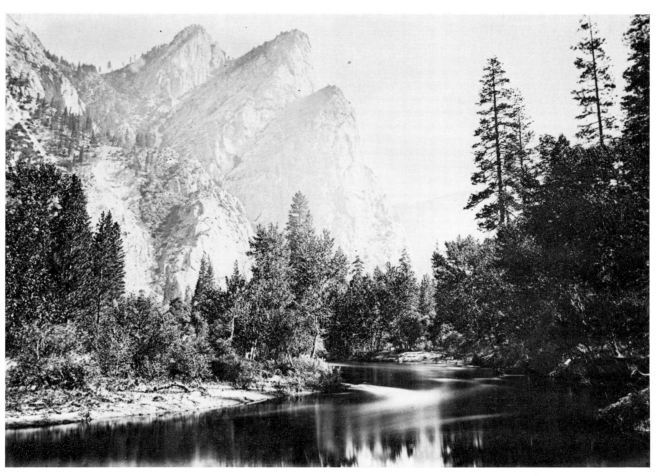

An American western landscape photography school was unobtrusively launched in 1861 when Carlton E. Watkins, a photographer in San Francisco, employed the first ''mammoth-plate'' camera (able to make photographs as large as 22 x 25 inches) on a trip to the Yosemite Valley. The unattributed photograph (above), was probably made at Yosemite by Watkins, since it is strikingly similar to one he is known to have made there in 1861.[299] Watkins came to San Francisco from Oneonta, New York, in 1851, then worked for Robert Vance before opening a gallery of his own in 1857. The camera he used in 1861 was probably made to order by a skilled cabinetmaker. Only about twenty-five mammoth-size photographs made by Watkins in 1861 are known to survive. The first photographer to make views in Yosemite was another Vance protégé, Charles L. Weed, but his photographs, made in 1859, were of the glass stereograph variety.

1861

EXIT HENRY HUNT SNELLING

For all of photography's first two decades, the name of Henry Hunt Snelling stands foremost as a chronicler of the American era of isolated practice. During the 1850s he endeavored to ride two horses—the one, his photographic journal, founded in 1851; the other his position as general manager of Edward Anthony's photographic supplies business. To handle these responsibilities he frequently worked as many as 16 hours a day. In 1857 he severed his association with Edward Anthony and engaged more heavily on his own in photography, while continuing at the same time to edit his *Photographic & Fine Arts Journal*. Reportedly, he suffered from nervous prostration at this time. In 1860, he was forced to relinquish control of his journal, and its management passed temporarily to William Campbell and Joseph Dixon of Jersey City. Then, in November 1860, it was absorbed by Charles Seely's *American Journal of Photography*. For Snelling there were no laurels or banquets proffered by a fraternity he so diligently supported—and lectured; and when Seely acquired his records he found there was enough in unpaid dues from subscribers "to make him [Snelling] a competency for his lifetime." Seely asked Snelling to write a small *adieu,* and the latter responded: "The photographic operators of the United States will, therefore, please consider my cap doffed, and with a low bow, I will say goodbye! and good riddance to bad rubbish!"

The son of a military officer, Snelling spent his boyhood on army posts on northern and northwestern frontiers. In 1837, he married the sister of publishing magnate George Palmer Putnam, whose son, George Haven Putnam, later described Snelling as "a good natured 'Skimpole' kind of a man, who was always in need of help from his brother-in-law."

Snelling's *History and Practice of the Art of Photography,* published in 1849, was considered the first American book on photography until attacked in 1973 as having been largely plagiarized from an early work by George T. Fisher, Jr. (an infrequent contributor to Snelling's journal in the early 1850s). But plagiarism among journals was more common in the nineteenth century, and Snelling was never attacked by others in his own time as were such other editors as Samuel D. Humphrey and Edward L. Wilson.

After giving up his journal, Snelling continued for a year to participate actively in meetings of the American Photographical Society, and during the 1860s he worked for several

H. H. Snelling in 1855—negative by Brady.

government agencies. During this period he reportedly suffered a breakdown, and in the 1870s assumed editorship of a Cornwall, New York, weekly newspaper. He became blind in 1887, and after the death of his wife he was forced to spend his last years in a home for the aged in St. Louis, where he died in 1897.[300]

that Sutton's panoramic lens "appreciated the advantage of the curvature of great angle."

Rutherford, who produced negatives and prints made with a *Globe* lens at the January 14 meeting, inquired of Seely:

"Have you seen the work of the panoramic lens?"

"Yes," Seely replied, but admitted that "it is not comparable to what is here exhibited. The field of the panoramic is curved, a fact which is a serious objection to it."

The Photographical Society appointed a committee to determine if the society should issue an official commendation of the *Globe,* but before the members could contact Harrison, he became ill for an extended period. Then, because of what Seely termed Harrison's subsequent "withdrawal," the committee was unable to prepare its report. On August 29, Seely called on Harrison's agent, but "was politely informed that the lens was not ready for exhibition, and that no information about it would be given at present." Seely was annoyed. "There is a good deal of unpleasantness hanging about this matter," he said. "We think also we perceive a slight odor of humbug . . ." He promised the readers of his journal that he would try to "blow away some

of the fog," but two years would pass before the lens would be accorded universal technical acclaim on both sides of the Atlantic.[301]

Prior to this time, the world had not engaged in any extensive debate as to whether photography should be considered one of the fine arts, although the matter would become an increasingly important topic over the next several decades. As early as 1856, it was suggested that photographs be included in exhibitions of the French Academy of Fine Arts, but in 1861 agents of Queen Victoria excluded photography from an exhibition of fine arts, setting off what Coleman Sellers described as a "war" between Her Majesty's commissioners and British photographic societies. Sellers chose this opportunity to author one of the earliest American essays on the subject, from which the following has been excerpted:

> The exclusion of photography from the ranks of the fine arts seems to me very unjust. That art or employment which confers the greatest amount of good on the greatest amount of people, and at the same time calls for the exercise of the highest mental attainments on the part of the artist or operator, is the one entitled to the greatest respect in its class.
>
> The engraving or etching claimed among the "modern fine arts" is not the work of an artist, it is the work of a printer, who may be a very uneducated man with no artistic taste.
>
> The copper plate which produced the print is the work of the artist, and in the print we see the proof of the perfection of the artist's work. This artist, however, has but the one mental faculty called into play. He has acquired great skill in cutting certain lines, all according to certain fixed rules and much—very much of his work has perhaps been performed by ruling machines and lathes of the construction of which he is ignorant. If now an ingenious mechanic should arrange machinery that an oil painting could by the machine be copied on a plate of copper, each shade and form reproduced by certain combination of lines and stipple, the print from this mechanical engraving would take its place among the works of great masters and enjoy the select society of the fine arts.

We know that a medal or other bas relief can be engraved by a ruling machine in a much more perfect manner than can be done by hand, yet the product is a picture produced by a machine; that machine is then the artist, or the workman who turned the crank is, for the product of the machine is an engraving and can be admitted into Section 4 (fine arts category) of the great exhibition. If now we take a step above engravings and into the domain of painting, let me not be charged with disrespect if I assert that it is more of a mechanical operation than photography. A grandson of Charles Wilson Peale, I claim as the descendant of a painter, a right to speak of painters, many of whom I am moved to say have been my dearest friends.

In old times before the making of colors became a trade, the pupil of a great master was first put to grinding paints; he was through a long course of apprenticeship taught to mix and compound from earths, metals, and vegetables all the brilliant colors that were the special charm of his master's work. That the works of the great masters have in some cases been more permanent than that of others, was due to their greater skill in preparing their pigments. Here there was required a practical knowledge of the chemistry of the substances used and scientific skill outside of painting. Now, however, the artist furnishing stores have put up in such neat little metal tubes, all kinds of tints and shades of color, that the modern artist is almost ignorant of the slab and muller.[302]

The problem, Sellers felt, was that "photographers are looked upon as men who without any scientific skill slop a plate with collodion, dash over it sundry liquids, and lo! and behold! a picture is made, in far too easy a way to be genteel." But in truth, he said, the success of the photographer depended upon his being well versed in chemistry, composition of the picture, and the delicate study and mastery of light and shade. He must also be a student of nature with a keen perception of the beautiful, and in the case of portraiture able to see character, notice peculiarities, and immediately highlight or compensate for these in making his finished product.

The zoetrope device, above, was invented before photography and was sold in toy stores for many years. When spun, illustrations painted inside appeared animated, but at the same time blurred, through viewing slots on the side. In his *Kinematoscope* (page 151), Coleman Sellers provided a mechanism for holding each image momentarily stationary during viewing, eliminating blurring.

HERE'S TO THE GIRL I LOVE

GOING HOME

OVER THE BAY

GOOD·NIGHT

INSTANTANEOUS STUDIO PHOTOGRAPHY

"Instantaneous photographs are always highly admired, and yet photographers rarely take them," S. D. Humphrey lamented in 1858. With the adoption by photographers of multi-tube cameras able to secure a series of portraits on one negative plate, infrequent attempts were made in the 1860s by some portrait photographers to obtain instantaneous ("candid," in modern terms) photographs of their sitters. The series above, probably made in 1861–62 by H. Skinner of Fulton, New York, is among the earliest examples in American photography of a storytelling sequence acted out before the camera. Although four of the scenes appear posed, the scene at bottom (left) has caught the movement of the youth's arm raising the bottle over his head in a gesture of reckless abandon.

1862

Most nineteenth-century photographs encountered today—whether a standard-size card portrait or a mounted print of larger or irregular size—will be found printed on extremely thin paper (which curls easily, if separated from its mount), having a glossy and brownish appearance. This indicates the extent to which albumen paper came to be used by photographers everywhere in making their photographic prints. By February 1, 1862, *Humphrey's Journal* announced that the use of albumen paper "is now the rage, and our country operators must learn this process very thoroughly if they wish to keep up with the times." Albumen paper had been adopted more extensively in Europe during the 1850s than in the United States, but by this time it became the American standard as well, lasting until nearly the turn of the century.

D. D. T. Davie, the veteran Utica photographer long prominent in the ranks of the so-called practical photographers in New York state, appears to have been a principal early proponent of its use, and was among the first to publish a series of articles (which he copyrighted) covering the workings of the process. The paper was "much preferable," he said, for use in landscape and architectural photography, and for photographing objects where detail was an important factor. Davie was also among the first to point out that the collodion negatives used for making albumen prints "must be made with collodion from very intense cotton iodized principally with potassium," which he said gave greater intensity than either cadmium or ammonium. Photographers, he said, should also abandon use of pyroxylene and other materials generally used in making negatives for printing on plain paper, because negatives made with these materials printed too feebly on the albumen paper, causing red tones "of which we hear so many complaints from all parts of the country."[303]

In this early period, improperly made papers added to the photographers' problems in adopting use of the albumen paper. "The New York market is constantly flooded by irresponsible parties with worthless trash at low rates," Davie cautioned one distraught photographer, "which proves as disastrous to country photographers as it is disgraceful to these money-seeking Abrahams who sell them." Davie also said, "if you would use the albumen paper and chemicals manufactured by the Daguerre Manufacturing Company and sold by dealers generally throughout the country, you would find immediate relief from those metallic tints and nearly all of your other troubles." The problem of print yellowing, he added, "may arise from two causes: for instance, there may be traces of hyposulphite of soda in your dishes, but it is more probable that your paper is coated with *rotten* eggs."[304]

About the same time, the writer of a communication to Seely's journal, identifying himself only by the single initial "L," complained that as far as the dealers in albumen paper which he had encountered, "not one of them knows whether it is salted with five or fifteen grains of salt, so that the purchaser can tell how to silver it only by experiments,

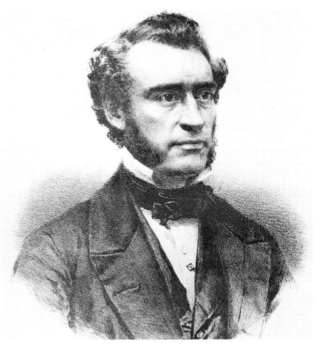

D. D. T. Davie, from *Humphrey's Journal,* September 1851.

which must be repeated every time a new purchase of paper is made." Every batch of paper, "L" said, should come marked on the margin with the salting. In response to this, Seely commented editorially: "Purchasers of albumenized paper should insist on knowing the strength of salting; a little agitation of the subject will bring about the much needed reform."[305]

The undertones of discontent evidently persisted, and in July 1863, *Humphrey's Journal* reported:

> The demand for albumen paper has fallen off tremendously of late, and nothing at all is doing in it. It is one of the worst articles in the trade to have anything to do with, there is such a want of uniformity in it, and each make seems to require a different formula for toning. If an operator now-a-days has anything the matter with his picture, he will be sure to lay the fault to the "albumen paper." We have seen some of the finest results we ever saw produced on albumen paper returned by country operators as "not good," "can't work it," etc. The different dealers in town we know sell tip-top paper and yet all have more or less complaints.[306]

With the benefit of hindsight it is not too difficult to see why *good* photography remained an elusive goal sought by many, but achieved only by a few. Davie had said that "very intense cotton" iodized with potassium was wanted to give deep shadows and clear highlights in albumen prints, but for the photographer this meant that if ready-prepared gun cotton of the required "intensity" was not available commercially, he must make his own. But the manufacture of gun cotton, N. G. Burgess pointed out in

PHOTOGRAPHY AND THE CIVIL WAR

"A spirit in my feet said 'Go,' and I went." This was how Mathew Brady, shown above with Maj. Gen. Ambrose E. Burnside before the confrontation with Confederate troops at Fredericksburg in December 1862, described the personal motivation which led him to organize his own photographic coverage of the Civil War—putting men, as he said, "in all parts of the Army, like a rich newspaper." The undertaking cost him $100,000, and it placed him in debt for the rest of his life. He did not himself become a prominent field photographer, but he covered the route of the Army of the Potomac at the first battle at Bull Run in July 1861, the abortive sieges at Antietam (September 1862) and Fredericksburg (December 1862), the Union defeat at Chancellorsville (May 1863), the battle at Gettysburg (July 1863) and the nine-month siege of Petersburg (June 1864–April 1865).[307]

At the wooded photographer's studio (top right), a mammoth-plate camera is used to make large negatives and prints of hand-drawn maps, which could then be distributed to Union field commanders. Government agencies, following Brady's lead, also put photographers in the field during the war, and the "camp-following photographer" was to be found everywhere, principally making tintype or ambrotype portraits of soldiers to be sent home to loved ones. The ambrotype tent (bottom right) was set up at Cloud's Mill, Virginia. Because the collodion process could not easily cope with movement, only four views are of actual battle scenes among the thousands of Civil War photographs in the Library of Congress.

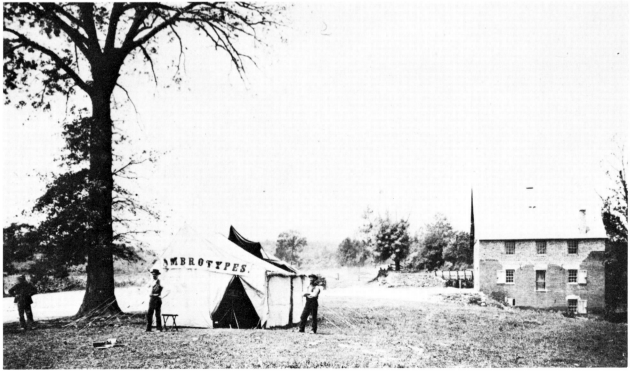

Oliver Wendell Holmes (1809–1894) was a proponent of stereophotography. He advocated libraries of card stereographs for all major cities, and invented the hand-held stereoscope with hooded pair of lenses which became the most popular and widely used card stereograph viewing device in the nineteenth century.

ALBUMEN PAPER MANUFACTURE REQUIRES COOPERATION OF 10,000 YANKEE HENS

Oliver Wendell Holmes, the author and physician, visited E. & H. T. Anthony & Co. late in 1862, where he found that the eggs from some 10,000 Yankee hens were required to coat the large stock of paper which the Anthonys had on hand for making albumen photographic paper.

The paper was sold dry to the trade, and had to be floated (albumen side down) in trays of silver nitrate solution for sensitizing before use. Photographers sensitized their paper daily, as the paper would not keep in its sensitized state. After exposure of a glass negative in the camera, the sensitized paper was placed in a printer's frame against the collodion film of the negative and development took place under exposure to sunlight, usually on the rooftops of buildings housing photographic galleries. In the case of the larger establishments, long racks were used providing room for as many as a hundred frames. The action of the sunlight was allowed to continue until a print obtained what the printer considered to be its suitable contrasts. No chemicals were used in the development process, and printing could not be accomplished on dull or rainy days. Developed prints were subsequently washed in a darkroom, toned with a solution of gold chloride, and fixed, as they are today, in hypo.[308]

his *Photography Manual,* first published in 1862, "is usually attended with many difficulties, and liable in all cases to result in failure from the slightest variation of the process, and withal is quite detrimental to health. It is therefore recommended," he said, "to purchase the gun-cotton, when possible, thereby saving all the perplexity and uncertainty attending its preparation."

When the subject of making collodion negatives came up in a discussion at the Photographical Society at this time, Lewis Rutherford said he felt that when all was said and done, the making of the best negatives was a matter of compromises:

> To get the minutest detail, thin collodion must be used; but the print from such a negative is without any life. If a thick collodion, or a strengthener be used to secure the vigor, it is at the expense of detail. We cannot have strength and fineness of definition at the same time. The subject of the picture, our tastes, etc., must determine in what proportion we shall have these combined. I think it is better to get the negative desirable without recourse to strengtheners. A negative which owes its intensity only to strengtheners is harsher than when it is obtained by the simple development. Yet as we have not the skill to control the conditions of developed intensity, we must occasionally resort to strengtheners, and hence their peculiarities of behavior are worth study.[309]

Small wonder, too, that the ranks of amateur photographers did not become substantially larger, even though the carte de visite and card stereograph were bringing photography into every home to an extent never before known. One of the most illustrious amateurs of this time, Henry J. Newton (later president of the American Photographical Society), recounted his early experience in these words:

> To succeed then meant hard work and study. You were required to know how to make almost everything connected with the production of a photographic print. You must know how to make collodion; how to coat a plate and how to sensitize and develop it; how to construct the silver bath in which the plate was sensitized; how to make the developer; how to clean the plate; how to prepare the nitrate of silver bath for sensitizing the albumen paper; to fume, print, tone and fix the prints; how to make paste, and how to mount the prints. The amateur of those times was further required to make himself familiar with the chemistry involved in all this work: first, in order that what he did he might do intelligently and successfully; and, second, to be qualified to determine with a degree of certainty what was the matter when his chemicals gave unsatisfactory results. The negative bath was one of his most treacherous friends; he could not predict, with any degree of certainty, what would happen to the next plate by the result on the one immediately preceding it.[310]

Tricks of the trade were legion. Today, some of the earliest card stereographs to be found in the archives of the Library of Congress are a series donated to the library in the period 1858–61 by Franklin and Luther White, of Lancaster, New Hampshire. The views are principally of the White Mountains, and at a meeting of the American Photographical Society on December 8, 1862, Franklin White said the trick used by the brothers to keep their collodion plates moist while hiking in the mountains was to wrap them in wet towels and carry them in a "close-fitting box." This procedure, White said, kept the plates moist for at least three to four hours.[311]

SNELLING—OUT OF STEP—ARGUES AGAINST USE OF ALBUMEN PAPER

The deterioration or fading of photographs made on albumen paper remained a much-talked-about subject throughout the nineteenth century, suggesting a certain prophecy in these remarks by H. H. Snelling at a meeting of the American Photographical Society:

Notwithstanding the brilliancy and strength given to the picture by albumen, I am decidedly adverse to its use, as from its very nature, and the necessary preparation of it for photographic purposes, it must be considered the least calculated to ensure permanency. I repudiate the idea, that, because its present results are so fine, and the people at large prefer it, photographers should use and recommend it. The ultimate results should alone be considered if we desire to perfect photography and give confidence in it to the public mind. The natural affinity between sulphurated hydrogen and albumen is increased by the various processes through which albumenized paper passes during photographic manipulation, and, although I have seen thousands of albumen prints from all parts of the world, and of every size, I have yet to see one, of more than a few months' existence, uninfluenced in a greater or less degree by the destructive agency of this sulphurated hydrogen. Pure albumen may be dried and hardened, cut and shaped so as to resemble amber, and so it will remain so long as it is kept perfectly dry, but let it become saturated with moisture, sulphurated hydrogen will attack and destroy it. In photographic printing on albumen the toning and hyposulphate baths render the albumen more disposed to absorb moisture and consequently it is more easily attacked by the sulphurated hydrogen of the atmosphere. Decomposition by this obnoxious gas often occurs in albumen paper before it gets into the photographer's hands, and hence arise some of the complaints constantly dinned into the dealers' ears.[312]

ENTER HENRY J. NEWTON

About 1858, Henry J. Newton, then thirty-five, had made a small fortune in the burgeoning field of American piano manufacture and decided to take up amateur photography. He joined the American Photographical Society in 1863, became its treasurer in 1864, and its president by 1874.

Newton was born in Pennsylvania, but grew up in Somers, Connecticut, and received his education at the Literary Institute in Suffield. In 1845, he began a four-year apprenticeship to learn "the art and mystery of piano-forte making." In those days, a grand piano (shown below) was simply "the most perfect and magnificent" of the three styles of square pianos sold under the name piano-forte.

In 1849, Newton established a business with C. F. Lighte. At that time, American-made pianos were a rarity, and European concert artists visiting the United States customarily traveled with their own instruments. Newton's name was gone from the business by 1869, when the name of the firm was listed as C. F. Lighte & Co., ninth after Steinway on a list of twenty-six of the most prominent United States manufacturers.

Newton bought his first supply of photographic apparatus and materials from Charles Seely, who operated a store on Canal Street in addition to publishing the *American Journal of Photography*.[313]

Accidents, too, were frequent. Louis M. Dornbach, a manufacturer of gun cotton in Brooklyn, New York, suffered the demolition of one three-story brick building in an explosion of the gun cotton, then was killed in yet another explosion on June 22, 1862, while packing a shipment for Connecticut at a second factory in a remote area of the Williamsburgh (now Williamsburg) section of Brooklyn. Dornbach, thirty, manufactured gun cotton at the rate of a hundred pounds daily, and was using a heavy stick to press down the cotton in 20-gallon waterproof casks made of stout oaken. A thrust, probably heavier than usual, ignited the mass, according to a later account.

When a photographer told of an explosion of a collodion bottle which he was endeavoring to clean with a bottle brush, water and alcohol, Coleman Sellers responded with a word of caution to all photographers against using wire brushes inside a glass tube. "It is a well known fact that if the inside of a glass tube be touched by a rough wire it will be scratched," Sellers explained, "and that scratch though ever so slight will be the starting point from which a [spontaneous] disintegration of the tube will radiate; and the fraction is always in rings and of a conchoidal form."

Mice "frolicking among a lot of matches," which *Humphrey's Journal* said had caused earlier fires, was the cause of a fire which destroyed D. D. T. Davie's gallery in Utica in August 1862.[314]

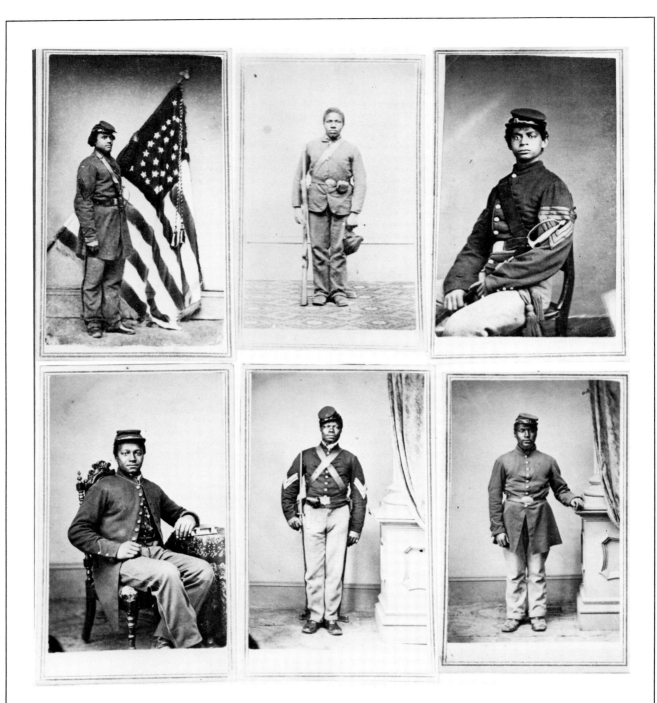

The blacks' role in the Civil War began when the fugitive slaves, who followed Union forces everywhere, were pressed into service in labor battalions, then were recruited for guard detachments and given castoff army uniforms. Early in 1863, the government authorized the organization of black regiments to be officered by whites, and to be available for combat duty. The pride which many of these men must have felt is reflected in these rare carte de visite photographs made by post photographers at barracks in Rock Island, Illinois, and neighboring Camp McClellan in Iowa. By the war's end, more than 150,000 black soldiers had been placed in uniform.[315]

1863

Having taken it upon himself to fund a large-scale photographic coverage of the Civil War, Mathew Brady evidently decided that other events demanded his personal attention, and he was therefore not present when Abraham Lincoln dedicated the battlefield cemetery at Gettysburg, Pennsylvania, on November 18, 1863. Brady was in New York, where a squadron of Russian naval vessels had arrived on October 1. After the admiral and his staff had posed for Brady's cameras, weeks of celebrations followed, ending just about the time of the Gettysburg dedication with a reception by the city of New York which Brady attended at the Astor Irving Hall.

Alexander Gardner and Timothy O'Sullivan, whose photographs of dead soldiers at Gettysburg had shocked Lincoln and the nation only a few months earlier, were also absent. While one or more photographers from Brady's staff, as well as other local photographers and several stringers were on hand, it appears that only one prominent nineteenth-century photographer was there. This was David Bachrach, Jr., then only eighteen, and later founder of the noted firm of chain portrait studios which still bears his name. Bachrach was serving as an apprentice to William H. Weaver, who was acting as a stringer for *Harper's Weekly*. His presence at Gettysburg went unnoted at the time, and would have remained so were it not for this brief description of his participation in the events of that historic day which were recorded in the *Photographic Journal of America* (formerly *Wilson's Photographic Magazine*) fifty-three years later:

> My employer was called on by a photographer sent by the Harpers to aid in photographing the dedication of the Hill cemetery at Gettysburg. I took the portable dark-room and drove over the hills by way of Westminster and Emmittsburg, a day and a half being consumed, and did the technical work of photographing the crowd, not with the best results with wet plates, while Mr. Everett was speaking. After this hour and a half of oratory, Mr. Lincoln got up (I was on a temporary stand about ninety feet away) and in about three minutes delivered his famous address, which drew no demonstration and was hardly even noticed by the current papers. . . . The negatives, 8 x 10, were of no real interest, I then thought, and the gentleman took them for the woodcut artists.[316]

It was customary in these times to give original photographs of public interest to engravers or woodcut artists for use in preparing magazine, newspaper, or book illustrations. Brady, for example, was doing precisely the same thing in New York with his photographs of the visiting Russian naval officers. Presumably, whatever photograph or photographs Bachrach secured of Lincoln and passed on to the woodcut artists were discarded by them, or became lost thereafter. This, too, was the customary fate of many important photographs, as we have already seen.

If Bachrach retained any negatives of the Gettysburg events, they were lost or sold. According to Bachrach family records, many of Bachrach's early negatives were destroyed in the great Baltimore fire of 1904, although the Bachrach studio, at Eutaw and Lexington streets, was several blocks west of the vast downtown district which burned. At some point in the early 1900s, Bachrach reportedly sold certain of his Civil War negatives to Charles Bender, of Philadelphia, who with his father made a business of buying photographers' glass negatives (at the rate, sometimes, of a million plates a year, according to Bender) in order to remove the negative emulsions and resell the clear plates again (in bulk form) to various customers, including photographers and gas meter manufacturers. Among the Bachrach negatives which Bender reports buying were those of the hanging of Mrs. Mary Surratt after the assassination of Abraham Lincoln, and of "those guilty in the [1901] assassination of President McKinley."[317]

By this time, several methods of making photographs with a *dry* collodion process had been introduced, but only five months prior to Lincoln's speech, the new editor of *Humphrey's Journal,* Prof. John Towler, was telling his readers that "it must be confessed that the same degree of sensitiveness in the dry process has not yet been attained as in the wet process; and instantaneous pictures," he added, "are the result only of the latter." A short time later (two months before the Lincoln speech), Towler claimed that it would be "absurd, because as yet impossible of success, to attempt by means of dry plates to photograph the vitality of Broadway, the mobility of old Ocean, the moving, undulatory masses of water at Niagara, or the onslaught of a Brigade on the field of battle." On the basis of these comments, the reported use of dry plates by one photographer at Gettysburg must have been something of a novelty.[318]

But a year prior to the Gettysburg battlefield dedication, a British journal observed that while the number of amateur photographers in the United States was "decidedly limited" (when compared with the number in Britain), nevertheless, "since dry photography has begun to be appreciated there, the number of amateurs has increased." With this, Towler was in agreement. "With amateur photographers, the wet collodion process," he said, "in a great measure is becoming gradually relinquished, and the various dry processes are taking its place; hence the great search after preservatives by which the sensitized collodion film can be maintained for a long time in a normal condition of sensitiveness even when the film of collodion is dry. Amonst the preservatives in vogue are found: tannin, gums, resins, milk, honey, syrups, malt, serum, etc. The best seems to be, without doubt, tannin; and the attention of photographers is directed mainly to the perfection of the tannin process."[319]

Although it is not usually considered in this light today, the albumen process—either Niépce's or Whipple's process—was considered a *dry* photography process at this time, as was, also, Le Gray's waxed-paper process. But the *collodion* dry processes introduced in the 1850s and 1860s all involved the use of a preservative coating of one kind or another (among them albumen) atop the wet collodion, which, when dried, allowed the plates to be kept for a matter of weeks, or up to six months before use. The preserva-

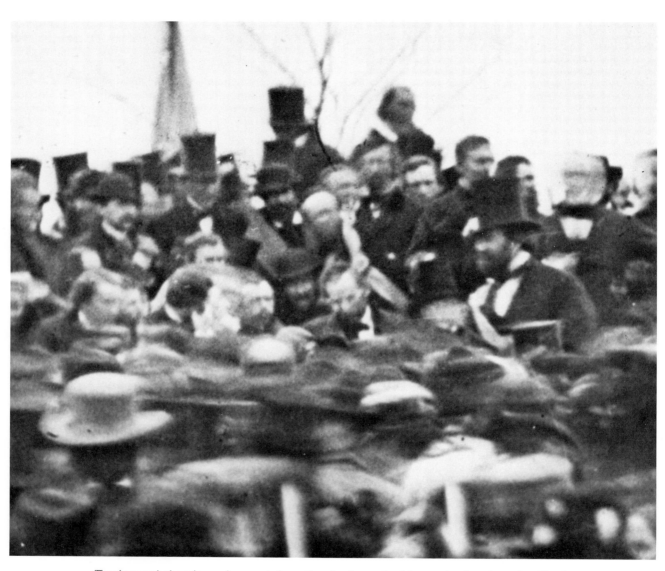

The photograph above is an enlargement of a portion of a view made of the crowd at Gettysburg when Lincoln dedicated the cemetery on November 18, 1863. Lincoln appears bareheaded in the center, his head inclined slightly forward, while white-haired Edward Everett, who gave the principal oration of the day, stands out second from the right at top. The photograph is said to have been taken by an assistant of Mathew Brady, who was in New York at the time. David Bachrach, Jr., who later founded the noted chain of Bachrach portrait studios, was ninety feet away, but it is unclear from statements he made fifty-three years later whether he photographed the President during or after his brief address.

1863

tive processes were all of English or French origin, and of all of them the tannin process, introduced by Maj. Charles Russell in 1861, did indeed become the most popular in the United States.

The process involved coating the wet collodion negative with tannic acid, which in addition to acting as a preservative also had a beneficial effect on negative development after the plate was exposed in the camera. As with most photographic processes, this one was also modified by users in one way or another. Prof. Edwin Emerson of Troy University, for example, found he could gain increased sensitiveness for his tannin plates by adding honey to the tannic acid.

Among the earliest users was A. F. Styles, a professional photographer in Vermont, who retired to Florida for health reasons at this time, taking his tannin plates with him. He took orders for pictures, then sent the negatives back to his Burlington, Vermont, gallery for processing and forwarding to his customers in the North. For three winters he did a large business, principally in card stereographs, securing a monopoly of the photographic business for himself in Florida. Then, having become enamored of life there, he sold his Vermont property entirely, bought a tract of land five miles south of Jacksonville, and began an orange grove.

Most collodion dry plates became articles of commerce after 1860, but in 1862 a British writer lamented that "dealers in photographic apparatus have never yet had the enterprise to establish a manufacture and sale of dry plates in such a way as to insure their popularity." The problem was that few plates could be depended upon. "Some will not keep long enough before exposure; some will not keep at all after exposure; some fail in sensitiveness; some spoil soon after they are opened; to say nothing of the constant liability of stains, irregularities, blisters, and all sorts of troublesome and annoying defects, which not only spoil the operator's work but—what is of more importance—destroy all reliance on his operations, and so discourage him from undertaking them."[320]

After a period of several years' silence, Charles C. Harrison's *Globe* lens received a full measure of laurels in the spring of 1863—both from technical leaders in the photographic community and from the United States government. In February, a long discussion on the attributes of the *Globe* was held by the Photographic Society of Philadelphia in which various members, among them Coleman Sellers, attested to the superiority of the lens after field trials. In May, Sellers published a lengthy tribute to the lens in the *American Journal of Science,* stating at the end of the article:

> Its advantages may be summed up in a few words. Short focus, clear definition, wide angle of included vision, absolute correctness of copy on a plane surface, and tolerably quick work. It takes the place entirely of the orthoscopic lens, giving absolute correctness to marginal lines, while the orthoscopic was only approximately correct. It fills all the requirements of a lens for landscape and architectural work, and is wanting only in the one thing of absolute instantaneity of action.[321]

The United States Coast Survey came to a similar conclusion after trials in which the *Globe* was used to make photographic copies of large maps without line distortion. In En-

THE APPRENTICESHIP OF A FAMOUS PHOTOGRAPHER

In 1858, Robert Vinton Lansdale (above) established a photography gallery in Baltimore where he reportedly took the first daguerreotype of Madam Jerome Bonaparte, the former Elizabeth Patterson of Baltimore, whose husband was King of Westphalia and a brother of Napoleon I. His first apprentice was David Bachrach, Jr., later founder of the Bachrach chain of portrait studios.

Landsdale, according to Bachrach, "was different from most of the leading artists, more intelligent and full of the experimental spirit, which suited me exactly, and further, he was a man of high moral character and free from the scandals connected with some of the leading photographers. He thoroughly understood the technique of the business and was fairly artistic. I kept up my friendship for him until he passed away."

In 1861, Bachrach was employed by William H. Weaver, an ornamental painter who had made a specialty of outdoor photography, and who was employed at times for special jobs by *Harper's Weekly.* "On account of the chemical and technical experiments made by the influence of Mr. Lansdale, to which I was naturally adapted," Bachrach recalled later, "I found myself knowing more about that part than the employers I was with, and, as a result, I had my own way and was hardly an employee at all." This applied particularly, he said, to Lansdale and Weaver, and later with William Chase for whom he worked from circa 1866–68.[322]

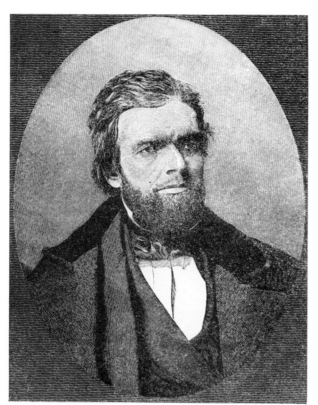

This woodcut illustration of camera and lens manufacturer Charles C. Harrison, which appeared in the February 1855 issue of the *Photographic & Fine Arts Journal,* was said by editor H. H. Snelling to have been the first American photograph secured from a glass negative on a wooden surface. The feat was accomplished by Harrison's former associate, J. DeWitt Brinckerhoff, and signaled the start of this direct mode of making woodcuts for book and magazine illustration. George Barnard developed a method for taking photographs on wood for engravers, and in 1857 he sold his gallery in Syracuse to devote full time to this branch of photography. The practice became commonplace after the Civil War.

DRY COLLODION PROCESSES

Between 1855 and 1861, various methods were introduced for coating wet collodion negatives with other preservative substances, after which the plates could be dried and kept for later use. In 1864, a workable process was developed for bottling a negative sensitizing emulsion (collodio-bromide of silver) which could be flowed on a glass plate when the photographer was ready to take a picture. But all dry collodion methods required long camera exposures, and none served to *supplant* the wet plate. The principal preservative methods were the following:

TAUPENOT PROCESS—Introduced by Dr. J. M. Taupenot, the wet collodion film was given a coating of iodized albumen. After drying, the plates could be kept several weeks.

NORRIS PROCESS—Introduced by Dr. Richard Hill Norris, of Birmingham, England, the wet collodion film was given a coating of liquid gelatin (which would soften in water during later negative development, allowing the developer to pass into the collodion base). These plates could be kept dry for six months, and were the first to be sold as articles of commerce.

FOTHERGILL PROCESS—Introduced by Thomas Fothergill, the wet collodion film was given a coating of albumen (as in Taupenot's process), but was washed off, leaving just enough in the pores of the collodion base to allow proper action of the developer during negative development. These plates were also sold commercially.

TANNIN PROCESS—Introduced by Maj. Charles Russell, the wet collodion film was given a coating of tannin, which was a further aid in negative development.[324]

gland, John Werge, having heard so much about the *Globe,* imported a 5 x 4-inch lens, which he found "embraced a much wider angle than any other lens known." C. Jabez Hughes used it to photograph a royal bridal suite in the Isle of Wight, after which Werge said, "I feel certain that no other lens could have done the work so well." Werge also showed the lens to John H. Dallmeyer. "He thought he could make a better one," Werge said, "and his wide-angle Rectilinear was the result."

Not only Dallmeyer but also Thomas Ross of Edinburgh, and Darlot in France, copied the *Globe* design, as evidenced in an article published in 1865 by M. Carey Lea (reproduced on page 167). As of May 15, 1863, Harrison had manufactured 307 of his *Globe* lenses, and some 8,817 portrait and other view lenses.

According to Snelling, Harrison was a large man, but not physically strong. Virtually nothing is known today of his life, and there appear to be no records of his successive achievements culminating in the *Globe* objective. On November 23, 1864, Harrison died of apoplexy, and we have only Snelling's word that he died "while still quite young." Several weeks after his death, D. D. T. Davie wrote in *Humphrey's Journal:* "I did not know of the death of Mr. Harrison until I read the obituary notice in your journal. I have a desire to find his grave, to visit it as a mourner."[323]

The phenomenon known as "spirit photography" made its appearance at this time, and like the spiritual séance, it quickly gained its adherents and detractors. The photographic press took first notice of the movement in January 1863, reporting its origins in the hands of one William Mumler in Boston. "The subject is introduced with an apology," Seely commented in his journal, "for we are persuaded that in a short time spirit photographs will be generally looked upon as a low swindle." But he was wrong. Spirit photographs would continue to be a matter of discussion and debate for a dozen years. As early as the summer of 1862, carte de visite portraits depicting the appearance of a "spirit" behind and above the sitter were sold at five dollars a dozen to vast numbers of customers in Boston. Despite the fact that the trick could be easily performed by letting the "ghost" appear suitably draped in a white sheet for only a portion of a camera exposure, photographers, "out of curiosity to see how the spirit photographs are made," flocked to see them at their first New York showing

THE GLOBE LENS IN WORLD PERSPECTIVE

M. Carey Lea was one of the foremost authorities on photochemistry in the nineteenth century, and his *Manual of Photography* published in 1868 was long considered a standard work among photographers. He served as American correspondent for the *British Journal of Photography,* and by 1875 was credited with publication of nearly fifty papers in American and British journals. The article below was published in June 1865.

SOME REMARKS ON GLOBE LENSES.

BY M. CAREY LEA.

I HAVE several times already had occasion to speak of these lenses, moved thereto by what has seemed to me, extravagant praise. I now return to the subject, because I regret quite as much to see them made, in some quarters, the subject of unreasonable blame, and reproached with faults, with which, whatever be their real shortcomings, they are not chargeable.

The "Globe" principle, that is, the giving a great curvature to the posterior and anterior surfaces of the combination, has some advantages so evident that after having been once introduced by Messrs. C. C. Harrison and I. Schnitzer, of New York, the idea has been rapidly copied elsewhere. The new wide-angle lens of Mr. Ross, figured lately in the English journals, and in the Bulletin Belge, is extremely similar to the American Globe. And Darlot, of Paris, the successor of Jamin, has now produced a lens, the nature of which is admitted to partake largely of the same principle. *La Lumière* speaks of it in the following terms:

"The Americans were the first to construct objectives on this plan; but, in consequence of the exaggeration of the curve of the anterior glass, the vertical lines near the edge were bent to an intolerable extent.

"By an extended and attentive study of this new system of objectives, M. Darlot has succeeded in obtaining everywhere a perfect straightness of lines, and, for all his plates, a diameter which exceeds one-half more than the length of the focal distance, with a uniform sharpness from the centre to the edges, for the most distant objects. This is a magnificent result," &c.

I do not mean to say a word against M. Darlot's lenses, which are no doubt excellent. And no one will accuse me of any undue partiality for the Globe lens, whose faults I have frequently commented upon, but the charge that the "vertical lines near the edge were bent to an intolerable extent," is certainly amusing. It has led me to examine carefully a negative which I took a few days since with a Globe lens of Harrison's make.

The lens in question is one belonging to me. It is called a "3-inch focus" lens, and I find that its circle of light measures full seven and a half inches, or two and a half times the focal length.

This focal length is measured from the centre of the back lens to the focussing surface,—an incorrect mode of measurement, but one in general use, and probably that adopted also in measuring the focal length of the Darlot lens.* It will be seen, then, that while a diameter of one and a half times the focal length is, in the article referred to, insisted upon as an extraordinary achievement, in the American lens *two-thirds more* than this is accomplished.

The negative that I am speaking of, includes a building which occupies one-half of the circle of light, from the middle to the extreme edge. All the lines are perfectly straight, even those which are almost lost at the edge of the picture. Of course, the definition at the edge of the picture is not equal to the rest. I have yet to see a lens capable of accomplishing this, and if M. Darlot's will effect this, as its eulogist (I fear rather rashly) claims, he has accomplished something unparalleled in photographic optics. But this leads to another reflection.

The Globe lens of which I speak, gives with a 3-in. "back focus," a circle of light of seven and a half inches. M. Darlot's, of the same focal length, would give one of four and a half inches, viz., one and a half times the focal length. Now, as the areas of circles are as the squares of their diameters, the superficial sizes of the respective pictures produced by the American and French lenses of equal focal distances, will be as 225 : 81, that is, the American lens gives *nearly three times* as large a picture as the French of equal focal length.

Again, were I to cut off from my picture an annulus one and a half inches wide all round, the remaining central piece would be of the same size as that given by the French lens, viz., four and a half inches diameter, and would be excellently sharp all over. The advantage, therefore, will be with the American lens, in all those points which have been specially pressed as the peculiar strength of the French. It is possible that the French lens may not have the faults of the Globe, viz., want of atmospheric effect and exaggerated perspective, but it will probably be found that these faults are inseparable from an extremely short focus.

I must also, in strict fairness, observe that mine is a remarkably good Globe lens, and that the usual circle of light given by the three-inch focus size is six inches; occasionally, but rarely, less. I have seen another, however, which performed about

equally well as mine, and do not doubt that there are many such made. In fact, I do not see why the manufacturer cannot make all his lenses alike or very nearly so, in this respect. The construction is also ill-devised: too much of the tube is thrown inside the camera; this necessitates a longer camera, and the extreme inconvenience of having to unscrew the tube from the flange to alter the diaphragm. This difficulty is avoided in the French lens. The prices demanded for the Globe are also absurdly high; a competition of French lenses of large angle will probably lead to a reduction in the price of the American. The Globe principle cannot, so far as I see, be controlled by a patent. Lenses of which the posterior and anterior surfaces form parts of the surface of a sphere, with an intermediate stop, are very old. One form, in which the effect of a diaphragm is produced by grinding away the equatorial portions, will be found figured in *Brewster on Optics.* (American Edition, 1833, p. 282.) Wollaston had previously proposed something of a similar nature, but in separate pieces, with a metallic diaphragm.

I have here specially referred to the remarks in La Lumière, but others, very similar, and, to my mind, equally unjust to the Globe lens, were made at one of the meetings of the Photographic Society of Berlin some months back.

One thing is clear, that the increasing disposition of the best makers everywhere to give a much greater convexity to the posterior and anterior surfaces of their objective doublets, demonstrates that the Globe principle possesses certain incontestable advantages, and must be regarded as a valuable acquisition to the photographic repertory.

PHILADELPHIA, May 10, 1865.

———❦———

* The expression in the article quoted is simply "focal distance,"—not equivalent focus,— and the presumption is that the back focus is meant, because that is the commonest mode of measurement. And this presumption is heightened by the expression "exaggeration of the curve," used in reference to the Globe, from which it is probable that M. Darlot's lens is one of flatter curvature and less included angle. 325

Dr. Charles Rice of Bellevue Hospital, New York, poses for a "spirit" carte de visite portrait taken by O. G. Mason, the hospital's resident photographer and secretary of the American Photographical Society. Mason said the portrait was made "in illustration of the [William] Mumler method," referring to the Boston photographer who introduced the craze in January 1863. Various methods were used to make the trick photographs, which were considered by many to be the workings of true "spirits."

at A. J. Davis & Company. "The spiritual people at once endorse the new art, and defend it with a passion," Seely observed. "They throw down the gauntlet to all who are not 'progressed.'"

In April, the matter became a topic of discussion at a meeting of the Photographic Society of Philadelphia. Coleman Sellers introduced the subject by reading a letter from an acquaintance in Boston who had participated in an investigation of the Mumler photographs. "I agree with you perfectly," the correspondent reported, "in supposing that the plate in the bath is changed during the time that the darkroom is entirely without light, as is the case when the plate is removed from the bath." According to the minutes of the society's meeting, J. W. Hurne exhibited two card pictures with spirit accompaniment, which he said he had made himself. Hurne's remarks were then recorded as follows:

> He said that his acquaintance with the spirit world had been so recent that he had not been able to prepare as many of these specimens as he should have liked. The spirit pictures were exactly like the ones made by Mumler, but the photographs as a whole were far better than his; he had gone ahead of Mr. Mumler in one respect, inasmuch as one of his spirits was head downwards, showing conclusively that it must have been taken in the act of descending to the earth. After many amusing comments on them by himself and others, he said that the spirits were from positives, the impression being made by lamp light in one or two seconds, the portrait of the sitter being made afterwards with the usual exposure.[326]

Seely expressed his sentiments regarding spirit photographs in this brief editor's note: "What a shame that all these things should come to pass in the nineteenth century, and in America."

1864

The photography business generally remained good in the North during the Civil War, but as early as 1861 the southern artists were reported to have "nothing to work with, and nobody to work for, and, probably, are forced to go soldiering." Nitrate of silver, which was estimated to be a $6.5 million business on the international market in 1864, became increasingly in demand for treatment of the sick and wounded, and a certain amount of hoarding of this and other photographic materials took place, prompting *Humphrey's Journal* to warn in July 1864:

> Dealers who have goods now are not anxious to sell—not they; the goods are all the time rising on their hands, and they look at one another, and say: "Very well; they've got to have 'em by-and-by, and *then* they'll have to pay for 'em; I'd rather *not* sell now." This will all be very nice, provided Grant continues inactive around Richmond; but just let him achieve some splendid military success, and gold will drop, and prices will fall, and those who have small stocks *then* will be very glad of it.[327]

One photographer who elected to go south at the beginning of the war was J. H. Fitzgibbons, of St. Louis. In 1861, he sold his gallery and relocated in Vicksburg, Mississippi, then a bustling commercial center of 4,500 with strong economic ties to the North, and its citizenry predominantly opposed to secession. But the war was soon brought to its doorstep, and after the long winter siege in 1863, Fitzgibbons left the city, tried to run the blockade, but was captured and sent to New Orleans. From there he was able to travel directly to New York, where Seely gave this report of his trials and tribulations:

> He had at the beginning of the war one of the best appointed photographic establishments in the southwest, with materials for a protracted siege. But he was unable to stand the continued pressure. Finally with alcohol at $24.00 per gallon, and many other useful things not procurable at any price, and with no money among the people to pay for pictures if he could produce them, he very properly felt that he had a call for a cooler climate. He is thankful, we presume, to get away with a whole skin and a good suit of clothes. There has been little photography in Jeffdom for the past two years. It is only in Charleston and perhaps Richmond that any photographs at all are made. By favor of our British cousins who run the blockade with powder and guns, our friend Cook of Charleston has still a precarious stock of photographic materials and still makes a business in the shadows of the people.[328]

Aside from the war, *Humphrey's Journal* felt that the photographic art—principally through the carte de visite revolution—"has done a good deal to make people personally acquainted. Everybody keeps a photographic album, and it is a source of pride and emulation among some people to see how many cartes de visite they can accumulate from their friends and acquaintances. Young gentlemen who travel on their appearance, have their cartes printed off by the dozen, and distribute them under the impression that they are affording a gratification to their numerous friends and acquaintances. But the private supply of cartes de visite is nothing to the deluge of portraits of public

BOSTON STUDIOS

John A. Whipple (1822–1891) and James Wallace Black (1825–1896) operated as partners during the years 1856–59, then went their separate ways thereafter. Whipple's studio at 96 Washington Street is shown (top) where he operated until 1874 when he retired from photography. Black operated establishments at 163 and later 173 Washington Street, having as his business partner a Mr. Case during the 1860s and 1870s. Whipple and Black are ranked among the foremost American photographers of the nineteenth century.

characters which are thrown upon the market, piled up by the bushel in the print stores, offered by the gross at the book stands, and thrust upon our attention everywhere. These collections contain all sorts of people, eminent generals, ballet dancers, pugilists, members of Congress, Doctors of Divinity, politicians, pretty actresses, circus riders, and negro minstrels. To the theatrical profession photography is a good advertising medium. The protean actress adorns the doors of the theater at which she appears, with a highly colored photograph of herself as she appears in private life, surrounded with other pictures in character. The Ethiopian comedian, following suit, has himself taken in twenty-five different dresses and attitudes.''[329]

Photographers in Boston were generally getting higher prices at this time than in New York. Although the city seemed unable to support a photographic society (such as had been organized in Philadelphia, Cincinnati, and other major cities), there were approximately seventy galleries, most of them selling cartes de visite at $3 a dozen ($4 a dozen if vignetted). A demand for larger pictures was evidencing itself, prompting one observer to remark: "It is supposed that the albums are now full, and that the public now intend to fill their walls."

Having dissolved their partnership in 1859, John A. Whipple and James Wallace Black now maintained separate studios on Washington Street, the celebrated photography row of Boston. Whipple was at No. 96, and Black at Nos. 163 and 173. Even by this time, Whipple continued to make

more daguerreotypes than all the rest of the New England operators combined.

Although Black is not as well known today as he was in his own time, Marcus Root felt (in 1863) that Black's "success for the last five years in all branches of his profession is probably without a parallel in the United States." Black took on a business partner, a Mr. Case, about this time, who remained with him during the 1860s and 1870s. The Washington Street gallery was described in 1864 as "a wilderness of rooms, upstairs, downstairs and in the lady's chamber, evidently patterned after the style of Boston streets." The firm employed about sixty persons of both sexes, and although some forty thousand glass negatives were stored "seemingly here, there and everywhere," any desired one could apparently be readily found. In the handling of patrons, "Mr. Black himself attends to the positions, and another assistant develops."

Black and Case, at this time, introduced the porcelain photograph, which was given this notice in *American Artisan:*

> The effect is quite pleasing, the picture being clear and distinct like a fine line engraving, and especially beautiful when suspended where the light can pass through the porcelain, which renders the shading soft and delicate, and brings out many effects which cannot be produced in an ordinary picture.[331]

The year 1864 may be said to mark the birth of a more flamboyant style of gallery photography, which was soon coupled with new techniques in lighting and posing to render more dramatic, and in many cases more artistic, photographic portraits. The prime innovator was Napoleon Sarony, who was born in Quebec in 1821, the year Napoleon I died, and was named for him because of his father's great admiration for the French emperor.

During the 1840s, Sarony worked for Currier & Ives, then operated his own lithographic business in New York during the 1850s under the name Sarony, Major and Knapp. He evidently operated a daguerreotype gallery for a year in Yonkers, New York, and was one of the founding members of the American Photographical Society.

In 1858, he decided to retire from his lithography business in order to study art in Europe. Sarony's brother, Oliver Sarony, was already established as a photographer of considerable note in England, and Napoleon Sarony operated a gallery of his own, for a short time, in Birmingham, England, while continuing to study art. In 1864, he returned to the United States and opened his first New York establishment on Broadway near Bond Street.

This short (5 feet, 1 inch in height), colorful man, sporting a beard, polished calvary boots, and a Turkish fez or astrakhan cap, soon became a familiar and evidently much-liked figure on the New York scene.

He was the first of New York's fashionable photographers to become a part of the American art world. He was a founder of the Salmagundi Club, and a member of the Tile Club on East Tenth Street, which was decorated by Stanford White, and where William Chase, Hopkinson Smith, Swain Gifford, and many others met to talk, drink beer, smoke, and criticize one another's work.

In addition to breaking new ground in the style for studio lighting, settings, and accessories, Sarony perfected what

A MODEL SKYLIGHT

With the explosion in business brought on by the carte de visite, Abraham Bogardus bought the Root gallery at 363 Broadway and installed what the *American Journal of Photography* termed a "model sky-light":

> The light fronts the south. This is the capital fact about it. Of course we know it is not the first light which has been made to face the south. But we believe it to be the first that was deliberately and designedly so constructed, a southern aspect being preferred to any other. The top light is 14 feet square; the bottom or side light, meeting the top light, is 10 feet high and 14 feet wide. The upper edge of the top light is 15 feet from the floor. The top light has a pitch of about 20 degrees. The glass of these lights is the ordinary white ground glass; but the glazing is double and we have only described the outside. Six inches within, and parallel to the ground glass, are sashes glazed with blue glass. There are four sashes for the bottom light, sliding lightly on rollers. The operation of the whole contrivance is this: the pure sunlight easily gets through the ground glass, but the rays are diffused and softened; these diffused rays meet the ground glass, and everything in them which is not wanted is held back and only the uncontaminated chemical force passes down into the room. Mr. E. M. Howell, late of Fredericks, the skillful manager of the camera, told us that he found it best to make his sitters face the sun, and accordingly the position of the background was constantly changed during the day to secure the desideratum. A wonderfully small stop on bright days is used on the camera, and 15 seconds are considered a long time for exposure. On such days with lens at full aperture, the sitting is less than one second.[330]

America was still without an accomplished landscape photography school in the 1860s, and few American-made photographs will be found today to match the works of such English and European masters of this and earlier periods as Philip Delamotte, Francis Frith, Gustave Le Gray, Maxime Du Camp, or Charles Nègre. The *Philadelphia Photographer*, which commenced publishing in 1864, encouraged submission of landscape views such as this one by the Philadelphia photographer F. A. Wenderoth, which was printed in quantity and bound separately into each copy of the magazine's March 1864 issue.

1864

Napoleon Sarony, only just over 5 feet tall, always dressed colorfully in Turkish fez and trousers tucked into highly polished cavalry boots. He was among the first of New York's fashionable photographers to move in literary and art circles.

Edward L. Wilson, editor of the newly established *Philadelphia Photographer* described several years later as a "posing machine." A sitter's head, back, arms, sides, "and in fact the whole person were at perfect rest and repose" in the Sarony device. "We were comfortable and could keep still an hour in its pleasant embrace," Wilson said. "The sensation is almost indescribable. It must be experienced to be fully realized." Sarony customarily made eight poses on a single plate, which prompted Wilson to observe that "those who have four positions of the same person, will notice the changes in position that can be rapidly made in using Mr. Sarony's machine. With the old arrangement it would be almost impossible to secure eight positions before the film became dry and horny." Sarony made his prints "entirely in the shade," Wilson said, and the tone of the prints he characterized as "peculiar to Mr. Sarony's paper."[332]

The new American photographic journal, *Philadelphia Photographer,* begun by Edward L. Wilson and M. F. Benerman in January 1864 (using a combined capital of only $100, and working principally at night), soon became the principal journalistic medium for the photographic community. On the occasion of photography's fiftieth anniversary, it was given a new title, *Wilson's Photographic Magazine,* then, in 1915, was retitled the *Photographic Journal of America.* Wilson quickly acquired the mantle worn in pre-

vious years by Snelling, and functioned as a prime chronicler of photographic events throughout the rest of the nineteenth century.

Among the first steps taken by the magazine was that of giving greater exposure to landscape photography—both American and foreign. The photographs of John Moran, brother of the celebrated painter, and other Philadelphia photographers were printed separately and inserted as frontispieces for many issues in the period 1864–66. But only two or three photographers—among them Moran, John Carbutt of Chicago, and the Bierstadt brothers—were doing "really first class outdoor work," Wilson felt. Prof. Towler was of the same opinion, judging by these remarks in an article on lake scenery which he published in the December 1 issue of *Humphrey's Journal:*

> Judging from the public exhibition of views and scenery by means of the stereopticon, the stereoscope and albums, a stranger would be inclined to conclude one of two things: either that this vast continent of ours was a flat country devoid of all interesting accidents, or that we Americans were behind the times in landscape photography. He is justified in this conclusion; for it is almost an impossibility to get a sight of any of our magnificent land and water formations reproduced by photography, whilst thousands of inspired views of bare walls and naked plains in Egypt, Palestine and Italy, without a single native living being to give vitality to the scenery, or a single native object, as a wheelbarrow, a wagon, or a toll-gate to characterize the country, may be seen and obtained at almost any of our photographic depots: an abundance of trash![333]

America in the 1860s was without any counterparts to such professional landscape and architectural photographers across the Atlantic as Francis Frith, Gustave Le Gray, Maxime Du Camp, Henry Peach Robinson, Carlo Ponti, or the brothers Louis and Auguste Bisson. For most of the decade, this was an activity practiced principally by amateurs, or by photographers whose names would become more prominent in the 1870s. One American amateur much praised in his time, but whose works are today unknown, was Henry J. Newton.

Like Victor Prevost, Newton adopted a form of calotype practice, and both men on several occasions exhibited prints to members of the American Photographical Society. P. C. Duchochois said he had never seen "the paper negatives excelled in delicacy and finish," after viewing Newton's work. Newton first tried, but "became disgusted" with the tannin process. He began experimenting with paper negatives, and found he could make negatives in half the exposure time for the tannin method. "I made a great variety of experiments, and finally settled on a process which made beautiful work. Instead of using wax, I used paraffine. I think I was the original operator in that direction, and the paper prepared with paraffine was much more sensitive than that prepared with wax." Duchochois found Newton's prints "particularly admirable for the absence of granulation and mottlings of the paper." Outdoor views could be made with the paraffine paper in exposures of as little as 45 seconds.[335]

During the years 1856–63, Marcus A. Root was at work compiling the first history of photography to be published in the United States. Entitled *The Camera and the Pencil,* the book appeared in 1864 with apologies from Root that it con-

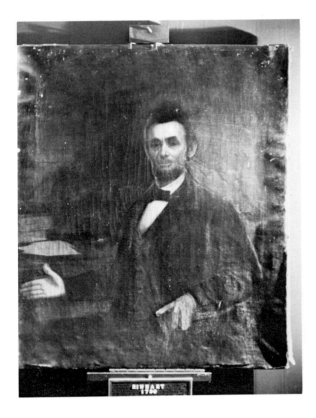 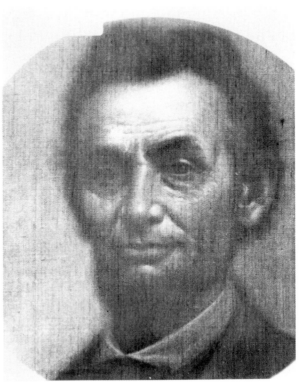

UNRECORDED PHOTOGRAPH OF LINCOLN APPEARS
REVEALED IN X-RAY OF OIL PORTRAIT

What is believed to be an unrecorded life-size photograph of Abraham Lincoln (right) has been found beneath the oil painting (left) which was acquired in 1973 by George R. Rinhart of New York City from heirs of the French-born landscape and portrait painter Alexander Francois, who died in Albany, New York, in 1912. The photographic likeness has been reproduced from one of a series of X-rays made of the portrait by Grace Galleries, Inc., of Englewood, New Jersey, a restorer of paintings. The twill-weave canvas, which measures approximately 50 x 40 inches, has been painted over several times, and because of an irregular shrinking on the part of the various layers of thick and thin paint, the canvas support has become buckled and warped. Test cleanings with different solvents applied locally to the painting's surface have indicated the presence of a photographic emulsion which appears to be sepia tone in color. According to Grace Galleries, the X-rays would pick up the presence of silver salts in a photographic emulsion, and this would account for the X-ray likeness exhibiting a stronger appearance than the emulsion probably would have appeared to the human eye at the time it was secured on the canvas. The highlights in Lincoln's face can be attributed to the presence of lead in the paint. The likeness in the X-ray can be dated to 1863–65, suggesting that it is from a negative made at that time either at the Brady or Alexander Gardner studios in Washington, D.C. The enlargement on the canvas would have been made with a solar camera, which both Brady and Gardner are known to have used. According to records accompanying the painting, it was first offered for sale by Francois in 1870. Besides the inventor, David Woodward, one photographer who used the solar camera regularly to make photographic portraits on artists' canvases was Woodward's fellow Baltimorean David Bachrach. In later years, Bachrach recalled in these words the method he used after opening his business in 1869:

Paintings on canvas over photo portraits were then largely used, and I think we made over two thousand of them with our solar cameras. They were as good as prints on paper. Various journals at the time published my method both in this country and Europe. It consisted in first cleaning the oil [Bachrach here probably refers to the painting's prepared base] partly with a solution of ammonia and then hardening the same with acetic acid No. 8. I then used gum mastic or gum benzoin in an alcoholic solution containing the chlorides, and this united perfectly with the surface, but citric acid was also used in the solution. It was then ready for silvering and printing.[334]

Marcus A. Root.

Marcus A. Root, from a newspaper illustration at the time of his death in 1888.

tained "not a little repetition" in subject matter. "One reason for this," he said, "is that I was specially anxious to impress these subjects on all within my reach; and another, that the book having been seven or eight years in hand, it was impossible to carry the whole in my mind, so as to avoid occasional reiteration." Another contributing factor was that one of Root's legs had been broken in two places (above the knee and at the ankle) in a freak railroad accident in 1856, and he was long in recovering from these injuries.

When his book was published in 1864, he described it as an attempt at "embracing the theoretic basis of the art," and promised a second volume which would delve into photography's "practical processes, formulae, etc." The first volume is long on the "theoretic basis," and tantalizingly brief on specific doings and achievements of American photographers prior to the Civil War.

The planned second volume, from a man so closely acquainted with all of the major personalities and events of the daguerrean era, would today be an invaluable reference source for those who still thirst for records of photography's formative years, but, unfortunately, it was never issued. A letter dated November 21, 1866, which was addressed to Prof. J. C. Booth in Philadelphia from A. Muckle, who had made "a number of contributions" to Root's second volume, informs us that Root was still "getting up" the second work. But after the second part had been stereotyped and placed on the press, the building in which the plant was housed was destroyed by a fire, and the manuscript as well as the plates were lost.[336]

1864

1865

Faulty generalship by Maj. Gen. Benjamin Butler, who concentrated on digging a canal to straighten a loop in the James River, prevented Gen. Ulysses S. Grant's forces from taking Petersburg, Virginia in 1864, and helped prolong the Civil War into 1865. Petersburg and Richmond were abandoned by Gen. Robert E. Lee's forces two days before Lincoln's second inauguration on April 4, and Lee's surrender at Appomattox followed on the ninth. Five days later Lincoln was dead at the hands of an assassin, unleashing an era of political rivalry, bitter feelings, and social upheaval which continued unabated for several years.

Ten days after the assassination, Lincoln lay in state in New York's City Hall, where Mayor C. Godfrey Gunther allowed—or deliberately selected—Benjamin Gurney to take photographs of the dead president in his coffin. Gunther was a "peace Democrat," and like many New Yorkers (who provided the greatest amount of supplies and paid the most taxes to keep the war going), he was of a similar opinion as other "peace Democrats," whose slogan was: "Restoration of the Union as it was and the maintenance of the Union as it is." Other Democrats in New York were ardent supporters of the war, and had joined with Republicans to form the Union party. The two factions, in the frenzied state of affairs which followed the assassination, gave vent to their prejudices and anger over the photography which took place at City Hall.

Gurney, son of Mathew Brady's chief rival, was evidently opposed to the war, and was considered a "Copperhead" (a northern sympathizer with the southern cause) by others in the New York fraternity. Thus it was he, and he alone, who was allowed "uninterrupted possession of the premises for several hours" at City Hall, making photographs of Lincoln and of scenes in and around the hall. No other photographer was given similar privileges by city officials. A correspondent identified only as "Union," in a letter to *Humphrey's Journal,* decried the action, asserting:

> Where was the necessity of photographing the remains? Was there not already millions of good representations of the living man that they must desecrate the dead? And why should this privilege be granted to Mr. Gurney, to the exclusion of all other photographers. The reason is simply this. Mr. G. is a *Copperhead;* Mayor Gunther is another. Had not Mr. Gurney, during President Lincoln's four years administration, sufficiently exhausted his vial of wrath and venegeance against him, that he must now disturb the repose of the dead, and insult and injure the bereaved family and true friends of the departed? The whole scheme was a disgraceful outrage upon humanity, and deserves the execration of every American citizen.[337]

Secretary of War Stanton, on hearing of the City Hall photography, dispatched agents to the Gurney establishment in New York where they seized the negatives in the name of the United States government. Gurney followed the agents to Washington in the vain hope of retrieving them. But as "Union" stated in his letter to *Humphrey's Journal:* "Mr. G. did *not* recover these negatives, nor never will. In this case justice has been meted out to avarice; the negatives

were totally destroyed by order of Secretary Stanton, and thus ends Mr. Gurney's disgraceful speculation."

But "Union" was wrong. The photographs were *not* all destroyed. Stanton retained at least one for himself, and this was given by his son to John Nicolay, secretary to Abraham Lincoln, in later years. The photograph remained unnoticed among Nicolay's papers until 1952 when it was discovered among the papers at the Illinois State Historical Library by a fifteen-year-old student, Donald Rietveld, of Des Moines, Iowa.[338]

As early as 1859, it had been discovered that extreme brightness coupled with favorable actinic qualities could be achieved by burning magnesium wire, and photographic portraits using this method were made in England in 1864. A different mode of using magnesium for artificial light—namely, igniting it in powdered form—was proposed in 1865, but this was not put to practical use for nearly two decades. In the meantime, when the price of an ounce of magnesium fell to a little more than twice that for an ounce of silver (also in 1865), experimentation began more in earnest with the wire mode. Because of a higher exchange rate, New York prices were higher than in England. Charles Seely said some dealers charged 25 cents an inch for the wire, while others charged 50 cents a foot. He also estimated that the wire used by photographers burned at the rate of about one foot a minute.[339]

On the nights of October 26 and 27, 1865, a series of photographs was taken at the home of the Philadelphia amateur photographer John C. Browne, using magnesium lighting. Edward Wilson was present for the occasion (posing in at least one of the photographs taken), and the experiments were given prominent notice in the *Philadelphia Photographer.* Most of the negatives were made with a pair of Jamin stereoscopic lenses of 4½ inches' focal length. The length of exposures ranged from 15 to 30 seconds, and the number of tapers of magnesium wire used in the case of each exposure ranged from three to six (120 tapers being roughly equivalent to a pound of magnesium). In all cases, there were heavy shadows in the pictures, but Wilson felt that these might have been overcome if two instead of only one reflector had been placed near the camera. The problem of shadows in making photographs by the light of a burning magnesium wire was not one which would ever be fully overcome. As Professor Draper explained at a meeting of the American Photographical Society, all shadows would appear obscure "in consequence of the light emanating from a very minute point." Nor was the magnesium light used with any regularity in photographic galleries, because apart from the harshness of the illunination, the white smoke from the burning tapers lingered after an exposure, and could not be readily dissipated.[340]

While the experiments conducted at the home of John C. Browne were among the earliest with magnesium light, John A. Whipple had managed to secure several nighttime photographs with electric light in Boston Common as early as August 6, 1863. When these were exhibited at the Amer-

After Benjamin Gurney was permitted to take photographs of Lincoln lying in state at New York's City Hall, Secretary of War Edwin M. Stanton confiscated the plates and prints, but retained one print himself from which the illustration above has been reproduced. The print was given by Stanton, or his heirs, to John Nicolay, Lincoln's secretary, and remained in the latter's papers at the Illinois State Historical Library until discovered by a researcher in 1952.

Baron F. W. von Egloffstein

EXPERIMENTS ARE BEGUN WITH HALFTONE REPRODUCTION

Although the halftone process by which photographs today are printed in books, magazines, and newspapers wasn't perfected until the 1890s, Baron F. W. von Egloffstein began experimenting with a method of photomechanical printing (i.e., securing photographic images on a printing plate) in 1861. A halftone is made by putting the original photograph through a screening process which converts the images into fine dots of varying size. The dot images are then transferred to a metal ·plate where they are etched into relief for inking and printing along with the text.

Baron von Egloffstein has been called the "father of the halftone." He was a former member of the Prussian army who began his experiments in Philadelphia. In this he was assisted by the noted engraver Samuel Sartain, who prepared the screens (lines evenly ruled on a glass plate) through which von Egloffstein made photographs on a steel plate coated with asphaltum. But the baron ran out of bensole, a solvent which he considered essential to the experiments, and temporarily abandoned his work after trying in vain to obtain a new supply. He joined Gen. Burnside's forces in the Civil War, but was severely wounded in a battle near New Bern, North Carolina, in 1862. Recovered, he again resumed his experiments in New York and on November 21, 1865, was issued a patent for a primitive halftone method. But despite being given a large amount of financial backing by Jay Cooke & Co., von Egloffstein remained unsuccessful in his efforts to perfect the process and over the next thirty years his pioneering work was forgotten.

Baron von Egloffstein and Sartain had differed on the number of lines to the inch for the screen plates. "He wanted them made over 250 lines to the inch," Sartain said in later years, "which I told him could not be well printed with the ink then in common use." Sartain made screens with 220 lines to the inch, but these were also finer than those used when the halftone process was fully perfected in 1893 (see pages 362 and 369), leading experts to conclude that the extreme fineness of lines prevented von Egloffstein and Sartain from achieving ultimate success.[341]

ican Photographical Society, they were pronounced "very fine." The minutes of the meeting also reveal that the spray of a fountain depicted in the photographs was "well shown." Whipple used a 5-inch Voigtlander lens with a 16-inch focus, and made his exposures at full aperture in about 90 seconds. In a note accompanying the prints he stated:

> The image came up immediately, strong without re-developing. A very curious effect is given to the trees; those leaves only are photographed which were in position to reflect the light directly into the instrument; their number is few, and the trees appear to be nearly bare of foliage. The effect of the electric light as compared with sunlight is about in the proportion of one to one hundred and eighty—ninety seconds exposure being required in

the former case, while in sunlight, or slightly hazy daylight, about one-half a second is sufficient to produce the same effect.[342]

During the Civil War, the photographers' attempts to resist licensing of the collodion process under the provisions of the 1854 Cutting bromide patent had remained dormant. But by March 1865, T. H. Hubbard of Boston assumed the reins of the various suits, and in the face of a widespread collapse of opposition by individual operators (Brady and Bogardus among them), he began collecting $50 in arrears, and another $25 for each remaining year of the patent as licensing fees (which was good until 1868) from one and

ALEXANDER GARDNER'S
WASHINGTON D.C., GALLERY

Alexander Gardner, from a carte de visite made at Mathew Brady's Washington studio, circa 1861–62.

The photographer most active in Washington, D.C., photographing Lincoln's funeral, the assassination conspirators, and their hanging outside of the Washington penitentiary on July 7, 1865, was Scottish-born Alexander Gardner (1821–1882). Trained both as a jeweler and chemist, Gardner mastered collodion photography before emigrating in 1856 to New York, where he was employed by Mathew Brady. Gardner is credited with having introduced the Woodward solar camera at the Brady gallery, used in making Brady's "imperial" photographic portrait enlargements, and in 1858 he was named manager of Brady's gallery in Washington, a position he held until 1862 when he parted company with Brady after a dispute over copyrighting of photographs made at the gallery. Gardner's departure was Brady's loss, because not only had Gardner arranged for mass production of carte de visite photographs by E. & H. T. Anthony & Co., using negatives supplied by the Brady gallery, but he had introduced bookkeeping methods which, if adhered to, might have prevented or alleviated Brady's later financial woes.

After a brief stint as photographer to the Army of the Potomac, Gardner established his own gallery first at 332 Pennsylvania Avenue, then in 1863 at 511 Seventh Street, just around the corner from Brady. He was joined by his brother James, and by a number of Brady staffers, including Timothy O'Sullivan, George Barnard, D. G. Woodbury, and Egbert Guy Fox. Among Gardner's first sitters was President Lincoln, who posed on August 9, 1863, both alone and with his secretaries, John G. Nicolay and John Hay. Gardner's photographs of Lincoln made at the August 9 sitting, and again on November 15, are considered by many to be the best ever made of Lincoln. On the day of General Robert E. Lee's surrender at Appomattox (April 9, 1865), Lincoln again went to Gardner's studio with his son, "Tad," where the last photographs of the sixteenth president were made in a series of now-famous poses. In 1864, William A. Pinkerton, son of the celebrated detective, called Gardner "the best artist in the country," and today Gardner's two-volume *Photographic Sketchbook of the War* is considered the equal of any work executed during the Civil War by Brady or others. For a time after the war, the Gardner studio was the scene of many official group portraits. These included visiting delegations of Indians and the members of the U.S. Supreme Court which, with the appointment of Chief Justice Salmon P. Chase in December 1864, became known as the "Lincoln Court" (Lincoln was the first president after Washington to appoint a controlling number of sitting justices). In 1867, Gardner made card stereograph views together with larger photographs of scenes along the route of the Union Pacific Railroad, and the latter were much admired in 1868 at a meeting of the Philadelphia Photographic Society. He enjoyed a separate income from real estate interests, and in 1873 he set up the first Rogues' Gallery at Washington's Metropolitan Police headquarters.[343]

After working for Mathew Brady in New York and Washington, D.C., from 1856 to 1862, Alexander Gardner established a gallery of his own (shown above) at 511 Seventh Street, just around the corner from Brady's Washington studio. A number of the most famous photographs of Abraham Lincoln were taken at this gallery on August 9 and November 15, 1863, and again on April 9, 1865.

The justices of the U.S. Supreme Court posed for this photograph in Gardner's gallery possibly before Lincoln's assassination. They are, from left to right: Daniel W. Middleton, clerk; David Davis; Noah Swayne; Robert C. Grier; Chief Justice Salmon P. Chase; Samuel Nelson; Nathan Clifford; Samuel F. Miller; and Stephen J. Field. Lincoln appointed Chase, Davis, Swayne, Miller, and Field.

all. On November 15, C. D. Fredericks announced that he had expended all of the funds provided in 1860 by the fraternity, plus a still larger sum of his own, and that he had made settlement with Hubbard. Similar announcements recommending acquiescence to licensing came from the principal supplies dealers: E. & H. T. Anthony & Co.; the Scovill Manufacturing Co.; Willard & Co.; O. S. Follett; and Wilcox & Graves.

Once again, as many as 150 photographers met at the Cooper Institute on December 3 for the first of three "adjourned" meetings of the Photographers' Protective Union of the United States. At the first meeting, a long list of names was given of men who pledged "their lives, their fortunes, and their sacred honors" to resistance of all patents (the Ormsbee & Wing patent for the multiplying camera included), but according to the minutes of the meeting, "no money was paid, and no treasurer [was] appointed" at adjournment time. At the successive meetings, Brady and Bogardus were named to positions as top officers of the association, but declined on the basis that the association was viewed by some, legally, as a "criminal conspiracy" against a lawfully granted government patent. During all of the sessions, Nathan G. Burgess, as the designated vice president of the association, presided, but was never formally elected president. At one meeting, both Marcus Ormsbee and W. A. Tomlinson, Hubbard's New York agent, applied for membership in the body, but were rebuffed. Even Hubbard himself was proposed for membership, making a speech in which he declined membership, but "recognized fully the right of anyone to determine the validity of any claim upon him," a statement which, according to the minutes, was received with "much applause." By the final meeting (December 19), there had been much discussion, but no actions taken.[346]

John C. Browne, long prominent in Philadelphia's early amateur photography circles, poses in his home for a photograph taken at night with the aid of magnesium light.

In October 1866, the directors of the Union Pacific Railroad posed for John Carbutt's camera at the 100th Meridian near what is now Cozad, Nebraska. The fund-raising ceremonies, covered by all major newspapers, may be said to mark the beginning of the flowering of American western photography, which centered principally at first on the building of the transcontinental rail lines, and in recording scenes at locales along the way.

1866

1866

With the Civil War ended, American photographers set out to catch up with their English and European colleagues in landscape and urban photography. Benjamin and Edward Kilburn established a photography business in Littleton, New Hampshire, in 1865 which soon mushroomed to the point where that quiet New England town became a world capital for card stereograph production. By 1866, the brothers were on a second issue of several hundred card views of the White Mountains and other New England scenery. Residences of the elite of Newport, Rhode Island, were photographed by J. W. Black and Case, and by the Bierstadt brothers (who also provided the *Philadelphia Photographer* with 120 views of the White Mountains, New England, New York, and New Jersey scenic meccas). In May, someone brought *Humphrey's Journal* an album containing twenty large (17 x 22-inch) prints of Yosemite and other western scenes by Carleton E. Watkins, who the following year copyrighted about 1,600 views taken by him in the West prior to that time.[347]

The greatest focal point for photographic coverage centered on the activities associated with the laying of tracks between Omaha and San Francisco by the Central Pacific and Union Pacific railroad companies. Things had gone slowly after passage of the Pacific Railroad Act of 1862, but now the Union Pacific was laying tracks at the rate of a mile a day.

Among the first to record views of the rail construction, and of the scenery and urban life on the plains, was the Chicago photographer John Carbutt. He began with the famous publicity and fund-raising stunt which the directors of the Union Pacific decided to stage in October.

The occasion was an excursion for about 250 distinguished Americans organized by the line's vice president, Thomas C. Durant, to travel the full length of the tracks then constructed (about 250 miles) to the one hundredth meridian near the present town of Cozad, Nebraska. Reporters from most major newspapers were taken along, as were two brass bands, a staff of chefs, a French marquis, an English earl, government commissioners, and, of course, the rail's directors. Carbutt made about three hundred card stereographs of scenes and life along the Union Pacific route during 1867.

From the fall of 1867 to well into 1868, Alexander Gardner followed the line, making about half as many stereoviews, and larger prints (up to size 11 x 14) which he exhibited at the Philadelphia Photographic Society in 1868. During the years 1868–69, Capt. Andrew J. Russell, formerly a Union photographer who had specialized in railroad photography, was employed as the line's official photographer.

The principal photographer who made views along the route of the Central Pacific line was Alfred A. Hart, of Sacramento. Hart's views numbered about three hundred, and were bought by C. E. Watkins in 1869 following Hart's early death.

On May 10, 1869, when the Central Pacific and Union

From Baltimore to Niagara Falls.

With the blossoming of card stereophotography, David Bachrach, Jr., made stereoviews on an extended trip from Baltimore to Niagara Falls in 1866–67, which were published by William M. Chase in Baltimore. The illustration, top, of the U.S. Custom House in Buffalo is from the right-hand portion of card number 1290 in the Chase series. The illustration, bottom, is of the back side of the full card, with 1290 underlined to indicate view on the reverse (picture) side.

A PRESIDENT PHOTOGRAPHED WHILE IN THE
PROCESS OF COMMITTING POLITICAL SUICIDE

Card stereographs made locally of a celebrity or major event were seldom printed in large quantities, and those of this nature which have survived to modern times are extremely rare, and frequently of historical importance. This applies to the unpublished photograph (above) of President Andrew Johnson (right), Gen. Ulysses S. Grant (left), and Secretary of the Navy Gideon Welles. The illustration has been reproduced, enlarged, from one half of a card stereograph whose maker, as well as the place and date, are unknown. Presumably the trio were photographed during a self-defeating political tour which Johnson made through New England and midwestern states during the period August 28 to September 15, 1866. At the time, Johnson and the Radical Republican leaders of the 39th U.S. Congress were in open warfare over Constitutional amendments and legislation affecting reconstruction. To rally support for his cause in the upcoming congressional elections, Johnson took a "swing around the circuit," taking with him various members of his cabinet and the two Civil War heros, Grant and Adm. David Farragut. But everywhere he went he encountered hostile audiences, and his speeches became increasingly intemperate. Lampooned in the press by humorists and cartoonists, Johnson's tour led directly to sizeable gains by the Radicals in the November election. Worse, still, the president's intemperate speeches, in which he allowed himself to indulge in personal debates with persons in his audience, were later cited as grounds for his impeachment trial in 1868.[348]

Pacific lines were joined at Promontory, Utah, the most celebrated photograph of the ceremonies was taken by the Salt Lake City photographer Charles R. Savage.

Timothy O'Sullivan, the Civil War photographer better known for his western views of the 1870s, joined the first of the major geological surveys following the war, which was headed by the scientist Clarence King. This was the survey which the historian Henry Adams described as a feat that "paralleled the Continental Railway in Geology; a feat as yet unequalled by other governments which had as a rule no continents to survey."

The expedition began in July 1867, with a visit to the Nevada mining camps, then moved eastward along the 40th Parallel recording data and views of the land and its inhabitants. King had persuaded Congress to appropriate the necessary funds for the venture, and to Adams it amounted to inducing Congress "to adopt almost its first modern act of legislation."

Eadweard Muybridge, whose western views taken in the 1870s are among the best examples of early American scenic photography, also started out in 1867 making views in the Yosemite Valley. Under the name "Helios," he published seventy-two views in size 6 x 8 inches, and 114 card stereographs, which are today extremely rare items. A contemporary newspaper felt that Muybridge's views "surpass in artistic excellence anything that has yet been published in San Francisco," adding: "In some of the series, we have just such cloud effects as we see in nature or oil-painting, but almost never in a photograph."[349]

The year 1866 marked the first time that certain United States photographers began issuing various series of card stereographs separately from the larger publishers. In addition to Carbutt in Chicago, Hart in Sacramento, and the Bierstadt brothers (operating out of New Bedford, Massachusetts), others were John Soule and DeLoss Barnum in Boston; J. A. Williams in Providence; James Cremer and John Moran in Philadelphia; and William M. Chase in Baltimore. In the latter instance, Chase's work was done mostly by David Bachrach, Jr., who described his association with Chase some fifty-four years later in these words:

> About a year after the war I fell in with Mr. William M. Chase, a former Army officer of volunteers, afterward a sutler, from Massachusetts, who went into the publication of stereoscopic views, very popular at the time. I made the negatives for him for about two years, over 10,000 of them, and from the few copies I saved I must say I have never seen better results since. We went all over Maryland, the Cumberland and Shenandoah Valleys, in the Alleghenies, Washington, D.C., on the Hudson and Niagara Falls. At the latter place we were handicapped with lenses rather slow for real instantaneous views of the rapids, so I went back to an old experiment, and used the front lenses of a celebrated make of French field glasses, which required very little stopping down. With a home-made drop shutter, we made perfect views of the spray of the rapids.[350]

Like the New Hampshire photographers, Franklin and Luther White, who used wet towels to keep their collodion plates moist, Bachrach perfected his own unique techniques for working in a portable darkroom:

> We had many dodges for keeping plates wet, but the best plan, partly my own invention, was to have two silver baths, one with the usual solution, and another made up one-half with glycerin

Prof. John W. Draper (circa 1870); cabinet card portrait by Jose M. Mora.

THE NEW SIZE

In October 1866, Edward Wilson said that "something must be done to create a new and greater demand for photographs. Photographers in all directions are complaining that trade is dull. The carte de visite, once so popular and in so great demand, seems to have grown out of fashion. Everyone is surfeited with them. All the albums are full of them, and everybody has exchanged with everybody." Wilson also said: "We think we have noticed that there is an inclination on the part of the public to sit for larger and better pictures than the carte de visite, and that operators have found that the tide is turning in that direction, though nothing new has been adopted yet. The adoption of a new size is what is wanted. In our experience, we have found that fashion rules in photography as well as in mantua-making and millinery, and if photographers would thrive, they must come into some of the tricks of those whose continual study it is to create a fashion, and then cater to its tastes and demands." A new size, called the *cabinet card*, had just been adopted in England, the prints measuring approximately 4 x 5½ inches on cards of size 4¼ x 6½ inches. By November, Wilson reported that "the New York people have held a meeting, and adopted it." E. & H. T. Anthony & Co. began immediately to make albums for the new size, and Sherman & Co. began manufacturing the new card mounts.[351]

instead of water. This latter solution was exposed to sunlight to reduce the organic matter until the solution was clear, otherwise the plates would have been hopelessly fogged. I have thus carried plates for over an hour, and obtained perfectly good negatives. I had this to do one time on top of Maryland Heights, opposite Harper's Ferry, where we had no water to wash off the plates.[352]

Snelling's *The Photographic Art Journal,* in the 1850s, had been one of the first publications to publish original hand-printed photographs bound in with the text. This practice was later followed by the *Philadelphia Photographer.* But few books illustrated with original, separately bound-in photographs came off American presses prior to the 1870s.

PRE-1865 PHOTOGRAPHS ARE REMOVED FROM COPYRIGHT

A decision by Judge Shipman, in the United States Circuit Court, furnishes an interesting example of how the changes and advances in science compel changes in laws. In the year 1831, Congress amended the copyright laws, so as to extend their benefits to artists, giving to anyone who should "invent, design, etch, engrave, work, or cause to be engraved, etched, or worked from his own design, any print or engraving * * * the sole right and liberty of printing, reprinting, publishing and vending such print, cut or engraving, in whole or in part, for the term of twenty-eight years." A very useful and proper law was this; for there was no reason why the artist should not be able to derive advantage from the workings of his brain as well as the author. But since that law was passed, the art of photography has been invented and brought into general use; and this art, as was easy to be seen, brought with it possibly the entire destruction of the law, and the overthrow of the object for which it was passed. For photographic copies of engravings were as good for many purposes as printed ones, and their use would necessarily interfere with the profits of the artists, unless they could be brought within the terms of the law. There was so much doubt whether they could be so brought that Congress by an amendment, passed March 3, 1865, amended the act so as to include photographic copies as well as engravings. The decision to which we refer shows that this action of Congress was needed. The suit was brought to test the question, the plaintiff claiming that photography was covered by the word "print," inasmuch as in taking the copy from the negative on paper, the paper was pressed firmly against the plate by springs. But the judge holds that this is not so; that this process of procuring a picture upon sensitive paper by the action of light upon it, passing through the negative upon glass, is not printing, although it is so called; the art was not in existence at the time the act of 1831 was passed, and of course Congress could not have meant to include that idea in the language which they used. The effect of the decision is very manifest. It is to take out from the restrictions of the Copyright Act photographs of all pictures made before the act of 1865, and to throw them open to the public.

—Humphrey's Journal, July 1, 1866

1866

"In England, books illustrated by photographs are quite common and obtainable at a reasonable price," Wilson told his readers in January 1866. "A few faint attempts at it have been made in this country, but we hope before another holiday season we shall have something really fine."[353]

All books published with original photographs bound in with the text enjoyed only limited editions, because of the high cost of printing the photographs separately and marrying them to the type pages at the binder—or in pasting them onto printed pages in spaces specifically reserved for them. Nevertheless, before embarking on his mission, beginning in October 1866, to photograph the activities and environs of the Union Pacific rail route, Carbutt made photographs of some of Chicago's leading citizens for purposes of preparing the first American biographical dictionary to be illustrated photographically. In February 1866, Wilson noted in his journal:

John Carbutt of Chicago has near completion the largest order for portraits we ever heard of. It numbers 45,000 to 50,000 of the new cabinet size of eighty to ninety of the most prominent citizens of Chicago, which are to illustrate a work shortly to be published there. And this is being done without in the least interfering with his regular portrait business, so great are the resources of his establishment.[354]

Twenty of Muybridge's 1867 views of Yosemite were used as illustrations for the first guidebook to the Valley, *Yosemite: Its Wonders and Its Beauties,* by John S. Hittell, published in 1868 in San Francisco by H. H. Bancroft. The Hittell book is now classed as a rare book, as are other recorded volumes published at this time with photographic illustrations. Occasionally, an unrecorded, privately published volume of this period will be found containing photographic illustrations, such as *Sketches of a Summer Tour* printed by William J. Read in 1866 at Brownson's Steam Job Printing Establishment at 45 Fulton Street, New York (see opposite page).

The so-called magic photograph became a popular craze this year. The technique for making such a photograph had been described by Sir John Herschel in 1840, but that was in a technical journal, and had not received much popular attention. The idea was to make a photograph disappear by immersing the print in a corrosive sublimate (Herschel suggested mercury bichloride) until the image literally disappeared. However, the "disappeared" picture, like invisible writing, had not been obliterated. Though invisible, it was merely dormant; and the paper on which it remained in this state appeared otherwise perfectly clear, and could be used for writing, drawing, etc. Evidently someone reread Herschel, or rediscovered the simple process again; for early in 1866, dealers began offering invisible pictures along with a piece of blotting paper which had been saturated with hyposulphite of soda and dried. All the customer had to do was to dip the latter in a tray of plain water, then lay it upon or against the former. This would immediately revive the image, and presto! A "magic photograph!"

In July, Wilson described the new craze in these words:

Quite an excitement has been prevailing since our last number was issued over the Magic Photographs. . . . We, with the rest, have been making them, and have had much pleasure in showing them to many. Prof. Towler has written a little book on

The Noerodalen (Norway.)

The City of Pesth (Hungary).

The Grand Canal (Venice).

SKETCHES

OF A

SUMMER TOUR.

NEW YORK:
PRINTED BY WILLIAM J. READ,
(AT BROWNSON'S STEAM JOB PRINTING ESTABLISHMENT,
No. 45 Fulton Street.
1866

The Ponte Vecchio (Florence).

Throughout publishing history, individuals have privately printed books in limited editions for distribution to family, friends, libraries, etc. *Sketches of a Summer Tour* (above) is one of the earliest such American books published with original photographs bound-in separately from the text. The book consists of a series of letters to a friend (signed simply "J," in most instances) describing a voyage to the British Isles and Europe. Shown above are four of eleven albumen prints, each pasted on a separate page in the book. By this time, according to one authority, the wet-plate collodion process was being relinquished by amateur photographers in favor of a dry collodion or dry (albumen) glass negative or paper negative process more convenient for traveling. As can be seen from some of the illustrations, the author used a stereoscopic camera. Perhaps he had read an article in an 1862 issue of *Humphrey's Journal* (reprinted from a British magazine) in which the author recommended use of a stereoscopic camera for traveling, citing one portable camera that was no larger than "a good-sized octavo book." The purpose in taking pictures while traveling, the writer of the article pointed out, "is not to make large and valuable artistic pictures—that we must always leave to the professional man—but it is simply to preserve faithful representations; and this may be done as well on the small as on the large scale, and with infinitely less trouble." [355]

the subject. Wilson & Hood of our city, and Farris, of New York, are offering them for sale in neat packages, and are selling thousands of them. All sorts of advertisements are to be seen in the papers about them. Some call it *photoprestigiation,* others, *acquamirabilisographictrickography,* etc., etc. The dealers tell all sorts of stories about those who call upon them to see what the Magic Photographs are. Many expect that with a few drops of water they may make any photograph they desire.[356]

If the customer wanted to keep his magic photograph for any length of time, Wilson recommended that the revived print be washed for three or four hours in changing water. This, he said, "will secure prints as permanent as many that are sold now-a-days, and not of an unpleasant tone."

It appears that pending application (in 1868) for a renewal of the 1854 patent awarded to James Cutting to, in effect, license the collodion process, photographers across the country were generally "caving in," as *Humphrey's Journal* expressed it, to individual visitations or lawsuits pressed by T. H. Hubbard, the successor to the patent following Cutting's commitment to an insane asylum in 1862. In March, it was reported, too, that Hubbard had retained counsel to press a claim of infringement against the biggest of all users of the collodion process—the United States government. Wryly, *Humphrey's Journal* pointed out that the claim was "certainly a strong argument, if not in favor of the validity of the patent, at least in favor of the strong faith which its owners, and their legal advisers, have in its validity," adding that if the government had, indeed, derived all of the asserted benefits from the numerous photographers engaged during the Civil War, "we certainly can see no great and valid defense which the Government can set up against the covenant of its own deed, adjudged by its own courts to be valid and legal."

In June, the Chicago *Evening Journal,* under a heading "Interesting to Photographers," carried a statement by the president of the Northwestern Photographic Society, James R. Hayden, that that society had also decided to submit to Hubbard's demands. In a letter to *Humphrey's Journal,* Carbutt elaborated further on this development:

Mr. Hubbard respectfully invited me to a private conference, in order to show me certain documents that he averred would satisfy me as to the validity of the patent, and that it would be a waste of time and money to contest it. After a two hours' conference and examination of his papers, I could come to no other conclusion than to submit to his claims. A meeting was held by the photographers, Mr. Hubbard attending and explaining his position, and it was amusing to see the ignorance that prevailed among some of the photographers in relation to the evasion of payment of his claims. A committee was appointed, of which I was one, to wait on Mr. Hubbard, and get his best terms for the city of Chicago. We did so, and thirty-two of us bought the right for the city, and formed ourselves into an association to be known as the Cutting Bromide Association. We propose to charge the balance of the photographers a less sum than Mr. Hubbard would have charged them, and so everything has been settled with perfect good feeling. Mr. Hubbard has done a

wholesale business in selling territory today; three others and myself have bought the balance of the State of Illinois. Mr. G. B. Green has bought Wisconsin, Iowa and Minnesota, so that you see instead of Mr. Hubbard finding us prepared for war, he has been saved the expense of bringing suits, and his interest in the Northwestern States bought up . . . Mr. Hubbard met the members of the Northwestern Photographic Society on Friday evening, May 11, and expressed to them his great joy and surprise at the amiable manner in which Chicago had settled up his claims, and we, to show him we bore him no ill will, presented him with a gold-headed cane.

Humphrey's Journal was aghast, but could not help but express its admiration for Hubbard:

So it seems to be with Mr. Hubbard; as soon as he appears before a meeting of photographic doubters, he explains his claims, and answers satisfactorily every objection and all opposition at once vanishes; everybody caves; everybody thinks he is a capital fellow, and the Chicagoans even went so far as to give him a gold-headed cane, which cost, we are told, $150! Well, really this Mr. Hubbard must be a wonderful man; we think we could make money by hiring him to canvass for our Journal; we could well afford to give him $5,000 a year as salary.[358]

CRIME IN THE STUDIOS

The end of the Civil War brought a rise in crime, which also found its victims in the photographic community, as these separate reports from the *Philadelphia Photographer* reveal:

1865: S. H. Grove, of Baltimore, was murdered in his photographic parlor on October 29, and the murderer was caught with the negative of himself (made by Grove) in his possession. It is supposed that the latter called to have a picture made, and doubtless, with the intention of committing robbery, performed this devilish act. Photographers who work alone should be protected in some manner in these times of murder and rapine.

1866: A short time ago we cautioned our Western friends against a certain L. D. Furlong who was at that time going about victimizing and swindling photographers. We learned a few days ago that he has been in our own city, and had successfully swindled two of our ferrotype men. He reported that he was with Mr. S. M. Fassitt of Chicago, and had been sent here to learn how to make pictures on watch dials, but he had been robbed in the cars, and wanted to borrow money to telegraph with and pay his way until he could get a remittance from Mr. Fassitt. We wrote to Mr. Fassitt about him and learn that he has not been in Chicago for over a year. Mr. Fassitt says he has heard of four persons who have been lately swindled by this individual. He is a tall, rather slender man, of fair complexion, and rather prepossessing at first sight. He is of good address, and likely to deceive almost anyone. He sails under various aliases, some of which are J. D. Farlan, J. D. McFarlan, and George Bernard. Our friend Carbutt has sent us a picture of him, which we will be glad to show those who desire it. Look for him, and have him arrested if you can.[357]

1867

Seventeen years after the birth of photography, the Duc de Luynes, a French archaeologist and member of the French Institute, placed 10,000 francs at the disposal of the Photographic Society of France to be offered to the inventor of some process which would produce photographic prints that could be considered *permanent,* and unsusceptible to fading. At the time of this gesture, the society's president, the French chemist Henri Regnault, suggested that inventors concentrate their attention on carbon, stating:

> Of all the substances with which chemistry has made us acquainted, the most permanent and the one which best resists all chemical reagents in the temperature of our atmosphere is carbon. . . . The present condition of ancient manuscripts shows us that carbon, in the form of lampblack on the paper, remains unchanged for centuries. If, therefore, it were possible to form photographic pictures in carbon, we should then have the same guarantee for their permanency that we now have for our printed books; and that is the best which we can hope or wish for.[359]

No one inventor received the full amount of the prize, but the Frenchman, Alphonse Poitevin, received the lion's share of the award in 1867 for having developed a basic method of printing photographs in carbon (in 1855) which was improved upon and patented in 1864 by Sir Joseph Wilson Swan. In the Swan process, photographic images could be secured on paper treated with pigments of powdered carbon in gelatin. But it was a process requiring expert hands, since the treated paper (sold as "carbon tissue") could not be worked on, and any desired manipulations or retouching had to be done on the negative before it was exposed in contact with the tissue.

Carbon printing was slow in being adopted—and then only by a limited number of dedicated practitioners and those fashionable photographers whose customers were willing to pay the higher cost for prints. Swan took two years to introduce his process commercially, then sold the rights in 1868 to the Autotype Printing and Publishing Company in London. In a short time, that company became the principal British licensee of the process to professional photographers, providing at the same time a printing service which enabled individual practitioners to free themselves from many of the complicated manipulations called for.[360]

In the United States, Charles Seely experimented with carbon printing in 1858, and gave brief but inconclusive reports on his progress in the *American Journal of Photography*. Prof. John Draper, like his French counterpart, Regnault, recognized the potential of the medium, and in an annual address to the American Photographical Society, he pointed to the "great changes" which carbon printing might bring to photography in the future.

At first, noted European photographers such as Adolph Braun sent portfolios of large carbon prints to America which were offered for sale by dealers such as Wilson and Hood in Philadelphia. In the case of the Braun photographs, E. L. Wilson described them in the pages of the *Philadel-*

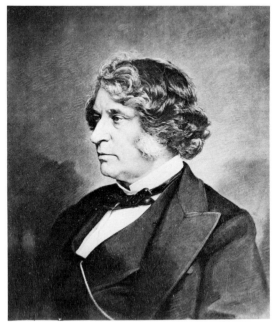

Carbon print of Sen. Charles Sumner of Massachusetts.

AMERICAN CARBON PROCESS

An American process for making carbon prints, which differed from the British method patented in 1864, was developed by a Boston photographer, Frank Rowell. After working in secrecy for six months, he sent his first specimens to E. L. Wilson, together with a letter, dated February 10, 1867, in which he announced that he would be ready "in a few days" to supply prepared paper ("carbon tissue") to the trade. Rowell triumphantly predicted that photographs "will hereafter be as permanent as the engravings which adorn the walls of our dwellings," and claimed that carbon prints could be made more cheaply than conventional photographic prints, and with greater ease and certainty. Rowell and a partner, E. L. Allen, continued to advocate and to practice the carbon process, but in 1877 Allen said "it has taken from that time (1867) to this to make it anything like a success financially." The Allen and Rowell print (above) made in quantity for an 1874 memorial to Sen. Charles Sumner, has retained its original strength and luster.[361]

PHOTOGRAPHY AND PHOTO-CHEMISTRY

By Prof. John W. Draper

Photography, interesting and extensive as it is, is only a department of a far higher subject, Photo-chemistry—the influences of light in producing chemical action. Within the last four years the attention of the chemical world has been strongly directed to that subject, particularly in the application of spectrum analysis, and it may now be said to have succeeded to the prominence accorded a few years ago to organic chemistry. There is a striking parallel between the condition of chemistry now and that as exhibited sixty years ago. At that time, every one was occupied with the influence of electricity in producing chemical charges, the Voltaic battery had been invented, the decomposition of water and other substances had been accomplished by its means, soon a great revolution was to occur in chemistry through the decomposition of the alkalies and earths by [Sir Humphrey] Davy, the production of metals light enough to swim on water, and even to accomplish the proverbial impossibility of setting it on fire. The nomenclature of the science had to be changed, discoveries crowded upon one another with such rapidity that in succession many subordinate but yet extensive and mathematical sciences, such as electro-magnetism, magneto-electricity, came into existence, the polarity of the needle was explained, and the practical application culminated in the great and inappreciably valuable invention of the electric telegraph.

Now it seems that Photo-chemistry is about to run through the same career as Electro-chemistry, but with the conspicuous superiority at its starting point. When the great development of the latter took place, there was no important, no master fact, foreshadowing the value of what was about to ensue, or indicating the direction that discovery would actually take. With Photo-chemistry how different! Long ago it was recognized that the sunlight is the cause of all vegetable organization. The myriads of plants that we see, from the moss upon the wall to the great palms of the tropics, are all children of the sun, the countless combinations they contain, their oils, their acids, their beautiful coloring materials, have all originated in the action of the solar rays. What a world of phenomena have we here, unrivalled in variety and importance! And we must also remember that, even the animal kingdom is affiliated to these facts, for animals find their nutrition in plants, and in turn render nutrition to them. The heat of the sunbeam is the source of the warmth that pervades our bodies, the blush of shame that suffuses our faces, the fever that consumes us in sickness. That heat was incorporated in plants, and is restored to the outer world again by animal life.

There is therefore a grand future in prospect for Photo-chemistry, and that not only as a science but as an art. Every advancement it makes in the scientific direction will be quickly made available for his purposes by the photographer. And hence there is every inducement to cultivate it in both these forms. It is not to be believed that we know at present the best photographic compounds that exist. The salts of silver were the first to be used, and it may be said that thus far they have preserved their pre-eminence. But they are not the substances employed by nature. It is, in the main, compounds of carbon with which she deals. I look for great changes in our art in this respect, both as regards more truly working material—in which the natural order of light and shade will be better preserved—and also more sensitive and more durable preparations.[362]

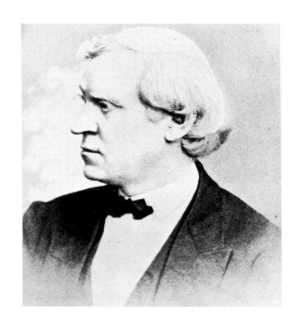

EXIT CHARLES A. SEELY

Charles A. Seely was a wearer of many hats during a career in which he was awarded nineteen patents in the field of photography (covering methods for manufacturing collodion; preparing a toning bath; designs for cameras; etc.). In 1838, at the age of thirteen, he became a laboratory assistant to Dr. Chester Dewey at the Collegiate Institute in Rochester, New York, and was graduated from Union College, Schenectady, New York, in 1847. After serving on the staff of the *Scientific American,* he founded the *American Journal of Photography* in 1855, and served as its publisher until 1867. During these years he also engaged separately in the manufacture of photographic chemicals, both alone and later in partnership with Henry Garbanati and others. In 1859, he became a charter member of the American Photographical Society, and an analytical and consulting chemist at the New York Medical College and the New York College of Dentistry. Although he did not obtain a doctorate until 1878, his identification in the minutes of meetings of the American Photographical Society changed from "Mr." Seely to "Professor" Seely, beginning on October 8, 1861.

In 1867, the same year in which he ceased publication of the *American Journal of Photography,* Seely became an organizer of the American Electric Light Company, and removed himself thereafter from the American photographic scene. His departure appears to have been sudden and complete, for having carried the battle against James A. Cutting's endeavors to license all practice of collodion photography virtually to the finish line, he was absent at the time of the final showdown in the early months of 1868. Seely twice lost his papers and books, first in a fire at 26 Pine Street in 1874, and again in a fire at the World Building in Park Row in 1882. This led an editor of the *Photographic Times* to comment at the time of Seely's death in 1896: "Perhaps to this double calamity is due the fact that of his *American Journal of Photography,* there is no complete file known to the writer." Today, there are no known copies of the first volumes published between 1855 and 1858; and no complete sets of issues for the years 1858–1867 are to be found at any single library or institution.[363]

phia Photographer as ''probably the finest landscape photographs in the world.''

In February 1867, Frank Rowell of Boston introduced an American carbon process which was basically similar to Swan's method, but used a carbon tissue which Rowell claimed was ''entirely distinct'' from Swan's. Among the first to take up the carbon process in New York was the firm of Huston & Kuhns (William Huston and W. J. Kuhns). In April 1868, when the partners exhibited carbon prints at an American Photographical Society meeting, Huston said that he and Kuhns felt that the stock of carbon tissue offered by Rowell, and another offered by Braun (whose home base was in Dornach, Alsace) were superior to Swan's (which they considered too soluble and troublesome to use), but that Swan's mode of printing was simpler and otherwise more preferable.[364]

No process for making photographs received greater attention in the photographic press throughout the remainder of the nineteenth century than the carbon process. Among the first to herald its arrival was the New York *World:*

> As far as pictorial beauty is concerned, we have never seen anything in silver that compares with the new prints. No consideration of simplicity, economy, or permanency would avail to popularize the new process, if the results were inferior to those attained by the old method. The advantage in this respect, however, lies with the carbon prints. The minutest details of the finest negative, each delicate gradation of light and shade, and every monochromatic tint possible in art, is reproduced with an accuracy that is truly remarkable. The albumen gloss so much objected to in silver prints is rendered unnecessary by the new process, and the lusterless surface adds greatly to the effect of the pictures. The permanency of this work, however, is its chief advantage. . . . The image is taken on a bed of India ink, carbon, or some other permanent pigment, and it may be easily demonstrated that the picture will last as long as the paper on which it is printed. We have seen variously tinted prints, resembling the most delicate drawings in India ink, sepia, India red, and other colors never before attained in photography. Some old paintings copied in this way are more beautiful than anything of the kind we have ever seen. . . .
>
> We welcome this discovery as the great desideratum so long sought by scientific photographers, and can only wish that an American had discovered it. As it is perfectly new and but little known, it has found but few who are willing to try it and demonstrate its superiority over the old process. The successful experiments in Boston and our own city will tend greatly to popularize it, and for both fancy pictures and portraits it must eventually supersede the silver prints.[365]

Seely, on the other hand, felt that carbon prints would never rival the conventional or ''silver'' prints either in fineness of detail or in general artistic effect. Further, he prophesied (accurately, as it would be proven in the future) that the general public would not sufficiently appreciate its good qualities to made its practice financially rewarding to a large number of photographers. In Philadelphia, F. A. Wenderoth gave a formal presentation on carbon printing to the Philadelphia Photographic Society, citing its greater cost (''We have tripled the cost of manual labor, as we have to employ three times the amount of help to finish, in a given time, the same amount of carbon prints as of silver prints''), the greater number of printing operations required (fourteen in the case of the carbon process, which had to be

POSED FOR THE EXODUS

The years 1868–78 have been termed those of ''the grand flowering'' in American stereophotography, when photographers such as the unidentified operator, posing (below) with his stereo camera, took to the field to record a civilization shedding its agrarian heritage and opting for a new industrial and urban way of life. They went individually, or as representatives of publishers bent on stocking card stereographs of people, places, and events everywhere. Many headed west, and scenes of Yosemite, other tourist meccas and shrines became stocked on display racks all across the country. Every railroad line and its surroundings was photographed, as was every bridge standing in 1860, or built thereafter. Views were made of statuary and of noted murals and other works of fine art. At the same time, the card stereograph was adopted by merchants for advertising, and by publishers for adding an entirely new dimension to education and entertainment.

ROOFTOP SOLAR CAMERAS BASK IN THE SUN

In 1865, Prof. John Towler, editor of *Humphrey's Journal,* observed that solar cameras had become "the favorite mode" for making enlarged photographs. In midsummer, 1867, he noted that there were a "great number of solar cameras now visible on the roofs of photographic establishments, as well as in their windows and gardens." The view of a New York parade (above), made by E. & H. T. Anthony & Co. in 1871, is possibly the only surviving photograph depicting a solar printing establishment with a bank of solar cameras on the rooftop. Solar printing was a special art, and to those engaged in its practice, Towler gave these helpful suggestions:

Positioning the Camera. "When about to print, take out the camera upon the roof or elsewhere, if it is of the portable kind, and place it in a position where there will be no need of moving it from this position, until the printing operation is complete; place it, too, where it is not liable to be jarred or agitated by the wind."

Drying and Positioning the Enlargement Paper. "Albumen paper is sensitized in the usual way and hung up to dry. As soon as all excess of silver has drained off from the lowest corner, and the sheet is no longer wet on the surface, but simply embued and expanded with moisture, place the sheet on a large flat board and pin down the edges all around firmly to the board, and set it aside to dry *completely.* Whilst drying, the sheet contracts and becomes perfectly flat. When dry, the film may be formed, just as you are accustomed to operate in this respect. Be very careful that the sheet is *perfectly dry* before you substitute it for the focussing paper. Pin it well in place, turning the portable camera, of course, away from the sun during the operation. . . . If the sensitive sheet were not dry when the sun was turned on, the picture will be nowhere sharp; for, by contracting as it dries, the paper gradually recedes from the picture and makes the impression nowhere perfect. Frequently, the drying is irregular, or the pins give way more on one side than on another, in which case the contraction is sudden in a given direction. By this means, lines, points, leaves, etc., become doubled." [366]

accomplished over a period of from 14 to 24 hours; eight for silver printing, which required no more than 5½ hours time), and challenging the contention that the process was more "permanent." Carbon prints, he pointed out, consist of a more or less thick layer of gelatine, and some coloring matter, resting *on* the surface of the paper, whereas a silver print is not on, but *in* the paper to a larger extent. To his way of thinking, the silver print would be "safer from injury than one which rests only on the surface." Then there was the problem of retouching or coloring of carbon prints. The demand for colored prints was high in every photographic establishment, yet, according to Wenderoth, "a leatherified carbon print repels water colors even more than albumen silver prints, and makes retouching and coloring near impossible." [367]

John R. Clemons, the largest American manufacturer of albumen paper, recognized the problem of print coloring on the glossy surface of the albumen paper, and as early as 1863 he began concurrent manufacture of plain salted photographic paper which, he said, had been "kept on the shelf" during the first years of printing of card stereographs and cartes de visite on albumen paper. In 1867, Clemons introduced a matt-surface paper under the brand name of "Clemons Arrowroot Paper," and while he also continued to make the plain slated paper, the matt paper became, in time, a more popular article. [368]

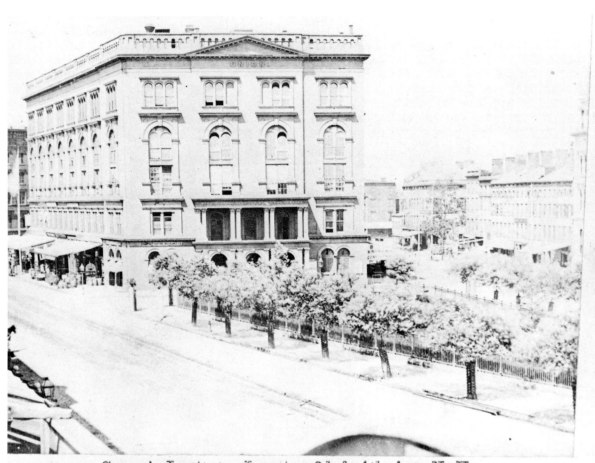

Cooper's Institute, Junction 3d & 4th Avs. N. Y.

THE COOPER INSTITUTE CIRCA 1868

Peter Cooper was among the organizers of the American Photographical Society, and the society's first meetings were held at his Cooper Institute, situated then, as now, at the northern tip of the Bowery section of New York City. In 1860, Abraham Lincoln delivered one of his most famous campaign addresses there, and on the same day Mathew Brady took a picture of Lincoln which together with the speech Lincoln later said were most responsible for electing him to the presidency.

Erected at a cost of nearly half a million dollars, the brown stone building was constructed with steel beams manufactured at Cooper's own rolling mills in Trenton, New Jersey. The Institute's purpose was to provide gratuitous instruction for the "working classes" in science, art, telegraphy, English literature, and foreign languages. One department was a school of design for women. The operation was liberally endowed, and ground floor stores and offices elsewhere in the building were providing a recorded annual income of $30,000 in 1872. Of the Institute's neighborhood, it was said in 1872: "Respectable people avoid the Bowery as far as possible at night. Every species of crime and vice is abroad at this time watching for its victims."[369]

THE FRATERNAL YEARS
1868

On April 7, 1868, the nation's photographers gathered for the first time in a National Photographic Convention, which was held for two days at Cooper Institute in New York. The purpose of the gathering, which had been advertised in the March and April issues of the *Philadelphia Photographer*, was to map a campaign of resistance to the imminent possible extension by the government of a patent which would, in effect, allow one man and his agents to license virtually all photographic practice. Ordinarily, this noteworthy event might have attracted considerable public attention, but the eyes of the country were focused elsewhere on the Congress of the United States, which for the first time in American history, had begun impeachment proceedings against a sitting president.

Many of photography's biggest names were on hand for the convention: Mathew Brady, Abraham Bogardus, D. D. T. Davie, John A. Whipple, James W. Black, Edward L. Wilson, Henry T. Anthony, James F. Ryder, Edward T. Whitney, J. E. Whitney, Alexander Hesler, John Carbutt, and James Cremer. Those from out of town came as delegates, their attendance funded in most cases by the treasuries of local societies or fraternal organizations. On the eve of the convention, *Humphrey's Journal* (which ceased publication a week later) ran this brief notice, which would make it appear that the delegates were meeting unnecessarily:

> We are informed by Mr. Tomlinson, the party owning the patent for New York and Brooklyn, that no measures whatever are being taken to renew it; that the thing is "dead" and will never again rear its head to trouble photographers. But it is best to be on the alert . . . Cutting is dead; he died in a mad-house and left no heirs. Was the ill success of his Patent the cause of his insanity? We are told that it was . . . as we are informed, no one has any legal right to speak for him or to claim a renewal of the Patent in his behalf . . .[370]

The article evidently went unnoticed, and failed to forecast the events to come. James A. Cutting, the original patent holder, was in fact committed to the Worcester Insane Asylum in Worcester, Massachusetts, in 1862, and died there in 1867. The patent assignee during the period of his confinement was Thomas H. Hubbard, whose legal standing now became a matter of dispute (Hubbard claimed rights to the patent extension, but to no avail). It was the administrator of the Cutting estate, Asa Oliver Butman, who made the official move for extension (which he did on April 11, 1868, the last day on which such action could be legally taken). Anticipating this move, meanwhile, the delegates set about establishing the necessary funding and battle plan which would take effect as soon as the expected patent extension application was made.

Henry T. Anthony was chosen temporary chairman at the outset of the convention, and the committee established to nominate a slate of officers and present guidelines for a *permanent* photographic organization consisted of G. H. Loomis, of Boston, Mathew Brady, of New York, and Alexander Hesler, of Chicago. The officers nominated and

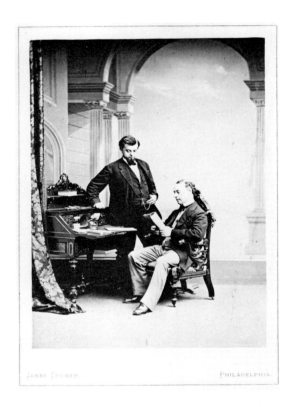

PHOTOGRAPHERS' LEGAL COUNSEL

In applying for an extension of the so-called bromide patent awarded in 1854 to James A. Cutting, the administrator of the Cutting estate engaged a Boston lawyer, James B. Robb, and the Washington law firm of Holmean & Hollingsworth to prosecute the case. Delegates to the National Photographic Convention, meanwhile, had made provision for funds to engage legal counsel to fight the patent renewal if required. The convention empowered its secretary and treasurer, Edward L. Wilson, to take this action, which he did immediately after those above were chosen by the Cutting estate administrator. The men chosen by Wilson, shown above, were Henry Howson, standing, and Furman Sheppard, both Philadelphians, the former, a patent solicitor and the latter, in Wilson's words, "one of the most prominent patent lawyers in the country." He had not anticipated the need to employ two counsel, Wilson said later, "but, finding the other side so largely provided for in this direction, it was deemed expedient to employ the very best counsel that could be had." He described the pair as "well versed in patent law, and fully up to any game that might be played by our wily opponents."[371]

JEX BARDWELL

The Detroit photographer Jex Bardwell became one of the unsung heros of American photography in 1868 when he journeyed to New York with a private collection of old pamphlets and journals which proved invaluable as evidence in disputing the claims of attorneys for the heirs of James A. Cutting in their fight to renew the bromide patent. That one man's records should prove so crucial to this important litigation attests to the carelessness of other photographers in maintaining records of their own, as well as the wantonness with which photographic records were discarded. Bardwell made daguerreotypes of Indians in the 1850s, and adopted dry-plate photography for outdoor work after 1860. The photograph above was made after 1893, when he asked the photographic fraternity to come to his aid in a period of severe financial stress.

manent "National Photographic Union," the fourth read as follows:

> *Resolved,* That the present state of isolation among photographers leaves them exposed to the designs of any one who may prey upon them, to the mercy of the process-monger, the exactions of the patent-seeker and owner, and to suffer the degrading influence of the cheap and incompetent.

Most of the resolutions were at least discussed, and some were amended by the delegates; but the fourth resolution was adopted unanimously without any discussion. Symbolically, by this unanimous vote, photography's formative years of isolated practice were declared *finis.*

When, at the eleventh hour, Butman filed for the patent extension, he was represented by two lawyers, James B. Robb, from Boston, and another representing the prestigious Washington law firm, Holmean & Hollingsworth. Wilson had been empowered by the photographers' convention to engage legal counsel when and if such counsel was required, and he immediately engaged the Philadelphians Furman Sheppard and Henry Howson. "A few hours after our first consultation," Wilson recalled afterwards, "telegrams were flying here and there, and busy pens were at work initiating the movement against the extension of this odious patent."

On April 29, James Black served notice on Butman in Boston that the application would be contested; objections to the extension were subsequently filed with the Patent Office on May 11. Between May 23 and June 4, the official testimony in the case was presented by both parties in the presence of an alderman in the cities of Philadelphia and Boston. The greatest amount of factual information came from one source, cited by Wilson in this tribute, which he included in his report of the case:

> It is not out of place to say here that these books were mainly procured for us by Mr. J. J. Bardwell, of Detroit. We had been informed that it had been his habit, for many years, to purchase most of the works on photography that were published, and that he had used bromide of potassium in collodion in 1853. Considering this most valuable testimony, he was asked to come to Philadelphia, bringing his books with him. He replied at once, volunteering to close his gallery (having no assistant), and to give all the time necessary. On his arrival here, I found he had carefully read over his large number of books, and marked the pages useful to the case, so that they were ready to offer in evidence, as above, at once. He also had a list of other books, known to contain matter of value to our case, which were purchased and given to him to examine.

There were also a number of interesting revelations which emerged from the testimony taken in Philadelphia and Boston. First, it appears that the chain of events which led to Cutting's application for the original patent in 1854 began with an earlier visit he made to Whipple's gallery in Boston, ostensibly to purchase the rights to practice the collodion process Whipple was then using. Whipple's deposition follows:

> Q. State under what circumstances you first became acquainted with him.
> A. Mr. Black and myself owned a patent for taking negatives on glass; Mr. Cutting came to my place and wished to purchase a right to use it; he thought the price we asked for it exorbitant,

quickly elected were the following: Abraham Bogardus, president; six vice presidents, consisting of James W. Black, Boston; W. E. Bowman, Ottawa, Illinois; James Cremer, Philadelphia; David Bendann, Baltimore; James F. Ryder, Cleveland; and Edward T. Whitney, Norwalk, Connecticut. Edward L. Wilson was chosen secretary and treasurer. The agenda for the convention was prepared by a committee consisting of Loomis, John A. Whipple, B. Gurney (son of Jeremiah Gurney), Ryder, and Wilson. Among the five resolutions on the agenda, which called for resistance to the patent extension and the establishment of a per-

The U.S. Patent Office examiner who, in 1854, had recommended award of the so-called bromide patent to James A. Cutting, now stated, fourteen years later, that the patent was wrongfully granted, and that its extension to the administrator of Cutting's estate should be denied. His recommendation was officially adopted a month later.

EXAMINER'S REPORT.[372]

UNITED STATES PATENT OFFICE,
June 15th, 1868.

To A. M. STOUT, ESQ.,
Acting Commissioner of Patents.

SIR: After a careful examination of the application of Asa Oliver Butman, administrator of the estate of James A. Cutting, deceased, for the extension of a patent for a composition for making photographic pictures, granted on the 11th of July, 1854, numbered 11,266, I have the honor to report: At the time Mr. Cutting applied for the above-named patent, there were a number of originators of the same invention in Europe and in this country. The only difficulty was, in getting proof of priority in the time of invention; within the meaning of the law, the composition claimed was not found definitely "described in any printed publication in this or any foreign country." (Act approved July 4th, 1836, Section 7.) But the application was rejected. Mr. Cutting was then allowed by the Commissioner of Patents, on personal appeal, to procure evidence anterior to his application, against the foreign printed evidence. He procured the testimony on file of Milo S. Torsey, fixing the 2d of April, 1853, and Isaac Rehn, 1st day of July, 1853.

The earliest foreign evidence, although close by, did not mark so early a period of time. Dr. Cresson's notice of his discovery, in the Franklin Institute Journal, May 20th, 1852, although unknown at the time, is too indefinite to offer any serious opposition. Mr. Cutting's claim, as an original inventor, is not undisputed. See Giles Langdell's testimony, taken for the remonstrants.

Now, it fully appears that Dr. Charles M. Cresson, of Philadelphia, had the composition fully in use, as early as the month of April, 1852, one year before Mr. Cutting, a fact known to Mr. Cutting when he obtained the patent.

The invention "was not new, or patentable, when patented." (See Act approved May 27th, 1848, Section 1st.) That it is useful, is proved by simultaneous invention, and the fact of its use by all photographers in this and other countries.

That it is valuable and important to the public, is proved by the fact of its being in almost universal use: the patent to the contrary, notwithstanding.

As Mr. Cutting was not entitled to the patent when it was granted to him, I do not touch on the question of his adequate reward, for the invention, I believe he was fully rewarded, while others, with equal, if not superior claims, including Dr. Cresson, remained passive, and sought no monopoly.

Photography has arisen, now, to that state, in which the properties of materials used, and the modes of compounding them, are well understood. Bromine is one of the standard substances in use, in all countries, for photographic purposes, in its various compounds; and, although it may be shown that chlorine, with other compounds, may, in some cases, be substituted for bromine, the monopoly of so useful a substance, would be an infringement on the liberty of the public, unless an inventor can clearly prove himself to be the original and first to propose and introduce his invention for public good, as well as individual profit.

James A. Cutting was not the original or first inventor of the compound of bromine for making photographic pictures, for which the patent was granted him on the 11th of July, 1854. This fact being clearly proved, I have only to suggest that the extension of the patent now sought by the petitioner, A. O. Butman, cannot be granted without great injustice to the public.

Respectfully submitted,

T. R. PEALE,
Examiner Fine Arts.

and angrily said he would be damned if he didn't find out some other way to do it; in about three weeks afterwards, he brought me a picture; said he made it from a negative taken as quick as a daguerreotype; that's all the conversation we had at that time that I now remember.

Q. Did Mr. Cutting ever travel for you, or any firm to which you belonged? If so, for what purpose?

A. He did; for the purpose of selling the rights to use our combined patents.

Q. When, and for what reason, did Cutting's services as a traveller on account of these patents cease?

A. I should say in 1855 or 1856; because I had no confidence in him as a business man or in his strict honesty; I never had any settlement with him, or could bring him to a settlement, of our affairs, and finally dissolved partnership with him, he giving me the free use of his patent, and I giving him the free use of my patent, as we considered them both worthless in a legal point of view; that was our talk together as we talked the matter over and passed the papers.

Secondly, the testimony in this case points strongly to the likelihood that Cutting derived the formula spelled out in his 1854 bromide patent from the experiments of two men—Dr. Giles Langdell, then of Boston, but later a resi-

dent of Philadelphia; and Dr. Charles M. Cresson, the Philadelphia chemist—after which (sometime in 1853) Cutting contacted a friend, Isaac Rehn, and prevailed upon Rehn to become his business partner.

The historian Marcus A. Root tells us that Langdell procured a published account of Scott Archer's collodion process in 1853, and after several experiments succeeded in making "very good" collodion portraits on paper. Langdell's own testimony at the patent renewal hearings not only substantiates this but reveals that he conducted his experiments jointly with Cutting. Langdell's deposition also asserts that it was he who first used bromide of potassium in these experiments:

Q. Please describe a little more fully the nature or general character of these experiments you were then making with collodion.
A. We commenced with experiments by using the collodion simply excited by the iodide of potassium; I should judge that we were experimenting with that alone for some two or three weeks, with various results, and I made a little alteration myself by introducing the bromide of potassium.
Q. Introducing it into what?
A. In combination with the iodide of potassium in collodion.
Q. What led you to introduce the bromide of potassium into collodion?
A. Well, from some hint in some publication, and I cannot state positively what that publication was; and from the fact that we were using it in the albumen process in connection with iodide of potassium also, as well as in the daguerreotype process.
Q. By whom, at that time to which you are referring, was the bromide of potassium in combination with the iodide of potassium introduced into the collodion?
A. By myself.
Q. Had such introduction been suggested, or taken place during these experiments, prior to the time when it was done by you?
A. No.
Q. Had Mr. Cutting, during those experiments, suggested, or made any use of the bromide of potassium, in combination with the collodion?
A. Not at all.
Q. After having made this alteration, by the introduction of the bromide of potassium, did you take any pictures by the altered process? And if so, with what result?
A. I made our usual experiment; that was pointing out and taking the steeple of one of our churches, I don't remember which; the result was very different from any previously made. I showed it—the picture—to Mr. Cutting, and he was astonished at the result, and wished to know how I proceeded to obtain it. I told him I had introduced bromide of potassium in combination with the iodide. Then we continued on experimenting and working with the bromide after that.

Further in his deposition, Langdell stated that Cutting suggested that the pair take out a patent for the use of bromide of potassium, but that he (Langdell) "remarked to him 'that the idea was absurd,' or something to that effect, and stated to him that I did not think there was novelty in it sufficient, for bromine had already been in use for years, both in the albumen process and the daguerreotype. That was about all that was said in regard to it. That was the last he ever said to me."

It is quite possible that the collodion pictures shown by Cutting to Whipple in 1853 were made after the Langdell experiments cited above. It also appears that Cutting became aware of Dr. Cresson's experiments in Philadelphia, possibly reading about them in the May 1852 issue of the *Journal of the Franklin Institute* (but which he could not have seen until after the Langdell experiments, Langdell possibly having read about them first).

Dr. Cresson also gave a deposition at the patent renewal hearings, stating that he had used bromine in combination with collodion to make collodion pictures between April 15 and May 20, 1852. He also produced a bottle at the hearings containing the ingredients of his 1852 formula (and still bearing its 1852 label). After the 1852 experiments, Cresson said, he was contacted by Cutting with respect to a patent which Cutting had applied for, or was then applying for:

Q. Please state what, if anything, he said, and all that took place between you on the subject.
A. Mr. Cutting asserted that he had been experimenting on the subject for some time, and had exhausted his means, and desired me to withdraw any claims which I might have, which would secure any patent right to myself, and, if I recollect clearly, I signed a disclaimer of some sort, the particulars of which I have now forgotten.

A deposition taken from Isaac Rehn at the hearings reveals that Cutting contacted Rehn in 1853 in York, Pennsylvania, and persuaded Rehn to join him in Philadelphia to take up the practice of collodion photography. Possibly this occurred after Cutting secured a disclaimer from Cresson. After that, according to Rehn, the pair "travelled here and there over the country, selling rights and teaching the process." But as we have already seen, their "teaching" began as early as 1853, or six months to a year prior to the award of the bromide patent to Cutting in July 1854. Rehn belittled all of the exhibits provided at the hearings in behalf of the photographic community. This applied to Dr. Cresson's bottle of ingredients used in 1852 to make collodion photographs (the bottle was of no avail because no proportions were given, Rehn said; in addition, the pictures made by Cresson with the formula were not "merchantable"), and it presumably applied to all of the books and articles provided by Bardwell. Rehn contended that the proportion of bromide used in iodized collodion must be such as to create bromo-iodide of silver in the film, and that this result could only be secured by the Cutting formula. Cutting, he contended, had been the first to succeed in making collodion photography workable, where all before him had failed.

After the filing of all official documents in the case, the same Patent Office examiner who, in 1854, had recommended to his superior that the Cutting patent be granted, now reversed himself, and on June 15 recommended against further extension of the patent. All parties appeared before the Acting Commissioner of Patents on July 7, and three days later the Commissioner issued a lengthy opinion upholding the Examiner's position, and denying the patent extension. Having thus banded together and successfully won their cause, the photographers of the nation now made plans to perpetuate their newly formed union in a National Photographic Association.

The fraternal years had begun.[373]

1869

Many factors converged to make 1869 a turning point in American photographic history. At long last a fraternity was born out of a necessity to wage a common war against a syndicate bent on licensing virtually all photography. The voices of Snelling, Humphrey, and Seely—as well as their journals—were now gone from the scene. Not until February 1870 would there be any competition for the *Philadelphia Photographer*, which would then come from the house of E. & H. T. Anthony & Co. Edward L. Wilson was now the predominant spokesman for American photography, and would remain so throughout the remainder of the century. In 1871, he began publishing a companion magazine, *Photographic World* (suspended in 1875), and began issuing a supplement to *Philadelphia Photographer*, entitled the *Photographic Times*. The latter publishing venture was at first sponsored by the Scovill Manufacturing Company, but after 1875 was published independently by Scovill until 1902.

This year also saw the final completion of the nation's first transcontinental rail line, which enhanced people's interest in the scenic wonders of the American west. This, in turn, sparked a widespread increase in the demand for stereoviews and for large landscape views (photographs of size 18 x 21 inches, or larger) which could only be made at this time with mammoth-plate cameras previously custom-made for only a handful of entrepreneurial photographers operating out of San Francisco. This year also saw a stirring of activity in Europe in the field of color photography, and in mechanical means of producing photographs from images secured on a printing plate.

When the members of the newly formed National Photographic Association gathered for their first annual convention in Boston on June 1, 1869, they were greeted with another revelation, marking an important turning point in photography. This was an exhibit of photographic portraits made from retouched negatives. Negative retouching had not heretofore been practiced in the United States, although it had made its appearance several years earlier in Europe. Previously, retouching had been limited to the doctoring of finished daguerreotype, ambrotype, or tintype images, or photographic prints; but now it was to be applied to the negative itself, in order to improve facial characteristics in portraiture, or to secure a greater variety of intermediate tones such as a collodion negative could not by itself record.

The exhibit at the NPA convention was staged by the Cleveland photographer James F. Ryder, who characterized negative retouching as "the most important and first real improvement to the portrait photographer after the advent of collodion." In later years Ryder recalled how it had been he, rather than "some prominent New York photographer," who was responsible for the innovation:

> Dr. Hermann Vogel sent examples of this work to Edward L. Wilson, and from him I secured a small collection. The pleasure I found in these little portraits which got their smooth, soft, and delicate finish from the retouched plate was most gratifying. The coarse skin texture, the pimple and freckle blemishes were converted into fine, soft complexions, most gratifying to the

Abraham Bogardus (top) and James F. Ryder (bottom) emerged as two of the guiding lights of American photography's early fraternal years. Bogardus was named president of the newly formed National Photographic Association, and Ryder, after displaying retouched photographic portraits at the Boston 1869 convention, was given the responsibility of hosting the 1870 convention in Cleveland. Both men began their respective practices modestly in the period 1846–47, and both survived to the early years of the present century. Ryder operated an extensive art gallery as well as a photography studio in Cleveland.

eye, and especially to the eye of the person represented in the picture. This was a phase of art wrought out by the patient German and but recently introduced by him, while in America it was unknown.

I expected it would be captured and introduced by some prominent New York photographer, as we look to that city to take the first bite at every pie coming from abroad. I was anxious it should so happen that I could take a later chance at securing it for my own practice. The metropolis was tardy; I was impatient. I concluded to take the liberty of giving Cleveland a chance, and set about it.

Mr. Cyrenius Hall, an artist skilled in water-colors and India-ink work, who had been some years in my employ as a finisher

of photographs, had gone to Germany to study more serious art. To him I wrote, telling him of my want, describing what I had seen, and asking him to secure for me a skilled artist in retouching. He was successful in finding an excellent man—Herr Karl Leutgib, of the Munich Academy, who was desirous of coming to America. Mr. Hall soon closed a contract with, and secured passage for him on the steamer *Schmidt* for New York.

I had a friend to meet him at the steamer's dock, with photograph in hand, held aloft, standing by the bridge as he came ashore and see him safely on board the train for Cleveland. For reasons, I did not want him to loiter about New York or visit any photographic establishment in that city.

On his arrival in Cleveland we made him very welcome and

SCOTTISH, FRENCH EXPERTS ESTABLISH FOUNDATIONS OF COLOR PHOTOGRAPHY

The human eye contains millions of color-sensitive cones which are believed to be blue-sensitive, green-sensitive, and red-sensitive. By being stimulated in varying degrees, they enable the eye to distinguish several million different colors. In 1861 this was demonstrated by the Scottish physicist, Sir James Clerk-Maxwell, by projecting three diapositives from three magic lanterns onto a screen through red, blue, and green filters, respectively. When the diapositives were superimposed in register, the audience saw a colored photograph, albeit one that was a far cry from the type of colored photograph one is used to seeing today. The principle involved in the Maxwell demonstration is depicted schematically right: where red and green mix, we get yellow; green and blue-violet give us a peacock blue; where blue-violet and red overlap, we obtain a purple; and in the center, where all three colors overlap, they give us white.

In 1869, the French experimenter Ducos du Hauron, proposed three different ways in which to reconstitute (i.e., obtain) colored images, either for viewing or in print form. In these experiments, he laid the basis of modern color photography:

First, du Hauron proposed a method based on the Maxwell concept which would allow superimposing filtered images in a chromoscope viewing instrument (an idea suggested independently at the same time by another Frenchman, Charles Cros). On this concept was based the most successful form of color photography achieved in the nineteenth century. But it was not a method of achieving colored photographic prints; only a method, best exemplified by the achievements of Frederic E. Ives in later years (see page 360), of achieving photographs in natural colors for momentary viewing.

Second, du Hauron noted that metallic pigments absorb or subtract from light all colors except their own. Thus he took three color separation negatives through separate color filters and made positives on thin layers of bichromated gelatine containing carbon pigments complementary in color to those of the negatives. After conventional treatment of the gelatine surfaces (i.e., washing away the portions upon which the hardening ef-

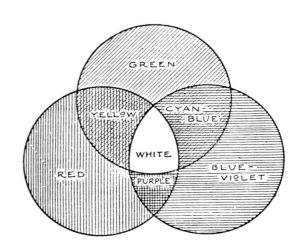

fect of light had not acted), it became possible to obtain superimposed colored photographs either on paper or on glass. Ducos du Hauron's earliest surviving photograph produced by this method appears to be one made in 1877, after further experimentation and progress was accomplished by Dr. Hermann Vogel, who used colored dyes to increase the color range (see page 233). Colored photographs obtained by this method, however, were weak and unbalanced by modern standards.

Third, du Hauron proposed performing Maxwell's triple operation through a glass screen ruled with colored lines (crosswise) that were so fine as to be indistinguishable to the naked eye. This concept, never perfected in the nineteenth century, provides the basis of modern screen-plate color photography.[374]

comfortable, sounding no trumpets in his honor or in our exaltation. Very quietly we prepared a creditable display of the new work, selecting well-known citizens among which were beautiful young ladies and children. These we exhibited with pride.

A decided impetus was given our business from the introduction of the new finish, and I soon imported two more artists. In the spring of 1869 was to be held in Boston the first convention exhibition of the newly organized National Photographers' Association. For that event I made special preparation and took a carefully prepared collection of the ''new finish'' work, the first exhibited in America by an American photographer. It was really the sensation of the exhibition, and created a very favorable impression. It caught like measles, and became an epidemic. Now came a craze for retouching and retouchers. Great was the demand and meagre the supply.[375]

Some important new names in American photography were also now appearing on the scene. After traveling around the country for William M. Chase, and then working part time for a tintype photographer in Baltimore, David Bachrach, Jr., age twenty-four, bought out the latter's business ''with a few hundred dollars,'' and, in October 1869, started the Bachrach firm which has continued among the most prestigious names in world photography to the present day. ''I had to acquire a little taste in posing and lighting, which took years to succeed with partially,'' Bachrach recalled later. ''But the advent of Sarony [Napoleon Sarony, of New York] with the occasional access I had to his studio, and his friendliness, helped me a lot.'' Bachrach also paid tribute to a man younger than himself in helping further his education as well; this was Benjamin J. Falk, also of New York, who opened his first gallery in 1877. In Bachrach's words, Falk was ''a splendid fellow'' who was ''always open and friendly, and I gained a good deal from him.'' Bachrach immediately discontinued tintype portraiture at his new Baltimore gallery, but it was a year's time before he could build up his business to a level of $150 a week in receipts, and two years before he could add a receptionist and farm out his retouching work.[376]

America also now had a major western school of landscape photography. Like the Hudson River school in painting, which encompassed artists with varied careers and began with the works of a single artist (Thomas Cole) a decade before gathering momentum, the new landscape photography school began with a series of mammoth-plate views taken by Carleton E. Watkins in the Yosemite Valley in 1861.

In 1865, the California Art Union was established in San Francisco for purposes of exhibiting works of local artists (as well as the works of the Hudson River school), and in the same year the San Francisco photography dealership, Lawrence and Houseworth, began offering mammoth-plate photographs made by the new landscape school. Although copyrighted by Lawrence and Houseworth, the landscape photographs were made by Watkins, Weed, Alfred A. Hart, and a newcomer, English-born Eadweard Muybridge. After the Civil War, the landscape school was joined by still other noted photographers, namely Timothy O'Sullivan (who made his views while traveling on the Clarence King geological survey of the 40th Parallel and Andrew J. Russell (who worked in the employ of the Union Pacific Railroad). In 1869, King exhibited O'Sullivan's views in Washington,

By 1869, America's western landscape photography school was in full bloom. Its two principal, early guiding lights were Carleton E. Watkins and Thomas Houseworth, sole proprietor (after 1867) of a dealership in western landscape photographs, which had been founded in 1865. Watkins' gallery and the Houseworth gallery, shown above (circa 1867), rivaled the California Art Union which had also been opened in 1865 to exhibit works of San Francisco artists, as well as artists of the celebrated Hudson River school.

New York, and Boston, where they were widely acclaimed. Watkins' photographs were also exhibited at this time in New York at the prestigious Goupil Gallery, and in 1869 the Union Pacific Railroad published *The Great West Illustrated,* each copy containing fifty large photographs by Russell bound in with the separately printed text.[377]

Another European innovation introduced in America at this time was the first of various photomechanical processes—techniques wherein a photographic image could be secured on a printing plate and produced on fine quality paper in considerable volume (although not on the same press used for printing type). There were a number of independent inventors of photomechanical processes, but Alphonse Poitevin (a French chemist and photographer) and Walter B. Woodbury (an English photographer) may be considered the fathers of the basic methods of photomechanical printing.

Poitevin was first to secure a patent in 1855 for what was essentially a forward step in photolithography. The patent covered a method of securing an inked gelatin printing surface on stone, which later inventors secured (as Poitevin had indicated would be possible) on metal, glass, wood, etc. All of these subsequent processes—each known by a particular name (usually that of its ''inventor'')—can be de-

PHOTOGRAPHY ILLUSTRATES
A BIOGRAPHICAL DICTIONARY

In February 1868, a notice appeared in the *Philadelphia Photographer* stating that John Carbutt was nearing completion "of the largest order of portraits we ever heard of." The order was for nearly fifty thousand cabinet-size portraits of about one hundred leading citizens of Chicago. These were used to illustrate *Biographical Sketches of the Leading Men of Chicago*, published by Carbutt in 1869. Biographical dictionaries of this type were illustrated prior to this with woodcuts, or engravings prepared from artist renderings, or (after 1840) copied from daguerreotypes. Carbutt's was the first to appear with actual photographic prints bound in separately with the text. The edition was limited to about five hundred copies, and many were lost two years later in the great Chicago fire. Similar biographical dictionaries were published with photographs of leading citizens during the 1870s in Baltimore, Cincinnati, Syracuse, and the state of Nebraska. A less comprehensive "gallery" of 311 photographic portraits of members of the 35th U.S. Congress published in 1856 by McClees & Beck was claimed at the time to be the "largest collection of perfectly authenticated photographic portraits ever published."[378]

scribed collectively as collotypes, since they are all of the same family and modern dictionaries include the word *collotype*, but not always the other "types" (most of which are described, individually, in later pages of this book).

Woodbury, in 1864, patented a method of embossing photographic images on paper with a metal mold containing the gelatin relief of a photographic negative. No ink was employed in printing; however, colored gelatin was used and was referred to as ink.

The Woodburytype process allowed the securing of photographs on glass as well as on paper, and both glass and paper Woodburytypes were exhibited by Wilson at a meeting of the Photographic Society of Philadelphia in December 1869. The minutes of the meeting record that "it was the general expression of opinion that they [the Woodburytypes] were the finest pictures ever exhibited before the society—perfect in light and shade, of exquisite tone and brilliancy, and leaving nothing desirable but color to make complete pictures."[379]

In 1868, the Bavarian court photographer Josef Albert perfected a collotype process in which inked gelatin printing surfaces were secured to finely ground glass plates. His "Albertype process" evidently appealed more quickly to American photographers than any of the other photomechanical modes—possibly because of the ready availability of glass for experimentation. David Bachrach said he thought he was the first American to make an Albertype in the winter of 1868 when he was still in the employ of Chase, making negatives in Washington, D.C.:

> I believe I am the first one who made an Albertype in this country. In the winter of 1868, I believe, I was employed by Mr. William M. Chase, the stereo publisher, in making a set of negatives of Washington. We received the *Philadelphia Photographer* on the second of the month containing a European letter, which gave the bare outlines of Albert's method, *just patented*. It being a rainy day, I at once prepared a plate, guessed at the proportions, exposed it next morning on a negative of Wallach's New School-house, and took it to a lithographer on Ninth Street, near the Avenue, to be printed. They were all surprised when it was inked up and a print was made from it; but, of course, not knowing how to put it in the press, the plate was smashed. Mr. Chase kept the print, and some others that I made, for a number of years as a curiosity.[380]

A large number of Albertypes made in Munich were exhibited at the December meeting of the Photographic Society of Philadelphia. Although they were deemed "very interesting and beautiful examples of the Albertype," nevertheless, a spokesman for the society complained that "the tone of almost all of the prints seemed cold, resembling the appearance of an over-toned silver picture." Edward Bierstadt made Albertypes in 1869 and exhibited them in January 1870 at a meeting of the Photographic Section of the American Institute (formerly the American Photographical Society, which had decided in May 1867 to merge with the Institute). One of Bierstadt's Albertypes was as large as 20 x 25 inches. According to the society's minutes, the pictures were "pronounced by all to be superb." The Albertype was patented in the United States in November 1869, and the American rights were thereafter acquired by Bierstadt, who became the foremost practitioner of this and other photomechanical printing processes.

1870

Motion pictures shown in theaters did not result from a single invention, but rather from three separate realms of development, viz., the camera, the film (after 1890), and the projector. The process was evolutionary in each instance.

Coleman Sellers' *Kinematoscope,* shown in 1861, was a first step toward camera development, in that the card stereographs used were fitted into slots in the machine's revolving drum, preventing blurring when the rotating cards were viewed through the eyepiece.

On February 5, 1870, a primitive motion picture projector was demonstrated publicly in Philadelphia which, for the first time, equated moving images projected on a screen with sound and music. The device, called the *Phasmatrope* by its inventor, Henry Heyl, was built around a conventional mercury oil lantern, on the front of which was mounted (vertically) a skeleton wheel holding sixteen thin glass photographs (each only ¾ of an inch in height) around the wheel's periphery. As the wheel was revolved in the rays of the lantern, the images were projected life-size and in sequence on the screen.

The event was a night to remember, although it was given little notice at the time. The program was billed, simply, as the "Ninth Entertainment of the Young Men's Society of St. Mark's Evangelical Lutheran Church, Philadelphia," but was held at the Academy of Music in the presence of an orchestra and an audience of 1,500 paying customers. There were three separate showings, and a separate skeleton wheel was used for each. The program was conducted by the photographer, O. H. Willard, and opened with a wheel of photographs depicting a speech by Brother Jonathan (as "Uncle Sam" was called at this time), which was projected while the voice of a reader supplied audible words coinciding with the pantomimic gestures and lip movements of Brother Jonathan. A second wheel of images depicted an acrobatic performance by a popular Japanese gymnast, "Little All Right." The most colorful of the showings involved projection of eighteen images of Heyl and his wife, appropriately costumed, dancing a waltz in perfect synchronism with the same music performed by the Academy's forty-piece orchestra.[381]

In retrospect, this was quite an undertaking for such an obscure man in photographic history, and it was repeated a month later at the Franklin Institute. Heyl has been described as "a little man, thin, wiry, with sandy hair and blue eyes," who "wore thick glasses and very often used a pocket magnifying-glass when looking at small objects." It has also been said of him that he was "quite nervous, and his brain was constantly working out some idea which he would burst out with when he was in the company of people. He was quite musical, was a good singer, and a devout Christian. He never missed attending the Lutheran Church wherever he was. He was very kind and had a gentle voice."

Born in Columbus, Ohio, in 1842, Heyl moved to Philadelphia in 1863. As a boy he is credited with having invented the paper collar, and later patented a folding paper-

Dr. Michael McMahon, director of historical programs at the Franklin Institute, examines the primitive *Phasmatrope* motion picture device demonstrated by Henry Heyl at the Philadelphia Academy of Music on the night of February 5, 1870. The skeleton wheel device holds sixteen small glass photographs, each depicting Heyl and his wife, appropriately costumed, in different stages of dancing a waltz. The wheel is mounted on a conventional magic lantern, of the type shown at right, and on the 1870 occasion the revolving images were projected on a screen in perfect synchronism with the same music as performed live by the Academy's forty-piece orchestra. An audience of 1,500 was present for the demonstration.

box machine and other machines for stitching and sewing books. In 1898, some three years after the first showing of motion pictures in public theaters, Heyl felt compelled to draw attention to his pioneering effort, and sent a letter to the *Journal of the Franklin Institute* recalling further details of the 1870 Academy of Music event:

At that day flexible films were not known in photography, nor had the art of rapid succession picture-making been developed; therefore, it was necessary to limit the views of subjects to those that could be taken by time exposures upon wet plates, which photos were afterwards reproduced as positives on very thin glass plates, in order that they might be light in weight. The waltzing figures, taken in six positions, corresponding to the six steps to complete a turn, were duplicated as often as necessary to fill eighteen picture-spaces of the instrument which was used in connection with the lantern to project the images upon the screen. [The pictures on the skeleton wheel were placed] in such relative position, that as the wheel was intermittently revolved, each picture would register exactly with the position just left by the proceeding one. . . . A shutter was then a necessary part of the apparatus to cut off the light rays during the time the pictures were changing places. This was accomplished by a vibrating shutter placed back of the picture wheel, that was

operated by the same drawbar that moved the wheel, only the shutter movement was so timed that it moved first and covered the picture before the latter moved, and completed the movement after the next picture was in place. This movement reduced to a great extent the flickering, and gave very natural and life-like representation of moving figures.[382]

According to his son, in later years Heyl (who died in 1913) always held to the belief that his *Phasmatrope* embodied the basic operating principles of the modern motion picture projector, but that he never obtained a patent because he regarded it as an amusement without commercial possibilities (a sentiment which Thomas Edison would also later reflect with respect to his own first motion picture projector). Heyl's (and perhaps Willard's) thoughts on the significance of the Academy of Music event were summarized in the speech which the audience heard from Brother Jonathan:

> We are here tonight to see for the first time, photographs of persons shown upon a screen by the aid of a magic lantern, the figures appearing to move in most lifelike ways. How this effect is produced we cannot briefly explain, but you will have the evidence of your own eyes to convince you that this new art will rapidly develop into one of the greatest merit for instruction and enjoyment. This beginning of greater things is not an imported product, but it was perfected right here in Philadelphia, where it adds one more to the list of first inventions of real merit that stand out to the credit of the City of Brotherly Love. The photographs were made at 1208 Chestnut Street in the studio of Mr. O. H. Willard, which place may now be well named "The Cradle of the Motion Picture."[384]

After it was all over, a Philadelphia newspaper columnist writing under the heading "Current Topics of the Town," quoted a proud Heyl as stating: "We came out of the entertainment with $350 in clean money. Pretty good for one picture show, wasn't it?"[385]

Because of the success of his exhibit of retouched photographs at the first N.P.A. convention the previous year, James F. Ryder was designated general chairman of the 1870 convention, which was held at his home city, Cleveland, with over five hundred photographers in attendance. Of these, some two hundred and fifty exhibited photographs, and the number of general visitors passing through the exhibits at a given time reportedly ran as high as two thousand. "The Bromide Patent extension man, with his visions of a yearly revenue of a million or more, did not start out with a view of calling into existence a powerful association with powerful prejudices against unjust patents," Ryder said of the gathering. "He *administered well* for us, and we owe him much. For the good of our young but rapidly growing art, nothing can be of more value to us than unity, that we may all pull together in the direction of improvement." Two appeals to Congress by the successors of the Cutting patent were made seeking the patent's reissue, but both were successfully fought by the N.P.A. counsel. Indeed, the success of the 1870 convention was such as to wipe out all past debts in the patent litigation, plus the cost of renewed resistance.[386]

The greatest attraction of the Cleveland convention, however, was the German scientist and photographic editor Dr. Hermann Vogel. A contributing editor to the *Philadelphia Photographer* since 1865, the thirty-six-year-old founder of the Imperial Technical High School of Photography in Berlin was just at this moment becoming a favorite with the American fraternity. Letters from Edward Anthony and E. L. Wilson and a cable from William Kurtz were dispatched to Berlin inviting him to attend the convention and to be the guest of photographers at their homes. His address to the convention paid marked tribute to his American hosts:

> We in Europe sometimes labor under the hallucination that American photography has not yet arrived at a high point of perfection, because but few good American pictures find

WOODBURYTYPE

The Chicago photographer John Carbutt was so favorably impressed with photographs he saw in England which were produced by Walter B. Woodbury's photomechanical process, that he sold his gallery, acquired the U.S. rights, and established the American Photo-Relief Printing Company in Philadelphia in 1870 to launch what he considered to be a major new bonanza for photography. While it is true that the process was the first commercially viable mode of reproducing photographic intermediate tones (i.e., halftones) repeatedly by machines, rather than by the photographer's hand, nevertheless the process had its drawbacks, and Carbutt's enterprise did not materialize into the bonanza envisioned. Woodburytype photographs were secured by embossing a photographic image on paper with a metal mold containing the gelatine relief of a photographic negative. Elaborate machinery was called for, including hydraulic molding presses able to exert a force of five tons per square inch in configuring the gelatine relief matrices; paper calendars to give a special surface to the nonabsorbent paper used; and hand-operated presses on which finished prints were produced from the matrices. The first French presses installed by Carbutt fractured, and it was well into 1871 before he could obtain newly designed replacements from the noted American manufacturer R. Hoe & Co. Also, Woodbury's claims for production efficiency proved unrealistic because of the delicacy of the molded gelatine relief images. While British and French operators further mechanized their production by installing rotating tables for the hand-embossing presses (thereafter claiming production figures of from 30,000 to 55,000 prints from a single matrix), Carbutt's output does not appear to be recorded.[383]

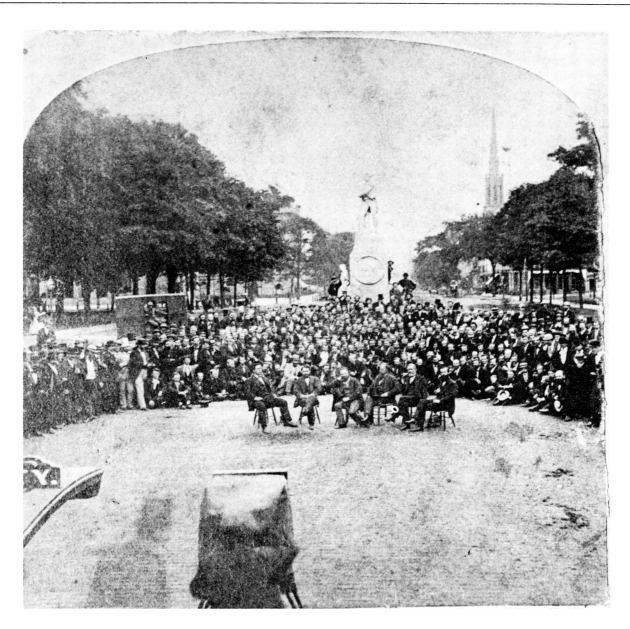

AMERICAN PHOTOGRAPHERS AT CLEVELAND

A photograph may have been taken of the delegates attending the first annual convention of the National Photographic Association held in Boston, Massachusetts, in 1869, but if so it was not recorded. The first appears to be the group picture above taken by T. T. Sweeny at the 1870 convention held in Cleveland, Ohio. To the convention chairman, James F. Ryder, looking back on it twenty-two years later, this was the greatest moment in American photography's fraternal years. "All was harmony. The man with a sore head was not there. No axes to grind; no wrangles; no jealousies; no smart Aleckism; no cheap Johnery. The abundance of good fellowship was marked; a happier lot of people would be hard to find." All the great lights of the profession were there, gathered at the foot of the Perry Monument. At the center was N.P.A. president Abraham Bogardus with permanent secretary

Edward L. Wilson and treasurer Albert Moore. Surrounding them were H. T. Anthony, W. Irving Adams, Col. V. M. Wilcox, Dr. Hermann W. Vogel, Gustave Cramer, John Carbutt, John A. Fitzgibbons, George G. Rockwood, James Wallace Black, Henry Rocher, William H. Jackson, William H. Rulofson, W. H. Rhoades, J. C. Elrod, C. W. Zimmermann, William G. North, W. E. Bowman, J. A. Scholten, A. J. Fox, David Bendann, and a host of others. As for the exhibition of photographs at the convention, Ryder considered it "the best and largest ever brought together up to that time. And what a display of apparatus and fine goods! It may have been surpassed since, but we don't remember when or where. Three happy days of cheerful work, and at the end the great building echoed with songs at parting. Who would not like to attend another such meeting?"[387]

PHOTOGRAPHERS WIN COPYRIGHT PROTECTION

Congress passed a new copyright law on July 8, 1870, which for the first time gave protection to photographers against what the *Philadelphia Photographer* termed the "piratical stealing" of negatives. Alexander Gardner headed a committee appointed by the newly established National Photographic Association to lobby for inclusion of the photographers' interests in the new law, and reportedly was responsible for "interpolations" made in the act even after it was printed. In addition to operating his gallery in Washington, Gardner made portraits of criminals for the Metropolitan Police and set up a rogues' gallery for the department in 1873. Following are the provisions of the 1870 law applicable to photography: [388]

SECTION 86. Any citizen of the United States, or resident therein, who shall be the author, inventor, designer, or proprietor of any photograph, or negative *thereof*, and his executors, administrators, or assigns, shall, upon complying with the provisions of this act, have the sole liberty of printing, reprinting, publishing, completing, copying, executing, finishing, and vending the same.

SECTION 87. Copyrights shall be granted for the term of twenty-eight years from the time of recording the title thereof, and they may also be extended and assigned the same as patents.

SECTION 90. No photographer shall be entitled to a copyright unless he shall, before publication, deposit in the mail a printed copy of the title of the photograph for which he desires a copyright, addressed to the librarian of Congress, and within ten days from the publication thereof, deposit in the mail two copies of such copyright photograph, to be addressed to said librarian of Congress, as hereinafter to be provided.

The titles aforesaid are recorded in due form in a book, by the said librarian of Congress, and he shall give a copy of the title under the seal of his office to said proprietor, whenever he shall require it.

SECTION 92. For recording the title of any photograph, the librarian of Congress shall receive from the person claiming the same, fifty cents, and for every copy under seal actually given to such person or his assigns, fifty cents.

SECTION 93. The proprietor of every copyright photograph or negative shall mail to the librarian of Congress, at Washington, within ten days after its publication, two complete copies or prints thereof of the best edition issued, and a copy of any subsequent edition where any substantial changes shall be made.

SECTION 94. In default of such deposit in the post-office, said proprietor shall be liable to a penalty of $25, to be collected by the librarian of Congress.

SECTION 95. Any such copyright photograph may be sent to the librarian of Congress by mail, *free of postage*, provided the words "*Copyright Matter*" are written or printed on the outside of the package containing the same.

SECTION 96. The postmaster to whom any such copyright photograph is delivered shall, if requested, give a receipt therefor, and when so delivered, he shall mail it to its destination, without cost to the proprietor.

SECTION 97. No person shall maintain an action for infringement of his copyright, unless he shall give notice thereof by inscribing upon some portion of the face or front thereof, *or on the face of the substance on which the same shall be mounted* the following words, viz.:

"Entered according to Act of Congress, in the year ——, by A. B., in the office of the librarian of Congress, at Washington."

SECTION 98. Any person impressing such notice upon any photograph for which he has not obtained a copyright, for so offending, shall forfeit and pay $100.

SECTION 99. Any person infringing a photograph copyright shall forfeit all copies to the proprietor, and also suffer suit for damages by said proprietor in any court of competent jurisdiction.

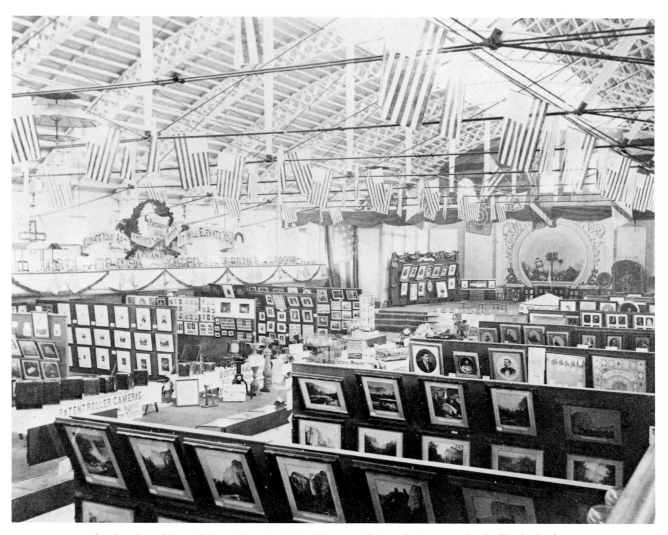

Interior view of the exhibition hall at the National Photographic Association convention in Cleveland, 1870. Note the display, in foreground, of mammoth-plate views of Yosemite Valley, possibly taken by C. E. Watkins, C. L. Weed, or Eadweard Muybridge.

their way to Europe. The actual observations, however, which I have made during my brief sojourn among you, have filled me with wonder and admiration.

He who would judge of the merits of American photography, must in person tread upon American soil.

The photographer in your country works under greater and more manifold difficulties than the photographer in our country. Time and labor being of but little value in Germany, the German artist can finish his work at leisure; while you in America must make the best possible use of every moment, giving you less time to devote to your study and experimenting. Yet the art, in America, has been much advanced by your readiness and willingness to grasp and bring into practice all that is new and good; while, on the con-

trary, in Germany, as our celebrated Professor Liebig says, "each new discovery must pass through three different periods before meeting with a general acknowledgment." At *first*, it is proven that the new discovery is worthless and impracticable; *second*, later it is asserted that it is nothing new—that a ,similar discovery was made perhaps a hundred years ago; and it is not until the *third* period that the discovery is acknowledged and put into practical employment.

Quite different is it with you. Whenever any new and useful discovery is made, the American people are the first to recognize the same according to its real merits or demerits; and for this reason I wish success and prosperity to American science, American art, and, above all, to American photography. [389]

1870

207

ALFRED M. COLLINS,
CARD MANUFACTURER,
WAREHOUSE,
Nos. 506 and 508 MINOR STREET,
PHILADELPHIA.

H. H. COLLINS,
EDWARD COPE.

PHILADELPHIA SUPPLIER CORNERS WORLD MARKET
FOR PHOTOGRAPHIC CARDBOARD

Production figures are hard to come by covering photographs or the materials used in their making during the nineteenth century. Frequently, isolated news accounts, such as the following by Edward L. Wilson, provide the only known data on a particular subject—in this case the cardboard used for mounting stereographs, cartes de visite, cabinet, and other forms of photographic prints. Wilson's visit was made in August or September 1870, in the company of Dr. Hermann Vogel, who remained in the United States for several months following his attendance of the 1870 annual National Photographic Association convention in Cleveland: [390]

HOW CARDBOARD IS MADE.

OUR readers are probably not aware that the major portion of photographic cardboard used in this Western World is manufactured in Philadelphia, by Messrs. A. M. Collins, Son & Co. Such is the fact, however; for their machinery is so perfect and their facilities so great, that no one has been able to compete with them successfully either in quality or price. All the large and small dealers draw their supply from this great factory, which is four stories high, and 75 feet deep by 100 feet front.

We were never within its busy walls until a few days ago, when we visited it with our good friend, Dr. Vogel. Until that hour, we had hardly ever given a thought as to how all the cardboard used for mounting pictures upon is made. How seldom do any of us, by the way, think how much skill and tact, and brains and machinery are used in manufacturing what we daily consume.

The manufacture of cardboard is attended with a great deal of labor, and the thousands of reams and rolls of paper that are thrown from the paper-mill into this great hopper run through a great many manipulations, between many nimble fingers, and through sundry muscular machines, before they come out in the shape of pure, white, stiff, hard, calendered sheets, ready for our use.

Nearly all of the paper is received at the factory in huge "endless" rolls. When it is needed to be glazed or colored, the rolls are placed in the machine and passed over rollers and brushes, which lay on the color evenly and uniformly. The paper is then caught by automatic fingers, carried up to the ceiling, and hung up to dry, one length after another, as rapidly as the machine supplies it. After it is dry, it is again rolled up, and is ready for cutting into sheets for pasting.

The pasting-room is one entire floor, filled with benches, and busy girls, who paste the sheets together with astounding rapidity. When the sheets are pasted together, two, three, or four "ply," as the case may be, they are hung up by one edge in "clips" to dry thoroughly. When dry, the sheets are run between immense rollers, which calenders them to any extent desired. After this they are ready to be cut into shape, and printed with whatever the trade may require.

Then there are dozens of other machines used to cut the cards into shape, to round the corners, to print the lines, to cut out the mats, to count the cards as they are cut, to polish the colored sheets, and so on, all of which could only be described by means of diagrams, and matter enough to fill our entire issue. Over three million sheets were turned out here during the year past. Where does it go!

We would like to give more details, but our purpose is served in calling attention to this most important industry. The utmost care is taken to prevent all impurities in their cardboard by Messrs. A. M. Collins, Son & Co., and the variety they manufacture is endless. You all use their boards and know how they please you.

LANTERN EXPLOSION

James Wallace Black, the former partner of John A. Whipple, served in the vanguard of the Cutting patent fight, and became a noted authority on the use of magic lanterns as they came into wider use in the 1870s. He became the official photographer for the Boston police department, and a long-time member of the National Photographic Association executive committee. His assistant, who became involved with him in the mishap recounted below, was his brother-in-law (who recovered from his injuries and later accompanied the artist and explorer William Bradford to the polar regions):

SAD ACCIDENT: On the evening of February 4th while Mr. J. W. Black of Boston, and his worthy assistant, Mr. J. L. Dunmore, were about to commence a lantern exhibition in Lowell, one of the gas bags exploded with tremendous force, threw Mr. Dunmore high in the air and burned him sadly about the face and eyes, knocked Mr. Black senseless, drove a stick through the nose of the organist, and damaged the organ-loft, organ and church considerably. Mr. Dunmore at this writing still lies suffering much and very low, but, with great care, it is hoped, may recover his sight. Mr. Black, though much hurt and quite deaf, faithfully applied restoratives to Mr. Dunmore the whole night of the accident, or the poor sufferer's sight would have been gone. Mr. Dunmore's many friends will be grieved to learn this, and with us heartily sympathize with him and hope for his speedy recovery.

We have not yet learned the cause of the accident. When the explosion occurred, some old revolutionary female spirit innocently inquired of her neighbor if that was the signal to commence the exhibition! [391]

ALBERT SANDS SOUTHWORTH
1811–1894

Albert Southworth had been out of active photographic practice for eight years when he addressed the National Photographic Association's second annual convention at Cleveland in June 1870. Having established a partnership with Joseph Pennell in 1840, and with Josiah Johnson Hawes in 1843, he became a lecturer after 1862 and took up the study of photography as it might be applied to handwriting. Unlike the major daguerreotype collections of Edward Anthony and Robert Vance, which were destroyed or lost, nearly 1,500 priceless daguerreotype portraits by Southworth and Hawes passed from Hawes's heirs in the 1930s to the archives of such institutions as the Metropolitan Museum of Art, the Boston Museum of Fine Arts, and the International Museum of Photography at George Eastman House. The collection represents the largest and most complete body of extant portraits from a single daguerrean gallery.

The veteran Boston pioneer Albert S. Southworth also gave a major address at the Cleveland convention. Vogel had taken the position that the pressures of the American way of life gave photographers little time for study and experimentation. Southworth was less compassionate:

Unsparing efforts have been made by names of merit, known and unknown to fame, and not less in amount of ingenuity and perseverance have been the contributions of those unknown to fame or fortune, and now, at this late day, by far the larger majority practicing photography as a profession have little knowledge of its chemical or optical combinations or artistic requirements, nor are they disciplined in any principles of the fine arts, or in any mechanical employments whatever. Wisdom and prudence enter upon new and untried paths with cautious steps, eagerly observing every new sign and watchful of new developments, whilst youth, inexperience and ignorance push impetuously forward, reckless of consequences, accomplishing sometimes accidental success, oftener doomed to inglorious defeat. Into the practice of no other business or art was there ever such an absurd, blind, and pell-mell rush. From the accustomed labors of agriculture and the machine shop, from the factory and the counter, from the restaurant, the coach-box, and the forecastle, representatives have appeared to perform the work for which a life-apprenticeship could hardly be sufficient for a preparation for duties to be performed, or of a character to deserve honorable mention. [392]

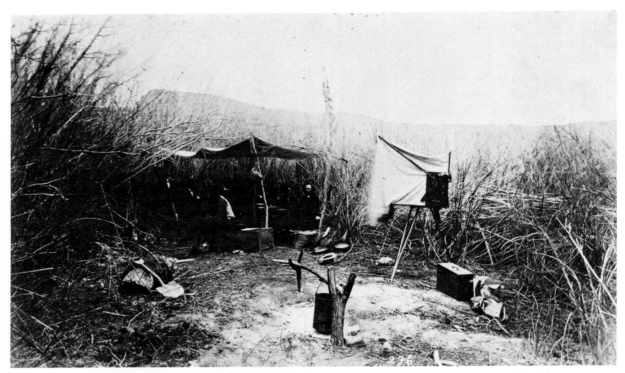

The rustic life of the survey photographers is evidenced in this view of E. O. Beaman's encampment during his travels in the canyons on the Powell expedition.

PHOTOGRAPHY ON THE POWELL SURVEY

During the first seven months of the second survey of the Grand Canyon by Maj. John Wesley Powell, the official photographer, E. O. Beaman, made some four hundred negatives during the party's travels over a distance of 600 miles, two-thirds of it through canyon walls from 500 to 3,800 feet high and nearly three hundred rapids, fifteen of which required unloading of boats and carriage of supplies over treacherous rocks. Among his greatest "disadvantages," Beaman said, was the necessity of working with alkaline and mineral-impregnated water. In December 1871, he sent this report to the Anthony firm in New York:

We have found our finest scenery in the roughest cañons; and here, while making from ten to fifteen portages in a day and running as many rapids at a break-neck speed, I have made from ten to twenty negatives. The sand and dust are so thoroughly compounded with alkali, that it is hard to elude that great pest to the photographer, *pin-holes;* and some of my finest stereoscopic negatives are nearly spoiled. The upsetting of chemical boxes and blowing down of the dark tent is a common occurrence, while we often have to station a man at the tripod to keep the camera from going down the cañons on an exploring trip of its own, carried by the frequent whirlwinds which visit us during the calmest days. Often with two or three assistants I climb from one to three thousand feet, and with one or two quarts of muddy water develop eight or ten plates. About the 15th of July we arrived at the mouth of the Uintah, distant from our starting point about 300 miles. In company with Professor Thompson, I started for the Agency, dis-

tant forty-five miles, which we accomplished in one day. With my dark tent and chemical boxes packed on the back of a mule, and myself on top of these, I have managed to steer clear of rocks and shoals, not, however, with as much confidence as I should have done in one of our boats on the river. At the Agency we found about a dozen white men, employed by the Government in taking care of about 300 Uintah Utes. The Agency is situated in a beautiful and fertile valley on the head-waters of the Du Shine and Uintah rivers, and about 200 miles south-east from Salt Lake City. Photography is a new science among the Utes, and we had some difficulty in getting them to sit for pictures; they were, nevertheless, highly interested with my bottles, and I was often greeted with the short but significant interrogatory—"Whixee?" A few applications, however, of the ammonia bottle to the olfactories soon settled that point, and I was considered "koch weno" (no good) Medicine man. After some persuasion and a pro-

mise from Mr. Bassor, the trader, that no harm would come of it, we had an opportunity of shooting our gun, as they called it, at a group of these noble sons of the forest. We were warned, however, that should any of them get sick, or a pony die, our stay in that part of the country would be short; they then returned to their camp, and we awaited coming events with some anxiety. Early next morning a shabby-looking fellow, enjoying the high-sounding name of General Grant, and wearing an old cocked hat, came into the Agency—his face terribly swollen, probably from toothache—and said that I had looked so hard at him through my instrument that it had made his face "heap sick;" another soon followed with the cheering intelligence that "his pony was heap sick," also. The chief soon arrived, however, and being shown a print from the negative was highly pleased. As it did not make him nor his favorite squaw sick, we were looked upon with considerable favor. 393

One day in August 1871, the editor of the *British Journal of Photography* became ill and found himself at the same time short on material for his next weekly issue. He issued a call for help to several of his friends in the photographic community, among them Richard Leach Maddox, a physician and photochemist. Maddox dutifully responded with "a hurriedly written and fragmentary article," which described experiments he was then in the process of conducting with gelatine, hoping to come up with a more suitable article than collodion for making dry plates. Maddox had added bromide of silver to his gelatine, and had just had his attention drawn by the Philadelphian, Matthew Carey Lea, to a chemical mixture called aqua regia (nitric and hydrochloric acid). He added this to the gelatine, "fancying that its use would decompose some of the gelatine and furnish the extra silver a chance of forming an organic salt of silver, which might improve the image." Then he made some photographs from "sundry negatives" and sent them off to the *Journal* along with his article, which appeared on September 8. "As there will be no chance of my being able to continue these experiments," he said at the conclusion of the article, "they are placed in their crude state before the readers of the *Journal,* and may eventually receive correction and improvement under abler hands. So far as can be judged, the process seems quite worth more carefully conducted experiments."

With these modest remarks, Robert Maddox dismissed his pioneering steps—and did not thereafter participate in further steps taken by others during the 1870s—in perfecting the gelatine dry-plate glass negative universally adopted after 1880. Like Frederick Scott Archer before him (who died penniless after giving the collodion wet-plate process freely to the world in 1851), Maddox fell on hard times (principally from a prolonged illness which kept him from further experimentation), but became the beneficiary of a fund established by the Photographic Society of Great Britain, and the recipient of several major international awards. In 1891, the Franklin Institute awarded him its coveted Scott Legacy Medal and Premium, stating of his process first published in 1871:

They [subcommittee of the Committee on Sciences and the Arts] find that although gelatine had been employed photographically in a variety of ways, and although silver haloid salts had been emulsified successfully with collodion in photographic practice, prior to the publication by Dr. Maddox of his gelatino-bromide process, nevertheless the successful emulsification by him of silver haloids with gelatine and the perfecting of a working process founded upon it, involved so much painstaking experimentation and investigation, and was such a departure from old methods that it merits recognition, on account of its marked influence on the progress of photography, on the enlargement of its practise and the multiplication of its applications in technical and purely scientific directions. The process, though affording negatives of good quality, was soon improved in regard to the quality and sensitiveness of the plates by different individuals, by the removal of the soluble salts, by heating to higher temperatures, by prolonged digestion, by the addition of ammonia, and by changes in minor details.[395]

THE RIGORS OF PHOTOGRAPHY IN THE YOSEMITE VALLEY

After the Civil War, Thomas C. Roche became for a time one of the principal field photographers for E. & H. T. Anthony & Co. On June 10, 1871, he sent in this report from the Yosemite Valley:

It is very difficult to work long with the same bottle of collodion, as it is so hot (110) that it thickens up after you coat five or six plates, and flows like syrup. Collodion in this state becomes very tender. To avoid this, I have to pack three or four small bottles. Adding ether in the field, and shaking up, will not do quite so well. So far my work is all right, and plenty of it; but I could keep on and make very many valuable pictures here for the next six months, but I will have to stop. I have about one week's more work in the valley, and then, if I can get a good man and pack-mule, I will make a trip to Lake Tenaya and the highest range of the Sierras, fifteen thousand feet above the sea. This will take, out and back, nearly two weeks. I have had no less than six different men to help me. They will not work when it comes to starting at 3 A.M. and tramping all day long. They prefer to pick up jobs around the valley.

There is a Mr. Garrett, of Wilmington, Del., photographing here. He came out by steamer, and has an E. A. view tube. He got his traps and big photo tent in here; but the pack-train mule, in coming up at night, undertook to ford the river, and was carried down the stream, when he rolled over with all the photo traps, and was drowned. A man swam out and tied him to a tree until morning, when they went out in the river and cut the boxes off. All his things were soaking wet. His plates were all albumenized. This, of course, used him up for about two weeks; then he commenced, but could not move half a mile, his traps were so heavy. His plates were all fogging. He had a Philadelphia collodion which has a separate sensitizer. This he mixed as he wanted to use it; but the result has been nil. I gave him half a pound of your new negative collodion, when his plates came out all right. He has now sent to Mr. Taylor, in San Francisco, for two pounds of it. I hope Mr. Taylor has it on hand.

There is also a Mr. Pond, a photographer from Buffalo, N. Y., here. Mr. Pond has a pair of the Ross wide angle. They are not to be compared in any way alongside of the little Dilly Rect. lens. Riley says the Rect. Stereo. beats anything he ever used. He is taking all his groups with it. The Ross wide angle stereo. will not cut the field sharp all over.[394]

"TWELVE TINTYPES FOR TWENTY-FIVE CENTS"

In his book, *Thirty-three Years under a Skylight* (Hartford, 1873), H. J. Rodgers describes a number of tintype galleries which he visited in 1871:

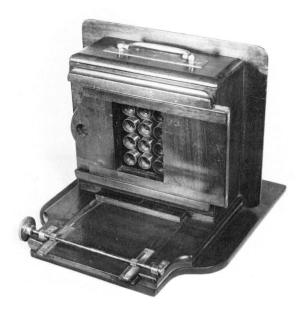

One day my attention was called to a sign conspicuously displayed over a doorway, (an entrance to a picture gallery,) where distortions and contortions were displayed in profusion, and after some considerable time deciphering the hieroglyphics which resembled the oriental characters on a tea box, " Twelve tin-types for twenty-five cents," I started as a matter of curiosity, for the artist's sanctum. I had not ascended more than six flights of stairs when I met great numbers and varieties of people coming down. One woman declared that she would not let John see hers; she'd burn them up just as soon as she got home. She knew her nose wasn't long, nor her mouth wide. Another, somewhat vehement in her manner, said hers were a " perfect fright." She hoped she would know enough next time to go where comfort, cleanliness and convenience were regarded. An old gentleman, turning to his wife, said, " Betsey, we've seen a good deal of this world; but we've got humbugged agin. Live and learn' Betsey. Ha! ha! ha! "

About three o'clock in the afternoon, I strolled into another cheap tin-type room, in which was a man, his wife and baby, with right-minded brothers, devoted sisters, fond grandpapas, child-spoiling grandmammas, maiden aunties, generous uncles, expectant neices, and hopeful nephews; all there together, to get a tin-type of that promising baby; and during the operation, I passed away an hour in conversation with the man down stairs, who concluded, sensibly, that in order to succeed with his baby, it didn't require his services, as there were already, twenty-seven in the operating room.

Said he, " This paying for a name, I don't believe in, you know. I can get a good picture here, you know, for five cents; and what's the use throwing away seven or eight dollars at some fashionable place, you know. I went into one before I came here, you know, and the artist said his goods were all imported, you know, and nobody had the kind he did, you know. Well, I spose a good many'll go into a nice place, and pay high for the name on't, you know. The picture taker here, wanted ten cents for the baby, you know, but we beat him down to five cents, and I guess that's reasonable, you know; that is, if he gets a good one. Babies are so hard to get, you know, and he's all life, and ain't still when he's asleep. I shouldn't wonder if they had a regular time on't, keeping the little shaver still."

At this point, Aunt Sophia came down stairs, rather impatiently. Said she:—

" Ezekiel, I jest wish you'd come right up;—we can't do nothing with Johnny, and the artist is crosser'n 'lection. We've tried many's a dozen times, and if 'taint good we shan't take it. He haint got a bit of patience. Come rite up, now! "

1871

212

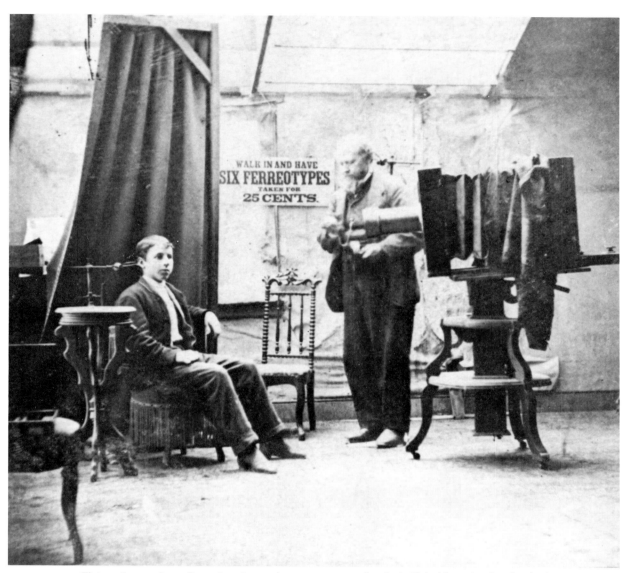

Tintype photography studios such as the one above were commonplace in the United States by 1871, but the tin-type process itself remained an ''American novelty'' in England and on the continent where tintypes were made only by beach and street photographers. A ''gem'' tintype camera (top left) contained 36 tubes (with lenses) and could make thirty-six images at one sitting on a single negative plate. An example of a multi-image tintype plate is shown below left.

The improvements made "by different individuals" in the Maddox process came principally from English and Belgian experimenters, and by 1874 a number of British amateur photographers had begun exhibiting photographs made with homemade gelatine dry-plate negatives. But as we shall see, experimentation in the United States during the 1870s continued to center on collodion-bromide emulsions as a vehicle for making dry-plate negatives. As early as February 1870, for example, E. & H. T. Anthony & Co. announced that the "gratifying success" achieved with the collodion emulsions "impels us to offer them for sale to amateurs or the trade." The announcement stated that prospective purchasers need only "state distinctly, in inches, the sizes wanted." [396]

The summer of 1871, meanwhile, also represents a great turning point in American landscape photography, particularly in the West. The Philadelphian John C. Browne, in his report on the progress of photography at the N.P.A. convention, made a point of emphasizing that "this department of our art does not show the improvement that its importance justifies." Continuing on this theme, he told his audience:

Landscape photography in America does not occupy the position that it should, and we earnestly entreat photographers to pay more attention to this subject. In Europe, landscape photography is fully on a par with portrait work, and is very remunerative; both stereoscopic and large pictures are eagerly sought for at all places. There is undoubtedly a reason for this, insomuch that in Europe there are more really fine subjects for outdoor work than in America. We have fine scenery, embracing mountains, rivers, lakes, and waterfalls, but we lack the exquisite pictorial effect of the quaint old buildings, bridges and fine specimens of landscape gardening that are so constantly to be met with in Great Britain, Germany, France and Italy. Much of the scenery of America is unique, for example, the magnificent Yosemite Valley and Falls of Niagara; but, without wishing to underrate our fair country, we are deficient in the *bits* that go so far in making a charming landscape picture. While this may account in some measure for the exquisite beauty of outdoor foreign photographs, and add largely to their demand, yet there is more to be considered than the question of old buildings, picturesque bridges, etc. The simple truth of the matter is that at present we cannot successfully compete in execution with the best foreign landscape photographers. The quicker, then, those interested in this subject apply themselves attentively to outdoor manipulation and pictorial effect, the better it will be for the credit of photography in America. [397]

Browne may have been aware of but gave no recognition in his address to the works of the western landscape school represented by this time by such photographers as Watkins, Muybridge, O'Sullivan, Russell, Charles R. Savage, and a newcomer, William H. Jackson. Also, scarcely a week prior to Browne's speech, a San Francisco newspaper was taking note of the fact that the Yosemite Valley "abounds in photographers, and their signs hang upon the outer walls of their canvas houses, notifying men and women that their shadows may be secured with El Capitan, or any of the falls, in the background." The newspaper gave particular notice to the activities of Thomas C. Roche of E. & H. T. Anthony & Company:

Roche is interested in earnest in his business. He is ever on the hunt for new views and bits of mountain scenery in far-off and

C. L. Pond of Buffalo, New York, probably shown on his horse (above), was among the many photographers arriving in the Yosemite Valley in 1871. Another new arrival, T. C. Roche of E. & H. T. Anthony & Co., contended that the Ross wide-angle lens used by Pond was inferior to the Dallmeyer Rectilinear used by himself and others.

almost inaccessible mountain localities, whither, with his apparatus, he betakes himself, regardless of time, trouble or expense. He essays also with infinite patience to catch the grand but momentary effects of certain of the mists and clouds, as slowly from the valleys they rise and partly veil the face of the cliffs, disclosing, in some jagged, rent pictures of pines and rock, pinnacles a thousand feet in the air over your head; and then everything is hidden for another five hundred feet, when another bit of sky territory is dimly disclosed. [398]

Roche's own report of his activities is contained in a letter addressed to *Anthony's Photographic Bulletin* just two days prior to Browne's N.P.A. address, and an example of his work will be found on page 364. The *Bulletin* had been started by the Anthony firm the previous February, and during most of the 1870s it served as the prime competition for the *Philadelphia Photographer*. Roche is not today included among the ranking photographers of the western school, but his photographs, like those made in the Yosemite Valley by A. S. Robbins of Cleveland, as well as others, were sold to the public along with those by photographers of now more noted fame in the landscape school. In November, the following announcement appeared, for example, in the *Bulletin:*

Anthony & Co. offers a series of foreign and U.S. large views as suggestions for Christmas presents. In Europe there exists a great and laudable competition among the celebrated amateurs and professionals in the production of artistic results. The ex-

cellence of some is truly astonishing, especially the works of Robinson and Cherrill, Col. Stuart Wortley, Capt. E. D. Lyons, Frith, England and Frank M. Good. We have, of our own publication, a series of Yosemite Valley, Pacific Railroad, Niagara, Central Park, and New York City, and also William Notman's extensive and lovely Canadian scenes; Stoddard's Lake George, Upton's Western and Minnehaha, and Beer's Catskills.[399]

The views "of our own publication" were presumably Roche's, and in the light of Browne's remarks the previous June, it is interesting to see that within six months the Anthony firm was giving active promotion of landscape views by such other photographers as Seneca R. Stoddard, of Glens Falls, New York; Beer and Company, of New York; and B. F. Upton, of Minneapolis.

Roche returned to New York after the summer of 1871 and gave many "valuable suggestions" to another photographer, E. O. Beaman, who purchased his supplies from the Anthonys before joining Maj. John Wesley Powell's second expedition to map the Colorado River's passage through the Grand Canyon. Beaman's reports of his exploits as the survey's first official photographer reveal the difficulties and hardships faced by photographers accompanying these early government surveys. After September 1872, Beaman left the Powell expedition to conduct a photographic venture of his own in the Adirondack Mountains in the east, but then disappeared entirely from the photographic scene.

Evidently there was a falling out between Powell and Beaman. After the latter's departure, an assistant, Clement Powell (a cousin of Powell's), was unable to get good pictures with the chemicals Beaman left behind, and payment was stopped on Beaman's final salary check on the supposition that he had deliberately ruined the solutions (an accusation which Beaman reportedly denied). James Fennemore, a photographer in C. R. Savage's Salt Lake City gallery, was first chosen to replace Beaman, but soon afterwards John K. Hillers became the official photographer for the remainder of the Powell surveys (which continued on for another six years).

In a letter to the Anthonys mailed from Utah just before Christmas 1871, Beaman said he had made some four hundred negatives of "some very fine scenery, several of them instantaneous." But today there are no large photographic views attributed to Beaman among the photographs in the Library of Congress taken on the Powell surveys. There are, however, a handful of card stereographs by Beaman in the Library's collection.[400]

About this time, Edward Anthony visited J. H. Dallmeyer while on a trip to Europe, and the latter insisted that E. & H. T. Anthony & Co. become his American agent for Dallmeyer lenses. This report from *Anthony's Photographic Bulletin* on the doings of the 1871 N.P.A. convention indicates that the firm was by then actively promoting the British lenses:

At the National Photographic Association convention in Philadelphia, naturally, great interest was manifested in the Dallmeyer lenses; for it was generally found that those pictures (portraits) which had special claim to favor were made by them, and the idea was expressed that much of the progress and interest of the exhibition was due to the very marked improvement manifest in portraiture generally, resulting from the use, even in less skillful hands, of the lenses of Mr. Dallmeyer.[401]

Col. V. M. Wilcox, a partner in the Anthony firm after 1880, recalled in later years how he was personally involved in selling the first of the Dallmeyer portrait lenses in New York, presumably about this time:

The first lens that was used in New York City, to my knowledge, was one I took up to Mr. J. Gurney. I asked him to take the 3B Dallmeyer lens and use it. He said he had enough lenses. I left it with him, however, and after about a month I went to Mr. Gurney's and asked him if he did not want the lens. He said he did not want it; he did not see but that his lenses were just as good. Mr. Frank Pearsall was his operator then. There was a well-hole in the center of the building, and he overheard the conversation between Mr. Gurney and myself, and he put his head over the well-hole and said, "If you let that lens go I will go." The lens stayed, and from that day to this it has been the favorite with first-class photographers throughout the country; not only this, but scientific men, men in the employ of the Government, have used the Dallmeyer lens more than any other.[402]

Prior to the N.P.A. June convention, a number of notices had appeared in the *Philadelphia Photographer* concerning the destruction of photographic galleries by fire. In one an-

Few photographs exist of the fire which ravaged Chicago on October 8, 1871, but photographers in Chicago, and others who came from Cleveland, Toledo, St. Louis, and even New York, made numerous card stereograph views of the aftermath, which were sold widely. The A. J. Marks store (above) placed a sign in front of its building to advertise the availability of photographs taken in Chicago both before and after the fire.

1871

215

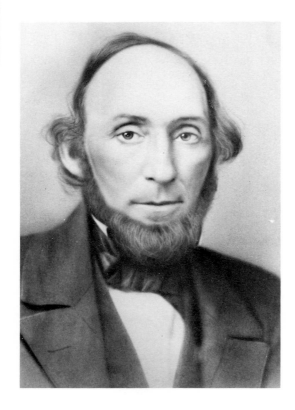

IN MEMORIAM:
JOHN JOHNSON

The minutes of the American Photographical Society, in its early years, occasionally record the comments or doings of its first treasurer, John Johnson, such as when he demonstrated a gas burner projection device in 1862, or when he presented a paper on the influence of light on the growth of plants (in 1863). But by 1866, the former partner of Alexander Wolcott had returned permanently to his native Saco, Maine, where in that year he helped found and became the first president of the York Institute, a repository of artifacts and records associated with natural history which survives to the present day as the Dyer-York Museum and Library. Records of this institute reveal that over a period of four years, Johnson donated a variety of minerals obtained locally and from other sites in New England, Georgia, and Canada. In his new capacity as president of the Institute, Johnson acquired the title "Professor," and a biographical sketch of his career prepared in the 1890s described him as not only a pioneer in photography but also as a "patron of learning." He died in Saco on May 3, 1871.[404]

nouncement of three fires in March 1870, for example, it was stated that S. W. Sawyer was burned out in Bangor, Maine, and thereafter moved to Chicago where he bought John Carbutt's gallery, which had been advertised for sale that same month. At the N.P.A. convention, a committee was established to determine the basis for action "at some future time" leading to the creation of a photographers' fire insurance company to be established under N.P.A. auspices. But no action had been taken, and Sawyer was presumably ensconced in his new quarters when, suddenly, on October 8, Chicago was struck by the great fire which raged through the city for two days, killing three hundred people and leaving ninety thousand homeless. Alexander Hesler lost his Lincoln negatives along with forty thousand other valuable negatives and prints. Charles W. Stevens watched his gallery burn, then calmly set about obtaining new quarters and new supplies from New York:

> He came upon a place where fresh meat was wont to be sold, and there began to ply his persuasive powers upon he of the knife and cleaver until success crowned his efforts, and the lease for the store was signed. The butcher's block and the rows of meat-hooks had to give way to shelves for the American Optical Company's apparatus and Union Goods, Sun Plates, &c. Leaving the rest in the hands of his assistant, he proceeded to arrange for an immediate trip to New York to lay in fresh supplies. But lo! on searching for funds, he found one dollar and a quarter was all he had. He was dismayed, for there was no use trying to borrow anything there while Chicago was still in flames. His faithful porter came to the rescue, loaned the money, and in fifteen hours after his store was burned our hero was on his way to New York. He was delayed twelve hours on the way, but arriving on Wednesday, dusty and smoky, his face still black with the embers of poor, saddened Chicago, he entered the store of Scovill Manufacturing Company just as they were closing on Wednesday evening. He was scarcely recognized by his friends there. After hand-shaking and words of sympathy, he said "I have a store. I am going to open again. I want some more goods. Will you help me lay them out to-night?" Of course his wishes were all granted. The alarm was sounded around the store that "all hands must work to-night," and in a few moments a brilliant scene followed. Our hero doffed his coat, put on his slippers, and went to work with the rest. Beginning at one end of our store, the whole was gone over by midnight, he laying out such goods as he desired, and our employees at once entering and packing them. At eleven A.M next day, Thursday, several cases were on the way in the freight train which left New York at that hour for Chicago.[403]

1872

The grand flowering of the western school of landscape photography was by this time in full swing. Although wheeled vehicles could not yet penetrate the Yosemite Valley floor, new trails were added to the flatland between Vernal and Nevada Falls, and from the base of Sentinel Rock to Glacier Point, affording new vantage points for photography. By this time, too, the first of a number of scenic wonders in the West had been named for a photographer of the new school. This was Jackson Canyon, a picturesque ravine a few miles south of what is now Casper, Wyoming, which was named for William H. Jackson.

Jackson left a position as a photographer's artist in Rutland, Vermont, in 1866 after quarreling with his fiancée, and headed west, where he settled in Omaha. In 1870 he was named official photographer for a decade-long series of topographical surveys of the Rocky Mountains conducted by Ferdinand V. Hayden, head of the U.S. Geological Survey. The noted landscape painters Thomas Moran and Sanford R. Gifford each joined the expedition for a year in the period 1870–71, and the presence of these men was particularly valuable in helping Jackson (then twenty-seven) evolve a style of his own in landscape photography.

Photographs and paintings made respectively by Jackson and Moran in the unchartered headwaters of the Yellowstone River in 1871 were notably influential in gaining passage of legislation through Congress in 1872 which established Yellowstone as the nation's—and the world's—first national park. A single photograph made by Jackson in 1873 of the Mount of the Holy Cross in the heart of the Rockies—the mountain's deep ravines displaying a vast cross of snow—chanced to fall into the hands of the poet Longfellow, who once again (as with the Hesler daguerreotype of Minnehaha Falls) based the lines of a poem on the thoughts which were brought to his mind from viewing a photograph.

Many notable landscape views were also made at this time by Timothy O'Sullivan and William Bell on Lieut. George M. Wheeler's surveys in Utah and Arizona, and by John K. Hillers on the remainder of the Powell surveys in the Grand Canyon. A Chicago photographer, T. J. Hines, made photographs on Capt. John W. Barlow's reconnaissance of Wyoming and Montana territories in 1871, but waited until his return to Chicago to make prints. His negatives were then destroyed in the great Chicago fire, but sixteen of his prints were reportedly saved.

Although Eadweard Muybridge and Carleton E. Watkins are now considered by many knowledgeable curators to be the foremost photographers of the western landscape school, Muybridge's attraction to this form of photography was only temporary, and his fame rests more fully on the photographic studies he later made of animal and human locomotion. After emigrating to America when he was about twenty, Muybridge is believed to have learned photography from Silas Selleck, an organizer of the Daguerrean Association in 1851 (see page 85). When Selleck later moved to San Francisco, Muybridge followed and

TIMOTHY O'SULLIVAN

During the Civil War, when he was twenty-three, Timothy O'Sullivan photographed the dead on the battlefield at Gettysburg, and the published engravings made from these photographs provided a major inspiration for Lincoln's Gettysburg Address. In 1867, O'Sullivan was named official photographer on the first of four major United States government surveys of the West, and while the photographs he and others made on these surveys were essentially documentary, many are today classed as among the most celebrated works of the western landscape photography school. From 1867 to 1870, O'Sullivan operated with Clarence King on a geological survey of the 40th Parallel, which took him to the lakes, mines, and wastelands of Nevada, and to Salt Lake City, Wyoming, and Colorado. In 1870, he served for seven months as official photographer on a survey of the best route for the Panama Canal. Back in the West in 1871, he worked for three years with Lt. George Wheeler on a survey of the 100th Meridian, which took him through the canyons of Colorado, and to Indian habitats in Arizona and New Mexico. Along the way, O'Sullivan contacted tuberculosis, and after serving briefly as photographer to the Treasury Department, he died in 1882 at age forty-two.[405]

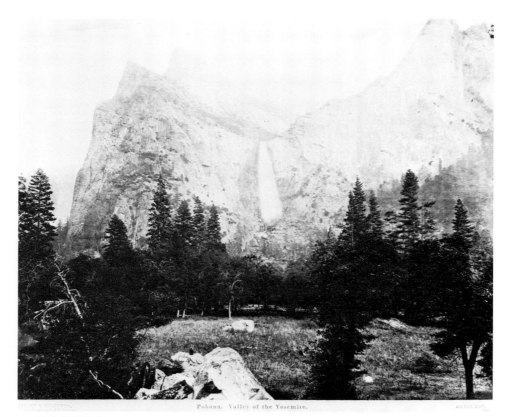

Pohona. Valley of the Yosemite.

Tutokanula. Valley of the Yosemite.

1872

218

The Yosemite Valley served as the focal point for many photographs made by the first cadre of American western landscape photographers. These 1872 views by Eadweard Muybridge were included in a portfolio of fifty-one of Muybridge's Yosemite photographs which won the International Gold Medal for Landscape Photography at the Vienna Exposition of 1873. The portfolios were sold publicly by the San Francisco dealers and photographers Bradley & Rulofson.

operated a bookstore there from 1855 until he adopted photography as his principal vocation. His first major landscape works were created in the Yosemite Valley in 1872, and the superiority of these photographs was acknowledged internationally with the award of a gold medal for landscape photography at the Vienna World's Fair of 1873. Lieut. Wheeler submitted photographs by O'Sullivan to the Vienna exhibition, but these apparently went unrecognized.

Muybridge was the fourth photographer to venture into Yosemite (in 1867), and the first to capture the presence of clouds in the skies above the mountains and ravines which he photographed there. This was accomplished with the aid of a homemade shutter which allowed for varying exposures on a single negative plate, either vertically or horizontally, to compensate for the difference in the sensitivity of the plate to different colors, and to the brightness or softness of the sky.

Muybridge made photographs in the Yosemite Valley throughout the spring and summer of 1872, and his activities drew considerable attention in the San Francisco press. The *Alta California*, for example, reported in April that

> he has waited several days in a neighborhood to get the proper conditions of atmosphere for some of his views; he has cut down trees by the score that interfered with the cameras from the best point of sight; he had himself lowered by ropes down precipices to establish his instruments in places where the full beauty of the object to be photographed could be transferred to the negative; he has gone to points where his packers refused to follow him, and he has carried the apparatus himself rather than to forego the picture on which he has set his mind.[406]

At precisely the same time that Muybridge returned to San Francisco to print his photographs for a deluxe edition, E. O. Beaman completed his travels with the Powell survey, and with a companion, two mules ("Tom" and "Jerry"), a supply of a hundred stereoscopic negatives, and some articles to trade with the Indians, he set out to photograph the Aztec cities in the Arizona desert. In a letter to *Anthony's Photographic Bulletin* dated September 15, he described his transportation system:

> For an outfit of one hundred 5 x 8 negatives I require three boxes of about the following dimensions: eight inches wide by fourteen deep and eighteen long. In one I carry my camera, instruments and about thirty plates for immediate use; in another my bath and chemicals for working with, and in the remaining one my stock of glass, etc. These boxes, with leather straps around them, make a very easy pack to fasten on an animal; by hanging them on the pack saddles, and covering over with dark tent, blankets, etc., and then throwing the diamond hitch around them in the packer's style, a mule will carry them all day without the least danger of breakage.[407]

Public interest in large photographs of the American West, meanwhile, was running high. In New York, the Anthonys began offering prints (presumably by Watkins, Weed, Hart, and Muybridge) which were supplied by the San Francisco dealer Thomas Houseworth & Co. James W. Hutchings, the proprietor of the principal Yosemite Valley hostelry (and the valley's official guardian), took to the lecture circuit, carrying large photographs of Yosemite supplied by the Anthonys. When he appeared in Boston in January 1872, he drew a large audience despite a storm.

Expeditionary photographers such as William H. Jackson (top), E. O. Beaman, Timothy O'Sullivan, and others operated out of makeshift tents in the field, and transported their equipment, including mammoth-plate cameras, on mules, as did the unknown photographer (bottom). Photographs made by Jackson at Yellowstone in 1871, while traveling with the F. V. Hayden geological survey in Wyoming, helped Congress to decide to establish the Yellowstone National Park there in 1872. Jackson also was first to make photographs in what is now the Grand Teton National Park, and served for the longest period of time (until 1879) as an expeditionary photographer on the western government surveys.

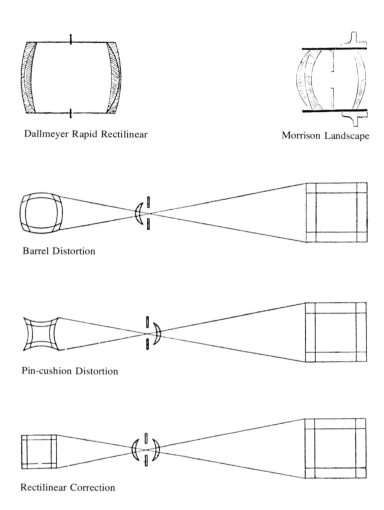

Dallmeyer Rapid Rectilinear

Morrison Landscape

Barrel Distortion

Pin-cushion Distortion

Rectilinear Correction

LANDSCAPE LENSES

Although photographers such as David Bachrach swore by the Harrison *Globe* lens throughout their careers, the "Rapid Rectilinear" (essentially a pair of aplanatic lenses mounted back to back at each end of a short tube) became the universal standard until perfection of the anastigmat lens (see page 336 for description) in 1890. Dallmeyer, Ross, and Swift were the principal manufacturers of the rapid rectilinear, which provided the modern equivalent of an f/8 aperture and overcame the distortion of straight lines, such as is evidenced in the "barrel" and "pincushion" line distortion shown in the two illustrations indicated above. Where barrel distortion is evident, the diaphragm opening, or lens "stop," is shown placed in front of the lens; pin-cushion distortion results from placement of the stop behind the lens, where a bending of lines occurs in a direction opposite to that evidenced in barrel distortion. In the corrected rectilinear (bottom illustration), the lens stop is placed between

two lens cells, which balances the opposing forces and creates an image with straight lines. Barrel distortion was acceptable in most landscape work, but was unacceptable for interior or architectural photography where straight lines would be found near the edges of the plate. E. & H. T. Anthony & Co. became agents for the Dallmeyer lenses.

Richard Morrison, an employee of C. C. Harrison, modified the *Globe* in 1872 by overcorrecting one lens, and providing a crown-glass meniscus in place of the other. William Bell used the Morrison on the Wheeler surveys, and S. N. Carvalho found them better than the Dallmeyer for use in Martinique. The Scovill Manufacturing Co. became agents for the Morrison, which was manufactured at a plant in Brooklyn. In 1883, the *Photographic Times* described the Morrison plant as offering a more varied selection of lenses than any other American supplier.[408]

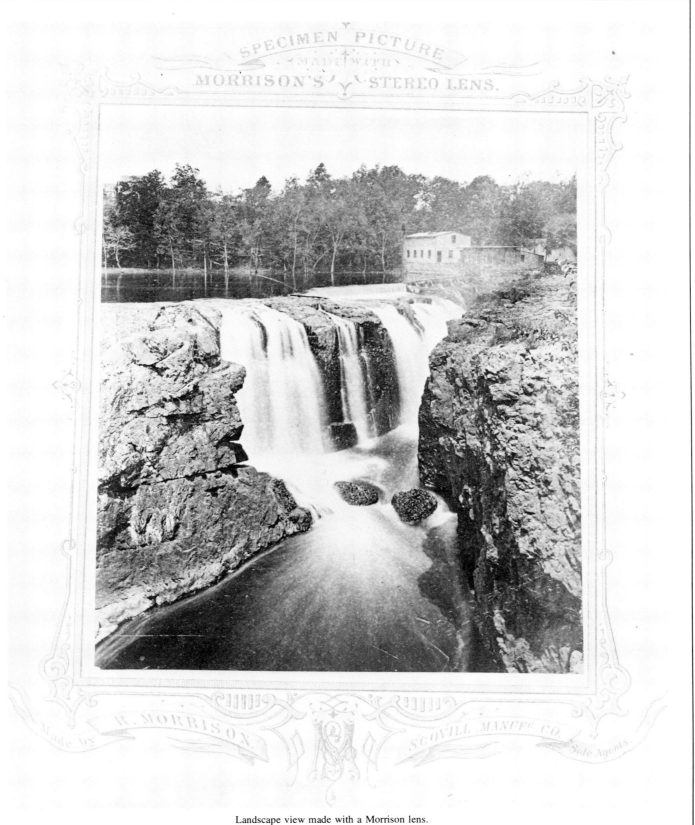

Landscape view made with a Morrison lens.

ALBERTYPES

Edward Bierstadt obtained the United States rights to the Albertype process, and by 1872 had several presses in full operation in New York. This prompted Prof. John Towler to state in a formal address that he "presumed" that Bierstadt would soon sell legal rights to practice the process, or to execute orders for book illustrations, government surveys, or the production of standard engravings. Towler described the Albertype process in these words:

> The Albertype is a print in *printers' ink, made by the lithographic press*, equal in every respect and similar to the silver print obtained from the same negative, and possessing advantages over the silver printed picture in the fact that neither washing, toning, fixing, nor mounting is required, that the print is perfect when it has passed through the press, that a graded border can be printed around the picture at the same impression, and that titles, descriptions, dates, &c., are in like manner all printed at the same time. Furthermore, I may add that any kind of paper can be used, and also that any of the colored inks of the typographer may be employed; consequently prints on albumen paper are most easily simulated, and engravings, lithographs, and maps reproduced so perfectly as not to be distinguished from the originals. Finally, by means of the ink-rollers, it is possible to grade the lights and shadows to suit the most fastidious artistic taste.
>
> Again, let us extend our investigations into the merits of this beautiful type. The negative can be stereotyped ad infinitum, that is, *one impression* can be prepared so as to keep *one press* in operation, or *twenty impressions* can be prepared so as to keep *twenty presses* at work simultaneously, or an indefinite number of presses may be maintained in operation upon the same picture at the same time. This is a very great advantage. One operator, attending to one press, can produce about two hundred prints in one day.

But although Bierstadt could achieve as many as 4,000 impressions from a single Albertype plate, the process—like all forms of collotype printing—remained about as costly for book illustration as the use of original photographs printed in volume and bound in separately from the text.[409]

But this aroused public interest was also being matched by a vast increase in the number of people who now had improved transportation means for visiting these western meccas themselves. By 1874, when wheeled vehicles gained access to the Yosemite Valley, the state of California deemed it advisable to purchase all private claims in the area. With the influx of travelers there came a change in the role of photographers making landscape photographs at Yosemite and elsewhere. Scenic views which had been made for aesthetic reasons (or on government surveys) became of less interest, generally, than photographs made of scenes with which the tourists could more readily identify. Such photographs, which from a critical standpoint would be considered inferior to the earlier works of Watkins or Muybridge, now came into greater supply, ending the short reign of the pioneer photographer-entrepreneurs.

After publishing his views taken in 1872 in Yosemite, Muybridge went on to other exploits. Watkins went to Oregon, where he made more of his aesthetically oriented photographs, but when the financial panic of 1873–74 spread across the land, he was declared bankrupt. Alfred A. Hart was already dead (his negatives had been acquired by Watkins in 1869), and Andrew J. Russell headed back to New York where he opened a Broadway gallery and became associated with *Leslie's Weekly*. After 1875, Timothy O'Sullivan, too, returned east. For a short time he served as chief photographer for the U.S. Treasury Department, but succumbed to tuberculosis in 1882.

Only William H. Jackson among the early "greats" of the western landscape school remained on the scene, continuing (until 1879) as official photographer on the Ferdinand V. Hayden geological surveys. In 1874, Jackson and Ernest Ingersoll of the New York *Tribune* discovered the ruins of cliff dwellings in what is now the Mesa Verde National Park, which Jackson photographed. In June 1876, the *Rocky Mountains Presbyterian* drew attention to a series of landscape negatives, 20 x 24 inches square, which Jackson had made of views around the Rockies, San Juan, and Uncompagre mountains in Colorado. "These are the largest plates ever used in field photography in this country. They convey an impression of the real grandeur, and the magnitude of mountain scenery that the smaller views cannot possibly impart." Jackson lived to experiment with Kodachrome color film in 1939, and died three years later at the age of ninety-nine.[410]

The proliferation of card stereographs, and of stereoscopic viewing equipment, also occurred at this time. Most of the western landscape photographers carried stereocameras as well as mammoth-plate cameras on their various expeditions, or on government surveys. Some, like John Soule of Boston and William G. Chamberlain of Denver, specialized in making stereoviews. The majority of the surviving photographs of Indians made at this time are in card stereograph form. These were made principally on government surveys by men such as Beaman, Hillers, and Jackson, but were also made independently by such photographers as C. R. Savage, operating out of Salt Lake City; S. J. Morrow, operating on the upper Missouri River and Yankton area; and H. H. Bennett, operating in New Mexico.

Beaman related his experience in trying to make photographs in the ancient Aztec cities in these words:

HELIOTYPES

The English photographer Ernest Edwards patented a modification of the Albertype process in England in 1870, which he designated the Heliotype. Then he obtained an American patent, and about 1872 came to the United States to reside permanently, and became associated with the Boston publishing house James R. Osgood & Co., which purchased the American rights. The Heliotype process made use of the same materials as the Albertype, but the gelatine was made thick enough to sustain itself when detached from the glass plate on which it was made for transfer to a metal printing plate. The process was evidently perfected as a result of what Edward Bierstadt contended were ''magnified'' fears of breakage of the glass plates used in Albertype printing. However, Bierstadt pointed out that the Heliotype method used only vertical pressure, while the Albertype used all modes of pressure known in printing. In the case of the Albertype, the glass plate was imbedded in plaster of paris on a printing stone, and, according to Bierstadt, became as solid as the stone itself. Because of its greater thickness, five times as much gelatine was required on an average for use with the Heliotype, as opposed to the Albertype process. As in lithography, it was necessary after every impression to dampen a Heliotype plate with water. A mask of paper was used to secure white margins for the prints, after which the impression could be pulled for issue. Two or more inks were sometimes used in producing one picture, because it was found that where the light acted deeply, a stiff ink was called for, whereas a thinner ink would be satisfactory where the light did not act so deeply (i.e., in the halftones). Thus, a stiff ink was first used for shadows, followed by a thinner ink for the areas of halftone. Three or four inks were sometimes used in printing a single impression. Because of this, the Heliotype offered a superb range of halftones. It was used by many first-class photographers, among them Mathew Brady and William Notman.[411]

ENGLAND REMAINS SCENE FOR GELATINE DRY-PLATE STUDY

The publication by Dr. Richard L. Maddox of his gelatine dry-plate process stimulated further experimentation along similar lines, but principally in England. A London photographer, John Burgess, is credited with being the first (in July 1873) to offer a gelatine dry-plate emulsion, commercially, which could be poured on a glass negative plate and allowed to dry. Its sensitiveness in the dry state was held to be equal to the sensitiveness of a collodion emulsion in its wet state. But others in England were making, and possibly selling, dry plates at least as early as the fall of 1872. This was pointed out at that time by *Anthony's Photographic Bulletin* in this excerpt from an article on landscape photography:

> We are not one of those that expect to see the dry plate entirely supersede the wet, in ordinary landscape photography, but in the present knowledge upon the subject, it at least deserves serious consideration.
>
> The advocates of the various dry processes are untiring in their search after a quick and certain method for preparing plates, and from recent improvements, it would appear that there is much to be looked for in that direction.
>
> In England, the manufacture of dry plates is carried on extensively, and with such uniform success that they are largely used by photographers both at home and abroad.
>
> The results of a series of experiments recently made upon plates prepared in England, but exposed and developed in America, proved that an excellent article can be manufactured that will retain its sensitiveness for years, and will (when not tampered with by ignorant custom-house officials) yield uniformly good results.
>
> The manufacture of American dry plates of acknowledged merit, is a subject that is worthy of attention. Photographers could then procure a supply of plates at short notice, and not be obliged, as is now the case, either to experiment, and prepare dry plates themselves, or run the risk of accident and delay in importing them from England.[412]

This people, dwelling in houses three and four stories high, and peace-loving and intelligent beyond any other tribe that I have ever met with, are nevertheless very superstitous, so much so that I have found great difficulty in making negatives of them without getting myself into trouble.

They looked upon pictures that I made of their houses with wonder and amazement; and, when I presented them with some of my best efforts in the way of photographs of themselves, so soon as my back was turned they were immediately destroyed or thrown away. Had they been warlike, I presume that I should have come away minus a small lock of hair; as it was, I was politely request- ed to leave their towns. Nearly all the groups that I took of them are instantaneous views, or taken when they were not aware of what I was doing. They evidently look upon a picture as a sure passport to the happy hunting-grounds of another world.[413]

One historian estimates that only 2,000 to 2,500 stereoviews were ever made of Indian life and habitats prior to 1885, while the number of such card photographs made in California—principally of Yosemite and the Big Trees—has been estimated to total 12,000 to 15,000.

By Christmas, 1871, *Anthony's Photographic Bulletin* observed that the "demand for stereoscopic views is really surprising, chiefly of course for American scenery, but including every known and almost unknown foreign object of interest, whether in landscape, works of art, or portraiture." Among the principal topics of interest in stereoviews were the following: views of the world peace jubilees in Boston in 1869 and 1871; the completion of major new buildings and the paving of streets in the nation's capital; views of cemeteries, mausoleums and monuments; the building of landmark suspension bridges and viaducts; interior views and statuary of noted public buildings; and the scenic routes of all major railroad lines.

The *Bulletin* drew attention to an "immense collection of stereoscopic views on glass," imported from France. Few American photographers, evidently, made glass stereoviews.

With the onset of the 1873–74 financial panic, prices for card stereographs were cut, and the quality of items offered declined in many cases. Reportedly, the Anthonys curtailed production, but in New Hampshire, where the effects of the recession were possibly less severe, the Kilburn brothers' establishment added a new factory to their Littleton facility, which upped production of cards to two thousand a day. Benjamin Kilburn also set out at this time on a photographic tour of Europe and the Near East. This led to publication of hundreds of new titles of foreign tourist meccas, which sold very well during the 1870s and 1880s. At the time of the financial recession, E. L. Wilson reportedly was importing foreign stereoviews at the rate of three hundred thousand annually, jobbing them in gross lots.

1872 After the Civil War, the variety of stereoscopic viewing equipment offered commercially also became quite large. 224 E. L. Wilson, for example, maintained a stock of eighteen

Simpson, Robinson, Dallmeyer.
No. 54

AN ENGLISH CONNECTION

These Englishmen who posed together circa 1873 had a notable effect on the course of American photography. They are, from left to right: George Wharton Simpson, Henry Peach Robinson, and John R. Dallmeyer. Simpson, editor of Britain's *Photographic News* from 1860 to 1880, critiqued American photographic literature (see page 227) and invented a collodio-chloride formula used in the manufacture of *aristotype* paper. Robinson, the most influential pictorial photographer of his day, judged entries at one of the earliest American art photography competitions (see page 355). Lenses made by Dallmeyer were used predominantly in American landscape photography, and were sold through E. & H. T. Anthony & Company (see page 215).[411]

different models which he sold wholesale at prices ranging from as little as 65 cents to $23. In many homes, finely made furniture, from simple floor racks to large cabinets, housed boxes or trays of stereoviews. The cards were also packaged in cases resembling finely made books for display on bookshelves.[414]

1873

"As an industry, photography has grown to proportions that surprise," the editors of a new book, *The Great Industries of the United States,* observed in 1873, a year of economic panic. Ready-sensitized albumen paper had become available the previous year, but how extensively it was used before albumen paper was gradually phased out in the 1890s does not appear to be recorded. In any event, *Great Industries* pointed to statistics covering the import of albumen paper from German and French mills, and concluded that 3,500 reams of the paper were being brought to the United States annually. From this the conclusion was made that American photographers were making 55,400,000 photographs a year. This was based on the calculation of 480 sheets of photographic paper to a ream, and the assumption that each photographer "makes probably thirty pictures" from each sheet, or a total of 14,400 photographs from a ream. Whatever the overall figures might be precisely, the book provided additional interesting data on the average metropolitan gallery operation which would be hard to find elsewhere:

> There are about 5,250 persons in the United States who follow photography as a business, and the leading house in this country in photographic materials estimates that each gallery or operator consumes two hundred dollars' worth of chemicals and paper annually. To obtain a cheap outfit for making cards of the usual size, one requires an outlay of some $200 to $250. The great galleries of the metropolis, where sometimes eighty or a hundred first-class pictures are made in a day, have expended at least $3,000 in their chemical and mechanical outfit, and, including the darkroom, the drapery, and the various devices for regulating the light, the outlay for equipping a first-class gallery is not less than $10,000.[415]

The foremost United States manufacturer of albumenized paper, John R. Clemons of Philadelphia, evidently was not included in the *Great Industries* survey, nor apparently were other American producers such as Daniel Hovey of Rochester. The Clemons factory appears to have escaped the camera's notice in the illustrated Philadelphia business directories of this period, but the facility is known to have been in operation at 915 Samson Street as early as December 1871. In that month, notice was given in the *Philadelphia Photographer* that a barrel of fifty dozen fresh eggs was delivered to Clemons on a particular day for albumenizing, but that while the proprietor was out to lunch all six hundred eggs were inadvertently hatched.

In February 1873, the editors of the *Photographic Times* paid Clemons a visit. After citing various problems and frustrations faced by photographers working with albumen paper, the *Times* gave this account of the visit:

> We were aware that his albumen paper was second to none in quality, but never fully understood the secret of his success. He first showed us his patent Churn, which cost him $300. To this he added an ingenious contrivance of his own, by means of which the cells containing the albumen were broken during the revolutions of the huge wheel, which is rapidly turned by the *"one man power"* applied to the crank outside. Into this huge

The scene above is at John McAllister's in Philadelphia, where a customer could probably buy as many different model stereoscopes in the 1870s as one could buy television sets today at a modern commercial establishment.

Churn is placed many gallons of the whites of eggs. After the brisk turning of the crank for a few moments, the frothy substance is now in the right stage to add of milk and old Jamaica rum *quantum sufficit* to produce a glorious eggnog; but no, our good Methodist brother John won't hear of such a wicked thing, and despite our mouth waterings, inward yearnings and vain expostulations, away it goes into an immense strainer of Mr. Clemons' own peculiar construction, and soon percolates through, limpid and clear as crystal. Then is added a *secret* chemical compound which dissolves all the striated, or fibrous tissues, which, though almost invisible, produce in some makes of albumen paper the reticulations of surface which war against fine, soft, even tones in the finished print, notwithstanding the greatest care is observed by the painstaking photographer. To this secret agency is due the uniform smoothness of texture so peculiar to Mr. Clemons' paper.[416]

Citing Clemons' extensive albumenizing and drying rooms (facilities which, for example, would prevent the occurrence of diagonal streaks running through the paper because of improper drying), the article also observed that the Clemons paper was celebrated for its rich bluish-gray tints

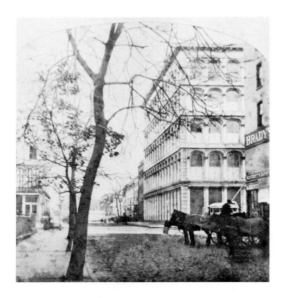

MATHEW BRADY FLEES NEW YORK

Mathew Brady's Broadway and Tenth Street gallery in New York was America's finest when it was opened in 1860. The Prince of Wales was among its first patrons, and *Leslie's* said of it: "If Brady lived in England his gallery would be called the Royal Gallery." The view (above) shows only one side of the building in which the gallery was housed. In the background, on the southeast corner of Broadway and Tenth, running all the way to Ninth Street, is A. T. Stewart's famed department store, which in the twentieth century became John Wanamaker's department store before its destruction by fire. But Brady had overextended his resources in opening the Tenth Street showplace, much as he had in even greater fashion by personally funding the principal photographic coverage of the Civil War. By January 1873, the demands of ninety-four creditors could no longer be staved off and Brady was declared bankrupt. But Brady had political connections with Boss Tweed's Tammany Hall, and he conspired with the Tweed-appointed Sheriff of the City of New York to spirit away nineteen cartloads of goods from the gallery before the U.S. Marshal's Office could obtain an injunction halting the action. Brady himself fled to Washington where for the first time he established his permanent residence.

"which vary from delicate pearl to deep blue, according to the taste of the photographer. These tints, unlike those produced by many albumenizers, *do not fade*. The deeper shades are particularly adapted for views, giving bluish skies so desirable in outdoor effects."

The financial crisis which struck the nation in 1873 was possibly the worst of the century. It began on September 18 with the failure of Jay Cooke & Co. in Philadelphia, the banking firm which had acted as the federal government's agent during the Civil War in floating bond issues to meet military requirements. The Federal Reserve System did not exist at this time, and a general suspension of banking was averted only by an agreement among the banks themselves to give dictatorial powers to the New York Clearing House Association, an organization headed by Frederick Dobbs Tappen (see illustration, page 259), which had been established merely to facilitate the exchange of checks. No solvent bank was allowed to fail because of depletion of cash reserves, and before the crisis eased, over $26 million in clearinghouse certificate loans were issued. But generally unfavorable economic conditions, including severe unemployment, persisted for another five years.

Many a photographer's business was brought to a standstill, and Carleton E. Watkins, as we have already seen, was forced into bankruptcy. John G. Vail, of Geneva, New York, waited the crisis out until as late as 1880, but finding that he still could not fulfill orders for a profit, he took all his negatives in a rowboat to the center of Geneva Lake and dumped them overboard (an action which he said he felt was necessary to prevent their falling into "unscrupulous hands").

Mathew Brady was another who was declared bankrupt in 1873. Brady's troubles began immediately after the Civil War when he failed in his efforts to have either the 40th or the 41st Congress appropriate funds for the purchase of his wartime photographs. Management problems in his Washington gallery and mounting debts at both his Washington and New York galleries came to a head in 1872, the same year that the Tammany Hall leader William Marcy ("Boss") Tweed went to jail. Brady had previously enjoyed a political helping hand from the Tweed forces against certain court judgments which had long been pending against him in New York, but with the demise of the Tweed machine, these court actions were prosecuted, resulting in the rendering of judgments against Brady by ninety-four creditors. But before the U.S. Marshal's Office could seize his property and goods, Brady prevailed upon his friend Matthew T. Brennan, Sheriff of the City of New York and a longtime Tammany sachem, to help him spirit away his goods to Washington.[417]

One who was untouched by the economic problems of the day was Edward L. Wilson. Wilson had struck up a close friendship with Dr. Hermann Vogel, and the pair decided to attend the 1873 World's Fair at Vienna. Wilson attended the opera in Berlin and was feted by the German Society for the Advancement of Photography. He and Vogel watched a parade led by Emperor William I, and visited the art studios of Loescher & Petsch, Meister, Tolbat, Obernetter and Schaarwachter. After the Vienna fair, the pair traveled together to Paris, Switzerland, and Italy.

Laurels were heaped on Wilson this year, too, by the

British photographic press, which cited his energy and enthusiasm as the principal motivating force behind a grand flowering of American photographic literature. "There was a time," wrote George Wharton Simpson, "when the photographic literature of America was of the most meagre and feeble description, its periodicals being chiefly filled with gleanings from English journals, whilst books of any pretension or completeness there were none. Now we look in vain in any other country for a photographic literature so copious and complete." Simpson cited American authors such as Matthew Carey Lea, whose *Manual of Photography* first published in 1868 became a world standard; Elbert Anderson, whose *The Skylight and the Dark-Room* Simpson felt "ought to grace every photographer's library"; and Wilson's own *Carbon Manual* and other books which had "teemed from the press" in America at this time. Publication of Simpson's article prompted H. H. Snelling, by now residing in upstate New York, to address a letter to the editor of the *Photographic Times* in which he also voiced praise for Wilson's efforts, but at the same time added this slight dash of cold water: "When Mr. Wilson established the *Philadelphia Photographer* he conceived nothing new, but simply continued the planned purpose of a predecessor, who failed in his enterprise because he was 'ahead of the times.'" The "predecessor," of course, was a reference to Snelling himself. In a separate editorial comment on Snelling's letter, the editors of the *Photographic Times* put a different perspective on the matter:

> Entering upon his duties, nearly ten years ago, he [Wilson] seemed at once to sympathetically comprehend and understand the interests of the fraternity, and with cheerful persistence, saying *"come,* boys," rather than *"go,* boys," he has the pleasant consciousness which earnest labor always brings, of having been *useful* to those who look to him for their instruction and encouragement.[418]

Just as there was now a flowering of American photographic literature, so, too, the works of the western landscape school for the first time placed Americans in the "big league" of English and European fine-arts photographers. This was the league dominated in the 1850s and 1860s by such names as Dr. Thomas Keith (of Edinburgh), Robert MacPherson, Roger Fenton, Philip H. Delamotte, Charles Clifford, Gustave Le Gray, Edouard Baldus, Adolphe Braun, Maxime Du Camp, and Charles Negre. In the 1870s, the most prominent names were British: Francis Frith, Henry Peach Robinson, and John Thomson. Now Eadweard Muybridge and Carleton E. Watkins could be counted among the ranks of well-known photographers whose works won prizes at international exhibitions. To these should also be added the names of William H. Jackson and Timothy O'Sullivan, whose original prints today have a high value despite the lack of recognition given O'Sullivan, for example, at the 1873 Vienna fair.

For a number of years dealers and booksellers such as Wilson & Hood in Philadelphia, and E. & H. T. Anthony & Co., Charles Scribner's, Julius Bien, and C. F. McKim in New York, offered albums and portfolios of photographs published in England, or in Europe. Now, at last, there were some American counterparts, including Muybridge's *Views of the Valley of the Yosemite* (San Francisco, 1873),

1873

227

277—Rapids above American Falls.

Seascape photographs remained uncommon in the 1870s, and the view above at Niagara Falls was probably made after 1880. The subject was rarely discussed in photographic literature of the period, but in July 1873, *Anthony's Photographic Bulletin* published these remarks by F. R. Elwell at a meeting of the London Photographic Society: "Every aspirant of our art has eagerly longed for the means whereby he might *faithfully* depict the breaking waves, the sunlit landscapes sprinkled with its accompanying passing clouds, the fleeting and ever-changing expressions of children. All these are as yet satisfactorily possible only to a very limited extent; but with patience, and chemicals always kept in a high degree of sensitiveness, a great deal may be accomplished." Elwell said he had tried "various shutters," but concluded that a lens cap and "a small amount of hand practice" were still the best ingredients for rapid exposures.[420]

containing 51 large prints, 36 in size 5½ x 8½, and 379 card stereographs; W. H. Jackson's *Yellowstone's Scenic Wonders* (1871), and *Photographs of the Yellowstone National Park and Views in Montana and Wyoming Territories* (1873), both albums of photographs made on the F. V. Hayden surveys and published in editions of unknown size. Earlier (in 1870), Clarence King had prepared a small book of poetry, *The Three Lakes, Marian, Lall and Jan and How They Were Named*, which he illustrated with some of O'Sullivan's most picturesque photographs taken on King's surveys of what is now Wyoming and Colorado. Efforts were evidently also made at this time to publish folio-size books of landscape photographs taken by eastern photographers, but today such items are little heralded. One example is *Pictures of Edgewood*, published in 1869 by Scribner's, containing ten large mounted albumen photographs of the New Jersey town by George G. Rockwood, and text by Donald G. Mitchell. The book was issued in a limited edition of three hundred copies. There is no easy way of compiling a full listing of published works covering American landscape photography at this turning point of the medium's history, and the existence of works such as the Rockwood book frequently remain unknown until they appear at public auctions.

1874

Except in isolated instances, photographers in the daguerrean era did not make what are now called "documentary" or "news" photographs. The daguerreotypes made by Robert Vance of San Francisco and environs during the gold rush years constitute the first such major undertaking, but unfortunately these photographs were lost. After the introduction of the card stereograph, however, these types of photographs gradually became more common. Photographers soon found that if card stereographs could be made of major public events or disasters, they could be profitably retailed locally, and sometimes nationally, depending upon the nature of the event or calamity. The thousands of card stereographs made during the Civil War, while they are classed as "wartime" photographs, are among the earliest documentary and news photographs produced on a large scale. But even in that day, only a small handful of the stereoviews (or larger views) taken were of actual battle scenes.

Card stereographs of the aftermaths of the disastrous fires in Portland, Maine (1866), Chicago (1871), and Boston (1872) were made by scores of photographers in each of these cities, and these were sold not only locally by the photographers themselves but nationally by E. & H. T. Anthony & Co. and other major commercial stereograph publishers. Most of the time these publishers would acquire negatives made locally, but occasionally they would dispatch photographers of their own to record an event or happening, and such ventures may truly be described as documentary or news photography in its earliest commercial form.

The first flash flood which caused loss of life and attracted public interest in locally produced photographs of the event was the flooding of the Allegheny Valley just north of Pittsburgh in 1873. But there was no first-rate stereophotographer in Pittsburgh at the time; hence, the photographs taken of the aftermath of the flood are extremely poor. In 1874, however, a number of photographers provided excellent coverage of the aftermath of the Mill River flood in western Massachusetts which ravaged the towns of Williamsburg, Skinnerville, Haydenville, Leeds, Florence, and a portion of Northampton, following the collapse of the Williamsburg Reservoir dam early on the morning of May 16. In many respects the photographic coverage of this tragedy is a classic in early American news photography, for not only did the photographers record the many scenes of damage but at the same time they also made photographs of the principal heros of the event. A. E. Alden, of Springfield, photographed the two "Paul Reveres" who rode through the towns warning residents to run for their lives minutes before the calamity struck. One of these was a young Civil War veteran, George Cheney, the gatekeeper of the dam at the 111-acre Williamsburg Reservoir. When the dam broke, he leaped on a horse and rode bareback three miles to Williamsburg to shout warnings of the impending disaster, which caused more than 130 deaths. Another was a milkman, Collins Graves, who, upon hearing Cheney's

NEWTON METHOD FREES PRINTS FROM HYPO CONTAMINATION

"Washing long and washing well is one of the fundamental laws of photography, the first learned and the longest remembered by every photographic printer," Henry J. Newton said in 1871. "This may be necessary," he added, "but I do not practice it for two reasons: first, I do not believe the necessity for it exists. Second, I am sure it injures the prints." Newton proposed measured use of acetate of lead in a series of washings to be sure that all hypo would be removed in print making, stating that "the whole process need not occupy more than fifteen minutes."

In July 1874, a committee was appointed by the Photographic Section of the American Institute (of which Newton was president) to test the Newton formula. The committee consisted of Henry T. Anthony, O. G. Mason (photographer-in-residence at Bellevue Hospital), James B. Gardner, and James Chisholm. On October 7, the group issued its report, from which the following has been excerpted:

> The committee in their experiments have demonstrated in many ways the wonderful tenacity with which the hyposulphite clings to albumenized silver prints, and thus arrived at the conclusion that perhaps not one picture in a thousand was ever absolutely free from it. If, therefore, Mr. Newton's mode of removing it was true and practicable, it should be proven and made known to every photographer who takes even the smallest interest or pride in the permanency of his work.
>
> At one of the meetings of the committee, it was determined by careful experiments that of all the known tests for detecting the presence of hypo, the starch and iodine was the most reliable when freshly and properly prepared. By this test, not even the 250th part of a grain in an ounce of water, or $\frac{1}{112000}$ part, escaped detection.
>
> It was also demonstrated by experiments that the acetate or nitrate of lead was the best known means of decomposing the hypo. Prints that were washed after coming from the lead solution in simply four changes of water, showed no trace of hypo, while those washed in running water for twelve hours or more (without the lead solution) were still found contaminated with it.[421]

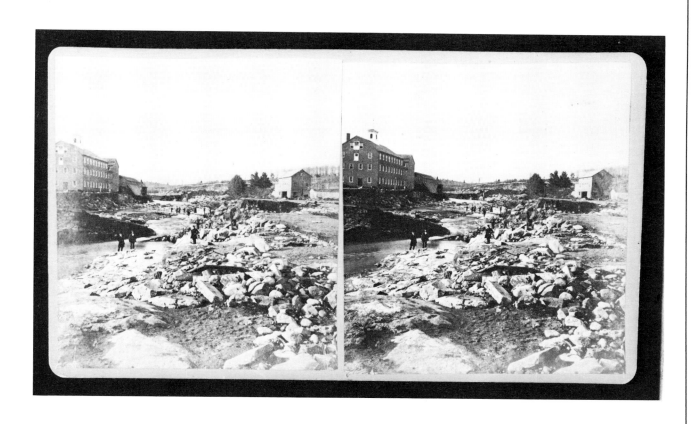

MILL RIVER FLOOD DISASTER

Photographic coverage of the disastrous flooding of the Mill River in western Massachusetts on May 16, 1874, stands as a classic in early American news photography. Card stereographs made after the tragedy provided lucrative returns for at least three photographers. These essentially news photographs were made and sold by A. E. Alden of Springfield, Massachusetts, depicting the damage to the Nonotauk Silk Works in Florence (top left), and to the Hayden, Gere & Company brass works in Haydenville (above). Bottom left stereoview is of milkman Collins Graves in front of his Williamsburg home, which was spared in the tragedy. After the Williamsburg dam burst, Graves rode Paul Revere-style to neighboring Skinnerville and Haydenville, shouting warning minutes before the flood ravaged these towns. Card stereographs not shown here were also made of the dam's gatekeeper who posed afterwards on the horse he had ridden bareback to Williamsburg to warn residents of impending disaster.

shouts, cut his horse loose from the milkwagon and set out at a gallop for Skinnerville and Haydenville. Collins arrived only five minutes ahead of the flood in Skinnerville and three minutes ahead of it in Haydenville. Alden afterwards photographed Cheney on his horse, and Graves in front of his home, and on his milkwagon (see pages 230–231). He also photographed George Roberts, a ''little hero'' who was rescued after being caught for an hour in the rampage. Alden printed and sold a series of forty-eight views of the flood, each card carrying the following advertisement on the back side:

> Having lived in the vicinity of the ruined villages, we have had superior facilities for securing views from the best points, and

DRAPER PROPHECY: PHOTOGRAPHIC OPERATION OF LIGHT AFFECTS PRODUCTION OF COLOR

In 1863, Prof. John W. Draper observed that certain vegetable tints were destroyed by light of a complementary color, and he suggested that the converse of this observed phenomena might have a bearing on photography:

> If you take a seed and make it sprout or germinate in a dark place, the young plant emerges of a pale and sickly yellow hue. If you persist in exposing it to such a trial, you soon find that it has no power of adding to its height, for with the exception of water it contains nothing more than was in the original seed. But set it where the sun can shine upon it, and soon its sickly yellowness is lost, its leaves turn green, it steadily increases in height. Its stem become firm, its branches put forth, in due season it bears its colored flowers, it reproduces its seeds, and so completes the cycle of life. Now, the accomplishment of all this turns on the chemical fact, that under proper circumstances the sun's rays can separate carbon from oxygen, and combine it with other elements into new and organized forms. Connected with this production of colors and forms by the influence of light, there is an interesting fact that well deserves the serious meditation of every photographer. I refer now to natural bleaching operations, or the destruction of colors by light. In vegetable tints of any kind, bleaching or destruction is accomplished by light of a complementary color; a green tint is destroyed by red light, a red tint by a green. Now those who have attempted the solution of that which must be universally considered as the grand problem of photography, the artificial representation of external objects in their natural colors, have perhaps come too hastily to their conclusion that there is no relation between the photographic operation of light, and the production of color. Obviously there is in the case of carbon compounds such a relation as regards their destruction, and therefore perhaps the converse of this is not so improbable as some have been led to suppose. But I have been alluding to carbon as the natural photographic material, for the purpose of illustrating my assertion that in photography we are at present only at the beginning of our work. We have used one material, Nature uses another. There are multitudes which neither we nor Nature have thus far resorted to. So there is a boundless field before us.[422]

IN MEMORIAM: WILLIAM LANGENHEIM

The death of William Langenheim on May 4 brought to a close the illustrious Philadelphia business of Frederick and William Langenheim, begun about 1842. Within six months, Frederick sold the business and himself died five years later. The Langenheims failed in their attempts, in the 1840s, to license American photographers for the early calotype paper photography practice, but they are the recognized pioneers in the development of photographic slides for audience viewing, and in establishing the American market for card stereographs. Through their brother-in-law, Friederich Voigtlander, they also introduced the first true camera lens (the Petzval lens, manufactured by Voigtlander) on the American market.

have taken time and pains to make our list the most complete and interesting that could possibly be obtained. We have secured a complete set from Williamsburg Reservoir to Northampton.[423]

Documentary photographs of the exterior, and in some instances the interior, of various New England mills and factories were made in the latter part of the 1860s and in the 1870s. T. Lewis, of Cambridgeport, Massachusetts, for example, made forty-four views covering the building and activities of the Waltham Watch Company in 1872. Other card stereographs were published in the period 1868–74 by Presscott & White, of Hartford, covering the Willimantic Linen Company; and by J. N. Webster, of Barten, Vermont, covering the Lydonville Machine Shop in Lydonville, Vermont.

The photograph of President Andrew Johnson on the front porch of a building with General Grant and Gideon Welles (see page 184) is a prime example of an instance in which a local photographer secured what is essentially a news photograph of a president on the campaign trail. But unfortunately, the name of the photographer as well as the location where the picture was taken remain unknown. While it was not uncommon for local photographers to make such photographs, there were no news photo services at the time, and occasions were few on which the large commercial publishers would put in a request for photographs taken locally for one reason or another. The Johnson card

Dr. Hermann Vogel, from a photograph circa 1872.

ORTHOCHROMATIC PHOTOGRAPHY

That there was a "relation between the photographic operation of light, and the production of color," as stated by Prof. John Draper in 1863 (see left), was observable in a vast number of photographs. Violet and blue colors were reproduced too light, while green, yellow, and red would appear too dark. In landscape photographs, much detail was lost in the foliage; blue skies would appear as light as the white clouds, often rendering the latter invisible. In portrait photography, auburn or red hair would come out too dark, and freckles much too prominent; blue eyes and blue or pink dresses would appear entirely too light.

The first action based on this observable phenomenon appears to have been taken in December 1873, when Dr. Hermann Vogel disclosed that certain aniline dyes could be used to increase the color-sensitiveness of the silver salts in a photographic negative to those rays of the spectrum which they absorb. "I fastened a dark-blue silk ribbon on a piece of yellow silk, and took a picture from it with an ordinary wet collodion plate," Vogel recalled later of his first experiments. "The result was a white ribbon on a dark piece of silk. It was obvious that I could not succeed much better with a corallin-dyed bromide of silver plate, because the action of the yellow in the spectrum on it was much stronger than that of the blue. Therefore, I interposed a yellow screen between the subject and the lens, depressing the intensity of the blue rays; and now I got indeed a negative which was a true positive print, wherein the dark ribbon was dark and the yellow silk was light." Vogel's discovery was a first step toward orthochromatic photography,

a way of using dyes to tender truer color values in a black and white photograph (the process was not one able to produce color prints).

D. C. Chapman, at a meeting of the Photographic Section of the American Institute in February 1874, called it the most important improvement since the invention of photography itself. "The process," he said, "appears to be adapted entirely to dry-plate photography, and is more particularly applicable to the bromide of silver alone." In photographing paintings, in which certain colors predominate, Chapman said it would now be possible to flow the dry plates with special ingredients so that "the predominating color of that picture may be made to give the predominating action on the plate; so that we may proportion the dry plates to the special purpose, and make those colors which appear the strongest show upon the photograph the strongest." In outdoor photography, he said it would be possible to "diminish the action of the clouds and the sky, and increase the action of the green."

Vogel's discovery led other investigators to experiment along similar lines, and better dyes were soon perfected. But despite these further advances, photographers were not given the means—even with the orthochromatic plates manufactured after 1884—to make their monochrome negative plates sensitive to all colors. The plates remained comparatively insensitive to red, and oversensitive to blue, unless a yellow filter was used to correct these drawbacks. After the appearance of the panchromatic plate in 1906, the photographers' monochrome plates were made sensitive to all colors, including red.[424]

stereograph was probably sold locally, and only in a relatively small number. With the great loss, or destruction of photographs and negatives made in the nineteenth century, many, if not most of such locally made news photographs should be considered one of a kind, just as a daguerreotype or ambrotype is a one-of-a-kind photograph lacking a negative or duplicate prints.

The numerous government surveys begun after 1870, of course, provided another stimulus to documentary photography, and by 1874 *The Nation* made note of the fact that a photographer was "now considered indispensable to all Government expeditions of the first class." Citing the Hayden, Wheeler, Powell, King, Selfridge, and other surveys, the periodical observed that the number of negatives accumulated in Washington (stereoscopic views, and photographs in size 11 x 14) "has become really enormous," and that "the peculiarities of a country and of its human and other inhabitants can thus be exhibited in a very satisfactory manner." But why, the magazine asked, could not all of these photographs be made readily available to the general public?

It is greatly to be regretted that no provision is made by Government for the publication of these pictures, so that they may be acquired by those who wish for them at a reasonable price. They are now to be had only by special favor of the heads of the departments, and a complete series cannot be obtained without great difficulty. A few sets might be distributed gratuitously to public institutions, others sold singly or collectively to individuals, at cost price. It is quite safe to say that the series of large plates amounts to over a thousand, while of stereoscopic pictures there are two or three times that number.[425]

The original negatives and prints made by the photographers themselves on these government surveys have, in many instances, found their way into the archives of libraries and historical societies, or into the hands of collectors. Those prints deposited with government agencies remain essentially where they were, or in the Library of Congress or Smithsonian Institution.

1875

"It is difficult to go into a bookstore now without seeing various works illustrated by means of one or more of the various photomechanical printing processes," the *Philadelphia Photographer* observed in February 1875. But in all of these methods used to incorporate photographic images with book text, it was still necessary to print the illustrations separately (i.e., on separate printing plates), then bind them together with the pages of separately printed type. The processes principally used included the Woodburytype, Albertype, and Heliotype. Publishers also continued to issue small editions of a few books containing mounted photographs printed in volume from original negatives, and likewise bound together with separately printed type pages. John Carbutt's 1868 *Biographical Sketches of the Leading Men of Chicago* was followed by volumes of a similar nature published in Baltimore, Cincinnati, Syracuse, and Nebraska. Where Carbutt had printed nearly 50,000 cabinet-size photographic portraits for his Chicago book, James Landy printed 65,000 cabinet-size prints for the Cincinnati book, issued in 1873.

Literary classics were published, principally in England or on the continent, in new limited editions with separately bound-in photographs, either made from original negatives or by the carbon, or a photomechanical process. One example of an American classic published in this manner was that of Washington Irving's *A Legend of Sleepy Hollow,* issued in 1870 with four carbon prints by Napoleon Sarony of actor Joseph Jefferson in the role of Rip van Winkle. In 1874, Edward Bierstadt's Photoplate Printing Company was given the job of making Albertype prints to illustrate a book on western scenery, using negatives made by W. H. Jackson in Yellowstone National Park, but all of the materials for the book were lost when the building in which Bierstadt's company was housed was destroyed by fire in January 1875.[426]

Two other photomechanical methods adopted by some publishers for line illustrations were photolithography, used principally for map illustrations, and photozincography, a process similar to photolithography, but one which made use of a zinc printing plate instead of a stone. But even to the present day a certain amount of confusion exists—even among so-called experts—as to whether various books published in the 1870s and 1880s contain woodcuts or line illustrations made by a photomechanical process.

Beginning in the early days of the daguerreotype, attempts were made—some successfully—to secure impressions from a photographic image on a metal printing plate. In 1842, for example, the U.S. Mint's chief engraver, Christian Gobrecht, made a daguerreotype view of the Mint building in Philadelphia, then made a bas-relief from this on a metal plate, from which he was able to make a facsimile, lead-backed printing surface by the then newly discovered art of electrotyping. With this printing plate, Gobrecht was able to make an engraving of the Mint which served as a line illustration in Eckfeldt and Du Bois's *A Manual of Gold and Silver Coins,* published that same year.[427] But the prin-

PHOTOENGRAVING

Of all the photomechanical printing modes, photoengraving made the least progress because it remained a slow and expensive process. R. W. Bowker gave this description of the art for the readers of *Harper's:*

> The engraver has upon his table a smooth block of boxwood, upon whose surface appears, reversed, the drawing or a photograph from the picture which he is to reproduce. Modern photography has been able to coat the wood with a sensitive film which takes an exact photograph, reversed, of a picture to be copied, leaving the picture itself as a guide to the engraver. This is a double gain, and most artists now draw directly on paper in wash or body color, in preference to drawing backward on the wood itself, a design which the engraver's tool must destroy as he interprets it. The block is placed upon a cushion on the engraver's table, and between the block and his eye is a magnifying-glass supported from a frame, through which the eye directs and follows the hand. Thus equipped, the engraver uses otherwise only the simplest tools—gravers of well-tempered steel, sharpened occasionally on a whetstone near at hand, and sometimes the multiple graver or "tint tool," which has a cutting series like a comb, and cuts parallel furrows. This last is seldom used by the best men. Line by line, with exquisite patience, the engraver pursues his wonderful work, in whose highest reach there is no secret beyond the eye careful to see, the hand deft to cut, the artistic judgment which dictates the right kind, direction, and width of line to interpret the artist's feeling. The graver cuts away the furrows in the wood, leaving ridges which are to be the lines of the print, so that a magnified wood block is simply a carefully ploughed field.[428]

cipal reason these early attempts at photoengraving were not generally successful, commercially, was due probably to the softness of the metal at first used, which allowed only a limited number of good impressions. This situation was later remedied by the adoption of steel-faced plates, which made it possible to secure a greater number of engravings during a press run.

The earliest means of transferring a photographic image to an engraver's plate, while at the same time retaining some measure of the lights and shades of halftone, was accomplished in Europe. During the 1850s and 1860s, these processes included phototype printing, heliography, photogalvanography, and the aforementioned photozincography. By 1874, the New York photographer George G. Rockwood was advertising the capability (see page 236) of producing "thousands of pictures . . . with all the facility of the ordinary lithograph upon a press with ink." How successful, commercially, the several methods used by Rockwood were does not appear to be recorded.[429]

Two names which figure prominently in early American photoengraving activity were the brothers Louis and Max Levy, the sons of Bohemian parents, who grew up in Detroit. In 1866, at age twenty, Louis Levy took up pho-

ROCKWOOD PROCESS

In April 1874, George G. Rockwood offered to sell rights to a new photoengraving process, which he described in these words:

> Ten or twelve years ago, some progress was made in France in what was called "heliographic engraving," in which metal printing plates were obtained by the action of light; and more recently, in this country, some attention was bestowed upon the maturing of a process of this character, with varying success. Having devoted a long time and considerable means to the development and perfection of this process, it has steadily developed till now it is of the simplest and most reliable nature. Under ordinary photographic negatives, prepared plates of glass, zinc, and stone are exposed to the action of light, and from these plates thousands of pictures are printed with all the facility of the ordinary lithograph upon a press with ink. The effect of the light upon the sensitized plate is to transform it into a veritable lithographic plate—the parts exposed to the action of light having an affinity for fatty or printer's ink, and the portion protected from light rejecting the ink and absorbing water. So, first, a wet roller is passed over a plate ready for the press, followed by an ink-roller, and the paper then placed on the press, and run through the rollers at the rate of about sixty or seventy an hour. Specimens can be seen of this new process of very great variety—portraits, landscapes, and copies of mechanical drawings, music, and ordinary letter-press.

Rockwood's reference to previous French progress probably alludes to the "heliogravure" experiments conducted in the 1850s by Niépce de Saint-Victor, Edouard Baldus, and Charles Negre, all of whom used a bitumen coating on steel plates. Rockwood's use of glass suggests that he was following Paul Pretsch's 1854 patent for "Photogalvanography." Rockwood's other processes are probably more accurately described (with the benefit of hindsight) as photozincography (in the case of the zinc plates) and photolithography (in the case of the negatives prepared on stone). Several months later, Rockwood did, in fact, refer to his commercial activities in this area as photolithography.[430]

LEVYTYPE

This photoengraving process was patented in January 1875, by Louis E. Levy and David Bachrach, Jr. It was based on the "swelled gelatine" photogalvanography process invented in 1854 by Paul Pretsch of Vienna. In the Pretsch method, a gelatine mixture was coated on a glass plate, and the parts *not* acted on by light were swollen by water and made to serve as the basis of electrotyping. The Levytype process followed much the same procedure up to the time of exposure to light of a photographic negative in contact with the plate. The subsequent differing steps were described by Bachrach in these words:

> After exposure, the plate is immersed in cold water, and at once a curious phenomena occurs. Those parts of the plate not exposed to the light *swell* by the absorption of water, while those exposed remain unaffected. This, it will be seen, forms the relief. As soon as this action has begun all over the plate, we plunge it into a 20-grain silver solution until the relief is high enough, *but not a minute longer,* for if the action is carried too far the lines become rounded at the bottom, and sharpness is lost. This part of the process is very important, and is our original invention. We have patented this step particularly, as it is peculiar to our process alone. The advantage of this operation lies in the fact that it sharpens the lines, and allows greater relief being obtained without injury—very important for practical printing qualities—which advantage is recognized by printers using our cuts, which they prefer on this account over those made by other processes. The film, becoming full of bichromate of silver by this step, obtains greater consistency and solidity, and is capable of standing more handling in the subsequent steps.[431]

tography in order to record microscopic observations he was then making for the U.S. Meteorological Service. In 1873, he began experiments in photoengraving and became acquainted with David Bachrach in Baltimore, who allowed Levy the use of his gallery facilities for experimentation. Bachrach himself became interested in Levy's experiments, which concentrated on the photogalvanography process which had been invented in Vienna by Paul Pretsch in 1854.

1875 By January 1875, Bachrach and Levy jointly obtained an American patent for an improvement of the Pretsch method which involved a means of swelling gelatine to provide a

hardened surface for electrotyping. The process was at first given the name "Photo-Relief Printing," but has since come to be identified as the Levytype—principally because Levy alone continued to improve upon it. With his brothers Max and Joseph, he formed the Levy Photo-Engraving Company in Baltimore to market the process, then in 1877 moved to Philadelphia where he established the Levytype Company.

The process was evidently promoted successfully—presumably for book illustration—and in 1880 Max and Joseph Levy established the first photoengraving enterprise in Chicago, followed by a similar new venture in Cleveland. After 1880, new techniques introduced in photoengraving by others—most notably John Calvin Moss and Frederic E. Ives—made their appearance. Bachrach, reminiscing in later years, said the Levytype "became obsolete in about two years' time," but this observation is at variance with the recorded expansion of the Levy business to Chicago and Cleveland after 1880. One prominent photographer who used the Levytype process in the 1880s (and probably Ives's process later in the decade) was the Philadelphian Frederic Gutekunst. The latter also made use of the Woodburytype at this time, although after 1873 this process was not used as widely for book illustration as the photoengraving and various collotype photomechanical printing modes.

A principal advantage in collotype printing was the fact

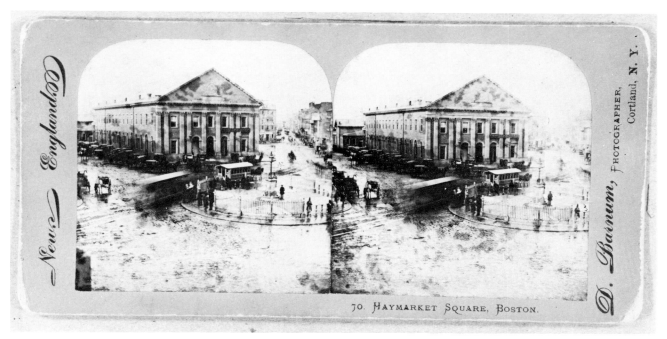

70. HAYMARKET SQUARE, BOSTON.

The continued inability of most cameras to arrest motion is reflected in this 1870s card stereograph of a horse-drawn trolley passing through Haymarket Square in Boston. Eadweard Muybridge's successful photographing of trotting horses at Leland Stanford's California racetrack remained during the 1870s just what the world thought of it: a wonderful scientific achievement. But there were several isolated achievements by photographers unknown to us today, which drew the attention of *Anthony's Photographic Bulletin* in June 1875. A photographer by the name of Maynard, of White Plains, New York, for example, made a photograph "in which the snow flakes are caught in the act of falling." Phillips and Crew, of Atlanta, produced stereoviews of "statuary contrasted with green foliage—very difficult subjects."

that illustrations produced by this method could be printed on a page with any desired margin, whereas in Woodbury-type printing the images had to be "bled" in printing, then mounted (like a photographic print from an original negative) on a page if a margin around the illustration was wanted. In one of his occasional communiqués to the photographic press from his position of retirement, H. H. Snelling drew attention to the drawback to book illustration caused by the necessity to mount the photographs used on cardboard:

. . . the objection is a serious one, not only on account of the thickness of the boards and the difficulty of binding them up with ordinary printing paper, but because of their giving too great weight to the volume. There are thousands of works published, scientific, medical, mechanics, poetry, biography, etc., of limited sale, many never rising above 1,000 copies, and the most popular of them barely reaching 5,000 copies. These, if none others, can be more cheaply illustrated by photography than by steel, copper, or wood engravings, or by lithographs, except in cases where the woodcut is printed with the letter-press in the body of the page. A thousand photographs of a given size can be furnished the publisher at less cost to him than the engraving of the steel or copper plate, or fine woodcut, if printed so as not to require mounting. I have no doubt if a suitable paper could be had, octavo photographs (i.e. printing of an octavo volume) could be furnished at $15–$20 a thousand, which would be a saving to the publisher in an edition of 5,000 copies.[432]

The year 1875 marked a turning point in another realm of photography, namely, that of viewing slides from the magic lantern. Up to 1874, the two major manufacturers of slides were the Langenheim brothers and Casper W. Briggs, of Norton, Massachusetts. Upon the death of William Langenheim, his brother sold the Langenheim business to Briggs, who consolidated all production thereafter in Philadelphia. By May 1875, *Anthony's Photographic Bulletin* observed editorially that "this instrument is now fast taking its deserved position as the medium pre-eminent for the diffusion of knowledge, and for the instruction and amusement of persons of all ages, and all classes of society. This has been brought about, in a great measure, by the important improvements which have taken place both in the lanterns and in the pictures used as illustrations, as well as by the growing desire for scientific knowledge which seems to characterize this generation."

The term *stereopticon* referred to a combination of two projectors which made it possible to dissolve views while showing them in sequence. This type of projector utilized limelight as opposed to oil for illumination and was the principal type used after 1870. Another version of the basic instrument was the artopticon, which was designed to use oil but could be adapted for the gases. In the stereopticon, oxygen and hydrogen gases were burned against a pellet of lime. By using large parabolic reflectors with a stereopticon, it was possible to spotlight the stage, which gave rise

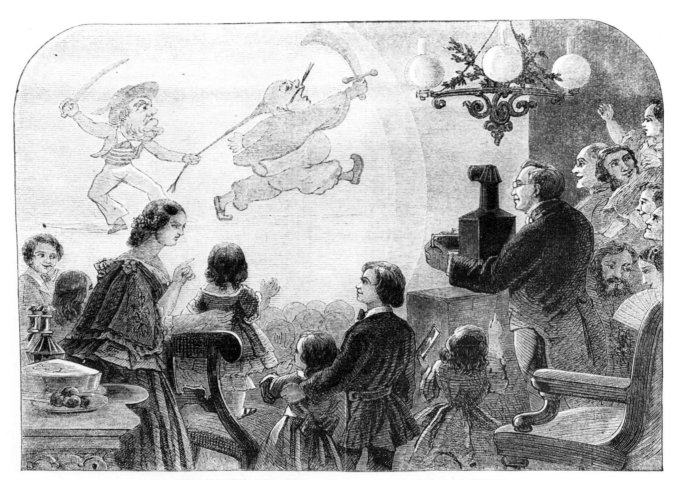

AMUSEMENTS FOR THE HOLIDAYS. THE MAGIC-LANTERN.

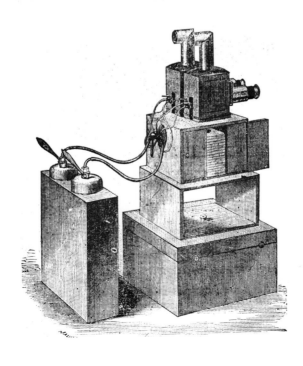

By 1875, William Langenheim was dead and his brother, Frederick, decided to sell out to Casper Briggs, of Norton, Massachusetts, a competitor in lantern slide manufacture. But the center of activity remained in Philadelphia, where Briggs soon concentrated all production, dominating the slide-making field until after World War I. Briggs has been described as something of a forerunner of Hollywood, because of his introduction of a wide range of religious, literary, historical, scientific, and humerous slides (see above) used on the lecture circuit.

Rear view of a magic lantern slide projector with attachments for the supply of hydrogen and oxygen. Illumination was achieved by burning the gases against a pellet of lime.

1875

238

to the expression that a speaker or performing artist so spotlighted was "in the limelight."

The lime or calcium light by now almost universally employed for public lantern exhibitions, the *Bulletin* maintained, "has by modern science been rendered perfectly safe to use, and can be easily and successfully operated." The *Bulletin* at the same time perceived a demand for "a better class of pictures" than those previously offered on the market, and said this was now being met by the introduction of "an entirely new class of photographic views, which are really works of art." The *Bulletin* also made this prophesy:

> We believe the time is not far distant when a good magic lantern and slides will be considered just as great a necessity in every school as is now the spelling book or reader. For instance, if the schools of any city were each supplied with a lantern, and, say thirty slides, no method of instruction would be more popular with the scholars themselves. The slides should be different, and could at stated times be exchanged one with the other, until they had gone the rounds of every school, and had been seen by all. It is not necessary in lantern exhibitions that the room should be entirely dark; it is only requisite that no light from any other source than the lantern should fall upon the screen. With the oxyhydrogen light, good effects can be produced when other lights are burning low, at the back of the hall, and even with the oil light, if the screen is placed against a wall and has around it black cloth, made like a box, say three feet deep. Thus one of the objections to its application for school purposes, that of leaving the children entirely in the dark, can be avoided. Sunday schools and churches may also with profit own a lantern and views, with which entertainments can be frequently given to raise money for the school, or for charitable purposes. [433]

The Langenheims had used the albumen negative process to make their slides during the years 1850–1874, but Briggs used the collodion process, which his father before him had learned in 1853 from John A. Whipple in Boston. When the gelatine dry-plate process was introduced after 1880, Briggs experimented with this process, but returned again to the collodion method because he remained convinced that the best results were to be achieved only by this method. [434] In this he was joined by Thomas C. Roche, and by the British photographer Alfred Brothers (see page 380).

One thing remained lacking in the United States, despite its advancements after the Civil War in landscape photography, the flowering of a new photographic literature, and the various technical strides so far discussed. This was an artistic achievement in photographic portraiture which simply never rose to a level in America recognizable in the works of a number of contemporary English and French masters of this period. Except possibly for Brady, there were no men or women of such stature in the United States as Mrs. Julia Margaret Cameron, or William Barraud in England; or Nadar (Gaspard Félix Tournachon), Etienne Carjat, or A. S. Adam-Salomon in France. Much of the reason for this has been attributed to a lack of the large number of

During the late 1870s, a number of new variations of the basic cabinet card form of photograph were introduced. A "new style" announced in 1875 was the "Promenade," measuring about 7 x 4 inches, an example of which is shown above. The scene is at Niagara Falls. For portraiture, the Promenade was intended for use in making three-quarter or full-length standing figures. "There isn't the appearance of squattiness that there is about the Cabinet size," the *Philadelphia Photographer* contended approvingly. The Promenade was said to have been first introduced in San Francisco by I. W. Taber. [435]

cultured amateurs of the professional, middle, and upper classes, which were to be found in Britain and France at this time. In addition, these now-recognized masters were artists to begin with, or were well schooled in art prior to taking up photography. Nadar and Carjet, for example, were formerly caricaturists, while Adam-Salomon was a sculptor (a vocation which was late in developing in the United States). Among American amateurs there was no counterpart to the self-taught Mrs. Cameron, a member of the English aristocracy who was in her sixties when she took up photography,

and whose photographic portraits are now recognized to be possibly the most outstanding of the entire Victorian era.

A leading American amateur of this period was Henry J. Newton, who had retired early from a business career. But while he headed the country's most prestigious photographic society for many years and was a prodigious experimenter, few, if any of his photographs will today be found among the archives of museums or libraries, or in the hands of collectors. But in men such as Napoleon Sarony in New York, an awakening to new forms and possibilities in portraiture was beginning to express itself. David Bachrach began following the Sarony style in lighting "as far as I could," as he expressed it in later years. Another Baltimorean, writing in *Photographic Rays of Light,* expressed the belief that Sarony was responsible for the beginnings of a new artistic movement in the United States. Speaking of a new style of head rest, and an "extra glossy surface" paper which Sarony offered, the writer, Nod Patterson, wrote:

> Photographers like the paper—but the artistic effect of the studies, as they were called, set them wild. There was an ease, a grace, an artistic elegance about them that was refreshing and *new*. Outside of New York, the writer disposed of the first "rest" Mr. Sarony sold, and wherever he showed the "studies," operators *would* have them. Mr. Sarony being so earnestly solicited to open a gallery and produce "such results," he finally did so. What was the result? *Artistic photography* has placed him, with an immense business, in his palatial "Le Salon." . . . We are inclined to think the "Sarony studies" started the ball of artistic photography in motion in this country.[436]

Before the foreclosure of Brady's New York gallery, Brady's assistant, Alva A. Pearsal, perceived—evidently before anyone else at this time—that there was yet another dimension lacking in American photographic portraiture, namely, "instantaneous sittings." The "true artist," Pearsal contended in a letter to *Philadelphia Photographer,* could not carry out his conception of the picture he was about to make if, after all his efforts at posing and arranging the setting, etc., the picture was destroyed, either by movement or a want of harmonious expression:

> With all the advancement in the art, the vexatious custom of making your subject a living mummy for the space of twenty-five seconds or more still remains with us, and my experience goes to show there is nothing more trying or more dreaded by the sitter, not excepting even the much-abused head-rest. I have long wished for the time when instantaneous sittings could be made, or sittings so nearly instantaneous as to be practically so, and I believe that the time will come. When it does, then good-bye to the horrid head-rest, and the unnatural expressions so often seen in the photographs of the present day. But as far as I can learn, there seems to be no one striving in this direction, and, in my opinion, the present time is the most auspicious for agitating the subject. Photography has advanced so wonderfully in all other directions, that it seems only instantaneous exposure is wanted to make the results perfect, and photo-portraiture a pleasure to the sitter, as well as to the artist.
>
> If photographers would only realize the great importance of an apparent instantaneous exposure, and would go at it with a determination to master it, I think it would soon be an accomplished fact.[437]

1875

1876

The American photographic community managed to raise sufficient funds ($20,000) to construct a separate building for photographic exhibits at the Philadelphia Centennial Exposition, which opened May 10, 1876. Technological progress was the chief theme of this first American international fair, and in photography as well as in numerous other fields, the world was truly at the threshold of a new era. Just around the corner was the telephone (demonstrated at the fair), electric light, the talking machine, and the gasoline automobile. Just around the corner, too, was photography's first universally accepted dry negative process, which would revolutionize the medium by the turn of the century.

Approximately seventy-five awards were given at the fair for photographs exhibited by photographers from England, eleven European countries, Canada, Mexico, Brazil, Japan, and New South Wales (Australia). Americans awarded premiums for photographs were the following: Centennial Photo Company, Carl Seiler, and John Carbutt, all of Philadelphia; Napoleon Sarony, William Kurtz, and the American Photo Lithographic Company, of New York City; Henry Rocher and C. D. Mosher of Chicago; James F. Ryder, of Cleveland; Carleton E. Watkins, Thomas Houseworth, and Bradley & Rulofson, of San Francisco; James H. Kent, of Rochester, New York; E. G. Bigelow, of Detroit; John Reid, of Paterson, New Jersey; Charles Bierstadt, of Niagara Falls; D. H. Anderson of Richmond, Virginia; and J. J. Woodward, of Washington, D.C. Other awards of particular interest were those given to John R. Clemons, for albumen and mat paper manufacture; David A. Woodward for his invention of the solar camera; and Alexander Beckers for his revolving stereoscopes. All of the principal English and European lens manufacturers were given awards, among them Dallmeyer, Voigtlander, Ross, Rathenow, and Darlot. No awards were forthcoming, however, for American lens manufacturers. John Carbutt felt that "quite a number of deserving exhibitors" in Photography Hall had failed to receive awards, and on behalf of twenty of these unnamed exhibitors (and unknown to them, too, Carbutt added), he submitted a formal complaint in November to the Committee on Contests and Appeals.[438]

The vast majority of photographs exhibited were made with collodion negatives, and among those attracting particular attention were a series of large transparencies (some as large as 28 x 36 inches) of scenic views of the American West made by W. H. Jackson. The U.S. Department of Interior, by this time, was offering copies of Jackson photographs at cost price in Washington, D.C. The collection numbered upward of 2,000 landscape negatives made on the F. V. Hayden surveys, plus another 1,000 negatives evidently made in part by Jackson under the sponsorship of a patron—William Blackmore, a wealthy Englishman, described at the time as "deeply interested in ethnography." The Blackmore collection also included other photographs, presumably of Indian culture, dating back over a period of twenty years.[439]

CENTENNIAL SNAFU

E. & H. T. Anthony & Co. contributed a gratuity of $500 toward construction of Photography Hall at the Philadelphia Centennial Exposition. But then a major snafu occurred, described as follows in *American Stationer:*

THE Centennial Exposition has proved, in some respects, a disappointment to many. It was hoped that business of all kinds would suddenly revive, and that every branch of mechanical industry would be stimulated under the high pressure of increased patronage and competition. So much labor in preparation, such vast expenditures, it was predicted, would assuredly restore activity.

With this conviction the firm of Messrs. E. & H. T. Anthony & Co., in common with others, contributed largely in means (a gratuity of $500), and through its influence with the class of professionals with whom it is associated by means of a monthly devoted exclusively to the practice of photography, towards the erection of a building at the Exposition in Philadelphia which should be specially adapted to the requirements of that industry.

At the appointed time, when arrangements had been completed for the transportation to Philadelphia of the splendid display, which had been manufactured by the Messrs. Anthony, on the very eve of their departure that firm received a notification that its exhibit could not be admitted, because the show cases which had been supplied for the protection of their goods exceeded four feet in height. No amount of persuasion, reasoning or argument would avail; the four-foot rule was made, and there was no breaking or bending it. But it was not alone the photographic fraternity which was thus ridiculously denied the opportunity of public inspection. The manufactures of that firm include a large variety of articles in which the stationery trade and the public generally are alike interested. Its display would have included, perhaps, the finest and richest assortment of photographic albums ever offered, together with a new and indestructible variety, lately patented, and known as the "Perfect Album." Novelties in richly gilt and velvet frames and passepartouts; one variety introduced, and already very popular, the "Continental," in banner form; the patented folding graphoscope in unapproachable richness and elegance of construction; the stereoscope in every conceivable style; stereoscopic views, the wonder of everybody; inimitable portraits of American and foreign celebrities; beautifully executed landscapes of every clime, on sea and land, colored in the most artistic manner, as well as uncolored. These and many other goods were all excluded, as well as the most elaborately finished and unapproachable variety of material required by the photographer ever exhibited in this or any other country.[440]

THE LAMBERTYPE

Surviving photographs labeled carbon prints, which were made in the 1870s or 1880s, may, in some instances, be Lambertypes or Chromotypes. Both processes were essentially Swan's process "in a new suit of clothes," according to the inventor, whose arrival in the United States in June 1876 was noted in *Anthony's Photographic Bulletin:*

WE are pleased to announce to our readers the arrival in this city of Mr. Leon Lambert, the inventor and patentee of the style of pictures known as the Chromotype and Lambertype, largely used now in England and France, and very highly esteemed. Mr. Leon Lambert, accompanied by Mr. T. S. Lambert, is now about to teach to such persons as may, in accordance with an advertisement in our columns, desire and propose to learn his processes in this country.

These processes of Mr. Lambert come under the general head of carbon pictures, the Chromotypes being printed on Mr. Lambert's special tissue, and of the same size as the original negative; and the Lambertypes being enlargements produced by means of a special tissue, for a transparency from which and by means of the Lambertype process of retouching, which is very simple, quick and effective, an enlarged negative is produced.

As there seems on many accounts to be a demand for something new in the business, and as a great many persons are deterred from getting photographs of themselves through doubt of the permanency of silver prints, there would seem to be an immediate opening for this new method of making pictures. Their qualities are extreme brilliance, uniformity of color, no necessity of toning, perfect freedom from chemicals which by their reaction have a tendency to destroy the picture, and a perfection of half tone and delicacy of shading which no silver print can equal. The materials will all be furnished by the manufacturers; all that is necessary for the operator to do, being the sensitizing of the tissue, printing by aid of an actinometer and attaching the print to a properly prepared glass, developing by warm water alone.

The printing is conducted in the shade, and is so graduated that no mistake can well be made. One especial peculiarity of these pictures is the perfect purity of the whites and the rich, deep color of the dark portions, every shade between the highest lights and the darker shadows being perfectly rendered.

So much importance is attached to the excellence of these pictures in every respect in England, that the Queen has decided, as we are informed, that all photographs for her use or possession shall hereafter be made by the Carbon process.[441]

The meetings of the Photographic Section of the American Institute during this period (1875–76) concentrated heavily on experiments conducted by the society's president, Henry J. Newton, and others with dry plates made with collodion-bromide emulsions. No attempt appears to have been made, as indicated earlier, to experiment with, or to otherwise perfect, a dry negative process based on use of a gelatine-bromide emulsion. As early as November 1874, however, T. C. Roche exhibited negatives made with a collodion-bromide emulsion which he said required one-third less exposure than the ordinary collodion wet-plate process. Roche also contended that with the formula used, the plates would grow more sensitive with age rather than the reverse, which was normally the case with ordinary collodion used in making wet-plate negatives. But Newton observed that it was necessary to add silver to a collodion-bromide emulsion to bring it to its greatest point of sensitivity, and that this would then destroy its keeping power.

On his part, Newton found success with various experimental collodion-bromide formulae in which the emulsion was made with the silver in excess (enhancing sensitivity), after which the excess was neutralized with an alkaline or metallic chloride. The *British Journal of Photography* found this particularly noteworthy:

The addition of a soluble haloid to an emulsion which has reached its full point of sensitiveness is well known to keep it in working order for a lengthened period; but we should scarcely have anticipated that the rejuvenating power of a simple chloride would have been so marked in the case of an emulsion which has become totally useless. This is, we believe, the first time the fact has been noticed.[442]

Matthew Carey Lea came up with a somewhat similar formula at this time with what Newton described as the "novel and important feature [of] adding a small percentage of the iodine ammonium to the collodion-bromide emulsion." But while this increased the plate's sensitiveness, it did not do so to the extent Lea claimed, Newton said, based on his own trials. The English photographer William J. Stillman tried Lea's method, but after running into trouble said that "on the whole, I suspect that Mr. Lea has been working with chemicals very much inferior to those we use here." He elaborated further:

Mr. Lea speaks of tannin as always giving opalescent solution. Mine is as clear as pale sherry and filters like water, and it is only the ordinary commercial article of Messrs. Hopkin and Williams, being sold, I believe, at a shilling or two the pound. Mr. Lea's albumen does not coagulate with his tannin; mine does, take what precaution for mixing I will. The fault may be in the tannin, or it may be in me; but as my albumen is taken from fresh eggs, and that does not vary with the climate, I do not see that it can be in fault. My impression is that Mr. Lea does not use that exactitude in his experiments to which we have long been accustomed on this side of the Atlantic.[443]

Lea enjoyed an international reputation by this time, based upon the success of his *Manual of Photography* (first published in 1868, and now in its second edition), and he also served as American correspondent for the *British Journal of Photography*. Possibly because of this position of esteem (the British journal had only a month before published a glowing profile of Lea), Stillman bore down heavily on

While the outcome of the 1876 presidential race between Samuel J. Tilden and Rutherford B. Hayes remained deadlocked in electoral votes (necessitating the appointment of an Electoral Commission by Congress), the American Centennial Exposition was opened (above) at Philadelphia. Fifty nations provided exhibits which were housed in 180 buildings, one of which was devoted to photography.

A collection of photographs by the celebrated photographer of animals George Francis Schreiber (1803–1892) appears at the left of this interior view of the photography hall at the Philadelphia centennial fair. In the foreground in a wall cabinet is a collection of old daguerreotypes by Marcus A. Root. Portraits and scenic views by Frederic Gutekunst line the next divider wall. The effort to fund and manage construction of the hall was among the last undertakings accomplished by the National Photographic Association. Professional affiliation remained dormant until formation of the Photographers' Association of America in 1880.

Lea, asserting further that "if, with the experience I have had with emulsions, I cannot make it work, I venture to say that the public, and even the mass of amateurs, will find it of little use."

Immediately before, and after, the opening of the Centennial Exposition in Philadelphia, Newton exhibited emulsion plates and photographs in New York, and said he was working on an emulsion which he hoped could be adapted for portrait work in photography studios. Negatives he made of Edward Bierstadt in January, he said, were "thought to be so good that one of Mr. Bierstadt's friends had carried all the prints off with him." John Gurney (possibly a son of Jeremiah Gurney) exhibited portraits made with emulsion plates, and Andrew J. Russell (now photographer-in-chief for *Leslie's Weekly*), announced at a meeting of the Photographic Section of the American Institute in December 1875: "I have been converted today to Mr. Newton's emulsion process."

1876 Russell used an American Optical Company 4 x 5 pocket camera with tripod and dry-plate changing box. In February, he exhibited negatives taken in Philadelphia with New-

ton's emulsion which he said had given him as much satisfaction as with any wet-plates he had previously used. Russell said he had made 260 negatives, and had experienced only nine failures, prompting Newton to point out:

> At this time of the year the exposure has to be at least two or three times what is required in May or June. In the negatives that I exhibited in June, the exposure was from 12 to 20 seconds. In the fall we should have to give about 90 seconds.[444]

Newton, like Maddox, considered his dry-plate experiments and specimens "more as a prophesy of the future of emulsion" than as a perfected process. Maddox's was the true process of the future, but Newton accurately prophesied the way this came about:

> There has never been a photographic process perfected by one person. One individual, in following out the experiments and suggestions of another, will think of methods of improvement in one direction, another will make some important change for the better in a different branch of the process, and so on, gradually improving until the utmost capacity of the process is developed.[445]

Like Stillman, Newton exchanged verbal jibes with Carey Lea over their respective emulsion experiments, but few explosions rocked the American photographic community to such an extent as the arrival (from England) of the brothers Leon and T. S. Lambert in June 1876 to sell licenses to the Lambertype process. The Lamberts had purchased Swan's carbon process (including the American as well as English rights), and had thereafter "packaged" it under two separate operating modes, one, the Chromotype (for making prints of same size from an original negative) and the other, the Lambertype (enlarged prints from a smaller negative), both requiring use of "special" gelatine-coated paper "tissues." Leon Lambert made no bones about calling them Swan's process "in a new suit of clothes." He had endeavored to solicit E. L. Wilson's interest in acting as his American agent, but having been given the cold shoulder by the latter, he signed with E. & H. T. Anthony & Co. Although Wilson had authored the *American Carbon Manual* in 1868, and accepted Lambert's advertising in *Philadelphia Photographer,* he now said he "had no faith in any process based on carbon," and refrained from reporting editorially on the Lambertype.

Undaunted by what soon became open hostility, the Lamberts set out on an extended selling tour in September, which lasted until January 1877, and took them to the establishments of such dealers and photographers as Benjamin French in Boston; Richard Walzl in Baltimore; John Carbutt in Philadelphia; J. W. Morrison in Pittsburgh; and Napoleon Sarony in New York (who in November was quoted as saying: "Having tried Mr. Lambert's processes, I have found them to surpass my expectations, and in the hands of intelligent photographers will do all that he claims for them"). The Lamberts also held teaching sessions for groups of photographers at the Vanderbilt House in Syracuse, the Osborne Hotel in Rochester, Stanwix Hall in Albany, and the Exchange Hotel in Richmond. After selling the rights to the state of Virginia to D. H. Anderson in Richmond, the pair lost their luggage in a hotel fire on the way to Philadelphia, but were sent samples newly made by photographers previously visited, allowing them to keep the show on the road.

When Thomas H. McCollin, who had assisted Lambert in demonstrations at Gutekunst's Philadelphia gallery, bought the rights to the state of Pennsylvania, Wilson, in Lambert's words, "broke loose in a dozen-page article."

From this point, well into 1878, a bitter war of words was carried on between the two, with Lambert's responses appearing in *Anthony's Photographic Bulletin.* The *St. Louis Practical Photographer,* meanwhile, citing Swan's blessing for the Lambertype, and the "intense interest in it all over Europe," began referring to Wilson in several articles as "our oily-tongued friend," and joined Lambert in criticizing Wilson for his failure to report details of the process in *Philadelphia Photographer.* David Bachrach also joined the fray. He was skeptical of the process and unimpressed with Lambert:

As soon as Lambert's arrival was announced, there was a general eagerness manifested, on account of the fine samples shown and flaming advertisements. After consultation with a brother photographer, I had a meeting called at Busey's gallery of all who were interested, so as to act together. A committee of four (Bendann, Busey, Perkins, and myself) were authorized to investigate and act for the *thirteen* who responded. One hundred and ten dollars was demanded as a license, which we informed Mr. Lambert was too much for any of us; he then (this was T. S. Lambert, the fugleman of the inventor) proposed to sell the city for six licenses to the committee, and they to license the others. We finally offered to pay the price of four licenses, and then only after the process had been fully demonstrated to the committee. At this he was highly indignant, fumed and expostulated, and told us we would all be *compelled* to buy it afterwards at a higher price, if we did not *accept the present offer,*etc.,in his well-known arrogant style, which is a regular dodge with him since. We were, however, inexorable, especially as Messrs. Bendann and Perkins had been taken in by this same weather-eyed chap on the Sarony crayon process, and they were suspicious. (I had warned several of my friends against that process, but without avail.) Well, he found there was no other way of selling it here, and so our terms were accepted. The result was, it cost each of us about thirty-five dollars; about all it was worth. [446]

Winning chromotype by Staten Island photographer J. Loeffler, at competition held in June 1877 at the offices of E. & H. T. Anthony & Co. The name "chromotype" was given by Leon Lambert to pictures made from carbon or pigmented tissue according to his particular mode of operation.

1877

An upsurge in the so-called permanent printing processes took place this year at photographic galleries across the country. One of the most important of these modes—the printing of photographs in the salts of platinum, as opposed to the pigments of carbon—was yet to come, but the flurry of activity which centered around the Lambert brothers (who remained in the United States for several years) clearly rejuvenated the somewhat dormant practice of carbon printing, and at the same time led to widespread adoption of the Lambertype and Chromotype.

On January 11, 1877, the Anthonys staged an exhibition on their premises in New York, at which 355 photographs made by the patented Swan or Lambert processes were hung. A gold medal was awarded by Leon Lambert at the conclusion of the exhibition to a photographer from the town of Tomkinsville, on Staten Island. In December, a second exhibition (billed as "the second annual exhibit of permanent prints") was held in New York, at which 1,497 photographs in carbon were exhibited by photographers from almost every state in the Union, as well as from Canada. Twenty-four more exhibitors arrived on the scene too late for the judging. The first prize for a Chromotype was awarded to William H. Illingworth, of St. Paul, who in 1874 had taken a noted series of photographs while accompanying Gen. George Custer's ill-fated expedition to the Black Hills of North Dakota. The first prize for a carbon enlargement (i.e., a Lambertype) was awarded to a St. Johnsbury, Vermont, photographer by the name of Clifford. At the third such exhibition (on December 20, 1878), an American Carbon Society was formally established with George Gentile as president, and T. C. Roche as treasurer. Officers were also chosen to represent twenty-four states, Nova Scotia, British Columbia, Newfoundland, New Brunswick, and the Canadian provinces of Quebec and Ontario.[447]

Early in 1877, Lambert took note of a "certain Dr. Ott," who was endeavoring to sell licenses to a "certain process," which Lambert contended was akin to his own, and he cited Ott for acting in violation of his U.S. patent rights. Lambert notified American photographers, through the medium of *Anthony's Photographic Bulletin,* that if they used Ott's process commercially they would be prosecuted to the fullest extent of the law. He refuted those who said he would be unable to prosecute anyone placed in debt over such litigation:

I have received an anonymous letter stating it was impossible to stop infractions from irresponsible parties, as there is no imprisonment for debt in this country; and the infringers not having enough to pay the heavy damages allowed us can thus escape scot-free. This is in error, for if the first offense from penniless infringers remains unpunished, an injunction from a court to cease infringing would make a repetition of the offense contempt of court, which is punishable in the United States both by fine and imprisonment.[448]

Theodore Lilienthal, the noted New Orleans photographer, was among the first who "practically abandoned silver printing" to work the carbon process, and according

FIRST EXHIBITION HELD OF "PERMANENT" PRINTS

The demonstrations and promotion of the Lambertype at all major eastern and southern cities evidently sparked a new interest in the carbon practice, both in its original and new form. On January 11, 1877, the first "annual exhibition" of prints made by the carbon and Lambertype processes was held at E. & H. T. Anthony & Co. in New York:

There were fifty exhibitors from various parts of the United States and Canada, and some pictures made by European artists were also shown. Col. Stuart Wortley had sent some from England, but although they had arrived in this port, they could not be got through the Custom House in time to be placed on exhibition. M. Liébert, of Paris, had proposed to send his Centennial display, but in consequence of the high charge for U.S. duties they were returned to France. The whole number of productions by the various processes was 355, and it may be fairly said that there were none that were not equally as good as silver prints could have been made by the same persons, while the larger quantity were far superior, in our opinion, to any that could be made by silver from the same negatives.

We were quite pleased, if not surprised, by the large number of exhibitors and the prevailing excellence of the work. Besides the exhibits for which medals have been awarded, and several arrived too late for competition, were some very excellent productions by the Lambertype Processes from Messrs. Dimmers, of New York; Wykes, Quincy, Ill; Wallin, Fort Wayne, Ind; Milnes, Hamilton, Can.; Vail, Geneva, N. Y.; Poole, St. Catherines, Can.; Saunders, Alfred Center, N. Y.; Allen, Pottsville, Pa.; Potter, Warren, O.; Klauber, Louisville, Ky.; Brooks, Dundee, Can., Smith, St. Albans, Vt.; Roth, New Orleans, La.; Higgins, Bath, Me.; Sherman, Elgin, Ill.: Ross, Syracuse, N. Y.; Holton, of Boston, Mass., and others.[449]

THE GREAT RAILROAD STRIKE OF 1877

The earliest surviving photographs of an American labor dispute appear to be those made in 1877 after a strike of Baltimore & Ohio Railroad workers in July spread spontaneously during the remaining days of that month to the Philadelphia & Reading, Pennsylvania, Erie, and New York Central lines. A virtually unknown photographer, S. V. Albee, published forty-two card stereographs of scenes which he made *during,* as well as after, pitched battles in Pittsburgh between the strikers and state militia. In the photograph above, left (from an Albee stereoview), Albee's photographic wagon is shown in the foreground with a stranded engine and burned railroad car at the bottom of a hillside opposite Twenty-eighth Street where, according to Albee, ''citizens were shot'' on July 21–22. Albee made views of Pittsburgh's upper and lower round houses (where he said ''troops were besieged''), of burnt machine shops and burnt passenger cars in the Union Depot, and of troops in retreat from the rail line's carpenter shop. The scene depicted above, right, is a woodcut illustration from the August 11, 1877, issue of *Harper's Weekly,* and shows members of the Maryland 6th Regiment firing into a crowd of strikers in Baltimore, killing 10 persons and wounding many more. The illustration, which is reminiscent of the Boston Massacre of March

5, 1770 (or of the more recent killing of four students in a crowd of war protestors by National Guardsmen at Kent State University in Ohio on May 4, 1970), was made from a photograph—evidently now lost—by the Baltimore photographer David Bendann.

The depression of the 1870s had earlier caused strikes in the textile and coal mining industries, and in the case of railroading, the unrest began after the companies periodically lowered wages while in some cases doubling the number of cars on trains (without adding additional trainmen) to increase revenues. When the unled uprising of B. & O. strikers was begun in Baltimore, the Baltimore *Sun* contended that ''in all their lawful acts'' the strikers ''have the fullest sympathy of the community.'' But public sympathy was reversed after rioting broke out in Pittsburgh, Chicago, and other midwestern cities, causing President Rutherford B. Hayes, for the second time in the nation's history, to call out federal troops to end warfare between private industry and its employees. The 1877 strike led to additional appropriations by states for expanded National Guard training and facilities, and to increased use of Pinkerton detectives in the private armies of railroads and other large corporations.[450]

to *Anthony's Photographic Bulletin* (March 1877), "he is making money and is enthusiastic." His success evidently continued, as in February 1880, Lilienthal brought suit against another New Orleans operator, William W. Washburn, for infringing on his rights to the process for the state of Louisiana. In his suit, Lilienthal was joined not only by the Lambert family but by the inventor, Joseph Swan.[451]

To David Bachrach's way of thinking, Lambert was merely the first of "a lot of 'secret' process men" who came along in the 1870s and "gradually robbed the mass of ignorant photographers." Lambert, Bachrach felt, was "particularly vicious and tricky," but he saved his furor for yet another battle over another new process, the Artotype, which appeared on the scene in 1879. Bachrach in the meantime allied himself with Wilson, who by this time had soured on carbon printing in general. "To make preparation for its practical use," Wilson said, in referring to all modes of carbon printing, "considerable expense is necessary, even to work it on a small scale, and its manipulations are so entirely different from any other photographic process that one not at all skilled in ordinary photographic printing can manipulate carbon better than an old silver printer. Moreover," he added, "gelatine, which is the basis of carbon tissue, is of such obstreperous nature as to be subject to the least climate change, and thence springs the principal difficulties which are met by the carbon worker."[452]

Alexander Hesler was another who exhibited no interest in carbon printing. "At the present price of material it costs more than silver prints," he said, "and, in a small way, a man cannot make as many card prints with the process as by silver printing. For strong negatives the results are better than silver," he admitted, but "for weak negatives, not so good. . . . It is at present too much trouble to make people appreciate the difference, and pay the advanced price over silver prints."[453]

Even the first American practitioner of Swan's process, E. L. Allen, of Boston, admitted that his firm (Allen & Rowell) could "make no money" on cabinet cards printed in carbon. Allen also noted that his customers had become more "fastidious" since the first days of carbon practice in 1867:

> Then one sitting as a general thing sufficed; now it is the exception when a sitter orders from the first set of pictures. The rule is to sit twice; and often three times, not because we have not made good pictures; they acknowledge they like them, but want to try again, just to see if they cannot get something better. Even babies are brought to sit over, on account of expression, so fastidious have our customers become. We use three glasses on a sitter, as a rule, making two impressions on a glass for cards, and the same size glass for cabinets, making one impression.[454]

The continuing economic depression was a major hindrance to carbon printing, the editors of the *St. Louis Practical Photographer* felt. "Let times brighten, and carbon will yet rise higher than ever among our better class artists." But the magazine also felt that the process had been falsely heralded as "easy and simple," and that the exclusivity in licensing also prevented its broader popularity:

> Look, for instance, at St. Louis: one man owned the exclusive right for the city and state; wanted a big price for rights; could

GALLERY FIRES

An insurance journal report in 1876 found that photographic galleries were more of a fire hazard than paper or woolen mills, steamboats or breweries. A fire in Abraham Bogardus' darkroom, and several other conflagrations, prompted this editorial comment from *Anthony's Photographic Bulletin* in January 1877:

> FOUR fires have recently occurred in photographic galleries in this City. As this is an exceptionally large number, even for a city containing as many of them as New York, it is a matter of interest to know, if possible, what were the causes. In one case the theory is that the fire was caused by a portion of a rocket falling through the skylight; another was caused by the carelessness of a person who was mixing collodion in a small dark room with a *lighted stove* in it. In the two other cases the cause is not known; but as they both occurred in places which for a very long time had been used, and where it is known that portions of the floor and shelving had become saturated with nitrate of silver, the reasonable supposition, from the known great inflammability of wood thus saturated when in a perfectly dry state, is that the nitrated wood was the cause of the fire. It is unnecessary to particularize instances that have occurred; it is sufficient to know that want of care in dealing with the silver solutions entails not only loss but ultimate danger, to induce photographers to be more careful both in regard to the waste and the possible danger lurking in places where the nitrate has been allowed to permeate the wood-work. The greatest care should be exercised to prevent fire in the shape of stumps of matches or of cigars being thrown upon such places, of which there are undoubtedly many throughout the land.
>
> In the fire which occurred in Mr. Bogardus's dark room it is a curious fact that two paper boxes containing soluble cotton, which stood on the shelf, were not destroyed. The shelf and all the wood-work of the room were burnt to a coal; the bottles containing collodion were burst and the collodion consumed, yet the article considered generally the most dangerous in a gallery, and of which insurance companies, steamship captains and old women have such great dread, *the soluble cotton, was not in the least affected*.[455]

not sell them. His next move was to open a gallery and try it himself; had all the other artists down on him and carbon. The result was he busted, and sold the right of the city and state to a gentleman who lives in New Orleans, and he, being independent, is in no hurry to sell or open up a gallery here himself. The result is that St. Louis, with a population of 500,000, has no carbon worker, or is likely to have any very soon.[456]

By January 1878, the vindictive warfare between Lambert and Wilson was again taking up the pages of *Anthony's Photographic Bulletin* and the *Philadelphia Photographer*. In one issue of the *Bulletin,* Lambert gave a detailed, comparative analysis of wording to support his assertion that Wilson had plagiarized George W. Simpson's *Carbon Instructor* (1867) in publishing his *American Carbon Manual* (1868). In this contention, Lambert was joined by the *St. Louis Practical Photographer:*

> [Wilson] even went so far as to republish an English work on carbon and copyright it, having taken the precaution to alter the arrangement of the chapters, write a preface, and interpolate a few words here and there just sufficient to show his ignorance of the entire subject he was writing about.[457]

AN AMERICAN MAKES NIGHT PHOTOGRAPHY "FASHIONABLE" IN LONDON

Photographs had been made at night previously with the aid of artificial light, but those who experimented along these lines had never made a commercial success of such undertakings. It remained for the son of the editor of the American trade journal *Manufacturer and Builder* to make a commercial success of it in London in the spring of 1877:

> Our clear smokeless American sky gives us no idea of the drawbacks connected with photographing in a smoky and foggy city like London, England, where the days in the business season are much shorter than here, and even the best parts in any season are usually obscured by smoke, mists, clouds, and fogs. It is not surprising that such a locality should be the first to develop the method of taking photographs by artificial light, which several years ago was attempted in the United States, but with very indifferent success. The simple reason of this was that those who attempted to apply the method, had not the least artistic idea of the kind of illumination required to produce a good and pleasing picture. These photographs had no middle tints, showed only white and black, and looked as if the sitter had been exposed to direct sun-light, with no reflection whatever in the shaded parts. The general judgment of the public was naturally that these photographs were "no good," and the method was abandoned, as it did not take, and therefore did not pay.
>
> It was reserved for an accomplished artist to correct these defects and to arrange an artificial illumination which, by combining larger and smaller artificial lights and proper reflections, produced an illumination equal, if not superior, to that produced on the most favorable days by sun-light, and thus to obtain perfectly satisfactory results. This artist was Mr. Henry Van der Weyde, a son of the editor of this journal, who is now stirring up the city of London with his new method of taking photographs at night.
>
> It appears to have become fashionable there at present to have one's picture taken after leaving the opera or a dinner late at night, and as the pictures are more satisfactory than those taken during the very inconvenient hours of the day, it promises to be a new era in this branch of business.
>
> The New York *Times* contained recently a correspondence from London in which this was mentioned in a very awkward manner, which was not calculated to raise Mr. H. Van der Weyde in the estimation of those who possess information on the subject. Instead of stating what we have said above, it was asserted that he was attempting to bottle up sun-light, had made for this purpose a water lens, which broke and injured him, etc.; in short, he was represented as an ignoramus, who attempted absurd and impossible things, and ended by doing what had been done here several years ago—taking photographs at night, and perhaps poor ones at that.
>
> The method followed by Mr. H. Van der Weyde, can of course be nothing but illumination by an artificial light of actinic power, such as that produced by burning magnesium, hydro-oxygen light, electric light, sulphur burning on melted niter, and other methods, which are available for the purpose, but to apply several of these lights simultaneously in such an artistic manner as to obtain results as satisfactory, if not more so, than can be obtained on the brightest days.
>
> We need not say that this involves a revolution in the photographer's business; instead of waiting in the day-time for favorable periods, the photographer abandons the uncertainty of a London atmosphere and trusts to the results obtained by science and art to illuminate his sitters at midnight, independent of fogs or smoke, and he is sure of his results, and consequently (what is the main thing in all kinds of business) of his pay.
>
> The success of such an enterprise in a city like London is undoubted, and the only reason why it will not be so soon generally introduced here is that our need for it is not so great. Still it was produced here several years ago. A few years ago we assisted in taking photographs at night by means of electric light and hydro-oxygen light, but, as above stated, they were so unsatisfactory that it offered no encouragement.[458]

1877

250

Wilson must not have taken these charges seriously, for he never commented on them.

George Gentile, president of the newly formed American Carbon Association, recognized the problem, raised by Wilson, that climate had a direct bearing on the success or failure of working carbon, but he suggested that "the majority of photographers who have commenced to experiment in carbon printing have not given it a fair test. They ought to study the nature of bichromate gelatine, so that in their own particular locality it can be successfully worked." No operator in carbon could be successful, Gentile asserted, "unless he well understands the behavior of chromated gelatine with heat and moisture." [459]

As Gentile pointed out, there were photographers "who have and are making money by working the process," but perhaps when all was said and done the lesser extent to which the carbon or Lambertype processes were put to practice in the United States may have been due to the absence of a central processing establishment which could take the "somewhat complicated manipulation" out of the hands of the average worker and handle the processing much as film development was later to be handled for amateurs. In England, most photographers making carbon photographs availed themselves of a printing service provided by the Autotype Company in London. No such organization was ever established in the United States. [460]

If weather was a problem for carbon or Lambertype work, it posed a restraint as well on regular collodion practice. How many photographers, for example, made landscape or city views in cold weather? The reason was simple: the silver nitrate would freeze on the plate if used out-of-doors in winter weather. "The combination of photographic materials, to produce their best results," *Anthony's Photographic Bulletin* informed its readers, "take[s] place at temperatures the most pleasant and agreeable to the human system." The *Bulletin* gave this further advice for printing in cold weather:

> It behooves operators, for the purpose of obtaining uniform results, to endeavor to keep their materials at as nearly as possible uniform temperatures. Never let your negative bath get much below the temperature at which you find it to work best; always in cold weather be provided with the means of readily warming your developer, and in hot weather of cooling it; never float your paper on a very cold silver solution and then print in a freezing temperature. [461]

The *Bulletin* repeated this advice again in a later issue "not only to save photographers time and expense but also to relieve ourselves of a great deal of unnecessary letter writing."

If it was a question of "to be, or not to be" a carbon worker, so, too, the dilemma for photographers was becoming more acute as to whether or not to begin using the new collodion-bromide emulsion plates. At this stage in photography, it was a question of "damned if I do, and damned if I don't." For some, the fact that you could know—right on the spot—if your pictures were successful overcame the objections of having to carry chemicals and luggage for making the standard collodion wet-plate negatives out-of-doors. In addition, the new emulsion plates required time to prepare before going out in the field, and just as much time, when all was said and done, to develop and fix them after returning to the darkroom. The *Photographic Times* contended that "the experience of dry-plate workers has been that the failures occur on the subjects they are most anxious to secure; such as some rugged nook, with strong contrasts of light and shade, or a shady glen where the sunlight only penetrates at a certain hour of the day, and where it is found to be almost impossible to get sufficient exposure on a dry plate while the light lasts." Just as Gentile could point to many prominent photographers working carbon, the *Times* could say that, "associated with this branch of photography [dry-plate work] are the names of many of the most intelligent, industrious, learned, and scientific men that have ever given attention to the heliographic art." But the *Times* also contended:

> It would seem that invention and research had been exhausted in the multifarious processes which have been claimed as meritorious or superior. We have had dry collodion, albumen, gelatin, emulsions, with preservatives of tannin, tea, coffee, beer, albumen, tobacco, besides numerous mixtures of poisonous drugs; and developers, acid and alkali, hot and cold *ad infinitum*, till the beginner is bewildered in the mazes of the chemical nomenclature which present themselves to him as the A B C's of dry-plate photography.
>
> It is doubtless this great variety of processes, and the uncertainty of their merits, that have deterred many from practicing dry-plate work, and especially is this true of professional photographers, who find it necessary that time and effort should count, and who are disposed to adopt that process which they can have most completely under control, and which will yield them the greatest amount of successful work.
>
> We are not prepared to predict, nor do we anticipate that either the wet or dry will supersede the other, but rather that each will find its proper place, and be adopted by professionals, as well as amateurs, according to the work to be done, and the convenience and capabilities of each.

1877

251

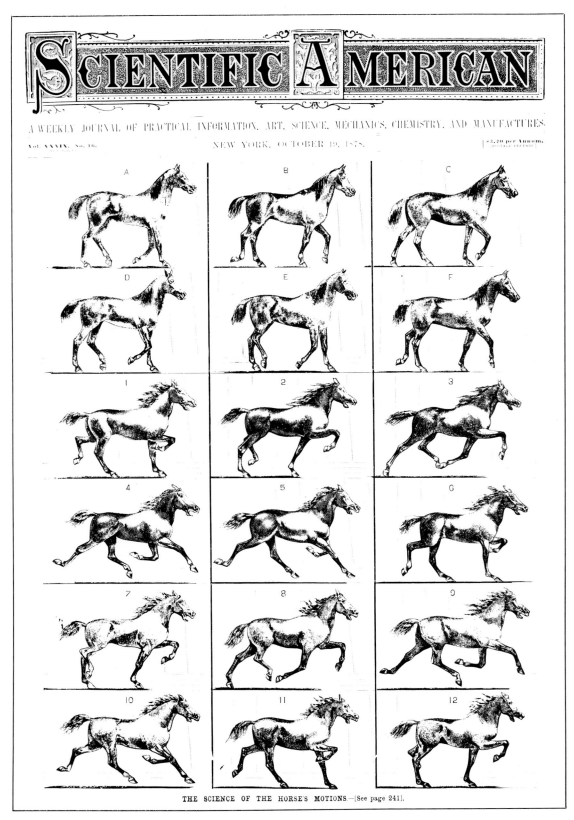

SCIENTIFIC AMERICAN

A WEEKLY JOURNAL OF PRACTICAL INFORMATION, ART, SCIENCE, MECHANICS, CHEMISTRY, AND MANUFACTURES.

Vol. XXXIX. No. 16. NEW YORK, OCTOBER 19, 1878. [$3.20 per Annum. POSTAGE PREPAID]

THE SCIENCE OF THE HORSE'S MOTIONS.—[See page 241].

1878

252

On June 15, 1878, Eadweard Muybridge made a series of photographs of Leland Stanford's horse, Abe Edgington, traveling at a gait of 40 feet a second. When the *Scientific American* got around to publishing a set of engravings made from Muybridge's photographs on its cover four months later, the world sat up and took notice. Soon, Muybridge became an international celebrity.

When Eadweard Muybridge was making his most famous photographs of the Yosemite Valley in 1872, Leland Stanford, former governor of California and president of the Union Pacific Railroad, talked with him about making a series of instantaneous photographs of his trotter, Occident, on the run. Stanford contended, in a $25,000 wager, that the horse lifted all its feet off the ground at certain full-speed gaits, and he wanted photographs to prove it. Muybridge made several negatives of Occident that year, and again in April 1873, at the Sacramento Race Track. Stanford was satisfied that the "photographic impressions" which Muybridge obtained proved the correctness of his wager, but the photographs were subsequently lost and there remains no accurate description of them. During the years 1874–77, further efforts at racetrack photography were suspended after Muybridge shot and killed a lover of his young wife, and the sensational murder trial which followed (resulting in a judgment in Muybridge's favor) caused him to leave the country for several years.

While out of the country, Muybridge experimented with chemical means of accelerating camera plate action, and made further improvements on a shutter mechanism which he had developed in 1869, and had described in a photographic journal at that time. Back in the United States, he again made photographs of Occident in July 1877, at Sacramento, but this time with exposures which he claimed were less than one-thousandth part of a second. Several newspapers, after viewing one of these photographs, termed it a "triumph" of the photographic art.

In the spring of 1878, Muybridge began a series of large-scale experiments with elaborate equipment at Stanford's Palo Alto Stock Farm. These experiments officially launched a career in animal, and later human, locomotion studies for which he gained international fame. Special cameras were ordered from the Scovill Manufacturing Company, and a set of Dallmeyer lenses was procured for use with them (Muybridge contended that these lenses afforded "extraordinary rapidity and wonderful depth of focus"). Special electrically operated timing mechanisms were designed and constructed at the Central Pacific car shops, and these were installed with twelve cameras in special housings along the southern side of Stanford's mile-long training track.

On June 15, all was in readiness for the press demonstration at which negatives were taken, and a dozen on-the-spot "automatic electric-photographs" made of Stanford's horse, Abe Edgington, traveling at a gait of forty feet a second. The photographs were made consecutively by each of the twelve cameras as the galloping horse tripped each camera shutter by striking threads strewn across the track like a series of finish lines. A white background, installed across the track opposite the bank of cameras, contained vertical black lines painted 21 inches apart, making scientific analysis possible of the motion "captured" in each successive photograph. The effect was not of motion as the eye sees it, but rather as the consecutive movements would be seen by a

SENECA ROY STODDARD

No eastern or midwestern landscape photography schools emerged in the 1870s or 1880s to compete with the western school, but certain photographers such as Seneca Roy Stoddard of Glens Falls, New York (shown at work in the field, above), deserve greater recognition for their dedication to landscape photography in their immediate locales in this period. Stoddard, Albert Bierstadt, Benjamin Kilburn, and George E. Curtis, of Niagara Falls, were cited for their landscape works at the 1876 Philadelphia Centenial, for example. Stoddard also published a number of picture books containing his views made in the Adirondack Mountains, at Lake George, and elsewhere in the period 1873–1915. In 1880, he began donating copies of his photographs (most of them on imprinted mounts) to the Library of Congress, which is now a principal repository of his landscape views.

THE EXCLUSIVE BUSINESS OF COLLEGE PHOTOGRAPHY

The first recorded photograph of a college class was the daguerreotype made in 1840 by Prof. S. F. B. Morse of the Yale class of 1810, while attending its thirtieth reunion in New Haven (see page 28). Daguerreotypes of graduating classes were also made in 1843 at Princeton, in 1847 at Brown, and in 1848 at Yale and Bowdoin. George K. Warren, who operated out of various Boston-area cities, appears to have been first to make a specialty of graduating-class photography. He made all photographs for Dartmouth's first class photo album in 1858, and beginning in 1859, he kept a virtual monopoly on university photography for more than a dozen years. But by 1878, the scene had begun to change. "The photographer who bases his calculations on the likelihood of retaining the patronage of a given college for a long series of years," the New York *World* contended, "is tolerably certain, whatever the degree of his artistic success, to come to grief at the end." The *Harvard Crimson,* for example, viewed Warren's 1877 class photographs

with "disappointment." In 1878, Harvard selected George W. Pach. In 1877, the Brown graduating class selected a local photographer, Henry Manchester, then in 1878 their successors chose Manchester's "hated rival," a Mr. Jones, also of Providence. Napoleon Sarony photographed Yale's 1869 graduating class, then in 1870 secured the votes of half a dozen or more colleges. The Montreal-based William Notman (who also operated out of Boston) gained his first popularity in 1872, and in the period 1872–77 "probably manufactured more college photographs than all his rivals combined," according to the *Photographic Times.* By 1878, the mantle appears to have passed to Pach, who secured contracts for the 1879 graduating classes at Yale, Harvard, Princeton, Dartmouth, Williams, Wesleyan, Vassar, and West Point. This patronage continued to the turn of the century, when Pach Brothers maintained "contributory" photographic galleries in most of the major college towns and cities.[463]

RECORDED CLASS PHOTOGRAPHS

A = Atkinson, Troy, New York
F = Foreshew, Hudson, New York
J = Jones, Providence, Rhode Island
L = Lovell, Amherst, Massachusetts
M = Manchester, Providence, Rhode Island
N = Notman & Campbell, Montreal
P = Pach Brothers, New York
R = Reed, Brunswick, Maine
S = Sarony, New York
W = Warren, Cambridgeport, Massachusetts
Boston, Massachusetts

	'59	'60	'61	'62	'63	'64	'65	'66	'67	'68	'69	'70	'71	'72	'73	'74	'75	'76	'77	'78
Harvard			W	W	W	W	W	W			W		W	W					W	P
Yale			W			W				W	S					W			W	P
Princeton	W	W	W		W	W			W				W						W	N
Dartmouth	W	W	W	W		W	W	W						W					N	N
Williams	W		W	W		W	W	W	W		W	W				W			L	A
Brown	W	W		W	W				W	W			W	W					M	J
Rutgers	W	W	W	W																
Wesleyan							W	W	W	W	W			W			W			F
Union		W				W	W		W	W	W									
Amherst															W					L
Bowdoin																	W	W	R	R
Trinity																		W	N	N
Tufts														W		W				
Hamilton											W									
Michigan												W	W							
West Point						W		W		W			W	W		W	P	P	P	P
Cornell																		A		
Vassar																				P
Columbia																				P

series of eyes at different viewpoints. Because each photograph was an independent picture taken from a separate point of view, the result was not a *synthesis* of the movement such as is captured by the modern motion picture camera from a single point of view. This distinction is important in evaluating these experiments as the milestone they represented in the perfection, later, of motion picture photography.

One local newspaper reported after the press demonstration that the photographs showed the gait of Abe Edgington "in a manner before impossible," adding: "A long description even would be unintelligible, while the photographs show the whole stride at a glance." During the remainder of the summer, more of Stanford's horses were photographed at the Palo Alto track, and a series of card photographs was published by Muybridge, each illustrating a particular horse in either six, eight, or twelve positions. This series was the first of Muybridge's photographs to attract international attention, and on October 19 the *Scientific American* reproduced a full page of wood engravings on its cover made from the Abe Edgington series. The editors recognized that the engravers' work could not convey the convincing force of the actual photographs themselves; nevertheless, they conveyed what came as a shock to many artists around the world. The analysis of the horse's movements during various gaits had long been a matter of study and debate among artists, but now it was made apparent to all that a horse had, indeed, all four legs off the ground during one phase of its gallop. Stanford visited the noted French painter Jean Meissonier in 1879, and again in 1881, and the great master at first reacted in utter disbelief to the photographs shown him. But in November 1881, Meissonier gave Muybridge a spectacular reception at his Parisian residence, which was attended by many of Europe's artistic and scientific elite. As Muybridge recounted the affair later: "Many of the most eminent men in art and science and letters in Europe were present at the exhibition; and men like Dumas, Gerome and Millet requested the pleasure of an introduction to me. Happily I have strong nerves, or I should have blushed with the lavishness of their praises." [464]

But before his entrée into the councils of Europe's elite, Muybridge toured the lecture circuit in the United States, beginning just a month after the June 1878 press demonstration. At first he projected lantern slides of his photographs life-size in quick succession before enthusiastic audiences. The near-synthetic effect achieved from one slide quickly following the other is believed to have made him determine to devise a way to project them in quick enough succession as to correctly reconstitute the motion which his instantaneous photographs had stopped. Muybridge thus devised a projector based on the design of an earlier device, and to this he gave the formidable name *Zoopraxiscope*.

Drawings based on his photographs were first mounted around the periphery of a glass disc. Next, a second opaque disc of same size, but containing a series of slots equal in number to the drawings on the glass disc, was mounted in front of the glass disc on the lantern-style projecting apparatus. When the two discs were revolved in opposite directions in front of the lantern, images of the drawings were flashed onto the screen in rapid succession, presenting to the

PHOTOGRAPHING INTERIORS

This branch of photography remained in "a very crude state," according to David Bachrach. There were certain requirements for success, which he enumerated as highly sensitive collodion; a rapid lens (a large aperture, but not having a wide angle in this instance); and some means of keeping the negative plate moist for the longest possible time. With respect to lighting, he offered the following suggestions:

> It should be borne in mind that the weakest solar light is far preferable to any artificial method of producing it. But if artificial light must be used, unless a great deal of experience has been had with it, great difficulties will be encountered. With the exception of the electric light, which is not yet available, magnesium gives the most actinic of all artificial lights. But all the lamps made for this purpose, with clock-work or otherwise, that I have ever seen, are practically useless. The best method of using it is to buy the twisted tapers and station persons at various points on the sides between the instrument and the objects or space to be photographed, so that they do not come upon the plate, and light all of them simultaneously and burn as many as necessary to produce the effect desired upon the plate. The smoke and fumes caused by the fine powdered calcined magnesia, produced by its combustion, have not by any practical method been avoided as yet. It will not be found very practical to photograph a larger space than say 30 feet in area each way at one time by artificial light, on account of the loss of actinism as the light travels, unless a very large number of lights are used. I had occasion to photograph sections of a tunnel at one time, showing the junction of brick and timber work, and tried magnesium, but the smoke and fumes made it impracticable (with a clock-work lamp) in such a confined space. So I proceeded to procure six calcium lights, with oxy-hydrogen combustion, and threw the light with concave reflectors on the objects. Only three of them, however, were effective, as the other reflectors were in too poor condition and of too long focus. I succeeded in lighting a space of about 8 by 12 feet in width and height, and 20 feet in depth, and obtained a good image in twenty minutes. For small spaces this is the most reliable light, and though containing more yellow rays than magnesium, it is more easily controlled and steady. The reflectors should be in the best condition and of a focus so as to throw all the light, without loss, on the objects to be illuminated. This whole subject of artificial light, so far as its practical use by the regular photographers is concerned, is yet in a very crude state. [465]

Clarence Johns's 1873 oil painting of a western roundup (above) illustrates the mistaken way in which artists depicted galloping or trotting horses on their canvases prior to the widespread publicizing of Muybridge's photographic achievements. Among the first to recognize the art world's need to change was the French painter Jean Meissonier.

audience a much more realistic portrayal of a horse in motion. In later years (1899), Muybridge said of his *Zoopraxiscope* that it was "the first apparatus ever used, or constructed, for synthetically demonstrating movements analytically photographed from life, and in its resulting effects is the prototype of all the various instruments which, under a variety of names, are used for a similar purpose at the present day . . ."[466]

But was it? It has been said that when Henry Heyl saw the *Zoopraxiscope*, "he thought he recognized his *Phasmatrope*." Heyl never contested Muybridge's claim, nor did he travel the lecture circuit demonstrating the *Phasmatrope*. It is quite possible, therefore, that Muybridge never was aware of the *Phasmatrope*'s existence. Presumably, Muybridge's and Heyl's paths did not cross during the years after 1884 when Muybridge was engaged in camera re-

search at the University of Pennsylvania, and certainly not after 1894 when Muybridge returned to his native Kingston-upon-Thames in England.

Perhaps, too, Heyl did not feel that he was entitled to a prior claim for having "synthetically demonstrated movements analytically photographed from life" with his *Phasmatrope*. As he himself stated in 1898, looking back to his 1870 demonstrations at the Philadelphia Academy of Music, and the Franklin Institute: "At that day flexible films were not known in photography, nor had the art of rapid succession picture-making been developed." With respect to the latter, this was possibly a reference to—and an appreciation of—Muybridge's world renowned feats at Palo Alto, which Heyl may have thought attached greater significance to the *Zoopraxiscope*. But the flexible films Heyl referred to, in either case, had yet to be developed.[467]

1878

1879

Up until this time, virtually all of the discussion and reports on dry-plate activity in American photographic literature had been concerned with collodion-bromide processes. Records are meager covering mention of gelatine dry-plate experimentation, yet John Carbutt, for one, tried making gelatine dry plates in Chicago as early as 1868. Foreign journals periodically gave reports on experimentation with, or the use of, Maddox's gelatine process, and in 1876 an amateur photographer in Philadelphia appeared before the Photographic Society of that city to report on his success with gelatine plates, which he said had been prepared on the basis of reports he had read in British photographic journals.

Things began to come to a head this year. Carbutt had abandoned his efforts to engage in large-scale photomechanical printing, and after perfecting a gelatine dry-plate process to his satisfaction, he placed a commercial article—the *Keystone* dry plate—on the market. Either this year, or as early as 1878, Albert Levy of New York (not known to be a kin of Louis, Max, or Joseph Levy) also began the commercial supply of gelatine dry plates. In England, a twenty-five-year-old American, George Eastman, of Rochester, New York, was awarded a patent on July 22 for an improved process of manufacturing gelatine dry plates.

Photographers such as Andrew J. Russell had already adopted use of Henry J. Newton's collodion-bromide emulsion process (a bottled formula ready to use in preparing a dry-plate negative), and as early as 1877 E. & H. T. Anthony & Co. had advertised the availability of packaged dry plates—presumably made with a collodion-bromide emulsion developed by T. C. Roche. In its advertising, the company said it considered the plates "quite equal to the wet plate in rendering of detail, and in vigor, while they are perfectly easy to develop either by the alkaline or pyrogallic methods." Prepared dry plates made with Newton's emulsion formula also now became a commercial article. In July, the *Photographic Times* announced:

> Mr. H. J. Newton, the pioneer emulsionist in America, has consented, in compliance with the many urgent requests from all parts of the country, to supply through Scovill Manufacturing Company dry plates made from an emulsion which he shall have tested and approved. . . . These plates will produce strong, brilliant negatives, in which the halftones are blended beautifully with the shadows and highlights, happily in contradistinction to the dull, chalky, black-and-white negatives produced by most emulsions.[468]

How early Levy's and Carbutt's gelatine dry plates became available does not appear to be recorded, but by April 1879, the *Photographic Rays of Light,* a new journal published in Baltimore, observed that dry-plate photography was becoming quite popular in England. The following remarks in the same article would seem to suggest that the summer of 1879 was the proverbial lull before the approaching storm:

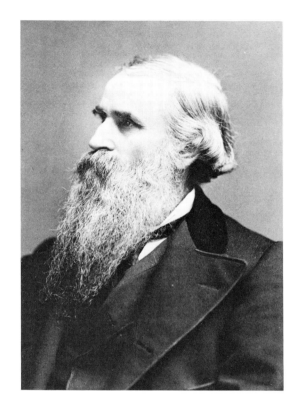

HENRY J. NEWTON

Revered in his time as America's "pioneer emulsionist," Henry J. Newton perfected a collodion dry-plate negative process which became a commercial article just at the time when the attention of the photographic world turned to the gelatine dry plate. As early as February 1876, he exhibited emulsion plates for studio portraiture, which were perfectly satisfactory for use even on cloudy days. All the photographer had to do was flow his glass negative with the bottled Newton emulsion and let it set. Within a minute, an alcoholic preservative could be applied and the plate was ready for an exposure. The Scovill Manufacturing Company began offering Newton's collodion plates commercially in January 1880, and it is possible that the *Defiance* dry plate put on the market that same year by E. & H. T. Anthony & Co. was also a collodion version. But we do not know how successful Newton's plates were—or might have become—because by December 1880, the gelatine plates eclipsed the collodion versions.[469]

Now that the numerous uncertainties which were such serious drawbacks to the dry-plate system, at its first or early stages, are overcome, and its practicability thoroughly recognized and established, it is astonishing so few photographers in this country have turned their attention to it. The plates, emulsion, etc., are manufactured now in the United States, and can readily be obtained. We trust many of our landscape artists will this season try their hand on dry plates, as long as the process is now so simplified that they need not apprehend any trouble.[470]

Emulsion plates, possibly of both the gelatine and collodion variety, were used for the first time by all of the members of the Photographic Society of Philadelphia during the society's fourth annual field trip in the summer of 1879. Two hundred and twelve plates of seven different varieties were used, and exposures ranged from 30 seconds to as long as 15 minutes in making photographs of differing subject matter. A considerable amount of difficulty, however, was encountered in developing the negatives.[471] Just before this excursion, some professional comment and advice from France had been published in the *Photographic Times* on the preparation and use of collodion dry plates, and this may have proven helpful to those making the trip. Among the most important points cited in the article was the necessity of insuring that the emulsion coating was made firmly secure to the glass negative plate. Several methods were given to accomplish this. With respect to developing the plates after an exposure, practitioners were warned that there was no "exact formula" to insure proper development, first, because different bottles of emulsions would give very different results, and secondly, because the carbonate of ammonia required for development was a product of unstable nature:

> All formulae are good, either by mixing together at the very start the bromide of potassium, pyrogallic acid, and the carbonate of ammonia, or, by first covering the plate with bromide and pyrogallic acid, or with bromide and carbonate, to which the third product is finally added; the only essential point to obtain a development free from fogs is to use from the start a sufficient quantity of bromide of potassium. It is at the commencement of the development that the plate has the greatest tendency to fog. When the appearance of the image is about complete, pyrogallic acid or carbonate of ammonia should be added until the required degree of intensity is obtained.[472]

About the time of the Philadelphia outing, Alexander Hesler reported the results of his own preliminary trials with dry plates, in which camera exposures evidently required 15 seconds, as opposed to 5 seconds for wet-plate negatives. "Every plate came out spotted," Hesler said of the Levy emulsion plates used. "Nearly all show crepe-like lines in the direction which the emulsion was drained from the plate."[473]

In its review of "twelve months of gelatine studio work," the *St. Louis Practical Photographer* was a little more bullish:

> Less assistance is required in taking pictures. Many more can be taken in the day; they save the time previously occupied in filtering baths, washing out, etc., and the waste in wear and tear of apparatus. All this means money; but, besides this, pictures cost less on dry plates than on wet collodion. One hundred half-plates can be developed with one ounce of pyro, one pound of ferrocyanide of potassium, and two ounces of ammonia. This

PLATINOTYPES

Metallic platinum in its blackened, powdered form, remains unaffected by air, moisture, or acids—as do the pigments of powdered carbon. A process of securing photographic prints in platinum was invented in 1873, and a series of American patents was awarded in 1876 and 1879 to William Willis, Jr., and Alfred Clements, both natives of England (Clements had been the first to emigrate to the United States in 1867 to work for E. & H. T. Anthony & Co.). Platinum printing depended not on the direct influence of light on the platinum salts, but on its influence on certain organic salts (ferric oxalate, oxalate potash, potassic chloro-platinite, etc.) also used in the process, which then convert the platinum salts to a metallic state during print development.

While the 1879 patent was a great advance over the original invention, none of the three principal organic salts mentioned above was commercially available, necessitating their costly manufacture. Added expense in working the process resulted from the loss of platinum when the platinum salt was mixed with the developer and heated. Another obstacle turned out to be the difficulty in obtaining a good plain paper for print making. "There was none on the market free from animal sizing," Clements said, "and as platinum salts have a great desire to remain in contact with such sizings, it was impossible to get a print having pure whites." As a solution to this problem, Clements went to Germany where he succeeded in making arrangements with the Steinbach factory to make a suitable paper.

During the period 1880–81, Willis and Clements developed improved means of heating during development (which reduced the amount of platinum lost in this operation), and experimented with printing by electric light, since sunlight proved to be yet another "uncertain factor" in working the process. But platinum printing remained troublesome and expensive, and did not become popular until the 1890s.[474]

can be done in two-thirds of the time required for wet plates, and with one-eighth of the exposure. . . . One of the most fertile causes of failure in dry plate work is over-exposure, and this is why the remark has been made that they work better in dull than in fine weather; but we must look at this from another standpoint: in the writer's experience it was found on beginning dry-plate work that the usual card lenses were too rapid, the exposure being so brief that it was not under control. This has been remedied by the double operation of using longer focus lenses (3A, instead of 2B) and interposing between the sitter and the light a much more opaque medium than usual.[475]

Another variation of the collotype family of photomechanical printing processes—the Artotype—made

ARTOTYPES

Close on the heels of the Lambertype came the Artotype, which even its promoters agreed was "similar in some respects to the Albertype." But most importantly, it was "different in patentable points." The *Buffalo Express* gave this account of the process in the spring of 1879:

> THE Artotype process seems destined to revolutionize the photographic business. In permanence, cheapness and artistic beauty the new process possesses extraordinary advantages over the old style of picture-taking, and we shall be greatly surprised if the Artotype does not in a few years bear the same relation to the photograph that the photograph now bears to the old-fashioned ambrotype. The Artotype process, let us say, is the obtaining of superior photographic prints by means of the regular hand press and printer's ink. The credit of inventing and discovering this particular process is due to Mr. J. B. Obernetter, a celebrated chemist of Munich, and the credit of applying the discovery in this country belongs to Messrs. T. S. Lambert, W. A. Cooper and A. Mueller, who comprise the Artotype Company of New York, to which belongs the entire right for the United States. The manner in which the Artotype is produced may be briefly described as follows: The impression of the person or object is first taken on the negative, the same as an ordinary photograph ; then the negative is put with a plate of prepared glass and subjected to the action of the sunlight. A coating of gelatine is first put on the glass, and that rendered sensitive to light after having passed through a hardening process causes the film to adhere to the glass, so that an unlimited number of prints can be taken off. A perfect picture having been indelibly printed on the plate by the sun's rays, the hand-press and a little printers' ink are only required to produce any number of finely finished pictures. The plate is used the same as a lithographic stone, and photographs can be printed from it in all of the natural colors, by skillful manipulations. These photographs are different from the sun-printed pictures, inasmuch as they will never fade, never turn yellow or become blurred—the colors and tone being permanent. People can select their own colors or tones even after the negative has been printed, and impressions can be taken from the same negative of either soft or brilliant tints. Nothing but unprepared artists' paper is used, and prints can be made with either mat, brilliant or enamel surface, without losing any of their brilliancy.[476]

AN ARTOTYPE OF A "DICTATOR"

Edward Bierstadt became probably the foremost user of the Artotype process at his New York establishment after 1879. He used it primarily to make illustrations for business catalogs, and his orders would run to 120,000 sometimes on a single job. His use of the process to make photographic portraits for book illustration was considered "secondary." But Charles D. Fredericks evidently found it quite suitable for book illustration. In 1882, for example, Fredericks published a book, *The Bank Officers of the National and State Banks of the City of New York,* which contained nearly two hundred Artotype portraits, among them that of Frederick D. Tappen (above), the acknowledged "banking dictator" of America. Tappen was repeatedly given dictatorial powers by the financial community in all major economic panics prior to creation of the Federal Reserve System in 1913.[477]

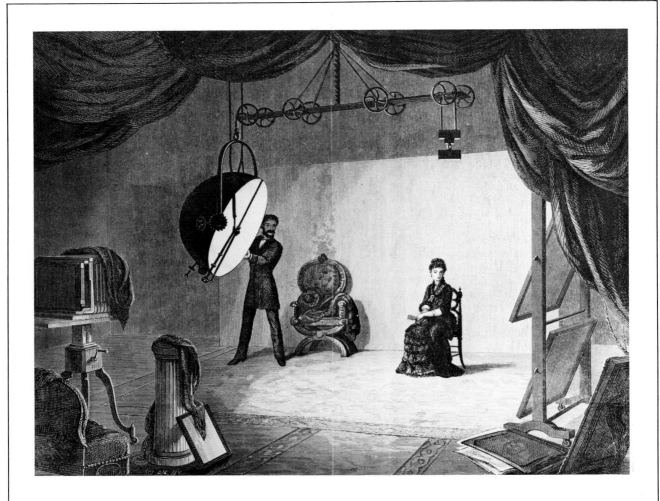

PHOTOGRAPHY BY ELECTRIC LIGHT

In April 1879, the *Philadelphia Photographer* marveled at an interior photograph of the Willimantic Linen Company taken by electric light, which the magazine received from Isaac White, of Hartford, Connecticut. The print depicted the room in which the thread was wound for linen manufacture. "This room is lighted by two electric lights, which take the place of sixty-two 5-foot gas burners," the magazine reported in an article describing the photograph. "Time: only twelve seconds. This is a wonderful achievement. We have seen many interiors taken by sunlight, with long exposures, that have not had so much detail as this one taken by electric light."

Isaac White's feat took place nearly half a year before Thomas Edison brought three thousand spectators to his New Jersey facility in special trains to witness a demonstration of hundreds of incandescent lamps. This marked the beginning of electricity's ability to compete with gas for home lighting. By this time, too, Henry Vanderweyde was specializing in electric light portraiture at the London studio where he first made portraiture by artificial light "fashionable" in 1877. In a report on Vanderweyde's activities, *Anthony's Photographic Bulletin* contended that "it is impossible, from an examination of the pictures produced, to arrive at a conclusion that they were produced by artificial light. Instead of the harsh, chalky lights and black shadows without gradation, which experience associates with the majority of examples of portraiture produced by artificial light, these are for the most part remarkable for their softness and their singular perfection of gradation and modelling. Not only is every highlight picked out crisply and precisely, but every gradation of halftone is accurately rendered. The highlights are surrounded by delicate pearly greys, which remove all baldness and crudeness of effect, and the shadows are made transparent by the plenitude of reflected lights carrying detail into the deepest shadows." [478]

its appearance this year, touching off yet another round of dissension between the houses of Wilson and Anthony (as well as among other prominent members of the photographic fraternity). In January, Wilson refused to accept advertising in the *Philadelphia Photographer* from the newly established Artotype Company of New York, whose owners included Wilson's former adversary, T. S. Lambert, W. A. Cooper and A. Mueller. The advertising, Wilson contended, was "extravagant, and could not be verified by facts." The only people opposed to the new process, *Anthony's Photographic Bulletin* shot back, were Wilson, David Bachrach, John Carbutt, and R. Benecke of St. Louis. The *Bulletin* even expressed the opinion that the attacks made by this group both on Lambert and on the process itself resulted from "a personal opposition on the one hand, and on the other, from the persistent desire to do everything possible to 'beat Anthony.' "[479]

But just the previous month (December 1878), the judges of the forty-seventh annual fair of the American Institute had awarded a "medal of superiority" to the Artotype Company for its exhibit of prints at that fair, noting in its report: "All distortion, which is so common in silver prints, is entirely overcome. The printing is likewise done in different tints, and some very nice pictures have been shown . . . done in three different colors, thus to a certain extent solving the art of photographing in color."[480]

Beginning in May, representatives of the Artotype Company, following the method used by Leon and T. S. Lambert several years earlier, began a schedule of free demonstrations of the process at hotels in Rochester, Buffalo, Cleveland, Chicago, St. Louis, Louisville, and Cincinnati. But even before this schedule went into effect, the *Bulletin* ran a series of laudatory letters received (probably with no little solicitation) from William G. Chamberlain in Denver; J. A. Williams in Newport, Rhode Island; C. H. Muhrman in Cincinnati; W. J. Baker in Buffalo (who purchased the rights to the process for Erie, and six other New York State counties); and W. H. Illingworth, who wrote that he had discharged his silver printer and was "now turning out nothing but permanent work, carbon and artotypes. Is Minneapolis," he inquired, "still for sale?"

Two months before the Artotype Company demonstrations began, John Carbutt did an about-face, and signed up:

As there seems to be an increasing conviction that my mode of photomechanical printing is a direct infringement of some of the patents now legally held by the Artotype Company, some of which are undoubtedly valid, and not wishing to go into long and costly litigation, or endanger others who might learn of me, I have concluded to give no further instruction in photomechanical printing. I have secured the exclusive license of Artotype Company's patents for Philadelphia and vicinity, and will henceforth fill no orders from negatives originally taken in the localities for which the exclusive license of Artotype Company had been sold, wishing to be similarly protected in my own territory.[481]

David Bachrach, meanwhile, contended that Artotype printing should be confined to major photomechanical printing establishments, such as Carbutt's or Edward Bierstadt's in New York. Wilson called on Bachrach to join him in the fight, and as Bachrach recalled in later years: "I was young

CAUSES OF PRINT FADING

"Outside influences" were the most destructive causes of print fading, F. A. Wenderoth of Philadelphia contended. Prints surviving from the nineteenth century attest to the veracity of his remarks in a long article on the subject in *Philadelphia Photographer*:

Silver photographs made on different papers are influenced differently, and withstand the destroying elements differently. Albumen prints, with very few exceptions, fade and discolor simultaneously; prints on plain paper fade but do not discolor, at least the paper does not more so than ordinary paper under the same influences. Since the introduction of highly albumenized papers this discoloration has very much increased.

Another decided difference is in the tint of fading prints on these two kinds of paper. On the single and on plain paper the remaining tint of the image is blackish, whereas on the double paper the remaining tint of the image is mostly brown or reddish-brown always on a more or less discolored albumen film.

It will be asked what produces the difference in the amount of fading of silver prints made on the same paper under similar conditions. This, I think, in most cases, can be explained by the difference in the strength of the negatives, difference of albumen film, over- or under-printing, and consequently great difference in the changes produced by the gold toning bath.

I think it admits of no doubt that prints made from strong negatives, consequently stronger printing and gold toning, will resist fading influences better than those made from thin negatives and slight toning.

Prints on thinly albumenized paper permit of a deeper incorporation of the image in the body of the paper support, and having less organic matter to expose to atmospheric influences, will suffer less and keep an even surface even after the application of water. This is entirely different with double albumenized papers. Prints on these papers, when closely examined after being mounted, will be found to have cracked into millions of particles, but firmly adhered to the paper; after the application of water, these little pieces curl up, leaving open seams between them, giving free entrance to their great enemy, the sulphuretted hydrogen of the atmosphere, and the body of the albumen film being of considerable thickness, the absorption of moisture will be greater, consequently, the process of fading more energetic and quicker than with single albumenized paper. I think the sooner these highly albumenized papers are discontinued the better. [482]

and full of fight . . . I thoroughly checkmated the fellow [Lambert] by issuing a pamphlet to every photographer I could reach, giving the entire absurdity of the scheme away. There were no more taken in then; in fact, but few had been. I received scores of letters acknowledging their obligations to me.'' Of the thirteen Baltimore studios that had bought the Lambertype process two years earlier, his was the only gallery using it with any regularity, Bachrach contended, ''and then only for porcelain negatives and the reproduction or enlargement of negatives.'' Bachrach lashed out equally sharply against efforts by ''the process mongers'' to license the Artotype:

> I wish to say a few words to you, fellow photographers. So long as you will be easily gulled by every foreign-named process-monger, so long as you will, in your eagerness to get ahead of your neighbor, try to cut each other's throats, so long as you will not act together against the common enemy of process- and patent-mongers, so long will you be open to just such conspiracies against your pockets.[483]

The causes of print fading provided yet another major topic on which disagreement—albeit, in milder form—was aired in the photographic press this year. F. A. Wenderoth of Philadelphia identified three principal causes: namely, the use of improper mounting material; failure to remove hypo during printing (not as bad a problem, Wenderoth felt, as Newton and others said it was); and the effect of outside influences. Alexander Hesler argued that improper al-bumenizing of the paper was a major cause of print deterioration. The use of hard, very dry paper in coating provided an albumenized paper susceptible to blistering, he contended, whereas if the albumenizers would use paper previously dampened, and allow it to fully absorb the albumen into the paper's fibers, no blistering would result. The Philadelphia manufacturer of albumen paper, John R. Clemons, responded to this with a different theory:

> Now, my theory is that the sizing at the paper manufactory is not made as it used to be; perhaps made in such large quantities that it is lumpy, and these lumps are of various sizes, and they become the nucleus, turn sour, and then enter into the pulp, all passes through the rollers, when they are spread out, small and large. Then the poor albumenizer gets it; from him it passes to the printer, and the printer pours a big lot of cussedness upon the very spot where it don't belong. Now we will look at this in another light. If it was the fault of the albumen, why do not all the albumen prints leave the sheet, and not blow up in spots by the gases engendered in the sour sizing? I may be wrong, but I think I am as near right on *that* blister as anyone else who has guessed.[484]

Frank Thomas, in a letter to the *Philadelphia Photographer,* agreed with Clemons. But, Clemons excepted, ''the majority of albumenizers make one mistake,'' he said, ''and that is they do not tell us how strong they salt their paper; we would have less trouble in silvering correctly, did we possess that information.''[485]

1880

Newspaper illustrations made their appearance in the 1830s. Among the first in an American newspaper was a woodcut view of the ruins of the great New York fire of December 16–17, 1835. In an early journalism "extra," the New York *Sun* published a lithograph of the burning of the steamboat Lexington in Long Island Sound three days after the tragedy on January 13, 1840. Thousands of copies of the extra were sold on the streets throughout New York, establishing an overnight reputation for the young lithographer Nathaniel Currier. But after 1850, newspapers virtually ceased using illustrations, and the public obtained its visual accounts of people, places, and events through the pages of such illustrated weeklies as *Harper's* and *Leslie's*. As we have already seen, the woodcut illustrations in these weeklies were frequently copied directly from supplied photographs.

In 1873, the New York *Daily Graphic* made its appearance, using lithography for the printing of both type and illustrations (photolithographs). Stephen H. Horgan was hired as a photographer, but soon took over management of the paper's photomechanical printing operation. As he said later, the appearance of this newspaper "startled the whole printing world, for it demonstrated that photography was going to usurp the place of wood engraving." This it did for the first time on March 4, 1880. What F. W. von Egloffstein had endeavored to accomplish in the 1860s now appeared on the *Graphic's* editorial page in the form of a halftone illustration printed on the same press with the columns of newsprint. The brief explanation of the illustration read as follows:

On the lower left hand corner is an illustration entitled "A Scene in Shanty Town, New York." We have dealt heretofore with pictures made from drawings or engravings. Here we have one direct from nature. Our photographers made the plate from which this picture has been obtained in the immediate presence of the shanties which are shown in it. There has been no redrawing of the picture. The transfer print has been obtained direct from the original negative. As will be seen, certain of the effects are obtained by use of vertical lines. This process has not yet been fully developed.

On March 2, 1880, the New York *Daily Graphic* appeared with the illustration of Shanty Town dwellings (above) modestly placed on the editorial page. There was no public fanfare, and it was not labeled a "first." But it was. It was the first time that a newspaper converted a photograph by screening to a halftone block for printing with type without the aid of an engraver.

AN UNANNOUNCED PREVIEW

When the members of the Photographic Section of the American Institute attended the society's regular monthly meeting on March 2, 1880, O. G. Mason, secretary, greeted them with an advance copy of the world's first newspaper halftone illustration:

> I have here a print, which might be called an advance copy of a supplement of the New York *Daily Graphic*, which will be issued in two or three days hence. Knowing that I have taken a good deal of interest in the various printing processes which were founded on photography, the publishers, and Mr. Hogan, who has charge of the photographic work, took pains to send me this sheet. It is particularly interesting to *us* from the fact that it has in it a picture made and printed in the power press directly from a negative by our chairman. It is issued on this advance sheet and will be printed in the paper by the thousand, without the slightest touch of the hand on the photographic work. The method of producing it may be described as follows: A negative is made from a series of fine rulings slightly out of focus. The film of that negative, if transferred by the use of collodion—or rather taken off and placed between the negative from nature and the bichromated gelatine film—a print made and treated as the ordinary photo lithographic prints are treated, the effect is to produce detail in the shadow parts, and where there is a light portion the ruling shows very slightly. Another interesting picture is made upon a photographic base; that is, a photograph is made and a drawing in ink finished upon this, the outline and shade put in; then the photograph is bleached out by the use of chloride and alcohol, leaving only the drawing, from which the work is carried forward. Another interesting picture of the series shows the artistic corps preparing a picture for the next day's issue; the original picture from which that was made I have here. The drawing was made in about one hour, a hand drawing, upon a peculiar paper which they call grain paper, which admits the photographic process being worked without filling up the shadows. This sheet is a most admirable illustration of the utility of photography in the production of illustrations for the daily press. [486]

Stephen H. Horgan, circa 1890.

The original photograph of "Shanty Town" was an Albertype made by Henry J. Newton. To process it as a halftone illustration, Horgan prepared a screen of seventy lines per inch, by which the picture was broken up into lines and dots that could be secured on a printing block. The clarity of the "Shanty Town" illustration, as it appeared in the *Graphic,* is not up to today's standards, but was comparable to a halftone illustration of E. L. Wilson which was published in an 1881 issue of *Philadelphia Photographer* (see page 369). Detail in the shadows is evident, and intermediate tone (halftones) were secured without the hand of an engraver. The *Graphic* produced other halftone illustrations after this, but printing difficulties precluded use of the method with any regularity. In addition, the *Graphic* did not fulfill the role of a news publication, and in 1889 it was forced to close down.

Although honored (in 1930) for his pioneering work in halftone, Horgan's efforts were only the first which ultimately led to the perfection and subsequent universal use of halftone printing after 1890. Horgan became art director of the New York *Herald* in 1893 and the methods he developed on the *Graphic* were later adopted for high-speed press work by the New York *Tribune*. [489]

"HEADQUARTERS FOR EVERYTHING PHOTOGRAPHIC"

From the *New York Review*

"The pedestrian who travels down Broadway will, if he be of an observant disposition, notice about midway between the Post Office and Grace Church, a good many showcases containing photographs of celebrated actors, actresses, public men of this and other countries, and photographic pictures of nearly every imaginable description. Most people stop now and again to admire these pictures, and some, more thoughtful than the rest, wonder "where they all come from." To find out something precise and definite on this head a *Review* reporter made it his business the other day to pay a visit to the leading establishment in this line—that of E. & H. T. Anthony & Co., of 591 Broadway, opposite the Metropolitan Hotel. Knowing the widespread celebrity of this house, the reporter was prepared to find things upon a pretty large scale, though nothing like so extensive as the reality turned out to be had ever entered his head.

Messrs. Anthony & Co., carry on business as manufacturers and importers of photographic materials, stereoscopes, views, albums, frames and fancy goods, and make of photographs of celebrities a great specialty. The business was established originally in the year 1842, by Mr. E. Anthony and Mr. H. T. Anthony, brothers. They were both civil engineers by profession and had practiced as such before commencing their present business. They started in a very small way, but now do the largest business of any house in this line in the United States. At the above address they occupy four floors, each 100x30 feet, and also a rear building of four 100x30 floors. At the corner of Elm and Centre streets they have a factory, over the Hartford & New Haven R. R. depot, and they have another very large

one in the lower part of Broadway, and in New Jersey they have a third, where photographic chemicals are manufactured. They employ in all over 300 experienced hands, and the quantity of work turned out is simply enormous. Of frames alone they make fourteen gross per day, or nearly 700,000 per annum. Their goods go all over the world, being regularly sold in London, Paris, Spain, Germany, Australia, China, Japan, the West Indies, and in South America alone the firm have four regular agents. Their customers are jobbers and wholesale dealers, who in turn supply the retail trade.

The house is the chief source from which the United States Government draws its supplies of this character, and of general photographic materials. Amongst other foreign houses that are represented is that of J. H. Dallmeyer, whose telescopes and best photographic lenses are well and favorably known all over the world. For this house Messrs. Anthony & Co. are sole agents. The *Review* reporter was courteously conducted through the establishment by Mr. H. E. Pierce, who has general charge of the stereoscopic department. He was shown an amazing variety of choice and tempting goods, the entire stock being one that certainly could not be equalled in the United States and probably not in Europe. The display of velvet, satin, silk, gold, ebony and other styles of frames attracted particular attention. It includes all the newest and most beautiful designs, including many that are entirely original and could not be met with elsewhere. All grades are included so that all tastes can be suited. Of albums the stock is beyond description. They range from the tiniest pocket-book albums to the largest and most expensive ever made. There are im-

itations of English and French goods, of which it may be said that the copies are better than the originals, and there are amazingly tempting productions in calf and morocco, which only need to be seen to be admired.

In another department is a collection of stereoscopic views that seem to have no end, and the reporter is quite prepared to believe his guide when the latter says that it includes 50,000 different subjects. Included are views of nearly every pretty piece of scenery in the United States, together with tit-bits gathered up from every country under heaven. In the arrangement and classification of these goods a most comprehensive system is observed, so that no matter what a buyer may require it can be found in a moment. Elsewhere is seen a superb line of stereoscopes, and the reporter learns that the firm control a very fine patent folding stereoscope that is intended for the use of travelers. The collection of photographs of celebrities calls forth the statement that Messrs. Anthony & Co. are sole agents for Sarony's productions in this line. They color them themselves and sell them in immense quantities.

The house is, in short, headquarters for everything photographic, no matter of what nature, and in every department of their business they lead the trade. The firm publish a book called the "Silver Sunbeam," which refers to various matters of interest connected with the photographic art. "*Anthony's Photographic Bulletin*" is another well-known publication of the house, now in its tenth volume.

The concern is now in reality a joint-stock corporation, of which the Messrs. Anthony and Mr. V. M. Wilcox are the heads. 487

E. ANTHONY, H. T. ANTHONY and V. M. WILCOX.

E. & H. T. Anthony & Company was incorporated in 1877 with Edward Anthony (left) as president, and with brother Henry T. Anthony (center) and V. M. Wilcox (right) as vice presidents.

1880

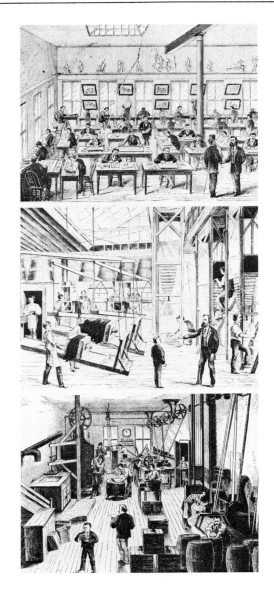

MOSS PHOTOENGRAVING PROCESS

These appear to be the only surviving illustrations depicting the birth of American photoengraving, either at 67 Park Place, New York, where John Calvin Moss (1838–1892) operated his pioneering business in the late 1870s, or at 535 Pearl Street, where Moss moved in 1881, becoming, in the words of Stephen Horgan, "the best-known photoengraver in the world." To prepare book and magazine illustrations, Moss's draftsmen prepared line drawings on top of photographs in a special way (top), after which the drawings were photographed (middle), and the negatives made of the drawings were exposed on a sensitized gelatine surface. In this operation, the portion of the gelatine exposed to light (i.e., the lines of a drawing) was rendered insoluble, while the remainder of the gelatine (i.e., the white surfaces) could be dissolved chemically, creating hardened gelatine molds into which metal was poured (bottom). In this manner, photomechanically produced illustrations were created in stereotype plates which could be printed on a press with type.[488]

Despite the handwriting on the wall personified by "Shanty Town," the demise of the hand engraver did not immediately follow. During the lull in halftone development, which lasted up to about 1893, wood engraving continued unabated, while at the same time the new methodology of photoengraving began taking on sizeable proportions.

The first to introduce photography into successful commercial engraving was John Calvin Moss, a native of western Pennsylvania. But Moss's was an agonizing route to success, and one which he was fortunate in being able to share with an equally dedicated wife, Mary. Together, the couple experimented at nighttime during all of the 1860s on what must have seemed many times to be a fruitless endeavor. Originally, Moss's interest had been aroused by the failure of another to produce an engraved plate by etching out a daguerreotype image. Why not, he thought, etch through the thin coating of silver on a daguerreotype plate, then place the plate in another chemical solution which would act upon the copper base—but not the silver coating—and thus allow further etching to the required depth for plate printing? The first plate was produced in short order, but as *Anthony's Photographic Bulletin* observed later, Moss and his wife "did not realize that nearly ten years of constant experimenting under the most trying circumstances, often in great poverty and want, would roll away before they would be able to make the first plate that would be paid for and used." On their first large order, the couple found that their chemicals "would not work as they had worked before," but somehow the job was completed and capital was forthcoming after that to fit up a loft in New York where manufacturing operations could be carried on on a larger scale.

Business prospered at the loft, but Moss and his wife again embarked on a decade-long period of adversity which saw the establishment and dissolution of two companies in which interim financing had been provided by outsiders. Finally, in the spring of 1880, the Moss Engraving Company was formed with Moss as president, his wife as treasurer, and a son, Robert, as assistant superintendent. Two longtime employees were named, respectively, secretary, and assistant secretary of the company. During the 1880s, Moss became, in Horgan's words, "the best known photoengraver in the world."

Moss's success resulted from training an entirely new school of pen-and-ink draftsmen who took the place of wood engravers in preparing line illustrations that could be transferred photographically to a stereotype printing block. Among the most noted artists whose works were reproduced by the Moss process for magazine and book illustration was the author and illustrator Howard Pyle. The accuracy of the pen-and-ink draftsmanship was essential. As the *Philadelphia Photographer* noted some years later: "The Moss-type process can produce photographs and drawings and mezzotint engravings with photographic accuracy, but it is necessary, however, to have no defects in the original, as they will be reproduced in the plate."[490]

Records are lacking on the accomplishments of the Moss Engraving Company during the 1880s, but it appears that even among so-called experts the question cannot readily be answered as to whether a woodcut, or a photo-technology

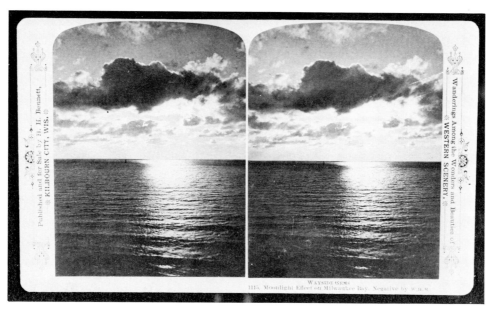

Published and for Sale by H. H. Bennett, ❀ KILBOURN CITY, WIS. ❀

Right side vertical text: Wanderings Among the Wonders and Beauties of ❀ WESTERN SCENERY. ❀

WAYSIDE GEMS
1115. Moonlight Effect on Milwaukee Bay. Negative by H.H.B.

PHOTOGRAPHY BY MOONLIGHT
From the *Photographic Times*

IF "seeing is believing," there was no mistake at all as to its being a genuine moonlight picture which was submitted for our inspection. In the first place, it was labeled as such; while, secondly, *there* was the full moon, high in the sombre midnight heavens, imparting a silvery lustre to the skirts of the adjacent clouds, and giving a beautiful reflection from the tips of the waves of the sea which formed the centre of the fine picture, and across which boats —some in full sail—were depicted with such fidelity to nature that every rope could be seen. The moon itself, too, courted examination through a magnifying-glass, by which the details of its selenographic features were clearly to be distinguished. An instantaneous view by moonlight!—that was the claim. And why should it not be received?

We shall speak of photography by moonlight, first, in a philosophical, and, secondly, in a practical spirit.

What is the difference between the luminous energy of the sun and that of the moon?

Some individuals, possessing an abnormal degree of the poetic or imaginative faculty, have been known to describe a fine moonlight night as being "almost as light as day." Pretty, but altogether untrue.

Computations to determine the comparative degree of luminousness of the sun and moon have been made by several *savants*, among others, by Leslie, Bouguer, and Wollaston. The first of these, Prof. Leslie, very strongly supported a theory to the effect that there is possessed by the moon a phosphorescent principle, brought into action by the influence of the sun, by which the latent light was thus emitted. He computed that the sun's light remitted from the moon to the earth was attenuated 105,000,000 times, and found the intensity of the moon's light to approach the $\frac{1}{150000}$ part of the direct light of the sun; so he reasoned that, as the utmost possible quantity of reflected light could not exceed the $\frac{1}{150000}$ part, the excess must be owing to the spontaneous light of the moon, which, consequently, is a phosphorescent body.

Bouguer's experiments led him to conclude that the moon's light is between the $\frac{1}{150000}$ and $\frac{1}{300000}$ part of the direct light of the sun, or about three hundred and fifty times greater than the computed amount of reflected light. The best astronomers, however, give the preference to the measures of the brightness of the sun and moon determined by Dr. Wollaston, and which give the former equal to $\frac{1}{801072}$ of the latter at full. This comes very near what one might deduce from the distance of the moon from the sun, the direct reflecting power of a rocky surface, and the angular subtension of the moon from the earth.

From the foregoing, the following deduction is made — that, as the light of the moon is 801,072 times less than that of the sun, if a photograph of any terrestrial object, while lighted by the sun, can be taken during an exposure of one second, a similar picture of the same subject, when lighted by the full light of a full moon, will require an exposure of two hundred and twenty-two and a half hours, or a space of time equal to nine and a quarter days.

This renders quite unnecessary any further argument against the idea of obtaining instantaneous moonlight pictures.

Now, it is not only quite legitimate to produce pictures possessing moonlight effects by the agency of the sun's light, but it is a fascinating department of photographic practice; and numerous exquisite pictures have been thus obtained. There are, however, only a limited class of subjects capable of being made subservient to the interests of the so-called moonlight photographer. Those containing water and trees are the most effective for this purpose, and the binocular camera is the instrument by which such scenic representations can be best made. The camera should be planted straight in the direction of the sun, the arrangement being such as to have the sun itself included in the picture. To secure this, the picture should be taken either in the morning or evening, when the great orb has not attained such a degree of altitude as to prevent it from being included.

In order that the full effect of the "moonlight on the waters" be obtained, the exposure should be extremely rapid, the arrangement of the shutter being such as to admit the minimum of light from the sky, and thus prevent the sun from being solarized. Among the expedients for insuring this is the placing the stop of the lens in such a position as not to form a right angle with the axis of the lens, as usual, but with a leaning downward toward the immediate foreground. This causes a very attenuated pencil of light to be admitted from the top of the picture, where the sun is situated, and a large volume of light from the more dimly-lighted foreground. To suit the exigencies of this case, cardboard stops should be provided. At any rate, the stops must be very small and the exposure very rapid.

It is essential to good effect that the negative be under-exposed, with well-marked high-lights, so as to imitate nature as seen in the moonlight, when the Goddess of Night is in front of the spectator.

The method indicated is that by which the finest French "moonlight views" are taken, the image of the sun, unless in exceptional instances, being made to do duty for that of the moon. The difference in apparent diameter of these two orbs is too slight to be capable of being detected in a photograph, that of the sun being 32′ 2″, while that of the moon is 31′ 26.5″.

It is when such a photograph is printed as a transparency that it shows to most advantage; and the enormously high prices asked and readily given by *connoisseurs* for such stereoscopic slides attest the estimation in which they are held. Consummate art is displayed in printing such transparencies. If they are printed upon albumenized paper, it will be well to impart a final bluish tint to the picture by one of the preparations of anilin, which can be locally discharged, where required, by means of acid. 491

ENTER GEORGE EASTMAN

In 1877, George Eastman, twenty-three, a junior bookkeeper at the Rochester Savings Bank in Rochester, New York, bought a camera and employed a local photographer, George H. Monroe, to teach him the wet-plate process. He also began reading photographic litrature, and was attracted by an improved gelatine dry-plate formula which first appeared in the March 28, 1878, issue of the *British Journal of Photography* (and was republished in American journals). This was the process of Charles Bennett, an English amateur, who improved Maddox's gelatine process by ripening the gelatine by heating. Eastman began making his own plates, and in the summer of 1879 Monroe began using them in his own photography. Eastman moved quickly; he went to England in 1879 to see how gelatine dry plates were produced there, and before returning to the United States applied for a British patent on a device for mechanically coating the gelatine emulsion on a glass plate (an American patent for the same device was applied for and awarded on April 13, 1880). Word of Monroe's and Eastman's successful use of gelatine emulsions reached the Photographic Society of Philadelphia in November 1879, and in a short report under the heading "Society Gossip," in Wilson's journal, a society member said he "thought that possibly plates would be sent out from there [Rochester] commercially." The thought was also expressed at the meeting that Rochester might be a particularly favorable location for dry-plate manufacture because of its location near a large body of water where less extremes in humidity were to be found. In January 1880, a correspondent, E. K. Hough, visited Rochester and sent word back to the *Philadelphia Photographer* that he had seen, and was particularly impressed with, Monroe's photographs:

> He intends to use the plates in gallery work, and said that a day or two before he

had taken a portrait indoors in two or three seconds, full timed on a gelatin plate, which was under-timed under the same conditions with a good working regular bath and collodion, with twenty seconds, and that speaks volumes for its rapidity.

He works the modified Bennett process, but modestly disclaims any credit of his own, giving all the honor, whatever there may be, to Mr. George Eastman, an amateur there, who worked it all out in his own way, and gave it to Mr. Monroe.

I asked if he thought the lake had any influence. He laughed at the idea, and he does not believe that it makes a particle of difference. I asked if he found any difficulty in hot weather, as some have. He said, not any; some of his best negatives were prepared and made in the hottest part of the summer.

The power of controlling it thus is what Mr. Eastman has discovered, if I rightly understood him, and is what will make it generally practical.

On a trip to the Thousand Islands in the summer of 1880, Monroe met Edward Anthony, who expressed interest in the Eastman dry plates. A correspondence was struck up between Eastman and Anthony, and in December 1880, E. & H. T. Anthony placed the Eastman plates on the market commercially.[492]

process was used in making line engravings in various magazines and books of this period. Only recently, for example, was Moss's role in Howard Pyle's work recognized.

Moss also prepared illustrations for direct sale to the public. We find in *Anthony's Photographic Bulletin*, for example, that an "art album" prepared by the Moss Engraving Company was offered at Christmas time in 1877. The album contained twelve "beautiful pictures" produced by the Moss process, and the announcement said that it was being offered "as a contribution to the effort to disseminate widely samples of the best pictures for the entertainment of

the masses and the development and education of a popular taste."

Moss's establishment was described, in 1884, as "the largest establishment of its kind in the world." But subsequent developments in the photoengraving art soon outpaced Moss, and he was forced to adopt the newer modes because of their greater artistic quality for magazine and book illustration. According to Horgan, Moss died a "disappointed man," but in his obituary in 1892 the Moss Company was said to employ two hundred people who "do the work of 2,000 wood engravers."[493]

DAWN OF THE MODERN ERA

EMULSIONWARD

By Edward L. Wilson

UNDOUBTEDLY photographers are softening toward Emulsion. It has a long time been pounded into them, and, thanks to the persistency of its advocates, it is rapidly coming into favor. The way things look now it won't be *very* long before the bath and the dipper are laid away among the buff-wheels and mercury-boxes, and even the useful Bonanza Plate-Holder will stand aside with not a splash to bless it.

In a few years the now young scions of the art will exhibit their work at the grand conventions and think themselves veterans because they will be able to say, "I used to use collodion and a silver bath; I made wet-plate negatives," just as the veteran of to-day swells up with pride, and preludes his say at the meetings with, "Mr. President, I made daguerreotypes!"

Do not understand, however, that this happy day has yet come. Much, very much, has been accomplished by emulsion-workers and plate-makers, but we haven't *all* we need yet. There are drawbacks to overcome, improvements to make, and qualities yet to secure, before we are ready to take emulsion plates entirely to our hearts and depend wholly upon them for our best results. But it will soon come.

It can hardly be supposed that any one who has read the PHOTOGRAPHIC TIMES for the past year or two can be ignorant of what emulsion plates—dry and wet, collodion and bromo-gelatine—are, or fail to understand fully their advantages. For this magazine has been fraught with fervor on the subject, its live editor seeing with an intuition and an insight all his own what must surely become the popular method of negative-making.

It is not the purpose of this article, therefore, to do more than two things,—namely: 1, to impress the live photographer with the necessity of making trials of the process, thus helping on a work that is sure to benefit him; and, 2, to point out a few of the drawbacks and give a suggestion or two as to how they may be overcome.

First, then, the growing ones of our craft should no longer hesitate to make purchase of emulsion plates and carefully experiment with them; study their natures and wherein they require treatment different from that needed in the wet process, and give an account of your successes, your failures, and your discoveries to the craft. This is the way to make the thing grow, and a sure means of heading off the swarm of secret processes which are sure to infest us in due season unless the utmost liberality is followed by the enlightened portion of our fraternity.

If you haven't a nice, clean, well made and handy camera box, be sure to get one, and give the process every chance. If you have, why, a new, clean holder (no silver saver needed) should be had, for nitrate of silver often fogs the sensitive emulsion plate.

Thus equipped, go ahead. Each maker of plates supplies you with full and faithful directions. Forget that you ever worked a wet plate. Drop all your old wrinkles, get out of the rut, follow directions faithfully, and your results will charm you.

Second, as to some of the drawbacks of the emulsion method. The plates are extremely sensitive, and work very rapidly as a rule. This is considered an advantage by some. It would be entirely so were it not that such a quality compels the utmost care in protecting the plates from any white light whatever from the moment they are taken from the manufacturer's package up to the time of the application of the developer. The trials which come from this are obvious; but, when one is accustomed to them, they will be felt but little. The extreme care necessary in development and the entirely different operations thereof may also be considered a drawback, but time will also modify, simplify, and improve this also, and we must not be discouraged yet.

As to the process of making the emulsion, it is complicated and troublesome, hence it seems wiser—at present, at least—to purchase the plates you need already emulsionified. The prices asked seem high, but they are not unfair, all things considered. Doubtless ere long the manufacturers will have more plates demanded than they can supply, and then they will furnish the sensitized emulsion in the form of a dried pellicle, which you can soften and coat upon the plates in your leisure hours. Thus the bugbear of price will be overcome.

Everything looks hopeful. The results both in outdoor work and portraiture which some of our leading artists are securing are most admirable; the quality of the plates offered is so superior to those of a year ago, and the encouragements so great to adopt the new method, that it seems as though now only the ones content to stand still and lag behind will fail to look into emulsion and get the good out of it. [494]

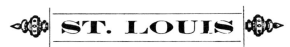
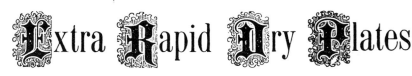

DRY PLATES, ROLL FILM, AND MOTION PICTURES
1881

Concurrently with the progress of the presidential campaign of 1880, in which James A. Garfield won election by a narrow margin, photographers across the land began switching to dry-plate practice. Albert Levy's gelatine dry plates and E. & H. T. Anthony & Co.'s *Defiance* plates were taken off the market by January 1881. But others were appearing on the scene. In St. Louis, Gustave Cramer teamed up with Herman Norden (who was "one of the first to introduce dry plates in this country," according to Cramer) to perfect a commercial plate that would be better than anything previously offered. Their activity was another of the proverbial "burning the midnight oil" variety, as Cramer recalled in later years:

> In the beginning we usually worked until late into the night, and once when we had finished working one emulsion we came to the conclusion to try an entirely different method, and to do so at once. Our stock of nitrate silver being exhausted, I had to go quite a distance to my gallery for a new supply. It was 2 o'clock in the morning when we started the new emulsion, which kept us at our work all night. Fortunately, the new way proved to be a success and gave us the first perfect plates, of which I took samples to the national photographers convention in Chicago.[495]

The convention referred to by Cramer was the first held by the newly established Photographers Association of America, successor to the National Photographers' Association of America, which had run out of steam several years earlier. The P.A.A. convention was held in Chicago in the summer of 1880, and Cramer and Norden were not alone in bringing dry plate samples for exhibit. Competitive items were also brought by John Carbutt (his *Keystone* plates) and by D. H. Cross of Indianapolis, who brought samples of his new *Indianola* dry plates. A committee was established at the convention to investigate and report on the merits of the three makes, but since the members of the committee were located in different sections of the country, it was decided that their individual reports would be submitted separately, rather than jointly. The first to respond in January 1881 were T. M. Schleier, of Nashville; Edward Bierstadt, of New York; and E. Klauber, of Louisville. Cramer and Norden's *St. Louis* brand, although thought to possess too much intensity by Schleier and Bierstadt, was adjudged superior from an overall standpoint, making this the first professionally certified dry plate in America. The *St. Louis* plates "work well, develop easily with either oxalate or pyro, and give soft and brilliant effects," Klauber said in his report. "They are equal in every particular to wet plates, and work—as do all of the different manufactured plates named—in about one-eighth of the time." (At a Franklin Institute lecture in the spring, Carbutt said exposures with his *Keystone* plates were made in 150th part of a second, which he calculated to be one 270,000th the amount of time required for an exposure in the days of the daguerreotype).[496]

Edward L. Wilson was not happy with the reports. "What the fraternity wants to know *now*," he said, "is not

THE CHEMISTRY OF EMULSIONS

The term "emulsion" was a familiar one to all photographers by this time. It applied to bottled formulae which photographers could buy and apply themselves to a glass negative; and to the formulae used by Eastman, Carbutt, Cramer, and others in coating glass plates (dry plates) which they supplied ready-made. Although little, if anything, appears on collodion emulsions, or collodion dry-plates in American photographic literature after 1880, the definition of the term, below, published in 1893, suggests that collodion dry plates were used at least to some extent during the last two decades of the nineteenth century:

> As is well known, modern photography is based on the sensitiveness of certain silver salts, notably the bromide, iodide and chloride, to the action of light. In order to bring a thin film of these salts in contact with the light in such a manner as will produce the best results, they are suspended in some medium in a state of fine division and the solution flowed over a glass plate, upon which it dries in the form of a thin film carrying the sensitive silver salts in suspension. Two substances are generally employed for this purpose, gelatine and collodion, the latter being a solution of gun cotton (nitrocellulose) in a mixture of alcohol and ether. A solution of this kind is termed an emulsion, and hence we have the terms gelatine emulsion and collodion emulsion. It is possible to make the former of a much higher degree of sensitiveness than the latter, and for this reason gelatine-emulsion plates are in much more general use than collodion-emulsion ones.[497]

whose plates are best (for as with paper, so with plates, the make of one party may work better than that of another in certain hands), but whether or not the time has now come for photographers to take up the emulsion process with reasonable hope of success." But in the same breath Wilson observed that "it seems photographers are not going to wait for any committee, but are already pretty deeply involved in emulsion."

Eastman's dry plates were placed on the market by the Anthonys in December 1880 and, hence, were not included in the P.A.A. competition. But by June, their use had become widespread. George Rockwood began using them at the rate of fifty a day, finding no problems in their use during a hot spell. He also considered them "a wonderful thing for babies at 5 o'clock in the afternoon." Edward Bierstadt was delighted with their "cleanliness," and "the absence of a thousand and one imperfections that beset the negative bath." George W. Pach said he was using the Eastman plates "with great success for interiors and all other occasions where long exposures were necessary." Hugh O'Neil, chief operator at the William Kurtz gallery, disclosed that "Mr. Kurtz will have nothing else." As for himself, O'Neil said, "I presume that I have made as many, if

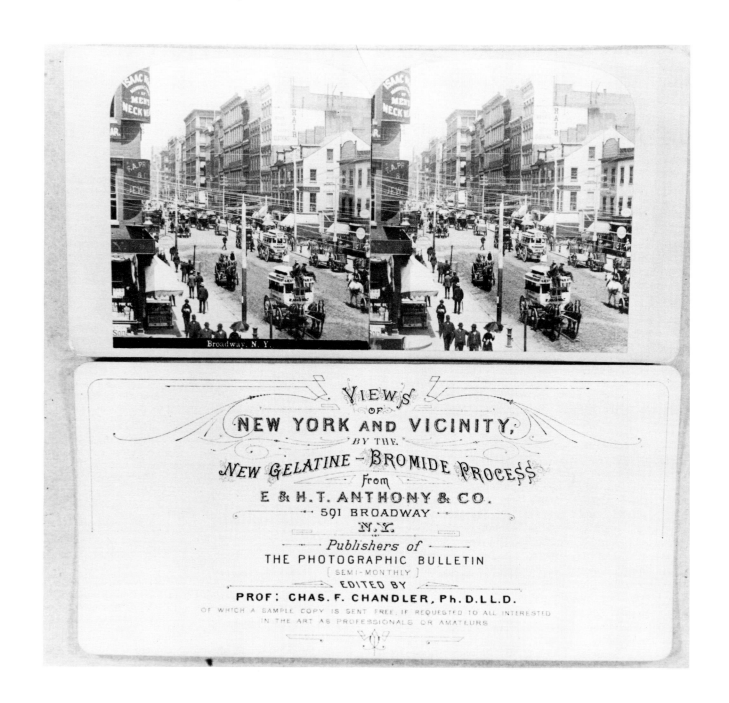

LAST ANTHONY STEREOVIEWS

As photographers everywhere began at last to adopt the new dry plates for camera work, E. & H. T. Anthony & Company issued a new series of card stereographs entitled ''Views of New York and Vicinity by the New Gelatine-Bromide Process.'' The front and back of one of the cards in the series is shown above. But the prints were in no way superior to those in the many different series made previously by the company with the collodion process. In any event, the series proved to be the company's last, after having pioneered the ''instantaneous'' card stereograph in 1859 and having issued more than ten thousand titles thereafter.

1881

not more, wet plates than any man in this country . . . [and] for the first time in my experience I have been enabled to make, with dry plates, portraits as they appear on the ground glass.''

At a meeting of the Photographic Section of the American Institute held on February 1, T. C. Roche gave this report, which, as he was a principal of the Anthony firm, presumably pertained to the Eastman plates:

I made a trip to Niagara Falls the other day to put these dry plates into practical use; but the weather was not such as I desired. The light was so strong that I had to use a small stop, the diaphragm in the Dallmeyer lens being too large. I had to make smaller ones, one the thirty-second part of an inch and one the sixteenth part of an inch. I had to bring the plates back to New York to develop. I made up my mind that the ordinary developer would spoil all my negatives; I could only put a trace of iron in it and gradually coax the picture out. I developed more than forty, and I now have confidence in the plates and would take the risk of going anywhere with them.[498]

The word from Chicago was much the same. A correspondent for the *Photographic Times,* writing on May 7, observed that "about all you hear now, as you pass from studio to studio—from the most elegant to the obscure—is dry plates. The craze is upon the fraternity, and all are anxious to learn of them and to test their merits." An entire meeting of the Chicago Photographic Association was devoted to a discussion and exhibit of gelatine dry plates, and several suppliers in addition to Eastman, Carbutt, and Cramer and Norden were represented in these exhibits. Among them were the Eureka Dry Plate Company of St. Louis; the Des Moines Dry Plate Company; and a manufacturer by the name of Howe, whose plates were described as "now out of the market." Photographs from dry plates of individual make were exhibited by a number of photographers, including W. J. Baker of Buffalo; G. W. Taylor of Sycamore, Illinois; and Joshua Smith, of Chicago. The firm of Douglass, Thompson & Co. provided an exhibit which illustrated the requisites for making dry plates. These included Nelson Nos. 1, 2, and 3 gelatine; the Coignet brand gelatine; paper used by Carbutt and others; ruby glass; boxes for holding plates in a darkroom (or for holding negatives after exposure); lamps of various styles and pricing; and developing trays, one of a heavy Russian iron design, and another of a very light, japanned design. The Scovill Manufacturing Company provided what was described as a "splendid array of camera boxes." In great demand at the meeting were copies of the *British Journal Almanac and Yearbook* for 1881, which had been imported and bound by Scovill for distribution nationally. "It is rich in gelatine information," the *Times* correspondent noted, adding that after it was quoted from by a lecturer at the Chicago meeting, copies were sold to "a large number who had not thought to purchase before."[499]

T. M. Scheier, in his P.A.A. report in January, contended that the high cost of available dry plates resulted from high labor costs, rather than materials costs, and he suggested that "unless competition reduces the price of the plates, photographers . . . will make their own plates just as they make their own collodion, etc." Other professional studios besides those exhibiting at the Chicago event began making plates of their own, and to meet this competition

EXPLOSION DERAILS PLATINUM PROCESS DEVELOPMENT

To overcome one of the major drawbacks in platinum printing, Alfred Clements tested the sensitiveness of the platinum paper to a powerful light at the Technological Institute (now the Stevens Institute of Technology) in Hoboken, New Jersey, and decided that electric light would be preferable to ordinary sunlight for making enlargements by the platinum process. Clements and his partner, inventor William Willis, Jr., thereupon installed new equipment, including a steam boiler and engine to operate the lighting, at their New York establishment. Shortly before Christmas, 1880, an explosion took place which marked the first of a new series of setbacks to the process, and caused the firm to cease operations altogether in 1881 (Clements thereafter moved to Philadelphia where he began the manufacture of chemicals for the process, and to license those who wished to practice it). Following is a newspaper account of the New York explosion:

NEW YORK, December 18: The boiler in Willis & Clements' platino-zinc works, at 123 West 26th Street, was blown up shortly before midnight last night, and was thrown over the roof of several 5-story houses into the yard of No. 441 Sixth Avenue, 200 feet away. The house No. 123 is an ordinary dwelling house, in the basement of which is placed machinery. In a one-story brick house adjoining the rear wall of the main building stood an upright boiler of 5 horse power, and weighing about 2 tons. The fire under the boiler had been raked according to the statement of the engineer, and left to die out last evening, and workmen had gone away and closed up the house. At 11:30 P.M., neighbors were startled by a heavy crash and a loud rushing noise. Looking out they beheld the boiler house a heap of ruins. Doors and windows were broken and machinery upset or wrecked. The boiler was discovered in the yard in the rear of 441 Sixth Avenue, 200 feet from the place where it had stood. It had fallen into its proper position and had cut a passage for itself through the branches of a tree under which it stood in a manner that showed that it had come down almost perpendicularly, after passing over the roof of an intervening 5-story extension and a telegraph wire that ran diagonally across the block. It must have risen far above the adjoining houses, and from its position at the start and at the fall and the distance between these points, Mr. Willis, who is an engineer, thought that it must have ascended hundreds of feet. When the boiler was examined it was apparently uninjured. Only the walls of the furnace had been torn out. Two gauges that had been attached to the boiler were flung as far as 28th Street and Sixth Avenue, where they fell through the skylight of a house and into a bedroom on the upper floor in which a man was asleep. Where the boiler was found, it had done no damage except to the pavement in the yard. The damage to the machinery and the house by the explosion is estimated at $2,500. The boiler was new and had been twice examined. The inspectors will make an investigation.[500]

IVES PROCESS

Frederic E. Ives, twenty-five, who was born near Litchfield, Connecticut, but became a resident of Philadelphia, received two patents February 8 and August 9, 1881, for a "swelled gelatine" photoengraving process which he had perfected while working at the photographic laboratory of Cornell University. The process, which Ives considered superior to Moss's process, was described as follows by the *American Journal of Photography* in 1887:

Ives' original method, invented in 1878, was to take an inked Woodbury relief and to press it against grained or embossed paper. The higher parts of the relief were forced most strongly against the paper, and consequently crushed down the grain upon it, producing a more or less solid black. The lowest part of the relief did not touch the paper at all, and consequently left no mark upon it. The intermediate parts touched the points of the paper lightly, and they received a little ink, or partly flattened them, so that they received a greater quantity, thereby producing a stipple that was perfectly graduated from solid black through a coarse grain, growing gradually finer up to pure white. The picture in this first process was copied in the camera, or transferred directly to stone or zinc for the production of an etched block by any of the known methods.

The next improvement, patented in 1881, was to substitute a swelled gelatine relief for the Woodbury relief, and to take a cast from this in plaster. On this plaster cast the lines or stipple were impressed by means of an inked elastic stamp of V-shaped lines and dots, and this plan, Mr. Ives says, gives the operator considerable control over the effect. By flowing over the inked plaster with collodion, the ink picture was transferred to the resulting film, and after stripping this film off, a print was made on a dry plate. Other improvements followed, one of which was the transfer of the ink impression to a sheet of soft rubber, and thence to stone or zinc. Still more recent modifications and improvements have been made by Mr. Ives, but have not been published, because they do not concern the general public.[501]

Eastman introduced a dry-plate emulsion which could be dissolved in water then coated on glass plates by photographers themselves. But by the fall of 1881, prices of prepared dry plates were materially reduced, and the Eastman emulsion was discontinued thereafter.[502]

For the first time, David Bachrach was chosen to give the annual report on the progress of photography at the 1881 P.A.A. convention. After reporting that he could obtain dry-plate negatives equally as good as wet-plate negatives, using the *Keystone* plates (substituting ferrous oxalate for the alkaline pyro developer), he moved to the topic of photomechanical printing. He made no reference in his remarks to the controversy which had surrounded the Artotype practice, but did make the observation that "this branch of photography (photomechanical printing) is really not a part of our profession which has any practical value for the mass of photographers, being really of benefit only in connection with publishing on a large scale, as carried on by the Heliotype Company of Boston and similar establishments." The same remarks, he said, "will apply to the photo-relief processes for the typographic press." The largest amount of business in this branch of the art, he noted, was being done by the Moss Engraving Company, and the Levytype Company. Bachrach also drew attention to a new arrival on the photomechanical printing scene, namely Frederic E. Ives of Philadelphia, whose new photoengraving process, just patented, provided a mode of obtaining typographic plates with halftone direct from photographic negatives. Bachrach indicated that Ives's results together with those achieved by others in France "give hope that this will also finally become a practical success, and when that is accomplished the application of photography to publishing purposes will be such as will astonish even the most sanguine of our art."[503]

Ives, unlike his competitor, Moss, perfected a "swelled gelatine" photoengraving method in which a photographic image was secured on sensitized gelatine. The gelatine was then made to swell, with the light parts of the picture standing out in hilly contour, and the dark parts remaining as valleys. By making a plaster cast from this, the dark parts would become the "hills" and the light parts the "valleys" (see right).

Ives's process differed from Moss's not only in the differing method of hardening the gelatine but also in the use of a type of gelatine which gave sharper relief cuts, and in the use of a different method of negative intensification. The process had essentially been perfected by Ives while he worked at the photographic laboratory of Cornell University. In 1879, he accepted a position with Crosscup & West, a Philadelphia wood engravers' firm which felt that the invention would have important commercial applications. Like Moss, Ives virtually wore himself out working around the clock during the years 1879–81, and at one point even his Philadelphia neighbors became suspicious:

As soon as I was able to have a house of my own to live in, the third story front room was made into a workshop, study and private printing office, in which I carried on experiments and set the type for and printed two books, together with all the circulars and handbooks for the instruments I was developing. This workroom was considered a great curiosity shop by many who

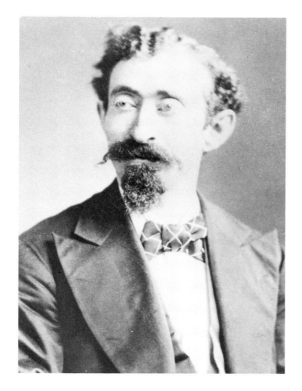

DAVID BACHRACH, JR.

David Bachrach was born in Hesse-Cassel, Germany, and came to the United States as a boy, receiving his boyhood education in Hartford, Connecticut. He was chosen to report on the progress of American photography for the first time at the fraternity's annual convention held in 1881. This was just after he turned thirty-seven on July 16 and his wife, Fannie, gave birth, on the same day, to the couple's first son, Louis Fabian Bachrach. During the 1870s, David Bachrach made a specialty of making large photographs on canvas with a solar camera, after which the photographs were painted over in the manner envisioned by the camera's inventor, David Woodward, also of Baltimore. In 1875 the firm became known as Bachrach & Brother, but the name of the younger brother is not contained in present-day historical material on the famed family. Bachrach's sons, Louis and Walter Keyser Bachrach, operated separate chains of photographic studios in New England, the Midwest, and South prior to World War I, but united all of these operations to form Bachrach, Inc., in 1925. David Bachrach died in Batimore in December 1921, at the age of seventy-six. Many of his nineteenth-century negatives were lost in the great Baltimore fire of February 7, 1904.[504]

"SWELLED GELATINE" METHOD OF PHOTO-RELIEF PRINTING

To convert an untoned photograph on paper to an image which could be secured on a printing block by the so-called swelled gelatine process, the artist made an India ink drawing over the print to alter light, shade, composition, etc. The remainder of the print was then bleached away, and a new photographic negative made which was placed in contact with sensitized gelatine. After the latter was exposed to light, it was placed in a tray of water. The portions unhardened would then swell, and a cast was taken in a waxy composition, from which could be made a plaster of paris mold in which to cast the type-metal stereotype. The several stages of the photo-relief method can be depicted as follows:

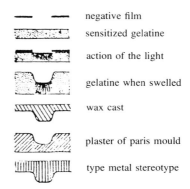

This process, as well as the electrotype and zinc etching modes of photoengraving served as the principal methods for creating magazine and book illustrations photographically until the perfection of halftone printing in the 1890s. In halftone printing, a screened photographic negative is made of the original photograph, breaking the image up into fine dots of varying size. No handiwork by an artist is required, and the dotted image can be transferred to a *metal* plate where it is etched into relief for printing on the same typographic press with textual material.[505]

THE SUPERIORITY OF CALIFORNIA PHOTOGRAPHY

After profiting handsomely from the moneymaking voyage of the *Hebe* in 1850, Isaiah W. Taber (1830–1916) became a gold miner then a rancher before returning a rich man to his native New Bedford, Massachusetts, in 1854. At first he became a dentist, but took up photography as a permanent vocation and was among the first to open a photographic gallery in Syracuse, New York. In 1864 he was invited to join the prestigious San Francisco gallery of Henry Bradley and William H. Rulofson, and in 1871 established his own gallery there. An illustrious career still lay ahead when Taber penned the article, below, to the *Philadelphia Photographer* in 1881. In 1888 he was named a commissioner of the Yosemite Valley area, which was formally established as a park in 1890. He photographed Queen Victoria's Jubilee in 1897, and later made portraits of King Edward VII. In the San Francisco earthquake and fire of 1906, he lost an estimated 80 tons of portrait negatives and another 20 tons of view negatives, an irreplaceable visual record of early California history.

In response to a query that has been put to me respecting the chief features of difference from the photographer's point of view between California and the Eastern Atlantic States, I will place myself on safer ground if I confine my localities of comparison to San Francisco on the one hand and the State of New York and north of it on the other.

As a photographer in San Francisco, I am very proud to find that public opinion has issued its pronunciamento that the quality of photographic portraiture in that city is somewhat higher than in any other city in the United States. This statement I do not make with any feeling of boasting, but merely to serve as a text, or rather a pretext for an inquiry into the reasons why the city within the Golden Gate should have this honorable position conferred upon it.

The great skill of photographers elsewhere—New York City, for example—being conceded, it is evident that it must be to something else than either artistic ability, chemical talent, or manipulative dexterity to which the Queen of the Pacific Coast owes its proud position.

One great cause lies in the equable temperature that prevails in San Francisco.

Owing to causes to be referred to presently, the heat is not so great there during the summer months as it is in New York, while during the very depths of winter it is so mild and genial that flowers and creeping plants upon the walls of the houses are in full bloom at the time when with you in the East the thermometer stands in the vicinity of zero, the water in pipes and tanks being all frozen, and the air so keen and sharp as to inflame one's face if exposed to a blast of it.

Is it to be wondered at if chemicals to be made use of in such a delicate operation as photography do their duty in an imperfect manner when furnaces or lamps have to be kept alight in the operating room to prevent the solutions from solidifying by the cold? The great wonder is, that under such circumstances they work so well as they do. It is a well known axiom that all chemical action is assisted by heat, and, if this be so, what kind of action can be expected when intense bitter cold is prevalent? The most favorable condition for working chemicals assuredly is not to be found when they are liable to become frozen out at night and have to be thawed down before getting into working condition in the morning.

Now, in San Francisco, we entirely escape this source of failure or difficulty, for, as I have said, a temperature of the nature indicated above is there quite unknown. The weather being invariably genial and mild, the chemicals always keep in good order so far as concerns the influence of temperature upon them.

Then, again, in summer, we are altogether unacquainted with that oppressive heat that prevails in the Eastern cities, and which necessitate lumps of ice being kept around the bath, collodion, and other chemicals. I have heard an Eastern photographer say that he has seen collodion frizzling on the plate when poured on, such was the heat of the latter. This is a kind of experience that is totally unknown in San Francisco. Even in the middle of summer there is a fine cool wind that blows in from the Pacific by which sultriness is altogether prevented. Our chemicals, therefore, are by comparison kept cool in the summer and warm in the winter by atmospheric agencies alone. In this, I think, is to be found the secret of the excellence of the photographic work here, coupled doubtless, with an admirable and strong light.[506]

Frederic E. Ives's patented "swelled-gelatine" photoengraving process was used to achieve improved halftones (in the printing plate) in reproducing this illustration by William Hamilton Gibson for E. P. Roe's book, *Nature's Serial Story*. Typographic plates with halftones could also be made directly from a photographic negative by Ives's new process (see page 369 for a pioneer halftone reproduction of a photograph of Edward L. Wilson, which was made by Ives's process and reproduced on soft paper in the June 1881 issue of *Philadelphia Photographer*).

visited me. . . . The fact that I spent so much time alone in this room made my next door neighbors suspicious about my occupation, and they reported to Government Secret Service agents that they thought I might be a counterfeiter. The agents visited me, but all the money I could get above living expenses at that period went promptly into new experiments and they could find no money of any kind in my place or upon my person.[507]

In Europe, meanwhile, photoengraving modes using a screening process, such as Baron von Egloffstein had used in 1865, were adopted by Joseph Swan in 1879, and by Georg Meisenbach, a Munich engraver, in 1882. These were single-line screens which were rotated or turned during exposure with a negative to achieve a cross-line effect in the image secured on the sensitized printing surface. A year later, Ives developed a "cross-line" screen (not introduced commercially until 1886) which consisted of two single-line screens cemented together face-to-face at right angles. Presumably, this materially enhanced his photoengraving process, however in later years he made the statement that at the time he made the change to the cross-line screen, none of his customers "discovered any difference in the character or quality of my work." But throughout the remainder of the 1880s, Ives's plates were still no match for a sturdy typographical press (used in type printing) because the screening was too fine for the printers, and the illustrations so prepared had to be printed separately, and usually on paper of a high-gloss character. Ernest Edwards, in one of his many reviews of the photomechanical printing art, agreed that the results were "not satisfying to the photographic eye" in mechanically produced photoengravings, but said there was no getting around the fact that "in order to approximate the photographic effect, the lines or dots have to be so fine that the cuts cannot be satisfactorily printed with type."[508]

Nevertheless, as the decade wore on—and particularly after the introduction of the cross-line screen—more book publishers utilized photographically produced halftone engravings, and an increasing number of such illustrations began to appear in such magazines as *Harper's* and *The Century*. In 1886 the *Philadelphia Photographer* "noticed" that Ives's process "is preferred by many leading publishers," while similar work produced abroad, the magazine said, should be classed as "miserably bad," and "wretchedly printed."[509]

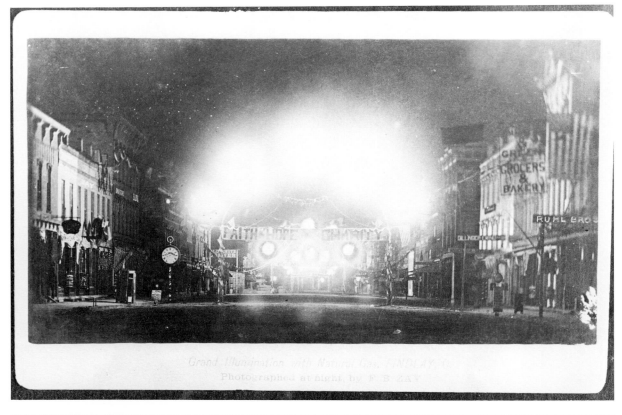

Prior to the 1890s, photographers rarely attempted to make outdoor nighttime photographs even with the aid of artificial light, because of the long exposures required. The top view (above) is from a cabinet card print which the photographer evidently secured by pointing his camera directly at a carnival scene illuminated by gaslight. In the bottom view, reproduced from a late 1880s card stereograph, the unknown photographer (or others) may have walked about on the street during the timed exposure carrying a lantern, which would account for the thin, wavy lines of light appearing on the sidewalk in front of the Palace Saloon (left) and crisscrossing the street to H. I. Brown's City Restaurant (right) and other buildings in the background. The town where the photograph was made is not known.

1882

278

1882

When electric light was used to illuminate an exhibition at Baltimore's Maryland Institute in January 1879, the *Photographic Rays of Light* found it "too unsteady or flickering for photographic purposes," but added: "We understand, however, that Mr. Edison has overcome this difficulty." And so he did; by September 1882, an Edison-built power generating station had been installed in lower Manhattan, for example, which was able to light up fifty-nine buildings. Although costly, this lighting was suitable for indoor photography. But exposures by electric light in photographers' studios remained about twice as long as for those made in daylight, depending on the power of the available electric light, through the 1890s.

Electric lighting installed on the exterior of buildings, or in parks, did not lend itself quite so readily, however, to outdoor night photography. Photographs were made of the Perry Monument in Cleveland by electric light in March 1882 (see next page), but the amount of time required for the exposures ranged from 3 to 4 *hours* each.

Although a few portrait galleries made a specialty of taking likenesses by the aid of electric light, it was not extensively employed for either indoor or outdoor photography during the remainder of the century. The chief problem was the high cost of its use, but it was still used to a greater extent in the United States than in Europe because of the more extensive lighting of buildings in American cities.

William Kurtz was the first to adopt it as a specialty in the fall of 1882. A year later he gave this brief description of the lighting system he used, comparing it to the system used in London by Henry Vanderweyde:

> I thought it would be best to build a chandelier, so that instead of being a slave to the light, the light becomes my slave, and this is brought about by arranging the six different lights so that each may be separately directed to the spot where the single subject or group is posed. The light falls at an angle of 45 degrees on the sitter. I have two lights near the ceiling, one about a foot from it, the other in the middle of the room. The lamps are the same as those used on the street, and the light is always available. This system of mine is much better than Mr. Vanderweyde's, because with his there is a single light only, while I have many lights, each of which diffuses with the others, thus neutralizing their individual shadows. I do not claim originality, but have simply adopted the plan universally employed by the artists all over the world, and applied it to photographic portraiture. There is no patent on it. All are welcome to it.[510]

Electric light brought a new brightness and bustle to cities at nighttime, and this tended to focus increasing public interest on theatrical personalities, adding further to an already popular "craze" of collecting cabinet card and carte de visite portraits of celebrities in all fields. A burgeoning of sales of card portraits began in the 1870s, principally motivated by photographers such as Sarony, Kurtz, José M. Mora, C. D. Fredericks, and Frederic Gutekunst—all of whom used photomechanical printing to some extent. These men set the style, using elaborate studio backgrounds, the "Rembrandt" effect in lighting (comparable to the effect

People's Picture Gallery,
LEE & STARNER,
PHOTOGRAPHERS,
COR. FOURTH & WALNUT STREETS,
WILLIAMSPORT, PA.

Photographs Taken by Electric Light.

The cabinet photograph (top) of three brothers, presumably triplets, was made with the aid of electric light, according to the photographer's printed statement on the reverse side of the card (bottom). But although it was considered an inducement for patrons in this instance, electric light was not widely used for making studio portraits in the nineteenth century.

CLEVELAND PARK.

CLEVELAND'S PERRY MONUMENT IS PHOTOGRAPHED AT NIGHT BY ELECTRIC LIGHT

On the night of March 14, 1882, the Cleveland photographer Liebich made two photographs of the Perry Monument in Cleveland's public square with the aid of electric light. He used a stereoscopic camera with a Dallmeyer rapid rectilinear lens and gelatine dry plates. His exposures ranged from an incredible 3 hours for one stereoview to 4 hours for the other. Although he sent prints to *Anthony's Photographic Bulletin,* his views are not known to survive. The Cleveland *Leader,* in an article published two days after the feat, termed it "the first successful outdoor photograph by the electric light," but this was in error. John A. Whipple, of Boston, made two photographs by electric light of the Fountain in Boston Common on the evening of August 6, 1863. These prints are also not known to survive, although they were exhibited at a meeting of the American Photographical Society at the time. Whipple used a Voigtlander camera and made his exposures in only 90 seconds at full aperture. When Liebich made his photographs in Cleveland Park, the Cleveland *Leader* reported that the light on top of the 260-foot mast was twice as strong as the full moon, and double that of the gas lamps which formerly illuminated the park. The newspaper gave this description of one of Liebich's photographs:

The photograph has many peculiarities. Unlike moonlight photographing the sky is dark, and the foliage and surrounding objects remarkably clear and light. The small branches, and even the bark on the trunks of the trees, are distinctly visible. A miniature marten's house in the limbs of a tree far beyond the monument, at the corner of the park, is so perfectly photographed that the doors and windows are visible. The masts, anchor posts, and wire rope with its swivel, are portrayed clear and distinct, while even the shadow of the little railing that surrounds the drinking fountain is clear cut on the grass, the perfect detail of which is visible. In the distance the effect is alike remarkable. The buildings show as clearly as if photographed in the sunlight, and even the displays in dry goods windows across the street are seen while the sign "dry goods" on the side of the building can be read without the aid of a glass. Looking down Euclid Avenue one can easily read the signs, one of the most distinct of which is Brainard's, which is more than a block distant from the camera and nearly two blocks from the electric light. The white telegraph poles, with their outspread arms, stand out as distinctly as in daylight. But the monument itself, the central object of the photograph, is perhaps more remarkable than the surroundings. It would be difficult to get any picture with the corners and details cut sharper or more distinct. The shadows seem even more distinct than in sunlight photographs. Every detail of the sculpture is clear and the name of Oliver Hazard Perry can be read, while the inscription under the medallion itself, can be easily traced. All the weather stains on the front of the monument show up with a familiar distinctness.[511]

achieved in oil portraiture by the seventeenth-century Dutch master), or a dramatic and—for the first time—an artistic attitude toward posing. The interest in theatrical celebrities caused "runs" on orders for cabinet portraits of different actresses every year. In the early 1870s, this had been a highly profitable business for the innovators, but by 1880 the market had become glutted with cheaper-grade photographs sold by small shopkeepers and street peddlers. As one New York dealer told a *New York Times* reporter in November 1882: "People will scarcely pay fifty cents for a portrait when they can get the same thing, with a little less finish, for five cents."

The actress whose photographs were most in demand in 1882 was Mary Anderson. "She has sat for more pictures than any other woman who ever lived," according to the article in the *Times*. "It is no exaggeration to say that her photographs outsell those of any other actress two to one. She has been taken, it may be, a thousand times by every first-class photographer in the country in every possible attitude and character." Photographs of Lillian Russell ranked in popularity along with those of Mary Anderson, according to another account just three months later. Among the male attractions, the assassination of President Garfield had caused his portrait to be the heaviest in demand. As the New York dealer just quoted expressed it:

> Nothing has ever found so extraordinary a market as the Garfield pictures. The day after the President died the rush for those that had characterized his illness was trebled. One man came to me and said: "I want a million cheap photographs of Gen. Garfield and family in all the styles you have at 48 hours notice." I couldn't supply him, of course, but I kept 300 negatives running, got out ten thousand a day for three months, and couldn't begin to fill the orders.[512]

There were, just in New York City alone, half a dozen dealers at this time who handled nothing but photographs of noted people—actors, actresses, authors, lecturers, soldiers, preachers, statesmen, and politicians. The combined annual sales of these dealers was estimated by the *New York Times* to total "several hundreds of thousands" of dollars. Peddlers hawking cheap photographs on the streets multiplied tenfold after 1880, and their aggregate annual sales, according to the *Times,* totaled "a million dollars or more." American copyright laws protected American photographers from piracy of their negatives, but there was no international copyright law to prevent others (including American photographers) from copying photographs made abroad, either of foreign or American celebrities. In addition, all American-made photographs of a particularly popular celebrity were not copyrighted, because of the expense involved.

Just as the portrait of a particular actress would be "all the rage" for a while, only to be followed by that of another, so events, too, held sway on the market. In an analysis of the subject published on February 25, 1883, the *Times* observed:

> Each exciting political, social, or business event that brings into prominence certain persons is sure to be followed by a deluge of the photographs of the conspicuous individuals. The last election in this state, for instance, caused a widespread demand for the photographs of Grover Cleveland, the Democratic Governor. People are still buying his pictures out of curiosity to see

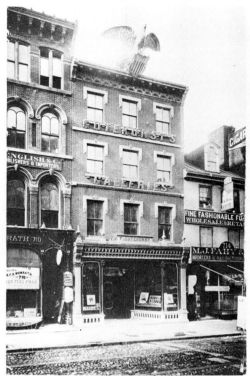

PHOTOTYPE.
(PHOTOGRAPH IN PRINTER'S INK.)
F. GUTEKUNST'S IMPERIAL GALLERIES,
712 Arch Street, Philadelphia.

Frederic Gutekunst, whose Philadelphia gallery is depicted in a circa 1870s photograph (top), and William Kurtz (bottom) adopted photochemical printing techniques to enlarge volume of sales in cabinet card and other photographs of people prominent in politics, the theater, business, and other walks of life. Gutekunst opened his gallery in 1856 and operated it until his death in 1917. Kurtz operated his at Madison Square, New York, until the turn of the century.

A EUROPEAN ESTIMATE OF AMERICAN PATRONS

Among the most noted photographers of celebrities was José M. Mora, a refugee from the Cuban revolution of 1868. Mora learned his trade from Napoleon Sarony, then established his own gallery in 1870 at 707 Broadway. In January 1881, he gave this view of what European photographers thought of their American customers:

> AMERICAN people enjoy the reputation of being the most fastidious and troublesome in the world in regard to sitting for their photographs.
>
> Of course it is only by intercourse with the photographers of other nationalities that we can arrive at any correct idea of the national peculiarities and idiosyncrasies of their sitters, and when I was in Europe two years ago, and visited many of the leading photographers in Paris and London, I was invariably made aware of the fact that when they were about to take portraits of Americans they entered upon the task in the full assurance of having to take them at least a second time, no matter how perfect might be the pose and the negative made by a first attempt. They insist upon their re-sit apparently for the excitement and pleasure it affords themselves and the desire to have a selection, quite oblivious of, or professing to ignore, the fact that such repeated sittings entail expense to the photographer, whose valuable time is also wasted upon efforts which he knows are unneeded, and ought not to be called for.
>
> European sitters do not appear to be so unreasonable ; or then the artist there makes them feel that *he* is the master of the situation, and it is for *him* to decide upon the merits of the picture. Said an eminent French artist to me : "I invariably make the best possible pose the first sitting ; and why then should I take a second, which is thus certain to be inferior to the first if I make any alteration ?"
>
> Alluding to the prevalent multi-pose fashion in the New World, my French friend inquires why this is so, and whether American photographers are not themselves to blame for thus educating the people by pandering to unreasonable and, in many instances, whimsical and silly demands.[513]

IN MEMORIAM: JOHN W. DRAPER, LL.D.

Prof. John W. Draper, one of the acknowledged "fathers" of American photography, died at his home at Hastings-on-Hudson, New York, on January 4, 1882. For most of his life he served as professor of chemistry, and later head of the New York University Medical College. Princeton gave him an LL.D. in 1860, and during the Civil War he served as one of the U.S. commissioners, inspecting hospitals after the battles of Antietam and Gettysburg. In 1875, the American Academy of Science and Arts awarded him its Rumford medal for his researches in radiant energy, and in 1876 he was elected the first president of the American Chemical Society. He was the author of numerous works, including a three-volume history of the Civil War, but his most celebrated book was the *History of the Conflict Between Religion and Science,* published in 1874. This book passed through twenty editions in the English language, and was translated into the French, Spanish, German, Dutch, Russian, Portuguese, Polish, Italian, and Serbian languages. Rome placed it on her "Index Expurgatorius," with the result that Prof. Draper joined Galileo, Copernicus, Kepler, Locke, and Mill on the list of those under the ban of the Catholic Church.[514]

the man who received the largest majority ever given to any candidate in a single state. . . .

Since Chester A. Arthur's elevation to the Presidency his portraits have had a fair sale, which has increased notably during the last few weeks, probably owing to the prominent figure that he occupied during his recent very brilliant social season in Washington. Ex-Senator Roscoe Conkling and the Hon. James G. Blaine are about in equal demand among the photograph buyers. They both rank as "first class staple goods." Although there has been a great falling off in the demand for Gen. Grant's pictures during the last few years, the "hero of Appomattox" still has an excellent rating among the picture-dealers and he is credited with selling the best of any of the war Generals. Next to Grant comes Maj. Gen. Hancock, Gen. Sheridan, Gen. Sherman and Gen. McClellan. According to some of the sellers of photographs there is a steady and a considerable demand for photographs on the part of persons who are engaged in getting up classified sets for preservation. One buyer will want a set of military heroes; another buyer will want a complete set of the Presidents of the United States, a third will want a "set" of actors or actresses, and a fourth, perhaps, will want preachers or literary people. Of the Presidents there are three who outsell all of the others fifty to one. Those three are Washington, Lincoln and Garfield. Of the preachers, Henry Ward Beecher is, and has been for years, the most salable in a photographic sense. . . . Of the literary celebrities, Longfellow's pictures are in the greatest demand at present. There was a brisk sale of Disraeli's and George Eliot's photographs at the periods of their respective deaths, but the American people seem to care much more for the pictures of their own native born authors than for those of foreigners, no matter how popular and gifted the latter may be.[515]

1882

282

LILLIAN RUSSELL
IN "THE PRINCESS NICOTINE"

Schloss — 57 West 23rd St.
New York.

Mora 707 BROADWAY, N. Y.

PORTRAITS IN GREATEST DEMAND

Cabinet card portraits which sold the most in the early 1880s were those of actresses Lillian Russell (above), Mary Anderson (above, right), and James A. Garfield (right), whose assassination in 1881 caused his likenesses to become the heaviest in demand of any male portraits. Frederic Gutekunst of Philadelphia reportedly compiled the largest collection of celebrity cabinet card portraits.

PACH, PHOTO N. Y.

SENATOR JAMES A. GARFIELD.

1882

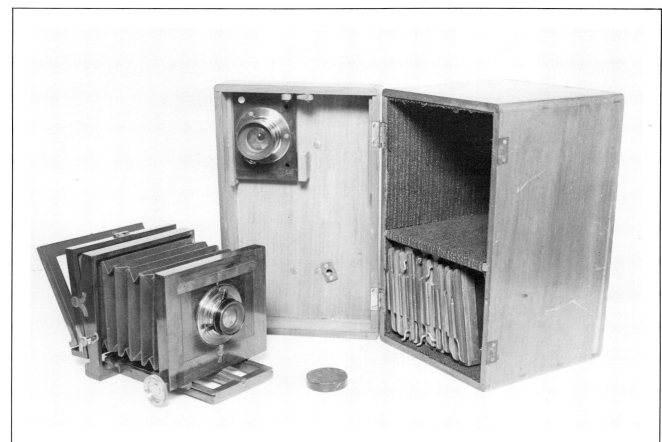

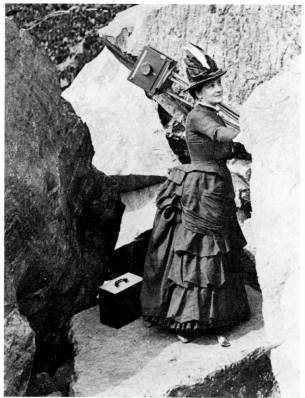

PORTABLE VIEW CAMERA

The American Optical Company's portable view camera (above), introduced in 1883, is typical of a new style of compact, easily transportable camera placed on the market at this time to appeal to members of a growing number of new camera clubs. The camera and tripod, held by an unidentified amateur photographer (left), is believed to be one of the American Optical Company's view cameras, whose carrying case is shown on the ground. Four years previous to this, a woman carrying and operating such a camera in the field would have been considered a curiosity. At that time, *Anthony's Photographic Bulletin* observed, "few towns indeed boasted the distinction of possessing such an individual, and the general public knew as little of such a personage as of amateur surgeons." But now, the magazine said, "thousands of pictures are being taken outside of the profession where one was taken before." The new amateurs "go into the highways and hedges, and secure negatives that no professional would have considered profitable to take. They become, as it were, omnivorous, and seize upon everything that comes in their way, which is capable of being photographed." Perhaps the new American Optical camera proved particularly attractive to photographers in Baltimore who, only four years earlier, were characterized by David Bachrach as being "far behind in outdoor photography." American Optical had a major outlet in that city in the Richard Walzl organization, which in 1883 functioned not only as a dealership for American Optical equipment but at the same time operated three photographic galleries in Baltimore.[516]

1883

284

1883

On two occasions in 1881, an English amateur photographer, Thomas Bolas, described in a British photographic journal the design of a hand-made box camera which he labeled a "Detective" camera because of its inconspicuous nature, and the minimum number of "suspicious looking features" used in making photographs with the device. As is frequently the case with a revolutionary new product, established manufacturers failed to see the immediate potential.

Two years later, on January 3, 1883, William Schmid, of Brooklyn, New York, was awarded an American patent for the first commercial version of the hand-held "Detective" style box camera. It weighed 3.3 pounds, and provided a rectangular viewing window which enabled the user to see the photograph he or she was about to take. The rear of the camera accepted one double plate holder, which could be used twice to make a 3¼ x 4¼ exposure on a glass negative. Schmid assigned his patent to E. & H. T. Anthony & Co., enabling that firm to be first on the market with this revolutionary style of camera.[517]

Other cameras came on the market at this time which also played significant roles in the coming boom in amateur photography. One was a small, square "pocket" camera developed by William H. Walker & Co., of Rochester, New York, which would make single exposures of 2¾ x 3¼ inches on a dry plate. The camera was designed for use on a tripod, but its most unique aspect (from the amateur's standpoint) was that it was manufactured of interchangeable parts, which allowed easy parts replacement. In addition, it was sold as part of a complete photographic outfit, consisting of chemicals, darkroom accessories, printing paper, cards for mounting finished prints, and an instruction booklet. To anyone who would form a photography club and send in an order for five cameras (which could be purchased separately), an additional camera was offered free. In another "first," Walker placed advertising for his camera in more popular magazines, such as *The Century,* as well as in the standard photographic journals.

The American Optical Company, noting the rapid growth in photography clubs and "outings," placed an attractive portable "American View Camera" on the market which provided compact space for a camera and carriage of up to a dozen dry plates (see opposite page).

Another "Detective" camera was introduced in 1855 by H. V. Parsell, and H. V. Parsell, Jr. (see next page). It was a rectangular box design patented by the father-and-son team. According to their promotional literature, the Parsells designed the camera "to resemble a lady's reticule, or a case such as a physician frequently carries." Following the placement of the Parsell camera on the market, E. & H. T. Anthony & Company's principal competitors, Scovill Manufacturing Company and the Blair Camera Company (of Boston), joined in the competition, and thus began photography's mass merchandising of hand cameras in a variety of forms which has characterized the camera market ever since.

William Schmid's "detective" camera, patented January 2, 1883, was the first of the hand-held, box style variety produced in the United States which could take "instantaneous" pictures in the manner in which candid pictures are taken today. Camera was marketed by E. & H. T. Anthony & Co.

The Schmid camera, a year after its introduction, was said by its manufacturer to have "practically revolutionized" the taking of instantaneous photographs:

Until very recently, the taking of an instantaneous picture was not a work to be undertaken without a great deal of preparation, and so much apparatus, that few except the most courageous amateurs dare face the inevitable crowd, which in all public places attended the artist, without at least one assistant. A picture in a crowded street, a workshop in any busy corner where interesting subjects were to be found, was as impossible as to set up an instrument in the centre of Broadway upon a week day.

The Detective Camera, however, has practically revolutionized the taking of instantaneous pictures. This small sized, complete, portable instrument, with the still more complete methods of controlling the exposure, is what its name denotes, a Detective Camera, capable of being used in almost any situation. It is so compact that it may be taken under the arm and a lady might without attracting any attention go upon Broadway, and take a series of photographs, feeling perfectly sure that she would attract no more attention than she would if she carried a work-box or work-basket. With such an instrument, all fields are open to the amateur. His apparatus can go with him wherever he can carry it, and whenever there is sufficient light for work he is enabled to seize his subjects at the very best moment and secure effects which are utterly beyond the reach of one who has to travel with a more elaborate apparatus. [518]

The Parsell camera (shown above) made dry-plate photographs of size 2.5 inches square. The camera could hold six double plate holders, one in position for taking pictures and five in a rear compartment. A shutter mechanism allowed taking of either timed or instantaneous exposures.

But with the mushrooming sales of new dry-plate cameras of great variety, there was now, as Anthony's *Bulletin* observed, "scarcely a limit to the size of prints of this character that can be produced." The magazine marveled at instantaneous photographs of size 12 x 15 inches which George Rockwood made in February 1883 of a yacht under full sail. Rockwood followed this in May by hiring a steam tug to go out into New York Bay at the time of the opening of the Brooklyn Bridge, where with some sixteen operators and assistants he made 160 exposures of moving objects in the bay on plates ranging in size from 5×8 inches to 14×17 inches. Rockwood wrote Edward L. Wilson with considerable pride that he had secured "over a hundred good negatives *of* these moving objects, taken *from* a moving object." Responded Wilson: "Who can beat it, and what other process [gelatine dry-plate process] makes such a feat possible as this?"[519]

Most of the new dry plates being offered commercially were about ten times as sensitive as the wet collodion plates previously in universal use. To some, this sensitivity was not recognized at first, and after overexposing their plates they complained of the results. Even George Eastman ran into trouble because of his (and presumably everyone else's) failure to understand, precisely, what it took to preserve the sensitivty of the gelatine in supplied dry plates. A sulphur-bearing compound was required, but this was not at first recognized. When complaints began to come in about the sensitivity of Eastman's plates (relayed through the Anthonys), Eastman closed down his Rochester plant and rushed to England to purchase the best plate formulae for comparison with his own. The problem was quickly recognized thereafter, and Eastman renewed his manufacture, refunding the purchase price on all spoiled plates.

1883 Problems or uncertainties lingered among professional photographers, as well as amateurs, in their use of dry

286 plates. "I would like to hear of the quickest way of fixing

gelatine negatives, with which I have had trouble," Benjamin J. Falk stated at a meeting of the Photographic Section of the American Institute on January 2. This led to a discussion on the pros and cons of using cyanide, after which the chairman, Henry J. Newton, asserted:

> In my experience in trying different makes of emulsion gelatine plates, I have found no two have worked just alike, especially in the fixing, and from my observation I have learned that the makers as a rule went upon the principle of getting on all the gelatine they could, depending on its quantity rather than bromide of silver to produce the picture. Now it may seem like economy, but I think it is very poor economy, because if I can coat two plates with an ounce of gelatine and the proper quantity of silver instead of one, by putting it on thin I economize. Some commercial plates will fix as quick as collodion emulsion, so much depends on the quantity of gelatine used.[520]

Dr. Hermann Vogel, who once again visited the United States to attend the annual convention of photographers, indicated that similar problems were being encountered in his country. "There is much more difficulty to fix and to work out a gelatine plate than a collodion plate, especially if the first be reinforced by mercury salts, and many careless photographers who look after their gelatine negatives of the past year find them discolored and useless to make a print from." Elsewhere in his speech, Dr. Vogel alluded to the importance of amateurs throughout the history of photography's development, most recently in perfecting the gelatine dry plate. Then he made this rather profound analogy:

> We have a very interesting instance in Germany that amateurs elevate the art. Why is Germany the most musical land of the world? Why do you find music there more appreciated than in any other part of the world? Because we have so many musical amateurs. And in spite of the numerous amateurs, the position of the musician in Germany is an excellent one; they are esteemed there more than in any other country.[521]

The swelling of the ranks of amateur photographers, both in Europe and the United States, was just beginning to take place at this time. Soon, this phenomenon would be followed by various movements seeking to achieve "aesthetics," "naturalism," or "impressionism" in photography, and within a decade amateurs would organize the first major exhibitions of artistically rendered photographs at museums in Germany. But for the time being, there remained what one photo historian has characterized as a "dearth" of artistic expression in photography the world over.

A loosely organized revolt against the alleged "conservatism" of the National Academy of Design's leadership in the art world does appear, however, to have had an effect on photographic portraiture. The New York author and art critic Charlotte Adams pointed this out in a series of articles which appeared in the *Philadelphia Photographer* in the summer of 1883:

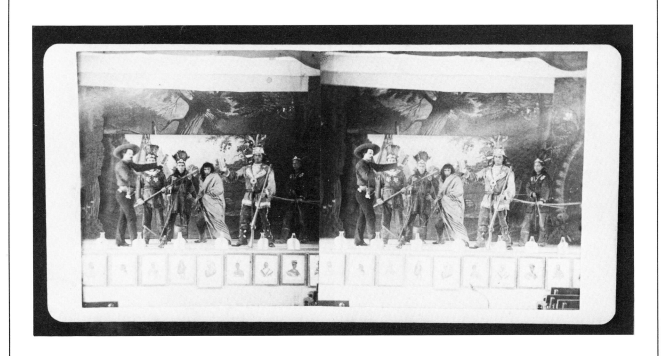

ACTORS PHOTOGRAPHED ON STAGE WITH THE AID OF ELECTRIC LIGHT

At midnight, May 2, 1883, Benjamin J. Falk made a celebrated photograph of the cast of ''A Russian Honeymoon'' on stage at the Madison Square Theater in New York, using thirty electric lights suspended from the ceiling around the theater. ''The result obtained,'' Falk said after the feat, ''seems to establish beyond a doubt the fact that the electric light in large quantity can be managed photographically to exactly imitate the effect of sunlight over an extended surface; also that it exerts almost identically the same actinic force on the sensitive plate.'' Although considered a ''first'' at the time, Falk's achievement was preceded by a similar undertaking accomplished three years earlier by William Notman, who photographed a group of Harvard students on stage in the Greek play ''Oedipus'' at the Saunders Theater in Cambridge, Massachusetts. ''The thing was with Mr. Notman more an experiment than a speculation,'' the *Photographic Times* noted later, ''and it cost him about $500 to put in the apparatus and accomplish the deed; but the pictures were so admirable that he unexpectedly *cleared* by the sale of them about $1,000.'' The stage scene depicted in the card stereograph above is undated, and unidentified as to location or performance, but appears to have been made in the 1880s.[522]

GEORGE G. ROCKWOOD

One of the little known sidelights of history is the fact that some of the earliest photographs ever taken of moving vessels from the deck of another moving vessel were those made by George G. Rockwood during the colorful ceremonies attendant to the opening of the Brooklyn Bridge in May 1883. Rockwood was managing editor of a Troy, New York, daily newspaper when he took up photography in 1853, and moved to St. Louis. He had established his first New York gallery when, reportedly, he made the first carte de visite photograph in America (in 1859), of Baron Rothschild. His first female patron was Mrs. August Belmont, of whom the first American vignetted carte de visite was also reportedly made. "Probably few photographers have personally made so many sittings," *Anthony's Photographic Bulletin* observed in 1881. The estimate then was 113,000. Rockwood experimented with photoengraving in the mid-1870s, but is not known to have been successful in this venture. He is credited with being among the first to adopt use of Eastman's dry plates. Rockwood's gallery was located at 17 Union Square in New York.[523]

The great art-movement which has been going on all over the country during the past few years, has naturally influenced all those branches of art, which, fundamentally considered, are also mechanical processes, and, proportionately, the claims of photography to rank as an art, have been increasing in strength and importance. A new school of photography is arising, notably in New York, the actual art center of the United States, which bears about the same relation to the old that the younger body of American artists does to the elder. This new school of photographic art is not satisfied with merely producing likenesses of literal representations of figures or objects. It accords to its subjects, and seeks to employ in its methods, approximately the same treatment that would be given to a picture in oil or watercolor. Pose, composition, both of ensemble and of detail, warmth or coldness of tone, breadth, force and delicacy of treatment, effects of light and shade, the various qualities of color produced by different handling of black and white, are all considered by the artistic photographer of today. The progress of American photography is keeping pace with that of American art, and the relation and reciprocal influence of these two forms of artistic production, hitherto considered widely distinct, are every day becoming closer and more powerful. The term "photographic" is losing its contemptuous significance as applied to the character of a picture, and on the other hand, the highest praise that can be accorded a photograph is to say of it that it is artistic or pictorial. It is to the younger American artists that photography owes much of its present impulse in the direction of artistic development. This has arisen partly from the general interest which has been awakened among artists at large, with regard to reproduction processes—the so-called "mechanical processes" of various kinds—and partly from the fact that photography is largely employed in engraving and kindred arts of illustration, forcing a sort of interpretive medium between artists and the public. Many New York artists are now directly interested in photography, some for the sake of the art itself, others for the advantage of being able to photograph their own works, others in order to catch a fleeting landscape effect, and others for convenience in painting accessories. . . .[524]

Despite such encouraging signs in photographic portraiture, David Bachrach was at the same time lamenting the loss of taste and quality in American stereophotography. In an article suggesting an improvement in stereoscopes, he lashed out at what he called the "decadence" of stereo pictures currently on the market:

> There is not a man in this country who has the backbone and grit to get up a reputation and command the prices of Mr. Wilson, of Aberdeen, whose views, in my opinion, have never yet been equaled, both for selection and execution. When we do as he does—keep only the best negatives; work for quality, not quantity; issue only the best prints and make a reputation gradually, and adhere at the same time to living prices—then, and not until then, will the better class of patrons again take hold of them. Is it not about time to learn the lesson taught by the "chromo?" To cheapen art in quality and price is to kill it. In this country we are short-sighted. Everything is done for present profit, leaving the future to itself. No sooner does anything pay than a horde rush into it and kill the goose that lays the golden eggs.

VOGEL COMPARES AMERICAN, EUROPEAN PHOTOGRAPHY

Attending a national American photography convention for the third time, Dr. Hermann Vogel made this analysis of the photography scene:

Thirteen years ago only a few American pictures reached us in Europe; to-day we find in every art shop window of Berlin American pictures, and they are sold by our photographers as masterpieces. We have introduced into Europe, American cameras and American backgrounds. If you have learned in the past from us, we now learn from you.

Very often I am asked, What is the difference between American and European photography? Is there any in general? It is true you use the same lenses, the same apparatus, the same chemicals and papers as we do. The main field of photography is in America and Europe the same—the portrait, the likeness. You retouch the negative as we do, and, are anxious to improve the artificial qualities of a picture. But in America you have not so many portrait painters as we in Europe. Life size photographic pictures are an exception in Europe, because our painters make them, while in America the life size picture is an important branch of portrait photography, and, I must confess, in this branch American photography goes ahead.

Still more difference I observe in landscape photography. The stereoscopic picture is much more esteemed in America than in Europe; I think there is no parlor in America where there is not a stereoscope. The main difference is that photography in America is much more esteemed by the scientific men, by the men of industry, and the people in general, than in Europe. If any scientific expedition is sent to the far West or to any part of the world from America, certainly a photographer will join it. More than that: American photographers have been the pioneers and have told by true pictures to the world the wonders of the mammoth trees of the Yosemite Valley and the Columbia River before scientific men reached there. American photography has more merits for geographical knowledge than big hand books. In Europe, I am sorry to say, the scientific value of photography is only partially acknowledged.

A great many scientific men who intended to travel in Asia and Africa have visited me a few days before their departure, to learn in a hurry something of photography in twenty-four hours; and because photography is esteemed in America by everybody, its position is a better one, and the photographer is more honored than in Europe. [525]

WHAT CONSTITUTES ART IN PHOTOGRAPHY?

The veteran Civil War photographer J. F. Coonley gave these opinions on this subject at an 1884 meeting of the Photographic Section of the American Institute:

In looking over the great number of photographs that we see in such profusion, if we examine them critically we are forced to the conclusion that far the greater part of them were made by persons who have very little taste or education in the direction of art, and if the same tests were applied to them that pictures in an art exhibition are subjected to, but few would pass the ordeal without being terribly scarified. The same defects are apparent whether they are portraits or out-door views from nature. The most of them will be found wanting in one or more particulars, and not what they might have been if made by some one with more taste or cultivation in securing picturesque effects. This talent, or whatever you may choose to call it, is a natural gift born with the individual possessing it, and is capable of being developed to an extent often arriving at a degree of excellence so that anything it comes in contact with of this nature not in harmony with its ideas or feelings causes as palpable a discord to the feelings of its possessor as does a false note in music to the ear of an accomplished musician.

Pictures of all kinds, no matter how made or by whom produced, are a combination of effects, and the more harmonious and brilliant these effects can be produced, the nearer they approach nature and the ideal of the true artist. Without these characteristics they partake less of the artistic and more of the mechanical. Comparatively few of the great army of men engaged in photography ever attain a name or celebrity beyond a limited circle or local reputation. The great world beyond or outside never hears of them or knows that they have being. Those who do make their mark and become famous will be found in every instance to be men who have a natural talent in the direction of art, and in many instances have devoted years of their lives as professional artists in some of its various forms before they embarked in photography. The school they have thus passed through has admirably fitted them to assume and take position in its foremost ranks. They may be young in the business, but their natural gifts in art studies, and their former associations in this direction has enabled them to assume prominence by the superior quality of their works, and their names are household words in many lands. [526]

In 1883, the St. Louis dry-plate photography pioneer Gustave Cramer and his co-worker Herman Norden dissolved their partnership which had led to introduction (in 1881) of the first professionally certified dry-plate negatives in the United States (see page 271). Although Norden went into business for himself (first in St. Louis, then in the east), he returned to St. Louis in 1889 to take charge of a department in a much larger business operation which Cramer had by then established. Cramer continued to manufacture dry plates and other photographic supplies until the turn of the century.

The only way to check this tendency is to cultivate the public taste up to the appreciation of quality. [527]

But ironically, just the sort of revival Bachrach wanted was getting underway at that very moment—but as a vast and profitable business undertaking, not simply a revival or renewal of taste as exercised by individual photographers or the established publishers. In Kansas, the brothers Elmer and Benjamin Underwood (neither of them yet twenty-one) were arranging for a new distribution network for card stereographs west of the Mississippi, and in 1884 established themselves as the sole agents throughout the United States for Charles Bierstadt of Niagara Falls; J. F. Jarvis of Washington, D.C.; and the Littleton View Company in New Hampshire. Thus was launched the famed Underwood & Underwood enterprise which quickly revitalized the trade, principally through sales of boxed sets of stereoviews and through the packaging of whole series of expertly made and professionally approved views for educational instruction. The company pioneered door-to-door sales of stereoviews, and by 1901 was manufacturing views at the rate of twenty-five thousand a day. In the 1890s, another major competitor, the Keystone View Company, entered the field, ultimately purchasing the negatives of vast numbers of publishers, including Kilburn and (in 1912) Underwood & Underwood as well. [528]

1884

By 1884, vast numbers of new recruits had joined the ranks of amateur photographers, attracted by the simplicity of the new "Detective" and other hand-held or easily transportable cameras using dry plates. In the spring, *Anthony's Photographic Bulletin* said the increase was so phenomenal as to have no parallel in the history of any other art. The *New York Times,* on August 20, observed editorially that the new "camera epidemic" could be likened to the cholera disease then spreading throughout Europe. The "worst ravages" of the "true lamina sicca type" of the camera variety, the *Times* said, were occurring in the summer resorts of northern New York, and in Long Branch, New Jersey, and Newport, Rhode Island.[529]

But William Metcalf, writing several years earlier in the *Photographic Times,* had put his finger on a problem which continued to plague photography as well as other art forms in America. This was "a well-developed love for art," which he contended was wanting among Americans:

> Their reputation for mechanical ability is known the world over. No nation equals them for inventive genius. Their artistic qualifications—"aye, there's the rub"—are still slumbering, and will only be awakened when the fathers and mothers of the nation come to a realizing sense that the æsthetic side of their children's nature needs care and culture quite as much as those others which, until quite recently, have received exclusive attention. The common-school education which the American boy receives is quite enough to start him well in life, enable him to make a comfortable living, and perhaps a fortune; but his dormant sense of form and color has received no impulse, and he jogs on through the world cheated out of much that helps to make life worth living.
>
> When every pupil in every public and private school in the land shall be carefully instructed in the elements of drawing and coloring, not as an accomplishment merely, but as a part of his education as important as arithmetic, then, and not until then, may we hope to see more amateurs in every branch of art; then shall we also find in our decorative workshops American designers, places now filled almost without exception by foreigners.[530]

David Bachrach's career may be taken as typical of what Metcalf was talking about. At age thirteen or fourteen he served as a tintype photographer's apprentice, and at sixteen he was launched on his illustrious photographic career. Then came the years of stereophotography around the American circuit, followed by the opening of a gallery of his own when he was twenty-four. After that, as Bachrach

himself confessed towards the end of his life, he "had to acquire a little taste in posing and lighting, which took years to succeed with partially."[531]

But in the career of another famous American photographer, Alfred Stieglitz, we find a totally different story. Initially, Stieglitz's father took his son to Europe when Alfred was seventeen and entered him in the Berlin Polytechnic Institute, believing that the future belonged to engineers. But Stieglitz became attracted to photography after seeing an inexpensive camera outfit in a Berlin shop window, and when he learned from a co-student that Dr. Hermann Vogel was lecturing on aesthetic theory as applied to photography in another course at the Institute, he enrolled immediately in Vogel's class. "The other students," he said later, "had no inkling about the driving force within me." Stieglitz's sense of form and color was anything but "dormant," and now he was given that added "impulse" to embark on a career which not only helped to bring about but in the fullest sense *personified* a new dimension in American photography.

Stieglitz was less interested in Vogel's lectures on photochemistry and spent as much time as he could working in the Institute's laboratory. When he complained about restrictive hours of scheduling for their use, he was allowed to volunteer to be responsible for the rooms during hours of his own choosing. Dr. Vogel taught him the rudiments of focusing, curtain manipulation, and lighting control, and he soon began the practice of photographing an object—a brick wall, a plaster cast of the head of "Apollo Belvedere," etc.—in repeated exposures in an effort, as he expressed it, "to fathom the secrets of variations of light." In this early period of his studies, he also developed a preference for platinum paper over the standard albumen, using it almost exclusively until years later when it became difficult to buy. The blue-black appearance of the images printed on platinum paper he found much more to his liking, compared with what he characterized as the "hard, cold prints" on the albumen paper.

One day in 1884, Dr. Vogel asked to show some of Stieglitz's photographs to a group of distinguished painters. While Europe's awakening to the potential of artistic expression in photography was still several years away, it appears that this twenty-year-old American in Berlin was among the first to awaken this interest among some of Germany's leading artists. Of the group who were shown Stieglitz's prints, several expressed the desire to have copies; one, according to Stieglitz, remarked: "Isn't it too bad your photographs are not paintings. If they had been made by hand, they would be art."

Stieglitz at first worked the wet-plate process, but soon acquired dry-plate equipment. Speed in the taking, developing, and printing of his photographs became a mania with him, and when he was asked why this was so, he responded that newspapers would in future be reproducing photographs more frequently, and that speed would become of increasing importance in this type of activity.[532]

NEW YORK AMATEUR SOCIETY TAKES ITS FIRST FIELD TRIP

On June 20, 1884, shortly after the founding of the Society of Amateur Photographers of New York, a party from the society took a field trip on the Hudson River aboard a private yacht. Among those in the group was the society's founding president, Frederick C. Beach, an editor of the *Scientific American;* Beach's uncle, Moses S. Beach, a former owner of the New York *Sun;* and Henry J. Newton. The *Photographic Times* gave this description of the event:

The beautiful river and mountain scenery between Peekskill and West Point, on the Hudson River, was the objective locality selected, and afforded the party abundant opportunity to make picturesque photographs.

The party took the eight o'clock train from the Grand Central Depot, for Peekskill, and were met there by Dr. P. H. Mason, Moses S. Beach, and Mr. Atwood, formerly of New York. They were then conducted to the steam yacht "Zephyr," which lay at the wharf near the depot, by Dr. Mason and Mr. Beach. Cameras were now unpacked, mounted upon their tripods, and everything made ready for work.

Prior to their departure, photographs of the party were made by Mr Atwood, formerly of New York.

The light was excellent and the day very clear, the atmosphere having been purified the night before by thunder showers. Light clouds dotted the sky, casting their shadows upon the round and symmetrical mountain-tops, forming a superb background for the many landscape views which were secured. A light north-west wind made the sail up the river comfortable and agreeable. The following amateurs were with the party: Henry J. Newton, James B. Metcalf, P. Grant, P. Grant, Jr., Wm. Chamberlain, Gilbert A. Robertson, C. W. Dean, Dr. P. H. Mason, Jacque M. Rich, F. C. Beach, President, and Jos. S. Rich, Treasurer. Dr. Mason assumed command of the boat, and she was headed down stream for a short distance. Here Mr. Newton, Mr. Robertson, and Mr. Beach took a small boat ashore to obtain some views of the Raceway and Dunderberg mountain opposite. Continuing on up the river, the next excitement was the photographing of the "Chauncy Vibbard," as she passed by under the shadow of Dunderberg mountain, on her way to Albany. It was an interesting sight to see some seven or eight men standing on the deck behind their cameras ready to let go the shutters as the steamer speeded by, and the successive click of each shutter as the "Vibbard" came opposite the center of each instrument reminded one of the firing of guns by infantry in succession. Some good pictures were obtained, and their effect was heightened by the beautiful clouds which appeared at that moment.

Passing on, several views were made from the boat of the fine rock scenery which jutted abruptly into the water, and in a short time the party were brought to Iona Island, a locality noted for the height of the surrounding mountains and the beautiful scenery. Here all hands disembarked, carrying their instruments ashore; several views were taken, the one which proved the most attractive being that of Anthony's Nose, on the east bank of the river opposite the island.

On boarding the yacht again, the party were conveyed up the river to Garrisons, and *en route* refreshed with lunch, which had been provided by Dr. Mason. A few drop-shutter exposures were made on passing vessels. At Garrisons, a belated member of the party was taken aboard, and the boat continued on to West Point, the authorities there having kindly given Dr. Mason the privilege of landing.

West Point foot-way was ascended, in a broiling sun, by six or seven of the party, who were repaid for their labor in securing some fine views of the river and surrounding mountains. Pictures of the cadets and their camp were taken, and of portions of the celebrated Flirtation Walk which winds through the woods from the hotel to the wharf. Those who remained on the yacht were successful in obtaining excellent drop-shutter photographs of the steamer "Albany" on her way down the river.

At three o'clock, the whistle was sounded for members to return, and in few minutes thereafter the yacht started up the river. Some views of the Storm King and bits of scenery along the river were taken from the boat. She then turned homeward, stopping occasionally by the way for a view.

Shortly after five o'clock the party landed at Peekskill and took the six o'clock train to this city.[533]

The Paterson, New Jersey, photographer, J. P. Doremus, fitted out this floating gallery at a cost of $4,000 to make scenic photographic views of the Mississippi River and its tributaries, extending from the Falls of St. Anthony to the Gulf of New Mexico. The circa 1884 card stereograph was made of the gallery at Oceola, Wisconsin.

Possibly Stieglitz was influenced by the increasing attention which various photographic journals were paying to what was now characterized as "process work" (see page 294). Stieglitz's sentiments were expressed concurrently by others. George Gentile, in reporting on the progress of photography in the spring of 1885, for example, said "I predict it will not be long before every newspaper of any importance will have a photographer attached to their staff." *Anthony's Photographic Bulletin* foresaw "a new branch of the photographic business" wherein amateurs would play a new role (much like the modern picture agency) in servicing artists as well as illustrators:

> With such an army of photographers seeking every view which by any possibility can be made into a picture, trying every possible experiment and working with a zeal and courage that is worthy of all commendation, it seems as though their labors should be made remunerative not only to the individual but to the public. The most feasible plan that we have been able to devise by which the work can be utilized seems to be one which practically introduces a new branch of photographic business, and which may not only make the labor of the amateur profitable to the world but of pecuniary benefit to himself.

> We must remember that this is an age of illustrations, and every year brings with it an increasing use of pictures of every description, for amusement, instruction and pleasure. Indeed it would not be surprising if history should call this the beginning of the age of art. To the artist a "study," as it is called, is absolutely essential. Without studies, pictures of a high class would become well nigh impossible. To produce studies, however, requires much time and labor, and many artists are buying photographic outfits in order to enable them to obtain a certain kind of studies, which they need for various classes of their work, with ease and speed. Until the advent of instantaneous photography certain subjects were rarely attempted, save by specially favored artists, or those who were unusually gifted by nature with quick and accurate perceptions.

> Suppose now that at some central point an exchange or business agency be established where the army of amateurs can send

FIRST WHO'S WHO OF
DRY-PLATE MAKERS

The list below, published in January 1884, grew to nearly thirty by 1889, when the annual output of plates was estimated to have reached 80 million:[534]

John Carbutt, 628 Chestnut Street, Philadelphia, Pa.

G. Cramer, Buena Vista and Shenandoah Avenues, St. Louis, Mo.

Chicago Dry Plate and Mfg. Co., 2449 Cottage Grove Avenue, Chicago, Ill.

C. F. Richardson, Leominster, Mass.

M. A. Seed Dry Plate Co., 306 Walnut Street, St. Louis, Mo.

Monroe Dry Plate Co., Rochester, N. Y.

Neidhardt Dry Plate Co., 360 Milwaukee Avenue, Chicago, Ill.

Rockford Dry Plate Co., Rockford, Ill.

Allen & Rowell, Boston, Mass.

David T. Weld, Freeport, Ill.

H. Norden, 827 Chouteau Avenue, St. Louis, Mo.

Dumble & Mawdsley, Rochester, N. Y.

Inglis & Reid, Rochester, N. Y.

W. L. Colclough, 1846 Fulton Street, Brooklyn, N. Y.

Blair Tourograph and Dry Plate Co., 471 Tremont Street, Boston, Mass.

C. & V. E. Forbes 22 Tremont Street, Rochester, N. Y.

Hub Dry Plate Co., Mason and Aborn Streets, Providence, R. I.

Johnston Dry Plate Co., 14 Arcade Building, Buffalo, N. Y.

Crystal Dry Plate Co, 76 West New York Street, Indianapolis, Ind.

Iowa City Dry Plate Co., Iowa City, Iowa.

Challenge Dry Plate Co., 231 Centre Street, New York City.

I. W. Taber, San Francisco, Cal.

Dr. S. C. Passavant, San Francisco, Cal

G. H. McDonald, 289 West Madison Street, Chicago, Ill.

H. A. Hyatt, 411 North 4th Street, St. Louis, Mo.

New York Gelatine Dry Plate Works, Ralph Avenue and Monroe Street, Brooklyn, N. Y.

Eastman Dry Plate Co., Rochester, N.Y.

Hazenstab Bros., St. Louis, Mo.

Crowell Dry Plate Co., Rochester, Minn.

Frank Norris, Suspension Bridge, N. Y.

H. Schaefer, German Dry Plate Co., Coldwater, Mich.

St. Paul Dry Plate Co., St. Paul, Minn.

PROCESS WORK

A new term, "process work," had crept into the photographic language by this time, and within another ten years it would become the subject of regular sections of news coverage in photographic journals. The term applied to the techniques used in utilizing photographic negatives in the printing press. By 1884, all portraits published in newspapers were being made from photographs, as were those landscape or other views where extreme accuracy in reproduction was wanted. Photographs were customarily altered before their final reproduction by a printing press. They were either photographed on wood and then passed on to engravers (who could make the changes or alterations before printing) or untoned photographic prints were made on plain paper, over which artists could trace the designs with pen and India ink (making such changes or alterations as were wanted). Prints made in this fashion were bleached away, after the pen-and-ink alterations, with a solution of bichloride of mercury in alcohol, leaving a drawing on perfectly white paper. Once again, photography was used to make the printing block by one of various "processes." These could be classed under three headings: the etching method; the photo-relief plate method (see page 275); and the photo-electrotype method. The etching method was performed usually on a plate of zinc, in which the whitest or hollow portions of the plate were dissolved by an acid. The photo-relief method, as we have already seen, would produce a printing plate in stereotype metal. The electrotype method involved sensitizing gelatine differently from the manner used in photo-relief, and provided an electrotype plate. This was considered the most serviceable plate for newspaper work, although zinc plates were considered better (particularly in Europe) because of the superior results achievable with highly skilled labor in plate making.[535]

prints from their negatives, and place them on sale. Here, classified, catalogued and ready for reference they would be accessible to the artist, the author, the illustrator, the designer, the teacher and in fact by all classes of people who desire studies. It would form a library of artistic information whose value it is difficult to form a conception of in advance of its establishment. Not only would the work of the amateur be made practically useful with such an or-

A TESTIMONIAL DINNER FOR
THOMAS C. ROCHE

One of the most obscure but significant episodes in the annals of nineteenth-century American photography was a testimonial dinner for Thomas C. Roche held on the night of March 18, 1884, at Martinelli's Restaurant, 110 Fifth Avenue, New York. The idea was conceived by Henry N. Grenier by way of "reciprocity" for what he considered the "many good services" which Roche had performed for the photographic fraternity. It was meant to be a quiet affair, but the responses to the invitations sent out necessitated holding it at a large restaurant. "Never before in this city were seated together so many honored and shining members of the craft, to render homage to one of its humblest though worthiest of representatives," observed *Anthony's Photographic Bulletin* following the event. Although neither Anthony was present (Henry T. Anthony was ill), both Edward and his brother sent congratulatory messages to be read at the dinner. It was a night of many speeches, not only touching on Roche's career but covering progress in such fields as amateur photography and photomechanical printing. Among those who gave the speeches were: Col. V. M. Wilcox, Grenier, Abraham Bogardus, C. D. Fredericks, George Rockwood, Andrew J. Russell, J. F. Coonley, W. E. Partridge, James B. Gardner, Percy McGeorge, Theodore Gubeman, a Mr. Atwood, a Prof. Dudley, and a Dr. Gammage.

Roche's was a unique career in American photography. Beginning in the Civil War, he made several hundred large photographs (of size 10 x 12) for the United States government, and thousands of stereoscopic views of war scenes for E. & H. T. Anthony & Co. After the war, he traveled all over the United States making upwards of fifteen thousand negatives for the Anthony firm, including some of the earliest landscape views of Yosemite and other tourist meccas in the Far West. Views he made in New York's Central Park won high praise from James Gordon Bennett. Thereafter he proceeded to other exploits at the Anthony firm. Among the first was a patented method of collotype printing placed in commercial use by the Anthonys, and by Osgood & Co., of Boston. In 1880, he perfected a particular type of gelatine dry plate for use in tropical weather, which was patented and sold as the Eastman Tropical Dry Plate. At the same time he developed a gelatine-bromide photographic paper which, because of its rapidity in

Thomas C. Roche, from a photoengraving by the Moss Engraving Company, published in *Anthony's Photographic Bulletin*, April 1884.

printing, immediately revolutionized the making of direct photographic enlargements, using artificial light. After 1886, when Eastman Kodak took up the manufacture of the paper on a large scale, it gradually surpassed albumen paper in commercial and amateur use.

As testimonial dinners go, the Roche dinner was clearly convivial. When C. D. Fredericks rose to make his tribute, he looked at the menu card, then said:

> This is all very dry; the wet has not been much (*laughter and applause*). This bottle shows (*turning upside down*) that the wet is played out and it is very dry; and I suppose we all are (*laughter and applause*). I love certain things; I love everything that is good. I did at one time love this old wet thing; but it is played out. I now love the dry. I love old Roche, because he is a good fellow; and I love you all, and though it is dry enough, that is all I have to say (*laughter and applause*).[536]

ganized centre, but it would receive a new stimulus. Instead of taking subjects at random here and there, as caprice or fancy dictates, subjects would be opened to him from which he would select his work according to his tastes, opportunities and apparatus.[537]

If Alfred Stieglitz's thoughts were running to the mechanization of photography, one of Japan's earliest photographers—a man only four years older than Stieglitz—was at this time also considering the possibility of large-scale book illustration with photography. This was K. Ogawa, the son of a deposed landowner of the Japanese feudal system (which had ended with the revolutionary wars of the 1860s). A love of photography had become a consuming passion with Ogawa to the same extent it had with Stieglitz. Ogawa learned the rudiments of the wet-plate collodion process and even took up the manufacture of collodion (using Japanese paper instead of cotton, which was normally mixed with the ether and alcohol), because of the short supply (which resulted from the fact that one Uchida held a virtual monopoly on photography in Japan at this

time, charging the equivalent of $75.00 for a carte-de-visite size glass positive!).

Just about the time that Stieglitz signed up for Dr. Vogel's course in Berlin, Ogawa got himself hired as a sailor aboard the American Asiatic frigate *Swatara,* and set sail to seek his fortune in the United States. He disembarked in Washington, D.C., January 1883, and remained in the United States until June 1884. He went first to Boston, where he studied portraiture with the firm of Rizey & Hastings, and carbon printing with Allen & Rowell. He also studied collotype printing in its various forms before proceeding to Philadelphia, whre he spent considerable time with John Carbutt, learning the rudiments of dry-plate making as well as dry-plate photography. Ogawa evidently possessed a nature which, as a contemporary observer put it, "inclines all men to him." Not only was he given assistance by officers aboard the *Swatara* after landing in the United States but he soon thereafter made the acquaintance of Viscount N. Okabe, who was described as "a man of means who saw the talent there was in the young man," and who "put at his disposal what capital he needed." [538] disposal what capital he needed." [538]

The parallel between Stieglitz's and Ogawa's careers did not end with their respective beginnings in foreign lands. Ogawa returned to Japan where, for a time, he operated a large studio in Tokyo. Soon he was photographing the heir-

— · K · OGAWA · —

K. Ogawa, from a photograph published in *Anthony's Photographic Bulletin* in March 1890.

IN MEMORIAM: HENRY T. ANTHONY

On the night of October 8, 1884, while attempting to cross what is now Park Avenue South at Seventeenth Street in New York City, Henry T. Anthony was struck by a cab which "rolled rapidly away" after the accident. Anthony, who was seventy, suffered from vertigo, and according to the *Photographic Times,* "may have fallen in consequence of a sudden rush of blood to the head, occasioned by a sense of impending danger." He was taken to New York Hospital where he was revived and gave his name and address (108 Lexington Avenue). He was immediately removed to the residence of Edward Anthony at 715 Madison Avenue, where recovery at first seemed possible. But three days later he died, after having sat up in bed and heard his brother read a glowing tribute to him published in the then current issue of the *British Journal of Photography.* Among those who attended his funeral in New York were: Mathew Brady, Abraham Bogardus, Jeremiah Gurney, Alexander Beckers, C. D. Fredericks, Andrew Prosch, W. B. Holmes, James B. Gardner, John Barnett, George Barnett, Charles Cooper, Wilfred French (son of Benjamin French, of Boston), and W. Irving Adams (later a partner in the firm Scovill and Adams, a merger effected in 1889).[539]

apparent to the Japanese throne—a vastly greater honor in Japan than for a similar feat performed in any capital of the western world. He founded the *Shashin Shimpo,* Japan's only photographic periodical, and established a photomechanical printing factory in Tokyo. The first practical result from the latter undertaking was a collotype print used as a supplement to the *Shashin Shimpo.* Ogawa traveled with an expedition that unearthed and recorded art treasures hidden in many old temples in Japan, and by 1890 he was making large collotype reproductions of photographs made on this expedition to illustrate the *Art Journal of Japan.* Alfred Stieglitz, meanwhile, remained in Europe until 1890, after which he returned to the United States to become the protagonist of the American fine-arts photography movement, and founder of two of the country's most influential turn-of-the-century journals, *Camera Notes* and *Camera Work.*

1885

"Amateur photographers are now counted by the thousands, and in the different cities are organized into flourishing and growing societies," the *Photographic Times* stated in its year-end review of photographic activities. In 1885 the Pittsburgh Amateur Photographers' Society admitted women to membership, assuring them that "there are no difficulties in the way that cannot be surmounted by any young woman of intelligence and possessed of artistic tastes and instincts." By summer, the country boasted two weekly photographic periodicals, the *Photographic Eye* of Chicago and the *Photographic Times,* which had converted from monthly publication in the fall of 1884. *Anthony's Photographic Bulletin,* a monthly, now commenced to publish fortnightly.

"The most beautiful photographs taken in this city," observed the New York *Mail & Express* in April, "are by a young lady." Identifying her only as the daughter of a prominent banker, the newspaper said that her photographs "only circulate privately," but that they excited admiration wherever they were seen:

> She belongs to a knot of young women who are studying art, and for their own benefit they pose for one another, and for such a collection of artistic studies there is many an artist that would give a pretty penny. These are, however, carefully guarded from sacrilegious eyes. The peculiarity of these photographs is in the use made of shadows and the softness of lines. The professional photographer gets a glare of light and brings everything to a sharp focus. This young woman keeps her subjects in shadow and her instrument just a little out of focus.

The newspaper also drew attention to the works of the department store head, Frederick Constable:

> Last year he took 500 negatives in and about New York. This fact was formerly the despair of his wife, who could trace him by the blackness of nitrate of silver and the destruction of his shirts. Since the modern discoveries in photography, which render it, as they say in the advertisements, a light, clean and easy employment, his wife has become as much interested in photography as he is, and accompanies him in his photographic prowls.[540]

On October 17 and 18, the Society of Amateur Photographers of New York held their first annual exhibition in the Sloan Building at Broadway and Thirty-second Street. Judges at the event (at which some seven hundred prints were exhibited) were George W. Pach and the marine artist J. O. Davidson. The judges' awards were given to exhibitors whose names are today unknown, but the flavor of the exhibit was caught by *Anthony's Photographic Bulletin* in its summary of the judging. The society's president, F. C. Beach, exhibited photographs of yachts at sail. Mr. and Mrs. Robert DeForest exhibited prints from photographs made in the Middle East, including scenes of the olive trees of Mount Hymettus near Athens; views of Egypt and its temples; and "uncommonly fine" views of boats on the Nile. L. P. Atkinson exhibited stereoscopic views of New York street scenes, and of the elevated railroads. R. A.

F. A. P. Barnard, from a carte de visite, circa 1880.

THE "PROMINENT AMATEURS"

Among the prominent amateur photographers listed by the New York *Mail & Express* in April 1885 were: Frederick A. P. Barnard, president (since 1864) of Columbia College, who was in the throes of establishing an affiliated college for women (designated Barnard College six months after his death in 1889); one of the younger Harper brothers; J. Wells Champney, the artist; Louis Tiffany, the glass-maker and son of the founder of the jewelry firm; and "Ted" Hewitt, a fourteen-year-old grandson of Peter Cooper. The newspaper also listed Joseph Drexel, Arthur Doremus, and such "Wall Street men" as John A. Cisco; R. A. C. Smith, president of the Havana Gaslight Company; and Low, a partner in the firm Low, Harriman & Co. With obvious reference to amateurs of the "Wall Street" caliber, the newspaper observed that "with a bit of magnesium wire, the busy man through the day amuses himself in the evening with family photography—the wire furnishes him all the light he needs."[541]

C. Smith exhibited views and photographs of laborers in Cuba. Dr. P. H. Mason exhibited views made along the highlands of the Hudson (possibly some made on the excursion of his yacht, *Zephyr,* the previous July). C. W. Canfield exhibited still lifes of flowers (winning a top award in that class), and J. H. Maghee exhibited platinum prints of seascapes, which won a like award in marine prints.[542]

With the amateur market expanding in leaps and bounds, the young innovator George Eastman was looking about for ways to better serve the market. William H. Walker, the Rochester camera maker and dry-plate manufacturer, had joined forces with Eastman, and together the pair began experimenting with an entirely new mode of packaging and using camera film. By 1885, the announcement was made that the Eastman company was prepared to provide a box attachment for standard view cameras, in which a compact roll of negative film (the film being a gelatine emulsion coated on photographic paper) could be placed on, and then unwound from a roll holder to make as many as twelve or twenty-four exposures. All the user had to do was observe a clicking device, which indicated the proper position of the film in making each exposure. Loading and unloading the film was to be accomplished in a darkroom. After unloading, the film was to be cut up into individual negatives, each of which could be made translucent by an oiling procedure. After this, developing and fixing of prints could be accomplished with customary darkroom chemicals and equipment. Eastman labeled his new product "Negative Paper," but it was not long before an old problem experienced by calotype workers forty years earlier became apparent: the grain of the film's paper base showed up frequently in the prints.

Eastman next resorted to making the negative film strippable from the paper base. Film stripping was not something new; for many years in photomechanical printing, for example, the exposed collodion negative film was stripped off its glass plate and supported by a thin transparent material, which allowed printing from the reverse side of the negative. In the Franco-Prussian War of 1870–71, strippable films were utilized to enable Paris to carry on a cor-

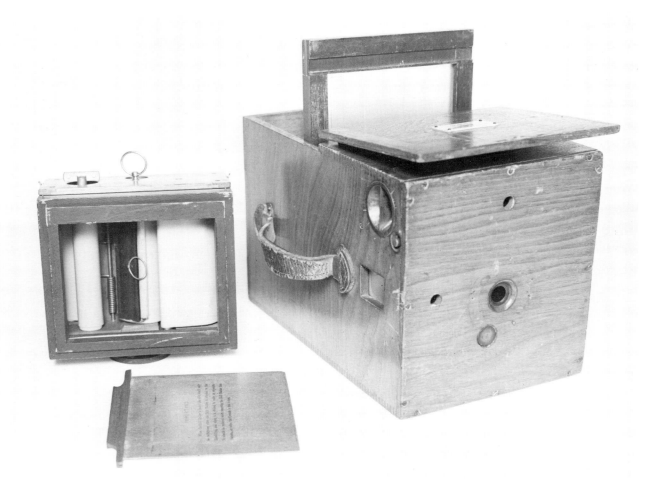

Roll holders were introduced by George Eastman in 1885 as standard attachments for the back of Eastman-produced and other cameras. These provided rolls of negative film (the film being a gelatine emulsion coated on photographic paper) which took the place of separately inserted dry plates, and could be simply unwound to make as many as twelve or twenty-four exposures. Roll holder (above left) could be used in rear of this "detective" camera, eliminating use of single plate holders such as the one shown in a raised position in camera.

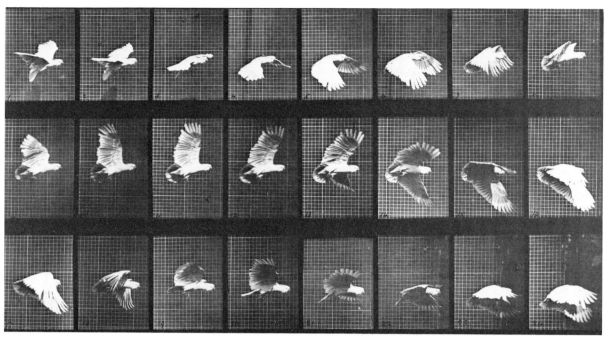

The series of photographs (above) are from *Animal Locomotion*, the summary of Eadweard Muybridge's instantaneous photographic studies published in 1887.

MUYBRIDGE PHOTOGRAPHS SHOW PIGEON
MAKES FIVE "ROUND" FLAPS IN A HALF-SECOND

In 1881, Eadweard Muybridge visited the French physiologist Étienne Marey, but the photographs he brought with him of birds in flight were unsatisfactory for the scientific studies which the Frenchman was then conducting along similar lines. After Muybridge returned to the United States, he began a new series of photographic experiments at the Philadelphia Zoo, and in the summer of 1885 the *Philadelphia Ledger* published this report on his findings:

Mr. Muybridge yesterday examined the plates taken from his cameras on the previous day when, by his "instantaneous" system, he and his assistants photographed half a dozen pigeons in motion. The apparatus was so adjusted as to be capable of making twenty-four successive exposures in half a second. Twenty-four distinct electric currents were connected with as many cameras. The largest number of exposures which Mr. Muybridge succeeded in obtaining from one flight of a pigeon on Wednesday was twelve in half a second. In that time the pigeon made five "round" flaps with its wings, the upward and downward movement together being counted one flap.

"I was surprised by this discovery," Mr. Muybridge said. "I had thought that a pigeon would not make more than about one and a half flaps in half a second. A well-known pigeon fancier, whose opinion on the subject I had asked, said he thought the number of flaps made in a minute would

be about fifty. The pigeon in question moved its wings at the rate of six hundred flaps a minute; but that was just after starting from the trap or box. I think the bird's wings do not long continue moving as fast as that.

"Those five flaps were divided into twelve exposures. We want to get at least twelve exposures of one flap, and, with that end in view will try pigeons again in a day or two. It is desirable to get twenty-four exposures of one flap. I think we will be able to demonstrate that a pigeon in soaring can operate every feather of the wing, while the wing, as a whole, is apparently not flapping. We propose to double our battery power and make a series of twenty-four exposures in, at most, one-fifth of a second. If we wish we can make several series like that simultaneously. If we can make and break the electric currents fast enough we will try to reduce the time of making such a series to one-eighth or one-tenth of a second."

Yesterday Mr. Muybridge experimented with a crow, a fish hawk, a red tail hawk, a black vulture and an owl. The plates taken of these will not be sufficiently developed for examination until some time to-day. All these birds were tied with a very light cord to prevent their escape. The pigeons had not been tied, as they fly around the "Zoo" at will. The hawk's flight was not entirely satisfactory and only four exposures of it were obtained. The owl's flight was also unsatisfactory, owing to its long confinement and nocturnal nature. Mr. Muybridge said he was well pleased with his experiments with the two hawks, and the vulture's flight gave almost equal satisfaction.

The pigeon photographing, Mr. Muybridge said, corroborated statements that have been made about the comparative slowness of the downward movements of the wing. In moving half way down from the top of the flap, he said, the wing consumed as much time as in making the remainder of the flap. [543]

respondence with the outside world by means of a "pigeon post." In this instance, stripped collodion positives—copies of dispatches, letters, or other important documents reduced to sizes of 1 x 2 inches—were enclosed in a quill (about the size of a toothpick) and attached to a pigeon's tail. After reaching their destination, these minute photographs were projected on a screen by a magic lantern, where the documents could be read with ease.

The strippable "American Film," which Eastman now introduced, produced negatives that were transparent and free from any graininess. But the process was not exactly easy, and extreme care had to be taken in order to prevent damaging the film during the stripping operation. As a result, Eastman introduced a developing service in which the customer could send the exposed film to Rochester where regular-size prints or enlargements would be made in sizes ranging from 10 x 12 inches to 30 x 40 inches.

In addition to weight savings (a film negative weighed only a twentieth the amount of a glass negative of same size), Eastman's more flexible film photography offered several immediate advantages for the beginner: a roll could be taken from a holder and another substituted in its place in no more than five minutes, whereas it would take half an hour or more to change a dozen standard dry plates; in addition, beginners were in the habit of exposing the same plate twice with a camera using glass negatives. This problem was virtually eliminated with use of only a single film holder.

But J. Murray Jordan, writing in the *American Journal of Photography* in the spring of 1886, found the public apathetic:

> The melancholy fact remains, however, that instead of trying the new invention, which could be done at a very small cost, the average amateur begins at once to pick it to pieces without knowing anything whatever about the process. He talks learnedly upon the subject, insists that the grain will show; that the paper will rot in time from the use of oil; that re-oiling is necessary every time the negative is printed, or that the odor of castor oil is disagreeable to his aristocratic nose. All these objections I have heard, and upon asking: "Have you given the negatives a fair trial?," the answer has generally been: "No; but so-and-so has, and he don't appear to think much of them"—or someting to that effect.

CYANOTYPES

Sir John Herschel discovered a method of "fixing" a photographic image with potassium ferricyanide in 1839. It gave prints with a blue color, and he found he could make photographic line impressions of algae in blue by this means, some of which survive to the present day. The process, which Herschel labeled "Cyanotype," was used sparingly (by photographers such as Henri Le Secq in Paris in the 1850s), but essentially remained dormant until 1881 when a London photographic publisher began selling the prepared paper both to amateurs and to government agencies and manufacturers for making cheap white-line "blueprint" reproductions of drawings, plans, etc. While the blueprint process was universally adopted by architects and engineers, amateur photographers also adopted its use because of its ease in making photographic prints. The steps involved: 1) A chemical solution (potassium ferricyanide and ferric ammonium citrate) was brushed on sized paper and allowed to dry; 2) the sensitized paper was exposed under a negative to sunlight or artificial light; 3) the paper was then washed in ordinary water (no hypo was required), after which an intense blue image would appear on the paper's surface. In 1888, George Rockwood began providing his patrons with a specially printed circular in blue, which provided full instructions on how to make "leaf prints" by the cyanotype method. The process was chiefly used by amateurs for instantaneous photographs made with hand cameras, but towards the end of the century it was used to some extent in landscape work.[544]

There are but few of my photographic acquaintances who have a roll holder, and not more than half a dozen who have tried the paper at all. "I want," they say, "to be absolutely sure the paper is a perfect success, and then perhaps I may try it.[545]

As late as the winter of 1888, Wilson's journal reported that the new film photography was "more popular abroad than here where it was perfected." But on a note of optimism, the journal concluded: "Another season will probably show a great change in this direction."

1886

In the spring or summer of 1886, George Eastman selected Paul Nadar, son of the just-retired Parisian photographer, as his agent in France for the new Eastman roll film system. By happenstance, the editors of *Le Journal Illustré* at about the same time asked Nadar to make photographs of the famous chemist Michel Chevreul in celebration of the latter's one hundredth birthday on August 31. The result was that the younger Nadar used a camera fitted with Eastman roll film to record the world's first photographic interview for a news publication. Nadar reportedly wanted to use a phonograph to record Chevreul's voice during the interview, but instead his father sat with the centenarian asking the questions while a stenographer recorded the conversation, and Nadar took over a hundred photographs, each exposure being made at a reported $1/133$ of a second (using a special instantaneous camera shutter). Thirteen of the photographs secured in the interview were reproduced by the "Krakow" halftone process and published in the journal's September 5 issue. Four showed Chevreul in the process of writing, while the remainder showed him in animated conversation, expressing interest, amusement, earnestness, etc. In the course of his discussion with the senior Nadar, Chevreul reminisced on his acquaintanceships with Joseph Nicephore Niépce and Daguerre, giving the most plaudits to the former rather than the latter. He also contrasted the 15-minute lens of the daugerreotype era with the instantaneous exposures achievable with the Nadar camera and dry film.

The appearance of the September 5 issue of *Le Journal Illustré* was evidently greeted with extraordinary interest by Parisians. By evening of the day in which the publication appeared on the newsstands, copies of the 15-centime paper were changing hands for five francs. But strangely, this first-of-a-kind feat—so common today—was not soon thereafter repeated. Two months later, the *Photographic Times* offered some suggestions along these lines, but evidently to no avail:

> There are many suggestions that occur to the mind, of further application of this principle of photographic interviewing. Why cannot celebrated actors and actresses be got to go through their principal roles before the camera?, giving thus a living meaning to the words. So with orators and statesmen. As it is a common complaint that photographic portraits give only one phase of a *mobile* countenance, why not take a series of the same person, engaged in conversation with the photographer or a friend? [546]

If the Chevreul interview was an event ahead of its time, so photographers for the most part—the new amateurs as well as the professionals—were not yet really oriented in their thinking as to the general "newsworthy" aspects of the medium. This was pointed out earlier by Stephen H. Horgan at a meeting of the Photographic Section of the American Institute in New York. Amateurs throughout the country, he said, were beginning to pile up valuable negatives, most of which were only being seen by their immediate friends. Once a photograph was taken, amateurs would customarily turn their attention to the next subject. While

this "restless, unsatisfied spirit" was a good thing in its way, Horgan said, "they should not hide their accomplished work. Let the public see it." The best medium, of course, was the newspaper, which Horgan said was "gradually reaching a position to use the contribution of the camera." In fact Horgan characterized the new demand for photographs for newspapers as being "in the form of a revolution," which was "bound to succeed." A picture, he said, was the quickest and most agreeable method of conveying an idea or impression. "In this rapid age, people want to grasp a situation or get their impression of a public man at a glance. A picture tells the whole story at once, and in a better way sometimes than columns of type." While admitting that "current newspaper cuts" were not particularly "artistic" (because skilled draftsmen were scarce), nevertheless, the quality of newspaper illustration *was* gradually improving, he maintained, and this improvement would be further hastened if photographers would but give a helping hand:

> The way to proceed might be something like this: Find first if you have among your negatives or in your vicinity a subject that is likely to be of national, sectional, or local interest. This subject may be a portrait, residence, a recent event or accident.
>
> By way of illustration I might mention a few of the thousands of subjects around us in which the public of the whole country would be interested:
>
> There is John C. Fremont, the "Pathfinder," one of the great characters in our history, who has probably never been photographed since he was a candidate for the Presidency in 1856. He comes to his office on Broadway every day, yet no one thinks of securing a negative of him. The residences of such men as George William Curtis or Charles A. Dana, are of general interest, because even the exterior of a house reflects somewhat the character of its inmates. From the site of the proposed bridge across the Kills at Staten Island to the shattered Andre Monument. From the Croton Valley, where the largest dam in the world is about to be constructed, along the line of the new aqueduct to the Crematory at Fresh Pond, Long Island, plenty of subjects for the camera may be found which the people of the whole country would like to see, and the further away from New York, often the greater the interest in these scenes.
>
> How true it is that we do not appreciate that which is within our reach. On the death of the late General Robert Toombs, of Georgia, recently, a telegraphic application was made to the local photographer

« ...Il est mort vingt ans après, — sans être jamais venu me voir aux Gobelins, comme je l'en avais prié..... »

 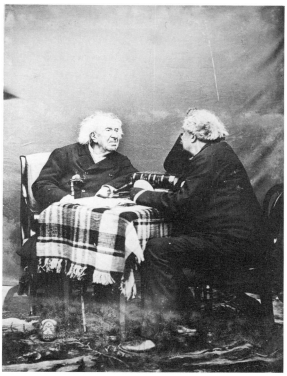

ROLL-FILM CAMERA USED
FOR PHOTOGRAPHIC INTERVIEW

On his hundredth birthday, August 31, 1886, the French scientist Michel Chevreul granted history's first recorded photographic interview. During the interview, Chevreul engaged in animated conversation with the celebrated Parisian photographer Felix Nadar (Gaspard Félix Tournachon), shown with back to camera, while the latter's son, Paul Nadar, photographed the event with a camera fitted with George Eastman's new roll film. The three illustrations above have been copied from poster-size original photographic prints, suggesting that the Nadars may have placed large prints of the photographic interview on display at their gallery or elsewhere. Halftone reproductions of the Nadar photographs, together with a story on the interview, appeared in the September 5, 1886, issue of *Le Journal Illustre*. But despite the fact that newsstands immediately sold out all copies of the issue, other attempts at photographic interviews were not made for sometime either in Europe or the United States.

1886

BEFORE THE COLORS FADED

In an address to the Photographic Section of the American Institute in 1886, Stephen Horgan goaded photographers into making negatives of "the thousands of subjects around us in which the public of the whole country would be interested," citing John C. Frémont as one man who "probably never has been photographed since he was a candidate for the Presidency in 1856." The cabinet card provided a suitable medium for making and distributing likenesses of famous people of an earlier time, but such likenesses are uncommon among the vast numbers of surviving photographs of this style. Two examples above are those of the Civil War general Benjamin F. Butler (1818–1893) (left) and Lincoln's childhood companion, Dennis Hanks (1800–1893) (right). In Butler's case there was good reason for photographing him, in that he had served as a Massachusetts congressman for eleven years after the war, was governor of the state in 1880, and a candidate for president in 1884. But although Dennis Hanks may be familiar to all who have read of Lincoln's early years in a log cabin, his name will be found in few biographical dictionaries of illustrious Americans. Dennis was the adopted son of neighbors of Lincoln's parents. At age nine, he spent the night rolled up in a bearskin before the fireplace after Lincoln was born, and was Lincoln's constant companion before he married one of Lincoln's half-sisters. Much of the folklore which was grown up around the Great Emancipator's childhood came from the tales which Dennis told for twenty-eight years after Lincoln's assassination.[547]

for a photograph of the General's home. The answer received was that he had never thought of making a negative of it. How interesting to us, North, would be the pictures of the homes of these great war figures, Toombs and Jefferson Davis, yet it is not likely that even the latter has ever been photographed. In the town of Springfield, Ohio, is a rapidly decaying structure now used as a livery stable. It was once a church, and the one in which Henry Ward Beecher preached his first sermon. The local photographer would, no doubt, dislike to waste a plate on it. Still it is just the sort of picture the public would like to see. Innumerable similar examples might be mentioned of picturesque subjects of historical interest at which the camera is never aimed, while much good ammunition is wasted on landscapes or figures of no particular interest.[548]

Despite the slow awakening of interest and activity in photojournalism, numerous other innovations and advances were rapidly taking place in the photography arena. Just to touch on some of them, Dr. Arthur H. Elliott, associate editor of *Anthony's Photographic Bulletin,* gave what appears to be one of the most lengthy reports ever given at a national photographic convention, covering the recent progress of photography. The speech was delivered at the Photographers' Association of America's seventh annual convention, which was held in June at St. Louis.

First, Dr. Elliott covered various new innovations in cameras, which included three new "detective" devices. One, from G. B. Brainerd, offered improvements in focusing and plate exposure; another, developed by Richard Anthony, son of Edward Anthony, was designed to fit an alligator hand-satchel carried on a shoulder strap; a third, from the Eastman company, turned out to be a flop.

This camera was shown for the first time at the St. Louis convention, and one would have expected that it would eclipse all previous detective models, based on previous Eastman camera innovations. But in November, just before a patent for the camera was issued to Eastman and co-inventor Franklin M. Cossitt, Eastman announced that he had been unable to obtain a special brass fixture for securing the roll holder in the camera, and would not fulfill orders until he did. Although the camera was advertised for sale two months later, no orders were forthcoming. Only fifty were made, and in January 1888, Eastman unloaded forty of these with a Philadelphia dealer, stating: "We shall not make any more of them, owing to the expense, there being no probability of our being able to make anything on them in any quantity." But it is more likely that Eastman's attention was focused not on the detective device, but on an entirely new line of cameras which was to be announced later that year.[549]

Dr. Elliott also gave a report at the P.A.A. convention on the new "vest pocket" camera developed by the St. Louis photographer, Robert D. Gray (see description, page 306). Of numerous "concealed" cameras developed in the nineteenth century, this was among the most famous and successful. Suspended from the neck behind a vest, the camera

PHOTOJOURNALISM AT SCENE OF A
BUILDING COLLAPSE

News events were still covered at this time by artists, as well as by reporters, but a correspondent sent E. L. Wilson this account of photography's role in a news story on which the writer accompanied two New York *World* artists (identified only as "McDougal" and "Folsom") to the scene of a building collapse on Bethune Street in lower Manhattan:

McDougall and his assistant, Folsom, sprang to their feet, and donning their rubber coats, for it was raining hard, and giving me an invitation to accompany them, started for the scene of the accident. It was then five o'clock, and the pictures were to be in the paper the next morning. I expressed some doubt in regard to their appearance, but McDougall's confident smile assured me that it was a certainty. Arriving at the entrance to the street, we passed the 'fire lines,' and saw the ruins of a large building, whose walls had fallen into the street, killing a woman and injuring several men. It was already dark, and the fitful light of a street lamp showed the dark outlines of the remaining walls looming up against a cloudy sky. The black figures of some firemen were seen on the roof of an adjoining house. Almost by feeling, McDougall sketched the scene with a blue pencil, while Folsom darted in another direction. Twice McDougall had to go to the street lamp to judge of the correctness of his sketch. It was finished in an amazingly quick time, and we hurried to the roof of the house where the firemen were removing a mass of bricks. Here he made a plan of the ruins, locating the scene of the fatality, and we went again to the street. Another sketch was made, this time by the light of a fireman's lantern, and after taking a few notes we hurried back to the *World* building, where we found Folsom already busy at work.

"With increasing interest I watched the pictures growing beneath their fingers. McDougall had taken in the entire scene, showing the street in perspective, with a great heap of bricks and timber lying across it. At 7:45 the first double column sketch was finished. The drawing was made about ten inches wide, and with an amount of detail and shading that surprised me. This was despatched to the photo-engraver, and he then made a sketch of a horse and its driver escaping from the falling walls, which was followed by the drawing of firemen searching for bodies in the debris. These were all drawn with India ink on Bristol board. Mr. Folsom had completed the sketch of the building before the fall, the plan of the buildings, and removing the bodies to the hospital. All but the first sketch were for single column cuts, and all were sent to the engravers by 9 o'clock.[550]

could be used to take up to six small circular negatives on a circular plate rotated before each exposure. The camera was styled the "Button Camera" in Germany, and was said to have been sold in a quantity of three hundred to Russian police.

In addition to the various new cameras, Dr. Elliott pointed to a number of improvements in shutter mechanisms:

In the matter of improvements in shutters, it is almost impossible to give an idea of the many devices that have been brought out for exposing the sensitive plate. All are modifications of the well known sliding plates either working horizontally or vertically, or else they are rapidly moving disks passing one another. Quite a variety of positions relative to the lens have been assigned to shutters—some work behind the lens, some in front; while others take the same position as the diaphragm.[551]

London, calling it the most suitable shutter mechanism for the fast-acting gelatine plates now in universal use.[552]

Cameras were being given "f/" numbers (designating the size of the lens diaphragm) at this time, and several Englishmen, in the period 1885–87, published tables which were a primitive form of guide to actinic light measurement under varying light conditions. But in 1887, when Edward L. Wilson published *A Quarter Century of Photography,* he could say nothing more about precision in determining a camera exposure than that it was "largely a matter of inspiration, of feeling." Earlier (1885), the *Photographic Times* published this rather incomprehensible but "popular" method which could be used to estimate exposure times:

> If a pendulum be formed by attaching a circular disc of black-ened metal to a string 40 inches in length, and this be caused to swing in front of a white ground on which are placed marks to show the extent of the oscillations, such pendulum will perform its vibration in one second. By photographing it while in transit, and comparing the longer diameter of the more or less oval form of the pendulum ball in the negative with the shorter, which represents the diameter of the circle, and these with the whole distance which the pendulum travels during a second, an excellent idea may be had of the duration of the exposure.[553]

Because the first universally accepted dry plates were coated with a gelatine-bromide emulsion, the same emulsion (in a weaker state) as well as other emulsion formulae were coated on photographic papers and supplied ready to use. Eventually, these emulsion papers supplanted the albumen paper used by most professional and amateur photographers. Printing was much faster with the emulsion papers; where, for example, one firm could print only as many as six prints a day from a single negative on albumen paper (in 1886), Morgan & Kidd of London could report in 1887 its capability of producing a thousand prints a day from one negative on bromide paper. While Dr. Elliott credited T. C. Roche in his P.A.A. address with patenting an American bromide paper, David Cooper told those attending the St. Louis convention that the paper was proving ideally suited for use by photographers themselves in making enlargements (where previously such work was sent to establishments specializing in solar camera work):

GRAY'S VEST CAMERA

"Outwardly it resembles a nickel-plate circular bon-bon case," the *Philadelphia Photographer* said of R. D. Gray's vest camera in October 1886. About six inches in diameter and an inch thick at the center, its lens was designed to protrude through the buttonhole of a vest. Inside was a circular sensitized plate and positioning mechanism, which rotated the plate for as many as six circular exposures of size 1¾ inches. But nothing could be photographed closer than six feet. The circular "instantaneous" plates were manufactured by John Carbutt, and a special developing and printing outfit was supplied by Scovill Manufacturing Co.[554]

> It is no exaggeration to state that never before in the history of photography has anything like the class of work which is accomplished by this process in enlargement been placed before the public. The results are as near perfection as the comparative infancy of the method will admit. . . . Nothing can exceed the softness and beauty of an enlarged print, say life-sized, from a well-retouched and otherwise perfect cabinet negative. It is a fact that prints far superior in softness and detail are to be obtained by enlargement by this process, than can be got by contact printing from the same negative on albumen paper. . . . It is rather early, perhaps, to urge the adoption of the permanent bromide paper for geneal work (in enlarging), as the public needs to be educated gradually to a change. Don't persuade yourselves that it is best for you to wait until Smith or Jones or Robinson makes a success of it before you will try, because either one or both of them will get your trade while you are waiting.[555]

Elliott did not identify them as such, but the new shutters which he said operated behind the camera lens immediately in front of the negative plate were soon given the designation "focal-plane shutter"—a new term in photographic lingo. The British photographer William England had used a shutter of this variety in the 1860s, and in 1879, B. J. Edwards had demonstrated the use of such a device in

But as is frequently the case among experts, not everyone was in agreement. The editor of the *American Journal of Photography,* for example, indicated three years later that

he was inclined to think that a direct large negative would render halftones more beautifully than would be the case with an enlargement made from a small negative:

> In the enlargement, the relation of the patches of light and shade is not by any means so harmonious as in a direct negative. There is always an unavoidable break, a falling off in the half-tones, so that up to a certain size it could be better to make direct negatives. But when larger sizes are demanded, the additional factors of increased expense of plate, camera, etc., enter into consideration, as well as the great increase in mechanical difficulties attending the production of large direct negatives.[556]

Some six years after Cooper's P.A.A. address, the English photo historian Alfred Brothers agreed that bromide print enlargements, "when carefully worked upon by a skillful artist, have qualities which are possessed by no other prints, with the exception of carbon," but suggested that bromide printing was still of "too recent date" for tests "to have been effectual" on the comparable permanency of bromide prints (with the known permanency of carbon prints) from exposure to atmospheric influences over long periods of time.[557]

Dr. Arthur H. Elliott, from a carte de visite, circa 1880.

Theodore Roosevelt poses with residents on the steps of a New York tenement.

CAUSE AND EFFECT

Following publication of *How the Other Half Lives,* Jacob Riis returned to his office one day after an absence of some hours and found on his desk a calling card from Theodore Roosevelt, then a civil service commissioner, on which was written: ''I have read your book and I have come to help.'' The two quickly became warm friends, and in his autobiography written in 1913, Roosevelt said, ''My whole life was influenced by my long association with Jacob Riis, whom I am tempted to call the best American I ever knew.'' During Roosevelt's years as Police Commissioner of New York (1895–97), Riis became ''the man who was closest to me,'' Roosevelt said. Riis's influence soon led the commissioner to abolish police-lodging houses, which Roosevelt termed ''tramp lodging-houses, and a fruitful encouragement to vagrancy.'' He made frequent visits to the tenement regions (usually in company with Riis) to check up on health and police department enforcement of laws and codes. ''The midnight trips that Riis and I took,'' Roosevelt said, ''enabled me to see what the Police Department was doing, and also gave me personal insight into some of the problems of city life.'' Later, when he became governor of New York, Roosevelt secured passage of laws to regulate and improve sweatshop labor, then, in the company of Riis, made sudden and unannounced visits to such shops picked at random. As a result of these inspections, he said, ''we got not only an improvement in the law, but a still more marked improvement in its administration.''[558]

1887

In 1870, when he was twenty-one, Jacob Riis emigrated from Denmark to New York and spent the next seven of those American depression years going from job to job, often hungry, and once walking all the way to Philadelphia to seek a job from a Danish family he knew. Several times he spent nights in a police lodging house in New York. As a youth in Denmark, he had helped his father prepare copy for a weekly newspaper, and this experience finally proved helpful in landing a job as a police reporter for the New York *Tribune* in 1877.

The plight of his fellow immigrants remained uppermost in his mind, and soon his daily stories of unsanitary and inhuman conditions on the Lower East Side helped to bring about the establishment of the city's first Tenement House Commission. But as he said later, "the wish kept cropping up in me that there was some way of putting before the people what I saw there. A drawing might have done it, but I cannot draw." So he merely continued to write, "but it seemed to make no impression."

Then, one morning in September or October 1887, while scanning his morning newspaper at the breakfast table, an article caught his eye. "I put the paper down with an outcry that startled my wife, sitting opposite. There it was, the thing I had been looking for all those years. A four-line dispatch from somewhere in Germany, if I remember right, had it all. A way had been discovered, it ran, to take pictures by flashlight. The darkest corner might be photographed that way." If Riis had been a practicing photographer, he might have read this fuller description of what took place in Germany, which appeared in the October issue of the *American Journal of Photography:*

Instantaneous photography by artificial light is the latest novelty. Messrs. [Johannes] Gaedicke and [Adolf] Miethe, at one of the recent meetings of the Berlin Society for the Advancement of Photography, exhibited a process which excited much interest. They used magnesium, but instead of slowly burning the wire, employed the metal in the state of a powder, mixing it with salts evolving oxygen, such as chlorate and nitrate of potassium. The mixture produced an extremely brilliant white light, burning with such rapidity as to permit the photographing of moving objects. Instantaneous pictures were shown, produced by the process. The burning can be accomplished in one-fortieth of a second. The inventors have produced a very complete arrangement for avoiding the fumes. The powder is burned in a lantern, consisting of a strong case with a glass front; the case being impervious to the fumes, none escape. The lighting of the shadows is effected by tinfoil reflectors, and the light softened by interpositions of tissue screens.[559]

The magazine listed a number of advantages of the new process, among which was the statement that "portraits can be taken in ordinary dwelling rooms without skylight." The report which Riis had seen said much the same thing, and this was enough for him. "I went to the office full of the idea and lost no time in looking up Dr. John T. Nagle, at that time in charge of the Bureau of Vital Statistics in the Health Department, to tell him of it. Dr. Nagle was an ama-

Danish-born Jacob Riis (1849–1914), journalist, social reformer, and author of *How the Other Half Lives,* published in 1890. Riis was on the staff of the New York *Tribune* when this photograph was made. He joined the New York *Evening Sun* in 1888.

teur photographer of merit and a good fellow besides, who entered my plans with great readiness. The news had already excited much interest among New York photographers, professional and otherwise, and no time was lost in communicating with the other side. Within a fortnight, a raiding party composed of Dr. Henry G. Piffard and Richard Hoe Lawrence, two distinguished amateurs, Dr. Nagle and myself, and sometimes a policeman or two, invaded the East Side by night, bent on letting in the light where it was so much needed."[560]

Riis soon realized that the camera was not a tool to be left in the hands of others in helping him further his cause; he would have to learn, himself, to master its use. In doing so, he became America's first celebrated photojournalist and its first social documentation photographer. He soon produced a visual record which clearly achieved the "impression" he had long sought to make on the New York community at large. With the publishing of his book, *How the Other Half Lives,* in 1890, he single-handedly altered American society's perception of the term Social Justice (even though the book was illustrated with drawings, instead of the actual photographs from which the drawings were made).

Jacob Riis flashlight photo of a ten-year-old boy pulling threads in a New York sweatshop, circa 1889.

THE MAKING OF TWO PHOTOJOURNALISTS

The illustrations on these pages are early examples of social documentation photographs made of slum life and child labor working conditions in nineteenth-century America. Those on two pages were made by Jacob Riis (1849–1914), the Danish-born New York newspaperman who was at heart a reformer, and who considered the camera simply as a tool for social reform. Jacob Riis concentrated his full attention on slum life in the tenements of New York's Lower East Side. First, he asked amateur photography friends to accompany him on his nighttime visits, but when these abandoned him "just when I needed help most," he engaged a professional photographer. Although he paid the man well, the photographer "repaid me by trying to sell my photographs behind my back," Riis said, so he resolved to master the use of a camera himself. Instead of firing a pistol to obtain his flash light, he substituted a frying pan for the revolver and flashed his light on that. "It seemed

more home-like," he said. But he was by his own admission "clumsy." Twice he set fires in the buildings where he photographed, and once set fire to himself. "I blew the light into my eyes on that occasion," he recalled later, "and only my spectacles saved me from being blinded for life." On one mission when he set fire to a tenement room with five blind people in it, he barely managed to smother the flames he had ignited. Afterwards, when he met a policeman in the street, the latter joked about his concern: "Why, don't you know that house is the Dirty Spoon?" the officer laughed. "It caught fire six times last winter, but it wouldn't burn. The dirt was so thick on the walls it smothered the fire!"

The illustration of the "breaker boys" at work in a Pennsylvania coal mine (above right) might well have been made by Riis, but was in fact made by Frances B. Johnston (1864–1952), a celebrated photojournalist in the years leading

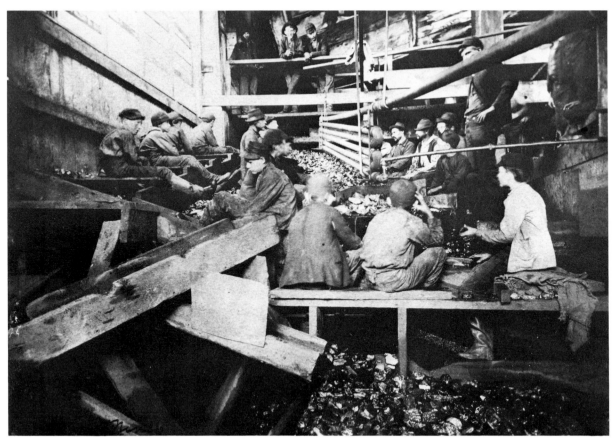

Frances B. Johnston's photo of a group of breaker boys at the Kohinoor mines near Shenandoah, Pennsylvania, 1891.

up to World War I. In the late 1880s, Miss Johnston reportedly asked George Eastman to recommend a camera for her when she abandoned an art career for photography, and he is said to have sent her a Kodak. In 1889 she made first photographs of life in the White House, and as she repeated this in later administrations she became known as "the photographer of the American court." Miss Johnston was a documentary, as opposed to a *social* documentary, photographer. Her visit to the Pennsylvania coal mines in 1891 was made not at her own volition, but at the suggestion of a publisher. Soon thereafter she photographed workers in a shoe factory in Lynn, Massachusetts, and life aboard Admiral George Dewey's flagship, *Olympia*. She also photographed Theodore Roosevelt and the "Rough Riders," and her photographs of student life at Virginia's Hampton Institute, made at the turn of the century, today rank among the finest examples of American documentary photography.[561]

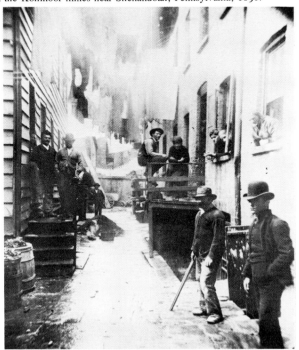

Jacob Riis photo of "Bandits' Roost" near what is now Columbus Park in the heart of New York's Chinatown.

1887

A PHOTOGRAVURE OR GELATINE PRINT?

In February 1887, Ernest Edwards said he had just looked over some new books said to be illustrated with photogravures, but found that they were illustrated, instead, with photo-gelatine prints. Several months earlier, the *Art Review* noted the confusion in the public mind over photomechanical terms, and said "the difference in appearance between a gelatine print and a genuine photogravure—that is, a print from the face of a copper plate—is easily detected on placing them beside each other; the former has a flatness and surface-effect that is exchanged in the photogravure for depth and richness of color. But there is just enough similarity between them to deceive the inexperienced, and perhaps it is for this reason that the photo-gelatine prints of a certain eastern firm are now masquerading in the market as so-called 'photogravures'." The illustration (above) is taken from *The Great Cathedrals of the World,* by Fred H. Allen, published by the Haskell & Post Company (Boston and New York, 1886), and said to contain 130 full-page, plus additional smaller-size, photogravure plates.[562]

With the benefit of hindsight, it is interesting to compare, now, how differently the invention of flashlight photography was viewed by others. Where Riis immediately saw its value for social documentation, the *American Journal of Photography* saw it as a boon to glamorizing social night life:

The instantaneous flashlight is destined to be something more than a passing novelty. Judging from the excellent results so far obtained, it looks as if the day were not far distant when it would be called into active service by the professional, to secure pictures of people in evening costumes at their homes, and as a supplementary illuminator for full daylight exposures.[563]

As its first flashlight photograph illustration (an original bromide print bound in separately from the text in all copies of the December issue), the *American Journal of Photography* used an attractive young woman posed in evening dress with train.

No photographs taken at night were among those exhibited this year at the first joint exhibition of works by members of the New York, Boston, and Philadelphia amateur photographic societies, which was held at a Broadway gallery in New York between March 26 and April 2 under the auspices of the New York society. "But from the standpoint of the great public," *Anthony's Photographic Bulletin* observed, "the exhibition can hardly be called one of photographs." By this was meant the customary silver prints (photographs made on albumen paper). "Glossy albumenized silver prints occupy less space on the walls than the blacks and whites and blues," the magazine noted. Thus, for the first time at a major showing of amateur works, platinum prints, cyanotypes, and prints made on bromide paper were the mediums principally chosen for exhibition. In the case of the platinum and bromide prints shown, viewers evidently were unable to tell the difference between the results made by either process:

The relative artistic merits of the platinum prints as compared with the bromide of silver has not been settled by the exhibition. Practically, one could not say which was which. One exhibitor, Mr. Cowee, of Troy, N.Y., showed a platinum landscape mounted on a sheet of bromide paper on which a border had been printed. Before they were hung, several gentlemen examined these pictures closely at the rooms of the society. No one who saw them discovered the slightest difference in the different parts of the work, and it was only when the blank for the catalogue was examined that the difference in the paper was discovered. Even then it had to be taken on faith.

The *Bulletin* waxed enthusiastic over the bromide prints:

Every shade from a velvet black up is obtainable. Vigor or softness, or both, were successfully obtained, and the results were so frequent and so uniform as to show that the process is not overrated by its friends. Some of the skies printed on bromide paper were certainly the finest things of the kind that have yet been shown. They seemed more like delicate washes of Indian ink than anything producible by photography.[564]

But a year and a half later, the *American Journal of Photography* sounded somewhat less enthusiastic:

It seems . . . desirable that a method may be found by which the tone of a bromide print should be brought under control. Since bromide printing first became popular, it seems that few, if any, attempts have been made to modify the cold blacks and

PHOTOGRAVURE

This process became one of the most artistically satisfying of all the photomechanical printing modes. A negative image of a retouched photograph was secured on the gelatine-coated surface of a steel-faced copper plate, then etched in varying depths proportionate to the tones of the original picture—the shadows being the deepest and thereby holding the greatest amount of ink. Etching was accomplished with a mezzotint tool able to cut more sharply and deeper than was possible with chemical means used in preparing plates by other photomechanical modes. This allowed doctoring by hand (usually the photographer's) to achieve artistic results, and also allowed use of transparent inks made of a soft color, such as bitumen, or Vandyke brown, in place of black or burnt umber inks. The deeper photogravure plate rendered a softer, more glowing print than could be achieved in printing from a chemically etched plate. But photogravure plates were weaker than ordinary copper engraved plates, and only the steel facing made it possible to use photogravure in book illustration. The art of making a really good, yet thin steel facing was also difficult, making it impossible to obtain more than about a thousand first-class prints off one facing before it would give away. Sized paper (which, when used, could add to the brilliancy of the darks of a print) or paper with a coarse fiber (of the type admired for etchings) could not be used for photogravure, as the hard, rough texture would not enter into the tiny pits of a photogravure process plate. One great advantage of photogravure was that prints produced by the process were always uniform.[565]

grays produced in the direction of rendering them warmer, and more like sepia or burnt sienna drawing.[566]

A study of the catalogue for the New York exhibition, meanwhile, revealed that exhibitors favored foreign-made lenses. A "hasty count of noses" by the *Bulletin* showed "103 Dallmeyer, 55 Ross, 51 Darlot, 41 Euryscope, 27 Beck, 15 Morrison and 6 or 8 single landscape lenses." The count also revealed a "prejudice against single lenses," which the *Bulletin* was at a loss to account for.

A preference for foreign-made lenses among professional photographers was also noted by Dr. John Nicol in an address to the annual meeting of the Photographers' Association of America. Among American-made lenses, he cited the "Universal Photographic Objectives" of Bausch & Lomb, and the Morrison *Leukoscope* lens for large portraiture as the newest candidates for public favor.

Nicol also eloquently summarized for the P.A.A. the advanced state to which the gelatine dry-plate process had by this time been brought:

The conditions under which silver bromide and iodide suspended in a solution of gelatine can be made to assume particular qualities or properties are almost daily being better and better understood, so that makers of sensitive surfaces can now at will produce plates sufficiently varied in character to suit any particular requirement. The intelligent photographer is now able to select just the kind of plate that is best suited for any special purpose, and the time will soon come, if it has not already arrived, when we would as soon think of using one particular va-

riety of plate for all the various kinds of work, as driving tacks and tenpenny nails with the same hammer.[567]

Photography was in a better condition commercially, too, Nicol contended, because of improvements in "process work." The Austrian-developed photogravure process had by this time been introduced commercially in the United States, and Nicol felt that the Photo-gravure Company, as well as the other major process workers (Moss, Gutekunst, and "the company working Ives's process") were turning out work "superior to anything in the same line in any other part of the world."

The first book illustration produced by the photogravure process in the United States was a reproduction of an oil painting by Theobald Chartran in Edward Strahan's *Masterpieces of Centennial International Exhibition* (Philadelphia, 1877). But this was published at a time when the process was still under wraps, and before it was introduced anywhere commercially. Thus, when E. L. Wilson ran a photogravure frontispiece in the January 16, 1886, issue of *Philadelphia Photographer,* he could probably claim, justifiably, that it was "the first of its kind which has been given in any photographic magazine, we believe."

Among the first major publishing ventures in which the Photo-gravure Company became engaged was the eleven-volume work *Animal Locomotion,* by Eadweard Muybridge (Philadelphia, 1887), which contained a total of 781 folio-size prints. But Muybridge's publishing venture appears not to have been followed by similar publications of either book or portfolio variety which were comparable to those beginning to appear in England and on the continent. Peter H. Emerson, the son of American and English parents, led off with a "naturalistic" school of fine-art photography in London. His first work was a portfolio of platinum prints, *Life and Landscape of the Norfolk Broads,* which appeared in 1886. This was followed over a period of nine years by additional books and portfolios of artistically rendered photographs in photogravure. As soon as he adopted the latter process, Emerson continued to make use of it thereafter. He considered it more artistic, and able to render softer prints than could be obtained by any other photographic process. An "impressionist" school of photography followed close on the heels of the Emerson school, and many of the most noted works of this school were also rendered in photogravure.

The first American photogravure style photographs were made at this New York establishment by Ernest Edwards, the English photographer and inventor of the heliotype who became a principal spokesman for the art of photomechanical printing. Edwards gave a major address on photogravure printing at the World Congress of Photographers in Chicago in 1893.

1888

Eadweard Muybridge began a new series of lecture tours in the United States, Britain, France, Germany, Switzerland, and Italy following publication of his *Animal Locomotion* in 1887. In January 1888, the *Nation* expressed the thought that his *analysis* of human and animal motion could now be followed by a *synthesis* "with the aid of the zoetrope, and especially with the aid of the stereopticon." All that was needed, the magazine contended, was a large "battery" of cameras in large cities to record people and events in moving pictures. The *Nation* also suggested that Edison's phonograph might be used with such a battery of cameras to record, verbally, what people said or did in the act of speaking or walking. Muybridge did meet with Edison at this time, but his accomplishments left the latter "unsatisfied," according to one Edison biographer. In later years Muybridge contended that he had discussed with Edison the possibility of combining the zoopraxiscope and the phonograph, but Edison maintained, also in later years, that the subject had *not* been raised in their meeting.

The world of communications was such, in 1888, that the *Nation* was unaware that a Frenchman had received an American patent in January 1888 for a motion picture machine which could, in fact, provide a true synthesis in motion picture recording by making its record with a single camera from a single point of view. Muybridge's photographs showed moving bodies always before the camera with the background scenery moving backwards. The effect was not of motion as the eye sees it, but rather as the consecutive movements would be seen by a series of eyes from differing viewpoints.

The Frenchman was Louis A. Augustin Le Prince, forty-six, a man of considerable wealth who journeyed to the United States in 1881 and for a number of years constructed panoramas for exhibit in various United States cities. In 1885, he began serious experiments in obtaining photographs of movement in series. This was accomplished in the workshop of the Institute for the Deaf, then at One-hundred-sixty-third Street and what is now Fort Washington Avenue in New York. Because of his mysterious disappearance five years later, little can be actually documented as to Le Prince's experiments which led to the development and patenting of several cameras, and the making of several motion pictures which happily have also survived.

Le Prince's first machine (page 317) had sixteen lenses which recorded photographs alternately on two bands of film, made from sensitized gelatine, mounted on spools in a wooden compartment attached to the back of the camera. The camera could take sixteen pictures per second. But the sensitized gelatine could not be used when the camera was converted to a projector, because the heat of the arc lamp lighting attachment inside the device caused the material to swell and blister, throwing the pictures out of focus.

In 1887, Le Prince returned to Leeds, England, where he had founded the Leeds Technical School of Art following service in the French army during the Franco-Prussian War.

After publication of his *Animal Locomotion* in 1887, Eadweard Muybridge became a world famous lecturer, visiting and speaking before groups of renowned artists and scientists in England and on the continent.

In Leeds, he completed a new single-lens camera in which animated pictures could be secured on a sensitized roll of paper (probably Eastman's "paper film"). But while paper recorded an excellent negative, it was not successful as a "positive" for projection purposes, being neither sufficiently strong nor sufficiently translucent. Nevertheless, Le Prince made a successful motion picture film with the camera (see page 316) which survives today in the Science Museum in London.

In 1889, Le Prince obtained a supply of sensitized, transparent celluloid film in sheets (see next chapter) which he cut and joined together for purposes of new film experimentation. But here the story ends. Le Prince had taken out American citizenship papers in 1886, and in September 1890, he journeyed to Dijon, France, to say good-bye to a brother before returning to the United States. On September 16, he boarded an express train at Dijon headed for Paris

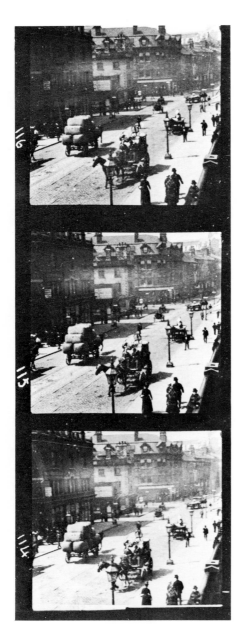

A PRIMITIVE MOTION PICTURE

The frames above are from motion picture film made in 1888 of traffic on a bridge in Leeds, England. The images were secured (at the rate of twenty a second) on a roll of sensitized paper (probably George Eastman's "paper film") by Le Prince, who had perfected his first motion picture device in New York City in the period 1885 to May 1887. The single-lens camera which he used for filming in Leeds (where he had founded a Technical School for Art sixteen years earlier) was built several months after he had been awarded the patent for his 16-lens camera. The single-lens device was equipped with a shutter which reportedly operated fifteen times more rapidly than the shutters on the 16-lens camera.

IN MEMORIAM:
EDWARD ANTHONY

Edward Anthony did not long survive his brother. It appears that among his last major accomplishments at the Anthony firm was the interest he took in George Eastman's dry plates, following the meeting Anthony had with Eastman's friend, George Monroe, at the Thousand Islands in the summer of 1880 (see page 268). Anthony was described in one obituary as having been in "feeble health" for some time prior to his death, but in *Anthony's Photographic Bulletin* it was said that he suffered a heart failure on December 7, 1888, and died seven days later. He was survived by his wife, a son, Richard Anthony, and two married daughters. In later years, the contents of Edward Anthony's desk were obtained from Richard Anthony's daughter, Mrs. Dudley Morriss, of Washingtonville, New York, by the noted collector Alden Scott Boyer (1887–1953), who donated his collection to the International Museum of Photography at George Eastman House in 1951.[568]

and was never seen or heard from again. In New York, his wife had only a year before moved into the Roger Morris mansion in what is now Morris Park at One-hundred-sixtieth Street and Edgecomb Avenue. The house had been redecorated, and its large drawing room was ready for the public showing of moving pictures which her husband had indicated he planned to schedule soon after his return to New York. A Le Prince panorama of the Civil War engagement of the gunboats *Monitor* and *Merrimac* was for many years a cultural attraction at Madison Avenue and Fifty-ninth Street in the 1880s, and it is likely that had Le Prince returned to the Morris mansion, this historic site would today be heralded as the birthplace of the motion picture industry.[569]

Eadweard Muybridge, meanwhile, adopted the position that photography's "more popular use is now entirely subordinated by its value to the astronomer and the anatomist, the pathologist and other investigators of the complex problems of nature." That was the framework within which he worked, and there is no evidence to suggest that he harbored thoughts of originating anything like a motion picture when, in 1893, he gave demonstrations of his zoopraxiscope in a Zoopraxographical Hall erected for this purpose at the Chicago World's Columbian Exposition.[570]

This (1888) was also the year in which people began taking indoor photographs at banquets and other social and

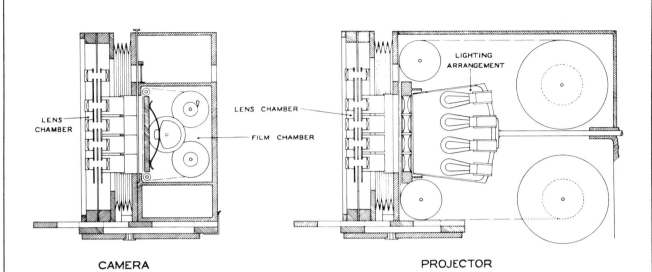

LENS
CHAMBER

LENS CHAMBER

FILM CHAMBER

LIGHTING
ARRANGEMENT

CAMERA

PROJECTOR

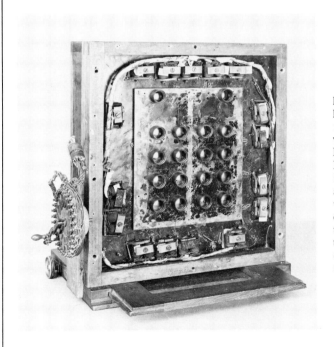

During the period May 1887 to February 1888, Louis A. A. Le Prince, the French-born photography experimenter, built the 16-lens motion picture camera (left) according to the provisions of an American patent awarded January 10, 1888. Le Prince built the camera in Paris and used it to make film there. In making exposures, eight lenses facing one film were set off in rapid succession (top), after which the eight other lenses facing another roll of film were discharged while the first roll of film was advanced for a succeeding set of eight pictures. Each set of eight lenses was thus used alternately, and the release of shutters was so arranged that there was a slight overlap in consecutive exposures. When the camera was used as a projector, this overlap meant that there was no period of darkness between successive pictures.[571]

1888

business gatherings. The first of these was taken at Delmonico's restaurant facing Madison Square. Characterized at the time as "an unprecedented feat," the photograph of feasting journalists at a press club dinner was taken by W. I. Lincoln Adams, editor, and Charles Ehrmann, associate editor, of the *Photographic Times*. The pair used a camera supplied by the Scovill Manufacturing Company, Gustave Cramer's dry plates, a Morrison wide-angle lens, and "an unusual quantity of Carbutt's magnesium 'flash light' compound." Just a week earlier, the New York *Sun* had published a major story on Jacob Riis's nighttime visits to the Lower East Side slum tenements, illustrating the article with wood-cut drawings made from the flashlight photographs. Within another two months, the *Philadelphia Photographer* would make special mention of the taking of instantaneous photographs by flashlight at a nighttime social gathering at the home of Mrs. Fitzgibbon Clark, 2334 Olive Street, Philadelphia.[574]

The danger of using magnesium flash powder was early recognized. Dr. Henry Piffard, an amateur photographer who accompanied Riis on the latter's first "raiding party," appeared before the New York amateur society to describe how he used the powder, and to warn of the danger of a premature explosion—"a danger that will be appreciated by all who are familiar with the behavior of mixtures containing chlorate of potash." Piffard said it was his understanding that the compound originally introduced in Ger-

many by Gaedicke contained this substance, but this was denied several months later by R. Gaedike, of Brooklyn, New York (not known to be related to Johannes Gaedicke, the German inventor). Piffard recommended mixing gunpowder with the magnesium. "If one part of gunpowder be mixed with four parts of magnesium powder and ignited in an open space," he said, "an extremely actinic light is instantly developed. This mixture is absolutely safe, as it cannot be ignited except by the application of fire, and will not explode by concussion." Probably referring to his visits to the tenements, Piffard said, "I have made several negatives by the flash of a pistol, the weapon being loaded with a mixture of gunpowder and magnesium."[575]

Newspapers as well as the photographic press devoted considerable attention to deaths and injuries which resulted from improper use of flash powder. In one major incident, a Philadelphia factory worker, John E. Richardson, was killed shortly before Christmas (1887) while mixing magnesium, chloride of potash, bichloride of potash, and picric acid by chaser-wheels. This prompted the *Photographic Times* to assert that "the death not only of this man, but past accidents to all photographers who might be using the mixture, is due to the criminal negligence of those who allowed their workmen to use such dangerous agents without any knowledge of their danger. What a pretty substance, indeed, is picric acid to place in the hands of an ignorant workman?"[576]

REVIVAL SEEN IN PLAIN PAPER USE

"There seems to be a reaction in favor of plain paper; at least mat surface prints are beginning to dispute the monopoly hitherto enjoyed by albumen photographs," the *American Journal of Photography* observed in March 1888. "The effect obtained on bromide and platinum papers may have directed the attention of photographers to the old method, and some of our veterans may have recalled the fine artistic results in the days gone by. Albumen prints, with their glossy surface, do not generally receive the commendation of artists, but it must be confessed that better results may often be obtained with albumen, when a rather poor quality of negative is used, than with mat surface. A great many of the plain prints, by inexperienced amateurs, are characterized by a lack of vigor. The defects in the negative are not easily masked with plain paper as with albumen. But on the whole we are inclined to favor the revival." Dr. Charles Mitchell, in a paper read at this time to the Photographic Society of Philadelphia, noted the introduction of various mat surface papers (bromide, "alpha," and platinum papers in particular), and suggested that many of the desirable goals sought in using these newer papers could be achieved equally well by reviving the old salt print. Printing on plain paper, he contended, "gives results which, for softness, delicacy and perfection of tint, cannot be surpassed by any other method with which the writer is acquainted."[572]

HOTEL DARKROOMS

On May 5, 1888, the *Philadelphia Photographer* disclosed that the proprietor of several hotels in Madeira had established darkrooms in each of his hotels for use by amateur photographers visiting the island. The following year, Coleman Sellers provided this list of American hotels which he said provided darkrooms for guests:

WESTPORT INN, Westport on Lake Champlain, New York
THE MAPLEWOOD, Pittsfield, Massachusetts (A. W. Plumb, proprietor)
THE ARLINGTON, Washington, D.C. (T. E. Roessle, proprietor)
THE FOUR SEASONS, Harrogate, Tennessee
TAMPA BAY HOTEL, Tampa, Florida (J. H. King, proprietor)

"Many a batch of pictures have been spoiled from the want of the treat of first exposure at a new place, where the light may be different from what it is at home," Sellers maintained. "If others will help me scatter seeds of instruction among hotel keepers, the time will come when we will find a good darkroom in all hotels at watering places." On a visit to Atlantic City, Sellers encountered an Englishman "with some sort of a detective camera in his hand," who also complained that none of the hotels there provided a darkroom where he could change his plates. Sellers applied to a photographer's gallery on the boardwalk and was offered free use of the photographer's darkroom, which was not then being used. Two other darkrooms were loaned to Sellers while he was in Atlantic City, "the owners feeling pleased when not busy to chat with the tourist."[573]

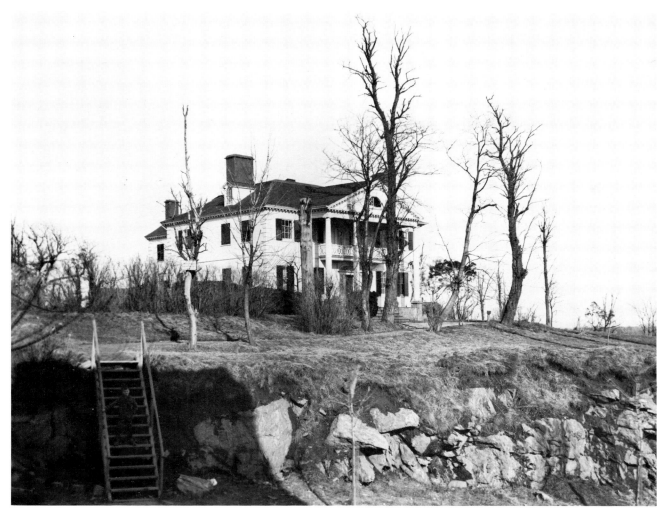

HISTORIC GEORGIAN MANSION LOSES ROLE IN MOTION PICTURE HISTORY

Motion picture pioneer Louis A. Augustin Le Prince mysteriously disappeared from an express train in France two years before this photograph was made of his home, now a museum in Morris Park, New York City. Built in 1765 as a summer residence by Roger Morris, the mansion served as headquarters for both George Washington and British troops in the American Revolution, and was restored in 1810 by Stephen Jumel. While Le Prince was in Europe in 1889, his wife took possession of the house and completed redecorations for a planned showing of motion pictures that was to have taken place in a large drawing room, using a new camera perfected by Le Prince abroad.

The R. Gaedike mentioned above addressed a letter to the *Photographic Times* from Brooklyn on January 20, 1888, and in this letter he spelled the name of the German flash powder inventor (Gaedicke) the same way he spelled his own name (Gaedike), suggesting the possibility of a family connection. R. Gaedike contended in this letter that the Gaedike (sic) and Miethe flash compound did *not* contain chlorate of potassium, but did not further describe the mixture, stating only that it was "put up separately in tin boxes," neither of which was explosive.[577]

Two Rochester, New York, photographers reported favorably on a "Blitz-Pulver" flashlight compound, but the aftermath of smoke remained a problem. Piffard contended that the best results in flashlight photography were to be obtained by professional photographers skilled in the use of screens, reflectors, etc., but the *American Journal of Photography* contended that "there is so little variety in the character of the illumination employed by photographers, that the production of one gallery scarcely differ[s] from those of another, save in technical qualities." In a year-end report on the progress of photography given on August 10, 1889, W. I. Lincoln Adams said that although photographers had undoubtedly improved in their "management" of the light effect, it could scarcely be said that the use of flashlight photography had generally increased:

On the contrary, it is probably considerably less used now than it was a year ago, though those who do employ it are more skillful in its use. The tendency at present is to use magnesium powder in a pure state; and many ingenious lamps and devices for lighting and burning it have been invented.[578]

THE YOUNG PHOTOGRAPHY BARON

"The full import of George Eastman's discoveries in photography are not yet fully recognized by the world at large," the writer of an 1891 profile of Eastman observed. "Outside of the trade and scientific circles it is scarcely known that Eastman's dry plates were the first dry plates made in this country, or that they are so much superior to any ever made anywhere that Rochester goods are now the standard of Europe as well as America."

George Eastman was essentially a natural-born captain of industry who happened to have chosen photography as his field of interest. In the beginning, he secluded himself to experiment with and perfect a dry-plate process, but even at this stage his mind was concentrated on the enterprise that was to follow. His way was the opposite of John Calvin Moss, for example, who with his wife remained closeted for over two decades grappling day after day with the intricacies of photoengraving, finally establishing an enterprise of only momentary significance. Eastman agonized for only the briefest of moments when customers began to complain of a loss of sensitivity in his first dry plates; he simply shut down operations, went to England to buy the formula for the best plates, compared them with his own, and found the root of the problem immediately. Eastman's policy became one of buying the basic patents, as well as the talents of individuals and entire companies whose activities or operations posed a threat to, or would be beneficial to, his present or future plans. In 1884 (probably as early as January), he hired William H. Walker, another Rochester camera manufacturer, to help him perfect a roll-film system. Walker contributed a needed mechanical skill (to complement Eastman's previous experimentation with paper-based film), and he also offered valuable production and administrative talents (the Walker pocket camera introduced in 1881 having been among the first to be manufactured with interchangeable parts). This association led to the Eastman-Walker roll holder, the first of its kind. When Eastman decided that a transparent film should replace the paper-base roll film (which had to be stripped off its paper base during film development), he hired a young chemist, Henry M. Reichenbach, to perfect it for him. An Eastman biographer calls this "one of the first industrial research assignments" to be given in American industry, but in any event the film was ready by the end of 1889. But Reichenbach became one of few of Eastman's "inner circle" to pass quickly from the scene. In 1892, Reichenbach and two assistants were discharged for conspiring to form a rival company, and Eastman later brought suit against them.

In the 1890s, Eastman would emerge as an industrialist of

George Eastman, from a cabinet photo taken in Paris circa 1886.

the first order. His first company was organized with a capital of $1 million, then was recapitalized twice (despite a financial recession) at $5 million, then (in 1898) at $8 million. Eastman bought the process which allowed film loading in daylight, and he bought the company which invented the "little red window" for keeping track, by the number, of film movement inside the camera. After 1900, the road to a vast monopoly lay ahead, which would make Eastman one of America's five leading philanthropists.[579]

KODAK REVOLUTION
1889

The outset of photography's second half century coincided with the introduction of the Kodak camera and nitrocellulose film—both hallmarks of a new era for the medium. The new negative film process was an American development, resulting from independent research and development activities in Philadelphia, Newark, New Jersey, and Rochester. The Kodak camera was actually patented on September 4, 1888, and was on the market at the outset of 1889. It was small (6¾ x 3¾ inches) and lightweight (22 ounces), and was strictly a film camera. The roll holder was an integral part of the camera, and was inserted into or removed from the camera through a rear panel in the manner of all subsequent "box" cameras. The name "Kodak" was selected by the patentee, George Eastman, because he thought *K* was a "strong and incisive sort of letter," and by trying out various combinations of other letters to follow the *K,* he arrived finally at "Kodak."

As many as a hundred exposures could be secured on a single roll of film supplied with the first model Kodak. The images were circular (each 2½ inches in diameter) because the camera's image frame was circular. Eastman's "American" (stripping) film was used with the camera, and the company launched a full-scale promotional effort to have camera users mail their exposed film to Rochester for processing and printing. "You press the button, and we do the rest," the advertisements stated. By September 1889, Eastman had sold over 13,000 Kodaks, and a month later the company was reported to be processing between sixty and seventy-five rolls of exposed film daily (or the equivalent of 6,000 to 7,000 negatives a day). Great public events were soon found to have a measurable effect on the film processing. After the inauguration of the New York centennial celebration, for example, some 900 Kodaks were received in the mail within a single week for film processing.

E. L. Wilson's son, Fred Hart Wilson, visited the Eastman factory in October for his father's publication (the title was changed in January from *Philadelphia Photographer* to *Wilson's Photographic Magazine),* and observed that "in the short period of its astonishing existence, this little black box has persuaded thousands to the pursuit of photography, and its name has become a household word. It is the pioneer of a new type of camera, the creator of a new class of photographers, and has brought all the pleasures of the art-science within the reach of those who never thought they should enjoy them before it came upon their view; it has added largely to the ranks and considerably changed the methods of amateur photographers." [580]

Film processing called for printing by sections of twelve images in an "airy" printing room on the roof of the Eastman factory, looking out towards the Genesee Valley. According to Wilson, the foreman inspecting the prints would find "woful evidences of fog and double exposures, and other ills amateur work is heir to," but "very seldom" any faults due to defects in camera mechanisms or in the paper.

Such may have been the case in October 1889, with the paper-base "American" film, but Eastman's adoption of

"AMERICAN FILM" MANUFACTURE

The first Kodak cameras sold used Eastman's "American Film." After making exposures, people sent their rolls of film to the Eastman factory where the exposed film was stripped from its paper base and developed. *Wilson's Photographic Magazine* gave this description of the film's manufacture on October 19, 1889:

The making of the film that is carried in the Kodak is not only an interesting but an impressive process. The emulsion-making is carried out after the ordinary methods, and presents no particular interest more than any other emulsions. It is the process of coating which is the imposing part to watch. You pass through the usual double door into the big, cool dark-room on one of the upper floors, and, clinging close in the obscurity to the hand of the foreman, who guides you, cross over to where, by the dim light of electric lamps shining through lanterns of red tissue-paper, you see the outlines of a great machine, which a few black forms hover about, and whence proceeds at intervals a sharp measured click of wood striking against wood. It suggests, with the dim crimson glow of the cylindrical lanterns, a lawn fête of demons, after most of the diabolical guests had departed and the lights were going out. Slowly travelling up the front of the machine and over its top, is a broad white band, that gleams wetly under the light of two of the red lanterns. It is the paper in process of coating; and, looking closer, one sees the trough full of emulsion, whose presence had been announced to the nose some time before by its rather pleasant, though eminently photographic, smell. The band of paper that passes through the trough is forty inches wide, and is being fed from an enormous spool. It travels at quite a fair speed, and gives one a very vigorous impression that a great deal of that paper must be coated in the day's work—not to speak of the trough that holds several gallons of the emulsion, and yet must be renewed constantly, and the yards of paper stretched drying on the racks. The paper passes over the top of the machine for some fifteen feet, and under again, by which time the emulsion is set; then it is taken up by long wooden arms and hung in loops of about the same length, to complete the drying. About six thousand feet is a day's work. It only takes between three and four hours to run it through the machine; the rest of the time is spent in drying. In the morning it is wound off upon a spool, and thence slit in rolls of two and three-quarter inches, to be wound off on the small spools. Often there will be a slight surplus of length, which the purchaser has the benefit of, so that some Kodaks carry ten or a dozen exposures over the hundred. [581]

the transparent celluoid film (under a patent awarded December 10 to Eastman's principal chemist, Henry M. Reichenbach) resulted in later problems, both real and imagined. After 1890, for example, it became apparent that celluloid film had a tendency to bulge up during development, and once developed and dried, it had a tendency to curl up into a tight roll. Ultimately, of course, a noncurling film was developed to eliminate this problem.

But the pioneering development work on celluloid was accomplished elsewhere. The material itself was developed in England in 1861, but appears not to have been exploited there. After 1869, it was manufactured commercially by the Celluloid Manufacturing Company of Newark, New Jersey. People had *suggested* its applicability to photography earlier in the 1880s, but it was considered at that time to be too

thick to be practical as a negative base support for emulsion coating. But it was hard, durable, almost entirely unaffected by acids or alkalies, and unchangeable under ordinary atmospheric conditions. About 1884, John Carbutt persuaded the proprietor of the Celluloid Manufacturing Company, John Wesley Hyatt, to try manufacturing some of the material in thin sheets. By 1888, Hyatt provided a suitable article only 0.01 inches in thickness. For Carbutt, this constituted "the most complete and perfect substitute for glass yet discovered." In addition to being light, tough, and flexible, it could be treated during development in the same way that a glass negative was treated.

This was the ultimate, and presumably the most successful, undertaking of Carbutt's long career of attempted and achieved "firsts." He described the film's development in a

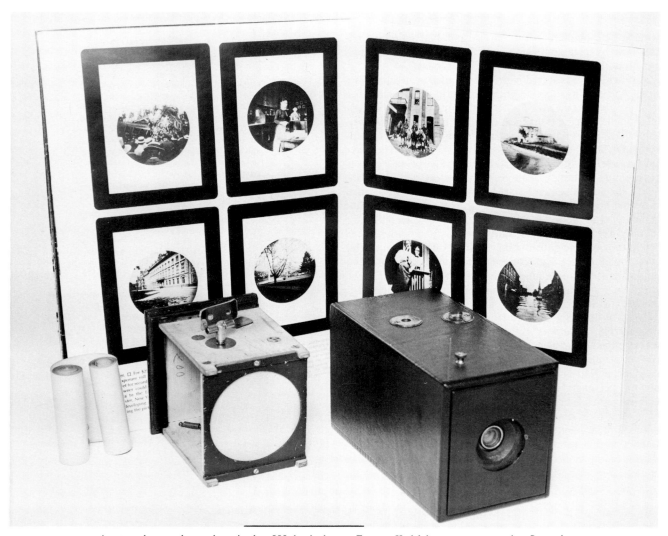

Amateur photography was booming by 1888, but in the new Eastman Kodak box camera patented on September 4, 1888, and placed on the market at the outset of 1889, photography was given its true "Model T" among cameras for all people. It was strictly a film camera, and the roll holder (left) was an integral part of the camera, inserted into or removed from the camera through a rear panel in the manner of all subsequent "box" cameras. Images were printed circular (see samples, rear) because the camera's image frame was circular. First Kodaks used a paper base "American" stripping film, which could accommodate one hundred exposures. Subsequent Kodaks, beginning in 1890, used celluloid film allowing twelve exposures.

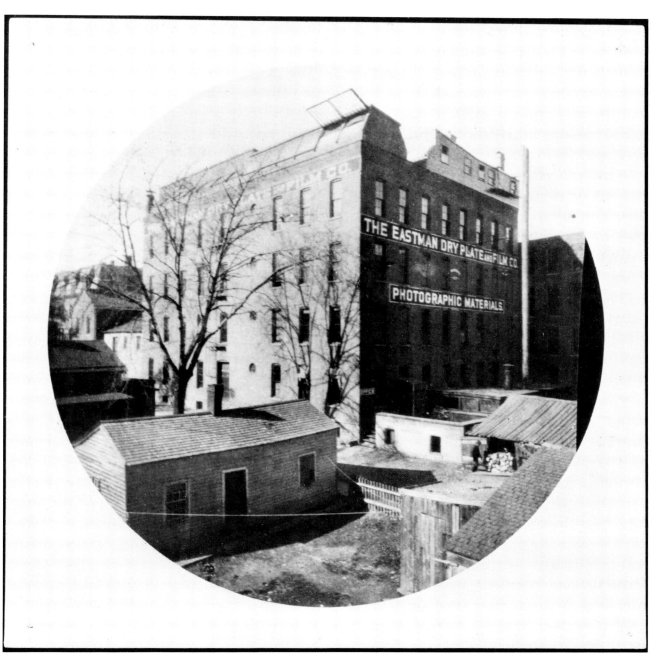

This circular Kodak camera print shows the factory building at Rochester, New York, where George Eastman, with Henry A. Strong, founded his Eastman Dry Plate Company in 1879. Company was recapitalized in October 1888, as the Eastman Dry Plate & Film Company, to include manufacture of celluloid film.

1889

lecture at the Franklin Institute in November 1888, and was first on the market with a commercial celluloid dry plate to be used in a plate holder in exactly the same manner as a glass plate. Carbutt's "Flexible Negative Films" joined his *Keystone* dry plates as popular commercial products for the remainder of the century. After 1900, the thickness of the film manufactured by the Celluloid Manufacturing Company for Carbutt, as well as for others, was further reduced.

Neither Carbutt nor Hyatt applied for a patent for the new celluloid photographic film, possibly because the retiring rector of the neighboring House of Prayer in Newark, the

JOHN CARBUTT

An Englishman who emigrated to America in 1853 at age twenty-one, John Carbutt became something of a "man for all seasons" in American photography, although he is today little known. He was among the first to follow and to photograph the building of the transcontinental railroad. After this he made photographic portraits of the leading citizens of Chicago, which were published in book form. In 1871 he moved to Philadelphia to establish the first American photomechanical printing establishment, utilizing the British-developed Woodbury-type process. At this time he also began experimenting with gelatine dry plates, and was first on the market with a commercial article in 1879. Next, he took up the manufacture and standardization of lantern slides. He pioneered the American manufacture of X-ray film, and became a supplier of magnesium powder for flashlight photography. About 1884, he commenced experimenting with celluloid as a substitute for the glass negative, and once again was first on the market with a commercial product. In 1880 he was named the first president of the Photographers' Association of America, successor to the National Photographers' Association formed in 1868.[582]

Rev. Hannibal Goodwin, had applied for a patent on May 2, 1887, for a method of making photographic film of nitrocellulose in a manner which was not described in very specific terms. Like David Woodward of Baltimore (who invented the solar camera as a means of improving his portrait painting), Goodwin had turned to experimenting with photography after trying in vain to find illustrative material which he considered suitable for use in lantern slide lectures for the young people of his parish. The experiments were evidently conducted over a long period of time (ten years), and were centered on trying to find a substitute for the glass negative. The proximity of the Celluloid Manufacturing Company may have had something to do with the direction of Goodwin's endeavors, and, conversely, his achievements may have discouraged Carbutt and Hyatt from seeking patents of their own.

Between May 2, 1887, and September 12, 1889, Goodwin's patent was revised seven times, and it was during this period that George Eastman determined that the future resided with a flexible negative film of some sort, and that he had better do something about it. Thus he hired a young chemist, Henry M. Reichenbach, to develop a new flexible film for the Kodak camera. The result was an application by Reichenbach for a patent, which initially ran afoul of the Goodwin patent in the U.S. Patent Office, but was ultimately granted on December 10, 1889.

Although records are now lost, it appears that T. C. Roche may have experimented with celluloid film as early as (or before) Goodwin. John Carbutt stated at the tenth annual convention of the Photographers' Association of America, held in August 1889, that "since I have become a manufacturer of the article, I have learned that I was antedated two or three years. . . . I was shown in New York, in the offices of Messrs. Anthony, a film said to have been made some five years ago on celluloid." The transcript of Carbutt's remarks reveal that a Dr. Eliot (presumably Dr. Arthur Elliott) responded with this statement:

> Mr. Carbutt has very generously credited Anthony & Co. with the making of the first films. I happen to know that it was the old veteran T. C. Roche who had the first idea. T. C. Roche, of New York, was the man who had the first idea of using celluloid and making films. But somehow or other it fell through.[583]

The Blair Camera Company of Boston also became a supplier of rollable celluloid film, principally for the popular Hawk-Eye detective camera (introduced about 1889 by the Boston Camera Company, which Blair acquired in January 1890), and the Kamaret (Kodak-style) box camera introduced in 1892. In 1902, T. H. Blair gave a description of his company's manufacturing process, which may be summarized briefly as follows: The film base (taking the place of negative glass) was formed by spreading the liquid nitrocellulose material on an endless moving surface, as for example a cylinder, where it was given sufficient time to harden to the point where it could be handled without injury by machinery. The film was then stripped from its supporting surface and placed in motion over rollers, allowing air to pass over both sides of the film until it was further "seasoned." The film was then transported to a coating machine in a nonactinic department where the sensitive emulsion was applied. Once again, the film was transported on de-

A TRIP THROUGH CHINATOWN
WITH A KODAK CAMERA

From the Los Angeles *Times*

A gentleman, the happy owner of a most fluent tongue, entered the *Times* local-room last night, and laying a small box, about six inches long by three high, on the city editor's desk, asked if he would like to go out "shooting" that evening. The mandarin of the blue pencil replied that he had no great hankering for the sport at that moment, being at peace with all mankind, except a few unesteemed contemporaries, and these he preferred should die a lingering death. The visitor hastened to state that he was not thinking at all of shooting to kill, only of shooting for views. He simply desired to exhibit, for the benefit of the local-room, a little dodge for taking instantaneous photographs by day or night. Turning to a companion who had entered with him he desired him to fire a "shot." That gentleman produced a kind of scoop shovel, painted white, and pulled the trigger, while the first visitor pointed the little box at an occupant of the room. Suddenly a snap was heard, a flash like lightning dazzled the eyes, a little puff of smoke rose to the ceiling and the "subject" was informed that his photograph had been taken. "That's all the 'shooting' I do," said the visitor. "My name is S. C. Jones, agent for the Kodak Instantaneous Camera, and if you will send a reporter with me this evening I'll show him a little night gunning."

A reporter was detailed to accompanying the head artilleryman, who proposed beating the Chinatown preserves by lamplight. The expedition numbered four; the head cannon-box carrier, the "flash" firer, an aide-de-camp and note-taker. Mr. Jones said he had reconnoitered the ground the previous night, and was prepared to lead the way. He marched the invaders into a little 6 x 10 cubby hole in a dark alley, down in Chinatown, used as an opium den by a fat, old, spectacled Chinaman named Yuen Kee, but whom Mr. Jones familiarly addressed as "papa." "Papa" was very glad indeed to see Mr. Jones, and showed the army the opium stalls where a few Chinese fiends were "hitting the pipe." Mr. Jones explained most eloquently to "papa" and his customers that he was the agent for a cheap electric light, without which no Chinese residence was complete, and offered to give an illustration of how it worked. Assent was freely given, and literally in a flash, the assistant artilleryman shot his apparatus, and a good picture of the opium fiends, puffing away, was taken. "Papa" seemed delighted, and never suspecting his picture was being stored up in the box, rubbed his eyes and asked for more. More flashes, and "papa" in various attitudes, his customers and his den, were transferred to the films. The flashes attracted a large number of Chinese, who peeked in through the windows in astonishment. Gen. Jones led the way next to a Chinese barber shop, where, though no electric lights were needed by the proprietor, no objection was made to an exhibition. With the diplomacy of a Bismarck, Gen. Jones "shot" a highbinder who

was getting his head shaved, another washing his face, and the boss barber and his assistants in various attitudes of astonishment.

Next a raid was made on a Chinese general store, where another "shot" was taken and a firstrate picture obtained. All this time it must be remembered not even a suspicion of the true object of the visit passed over the Chinese mind, Gen. Jones talking most evangelically about his electric light, and sighting his cannon camera so skilfully that no attention was paid to the deadly machine.

A Chinese fruit stall was next "shot," and then a blonde young woman with a red wrapper and a hoarse voice, who peeped through a latticed window and invited the army to pay her a fleeting visit, fell a victim. She, however, was the only one so far who objected. She anathematized the "shooters" forcibly and fluently. But then she was an American and not Chinese.

Another Chinese store was raided, where the proprietor and two of his wives were standing behind the counter putting up Chinese delicacies in packages. When the flash went up, the two Chinese girls squawked in terror, and, crouched behind the counter, jabbered something about white devils. Preparations were being made to carry the war into Africa and Mexico, when the assistant artilleryman made the alarming discovery that the ammunition was all expended. A council of war was accordingly held and a cessation of hostilities for the night ordered by Gen. Jones. The army then took a wet "shot" themselves and disbanded.

The instrument with which the cannonading was done is what is known as the Kodak camera for taking instantaneous photographs either by day or night. It is 7½ inches long by 3¼ deep and three inches wide, and weighs, when ready for action, just one pound and ten ounces. All that is necessary for good work is a little practice in pressing the button on the top of the camera which opens and closes the lens, and, perhaps the most important of all, holding it perfectly steady. For night work one must have an assistant to set off the flash. This is composed of *Blitz-Pulver*—a magnesium powder made in Philadelphia. It is spread on a small plate, shielded at the back by an upright piece of tin to protect the eye. A toy pistol cap is placed in the center of the powder and discharged by pulling the trigger of a small hammer. A flash as vivid as lightning occurs immediately, and the photograph is taken. It can be used in a lighted room or in a dark one, in the street or inside the house—in fact, anywhere. There is enough material in the camera to take 100 photographs, which can be taken consecutively as fast as the button can be pressed. The lens produces a photograph about three inches in diameter. These can be sent to any photographer to be developed, and printed either on blue, albumen or bromide papers. They can also be enlarged or reduced at wish.[584]

1889

ELECTRIC LIGHT ENLARGER

"Very few who can get the electric light will use the old solar camera," G. Hanmer Croughton said in April 1889. Solar cameras were expensive to use, and the sun could not always be depended upon, he observed. Describing a much more economical electric light apparatus (left), he said the arc light should be placed in a closed box or cupboard (1), and a pair of condensers (2) should be utilized which would have sufficient diameter to cut to the corners of the size of the negative used. A ground glass placed between the two condensers (3) could be omitted to shorten exposures, but only at the expense of softness in the copy print. The camera and plate holder are shown respectively by 4 and 5, and the copying board on which the sensitized paper for the enlargement is to be pinned as labeled as 6.[586]

vices which allowed drying and exposure of air to both the newly coated surface and undersurface of the film. Blair emphasized that air was given constant access to both sides of the film during the entire series of operations (seasoning, coating, and drying). Seasoning, he also explained, could be prolonged to any extent of time desired by simply extending the area over which the film was transported.[585]

There are grounds for concluding that the Rev. Goodwin could have prevented issuance of a patent to Reichenbach for celluloid photographic film manufacture, but in any event, Goodwin's patent application went through a long series of rejects and revisions before it was finally granted in 1898. In 1900, Goodwin organized the Goodwin Film and Camera Company, and began construction of a new plant in Newark where the Goodwin film was to be manufactured in competition with Eastman and other film suppliers. But in the summer of 1900, Goodwin was injured in a streetcar accident, and he died the following December. Two years later, E. & H. T. Anthony & Co. acquired a controlling interest in the Goodwin Company, and F. A. Anthony, a nephew of Edward Anthony, became the company's president.

Troubles had already arisen between the Anthonys and Eastman in 1887, when Eastman sued the Anthonys for infringements of patents covering the machinery used in coating bromide paper, and the Anthonys countered by bringing suit against Eastman for infringement of the patent issued to Roche for the formula used in manufacturing the paper. These suits were ultimately settled out of court, but after the Anthonys gained control of the Goodwin operation, a suit was filed against Eastman's company claiming infringement of the Goodwin patent (on the grounds that Eastman had departed from the specifications of Reichenbach's patent, and had in effect adopted Goodwin's process).

This case turned into one of the most important legal controversies in the whole history of photography, but unlike the Cutting patent warfare nearly half a century earlier, it did not involve the fraternity. The case was not settled until March 1914, but in the process, the legal determination was made that Goodwin was, in fact, the rightful inventor of celluloid photographic film. The decision compelled Eastman to make restitution to Goodwin's heirs and to the Ansco Company (the surviving company which followed the merger of the Anthony firm with Scovill & Adams in 1902), and on March 27, 1914, George Eastman sat down and wrote out a check for $5 million.[587]

1890

Although it was still not possible to make color photographs in the modern sense, photographers by this time had at their disposal an assortment of special plates and color screens (color filters, in modern terms), the use of which would enable them to render better "color values" in their black and white prints. The basis of the technology involved was the orthochromatic or isochromatic principle enunciated by Dr. Hermann Vogel in 1873. Both terms meant the same thing; when a photograph was taken, the use of negative plates containing a dye, or dyes, and the placement of a colored screen behind the lens would reproduce, in the uncolored print, a more correct brightness in the colors which the eye could see in making the photograph, but the photographic print would not otherwise adequately record. Stephen Horgan explained that "it is what wood engravers have aimed to do, that is, to render in black, or white, or monochrome what they term 'tone values' of a painting, portrait or landscape." For this very reason, he said, a magazine such as *The Century* kept a distinguished engraver (Timothy Cole) in Europe to make his engravings on wood before the paintings and frescoes of the celebrated masters, thus ensuring that he recorded on his blocks a "true orthochromatic reproduction" of the masterpieces copied.[588]

Among the first American-made "isochromatic" plates were those perfected by Frederic E. Ives. At first he used Newton's emulsion plates treated with an alcoholic solution of chlorophyll from blue myrtle or periwinkle leaves. But because these early plates were less sensitive to green than to blue or red, he added eosine to the chlorophyll and got what he considered more satisfactory plates. In 1886, Ives was awarded the Scott Legacy Medal by the committee on science and arts of the Franklin Institute for his isochromatic plates, which the committee (headed by Henry Heyl) held were the "first successful application" of the orthochromatic principle.

During the 1880s, numerous other dyes were introduced for orthochromatic plates, among them: erythrosine, cyanine, fuchsine, azaline, aurantia, rose Bengal, quinoline red, xanthophyll, gallocyanin (a blue dye), chrysanaline, corallin, and aldehyde green (most of them derived from coal-tar distillation). But "from all the evidence available," Alfred Brothers wrote in his *Manual of Photography* (London and Philadelphia, 1892), "it does not appear that any one of the substances hitherto used is, in itself, sufficient to render plates color-sensitive to all the rays, and that no single one is altogether satisfactory for the red." Such a complete color sensitivity would have to wait for the panchromatic plate introduced after the turn of the century.[589]

By June 1890, Dr. Vogel termed orthochromatic photography "an old thing," but said that there were a great many people who knew nothing about it, or didn't believe in it:

Only in Germany, where color-sensitive photography was invented, is it duly appreciated. In the establishments of Braun (Dornach), Albert & Naunfstängl, Obernetter, Bruckmann

A PHOTOGRAPHIC INSTITUTE

The founders of the American Photographical Society took steps to collect and preserve photographs made by photography's early pioneers, but to no avail. In 1860, and again in 1872, J. H. Fitzgibbons proposed establishment of a photographic museum in New York, but to no avail. When the suggestion was made in 1890 to establish such a museum in Great Britain, E. L. Wilson penned an article pointing out that such proposals, including those occasionally made at American photographic conventions, are usually made "without any practical plans for their organization and maintenance." Since interest in a possible American photographic institute appeared again to be growing, Wilson cautioned against beginning at the wrong end:

Not only must the cost of the home be counted, but the money for its erection and for its maintenance for a while must be secured in the very beginning. This suggestion—and we admit it is a miserable one—is not intended to cast a veil upon the enterprise, to chill it and discourage it. We cannot, however, refrain from facing the facts. At the present time our art as a business is at a low ebb. Photographers in America, as a class, to speak humanly, are not doing well. Competition is hard, prices are low, and depression is general. Evidently if the institute or home is to be started soon, the chief power must come from the amateur side of the camera-lovers. This would not be hard. Many of the wealthiest men and women of our country are able amateurs. To many of them photography is an apt and valuable helper in business; it adds to their incomes. May we look to them to start the ball on the rise and for help to keep it up for a time?[590]

(Munich), the Photographische Gesellschaft (Berlin), are many thousands of subjects reproduced by color-sensitive collodion, and in the British Museum such plates have been used. Color-sensitive gelatine plates are already made in at least six manufactories in Germany, one in England, and one in America. In using these plates, a yellow screen is required to diminish the action of the blue rays; but there is one kind of plate by which the right color effect is produced without the yellow screen in taking landscapes; this is the eoside of silver plate.[591]

The necessity to use the yellow screen was a bugaboo to many photographers. Not only did its use necessitate longer exposures, but in addition, its interposition behind the camera lens changed the focus, necessitating refocusing after the screen was in place. This was difficult because of the feeble light admitted through the screen. The St. Louis plate maker Gustave Cramer told photographers attending the 1890 Photographers' Association of America convention in Washington, D.C.:

It is now the aim of the experimentalists to prepare orthochromatic plates in which the sensitiveness to the violet and blue rays is reduced to a minimum, and the sensitiveness to the green, yellow, orange, and red increased to the highest degree, so that the use of yellow screens is rendered unnecessary, and I

ORTHOCHROMATIC PRINT DIFFERENCE

Probably only those who have made a study of nineteenth-century orthochromatic photography can discern from examining an old print whether or not an orthochromatic negative plate (or isochromatic plates, as they were also termed) was used in the camera to make the picture. But the difference can be clearly seen when one has two photographs of the same subject, as above, the one (left) made with an ordinary negative, and the other (right) with an orthochromatic (or isochromatic) negative. A dye or dyes used on the latter plates, together with placement of a colored screen behind the lens in the camera, reproduced in the uncolored print a more correct rendering of brightness in colors which the eye could see in making the photograph, but which the print could not otherwise adequately record.

HALATION

The blurring of light around the window in an interior photograph remained a virtually unsolvable problem for photographers throughout the nineteenth century. This "halation" was caused by the light passing through the film during the exposure and reflecting itself back on the film, a situation aggravated by use of glass negatives. Halation was alleviated to some extent by use of paper negatives, or (after 1889) celluloid film. But by 1895 "nonhalation" glass or film dry plates became available which contained an inert coloring matter which would arrest the actinic rays then dissolve itself in the photographer's developer.[592]

STATUE OF LIBERTY IS PHOTOGRAPHED
AT NIGHT WITH AID OF FLASH LIGHT

The Glens Falls, New York, photographer S. R. Stoddard thought that to photograph the Statue of Liberty in daytime would be like "picturing a corpse." In justice to its generous donors, and to the sentiments it portrayed, he felt it must be photographed at night with a black sky and rayless surroundings in order to be, in fact, "Liberty Enlightening the World." Stoddard accomplished the feat with the aid of magnesium flash powder, and gave this description in an 1891 photographic annual:

In company with one of the soldiers stationed there, I climbed up into the shoulder of the statue, then, unlocking a grated trap intended to keep the inquisitive public back, we went up and up through the mighty arm (the coldest arm I ever had around me), and out on the platform surrounding the torch, from which point a strong wire was let down until it touched the base and was secured at top and bottom for use when needed. Experimenting, we found that neither a Le Clance battery nor the electric light plant of the island seemed to heat a fine platinum wire, A, sufficiently to ignite the flash powder or gun cotton, but finally, after much searching among powder dealers, I found an explosive cap used for blasting purposes, that could be exploded by passing a current through it from the electric light machine.

As night approached, I reared a battery of five cameras—a 16 x 20 with 23-inch Dallmeyer R. R. lens; an 8 x 10 with Morrison W. A. 13-inch focus; an 8 x 10 with a ten-inch Dallmeyer R. R.; a 5 x 8 with a five-inch W. A. Dallmeyer and a pair of Zentmayer stereo lenses of about four-inch focus—and then turned my attention to the proposed source of light.

To the wire that was suspended from the torch, at the point where it could be reached from the steps that led up to the door in the base of the pedestal, I attached a cardboard box, B, containing a pound and a half of flash powder with an ounce of pure powdered magnesium thrown in for good measure. In this I buried one of the cartridges secured for that purpose, to which was fastened two, fine, insulated copper wires, C, to complete the circuit and explode the cap when at the proper moment connection would be made with the electric light system of the island. The strong wire was then continued on over the ramparts to the water's edge and thence with plenty of slack, carried out on the water by men in a boat, until the box with its hanging wires was drawn out and as high up in air at the side as possible.

Then began a series of accidents. First the wire broke out toward the boat somewhere and the end had to be hunted up, spliced to another piece and carried out again. Then the wind was unfavorable and it was with much difficulty that the box, faintly seen in the air, could be brought to hang in the right position, then the copper wire that ran down to the hand of the electrician below, parted and came down and the distant boat must come in shore again until a new set of wires could be made fast and finally when all seemed right, the lenses were all uncapped and the signal given, but no explosion came. The electric current or the wire, or the magnesium or something was wrong.

The lenses were capped and new plates put in the holders—for of course it would not do to uncover the same plates twice with the certainty of having two bright spots where the torch sent its light out and down to the sensitive plates where there should be but one, and the whole performance had to be gone through with again. More experimenting followed to demonstrate that the current properly applied, would explode one of the two remaining caps, and the last one then put in position. Then once more, the wires were carefully overhauled, the long wire hauled taut by the boatmen, the lenses uncapped and the signal given.

Away up on the ramparts the black silhouettes of men could be dimly seen. The marble pedestal shone white in the glory of the arc-lights. Above, the black form of the statue was reared with the shadowy arm uplifted, while above all the gleaming torch sent its lines of light straight out over the waters of the bay. A moment of suspense followed, then the night seemed rent apart and for a moment all was white as blazing day, then in the sudden return of darkness a few burning bits of paper fluttered down through the air and all was over.

On developing the various negatives, I found that the 16 x 20 and the 8 x 10 made with the 13-inch Morrison were under exposed. The 5 x 8 and the stereoscopic plates came up very satisfactorily but were spoiled in the fixing bath from particles of partially dissolved salt that in some manner had become mixed with the hypo, while the 8 x 10, taken with the Dallymeyer 10-inch lens, proved a success and is the excuse for this article.[593]

172. LIBERTY ENLIGHTENING THE WORLD.
Photographed by Magnesium Light.
Copyright 1890, by S. R. STODDARD, Glens Falls, N. Y.

1890

William Gladstone, zinc engraving. William Gladstone, chalk engraving. William Gladstone from a photograph circa 1890.

PHOTOZINCOGRAPHY VS. THE "CHALK" ENGRAVING PROCESS.[594]

Photozincography, or more simply "zinc etching" as it was commonly termed, was by this time the predominant mode of photoengraving used to make newspaper illustrations. But a rival method advertised extensively as being better than any photoengraving process was adopted by some newspapers in various sections of the United States. This was the "chalk process," wherein a thin coating of plaster of paris and chalk was applied to a steel plate, after which an artist could draw through the chalk coating to make an intaglio-style engraving. After the drawing was completed, the plate was placed in an iron box and molten metal was poured against it to make a relief cast of the engraving for subsequent printing on a press.

Stephen Horgan contended that the chalk process was unsuitable for making reproductions of photographic portraits, and that it was mechanically impossible by this method to obtain the character necessary to produce an acceptable likeness. To illustrate the point, he published two illustrations of British Prime Minister William Gladstone, one made by photozincography and the other by the chalk process. Above left is an illustration made by Horgan by photozincography. Center is an illustration made by an artist by the name of Wagstaff on the Atlanta *Evening Journal,* using the chalk method. Right is a

contemporary photograph of Gladstone reproduced here in halftone for comparative purposes. The Atlanta artist was evidently pleased with his results and sent the chalk process illustration to Horgan, asserting that the process was among other things much quicker than photozincography. With tongue evidently in cheek, Horgan responded: "I will not question the likeness in this case. Mr. Wagstaff says his portrait is that of Mr. Gladstone, and I will take his word for it." But he challenged Wagstaff's contention that the chalk process was quicker (Wagstaff said his illustration was completed in 1¾ hours). In the presence of several witnesses, Horgan arranged for artist Alexander Zenope to make a drawing from the same original used by Wagstaff, then processed the reproduction by photozincography. The total amount of time involved was an hour and eighteen minutes, which Horgan said was broken down as follows:

Drawing portrait	18	minutes
Photographing and reversing negative	15	"
Preparing the plate for etching	14	"
Etching	15	"
Blocking and routing	5¼	"
Engraving and proving	10¾	"

for myself can report progress in my experiments in this direction, so that I hope soon to be able to place on the market an orthochromatic plate of good sensitiveness which can be worked without a yellow screen.[595]

A year later, John Carbutt, another supplier of orthochromatic plates, contended that color screens were rarely needed in making landscape photographs, except in cases where photographs were being made in brightly lit mountainous regions, or where white clouds were to be found in relief against a blue sky. Then a pale yellow screen would be called for, which, with a longer exposure, would better render details in the foreground of the picture. Carbutt said photographers should also make greater use of the plates for studio work, and he gave this description of the way in which to revamp a studio for this purpose:

> The best light I find is that coming through an orange-red medium, and as the orthochromatic plate is more sensitive to yellow than to blue, I would suggest that the walls of the studio be tinted a pale yellow, the side screens also, and the curtains to the skylight of yellowish cheese-cloth. The results in your portraits would be blue eyes rendered darker, auburn hair lighter than it is usually rendered, freckles much less conspicuous, and colors in drapery rendered with a truer color value, together with a more harmonious result generally . . .[596]

After a while, the matter probably became academic. Julius F. Sachse, the newly named editor of a revitalized *American Journal of Photography,* pointed out that no one buying a box of dry plates knew just how the maker's particular emulsion was prepared (since all manufacturers kept their formulae carefully secret), hence, there was nothing to hinder a manufacturer from using on his *ordinary* plate an emulsion to which had been added an orthochromatizing solution.

Stephen Horgan found as much when he took a tour through eight New York photographic stock houses in 1897 to purchase orthochromatic plates for comparative analysis. Frequently, he said, he was told (always "in confidence") that all dry plates by the best makers were made orthochromatic. In the guise of a one-man "consumer's union," Horgan subsequently published his findings, and his review would, in today's terms, be called "mixed." He found that Cramer's *Banner* plates possessed the advantage of photographing the violet one shade darker than Eastman's "extra rapid" plate, but that this was offset by Eastman's plate recording orange one shade brighter than the Cramer plate. Horgan considered Cramer's "slow isochromatic" plate the best in orthochromatic properties of all makes, but said it would photograph green and red one shade too dark in each case. Plates made by Wuestner and Carbutt, he said, possessed like properties, namely that violet (the darkest color) would photograph lighter than yellow (the brightest color), "leaving these plates hardly deserving the title of orthochromatic." The French-made Lumière "series B" plate, Horgan said, was the only plate that would photograph red at its proper value, but was in every other respect no better than the American plates.[597]

VOL. XXIX.—No. 749.　　　　NEW YORK, JULY 15, 1891.　　　　PRICE, TEN CENTS.

Puck

KEPPLER & SCHWARZMANN, Publishers.　　　COPYRIGHT, 1891, BY KEPPLER & SCHWARZMANN.　　　PUCK BUILDING, Cor. Houston & Mulberry Sts

ENTERED AT THE POST OFFICE AT NEW YORK, AND ADMITTED FOR TRANSMISSION THROUGH THE MAILS AT SECOND-CLASS RATES.

THE PEEPING TOMS OF THE CAMERA.

1891

334

1891

The explosion in amateur photography came at a propitious moment in the cultural history of America. This was the start of the Gay Nineties, when whole cities were characterized as "restless," and there was a push and hurry not to be seen in any other land. In art, it was a time for idealizing women, and this expressed itself in photography as well. Throughout the country there developed a preoccupation with the enjoyment of one's time in leisure hours. For some, this period was "the springtime of life," but to Alfred Stieglitz, newly returned from nine years of living in Europe, he could see only a "spiritual emptiness of life" which he found "bewildering." Bicycling for the first time became a national vogue. New "safety" bicycles were introduced with equal-sized wheels and cushioned rubber tires; "drop-frame" bicycles also appeared, which allowed a lady's skirts to veil most of the legs down to the ankles. Wherever the new hordes of bicyclists went, their new hand cameras went with them.

Despite the boom in the camera market, the term "detective" continued to be applied to a variety of the hand cameras introduced before the turn of the century (signifying, no doubt, an appreciation for privacy little known today). At the same time, a whole new breed of novelty cameras appeared on the scene, including those concealed in watches, binocular cases, hats, cane handles, and even scarves; or packaged in such fashion as to resemble a revolver, a set of books, etc. Among the professional photographers, considerable discussion began to take place among those who advocated the use of small versus large cameras. Cameras able to accept large plates had traditionally been used to make many of the finest photographs of exhibition caliber, but enlargement had become a simpler matter from negatives made with the new hand cameras.

As there was more to discuss in the trade, as well as among amateurs, so there appeared a new group of periodicals, particularly aimed at what was presumed to be a permanent new market of amateur readers. The three prime new publications, all of which first appeared in 1889, were the *American Amateur Photographer,* published in Brunswick, Maine (home of the editor and publisher W. H. Burbank); the *Photo-American,* published in Stamford, Connecticut; and the *Photo-Beacon,* published in Chicago. All were discontinued in 1907—perhaps a telling indication of just how long their subscribers were interested in reading up on photography before accepting the camera as just another adjunct of everyday living.

The Kodak's first competition, the Kamaret, a product of the Boston factory of the Blair Camera Company, made its appearance in 1891. Dr. Arthur Elliott, reporting on the progress of photography at the annual P.A.A. convention in July, described it as "the most compact hand camera now in the market" (principally due to placement of the roll film between the cone of rays and the side of the box); but the camera was not a success; later, even a Blair officer referred to it as a "lemon."

Among other camera styles which became more popular at this time were the reflex camera (which reflected the image to be photographed onto a viewing glass at the top of the camera) and the magazine camera, which stored a number of plates or cut films inside the camera (each plate being changed after an exposure by a mechanism of some sort). At the P.A.A. convention, Elliott lauded a new magazine camera just introduced by E. & H. T. Anthony & Co.:

> Coming to the use of plates in hand cameras, we must give the palm to the new magazine camera of Anthony. This embodies several new devices that are quite ingenious. First, the plates are made to come into focus automatically by means of a spring, and after exposure a single push on a button takes the exposed plate out of the way into a well, leaving another plate in place for further use. Second, after all the plates in the magazine of the camera have been exposed, the camera may be loaded up again by attaching a reservoir box to it containing a new lot of plates, which are readily transferred to the body of the camera by use of a couple of slides. The empty box can now be used to hold the exposed plates in the camera, and these are removed by attaching it to the bottom of the camera and with the movement of two slides the plates fall out to give place to those that are to be exposed afterward. When we remember that all these transfers are accomplished in open daylight, we must confess that this is a decided advance in the construction of hand cameras.[598]

JENA GLASS

In 1881, Ernest Abbe (of the Carl Zeiss lens manufactory) and Otto Schott established a glass factory in Jena to develop a new type of optical glass. By 1886, they were offering a variety of new glasses, including three versions of a new barium crown glass. This gave a new dimension to photographic optics, which had previously relied principally on flint glass. The new Jena glass enabled opticians to increase the angular aperture of their lenses, and to produce perfect flatness of field and freedom from astigmatism. The glass was applied to lens design in 1887, and as one British expert expressed it several years later, "it seemed as if mathematicians might play with the designing of lenses" for the first time. The first major application of the Jena glass was in the Zeiss Anastigmat, introduced commercially in 1890. In more technical terms, the Jena glass allowed a better compromise between roundness of field and astigmatism. Roundness of field was a lens defect wherein the definition at the margin of the plate is defective, while that at the center of field is good. By focusing, definition at the margin could be improved only by sacrificing definition at the center. Astigmatism was a lens defect also giving a want of marginal definition, but which could also be improved by sacrificing central definition.[599]

ANASTIGMATIC LENS COMBINATIONS

Astigmatism in a lens means that the lens does not have the ability to bring to a focus at a point all of the rays proceeding from a point in the subject or object being photographed. A point in the subject becomes something else in the image. The first anastigmats (corrected for astigmatism) were single lenses of two or as many as five pieces of glass. The single lens anastigmat, top left, has four glasses. Double anastigmats were introduced immediately after the single-lens versions. The example, top right, consists of two single lenses having a total of eight glasses in all.[600]

THE TELEPHOTO LENS

Photographers had long sought a lens that would, as one of them put it, "give enlargements direct in the camera." This was supplied in 1891 by two sources—T. R. Dallmeyer, in London, and Dr. Adolf Miethe in Berlin. While there was talk of priority, Dallmeyer had indicated privately that he was working on such a lens in 1890, at the behest of Peter H. Emerson. In the Dallmeyer lens, a diverging or achromatic concave lens was placed at the end of an internal extension tube which projected back into the camera from behind an ordinary portrait lens. By extending the camera, an image could be obtained of objects situated too far distant for adequate viewing by the naked eye. The optical principle was not new, but the ability to provide good definition and a flat field, together with plenty of light, was something of a technical breakthrough (not fully achieved at first, but evidently achieved by the time of the 1893 Chicago Exposition). W. K. Burton, a British photographer who was serving as secretary of the Photographic Society of Japan, discussed the powers of the Dallmeyer lens at the Chicago fair and said "it will be found that using the same back focus, that is to say, the same distance between the posterior lens and the ground glass, the telephotographic lens gives an image from about three to about five and a half times as large as is got by an ordinary form of lens, according to the extension of the camera, and the form of 'ordinary lens' used. This is linear enlargement, or 'diameters.' At first sight these figures may not seem very great. If, however, we consider a case or two it will be seen how enormous the advantage is. For example, 6 inches is a common enough focus for a quarter plate. Say, a single lens is used. We may, with the same back focus, get an image with the telephotographic lens as large as could be got by a single lens of 34 inches focus."[601]

Automatic photographing machines also were introduced this year. By putting a nickel in a slot you could have your picture taken and framed while you waited. But Elliott's reference to them was disparaging: "All we have seen are easily distanced by the poorest tintype artist that visits the smallest country town."

Photographers using magnesium flash powder found that by dividing the powder into a number of small charges (instead of lighting it in one large flash) they could overcome some of the hard shadows which characterized their early flashlight prints. They were finding, too, that they could easily modify the color of the magnesium light, and that this could be applied to particular advantage when using orthochromatic plates.

A proliferation of new lenses matched that of the many new camera styles. Oscar G. Mason, the resident photographer at New York's Bellevue Hospital, and one of the pillars of the Photographic Section of the American Institute, had observed several years previously that "the once prevalent idea that all kinds of photographic work might be done, and well done, by one or two combinations of lenses has passed. And it has been conceded that each maker's productions, if not each lens, is best adapted to a single kind, or quite limited field of work." One colleague, Mason noted, owned some forty lenses, yet "often wishes for a different combination for some of the strange cases which he is constantly meeting in his varied and curious practice."[602]

Perhaps the greatest boon to lens development was the introduction of a new type of Jena glass in Austria (see page 335). In his P.A.A. speech, Elliott lauded the new Zeiss anastigmat lens (made with the new Jena glass), and said "there is no doubt that this Jena glass, which has done such wonders in the field of microscopy, is destined to teach us some new things in the world of photography." The anastigmat was the first lens to virtually eliminate astigmatism—an inability to obtain sharply defined images of vertical and horizontal lines, especially at the edges of the field of view, at one and the same time.

The success of the Zeiss anastigmat quickly stimulated other opticians to work along similar lines, and may be said to have led German manufacturers to a new predominance in the lens market. C. P. Goerz, of Berlin, soon followed with a double anastigmat, which further reduced astigmatism and supplied increased illumination and general definition. In the period 1894–96, Voigtlander came out with the Collinear lens, which was said to be twice as rapid as the double anastigmat. For portraiture, the Petzval lens first supplied by Voigtlander in 1841 continued to be the world standard. As late as 1897, when Friedrich Voigtlander (fourth owner of the firm) visited the Boston Camera Club, he noted that the Petzval had "found a home in nearly every well-regulated studio throughout the world," and that this

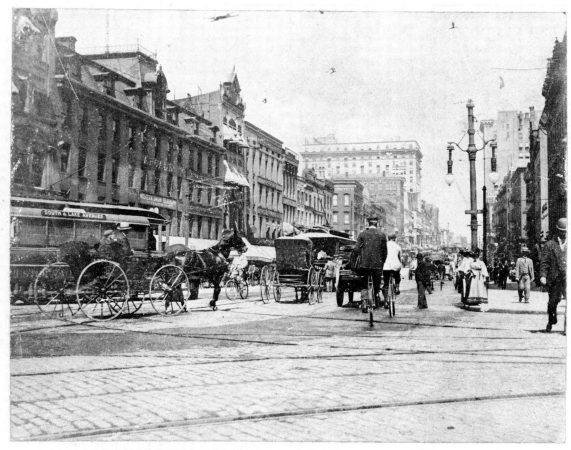

MADE WITH LONG FOCUS PREMO. ROCHESTER OPTICAL CO., ROCHESTER, N. Y. •

TELEPHOTOGRAPHY IN THE 1890S

The term ''long focus'' was applied to lenses with telephotographic capabilities, since the telephotographic lens could also be described as a long-focus lens (or battery of long-focus lenses) in a single instrument. Ten years after the introduction of this type of lens, the *Photo-Miniature* observed that ''it cannot be said that photographers generally have an intelligent appreciation either of the significance or uses of telephotography.'' The magazine also observed that, ''with the notable exceptions of Mr. Dallmeyer's comprehensive treatise, Dr. [Paul] Rudolph's monograph, and a few scattered papers by . . . others, there has been a stange lack of plain and practical information concerning the whole subject.''

At the World Congress of Photography held at the Chicago 1893 fair, the British photographer and secretary of the Photographic Society of Japan W. K. Burton said he was sorry not to be able to mention any ''recent radical improvement in photographic lenses by Americans,'' besides a new telephotographic lens just at that time introduced by Albert B. Parvin of Phila-

delphia. But Burton noted that ''few American lenses ever reach this country [he was presumably referring to England], and the description of new lenses in American journals are generally vague, if not misleading.'' A full description of the Parvin telephotographic lens was published by Parvin in *American Amateur Photographer* in June 1893.

Talbot Archer, another British writer, informed *Anthony's Photographic Bulletin* at the time of the 1893 fair that telephotographic lenses were being used by the British War Department to obtain views of distant fortifications, and by such Alpine travelers as C. T. Dent, who made surveys of snow-clad regions in the Himalayas, the Caucasus, etc.

T. R. Dallmeyer, in a series of articles covering the evolution of lenses which was published in 1900, gave scant attention to telephotographic lenses, asserting that ''the subject will require but very brief treatment.'' But he said he himself was working on a new telephotographic lens which could be used in hand cameras.[603]

lens, alone "was capable of producing the soft, round, plastic and delightful effect in portraiture, which is the artistic standard in this branch of photography for all time." [604]

Although heralded at the July P.A.A. convention, no anastigmats appear to have been used by those exhibiting prints at the joint exhibition of the New York, Boston, and Philadelphia amateur societies held at about the same time in New York. Of approximately 1,300 photographs (principally landscape views) exhibited by American and foreign photographers, roughly a quarter were taken with a Dallmeyer rapid rectilinear lens of one class or another. More than 150 of the photographs were made with a Ross doublet-style view lens, while another 94 were made with lenses manufactured by Ernest Grundlach, of Rochester, New York.

This may have been the first exhibition by an American photographic society to which the early followers of P. H. Emerson's "naturalistic" school of photography sent photographs, and it is likely that their participation was arranged by Alfred Stieglitz, who was himself an exhibitor and who four years earlier had been given first prize by Emerson at a London amateur photographic exhibition. There were three outstanding British photographers represented at the New York exhibit, all of whom were to become founding members, in 1892, of the Linked Ring Brotherhood. They included Frank M. Sutcliffe, Lyddell Sawyer, and Henry Peach Robinson, the noted "pictorial" photographer. The American landscape photography school was represented by William H. Jackson. Records of the exhibit reveal that the lenses used by the above photographers for the photographs they exhibited were as follows:

Alfred Stieglitz	Steinheil Rapid Rectilinear
William H. Jackson	Ross Rapid Symmetrical; Gray Periscope
Frank M. Sutcliffe	Dallmeyer and Ross lenses
Lyddell Sawyer	Ross Rapid Rectilinear; Darlot Portrait
Henry P. Robinson	(Not stated)

The Steinheil lens used by Stieglitz had an aperture of f/7, and was particularly suited to making outdoor portraits of individuals or groups, for which Stieglitz was noted at this time. Although the Dallmeyer Rapid Rectilinear was adopted for studio portrait work (Brady reported one stolen from his Washington gallery in January 1891), David Bachrach was of the opinion that portraits made with such "hard, wiry, sharp lenses" were "abominable." The use of

these lenses for portraiture required good lighting under any circumstances, and Bachrach felt their indoor use should be limited to group portraits. But whether because of the availability of the new Jena glass or due to other factors, opticians at this time improved on the manufacture of rapid rectilinear lenses, providing lenses with apertures that were actually f/8, whereas such lenses manufactured prior to 1890 more frequently than not contracted to less than f/8. Because of this, photographers attending the 1893 Chicago fair were warned that while secondhand rapid rectilinears might be excellent in every other respect, they were liable to be slower than newer lenses of the same make. [606]

IN MEMORIAM: JOHN A. WHIPPLE

Boston's illustrious pioneer photographer John A. Whipple died on April 11, 1891. After his partnership with J. W. Black was terminated in 1859, he operated alone until 1874, when he gave up his practice and engaged in publishing religious works. Whipple is remembered as the inventor (concurrently with Niépce de Saint-Victor) of the first (albumen) glass negative process, and of the "Crystalotype" paper prints made from these and the later collodion glass negatives. He was among the first to photograph the moon, and to make photographs through the microscope. His outdoor photographs taken by electric light in Boston Common in 1863 are the first of this type recorded in America. [605]

In many respects this was photography's most eclectic moment. Not only was there much that was new to choose from in equipment and apparatus but there were many choices to be made, as well, in processes. Still to come (but just around the corner) were entirely new dimensions, both in portraiture and in the means of printing "artistic" photographs for public exhibition and sale. Perhaps because of all the innovations—and in part, too, because of the onset of another severe financial recession—there was something of a lull in commercial business in 1892. David Bachrach blamed it on a rush to "cheapness and quantity," which he blamed for the fact that "among people of the class who in former years were liberal patrons and are able to pay good prices, *it is no longer fashionable to display photographs*, except as mere cheap souvenirs, and as a possible basis for future use in copying, etc." Bachrach had been a vocal opponent of various processes such as the Lambertype and Artotype, introduced in the 1870s, and he now began a series of analyses, pro and con, of the major photographic processes and papers, the series running off and on in *Wilson's Photographic Magazine* throughout the 1890s.[607]

S. H. Mora (possibly a kin of the New York photographer J. M. Mora) put the matter succinctly when he addressed the tenth annual convention of Canadian photographers: "At the present time, the question, 'What paper shall I use?' is one that is agitating the minds of a large percentage of the photographers throughout the world, especially in Canada and the United States." Among the so-called silver prints, there were now—in addition to the longtime standby, albumen paper—such choices as plain or mat surface papers (the modern versions of the original "salt prints" of the 1850s) and the carbon process; bromide paper; a series of collodio-chloride and gelatine-chloride papers; and the still little-used platinum paper.

Of the photomechanical printing modes, that which produced prints in photogravure had become the most popular, although principally, at this stage, only for book illustration. It was Bachrach's contention that albumen paper retained its popularity, and that the "liberal patrons" were not buying finely made photographs because even those made on plain or platinum paper were generally not up to the standards of taste exhibited in prints made from engraved plates:

> To read the articles written by the most artistic of our co-workers one would imagine that the first or plain-paper process, and the platinotype later on, should certainly have distanced all the rest by the engraving-like effects, and that only the persistent degraded taste of the people for "shine" and "polish" caused the meretricious and less permanent (albumen, gelatine, and collodion) processes to survive. I confess I have done my share in decrying the evil, but, after a careful reconsideration, I have come to the conclusion that the masses were, at least, partly right.
>
> Were it a fact that the plain-paper and platinotype prints are in every respect equal to prints from engraved plates, either line, mezzotint, or photogravure, then the condemnation

BROMIDE PAPER

Introduced in England in the 1870s, this paper, as patented in the United States by T. C. Roche (for E. & H. T. Anthony & Co.), was made with an emulsion holding in suspension the bromide haloid of silver. It was a developing-out rather than a printing-out paper, and being highly sensitive to light (giving it fast action in use), it could be developed under artificial light. This feature, alone, made it an attractive candidate for replacing albumen paper, which required printing-out in sunlight, usually on rooftops. But David Bachrach considered it only suitable for commercial work, or for enlargement of landscape or architectural photographs. "The process," he said, "is very useful for making enlargements quickly and very sharp from the densest negatives, which heretofore had to be done by very troublesome and roundabout methods." He also felt that its early adoption by "cheap Johns" and "charlatans of the profession" to make cheap enlargements of portraits at low cost had had a bad effect on the profession, and adversely affected business. In the spring of 1893, the *Photographic Times* reported that the paper "seems to be coming into more favor again," and that dealers were reporting large sales increases. In 1898, the Eastman company introduced a new variety which it labeled "Royal Bromide Paper." This was a creamy tinted paper of heavy weight, offered with a smooth or rough surface. But Charles Lovell, writing in Wilson's journal after the turn of the century, felt that one of the mysteries of the photographic business was the "contemptuous way" in which the paper was treated in the 1890s:

> It has been left altogether too much in the hands of that class of the young amateur who does not know what is a good print, or of the low-priced photographer who uses bromide paper as a substitute for platinum, and who often is as much at sea as the amateur as to what constitutes a good print.[608]

poured out on the artistic taste of the public would be justifiable. I contend that not one in fifty of such productions can compare in quality with plate prints of the kind mentioned; and, if they did equal them, I will again say that "the masses" would not so eagerly have preferred the glossy prints. A print from a steel or copper plate has its deepest shadows composed of such a depth of ink that the same shadows in a plain sil-

CHLORIDE PAPERS

S. H. Mora, in a speech to Canadian photographers in 1893, said albumen paper was "doomed," and "must step down and out." The claim that a gelatine emulsion was not as long lasting as albumen, he said, was a "false one." Just as many photographers had failed to produce permanent results with albumen or collodion papers, as with a gelatine paper:

> My honest belief is that all of the papers made today are permanent in the way in which we understand the word, when properly handled in manipulation. An intelligent photographer can easily answer the question to his own satisfaction by referring back to the negatives which he has made. He will find that there may be some that have turned color, but if they have turned color in spots it would indicate insufficient fixing. If they have turned over the entire surface, he will notice a crystallization of hypo, indicating insufficient washing. But he will find a large majority of his negatives are as clear today as they were when made several years ago. The same thing will apply to gelatine paper, as the base, gelatine, is the same, and consequently should not turn any more than the negative; the chemical emulsion is practically the same as a collodion emulsion. There is, therefore, no good reason why one paper should not keep as well as the other. A large number of photographers have tested the permanency of gelatine emulsion as compared to albumen or collodion, and I have not yet heard of a single case in which it did not hold out as well as, or better than, albumen or collodion.[609]

vered paper or platinotype print cannot hope to rival it in strength, and at the same time the picture is entirely on the surface, not sunk in as in the photograph, thus combining great delicacy in half-tone with great brilliance of light and shade. I deny that either of the processes mentioned ever give such a result except in very exceptional cases, and hence the preference of the public for the glossy albumen prints which give all that the engraving does in delicacy and depth, and at the same time a range of very pleasing tones. Let us be frank and acknowledge the truth that the people at large are not altogether to blame for their preference. I say this as the avowed friend and long practitioner of the platinotype process for large work.[610]

There was a direct analogy, Bachrach felt, too, between the "fate" of stereoscopic photographs and the current pursuit of cheapness and quantity about which he complained in professional work. Where stereocards were the attraction in every parlor twenty years ago, "quantity increased, quality decreased, prices kept pace with quality, the 'dollar stores' took hold of them, the parlors abolished them, and now who makes them?" Not one photographer in a hundred even *owned* a stereoscopic cmaera, he asserted.

Of all the emulsion processes, Bachrach was at first inclined to favor printing on bromide paper, although he changed his mind by 1896. But in the summer of 1893, he contended that:

> . . . of these various methods of producing prints by the modern processes of emulsion printing, the gelatine bromide, devel-

ARISTOTYPES

Like albumen paper, aristotype paper was a printing-out paper requiring development with the aid of sunlight, as opposed to development in a darkroom with the aid of artificial light. The aristotype came in two versions, one made with a collodio-chloride emulsion (paper containing silver chloride in a layer of collodion), and the other made with a gelatine-chloride emulsion. Both versions were first introduced in Europe in the 1880s, after which their manufacture was begun about 1890 by the New York Aristotype Company in one small room in New York City. About 1892, the company was relocated to a larger factory in Bloomfield, New Jersey. The founders of the American concern were the brothers W. M. and F. M. Cossitt (the latter presumably being the Franklin M. Cossitt who had been co-inventor, with George Eastman, of the ill-fated Eastman detective camera in 1886). In June 1893, an editor of the *Photographic Times* visited the Cossitts and gave a brief account of the company's operation, from which the following is excerpted:

> We were much struck by the size of the building and the enormous amount of paper prepared and sold. The coating room, containing the coating machine, and hanging and drying arrangement is no less than 220 feet long. Great rolls of the raw paper are fitted to the machine and made to pass around a roller dipped in the sensitive gelatine emulsion. After coating, it is carried right on to the other end of the room, looped up, so that in this space no less than two miles of paper is hung. This quantity, we are told, is usually prepared at one time. Two miles of photographic paper! What a number of pictures this quantity is likely to produce. In another part of the room stands the machine for coating the "kalona" or collodion paper. This is somewhat different to that used for the gelatine paper. After it is coated it runs through a trough about 120 feet long; this is heated and a current of air passed through to take away the ether and alcohol fumes. By the time the paper reaches the other end it is quite dry and is cut up into sheets and stored away.[611]

oped with ferrous oxalate, is probably the most permanent, if the iron is promptly and thoroughly eliminated after the development, and if the fixation has been thorough, and if the washing has been the same. Otherwise, they are worse than the average albumen prints produced by good establishments.[612]

Bachrach's greatest antipathy towards the emulsion processes was directed at this time towards the aristotype, a trade name applicable to certain photographic papers produced with either a collodio-chloride, or gelatine-chloride emulsion (see above). The aristotype, Bachrach said, outshone the albumen print in polish, and in effect this was simply continuing a mistaken course which had been first taken in the 1870s when a higher gloss in albumen paper was achieved by doubling the albumen layer. In the case of the aristotype, it was impossible to add more than one ounce

Photographs of nighttime fires were uncommon in the nineteenth century; hence, this "instantaneous" photograph of the burning of a famous hotel in a Virginia resort town was considered a technical feat, and as such was reproduced in the *American Journal of Photography*.

1892

Like the Cooper Institute in New York, the Franklin Institute in Philadelphia (left) was the scene of many important activities and events in nineteenth-century American photography. Frederic E. Ives, shown (right) in an 1896 photograph, chose the Institute as the forum for reporting on his continuing improvements in color photography, and was twice awarded medals by the Institute for his discoveries.

IVES "HELIOCHROMY" SYSTEM ALLOWS
VIEWING OF PHOTOGRAPHS IN COLOR

The perennial inventor Frederic E. Ives patented a "Trichromatic Camera" in 1892 which provided the basis of a system for viewing photographs in color, but not in securing them in color print form. Ives himself described the camera as "somewhat complicated in optical construction," but it was capable of securing three separate images simultaneously on one orthochromatic plate through three light filters (red, green, and blue-violet, respectively). From this triple monochrome negative, a triple positive was made on glass, which Ives called a "chromogram." Using red, green, and blue-violet lights, the triple images of the chromogram could be projected in register for viewing as one full-color photograph (using a magic lantern with three optical systems), or the images could be seen in color and in register through a viewing instrument (which Ives called a Heliochromoscope). This device allowed monocular viewing through a single eyepiece, but in 1894 Ives patented a stereoscopic viewing instrument, which he called the Photochromoscope, or "Kromskop," as the commercial version came to be known. Because the trichromatic camera required as much as two minutes to make an exposure, it was not used to make photographic portraits for color viewing. From 1892–94, Ives lectured on his "heliochromy" process in England (before the Royal Photographic Society and the Royal Institution), France, and Switzerland. In 1894 he made photographs with the trichromatic camera in Yellowstone Park, and in 1895 he was awarded the Elliott Cresson Medal for his invention by the Franklin Institute. But as the *Pall Mall Gazette* pointed out at the time of Ives's lectures in London, color photography still remained elusive:

> The invention in the sense of pure science does not claim to be color photography. In the strict meaning, a color photograph would be a picture taken directly by lens and camera with the colors and the light of nature. Such a thing has never been done, and there is nothing in the present state of science to justify the supposition that this result may ever be accomplished. It certainly has been possible to obtain upon a film of quicksilver some impression more or less fleeting of a few of the colors of the spectrum. It would, moreover, be practicable, with prolonged exposure, to obtain some kind of colored image from a powerfully illuminated object of, say, a red color. But the impression would be a mere silhouette of color without light and shade of gradation. Such successful experiments have frequently been made and chronicled from time to time in the newspaper press as the early promises of a great discovery. The last occasion may be fresh in the memory of many. This was the result of some researches by Prof. Lippman of Paris. But his discovery admittedly fails to render even the simplest combinations of color. It would appear that no clue exists to the secret of color photography. The dream may fascinate, and the hope may stimulate, but the search has hitherto been as fruitless as for the philosopher's stone.[613]

THE HAND CAMERA AND ITS ABUSE

From *Anthony's Photographic Bulletin*, November 12, 1892

The press-the-button photographer has considerable food for reflection this month. The summer has seen him, camera in hand, recklessly snapping the shutter in all sorts of inaccessible places, and the confidence he has had in his results is more than painfully amusing. The many rolls of film have been sent to the dealer for development and finishing off, the end being that a very disgusted individual finds himself the recipient of a very small percentage of poor prints, with a large bill to pay for the production thereof. The camera, or more often the film, is blamed, the operator rarely realizing that while photography is a wonderful art-science, it cannot be expected to supply brains and common sense to its votaries.

Large batches of such developed films have reached us accompanied in most instances by long letters of complaint, and often by the camera itself, for examination. In ninety-nine out of every hundred such cases, the fault has not been that of camera or film. The blame must, therefore, lie with the user of the instrument. Taking one such batch, we find, in some of the films, just a faint glimpse of a shelf and a clock; on another, a black patch representing a window; on another, a ghostly outline of trees; on the majority, nothing distinctly visible. All that has been written on photography has availed nothing with the producer of these results, and why? Because all that which has been written has never been read. The camera and films have been purchased, the instruction imparted by the vendor, carelessly listened to, forgotten, and all commonsense principles as to the lighting of the subject violated. And this disregard of the first principles of snap-shot photography is on the increase, judging by the quantity of useless matter produced.

The remedy for this is, obviously, education, obtained by careful perusal of photographic literature. Such education becoming general, the mechanical photographer will cease to exist, for the impossibility of an outsider to do justice to the work will be realized. And, more important still, the truly remarkable efforts put forth by these very-much amateurs will be gently restrained; no more instantaneous shots at picnic parties in shady glens, or lovers in cosy nooks under piazzas, will be attempted. The implicit trust that the mechanical photographer has in his instrument is really pitiful. It is to him the only factor in the work. But it is a factor concerning the properties of which he is, like his subjects, entirely in the dark.

There can be no doubt that the number of users of the hand camera is increasing at an enormous rate. The portability, compactness and general simplicity of action of the instrument commend it to all. But of all photographic instruments, it is the one calling for the exercise of judicious self-restraint and careful handling. The user must remember that an instantaneous picture is usually an under-exposed one, and that it is practically useless to attempt to photograph a poorly lighted object unless an exposure of one-half to one second can be given. The users of tripod cameras seldom expose with the shutter unless forced to do so, and the percentage of results ranks considerably higher than that of those of the hand camera. The users of the latter instrument rarely, indeed, use the time attachment, and, therefore, must depend on the extreme rapidity of their plates or films and on the choosing of well-lighted subjects. In most of the cheaper hand cameras the lenses are perforce diaphragmed down so as to give good depth of focus, for the focusing is done chiefly by a graduated scale. The lens will work usually about right if the light is really good. Under any other circumstances the negative will be poor and weak.

Now, the number of cheap hand cameras sold is very largely in excess of the expensive ones. With these cheap cameras good instantaneous pictures can only be obtained when working under the best possible conditions. This must be borne in mind in purchasing and in using them. Though it cost a pang to lose a good subject, it should be allowed to go; for it is simply throwing away material and labor to expend a plate upon it.

To users of films we would remark that very careful manipulation is required. Many, not well acquainted with the intricacies of their roll holders, partially fog the film by prolonged exposure to the red lamp. No lamp is perfect, and the less the film is exposed to any light the better. Then, the same cause of fogging must be avoided when cutting up the film for development. A glance at the back of the film, this being held so as to reflect the light, will reveal at once the position of the punctures. A long pair of scissors does the rest. Frilling round the edge from handling is a source of great annoyance; but care in handling and the confining of the attention to one film at a time will obviate this. All films should be soaked in water containing alcohol and glycerine before being allowed to dry, and should be stored face to face between cardboard. A film once cracked is like a plate broken.

The cut films do not receive the share of patronage they deserve. They are rigid, and have all the qualities of the best plates, and are easier to handle than the roll film. But the greater portability of this latter and its easy exchange will ever entitle it to favor, though these are the qualities rendering its employment dangerous because of its facility. In the abundance of material, recklessness and abuse arise, and the percentage of good results lowers.[614]

BICYCLE CAMERAS

Bicycling and photography came into vogue at the same time as new pastimes for leisure hours. W. I. Lincoln Adams described for the readers of *Week's Sport* which cameras were best suited for bicycling:

THERE are a number of cameras especially designed for bicyclists; the pocket photographic outfit, consisting as it does of a 3¼ x 4¼ inch camera, with a double dry-plate holder, hinged ground glass, and weighing only twelve ounces, being about the best. This little outfit contains an excellent lens, with diaphragms for increasing or diminishing the amount of light, and is sold complete for $10. A nickel-plated bicycle adjustable support costs only $2 extra. This outfit has no loose pieces, and is so accurately made that there is no side plate whatever. As its name implies, it may be carried in the pocket when not in use, and is a very convenient little camera. In photographing it may be adjusted to the handles of the machine by the adjustable support, and it makes excellent pictures.

Larger instruments are carried packed, attached to the wheel by a spring carrier, which is a kind of skeleton framework on springs mounted in front of the handle bar. Twelve or fifteen pounds may thus be carried easily without danger of breakage, or without adding extra work on the pedals. The larger cameras may also be used on handles of the machine a steel support being furnished for holding the wheel rigid while the exposure is being made, or if a tripod is carried, as some wheelmen prefer to do, the camera is set up on its legs, and the photograph is made in the usual manner.

Most cyclists prefer, on the whole, the hand camera in some form, such as the Waterbury, the Knack, or the Scovill, for it may be carried before the handles by means of the spring carrier already described and snapped from the wheel, even while in motion, if desired. It is usually supplied with an excellent instantaneous lens, so that "snap" pictures may be made at the right hand or the left during a run in the country. The hand camera may also be used on a tripod for making landscapes or other accurate pictures when desired.[615]

of hyposulphite of soda in 18 or 20 ounces of water in the fixing bath without bleaching the print out of sight. "I have seen more bleached, faded, yellow gelatino-chloride and collodio-chloride yclept 'Aristo' prints in one year than I have of albumen prints in the last three years," he said.[616]

No other spokesman for the finest that could be achieved in photography wrote consistently for one of the country's foremost photographic journals during the 1890s, and it must be presumed that Bachrach's influence on the profession was considerable. It is amusing to read, therefore, in a short memoir which he published just before World War I, that his influence on one major customer in Baltimore was anything but formidable. The customer was William T. Walters, a railroad tycoon who had previously made a large fortune in the wholesale liquor business and was the possessor of a vast art collection which is today housed in the Walters Art Gallery in Baltimore. As Bachrach relates it, the story (circa 1890) went as follows:

I had made some groups for him and, as a compliment, printed him one copy of platinotype and handed it to him, and asked his opinion. He looked it over carefully and said: "Bachrach, I made money by selling people the kind of whiskey they wanted, not the kind I thought they ought to have." Well, I followed his lead and it was five years before I made the serious attempt to do away with glossy paper.[617]

There is no indication in Bachrach's memoir, or in his writings in Wilson's journal during the 1890s, that he participated in any way in the amateur movement towards fine-art photography, which began at this time on both sides of the Atlantic. If Bachrach and men such as Alfred Stieglitz and P. H. Emerson were treading separate paths, their endeavors were headed toward a similar goal. Bachrach may have had trouble getting his customers to appreciate the platinotype, but there would shortly be many works in platinotype exhibited in some of the finest art galleries, as well as museums in the United States, England, and Germany.

About 1890, William Willis, Jr., and his partner, Alfred Clements, visited a London photographic exhibition and counted sixteen prints made on platinum paper—three or four of which were landscapes by Emerson. This prompted Willis to redouble his efforts to further improve on the manufacture of platinum paper (which at this time had a notably poor keeping quality), and, according to Clements, this was accomplished at some point prior to 1895. "Amateurs," Clements said, "began to force the professionals into adopting it for much of their work, though they resisted as long as possible."[618]

As the 1890s wore on, there was a strong revival, too, in the popularity of card stereographs. The "dollar stores," to which Bachrach disparagingly referred, may have included Underwood & Underwood, which moved its main office from Kansas to New York City in 1891, but more likely referred to the competition which Underwood & Underwood (followed by the Keystone View Company after 1892) soon displaced. Underwood & Underwood had opened branch offices in Baltimore in 1887, and in England (Liverpool) in 1889, and in the 1890s the company began producing high-quality stereoviews from negatives made by their own staff photographers, or purchased from photographers in localized areas.

1893

In Newport, Rhode Island, the modest opulence of the handful of remaining downtown wooden mansions of colonial times had become eclipsed by marble palaces (dubbed "cottages") on fashionable Bellevue Avenue. The country was in the throes of another financial recession (almost 600 banks and 15,000 businesses failed in 1893 alone), but the losers were predominantly wage earners and farmers, while the number of millionaires surpassed 4,000 (the vast majority of them in New York City, including more than 150 in Brooklyn). The Gay Nineties not only produced a row of new mansions in Newport but along New York's upper Fifth Avenue, on the shores of Long Island, and in Chicago (which boasted nearly 300 millionaires), San Francisco (about 150 millionaires), and other major cities. Along with all of this new splendor—as might well be imagined—there came a new opulence among a select group of "fashionable" photographers, whose photographic galleries eclipsed the earlier showplaces of Brady, or C. D. Frederieks. If the photographic periodicals of the decade are to be taken as a measure of what took place, no galleries exceeded in splendor those of Benjamin J. Falk in New York, or J. C. Strauss in St. Louis. Falk is perhaps most representative of this group, but while he was widely known in his day, his name is hardly a household word now.

Falk was a native New Yorker who took up a career in law after graduating from the City College of New York. But then the world of art suddenly beckoned more assiduously. He completed studies at the New York Academy of Design, then decided to take a job with photographer George G. Rockwood. In 1877, at age twenty-four, he opened his own gallery on East Fourteenth Street.

During the 1880s he moved several times to larger quarters and gained an international reputation as an "artist-photographer." When the new wave of mansions began appearing on the New York scene, Falk decided the time had come to make his own big move. In 1892, the same year in which William K. Vanderbilt completed "Marble House" in Newport (he had already completed a new mansion in New York), Falk constructed an entire building which became known as the Falk Building at Nos. 13 and 15 West Twenty-fourth Street, near Madison Square. Perhaps Falk's fame would be even greater today had he engaged Vanderbilt's architect, the celebrated Richard Morris Hunt, to design the building, rather than doing it himself.

But Falk's reputation was sufficient to bring a St. Louis reporter running to his hotel room in St. Louis one day in January 1893, when Falk was there for a short stay. The reporter started off his story after the interview by stating that "what a man who is famous in two continents, whose copyrighted pictures are seen in every shop has to say on the subject of this popular form of art [i.e., photography], should have the widest interest." The interview continued:

" What do you think of the work of the photographers as compared with that of a great portrait painter ?" Mr. Falk was asked.

" I will answer with what may sound like a paradox,

NEW EAGLE DRY PLATE WORKS

While the rising cadre of amateur photographers were in the market principally for roll film, the professional photographer continued to use glass negatives until a suitable flat film became commercially available in 1912. One major supplier of glass dry plates was the New Eagle Dry Plate Works, which had been founded by Edward Wuestner in St. Louis about 1885, then relocated to New Jersey about 1893. The plant was built south of Jersey City on the peninsula between Newark and the upper New York bays. The setting was described as one where "the air is always fresh and clear, and free from dust." The factory consisted of a main building, 50 x 150 feet, and a series of "out-houses" for boilers, a machine shop, and glass storage. Glass plates were cleaned and made ready for emulsion coating at the rate of 12,000 size 8 x 10 plates every four hours. Special machinery was used to coat and chill from thirty-six to forty of these plates a minute. Coating could be accomplished on plates ranging in size from 6½ x 8½ inches to 26 x 42 inches. One of the company's specialties was to supply plates to the trade in packages without separators, each plate placed film-to-film in its respective package. Thus, the drying of the emulsion films before packaging was a critical matter, and the operation was described as the only one of its kind among all plate manufacturers. The New Eagle company maintained three separate temperature-controlled drying rooms, and after they passed through these drying rooms, the plates had to be certified *bone dry* before packaging. Among its products, New Eagle was most noted for its orthochromatic and "Imperial" nonhalation dry plates.[619]

The camera is at once the best and most truthful medium for art work, as well as the one with the most limitations. There is a great class of work open to the painter which is entirely outside of the photographer's field, and such work should never be attempted by the latter. When it is the results are ludicrous, as is shown where positions of the human figure are attempted which the lens cannot reproduce without distortion or exaggeration. But this is technical. As far as portraiture pure and simple is concerned, the general impression seems to be that the realistic school is the only one for the camera. This is not true; if it were, one would get a map of the human face, but not a portrait. Everybody knows there is the same difference visible between good artistic photographic pictures and poor ones, although technically they may be equal as between good and poor portraits produced by pencil or brush. All of which shows what has come to be recognized pretty generally during the past ten years that the camera, like the brush or pencil, is simply a tool, and may be handled well or ill. Formerly the overcoming of technical difficulties was enough to give any photographer a prestige, but now that these have been swept away, the photographer has been placed on the same plane as any other artist, and he must be judged by the same standards."[620]

STRAUSS GALLERY

The new opulence in the 1890s also became reflected in several of the more posh photographic studios across the land. J. C. Strauss, who began working in a tintype gallery at age twelve, had come a long way by the time he opened this showplace in a French chateau-style building in St. Louis. Studio included an exhibition gallery (top), grand reception room (middle), and palatial stairway to the balcony and operating rooms (bottom). Gallery's Turkish waiting room was equipped with varicolored jeweled lamps. Of a display of autographed photographic portraits, Wilson's magazine commented: "Everybody who is anybody is there."[621]

Many of the great and famous in photography are known for their colorful antics in photographing the great and famous among their contemporaries. Alexander Hesler, for example, ran his hands through Lincoln's hair just before taking his likeness in 1857. In 1903 Edward Steichen would thrust a knife into a startled J. P. Morgan's hands to get the drama of the financier's personality. Still more recently (in 1941), Jousuf Karsh would snatch a cigar from Winston Churchill's mouth to catch the striking portrait which typifies Churchill's dogged spirit as no other likeness of the World War II prime minister does. B. J. Falk evidently had similar albeit more gentlemanly thoughts in mind when he decided on a course of action to obtain a dramatic likeness of President Grover Cleveland, newly elected to his second term in office (in 1892), having previously served one term from 1885 to 1889. The St. Louis reporter elicited this description from Falk of the Cleveland sitting:

> By the way, Mr. Falk, what kind of a sitter was President Cleveland?
> He came to the gallery all worn out with the excitement of notification week, entirely unlike the descriptions I have read of him, mild and gentile, and with a more worried expression than I had ever seen on any man's face. I was disappointed and looked about for something to say or do to drive this careworn look away. At the last moment I said: "Mr. Cleveland, there are six good democrats in our family." "Yes?," said he, and his face lighted up. That was the expression I wanted and it was caught and fixed by the camera. The result was the portrait you have seen.[622]

Like the celebrated London photographer of earlier years Oscar Rejlander, who made notable anecdotal pictures with allegorical compositions, Falk became a master of photographic compositions, as well as studies from life. Examples of these works included titles such as "The Fisher Maiden," "Judith," and "The Curfew Shall Not Ring Tonight." Falk also was among the first to photograph actors and actresses on stage in their roles. Like Sarony and Mora, he also became noted for his portraits of the stage celebrities, whom he would usually ask to perform the lines of a role in his studio until they got into the spirit of the part. "Then," as he said later, "it takes but a moment to seize upon a favorite attitude and expression and transfer it to the camera." An estimated 50,000 to 100,000 of Falk's professional portraits were sold annually throughout the world.

This was also the heyday period for the Pach brothers' firm, which occupied several floors of a building at 935 Broadway in New York, running from Broadway all the way through to Fifth Avenue. Here, too, were spacious reception rooms and galleries adorned with the finest in furniture and paintings, as well as photographs. Like Falk, the Pach firm made a specialty of printing cabinet cards, as well as larger prints, in platinum. Carbon printing, in which the Pachs also specialized, was handled by "a young worker of considerable promise" (a sign, possibly, of the new awakening to carbon printing which was taking place at this time). Pach Brothers engaged most heavily in college and school photography, operating through "contributory" studios in collegiate cities and towns throughout New England, New York, and New Jersey. All printing and finishing of these orders was accomplished at the New York headquarters, where the printing room handled as many as two thou-

Third floor reception room of the Pach Brothers' establishment in New York, running between Fifth Avenue and Broadway on the south side of Twenty-second Street, was approximately 50 x 20 feet. Its walls were covered with a maroon cloth and framed photographs of celebrities, interiors, still lifes, etc.

EDISON'S KINETOSCOPE

Although Louis A. Augustin Le Prince was already at work constructing a motion picture camera and projector, Thomas A. Edison concluded in 1887 that it should be possible "to devise an instrument which should do for the eye what the phonograph does for the ear, and that by a combination of the two, all motion and sound could be recorded and reproduced simultaneously." Edison's first move was to order some of John Carbutt's celluloid film coated with a photographic emulsion. With this he secured a primitive form of motion picture film by wrapping a 15-inch-long section of the coated celluloid around the cylinder of one of his phonographs. Edison's chief assistant at this time was William K. L. Dickson, and while Edison and his wife traveled to Europe to attend the World's Fair in Paris in October 1889, Dickson perfected a camera-projector on the basis of Edison's design specifications. Although both Le Prince and Edison were acquainted with the pioneer French experimenter Dr. Jules Marey, there is no evidence that Le Prince ever met, or corresponded with Edison. In any event, Le Prince had perfected his first camera by the time of the 1889 Paris exposition, and Marey exhibited a film sequence on celluloid film (of a man riding a bicycle on the Champs Élysées) at the Paris exposition. Marey briefed Edison on the camera he used to photograph moving objects in series, and showed him the "viewing box" which he used with the camera. But like Muybridge, Marey was interested primarily in the scientific aspects of motion picture photography, and took no steps to commercialize his inventions. When Edison returned to the United States following the Paris exposition, Dickson had already perfected a camera-projector and a film sequence which showed Dickson bowing and welcoming Edison home audibly, his words and lip movement on the film all perfectly synchronized. Edison quickly prodded George Eastman into supplying celluloid film in lengths up to fifty feet, and thinner than Carbutt's, and by 1890, Edison and Dickson had perfected and patented the kinetograph (opposite page), a camera which could start, move, and stop a strip of sensitized film, securing forty-six photographic images a second. The width of the film used on this primitive machine was 35 mm, which remains a standard in film projection to the present day. A total of nine hundred impressions could be made on a 50-foot film strip, which was carefully perforated with a series of holes along one edge. This made it possible to rerun the developed film over the same spools in accurate registration with a phonographic cylinder, the words or sounds precisely coinciding with the position, expression, lip movement, etc., of an actor or singer recorded on the film. The duration of each image during a film rerun was as little as one-ninety-second of a second. A lantern furnished with a light interrupter was used to eclipse the light between the movement of each of the nine hundred frames, and an entire film showing took no more than half a minute to complete. The idea for the kinetograph's light-interruption mechanism is said to have come from Edison's reading of a report published in 1889 by Ottomar Anschütz, an Austrian who described experiments then in progress in which he said he could view photographs on the rotating wheel of a zoopraxiscope with the aid of successive flashes of light from an electric discharge.

In 1891, Edison patented the kinetoscope (right), a peep-show cabinet which would allow one person to view the images of a kinetograph through an eyepiece. Immediately after the patenting of the kinetoscope, the *Scientific American* reported that "the daily papers have been filled with reports of interviews with Edison, from which the reading public would obtain the idea that Edison had lately invented something of paramount importance, whereas these inventions, as curious and wonderful as they appear, are, in reality, scarcely more than the pastime of the hour with Mr. Edison." In 1893, Edison built a tar paper hut (known as the "Black Maria") on his New Jersey estate, which could be revolved on a pivot base and was covered by a roof that could be opened entirely, or in sections, to sunlight. Here he recorded films of circus and music hall artists (Annie Oakley and Buffalo Bill among them) for the kinetoscope peep-show parlors which were opened on Broadway in April 1894. The films shown in these parlors remained at the 50-foot length, because longer lengths of film could not be drawn through the camera without jerking the film and causing it to break. Edison continued to view the kinetoscope as "a scientific toy," and under the press of other business, he failed to patent the invention in either England or France. The result was that the kinetoscope was first copied then improved upon in those countries, and a solution to the film breakage problem (use of an extra feed sprocket to provide a loop for slack film) was developed by others.[623]

Side view of kinetoscope cabinet shows film looping arangement beneath a coin-operated kinetograph machine, which sequenced a 50-foot length of film continuously for viewing through eyepiece.

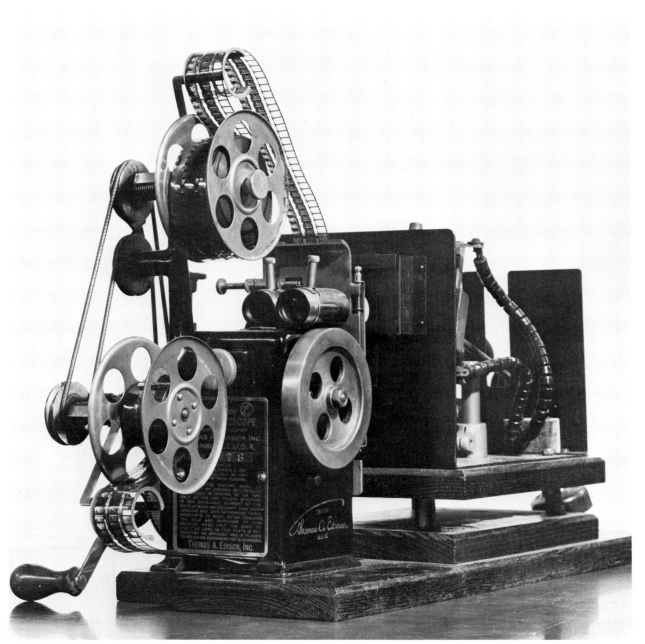

Thomas A. Edison's first kinetograph (above) is today housed in the archives of the Franklin Institute.

EXPOSURE METERS AND EXPOSURE TABLES

Beginning in the 1890s, a number of instruments were placed on the market having as their objective the correct timing of a camera exposure. These instruments included photometers, actinometers, actinographs, and exposure meters. Wynne's "Infallible Exposure Meter," introduced about 1893 by E. & H. T. Anthony & Co., was described by the company as "so very simple and exact that the spoiling of a plate because of error in exposure should hereafter be a rarity." The instrument was the size of a small watch, and was supplied with the actinometer numbers of various manufacturers' plates, together with a supply of sensitized paper. All the user was required to do was record the time it took to darken a piece of the sensitized paper (in sunlight) to a standard tint. But the Denver photographer W. H. Jackson remained unenamored of all such devices:

I do not think it possible for the out-of-doors or general all-around photographer, as distinguished from the portrait photographer, to always be able to make a correct exposure. It is all a matter of guess-work, and, other things being equal, the best is one who comes nearest guessing right. In this, more than in any other branch of work, experience is of the greatest use— an experience gained from long practice, that so educates the judgment as to enable the photographer to estimate at once, without reasoning, an approximately correct exposure.

In nearly all other operations connected with photography you can take your time and figure out carefully what you want to do and how you propose doing it; but in exposure, conditions change so rapidly that between focussing and putting your plate in the camera you may have cause to change your mind. Even with the exposure under way, one will increase or cut short in the time two or three times as much as first intended.

Many schemes have been devised to aid the photographer in the correct estimation of the intensity of the light, of the color, of the atmosphere, and of other factors entering into the question of exposure, aside from the apertures of his lenses and the speed of his plates. Exposure meters, exposure tables and the like are calculated with the greatest precision, and one would think that such a thing as failure could not occur—the whole business seemingly being reduced to fixed laws, which, being fully committed to memory, would enable you always to arrive at the correct result. As to the exposure meters, I confess myself in ignorance of the method of their application except in a very general way, but it has always seemed to me that in order to use them intelligently it would tax the understanding as much as is required to make an off-hand judgment.

Exposure tables, giving the difference in the quality of the light at different times of the day and year, and under the different circumstances of being on sea or on land, in the woods or on the plains, are mostly a delusion and a snare—they only approximate, in a very general way, the differences. The exposure tables, however, in which are given the differences in the apertures of lenses as regards their focal lengths, and the proportionate exposure required for such differences, are of some use, for in this we have the only approach to fixed laws to work from.[624]

sand individual frames, and three hundred sheets of albumen paper daily. In the case of all albumen prints, printing was done on the building rooftop in sunlight, where dozens of permanently situated tables could accommodate long rows of printing frames. The tanks in the toning and washing rooms below were so vast as to resemble a public bath.[625]

The scale of such elite and posh metropolitan galleries lasted only as long as there were wealthy patrons to support them, and it is unlikely that we shall ever see anything like them again. In one sense, Falk left a legacy which has survived to modern times. He was influential in helping David Bachrach "acquire a little taste in posing and lighting," as Bachrach later expressed it, and this has remained the hallmark of the Bachrach organization through successive generations of growth and prosperity.

The awakening of renewed interest in carbon printing, just mentioned, was sparked by the introduction by the Autotype Company in London (successors to the rights to Swan's carbon process) of a better carbon "tissue" (special paper coated with gelatine, colored in one of approximately fifteen available colors or shades). This occurred in 1893, but before its wide acceptance, W. A. Cooper gave an address at the 1893 Chicago fair in which he contended that photographers had been misled over the years by the cry for glossy-finished carbon prints, just as the same want of high glossiness had, in the opinion of many experts, plagued albumen paper printing. In technical jargon this meant that photographers using carbon printing had been giving preference to a double-transfer (higher gloss) rather than the original single-transfer (matt finish) process patented by Swan in 1864. But the chief attribute of the new carbon tissue was

that print drying could now be accomplished in daylight rather than in a darkroom.

Another stimulus to carbon printing proved to be the aristotype process, which produced prints with a matt finish. Not only was this a benefit to carbon users but, as Cooper said in Chicago, "now the desire is for matt surface in all gelatine printing papers." By May, the *Photographic Times* announced that a Brooklyn company (the Stillwell Manufacturing Company) had reorganized itself, and had been renamed the Photo Supply Manufacturing Company for the sole purpose of manufacturing carbon tissues on a large scale. The *Times* also gave this brief description of the change it had noted over the past four years in printing methods among the "better class of the trade":

As is well known, the style of photographic printing has changed to a considerable extent with the better class of the trade since the Aristotype papers were first introduced four years ago. We now see in the high class galleries plain paper printing, platinotype and other matt surface papers under different names put upon them by each gallery. We hardly think there is any of them that rivals this old-time friend [the carbon process], and doubt whether any of them equal it in permanency. We have lately noticed in some of the showcases of a few of the New York galleries some exceptionally fine carbon prints, especially in the upper part of the city, designated as photogravures. There has been a small quantity of carbon tissue manufactured in this country within the last year, but the main part has been exported from France. Whether the prices charged were too high for it to be generally adopted, or on account of its merits not being generally known, we do not know, but from the conversation which we have had we know that this will be overcome in the new photographic firm which has been organized for its production in large quantities.[626]

AN EAKINS PHOTOGRAPHIC PORTRAIT

The photograph of Walt Whitman (above) is from a platinotype made shortly before Whitman's death in 1892 by the Philadelphia artist Thomas Eakins (1844–1916). Eakins had been a leader of the revolt by young artists against the ''conservatism'' of the National Academy of Design in the late 1870s and, after 1880, added photography as another dimension to the celebrated ''realism'' of the works he executed in oil. But never in his own time was Eakins described as he has been by one modern authority as ''probably the greatest American painter, and certainly one of the greatest 19th-century painters on any acceptable list.'' Nor has he, until recently, been accorded proper recognition for his role (together with others in Philadelphia's amateur photography school of the late 1880s and 1890s) in demonstrating photography's capabilities as a fine-art medium. Eakins also painted Whitman (in 1888) before making a series of photographic portraits from which this profile has been selected.[627]

"NEW SCHOOLS" AND BUSINESS TRUSTS
1894

When Alfred Stieglitz returned to the United States in 1890, he soon realized, he said, "that 'photography,' as I understood the concept, hardly existed in America." [628] Because of his first-prize award at an 1887 London amateur photography competition, and the favorable recognition accorded him by European artists as well as photographers, Stieglitz became the sole American to actually participate (though not formally) in the movements begun at that time in England, France, Germany, and Austria to elevate photography to its rightful position as a fine art. The "pictorial" school begun earlier by H. P. Robinson was followed by the "naturalist" school headed by Peter H. Emerson, which narrowed its sights on capturing in photographs a "painterly" effect of what was seen in nature, and an "impressionist" school credited to the London photographer George Davison in which photographers sought to doctor their negatives to secure "controlled" images (otherwise known as "manipulated" prints) on various pigmented matt-surface papers or canvas. By 1892, many of the photographers in these schools had banded together in a Linked Ring Brotherhood.

Stieglitz was generally correct in his 1890 appraisal of the dearth of fine-art photography in America, but there was one encouraging note which had occurred prior to this at the 1887 joint exhibition of photographs in New York by the amateur societies of New York, Boston, and Philadelphia. Landscape photographs in bromide and platinum at this exhibition "completely outranked" other prints on albumen paper and toned in a conventional way, according to one reviewer.

In the period 1890–94, there were other isolated events which indicated that the movements across the Atlantic were having an effect on American photographers. In December 1890, for example, "impressionism" in photography was chosen as a topic of discussion at the Pacific Coast Amateur Photographers' Association; and in July 1891, forty American photographers attempted to exhibit 350 photographs at an art photography exhibit in Vienna.

This exhibition was among the first to put into effect the principle—adopted later by all photographic "salons"—that the members of the committees organizing such events would judge all contributions *prior* to a given exhibition, weeding out those items not considered to be up to the committee's standards. Thus, at the 1891 Vienna exhibition, thirty of the Americans submitting photographs were literally "thrown out with their works" before the event, leaving only twenty-five American entries supplied by ten photographers. Five of the entries were from Stieglitz; others were provided by photographers from Rochester, Buffalo, Chicago, and Lowell, Massachusetts. But of these, only the names of James L. Breese of New York and John G. Bullock of Philadelphia gained prominence at later exhibitions. [629]

More than any other single individual, Alfred Stieglitz provided a motivating force for an American art photography movement. This was further aided by his assumption of co-editorship with F..C. Beach of the *American Amateur Photographer* in July 1893. At the time this occurred, Stieglitz and several partners were operating a photoengraving company (the Photochrome Engraving Company) which, after 1893, supplied a number of halftone reproductions as illustrations for the *American Amateur Photographer* (many of them being reproductions of Stieglitz's work). But business was poor and in 1893 Stieglitz took to wandering the streets of New York with a hand camera. His first photograph was made on Fifth Avenue during a blizzard on Washington's birthday. At first his colleagues at the Camera Club scoffed at the blurriness of the small photograph, but were later astounded when it was blown up in slide form (see next page). Nothing quite like it had ever been seen before, and within a short time the feat was imitated by others.

Shortly after Stieglitz became an editor of the *American Amateur Photographer,* George Davison became its British correspondent. In his first article, which appeared in January 1894, under the title "To American Photographers," Davison indicated that, from his own standpoint (and presumably that of others in the Linked Ring), American fine-

THE LINKED RING

When the "artists" of the Royal Photographic Society in London "began to find they were being tolerated only," H. P. Robinson said, "Some of them left the society; others followed, and [in 1892] a little club was formed to promote the cause of art in photography." This was the Linked Ring Brotherhood, a loose organization without a president or council, whose members were elected on the basis of their evident artistic ability. With the possible exception of a calotype club which operated in London from 1847 to 1851, no organization of photographers had ever before been established for this purpose. Before the Brotherhood was organized, eight of the so-called "artists" had gotten together and published a series of folio-size monographs, each of which contained biographical material and samples of work (in photogravure) by a particular photographer among the group. The series was appropriately entitled *Sun Artists,* and the monographs were issued consecutively during the period October 1889 to July 1891. Although said to be the first publication to represent the "artistic" position of photography, it was not continued after 1891. But in 1893, the Linked Ring sponsored its first photographic "salon" in London, which was a decided success. For the next fifteen years, this became the most important annual event of this kind in the photographic world. In 1894, the first Americans were elected to membership. These were Alfred Stieglitz and Rudolf Eickemeyer, who was co-operator (with James L. Breese) of a New York studio specializing in carbon printing. [630]

"Winter—Fifth Avenue," by Alfred Stieglitz, taken on Washington's birthday, 1893, with a hand camera.

STIEGLITZ PHOTOGRAPH HERALDS
"THE BEGINNING OF A NEW ERA"

About 1892, Alfred Stieglitz saw some prints of size 4 x 5 inches made with a hand camera which he found extraordinarily beautiful. Thereupon he decided to buy a hand camera and "master its use." On Washington's birthday in 1893, a great blizzard raged in the city. Stieglitz stood at the corner of Fifth Avenue and Thirty-fifth street watching the lumbering stage-coaches moving slowly northward, and thought to himself: "Could what I was experiencing, seeing, be put down with the slow plates and lenses available?" F. W. Crane, writing in *Godey's* magazine two years later, said Stieglitz spent six hours at the corner getting the snap-shot he wanted. A short time later, even before the negative was dry, Steiglitz showed it to other members of the New York amateur photographers' society. "For God's sake, Stieglitz," one of the members said, "throw that damned thing away. It is all blurred and not sharp." But Stieglitz was entirely happy with his negative, and by his own account replied: "This is the beginning of a new era. Call it a new vision, if you wish." The next day, when he showed a lantern slide from the negative, the members all applauded. "No one would believe it had been made from the negative considered worthless." Stieglitz called his photograph "Winter—Fifth Avenue," and years later Edward Steichen said it was Stieglitz's "most exhibited, reproduced, and prize-awarded print." [631]

arts photography still lagged behind what was taking place across the Atlantic. American pictures, Davison wrote,

> appear to be concerned with trivial details and circumstances rather than with the broader effects; with complicated, made-up subjects rather than with simple natural beauties of light in landscape or expression in portraiture. Are there no varieties of weather in America, no mists, no rain, no atmosphere, no clouds, no wind, and no character in its landscape either simple or sublime? Do all photographers there go out religiously when the sun is vertical, and only then? Are all of them under bondage to their tools instead of masters of them?[632]

Despite Davison's criticism, there were a number of American photographers besides Stieglitz who were producing excellent pictorial works, although nothing of the pioneering nature of Stieglitz's wintery view of a stagecoach on Fifth Avenue, which he labeled "Winter—Fifth Avenue." Catherine Weed Barnes of Albany, for example, began photographing on her travels to Europe with her parents, and took up the study of chemistry in order to improve her darkroom work. She was an active member of the New York and Brooklyn amateur societies, and the only woman honorary member of the Chicago Camera Club. She was also an editor on *Outing,* and the editor whom Stieglitz replaced on *American Amateur Photographer* when she left for London to marry the British photographic editor Snowden Ward. There were, too, such acclaimed photographers as W. B. Post and James L. Breese of New York, and Breese's partner, Rudolph Eickemeyer, the second American to be elected to membership of the Linked Ring in 1894.[633]

The greatest center of activity in pictorial work at this time was Philadelphia, home of the Platinotype Company (the American counterpart to a similar company in London). Probably due to the close proximity of this supplier, a large number of the members of the Philadelphia Photographic Society, John G. Bullock among them, worked almost exclusively in platinum. In Stieglitz's view, this posed a real threat to New York amateurs, and as early as 1892 he published an article in which he cited the lack of progress in the use of the platinotype in New York:

> Probably not one in five hundred uses it in this city, while in Philadelphia it is in general use for all fine work. For exhibition work it is indispensable, and the sooner the New York amateur makes up his mind that, in order to compete successfully with the Englishman, or even with the Philadelphian, in the large exhibitions, he will have to discard all albumen paper, glazed aristotype (that *bete noir* for every fine-feeling eye), etc. . . .[634]

One member of the Philadelphia school, in particular, deserves recognition as an unheralded pioneer in American fine-arts photography. This was Alfred Clements, the proprietor of the Platinotype Company, who evidently worked quietly out of the limelight, and as early as 1887 took an award at the joint exhibition that year of the New York, Boston, and Philadelphia amateur socieities. His first notoriety came in an unusual way. In the summer of 1894, the *American Amateur Photographer* announced a special competition in which contributors were asked to send eight photographs under an assumed name to England for judging by Henry P. Robinson and George Davison. In December,

ALFRED STIEGLITZ

After "Winter—Fifth Avenue," Alfred Stieglitz made a series of other photographs of snowy street scenes which, as Paul Rosenfeld later said, provided photography and art "with a new motive." After this, city snow scenes made their appearance "in numbers" at exhibitions, as did night street scenes after Steiglitz made such photographs in 1896. In the course of his career, Stieglitz said of himself: "Photography is my passion. The search for Truth is my obsession." And for a man gifted with his insight and talents, it was inevitable that a touch of the contemptuous would reveal itself over the years towards others less committed in their lives and works. By 1894, he recognized that "Eastman's mass-production methods" were causing "enthusiasts" to lose interest in photography. Within the several New York photographic societies he identified what he termed the "dress suits" and the "democrats," who were figuratively pitted against one another. As far as he was concerned, "all factions were in a state of dry rot," nevertheless, he played a major role first in the amalgamation of the New York societies (in 1896), and ultimately in the founding (in 1902) of Photo-Secesssion, the American counterpart to the Linked Ring. Twelve years before his death in 1946, the Literary Guild published a "collective portrait" of Stieglitz in which Jennings Tofel summed up the man in these words: "Alfred Stieglitz must know, as well as most of us do, that there is no one else as venturesome and right, as unselfish and just, and as complex a personality as himself, in all the art life of this land at this time, and hitherto."[635]

A STRUGGLE FOR EXISTENCE. ALFRED CLEMENTS.

"A Struggle for Existence," Alfred Clements' prize-winning photograph in an 1894 competition among American photographers judged in England by Henry P. Robinson, founder of photography's "pictorial" school, and George Davison, originator of the "impressionistic" school. Entries in the competition were submitted under assumed names. Second prize was awarded to Alfred Stieglitz.

1894

when the judges' decision was announced, the first prize was found to have been won by "Dr. Malaria," who turned out to be Clements. The second and third prizes were awarded respectively to "Progressive" (who turned out to be Stieglitz) and "Iquitos" (who turned out to be Clarence B. Moore). Clements' prize-winning photograph was a platinotype of a sandy beach on which was a cluster of small trees in a sanded mound. The picture was entitled "A Struggle for Existence." In a critical analysis of the Clements photograph, Davison said it showed considerable taste in selection and treatment, adding:

> . . . it is made out of simple materials; the author has been quick to see the slightly fantastic character of the trees. There is unity and simplicity with strength, combined with distinct feeling and sentiment.[636]

No greater testimonial to Davison's credentials as a critic is to be found than in this comment made later by the third place winner, Clarence Moore:

> I wish to say that in each point where Mr. Davison criticizes my work unfavorably he hits the nail full on the head; and if we had over here such a worker as Mr. Davison, and such a just, fearless and competent critic, combined with workers who would give heed to his counsels, the cause of amateur photography on this side would be materially advanced.[637]

Although Clements' works are today unknown, he brought a definite style to the views he made in forests, fields, and along shorefronts. His own thoughts on the subject were expressed in an interview with the *Photographic Times* in 1895:

> It has always seemed to me as though temperament affected preference for subjects. Some may like figures while others prefer landscapes. As for myself I care little for the former because it is difficult to take away the conscious expression of the models, and this to me robs such pictures of all value as works of art. My preference is landscapes, or landscapes with figures where faces scarcely show. The weird things where the imagination can play suit me best.[638]

His fondness for pictures of this kind, the *Times* was quick to point out, was not due to any morbid tendency; on the contrary, for those who knew him best his pictures tell only of his "quiet, generous nature, and keen delight and admiration for those occupations and sports which take one into the sunlit woods and fields, and of his liking for the homely things in nature, and the desire to interpret her in all her varying moods, be they grave or gay." The *Times* was quite forthright in its evaluation of Clements' influence: "To Mr. Clements' efforts its [platinotype] success in this country has been due, and an artistic school of photography in America made possible."

There are distinct parallels in the motivation behind Clements' and Stieglitz's photography, and in making the comparison, the word "isolation" comes most quickly to mind. As Harold Clurman pointed out in later years:

> What was the New York that Stieglitz returned to at the end of the century? It was a world in which fragments of Old World grace were lost amid the rising emblems of New World power. But the skyscrapers that were being built and the whole life of which they were the most conspicuous symbols were also fragmentary, lacking the human and social integration that could be read clearly in every detail of European existence. The world

ALFRED CLEMENTS

A native of Kent County in England, Clements grew up as a farm boy, but at an early age went to work for William Willis, inventor of the aniline process used in engineering and architectural reproduction work. In 1867, when Edward Anthony bought the American rights to the aniline process, Clements was brought to New York to take charge of the activity. But the American climate was found to be too hot and dry for successful operation, and within a few months the undertaking was abandoned. Clements was thereupon reassigned by E. & H. T. Anthony & Co. to the Anthony photolithography business, represented by the American Photo Lithographic Company in Brooklyn, New York. After several years, Clements left the Anthony firm to become head of the New York *Daily Graphic,* which, as we have already seen, was printed by photolithography. During all of his years in New York, Clements maintained a correspondence with William Willis, whose son, William, Jr., invented the platinotype process in 1873 (receiving British and American patents in 1876). When Willis, Jr., came to the United States in 1877, Clements decided to go into partnership with him. Although the Willis & Clements manufactory became a successful one, improvements were attempted which were not equally successful in furthering wider use of the platinotype. Perfection of platinum printing in its final form was not achieved until after 1890.[639]

IN MEMORIAM: CHARLES D. FREDERICKS

After an illness of six months, death came to Charles D. Fredericks, seventy-one, on May 26, 1894. A native New Yorker, Fredericks was sent as a youth to Havana to acquire a knowledge of Spanish, then returned to New York for collegiate studies. But the panic of 1837 wiped out his father's fortune, and Fredericks was required to take up a gainful occupation. After working on Wall Street, he embarked for Venezuela to join his brother in a business venture, taking along a daguerreotype camera. But photography became his vocation, and he traveled widely in South America. In 1853, he established a gallery in Paris, but soon returned to New York, first in partnership with Jeremiah Gurney but after 1857 as operator of his own gallery. By 1861, John Werge was saying that "London and Parisian galleries do not compare with the Fredericks New York gallery." When he was burned out in 1886, his new quarters at 585 Broadway were viewed as the largest photographic enterprise in the country.[640]

that Stieglitz returned to was a lonely world: active, ambitious, pushing its way frantically and fantastically to a goal it did not know. Man was somehow shut out of this world, even while he was helping to make it.[641]

Where Stieglitz had earlier captured the charm and simplicity of children, and of older people in their European country and urban habitats, he developed, in New York, a new affinity for deserted streets. Clements, on the other hand, photographed *nature* in isolation. Stieglitz loved snow, mist, fog, and rain, and was attracted to scenes of man's endurance against these elements, as well as to other surmountables of everyday living. Clements also photographed misty mornings, but in remote settings; and his "Struggle for Existence" was typical of other photographs

he made at this time, depicting *nature's* dogged endurance in isolation.

But where Clements' motivation was singular—nature in isolation—Stieglitz's was many-sided. There was more illumination, now, to city nightlife, and this, too, held its attraction for Stieglitz. Independently—but simultaneously, as it turned out, with the English photographer Paul Martin who was photographing London streets at night—Stieglitz made a photograph of a nighttime street scene in New York, which he exhibited in 1895 at the second annual Salon of the Linked Ring. In the same year, Martin exhibited a set of lantern slides, "London by Night," at a meeting of the Royal Photographic Society. Soon, other photographers were following their lead, and as the decade wore on, photography of outdoor scenes at night became commonplace.

1895

The best that could be achieved with color photography in the nineteenth century was perfected experimentally, or brought to a viable commercial status in the period 1893 to 1895. Although prints in color could not be obtained from color negatives or color film in an ordinary camera, several methods were perfected which allowed people to view photographs in color on a screen, and, after 1893, good halftone illustrations could be produced in color on a photoengraver's letterpress.

The first to perfect a color halftone printing process was William Kurtz of New York. In 1892, he employed Dr. Herman Vogel's son, Ernst Vogel, to help him in these endeavors, and by the summer of that year he obtained what he considered to be satisfactory results. Among the first of these was a negative of some fruit on a table which he used to secure the image, in relief, on three separate printing plates, each screened to receive ink of a different color.

The three plates were used to print a large quantity of colored halftone reproductions of the image (showing the fruit in their natural colors), which Kurtz sent to Dr. Vogel in Germany. Presumably the publishing "first" which shortly followed was worked out in advance between Kurtz and the elder Vogel, but in any event the prints were bound in as color illustrations in all copies of the January 1, 1893, issue of *Photographische Mittheilungen*. The publication caught the photographic world by surprise, and left the *Photographic Times* wondering "why Mr. Kurtz, of New York, should have felt called upon to announce his results first in a foreign publication."

Kurtz soon thereafter made additional color prints from the same negative, and these prints were used as the frontispiece of the March 1893 issue of *Engraver & Printer*, published in Boston. Possibly because of the world's fair which took place in Chicago that year, photoengraving firms in that city became the first to gear themselves to this new mode of color printing, and their first results began to appear in the *Inland Printer* and other publications in 1894.

In addition to the Kurtz method, which Kurtz never attempted to patent, color printing took a variety of forms. Alfred Stieglitz, for example, applied color to one of his photographs made on platinum paper, then made photomechanical reproductions of the colored platinotype at his photoengraving company. These were used as the frontispiece illustration of the January 1894 issue of *American Amateur Photographer*.[642]

But just as it had not been possible to trap the images seen on the ground glass of a camera obscura prior to 1839, so it remained impossible, in the nineteenth century, to trap *in their natural colors* what the photographer and the camera could see and photograph in black and white. In retrospect, the best color photographs obtainable in the nineteenth century were those which could only be viewed momentarily on a screen. In 1892, as we have already seen, F. E. Ives perfected a means of viewing photographs in color, either when a superimposed image from three separately filtered glass positives were viewed through the eye-piece of a table-model "Heliochromoscope," or when the image was projected in superimposition on a screen, using a magic lantern with three optical systems. In December 1894, Ives patented a table-model Kromskop (see next page) as a replacement for the Heliochromoscope. The Kromskop allowed one-person viewing of stereoscopic glass positives in color. This instrument was exploited commercially in England, France, and Germany, beginning in 1895, but was not manufactured commercially in the United States until 1899.

Independently of Ives, Robert D. Gray, a New York lens maker, perfected another means of projecting superimposed images in color on a screen, using a modified lantern (see above). Ives had not yet applied for a patent for the Kromskop, and was in London when Gray's process was first demonstrated at Chickering Hall in New York City on January 10, 1894. Presumably alluding to his 1892 patent (for the trichromatic camera), Ives sent this brief but angry letter to the *American Amateur Photographer:*

> It is not true that there is one single new idea or improvement shown in Gray's demonstration. His claims are fraudulent, and he appears to be infringing my patent rights while trying to discredit my work by misrepresentation.

POST OFFICE RULING ENDS USE OF TIPPED-IN JOURNAL PHOTOS

The practice of binding-in original photographic prints with the text of a photographic journal began with Snelling's journal in 1851, and was continued after the war by Wilson's journal and the principal other journals in the field. On May 1, 1895, *Anthony's Photographic Bulletin* announced that it would abandon the practice as a result of having received, "with considerable surprise," the following communication from the U.S. Post Office:

> In accordance with instructions from the Post-Office Department, I have to inform you that it has been decided that photographs and other matter pasted to printed paper sheets, otherwise eligible to admission to the mails as second-class matter, subject them to a higher (third-class) rate of postage, for the reason that the law prescribes that second-class publications must be formed of printed paper sheets, and shall contain no writing, print or sign thereon or therein in addition to the original print, except as provided by Section 308, Postal Regulations (which relates only to certain permissible writing and printing on second-class publications and their wrappers). If it has been your practice heretofore to affix photographs or other matter to your publication, mailed at second-class rate, please discontinue it in future.

"Our readers will note," the *Bulletin* remarked editorially, "that we have not this month presented them, in accordance with our usual custom, with an actual photograph. . . . We regret exceedingly that the Post Office takes this stand, especially as for some thirty years publications containing photographs have gone as second-class matter unchallenged."[643]

Gray's response was contained in a letter to the same publication some three weeks later:

I have gone over the Ives matter. The only reply I could make would be an accurate description, with stereoscopic measurements of the absorptions, of the light filters used, properties of the plates used with each screen, and the results of the combinations. This I am unwilling to do, but will say they are very different from the formula published by Mr. Ives. We all know the superimposing idea to be old, and the means of getting the slides in register and of keeping them there are mechanical details not worth quarrelling about.[644]

Ives appears not to have indulged in any further criticism of Gray, or to have instituted any legal proceedings later on. Gray's invention may also have gone into production, as it was stated at the time that Gray gave a demonstration of his process at the New York Camera Club in July 1896, and that the machine used was "a Natural Color Triple Stereopticon" manufactured by J. B. Colt & Co., of New York. But Ives's Kromskop was by far the better recognized of the two systems in its own time. To the editors of the *Photographic Times,* the process was "a veritable realization of color photography to the extent of bringing before the eyes, by a simple and practical process, a photographic image in the natural colors which is far more perfect and realistic than any colored picture on paper could possibly be." The *Times* also drew this analogy:

The Kromskop photograph is therefore, although not a color photograph, a *color record,* just as the cylinder of the phonograph, although not a cylinder of sound, contains a record of sounds, and the kinetoscope ribbon, although not an animated photograph, contains a record of motion.[645]

Austin Leeds, who became publisher of the *American Journal of Photography* for a year before its merger (in 1900) with another new periodical, *Photo Era,* described the Kromskop's color photographs as "so intensely realistic" that they "can almost be handled." He labeled the Kromskop as "perfectly practical commercially as a means of advertising, as an instrument in educational and lecture courses, and as an adjunct to the study of art, medicine and natural history."

In 1900, Ives developed a "Junior" Kromskop, and a "Miniature" Kromskop, but at the same time candidly admitted that the tricolor cameras used to make the slides for color viewing in any of the Kromskop models were "complicated, costly, and delicate of adjustment, which puts them out of court for the amateur who wishes to go in for color photography with a moderate investment." In his autobiography (1928), Ives said that, despite all the "medals and other honors of scientific societies" which were conferred him, "the general public demanded prints on paper and refused to take sufficient interest to justify commercial exploitation."[646]

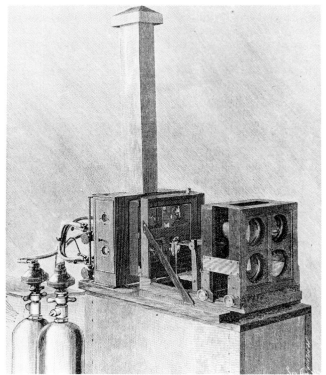

Although color photographs could not be obtained from color negatives or color film in an ordinary camera prior to the twentieth century, color photographs could be produced artificially for viewing through a table model device such as the Kromskop (left) or on a screen projected by a triple stereopticon of the type shown at right. But inventor Frederic E. Ives admitted that the Kromskop was too complicated, costly, and delicate of adjustment for the ordinary amateur photographer, and the triple lantern device, developed by R. D. Gray, is not known to have been widely used.

PHOTOMECHANICAL PRINTS
EXHIBITED IN COLOR

Although he gave up his photoengraving business in 1895, Alfred Stieglitz's Photochrome Engraving Company was one of nearly a dozen American and foreign firms to exhibit photomechanical prints in color at the New York Society of Amateur Photographers in December 1894. Prizes were evidently not awarded, but the "place of honor," according to *Anthony's Photographic Bulletin*, "undoubtedly" belonged to Edward Bierstadt, who exhibited four portraits from life, printed in collotype from three color separation negatives. "The total time required for the sitter to pose before the camera while the three negatives were exposed," the *Bulletin* said, "was at least seven minutes, and, judging from the excess of blue in the prints, it would appear as if the negatives for the red and yellow were undertimed. Though the results were not entirely satisfactory, they record progress, and it was only a man with the frankness of Mr. Bierstadt who would have exposed them to the criticism of those unaware of the difficulties attending their production." Bierstadt's were the only color portraits exhibited. Other exhibits were of watercolors, advertisements of rugs, still lifes, etc. The exhibition also featured showings of photogravures by American, French, and German firms, and halftone reproductions supplied by William Kurtz, Frederic Gutekunst, the National Chemigraph Company, and Stieglitz's Photochrome Company. In October 1895 (or just about the time Stieglitz withdrew from business), the *Bulletin* published a report on three-color process work which lauded Stieglitz's work, and said that his company was "too modest" about its productions. "A bit of still life which they show," the *Bulletin* contended, "is equal to anything that has been done, and yet Mr. Alfred Stieglitz, the artist of the firm, is seeking effects still higher before permitting them to bear the imprint of his company." [647]

THE ADULTERATION OF
PAPER STOCK

In July 1895, *Anthony's Photographic Bulletin* told its readers: "Now it is known that much of the modern book and magazine paper pulp will go to destruction within a generation. The coated papers, those used for halftone printing, will disintegrate the quickest and the illustrations be lost. It would appear as if, of all the flood of pictures we are now making, only platinotypes and pictures printed on cotton or linen papers would be preserved a century hence. The greed of the paper manufacturers and publishers causes them to close their eyes to the fact that most of the paper now used will in short time crumble to dust." The problem lay in the adoption of wood fiber in place of rags for paper making. But as far as one paper industry spokesman was concerned (in 1892), resistance to the use of wood fiber (mixed with sulphite and other chemicals) was comparable to the "Spanish grandee who fought against the windmills." With a mixture of good cellulose, soda, or sulphite, he contended, you could make pulp paper just as good as if it were made with rags. But the editors of the *Bulletin* were joined by Julius F. Sachse in identifying the problem with which modern libraries can only contend by microfilming bits and pieces of the pages of many publications of the 1890s which literally are crumbling to dust. In 1893, Sachse pointed out that things were going from bad to worse as mechanical methods of paper making gave way to cheaper chemical methods, followed by a further adulteration of the sulphite wood pulps with ground soapstone and talc, both mineral substances of a similar nature. "Few persons have the slightest idea of how great proportions this industry for the supply of adulterants for paper has assumed," Sachse said. "There are different mills throughout Pennsylvania exclusively for grinding soapstone into flour." When such mineral and chemical adulterations of the paper are brought into contact with fermenting animal or vegetable mountants, he said, "they certainly cannot be conducive to the permanency of the photographic product." [648]

There were two other methods perfected at this time for making color transparencies which could be projected by lanterns for screen viewing. One was developed by a Dublin physicist, Charles Joly, and the other was developed independently by James W. McDonough of Chicago. Taking their cue from the glass screen processes perfected for photoengraving halftone work, Joly and McDonough each prepared a glass screen ruled with fine lines alternating in the three primary colors. These screens were then placed in front of an orthochromatic plate and exposed in the camera. After the exposure, a positive black and white glass transparency was prepared. The same screen was used again and bound together with the black and white plate (the colored lines of the screen in register with the uncolored lines from the same screen on the black and white plate), and the combined plate and screen were placed in the plate holder of a magic lantern. What was projected was a photograph in full color—the equivalent, in every respect, to the results achieved differently by the Ives and Gray methods.

With respect to colored photographic prints which, according to Ives, the public "demanded," such pictures produced in the nineteenth century were not faithful records of the colors or objects photographed. Certain names do stand out, however, for the pioneering work which they undertook in the 1890s to secure colored prints of one kind or another. The first was Gabriel Lippman, professor of phys-

As electric lighting became commonplace, and photographers universally adopted use of the highly sensitive (i.e., quick acting) bromide paper, automatic printing of photographs became practical. The scene above is of the electric light exposing apparatus of the Automatic Photograph Company in New York, where 147,000 cabinet-size photographs could be produced daily.

PHOTOGRAPHY AND THE PRINTING PRESS

Automatic printing of a large volume of photographs from a single negative was attempted as early as 1861, when Charles Fontayne of Cincinnati appeared before the American Photographical Society in New York to demonstrate a hand-operated device which passed a roll of sensitized paper under a horizontally placed negative (the negative being pressed in contact with the paper during exposure). But although Charles Seely and others waxed enthusiastic over the machine, John Johnson remained skeptical, and nothing was heard of the project thereafter. By 1891, a French-designed "Autocopiste" (autocopy) machine was developed for studio use in printing collotypes on a relatively small scale, and men such as William Kurtz in New York and Frederic Gutekunst in Philadelphia maintained presses for a variety of photographic printing operations. These included printing of halftone reproductions and three-color photomechanical prints (done in competition with numerous photoengraving houses), and large-scale production of cabinet, or carte de visite photographs. Several periodicals devoted regular sections to the new "process work," and in February 1895, *Anthony's Photographic Bulletin* told its readers: "The money is to be made now in large editions only, and there is no

reason why the photographer should not control the complete output of prints from his original negatives, whether these prints are made by photography, or through the medium of the printing press."

In 1895, the Automatic Photograph Company, of 25 West Twenty-fourth Street, New York, installed a rapid printing machine which had been demonstrated at the previous year's P.A.A. convention (and which operated on much the same principle as Fontayne's earlier invention). The machine reportedly could make between 200 and 300 prints an hour on bromide paper, all perfectly uniform, and it was put to work publishing the numerous illustrations required for each issue of the magazine *Celebrities Monthly*. According to Wilson's journal, one man and one boy could produce from 50,000 to 80,000 cabinet-size photographs, finished and ready for mounting, in the same time it would normally take to produce an estimated 300 cabinet cards by hand. In an ordinary day's work (10 hours in 1895), output could total as much as 147,000 prints. The high sensitivity of the bromide paper made it adaptable for such rapid printing. Exposure by electric light of a number of negatives could be accomplished simultaneously, thus increasing

The Automatic Photograph Company's developing apparatus is shown above. Tanks held as much as 500 gallons of the developing solution in some instances. The company reportedly used 75 miles of bromide paper to make roughly 7½ million photographs in 1895. Exposed paper passed through different stages of development at the rate of 100 feet a minute.

output. During 1895, Automatic reportedly used 75 miles of the bromide paper (supplied in enameled form by the Nepera Chemical Company of Yonkers, New York), which worked out to roughly 7.5 million pictures. The paper was fed to the machines in rolls 1,000 yards long by a yard wide. Printing, developing, fixing, and rinsing were accomplished in essentially the same manner as they are done at large establishments today. But at Automatic, tanks were lined up along the sides of the developing room, each holding up to 500 gallons of the developer solution. A barrel of hypo was used at one time, and the exposed paper would pass through the different stages of development at the rate of a hundred feet a minute.

Other publishers and printers at this time began producing postcards and albums in booklet form with halftone illustrations. In February 1895, the *Bulletin* quoted a British source which stated that "a large view publisher, recognizing that his occupation must soon be gone, converted part of his factory into process work, and is successfully pushing for zinc-block business, in line and halftone. As we write, printers in London and Edinburgh are running night and day on magnificent halftone albums of celebrities." [649]

Detail of exposure apparatus (top) and of developer tank (bottom).

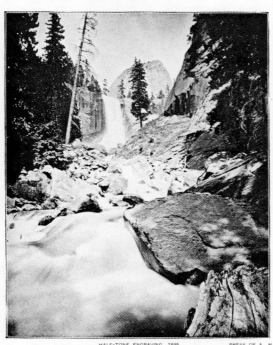 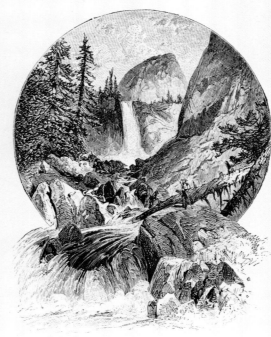

HALF-TONE ENGRAVING, 1895. PRESS OF A. H. KELLOGG, NEW YORK. WOOD ENGRAVING, 1872.

VERNAL FALLS, YOSEMITE VALLEY.

[ORIGINAL NEGATIVE BY T. C. ROCHE.]

FOR THE WOOD ENGRAVER, THE END OF THE ROAD

The two illustrations above, which appeared on the same page of an 1895 issue of *Anthony's Photographic Bulletin,* were produced from the same negative made in 1872 by Thomas C. Roche. To make the wood engraving, right, an ordinary photographic print was made from the Roche negative, and this was used by a wood engraver to make a sketch (in reverse) on a wood block. As can be seen in the example above, much depended upon the engraver's skill as to whether the details of the photographic negative were fully and accurately reproduced, or altered. To make the halftone engraving, left, Roche's negative was screened with a glass plate of finely-ruled cross lines, breaking up the image into dots which could be transferred to, and etched into relief on a printing plate. At first (in the early 1880s), a single-line screen was used in photoengraving, the screen being turned crosswise during its exposure with the negative, but in 1886 Frederic E. Ives introduced a sealed crossline screen to accomplish the same purpose more readily. Still, the halftones produced by Ives's or other photoengraving

methods were used only sparingly for magazine or book illustration, principally because of the coarseness of the screens at first used. But by May 1894, the *Photographic Times* observed that ''the work of the wood-cutter, except the very finest, and also for special kinds of work, is apparently dying out forever.'' By January 1895, the *Bulletin* could point to a revolution not only in illustration, but in the materials and appliances used in halftone printing:

Paper-making has been changed almost completely; coated paper, that is, paper in which the fibre has been covered up entirely with a hard and smooth enamel coating, has become a necessity, and develops a new industry. The superfine ink required has brought out new pigments, and more exacting care in their manufacture into ink. The printing presses that were considered wonderful examples of mechanical skill are being rapidly superseded by machines with cylinders turned true to the thickness of a hair, and journal bearings as carefully made as the works of a clock.[650]

ics at the Sorbonne. He tried applying the principle of light interference (as seen in a soap bubble, or a patch of oil on a wet road) to negative making, using a negative emulsion backed with a mirror layer of mercury. The mercury was supposed to reflect light rays back upon themselves in the emulsion during a prolonged camera exposure, which would then make it possible to trap the rays in the positive print made from the negative. But although Lippman reportedly secured images of "vivid coloring," they had to be viewed—like a daguerreotype—at an angle in order to observe the coloring. The process was also too uncertain to achieve commercial status.[651]

For a short time in 1897, too, E. & H. T. Anthony & Co. touted the prospects of a French-developed "radiotint" color photography process, but this quickly proved to be a dud. The process was another mode of working with chemical dyes (using them to perform a self-toning operation during print development), but the inventor, M. Chassagne of Paris, evidently could not produce colored prints with repeated certainty. Richard Anthony, son of Edward Anthony, went to Paris where he reportedly worked the Chassagne method successfully himself, but after the Anthony firm promised thereafter to demonstrate the process at the August 1897 P.A.A. convention, it was compelled to announce at the convention that chemicals sent to the United States from Paris had not worked in New York, and that a Chassagne representative subsequently dispatched to New York had been "unable so far to produce satisfactory results." After that, the radiotint process was heard from no more.[652]

IN MEMORIAM: HENRY J. NEWTON

In the early evening of December 23, 1895, the former long-time president of the Photographic Section of the American Institute was struck by a cable car at Broadway and Twenty-third Street (the site of the Flatiron Building constructed there a decade later). "This estimable man-citizen and friend of progress," the *Photographic Times* said in a eulogy, "was almost instantly removed from human activity, leaving a void in the hearts of his many friends, and an unfilled place in the ranks of those who lead humanity to a higher and nobler plane of existence." Newton was seventy-two.[653]

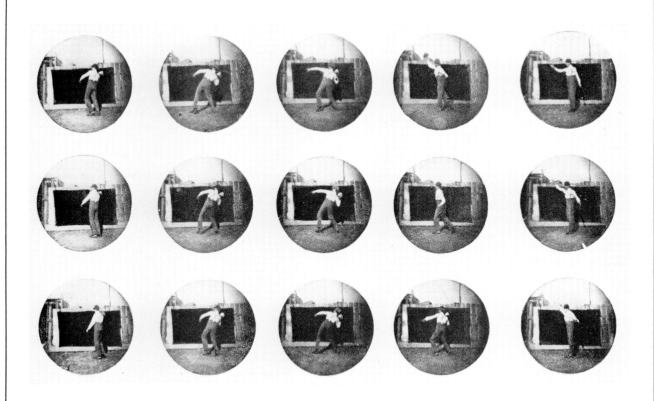

PHANTOSCOPE

Forerunner of Thomas Edison's Vitascope motion picture projector was the Phantoscope, invented by Charles Francis Jenkins. The prototype model, lacking many of its essential operating elements, is shown right at its repository, the archives of the Franklin Institute. Fifteen frames are also shown (above) which were made by Jenkins with the Phantoscope, illustrating the successive motions of shot-putting. The sequence is from one of the earliest motion picture films made in the United States.

1895

1896

The beginning of the motion picture industry in the United States is generally attributed to the showing of a film of vaudeville acts on the night of April 23, 1896, at the Koster & Bial Music Hall, which was situated where Macy's department store now stands on Thirty-fourth Street in New York City. The event was another which brought accolades to Thomas Edison for his role as a pioneer in the new industry, but the Edison Vitascope projector used on this occasion was an acquired rather than an Edison-invented machine. Developments had moved rapidly in the period 1894–95, and not only had counterfeit kinetoscope machines appeared on the market in England and France but also entirely new inventions began to make their appearance. By January 1896, for example, Parisians were queuing up daily to watch 20-minute showings of a motion picture film in a basement salon of the Grand Café, where the world premiere of the Cinematographe (invented by the Lumière brothers) had taken place the previous December 28.

The story behind the development of the Vitascope is one that is little known. The invention can be rightfully attributed to Charles Francis Jenkins, who in 1890 at age twenty-three left his family's farm in Indiana to become secretary to a United States Treasury Department bureau head in Washington, D.C. Basically an inventor, Jenkins took up photography as a hobby in 1890, and began concentrating on what he termed at the time as "devices for recording and reproducing motion." But the mechanical, optical, and photographic problems which he encountered "did not yield readily." Film posed a problem, so he bought some film intended for use in a Kodak camera, split it into strips in the dark, and spliced the strips together into "considerable lengths." Then, as he recalled later:

> Cameras for exposing this strip evenly and in rapid succession were made, as well as devices for developing this long length, and others for printing a positive therefrom for lantern projection. It was fascinating work, although the results were strange and awesome to the athletic friends who willingly enough tumbled, jumped, or otherwise performed in front of the strange camera without clearly understanding until days later what the resultant pictures were to look like.[654]

At first, Jenkins used an oil lantern as a source of illumination in filming, but in 1893, at the suggestion of a friend, Dwight G. Washburn, he fitted an arc lamp to his machine. By 1894, accounts of his successful motion picture exploits appeared in his hometown newspaper in Indiana, and in the *Photographic Times*. "As the plaything developed," he later said, "it attracted to itself more and more attention, as better and better screen pictures were attained, until in the summer and fall of 1894, demonstrations were rather regularly made."

Jenkins gave the name Phantoscope to his invention, and made application for two patents covering differing versions of the basic machine in the period 1893–94. These were U.S. Patent No. 536,569, awarded March 26, 1896, and U.S. Patent No. 560,800, actually submitted first but not awarded until May 26, 1896. The machine's first use was in an attempt to photograph the flight of a projectile from the great gun "Peacemaker," at the U.S. Navy Indian Head test site on the Maryland shore of the Potomac, south of Washington. "But the concussion of the very first discharge," Jenkins mused later, "split the camera into kindling. The tug brought back a wiser boy than it took down the Potomac River that morning."

In the winter of 1894–95, Jenkins was introduced to Thomas Armat, whom he described as "the junior member of a real estate firm in Washington, a man possessed of that great lubricant for inventions, money." One day prior to the award of U.S. Patent No. 536,569, Jenkins and Armat entered into an agreement to build a machine of the type described in this patent. By the terms of this agreement, Armat was given a half interest in whatever commercial applications might follow in return for his financial support of the undertaking. But the machine described in the 536,569 patent proved unsuccessful, whereupon Jenkins began construction of another device along the lines of an earlier experimental model not covered by either Jenkins patent. On August 25, 1895, Jenkins allowed Armat to cosign a joint patent application for this device, and in September the pair took three of the newer machines ("refined copies of that old 1894 projector," as Jenkins expressed it later) to Atlanta, Georgia, for demonstrations at the Cotton Sales Exposition. But at this fair, two of the machines were lost in a fire which destroyed the special buiding which had been erected for the film showings. One machine was saved, because it had been left in a trunk at a downtown hotel in Atlanta.

Both in his memoirs and in a letter addressed on August 27, 1897, to Henry Heyl at the Franklin Institute, Jenkins asserts that Armat, or a hired thief, stole the third machine from Jenkins' home and took it to New York where it was demonstrated to Edison's representatives in a vacant room in the Postal Telegraph Building on lower Broadway. Just when this occurred is not clear; but on November 25, 1895, when Armat was "out of town," Jenkins filed a new patent application on the improved machine, citing himself as the sole inventor. Both patent applications were subsequently declared to be in interference—one listing Jenkins and Armat as co-inventors, the other, Jenkins as sole inventor (the language of both applications being otherwise similar). For reasons not explained, Armat and several brothers prevailed upon Jenkins to sell out, whereupon the joint patent application (submitted August 25, 1895) was allowed to stand, and was approved July 20, 1897, and the November 25, 1895, application submitted by Jenkins alone was forfeited. Jenkins, evidently in financial straits, went back to secretarial work.[655]

But not for long. On December 18, 1895, Jenkins appeared before an audience of more than one hundred people at the Franklin Institute to demonstrate the Phantoscope, and was declared the sole inventor of the machine by a Dis-

CHARLES FRANCIS JENKINS

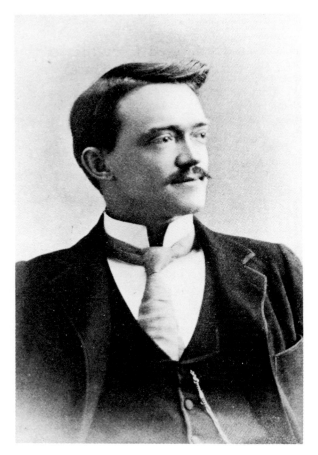

Few men are born inventors, and fewer still make a success of the inventive way of life. Charles Francis Jenkins (1867–1934) fitted both categories. At the beginning, there were ''grueling'' years in developing the Phantoscope, but even George Eastman recognized the value of some of Jenkins' early inventions, and, for example, acquired Jenkins' film perforator mechanism as the demand for long-length film began to mushroom. But Eastman had to cash his own check to Jenkins so that the latter would have enough money to buy his rail fare from Rochester back to Washington, D.C. In the latter part of the 1890s, the Phantoscope served as one of the less heralded machines sold in competition with such more famous projectors as the Vitascope and biograph; but it was the first motion picture projector carried to the Klondike gold rush, and was used to film ''The Battle of Shiloh,'' an epic in its day produced at the Sigmund Lubin pioneer motion picture studio in Philadelphia. While continuing to merchandise the Phantoscope, Jenkins applied his talents to other fields of endeavor. For example, he built the first horseless carriage seen on the streets of Washington, D.C., and in 1908 he developed the Graphoscope, a motion picture projector intended for educational use. This became a successful commercial product, and Jenkins established his own company to handle its manufacture and sales. Shortly before World War I, Jenkins took up flying and thereafter engaged in motion picture camera development for the United States Navy. At the same time he organized and was named the founding president of the Society of Motion Picture Engineers. In the 1920s and 1930s, Jenkins became a pioneer developer of radiovision and television equipment. Before his death, he had acquired over four hundred American and foreign patents covering numerous inventions.[656]

Inventor C. Francis Jenkins perfected a number of early devices and accessories for motion picture filming, among them a developing tray (left) and a film perforator (right), which according to Jenkins was built for the Eastman Dry Plate & Film Company to enable that company to handle the manufacture of increasingly longer lengths of camera film. Jenkins delivered the perforator personally to George Eastman in Rochester, where immediate payment was requested and provided, enabling Jenkins to pay his return train fare.

PERFECTION OF HALFTONE PROCESS

The importance of screening for successful halftone reproduction can be seen by comparing the primitive halftone engraving of Edward L. Wilson, top, which appeared in an 1881 issue of *Philadelphia Photographer,* and the true photographic effect achieved in the halftone illustration of Max Levy of Philadelphia, bottom, which was reproduced in the January 1896 issue of *Anthony's Photographic Bulletin.* The former was made with Ives's first photoengraving mode, described earlier. The latter was achieved with a screen of new design co-invented by Max-Levy and his brother, Louis. The Levy screen was made by etching cross lines on a glass plate and blackening the depressions with an opaque pigment. This type of screen made halftone printing both technically and commercially attractive, and by 1897 halftone illustrations (made with Levy screens) began appearing regularly in American newspapers. The *Bulletin's* halftone of Max Levy was made with a screen having about 152 lines ruled within an inch. Previously, Ives had complained that printers would not accept a screen more finely ruled than 120 lines to the inch. But then, as now, there was no "best" grade of screen ruling applicable for all purposes, and Max Levy gave these reasons why:

Manifestly, if we have only 100 given units of black in a square inch of white space, the effect will be much lighter than if there are 1,000 similar units of black on the same space, and the same is true inversely of the white dots in the shadow, so that it necessarily follows that the greatest difference in color between the deepest shadow which is not absolutely black, and the highest light not perfectly white will decrease as the the number of lines in a given area increases, and *vice versa*, and it follows that the strength of the resulting picture, and richness and variety of tones, will increase, as the ruling on the screen is coarser.

On the other hand, in cross-line work, as the *direction* of the lines never follows the contour of the details, but always cuts them more or less, the ruling will require to be finer as the details become smaller. Another point involved is the size of the picture under consideration. If this is quite small it will generally be viewed at short range, so that the lines of the screen will become more apparent than is likely to be the case in a larger picture, which will usually be viewed at a greater distance in order to take in the whole subject. From these considerations the following conclusions are drawn:

Very large pictures are best made with coarser rulings—very small pictures with finer rulings—very bold subjects yield bolder reproduction with coarser than with finer rulings, while the coarser ruling is fatal to fine detail. [657]

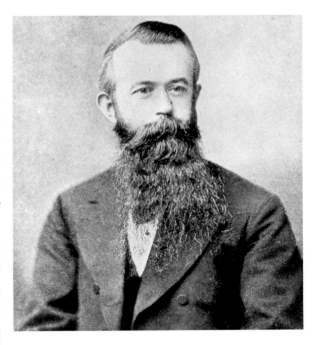

Edward L. Wilson, from an Ives process halftone engraving, 1881.

Max Levy, from an improved Levy process halftone engraving, 1895.

REPRODUCTION MADE WITH THE ROSS-GOERZ
ANASTIGMAT.

REPRODUCTION MADE WITH RAPID RECTILINEAR
LENS.

ANASTIGMAT LENS GIVES BETTER
PHOTOENGRAVING LINE REPRODUCTION

In June 1896, Edward L. Wilson took the position, editorially, that anastigmat lenses of the Ross-Goerz variety were proving superior to the standard rapid rectilinear "for all photographic work where extremely fine definition, great covering power, and rapidity of action are required." At the same time, a New York operator, William Weston, decided to make a comparative test, using an anastigmat and a rapid rectilinear to make separate negatives of a building drawing, from which two photoengraving plates were made to produce the two illustrations shown above. For both negatives, a lens of 19 inches focus was used, since this size was considered the most suitable for all-around purposes in photoengraving. In using the anastigmat, the drawing was positioned at the end of a camera stand (the camera used was a 14 x 14 process camera), the stop f/32 was inserted, and an exposure of one minute was made by electric light (using a mirror to brighten up the side of the image furthest away from the electric lamp). The illustration made from this negative is shown above, left. When the rapid rectilinear lens was used, it was found necessary to insert the diaphragm f/22 to insure definition, and the stop f/64 was selected for an exposure which required four minutes. The illustration made from this negative is shown above, right. An examination of the two illustrations reveals that although the vertical lines in the reproduction made with the rapid rectilinear lens are well rendered, the horizontal lines are less defined than the same lines in the illustration produced with the anastigmat. "In the negative taken with the rapid rectilinear," Weston said, "certain delicate parts of the original line-drawing were entirely lost, as they were so covered that in the printing preceding the etching, they were hardly visible, and disappeared entirely in the etching." [658]

trict of Columbia court after Armat endeavored to restrain his use and promotion of it commercially. The Edison "representatives" before whom Armat demonstrated a Phantoscope were Norman Raff and Frank Gammon, proprietors of Edison's Kinetoscope Company, which in 1895 was suffering from declining business. Reportedly, Raff and Gammon "prevailed" upon Edison to acquire the machine for which Armat now held full patent rights, after which Edison himself is said to have given it the name Vitascope.

The Phantoscope embodied two essential developments that were lacking in previously invented projectors. The first was the incorporation of a loop of slack film, the absence of which precluded drawing long lengths of film through the projector without jerking it and causing it to break. The other was the provision for a longer period of rest and illumination for each picture, coupled with a mechanism allowing quick movement from one picture to the next. In later years, these innovations would become important factors in prolonged litigation involving Edison and other inventors (but not Jenkins) over the origins of motion picture camera development, and in the end they would provide grounds for the ultimate legal opinion rendered in which no one individual was cited as the "father" of the motion picture camera.[659]

On December 1, 1897, the Science and Arts Committee of the Franklin Institute, chaired by Henry Heyl, published a notice in the Institute's *Journal* that Jenkins would be given the Institute's coveted Elliott Cresson Medal for the Phantoscope invention. Although a protest was lodged by Armat, Heyl and the only other member of the committee, John Carbutt, decided to dismiss the protest after further evaluation nearly a year later. Jenkins was thus awarded the Cresson Medal as the sole inventor of the Phantoscope.

In 1916, the Institute also awarded Jenkins its John Scott Medal for the Phantoscope invention. In light of the litigation involving Edison and others in the interim (1897–1916), the Institute's citation to Jenkins bears repeating:

> Eighteen years ago the applicant exhibited a commercial motion picture projecting machine which he termed the "Phantoscope." This was recognized by the Institute and subsequently proved to be the first successful form of projecting machine for the production of life-size motion pictures from a narrow strip of film containing successive phases of motion.[660]

Just as Henry Heyl proved to be an important factor in having credit given where it was due in Jenkins' case, so, too, we learn from the Heyl papers in the Franklin Institute that another prolific inventor, Rudolph Melville Hunter, of Philadelphia, engaged in motion picture camera development independently, but at the same time as Jenkins. Hunter was the holder of many patents in electrical engineering. His pioneering invention of a motion picture camera was described by Heyl in these words:

> After returning from the World's Fair Exposition in Chicago, in 1893, he [Hunter] devised improvements in photography and motion machines designed to project images from pictures arranged in consecutive order in film form, the film to be intermittently fed forward by mechanical devices, the light to be projected through the pictures upon a screen and the images to be intermittently shut out from view during the feeding of the film of pictures.[661]

SMALL AIR BUBBLES FOUND IN LENSES MADE OF JENA GLASS

Charles P. Goerz, the German lens maker, disclosed in 1895 that American photographers sometimes complained about air bubbles in the Goerz Double Anastigmat, and other high-quality lenses. This prompted the glass maker, Schott & Gen, to issue the following circular from their Austrian manufactory at Jena:

> "The efforts of opticians in the improvement of objectives in the higher characteristics of optical results have, in later years, particularly in photographic objectives, resulted in an increasing demand for such kinds of glass which, in their optical properties and chemical composition, differ very considerably from the crown and flint formerly used, and the production of which presents far greater technical difficulties to the producer than the former optical glass. Particularly does the majority of the kinds of glasses requisite in the construction of the improved photographic objectives, which have been recently introduced, offer unusual difficulties in the accomplishment of complete purity, that is, freedom from small air bubbles. The definite demands, which are made for these special glasses, varying from the ordinary materials in their conditions between refractive index and dispersive power, subject the chemical composition of the glass flux to such narrow limits, that the technique of melting leaves no choice in bringing about favorable conditions for the greatest possible purity. The result is that in such kinds of glass it becomes practically impossible to regularly produce pieces free from *small air bubbles.*
>
> "We must point out that the existence of such small air bubbles even in the most unfavorable cases, hardly reaches a loss of light amounting to ¼th per cent. and therefore is entirely without influence on the optical result of a lens system.
>
> "It is therefore apparently *unreasonable* to demand of the producer of optical glass that, to meet the increased demand of the optician in reference to all the *really* important properties necessary for the function of the objectives, he should reject ⅞ths of the produced glass merely because it shows a defect which, in application, is absolutely insignificant.
>
> "If the purchaser, especially of photographic objectives should, as has hitherto been customary, declare lenses with a few small air bubbles as "faulty," the optician will be constrained to explain that objectives of improved quality in *optical* results cannot be produced out of any crown and flint which may be selected at will, but only from such kinds of glass, in the selection of which higher considerations than the presence of a few small air bubbles must be decisive."[662]

SCIENTIFIC AMERICAN

(Entered at the Post Office of New York, N. Y., as Second Class matter.)

A WEEKLY JOURNAL OF PRACTICAL INFORMATION, ART, SCIENCE, MECHANICS, CHEMISTRY, AND MANUFACTURES.

Vol. LXXVI.—No. 16.
Established 1845.

NEW YORK, APRIL 17, 1897.

[$3.00 A YEAR.
WEEKLY.]

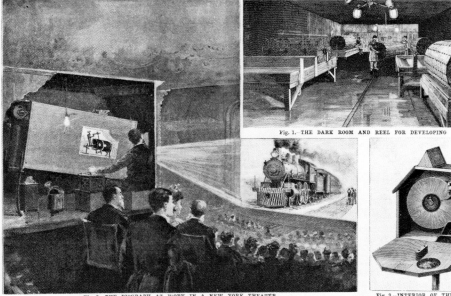

Fig. 1.—THE DARK ROOM AND REEL FOR DEVELOPING FILMS.

Fig. 2.—THE BIOGRAPH AT WORK IN A NEW YORK THEATER.

Fig. 3. INTERIOR OF THE "MUTOSCOPE."

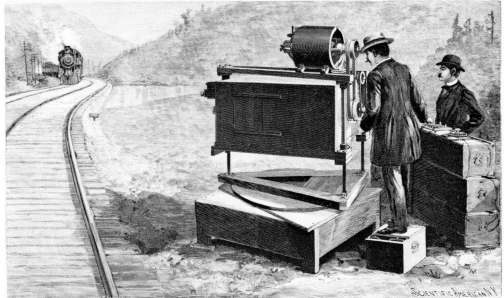

Fig. 4. THE "MUTOGRAPH" PHOTOGRAPHING THE PENNSYLVANIA LIMITED WHEN RUNNING AT THE RATE OF SIXTY MILES AN HOUR.

PHOTOGRAPHY AS AN ADJUNCT TO THEATRICAL REPRESENTATION.—[See page 248.]

MUTOSCOPE AND BIOGRAPH

In April 1895, W. K. L. Dickson left Thomas Edison to join the American Mutoscope Company, where he helped perfect a peep-show mutoscope device (Fig. 3) and biograph film projector (Fig. 2). A mutograph (Fig. 4) took pictures on location for viewing either in the mutoscope (competition for Edison's kinetoscope), or for projection on a screen by the biograph, which quickly became more popular than Edison's Vitascope. Figure 1 in this series (which appeared on the cover of the April 17, 1897, issue of the *Scientific American*) shows the darkroom for mutograph film developing.

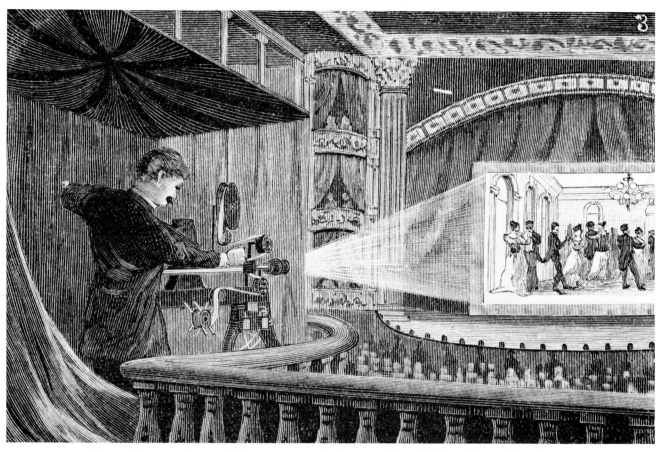

Thomas Edison gave the name Vitascope to the motion picture machine which he and his associates demonstrated at a showing of a film of vaudeville acts at the Koster & Bial Music Hall in New York on April 23, 1896. But the Vitascope was manufactured on the basis of the design for C. Francis Jenkins' Phantoscope, after Jenkins' partner, Thomas Armat, who had cosigned a patent application for the Phantoscope with Jenkins, took a model to Edison's associates, Norman Raff and Frank Gammon (proprietors of Edison's Kinetoscope Company). Armat bought out Jenkins' rights to the Phantoscope patent in 1896, or early 1897.

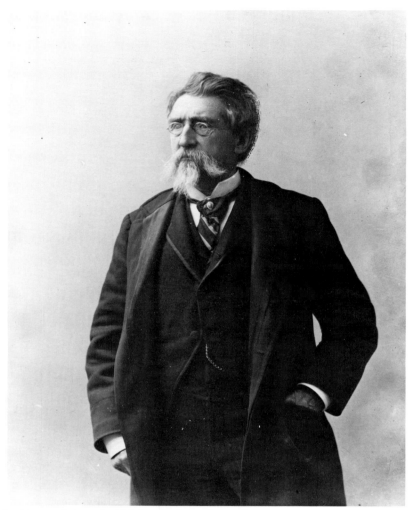

Last known photograph of Mathew Brady, made in 1889.

IN MEMORIAM:
MATHEW B. BRADY

Like his New York gallery, Brady's Washington gallery was shut down (in 1881) after foreclosure of outstanding mortgages. Brady was then left with several hundred daguerreotypes, about three thousand photographs, his desk, clock, some personal memorabilia and the chair given him by Abraham Lincoln (in which so many of the nation's celebrities had posed for his camera). From 1882 to 1894, he worked for, or in partnership with, others as a photographer. In 1887, his wife died, and he was forced to live with a nephew, Levin C. Handy, who had worked for Brady as a youth and succeeded to his business. Still trying to interest Congress in his Civil War pictures, he became "the sad little man" who haunted the desk of a public stenographer at the Riggs Hotel, who worked primarily for congressmen. Brady's final years were described by Handy in a letter which he sent E. L. Wilson shortly after Brady's death on January 15, 1896:

A change of administration and many other things discouraged him, and he finally mortgaged the remainder of his material, instruments, etc. This seemed to break his heart. In his eagerness to keep afloat he ventured out on the night of Emancipation Day, April 16, 1894, and in crossing the street in front of the Riggs Hotel, was run over by a carelessly driven carriage; his leg was broken, and he was removed at once to my house, where the limb was set. Mr. Brady was forced to remain indoors for nearly a year. While he lay on his back the parties holding the mortgage closed in on him and left him penniless. As soon as he was able to get out, he went to New York, where arrangements were being made that he should give an exhibition by the stereopticon of some of his celebrated pictures. All things seemed to favor this plan; the exhibition was to have taken place on the 30th day of January. Mr. Brady, while in New York on this last visit, was largely assisted by the Veterans of the 7th Regiment, of which he was a member, and the Artist Club, of which he was a founder, stopping for some time with William M. Riley, of 119 East Fifteenth Street. Mr. Brady, however, never fully recovered from the injury received in Washington. It caused a complication of troubles, and he was finally removed to the Presbyterian Hospital, where everything possible was done for him. An operation was performed, under which he gradually sank until he died.[663]

Hunter purchased and renovated a building in Atantic City for purposes of showing films in 1894, but for reasons unknown, the undertaking was aborted. Because of a misunderstanding over the dates of filing on the Edison and other motion-picture camera patents (and the press of other patent litigation), Hunter failed to prosecute his patent application, according to Heyl, with the result that it was later abandoned.

Another early inventor was Woodville Latham, who first sought Edison's help in perfecting a projector based on the kinetoscope design, but after being rebuffed, developed a machine of his own design which he labeled the Pantoptikon. Latham demonstrated the Pantoptikon in New York on February 22, 1895 (and thereafter became involved in the subsequent patent litigation), but his device (which he renamed the Eidoloscope) was not long lasting.

Edison's principal competition in the Vitascope came from his former assistant, W. K. L. Dickson, who left Edison before the latter's acquisition of the Vitascope to help found the American Mutoscope Company (initally to manufacture a peep-show device of different design from the kinetoscope). The company shortly changed its name to the American Mutoscope and Biograph Company, reflecting the name of its second important invention, the biograph.

The biograph was first publicly demonstrated at the Alvin Theater in Pittsburgh in September 1896. It was able to project larger pictures than the Vitascope, and these the Pittsburgh *Post* found to be more "clear-cut and distinct" than any previously seen. After an extended showing at the Koster and Bial Hall in New York from October 1896 to January 18, 1897, the biograph became the only one of the major projectors to remain in use at the major New York theaters. Over three hundred films for biograph shows were screened in the period 1896–1901, including scenes from the Spanish-American and Boer wars, and the Boxer Rebellion. In 1897, Edison began legal action against the American Mutoscope and Biograph Company, and this and other court battles over the various patented machines continued on into the twentieth century.[664]

A SAFE, CLEAN, AND RAPID FLASH MACHINE

There were five deaths in Philadelphia alone during the first two years in which magnesium flash powder came into vogue, and in 1891 several tin cans of the powder carried by W. H. Jackson in his luggage exploded during a change of trains in Chicago, causing serious injury to the baggage handler. On January 6, 1898, the New York *Sun* published a letter from a former first lieutenant in the Second U.S. Artillery, pointing to the "many accidents" caused by using dangerous flashlight compositions. "I have heard of flash powder being advertised as safe because it can be eaten," the lieutenant said. "It contains chlorate of potash, which is sometimes a remedy for sore throats, but this same chlorate of potash in any kind of powder is extremely dangerous." The fumes from powder containing the substance were also very corrosive, he added, and likely to injure draperies or other furnishings. In 1896, A. E. Johnstone, manager of the Automatic Printing Company, paid a visit to E. L. Wilson, inquiring where he could get a quick-acting flash apparatus for portraiture, which would at the same time be clean and safe. Johnstone found drawbacks to every suggestion put forward by Wilson, so the latter recommended that Johnstone design his own machine. In June 1897, Johnstone appeared again in Wilson's office "bearing under his arm the proverbial mysterious package." This proved to contain the apparatus shown above. The device consisted of a powder tray, "air engine," and a cylindrical spirit-lamp equipped with four gas jets, which was positioned to the rear of and beneath the powder tray. Traversing horizontally along the back of the tray was a spring-actuated rod bearing four platinum-tipped arms, each extending to a position just above the flame of a gas jet. Placement of the magnesium powder was not in the tray itself, but on a sheet of fireproof paper affixed to the tray with clips. Ignition of the powder was accomplished by actuating the horizontal rod, which propelled the red-hot points to a position beneath the tray where four equidistant perforations in the bottom of the tray allowed the heated points to penetrate through the paper to the powder. Because of the ease with which the paper could be removed after use and replaced with a new sheet, Wilson declared Johnstone's machine just as clean after a hundred exposures as after the first.[665]

1897

The choice of which paper to use in making photographic prints—whether for professional studio work or for exhibition purposes—remained more of a problem in the last decade of the nineteenth century than is perhaps generally recognized. Frequently, it is simply stated that the old reliable albumen paper was replaced by the gelatine-bromide papers "about 1890." But a close examination of photographic literature of the period suggests otherwise. In 1895, for example, *Anthony's Photographic Bulletin* pointed to evidence of a lack of permanency in its own printing with the gelatine papers, adding:

> However, we do not desire our readers to accept our own evidence unsupported, and would call their attention to the fact that the majority of the prominent professional photographers in this country are not using gelatine printing-out papers.[666]

E. W. Foxlee, writing in the *British Journal Almanac* in 1895, reported similar problems with the gelatine papers:

> I venture to say that, although gelatine-chloride has only been in vogue for two or three years, there are, in that short time, more gelatine prints in existence with brimstone-colored lights and bilious halftones than there are albumen ones made in any similar period, and kept for so brief a time.[667]

David Bachrach, as might be expected, was among the most forthright in his unfavorable evaluation of emulsion papers in general. To begin with, the poorest kind of negatives could be used to make passable prints on such papers, he contended, and "the most ignorant" of people could make them easily if they used a combined toning and fixing bath. But what was going to be the effect on the profession in general, he wondered, when one considered "the wholesale fading out, peeling off, and what not of the mass of the prints made on these papers." This was not a matter open to dispute, he said: "I boldly say that there are now in existence more badly faded prints, made in the last five years, than there ever has been from the twenty-five previous years of albumen printing." For him, it was time to "look backward." Except for carbon and platinum prints, well-manipulated single-albumenized paper prints would make the most permanent products of the photographic art. If other photographers, like himself, felt that they were "wandering after false gods and false ideals" to their ultimate financial destruction, "why not turn about now?" he asked. In his own case, he explained how this came about:

> From some time in 1893 to the summer of 1895 we used emulsion paper for our small work. The latter summer was hot and sultry, and we were using gelatine paper. I had long considered we were on the wrong track, and suspected that the prints were fading *en masse*, but had the common, foolish fear of being considered not up to date or a back number by doing what I thought was right. One memorably

A PHOTOGRAPHER'S APPEAL: RETURN TO ALBUMEN PAPER

In 1893, Walter E. Woodbury published a series of articles in the *Photographic Times* giving high praise to the then new gelatine chloride papers, and at the same time condemning the continued use of albumen paper. Peter C. Andrews responded in the same publication with these remarks, saying that he had given the new papers a try, but that he was returning to the use of "my old, tried and trusted friend," albumen paper:

> In the first place I do not find, and I am sure others will bear me out in this, that same evenness and regularity with these new kinds of paper. If I silver my own, as I sometimes do, I can vary my proportions to suit my negatives. This I cannot do if I use these new-fashioned papers, but am bound to put up with whatever the manufacturers like to give me. Printing may be a little quicker, perhaps, but the time thus saved is lost in the toning, for I have found it impossible to tone any large number of gelatine prints at one time. Others I believe have found the same fault with it. Whereas with a batch of albumen prints I can lay them in the toning solution fifty or a hundred at a time, and be certain of my results, with the gelatine or collodion paper I am obliged to tone but a few at a time, four or five only, and then if care be not taken uneven toning will result. As soon as we get the hot summer weather with us I am thinking that there will be not a few who will return to albumen paper.
>
> The want of toughness in the gelatine prints is another serious drawback. The films are far too tender for the ordinary professional work. The amount of handling that albumen prints will stand is surprising. They are far more easily mounted and burnished, and with a good brand of paper and a good burnisher I can get all the surface I want. I do not by any means admire the fearful glaze given to these gelatine prints. It is inartistic, gives false reflections, and only fit to please little childeren who delight in bright and pretty things.
>
> With regard to the collodion papers, whatever advantages it may have, are certainly set aside by its fault of curling up and becoming unmanageable. Whatever the makers may say I have never found it to lie flat. For uniformity and reliability give me albumen paper, and I hope what I have said will cause others to ponder before they rashly desert a process that has been a friend to them so long for an untried, and in my opinion, much overlauded rival.

Roving photographer Frances B. Johnston, her Kodak on the floor beside her, confers with Admiral George Dewey aboard the *Olympia* during 1899 visit in which she made 107 photographs of activities aboard the flagship vessel.

Above is a Sigmund Krausz photograph of a youthful Chicago street peddler of flypaper and matches.

These two boys, photographed on a bright, sunny day in Pennsylvania, convey the innocence of a rural way of life which has long since succumbed to more sophisticated ways of urban living. The photograph is from the collection of the early twentieth-century Photo-Secessionist John G. Bullock.

PURPOSEFUL AMATEURS

In many museums, libraries, and historical societies there will be found photographs dating from the 1890s of urban street scenes, unusual social gatherings or public events, and other views of an essentially documentary nature which have captured in a tasteful and sometimes candid fashion an element or moment in time having a lasting visual appeal. George Bernard Shaw complained that "the photographer is like the cod, which produces a million eggs in order that one may reach maturity." But along with the hand camera there came a new generation of photographers like Frances B. Johnston (above left) who took their Kodaks, Graflexes, etc., seriously. Enduring photographs were made for example by Miss Johnston and Moses Y. Beach, scion of a family of inventors and journalists, of President Benjamin Harrison's participation in the centennial observance of George Washington's first inauguration, which took place in New York City in 1891. About this time, the father-and-son team of Joseph and Percy Byron began making a record of life in New York which prompted Edward Steichen to say in later years: "They were among the earliest to realize that the camera

An unknown photographer made this early photograph of a world heavyweight championship fight, which took place at Carson City, Nevada, on March 17, 1897. A "brainy, modest and nimble-footed" San Francisco bank clerk, James J. Corbett, met and was defeated by the English-born knock-kneed Robert Fitzsimmons in the fourteenth round.

used for visual reporting opened up an endless field in photography. It became a good business because of their enthusiastic and tireless energy, their uncanny instinct for finding timely, newsworthy aspects in almost everything, whether photographed on the basis of a commission or on shrewd speculation of what would be saleable. Their only specialty was making photographs, photographs without opinion, comment, slant or emotion. . . . Their photographs are objective because the places, the things and the people photographed have a chance to speak for themselves without interference." In Chicago, Sigmund Krausz created a veritable "Street Life of Chicago" comparable to what John Thomson and Adolphe Smith had accomplished with their *Street Life in London,* published nearly two decades earlier. Between 1880 and 1900, S. R. Stoddard traveled throughout upstate New York and New England, making a vast record of the mountains and resort towns. Similarly, H. G. Peabody of the Boston Peabody clan concentrated on yachting and naval vessels. In San Francisco, a Berlin physician, Dr. Arnold Genthe, who settled there in 1895, made a

vast photographic record of the city's Chinese quarter, and of the great earthquake and fire in 1906. Afterwards, Genthe moved to New York where he became a celebrated photographer of the socially prominent. While the approach in the photographs made by the photographers just mentioned was purposeful, it may also be characterized as intellectual, and frequently artistic. This was true, too, of many of the photographs made at this time by members of the Photographic Society of Philadelphia (an example by John G. Bullock is shown left). Across the Atlantic, photographers such as Eugene Atget in Paris and Paul Martin in London made unparalleled records of the life and architecture of their respective cities around the turn of the century. Martin is particularly noted for his views of ordinary people, places, and events, not only in London but among English seaside resorts. In these endeavors, Martin was among the first to use a hand camera which had a concealed lens. When he pointed the camera in one direction, the lens could be focused, and a picture secured of a scene or of people located to his left or right.[669]

hot day the prints were more sticky than usual, and almost a whole batch of over three hundred spoiled while in the wash-water. I am one of those who, on rare occasions, under great provocation, not only act quickly, but use language more emphatic than elegant. Both things happened. The whole batch was thrown out, and I swore that not another print should be made on those papers. Two or three dozen sheets of albumen paper were sent to the printer to sensitize at once, to replace the prints spoiled, and from that day to this we have never used the glossy emulsion papers for our work. [670]

"LANTERN SLIDE YEAR"

"The past twelve months of the Camera Club of New York will, without question, be known in the pages of its annuals as the 'Lantern Slide Year,' Alfred Stieglitz declared in October 1897. Never before, he said, was there so much work done, or so much interest shown in this most peculiarly fascinating branch of photography. Slide making remained one of the few outlets for the wet-plate collodion practice. T. C. Roche favored the collodion process because it gave greater detail, and cleanness in highlights. In London, Alfred Brothers contended that those amateurs who took the trouble to learn the collodion process "would probably give it the preference over all others for making lantern slides." Although slide-making was viewed with disdain by some fine-art photographers, it was practiced by some of the best. Paul Martin, for example, made the first photographs of London by night on lantern slides, as did William Frazer, one of the first to specialize in making night photographs in New York. Alfred Stieglitz analyzed the subject in these words:

Many of our best amateurs devote themselves exclusively to this branch of work, our Mr. Frazer being a notable example, notwithstanding the fact that most of the leading pictorial photographers of Great Britain and the continent look down upon slide-making as outside the "art limits," and therefore beneath their artistic dignity. It has become an accepted fact among them that the process is purely mechanical, and that at best the tonality of slides was incorrect. As for the declaration that slide-making is purely mechanical, permit me to say that, after a conscientious writer's work in this line of photography, I have come to a different conclusion and claim that the technique of slide-making may be quite as interesting as that of the known printing processes. . . . As for incorrect tonality, in most cases that is due to the lack of knowledge and skill on the part of the slide-maker, who has not given the matter enough study or, who, perhaps, does not quite grasp the material with which he is working." [671]

The following year (1896), Bachrach began giving out this circular to his patrons:

"NOTICE TO OUR PATRONS.

"It will be observed that these pictures are the strong, well brought-out albumen paper prints, with a medium polish, similar to those we made up to three years ago, and which a twenty-five year test demonstrated to be permanent when made by reliable photographers, and are not the extreme high gloss aristo prints with a hard marble-like appearance, so much used of late.

"We have returned to this more expensive and troublesome process because the last three years' experience has shown not only the great liability to fade and defacement by rubbing and scratching of prints made on the high gloss papers, but it has also demonstrated the better artistic quality and truer resemblance to human flesh of the albumen prints. We have, therefore, considered it the interest of our patrons, and incidentally our own, by the greater value attached to such productions, to discard what we consider an inferior process, and return to that which years of experience has taught us to be the best.

"Anyone having high gloss prints made by us in the last two years showing signs of fading can have the same replaced with albumen prints without charge." [672]

If the gelatine papers posed such a problem, the question naturally arises, what other alternatives were there besides "looking backward," as Bachrach expressed it? The evidence points on the one hand to a marked increase in the use of the platinum and carbon printing methods, particularly by the more fashionable galleries, and by fine-art photographers; but it also suggests that there was a widespread adoption of the matt collodion papers, particularly those toned in platinum (papers known in the trade as "aristo-platino"). Foxlee noted that the price of collodion paper had become competitive with the gelatine or albumen papers, and he indicated that this should give an added boost to the collodion paper use:

Collodion paper possesses many advantages over gelatine. Like albumen, it does not require a special type of negative. It may be toned in almost any bath. Any color, from a red brown to a deep rich purple black, or even a cold black, can be obtained at will. It does not yield double tone, and vignettes with pure whites can as easily be obtained as with albumen paper. The prints can be blotted off and dried before the fire without risk of injury. Collodion, unlike gelatine and albumen, does not form a compound with the silver, therefore the results are more permanent than can be claimed for any other silver process, as time has proved. [673]

One of the best indications of a rank-and-file interest in aristo-platino paper is to be found in the annual report on the progress of photography given by a Dayton, Ohio, photographer, A. L. Bowersox, at the 1896 P.A.A. convention:

The paper that has found favor among the greatest number of photographers is the aristo-platino. The seeming simplicity with which this paper is worked is the cause of the increased demand for it. The final results are similar to carbon and more easily obtained. [674]

Bachrach, meanwhile, admitted that albumen paper was "by no means my ideal printing-out paper." The aristo-pla-

tino, he said, "is far nearer the ideal in results, platinum and carbon being my ideals for perfection to date." When the matt collodion paper was strongly printed and toned with platinum to the black stage, he felt that such prints would prove to be as permanent as the best-made albumen prints. But if they were rubbed against one another, or if they were used roughly, aristo-platino prints were subject to fatal injury, he contended.[675]

Bachrach was joined by many others in his preference for the platinotype. B. J. Falk made a specialty of it at his New York gallery, as did the new Midwest master of portrait photography, Isaac Benjamin, of Cincinnati. As Bowersox noted in his P.A.A. address, the better grade of platinum paper which had become available commercially from Willis & Clements in Philadelphia, had much to do with the new preference for it:

> With platinum, beautiful results can be obtained, and we are pleased to note that the manufacturers, Messrs. Willis & Clem-

ents, have succeeded in the past year in securing a much finer deposit than heretofore, giving still greater value to this already celebrated paper. The greatest obstacle to the more extensive use of this kind of paper is the obligation of the photographer using it to purchase the developer and chemicals from the manufacturers, not knowing what they are composed of.[676]

As far as Bachrach was concerned, nothing ever surpassed the platinotype during his entire career, and after his retirement he asserted that "we must take off our hats to Mr. Willis, and his years of splendid technical ability and work, as the savior of modern photography."[677]

Other suppliers of platinum paper appeared on the scene as its use increased in the 1890s. These included the American Aristo Company, the di Nunsio Company in New York, and John Bradley of Philadelphia. Possibly because of the close proximity of the Willis & Clements firm, Bradley maintained great secrecy concerning his business, and according to one source, he maintained this secrecy by employing only one person—a Chinaman.[678]

America's Alfred Stieglitz and England's Paul Martin pioneered in making photographs of city streets and parks at nighttime (in 1895), but to the New York photographer William Frazer must go the laurels for superior work of this character in the 1890s and early 1900s. The scene above, made by Frazer circa 1898, was entitled "Wet Night, Columbus Circle."

1898

The flowering of American fine-art photography, which had begun in a small way after 1890, came to its first fruition with the staging of a European-style photographic salon at the Philadelphia Academy of Fine Arts, October 24 to November 19, 1898. Previous to this, according to Joseph T. Keiley, the Wall Street lawyer turned photographer (and soon to become the fourth American elected to membership in the Linked Ring), the joint exhibitions of the various American amateur societies were for the most part run by "committees," which he described as "totally devoid of any artistic feeling or training." Artists were usually appointed to make the awards at these events, "but these gentlemen," Keiley contended, "rarely took their responsibilities any too seriously." As a result, the exhibitions were "rarely of any real international importance, and seldom even nationally representative."

In these sentiments, Keiley was joined by A. L. Bowersox, who, in his report on the progress of photography at the 1896 P.A.A. convention, asserted that "the only thing most needful of progress in the coming year is to try to realize our extreme art-poverty, and we shall feel the need of instruction in this line more real and urgent." Another who expressed similar sentiments was E. Lee Ferguson, of Washington, D.C., who made these remarks in an early issue of *Camera Notes:*

> While three of our largest and most cultured cities could not maintain a good exhibition once in three years, many provincial towns in Great Britain have the advantage of a view of some of the best work every year. The work of some of our best pictorial photographers is much better known abroad than at home. . . . We now have little but our petty local shows—usually a dreary collection of mediocrity—and a dream of what might have been had our great cities kept up the work.[679]

But there *were* several salons—albeit less heralded— which were held before the Philadelphia event, and these suggest that the American fine-art photography movement had actually gotten off to an earlier start. The first was a salon held in Washington, D.C., in the spring of 1896. This event was staged at the National Museum of the Smithsonian Institution, and was sufficiently successful to cause the Museum to purchase fifty of the prints exhibited. When a "National Photographic Salon" was scheduled to be held at the museum the following year, G. Brown Goode, the assistant secretary of the Smithsonian in charge of the National Museum, dispatched this letter to the designated chairman of the planned event:

> I am very much gratified to learn that it has been decided to hold a second exhibition of art photography in this city, under the name of the National Photographic Salon of 1897. The exhibition of 1896 must be regarded as the most impressive exhibition ever held in this country. It has demonstrated the right of photography to a place among the fine arts, and was suggestive of possibilities in the future which are by no means generally appreciated. Such exhibitions are useful not only to the photographers themselves, but to all those who have occasion to avail themselves of the possibilities of photography in the deco-

rative and graphic arts, in illustration of books and in the sciences. I am desirous of utilizing the coming exhibition for the purpose of extending the photographic collection in the National Museum, and therefore authorize you to announce that a number of the best photographs there exhibited will be purchased.[680]

Whether the 1897 event took place does not appear to be recorded in the photographic literature of the period; however, in March 1898, the Pittsburgh Amateur Photographers' Society staged an international salon at the Carnegie Art Galleries, which was considered one of the great American art centers at this time. Attendance at this salon was so great that the exhibition had to be extended.[681]

The Philadelphia salon followed closely on the heels of the Pittsburgh event. Many well-known European names were missing from the Philadelphia show, but those whose works were hung included A. Horsley Hinton, the principal spokesman for the Linked Ring and a noted British photographer of landscapes; and Frederick H. Evans, a London bookseller who, at forty-five, was just beginning an illustrious career as a photographer of literary giants, and of cathedrals in Britain and France (all of his work being accomplished in platinotype). Some 1,500 photographs were submitted, but of these, only 259 were hung. These were the works of a hundred photographers, seventy-six of whom were American. From Keiley's standpoint, the Philadelphia salon was a distinct American milestone:

> Individuality and correct tonality, with all that these two things imply, were evidently the essential qualities looked for by the majority of the judges in the prints submitted. The result was a surprise to all except the advanced workers, whose claims for photography it more than confirmed. For the first time it was realized that a Stieglitz, a Hinton or a Day [F. Holland Day, of Boston, the third American elected, in 1896, to membership in the Linked Ring] was as distinctive in style as a Breton, a Corot or a Verestchagin; that photography is open to broad as well as sharp treatment; that it had its impressionists and its realists.[682]

Without question, the salons held in the major European capitals, and the formation of the Linked Ring Brotherhood, had had a profound and stimulating effect on American fine-arts photography; another important contributing factor was Alfred Stieglitz. This is reflected in this tribute to him penned by the critic Sadakichi Hartmann:

> . . . not only during my first visit to the Camera Club but often since, it has seemed to me that artistic photography, the Camera Club, and Alfred Stieglitz were only three different names for one and the same thing. . . . I am not given much to eulogies of one man, but I am a hero worshipper in the truest sense. Any man who asserts himself in a certain vocation of life has my fullest admiration. There may be hundreds of amateur photographers in New York who do their very best to advance the art of Daguerre, but it would be absolutely foolish to deny that artistic photography in America would not have reached its present standard of perfection without Mr. Stieglitz. He has, perhaps, been prominent at exhibitions for a larger period than any other living American photographer, and a persistent ad-

View of a mountain scene made by John G. Bullock, an officer of the Philadelphia Photographic Society.

AMERICAN ART PHOTOGRAPHY

A desire on the part of members of photographic societies and camera clubs to record scenic outdoor views in artistic fashion began to flourish after a European-style photographic salon was held in Philadelphia in 1898. The Boston artist Darius Cobb expressed the belief that exhibits of some photographs by various camera clubs ''give sufficient evidence to the unprejudiced mind that photography is a fine art.'' Members of the Philadelphia Photographic Society worked almost exclusively with the platinum process, a situation which Alfred Stieglitz considered a threat to the artistic achievements of New York amateurs (see page 355). Frequently, camera clubs held outings with large groups of members (see right), but few individual photographers went to the extent to which Stieglitz did to capture what for the time was unusual in the extreme. One snowy night in sub-zero weather in the winter of 1898, for example, he put on three layers of underwear, two pairs of trousers, two vests, a winter coat and Tyrolean cape, and armed with tripod and camera, stole out of his apartment on East Sixty-fifth Street near Central Park in New York to photograph some glistening trees coated with ice adjacent to a snow-covered walk. No one had previously attempted to make a nighttime photograph of this nature under comparable conditions, although a group of photographers from a camera club in Orange, New Jersey, made a similar but unfruitful attempt several nights later when the weather was apparently much the same.

Maine seascape view made by Dr. Charles H. Mitchell, also a member of the Philadelphia Photographic Society.

Members of the Newark, New Jersey, camera club on an outing, circa 1900.

The photograph above has been reproduced from a gum print by Charles Job, an early practitioner of the process popularized in 1896 by the Parisian photographer and painter Robert Demachy.

GUM BICHROMATE PROCESS ("GUM PRINTS")

With the appearance of the "impressionist" photography school, this process, first used in 1855, became popular among avant-garde, fine-art photographers. The process involved sensitizing sized paper with potassium, or ammonia bichromate, coating the paper with a water-color paint mixed with gum arabic, exposure of the prepared paper (in contact with a thin negative), and development of the print in cold water (where the parts of the pigmented gum not hardened by light were washed out). Throughout all the stages of the process, it was possible to alter, or in numerous ways to modify, the procedures. To begin with, different papers would produce different results. Thus, a heavy-sized paper would yield excessive contrasts, which a lighter paper would not. Sensitizing and coating could be done separately, or at the same time. If sensitizing was done first and the paint and gum put on the paper afterwards, this called for a shorter exposure, or about the same amount of time as would be required for an exposure in working the platinum process. If sensitizing and coating were accomplished at the same time, the exposure required would be longer, or about the same time required in working with albumen paper. In print development, the amount of the pigmented gum washed out could be influenced by the warmth of the water, by spraying, sponging or brushing, depending upon the photographer's intentions. In the paper coating operation, it was desirable to lay as thin a coat of paint as possible with a brush, preferably with a badger hair brush (which precluded streakiness, and made for greater softness in the finished print). During development, portions of the image could be removed, while after development the finished print could be touched up with water color of painters' size to achieve desired artistic effects.[683]

GUM BICHROMATE POISONING

The side effects from working with photographic chemicals was not a new thing, but the gum process brought with it a new danger, described in this warning which appeared in *Wilson's Photographic Magazine*:

> About fifteen years ago a physician introduced to notice a new disease which he named the "bichromate disease." Very many people have scoffed at the thought of any danger in working with bichromate of potash, and it is only occasionally that a bad case crops up, but a number of workers have suffered from it and have found it very troublesome. The disease is most probably contracted during development, and not in sensitizing, the steady dabbling in the hot water, even with the necessarily very slight amount of bichromate present, being more dangerous than the dipping into a stronger but cold solution. The symptoms commence with a very violent itching between the fingers, and this itching spreads to the back of the fingers, and if the work is kept up the backs of the hands and wrists become affected. In extreme cases the system seems to become permeated with the poison, and the man in such a condition cannot continue his work. There seems to be no class or type of person more liable to attack than others, and some of the worst cases have been strong, robust men. But heavy or rich living and alcohol seem to foster the disease. As soon as any itching symptom is felt, precautions should be taken, for it is a disease that cannot be eradicated, except by discontinuing the work. The parts must not be rubbed or scratched. At night, rub well into the itching parts a little nitrate of mercury ointment, which a druggist will supply if told what it is for. . . . The only safe way to work after having contracted the disease, is by using rubber gloves.[684]

"INSTANTANEOUS PHOTOGRAPHY" BECOMES DEPARTMENTALIZED

Photo Era was founded in Boston in May 1898, and remained a prominent voice in photography for thirty-four years. This announcement appeared in December 1898:

> It has been deemed advisable by the board of editors of the *Photo Era* to establish a department to encourage and deal exclusively with instantaneous photography. This decision has been arrived at after considering the small amount of attention paid to this class of work by other photographic magazines. The time was—and it is not so very long since—when such a thing as really good, rapid instantaneous work was unknown, the pictures either being blurred by the movement of the subject during exposure, or so considerably underexposed as to be practically worthless. Even lenses which possessed sufficient aperture to give the illumination necessary for very short exposures were not capable of giving anything like accurate definition, except on a small area on the center of the plate. Now, everything has changed. With the advent of much more rapid plates have appeared anastigmatic lenses, which have developed more and more speed until they have culminated in the Zeiss Planar, Series I.a, with a speed of f/3.4, and perfect definition over the whole plate. In shutters, the changes have been not less marked, until, among the most rapid, we find the Prosch Manufacturing Company's "Athlete," Newman and Guardia's "Celeritas," and the Thornton-Pickard Company's and C. P. Goerz's focal plane instruments. With these changes in facilities should come a remarkable change in results—much more marked than is so far apparent—and it is this improvement which we wish to encourage and demonstrate.[687]

vocate upon the higher claims which have been made for photography. More than that, he has been a teacher to whom a great many owe whatever position they may hold today.[685]

Interestingly, the veteran daguerrean era photographer Albert S. Southworth pointed to the concurrent revolution in mechanical reproduction of photographs, and suggested that this was having an equally profound effect on the acceptance of photography as a fine art:

> Confining ourselves to this side of the Atlantic, American painters and sculptors, until a very recent date, were wont to sneer at and actually deride photography as an important adjunct of their professional work in the formative processes in their studios. This applied to the most distinguished members of our native art. The late George Inney [Inness] or A. H. Wyant at the head of the landscapists would show their teeth in the wildest kind of wrath should one suggest there were artistic expression, tone, perspective or power in the finest examples produced by the camera. The same was true of our leading portrait painters and sculptors, and it was not until the very highest class of magazines and art journals in the United States and Europe put aside wood and other engraving for halftones after the camera that the true art value of the latest development of the invention of Daguerre began to dawn upon and influence their professional workmanship.[686]

The 1890s remained a period of transition, both in the evolvement of new forms, tastes, and styles in pictorial photography and photographic portraiture and in the acceptance of the best of this work as a new medium in art. In May 1898, for example, *Scribner's* magazine published an article in which the contention was made that photography's influence on art had been more evil than good. On the one hand, the reasoning went, it was causing some painters to try to rival the photograph in its "accuracy of statement" (which would cause people, in the long run, to "resent being fobbed off with mere nature when they ask for art"). On the other hand, while it was true that nature sometimes "fortuitously arranges itself into a semblance of pictorial harmonies" (which enabled a photograph to "seize and perpetuate one of these accidental arrangements"), nevertheless, the *Scribner's* article contended, "the more consciously the photographer attempts to be an artist the worse, in general, are his results, because the complicated harmonies which the painter arranges on his canvas are impossible of achievement anywhere else."[688]

The Boston artist Darius Cobb took a different view, however:

> The exhibitions of some of the camera clubs give sufficient evidence, to the unprejudiced mind, that photography is a fine art. I am aware that adjusting the lenses is not a fine art, nor is the closing of the shutter, nor any distinctly mechanical operation in the making of a picture; neither is the process of etching a fine art, nor the mere act of painting with the brush; yet we say etching is a fine art, when etching itself is but a mechanical process, and we say painting is a fine art, although it is itself of so mechanical a character that the term is applied to painting a house as well as to painting a picture. The fact is, we term etch-

In July 1897, Alfred Stieglitz launched *Camera Notes,* a new quarterly journal of the New York Camera Club designed to stimulate members to greater artistic efforts in photography. In his own words, Stieglitz said the publication had Europeans talking about it "in one country after another" within three months. By 1898, he said, individual issues "sold for high prices at auction." Nevertheless, the journal received this mixed review from the critic Sadakichi Hartmann (an admirer of Stieglitz's), after the appearance of a dozen issues:

> *Camera Notes* has helped to make the N.Y. Camera Club known in photographic circles all over the world. Dignified in appearance as it is, it cannot help but to attract attention to its publishers. It is the most ambitious club publication in existence; there is no art magazine in this country which could compete with *Camera Notes* in its distinctive and peculiar make-up. The pictures are reproduced in a manner that leaves but little room for fault-finding. The letterpress, although not free of small imperfections, is on the whole satisfactory. The material, however, within the covers is very frugal and consequently open to criticism. The articles of a strictly technical and scientific character, of course, are in place, but as far as I can see the trend of the magazine, it is to initiate its readers in the artistic possibilities of their art. In this, it fails. The aesthetic laws which rule photography have not yet been determined; what we need most, therefore, are decided opinions which endeavor to solve this problem. It would be by far more profitable than the everlasting commenting upon half a dozen men and women, and their more or less doubtful artistic qualifications.[689]

IN MEMORIAM: DR. HERMANN W. VOGEL

American photography's staunchest European ally, Dr. Hermann W. Vogel, died in December 1898, at the age of sixty-four. Twice, he was invited to attend American photographic conventions, the first at Cleveland in 1870 and the second at Milwaukee in 1883. He was the founder, in 1864, and editor of *Photographische Mittheilungen* until a few years before his death, and had represented the German government as its Imperial Commissioner at international photographic expositions in Paris (1867), Vienna (1873), Philadelphia (1876), and Chicago (1893). "We entered the field of photographic editorship at nearly the same period," Edward Wilson recalled in a long obituary. "We very soon found each other and became close friends." For many years thereafter, Vogel served as German correspondent for the *Philadelphia Photographer*. "Every visit he made to America, every book he gave us, every article he wrote, was to all sincere photographers a true inspiration," Wilson said, "and served all as the benison of a true friend."[690]

ing an art and painting an art because by these words we understand the object of the etching and the painting. So, in speaking of photography as a fine art, we mean the mental process combined with the mechanical.[691]

Among the new processes adopted by a select group of photographers on both sides of the Atlantic at this time were those involving manipulation of finished prints. By the use of the gum bichromate process in particular, photographs could be altered to such an extent in printing that they could no longer be viewed as a merely mechanical reproduction by the photographer's apparatus. "One could proudly say these photographers have broken the tradition of the artificial reproduction of nature," one German authority, Dr. Karl Voll, said. "They have freed themselves from photography. They have sought the ideal in the works of artists. They have done away with photographic sharpness, the clear and disturbing representation of details, so that they can achieve simple broad effects."[692]

Whether or not photography qualified as a fine art, pictures hung at the various salons and camera club exhibitions were being bought, for the first time, by collectors. As we have already seen, the National Museum purchased fifty photographs at the 1896 Washington, D.C., salon, and expressed the intention of purchasing additional photographs at the projected 1897 salon. In Syracuse, a leading businessman and amateur photographer, George Timmins, began buying photographs at exhibitions, and on May 25, 1896, he opened a private display of his collection at the Hendrick Art Gallery in that city. Seventy-seven photographers from twelve countries were represented in the Timmins exhibition, all of whom were considered "artists" with the camera. Alfred Clements' 1894 prize-winning photograph, "A Struggle for Existence," was among the total of 278 photographs shown. The range of selection encompassed all of the current photography styles and movements.[693]

1899

Talk of a "new school" of photographers, and of "the new portraiture," was now prevalent in photographic circles. Exhibits sent to the National Academy of Design for its first exhibition of photographs in the fall of 1898 "were chiefly from men who are classified as belonging to the 'new school,'" E. L. Wilson observed in his review of the event. Among those he cited were: Isaac Benjamin and W. N. Brenner, of Cincinnati; J. E. Mock, of Rochester; G. E. Tinley, of Mystic, Connecticut; J. M. Appleton, of Dayton; H. H. Pierce, of Providence; C. P. Marshall, of Cazenovia, New York; E. Lee Ferguson, of Washington, D.C.; G. K. Kimball, of Concord, New Hampshire; Elias Goldensky, of Philadelphia; W. F. Schreiber, of West Bend, Wisconsin; and F. Holland Day, of Boston. "The prominent position taken by amateurs in portraiture, as well as in general work, was, we believe, a surprise to many professionals who visited the exhibition," Wilson said.

Among the new school was a small group of women, most of whom were just beginning illustrious careers. Foremost among these were Mathilde Weil, of Philadelphia, who said she was charging the highest prices paid for photographic portraits in the City of Brotherly Love; Zaida Ben Yusuf, of New York, a native Londoner who was encouraged to take up photography as a career by George Davison, and who subsequently emigrated with her family to New York, where she opened a gallery on Fifth Avenue; Eva Watson (later Eva Watson Schutze), also of New York, a close friend of Alfred Stieglitz and a specialist in the gum bichromate process; and Gertrude Kasebier, who studied painting at Brooklyn's Pratt Institute, and in Paris, before opening (in 1897) what was to become one of New York's most fashionable photographic studios.

Conspicuous for their absence from those exhibiting photographs at the National Academy of Design were "the great lights of the profession," as Wilson labeled them, although he noted the presence of photographs sent in by J. C. Strauss of St. Louis, and the C. D. Fredericks studio in New York. In his review of the works shown, Wilson made this distinction between those provided by professionals as opposed to amateurs:

Almost invariably, the professional had striven for a brilliant print with a good range of tones from black to white; the amateur, on the other hand, apparently gave more thought to the effect desired in his picture than in its range of gradation or colors. The portraits by the amateurs, for instance, were generally what the professional would describe as dirty, or muddy in tone, grays, sepias, and "off-colors" being the rule, whereas the professional portraits were, as a rule, rather too positive in color.[694]

As Wilson later expressed it, photographers all across the land (beginning about 1895) had become "awakened" to the idea that the old methods of portraiture did not satisfy new requirements. "A change of some kind was evidently necessary, he said, "as a means of relieving the stagnation

A SCULPTOR'S THOUGHTS ON THE "NEW PORTRAITURE"

After finding himself "startled" at some of the sentiments about "modern photography" expressed at the annual P.A.A. convention at Lake Chautauqua, New York, Prof. Lorado Taft expressed some of his own thoughts on "the art question" in an unscheduled address to the convention:

I have found that there is an entirely different standard erected by some of you for the photographer and the painter. I don't believe in that. You have not won me over yet; in fact, the more opposition I hear, the stronger I feel in my view, and I suppose the stronger you feel on your side—some of you. This is what I am worrying about: the fact that some of you consider detail everything in art. A certain amount of detail is good; a certain amount of detail is necessary in every art; even in sculpture I like to see some, even the veins and the arteries throbbing, as was suggested here the other day; but I don't like to see a marble bust that you can comb with a fine-tooth comb—I don't want to see every hair.

So let me say, the modern painter's effort is to discover that treatment which will best give the general effect as it may be gathered at a glance, seeking to give most closely the illusion of nature. And in your work I think you will have a number of faults to correct—many of you. To begin with, avoid those black shadows, which many of you think belong to the work of the old masters. That is a great mistake; their black shadows were not black, which to me make a portrait very unpleasant.

To go on to other things with which I have been quite strongly impressed, I feel that in general exaggerated lighting of the head is a detriment; I feel that, as far as possible, a softer treatment of the head is a little better than those extremely round heads. I like strong lighting for strong, rugged faces; but ordinarily you will get nearer to the illusion of life, the effect of nature as you see it in the streets, where you meet people in public places, if you have a softer and more diffused light.

Another thing which strikes me very unpleasantly is the cutting off of a figure within a frame. The frame should do the cutting off. We all have to be cut off—in our prime, sooner or later it may be—but to vignette the figure and leave the head and shoulders floating in blackness seems a very sad fate, to me very unpleasant. I think you should always represent the figure as far as you go, throwing it a little out of the focus, a little out of intensity, concentrating on the face; but let there be some legitimate means of stopping the figure, such as stopping it with the frame —not that cutting off with a black veil, or "vignette," as you term it.

I could go on indefinitely, because our arts are closely related. Very many of these things which I see among your exhibits here appeal to me strongly, as a sculptor.

I feel the essential thing is the face; everything should be subordinated to it. I think we are at a disadvantage in photographs, because the details, for instance, of a lady's hat are so inflexible, so insistent, in the photograph. In nature the head is generally bobbing: She will toss the head around and smile. You are looking at the lady and her face, studying her, not the head. In a picture among the exhibits the technical effects shown in the lady's hat are fine from that standpoint. The shadow under the hat is fine; that was evidently the object sought in the representation. It is a beautiful piece of modeling; but, after all, it is the hat that cries out for attention. I get a little tired of the punctures around the hat, the embroidery, etc. It is the hat, not the face. How to avoid the difficulty I cannot see. But the man who took that portrait is broad and big enough to avoid the fault if he tries. The impression on me is not that of a portrait of a lady, but of a lady's hat.[695]

Photography in platinum was not restricted to exhibitors at eastern photographic salons, and was used by an Omaha establishment, for example, to make over 1,200 dramatic likenesses of warriors from about forty North American Indian tribes. But prints from these sittings, like the one above, are now quite rare.

of business which followed the 'panicky' business years of 1890–95.'' Here and there, men attempted to solve the problem by putting more individuality into their work, with the result that gradually a few ''progressives'' founded what was to become the ''new school.''

This then divided the fraternity, Wilson said, into two camps. First, there were those who continued to favor the ''old methods'' of ''plain, straight-forward portraiture,'' making portraits which, whether they exhibited any ''pictorial value'' or not were technically and photographically good. In this school were such photographers as B. J. Falk, Frederic Gutekunst, Isaiah W. Taber, and a number of lesser-known names. All were men whose work had won them high reputations, ''and an apparent prosperity.''

The so-called new school, Wilson said, was distinguished less for a rigid adherence to photographic or technical quality than for a striving for a ''pictorial,'' or ''painter-like,'' effect in its works. Sometimes the portraits made by members of the new school would be thoroughly good, photographically, while in other instances they could be viewed as technically very poor examples of photography. But in the case of any portrait made by the hands of an intelligent and skillful worker, Wilson contended, ''it almost always exhibits the qualities of character, individuality, feeling, etc. (in other words, picture qualities) in a measure which makes it decidedly interesting.'' [696]

Prof. Lorado Taft, the noted sculptor and instructor at the Art Institute of Chicago, observed this division in the fraternity when he addressed those attending the P.A.A. convention at Lake Chautauqua, New York, in the summer of 1899:

I was surprised when I reached here a few days ago to find that there are two decided elements, two decided camps, among photographers. That is, the artists in their line, and the imitators of the old. To some of us the old masters are the foundation of our

Foremost among a "new school" of photographers to emerge in 1898 was Isaac Benjamin of Cincinnati, whose portrait in platinum made in 1908 of President-elect William H. Taft (above) is among the most noteworthy of his surviving photographs. Prior to 1889, Benjamin and others in his family made musical instruments.

faith; they are like the Bible to the Christian. We take it for granted of the old masters, as of the old prophets, that what they said was true, and we found our belief upon that. So when I find here that some of you consider that a mere species of rot—as it was so retailed to me—that the old masters had nothing to do with the modern masters, modern photography, I was a little startled. 697

Prof. Taft contested the idea that there was a different standard for the photographer, as opposed to the painter, in portraiture, but at the same time he cautioned his listeners against using too much "exaggerated lighting" in their studio work. In this respect he seemed to be somewhat at odds with one of the longtime "great lights" of the fraternity, namely George Rockwood.

Rockwood was an early proponent of the new school, and even went so far as to dub what he called "the new ultra-artistic phase of photography" as the "Vandyke style." To Rockwood, this meant not only subordinating everything to the portrait in photography (deemphasizing or entirely eliminating accessories) but going one step further and "subordinating everything in a portrait to the head or likeness alone." Rockwood drew this analogy to the work of another of the sixteenth-century Dutch masters:

Rembrandt, when he painted a portrait, used a skylight less than two feet square. In this beam of light he placed his sitters, and, as may well be understood, nothing could be seen but the head in this manner illuminated. There was nothing to divide the interest or distract attention from the portrait. The work of no other master has ever equalled his portraits. In this line I have for many years worked for artists and connoisseurs, until now there is a positive demand and appreciation of this new-old-style of portraiture. By this manner is developed the strong personality, character, and beauty of the human head, and in but a few cases have I failed to find it complimentary. 698

No more outstanding examples of the strong personality

From Alabama. Copyright by Rud. Eickemeyer.

on Carbon "VELOX" Paper.

By 1899, professional as well as amateur photographers had adopted the varied forms of velox paper, and a smooth matt surface version was used by Rudolf Eickemeyer to make the portrait of the unidentified black man (above left). By 1899, too, judges for American photographic salons were being selected entirely from the photography world, where previously awards had been determined principally by artists. The photograph at right is of the judges for the 1899 salon of the Philadelphia Photographic Society, and includes Henry Proth, center; Frances B. Johnston, seated left; Gertrude Kasebier, seated right; F. Holland Day, standing left rear; and Clarence H. White, standing right rear.

and character of the American Indian are to be found than the series of photographic portraits in platinum made at this time in Omaha, Nebraska, of the warriors of about forty North American tribes (see illustration on page 390). This undertaking was begun by the Omaha photographer F. A. Reinhart, at the United States Indian Congress of the Trans-Mississippi and International Exposition, which was held in that city in 1898 under the auspices of Capt. W. A. Mercer, of the United States Army. Credit for all, or many of the more than 1,200 platinotype portraits made of the braves, should probably go to Reinhart's assistant, A. F. Muhr, who identifies himself as the photographer in a catalog of the portraits made available commercially in 1899.[699]

Just as there was increased preference for platinum paper and carbon tissues among the new school, so the photographers welcomed a new competitor on the scene, which renewed interest in gelatine chloride papers. This was the new velox paper introduced as early as 1893 by the Nepera Chemical Company of Yonkers, New York. It was basically a gelatine chloride paper, but was sensitive enough to be printed by gaslight (or more quickly, if necessary, in weak daylight). By the late 1890s, the paper (offered in a

number of varieties) had become popular with professional as well as amateur photographers, and was adopted at such fashionable studios as those of Falk and Eickemeyer. After the 1898 P.A.A. convention, at which the largest exhibit was that held by the Nepera company, *Photo Era* expressed its complete enthusiasm for the velox paper:

The nature of this exhibit showed conclusively to anyone who might still think otherwise, that prints made on velox are fully the equal of, if not superior to, platinum prints, that special rough velox, in particular, seems to be eminently adapted for large works, while for smaller work, where detail is of more importance, portrait velox seems to be preferred. Some of the smaller prints exhibited by the company were made on portrait velox from negatives by Mr. Furman, of San Diego, Cal., and were strikingly similar to prints made on carbon tissue transferred to celluloid, and if it had not been for the label on these prints, anyone would have mistaken them for the latter.[700]

But there remained one major holdout—David Bachrach. "The fact stares us in the face," he said, "that less silver is produced in the operation of printing with emulsion papers, and, in consequence, less gold is formed in the final image. As to the relative stability and liability to chemical change

This portrait in carbon of an unknown young lady, by James Lawrence Breese, is typical of the more vivid and interesting "picture qualities" which Edward L. Wilson attributed to photography's "new school." Little known today like so many of his contemporaries, Breese operated the Carbon Studio in New York in partnership, for a time, with Rudolf Eickemeyer, Jr. In 1894, Breese authored an article for *Cosmopolitan* on the relationship of photography to art, and was evidently successful enough in his business to maintain a mansion in East Hampton, New York.

of the mediums employed in holding the salts of silver, coagulated albumen or hardened gelatine, the weight of evidence is certainly not on the side of gelatine.''

To this line of reasoning, Dr. Leo H. Baekeland, the president of the Nepera Chemical Company, responded:

> I will be glad to show by direct tests to Mr. Bachrach, and to anybody, that I can make prints on Nepera paper which has a hardened gelatine film rich in silver, toned in separate baths, and fixed in plain hypo, which will stand the test and outlast any albumen prints made by the leading photographers of the United States.[701]

Bachrach's adversary, in this instance, was probably one of the most formidable of his career. As a young Belgian chemistry professor, Baekeland attended a meeting of the New York Camera Club in 1889, where he was introduced to Richard Anthony. This led to his being asked to join the Anthony firm. But he had worked in Belgium on the chemical formula for a type of photographic paper sensitive enough to be printed by artificial light, and in 1893 he formed the Nepera firm in partnership with Leonard Jacobi to manufacture the paper. George Eastman was among those who thought well of the velox papers—so well, in fact, that he decided that Eastman Kodak should acquire Nepera. In 1899, Eastman contacted Dr. Baekeland. ''If you are interested in selling, come up to Rochester,'' he wrote. ''We can talk it over and, I am sure, come to terms.'' Baekeland made the trip and was reportedly paid $1 million for the Nepera operation. After that, Dr. Baekeland went on to yet another famous invention: oxybenzylmethylenglycolanhydride, or, as it is now commonly known, Bakelite.[702]

Eastman's acquisition of the Nepera Chemical Company was but one step in a much grander design. Earlier, the principal French and German paper manufacturers had formed a coalition and had doubled the price of their respective Rives and Saxe papers. This had naturally caused considerable reverberations in the photographic world, and on August 10, 1899, Eastman took the bold step of forming a large American combine with the twofold purpose of controlling *all* of the major American photographic paper business, and, at the same time, controlling—for North America—*all* of the sales of paper products by the aforementioned French and German manufacturers. The new combine was given the name General Aristo Company, and involved the purchase of, or a controlling interest in, the following companies: Eastman Kodak Company, of Rochester (photographic printing paper business, only); the American Aristotype Company, of Jamestown, New York; the Nepera Chemical Company; the New Jersey Aristotype Company, of Bloomfield, New Jersey; the Photo Materials Company, of Rochester, New York; and Kirkland's Lithium Paper Company, of Denver, Colorado.

E. L. Wilson hastened to assure his readers that the new combine was in no way a detriment to the American photographic community:

VELOX PAPERS

The introduction of a variety of velox papers by the Nepera Chemical Company brought a renewed interest in gelatine chloride emulsion papers, and after the turn of the century, papers made on the velox principle became the standard in contact printing. Wilson's journal gave this description of the papers in 1900:

> Taking the different kinds of velox, we see how completely the paper can be adapted to any kind of negative or subject. All velox papers may be divided into two classes, known as ''Special Velox'' and ''Regular Velox.'' These terms have reference to the time of exposure and development. Regular velox is designed for soft negatives and for those which need their contrast increased. It requires a much longer exposure than Special velox, but the image develops in half the time or less. Special velox is adapted to soften hard or contrasty negatives, and to give the most delicate gradations of tone of which the negative is capable.

VARIETIES OF VELOX

Regular

CARBON VELOX—Smooth matt surface
ROUGH VELOX—Rougher surface
GLOSSY VELOX—Prints can be produced with high polish

Special

SPECIAL CARBON—Surface similar to regular carbon
SPECIAL PORTRAIT—½ matt surface
SPECIAL ROUGH—Very artistic paper; gives broad effects; less detail
SPECIAL GLOSSY—Similar to regular glossy; quicker printing; longer developing
SPECIAL ROUGH (double weight)—Requires no mounting
VELOX POSTAL CARDS—Smooth matt surface like carbon[703]

It is not a combination of the interests of several individual concerns handled by promoters who do not understand the business and have no interest at stake except the profit of stock manipulation, but a company which has as much at stake in the proper care of its consumers and in the reputation of its goods as anyone of the individual concerns had previous to the consolidation. . . . We learn that there will be no increase in price, and that the company will not permit any competition to undersell them, quality considered.[704]

But the San Francisco *Call* dubbed the move ''imperialism,'' and foresaw ''the greatest rate war in photographic supplies that has ever been inaugurated in this country.'' Not so, said George Eastman. ''The *Call* reporter,'' he said, ''may not be able to grasp the idea, but for the future growth of our business and profit we do not look for a 'forcing up of prices,' but rather for such a reduction as shall enable us to make Kodakers of every school boy and girl, and every wage-earning man and woman the world over.''[705]

1900

Photography, like the horse and buggy, was poised for a coming age of mechanization, as the world passed into its twentieth century. At the outset, the former was clearly in the lead; there were, by this time, 100,000 Kodak cameras alone in the hands of amateurs, whereas only some 8,000 horseless carriages were registered as of 1900. Eastman Kodak was also ready with a new "Brownie" dollar box camera, which would shortly vitalize the camera market much as the Ford Model T would stimulate auto sales several decades later. The name "Brownie" was chosen principally because of the popularity of a children's book of cartoons of the same name, and partly, no doubt, because the camera was manufactured initially for Eastman by Frank Brownell, also of Rochester, New York. Just down the road, too, was the first of Eastman's famous line of folding, bellows-style pocket cameras, which would produce pictures of 3¼ × 5½ inches (postcard size, as they were popularly called at the time) from the camera's roll film.

Until 1900, the manufacture of emulsion-coated dry plates, as well as the supply of various types of photographic paper, was handled by small factories, principally firms in which the business was carried on under the direct personal supervision of the founder. But the new era of the business trust, and the dawn of chain-store retail merchandising, changed all this. The formation by Eastman of the General Aristo paper trust in 1899 led to the establishment, two years later, of the Eastman Kodak Company of New Jersey, the country's first holding company in the photography field. The New Jersey company absorbed the business of General Aristo, as well as British, German, and French Kodak operations, and beginning in 1900 George Eastman made other acquisitions which, by 1902, made his company the predominant supplier not only of paper but also of cameras and dry plates. At the same time, the company acquired the principal photography retail outlets in Boston, Chicago, and other midwestern cities.

The motion picture "industry," meanwhile, was dragging its feet, not only because pioneers like Edison and David W. Griffith failed to appreciate the medium's potential but also because the entire business was in a rut, with most of the early equipment developers battling one another in the courts over patent infringements, and all of them making unimaginative, action-oriented films of 5 to 10 minutes' length in secrecy at "factories" in New York, Philadelphia, and Chicago.

But changes were in the wind in this field as well. In 1903, the "story" film was inaugurated by an Edison cameraman, Edwin S. Porter. Porter was influenced by earlier British films in which a judicious cutting and splicing of film taken of different subjects or actions in a particular news event made the event seem more like a story, since the audience was given several points of view concurrently. Porter's "Life of an American Fireman," produced by Thomas A. Edison, Inc., in June 1903, became the first American motion picture drama to be photographed free from the perspective of a single stage, and to evoke a sus-

A "Brownie" with his new dollar box camera.

tained audience interest and suspense through similar film editing. By 1907, the motion picture "factories" likewise came under the control of a business trust, and films produced thereafter by the survivors of the various patent litigations were "packaged" and distributed by a single corporation to movie theaters across the land (see page 398).[706]

The adoption by newspapers of halftone illustrations made directly from photographs sparked the creation of the type of photographic news services envisioned earlier by Stephen Horgan (see page 301). These services managed to grow competitively, however, escaping management by a single trust.

The "father" of this type of business was a former St. Louis newspaperman, George G. Bain. Bain became Washington manager for the United Press in the 1890s, and adopted the practice of carrying a hand camera with him on special stories and interviews. He became a friend of Ohio Congressman William McKinley, and when the latter was elected to the presidency in 1897, Bain was allowed to make the first informal shots of a President and members of his cabinet on White House grounds.

At this time, newspapers did not pay for photographs provided by reporters or free-lance writers, and Bain decided that this tradition should be ended. About 1898, he formed the Bain News Service in the newspaper district of New York, an organization which remained in business until Bain's death in 1944. By 1905, he had accumulated a

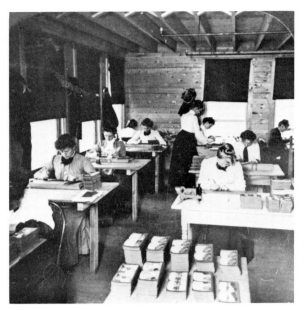

MASS RETAILING OF CARD STEREOGRAPHS

The popularity of card stereographs reached a new high by the turn of the century, sparked principally by new merchandising techniques, widespread interest in views of the Spanish-American and Boer wars, and the introduction of boxed series of cards covering geographical points of interest in foreign lands, and the workings of business and industry at home. Vast numbers of cards were also produced and endorsed by college and university heads as visual aids in educational instruction. The principal publishers at the turn of the century, all with sales outlets at major world capitals, were: Underwood & Underwood, Keystone View Company, Griffith & Griffith, and, from 1901 to 1914, the H. C. White Company, where the photographs above were made of the company's manufacturing operations. These views illustrate (top left) an automatic printing machine, (top right) mechanism for mounting the paired photographs on cards, (bottom left) sorting and trimming of inventory, and (bottom right) retouching department.

million photographs, all of them catalogued and cross-indexed, and most of them purchased or acquired from correspondents around the world. Among these prints, Bain had many "firsts," including the first photographs taken in a federal courtroom; Octave Chanute's experiments with aircraft before the advent of the Wright brothers; the first photographs of the U.S. Senate and House of Representatives in session; and the first automobile races at Newport, Rhode Island.

But all of Bain's photographs were lost when the Parker Building, in which his news service was housed, was destroyed by fire in 1905. Today, only the published illustrations from some of these photographs, which lie unrecorded in the pages of yellowed and crumbling newspapers in public libraries, are all that remain of Bain's pre-1905 inventory.[707]

Even fine-art photography was headed for the big time with an international photographic salon scheduled for 1900 at New York's Madison Square Garden. But after much talk of preparations in 1899, the event appears not to have taken place. As for the critic Sadakichi Hartmann, he felt it was "a great pity" that fine-art photography exhibitions were held on such an exclusive basis, whereas if they were made more accessible to the public they could do much to instruct people about the aims and accomplishments of photography as an art form. "Ninety-nine persons out of one hundred are not yet even familiar with the term 'artistic photography,' " he contended, "much less with its aspirations and aims." Hartmann argued that the artistic enterprises of the New York Camera Club, for example, "were managed on a too exclusive scale; their publications [i.e., *Camera Notes*] as well as their exhibitions only reach the profession, not the public at large."[708]

And what of the professionals, whose predecessors had started it all in the first place? Along with the "new school" in portraiture had come an even greater elegance among the most fashionable studios. "There is a glamour over Fifth Avenue, New York, such as is over no other photographic center in America," Wilson observed in November 1900. He cited several newcomers, among them Hollinger, D. H. Anderson, and Jeanette Appleton. Other "showcases" were the studios of Gertrude Kasebier, Zaida Ben Yusuf, Rudolph Eickemeyer, and the successors to Napoleon Sarony.

The one studio which Wilson found "difficult to describe without seeming to give way to unreasonable superlatives" was that of B. J. Falk, who had abandoned his Falk Building near Madison Square for the former quarters of a winter garden atop the Waldorf-Astoria Hotel on Fifth Avenue between Thirty-third and Thirty-fourth streets (site of the present Empire State Building). Opened in 1897, the hotel was comprised of two buildings of similar architecture, but built separately (and then joined together) by feuding members of the Astor family. Falk's studio occupied most of the top (fifteenth) floor, and when one considers that the industrialist John W. Gates paid a reported $20,000 annually for just a suite of rooms on a lower floor, one can only imagine the size of Falk's rental. But here, Falk could mingle with the new business elite, among them such regular patrons of the Men's Cafe as J. P. Morgan, Henry Clay Frick, and Charles Schwab.[711]

The increasing simplicity of hand cameras made it possible by the turn of the century to place new emphasis in promotional efforts on young people. At top, is the cover of an 1899 book described in the introduction as "a boy's adventures in the company of his camera." Above, a little girl poses with a No. 4 folding Kodak camera which was popular in the 1890s. The camera was the first of the bellows-style folding variety to feature roll film.

1900

George Eastman (left) and Thomas Edison (right) had become old friends by the time this 1930 photograph was taken with Charles A. Lindbergh.

THE MAKING OF THE "KODAK KING"

After the U.S. Supreme Court virtually repealed the Sherman Anti-Trust Law by sanctioning the formation of a monopoly (in the sugar industry) through the device of a holding company (in 1895), the way was paved for organization of the General Aristo Company in 1899 by George Eastman. But while this was a trust in the same sense that the sugar combine was, it differed in that control remained in the hands of one man— George Eastman—rather than in Wall Street. When New Jersey amended its incorporation statute to permit one corporation to own the stock of another, Eastman took the same step other "tycoons" were taking in other industries: he "wound up" General Aristo and the Eastman Kodak Company of Rochester, New York, and established a new holding company, the Eastman Kodak Company of New Jersey. This company was established on October 24, 1901, and became the direct owner of the previous General Aristo business operations in the United States, plus the owner of all of the capital stock of Kodak, Ltd. (Great Britain), and German and French Kodak operations headquartered in Paris and Berlin.

Already in the process of establishing a trust in the supply of photographic paper, Eastman made his next move in cameras. In 1900, he purchased the Blair Camera Company, of Boston, and the American Camera Company, of Northboro, Massachusetts. The same year he introduced a new dollar box camera, the "Brownie," supported by a vast advertising campaign. E. & H. T. Anthony & Co. offered, at this time, to sell out to Eastman, too, but the offer was rejected (after which the Anthony firm merged with the Scovill & Adams Company in 1901, forming Anthony and Scovill—a name ultimately shortened to Ansco). But despite the competition from Anthony and Scovill,

and a dozen other smaller firms, Eastman Kodak became the dominant manufacturer of cameras at the start of the twentieth century.

In 1902, Eastman acquired the principal competition in dry-plate manufacture. This included the M. A. Seed Dry Plate Company, of St. Louis (which had a corner on nearly half the market for American-made dry plates) and the Standard Dry Plate Company, of Lewiston, Maine. At the same time, he purchased the card-mount business of Taprell, Loomis & Company, of Chicago, and acquired control of the principal photographic retail outlets in Boston, Chicago, Minneapolis, St. Paul, Milwaukee, and Sioux City. The Boston acquisition was of the old-line firm, Benjamin French & Company.

As the motion picture industry began to mature after the turn of the century, and the prolonged litigation came to a head over the rights to basic patents in film projection equipment, yet another trust appeared on the scene. This was the Motion Pictures Patent Corporation, which operated through the General Film Corporation in distributing packaged reel films to movie theaters. While it was a boon (until 1912) to all participating companies, this trust was a particular bonanza for Thomas Edison, whose film company derived profits of up to $1 million annually in royalties and allotments in film productions. At the same time, through a special agreement with the trust, Eastman Kodak secured a monopoly on the supply of celluloid film. Eastman, in 1908, endeavored to establish an international cartel for photographic supplies, but in this he was countered by French and German concerns, which provided vigorous competition until Eastman's acquisition of the Pathé film plant in 1927.[709]

Frances B. Johnston worked occasionally on assignment for George G. Bain's pioneering photographic news agency (opened about 1898), and her photographs of President William McKinley made at the Pan-American Exposition in Buffalo, on September 4, 1901, provided an unexpected boon to the news service when McKinley was assassinated there two days later. In Miss Johnston's photograph (above) the President and Mrs. McKinley are shown touring the fair grounds with the fair's head, J. G. Milburn.

1900

399

DETAIL OF STAIRWAY. STATUE BY MORETTI. AN ALCOVE.

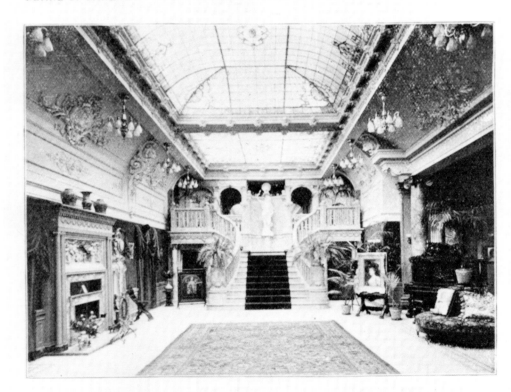

RECEPTION-ROOM.

"GLAMOUR OVER FIFTH AVENUE"

The most palatial of the photographic galleries on New York's Fifth Avenue was B. J. Falk's establishment (above), which occupied most of the top (fifteenth) floor of the Waldorf-Astoria Hotel between Thirty-third and Thirty-fourth streets (site of the present Empire State Building). A portion of the gallery included what had originally been intended as a winter garden. "Irresistibly," E. L. Wilson observed after examining the gallery's oak-paneled walls and Pompeiian tapestries and waiting rooms, "the mind recalls pictures of the Palace of Versailles as it was in the time of Louis XIV."[710]

Pirie MacDonald, one of the first to become a photographer of men only, and proprietor of another of New York's most fashionable studios, looked forward to new vistas, now that the chemistry of the art no longer demanded the largest part of a photographer's attention:

The new order of things has given an opportunity to men who are constituted differently. Now that the bonds are loosened and the mechanical part of the work is a secondary consideration, some rather curious changes have taken place. Men with sympathies in certain lines are able to gratify their notions. Men with certain artistical proclivities can spend their energies toward the fulfillment of their dreams without the distraction of mechanical problems. How much time and labor would be lost and how many of the better moments would be wasted and opportunities thrown away if a painter had to discover and grind his own colors. How the chemical problems chilled the artistic enthusiasm of photographers, only those who have had to go through the mill know.[712]

But for a member of the old school, James F. Ryder, who made his first photographs in 1848, the passing of the nineteenth century was a moment of nostalgia. The dry-plate process and the amateur's ability to make instantaneous photographs at random was to him something of a "left-handed blessing":

It has made the whole world photographers and people are not content now with snapshots which they and their friends make, and all there is for the photographer to do is finish the plates for the amateur. If the amateur snap-shotter gets a picture that is funny or cute, he is satisfied, and photographic art is left out of the question. How different it all is from the old times, when people went to the photographer and had a daguerreotype taken and finished so that they could take it away with them. If they wanted more than one they sat for each picture they wanted and paid $5 or $10 for each one. With a boy to help me, I used to make as much money as the big galleries with a dozen employees do now.[713]

BIBLIOGRAPHY AND KEY TO ABBREVIATIONS
USED IN THE NOTES TO THE TEXT

Books

ACKERMAN—*George Eastman,* by Carl W. Ackerman, Boston & New York, Houghton Mifflin, 1930.

ANDREWS—*Picture Gallery Pioneers,* by Ralph G. Andrews, N.Y., Bonanza Books, 1964.

APPLETON's—*Appleton's Cyclopedia of American Biography,* N.Y., D. Appleton & Co., 1888.

BEAR—*Life & Travels of John W. Bear, The Buckeye Blacksmith, Written by Himself,* Baltimore, D. Binswanger & Co., 1873.

BROTHERS—*Photography: Its History, Processes, Apparatus & Materials,* by A. Brothers, F.R.A.S., London and Philadelphia, 1899.

BURGESS—*The Photograph Manual,* by N. G. Burgess, N.Y., 1862 (Revised 1865 edition).

COALE—*Manual of Photography,* by George B. Coale, Philadelphia, J. B. Lippincott & Co., 1858.

DAB—*Dictionary of American Biography* (15 vols.), N.Y., Charles Scribner's Sons, 1935.

DAGUERRE—*L. J. M. Daguerre, The History of the Diorama and the Daguerreotype,* by Helmut and Alison Gernsheim, N.Y., Dover Publications, 1968.

DARRAH—*Stereo Views, A History of Stereographs in America and Their Collection,* by William Culp Darrah, Gettysburg, 1964.

EDER—*The History of Photography,* by Josef Maria Eder, translated from the German by Edward Epstean, N.Y., Columbia University Press, 1945.

GERNSHEIM—*The History of Photography,* from the camera obscura to the beginning of the modern era, by Helmut Gernsheim in collaboration with Alison Gernsheim, London, Thames & Hudson, 1969.

G.I.U.S.—*Great Industries of the United States,* by various authors, J. B. Barr & Hyde, Hartford & Chicago, 1873.

HARRISON—*A History of Photography,* by W. Jerome Harrison, London and N.Y., 1887 (available in reprint from the Arno Press, N.Y.).

HEATH—*Photography,* by A. S. Heath and A. H. Heath, N.Y., 1855.

HORAN—*Mathew Brady, Historian with a Camera,* by James D. Horan, N.Y., Bonanza Books, 1955.

HULFISH—*Motion Picture Work,* by David Hulfish, Chicago, 1913. Made available courtesy of the University Club of New York Library.

HUNT I—*Researches on Light,* by Robert Hunt, London, 1844.

HUNT II—*Photography,* by Robert Hunt, London and New York, 1852.

IVES—*The Autobiography of an Amateur Inventor,* by Frederic E. Ives, Philadelphia, 1928 (privately printed).

JAMMES—*William H. Fox Talbot, Inventor of the Negative-Positive Process,* by André Jammes, N.Y., Macmillan, 1973.

JENKINS—*The Boyhood of an Inventor,* by C. Francis Jenkins, Washington, D.C., 1931.

LOTHROP—*A Century of Cameras,* by Eaton S. Lothrop, Jr., Dobbs Ferry, N.Y., Morgan & Morgan, 1973.

LUBSCHEZ—*The Story of the Motion Picture,* by Ben J. Lubschez, N.Y., 1920.

MORRIS—*Incredible New York,* by Lloyd Morris, N.Y., Random House, 1951.

MUYBRIDGE—*Eadweard Muybridge, The Stanford Years, 1872–1882,* a catalog prepared by the Stanford University Museum of Art to accompany an exhibition held at Stanford University, the E. B. Crocker Art Gallery in Sacramento, and the University Galleries at the University of Southern California from October 1972 to March 1973.

NAEF—*Era of Exploration, The Rise of Landscape Photography in the American West, 1860–1885,* by Weston Naef in collaboration with James N. Wood, Metropolitan Museum of Art and the Albright-Knox Art Gallery, 1975.

NEWHALL—*The Daguerreotype in America,* by Beaumont Newhall, N.Y., Graphic Society, 1961.

NORMAN—*Alfred Stieglitz, an American Seer,* by Dorothy Norman, N.Y., Random House, 1960 (1973 revised edition).

PAGEANT—*The Pageant of America, A Pictorial History of the United States,* Ralph Henry Gabriel, editor, New Haven, Yale University Press, 1925 (15 vols.).

PRIME—*Life of Samuel F. B. Morse,* by S. I. Prime, N.Y., D. Appleton & Co., 1875.

RINHART I—*American Daguerreian Art,* by Floyd and Marion Rinhart, N.Y., Clarkson N. Potter, Inc., 1967.

RINHART II—*American Miniature Case Art,* by Floyd and Marion Rinhart, N.Y., A. S. Barnes & Co., 1969.

ROLLE—*California, a History,* by Andrew F. Rolle, N.Y., Thomas Y. Crowell Co., Inc., 1969.

ROOT—*The Camera and the Pencil,* by M. A. Root, Philadelphia, 1864. Reprinted by Helios Press, Putney, Vt., 1971.

RYDER—*Voigtlander and I,* by James F. Ryder, Cleveland, 1902 (available in reprint from Arno Press, N.Y.).

RUSSELL—*One Hundred Years in Yosemite,* by Carl Parcher Russell, University of California Press, 1947.

SANDBURG—*Abraham Lincoln, the Prairie Years and the War Years,* by Carl Sandburg, Reader's Digest Illustrated Edition, 1954.

SIPLEY—*A Half Century of Color,* by Louis Walton Sipley, N.Y., Macmillan, 1951.

SNELLING—*The History and Practice of the Art of Photography,* by Henry H. Snelling, N.Y., G. P. Putnam, 1849 (available in reprint from Morgan & Morgan, Dobbs Ferry, N.Y.).

STEPHENS I—*Incidents of Travel in Yucatan,* by John Lloyd Stephens, N.Y., 1843.

STEPHENS II—*Incidents of Travel in Central America, Chiapas & Yucatan,* by John Lloyd Stephens, N.Y., 1845.

STIEGLITZ—*America & Alfred Stieglitz, a Collective Portrait,* Waldo Frank, Lewis Mumford, Dorothy Norman, Paul Rosenfeld and Harold Rugg, editors, N.Y., The Literary Guild, 1934.

TAFT—*Photography and the American Scene,* by Robert Taft, N.Y., Macmillan, 1938 (available in reprint from Dover Publications, N.Y.).

TAYLOR—*Optics of Photography and Photographic Lenses,* by J. Trail Taylor, London, 1892.

THOMAS—*The Origins of the Motion Picture,* by D. B. Thomas, A Science Museum Booklet, London, 1964.

TISSANDIER—*History and Handbook of Photography,* by Gaston Tissandier, translated from the French and edited by John Thomson, London, 1876.

TOWLER—*The Silver Sunbeam,* by John Towler, N.Y., J. H. Ladd, 1864 (available in reprint from Morgan & Morgan, Dobbs Ferry, N.Y.).

WALDACK—*Treatise of Photography on Collodion,* by Charles Waldack and P. Neff, Cincinnati, 1857.

WERGE—*The Evolution of Photography,* by John Werge, London, 1890 (available in reprint from the Arno Press, N.Y.).

Articles

BACHRACH—"Over Fifty Years of Photography," by David Bachrach, Jr., *Photographic Journal of America,* Vol. 52, Dec. 1915, pp. 578–579; Vol. 53, Jan. 1916, pp. 18–20; Vol. 53, Feb. 1916, pp. 71–73; Vol. 53, Mar. 1916, pp. 117–119.

COBB—"Mathew Brady's Photographic Gallery in Washington," by Josephine Cobb, Archivist-in-Charge, Still Pictures Branch, The National Archives, a paper delivered at a meeting of the Columbia Historical Society, Feb. 18, 1953.

COULSON—"Philadelphia and the Development of the Motion Picture," *Journal of the Franklin Institute,* Vol. 262, July 1956, pp. 1–16.

MCCOSKER—"Philadelphia and the Genesis of the Motion Picture," *The Pennsylvania Magazine of History and Biography,* October 1941.

Periodicals

AAP—*American Amateur Photographer,* New York, 1889–1907.

AAOP—*American Annual of Photography,* N.Y., 1887–1953.

AH—*American Heritage,* New York, 1954–present.

AJP—*American Journal of Photography,* New York, 1858–1867 (n.s.); Philadelphia, 1879–1900 (n.s.).

AJS—*American Journal of Science,* New Haven, Conn., 1820–1879.

APB—*Anthony's Photographic Bulletin,* New York, 1870–1902.

ARASM—*American Repertory of Arts, Sciences & Manufacture,* New York, 1840–42.

BJP—*British Journal of Photography,* begun as *Liverpool Photographic Journal* (1854–56), then issued as *Liverpool & Manchester Photographic Journal* (1857–58), *The Photographic Journal,* Liverpool (1859), and BJP, London, 1864–present.

CN—*Camera Notes,* New York, 1897–1903.

CW—*Camera Work,* New York, 1903–1917.

DJ—*Daguerreian Journal,* New York, Nov. 1850–Dec. 15, 1851.

GA—*Graphic Antiquarian,* Indianapolis and Wilmington, N.C., 1971–present.

HJ—*Humphrey's Journal,* New York, April 1852–April 1862; June 15, 1862–April 15, 1863; May 1, 1863–April 15, 1868.

IAAPB—*International Annual of Anthony's Photographic Bulletin,* N.Y., 1888–1902.

JFI—*Journal of the Franklin Institute,* Philadelphia, 1823–present.

PA—*Photo-American,* Stamford, Conn., 1889–1907.

PAJ—*Photographic Art Journal,* New York, 1851–1853.

PAPS—*Proceedings of the American Philosophical Society,* Philadelphia, 1838–present.

PAS—*Pennsylvania Arts & Sciences,* Philadelphia, Pennsylvania Arts and Sciences Society, Philadelphia, 1935–1941.

PFAJ—*Photographic and Fine Arts Journal,* New York, 1854–1860.

PE—*Photo Era,* Boston, May 1898–March 1932.

PJ—*The Photographic Journal,* begun as *The Journal of the Photographic Society of London* (March 3, 1853–Dec. 1858); issued as PJ, London, 1859–present.

PJA—*Photographic Journal of America,* New York, 1915–1923 (New title for *Wilson's Photographic Magazine*).

PM—*Photo Miniature,* New York, 1899–1932.

PP—*Philadelphia Photographer,* Philadelphia, Pa., 1864–1888.

PRL—*Photographic Rays of Light,* Baltimore, Md., 1878–1881.

PT—*Photographic Times,* New York, 1871–1915.

PW—*Photographic World,* Philadelphia, 1871–72.

SLCPP—*St. Louis and Canadian Practical Photographer,* begun as *The St. Louis Practical Photographer,* St. Louis (1878–1882); issued as *The St. Louis Photographer,* St. Louis (1886–87); and as SLCPP, St. Louis, 1888–1905.

WPM—*Wilson's Photographic Magazine,* New York, 1889–1914. (New title for *Philadelphia Photographer*).

Bibliography
and Key

404

NOTES TO THE TEXT

1. *Journal of the Royal Institution,* Vol. 1, 1802, p. 160.
2. References: DAGUERRE, pp. 51–53: GERNSHEIM, 55–64.
3. References: DAGUERRE, pp. 69–84, 198–204; GERNSHEIM, pp. 65–74.
4. References: GERNSHEIM, pp. 75–85; JAMMES, pp. 6–9; PJ, Jan. 1941, "Sidelight on Fox Talbot," by J. Dudley Johnston, Hon. F.R.P.S., pp. 24–26; *Latent Image,* by Beaumont Newhall, N.Y., 1967, Anchor Books, pp. 55–56.
5. *Latent Image,* pp. 57–60.
6. DAGUERRE. pp. 87–88. APB, Vol. 26, Feb. 1, 1895, pp. 60–61.
7. APB, Vol. 26, Feb. 1, 1895, pp. 60–61.
8. References: *American Science and Invention,* by Mitchell Wilson, N.Y., Simon & Schuster, 1954, pp. 24–31 (Benjamin Thompson); PAGEANT, Vol. 10, pp. 301, 316; *Dictionary of American History,* Vol. 5, N.Y., Charles Scribner's Sons, 1940, p. 44; *Encyclopedia of American History,* Robert Morris, editor, N.Y., Harper & Bros., 1953, pp. 530–531; *The Harvard Graduates Magazine,* Vol. 3, Dec. 1894, pp. 195–197 (re: Josiah Parsons Cooke, Jr.).
9. *Dictionary of Scientific Biography,* N.Y., Charles Scribner's Sons, 1970, Vol. 6, pp. 114–115.
10. AJP, Vol.1, n.s., June 1, 1858, pp. 2–6.
11. SNELLING, pp. 11–12.
12. *New York Observer,* May 18, 1839.
13. *The Corsair,* Vol. 1, Apr. 13, 1839, pp. 70–72; JFI, Vol. 23, Apr. 1839, pp. 263–265.
14. *McClure's,* Vol. 8, Nov. 1896, p. 10.
15. *New York Observer,* May 18, 1839.
16. *The Corsair,* Vol. 1, Apr. 13, 1839, pp. 70–72. Thomas Cole quotation is from *American Album,* N.Y., American Heritage, 1970 abridged edition, p. 16.
17. PRIME, p. 407.
18. *New York Times,* Feb. 19, 1883.
19. HJ, Vol. 6, July 15, 1855, p. 97.
20. PRIME, pp. 402–404. In 1868 the perennial inventor Joseph Dixon claimed that he had daguerreotyped his wife with powdered face in a 15-minute exposure in bright sunshine in September 1839 (PP, Vol. 5, Feb. 1868, pp. 53–54).
21. APB, Vol. 14, 1882, p. 76.
22. *Eureka,* Vol. 1, Sept. 1846, pp. 7–8.
23. References for Draper statements: AJP, Vol. 1, n.s., June 1, 1858, pp. 2–6; ARASM, Vol. 1, July 1840, pp. 401–404. The former is a letter addressed by Draper on May 3, 1858, to a committee of the Mechanics' Club in New York, which had been charged with trying to ascertain who made the first photographic (daguerreotype) portrait, an undertaking which appears never to have been resolved. In this letter, Draper concludes: "How any doubt can be now entertained as to who took the first portrait [meaning himself], passes my comprehension." But Draper either ignored or was unaware of the tiny daguerreotype likeness made of John Johnson in October 1839, or of Robert Cornelius' self-portrait, or of Dr. Paul Goddard's likeness of Aaron D. Chaloner, both made prior to or during December 1839. The plaque affixed to the outside of the New York University building at Washington Square East and Waverly Place, which cites Draper as having made "the first photographic portrait of a human face" at this location, must be considered in error.
24. APB, Vol. 5, Sept. 1874, p. 399.
25. AJP, Vol. 2, n.s., 1859, p. 355; ROOT, p. 351.
26. AJP, Vol. 13, third series, July 1892, p. 310.
27. The series of photographs on this page were made of Goddard's equipment at the Franklin Institute in Philadelphia. Reference for text comes from AJP, Vol. 13, third series, Dec. 1892, pp. 546–548, "Early Daguerreotype Days," by Julius F. Sachse, AJP editor.
28. PAPS, Vol. 1, 1840, p. 155.
29. AJP, Vol. 13, third series, Aug. 1892, pp. 355–356. The Chaloner portrait was exhibited later at the American Philosophical Society in 1843, at the Franklin Institute in 1893, and at the Smithsonian Institution in 1939 ("Early Photography and the University of Pennsylvania," by Mrs. Joseph Carson, *The General Magazine and Historical Chronicle,* University of Pennsylvania, January 1941, p. 6).
30. PAPS, Vol. 3, 1843, p. 180; AJP, Vol. 14, third series, Aug. 1893, pp. 375–376.
31. References for Wolcott, Johnson, and Fitz activities: *Eureka,* Vol. 1, Oct. 1846, p. 24; minutes of forty-second meeting of the American Photographical Society, recorded in AJP, Vol. 5, n.s., Nov. 15, 1862, p. 238; *United States National Museum Bulletin 228,* p. 168.
32. PT, Vol. 15, Sept. 11, 1885, p. 521.
33. ROOT, p. 354.
34. References on Hale, Gouraud, and Bemis activities: *McClure's,* Vol. 8, Nov. 1896, p. 10; *Image,* Vol. 9, Mar. 1960, p. 18; *Image,* Vol. 5, June 1956, p. 140.
35. Reminiscence in an address to the National Photographic Association, June 1970, recorded over a year later in PP, Vol. 8, Oct. 1871, pp. 315–323.
36. Table is from ARASM, Vol. 1, Mar. 1840, p. 132; commentary also based on "Instruments for Measuring Exposure," by Eugene P. Wightman and Beaumont Newhall, *Image,* Vol. 6, Jan. 1957, pp. 13–17.
37. *Eureka,* Vol. 1, Oct. 1846, p. 24.
38. *Photographic News,* London, Vol. 7, Dec. 11, 1863; PP, Vol. 5, 1868, pp. 175–177.
39. *Eureka,* Vol. 1, Oct. 1846, pp. 24–25.
40. PP, Vol. 8, Oct. 1871, pp. 315–323.
41. Ibid.
42. *Eureka,* Vol. 1, Feb. 1847, p. 92.
43. *Eureka,* Vol. 1, Oct. 1846, p. 25.
44. ROOT, p. 354.
45. APB, Vol. 14, Oct. 1883, pp. 334–335.
46. *Eureka,* Vol. 1, Dec. 1846, p. 60.
47. Draper letter in AJP, Vol. 1, n.s., June 1, 1858, pp. 2–6; Johnson report in *Eureka,* Vol. 1, Dec. 1846, p. 60.
48. PP, Vol. 8, Oct. 1871, pp. 315–323.
49. AJP, Vol. 3, Oct. 1, 1860, p. 142; also see TAFT, p. 40.
50. *Journal of the Royal Society of Arts,* Vol. 30, Aug. 18, 1882, p. 932; copied from an earlier article by Dudley Armytage in *Field Naturalist.*
51. *New York Observer,* Aug. 25, 1840.
52. PAPS, Vol. 1, 1840, p. 171.
53. AJP, Vol. 4, n.s., Mar. 1, 1862, p. 434.
54. AJP, Vol. 1; n.s., June 15, 1861, p. 41.
55. AJS, Vol. XL, 1841, pp. 137–144.
56. *Eureka,* Vol. 1, 1846, p. 92.
57. *Literary Gazette,* London, Dec. 12, 1840, p. 803. Exhibit of Goddard daguerreotype portraits to the Royal Society is described in the *Photographic News,* London, Vol. 8, May 13, 1864, pp. 232–233.
58. *Eureka,* Vol. 1, Dec. 1846, p. 61.
59. *Eureka,* Vol. 1, Feb. 1847, p. 92.
60. AJP, Vol. 14, Aug. 1893, pp. 375–377.
61. PAS, Vol. 4, July 21, 1937, p. 23.
62. References: GERNSHEIM, pp. 131–154; PP, Vol. 5, 1868, pp. 175–177; *Polytechnic Journal,* London, Vol. 4, 1841, pp. 248–250.
63. New York *Tribune,* Oct. 5, 1841.
64. PT, Vol. 14, Mar. 1884, pp. 122–125.
65. APB, Vol. 5, Sept. 1874, p. 309.
66. References: AJP, Vol. 13, Aug. 1892, p. 357; New York *Tribune,* Oct. 12, 1841; APB, Vol. 16, Feb. 14, 1885, pp. 90–92.
67. PT, Vol. 14, Mar. 1884, pp. 122–123.
68. HJ, Vol. 4, May 1, 1852, pp. 28–29.
69. Undated clippings from nineteenth-century Canandaigua, New York, newspapers in possession of Timothy Beard of New York, a Finley heir.
70. References: *New York Tribune,* Aug. 9, 1841; SNELLING, pp. 82–84.
71. *American Annual of Photography,* Vol. 63, 1949, p. 43.
72. "Silver Plates on a Swampy Shore, the Daguerreian Artist in Chicago," by R. Bruce Duncan, GA, Vol. 3, July 1972, pp. 10–18.
73. RINEHART I, pp. 57–62.
74. References: AJS, Vol. 43, Apr.–June, 1843, pp. 73–74; DAB (Channing); HUNT I, pp. 66–67; *Harvard Graduates Magazine,* Vol. 3, Dec.

1894, pp. 195–197; Vol. 32, June 1924, pp. 589–597; *Popular Science Monthly*, Feb. 1877, p. 385.

75. STEPHENS I, introduction; STEPHENS II, p. 175.
76. STEPHENS II, p. 32.
77. *International Annual*, APB, Vol. 1, 1888, pp. 490–492. In HORAN, p. 9, the author states: "The years 1841–43 of [Mathew] Brady's life are shadowy."
78. AH, Vol. 12, June 1961, p. 103.
79. *Exploring with Fremont*, Private Diaries of Charles Preuss, etc., translated and edited by Edwin G. and Elizabeth K. Gudde, Norman, Okla., 1958.
80. PFAJ, Vol. 10, Nov. 1857, p. 376.
81. APB, Vol. 14, Oct. 1883, pp. 334–335.
82. References: PFAJ, Vol. 10, Nov. 1857, p. 376; SLCPP, Vol. 2–4, Feb. 1880, p. 44; WPM, Vol. 26, Jan. 5, 1889, pp. 26–28.
83. *Daily National Intelligencer*, Washington, D.C., Mar. 11, 1844.
84. References: GERNSHEIM, pp. 131–154; *Photographic News*, London, Aug. 8, 1879; *Manchester Guardian*, June 29, 1850, p. 1; *London Times*, Dec. 22, 1961; *Biographical Review, Biographical Sketches of Leading Citizens of York County, Me.*, Boston, 1896, pp. 78–79.
85. GERNSHEIM, pp. 131–154; obituary on Alexander Wolcott, AJP, Vol. 4, Apr. 15, 1862, pp. 525–526.
86. AJP, Vol. 3, Sept. 15, 1860, p. 122.
87. AJP, Vol. 4, Nov. 15, 1861, p. 286.
88. AJP, Vol. 4, Mar. 1, 1862, p. 437.
89. HULFISH, pp. 5–7.
90. "The Development of Optics During the Present Century," by George Lindsay Johnson, originally published in England and reprinted in APB, Vol. 29, July 1899, p. 214.
91. References: "Photographs in One Second," by Arthur T. Gill, FRPS, PJ, Nov. 1973, pp. 556–557; WM, Vol. 35, June 1898, p. 288; GERNSHEIM, p. 157.
92. References: BN, p. 50; APB, Vol. 20, Mar. 9, 1899, pp. 144–146.
93. APB, Vol. 5, Sept. 1874, pp. 309–310.
94. *Daily National Intelligencer*, June 23, 1843, p. 3.
95. All information on case manufacture is from "Preservation of Daguerreotypes," by Frank Fraprie, *American Annual of Photography*, Vol. 63, 1949, p. 197.
96. *Daily National Intelligencer*, Feb. 28, 1843.
97. *Documents of American History*, edited by Henry Steele Commager, N.Y., 1948, p. 302.
98. References: APB, Vol. 19, Sept. 22, 1888, p. 558; BN, p. 148; PAJ, Vol. 6, Sept. 1853, p. 148.
99. References: JAMMES, pp. 11–12; *Latent Image*, by Beaumont Newhall, pp. 120–122; *Living Age*, Vol. 2, 1844, p. 337.
100. References: HORAN, p. 9; WPM, p. 9; WPM, Vol. 30, May 1893, p. 235.
101. APB, Vol. 20, Mar. 9, 1889, pp. 144–146.
102. *United States Magazine and Democratic Review*, July–August 1845, editorial.
103. References: Interview with Brady in the New York *World*, Apr. 12, 1891, p. 23; HORAN, p. 10; WPM, Vol. 30, May 1893, p. 235.
104. References: *Philadelphia Public Ledger*, June 4, 1846, p. 2; GERNSHEIM, p. 119.
105. *McClure's*, Vol. 9, July 1897, p. 802; TAFT, p. 464; HJ, Vol. 1–4, April 15, 1852, pp. 12–13; Brady interview in New York *World*, April 12, 1891, p. 23.
106. References: ROOT, pp. 359 and 390; AJP, Vol. 13, Oct. 1892, pp. 410 and 451.
107. BEAR, pp. 138–140.
108. "Progress and Present State of the Daguerreotype Art," by Antoine Claudet, JFI, Vol. 10, third series, July 1845, pp. 45–51, and Aug. 1845, pp. 114–118.
109. Newspaper quotations are from the *United States Journal*, Washington, D.C., Jan. 29, 1846, p. 2; and the Washington *Daily Times*, Feb. 20, 1846, p. 2.
110. "John Plumbe, Jr., and the First Architectural Photographs of the Nation's Capitol," by Allan Fern and Milton Kaplan, *Quarterly Journal*, Library of Congress, Vol. 31, Jan. 1974, p. 4.
111. *Daily National Intelligencer*, Mar. 11, 1846.
112. BEAR, pp. 140–142.
113. References: *The Making of the Nation*, pp. 247–248; *The History of Surgical Anesthesia*, by Thomas E. Keys, N.Y., 1941; *The Centennial of Surgical Anesthesia*, by John F. Fulton and M. E. Stanton,

N.Y., 1946; handwriting on original backing of framed daguerreotype image from which the copy photograph used here was made.
114. References: *Correspondence of Thomas Carlyle and Ralph Waldo Emerson*, C. E. Norton, editor, Boston, J. R. Osgood & Co., 1883, pp. 103–109; PAGEANT, Vol. 11, p. 138.
115. *Quarterly Journal* (see ref. 110), p. 16.
116. References: GERNSHEIM, pp. 147–148; BN, p. 149; Carson (see note 29), p. 12.
117. References: "Early Photographers: Their Parlors and Galleries," by Jacob C. Vetter, *Chemung County Historical Journal*, June 1961; BN, p. 70.
118. *Living Age*, Vol. 9, June 20, 1846, pp. 551–552.
119. APB, Vol. 15, 1884, p. 62.
120. APB, Vol. 19, Sept. 22, 1888, p. 563.
121. *Early Ohio Taverns*, by Rhea Mansfield Knittle, privately printed, 1937, p. 42.
122. References: ROOT, p. 360; *Daily Enquirer*, Cincinnati, Oct. 6, 1852, p. 3.
123. GERNSHEIM, p. 200.
124. References: *Handbook of Inorganic Chemistry*, by William Gregory, N.Y., A. S. Barnes & Co., 1857, p. 59; *History of the Eclectic Medical Institute*, by Harvey Wicks Felter, M.D., Cincinnati, 1902, pp. 103–104.
125. DJ, Vol. 2, Sept. 1, 1851, p. 242.
126. References: ROOT, p. 404; BN, p. 52; APB, Vol. 20, Mar. 9, 1889, pp. 144–146.
127. All correspondence from AJP, Vol. 1, n.s., Sept. 1, 1858, pp. 99–100.
128. References: APB, Vol. 19, July 28, 1888, pp. 434–435; LOTHROP, p. 7; RINHART II, p. 197.
129. APB, Vol. 19, July 28, 1888, p. 434. The profile of the Anthony firm in chapter 1880 indicates that the business partnership between Edward Anthony and his brother, Henry, began "in a small way" as early as 1842, the same year Edward Anthony, J. M. Edwards, and Victor Piard began making daguerreotypes in a committee room of the United States Congress in Washington, D.C. (see page 35). Further corroboration of the 1842 date will be found in PFAJ, Vol. 10, Nov. 1857, p. 382, in which H. H. Snelling announces termination of his "arrangement" with Edward Anthony "with whom we have passed fifteen years of pleasantness and peace." Snelling served both as general manager of the Anthony supplies business and as founder and publisher of his own photographic magazine.
130. BN, p. 118.
131. APB, Vol. 15, 1884, p. 62.
132. PT, Vol. 29, Oct. 1897, p. 468.
133. RYDER, pp. 14–20.
134. *Henry Clay*, by Carl Shurz, American Statesmen Series, Boston & N.Y., Houghton, Mifflin & Co., 1899, Vol. II, p. 298.
135. ROOT, p. 154.
136. BN, p. 81. The last daguerreotype likeness of Clay reportedly taken from life by N. S. Bennett, of Washington, D.C., was lost with sixteen other daguerreotypes of American senators in the sinking of the steamer *Empire*, according to a news item in HJ, Vol. 5, Sept. 15, 1853, p. 175.
137. *The Legacy of Josiah Johnson Hawes, 19th Century Photographs of Boston*, edited by Rachel Johnston Homer, Barre, Mass., 1972, pp. 9–19.
138. *American Annual of Photography*, 1887, pp. 144–146.
139. BEAR, pp. 150–152.
140. References: PAJ, Vol. 2, Aug. 1851, pp. 94–95; *Philadelphia in the Romantic Age of Lithography*, by Nicholas Wainwright, Historical Society of Pennsylvania, Philadelphia, 1958, p. 73.
141. PAJ, Vol. 16, Sept. 1853, pp. 148–149.
142. GERNSHEIM, pp. 194–196.
143. "Memories of the Past," by S. L. Platt, PP, Vol. 17, Jan. 1880, pp. 23–24.
144. PT, Vol. 25, Nov. 2, 1894, p. 218; APB, Vol. 16, Apr. 11, 1885, pp. 247–249.
145. References: APB, Vol. 15, 1884, p. 64; ROLLE, p. 218.
146. APB, Vol. 19, July 28, 1888, p. 435.
147. SNELLING, p. 44–45.
148. SNELLING, p. 45.
149. ROLLE, p. 219.
150. SNELLING, p. 184.

151. TAFT, p. 80.
152. H. H. Snelling reminiscence in APB, Vol. 19, July 28, 1888, p. 435.
153. *The Cholera Years,* by Charles E. Rosenberg, Chicago, 1960, pp. 144–145; *Appleton's Encyclopedia of Biography* (Worth); DAB (Worth).
154. BN, p. 52.
155. "Cincinnati Panorama," by Cliff Krainik, GA, Vol. 3, Apr. 1974, pp. 7 and 12.
156. PAJ, Vol. 5, Feb. 1853, pp. 126–129.
157. *American Biography and Genealogy* (Taber biography, pp. 756–761).
158. PAJ, Vol. 5, Feb. 1853, pp. 126–129.
159. For a description of 131 of the photographs in Vance's 1851 catalog, see *Collectors' Guide to Nineteenth-Century Photographs,* by William Welling, N.Y., Macmillan, 1976, pp. 177–179.
160. TAFT, p. 489, Note 275.
161. References: BN, p. 162; HJ, Vol. 2, July 1, 1852, p. 115; ANDREWS, p. 59.
162. DJ, Vol. 1, Nov. 1, 1850, p. 54.
163. *The Art-Journal,* London, Apr. 1851, p. 106.
164. *Manchester Guardian,* June 29, 1850, p. 1.
165. WERGE, pp. 48–49.
166. GERNSHEIM, p. 263.
167. WERGE, pp. 45, 54, 58, 71 and 74.
168. References: *The Flowering of New England, 1815–1865,* by Van Wyck Brooks, N.Y., E. P. Dutton, 1st Mod. Lib. ed., 1941, p. 170; PAGEANT, Vol. 11, p. 160; APB, Vol. 26, Aug. 1895, p. 259.
169. References: APB, Vol. 20, Mar. 9, 1889, pp. 144–146; ROOT, p. 369; PT, Vol. 19, Mar. 15, 1889, pp. 130–131.
170. APB, Vol. 16, Feb. 14, 1885, pp. 90–92; AJP, Vol. 2, n.s., June 1, 1858, p. 10.
171. References: PAJ, Vol. 1, Dec. 1851, pp. 362–365; Vol. 2, Apr. 1851, pp. 122–123; Sept. 1851, pp. 169–171; Oct. 1851, pp. 245–249.
172. PAJ, Vol. 2, Sept. 1851, pp. 169–171.
173. PAJ, Vol. 2, Aug. 1851, pp. 122–123.
174. References: PAJ, Vol. 2. Nov. 1851, pp. 313–315; HJ, Vol. 3–4, Nov. 1, 1852, pp. 217–234; RINHART I, pp. 108–110. In HJ, Vol. 16, 1865, pp. 315–316, editor John Towler noted at the time of Hill's death that Hill "always affirmed to this writer that he *did* take pictures in their natural colors, but it was done by an *accidental* combination of chemicals which he could not, for the life of him, again produce!"
175. *Secrets of the Dark Chamber,* by D. D. T. Davie, N.Y., 1870.
176. References: DJ, Vol. 2, 1851, p. 19; TAFT, pp. 69–70; *Illustrated London News,* Vol. 18, 1851, p. 425.
177. References: DJ, Vol. 3–4, Dec. 1, 1851, p. 61; PAJ, Vol. 1, Feb. 1851, p. 95; "Phrenology's Golden Years," by Elizabeth Shafer, *American History Illustrated,* Vol. 8, Feb. 1974, pp. 36–43.
178. PAJ, Vol. 2, Oct. 1851, pp. 250–251.
179. PAJ, Vol. 4, Sept. 1852, p. 151.
180. HJ, Vol. 4, 1852, p. 73.
181. PAJ, Vol. 4, July 1852, p. 62; Nov. 1852, p. 317.
182. GERNSHEIM, p. 182.
183. References: HJ, Vol. 6, July 1, 1854, pp. 90–95; TOWLER, p. 171.
184. References: Lecture on Victor Prevost to the twenty-first annual convention of the Photographer's Association of America, Detroit, Aug. 6, 1901, delivered by W. I. Scandlin; GERNSHEIM, p. 179; HJ, Vol. 3, Dec. 15, 1851, pp. 84–85; Vol. 1, Mar. 1, 1851, p. 243; profile on Brinckerhoff, APB, Vol. 12, July 1881, p. 224; "A Special Privilege," by R. Bruce Duncan, GA, Vol. 2, April 1972, p. 5.
185. TAFT, p. 263.
186. References: ROOT, p. 372; PP, Vol. 5, Aug. 1868, pp. 288–289.
187. WERGE, pp. 52–53.
188. References pertaining to Hawkins: *Daily Enquirer,* Cincinnati, Oct. 6, 1852, p. 3; HJ, Vol. 4, Jan. 1, 1853, p. 282; PFAJ, Vol. 7, Mar. 1854, p. 105; Vol. 10, Nov. 1857, p. 377.
189. HJ, Vol. 4, May 15, 1852, p. 44. Also see *Lights and Shadows of New York Life,* by James D. McCabe, Jr., N.Y., Farrar, Straus and Giroux, 1970 facsimile edition of the National Publishing Company 1872 edition, p. 700, for drawing of Chatham Square in which a building with a sign, "I. Lewis, Daguerreotypes, Ambrotypes," appears in roughly the same position as the daguerreotype establishment pictured in the Chatham Square illustration on page 62 of this book.

190. PAJ, Vol. 5, Feb. 1853, pp. 112–113; DAB (Dewey).
191. HJ, Vol. 3–4, Dec. 1, 1852, p. 255.
192. PFAJ, Vol. 8, Oct. 1855, p. 319.
193. Scandlin lecture on Prevost (referenced in note 184).
194. APB, Vol. 12, July 1881, p. 224.
195. HJ, Vol. 4, May 1, 1852, p. 28.
196. PAJ, Vol. 5, Mar. 1853, pp. 182–183.
197. "Silver Plates on a Swampy Shore," by R. Bruce Duncan, GA, Vol. 3, July 1972, p. 15.
198. HUNT II, p. 257.
199. HJ, Vol. 3, Dec. 1, 1852, p. 151.
200. HJ, Vol. 3–4, Apr. 15, 1852, pp. 12–13.
201. PAJ, Vol. 3, Apr. 1852, pp. 253–255.
202. References: HJ, Vol. 5, Apr. 15, 1853, pp. 9–10; Oct. 1, 1853, p. 90.
203. PAJ, Vol. 5, Apr. 1853, pp. 254–255.
204. Ehrmann lecture on Whipple process delivered at a meeting of the Photographic Section of the American Institute on April 7, 1885, and recorded in APB, Vol. 16, Apr. 11, 1885, pp. 247–249.
205. References: HJ, Vol. 4, May 15, 1852, p. 47; Vol. 5, Oct. 15, 1853, pp. 202 and 206; PAJ, Vol. 6, July 1853, p. 67.
206. HJ, Vol. 6, Apr. 15, 1854, p. 15; APB, Vol. 16, Apr. 11, 1885, pp. 247–249.
207. PT, Vol. 25, Nov. 2, 1894, pp. 281–283.
208. PAJ, Vol. 6, Dec. 1853, pp. 381–382.
209. WERGE, pp. 52–53.
210. New York *Tribune,* quoted in PAJ, Vol. 5, June 1853, pp. 334–341.
211. *Philadelphia Public Ledger,* May 28, 1855.
212. APB, Vol. 15, 1884, pp. 63–64. Other references: PAJ, Vol. 6, Aug. 1853, p. 127; Nov. 1853, p. 260; and Dec. 1853, pp. 381–382.
213. PAJ, Vol. 5, Mar. 1853, pp. 183–184.
214. PAJ, Vol. 6, July 1853, p. 63.
215. References: PAJ, Vol. 4, Oct. 1852, p. 254; AJP, Vol. 3, Feb. 15, 1861, p. 288.
216. PAJ, Vol. 5, Jan. 1853, p. 63.
217. PFAJ, Vol. 7, 1854, p. 320.
218. APB, Vol. 20, Mar. 9, 1889, pp. 144–146.
219. GERNSHEIM, pp. 254–255.
220. GERNSHEIM, pp. 255–256 and 260.
221. References: HJ, Vol. 6, Aug. 15, 1854, p. 137; Sept. 1, 1854, pp. 163–164; PFAJ, Vol. 8, Feb. 1855, p. 63.
222. References: HJ, Vol. 7, June 1, 1855, pp. 44–45; PAJ, Vol. 4, Aug. 1852, pp. 106–113.
223. HJ, Vol. 5, Feb. 15, 1854, p. 322.
224. "C.E.F." in London Notes and Queries column, HJ, Vol. 6, April 15, 1854, p. 1.
225. HJ, Vol. 7, June 1, 1855, pp. 44–45.
226. PP, Vol. 8, Oct. 1871, p. 337.
227. References: HARRISON, pp. 82–83; BROTHERS, p. 173; WERGE, p. 203.
228. PAJ, Vol. 6, Dec. 1853, pp. 377–378.
229. HJ, Vol. 6, Dec. 1, 1854, p. 249; PFAJ, Vol. 8, Feb. 1855, p. 48.
230. HJ, Vol. 6, Sept. 15, 1854, pp. 169–170.
231. HJ, Vol. 7, May 1, 1855, pp. 9–11.
232. ROOT, p. 373.
233. PFAJ, Vol. 8, Aug. 1855, p. 255.
234. PFAJ, Vol. 8, Dec. 1855, p. 384.
235. PFAJ, Vol. 8, Aug. 1855, p. 246.
236. PT, Vol. 25, Nov. 2, 1892, pp. 281–283.
237. The nineteenth-century photographs and information on this page have been provided courtesy of Mrs. Roy Douglass, a descendant of Simon van Duyne and present owner of the van Duyne homestead.
238. In 1860, Southworth assigned the rights to his invention to Simon Wing, of Waterville, Me. (see page 149), and another photographer. During the 1860s, Wing brought suit against photographers using the moveable plate idea in their own cameras without paying him a fee. One suit against E. & H. T. Anthony & Co. was carried all the way to the U.S. Supreme Court, and in this case. *Wing* v. *Anthony* (106 U.S. 142, October, 1882), Justice William Woods ruled in favor of the fraternity, declaring that moveable plates had been used prior to the Southworth "invention." Southworth's description of his invention, quoted here, is from the court decision, p. 143. Tabulation of daguerreotypes taken in Massachusetts in 1854 is from BN, p. 34.

239. References: PFAJ, Vol. 8, Dec. 1855, p. 384; HJ, Vol. 6, Feb. 1, 1855, p. 326.

240. References: PFAJ, Vol. 9, June 1856, p. 192; *Public Ledger,* Phila., Mar. 7, 1856, p. 1; PFAJ, Vol. 7, Apr. 1854, p. 127; *Ballou's,* Vol. 1, Mar. 1855, p. 293.

241. MORRIS, pp. 74–75.

242. HJ, Vol. 8, 1856, pp. 41–44, 52, 120.

243. "The Invention of the Tintype," by Thomas B. Greenslade, Jr., Kenyon College *Alumni Bulletin,* July–September, 1971, pp. 22–23.

244. HEATH, pp. 103–105.

245. HJ, Vol. 7, Feb. 15, 1856, p. 325.

246. "Gold Rush Photography," by R. Bruce Duncan, GA, Vol. 2, Oct. 1971, pp. 14–19.

247. References: *Daily Pennsylvanian,* Phila., April 11 and 12, 1856; *Memoirs of John C. Frémont,* Chicago and New York, 1887, pp. xv–xviii.

248. References: "Ambrotype, A Short and Unsuccessful Career," *Image,* Vol. 7, Oct. 1958, p. 177; PFAJ, Vol. 10, Feb. 1857, p. 56.

249. References: AJP, Vol. 3, Feb. 15, 1861, p. 284; HJ, Vol. 10, Feb. 15, 1859, p. 308.

250. HARRISON, p. 41.

251. Quoted in PAJ, Vol. 6, July 1853, p. 30.

252. HJ, Vol. 7, Jan. 1, 1856, pp. 274–276.

253. HJ, Vol. 8, Dec. 1, 1856, pp. 225–226.

254. References: *Photographic News,* Vol. 3–4, Feb. 10, 1860, pp. 269–270; speech by Antoine Claudet before the British Association, recorded in AJP, Vol. 3, Aug. 15, 1860, pp. 81–83; HJ, Vol. 17, Oct. 1, 1865, p. 176; TISSANDIER, pp. 148–151; GERNSHEIM, pp. 312–313.

255. Letter from Charles Meade to H. H. Snelling, PFAJ, Vol. 8, 1855, p. 253.

256. AJP, Vol. 1, Aug. 15, 1858, pp. 85–87; Sept. 1, 1858, pp. 107–108.

257. PFAJ, Vol. 12, June 1859, p. 30. Also see *Photographic Notes,* Vol. 4, Nov. 1, 1859, p. 261.

258. Report of Royal Society committee is recorded in AJP, Vol. 2, Apr. 1, 1860, pp. 322–330.

259. WALDACK, Introduction.

260. PT, Vol. 14, Mar. 1884, pp. 122–125. Also see APB, Vol. 6, Apr. 1875, pp. 97–100 (re: Frith "dexterity"); WPM, Vol. 29, Dec. 3, 1892, pp. 690–692 (re: Landy large photographs); PFAJ, Vol. 10, 1857, p. viii (re: Snelling offer).

261. References: PFAJ, Vol. 10, Apr. 1857, p. 121; Nov. 1857, p. 351.

262. AJP, Vol. 1, Aug. 1, 1858, p. 82.

263. *London Times,* Jan. 1, 1858.

264. AJP, Vol. 1, Sept. 15, 1858, p. 130.

265. References: BURGESS, pp. 76–79; PFAJ, Vol. 11, Dec. 1858, pp. 383–384.

266. COALE, pp. 12–14; 52.

267. PFAJ, Vol. 10, Jan. 1857, pp. 27–28.

268. WERGE, p. 203; Musgrave statement is from AJP, Vol. 8, Jan. 1, 1866, pp. 304–309.

269. AJP, Vol. 1, Dec. 15, 1858, pp. 223–225.

270. HJ, Vol. 10, Dec. 15, 1859, p. 241.

271. *Baltimore, A Picture History 1858–1958,* The Maryland Historical Society, 1957, pp. 26–30.

272. PFAJ, Vol. 11, Mar. 1858, p. 93.

273. *New York Times,* Jan. 21, 1859.

274. AJP, Vol. 1, July 1, 1858, p. 35.

275. WAINWRIGHT, p. 73; DAB (Cutting).

276. AJP, Vol. 2, June 1, 1858, pp. 10–13.

277. AJP, Vol. 1, Mar. 1, 1859, pp. 301–303; PFAJ, Vol. 12, June 1859, pp. 19–21.

278. AJP, Vol. 2, Oct. 15, 1859, pp. 148–149.

279. References: GERNSHEIM, p. 344; ROOT, pp. 303–305; Wenderoth letter in PFAJ, Vol. 12, June 1859, p. 6; "Grecian" mode is from AJP, Vol. 7, Apr. 15, 1865, pp. 476–477.

280. HJ, Vol. 11, Aug. 15, 1859, p. 113.

281. PFAJ, Vol. 12, June 1859, pp. 20–21.

282. References: *Kansas Historical Quarterly,* Vol. 24, Spring 1958, pp. 1–3; *Lives of the Painters,* by John Canaday, N.Y., W. W. Norton, 1969, Vol. 3, pp. 1059–1062; *The Crayon,* Sept. 1859, p. 337. Also see a series of four articles on Bierstadt's western photography by Howard E. Bendix in *Photographica,* Oct., Nov., Dec. 1974, and Jan. 1975.

283. *Photographic Notes,* London, Oct. 1859, pp. 239–240.

284. BURGESS, p. 19.

285. TAFT, p. 141.

286. References: AJP, Vol. 1, Mar. 1, 1859, pp. 298–301; PFAJ, Vol. 12, June 1859, p. 31; AJP, Vol. 2, Mar. 1, 1860, pp. 289–292; PP, Vol. 5, Aug. 1868, p. 290.

287. Burgess statement quoted in PFAJ, Vol. 10, Sept. 1857, p. 282; historical data derived from *The History of Baltimore City and County,* by J. T. Sharf, Philadelphia, 1881, pp. 662–664; *Baltimore, A Picture History 1858–1958,* p. 7.

288. "Brady Didn't Take Them All," *Post-Standard Sunday Magazine,* Syracuse, June 2, 1963, pp. 3–7.

289. AJP, Vol. 8, Jan. 1, 1866, pp. 304–309; discussion at Oct. 11, 1860, American Photographical Society meeting is from PFAJ, Vol. 1, May 1860, pp. 144–145, and AJP, Vol. 2, Dec. 1, 1859, pp. 207–208.

290. AJP, Vol. 4, July 1, 1861, pp. 85–86.

291. HJ, Vol. 14, Aug. 15, 1862, pp. 78–79.

292. HJ, Vol. 19, Mar. 15, 1868, p. 346.

293. References: HJ, Vol. 18, Feb. 1, 1867, p. 302; AJP, Vol. 3, Feb. 1, 1861, p. 272; Vol. 4, Jan. 1, 1862, p. 360.

294. HJ, Vol. 12, Mar. 1, 1861, p. 9; "Alexander Gardner," by Josephine Cobb, *Image,* Vol. 7, June 1958, p. 130.

295. AJP, Vol. 4, July 1, 1861, p. 67.

296. References: LUBSCHEZ, pp. 24–29; "Coleman Sellers," by Charles Coleman Sellers, *Image,* Vol. 7, Dec. 1958, pp. 233–235.

297. APB, Vol. 19, May 26, 1888, pp. 302–303; June 9, 1888, pp. 338–341.

298. AJP, Vol. 3, Feb. 1, 1861, pp. 268–269.

299. See NAEF, p. 95, plate 5.

300. References: DAB (Snelling); AJP, Vol. 3, Dec. 1, 1860, pp. 207–208; PFAJ, Vol. 1, n.s., June 1860, pp. 179–180; "Plagiarism in the 'First' American Book about Photography," by R. S. Kahan and L. J. Schaaf, with R. L. Flukinger, *Papers of the Bibliographical Society of America,* Vol. 67, 1973, pp. 283–304.

301. Discussion at Jan. 14, 1861, meeting of the American Photographical Society, recorded in AJP, Vol. 3, Feb. 1, 1861, pp. 268–269; also Seely remarks in AJP, Vol. 4, Sept. 1, 1861, pp. 165–167.

302. AJP, Vol. 4, Sept. 15, 1861, pp. 181–184.

303. HJ, Vol. 12, May 1, 1860, p. 1; May 15, p. 19; Nov. 15, p. 212.

304. HJ, Vol. 15, June 1, 1863, p. 47.

305. AJP, Vol. 4, Feb. 15, 1862, pp. 421–422.

306. HJ, Vol. 15, July 15, 1863, p. 96.

307. Brady interview in New York *World,* Apr. 12, 1891; HORAN, pp. 35–59; *Civil War Photographs 1861–1865,* a catalog of numbered Brady photographs available from the Library of Congress, compiled by Hirst D. Milhollen and Donald H. Mugridge, Washington, 1961, introduction, pp. v–x.

308. References: *Atlantic Monthly,* Vol. 12, 1863, p. 1; TAFT, pp. 144–147.

309. AJP, Vol. 4, Jan. 15, 1862, pp. 379–380.

310. APB, Vol. 20, Mar. 9, 1889, pp. 147–149.

311. AJP, Vol. 5, Dec. 15, 1862, p. 285.

312. AJP, Vol. 3, Apr. 15, 1861, pp. 337–338.

313. References: Newton profile in APB, Vol. 16, Feb. 14, 1885, pp. 65–68; obituary in PT, Vol. 28, Feb. 1896, pp. 104–105; *Great Industries of the United States,* J. B. Burr & Hyde, Hartford, Chicago, and Cincinnati, 1873, pp. 317–331.

314. HJ, Vol. 15, Aug. 15, 1862, p. 80. Other accounts recorded in AJP, Vol. 4, July 1, 1861, pp. 60–61; Vol. 5, July 1, 1862, p. 23.

315. *American Heritage History of the Civil War,* R. M. Ketchum, editor-in-charge, N.Y., 1960, pp. 418–423.

316. PJA, Vol. 53, Jan. 1916, pp. 19–20.

317. *Eye to Eye,* Dec. 1953, pp. 9–12. Bachrach family records were provided courtesy of Bradford Bachrach, grandson of David Bachrach, Jr.

318. References: HJ, Vol. 15, June 15, 1863, p. 49; Sept. 1, 1863, pp. 129–130.

319. HJ, Vol. 15, Sept. 1, 1863, p. 129.

320. HJ, Vol. 14, Oct. 15, 1862, p. 141 (reprinted from *Macmillan's Magazine*). Other references on tannin plate users: AJP, Vol. 5, Nov. 1, 1862, p. 199; APB, Vol. 17, Oct. 23, 1886, p. 619.

321. AJS, Vol. 35, 2nd Series, May 1863, p. 324.

322. PJA, Vol. 53, Jan. 1916, p. 18. Records pertaining to Robert Vinton Lansdale provided courtesy of Robert Lansdale of Baltimore, Md., a grandson.

323. References pertaining to Harrison and his *Globe* lens: AJP, Vol. 5, Apr. 15, 1863, pp. 453–459; WERGE, p. 78; ROOT, p. 375; APB, Vol. 19, 1888, p. 435; HJ, Vol. 16, Dec. 15, 1864, p. 256.

324. GERNSHEIM, pp. 323–327.

325. PP, Vol. 2, June 1865, pp. 97–99.

326. AJP, Vol. 5, Apr. 1, 1863, pp. 451–452. Remarks by Seely are recorded in AJP, Vol. 5, Jan. 1, 1863, pp. 329–330.

327. HJ, Vol. 16, July 15, 1864, p. 95; EDER, p. 144; AJP, Vol. 4, June 15, 1861.

328. AJP, Vol. 6, Sept. 15, 1863, p. 143.

329. HJ, Vol. 16, July 15, 1864, pp. 93–94.

330. AJP, Vol. 6, Oct. 15, 1863, pp. 190–191.

331. *American Artisan,* Vol. 1, Nov. 9, 1864, p. 215. Description of Whipple, Black, and other Boston operations is from AJP, Vol. 6, June 15, 1864, pp. 321–323.

332. PP, Vol. 3, Mar. 1867, pp. 82–83; TAFT, p. 342; MORRIS, p. 167.

333. HJ, Vol. 16, Dec. 1, 1864, pp. 225–229.

334. BACHRACH, Memoirs. Reference to Brady and Gardner use of the solar camera will be found in COBB, p. 13.

335. References: Minutes of the American Photographical Society recorded in AJP, Vol. 6, Feb. 15, 1864, p. 379; Vol. 7, July 1, 1864, pp. 14–15; Newton reminiscence published in APB, Vol. 16, Apr. 11, 1885, pp. 250–257.

336. ROOT, introductions by the author, pp. xiii–xviii, and by Beaumont Newhall in 1971 edition, pp. 5–9; Muckle letter provided courtesy of Mrs. Joseph Carson of Philadelphia.

337. HJ, Vol. 17, May 15, 1865, pp. 29–30.

338. SANDBURG, p. 602.

339. GERNSHEIM, pp. 427–428; minutes of the Nov. 14, 1864, meeting of the American Photographical Society, recorded in AJP, Vol. 7, Dec. 15, 1864, p. 277.

340. PP, Vol. 2, Dec. 1865, pp. 189–190.

341. References: APB, Vol. 26, April 1, 1895, pp. 136–138; WPM, Vol. 32, March 1895, pp. 132–133; International Annual of APB, Vol. 9, 1897, pp. 201–204.

342. AJP, Vol. 6, Jan. 1, 1864, pp. 304–305.

343. "Alexander Gardner," by Josephine Cobb, *Image,* Vol. 7, June 1958, pp. 124–136.

344. *American Artisan,* Vol. 1, Feb. 1, 1865, p. 308.

345. HJ, Vol. 17, Dec. 15, 1865, pp. 246–248.

346. References: HJ, Vol. 17, Nov. 15, 1865, pp. 218–219; Dec. 1, 1865, pp. 235–237; Dec. 15, 1865, pp. 248–253; Jan. 1, 1866, pp. 265–266.

347. HJ, Vol. 18, May 15, 1866; DARRAH, pp. 41–42.

348. *Charles Sumner,* by Moorfield Storey, American Statesmen Series, Boston, Houghton, Mifflin & Co., 1900, p. 322.

349. *Alta California,* Feb. 17, 1868. Other references for previous pages: TAFT, pp. 277–283; *Education of Henry Adams,* by Henry Adams, N.Y., Modern Library Edition, 1931, p. 312.

350. PJA, Vol. 53, Feb. 1916, p. 71.

351. PP, Vol. 3, 1866, pp. 311–313; 357.

352. Ibid.

353. PP, Vol. 3, Jan. 1866, p. 32.

354. PP, Vol. 3, Feb. 1866.

355. HJ, Vol. 14, Sept. 15, 1863, p. 111; Vol. 15, Sept. 1, 1863, p. 129.

356. PP, Vol. 3, July 1866, pp. 217–218; HARRISON, pp. 94–95.

357. References: PP, Vol. 2, Dec. 1865; Vol. 3, May 1866.

358. References: HJ, Vol. 17, Mar. 1, 1866, p. 324; Vol. 18, June 15, 1866, pp. 58–59.

359. HARRISON, p. 100.

360. GERNSHEIM, p. 340.

361. PP, Vol. 3, Mar. 1867, pp. 81–82; report of an American correspondent in the *Photographic News,* London, Vol. 21, Dec. 7, 1877, pp. 579–580.

362. AJP, Vol. 7, Apr. 1, 1866, pp. 436–438.

363. PT, Vol. 28, Mar. 1896, pp. 125–126; also records of early meetings of the American Photographical Society and other articles referenced, or quoted in previous pages of this book.

364. PP, Vol. 5, Apr. 1866.

365. New York *World* article quoted in HJ, Vol. 17, Jan. 1, 1868, pp. 259–260.

366. HJ, Vol. 19, Aug. 15, 1867, pp. 113–117.

367. Paper by F. A. Wenderoth delivered at a meeting of the Philadelphia Photographic Society, June 5, 1867, and reprinted in PP, Vol. 4, July

368. AJP, Vol. 4, May 1883, pp. 1–2.

369. *Lights and Shadows of New York Life,* op. cit., pp. 193 and 674.

370. HJ, Vol. 19, Apr. 1, 1868, pp. 358–361.

371. PP, Vol. 5, 1868, p. 281.

372. PP, Vol. 5, 1868, pp. 300–301.

373. All descriptions of the proceedings of the photographers' convention, depositions, etc., which are contained on pages 195–198 of the text are from PP, Vol. 5, 1868, pp. 135–150; 281–293; 300–301; 308–312.

374. References: "Color Photography," by R. James Walker, PM, Vol. 4, Apr. 1902, pp. 57–87; *Colour Photography,* by Eric de Maré, Penguin Books, 1973, pp. 41–42; *Color Photography,* by Robert M. Fanstone, London, 1935, p. 7.

375. WPM, Vol. 38, Apr. 1901, pp. 134–136; TAFT, pp. 324–331; PP, Vol. 5, 1868, p. 388.

376. BACHRACH, Memoirs.

377. NAEF, pp. 38, 70, 73.

378. A copy of the McClees and Beck book was displayed at an exhibition of photographically illustrated books held at the Grolier Club, New York, December 1974 through February 1975.

379. References on photomechanical printing: GERNSHEIM, pp. 547–549; meetings of the Philadelphia Photographic Society recorded in PP, Vol. 6, Dec. 1869, p. 444, and Vol. 7, Jan. 1870, p. 18; "Photomechanical Printing," by Edward Bierstadt, APB, Vol. 6, May 1875, pp. 129–136; paper on the Albertype by Prof. John Towler, PP, Vol. 9, June 1872, pp. 204–205.

380. PP, Vol. 16, Mar. 1879, p. 70.

381. COULSON, pp. 7–9.

382. JFI, Vol. 145, Apr. 1898, pp. 310–311. Also see MCCOSKER, pp. 406–408. Heyl statement indicating that the image wheel of *Phasmatrope* contained 18 picture spaces probably results from an error in memory, since the device at the Franklin Institute contains only 16 such spaces.

383. References: "The Woodburytype," by J. S. Mertle, *Image,* Vol. 6, Sept. 1957, pp. 165–170; PP Vol. 8, 1871, and Vol. 10, July 1873, pp. 241–244; TAFT, 431–432.

384. Heyl papers in the Franklin Institute Library.

385. Ibid. (undated newspaper clipping, "Current Topics of Town")

386. PP, Vol. 7, July 1870, pp. 225–235.

387. WPM, Vol. 29, Sept. 3, 1892, pp. 513–516.

388. PP, Vol. 7, Aug. 1870, pp. 299–300.

389. APB, Vol. 1, June 1870, pp. 77–78.

390. PP, Vol. 7, Sept. 1870, pp. 325–326.

391. PP, Vol. 7, Mar. 1870, p. 95.

392. PP, Vol. 8, Oct. 1871, p. 320.

393. APB, Vol. 3, Feb. 1872, pp. 462–465.

394. APB, Vol. 2, 1871, pp. 268–269.

395. PT, Vol. 21, Dec. 11, 1891, pp. 615–617. Also BJP, Sept. 8, 1871, quoted in GERNSHEIM, p. 238; and Maddox letter to W. Jerome Harrison, quoted in PT, Vol. 21, Dec. 4, 1891, pp. 603–604.

396. APB, Vol. 1, Feb. 1870, p. 15.

397. PP, Vol. 8, report on N.P.A. meeting June 8, 1871.

398. San Francisco *Daily Call,* May 28, 1871.

399. APB, Vol. 2, Nov. 1871, p. 370.

400. TAFT, p. 288.

401. APB, Vol. 2, June 1871, pp. 185–186.

402. APB, Vol. 23, Mar. 26, 1892, pp. 187–189.

403. PT, Vol. 1, Nov. 1871, pp. 160–161.

404. *Biographical Review,* containing sketches of leading citizens of York County, Maine, Boston, 1896, pp. 78–79.

405. NAEF, pp. 125–136.

406. MUYBRIDGE, pp. 39–45.

407. APB, Vol. 3, Nov. 1872, pp. 746–747.

408. References: HULFISH, pp. 8–9; TAYLOR, pp. 67–68; PT, Vol. 2, May 1872, p. 67, and Vol. 3, Mar. 1873, p. 35; PP, Vol. 2, Sept. 1872, p. 136.

409. References: PP, Vol. 9, June 1872, pp. 204–205, and Vol. 10, May 1873, p. 158.

410. *Presbyterian* article quoted in APB, Vol. 7, June 1876, pp. 186–187. See also NAEF, pp. 219–226.

411. References: Description of heliotype process in PP, Vol. 10, Aug. 1873, pp. 253–254; "Photomechanical Printing," by Edward Bierstadt, APB, Vol. 6, May 1875, pp. 129–136.

412. APB, Vol. 3, Sept. 1872, pp. 654–655.
413. Op. cit. (Note 407)
414. DARRAH, pp. 10, 51, 91–95, and 151.
415. G.I.U.S., pp. 880–881.
416. PT, Vol. 3, Feb. 1873, pp. 23–24. See also PP, Vol. 8, Aug. 1871, p. 275.
417. COBB, pp. 36–38; HORAN, p. 83.
418. PT, Vol. 3, Apr. 1873, pp. 52–54. See also Vol. 3, June 1873, p. 84, and WPM, Vol. 36, Mar. 1899, pp. 97–100.
419. PT, Vol. 3, Jan. 1873, pp. 4–5.
420. APB, Vol. 4, July 1873, p. 207.
421. PT, Vol. 4, Nov. 1874, pp. 171–172.
422. AJP, Vol. 5, Feb. 15, 1863, pp. 379–380.
423. Advertisement on back of an A. E. Alden card stereograph. See also *Holyoke Daily Transcript & Telegram,* July 17, 1937; "The Day Water Thundered Down Mill River," by Alice H. Manning (copy provided for this history, courtesy of Ms. Manning).
424. References: "Orthochromatic Photography," by George Cramer, APB, Vol. 21, Oct. 11, 1890, pp. 590–591; BROTHERS, pp. 126–133 (includes Vogel remarks); APB, Vol. 5, Feb. 1874, pp. 91–92 (includes Chapman remarks).
425. Quotation from *The Nation* in PT, Vol. 4, July 1874, p. 101.
426. PP, Vol. 12, 1875, p. 54. Also see Vol. 6, 1869, p. 133, and Vol. 10, 1873, p. 63.
427. *Smithsonian Studies in History & Technology,* No. 32, Smithsonian Institution, 1975, p. 13.
428. "Great American Industries, VI—A Printed Book," by R. W. Bowker, *Harper's,* Vol. 75, July 1887, pp. 165–188.
429. For a discussion of photomechanical printing see PP, Vol. 10, July 1873, pp. 241–244; APB, Vol. 6, May 1875, pp. 130–136.
430. APB, Vol. 5, Apr. 1874, p. 134; June 1874, p. 216.
431. PRL, Vol. 1, July 1878, p. 69.
432. PP, Vol. 9, Jan. 1872, pp. 11–12. Also see DAB (Louis Levy and Max Levy); BACHRACH, Memoirs; APB, Vol. 6, Apr. 1875, pp. 117–118.
433. APB, Vol. 6, May 1875, pp. 150–152.
434. "The Magic Lantern," by Louis Walton Sipley, PAS, Vol. 4, No. 1, 1939, pp. 39–43, 88–90.
435. PP, Vol. 12, 1875, p. 2.
436. PRL, Vol. 1, Jan. 1878, pp. 13–14.
437. PP, Vol. 8, Dec. 1871, pp. 385–386.
438. APB, Vol. 7, Nov. 1876, pp. 351–352.
439. APB, Vol. 7, June 1876, pp. 186–187.
440. APB, Vol. 7, July 1876, p. 246.
441. APB, Vol. 7, June 1876, p. 189.
442. BJP article quoted in APB, Vol. 6, July 1875, p. 213. Ref. to Roche exhibit will be found in APB, Vol. 5, Dec. 1874, p. 411.
443. APB, Vol. 6, Aug. 1875, p. 234.
444. APB, Vol. 7, Feb. 1876, p. 57. Russell remarks will be found in APB, Vol. 6, Dec. 1875, p. 370. Also see APB, Vol. 7, Apr. 1876, pp. 125–126; PT, Vol. 6, July 1876, pp. 145–148.
445. PT, Vol. 6, July 1876, p. 146.
446. PP, Vol. 16, Mar. 1879, p. 69. Other references on Lambertype will be found in APB, Vol. 7, 1876, pp. 282, 307, 348, and 369–373; SLCPP, Vol. 2, Nov. 1878, pp. 367–369.
447. APB, Vol. 9, Jan. 1878, pp. 28–29; Feb. 1878, pp. 60–61.
448. APB, Vol. 8, Jan. 1877, pp. 20–21.
449. Ibid.
450. References: Information on back side of S. L. Albee series of card stereographs covering the railroad labor strike (these card stereographs are today extremely rare); *Harper's Weekly,* Aug. 11, 1877; *The American Republic,* by Richard Hofstadter, William Miller, and David Aaron, Prentice-Hall, 1959, Vol. 2, pp. 207–210.
451. SLCPP, Vol. 4, Feb. 1880, p. 67; APB, Vol. 8, Mar. 1877, p. 96.
452. PT, Vol. 14, Mar. 1877, pp. 65–66.
453. *Photographic News* (British weekly), Vol. 21, Mar. 9, 1877, p. 116.
454. *Photographic News,* Vol. 21, Dec. 7, 1877, pp. 579–580.
455. APB, Vol. 8, Jan. 1877, p. 60.
456. SLCPP, Vol. 2, Nov. 1878, p. 362.
457. Op. cit. (Note 454)
458. *Man & Builder,* June 1877, p. 124.
459. PP, Vol. 16, Jan. 1879, pp. 24–25.
460. GERNSHEIM, p. 340.
461. APB, Vol. 4, Jan. 1873, p. 2.

462. PT, Vol. 7, Mar. 1877, pp. 50–51.
463. References: correspondence between Mrs. Joseph Carson of Philadelphia and various university officials in 1939 and 1943. Author is indebted to Mrs. Carson for making this correspondence available. See also PT, Vol. 8, Feb. 1878, pp. 34–35; and Vol. 9, Apr. 1879, p. 91.
464. MUYBRIDGE, p. 124; see also p. 69.
465. PRL, Vol. 1, Oct. 1878, pp. 100–101.
466. MUYBRIDGE, p. 25; see also p. 71.
467. Heyl remarks will be found in JFI, Vol. 145, Apr. 1898; see also COULSON, p. 11.
468. PT, Vol. 9, July 1879, p. 165. Earlier Anthony advertising will be found in APB, Vol. 8, Oct. 1877, p. 316.
469. Report on Newton's emulsion will be found in APB, Vol. 7, Apr. 1876, p. 124; *Defiance* dry plates were advertised in APB, Vol. 11, 1880, p. 150.
470. PRL, Vol. 2, Apr. 1879, pp. 38–39.
471. PP, Vol. 16, 1879, p. 216.
472. PT, Vol. 9, Apr. 1879, pp. 88–90.
473. PP, Vol. 16, 1879, p. 177.
474. References: "Alfred Clements and His Work," PT, Vol. 27, Oct. 1895, pp. 216–220; AJP, Vol. 13, Mar. 1892, pp. 97–98.
475. SLCPP, Vol. 3, Nov. 1879, pp. 833–835.
476. APB, Vol. 10, June 1879, p. 181.
477. "Bierstadt's Artotype Atelier," PT, Vol. 13, May 1883, pp. 195–198; DAB (Tappen).
478. APB, Vol. 9, Feb. 1878, pp. 40–41; PP, Vol. 16, Apr. 1879, p. 126.
479. APB, Vol. 10, Mar. 1879, p. 85; PP, Vol. 16, Jan. 1879, pp. 17–18.
480. APB, Vol. 9, Dec. 1878, p. 379.
481. APB, Vol. 10, Mar. 1879, pp. 90–93.
482. PP, Vol. 16, 1879, pp. 130–133.
483. PP, Vol. 16, Mar. 1879, p. 69; BACHRACH, Memoirs.
484. PP, Vol. 16, Jan. 1879, p. 8.
485. PP, Vol. 16, 1879, pp. 42–43.
486. APB, Vol. 11, Apr. 1880, p. 125.
487. SLCPP, Vol. 2–4, Feb. 1880, pp. 44–45.
488. References: Illustrations together with descriptive material provided courtesy of the Pennsylvania Historical and Museums Commission. See also DAB (Moss).
489. For a review of Stephen Horgan's career and work, see *Inland Printer,* March and April, 1924.
490. Article on Moss Engraving Company, APB, Vol. 15, 1884, pp. 192–195; PP, Vol. 24, Apr. 16, 1887, p. 254; obituary on Moss in WPM, Vol. 29, May 7, 1892.
491. PT, Vol. 10, Nov. 1880, pp. 248–249.
492. TAFT, pp. 378–382; PP, Vol. 16, Nov. 1879, p. 336; Vol. 17, Jan. 1880, pp. 8–9.
493. WPM, Vol. 29, May 7, 1892; APB, Vol. 8, Jan. 1877, p. 21.
494. PT, Vol. 11, Jan. 1881, pp. 12–13.
495. WPM, Vol. 37, Nov. 1900, pp. 506–507.
496. Dry plate committee report will be found in APB, Vol. 12, Jan. 1881, pp. 20–22; and in March 1881, pp. 78–79. Carbutt remarks will be found in PT, Vol. 11, July 1881, pp. 251–252.
497. APB, Vol. 24, Jan. 14, 1893, p. 1.
498. APB, Vol. 12, Mar. 1881, p. 87. Comments by other photographers mentioned will be found in APB, Vol. 12, June 1881, pp. 182–184.
499. "From the West," by Pyro, a letter to the editor of the PT, Vol. 11, May 1881, pp. 202–204.
500. SLCPP, Vol. 5, Jan. 1881, p. 32.
501. AJP, Vol. 8, July 1887, pp. 112–113.
502. TAFT, p. 382.
503. PT, Vol. 11, Aug. 1881, pp. 302–305.
504. References: BACHRACH, Memoirs; obituary in *The Sun,* Baltimore, Dec. 11, 1921.
505. Reference: "Photography and the Newspapers," by S. H. Horgan, PT, Vol. 14, May 1884, pp. 225–228.
506. PT, Vol. 11, July 1881, pp. 250–251.
507. IVES, p. 29.
508. AAOP, 1887, p. 135. Also see GERNSHEIM, pp. 549–551, and discussion in IVES, pp. 30–31; 48–55.
509. PP, Vol. 23, Dec. 18, 1886, p. 742.
510. APB, Vol. 14, Nov. 1883, pp. 371–372. Also see WPM, Vol. 29, Feb. 6, 1892, pp. 73–74.
511. APB, Vol. 13, Apr. 1882, pp. 130–131. Whipple feat recorded in AJP, Vol. 6, Jan. 1, 1864, pp. 304–305.

512. *New York Times,* Nov. 5, 1882.
513. PT, Vol. 11, Jan. 1881, pp. 10–11.
514. APPLETON'S, Vol. 2 (Draper).
515. *New York Times,* Feb. 25, 1883.
516. References: Walzl profile in PT, Vol. 13, Mar. 1883, pp. 102–104; APB, Vol. 15, Apr. 1884, pp. 164–166.
517. References: LOTHROP, p. 26; also "Collector's Notes," by Eaton S. Lothrop, Jr., in *Photographica,* Vol. 5, Mar. 1973, p. 9; May 1973, pp. 11–12.
518. APB, Vol. 15, Apr. 1884, pp. 164–166; also "Collector's Notes" (LOTHROP), *Photographica,* Vol. 6, Aug.–Sept. 1974, pp. 8–9.
519. PP, Vol. 20, July 1883, p. 224.
520. PT, Vol. 13, Feb. 1883, pp. 82–85.
521. Ibid.
522. References: APB, Vol. 14, June 1883, p. 190; PT, Vol. 14, May 1884, p. 230.
523. References: APB, Vol. 12, May 1881, p. 159; WPM, Vol. 26, July 6, 1889, pp. 401–402.
524. PP, Vol. 20, June 1883, pp. 179–183.
525. PT, Vol. 13, Aug. 1883, pp. 403–404.
526. APB, Vol. 15, Apr. 1884, pp. 167–168.
527. PT, Vol. 13, Mar. 1883, pp. 112–113.
528. DARRAH, p. 109.
529. *New York Times,* Aug. 20, 1884; APB, Vol. 15, Apr. 1884, p. 164.
530. PT, Vol. 11, Mar. 1881, pp. 93–94.
531. BACHRACH, *Memoirs.*
532. For a discussion of Alfred Stieglitz's studies and activities in Europe, see NORMAN, pp. 24–35.
533. PT, Vol. 14, July 1884, pp. 386–387.
534. PT, Vol. 14, Jan. 1884, pp. 48–49.
535. Op. cit. (Note 505).
536. For the text of speeches given at the dinner in honor of Roche, see APB, Vol. 15, Apr. 1884, pp. 136–153. An obituary on Roche appears in APB, Vol. 26, Nov. 1895, p. 367.
537. APB, Vol. 15, Apr. 1884, pp. 164–166.
538. For a profile in Ogawa, see APB, Vol. 21, Mar. 22, 1890, pp. 181–185.
539. PT, Vol. 14, Oct. 1884, pp. 537–539.
540. From the *New York Mail & Express,* as recorded in APB, Vol. 16, Apr. 11, 1885, pp. 222–223.
541. Op. cit. (Note 540).
542. For a report on the exhibition, see APB, Vol. 16, Nov. 28, 1885, pp. 683–687.
543. AJP, Vol. 6, Aug. 1885, p. 6.
544. References: PP, Vol. 22, Oct. 1885, p. 366; *Latent Image,* p. 62; *Scientific American,* Vol. 70, Jan. 6, 1894, p. 6.
545. AJP, Vol. 7, May 1886, pp. 1–3. For a discussion of Eastman film development, see TAFT, pp. 384–388; "Time Exposure," by Eaton S. Lothrop, Jr., *Popular Photography,* Mar. 1972, pp. 36 and 38.
546. PT, Vol. 16, Oct. 1, 1886, p. 520. Also see GERNSHEIM, p. 453.
547. Ibid (Horgan remarks).
548. PP, Vol. 23, Mar. 6, 1886, pp. 140–142.
549. Paper by Donald C. Ryon, curator of the Kodak Patent Museum, given at a symposium of the Photographic Historical Society, Rochester, Sept. 18–20, 1970.
550. PP, Vol. 23, Feb. 6, 1886, p. 74.
551. APB, Vol. 17, June 26, 1886, pp. 353–358.
552. GERSHEIM, p. 420.
553. PT, Vol. 15, Jan. 23, 1885, p. 38.
554. PP, Vol. 23, Oct. 16, 1886, pp. 638–639.
555. AJP, Vol. 7, Oct. 1886, pp. 4–8. Also see GERNSHEIM, p. 400.
556. AJP, Vol. 10, Jan. 1889, p. 9.
557. BROTHERS, p. 74.
558. *Theodore Roosevelt, an Autobiography,* N.Y., Macmillan, 1913, pp. 70, 185, 187, 218–219, 313.
559. AJP, Vol. 8, Oct. 1887, pp. 169–170.
560. *The Making of An American,* pp. 266–273.
561. References: *A Talent for Detail, The Photographs of Frances Benjamin Johnston,* by Pete Daniel and Raymond Smock, N.Y., Harmony Books, 1974, pp. 5, 27, 43, 57–59; *The Making of an American,* by Jacob Riis, N.Y., Macmillan, 1901, pp. 266–273; *How the Other Half Lives,* by Jacob Riis, N.Y. Dover Pub., p. 30.
562. Remarks by Edwards will be found in PP, Vol. 24, 1887, pp. 101–102.

563. AJP, Vol. 8, Dec. 1887, p. 224.
564. APB, Vol. 18, Apr. 23, 1887, pp. 242–245.
565. References: "The Limits of Photogravure," by A. Dawson, AJP, Vol. 10, May 1889, pp. 175–182; "Progress and Methods of Photomechanical Printing," by Ernest Edwards, AAOP, 1887, pp. 134–137.
566. AJP, Vol. 10, Jan. 1889, pp. 25–27.
567. PT, Vol. 17, Aug. 19, 1887, pp. 419–420.
568. References: APB, Vol. 19, Dec. 22, 1888, 737–739; WPM, Vol. 26, Jan. 5, 1889, pp. 26–28.
569. "Men in the Movie Vanguard," No. VI, Louis Aimé Augustin Le Prince, by Merritt Crawford, *Cinema,* Dec. 1930, pp. 28–31.
570. COULSON, p. 10.
571. THOMAS, pp. 26–27.
572. "Neglected Method of Silver Printing," by Charles D. Mitchell, AJP, Vol. 9, Feb. 1888, pp. 30–33; see also Mar. 1888 issue.
573. IAAPB, Vol. 2, 1889, pp. 209–210.
574. PP., Vol. 25, Mar. 3, 1888, p. 157; Apr. 7, 1888, p. 223.
575. AJP, Vol. 8, Nov. 1887, pp. 198–200.
576. PT, Vol. 18, Feb. 3, 1888, pp. 50–51.
577. PT, Vol. 18, Feb. 3, 1888, pp. 55–56.
578. AJP, Vol. 10, Aug. 1889, pp. 268–270; also Vol. 9, Jan. 1888, pp. 2–3.
579. The Eastman 1891 profile will be found in *Art in Advertising,* Vol. 5, Dec. 1891, pp. 120–121. Also see DAB (Eastman).
580. WPM, Vol. 26, Oct. 19, 1889, pp. 609–610.
581. Ibid.
582. References: Records compiled from recorded activities of Carbutt in nineteenth-century photographic journals, and DAB (Carbutt).
583. AJP, Vol. 10, Aug. 1889, pp. 277–279. For more on film photography development, see PM, Vol. 4, Apr. 1902; TAFT, pp. 391–403; GERNSHEIM, p. 408.
584. AJP, Vol. 10, Feb. 1889, pp. 73–75.
585. PM, Vol. 4, Apr. 1902.
586. WPM, Vol. 26, Apr. 20, 1889, pp. 247–248.
587. Op. cit. (items in Note 581); *Goodwin Film & Camera Co.* v. *Eastman Kodak Co., Federal Reporter,* Vol. 207, 1914, pp. 351–362; Vol. 213, pp. 231–240.
588. WPM, Vol. 33, Oct. 1896, pp. 462–465.
589. BROTHERS, p. 133. A report on Ives's process and the Franklin Institute award will be found in PP, Vol. 23, Dec. 4, 1886, pp. 699–700.
590. WPM, Vol. 27, Nov. 1, 1890, pp. 667–668.
591. BROTHERS, p. 127.
592. IAAPB, Vol. 1, 1888, pp. 306–307; 515–516; APB, Vol. 26, Jan. 1, 1895, pp. 4–6.
593. IAAPB, Vol. 4, 1891, pp. 190–194.
594. PT, Vol. 20, May 16, 1890, pp. 232–233.
595. APB, Vol. 21, Oct. 11, 1890, pp. 590–591.
596. WPM, Vol. 28, Aug. 15, 1891, pp. 505–506.
597. Op. cit. (Note 588). Sasche position recorded in AJP, Vol. 17, Apr. 1896, pp. 146–147.
598. WPM, Vol. 28, Aug. 1, 1891, p. 473. For a description of the Kamerat, see LOTHROP, p. 64.
599. "Recent Improvements in Photographic Lenses," by W. K. Burton, APB, Vol. 24, Oct. 28, 1893, pp. 650–656; "The Evolution of the Modern Lens," by T. R. Dallmeyer, a paper given at a meeting of the Royal Photographic Society on Oct. 9, 1900, and reprinted in APB, Vol. 31, Dec. 1900, pp. 384–387; Vol. 32, Jan. 1901, pp. 26–30.
600. HULFISH, pp. 12–13.
601. Op. cit. (Note 598)
602. IAAPB, Vol. 1, 1888, pp. 375–377.
603. References: Op. cit. (Note 598); PM, Vol. 3, May 1901, pp. 49–84; APB, Vol. 24, Apr. 8, 1893, p. 204.
604. WPM, Vol. 34, Dec. 1897, pp. 566–567.
605. An obituary on Whipple will be found in WPM, Vol. 28, Apr. 18, 1891, p. 256.
606. Op. cit. (Note 598). A report on lenses used at the New York amateur societies' exhibition will be found in WPM, Vol. 28, July 18, 1891, pp. 428–429. Remarks by David Bachrach will be found in his memoirs.
607. Bachrach quotation is from WPM, Vol. 29, Apr. 16, 1892, p. 233.
608. Lovell article will be found in WPM, Vol. 38, Aug. 1901, p. 322. Bachrach's remarks will be found in WPM, Vol. 29, Apr. 16, 1892,

pp. 231–234. Other references include PT, Vol. 23, Apr. 7, 1893, p. 184; and WPM, Vol. 35, Jan. 1898, p. 47 (contains ref. to Eastman paper).

609. AJP, Vol. 14, Dec. 1893, p. 567.
610. WPM, Vol. 29, Apr. 2, 1892, p. 197.
611. PT, Vol. 23, June 2, 1893, pp. 293–294.
612. WPM, Vol. 30, Aug. 1893, p. 368.
613. References: *Gazette* article quoted in AJP, Vol. 13, June 1892, p. 282; AJP, Vol. 12, Jan. 1891, pp. 27–28; July 1891, pp. 320–321; Vol. 13, Nov. 1892, pp. 515–517; APB, Vol. 23, June 25, 1892, pp. 374–375; WPM, Vol. 28, Oct. 17, 1891, p. 616; PT, Vol. 23, July 21, 1893, pp. 390–392.
614. APB, Vol. 23, Nov. 12, 1892, pp. 641–643.
615. PT, Vol. 21, Aug. 7, 1891, p. 397.
616. Ibid, p. 367.
617. BACHRACH, Memoirs.
618. Op. cit. (Note 474)
619. PT, Vol. 23, July 14, 1893, p. 376.
620. PT, Vol. 23, Jan. 20, 1893, pp. 33–34. For a profile of B. J. Falk, see WPM, Vol. 32, Nov. 1895, pp. 500–503.
621. WPM, Vol. 34, Aug. 1897, pp. 353–360.
622. Ibid.
623. References: PT, Vol. 21, July 17, 1891, p. 363; APB, Vol. 24, May 27, 1893, p. 293; Vol. 25, Apr. 16, 1894, pp. 208–212; PA, Vol. 5, June 1894, pp. 244–246; COULSON, p. 12; THOMAS, pp. 29–30.
624. WPM, Vol. 30, May 1893, pp. 219–220. Wynne device is described in APB, Vol. 25, Oct. 1, 1894, pp. 313–315.
625. For a review of the Pach brothers' operation, see WPM, Vol. 24, July 1897, pp. 305–310.
626. PT, Vol. 23, May. 5, 1893, pp. 241–242. Cooper address at the Chicago Exposition will be found in APB, Vol. 24, Sept. 9, 1893, p. 552. Also see "Pigment Printing in Suitable Colors," by Henry Russell, AAP, Vol. 10, Dec. 1898, pp. 539–546.
627. *The Lives of the Painters,* by John Canaday, N.Y., W. W. Norton, 1969. Vol. 3, pp. 1096–1110.
628. NORMAN, p. 35.
629. AAP, Vol. 3, July 1891, pp. 268–269.
630. References: CN, Vol. 3, Apr. 1900, p. 196; "The New Movement in England," by Henry P. Robinson, APB, Vol. 25, Jan. 1, 1894, pp. 8–11.
631. *Vogue,* Aug. 15, 1948, p. 186. Also see "Recent Amateur Photography," by F. W. Crane, AJP, Vol. 16, Oct. 1895, pp. 457–464 (reprinted from *Godey's,* Sept. 1895); NORMAN, p. 36.
632. AAP, Vol. 6, Jan. 1894, pp. 1–7.
633. For a profile of Catherine Weed Barnes, see PT, Vol. 22, Mar. 4, 1892, pp. 153–155.
634. AAP, Vol. 4, Apr. 1892, pp. 153–155.
635. STIEGLITZ, p. 251. Also p. 116; NORMAN, p. 42.
636. PT, Vol. 27, Oct. 1895, p. 220.
637. AAP, Vol. 7, July 1895, p. 321.
638. Op. cit. (Note 635)
639. Op. cit. (Note 474)
640. For an obituary on C. D. Fredericks, see PT, Vol. 24, June 8, 1894, pp. 355–356.
641. STIEGLITZ, p. 269.
642. For more on Kurz's pioneering work, aided by Ernest Vogel, see SIPLEY, p. 16; PT, Vol. 23, Feb. 17, 1893, p. 82.
643. APB, Vol. 26, May 1, 1895, p. 172.
644. Both letters will be found in AAP, Vol. 6, Apr. 1894, pp. 188–189.
645. PT, Vol. 31, Apr. 1899, pp. 164–167.
646. IVES, p. 38. See also AAP, Vol. 12, May 1900, pp. 221–224.
647. APB, Vol. 26, Oct. 1895, p. 334. A report on the exhibition will be found in APB, Vol. 26, Jan. 1, 1895, pp. 20–23.
648. "The Adulteration of Paper Stock," by Julius F. Sasche, AJP, Vol. 14, Feb. 1893, pp. 65–66. See also APB, Vol. 26, July 1895, p. 241.
649. APB, Vol. 26, Feb. 1, 1895, pp. 63–64 (quotation is from an earlier undated article in the British journal *The Photogram*). See also WPM, Vol. 32, Dec. 1895, pp. 549–554; PT, Vol. 27, Nov. 1, 1895, pp. 289–292.
650. APB, Vol. 26, Jan. 1, 1895, p. 21.
651. GERNSHEIM, p. 525. Joly and McDonough processes are described in GERNSHEIM, p. 253, and *Color Photography,* by Robert M. Fastone, London, 1935, pp. 7–8.
652. WPM, Vol. 34, Aug. 1897, p. 371. See also May 1897, pp. 237–238.

653. PT, Vol. 28, Feb. 1896, pp. 104–105.
654. JENKINS, p. 70.
655. References: JENKINS, pp. 77–79; and the following, which are among the archives of the Franklin Institute: Aug. 27, 1897, letter from Jenkins to Henry Heyl; Aug. 18, 1898, report of the Heyl committee approving award of the Elliott Cresson medal to Jenkins.
656. Ibid. (from the full text of the book)
657. PT. Vol. 24, May 23, 1894, pp. 325–326. Also see APB, Vol. 27, Jan. 1896, p. 26.
658. WPM, Vol. 13, June 1896, pp. 271–273.
659. In three separate articles, Jenkins claimed that his Phantoscope would make each fragmentary moment of film illumination exceed the period of time required for sequencing to a new film image. See PT, Vol. 28, May 1896, pp. 222–226; Vol. 30, Apr. 1898, p. 152; July 1898, pp. 296–297.
660. JENKINS, p. 73.
661. MCCOSKER, p. 413.
662. PT, Vol. 27, Aug. 1895, p. 121.
663. Handy's letter will be found in WPM, Vol. 33, Mar. 1896, p. 123. Also see COBB, pp. 42–43.
664. For a review of the early years of the biograph, see *Beginnings of the Biograph,* by Gordon Hendricks, N.Y., 1964, and a review of the first ten years of motion picture photography in Rochester, N.Y. by George Pratt in *Image,* Vol. 8, Dec. 1959, pp. 192–211.
665. WPM, Vol. 34, June 1897, pp. 266–267.
666. APB, Vol. 26, Mar. 1, 1895, pp. 76–78.
667. Ibid.
668. PT, Vol. 23, June 2, 1893, p. 289.
669. References: *Creative Photography,* by Helmut Gernsheim, Boston, 1962, pp. 115–118; introduction by Edward Steichen to *Once Upon A City,* by Grace M. Mayer, N.Y., Macmillan, 1958, pp. ix–x; "Amateur Photography and Journalism," by M. Y. Beach, AAP, Vol. 3, Dec. 1891, pp. 486–487.
670. WPM, Vol. 34, Oct. 1897, pp. 459–463.
671. APB, Vol. 28, Oct. 1897, pp. 314–319.
672. WPM, Vol. 33, July 1896, p. 292.
673. Op. cit. (Note 665)
674. WPM, Vol. 33, Aug. 1896, pp. 365–366.
675. Op. cit. (Note 669)
676. Op. cit. (Note 672)
677. BACHRACH, Memoirs.
678. PAS, Vol. 4, No. 1, 1939, p. 59.
679. CN, Vol. 1, Oct. 1897, pp. 28–29. Also see "Philadelphia Salon—Origin and Influence," by Joseph T. Keiley, CN, Vol. 2, Jan. 1899, pp. 113–132.
680. Goode letter is reproduced in AAP, Vol. 8, June 1896, p. 243.
681. AAP, Vol. 10, Mar. 1898, pp. 99–104; 119.
682. Op. cit. (Note 679, Keiley article)
683. "The Gum Bichromate Process," by J. W. Warren, WPM, Vol. 36, Apr. 1899, pp. 147–149.
684. WPM, Vol. 37, Apr. 1900, p. 152.
685. From "The New York Camera Club," by Sadakichi Hartmann, PT, Vol. 32, Feb. 1900, pp. 59–61.
686. PT, Vol. 29, Nov. 1897, pp. 510–511.
687. PE, Vol. 2, Dec. 1898, p. 172.
688. "The Lesson of the Photograph," by K. C., *Scribner's,* Vol. 23, May 1898, pp. 637–639.
689. Op. cit. (Note 684)
690. WPM, Vol. 36, Mar. 1899, pp. 97–100.
691. PE, Vol. 2, May 1899, p. 306.
692. Dr. Voll's remarks are quoted in *Creative Photography,* p. 126.
693. AAP, Vol. 8, July 1896, pp. 297–303.
694. WPM, Vol. 35, Nov. 1898, pp. 497–502.
695. Op. cit. (Note 696)
696. WPM, Vol. 37, Feb. 1900, p. 49.
697. WPM, Vol. 36, Aug. 1899, pp. 348–350.
698. "The Vandyke Style in Portraiture," by George G. Rockwood, WPM, Vol. 34, Aug. 1897, pp. 340–341.
699. From *Rinehart's Platinum Prints of American Indians,* F. A. Rinehart, Photographers, 1520 Douglas St., Omaha, Neb., 1899, a sales brochure in the collection of George R. Rinhart, and kindly made available for this history.
700. PE, Vol. 1, July 1898, p. 68.
701. WPM, Vol. 33, Feb. 1896, pp. 107–108. David Bachrach's remarks

are from an address to the annual convention of the Photographers' Association of America, printed in WPM, Vol. 34, Oct. 1897, pp. 459–463.

702. *American Science and Invention,* by Mitchell Wilson, N.Y., Bonanza, MCMLIV, p. 380. In GERNSHEIM, p. 400, author contends that "contrary to the claims made at the time [1893], this paper [velox paper] was not the invention of Nepera's founder and technical manager, the Belgian chemist, Dr. Leo Baekland."

703. WPM, Vol. 37, Sept. 1900, pp. 411–416.

704. WPM, Vol. 36, Sept. 1899, p. 431.

705. ACKERMAN, pp. 169–170.

706. References: "The Moving Image," by Robert Gessner, AH, Vol. 11, Apr. 1960, pp. 30–35, 100–104; *The History of World Cinema,* by David Robinson, N.Y., Stein & Day, First Paper Book Edition, 1974, pp. 21–31.

707. "The Father of News Photography: George Grantham Bain," by Emma H. Little, *Picturescope,* Vol. 20, Autumn, 1972, pp. 125–132.

708. Op. cit. (Note 684)

709. References: ACKERMAN, pp. 170–183; DAB (George Eastman, by Blake M. McKelvey); *Edison, A Biography,* by Matthew Josephson, N.Y., Toronto & London, McGraw-Hill, 1959, pp. 400–403.

710. WPM, Vol. 37, Apr. 1900, pp. 161–166.

711. For a description of the life and times of the Waldorf-Astoria Hotel opened in 1897, see MORRIS, pp. 234–246.

712. WPM, Vol. 37, Feb. 1900, pp. 68–69.

713. WPM, Vol. 37, Mar. 1900, pp. 103–104.

PRINCIPAL HOLDINGS OF NINETEENTH-CENTURY AMERICAN PHOTOGRAPHIC JOURNALS

Source	HJ 20 Vol.	PFAJ 13 Vol.	AJP 29 Vol.	PJA 60 Vol.	APB 33 Vol.	PT 47 Vol.	SLCPP 34 Vol.	AAP 19 Vol.	PB 19 Vol.	PA 19 Vol.	CN 6 Vol.
American Academy of Arts and Sciences, Boston			11	C							
American Antiquarian Society, Worcester, Mass.					15			NC			
Boston Public Library	15		10	C	C	C	22	14	12		C
Bowdoin College								17			
Brooklyn (N.Y.) Public Library					11						C
Buffalo and Erie County Public Library, Buffalo				58				5	2		
Bureau of Standards, Washington, D.C.					C						
California State Library, Sutro Branch, San Francisco							27				
Carnegie Library, Pittsburgh			11			NC	13	14			
Case Western Reserve, Cleveland							5	11			
Chicago Natural History Museum				28							
Chicago Public Library								15			
Cincinnati and Hamilton County Public Library, Cincinnati		2									
Cleveland Public Library				31	NC						
Columbia University	19	7	2	30					7		
Detroit Public Library		3		21		33					
Eastman Kodak Company, Rochester, N.Y.	12	2	10		25	45	19	18			
Enoch Pratt Library, Baltimore								15			
Franklin Institute, Philadelphia			14		18	NC					
Gettysburg College			C								
Harvard University				27	30	C	4	NC			
*Helios Press, Pawlett, Vt.	C	12		25							
Iowa State University of Science and Technology, Ames, Iowa				25		19					
John Crerar Library, Chicago	12	6		58	C	46	21	NC			
Kansas City Public Library								13			
Library of Congress	11	8	12	57	NC	45	17	C			C
Los Angeles Public Library						15					
Metropolitan Museum of Art, New York											C

Source	HJ 20 Vol.	PFAJ 13 Vol.	AJP 29 Vol.	PJA 60 Vol.	APB 33 Vol.	PT 47 Vol.	SLCPP 34 Vol.	AAP 19 Vol.	PB 19 Vol.	PA 19 Vol.	CN 6 Vol.
Mississippi State University					C						
Missouri Botanical Garden, St. Louis			7					9			
Newberry Library, Chicago									4		
New York Public Library	NC	12	19	NC	33	46	19	NC	14		C
New York State Library, Albany					27						
Ohio State University							C				
Oklahoma State University								5			
Philadelphia Free Library			13		7	NC					
Philadelphia Museum of Art											C
Queens Borough Public Library, New York				15							
Rinhart Library, George R. Rinhart, New York, N.Y.	4	I	8	21	16	32	7	II	6	5	C
Rochester Public Library					5						
Rose Polytechnic Institute, Terre Haute, Indiana						17					
Rutgers University			6					9			
Rutherford B. Hayes Library, Fremont, Ohio				15							
San Francisco Public Library				17							
St. Louis Public Library							I		9		
Smithsonian Institution, National Museum of History & Technology			7	58	25	34					
Spokane Public Library									5		
Union College			4								
United States National Library of Medicine				30			2				
University of Chicago					26	41					
University of Illinois, Urbana					28	20					
University of Maryland (College Park, Md.)			4								
University of Michigan				29	17			C			
University of Notre Dame									II		
University of Pennsylvania	8	I	6	19	6	41					
Yale University				27		44	I	12			

* = Holdings available in microfilm C = Complete run NC = Near complete run

SOURCES OF ILLUSTRATIONS

Private Collections

Bachrach	Bradford Bachrach, President, Bachrach, Inc., Watertown, Mass.
Beard	Timothy Beard, of New York City
Bendix	Howard Bendix, of Montclair, N.J.
Bokelberg	M. Bokelberg, Hamburg
Carson	Mrs. Joseph Carson, of Philadelphia
Collerd	Gene Collerd, of Caldwell, N.J.
Crane	Arnold Crane, of Chicago
Douglass	Mrs. Roy Douglass, of Pine Brook, N.J.
Duncan	R. Bruce Duncan, of Northfield, Illinois
Kaland	William Kaland, of New York City
Korn	Pearl Korn, of the Bronx, N.Y.
Lansdale	Robert Lansdale, of Baltimore
Lehr	Janet Lehr, of Janet Lehr, Inc., New York City
Lightfoot	Frederick S. Lightfoot, of Greenport, N.Y.
Marcus	Lou Marcus, of West Hempstead, N.Y.
Ostendorf	Lloyd Ostendorf, of Dayton, Ohio
Plummer/ Miller	J. Randall Plummer and Harvey S. Miller, of Philadelphia
Rinhart	George R. Rinhart, of New York City
Russack	Richard Russack, of Freemont, N.H.
Sprung	Jerome Sprung, of Teaneck, N.J.
Steinmann	Mr. & Mrs. David Steinmann, of New York City
Wagstaff	Samuel Wagstaff, Jr., of New York City
Walter	Paul F. Walter, of New York City
Weiner	Allen and Hilary Weiner, of New York City
Zucker	Harvey S. Zucker, of Staten Island, N.Y.

Key to Abbreviations, Institutional Collections

BL	Bancroft Library, University of California Library at Berkeley
CHS	Cincinnati Historical Society
DCL	Dartmouth College Library
DYLM	Dyer-York Library and Museum, Saco, Maine
FI	Archives of the Franklin Institute of Philadelphia
GEH	International Museum of Photography at George Eastman House, Rochester
HL	Houghton Library, Harvard University
ISHL	Illinois State Historical Library, Springfield
KC	Archives of Kenyon College, Gambier, Ohio
LC	The Library of Congress
LCPPD	The Library of Congress, Prints and Photographs Division
LLM	Lloyd Library and Museum, Cincinnati
MCNY	Museum of the City of New York
MFA	Museum of Fine Arts, Boston
MHS	Maryland Historical Society, Baltimore
NA	The National Archives
NYHS	New York Historical Society
OHA	Onondaga Historical Association, Syracuse
OSU	Floyd & Marion Rinhart Collection, Ohio State University, Department of Photography & Cinema
PHMC	Pennsylvania Historical & Museum Commission, Division of Archives & Manuscripts, Group 214, Warren J. Harder Collection, Harrisburg, Pa.
PM	The Peale Museum, Baltimore
RHS	Rochester Historical Society
SI	The Smithsonian Institution
SM	The Science Museum, London
UC	The University Club of New York City
UCL	University of Cincinnati Libraries, Special Collections Department
UM	McKeldin Library, University of Maryland, College Park
UMBC	Edward L. Bafford Photography Collection, University of Maryland, Baltimore County, Baltimore
UT	Gernsheim Collection, University of Texas at Austin

Frontispiece Collerd
1 Rinhart
2 SI
3 Zucker
6 Carson
7 UCL
10 Carson (unpublished)
11 Both: Rinhart (unpublished)
12 FI (unpublished)
13 *B*. LC (from AJP, Vol. 14, 1893)
 T. SI
14 Carson
16 *T*. FI (unpublished)
 B. Carson (unpublished)
18 LC (from ARASM, Vol. 1, 1840)
19 *B. SI*
 T. LC (from *Eureka,* Vol. 1, 1846)
20 *T*. Duncan (from PAJ, Vol. 2, 1851)
 B. Author
21 *B*. Duncan
 T. Carson (unpublished)
22 FI (unpublished)
23 *T*. Carson (unpublished)
 B. Rinhart (from *Evolution of Photography,* by John Werge)
25 Collerd
26 Zucker
27 Beard (unpublished)
28 Carson (unpublished)

30 HL
32 Rinhart
33 LCPPD
34 *T*. Author
 B. LC (from PFAJ, Vol. 10, 1857)
35 Carson (unpublished)
36 Bokelberg
38 UC (from *Motion Picture Work,* by David Hulfish)
39 *L*. UT
 R. Author
40 GEH
42 Author
43 Collerd
44 Carson (unpublished)
45 *T*. LC (from *Goggett Directory,* New York, 1843–44)
 B. Bendix
46 *L*. Collerd
 C. Rinhart
 R. Author
47 Author
48 *L*. GEH
 R. Carson (unpublished)
49 *L*. LC (from *McClure's,* Vol. 9, 1897)
 R. NA
50 Both: SI
51 UT
52 LCPPD
54 Crane

Sources of
Illustrations

417

Sources of
Illustrations

INDEX

TO TEXT

TO ILLUSTRATIONS OF PRINCIPALS

Project Management Body of Knowledge (PMBOK) Comparison

PMBOK Knowledge Areas	Coverage in *Project Management: The Managerial Process, 4e*
Integration management	Chapters 1, 2, 13, 16
Scope management	Chapters 4, 8, 16
Time management	Chapters 5, 6, 8, 9
Cost management	Chapter 13
Quality management	Chapter 14, 16
Human resource management	Chapters 3, 10, 11,12
Communication management	Chapter 4
Risk management	Chapter 8
Procurement management	Chapters 12, 14

Project Management

The Managerial Process

The McGraw-Hill/Irwin Series
Operations and Decision Sciences

Project
Management

The Managerial Process

Fourth Edition

Clifford F. Gray
Oregon State University

Erik W. Larson
Oregon State University

McGraw-Hill
Irwin

Boston Burr Ridge, IL Dubuque, IA Madison, WI New York San Francisco St. Louis
Bangkok Bogotá Caracas Kuala Lumpur Lisbon London Madrid Mexico City
Milan Montreal New Delhi Santiago Seoul Singapore Sydney Taipei Toronto

McGraw-Hill
Irwin

PROJECT MANAGEMENT: THE MANAGERIAL PROCESS

Published by McGraw-Hill/Irwin, a business unit of The McGraw-Hill Companies, Inc., 1221 Avenue of the Americas, New York, NY, 10020. Copyright © 2008 by The McGraw-Hill Companies, Inc. All rights reserved. No part of this publication may be reproduced or distributed in any form or by any means, or stored in a database or retrieval system, without the prior written consent of The McGraw-Hill Companies, Inc., including, but not limited to, in any network or other electronic storage or transmission, or broadcast for distance learning.

Some ancillaries, including electronic and print components, may not be available to customers outside the United States.

This book is printed on acid-free paper.

1 2 3 4 5 6 7 8 9 0 DOW/DOW 0 9 8 7

ISBN 978-0-07-352515-0
MHID 0-07-352515-4

Editorial director: *Stewart Mattson*
Executive editor: *Scott Isenberg*
Developmental editor: *Cynthia Douglas*
Associate marketing manager: *Kelly Odom*
Senior media producer: *Elizabeth Mavetz*
Project manager: *Jim Labeots*
Production supervisor: *Gina Hangos*
Designer: *Jillian Lindner*
Senior photo research coordinator: *Jeremy Cheshareck*
Photo researcher: *Teri Stratford*
Lead media project manager: *Brian Nacik*
Cover image: *© Veer Images*
Typeface: *10.5/12 Times Roman*
Compositor: *International Typesetting and Composition*
Printer: *R. R. Donnelley*

Library of Congress Cataloging-in-Publication Data

Gray, Clifford F.
 Project management: the managerial process / Clifford F. Gray, Erik W. Larson. —4th ed.
 p. cm. —(The McGraw-Hill/Irwin series, operations and decision sciences)
 Includes index.
 ISBN-13: 978-0-07-352515-0 (alk. paper)
 ISBN-10: 0-07-352515-4 (alk. paper)
 1. Project management. 2. Time management. 3. Risk management. I. Larson, Erik W.,
1952- II. Title.
HD69.P75G72 2008
 658.4′04—dc22 2007007198

About the Authors

Clifford F. Gray

CLIFFORD F. GRAY is professor emeritus of management at the College of Business, Oregon State University. He continues to teach undergraduate and graduate project management courses overseas and in the United States; he has personally taught more than 100 executive development seminars and workshops. His research and consulting interests have been divided equally between operations management and project management; he has published numerous articles in these areas, plus a text on project management. He has also conducted research with colleagues in the International Project Management Association. Cliff has been a member of the Project Management Institute since 1976 and was one of the founders of the Portland, Oregon, chapter. He was a visiting professor at Kasetsart University in Bangkok, Thailand in 2005. He has been the president of Project Management International, Inc. (a training and consulting firm specializing in project management) since 1977. He received his B.A. in economics and management from Millikin University, M.B.A. from Indiana University, and doctorate in operations management from the College of Business, University of Oregon.

Erik W. Larson

ERIK W. LARSON is professor of project management in the department of management, marketing, and international business at the College of Business, Oregon State University. He teaches executive, graduate, and undergraduate courses on project management, organizational behavior, and leadership. His research and consulting activities focus on project management. He has published numerous articles on matrix management, product development, and project partnering. He has been a member of the Portland, Oregon, chapter of the Project Management Institute since 1984. In 1995 he worked as a Fulbright scholar with faculty at the Krakow Academy of Economics on modernizing Polish business education. In 2005 he was a visiting professor at Chulalongkorn University in Bangkok, Thailand. He received a B.A. in psychology from Claremont McKenna College and a Ph.D. in management from State University of New York at Buffalo. He is a certified project management professional (PMP).

To Mary, Kevin, and Robert

To Ann, Mary, Rachel, and Victoria

C.F.G.

E.W.L.

Preface

Our motivation for writing this text was to provide students with a holistic, integrative view of project management. A holistic view focuses on how projects contribute to the strategic goals of the organization. The linkages for integration include the process of selecting projects that best support the strategy of a particular organization and that in turn can be supported by the technical and managerial processes made available by the organization to bring projects to completion. The goals for prospective project managers are to understand the role of a project in their organizations and to master the project management tools, techniques, and interpersonal skills necessary to orchestrate projects from start to finish.

The role of projects in organizations is receiving increasing attention. Projects are the major tool for implementing and achieving the strategic goals of the organization. In the face of intense, worldwide competition, many organizations have reorganized around a philosophy of innovation, renewal, and organizational learning to survive. This philosophy suggests an organization that is flexible and project driven. Project management has developed to the point where it is a professional discipline having its own body of knowledge and skills. Today it is nearly impossible to imagine anyone at any level in the organization who would not benefit from some degree of expertise in the process of managing projects.

Audience

This text is written for a wide audience. It covers concepts and skills that are used by managers to propose, plan, secure resources, budget, and lead project teams to successful completions of their projects. The text should prove useful to students and prospective project managers in helping them understand why organizations have developed a formal project management process to gain a competitive advantage. Readers will find the concepts and techniques discussed in enough detail to be immediately useful in new-project situations. Practicing project managers will find the text to be a valuable guide and reference when dealing with typical problems that arise in the course of a project. Managers will also find the text useful in understanding the role of projects in the missions of their organizations. Analysts will find the text useful in helping to explain the data needed for project implementation as well as the operations of inherited or purchased software. Members of the Project Management Institute will find the text is well structured to meet the needs of those wishing to prepare for PMP (Project Management Professional) or CAPM (Certified Associate in Project Management) certification exams. The text has in-depth coverage of the most critical topics found in PMI's *Project Management Body of Knowledge* (PMBOK). People at all levels in the organization assigned to work on projects will find the text useful not only in providing them with a rationale for the use of project management tools and techniques but also because of the insights they will gain on how to enhance their contributions to project success.

Our emphasis is not only on how the management process works, but more importantly, on *why* it works. The concepts, principles, and techniques are universally applicable. That is, the text does not specialize by industry type or project scope. Instead, the text is written for the individual who will be required to manage a variety of projects in a variety of different organizational settings. In the case of some small projects, a few of the steps of the techniques can be omitted, but the conceptual framework applies to all organizations in

which projects are important to survival. The approach can be used in pure project organizations such as construction, research organizations, and engineering consultancy firms. At the same time, this approach will benefit organizations that carry out many small projects while the daily effort of delivering products or services continues.

Content

In this latest edition of the book, we have responded to feedback received from both students and teachers, which is deeply appreciated. As a result of the this feedback, the following changes have been made to the fourth edition:

- Expanded discussions of managing virtual teams, communication plans, critical chain project management, phase gating, balanced scorecard, and risk assessment.
- Revised Chapter 12 to focus on the important trend toward outsourcing project work. Chapters 3, 4, 5, and 7 have been restructured and updated. Chapter 8 now includes both resource and cost scheduling and concludes with the establishment of a time-phased baseline budget. Chapter 16 has been revised to focus on project oversight—methods organizations use to improve their project management systems.
- New student exercises and cases have been added to most chapters. Several computer exercises have been revised.
- The "Snapshot from Practice" boxes feature a number of new examples of project management in action as well as new research highlights that continue to promote practical application of project management.

Overall the text addresses the major questions and issues the authors have encountered over their 60 combined years of teaching project management and consulting with practicing project managers in domestic and foreign environments. The following questions represent the issues and problems practicing project managers find consuming most of their effort: What is the strategic role of projects in contemporary organizations? How are projects prioritized? What organizational and managerial styles will improve chances of project success? How do project managers orchestrate the complex network of relationships involving vendors, subcontractors, project team members, senior management, functional managers, and customers that affect project success? What factors contribute to the development of a high-performance project team? What project management system can be set up to gain some measure of control? How do managers prepare for a new international project in a foreign culture? How does one pursue a career in project management?

Project managers must deal with all these concerns to be effective. All of these issues and problems represent linkages to an integrative project management view. The chapter content of the text has been placed within an overall framework that integrates these topics in a holistic manner. Cases and snapshots are included from the experiences of practicing managers. The future for project managers appears to be promising. Careers will be determined by success in managing projects.

Student Learning Aids

The Student CD-ROM accompanying the text includes study outlines, videos, Microsoft Project Video Tutorials and Web links. The trial version of Microsoft Project software is included on its own CD-ROM free with the text.

SimProject, a project management simulation, developed by Jeffrey Pinto and Diane Parente of Pennsylvania State University–Erie, can be optionally bundled with this text for

a modest additional cost. SimProject provides virtual experience in managing projects. Through the use of multiple scenarios and competitive and collaborative project teams, "firsthand" experience as a successful project manager is acquired. An appendix in the back of this text ties the simulation to the chapter sequence of the book.

Acknowledgments

We want first to acknowledge with special thanks and appreciation the contribution of Diane Parente–who prepared the SimProject extended case in the appendix. This case consists of a series of exercises tied to the chapters of this book that coordinate with and make use of SimProject, a project management simulation developed by Diane and her colleague at Penn State–Erie, Jeffrey Pinto. SimProject adds a hands-on, experiential dimension to this course.

In addition, we would like to thank Ed Blevins, DeVry University–Irving, for updating the Test Bank; Charlie Cook, University of West Alabama, for creating PowerPoint slides; and Julie Mehra for accuracy checking the text and Instructor's Resource Manual content.

Next, it is important to note that the text includes contributions from numerous students, colleagues, friends, and managers gleaned from professional conversations. We want them to know we sincerely appreciate their counsel and suggestions. Almost every exercise, case, and example in the text is drawn from a real-world project. Special thanks to managers who graciously shared their current project as ideas for exercises, subjects for cases, and examples for the text. Shlomo Cohen, John A. Drexler, Jim Moran, John Sloan, Pat Taylor, and John Wold, whose work is printed, are gratefully acknowledged. Special gratitude is due Robert Breitbarth of Interact Management, who shared invaluable insights on prioritizing projects. University students and managers deserve special accolades for identifying problems with earlier drafts of the text and exercises.

We are indebted to the reviewers of the first and second editions who shared our commitment to elevating the instruction of project management. The reviewers include Paul S. Allen, Rice University; Denis F. Cioffi, George Washington University; Joseph D. DeVoss, DeVry University; Edward J. Glantz, Pennsylvania State University; Michael Godfrey, University of Wisconsin–Oshkosh; Robert Key, University of Phoenix; Dennis Krumwiede, Idaho State University; Nicholas C. Petruzzi, University of Illinois– Urbana/Champaign; William R. Sherrard, San Diego State University; S. Narayan Bodapati, Southern Illinois University at Edwardsville; Warren J. Boe, University of Iowa; Burton Dean, San Jose State University; Kwasi Amoako-Gyampah, University of North Carolina– Greensboro; Owen P. Hall, Pepperdine University; Bruce C. Hartman, University of Arizona; Richard Irving, York University; Robert T. Jones, DePaul University; Richard L. Luebbe, Miami University of Ohio; William Moylan, Lawrence Technological College of Business; Edward Pascal, University of Ottawa; James H. Patterson, Indiana University; Art Rogers, City University; Christy Strbiak, U.S. Air Force Academy; David A. Vaughan, City University; and Ronald W. Witzel, Keller Graduate School of Management.

In the fourth edition we continue to commit to improving the text content and improving instruction of project management. We are grateful to those reviewers who provided helpful critiques and insights on the third edition, which helped us prepare this revision. The reviewers for the fourth edition include Nabil Bedewi, Georgetown University; Scott Bailey, Troy University; Michael Ensby, Clarkson University; Eldon Larsen, Marshall University; Steve Machon, DeVry University–Tinley Park; William Matthews, William Patterson University; Erin Sims, DeVry University– Pomona; Kenneth Solheim, DeVry University–Federal Way; and Oya Tukel, Cleveland State University. We thank you for your many thoughtful suggestions and for making our book better. Of course we accept responsibility for the final version of the text.

In addition, we would like to thank our colleagues in the College of Business at Oregon State University for their support and help in completing this project. In particular, we recognize Mark Pagell, Prem Mathew, and Ping-Hung Hsieh for their helpful advice and suggestions. We also wish to thank the many students who helped us at different stages of this project, most notably Neil Young, Rebecca Keepers, Katherine Knox, and Amanda Bosworth. Mary Gray deserves special credit for editing and working under tight deadlines on earlier editions. Special thanks go to Pinyarat Sirisomboonsuk for her help in preparing this edition.

Finally, we want to extend our thanks to all the people at McGraw-Hill/Irwin for their efforts and support. First, we would like to thank Scott Isenberg for continuing to champion and provide editorial direction and guidance through all four editions of the book, and Cynthia Douglas, who took over management of the book's development from Wanda Zeman for the fourth edition. And we would also like to thank Jim Labeots, Gina Hangos, Jeremy Cheshareck, Jillian Lindner, Brian Nacik, and Elizabeth Mavetz for managing the final production, design, supplement, and media phases of the fourth edition.

Clifford F. Gray

Erik W. Larson

Note to Student

You will find the content of this text highly practical, relevant, and current. The concepts discussed are relatively simple and intuitive. As you study each chapter we suggest you try to grasp not only how things work, but why things work. You are encouraged to use the text as a handbook as you move through the three levels of competency:

I know.

I can do.

I can adapt to new situations.

Project management is both people and technical oriented. Project management involves understanding the cause-effect relationships and interactions among the sociotechnical dimensions of projects. Improved competency in these dimensions will greatly enhance your competitive edge as a project manager.

The field of project management is growing in importance and at an exponential rate. It is nearly impossible to imagine a future management career that does not include management of projects. Résumés of managers will soon be primarily a description of the individual's participation in and contributions to projects.

Good luck on your journey through the text and on your future projects.

Brief Contents

Contents

Project
Management

The Managerial Process

Modern Project Management

What Is a Project?

The Importance of Project Management

Project Management Today—An Integrative Approach

Summary

Modern Project Management

All of mankind's greatest accomplishments—from building the great pyramids to discovering a cure for polio to putting a man on the moon—began as a project.

This is a good time to be reading a book about project management. Business leaders and experts have proclaimed that project management is a strategic imperative. Project management provides people with a powerful set of tools that improves their ability to plan, implement, and manage activities to accomplish specific organizational objectives. But project management is more than just a set of tools; it is a results-oriented management style that places a premium on building collaborative relationships among a diverse cast of characters. Exciting opportunities await people skilled in project management.

The project approach has long been the style of doing business in the construction industry, U.S. Department of Defense contracts, and Hollywood as well as at big consulting firms. Now project management has spread to all avenues of work. Today, project teams carry out everything from port expansions to hospital restructuring to upgrading information systems. Automakers such as Toyota, Nissan, and BMW credit their ability to capture a significant share of the auto market to the use of project management teams, which quickly develop new cars that incorporate the latest automotive technology. The impact of project management is most profound in the area of information technology, where the new folk heroes are young professionals whose Herculean efforts lead to the constant flow of new hardware and software products.

Project management is not limited to the private sector. Project management is also a vehicle for doing good deeds and solving social problems. Endeavors such as providing emergency aid to the Gulf Coast devastated by hurricane Katrina, devising a strategy for reducing crime and drug abuse within a city, or organizing a community effort to renovate a public playground would and do benefit from the application of modern project management skills and techniques.

Perhaps the best indicator of demand for project management can be seen in the rapid expansion of the Project Management Institute (PMI), a professional organization for project managers. PMI membership has grown from 93,000 in 2002 to more than 230,000 currently. See the PMI Snapshot from Practice for information regarding professional certification in project management.

It's nearly impossible to pick up a newspaper or business periodical and not find something about projects. This is no surprise! Approximately $2.5 trillion (about 25 percent of the U.S. gross national product) are spent on projects each year in the United States alone. Other countries are increasingly spending more on projects. Millions of people around the world consider project management the major task in their profession.

Snapshot from Practice The Project Management Institute

The Project Management Institute (PMI) was founded in 1969 as an international society for project managers. Today PMI has members from more than 125 countries and more than 230,00 members. PMI professionals come from virtually every major industry, including aerospace, automotive, business management, construction, engineering, financial services, information technology, pharmaceuticals, health care, and telecommunications.

PMI provides certification as a *Project Management Professional (PMP)*—someone who has documented sufficient project experience, agreed to follow the PMI code of professional conduct, and demonstrated mastery of the field of project management by passing a comprehensive examination. The number of people earning PMP status has grown dramatically in recent years. In 1996 there were fewer than 3,000 certified project management professionals. By the end of 2005 there were more than 200,000 PMPs! Figure 1.1 shows the rapid growth in

the number of people earning project management professional certification from 1995 to 2005.

Just as the CPA exam is a standard for accountants, passing the PMP exam may become the standard for project managers. Some companies are requiring that all their project managers be PMP certified. Moreover, many job postings are restricted to PMPs. Job seekers, in general, are finding that being PMP certified is an advantage in the marketplace.

PMI recently added a certification as a *Certified Associate in Project Management (CAPM)*. CAPM is designed for project team members and entry-level project managers, as well as qualified undergraduate and graduate students who want a credential to recognize their mastery of the project management body of knowledge. CAPM does not require the extensive project management experience associated with the PMP. For more details on PMP and CAPM,"google" PMI to find the current Web site for the Project Management Institute.

FIGURE 1.1 Growth in PMP Certification, 1995–2005

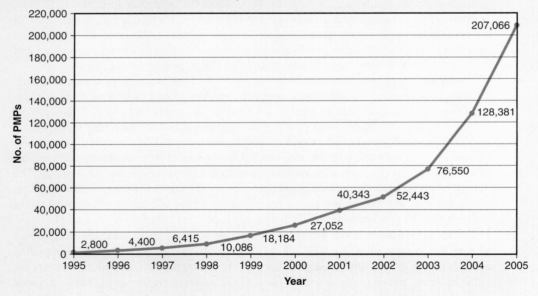

Project management is not without problems. The Standish Group has tracked the management of information technology (IT) projects over the years. This firm's periodic landmark reports summarize the continued need for improved project management. In 1994 approximately 16 percent of IT projects were completed on time, on budget; in 2004 the success rate moved up to 29 percent. Failed projects also declined from 31 percent in 1994 to 18 percent in 2004. However, the number of projects late or over budget has not changed; these "seriously challenged projects" remain at 53 percent.

The trend of improvement is clear, but there is an urgent need for elevating performance! The waste on failed projects and cost overruns is estimated in the neighborhood of $150 billion!

These statistics are limited to information technology projects. Discussions with project managers in other industries suggest application to other industries may be a stretch, but the seriousness of the problems is just as great.

Project management is not restricted to specialists. Managing projects is often a vital part of everyone's job. For example, Brian Vannoni, formerly of General Electric Plastics, states:

> We have very few dedicated project managers. Our project managers might be process engineers, they might be scientists, they might be process control technicians, maintenance mechanics, degreed and nondegreed people. A short answer for GE Plastics is that anyone, any level, any function could be a project manager.*

Companies recognize that their entire organizational staff can benefit from being trained in project management, not just project management wannabes.

The growth of project management can also be seen in the classroom. Ten years ago major universities offered one or two classes in project management, primarily for engineers. Today, many universities offer multiple sections of project management classes, with the core group of engineers being supplemented by business students majoring in marketing, management information systems (MIS), and finance, as well as students from other disciplines such as oceanography, health sciences, computer sciences, and liberal arts. These students are finding that their exposure to project management is providing them with distinct advantages when it comes time to look for jobs. More and more employers are looking for graduates with project management skills. The logical starting point for developing these skills is understanding the uniqueness of a project and of project managers.

What Is a Project?

What do the following headlines have in common?

New Web Video Phone Is Here to Stay

Farm Aid concert raises millions for family farmers

New Zealand BritoMart Transportation System opens ahead of schedule

Contract for building citywide WiFi site awarded

Optical Security System on Line

All these events resulted from the management of projects. A project can be defined as follows:

> A project is a complex, nonroutine, one-time effort limited by time, budget, resources, and performance specifications designed to meet customer needs.

Like most organizational effort, the major goal of a project is to satisfy a customer's need. Beyond this fundamental similarity, the characteristics of a project help differentiate it from other endeavors of the organization. The major characteristics of a project are as follows:

1. An established objective.
2. A defined life span with a beginning and an end.
3. Usually, the involvement of several departments and professionals.
4. Typically, doing something that has never been done before.
5. Specific time, cost, and performance requirements.

* Harold Kerzner, *Applied Project Management* (New York: John Wiley & Sons, 2000), p. 221.

First, projects have a defined objective—whether it is constructing a 12-story apartment complex by January 1 or releasing version 2.0 of a specific software package as quickly as possible. This singular purpose is often lacking in daily organizational life in which workers perform repetitive operations each day.

Second, because there is a specified objective, projects have a defined endpoint, which is contrary to the ongoing duties and responsibilities of traditional jobs. In many cases, individuals move from one project to the next as opposed to staying in one job. After helping to install a security system, an IT engineer may be assigned to develop a database for a different client.

Third, unlike much organizational work that is segmented according to functional specialty, projects typically require the combined efforts of a variety of specialists. Instead of working in separate offices under separate managers, project participants, whether they be engineers, financial analysts, marketing professionals, or quality control specialists, work closely together under the guidance of a project manager to complete a project.

The fourth characteristic of a project is that it is nonroutine and has some unique elements. This is not an either/or issue but a matter of degree. Obviously, accomplishing something that has never been done before, such as building a hybrid (electric/gas) automobile or landing two mechanical rovers on Mars, requires solving previously unsolved problems and breakthrough technology. On the other hand, even basic construction projects that involve established sets of routines and procedures require some degree of customization that makes them unique.

Finally, specific time, cost, and performance requirements bind projects. Projects are evaluated according to accomplishment, cost, and time spent. These triple constraints impose a higher degree of accountability than you typically find in most jobs. These three also highlight one of the primary functions of project management, which is balancing the trade-offs between time, cost, and performance while ultimately satisfying the customer.

What a Project Is Not Projects should not be confused with everyday work. A project is not routine, repetitive work! Ordinary daily work typically requires doing the same or similar work over and over, while a project is done only once; a new product or service exists when the project is completed. Examine the list in Table 1.1 that compares routine, repetitive work and projects. Recognizing the difference is important because too often resources can be used up on daily operations which may not contribute to longer range organization strategies that require innovative new products.

The terms *program* and *project* are often used interchangeably in practice, which sometimes causes confusion. Programs and projects are similar in the sense that they both are directed toward goals and require plans and resources to reach their goals. Both use similar tools, methods, and policies. The differences lie primarily in scope and time horizon. *A program is a series of coordinated, related, multiple projects that continue over extended*

TABLE 1.1
Comparison of Routine Work with Projects

Routine, Repetitive Work	Projects
Taking class notes	Writing a term paper
Daily entering sales receipts into the accounting ledger	Setting up a sales kiosk for a professional accounting meeting
Responding to a supply-chain request	Developing a supply-chain information system
Practicing scales on the piano	Writing a new piano piece
Routine manufacture of an Apple iPod	Designing an iPod that is approximately 2 × 4 inches, interfaces with PC, and stores 10,000 songs
Attaching tags on a manufactured product	Wire-tag projects for GE and Wal-Mart

time intended to achieve a goal. A program is a higher level *group* of projects targeted at a common goal. The classic example is the U.S. space program to place a space station on the moon to serve as a springboard to other space explorations.

Each project within a program has a project manager. A major difference between a program and project lies in scale and time span. Examples of programs and their goals are a set of projects that aim to increase computer chip speed each year; several new pharmaceutical products for arthritis; and Denver's 12-year, $4.7 billion urban transportation system that will extend 120 miles on six new rail lines.

The Project Life Cycle

Another way of illustrating the unique nature of project work is in terms of the project life cycle. Some project managers find it useful to use the project life cycle as the cornerstone for managing projects. The life cycle recognizes that projects have a limited life span and that there are predictable changes in level of effort and focus over the life of the project. There are a number of different life-cycle models in project management literature. Many are unique to a specific industry or type of project. For example, a new software development project may consist of five phases: definition, design, code, integration/test, and maintenance. A generic cycle is depicted in Figure 1.2.

The project life cycle typically passes sequentially through four stages: defining, planning, executing, and delivering. The starting point begins the moment the project is given the go-ahead. Project effort starts slowly, builds to a peak, and then declines to delivery of the project to the customer.

1. **Defining stage:** Specifications of the project are defined; project objectives are established; teams are formed; major responsibilities are assigned.
2. **Planning stage:** The level of effort increases, and plans are developed to determine what the project will entail, when it will be scheduled, whom it will benefit, what quality level should be maintained, and what the budget will be.

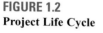

FIGURE 1.2
Project Life Cycle

Defining	Planning	Executing	Delivering
1. Goals	1. Schedules	1. Status reports	1. Train customer
2. Specifications	2. Budgets	2. Changes	2. Transfer documents
3. Tasks	3. Resources	3. Quality	3. Release resources
4. Responsibilities	4. Risks	4. Forecasts	4. Release staff
	5. Staffing		5. Lessons learned

Snapshot from Practice Project Management at Work*

Ryan McVay/Getty Images.

Investments in info-tech projects are indicative of rapid innovation within organizations. A few selected high profile organizations and their projects are described below. Although info-tech projects are hot, projects cut across small and large firms in diverse industries such as construction, biotechnology, nanotechnology, aerospace, and public transportation.

1. **Company: Krispy Kreme**
 Project: Network 320 stores to manage their inventory and take orders
 Payoff: New system provides many benefits: coordination alerts store managers of too much inventory; quick notification

3. **Executing stage:** A major portion of the project work takes place—both physical and mental. The physical product is produced (a bridge, a report, a software program). Time, cost, and specification measures are used for control. Is the project on schedule, on budget, and meeting specifications? What are the forecasts of each of these measures? What revisions/changes are necessary?

4. **Delivering stage:** Includes the two activities: delivering the project product to the customer and redeploying project resources. Delivery of the project might include customer training and transferring documents. Redeployment usually involves releasing project equipment/materials to other projects and finding new assignments for team members.

In practice, the project life cycle is used by some project groups to depict the timing of major tasks over the life of the project. For example, the design team might plan a major commitment of resources in the defining stage, while the quality team would expect their major effort to increase in the latter stages of the project life cycle. Because most organizations have

of the arrival of damaged goods at store; reduction of problem orders down from 26,000 to less than 3,000; district managers can now handle 320 stores, up from 144 three years ago.

2. **Company: Mattel (Toy manufacturer)**

 Cut Design Time Project: Move product design and licensing on line

 Payoff: Instead of molding prototypes (e.g., Hot Wheels or Barbie doll), virtual models are electronically sent directly to manufacturing sites. Approvals for new products have been reduced from 14 to 5 weeks. Revenue is expected to increase by 200 million.

3. **Company: Nike**

 Project: Online supply-chain link to manufacturing partners

 Payoff: Lead time for new shoe development has been reduced from nine months to six. Better forecasting has reduced speculation on what to produce from 30 percent to 3 percent. These efficiencies have upped Nike's gross margin 2.1 percent.

4. **Company: FBI**

 Project: Digitizing millions of fingerprint cards and connecting law enforcement agencies to the data base

 Payoff: Local law enforcement departments can have the FBI check against 46 million sets of fingerprints and respond within two hours. In addition, the FBI conducts background checks for private enterprises (e.g., schools, insurance and securities industry, private security agencies). This latter service resulted in revenue of 152 million for one year.

5. **Company: Kinko's**

 Project: Replace 51 training sites with e-learning network

 Payoff: E-courses online are available to 20,000 employees. Courses range from products, to policies, to new product rollouts. Kinko's expects to save around $10 million a year on employee training. Kinko's is now moving into training for customers—such as making banners, holiday cards, and jazzy transparencies. Stores offering online customer training saw revenues rise 27 percent versus 11 percent in non-online stores.

6. **Company: BMW**

 Project: Build cars to specific customer orders

 Payoff: Updating supply chain from suppliers to customer allows customer (or salesperson) to use the Internet to order cars without altering production-line efficiency; delivery date is delivered in five seconds. Suppliers are notified when order is confirmed so parts arrive just-in-time for production. Cars are off the production line in 11 to 12 days and can be in the United States in 12 additional days. Eighty percent of European buyers design their own custom Beemer. Thirty percent of U.S. buyers access the custom service with the number increasing each year.

7. **Company: Sony**

 Project: Produce and use a secure website to rescue *Lord of the Rings* schedule

 Payoff: Important special effects for the film *Two Towers* fell behind schedule. Coordination between New Zealand, London, and the U.S. became a nightmare. A secure website using special custom software allowed all sites to download and edit over 100 scenes. Simultaneously, each site could use a digital pointer to discuss specific details or pull up specific footage. The one million dollar cost was small relative to the potential wasted cost of missing the promotions and ads deadlines.

*Adapted from Heather Green, "The Web," *BusinessWeek,* November 24, 2003, pp. 82–104.

a portfolio of projects going on concurrently, each at a different stage of each project's life cycle, careful planning and management at the organization and project levels are imperative.

The Project Manager

In a small sense project managers perform the same functions as other managers. That is, they plan, schedule, motivate, and control. However, what makes them unique is that they manage temporary, nonrepetitive activities, to complete a fixed life project. Unlike functional managers, who take over existing operations, project managers create a project team and organization where none existed before. They must decide what and how things should be done instead of simply managing set processes. They must meet the challenges of each phase of the project life cycle, and even oversee the dissolution of their operation when the project is completed.

Project managers must work with a diverse troupe of characters to complete projects. They are typically the direct link to the customer and must manage the tension between

customer expectations and what is feasible and reasonable. Project managers provide direction, coordination, and integration to the project team, which is often made up of part-time participants loyal to their functional departments. They often must work with a cadre of outsiders—vendors, suppliers, subcontractors—who do not necessarily share their project allegience.

Project managers are ultimately responsible for performance (frequently with too little authority). They must ensure that appropriate trade-offs are made between the time, cost, and performance requirements of the project. At the same time, unlike their functional counterparts, project managers generally possess only rudimentary technical knowledge to make such decisions. Instead, they must orchestrate the completion of the project by inducing the right people, at the right time, to address the right issues and make the right decisions.

While project management is not for the timid, working on projects can be an extremely rewarding experience. Life on projects is rarely boring; each day is different from the last. Since most projects are directed at solving some tangible problem or pursuing some useful opportunity, project managers find their work personally meaningful and satisfying. They enjoy the act of creating something new and innovative. Project managers and team members can feel immense pride in their accomplishment, whether it is a new bridge, a new product, or needed service. Project managers are often stars in their organization and well compensated.

Good project managers are always in demand. Every industry is looking for effective people who can get the right things done on time. Clearly, project management is a challenging and exciting profession. This text is intended to provide the necessary knowledge, perspective, and tools to enable students to accept the challenge.

The Importance of Project Management

Project management is no longer a special-need management. It is rapidly becoming a standard way of doing business. See Snapshot from Practice: Project Management at Work. An increasing percentage of the typical firm's effort is being devoted to projects. The future promises an increase in the importance and the role of projects in contributing to the strategic direction of organizations. Several reasons why this is the case are briefly discussed below.

Compression of the Product Life Cycle

One of the most significant driving forces behind the demand for project management is the shortening of the product life cycle. For example, today in high-tech industries the product life cycle is averaging 1 to 3 years. Only 30 years ago, life cycles of 10 to 15 years were not uncommon. *Time to market* for new products with short life cycles has become increasingly important. A common rule of thumb in the world of high-tech product development is that a six-month project delay can result in a 33 percent loss in product revenue share. Speed, therefore, becomes a competitive advantage; more and more organizations are relying on cross-functional project teams to get new products and services to the market as quickly as possible.

Global Competition

Today's open market demands not only *cheaper* products and services but also *better* products and services. This has led to the emergence of the quality movement across the world with ISO 9000 certification a requirement for doing business. ISO 9000 is a family of international standards for quality management and assurance. These standards cover design, procurement, quality assurance, and delivery processes for everything from

banking to manufacturing. Quality management and improvement invariably involve project management. For many, their first exposure to project management techniques has been in quality workshops.

Increased pressures to reduce costs have not only led to the migration of U.S. manufacturing operations to Mexico and Asia, which by itself is a significant project, but also a transformation in how organizations try to achieve results. More and more work is being classified as projects. Individuals are being assigned responsibility to achieve a specific objective within a given budget and by a specified deadline. Project management, with its triple focus on time, cost, and performance, is proving to be an efficient, flexible way to get things done.

Knowledge Explosion

The growth in new knowledge has increased the complexity of projects because projects encompass the latest advances. For example, building a road 30 years ago was a somewhat simple process. Today, each area has increased in complexity, including materials, specifications, codes, aesthetics, equipment, and required specialists. Similarly, in today's digital, electronic age it is becoming hard to find a new product that does not contain at least one microchip. Product complexity has increased the need to integrate divergent technologies. Project management has emerged as an important discipline for achieving this task.

Corporate Downsizing

The last decade has seen a dramatic restructuring of organizational life. Downsizing (or rightsizing if you are still employed) and sticking to core competencies have become necessary for survival for many firms. Middle management is a mere skeleton of the past. In today's flatter and leaner organizations, where change is a constant, project management is replacing middle management as a way of ensuring that things get done. Corporate downsizing has also led to a change in the way organizations approach projects. Companies outsource significant segments of project work, and project managers have to manage not only their own people but also their counterparts in different organizations.

Increased Customer Focus

Increased competition has placed a premium on customer satisfaction. Customers no longer simply settle for generic products and services. They want customized products and services that cater to their specific needs. This mandate requires a much closer working relationship between the provider and the receiver. Account executives and sales representatives are assuming more of a project manager's role as they work with their organization to satisfy the unique needs and requests of clients.

Increased customer attention has also prompted the development of customized products and services. For example, 10 years ago buying a set of golf clubs was a relatively simple process: You picked out a set based on price and feel. Today, there are golf clubs for tall players and short players, clubs for players who tend to slice the ball and clubs for those who hook the ball, high-tech clubs with the latest metallurgic discovery guaranteed to add distance, and so forth. Project management is critical both to development of customized products and services and to sustaining lucrative relationships with customers.

Small Projects Represent Big Problems

The velocity of change required to remain competitive or simply keep up has created an organizational climate in which hundreds of projects are implemented concurrently. This climate has created a multiproject environment and a plethora of new problems. Sharing and prioritizing resources across a portfolio of projects is a major challenge for senior management. Many firms have no idea of the problems involved with inefficient management of

small projects. Small projects typically carry the same or more risk as do large projects. Small projects are perceived as having little impact on the bottom line because they do not demand large amounts of scarce resources and/or money. Because so many small projects are going on concurrently and because the perception of the inefficiency impact is small, measuring inefficiency is usually nonexistent. Unfortunately, many small projects soon add up to large sums of money. Many customers and millions of dollars are lost each year on small projects in product and service organizations.

Many small projects can eat up the people resources of a firm and represent hidden costs not measured in the accounting system. Organizations with many small projects going on concurrently face the most difficult project management problems. A key question becomes one of how to create an organizational environment that supports multi-project management. A process is needed to prioritize and develop a portfolio of small projects that supports the mission of the organization.

In summary, there are a variety of environmental forces interacting in today's business world that contribute to the increased demand for good project management across all industries and sectors. Project management appears to be ideally suited for a business environment requiring accountability, flexibility, innovation, speed, and continuous improvement.

Project Management Today—An Integrative Approach

Some project managers have used different tools that are useful for managing projects. For example, networks, bar charts, job costing, task forces, partnering, and scheduling all have been used—sometimes very successfully and other times with poor results. As the world becomes more competitive, the importance of managing the process of project management and "getting it right the first time" takes on new meaning. Piecemeal systems fail to tie to the overall strategies of the firm. Piecemeal project priority systems fail to connect the selected projects to resources. Piecemeal tools and techniques fail to be integrated throughout the project life cycle. Piecemeal approaches fail to balance the application of project planning and control methods with appropriate adjustments in the organization's culture to support project endeavors.

Today, emphasis is on development of an integrated project management process that focuses all project effort toward the strategic plan of the organization and reinforces mastery of both the project management tools/techniques and the interpersonal skills necessary to orchestrate successful project completion. For some organizations, integrating projects with strategy will require reengineering the entire business management process. For others, integration will mean carefully establishing linkages among the piecemeal systems already in place and altering the focus to one of a total system. At the individual level, for some professionals to become effective project managers will require augmenting their leadership and team-building skills with modern project planning and control methods. For others it will require complementing their administrative skills with the capacity to inspire and lead a divergent cast of professionals to project completion.

Integration in project management directs attention to two key areas. The first area is integration of projects with the strategic plan of the organization. The second area is integration within the process of managing actual projects. Each of these areas is examined next.

Integration of Projects with the Strategic Plan

In some organizations, selection and management of projects often fail to support the strategic plan of the organization. Strategic plans are written by one group of managers, projects selected by another group, and projects implemented by another. These independent

decisions by different groups of managers create a set of conditions leading to conflict, confusion, and—frequently—an unsatisfied customer. Under these conditions, resources of the organization are wasted in non-value-added activities/projects.

An integrated project management system is one in which all of the parts are interrelated. A change in any one of the parts will influence the whole. Every organization has a customer it is seeking to satisfy. The customer sets the raison d'être for the organization. Mission, objectives, and strategies are set to meet the needs of customer(s). Development of a mission, objectives, and organization strategies depend on the external and internal environmental factors. External environmental factors are usually classified as political, social, economic, and technological; they signal opportunities or threats in setting the direction for the organization. Internal environmental factors are frequently classified as strengths and weaknesses such as management, facilities, core competencies, and financial condition. The outcome of the analysis of all these environmental factors is a set of strategies designed to best meet the needs of customers. But this is only the first step (see Figure 1.3).

Implementing strategies is the most difficult step. Strategies are typically implemented through projects. Creative minds always propose more projects than there are resources. The key is selecting from the many proposals those projects that make the largest and most balanced contribution to the objectives and strategies (and thus, customers) of the organization. This means prioritizing projects so that scarce resources are allocated to the right projects. Once a project has been selected for implementation, the focus switches to the project management process that sets the stage for how the project will be implemented or delivered.

FIGURE 1.3
Integrated Management of Projects

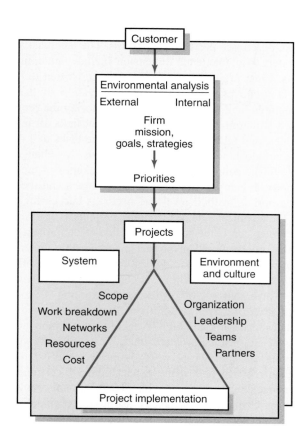

The phrase "works well with others" has long been a staple on grade school report cards; now, in the IT world, it's the No. 1 criterion for management candidates. In a nationwide survey conducted in 1999, 27 percent of chief information officers (CIOs) cited strong interpersonal skills as the single most important quality for reaching management levels. Advanced technical skills came in second, receiving 23 percent of the response.

The project was sponsored by RHI Consulting, which provides information technology professionals on a project basis. An independent research firm was hired to administer the survey. Over 1,400 CIOs responded to the questionnaire.

Survey respondents were also asked:

In 2005, how frequently will employees in your IT department work on project-based teams with members of other departments throughout the company?

Their responses:		
Very frequently	57%	
Somewhat frequently	26%	
Somewhat infrequently	10%	
Very infrequently	6%	
Never	1%	

Greg Scileppi, RHI Consulting's executive director, recommends that IT professionals develop their interpersonal skills. "The predominance of project teams has created a corresponding need for strong communication and team-player abilities. Technical staff put these skills to test daily as they work with employees at all levels to create and implement IT solutions ranging from simple troubleshooting to corporate web initiatives and system wide upgrades."

*Joanita M. Nellenbach, "People Skills Top Technical Knowledge, CIOs Insist," PMNetwork (August 1999), pp. 7–8.

Integration within the Process of Managing Actual Projects

There are two dimensions within the project management process (see Figure 1.4). The first dimension is the technical side of the management process, which consists of the formal, disciplined, pure logic parts of the process. The technical side relies on the formal information system available. This dimension includes planning, scheduling, and controlling projects. Clear project scope statements are written to link the project and customer and to facilitate planning and control. Creation of the deliverables and work breakdown structures facilitate planning and monitoring the progress of the project. The work breakdown structure serves as a database that links all levels in the organization, major deliverables, and all work—right down to the tasks in a work package. Effects of project changes are documented and traceable. Thus, any change in one part of the project is traceable to the source by the integrated linkages of the system. This integrated information approach can provide all project managers and the customer with decision information appropriate to their level and needs. A successful project manager will be well trained in the technical side of managing projects.

The second dimension is the sociocultural side of the project management process. In contrast with the orderly world of project planning, this dimension involves the much messier, often contradictory and paradoxical world of implementation. It centers on creating a temporary social system within a larger organizational environment that combines the talents of a divergent set of professionals working to complete the project. See Research Highlight: Works Well with Others. Project managers must shape a project culture that stimulates teamwork and high levels of personal motivation as well as a capacity to quickly identify and resolve problems that threaten project work. This dimension also involves managing the interface between the project and external environment. Project managers have to assuage and shape expectations of customers, sustain the political support of top management, negotiate with their functional counterparts, monitor subcontractors, and so on. Overall, the manager must build a cooperative social network among a divergent set of allies with different standards, commitments, and perspectives.

FIGURE 1.4
The Technical and Sociocultural Dimensions of the Project Management Process

Some suggest that the technical dimension represents the "science" of project management while the sociocultural dimension represents the "art" of managing a project. To be successful, a manager must be a master of both. Unfortunately, some project managers become preoccupied with the planning and technical dimension of project management. Often their first real exposure to project management is through project management software, and they become infatuated with network charts, Gantt diagrams, and performance variances and attempt to manage a project from a distance. Conversely, there are other managers who manage projects by the "seat of their pants," relying heavily on team dynamics and organizational politics to complete a project. Good project managers balance their attention to both the technical and sociocultural dimensions of project management.

Summary

There are powerful environmental forces contributing to the rapid expansion of project management approaches to business problems and opportunities. A project is defined as a nonroutine, one-time effort limited by time, resources, and performance specifications designed to meet customer needs. One of the distinguishing characteristics of project management is that it has both a beginning and an end and typically consists of four phases: defining, planning, executing, and delivering. Effective project management begins with selecting and prioritizing projects that support the firm's mission and strategy. Successful implementation requires both technical and social skills. Project managers have to plan and budget projects as well as orchestrate the contributions of others.

Text Overview

This text is written to provide the reader with a comprehensive, integrative understanding of the project management process. The text focuses both on the science of project management and the art of managing projects. Following this introductory chapter, Chapter 2

focuses on how organizations go about evaluating and selecting projects. Special attention is devoted to the importance of linking project selection to the mission and strategy of the firm. The organizational environment in which projects are implemented is the focus of Chapter 3. The discussion of matrix management and other organizational forms is augmented by a discussion of the role the culture of an organization plays in the implementation of projects.

The next six chapters focus on developing a plan for the project; after all, project success begins with a good plan. Chapter 4 deals with defining the scope of the project and developing a work breakdown structure (WBS). The challenge of formulating cost and time estimates is the subject of Chapter 5. Chapter 6 focuses on utilizing the information from the WBS to create a project plan in the form of a timed and sequenced network of activities.

Risks are a potential threat to project management, and Chapter 7 examines how organizations and managers identify and manage risks associated with project work. Resource allocation is added to the plan in Chapter 8 with special attention devoted to how resource limitations impact the project schedule. After a resource schedule is established, a project time-phased budget is developed. Finally, Chapter 9 examines strategies for reducing ("crashing") project time either prior to the initiation of the project or in response to problems or new demands placed on the project.

Chapters 10 through 12 focus on project implementation and the sociocultural side of project management, beginning with Chapter 10, which focuses on the role of the project manager as a leader and stresses the importance of managing project stakeholders within the organization. Chapter 11 focuses on the core project team; it combines the latest information on team dynamics with leadership skills/techniques for developing a high-performance project team. Chapter 12 continues the theme of managing project stakeholders by discussing how to outsource project work and negotiate with contractors, customers, and suppliers.

Chapter 13 focuses on the kinds of information managers use to monitor project progress, with special attention devoted to the key concept of earned value. Issues surrounding the termination or completion of the project are dealt with in Chapter 14. Implementation of project management in multicultural, international environments is the subject of Chapter 15. Finally, Chapter 16 notes the need for organizational oversight and how it impacts the management of projects. A special segment on pursuing a career in project management is also included.

Throughout this text you will be exposed to the major aspects of the project management system. However, a true understanding of project management comes not from knowing what a scope statement is, or the critical path, or partnering with contractors, but from comprehending how the different elements of the project management system interact to determine the fate of a project. If, by the end of this text, you come to appreciate and begin to master both the technical and sociocultural dimensions of project management, you should have a distinct competitive advantage over others aspiring to work in the field of project management.

Key Terms	ISO 9000	Project	Project Management
	Program	Project life cycle	Professional (PMP)
			Sociotechnical perspective

Review Questions

1. Define a project. What are five characteristics that help differentiate projects from other functions carried out in the daily operations of the organization?

2. What are some of the key environmental forces that have changed the way projects are managed? What has been the effect of these forces on the management of projects?

3. Why is the implementation of projects important to strategic planning and the project manager?

4. The technical and sociocultural dimensions of project management are two sides to the same coin. Explain.

5. What is meant by an integrative approach to project management? Why is this approach important in today's environment?

Exercises

1. Review the front page of your local newspaper, and try to identify all the projects contained in the articles. How many were you able to find?

2. Individually identify what you consider to be the greatest achievements accomplished by mankind in the last five decades. Now share your list with three to five other students in the class, and come up with an expanded list. Review these accomplishments in terms of the definition of a project. What does your review suggest about the importance of project management?

3. Individually identify projects assigned in previous terms. Were both sociocultural and technical elements factors in the success or difficulties in the projects?

4. Check out the Project Management Institute's home page at *www.pmi.org*.

 a. Review general information about PMI as well as membership information.

 b. See if there is a PMI chapter in your state. It not, where is the closest one?

 c. Use the search function at the PMI home page to find information on Project Management Body of Knowledge (PMBOK). What are the major knowledge areas of PMBOK?

 d. Explore other links that PMI provides. What do these links tell you about the nature and future of project management?

Note: If you have any difficulty accessing any of the Web addresses listed here or elsewhere in the text, you can find up-to-date addresses on the home page of Dr. Erik Larson, coauthor of this text: *http://www.bus.oregonstate.edu/faculty/bio.htm?UserName=Larson*

References

Benko, C. and F. W. McFarlan, *Connecting the Dots* (Boston: HBS Press, 2003).

Cohen, D. J. and R. J. Graham, *The Project Manager's MBA* (San Francisco: Jossey-Bass, 2001).

Kerzner, H. *Project Management: A Systems Approach to Planning, Scheduling, and Controlling* (New York: Wiley, 2003).

Larkowski, K. "Standish Group Report Shows Project Success Improves 50 Percent," *www.standishgroup.com*, 2004, Third Quarter.

Peters, T. *PM Network,* January 2004, Vol. 18, No. 1, p. 19.

Project Management Institute, *Leadership in Project Management Annual* (Newton Square, PA: PMI Publishing, 2006).

Stewart, T. A. "The Corporate Jungle Spawns a New Species: The Project Manager," *Fortune* (September 1996), pp. 14–15.

Wysocki, B. "Flying Solo: High-Tech Nomads Write New Program for Future of Work," *The Wall Street Journal* (August 19, 1996), p. 1.

Case

A Day in the Life

Rachel, the project manager of a large information systems project, arrives at her office early to get caught up with work before her co-workers and project team arrive. However, as she enters the office she meets Neil, one of her fellow project managers, who also wants to get an early start on the day. Neil has just completed a project overseas. They spend 10 minutes socializing and catching up on personal news.

It takes Rachel 10 minutes to get to her office and settle in. She then checks her voice mail and turns on her computer. She was at her client's site the day before until 7:30 P.M. and has not checked her e-mail or voice mail since 3:30 P.M. the previous day. There are 7 phone messages, 16 e-mails, and 4 notes left on her desk. She spends 15 minutes reviewing her schedule and "to do" lists for the day before responding to messages that require immediate attention.

Rachel spends the next 25 minutes going over project reports and preparing for the weekly status meeting. Her boss, who just arrived at the office, interrupts her. They spend 20 minutes discussing the project. He shares a rumor that a team member is using stimulants on the job. She tells him that she has not seen anything suspicious but will keep an eye on the team member.

The 9:00 A.M. project status meeting starts 15 minutes late because two of the team members have to finish a job for a client. Several people go to the cafeteria to get coffee and doughnuts while others discuss last night's baseball game. The team members arrive, and the remaining 45 minutes of the progress review meeting surface project issues that have to be addressed and assigned for action.

After the meeting Rachel goes down the hallway to meet with Victoria, another IS project manager. They spend 30 minutes reviewing project assignments since the two of them share personnel. Victoria's project is behind schedule and in need of help. They broker a deal that should get Victoria's project back on track.

She returns to her office and makes several phone calls and returns several e-mails before walking downstairs to visit with members of her project team. Her intent is to follow up on an issue that had surfaced in the status report meeting. However, her simple, "Hi guys, how are things going?" elicits a stream of disgruntled responses from the "troops." After listening patiently for over 20 minutes, she realizes that among other things several of the client's managers are beginning to request features that were not in the original project scope statement. She tells her people that she will get on this right away.

Returning to her office she tries to call her counterpart John at the client firm but is told that he is not expected back from lunch for another hour. At this time, Eddie drops by and says, "How about lunch?" Eddie works in the finance office and they spend the next half hour in the company cafeteria gossiping about internal politics. She is surprised to hear that Jonah Johnson, the director of systems projects, may join another firm. Jonah has always been a powerful ally.

She returns to her office, answers a few more e-mails, and finally gets through to John. They spend 30 minutes going over the problem. The conversation ends with John promising to do some investigating and to get back to her as soon as possible.

Rachel puts a "Do not disturb" sign on her door, and lies down in her office. She listens to the third and fourth movement of Ravel's string quartet in F on headphones.

Rachel then takes the elevator down to the third floor and talks to the purchasing agent assigned to her project. They spend the next 30 minutes exploring ways of getting

necessary equipment to the project site earlier than planned. She finally authorizes express delivery.

When she returns to her office, her calendar reminds her that she is scheduled to participate in a conference call at 2:30. It takes 15 minutes for everyone to get online. During this time, Rachel catches up on some e-mail. The next hour is spent exchanging information about the technical requirements associated with a new version of a software package they are using on systems projects like hers.

Rachel decides to stretch her legs and goes on a walk down the hallway where she engages in brief conversations with various co-workers. She goes out of her way to thank Chandra for his thoughtful analysis at the status report meeting. She returns to find that John has left a message for her to call him back ASAP. She contacts John, who informs her that, according to his people, her firm's marketing rep had made certain promises about specific features her system would provide. He doesn't know how this communication breakdown occurred, but his people are pretty upset over the situation. Rachel thanks John for the information and immediately takes the stairs to where the marketing group resides.

She asks to see Mary, a senior marketing manager. She waits 10 minutes before being invited into her office. After a heated discussion, she leaves 40 minutes later with Mary agreeing to talk to her people about what was promised and what was not promised.

She goes downstairs to her people to give them an update on what is happening. They spend 30 minutes reviewing the impact the client's requests could have on the project schedule. She also shares with them the schedule changes she and Victoria had agreed to. After she says good night to her team, she heads upstairs to her boss's office and spends 20 minutes updating him on key events of the day. She returns to her office and spends 30 minutes reviewing e-mails and project documents. She logs on to the MS project schedule of her project and spends the next 30 minutes working with "what-if" scenarios. She reviews tomorrow's schedule and writes some personal reminders before starting off on her 30-minute commute home.

1. How effectively do you think Rachel spent her day?
2. What does the case tell you about what it is like to be a project manager?

[Handwritten annotations:]

1. ✓ create project norms on team for efficiency and example
 ✓ schedule meetings efficiently w/ stakeholders, ie. Mary client herself.
2. ✓ her preparation for her meeting ⊕ ↑ meeting time efficiency
4. ✓ ⊕ in gaining resources w/ Victoria by meeting w/ Victoria
5. ✓ when leaving messages leave time slots (small items)
6. ✓ Relaxing? on Co time
7. ⊕ w/ Chandra for ⊕ reinforcement
8. interfering w/ client relations and creating a poor perception in

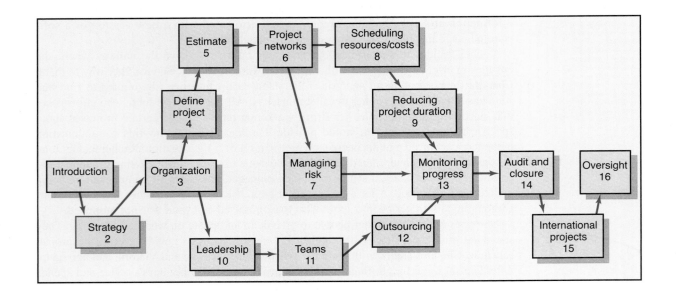

Organization Strategy and Project Selection

The Strategic Management Process: An Overview

The Need for an Effective Project Portfolio Management System

A Portfolio Management System

Applying a Selection Model

Managing the Portfolio System

Summary

Appendix 2.1: Request for Proposal (RFP)

Organization Strategy and Project Selection

Strategy is implemented through projects. Every project should have a clear link to the organization's strategy.

Project managers commonly complain that projects appear out of nowhere. Comments such as the following are samples of those heard in practice:

- Where did this project come from?
- Should I stop working on this project and start on the new one?
- Why are we doing this project?
- How can all these projects be first priority?
- Where are we going to get the resources to do this project?

There are too many organizations in which many managers cannot identify a project's priority and link it with the strategic plan. This is not good management! Every project should contribute value to the organization's strategic plan, which is designed to meet the future needs of its customers. Ensuring a strong linkage between the strategic plan and projects is a difficult task that demands constant attention from top and middle management. The larger and more diverse an organization, the more difficult it is to create and maintain this strong link. Ample evidence still suggests that many organizations have not developed a process that clearly aligns project selection to the strategic plan. The result is poor utilization of the organization's resources—people, money, equipment, and core competencies. Conversely, organizations that have a coherent link of projects to strategy have more cooperation across the organization, perform better on projects, and have fewer projects.

How can an organization ensure this link and alignment? The answer requires integration of projects with the strategic plan. Integration assumes the existence of a strategic plan and a process for prioritizing projects by their contribution to the plan. A crucial factor to ensure the success of integrating the plan with projects lies in the creation of a process that is open and published for all participants to review. This chapter presents an overview of the importance of strategic planning and the process for developing a strategic plan. Typical problems encountered when strategy and projects are not linked are noted. A generic methodology that ensures integration by creating very strong linkages of project selection and priority to the strategic plan is then discussed. The intended outcomes are clear organization focus, best use of scarce organization resources (people, equipment, capital), and improved communication across projects and departments.

Why Project Managers Need to Understand Strategy

Project management historically has been preoccupied solely with the planning and execution of projects. Strategy was considered to be under the purview of senior management. This is old-school thinking. New-school thinking recognizes that project management is at the apex of strategy and operations. Aaron Shenhar speaks to this issue when he states, ". . . it is time to expand the traditional role of the project manager from an operational to a more strategic perspective. In the modern evolving organization, project managers will be focused on business aspects, and their role will expand from getting the job done to achieving the business results and winning in the market place."

There are two main reasons why project managers need to understand their organization's mission and strategy. The first reason is so they can make appropriate decisions and adjustments. For example, how a project manager would respond to a suggestion to modify the design of a product to enhance performance will vary depending upon whether his company strives to be a product leader through innovation or to achieve operational excellence through low cost solutions. Similarly, how a project manager would respond to delays may vary depending upon strategic concerns. A project manager will authorize overtime if her firm places a premium on getting to the market first. Another project manager will accept the delay if speed is not essential.

J. P. Descamps has observed that project managers who do not understand the role their project plays in accomplishing the strategy of their organization tend to make the following serious mistakes:

- Focusing on problems or solutions that have low priority strategically
- Focusing on the immediate customer rather than the whole market place and value chain
- Overemphasizing technology as an end in and of itself, resulting in projects that wander off pursuing exotic technology that does not fit the strategy or customer need
- Trying to solve every customer issue with a product or service rather than focusing on the 20 percent with 80 percent of the value (Pareto's Law)
- Engaging in a never-ending search for perfection that no one except the project team really cares about

The second reason project managers need to understand their organization's strategy is so that they can be effective project advocates. Project managers have to be able to demonstrate to senior management how their project contributes to their firm's mission. Protection and continued support come from being aligned with corporate objectives. Project managers also need to be able to explain to team members and other stakeholders why certain project objectives and priorities are critical. This is essential for getting buy-in on contentious trade-off decisions.

For these reasons project managers will find it valuable to have a keen understanding of strategic management and project selection processes, which are discussed next.

The Strategic Management Process: An Overview

Strategic management is the process of assessing "what we are" and deciding and implementing "what we intend to be and how we are going to get there." Strategy describes how an organization intends to compete with the resources available in the existing and perceived future environment.

Two major dimensions of strategic management are responding to changes in the external environment and allocating scarce resources of the firm to improve its competitive position.

Courtesy Intel Corporation.

INTEL CEO Craig R. Barrett is planning his last hurrah only 15 months before his retirement to chairman of the board. His vision for INTEL is to move beyond computers: think INTEL everywhere. Barrett says, "Everything in the world is going digital." He wants INTEL chips to be the guts of every digital device on the planet—especially in the communications, consumer electronics, and entertainment industries. Think—cell phones, wireless home networks, video players, flat panel TVs—INTEL's expertise fits right in.

He is hitting the market today with a chip technology called WiMax "that can be used to deliver high speed Internet access throughout a small city (or 30 miles) for about $100,000, which is about one-tenth the cost of rolling out fiber optic lines today." (A competitor, WiFi, has a range of about 200 feet.) Cable and phone companies are very interested because of low entry costs.

Some critics believe Barrett's shotgun approach is too risky. He doesn't see it that way. Rather than following INTEL's past go-it-alone approach to new products, he wants INTEL to forge closer ties with customers by designing products they need rather than designing products no one asked for. He admits going into consumer markets will be a challenge and a half. He intends to provide financial support and cooperation for companies creating new products that will use INTEL chips. Barrett feels the risk of providing financial support for smaller companies creating new products is low, even if some go bust. If most of the new products take off, risk is minimized because their markets will lead to increasing demand for new, larger, and faster PCs where INTEL manufacturing dominates cost.

Implementing the new vision will not keep INTEL's manufacturing from remaining on the cutting edge. By 2005 five new factories will manufacture 12-inch wafers printed with 90-nanometer circuit lines, just 0.1 percent the width of a human hair. These plants are expected to slash chip costs in half.

The mission has been set: Create INTEL chips to meet the need of new digital products. Right or wrong, everyone in the organization knows the game plan and can focus their efforts in this new consumer-oriented direction. Projects related to digital products will be ranked high priority.

* Adapted from Cliff Edwards, "What Is CEO Craig Barrett Up To?" *Business Week,* March 8, 2004, pp. 56–64.

Constant scanning of the external environment for changes is a major requirement for survival in a dynamic competitive environment. The second dimension is the internal responses to new action programs aimed at enhancing the competitive position of the firm. The nature of the responses depends on the type of business, environment volatility, competition, and the organizational culture.

Strategic management provides the theme and focus of the future direction of the organization. It supports consistency of action at every level of the organization. It encourages integration because effort and resources are committed to common goals and strategies. See Snapshot from Practice: Move Beyond Computers. It is a continuous, iterative process aimed at developing an integrated and coordinated long-term plan of action. Strategic management positions the organization to meet the needs and requirements of its customers for the long term. With the long-term position identified, objectives are set, and strategies are developed to achieve objectives and then translated into actions by implementing projects. Strategy can decide the survival of an organization. Most organizations are successful in *formulating* strategies for what course(s) they should pursue. However, the problem in many organizations is *implementing* strategies—that is, making them happen. Integration of strategy formulation and implementation often does not exist.

The components of strategic management are closely linked, and all are directed toward the future success of the organization. Strategic management requires strong links among mission, goals, objectives, strategy, and implementation. The mission gives the general purpose of the organization. Goals give global targets within the mission. Objectives give specific targets to goals. Objectives give rise to formulation of strategies to reach objectives. Finally, strategies require actions and tasks to be implemented. In most cases the actions to be taken represent projects. Figure 2.1 shows a schematic of the strategic management process and major activities required.

Four Activities of the Strategic Management Process

The typical sequence of activities of the strategic management process is outlined here; a description of each activity then follows:

1. Review and define the organizational mission.
2. Set long-range goals and objectives.
3. Analyze and formulate strategies to reach objectives.
4. Implement strategies through projects.

Review and Define the Organizational Mission

The mission identifies "what we want to become," or the raison d'être. Mission statements identify the scope of the organization in terms of its product or service. A written mission statement provides focus for decision making when shared by organizational managers and employees. Everyone in the organization should be keenly aware of the organization's mission. For example, at one large consulting firm, partners who fail to recite the mission statement on demand are required to buy lunch. The mission statement communicates and identifies the purpose of the organization to all stakeholders. Mission statements can be used for evaluating organization performance.

Traditional components found in mission statements are major products and services, target customers and markets, and geographical domain. In addition, statements frequently include organizational philosophy, key technologies, public image, and contribution to society. Including such factors in mission statements relates directly to business success.

FIGURE 2.1
Strategic Management Process

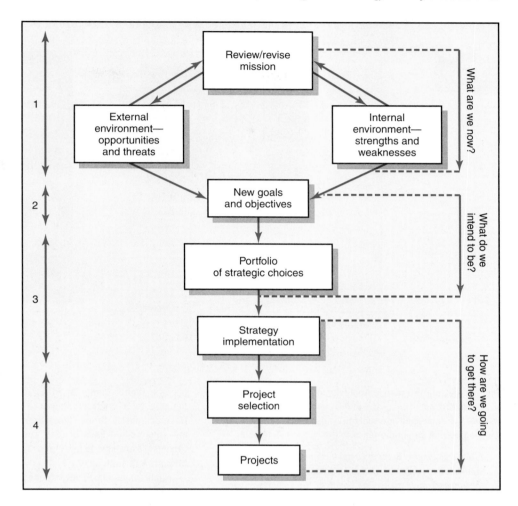

Mission statements change infrequently. However, when the nature of the business changes or shifts, a revised mission statement may be required. For example, Steve Jobs of Apple Computer envisioned the use of computer technology beyond the PC desktop. His mission was to look at computer technology as the vehicle for work and entertainment. As a result he developed the iPod for selling music and masterminded the development of animated movies such as *Finding Nemo* through the Pixar organization. See the adjacent Apple snapshot from practice to find out more about how Apple's mission shapes new product development projects.

More specific mission statements tend to give better results because of a tighter focus. Mission statements decrease the chance of false directions by stakeholders. For example, compare the phrasing of the following mission statements:

Provide hospital design services.

Provide voice/data design services.

Provide information technology services.

Increase shareholder value.

Provide high-value products to our customer.

Courtesy of Apple Computer.

Since Steve Jobs returned to Apple Computers as CEO in 1997, he has been strikingly successful in developing a turnaround strategy that has developed new markets and increased market share. It all begins with strict adherence to the mission statement:

Apple is committed to bringing the best personal computing experience to students, educators, creative professionals and consumers around the world through its innovative hardware, software and Internet offerings.

The thrust of the turnaround strategy includes mass customization and targeting market segments. Apple's primary competitive advantage is that it controls both the hardware and software aspects of most of its products. The vision, coupled with this strong strategic advantage, allows Apple to offer innovation in hardware, software, and Internet offerings. From the vision statement many product strategies have been forthcoming. For example, Jobs first segmented Apple's market into consumer and professional. This segmentation reduces the number of products and sharply targets products to specific end users.

Several specific strategies have developed for the consumer market. For example, Jobs believes users should be able to connect their MP3 players, iPods, DVD players, CD players, digital cameras, PDAs, DV camcorders, and other gadgets to a central computer, known as the digital hub. Development of iTunes allows users to mix and burn CDs from the comfort and ease of their computer. Along with burning CDs, users are able to use iTunes to sync their music files with MP3 players such as iPod.

Apple's competitive advantages provide strong support for its product strategies. Some of the more obvious are listed here:

- Control over both hardware and software—avoids compatibility problems
- High quality and innovation image
- Common Architecture fits most products and eases development time
- Free Software
- Ease of use
- Loyal customer base

For over ten years the string of innovative products from Apple has been spectacular. No end is in sight. Each new product endeavor closely aligns with the mission statement and current strategies. Launching new products in new markets requires executing projects within tight time, cost and scope constraints.

Clearly, the first two statements leave less chance for misinterpretation than the others. A rule-of-thumb test for a mission statement is, if the statement can be anybody's mission statement, it will not provide the guidance and focus intended. The mission sets the parameters for developing objectives.

Long-Range Goals and Objectives

Objectives translate the organization mission into specific, concrete, measurable terms. Organizational objectives set targets for all levels of the organization. Objectives pinpoint the direction managers believe the organization should move toward. Objectives answer in detail *where* a firm is headed and *when* it is going to get there. Typically, objectives for the organization cover markets, products, innovation, productivity, quality, finance, profitability, employees, and consumers. In every case, objectives should be as operational as possible. That is, objectives should include a time frame, be measurable, be an identifiable state, and be realistic. Doran created the memory device shown in Exhibit 2.1, which is useful when writing objectives.

Each level below the organizational objectives should support the higher-level objectives in more detail; this is frequently called cascading of objectives. For example, if a firm making leather luggage sets an objective of achieving a 40 percent increase in sales through a research and development strategy, this charge is passed to the marketing, production, and R&D departments. The R&D department accepts the firm's strategy as their objective, and their strategy becomes the design and development of a new "pull-type luggage with hidden retractable wheels." At this point the objective becomes a project to be implemented— to develop the retractable wheel luggage for market within six months within a budget of $200,000. In summary, organizational objectives drive your projects.

Analyze and Formulate Strategies to Reach Objectives

Formulating strategy answers the question of *what* needs to be done to reach objectives. Strategy formulation includes determining and evaluating alternatives that support the organization's objectives and selecting the best alternative. The first step is a realistic evaluation of the past and current position of the enterprise. This step typically includes an analysis of "who are the customers" and "what are their needs as they (the *customers*) see them."

The next step is an assessment of the internal and external environments. What are the internal strengths and weaknesses of the enterprise? Examples of internal strengths or weaknesses could be core competencies, such as technology, product quality, management talent, low debt, and dealer networks. Managers can alter internal strengths and weaknesses. Opportunities and threats usually represent external forces for change such as technology, industry structure, and competition. Competitive benchmarking tools are sometimes used here to assess current and future directions. Opportunities and threats are the flip sides of each other. That is, a threat can be perceived as an opportunity, or vice versa. Examples of perceived external threats could be a slowing of the economy, a maturing life cycle, exchange rates, or government regulation. Typical opportunities are increasing demand, emerging markets, and demographics. Managers or individual firms have limited opportunities to influence such external environmental factors; however, in

EXHIBIT 2.1
Characteristics of Objectives

S	Specific	Be specific in targeting an objective
M	Measurable	Establish a measurable indicator(s) of progress
A	Assignable	Make the objective assignable to one person for completion
R	Realistic	State what can realistically be done with available resources
T	Time related	State when the objective can be achieved, that is, duration

recent years notable exceptions have been new technologies such as Apple using the iPod to create a market to sell music. The keys are to attempt to forecast fundamental industry changes and stay in a proactive mode rather than a reactive one. This assessment of the external and internal environments is known as the SWOT analysis (strengths, weaknesses, opportunities, and threats).

From this analysis, critical issues and a portfolio of strategic alternatives are identified. These alternatives are compared with the current portfolio and available resources; strategies are then selected that should support the basic mission and objectives of the organization. Critical analysis of the strategies includes asking questions: Does the strategy take advantage of our core competencies? Does the strategy exploit our competitive advantage? Does the strategy maximize meeting customers' needs? Does the strategy fit within our acceptable risk range?

Strategy formulation ends with cascading objectives or tasks assigned to lower divisions, departments, or individuals. Formulating strategy might range around 20 percent of management's effort, while determining *how* strategy will be implemented might consume 80 percent.

Implement Strategies through Projects

Implementation answers the question of *how* strategies will be realized, given available resources. The conceptual framework for strategy implementation lacks the structure and discipline found in strategy formulation. Implementation requires action and completing tasks; the latter frequently means mission-critical projects. Therefore, implementation must include attention to several key areas.

First, completing tasks requires allocation of resources. Resources typically represent funds, people, management talents, technological skills, and equipment. Frequently, implementation of projects is treated as an "addendum" rather than an integral part of the strategic management process. However, multiple objectives place conflicting demands on organizational resources. Second, implementation requires a formal and informal organization that complements and supports strategy and projects. Authority, responsibility, and performance all depend on organization structure and culture. Third, planning and control systems must be in place to be certain project activities necessary to ensure strategies are effectively performed. Fourth, motivating project contributors will be a major factor for achieving project success. Finally, an area receiving more attention in recent years is prioritizing projects. Although the strategy implementation process is not as clear as strategy formulation, all managers realize that, without implementation, success is impossible.

The Need for an Effective Project Portfolio Management System

Implementation of projects without a strong priority system linked to strategy creates problems. Three of the most obvious problems are discussed below. A project portfolio system can go a long way to reduce, or even eliminate, the impact of these problems.

Problem 1: The Implementation Gap

In organizations with short product life cycles, it is interesting to note that frequently participation in strategic planning and implementation includes participants from all levels within the organization. However, in perhaps 80 percent of the remaining product and service organizations, top management pretty much formulates strategy and leaves strategy implementation to functional managers. Within these broad constraints, more detailed strategies and objectives are developed by the functional managers. The fact that these

objectives and strategies are made *independently* at different levels by functional groups within the organization hierarchy causes manifold problems.

Some symptoms of organizations struggling with strategy disconnect and unclear priorities are presented here.

- Conflicts frequently occur among functional managers and cause lack of trust.
- Frequent meetings are called to establish or renegotiate priorities.
- People frequently shift from one project to another, depending on current priority. Employees are confused about which projects are important.
- People are working on multiple projects and feel inefficient.
- Resources are not adequate.

Because clear linkages do not exist, the organizational environment becomes dysfunctional, confused, and ripe for ineffective implementation of organization strategy and, thus, of projects. The implementation gap refers to the lack of understanding and consensus of organization strategy among top and middle-level managers.

A scenario the authors have seen repeated several times follows. Top management picks their top 20 projects for the next planning period, without priorities. Each functional department—marketing, finance, operations, engineering, information technology, and human resources—selects projects from the list. Unfortunately independent department priorities across projects are not homogenous. A project that rates first in the IT department can rate 10th in the finance department. Implementation of the projects represents conflicts of interest with animosities developing over organization resources.

If this condition exists, how is it possible to effectively implement strategy? The problem is serious. One study found that only about 25 percent of *Fortune 500* executives believe there is a strong linkage, consistency, and/or agreement between the strategies they formulate and implementation. Middle managers considered organizational strategy to be under the purview of others or not in their realm of influence. It is the responsibility of senior management to set policies that show a distinct link between organizational strategy and objectives and projects that implement those strategies. The research of Fusco suggests the implementation gap and prioritizing projects are still overlooked by many organizations. He surveyed 280 project managers and found that 24 percent of their organizations did not even publish or circulate their objectives; in addition, 40 percent of the respondents reported that priorities among competing projects were not clear, while only 17 percent reported clear priorities.

Problem 2: Organization Politics

Politics exist in every organization and can have a significant influence on which projects receive funding and high priority. This is especially true when the criteria and process for selecting projects are ill-defined and not aligned with the mission of the firm. Project selection may be based not so much on facts and sound reasoning, but rather on the persuasiveness and power of people advocating projects.

The term "sacred cow" is often used to denote a project that a powerful, high-ranking official is advocating. Case in point, a marketing consultant confided that he was once hired by the marketing director of a large firm to conduct an independent, external market analysis for a new product the firm was interested in developing. His extensive research indicated that there was insufficient demand to warrant the financing of this new product. The marketing director chose to bury the report and made the consultant promise never to share this information with anyone. The director explained that this new product was the "pet idea" of the new CEO, who saw it as his legacy to the firm. He went on to describe

the CEO's irrational obsession with the project and how he referred to it as his "new baby." Like a parent fiercely protecting his child, the marketing director believed that he would lose his job if such critical information ever became known.

Having a project sponsor can play a significant role in the selection and successful implementation of product innovation projects. Project sponsors are typically high-ranking managers who endorse and lend political support for the completion of a specific project. They are instrumental in winning approval of the project and in protecting the project during the critical development stage. Savvy project managers recognize the importance of having "friends in higher courts" who can advocate for their case and protect their interests.

The significance of corporate politics can be seen in the ill-fated ALTO computer project at Xerox during the mid-1970s. The project was a tremendous technological success; it developed the first workable mouse, the first laser printer, the first user-friendly software, and the first local area network. All of these developments were five years ahead of their nearest competitor. Over the next five years this opportunity to dominate the nascent personal computer market was squandered because of internal in-fighting at Xerox and the absence of a strong project sponsor.

Politics can play a role not only in project selection but also in the aspirations behind projects. Individuals can enhance their power within an organization by managing extraordinary and critical projects. Power and status naturally accrue to successful innovators and risk takers rather than to steady producers. Many ambitious managers pursue high-profile projects as a means for moving quickly up the corporate ladder. For example, Lee Iacocca's career was built on successfully leading the design and development of the highly successful Ford Mustang. Managers become heroes by leading projects that contribute significantly to an organization's mission or solve a pressing crisis.

Many would argue that politics and project management should not mix. A more proactive response is that projects and politics invariably mix and that effective project managers recognize that any significant project has political ramifications. Likewise, top management needs to develop a system for identifying and selecting projects that reduces the impact of internal politics and fosters the selection of the best projects for achieving the mission and strategy of the firm.

Problem 3: Resource Conflicts and Multitasking

Most project organizations exist in a multiproject environment. This environment creates the problems of project interdependency and the need to share resources. For example, what would be the impact on the labor resource pool of a construction company if it should win a contract it would like to bid on? Will existing labor be adequate to deal with the new project—given the completion date? Will current projects be delayed? Will subcontracting help? Which projects will have priority? Competition among project managers can be contentious. All project managers seek to have the best people for their projects. The problems of sharing resources and scheduling resources across projects grow exponentially as the number of projects rises. In multiproject environments the stakes are higher and the benefits or penalties for good or bad resource scheduling become even more significant than in most single projects.

Resource sharing also leads to multitasking. Multitasking involves starting and stopping work on one task to go and work on another project, and then returning to the work on the original task. People working on several tasks concurrently are far less efficient, especially where conceptual or physical shutdown and startup are significant. Multitasking adds to delays and costs. Changing priorities exacerbate the multitasking problems even more. Likewise, multitasking is more evident in organizations that have too many projects for the resources they command.

EXHIBIT 2.2
Benefits of Project Portfolio Management

- Builds discipline into project selection process.
- Links project selection to strategic metrics.
- Prioritizes project proposals across a common set of criteria, rather than on politics or emotion.
- Allocates resources to projects that align with strategic direction.
- Balances risk across all projects.
- Justifies killing projects that do not support organization strategy.
- Improves communication and supports agreement on project goals.

The number of small and large projects in a portfolio almost always exceeds the available resources (typically by a factor of three to four times the available resources). This capacity overload inevitably leads to confusion and inefficient use of scarce organizational resources. The presence of an implementation gap, of power politics, and of multitasking adds to the problem of which projects are allocated resources first. Employee morale and confidence suffer because it is difficult to make sense of an ambiguous system. A multi-project organization environment faces major problems without a priority system that is clearly linked to the strategic plan.

In essence, to this point we have suggested that many organizations have no meaningful process for addressing the problems we have described. The first and most important change that will go a long way in addressing these and other problems is the development and use of a meaningful project priority process for project selection.

How can the implementation gap be narrowed so that understanding and consensus of organizational strategies run through all levels of management? How can power politics be minimized? Can a process be developed in which projects are consistently prioritized to support organizational strategies? Can the prioritized projects be used to allocate scarce organizational resources—for example, people, equipment? Can the process encourage bottom-up initiation of projects that support clear organizational targets?

What is needed is a set of integrative criteria and a process for evaluating and selecting projects that support higher-level strategies and objectives. A single-project priority system that ranks projects by their contribution to the strategic plan would make life easier. Easily said, but difficult to accomplish in practice. Organizations that managed independent projects and allocated resources ad hoc have shifted focus to selecting the right portfolio of projects to achieve their strategic objectives. This is a quickening trend. The advantages of successful project portfolio systems are becoming well recognized in project-driven organizations. See Exhibit 2.2, which lists a few key benefits; the list could easily be extended.

A project portfolio system is discussed next with emphasis on selection criteria, which is where the power of the portfolio system is established.

A Portfolio Management System

Succinctly put, the aim of portfolio management is to ensure that projects are aligned with strategic goals and prioritized appropriately. As Foti points out, portfolio management asks "What is strategic to our organization?" Portfolio management provides information that allows people to make better business decisions. Since projects clamoring for funding and people usually outnumber available resources, it is important to follow a logical and defined process for selecting the projects to implement.

Design of a project portfolio system should include classification of a project, selection criteria depending upon classification, sources of proposals, evaluating proposals, and managing the portfolio of projects.

Classification of the Project

Many organizations find they have three different kinds of projects in their portfolio: *compliance* and emergency (must do), *operational,* and *strategic* projects. Compliance projects are typically those needed to meet regulatory conditions required to operate in a region; hence, they are called "must do" projects. Emergency projects, such as rebuilding a soybean factory destroyed by fire, meet the must do criterion. Compliance and emergency projects usually have penalties if they are not implemented. Operational projects are those that are needed to support current operations. These projects are designed to improve efficiency of delivery systems, reduce product costs, and improve performance. TQM projects are examples of operational projects. Finally, strategic projects are those that directly support the organization's long-run mission. They frequently are directed toward increasing revenue or market share. Examples of strategic projects are new products, research and development. (See Figure 2.2.) For a good, complete discussion on classification schemes found in practice, see Crawford, Hobbs, and Turne.

The strategic value of a proposed project must be determined before it can be placed in the project portfolio. Under rare circumstances, there are projects that "must" be selected. These compliance or emergency projects are those that must be implemented or the firm will fail or suffer dire penalties or consequences. For example, a manufacturing plant must install an electrostatic filter on top of a smokestack in six months or close down. EU courts are trying to force Microsoft to open their software architecture to allow competing software firms to be compatible and interact with Microsoft. This decision may become a compliance project for Microsoft. Any project placed in the "must" category ignores other selection criteria. A rule of thumb for placing a proposed project in this category is that 99 percent of the organization stakeholders would agree that the project must be implemented; there is no perceived choice but to implement the project. All other projects are selected using selection criteria linked to organization strategy.

Selection Criteria

Although there are many criteria for selecting projects, selection criteria are typically identified as *financial* and *nonfinancial*. A short description of each is given next, followed by a discussion of their use in practice.

Financial Models For most managers financial criteria are the preferred method to evaluate projects. These models are appropriate when there is a high level of confidence associated with estimates of future cash flows. Two models and examples are demonstrated here—payback and net present value (NPV).

FIGURE 2.2
Portfolio of Projects by Type

Project A has an initial investment of $700,000 and projected cash inflows of $225,000 for 5 years.

Project B has an initial investment of $400,000 and projected cash inflows of $110,00 for 5 years.

1. The payback model measures the time it will take to recover the project investment. Shorter paybacks are more desirable. Payback is the simplest and most widely used model. Payback emphasizes cash flows, a key factor in business. Some managers use the payback model to eliminate unusually risky projects (those with lengthy payback periods). The major limitations of payback are that it ignores the time value of money, assumes cash inflows for the investment period (and not beyond), and does not consider profitability. The payback formula is

$$\text{Payback period (yrs)} = \text{Estimated Project Cost/Annual Savings}$$

Exhibit 2.3 compares the payback for Project A and Project B. The payback for Project A is 3.1 years and for Project B is 3.6 years. Using the payback method both projects are acceptable since both return the initial investment in less than five years and have returns on the investment of 32.1 and 27.5 percent.

EXHIBIT 2.3 Example Comparing Two Projects: Net Present Value (NPV) and Payback Method

	A	B	C	D	E	F	G	H	I	J
1										
2					Exhibit 2.3					
3										
4					Example Comparing Two Projects Using NPV					
5	Project A		Year 0	Year 1	Year 2	Year 3	Year 4	Year 5	Total	Formulas
6	Required rate of return	15%								
7	Outflows		–$700,000						–$700,000	
8	Inflows			$225,000	$225,000	$225,000	$225,000	$225,000	$1,125,000	
9	Net inflows			$225,000	$225,000	$225,000	$225,000	$225,000	$425,000	Project A: =C7+NPV(B6,D9:H9)
10	NPV	$54,235								
11										
12										
13	Project B									
14	Required rate of return	15%								
15	Outflows		–$400,000						–$400,000	
16	Inflows			$110,000	$110,000	$110,000	$110,000	$110,000	$550,000	
17	Net inflows			$110,000	$110,000	$110,000	$110,000	$110,000	$150,000	Project B: =C15+NPV(B14,D17:H17)
18	NPV	–$31,263								
19										
20										
21										
22	NPV comparison: Accept Project A---NPV is positive.									
23	Reject Project B---NPV is negative.									
24										
25										
26										
27					Example Comparing Two Projects Using the Payback Method					
28										
29				Project A		Project B				
30										
31										
32		Investment	$700,000		$400,000				Project A Payback: =(D32/D33)	
33		Annual savings	$225,000		$110,000				Project B Payback: =(F32/F33)	
34										
35		Payback period*	3.1 years		3.6 years					
36										
37		Rate of return**	32.1%		27.5%				Project A: =(D33/D32)	
38									Project B: =(F33/F32)	
39	Project A: Accept. Less than 5 years and exceeds 15% desired rate.									
40										
41	Project B: Accept. Less than 5 years.									
42										
43	* Note: Payback does not use the time value of money.									
44	** Note: Rate of return is reciprocal of Payback.									
45										

2. The net present value (NPV) model uses management's minimum desired rate-of-return (discount rate, for example, 20 percent) to compute the present value of all net cash inflows. If the result is positive (the project meets the minimum desired rate of return), it is eligible for further consideration. If the result is negative, the project is rejected. Thus, higher positive NPV's are desirable. Excel uses this formula

$$\text{Project NPV} = I_0 + \sum_{t=1}^{n} \frac{F_t}{(1 + k)^t} \quad \text{where}$$

I_0 = Initial investment (since it is an outflow, the number will be negative)

F_t = Net cash inflow for period t

k = Required rate of return

Exhibit 2.3 presents the NPV model using Microsoft Excel software. The NPV model accepts project A, which has a *positive* NPV of $54,235. Project B is rejected since the NPV is *negative* $31,283. Compare the NPV results with the payback results. The NPV model is more realistic because it considers the time value of money, cash flows, and profitability.

When using the NPV model, the discount rate (return on investment hurdle rate) can differ for different projects. For example, the expected ROI on strategic projects is frequently set higher than operational projects. Similarly, ROI's can differ for riskier versus safer projects. The criteria for setting the ROI hurdle rate should be clear and applied consistently.

Unfortunately, pure financial models fail to include many projects where financial return is impossible to measure and/or other factors are vital to the accept or reject decision. One research study by Foti showed that companies using predominantly financial models to prioritize projects yielded unbalanced portfolios and projects that aren't strategically oriented. Other studies make similar claims.

Nonfinancial Criteria

Financial return, while important, does not always reflect strategic importance. The sixties and seventies saw firms become overextended by diversifying too much. Now the prevailing thinking is that long term survival is dependent upon developing and maintaining core competencies. Companies have to be disciplined in saying no to potentially profitable projects that are outside the realm of their core mission. This requires other criteria be considered beyond direct financial return. For example, a firm may support projects that do not have high profit margins for other strategic reasons including:

To capture larger market share

To make it difficult for competitors to enter the market

To develop an enabler product, which by its introduction will increase sales in more profitable products

To develop core technology that will be used in next-generation products

To reduce dependency on unreliable suppliers

To prevent government intervention and regulation

Less tangible criteria may also apply. Organizations may support projects to restore corporate image or enhance brand recognition. Many organizations are committed to corporate citizenship and support community development projects.

Since no single criterion can reflect strategic significance, portfolio management requires multi-criteria screening models. These models often weight individual criteria so those projects that contribute to the most important strategic objectives are given higher consideration.

Two Multi-Criteria Selection Models

Since no single criterion can reflect strategic significance, portfolio management requires multi-criteria screening models. Two models, the checklist and multi-weighted scoring models, are described next.

Checklist Models The most frequently used method in selecting projects has been the checklist. This approach basically uses a list of questions to review potential projects and to determine their acceptance or rejection. Several of the the typical questions found in practice are listed in Exhibit 2.4. One large, multiproject organization has 250 different questions!

A justification of checklist models is that they allow great flexibility in selecting among many different types of projects and are easily used across different divisions and locations. Although many projects are selected using some variation of the checklist approach, this approach has serious shortcomings. Major shortcomings of this approach are that it fails to answer the relative importance or value of a potential project to the organization and fails to allow for comparison with other potential projects. Each potential project will have a different set of positive and negative answers. How do you compare? Ranking and prioritizing projects by their importance is difficult, if not impossible. This approach also leaves the door open to the potential opportunity for power plays, politics, and other forms of manipulation. To overcome these serious shortcomings experts recommend the use of a multi-weighted scoring model to select projects, which is examined next.

Multi-Weighted Scoring Models A weighted scoring model typically uses several weighted selection criteria to evaluate project proposals. Weighted scoring models will generally include qualitative and/or quantitative criteria. Each selection criterion is assigned a weight. Scores are assigned to each criterion for the project, based on its importance to the project being evaluated. The weights and scores are multiplied to get a total weighted score for the project. Using these multiple screening criteria, projects can then be compared using the weighted score. Projects with higher weighted scores are considered better.

EXHIBIT 2.4
Sample Selection Questions Used in Practice

Topic	Question
Strategy/alignment	What specific organization strategy does this project align with?
Driver	What business problem does the project solve?
Success metrics	How will we measure success?
Sponsorship	Who is the project sponsor?
Risk	What is the impact of not doing this project?
Risk	What is the project risk to our organization?
Risk	Where does the proposed project fit in our risk profile?
Benefits, value, ROI	What is the value of the project to this organization?
Benefits, value, ROI	When will the project show results?
Objectives	What are the project objectives?
Organization culture	Is our organization culture right for this type of project?
Resources	Will internal resources be available for this project?
Approach	Will we build or buy?
Schedule	How long will this project take?
Schedule	Is the time line realistic?
Training/resources	Will staff training be required?
Finance/portfolio	What is the estimated cost of the project?
Portfolio	Is this a new initiative or part of an existing initiative?
Portfolio	How does this project interact with current projects?
Technology	Is the technology available or new?

Selection criteria need to mirror the critical success factors of an organization. For example, 3M set a target that 25 percent of the company's sales would come from products fewer than four years old versus the old target of 20 percent. Their priority system for project selection strongly reflects this new target. On the other hand, failure to pick the right factors will render the screening process "useless" in short order.

Figure 2.3 represents a project scoring matrix using some of the factors found in practice. The screening criteria selected are shown across the top of the matrix (e.g., stay within core competencies . . . ROI of 18 percent plus). Management weights each criterion (a value of 0 to a high of, say, 3) by its relative importance to the organization's objectives and strategic plan. Project proposals are then submitted to a project priority team or project office.

Each project proposal is then evaluated by its relative contribution/value added to the selected criteria. Values of 0 to a high of 10 are assigned to each criterion for each project. This value represents the project's fit to the specific criterion. For example, project 1 appears to fit well with the strategy of the organization since it is given a value of 8. Conversely, project 1 does nothing to support reducing defects (its value is 0). Finally, this model applies the management weights to each criterion by importance using a value of 1 to 3. For example, ROI and strategic fit have a weight of 3, while urgency and core competencies have weights of 2. Applying the weight to each criterion, the priority team derives the weighted total points for each project. For example, project 5 has the highest value of 102 $[(2 \times 1) + (3 \times 10) + (2 \times 5) + (2.5 \times 10) + (1 \times 0) + (1 \times 8) + (3 \times 9) = 102]$ and project 2 a low value of 27. If the resources available create a cutoff threshold of 50 points, the priority team would eliminate projects 2 and 4. (Note: Project 4 appears to have some urgency, but it is not classified as a "must" project. Therefore, it is screened with all other proposals.) Project 5 would receive first priority, project *n* second, and so on. In rare cases where resources are severely limited and project proposals are similar in weighted rank, it is prudent to pick the project placing less demand on resources. Weighted multiple criteria models similar to this one are rapidly becoming the dominant choice for prioritizing projects.

FIGURE 2.3
Project Screening
Matrix

Criteria Weight	Stay within core competencies	Strategic fit	Urgency	25% of sales from new products	Reduce defects to less than 1%	Improve customer loyalty	ROI of 18% plus	Weighted total
	2.0	3.0	2.0	2.5	1.0	1.0	3.0	
Project 1	1	8	2	6	0	6	5	66
Project 2	3	3	2	0	0	5	1	27
Project 3	9	5	2	0	2	2	5	56
Project 4	3	0	10	0	0	6	0	32
Project 5	1	10	5	10	0	8	9	102
Project 6	6	5	0	2	0	2	7	55
⋮								
Project *n*	5	5	7	0	10	10	8	83

AP/Wide World Photos.

The Transrapid Shanghai train is deemed a great engineering success. The magnetic levitation train travels at 267 miles per hour (430 kph) from the Pudong International Airport to close to Shanghai's business center in less than eight minutes.

Although the super fast train is deemed an engineering and technical success, it has not been a financial success. The train can carry 453 passengers on a trip, but the trains are riding virtually empty; a total of only 500 to 600 passengers ride the train in a day. The train now operates on a reduced schedule. Basically, the price per ride is well beyond what most Chinese families can afford. Second-class tickets are 75 yuan (US$9), and first-class tickets cost 150 yuan (US$18). The return on investment has been severely under expectations. The link between final customer needs and the financial case was not a top priority. Imposed project deadline (operate before 2003), scope reduction (shift to a station away from downtown), and apparent misconception of community needs all contribute to poor utilization of the train. The current model actually forces people to leave the train, wait, and then take public transportation to downtown Shanghai; time lost and cost have not convinced potential riders of the benefits of using the train.

The project demonstrates a classic error of not linking customer need with return on investment. The political strategy outweighed public needs.

*———, "Case Analysis: A Derailed Vision," *PM Network*, vol. 18, no. 4 (April 2004) p. 1.

At this point in the discussion it is wise to stop and put things into perspective. While selection models like the one above may yield numerical solutions to project selection decisions, models should not make the final decisions—the people using the models should. No model, no matter how sophisticated, can capture the total reality it is meant to represent. Models are tools for guiding the evaluation process so that the decision-makers will consider relevant issues and reach a meeting of the minds as to what projects should be supported and not supported. This is a much more subjective process than calculations suggest. See Snapshot from Practice: A Derailed Vision.

Applying a Selection Model

Project Classification It is not necessary to have exactly the same criteria for the different types of projects discussed above (strategic and operations). However, experience shows most organizations use similar criteria across all types of projects, with perhaps

one or two criteria specific to the type of project—e.g., strategic breakthrough versus operational.

Regardless of criteria differences among different types of projects, the most important criterion for selection is the project's fit to the organization strategy. Therefore, this criterion should be consistent across all types of projects and carry a high priority relative to other criteria. This uniformity across all priority models used can keep departments from suboptimizing the use of organization resources. Anyone generating a project proposal should classify their proposal by type, so the appropriate criteria can be used to evaluate their proposal.

Selecting a Model In the past, financial criteria were used almost to the exclusion of other criteria. However, in the last two decades we have witnessed a dramatic shift to include multiple criteria in project selection. Concisely put, profitability alone is simply not an adequate measure of contribution; however, it is still an important criterion, especially for projects that enhance revenue and market share such as breakthrough R&D projects.

Today, senior management is interested in identifying the potential mix of projects that will yield the best use of human and capital resources to maximize return on investment in the long run. Factors such as researching new technology, public image, ethical position, protection of the environment, core competencies, and strategic fit might be important criteria for selecting projects. Weighted scoring criteria seem the best alternative to meet this need.

Weighted scoring models result in bringing projects to closer alignment with strategic goals. If the scoring model is published and available to everyone in the organization, some discipline and credibility are attached to the selection of projects. The number of wasteful projects using resources is reduced. Politics and "sacred cow" projects are exposed. Project goals are more easily identified and communicated using the selection criteria as corroboration. Finally, using a weighted scoring approach helps project managers understand how their project was selected, how their project contributes to organization goals, and how it compares with other projects. Project selection is one of the most important decisions guiding the future success of an organization.

Criteria for project selection are the area where the power of your portfolio starts to manifest itself. New projects are aligned with the strategic goals of the organization. With a clear method for selecting projects in place, project proposals can be solicited.

Sources and Solicitation of Project Proposals

As you would guess, projects should come from anyone who believes his or her project will add value to the organization. However, many organizations restrict proposals from specific levels or groups within the organization. This could be an opportunity lost. Good ideas are not limited to certain types or classes of organization stakeholders. Encourage and keep solicitations open to all sources—internal and external sponsors.

Figures 2.4 A and B provide an example of a proposal form for major projects. Note that this form includes a preliminary risk assessment as well as problem definition and project objectives. Risk analysis is the subject of Chapter 7.

In some cases organizations will solicit ideas for projects when the knowledge requirements for the project are not available in the organization. Typically, the organization will issue an RFP (Request for Proposal) to contractors/vendors with adequate experience to implement the project. In one example, a hospital published an RFP that asked for a bid to design and build a new operating room that uses the latest technology. Several architecture

FIGURE 2.4A
Major Project
Proposal

Date _____ Number _____

Project Title _____

Responsible Manager _____ Project Manager _____

☐ _____ ☐ General support ☐ Quality ☐ Legal ☐ New product
☐ _____ ☐ _____ ☐ Cost reduction ☐ Replacement ☐ Capacity
☐ _____ ☐ _____ ☐ _____ ☐ _____ ☐ _____

YES ☐ NO ☐ The project will take more than 500 labor hours?
YES ☐ NO ☐ The project is a one-time effort? (will not occur on a regular basis)
YES ☐ NO ☐ The project proposal was reviewed by the product manager?

Problem definition

Describe the problem/opportunity.

Goal definition

Describe the project goal.

Objective definition

Performance: Quantify the savings/benefits you expect from the project.

Cost: Labor hours, materials, methods, equipment.

Schedule: Overall duration in months.

firms submitted bids to the hospital. The bids for the project were evaluated internally against other potential projects. When the project was accepted as a go, other criteria were used to select the best qualified bidder. See Appendix 2.1 of this chapter for a complete description of requests for proposal (RFP).

Ranking Proposals and Selection of Projects

Culling through so many proposals to identify those that add the most value requires a structured process. Figure 2.5 shows a flow chart of a screening process beginning with the creation of an idea for a project.

Data and information are collected to assess the value of the proposed project to the organization and for future backup. If the sponsor decides to pursue the project on the basis of the collected data, it is forwarded to the project priority team (or the project

FIGURE 2.4B
Risk Analysis

What are the three major risks for this project?				
1.				
2.				
3.				

What is the probability of the above risks occurring?	0 to 1.0 none high	Risk 1 above	
		Risk 2 above	
		Risk 3 above	
What is the impact on project success if these risks do occur?	0 to 10 none high	Risk 1 above	
		Risk 2 above	
		Risk 3 above	

Resources available? _____ Yes _____ No

Current project status

Start date _____ Estimated finish date _____

Status: ☐ Active ☐ On hold

Update:

Priority team action: ☐ Accepted ☐ Returned

☐ Discovery—project not defined ☐ Duplicate to: _____

☐ Operational—proposal not a project Project # []

☐ Need more information—to prioritize project ☐ Completed project

office). Note that the sponsor knows which criteria will be used to accept or reject the project. Given the selection criteria and current portfolio of projects, the priority team rejects or accepts the project. If the project is accepted, the priority team sets implementation in motion.

Figure 2.6 is a partial example of an evaluation form used by a large company to prioritize and select new projects. The form distinguishes between must and want objectives. If a project does not meet designated "must" objectives, it is not considered and removed from consideration. Organization (or division) objectives have been ranked and weighted by their relative importance—for example "Improve external customer service" carries a relative weight of 83 when compared to other want objectives. The want objectives are directly linked to objectives found in the strategic plan.

Impact definitions represent a further refinement to the screening system. They are developed to gauge the predicted impact a specific project would have on meeting a

FIGURE 2.5
Project Screening
Process

particular objective. A numeric scheme is created and anchored by defining criteria. To illustrate how this works, let's examine the $5 million in new sales objective. A "0" is assigned if the project will have no impact on sales or less than $100,000, a "1" is given if predicted sales are more than $100,000 but less than $500,000, a "2" if greater than $500,000. These impact assessments are combined with the relative importance of each objective to determine the predicted overall contribution of a project to strategic objectives. For example, project 26 creates an opportunity to fix field problems, has no effect on sales, and will have major impact on customer service. On these three objectives, project 26 would receive a score of 265 [99 + 0 + (2 × 83)]. Individual weighted scores are totaled for each project and are used to prioritize projects.

Responsibility for Prioritizing

Prioritizing can be an uncomfortable exercise for managers. Prioritizing means discipline, accountability, responsibility, constraints, reduced flexibility, and loss of power. Top management commitment means more than giving a blessing to the priority system; it means management will have to rank and weigh, in concrete terms, the objectives and strategies they believe to be most critical to the organization. This public declaration of commitment can be risky if the ranked objectives later prove to be poor choices, but setting the course for the organization is top management's job. The good news is, if management is truly trying to direct the organization to a strong future position, a good project priority system supports their efforts and develops a culture in which everyone is contributing to the goals of the organization.

FIGURE 2.6
Priority Analysis

Must objectives	Must meet if impacts	...26	27	28	29
All activities meet current legal, safety, and environmental standards	Yes-Meets objective No-Does not meet obj N/A-No impact	n/a			
All new products will have a complete market analysis	Yes-Meets objective No-Does not meet obj N/A-No impact	yes			

Want objectives	Relative Importance 1-100	Single project impact definitions	Weighted score	Weighted score	Weighted score	Weighted score
Provides immediate response to field problems	99	0 ≤ Does not address ①= Opportunity to fix 2 ≥ Urgent problem	99			
Create $5 million in new sales by 20xx	88	⓪< $100,000 1 = $100,000–500,000 2 > $500,000	0			
Improve external customer service	83	0 ≤ Minor impact 1 = Significant impact ②≥ Major impact	166			
Total weighted score						
Priority						

Project number

Managing the Portfolio System

Managing the portfolio takes the selection system one step higher in that the merits of a particular project are assessed within the context of existing projects. At the same time it involves monitoring and adjusting selection criteria to reflect the strategic focus of the organization. This requires constant effort. The priority system can be managed by a small group of key employees in a small organization. Or, in larger organizations, the priority system can be managed by the project office or the enterprise management group.

Senior Management Input

Management of a portfolio system requires two major inputs from senior management. First, senior management must provide guidance in establishing selection criteria that strongly align with the current organization strategies. Second, senior management must annually decide how they wish to balance the available organizational resources (people

and capital) among the different types of projects. A preliminary decision of balance must be made by top management (e.g., 20 percent compliance, 50 percent strategic, and 30 percent operational) before project selection takes place, although the balance may be changed when the projects submitted are reviewed. Given these inputs the priority team or project office can carry out its many responsibilities, which include supporting project sponsors and representing the interests of the total organization.

The Priority Team Responsibilities

The priority team, or project office, is responsible for publishing the priority of every project and ensuring the process is open and free of power politics. For example, most organizations using a priority team or project office use an electronic bulletin board to disperse the current portfolio of projects, the current status of each project, and current issues. This open communication discourages power plays. Over time the priority team evaluates the progress of the projects in the portfolio. If this whole process is managed well, it can have a profound impact on the success of an organization.

Constant scanning of the external environment to determine if organizational focus and/or selection criteria need to be changed is imperative! Periodic priority review and changes need to keep current with the changing environment and keep a unified vision of organization focus. Regardless of the criteria used for selection, each project should be evaluated by the same criteria. If projects are classified by must do, operation, and strategic, each project in its class should be evaluated by the same criteria. Enforcing the project priority system is crucial. Keeping the whole system open and aboveboard is important to maintaining the integrity of the system and keeping new, young executives from going around the system. For example, communicating which projects are approved, project ranks, current status of in-process projects, and any changes in priority criteria will discourage people from bypassing the system.

Balancing the Portfolio for Risks and Types of Projects

A major responsibility of the priority team is to balance projects by type, risk, and resource demand. This requires a total organization perspective. Hence, a proposed project that ranks high on most criteria may not be selected because the organization portfolio already includes too many projects with the same characteristics—e.g., project risk level, use of key resources, high cost, nonrevenue producing, long durations. Balancing the portfolio of projects is as important as project selection. Organizations need to evaluate each new project in terms of what it adds to the project mix. Short-term needs need to be balanced with long-term potential. Resource usage needs to be optimized across all projects, not just the most important project.

Two types of risk are associated with projects. First are risks associated with the total portfolio of projects, which should reflect the organization's risk profile. Second are specific project risks that can inhibit the execution of a project, such as schedule, cost, and technical. In this chapter we look only to balancing the organizational risks inherent in the project portfolio, such as market risk, ability to execute, time to market, and technology advances. Project-specific risks will be covered in detail in Chapter 7.

David and Jim Matheson studied R&D organizations and developed a matrix that could be used for assessing a project portfolio (see Figure 2.7). The vertical axis reflects a project's probability of success. The horizontal axis reflects potential commercial value. The grid has four quadrants, each with different project dimensions.

Bread and butter projects typically involve evolutionary improvements to current products and services. Examples include software upgrades and manufacturing cost reduction efforts.

FIGURE 2.7
Project Portfolio
Matrix

Pearls represent revolutionary commercial advances using proven technical advances. Examples include next-generation integrated circuit chip and subsurface imaging to locate oil and gas.

Oysters involve technological breakthroughs with high commercial payoffs. Examples include embryonic DNA treatments and new kinds of metal alloys.

White elephants are projects that at one time showed promise but are no longer viable. Examples include products for a saturated market or a potent energy source with toxic side effects.

The Mathesons report that organizations often have too many white elephants and too few pearls and oysters. To maintain strategic advantage they recommend that organizations capitalize on pearls, eliminate or reposition white elephants, and balance resources devoted to bread-and-butter and oyster projects to achieve alignment with overall strategy. Although their research centers on R&D organizations, their observations appear to hold true for all types of project organizations.

Summary

Multiple competing projects, limited skilled resources, dispersed virtual teams, time to market pressures, and limited capital serve as forces for the emergence of project portfolio management that provides the infrastructure for managing multiple projects and linking business strategy with project selection. The most important element of this system is the creation of a ranking system that utilizes multiple criteria that reflect the mission and strategy of the firm. It is critical to communicate priority criteria to all organizational stakeholders so that the criteria can be the source of inspiration for new project ideas.

Every significant project selected should be ranked and the results published. Senior management must take an active role in setting priorities and supporting the priority system. Going around the priority system will destroy its effectiveness. The project priority team needs to consist of seasoned managers who are capable of asking tough questions and distinguishing facts from fiction. Resources (people, equipment, and capital) for major projects must be clearly allocated and not conflict with daily operations or become an overload task.

The priority team needs to scrutinize significant projects in terms of not only their strategic value but also their fit with the portfolio of projects currently being implemented. Highly ranked projects may be deferred or even turned down if they upset the current balance among risks, resources, and strategic initiatives. Project selection must be based not only on the merits of the specific project but also on what it contributes to the current project portfolio mix. This requires a holistic approach to aligning projects with organizational strategy and resources.

The importance of aligning projects with organization strategy cannot be overstated. We have discussed two types of models found in practice. Checklist models are easy to develop and are justified primarily on the basis of flexibility across different divisions and locations. Unfortunately, questionnaire checklist models do not allow comparison of the relative value (rank) of alternative projects in contributing toward organization strategy. The latter is the major reason the authors prefer multi-weighted scoring models. These models keep project selection highly focused on alignment with organization strategy. Weighted scoring models require major effort in establishing the criteria and weights.

Key Terms

Implementation gap
Net present value
Organizational politics
Payback
Priority system

Priority team
Project portfolio
Project screening
 matrix
Sacred cow

Strategic management
 process

Review Questions

1. Describe the major components of the strategic management process.
2. Explain the role projects play in the strategic management process.
3. How are projects linked to the strategic plan?
4. The portfolio of projects is typically represented by compliance, strategic, and operations projects. What impact can this classification have on project selection?
5. Why does the priority system described in this chapter require that it be open and published? Does the process encourage bottom-up initiation of projects? Does it discourage some projects? Why?
6. Why should an organization not rely only on ROI to select projects?
7. Discuss the pros and cons of the checklist versus the weighted factor method of selecting projects.

Exercises

1. You manage a hotel resort located on the South Beach on the Island of Kauai in Hawaii. You are shifting the focus of your resort from a traditional fun-in-the-sun destination to eco-tourism. (Eco-tourism focuses on environmental awareness and education.) How would you classify the following projects in terms of compliance, strategic, and operational?

 a. Convert the pool heating system from electrical to solar power.
 b. Build a 4-mile nature hiking trail.
 c. Renovate the horse barn.
 d. Replace the golf shop that accidentally burned down after being struck by lightning.

 e. Launch a new promotional campaign with Hawaii Airlines.

 f. Convert 12 adjacent acres into a wildlife preserve.

 g. Update all the bathrooms in condos that are 10 years old or older.

 h. Change hotel brochures to reflect eco-tourism image.

 i. Test and revise disaster response plan.

 j. Introduce wireless Internet service in café and lounge areas.

 How easy was it to classify these projects? What made some projects more difficult than others? What do you think you now know that would be useful for managing projects at the hotel?

2. Two new software projects are proposed to a young, start-up company. The Alpha project will cost $150,000 to develop and is expected to have annual net cash flow of $40,000. The Beta project will cost $200,000 to develop and is expected to have annual net cash flow of $50,000. The company is very concerned about their cash flow. Using the payback period, which project is better from a cash flow standpoint? Why?

3. A five-year project has a projected net cash flow of $15,000, $25,000, $30,000, $20,000, and $15,000 in the next five years. It will cost $50,000 to implement the project. If the required rate of return is 20 percent, conduct a discounted cash flow calculation to determine the NPV.

4. You work for the 3T company, which expects to earn at least 18 percent on its investments. You have to choose between two similar projects. Below is the cash information for each project. Your analysts predict that inflation rate will be a stable 3 percent over the next 7 years. Which of the two projects would you fund if the decision is based only on financial information? Why?

Omega Year	Inflow	Outflow	Netflow	Alpha Year	Inflow	Outflow	Netflow
Y0	0	$225,000	−225,000	Y0	0	$300,000	−300,000
Y1	0	190,000	−190,000	Y1	$ 50,000	100,000	−50,000
Y2	$ 150,000	0	150,000	Y2	150,000	0	150,000
Y3	220,000	30,000	190,000	Y3	250,000	50,000	200,000
Y4	215,000	0	215,000	Y4	250,000	0	250,000
Y5	205,000	30,000	175,000	Y5	200,000	50,000	150,000
Y6	197,000	0	197,000	Y6	180,000	0	180,000
Y7	100,000	30,000	70,000	Y7	120,000	30,000	90,000
Total	1,087,000	505,000	582,000	Total	1,200,000	530,000	670,000

5. The Custom Bike Company has set up a weighted scoring matrix for evaluation of potential projects. Below are three projects under consideration.

 a. Using the scoring matrix on the next page, which project would you rate highest? Lowest?

 b. If the weight for "Strong Sponsor" is changed from 2.0 to 5.0, will the project selection change? What are the three highest weighted project scores with this new weight?

 c. Why is it important that the weights mirror critical strategic factors?

Project Screening Matrix

Criteria / Weight	Strong sponsor	Supports business strategy	Urgency	10% of sales from new products	Competition	Fill market gap	Weighted total
	2.0	5.0	4.0	3.0	1.0	3.0	
Project 1	9	5	2	0	2	5	
Project 2	3	7	2	0	5	1	
Project 3	6	8	2	3	6	8	
Project 4	1	0	5	10	6	9	
Project 5	3	10	10	1	8	0	

References

Benko, C., and F. W. McFarlan, *Connecting the Dots: Aligning Projects With Objectives in Unpredictable Times* (Boston: Harvard Business School Press, 2003).

Bigelow, D., "Want to Ensure Quality? Think Project Portfolio Management," *PM Network,* vol. 16 (1) April 2002, pp. 16–17.

Boyer, C., "Make Profit Your Priority," *PM Nework,* vol. 15 (10) October 2003, pp. 37–42.

Cohen, D., and R. Graham, *The Project Manager's MBA* (San Francisco: Jossey-Bass, 2001), pp. 58–59.

Crawford, L., B. Hobbs, and J. R. Turne, "Aligning Capability with Strategy: Categorizing of Projects to Do the Right Projects and Do Them Right," *Project Management Journal,* vol. 37 (2) June 2006, pp. 38–50.

Descamps, J. P., "Mastering the Dance of Change: Innovation as a Way of Life," *Prism,* Second Quarter, 1999, pp. 61–67.

Doran, G. T., "There's a Smart Way to Write Management Goals and Objectives," *Management Review* (November 1981), pp. 35–36.

Floyd, S. W., and B. Woolridge, "Managing Strategic Consensus: The Foundation of Effectiveness Implementation," *Academy of Management Executives,* vol. 6 (4) 1992, pp. 27–39.

Foti, R., "Louder Than Words," *PM Network,* December 2002, pp. 22–29.

Frank, L., "On Demand," *PM Network,* vol. 18 (4) April 2004, pp. 58–62.

Fusco, J. C., "Better Policies Provide the Key to Implementing Project Management," *Project Management Journal,* vol. 28 (3) 1997, pp. 38–41.

Hutchens, G., "Doing the Numbers," *PM Network,* vol. 16 (4) March 2002, p. 20.

Johnson, R. E., "Scrap Capital Project Evaluations," *Chief Financial Officer,* May 1998, p. 14.

Kaplan, R. S., and D. P. Norton, "The Balanced Scorecard-Measures That Drive Performance," *Harvard Business Review,* January-February 1992, pp. 73–79.

Kenny, J., "Effective Project Management for Strategic Innovation and Change in an Organizational Context," *Project Management Journal,* vol. 34 (1) 2003, pp. 45–53.

Kharbanda, O. P., and J. K. Pinto, *What Made Gertie Gallop: Learning from Project Failures* (New York: Van Nostrand Reinhold, 1996), pp. 106–11, 263–283.

Leifer, R., C. M. McDermott, G. C. O'Connor, L. S. Peters, M. Price, and R. W. Veryzer, *Radical Innovation: How Mature Companies Can Outsmart Upstarts* (Boston: Harvard Business School Press, 2000).

Matheson, D., and J. Matheson, *The Smart Organization* (Boston: Harvard Business School Press, 1998), pp. 203–209.

Milosevic, D. Z., and S. Srivannaboon, "A Theoretical Framework for Aligning Project Management with Business Strategy," *Project Management Journal,* vol. 37 (3) August 2006, pp. 98–110.

Morris, P. W., and A. Jamieson, "Moving from Corporate Strategy to Project Strategy," *Project Management Journal,* vol. 36 (4) December 2005, pp. 5–18.

Shenhar, A., "Strategic Project Leadership: Focusing Your Project on Business Success," *Proceedings of the Project Management Institute Annual Seminars & Symposium,* San Antonio, Texas, October 3–10, 2002, CD.

Woodward, H., "Winning in a World of Limited Project Spending," *Proceedings of the Project Management Institute Global Congress North America,* Baltimore, Maryland, September 18–12, 2003, CD.

Case

Hector Gaming Company

Hector Gaming Company (HGC) is an educational gaming company specializing in young children's educational games. HGC has just completed their fourth year of operation. This year was a banner year for HGC. The company received a large influx of capital for growth by issuing stock privately through an investment banking firm. It appears the return on investment for this past year will be just over 25 percent with zero debt! The growth rate for the last two years has been approximately 80 percent each year. Parents and grandparents of young children have been buying HGC's products almost as fast as they are developed. Every member of the 56-person firm is enthusiastic and looking forward to helping the firm grow to be the largest and best educational gaming company in the world. The founder of the firm, Sally Peters, has been written up in *Young Entrepreneurs* as "the young entrepreneur to watch." She has been able to develop an organization culture in which all stakeholders are committed to innovation, continuous improvement, and organization learning.

Last year, 10 top managers of HGC worked with McKinley Consulting to develop the organization's strategic plan. This year the same 10 managers had a retreat in Aruba to formulate next year's strategic plan using the same process suggested by McKinley Consulting. Most executives seem to have a consensus of where the firm should go in the intermediate and long term. But there is little consensus on how this should be accomplished. Peters, now president of HGC, feels she may be losing control. The frequency of conflicts seems to be increasing. Some individuals are always requested for

any new project created. When resource conflicts occur among projects, each project manager believes his or her project is most important. More projects are not meeting deadlines and are coming in over budget. Yesterday's management meeting revealed some top HGC talent have been working on an international business game for college students. This project does not fit the organization vision or market niche. At times it seems everyone is marching to his or her own drummer. Somehow more focus is needed to ensure everyone agrees on *how* strategy should be implemented, given the resources available to the organization.

Yesterday's meeting alarmed Peters. These emerging problems are coming at a bad time. Next week HGC is ramping up the size of the organization, number of new products per year, and marketing efforts. Fifteen new people will join HGC next month. Peters is concerned that policies be in place that will ensure the new people are used most productively. An additional potential problem looms on the horizon. Other gaming companies have noticed the success HGC is having in their niche market; one company tried to hire a key product development employee away from HGC. Peters wants HGC to be ready to meet any potential competition head on and to discourage any new entries into their market. Peters knows HGC is project driven; however, she is not as confident that she has a good handle on how such an organization should be managed—especially with such a fast growth rate and potential competition closer to becoming a reality. The magnitude of emerging problems demands quick attention and resolution.

Peters has hired you as a consultant. She has suggested the following format for your consulting contract. You are free to use another format if it will improve the effectiveness of the consulting engagement.

What is our major problem?

Identify some symptoms of the problem.

What is the major cause of the problem?

Provide a detailed action plan that attacks the problem. Be specific and provide examples that relate to HGC.

Case

Film Prioritization

The purpose of this case is to give you experience in using a project priority system that ranks proposed projects by their contribution to the organization's objectives and strategic plan.

COMPANY PROFILE

The company is the film division for a large entertainment conglomerate. The main office is located in Anaheim, California. In addition to the feature film division, the conglomerate includes theme parks, home videos, a television channel, interactive games, and theatrical productions. The company has been enjoying steady growth over the past 10 years. Last year total revenues increased by 12 percent to $21.2 billion. The company is engaged in negotiations to expand its theme park empire to mainland China and Poland. The film division generated $274 million in revenues, which was an increase of 7 percent over the past year. Profit margin was down 3 percent to 16 percent because of the poor response to three of the five major film releases for the year.

COMPANY MISSION

The mission for the firm:

> Our overriding objective is to create shareholder value by continuing to be the world's premier entertainment company from a creative, strategic, and financial standpoint.

The film division supports this mission by producing four to six high-quality, family entertainment films for mass distribution each year. In recent years, the CEO of the company has advocated that the firm take a leadership position in championing environmental concerns.

COMPANY "MUST" OBJECTIVES

Every project must meet the must objectives as determined by executive management. It is important that selected film projects not violate such objectives of high strategic priority. There are three must objectives:

1. All projects meet current legal, safety, and environmental standards.
2. All film projects should receive a PG or lower advisory rating.
3. All projects should not have an adverse effect on current or planned operations within the larger company.

COMPANY "WANT" OBJECTIVES

Want objectives are assigned weights for their relative importance. Top management is responsible for formulating, ranking, and weighting objectives to ensure that projects support the company's strategy and mission. The following is a list of the company's want objectives:

1. Be nominated for and win an academy award for Best Picture of the Year.
2. Create at least one new animated character each year that can star in a cartoon or TV series.
3. Generate additional merchandise revenue (action figures, dolls, interactive games, music CDs).
4. Raise public consciousness about environmental issues and concerns.
5. Generate profit in excess of 18 percent.
6. Advance the state of the art in film animation, and preserve the firm's reputation.
7. Provide the basis for the development of a new ride at a company-owned theme park.

ASSIGNMENT

You are a member of the priority team in charge of evaluating and selecting film proposals. Use the provided evaluation form to formally evaluate and rank each proposal. Be prepared to report your rankings and justify your decisions.

Assume that all of the projects have passed the estimated hurdle rate of 14 percent ROI. In addition to the brief film synopsis, the proposals include the following financial projections of theater and video sales: 80 percent chance of ROI, 50 percent chance of ROI, and 20 percent chance of ROI.

For example, for proposal #1 (Dalai Lama) there is an 80 percent chance that it will earn at least 8 percent return on investment (ROI), a 50-50 chance the ROI will be 18 percent, and a 20 percent chance that the ROI will be 24 percent.

FILM PROPOSALS

PROJECT PROPOSAL 1: MY LIFE WITH DALAI LAMA

An animated, biographical account of the Dalai Lama's childhood in Tibet based on the popular children's book *Tales from Nepal*. The Lama's life is told through the eyes of

"Guoda," a field snake, and other local animals who befriend the Dalai and help him understand the principles of Buddhism.

Probability	80%	50%	20%
ROI	8%	18%	24%

PROJECT PROPOSAL 2: HEIDI

A remake of the classic children's story with music written by award-winning composers Syskle and Obert. The big-budget film will feature top-name stars and breathtaking scenery of the Swiss Alps.

Probability	80%	50%	20%
ROI	2%	20%	30%

PROJECT PROPOSAL 3: THE YEAR OF THE ECHO

A low-budget documentary that celebrates the career of one of the most influential bands in rock-and-roll history. The film will be directed by new-wave director Elliot Cznerzy and will combine concert footage and behind-the-scenes interviews spanning the 25-year history of the rock band the Echos. In addition to great music, the film will focus on the death of one of the founding members from a heroin overdose and reveal the underworld of sex, lies, and drugs in the music industry.

Probability	80%	50%	20%
ROI	12%	14%	18%

PROJECT PROPOSAL 4: ESCAPE FROM RIO JAPUNI

An animated feature set in the Amazon rainforest. The story centers around Pablo, a young jaguar who attempts to convince warring jungle animals that they must unite and escape the devastation of local clear cutting.

Probability	80%	50%	20%
ROI	15%	20%	24%

PROJECT 5: NADIA!

The story of Nadia Comaneci, the famous Romanian gymnast who won three gold medals at the 1976 Summer Olympic Games. The low-budget film will document her life as a small child in Romania and how she was chosen by Romanian authorities to join their elite, state-run, athletic program. The film will highlight how Nadia maintained her independent spirit and love for gymnastics despite a harsh, regimented training program.

Probability	80%	50%	20%
ROI	8%	15%	20%

PROJECT 6: KEIKO—ONE WHALE OF A STORY

The story of Keiko, the famous killer whale, will be told by an imaginary offspring Seiko, who in the distant future is telling her children about their famous grandfather. The big-budget film will integrate actual footage of the whale within a realistic animated environment using state-of-the-art computer imagery. The story will reveal how Keiko responded to his treatment by humans.

Probability	80%	50%	20%
ROI	6%	18%	25%

Project Priority Evaluation Form

Must objectives	Must meet if impacts	1	2	3	4	5	6	7
Meets all safety and environmental standards	Y = yes N = no N/A = not applicable							
PG or G rating	Y = yes N = no N/A = not applicable							
No adverse effect on other operations	Y = yes N = no N/A = not applicable							

Want objectives	Relative Importance 1–100	Single project impact definitions	Weighted Score	Weighted Score	Weighted Score	Weighted Score	Weighted Score	Weighted Score	Weighted Score
Be nominated for Best Picture of the Year	60	0 = No potential 1 = Low potential 2 = High potential							
Generate additional merchandise	10	0 = No potential 1 = Low potential 2 = High potential							
Create a new, major animated character	20	0 = No potential 1 = Low potential 2 = High potential							
Raise environmental concerns	55	0 = No potential 1 = Low potential 2 = High potential							
Generate profit greater than 18%	70	0 < 18% 1 = 18–22% 2 > 22%							
Advance state of film animation	40	0 = No impact 1 = Some impact 2 = Great impact							
Provide basis for new theme ride	10	0 = No potential 1 = Low potential 2 = High potential							
Total weighted score									
Priority									

PROJECT 7: GRAND ISLAND

The true story of a group of junior-high biology students who discover that a fertilizer plant is dumping toxic wastes into a nearby river. The moderate-budget film depicts how students organize a grassroots campaign to fight local bureaucracy and ultimately force the fertilizer plant to restore the local ecosystem.

Probability	80%	50%	20%
ROI	9%	15%	20%

Appendix 2.1

Request for Proposal (RFP)

Once an organization selects a project, the customer or project manager is frequently responsible for developing a request for proposal (RFP) for the project or sections of the project.

The responsible project manager will require input data from all stakeholders connected to the activities covered in the RFP. The RFP will be announced to external contractors/ vendors with adequate experience to implement the project. For example, government projects frequently advertise with a "request for proposal" to outside contractors for roads, buildings, airports, military hardware, space vehicles. Similarly, businesses use RFPs to solicit bids for building a clean room, developing a new manufacturing process, delivering software for insurance billing, conducting a market survey. In all of these examples, requirements and features must be in enough detail that contractors have a clear description of the final deliverable that will meet the customer's needs. In most cases the RFP also specifies an expected format for the contractor's bid proposal so the responses of different contractors can be fairly evaluated. Although we typically think of RFPs for external contractors, in some organizations RFPs are used internally; that is, the organization sends out an RFP to different divisions or departments.

The content of the RFP is extremely important. In practice, the most common error is to offer an RFP that lacks sufficient detail. This lack of detail typically results in conflict issues, misunderstandings, often legal claims between the contractor and owner, and, in addition, an unsatisfied customer. All RFPs are different, but the outline in Figure A2.1 is a good starting point for the development of a detailed RFP. Each step is briefly described next.

FIGURE A2.1
Request for Proposal

1. Summary of needs and request for action
2. Statement of work (SOW) detailing the scope and major deliverables
3. Deliverable specifications/requirements, features, and tasks
4. Responsibilities–vendor and customer
5. Project schedule
6. Costs and payment schedule
7. Type of contract
8. Experience and staffing
9. Evaluation criteria

1. **Summary of needs and request for action.** The background and a simple description of the final project deliverable are given first. For example, through simulated war games, the U.S. Navy has found their giant warships of the past are too vulnerable against today's technology (an example is the Silkworm antiship missiles). In addition, the Navy's mission has shifted to supporting ground forces and peacekeeping missions, which require getting closer to shore. As a result, the Navy is revamping ships for near-shore duty. The Navy will select three designs for further refinement from the responses to its RFP. In general, it is expected that the new ship will be capable of at least 55 knots, measure between 80 and 250 feet in length, and be fitted with radar absorbing panels to thwart guided missiles.

2. **Statement of work detailing the scope and major deliverables.** For example, if the project involves a market research survey, the major deliverables could be design, data collection, data analysis, and providing recommendations by February 21, 2008, for a cost not to exceed $300,000.

3. **Deliverable specifications/requirements, features, and tasks.** This step should be very comprehensive so bid proposals from contractors can be validated and later used for control. Typical specifications cover physical features such as size, quantity, materials, speed, and color. For example, an IT project might specify requirements for hardware, software, and training in great detail. Tasks required to complete deliverables can be included if they are known.

4. **Responsibilities—vendor and customer.** Failing to spell out the responsibilities for both parties is notorious for leading to serious problems when the contractor implements the project. For example, who pays for what? (If the contractor is to be on site, will the contractor be required to pay for office space?) What are the limits and exclusions for the contractor? (For example, who will supply test equipment?) What communication plan will be used by the contractor and owner? If escalation of an issue becomes necessary, what process will be used? How will progress be evaluated? Well-defined responsibilities will avoid many unforeseen problems later.

5. **Project schedule.** This step is concerned with getting a "hard" schedule which can be used for control and evaluating progress. Owners are usually very demanding in meeting the project schedule. In today's business environment, time-to-market is a major "hot button" that influences market share, costs, and profits. The schedule should spell out what, who, and when.

6. **Costs and payment schedule.** The RFP needs to set out very clearly how, when, and the process for determining costs and conditions for progress payments.

7. **Type of contract.** Essentially there are two types of contracts—fixed-price and cost-plus. Fixed-price contracts agree on a price or lump sum in advance, and it remains as long as there are no changes to the scope provisions of the agreement. This type is preferred in projects that are well defined with predictable costs and minimal risks. The contractor must exercise care estimating cost because any underestimating of costs will cause the contractor's profit to be reduced. In cost-plus contracts the contractor is reimbursed for all or some of the expenses incurred during performance of the contract. This fee is negotiated in advance and usually involves a percent of total costs. "Time and materials" plus a profit factor are typical of cost-plus contracts. Both types of contracts can include incentive clauses for superior performance in time and cost, or in some cases, penalties—for example, missing the opening date of a new sports stadium.

8. **Experience and staffing.** The ability of the contractor to implement the project may depend on specific skills; this necessary experience should be specified, along with assurance such staff will be available for this project.

9. **Evaluation criteria.** The criteria for evaluating and awarding the project contract should be specified. For example, selection criteria frequently include methodology, price,

schedule, and experience; in some cases these criteria are weighted. Use of the outline in Figure A2.1 will help to ensure key items in the proposal are not omitted. A well-prepared RFP will provide contractors with sufficient guidelines to prepare a proposal that clearly meets the project and customer's needs.

SELECTION OF CONTRACTOR FROM BID PROPOSALS

Interested contractors respond to project RFPs with a written bid proposal. It is likely that several contractors will submit bid proposals to the customer.

The final step in the RFP process is to select the contractor who best meets the requirements requested in the RFP. The selection criteria given in the RFP are used to evaluate which contractor is awarded the contract to implement the project. Losing contractors should be given an explanation of the key factors that lead to the selection of the winning contractor/vendor; appreciation for their participation and effort should be acknowledged.

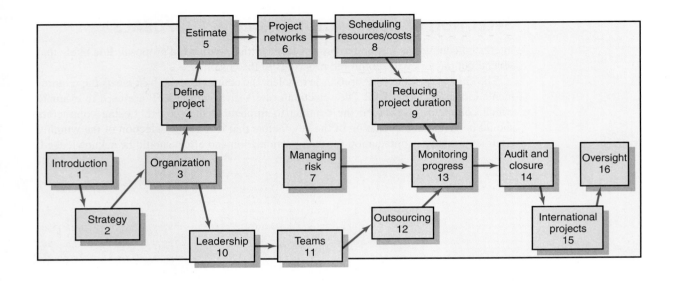

Organization: Structure and Culture
Project Management Structures
What Is the Right Project Management Structure?
Organizational Culture
Implications of Organizational Culture for Organizing Projects
Summary

Organization: Structure and Culture

Matrix management works, but it sure is difficult at times. All matrix managers must keep up their health and take Stress-Tabs.

—A Project Manager

Once management approves a project then the question becomes, how will the project be implemented? This chapter examines three different project management structures used by firms to implement projects: functional organization, dedicated project teams and matrix structure. Although not exhaustive, these structures and their variant forms represent the major approaches for organizing projects. The advantages and disadvantages of each of these structures are discussed as well as some of the critical factors that might lead a firm to choose one form over others.

Whether a firm chooses to complete projects within the traditional functional organization or through some form of matrix arrangement is only part of the story. Anyone who has worked for more than one organization realizes that there are often considerable differences in how projects are managed within certain firms with similar structures. Working in a matrix system at AT&T is different from working in a matrix environment at Hewlett-Packard. Many researchers attribute these differences to the organizational culture at AT&T and Hewlett-Packard. A simple explanation of *organizational culture* is that it reflects the "personality" of an organization. Just as each individual has a unique personality, so each organization has a unique culture. Toward the end of this chapter, we examine in more detail what organizational culture is and the impact that the culture of the parent organization has on organizing and managing projects.

Both the project management structure and the culture of the organization constitute major elements of the environment in which projects are implemented. It is important for project managers and participants to know the "lay of the land" so that they can avoid obstacles and take advantage of pathways to complete their projects.

Project Management Structures

A project management system provides a framework for launching and implementing project activities within a parent organization. A good system appropriately balances the needs of both the parent organization and the project by defining the interface between the project and parent organization in terms of authority, allocation of resources, and eventual integration of project outcomes into mainstream operations.

Many business organizations have struggled with creating a system for organizing projects while managing ongoing operations. One of the major reasons for this struggle is that projects contradict fundamental design principles associated with traditional organizations. Projects are unique, one-time efforts with a distinct beginning and end. Most organizations are designed to efficiently manage ongoing activities. Efficiency is achieved primarily by breaking down complex tasks into simplified, repetitive processes, as symbolized by assembly-line production methods. Projects are not routine and therefore can be like ducks out of water in these work environments. With this in mind, we will start the discussion of project management structures.

Organizing Projects within the Functional Organization

One approach to organizing projects is to simply manage them within the existing functional hierarchy of the organization. Once management decides to implement a project, the different segments of the project are delegated to the respective functional units with each unit responsible for completing its segment of the project (see Figure 3.1). Coordination is maintained through normal management channels. For example, a tool manufacturing firm decides to differentiate its product line by offering a series of tools specially designed for left-handed individuals. Top management decides to implement the project, and different segments of the project are distributed to appropriate areas. The industrial design department is responsible for modifying specifications to conform to the needs of left-handed users. The production department is responsible for devising the means for producing new tools according to these new design specifications. The marketing department is responsible for gauging demand and price as well as identifying distribution outlets. The overall project will be managed within the normal hierarchy, with the project being part of the working agenda of top management.

The functional organization is also commonly used when, given the nature of the project, one functional area plays a dominant role in completing the project or has a dominant interest in the success of the project. Under these circumstances, a high-ranking manager in that area is given the responsibility of coordinating the project. For example, the transfer of equipment and personnel to a new office would be managed by a top-ranking manager in the firm's facilities department. Likewise, a project involving the upgrading of the management information system would be managed by the information systems department. In both cases, most of the project work would be done within the specified department and coordination with other departments would occur through normal channels.

There are advantages and disadvantages for using the existing functional organization to administer and complete projects. The major advantages are the following:

1. **No Change.** Projects are completed within the basic functional structure of the parent organization. There is no radical alteration in the design and operation of the parent organization.

2. **Flexibility.** There is maximum flexibility in the use of staff. Appropriate specialists in different functional units can temporarily be assigned to work on the project and then return to their normal work. With a broad base of technical personnel available within each functional department, people can be switched among different projects with relative ease.

3. **In-Depth Expertise.** If the scope of the project is narrow and the proper functional unit is assigned primary responsibility, then in-depth expertise can be brought to bear on the most crucial aspects of the project.

FIGURE 3.1 Functional Organizations

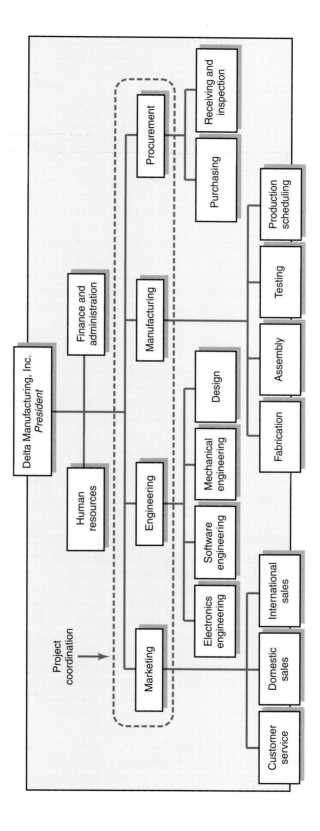

4. **Easy Post-Project Transition.** Normal career paths within a functional division are maintained. While specialists can make significant contributions to projects, their functional field is their professional home and the focus of their professional growth and advancement.

Just as there are advantages for organizing projects within the existing functional organization, there are also disadvantages. These disadvantages are particularly pronounced when the scope of the project is broad and one functional department does not take the dominant technological and managerial lead on the project:

1. **Lack of Focus.** Each functional unit has its own core routine work to do; sometimes project responsibilities get pushed aside to meet primary obligations. This difficulty is compounded when the project has different priorities for different units. For example, the marketing department may consider the project urgent while the operations people considered it only of secondary importance. Imagine the tension if the marketing people have to wait for the operations people to complete their segment of the project before they proceed.

2. **Poor Integration.** There may be poor integration across functional units. Functional specialists tend to be concerned only with their segment of the project and not with what is best for the total project.

3. **Slow.** It generally takes longer to complete projects through this functional arrangement. This is in part attributable to slow response time—project information and decisions have to be circulated through normal management channels. Furthermore, the lack of horizontal, direct communication among functional groups contributes to rework as specialists realize the implications of others' actions after the fact.

4. **Lack of Ownership.** The motivation of people assigned to the project can be weak. The project may be seen as an additional burden that is not directly linked to their professional development or advancement. Furthermore, because they are working on only a segment of the project, professionals do not identify with the project. Lack of ownership discourages strong commitment to project-related activities.

Organizing Projects as Dedicated Teams

At the other end of the structural spectrum is the creation of independent project teams. These teams operate as separate units from the rest of the parent organization. Usually a full-time project manager is designated to pull together a core group of specialists who work full time on the project. The project manager recruits necessary personnel from both within and outside the parent company. The subsequent team is physically separated from the parent organization and given marching orders to complete the project (see Figure 3.2).

The interface between the parent organization and the project teams will vary. In some cases, the parent organization maintains a tight rein through financial controls. In other cases, firms grant the project manager maximum freedom to get the project done as he sees fit. Lockheed Martin has used this approach to develop next generation jet airplanes. See Snapshot from Practice: Skunk Works.

In the case of firms where projects are the dominant form of business, such as a construction firm or a consulting firm, the entire organization is designed to support project teams. Instead of one or two special projects, the organization consists of sets of quasi-independent teams working on specific projects. The main responsibility of traditional functional departments is to assist and support these project teams. For example, the marketing

FIGURE 3.2 Dedicated Project Team

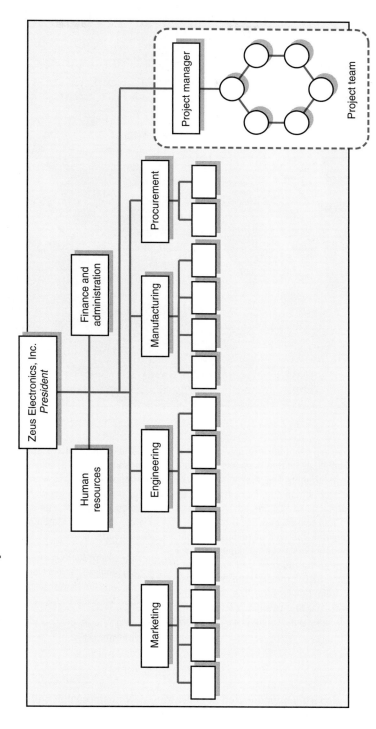

Courtesy Lockheed Martin.

In project management folklore, skunk works is code for a small, dedicated team assigned to a breakthrough project. The first skunk works was created more than a half a century ago by Clarence L. "Kelly" Johnson at Lockheed Aerospace Corporation. Kelly's project had two objectives: 1) to create a jet fighter, the Shooting Star, and 2) to do it as fast as possible. Kelly and a small band of engineering mavericks operated as a dedicated team unencumbered by red tape and the bureaucratic delays of the normal R&D process. The name was coined by team member Irvin Culver after the moonshine brewery deep in the forest in the popular cartoon strip Lil'Abner. The homemade whisky was euphemistically called kickapoo joy juice.

The project was a spectacular success. In just 43 days, Johnson's team of 23 engineers and teams of support personnel put together the first American fighter to fly at more than 500 miles per hour. Lockheed has continued to use Skunk Works to develop a string of high speed jets, including the F117 Stealth Fighter. Lockheed Martin has an official Skunk Works division. Their charter is:

> The Skunk Works is a concentration of a few good people solving problems far in advance—and at a fraction of the cost—by applying the simplest, most straightforward methods possible to develop and produce new products.

* J., Miller, *Lockheed Martin's Skunk Works* (New York: Speciality Publications, 1996).

department is directed at generating new business that will lead to more projects, while the human resource department is responsible for managing a variety of personnel issues as well as recruiting and training new employees. This type of organization is referred to in the literature as a *Project Organization* and is graphically portrayed in Figure 3.3.

FIGURE 3.3 Project Organization Structure

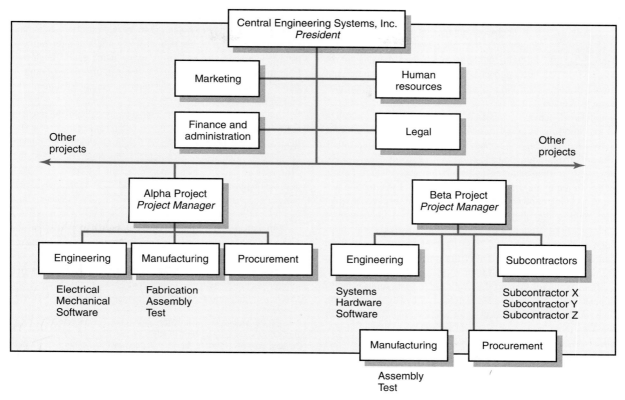

As in the case of functional organization, the dedicated project team approach has strengths and weaknesses. The following are recognized as strengths:

1. **Simple.** Other than taking away resources in the form of specialists assigned to the project, the functional organization remains intact with the project team operating independently.

2. **Fast.** Projects tend to get done more quickly when participants devote their full attention to the project and are not distracted by other obligations and duties. Furthermore, response time tends to be quicker under this arrangement because most decisions are made within the team and are not deferred up the hierarchy.

3. **Cohesive.** A high level of motivation and cohesiveness often emerges within the project team. Participants share a common goal and personal responsibility toward the project and the team.

4. **Cross-Functional Integration.** Specialists from different areas work closely together and, with proper guidance, become committed to optimizing the project, not their respective areas of expertise.

In many cases, the project team approach is the optimum approach for completing a project when you view it solely from the standpoint of what is best for completing the project. Its weaknesses become more evident when the needs of the parent organization are taken into account:

One of the advantages of creating dedicated project teams is that project participants from different functional areas can develop into a highly cohesive work team that is strongly committed to completing the project. While such teams often produce Herculean efforts in pursuit of project completion, there is a negative dimension to this commitment that is often referred to in the literature as *projectitis*. A we–they attitude can emerge between project team members and the rest of the organization. The project team succumbs to *hubris* and develops a holier-than-thou attitude that antagonizes the parent organization. People not assigned to the project become jealous of the attention and prestige being showered on the project team, especially when they believe that it is their hard work that is financing the endeavor. The tendency to assign project teams exotic titles such as "Silver Bullets" and "Tiger Teams," as well as give them special perks, tends to intensify the gap between the project team and the parent organization.

Such appears to have been the case with Apple's highly successful Macintosh development team. Steve Jobs, who at the time was both the chairman of Apple and the project manager for the Mac team, pampered his team with perks including at-the-desk massages, coolers stocked with freshly squeezed orange juice, a Bosendorfer grand piano, and first-class plane tickets.

No other employees at Apple got to travel first class. Jobs considered his team to be the elite of Apple and had a tendency to refer to everyone else as "Bozos" who "didn't get it." Engineers from the Apple II division, which was the bread and butter of Apple's sales, became incensed with the special treatment their colleagues were getting.

One evening at Ely McFly's, a local watering hole, the tensions between Apple II engineers seated at one table and those of a Mac team at another boiled over. Aaron Goldberg, a long-time industry consultant, watched from his barstool as the squabbling escalated. "The Mac guys were screaming, 'We're the future!' The Apple II guys were screaming, 'We're the money!' Then there was a geek brawl. Pocket protectors and pens were flying. I was waiting for a notebook to drop, so they would stop and pick up the papers."

Although comical from a distance, the discord between the Apple II and Mac groups severely hampered Apple's performance during the 1980s. John Sculley, who replaced Steve Jobs as chairman of Apple, observed that Apple had evolved into two "warring companies" and referred to the street between the Apple II and Macintosh buildings as "the DMZ" (demilitarized zone).

* J., Carlton, *Apple: The Inside Story of Intrigue, Egomania, and Business Blunders* (New York: Random House, 1997), pp. 13–14; J., Sculley, *Odyssey: Pepsi to Apple . . . A Journey of Adventure, Ideas, and the Future* (New York: Harper & Row, 1987), pp. 270–79.

1. **Expensive.** Not only have you created a new management position (project manager), but resources are also assigned on a full-time basis. This can result in duplication of efforts across projects and a loss of economies of scale.

2. **Internal Strife.** Sometimes dedicated project teams take on an entity of their own and a disease known as projectitis develops. See Snapshot from Practice: Projectitis—The Dark Side. A strong we–they divisiveness emerges between the project team and the parent organization. This divisiveness can undermine not only the integration of the eventual outcomes of the project into mainstream operations but also the assimilation of project team members back into their functional units once the project is completed.

3. **Limited Technological Expertise.** Creating self-contained teams inhibits maximum technological expertise being brought to bear on problems. Technical expertise is limited somewhat to the talents and experience of the specialists assigned to the project. While nothing prevents specialists from consulting with others in the functional division, the we–they syndrome and the fact that such help is not formally sanctioned by the organization discourage this from happening.

4. **Difficult Post-Project Transition.** Assigning full-time personnel to a project creates the dilemma of what to do with personnel after the project is completed. If other project work is not available, then the transition back to their original functional departments may be difficult because of their prolonged absence and the need to catch up with recent developments in their functional area.

Organizing Projects within a Matrix Arrangement

One of the biggest management innovations to emerge in the past 30 years has been the matrix organization. Matrix management is a hybrid organizational form in which a horizontal project management structure is "overlaid" on the normal functional hierarchy. In a matrix system, there are usually two chains of command, one along functional lines and the other along project lines. Instead of delegating segments of a project to different units or creating an autonomous team, project participants report simultaneously to both functional and project managers.

Companies apply this matrix arrangement in a variety of different ways. Some organizations set up temporary matrix systems to deal with specific projects, while "matrix" may be a permanent fixture in other organizations. Let us first look at its general application and then proceed to a more detailed discussion of finer points. Consider Figure 3.4. There are three projects currently under way: A, B, and C. All three project managers (PM A-C) report to a director of project management, who supervises all projects. Each project has an administrative assistant, although the one for project C is only part time.

Project A involves the design and expansion of an existing production line to accommodate new metal alloys. To accomplish this objective, project A has assigned to it 3.5 people from manufacturing and 6 people from engineering. These individuals are assigned to the project on a part-time or full-time basis, depending on the project's needs during various phases of the project. Project B involves the development of a new product that requires the heavy representation of engineering, manufacturing, and marketing. Project C involves forecasting changing needs of an existing customer base. While these three projects, as well as others, are being completed, the functional divisions continue performing their basic, core activities.

The matrix structure is designed to optimally utilize resources by having individuals work on multiple projects as well as being capable of performing normal functional duties. At the same time, the matrix approach attempts to achieve greater integration by creating and legitimizing the authority of a project manager. In theory, the matrix approach provides a dual focus between functional/technical expertise and project requirements that is missing in either the project team or functional approach to project management. This focus can most easily be seen in the relative input of functional managers and project managers over key project decisions (see Table 3.1).

In principle every major project decision and action must be negotiated. For example, the project manager is responsible for integrating marketing contributions and overseeing the completion of the project. The marketing manager is responsible for overseeing her people so that the marketing deliverables are done right.

TABLE 3.1 Division of Project Manager and Functional Manager Responsibilities in a Matrix Structure

Project Manager	Negotiated Issues	Functional Manager
What has to be done?	Who will do the task?	How will it be done?
When should the task be done?	Where will the task be done?	
How much money is available to do the task?	Why will the task be done?	How will the project involvement impact normal functional activities?
How well has the total project been done?	Is the task satisfactorily completed?	How well has the functional input been integrated?

FIGURE 3.4 Matrix Organization Structure

Different Matrix Forms

In practice there are really different kinds of matrix systems, depending on the relative authority of the project and functional managers. Functional, lightweight, or *weak matrix* are titles given to matrices in which the balance of authority strongly favors the functional managers. Middleweight or *balanced matrix* is used to describe the traditional matrix arrangement. Project, heavyweight, or *strong matrix* is used to describe a matrix in which the balance of authority is strongly on the side of the project manager. Here is a thumbnail sketch of the three kinds of matrices:

[handwritten: → PM ↓ authority, ↑ FM authority]

*[handwritten margin note: * Strong matrix = ↑ PM authority]*

- **Weak matrix**—This form is very similar to a functional approach with the exception that there is a formally designated project manager responsible for coordinating project activities. Functional managers are responsible for managing their segment of the project. The project manager basically acts as a staff assistant who draws the schedules and checklists, collects information on status of work, and facilitates project completion. The project manager has indirect authority to expedite and monitor the project. Functional managers call most of the shots and decide who does what and when the work is completed.

- **Balanced matrix**—This is the classic matrix in which the project manager is responsible for defining what needs to be accomplished while the functional managers are concerned with how it will be accomplished. More specifically, the project manager establishes the overall plan for completing the project, integrates the contribution of the different disciplines, sets schedules, and monitors progress. The functional managers are responsible for assigning personnel and executing their segment of the project according to the standards and schedules set by the project manager. The merger of "what and how" requires both parties to work closely together and jointly approve technical and operational decisions.

- **Strong matrix**—This form attempts to create the "feel" of a project team within a matrix environment. The project manager controls most aspects of the project, including scope trade-offs and assignment of functional personnel. The project manager controls when and what specialists do and has final say on major project decisions. The functional manager has title over her people and is consulted on a need basis. In some situations a functional manager's department may serve as a "subcontractor" for the project, in which case they have more control over specialized work. For example, the development of a new series of laptop computers may require a team of experts from different disciplines working on the basic design and performance requirements within a project matrix arrangement. Once the specifications have been determined, final design and production of certain components (i.e., power source) may be assigned to respective functional groups to complete.

Matrix management both in general and in its specific forms has unique strengths and weaknesses. The advantages and disadvantages of matrix organizations in general are noted below, while only briefly highlighting specifics concerning different forms:

1. **Efficient.** Resources can be shared across multiple projects as well as within functional divisions. Individuals can divide their energy across multiple projects on an as-needed basis. This reduces duplication required in a projectized structure.

2. **Strong Project Focus.** A stronger project focus is provided by having a formally designated project manager who is responsible for coordinating and integrating contributions of different units. This helps sustain a holistic approach to problem solving that is often missing in the functional organization.

3. **Easier Post-Project Transition.** Because the project organization is overlaid on the functional divisions, specialists maintain ties with their functional group, so they have a homeport to return to once the project is completed.

4. **Flexible.** Matrix arrangements provide for flexible utilization of resources and expertise within the firm. In some cases functional units may provide individuals who are managed by the project manager. In other cases the contributions are monitored by the functional manager.

The strengths of the matrix structure are considerable. Unfortunately, so are the potential weaknesses. This is due in large part to the fact that a matrix structure is more complicated and the creation of multiple bosses represents a radical departure from the traditional hierarchical authority system.

Furthermore, one does not install a matrix structure overnight. Experts argue that it takes 3–5 years for a matrix system to fully mature. So many of the problems described below represent growing pains.

1. **Dysfunctional Conflict.** The matrix approach is predicated on tension between functional managers and project managers who bring critical expertise and perspectives to the project. Such tension is viewed as a necessary mechanism for achieving an appropriate balance between complex technical issues and unique project requirements. While the intent is noble, the effect is sometimes analogous to opening Pandora's box. Legitimate conflict can spill over to a more personal level, resulting from conflicting agendas and accountabilities. Worthy discussions can degenerate into heated arguments that engender animosity among the managers involved.

2. **Infighting.** Any situation in which equipment, resources, and people are being shared across projects and functional activities lends itself to conflict and competition for scarce resources. Infighting can occur among project managers, who are primarily interested in what is best for their project.

3. **Stressful.** Matrix management violates the management principle of unity of command. Project participants have at least two bosses—their functional head and one or more project managers. Working in a matrix environment can be extremely stressful. Imagine what it would be like to work in an environment in which you are being told to do three conflicting things by three different managers.

4. **Slow.** In theory, the presence of a project manager to coordinate the project should accelerate the completion of the project. In practice, decision making can get bogged down as agreements have to be forged across multiple functional groups. This is especially true for the balanced matrix.

When the three variant forms of the matrix approach are considered, we can see that advantages and disadvantages are not necessarily true for all three forms of matrix. The Strong matrix is likely to enhance project integration, diminish internal power struggles, and ultimately improve control of project activities and costs. On the downside, technical quality may suffer because functional areas have less control over their contributions. Finally, projectitis may emerge as the members develop a strong team identity.

The Weak matrix is likely to improve technical quality as well as provide a better system for managing conflict across projects because the functional manager assigns personnel to different projects. The problem is that functional control is often maintained at the expense of poor project integration. The Balanced matrix can achieve better balance between technical and project requirements, but it is a very delicate system to manage and is more likely to succumb to many of the problems associated with the matrix approach.

What Is the Right Project Management Structure?

There is growing empirical evidence that project success is directly linked to the amount of autonomy and authority project managers have over their projects. See Research Highlight: Relative Effectiveness of Different Project Management Structures. However, most of this research is based on what is best for managing specific projects. It is important to remember what was stated in the beginning of the chapter—that the best system balances the needs of the project with those of the parent organization. So what project structure should an organization use? This is a complicated question with no precise answers. A number of issues need to be considered at both the organization and project level.

Organization Considerations

At the organization level, the first question that needs to be asked is how important is project management to the success of the firm? What percentage of core work involves projects? If over 75 percent of work involves projects, then an organization should consider a fully projectized organization. If an organization has both standard products and projects, then a matrix arrangement would appear to be appropriate. If an organization has very few projects, then a less formal arrangement is probably all that is required. Dedicated teams could be created on an as-needed basis and the organization could outsource project work.

A second key question is resource availability. Remember, matrix evolved out of the necessity to share resources across multiple projects and functional domains while at the same time creating legitimate project leadership. For organizations that cannot afford to tie up critical personnel on individual projects, a matrix system would appear to be appropriate. An alternative would be to create a dedicated team but outsource project work when resources are not available internally.

Within the context of the first two questions, an organization needs to assess current practices and what changes are needed to more effectively manage projects. A strong project matrix is not installed overnight. The shift toward a greater emphasis on projects has a host of political implications that need to be worked through, requiring time and strong leadership. For example, we have observed many companies that make the transition from a functional organization to a matrix organization begin with a weak functional matrix. This is due in part to resistance by functional and department managers toward transferring authority to project managers. With time, these matrix structures eventually evolve into a project matrix. Many organizations have created Project Management Offices to support project management efforts. See Snapshot from Practice: POs Project Offices.

Project Considerations

At the project level, the question is how much autonomy the project needs in order to be successfully completed. Hobbs and Ménard identify seven factors that should influence the choice of project management structure:

- Size of project.
- Strategic importance.
- Novelty and need for innovation.
- Need for integration (number of departments involved).
- Environmental complexity (number of external interfaces).
- Budget and time constraints.
- Stability of resource requirements.

Larson and Gobeli studied the relative efficacy of different project management structures. Their work is based on a sample of more than 1,600 project professionals and managers actively involved in project management within their organizations. Among the findings they report are the rated effectiveness of different structures for product development and construction projects. These results are summarized in Figure 3.5 and indicate a strong preference for either the project team or strong matrix. Both the functional approach and the weak matrix were rated ineffective, and the balanced matrix was considered only marginally effective.

Because these ratings may have been tempered by self-interest, with project managers advocating forms that give them more formal authority, the ratings of project managers were compared with those of top management and functional managers. No significant differences were found; the weak matrix and functional organization were considered the least effective even by functional managers.

This research was published at a time when matrix management was receiving a lot of negative press and when popular management media were advocating the dedicated project team approach. A key finding was that matrix management can be as effective as a project team—if the project manager is given significant control over project activities. The support is not without reservations; as one project manager reported, "Matrix management works, but it sure is difficult at times. All matrix managers must keep up their health and take Stress Tabs."

FIGURE 3.5 Rated Effectiveness of Different Project Structures by Type of Project

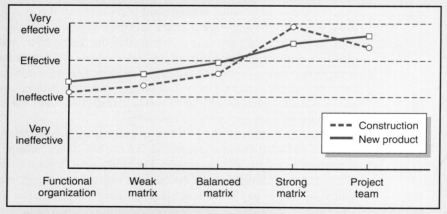

* E. W. Larson, and D. H. Gobeli, "Matrix Management: Contradictions and Insights," *California Management Review*, vol. 29, no. 4 (Summer 1987), p. 137.

The higher the levels of these seven factors, the more autonomy and authority the project manager and project team need to be successful. This translates into using either a dedicated project team or a project matrix structure. For example, these structures should be used for large projects that are strategically critical and are new to the company, thus requiring much innovation. These structures would also be appropriate for complex, multidisciplinary projects that require input from many departments, as well as for projects that require constant contact with customers to assess their expectations. Dedicated project teams should also be used for urgent projects in which the nature of the work requires people working steadily from beginning to end.

Many firms that are heavily involved in project management have created a flexible management system that organizes projects according to project requirements. For example,

Project offices (POs) were originally developed as a response to the poor track record many companies had in completing projects on time, within budget, and according to plan. They were often established to help matrix systems mature into more effective project delivery platforms.

Today, POs come in many different shapes and forms. One interesting way of classifying POs was set forth by Casey and Peck,* who describe certain POs in terms of being (1) a weather station, (2) a control tower, or (3) a resource pool. Each of these models performs a very different function for its organization.

- **Weather Station.** The primary function of the weather station PO is to track and monitor project performance. It is typically created to satisfy top management's need to stay on top of the portfolio of projects under way in the firm. Staff provides an independent forecast of project performance. The questions answered for specific projects include:

 - How are our projects progressing? Which ones are on track? Which ones are not?

- How are we doing in terms of cost? Which projects are over or under budget?

- What are the major problems confronting projects? Are contingency plans in place? What can the organization do to help the project?

- **Control Tower.** The primary function of the control tower PO is to improve project execution. It considers project management as a profession to be protected and advanced. Staff at the PO identify best practices and standards for project management excellence. They work as consultants and trainers to support project managers and their teams.

- **Resource Pool.** The goal of the resource pool PO is to provide the organization with a cadre of trained project managers and professionals. It operates like an academy for continually upgrading the skills of a firm's project professionals. In addition to training, this kind of PO also serves to elevate the stature of project management within the organization.

* W. Casey, and W. Peck, "Choosing the Right PMO Setup," *PM Network*, vol. 15, no. 2(2001), pp. 40–47.

Chaparral Steel, a mini-mill that produces steel bars and beams from scrap metal, classifies projects into three categories: advanced development, platform, and incremental. Advanced development projects are high-risk endeavors involving the creation of a breakthrough product or process. Platform projects are medium-risk projects involving system upgrades that yield new products and processes. Incremental projects are low-risk, short-term projects that involve minor adjustments in existing products and processes. At any point in time, Chaparral might have 40–50 projects underway, of which only one or two are advanced, three to five are platform projects, and the remainder are small, incremental projects. The incremental projects are almost all done within a weak matrix with the project manager coordinating the work of functional subgroups. A strong matrix is used to complete the platform projects, while dedicated project teams are typically created to complete the advanced development projects. More and more companies are using this "mix and match" approach to managing projects.

Organizational Culture

The decision for combining a discussion of project management structures and organizational cultures in this chapter can be traced to a conversation we, the authors, had with two project managers who work for a medium-sized information technology firm.

The managers were developing a new operating platform that would be critical to the future success of their company. When they tried to describe how this project was organized, one manager began to sketch out on a napkin a complicated structure involving 52 different teams, each with a project leader and a technical leader! In response to our further probing to understand how this system worked, the manager stopped short and proclaimed, "The key to making this structure work is the culture in our company. This

approach would never work at company Y, where I worked before. But because of our culture here we are able to pull it off."

This comment, our observations of other firms, and research suggest there is a strong connection between project management structure, organizational culture, and project success. We have observed organizations successfully manage projects within the traditional functional organization because the culture encouraged cross-functional integration. Conversely we have seen matrix structures break down because the culture of the organization did not support the division of authority between project managers and functional managers. We have also observed companies relying on independent project teams because the dominant culture would not support the innovation and speed necessary for success.

What Is Organizational Culture?

Organizational culture refers to a system of shared norms, beliefs, values, and assumptions which binds people together, thereby creating shared meanings. This system is manifested by customs and habits that exemplify the values and beliefs of the organization. For example, egalitarianism may be expressed in the informal dress worn at a high-tech firm. Conversely, mandated uniforms at a department store reinforce respect for the hierarchy.

Culture reflects the personality of the organization and, similar to an individual's personality, can enable us to predict attitudes and behaviors of organizational members. Culture is also one of the defining aspects of an organization that sets it apart from other organizations even in the same industry.

Research suggests that there are 10 primary characteristics which, in aggregate, capture the essence of an organization's culture:

1. **Member identity**—the degree to which employees identify with the organization as a whole rather than with their type of job or field of professional expertise.
2. **Team emphasis**—the degree to which work activities are organized around groups rather than individuals.
3. **Management focus**—the degree to which management decisions take into account the effect of outcomes on people within the organization.
4. **Unit integration**—the degree to which units within the organization are encouraged to operate in a coordinated or interdependent manner.
5. **Control**—the degree to which rules, policies, and direct supervision are used to oversee and control employee behavior.
6. **Risk tolerance**—the degree to which employees are encouraged to be aggressive, innovative, and risk seeking.
7. **Reward criteria**—the degree to which rewards such as promotion and salary increases are allocated according to employee performance rather than seniority, favoritism, or other nonperformance factors.
8. **Conflict tolerance**—the degree to which employees are encouraged to air conflicts and criticisms openly.
9. **Means versus end orientation**—the degree to which management focuses on outcomes rather than on techniques and processes used to achieve those results.
10. **Open-systems focus**—the degree to which the organization monitors and responds to changes in the external environment.

As shown in Figure 3.6, each of these dimensions exists on a continuum. Assessing an organization according to these 10 dimensions provides a composite picture of the organization's culture. This picture becomes the basis for feelings of shared understanding that

FIGURE 3.6
Key Dimensions Defining an Organization's Culture

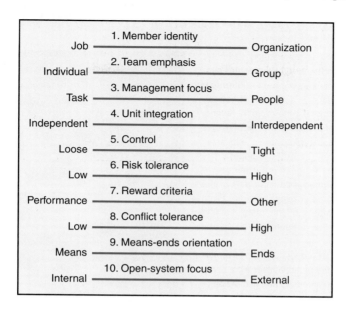

Job	1. Member identity — Organization
Individual	2. Team emphasis — Group
Task	3. Management focus — People
Independent	4. Unit integration — Interdependent
Loose	5. Control — Tight
Low	6. Risk tolerance — High
Performance	7. Reward criteria — Other
Low	8. Conflict tolerance — High
Means	9. Means-ends orientation — Ends
Internal	10. Open-system focus — External

the members have about the organization, how things are done, and the way members are supposed to behave.

Culture performs several important functions in organizations. An organization's culture *provides a sense of identity* for its members. The more clearly an organization's shared perceptions and values are stated, the more strongly people can identify with their organization and feel a vital part of it. Identity generates commitment to the organization and reasons for members to devote energy and loyalty to the organization.

A second important function is that culture *helps legitimize the management system* of the organization. Culture helps clarify authority relationships. It provides reasons why people are in a position of authority and why their authority should be respected.

Most importantly, organizational culture *clarifies and reinforces standards of behavior.* Culture helps define what is permissible and inappropriate behavior. These standards span a wide range of behavior from dress code and working hours to challenging the judgment of superiors and collaborating with other departments. Ultimately, culture *helps create social order* within an organization. Imagine what it would be like if members didn't share similar beliefs, values, and assumptions—chaos! The customs, norms, and ideals conveyed by the culture of an organization provide the stability and predictability in behavior that is essential for an effective organization. See Snapshot from Practice: Software Development Teams at Microsoft for an example of this.

Although our discussion of organizational culture may appear to suggest one culture dominates the entire organization, in reality this is rarely the case. "Strong" or "thick" are adjectives used to denote a culture in which the organization's core values and customs are widely shared within the entire organization. Conversely, a "thin" or "weak" culture is one that is not widely shared or practiced within a firm.

Even within a strong organizational culture, there are likely to be subcultures often aligned within specific departments or specialty areas. As noted earlier in our discussion of project management structures, it is not uncommon for norms, values, and customs to develop within a specific field or profession such as marketing, finance, or operations. People working in the marketing department may have a different set of norms and values than those working in finance.

Microsoft Corporation is the leading computer software company in the world. Microsoft's success stems in part from a corporate culture that supports teams of software developers to create and refine new products. No matter how big the project—even a complex one such as the development of the successful Windows 2000 operating system—the project is broken down into small parts that can be handled by teams of about 12 developers. The segment of the project each team is assigned is further subdivided so that each developer is assigned a specific part of the project to work on. Developers with greater experience are given more responsibilities than new members of the team, but the entire team knows that project success depends on the sum of their individual inputs.

Team members provide considerable support for each other. It is not uncommon to see two team members hunched over a computer screen trying to solve a problem. Team members can also be stern critics if a team member fails to perform at an acceptable level.

Developers are granted considerable autonomy in performing their work. At the same time behavior at Microsoft is governed by shared work culture that almost everyone follows. One set of informal rules governs the basic issue of working hours. Developers are free to adopt whatever work schedule suits them. If a developer has a sudden insight at midnight, it is not unusual for people to work until dawn. Likewise, if a developer's child is sick, the developer can stay home to take care of the child, and do makeup work at some other time. Along with these "rules" on flexible working hours, almost all developers abide by another norm: They put in the hours necessary to get the job done, even if it requires staying up all night to work on a particularly difficult part of a program.

Michael Newman/PhotoEdit.

* K., Rebello, "Inside Microsoft," *Business Weekly*, July 15, 1996, pp. 56–67; B., Filipczak "Beyond the Gates of Microsoft," *Training*, September 1992, pp. 37–44.

Countercultures sometimes emerge within organizations that embody a different set of values, beliefs, and customs—often in direct contradiction with the culture espoused by top management. How pervasive these subcultures and countercultures are affects the strength of the culture of the organization and the extent to which culture influences members' actions and responses.

Identifying Cultural Characteristics

Deciphering an organization's culture is a highly interpretative, subjective process that requires assessment of both current and past history. The student of culture cannot simply rely on what people report about their culture. The physical environment in which people work, as well as how people act and respond to different events that occur, must be examined. Figure 3.7 contains a worksheet for diagnosing the culture of an organization. Although by no means exhaustive, the checklist often yields clues about the norms, customs, and values of an organization:

1. **Study the physical characteristics of an organization.** What does the external architecture look like? What image does it convey? Is it unique? Are the buildings and

FIGURE 3.7
Organizational Culture Diagnosis Worksheet

I. Physical Characteristics
Architecture, office layout, decor, attire

II. Public Documents
Annual reports, internal newsletters, vision statements

III. Behavior
Pace, language, meetings, issues discussed,
decision-making style, communication patterns, rituals

IV. Folklore
Stories, anecdotes, heroines, heroes, villains

offices the same quality for all employees? Or are modern buildings and fancier offices reserved for senior executives or managers from a specific department? What are the customs concerning dress? What symbols does the organization use to signal authority and status within the organization? These physical characteristics can shed light on who has real power within the organization, the extent to which the organization is internally differentiated, and how formal the organization is in its business dealings.

2. **Read about the organization.** Examine annual reports, mission statements, press releases, and internal newsletters. What do they describe? What principles are espoused in these documents? Do the reports emphasize the people who work for the organization and what they do or the financial performance of the firm? Each emphasis reflects a different culture. The first demonstrates concern for the people who make up the company. The second may suggest a concern for results and the bottom line.

3. **Observe how people interact within the organization.** What is their pace—is it slow and methodical or urgent and spontaneous? What rituals exist within the organization? What values do they express? Meetings can often yield insightful information. Who are the people at the meetings? Who does the talking? To whom do they talk? How candid is the conversation? Do people speak for the organization or for the individual department? What is the focus of the meetings? How much time is spent on various issues? Issues that are discussed repeatedly and at length are clues about the values of the organization's culture.

4. **Interpret stories and folklore surrounding the organization.** Look for similarities among stories told by different people. The subjects highlighted in recurring stories often reflect what is important to an organization's culture. For example, many of the stories that are repeated at Versatec, a Xerox subsidiary that makes graphic plotters for computers, involve their flamboyant cofounder, Renn Zaphiropoulos. According to company folklore, one of the very first things Renn did when the company was formed was to assemble the top management team at his home. They then devoted the weekend to handmaking a beautiful teak conference table around which all future decisions would be made. This table came to symbolize the importance of teamwork and maintaining high standards of performance, two essential qualities of the culture at Versatec.

Try to identify who the heroes and villains are in the folklore company. What do they suggest about the culture's ideals? Returning to the Versatec story, when the company was eventually purchased by Xerox many employees expressed concern that Versatec's informal, play hard/work hard culture would be overwhelmed by the bureaucracy at Xerox. Renn rallied the employees to superior levels of performance by arguing that if they exceeded Xerox's expectations they would be left alone. Autonomy has remained a fixture of Versatec's culture long after Renn's retirement.

It is also important to pay close attention to the basis for promotions and rewards. What do people see as the keys to getting ahead within the organization? What contributes to downfalls? These last two questions can yield important insights into the qualities and behaviors which the organization honors as well as the cultural taboos and behavioral land mines that can derail a career. For example, one project manager confided that a former colleague was sent to project management purgatory soon after publicly questioning the validity of a marketing report. From that point on, the project manager was extra careful to privately consult the marketing department whenever she had questions about their data.

With practice an observer can assess how strong the dominant culture of an organization is and the significance of subcultures and countercultures. Furthermore, learners can discern and identify where the culture of an organization stands on the 10 cultural dimensions presented earlier and, in essence, begin to build a cultural profile for a firm. Based on this profile, conclusions can be drawn about specific customs and norms that need to be adhered to as well as those behaviors and actions that violate the norms of a firm.

Implications of Organizational Culture for Organizing Projects

Project managers have to be able to operate in several, potentially diverse, organizational cultures. First, they have to interact with the culture of their parent organization as well as the subcultures of various departments (e.g., marketing, accounting). Second, they have to interact with the project's client or customer organizations. Finally, they have to interact in varying degrees with a host of other organizations connected to the project. These organizations include suppliers and vendors, subcontractors, consulting firms, government and regulatory agencies, and, in many cases, community groups. Many of these organizations are likely to have very different cultures. Project managers have to be able to read and speak the culture they are working in to develop strategies, plans, and responses that are likely to be understood and accepted. Still, the emphasis of this chapter is on the relationship between organizational culture and project management structure, and it is necessary to defer further discussion of these implications until Chapters 10–12, which focus on leadership, team building, and outsourcing.

Earlier we stated that we believe there are strong relationships among project management structure, organizational culture, and successful project management. To explore these relationships further, let us return to the dimensions that can be used to characterize the culture of an organization. When examining these dimensions we could hypothesize that certain aspects of the culture of an organization would support successful project management while other aspects would deter or interfere with effective management. Figure 3.8 attempts to identify which cultural characteristics create an environment conducive to completing most complex projects involving people from different disciplines.

Note that, in many cases, the ideal culture is not at either extreme. For example, a fertile project culture would likely be one in which management balances its focus on the needs of both the task and the people. An optimal culture would balance concern with

FIGURE 3.8
Cultural Dimensions of an Organization Supportive of Project Management

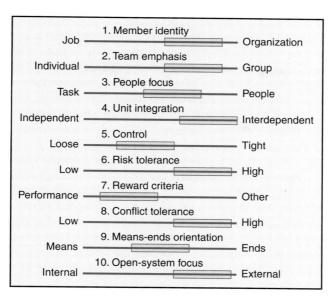

output (ends) and processes to achieve those outcomes (means). In other cases, the ideal culture would be on one end of a dimension or the other. For example, because most projects require collaboration across disciplines, it would be desirable that the culture of the organization emphasize working in teams and identifying with the organization, not just the professional domain. Likewise it is important that the culture support a certain degree of risk taking and a tolerance for constructive conflict.

One organization that appears to fit this ideal profile is 3M. 3M has received acclaim for creating an entrepreneurial culture within a large corporate framework. The essence of its culture is captured in phrases that have been chanted often by 3Mers throughout its history: "Encourage experimental doodling." "Hire good people and leave them alone." "If you put fences around people, you get sheep. Give people the room they need." Freedom and autonomy to experiment are reflected in the "15 percent rule," which encourages technical people to spend up to 15 percent of their time on projects of their own choosing and initiative. This fertile culture has contributed to 3M's branching out into more than 60,000 products and 35 separate business units.

The metaphor we choose to describe the relationship between organizational culture and project management is that of a riverboat trip. Culture is the river and the project is the boat. Organizing and completing projects within an organization in which the culture is conducive to project management is like paddling downstream: much less effort is required. In many cases, the current can be so strong that steering is all that is required. Such is the case for projects that operate in a project-friendly environment where teamwork and cross-functional cooperation are the norms, where there is a deep commitment to excellence, and where healthy conflict is voiced and dealt with quickly and effectively.

Conversely, trying to complete a project in a toxic culture is like paddling upstream: much more time, effort, and attention are needed to reach the destination. This would be the situation in cultures that discourage teamwork and cooperation, that have a low tolerance for conflict, and where getting ahead is based less on performance and more on cultivating favorable relationships with superiors. In such cases, the project manager and her people not only have to overcome the natural obstacles of the project but also have to overcome the prevailing negative forces inherent in the culture of the organization.

The implications of this metaphor are important. Greater project authority and time are necessary to complete projects that encounter a strong, negative cultural current. Conversely, less formal authority and fewer dedicated resources are needed to complete projects in which the cultural currents generate behavior and cooperation essential to project success.

The key issue is the degree of interdependency between the parent organization and the project team. In cases where the prevalent organizational culture supports the behaviors essential to project completion, a weaker project management structure can be effective. For example, one of the major reasons Chaparral Steel is able to use a functional matrix to successfully complete incremental projects is that its culture contains strong norms for cooperation. Conversely, one of the reasons behind the failure of Kodak's "Factory of the Future" project in the mid-1980s was that the culture at that time did not support project management.

When the dominant organization culture inhibits collaboration and innovation, it is advisable to insulate the project team from the dominant culture. Here it becomes necessary to create a self-sufficient project team. If a dedicated project team is impossible because of resource constraints, then at least a project matrix should be used where the project manager has dominant control over the project. In both cases, the managerial strategy is to create a distinct team subculture in which a new set of norms, customs, and values evolve that will be conducive to project completion.

Under extreme circumstances this project culture could even represent a counterculture in that many of the norms and values are the antithesis of the dominant, parent culture. Such was the case when IBM decided to develop their personal computer quickly in 1980. They knew that the project could get bogged down by the overabundance of computer knowledge and bureaucracy in the company. They also realized that they would have to work closely with suppliers and make use of many non-IBM parts if they were to get to the market quickly. This was not the IBM way at the time, so IBM established the PC project team in a warehouse in Boca Raton, Florida, far from corporate headquarters and other corporate development facilities that existed within the organization.

Summary

This chapter examined two major characteristics of the parent organization that affect the implementation and completion of projects. The first is the formal structure of the organization and how it chooses to organize and manage projects. Although the individual project manager may have very little say as to how the firm chooses to manage projects, he or she must be able to recognize the options available as well as the inherent strengths and weaknesses of different approaches.

Three basic project management structures were described and assessed as to their weaknesses and strengths. Only under unique circumstances can a case be made for managing a project within the normal functional hierarchy. When thinking only in terms of what is best for the project, the creation of an independent project team is clearly favored. However, the most effective project management system appropriately balances the needs of the project with those of the parent organization. Matrix structures emerged out of the parent organization's need to share personnel and resources across multiple projects and operations while creating legitimate project focus. The matrix approach is a hybrid organizational form that combines elements of both the functional and project team forms in an attempt to realize the advantages of both.

The second major characteristic of the parent organization that was discussed in this chapter is the concept of organizational culture. Organizational culture is the pattern of beliefs and expectations shared by an organization's members. Culture includes the behavioral norms, customs, shared values, and the "rules of the game" for getting along and getting ahead within the organization. It is important for project managers to be "culture

sensitive" so that they can develop appropriate strategies and responses and avoid violating key norms that would jeopardize their effectiveness within the organization.

The interaction between project management structure and organizational culture is a complicated one. We have suggested that in certain organizations, culture encourages the implementation of projects. In this environment the project management structure used plays a less decisive role in the success of the project. Conversely, for other organizations in which the culture stresses internal competition and differentiation, just the opposite may be true. The prevailing norms, customs, and attitudes inhibit effective project management, and the project management structure plays a more decisive role in the successful implementation of projects. At a minimum, under adverse cultural conditions, the project manager needs to have significant authority over the project team; under more extreme conditions firms should use dedicated project teams to complete critical projects. In both cases, the managerial strategy should be to insulate project work from the dominant culture so that a more positive "subculture" can emerge among project participants.

The project management structure of the organization and the culture of the organization are major elements of the environment in which a project is initiated. Subsequent chapters will examine how project managers and professionals work within this environment to successfully complete projects.

Key Terms

Balanced matrix	Organizational culture	Strong matrix
Dedicated project team	Projectitis	Weak matrix
Matrix	Project office (PO)	

Review Questions

1. What are the relative advantages and disadvantages of the functional, matrix, and dedicated team approaches to managing projects?
2. What distinguishes a weak matrix from a strong matrix?
3. Under what conditions would it be advisable to use a strong matrix instead of a dedicated project team?
4. Why is it important to assess the culture of an organization before deciding what project management structure should be used to complete a project?
5. What do you believe is more important for successfully completing a project—the formal project management structure or the culture of the parent organization?

Exercises

1. Going to college is analogous to working in a matrix environment in that most students take more than one class and must distribute their time across multiple classes. What problems does this situation create for you? How does it affect your performance? How could the system be better managed to make your life less difficult and more productive?
2. You work for LL Company, which manufacturers high-end optical scopes for hunting rifles. LL Company has been the market leader for the past 20 years and has decided to diversify by applying its technology to develop a top-quality binocular. What kind of project management structure would you recommend they use for this project? What information would you like to have to make this recommendation, and why?
3. You work for Barbata Electronics. Your R&D people believe they have come up with an affordable technology that will double the capacity of existing MP3 players and uses audio format that is superior to MP3. The project is code named KYSO (Knock Your Socks Off). What kind of project management structure would you recommend

they use for the KYSO project? What information would you like to have to make this recommendation and why?

4. This chapter discussed the role of values and beliefs in forming an organization's culture. The topic of organization culture is big business on the Internet. Many companies use their Web pages to describe their mission, vision, and corporate values and beliefs. There also are many consulting firms that advertise how they help organizations to change their culture. The purpose of this exercise is for you to obtain information pertaining to the organizational culture for two different companies. You can go about this task by very simply searching on the key words "organizational culture" or "corporate vision and values." This search will identify numerous companies for you to use to answer the following questions. You may want to select companies that you would like to work for in the future.

 a. What are the espoused values and beliefs of the companies?

 b. Use the worksheet in Figure 3.7 to assess the Web page. What does the Web page reveal about the culture of this organization? Would this culture be conducive to effective project management?

5. Use the cultural dimensions listed in Figure 3.6 to assess the culture of your school. Instead of employees, consider students, and instead of management, use faculty. For example, member identity refers to the degree to which students identify with the school as a whole rather than their major or option. Either as individuals or in small groups rate the culture of your school on the 10 dimensions.

 a. What dimensions were easy to evaluate and which ones were not?

 b. How strong is the culture of your school?

 c. What functions does the culture serve for your school?

 d. Do you think the culture of your school is best suited to maximizing your learning? Why or why not?

 e. What kind of projects would be easy to implement in your school and what kind of projects would be difficult given the structure and culture of your school? Explain your answer.

6. You work as an analyst in the marketing department for Springfield International (SI). SI uses a weak matrix to develop new services. Management has created an extremely competitive organizational culture that places an emphasis upon achieving results above everything else. One of the project managers that you have been assigned to help has been pressuring you to make his project your number one priority. He also wants you to expand the scope of your work on his project beyond what your marketing manager believes is necessary or appropriate. The project manager is widely perceived as a rising star within SI. Up to now you have been resisting the project manager's pressure and complying with your marketing manager's directives. However, your most recent interchange with the project manager ended by his saying, "I'm not happy with the level of help I am getting from you and I will remember this when I become VP of Marketing." How would you respond and why?

References

Block, T. R. and J. D., Frame, *The Project Office—A Key to Managing Projects Effectively* (Menlo Park, CA: Crisp Publications, 1998).

Block, T. R. and J. D. Frame, "Today's Project Office: Gauging Attitudes," *PM Network,* August, 2001.

Bowen, H. K., K. B. Clark, C. A. Holloway, and S. C. Wheelwright, *The Perpetual Enterprise Machine* (New York: Oxford University Press, 1994).

Brown, S. and K. R. Eisenhardt, "Product Development: Past Research, Present Findings, and Future Directions," *Academy of Management Review,* 20 (2) 1995, pp. 343–78.

Cameron, K. S. and R. E. Quinn, *Diagnosing and Changing Organizational Culture: Based on the Competing Values Framework* (Upper Saddle River, NJ: Prentice Hall, 1999).

Carlton, J., *Apple: The Inside Story of Intrigue, Egomania, and Business Blunders* (New York: Random House, 1997), pp. 13–14.

Casey, W. and W. Peck, "Choosing the Right PMO Setup," *PM Network,* 15 (2) 2001, pp. 40–47.

Collins, J. C. and J. I. Porras, *Built to Last: The Successful Habits of Visionary Companies* (New York: HarperCollins, 1994), pp. 150–58.

Deal, T. E. and A. A. Kennedy, *Corporate Cultures: The Rites and Rituals of Corporate Life* (Reading, MA: Addison-Wesley, 1982).

De Laat, P. B., "Matrix Management of Projects and Power Struggles: A Case Study of an R&D Laboratory," *IEEE Engineering Management Review* (Winter, 1995).

Filipczak, B., "Beyond the Gates of Microsoft," *Training,* September 1992, pp. 37–44.

Gallagher, R. S., *The Soul of an Organization: Understanding the Values That Drive Successful Corporate Cultures* (Chicago: Dearborn Trade Publishing, 2002).

Graham, R. J. and R. L. Englund, *Creating an Environment for Successful Projects: The Quest to Manage Project Management* (San Francisco: Jossey-Bass, 1997).

Gray, C., S. Dworatschek, D. H. Gobeli, H. Knoepfel, and E. W. Larson, "International Comparison of Project Organization Structures: Use and Effectiveness," *International Journal of Project Management,* vol. 8, no. 1 (February 1990), pp. 26–32.

Harrison, M. T. and J. M. Beyer, *The Culture of Organizations* (Englewood Cliffs, NJ: Prentice Hall, 1993).

Hobbs, B. and P. Ménard, "Organizational Choices for Project Management," in Paul Dinsmore (ed.), *The AMA Handbook of Project Management* (New York: AMACOM, 1993).

Hobday, M., "The Project-Based Organization: An Ideal Form for Managing Complex Products and Systems?" *Research Policy,* vol. 29, no.1 7, 2000.

Jassawalla, A. R. and H. C. Sashittal, "Cultures that Support Product-Innovation Processes," *Academy of Management Executive,* 15 (3) 2002, pp. 42–54.

Johnson, C. L., M. Smith, and L. K. Geary, *More Than My Share in All* (Washington, D.C.: Smithsonian Institute Publications, 1990).

Kerzner, H., *In Search of Excellence in Project Management* (New York: Von Nostrand Reinhold, 1997).

Kerzner, H., "Strategic Planning for the Project Office," *Project Management Journal,* 34 (2) 2003, pp. 13–25.

Larson, E. W. "Project Management Structures" in *The Wiley Handbook for Managing Projects,* P. Morris & J. Pinto (eds.) (New York: Wiley 2004), pp. 48–66.

Larson, E. W. and D. H. Gobeli, "Organizing for Product Development Projects," *Journal of Product Innovation Management,* vol. 5 (1988), pp. 180–90.

Larson, E. W., and D. H. Gobeli, "Matrix Management: Contradictions and Insights," *California Management Review,* vol. 29, no. 4 (Summer 1987), p. 137.

Larsson, U. (ed.), *Cultures of Creativity: The Centennial Exhibition of the Nobel Prize* (Canton, MA: Science History Publications, 2001).

Laslo, Z. and A. I. Goldberg, "Matrix Structures and Performance: The Search for Optimal Adjustments to Organizational Objectives?" *IEEE Transactions in Engineering Management,* vol. 48, no.1 2, 2001.

Lawrence, P. R. and J. W. Lorsch, *Organization and Environment* (Homewood, IL: Irwin, 1969).

Majchrzak, A. and Q. Wang, "Breaking the Functional Mind-Set in Process Organizations," *Harvard Business Review* (Sept.–Oct. 1996), pp. 93–99.

Miller, J., *Lockheed Martin's Skunk Works* (New York: Speciality Publications, 1996).

Olson, E. M., O. C. Walker, Jr., and R. W. Ruekert, "Organizing for Effective New Product Development: The Moderating Role of Product Innovativeness," *Journal of Marketing,* vol. 59 (January), 1995, pp. 48–62.

O'Reilly, C. A., J. Chatman, and D. F. Caldwell, "People and Organizational Culture: A Profile Comparison Approach to Assessing Person-Organization Fit," *Academy of Management Journal,* vol. 34, no. 3 (September 1991), pp. 487–516.

Pettegrew, A. M., "On Studying Organizational Culture," *Administrative Science Quarterly,* vol. 24, no. 4 (1979), pp. 570–81.

Powell, M. and J. Young, "The Project Management Support Office" in *The Wiley Handbook for Managing Projects,* P. Morris and J. Pinto, (eds.) (New York: Wiley, 2004) pp. 937–69.

Rebello, K., "Inside Microsoft," *Business Weekly,* July 15, 1996, pp. 56–67.

Schein, E., *Organizational Culture and Leadership: A Dynamic View* (San Francisco, CA: Jossey-Bass, 1985).

Sculley, J., *Odyssey: Pepsi to Apple . . . A Journey of Adventure, Ideas, and the Future* (New York: Harper & Row, 1987), pp. 270–79.

Shenhar, A. J., "From Theory to Practice: Toward a Typology of Project Management Styles," *IEEE Transactions in Engineering Management,* 41 (1) 1998, pp. 33–48.

Shenhar, A. J., D. Dvir T. Lechler and M. Poli, "One Size Does Not Fit All–True for Projects, True for Frameworks," *Frontiers of Project Management Research and Application,* Proceedings of PMI Research Conference, Seattle, 2002, pp. 99–106.

Smith, P. G. and D. G. Reinertsen, *Developing Products in Half the Time* (New York: Van Nostrand Reinhold, 1995).

Stuckenbruck, L. C., *Implementation of Project Management* (Upper Darby, PA: Project Management Institute, 1981).

Youker, R., "Organizational Alternatives for Project Management," *Project Management Quarterly,* vol. 8 (March 1977), pp. 24–33.

Case

Moss and McAdams Accounting Firm

Bruce Palmer had worked for Moss and McAdams (M&M) for six years and was just promoted to account manager. His first assignment was to lead an audit of Johnsonville Trucks. He was quite pleased with the five accountants who had been assigned to his team, especially Zeke Olds. Olds was an Army vet who returned to school to get a double major in accounting and computer sciences. He was on top of the latest developments in financial information systems and had a reputation for coming up with innovative solutions to problems.

M&M was a well-established regional accounting firm with 160 employees located across six offices in Minnesota and Wisconsin. The main office, where Palmer worked,

was in Green Bay, Wisconsin. In fact, one of the founding members, Seth Moss, played briefly for the hometown NFL Packers during the late 1950s. M&M's primary services were corporate audits and tax preparation. Over the last two years the partners decided to move more aggressively into the consulting business. M&M projected that consulting would represent 40 percent of their growth over the next five years.

M&M operated within a matrix structure. As new clients were recruited, a manager was assigned to the account. A manager might be assigned to several accounts, depending on the size and scope of the work. This was especially true in the case of tax preparation projects, where it was not uncommon for a manager to be assigned to 8 to 12 clients. Likewise, senior and staff accountants were assigned to multiple account teams. Ruby Sands was the office manager responsible for assigning personnel to different accounts at the Green Bay office. She did her best to assign staff to multiple projects under the same manager. This wasn't always possible, and sometimes accountants had to work on projects led by different managers.

M&M, like most accounting firms, had a tiered promotion system. New CPAs entered as junior or staff accountants. Within two years, their performance was reviewed and they were either asked to leave or promoted to senior accountant. Sometime during their fifth or sixth year, a decision was made to promote them to account manager. Finally, after 10 to 12 years with the firm, the manager was considered for promotion to partner. This was a very competitive position. During the last five years, only 20 percent of account managers at M&M had been promoted to partner. However, once a partner, they were virtually guaranteed the position for life and enjoyed significant increases in salary, benefits, and prestige. M&M had a reputation for being a results-driven organization; partner promotions were based on meeting deadlines, retaining clients, and generating revenue. The promotion team based its decision on the relative performance of the account manager in comparison to his or her cohorts.

One week into the Johnsonville audit, Palmer received a call from Sands to visit her office. There he was introduced to Ken Crosby, who recently joined M&M after working nine years for a Big 5 accounting firm. Crosby was recruited to manage special consulting projects. Sands reported that Crosby had just secured a major consulting project with Springfield Metals. This was a major coup for the firm: M&M had competed against two Big 5 accounting firms for the project. Sands went on to explain that she was working with Crosby to put together his team. Crosby insisted that Zeke Olds be assigned to his team. Sands told him that this would be impossible because Olds was already assigned to work on the Johnsonville audit. Crosby persisted, arguing that Olds's expertise was essential to the Springfield project. Sands decided to work out a compromise and have Olds split time across both projects.

At this time Crosby turned to Palmer and said, "I believe in keeping things simple. Why don't we agree that Olds works for me in the mornings and you in the afternoons. I'm sure we can work out any problems that come up. After all, we both work for the same firm."

SIX WEEKS LATER

Palmer could scream whenever he remembered Crosby's words, "After all, we both work for the same firm." The first sign of trouble came during the first week of the new arrangement when Crosby called, begging to have Olds work all of Thursday on his project. They were conducting an extensive client visit, and Olds was critical to the assessment. After Palmer reluctantly agreed, Crosby said he owed him one. The next week when Palmer called Crosby to request that he return the favor, Crosby flatly refused and said any other time but not this week. Palmer tried again a week later and got the same response.

At first Olds showed up promptly at 1:00 P.M. at Palmer's office to work on the audit. Soon it became a habit to show up 30 to 60 minutes late. There was always a good reason. He was in a meeting in Springfield and couldn't just leave, or an urgent task took longer than planned. One time it was because Crosby took his entire team out to lunch at the new Thai restaurant—Olds was over an hour late because of slow service. In the beginning Olds would usually make up the time by working after hours, but Palmer could tell from conversations he overheard that this was creating tension at home.

What probably bothered Palmer the most were the e-mails and telephone calls Olds received from Crosby and his team members during the afternoons when he was supposed to be working for Palmer. A couple of times Palmer could have sworn that Olds was working on Crosby's project in his (Palmer's) office.

Palmer met with Crosby to talk about the problem and voice his complaints. Crosby acted surprised and even a little bit hurt. He promised things would change, but the pattern continued.

Palmer was becoming paranoid about Crosby. He knew that Crosby played golf with Olds on the weekends and could just imagine him badmouthing the Johnsonville project and pointing out how boring auditing work was. The sad fact was that there probably was some truth to what he was saying. The Johnsonville project was getting bogged down, and the team was slipping behind schedule. One of the contributing factors was Olds's performance. His work was not up to its usual standards. Palmer approached Olds about this, and Olds became defensive. Olds later apologized and confided that he found it difficult switching his thinking from consulting to auditing and then back to consulting. He promised to do better, and there was a slight improvement in his performance.

The last straw came when Olds asked to leave work early on Friday so that he could take his wife and kids to a Milwaukee Brewers baseball game. It turned out Springfield Metals had given Crosby their corporate tickets, and he decided to treat his team with box seats right behind the Brewers dugout. Palmer hated to do it, but he had to refuse the request. He felt guilty when he overheard Olds explaining to his son on the telephone why they couldn't go to the game.

Palmer finally decided to pick up the phone and request an urgent meeting with Sands to resolve the problem. He got up enough nerve and put in the call only to be told that Sands wouldn't be back in the office until next week. As he put the receiver down, he thought maybe things would get better.

TWO WEEKS LATER

Sands showed up unexpectedly at Palmer's office and said they needed to talk about Olds. Palmer was delighted, thinking that now he could tell her what had been going on. But before he had a chance to speak, Sands told him that Olds had come to see her yesterday. She told him that Olds confessed that he was having a hard time working on both Crosby's and Palmer's projects. He was having difficulty concentrating on the auditing work in the afternoon because he was thinking about some of the consulting issues that had emerged during the morning. He was putting in extra hours to try to meet both of the projects' deadlines, and this was creating problems at home. The bottom line was that he was stressed out and couldn't deal with the situation. He asked that he be assigned full-time to Crosby's project. Sands went on to say that Olds didn't blame Palmer, in fact he had a lot of nice things to say about him. He just enjoyed the consulting work more and found it more challenging. Sands concluded by saying, "We talked some more and ultimately I agreed with him. I hate to do this to you, Bruce, but Olds is a valuable employee, and I think this is the best decision for the firm."

1. If you were Palmer at the end of the case, how would you respond?
2. What, if anything, could Palmer have done to avoid losing Olds?
3. What advantages and disadvantages of a matrix type organization are apparent from this case?
4. What could the management at M&M do to more effectively manage situations like this?

Case

ORION Systems (A)*

The office erupted into cheers when it was announced over the PA system that ORION had just been awarded the government contract to build the next generation of high-speed, light-rail trains. Everyone came over to shake Mike Rosas's hand and congratulate him. It was well known that Rosas would be the project manager for this important project, which would be code named Jaguar. Once the celebration subsided, Rosas gazed out the window and thought about what he had just gotten himself into.

The Jaguar project would be a high-profile project that would affect procurement of future contracts with the government. Increased competition had raised performance expectations regarding completion time, quality, reliability, and cost. He knew that major changes in how ORION organized and managed projects would be necessary to meet the expectations of the Jaguar project.

PROJECT MANAGEMENT AT ORION

ORION was a division of a large aerospace company with 7,000 employees. ORION evolved from a project organization into a matrix structure to conserve costs and better utilize limited resources. At any point in time, ORION could be working on three to five large projects such as the Jaguar project and 30 to 50 smaller projects. Project managers negotiated personnel assignments with the VP of operations, who ultimately decided project assignments. It was not uncommon for an engineer to be working on two to three projects during a week.

Figure C3.1 portrays how new-product development projects were organized at ORION. Project management was limited only to the design and development of the new product. Once the final design and prototype were completed, they were turned over to manufacturing for production and delivery to the customer. A four-person management team oversaw the completion of the project and their responsibilities are briefly described here:

- *Project manager*—responsible for all aspects of design and development of the product.
- *Planning and control manager*—responsible for building an overall project network, scheduling, managing the budget, controlling and evaluating the design and development program, and preparing status reports.
- *Electronics system engineer*—responsible for providing technical expertise on electronic systems issues.
- *Mechanics system engineer*—responsible for providing technical expertise on mechanical system issues.

* Prepared by Shlomo Cohen.

FIGURE C3.1
Organization of
Product Development
Projects at ORION

The core work was completed by 12 to 20 design teams. Each team had a leader, who was responsible for designing, developing, building, and testing a specific subsystem of the product. The size of individual teams varied from 5 to 15 engineers, depending on the scope of their work. These engineers split time across multiple projects.

Design engineers ran the show at ORION, and manufacturing, marketing, and other groups were expected to follow their lead. The special status of the design engineers was reinforced by the fact that they were actually paid on higher pay curves than the manufacturing engineers.

The overall product development and manufacturing process is captured in the master plan chart (Figure C3.2). New-product design and development evolves around five major reviews: system design review (SDR), preliminary design review (PDR), critical design review (CDR), test readiness review (TRR), and production readiness review (PRR).

Design and development work begins within the laboratory and progresses to field tests of specific subsystems and ultimately final product prototypes. Once completed, the design and prototype are turned over to manufacturing, which begins building the production line for the new product. Manufacturing also develops the necessary test equipment to confirm that manufactured components perform correctly. During this time, integrated logistical support (ILS) teams prepare product documentation, users' manuals, maintenance programs, and training programs for the customers who will be using the product. It typically takes ORION six to seven years to develop and manufacture a product such as the Jaguar.

ORION just completed a major assessment of how projects are managed. Below is a brief description of some of the major problems that were identified:

- *Higher than expected production costs.* Once products were developed, there was a tendency for them to be "thrown over the wall" to manufacturing to produce. Very little design for manufacturability was done, and the production ramp was complicated, inefficient, and stressful to the people in the plant.

- *Quality concerns.* Increased competition had raised customer expectations with regard to quality. Customers expected fewer defects and longer replacement schedules. ORION had a tendency to deal with quality issues after the fact, initiating quality improvements

FIGURE C3.2
Traditional Master Plan at ORION

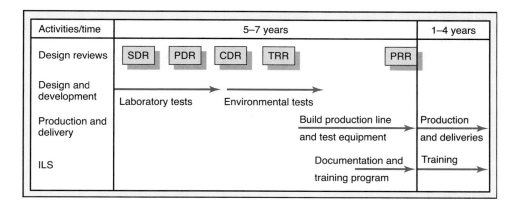

after the production process was set up. Not enough attention was devoted to incorporating quality considerations into the original design of products.

- *Problems with customer support.* User manuals and technical documentation sometimes failed to address all of a customer's concerns, and the follow-up training was not always adequately prepared. These problems contributed to increased costs in customer service and a decline in customer satisfaction.

- *Lack of strong project ownership.* While everyone accepted that a matrix arrangement was the only way to accommodate all the projects at ORION, the shifting back and forth of personnel across multiple projects took its toll on the progress of individual projects. Members often failed to identify with individual projects and develop the sense of excitement that contributed to superior performance. The shuffling of personnel slowed down progress because additional time had to be devoted to bringing returning members up to speed on current developments.

- *Scope creep.* ORION was renowned for its engineering prowess. However, there was a tendency for design engineers to get so absorbed with the science of the project that they lost focus on the practical considerations. This led to costly delays and sometimes design modifications that were inconsistent with customer requirements.

Rosas was aware of these and other concerns as he sat down with his staff to figure out the best way to organize the new Jaguar project.

1. What recommendations would you make to Rosas about organizing the Jaguar project, and why?
2. How would you change the organizational chart and master plan to reflect these changes?

Case

ORION Systems (B)

ROSAS'S PLAN

Rosas and his staff worked hard over the past week to develop a plan to establish a new standard for completing projects at ORION. The Jaguar project management team will be expanded to seven managers, who will be responsible for overseeing the completion of the

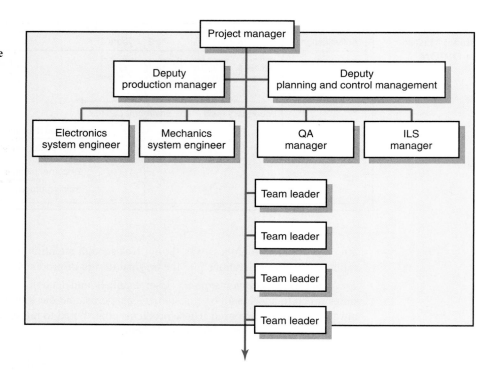

project from design to delivery to the customer. A brief description of the responsibilities for the three new positions follows (see Figure C3.3):

- *Production manager*—responsible for raising production issues during the design phase; responsible for building and managing the production line.
- *ILS (integrated logistical support) manager*—responsible for all activities that require project/customer support after delivery including customer training, documentation, and equipment testing.
- *QA (quality assurance) manager*—responsible for implementing a quality program that will enhance the reliability, availability and maintainability of the product.

These seven managers (the three just described plus the four discussed in Part A) will coordinate the completion of the project and see that their respective disciplines are factored into all major decisions. Rosas, as project manager, will work toward achieving consensus, but he will have the authority to intervene and make decisions if necessary.

The core work will be completed by 35 teams. Each team will have a "leader," who will be responsible for designing, developing, building, and testing a specific subsystem of the project. They will also be responsible for the quality and productivity of the subsystems and for doing the work on time and within budget.

Individual teams will consist of 5 to 12 members, and Rosas insists that at least half of each team be assigned to work full time on the project. This will help ensure continuity and enhance commitment to the project.

The second key feature to the plan is the development of the overall master plan for the project. This involves abandoning the traditional sequential approach to product development and adopting a concurrent engineering approach to the project (see Figure C3.4).

Once the system design is reviewed and approved, different teams will begin working within the laboratory to design, develop, and test specific subsystems and components.

FIGURE C3.4
Jaguar Master Plan

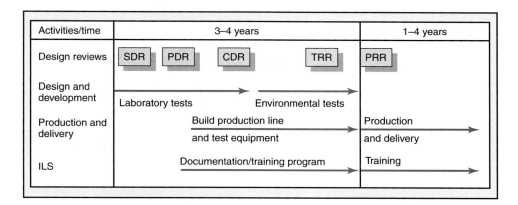

Soon after this has begun the ILS team will start gathering information and preparing product documentation. Once the PDR is completed, the production teams will begin designing the necessary production lines. The CDR will include not only resolution of major technical questions but also a plan for manufacturing. Once the CDR is completed, project teams will begin field tests under a variety of different environmental conditions according to government specifications. Subsequent design refinements will be closely coordinated with manufacturing and ILS teams so that, ideally, ORION will be ready to begin producing the Jaguar upon completion of the PRR.

Rosas believes that the phasing of the production and documentation work alongside the core development work will accelerate project completion, reduce production costs, and contribute to customer satisfaction.

1. What are the major changes between this plan and the way ORION has managed projects in the past?
2. How well do you believe these changes deal with the problems identified in Part A?
3. Who is likely to support this plan? Who is not likely to support this plan?

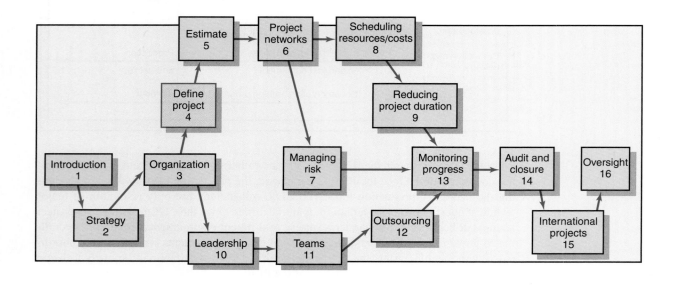

Defining the Project

Step 1: Defining the Project Scope

Step 2: Establishing Project Priorities

Step 3: Creating the Work Breakdown Structure

Step 4: Integrating the WBS with the Organization

Step 5: Coding the WBS for the Information System

Process Breakdown Structure

Responsibility Matrices

Project Communication Plan

Summary

Defining the Project

Select a dream

Use your dream to set a goal

Create a plan

Consider resources

Enhance skills and abilities

Spend time wisely

Start! Get organized and go

. . . it is one of those acro-whatevers,
said Pooh.[*]

Project managers in charge of a single small project can plan and schedule the project tasks without much formal planning and information. However, when the project manager must manage several small projects or a large complex project, a threshold is quickly reached in which the project manager can no longer cope with the detail.

This chapter describes a disciplined, structured method for selectively collecting information to use through all phases of the project life cycle, to meet the needs of all stakeholders (e.g., customer, project manager), and to measure performance against the strategic plan of the organization. The method suggested is a selective outline of the project called the *work breakdown structure.* The early stages of developing the outline serve to ensure that all tasks are identified and that participants of the project have an understanding of what is to be done. Once the outline and its detail are defined, an integrated information system can be developed to schedule work and allocate budgets. This baseline information is later used for control. In addition, the chapter will present a variant of the work breakdown structure called the *process breakdown structure* as well as responsibility matrices which are used for design and build projects. With the work of the project defined through the *work breakdown structure,* the chapter concludes with the process of creating a communication plan used to help coordinate project activities and follow progress.

The five generic steps described herein provide a structured approach for collecting the project information necessary for developing a work breakdown structure. These steps and the development of project networks found in the next chapters all take place concurrently, and several iterations are typically required to develop dates and budgets that can be used to manage the project. The old saying "We can control only what we have planned" is true; therefore, defining the project is the first step.

[*] Roger E. Allen and Stephen D. Allen, *Winnie-the-Pooh on Success* (New York: Penguin, 1997), p. 10.

Step 1: Defining the Project Scope

[handwritten margin notes: project scope / what you expect to deliver and # amount. at end and specific (tangible and measurable terms.)]

Defining the project scope sets the stage for developing a project plan. Project scope is a definition of the end result or mission of your project—a product or service for your client/customer. The primary purpose is to define as clearly as possible the deliverable(s) for the end user and to focus project plans. As fundamental and essential as scope definition appears, it is frequently overlooked by project leaders of well-managed, large corporations.

Research clearly shows that a poorly defined scope or mission is the most frequently mentioned barrier to project success. In a study involving more than 1,400 project managers in the United States and Canada, Gobeli and Larson found that approximately 50 percent of the planning problems relate to unclear definition of scope and goals. This and other studies suggest a strong correlation between project success and clear scope definition. The scope document directs focus on the project purpose throughout the life of the project for the customer and project participants.

The scope should be developed under the direction of the project manager and customer. The project manager is responsible for seeing that there is agreement with the owner on project objectives, deliverables at each stage of the project, technical requirements, and so forth. For example, a deliverable in the early stage might be specifications; for the second stage, three prototypes for production; for the third, a sufficient quantity to introduce to market; and finally, marketing promotion and training.

Your project scope definition is a document that will be published and used by the project owner and project participants for planning and measuring project success. *Scope* describes what you expect to deliver to your customer when the project is complete. Your project scope should define the results to be achieved in specific, tangible, and measurable terms.

Employing a Project Scope Checklist

Clearly, project scope is the keystone interlocking all elements of a project plan. To ensure that scope definition is complete, you may wish to use the following checklist:

Project Scope Checklist

1. Project objective *— answer Q, what when how?*
2. Deliverables
3. Milestones
4. Technical requirements
5. Limits and exclusions
6. Reviews with customer

1. **Project objective.** The first step of project scope definition is to define the overall objective to meet your customer's need(s). For example, as a result of extensive market research a computer software company decides to develop a program that automatically translates verbal sentences in English to Russian. The project should be completed within three years at a cost not to exceed $1.5 million. Another example is to design and produce a completely portable, hazardous waste, thermal treatment system in 13 months at a cost not to exceed $13 million. The project objective answers the questions of what, when, and how much.

2. **Deliverables.** The next step is to define major deliverables—the expected outputs over the life of the project. For example, deliverables in the early design phase of a project might be a list of specifications. In the second phase deliverables could be software coding and a technical manual. The next phase could be to test prototypes. The final phase could be final tests and approved software.

3. **Milestones.** A milestone is a significant event in a project that occurs at a point in time. The milestone schedule shows only major segments of work; it represents first, rough-cut estimates of time, cost, and resources for the project. The milestone schedule is built using the deliverables as a platform to identify major segments of work and an end date—for example, testing complete and finished by July 1 of the same year. Milestones should be natural, important control points in the project. Milestones should be easy for all project participants to recognize.

4. **Technical requirements.** More frequently than not, a product or service will have technical requirements to ensure proper performance. For example, a technical requirement for a personal computer might be the ability to accept 120-volt alternating current or 240-volt direct current without any adapters or user switches. Another well-known example is the ability of 911 emergency systems to identify the caller's phone number and location of the phone. Examples from information systems projects include speed and capacity of database systems and connectivity with alternative systems. For understanding the importance of key requirements, see Snapshot from Practice: Big Bertha.

5. **Limits and exclusions.** The limits of scope should be defined. Failure to do so can lead to false expectations and to expending resources and time on the wrong problem. Examples of limits are: local air transportation to and from base camps will be outsourced; system maintenance and repair will be done only up to one month after final inspection; client will be billed for additional training beyond that prescribed in the contract. Exclusions further define the boundary of the project by stating what is not included. Examples include: data will be collected by the client, not the contractor; a house will be built, but no landscaping or security devices added; software will be installed, but no training given.

6. **Reviews with customer.** Completion of the scope checklist ends with a review with your customer—internal or external. The main concern here is the understanding and agreement of expectations. Is the customer getting what he or she desires in deliverables? Does the project definition identify key accomplishments, budgets, timing, and performance requirements? Are questions of limits and exclusions covered? Clear communication in all these issues is imperative to avoid claims or misunderstanding.

Scope definition should be as brief as possible but complete; one or two pages are typical for small projects. See Snapshot from Practice: Scope Statement on page 95.

The above checklist is generic. Different industries and companies will develop unique checklists and templates to fit their needs and specific kinds of projects. Many companies engaged in contracted work refer to scope statements as *statements of work* (SOW). Other organizations use the term *project charter*. However, *project charter* has different meanings in the world of project management. One meaning is an expanded version of the scope statement, described above, that might include such items as risk limits, customer needs, spending limits, and even team composition. A second, and more useful meaning, which dates back to the original use of the word charter, is a document that authorizes the project manager to initiate and lead the project. This document is issued by upper management and provides the project manager with written authority to use organizational resources for project activities.

In 1991 Callaway Golf Equipment introduced their Big Bertha driver and revolutionized the golf equipment business. Big Bertha—named after the World War I German long-distance cannon—was much larger than conventional woods and lacked a hosel (the socket in the head of the club into which the shaft is inserted) so that the weight could be better distributed throughout the head. This innovative design gave the clubhead a larger sweet spot, which allowed a player to strike the golf ball off-center and not suffer much loss in distance or accuracy. Callaway has maintained its preeminent position in the golf industry by utilizing space-age technology to extend the accuracy and distance of golf equipment.

In 2000 Callaway introduced the Big Bertha ERC II forged titanium driver. The driver was technologically superior to any driver on the market. However, there was one big problem. The new version of Bertha did not conform to the coefficient of restitution (COR) requirement established by the United States Golf Association (USGA). As a result it was barred from use by golfers in North America who intended to play by USGA's Rules of Golf.

The USGA believed that the rapid technological advances in golf equipment made by Callaway Golf and other golf manufacturers were threatening the integrity of the game. Players were hitting balls so much farther and straighter that golf courses around the world were being redesigned to make them longer and more difficult.

So in 1998 the USGA established performance thresholds for all new golf equipment. In order to prevent manufacturers from developing more powerful clubs, the USGA limited the COR of new golf equipment to 0.83. The COR was calculated by firing a golf ball at a driver out of a cannon-like machine at 109 miles per hour. The speed that the ball returned to the cannon could not exceed 83 percent of its initial speed (90.47 mph). The USGA called the ratio of incoming to outgoing velocity the coefficient of restitution (COR). The intent of the USGA COR threshold was to limit the distance that golf balls could be hit since studies indicated that 0.01 increase in COR resulted in two extra yards of carry. The Big Bertha ERC II's COR was 0.86.

After numerous efforts to get USGA to change its technical requirements, Callaway's engineers went back to the drawing board and in 2002 introduced Great Big Bertha II, which conformed to USGA's 0.83 COR restriction.

* John E., Gamble. "Callaway Golf Company: Sustaining Advantage in a Changing Industry," in A. A. Thompson, J. E. Gamble, and A. J. Strickland, *Strategy: Winning in the Marketplace,* Boston: McGraw-Hill/Irwin, 2004, pp. C204–C228.

Many projects suffer from scope creep, which is the tendency for the project scope to expand over time—usually by changing requirements, specifications, and priorities. Scope creep can be reduced by carefully writing your scope statement. A scope statement that is too broad is an invitation for scope creep. Scope creep can have a positive or negative effect on the project, but in most cases scope creep means added costs and possible project

PROJECT OBJECTIVE
To construct a high-quality, custom home within five months at cost not to exceed $350,000.

DELIVERABLES

- A 2,200-square-foot, 2½-bath, 3-bedroom, finished home.
- A finished garage, insulated and sheetrocked.
- Kitchen appliances to include range, oven, microwave, and dishwasher.
- High-efficiency gas furnace with programmable thermostat.

MILESTONES

1. Permits approved—March 5
2. Foundation poured—March 14
3. Drywall in. Framing, sheathing, plumbing, electrical, and mechanical inspections passed—May 25
4. Final inspection—June 7

TECHNICAL REQUIREMENTS

1. Home must meet local building codes.
2. All windows and doors must pass NFRC class 40 energy ratings.
3. Exterior wall insulation must meet an "R" factor of 21.
4. Ceiling insulation must meet an "R" factor of 38.
5. Floor insulation must meet an "R" factor of 25.
6. Garage will accommodate two large-size cars and one 20-foot Winnebago.
7. Structure must pass seismic stability codes.

LIMITS AND EXCLUSIONS

1. The home will be built to the specifications and design of the original blueprints provided by the customer.
2. Owner responsible for landscaping.
3. Refrigerator is not included among kitchen appliances.
4. Air conditioning is not included but prewiring is included.
5. Contractor reserves the right to contract out services.
6. Contractor responsible for subcontracted work.
7. Site work limited to Monday through Friday, 8:00 A.M. to 6:00 P.M.

CUSTOMER REVIEW
John and Joan Smith

delays. Changes in requirements, specifications, and priorities frequently result in cost overruns and delays. Examples are abundant—Denver airport baggage handling system; Boston's new freeway system ("The Big Dig"); China's fast train in Shanghai; and the list goes on. On software development projects, scope creep is manifested in bloated products in which added functionality undermines ease of use.

If the project scope needs to change, it is critical to have a sound change control process in place that records the change and keeps a log of all project changes. The log identifies the change, impact, and those responsible for accepting or rejecting a proposed change.

Change control is one of the topics of Chapter 7. Project managers in the field constantly suggest that dealing with changing requirements is one of their most perplexing problems.

Step 2: Establishing Project Priorities

Quality and the ultimate success of a project are traditionally defined as meeting and/or exceeding the expectations of the customer and/or upper management in terms of cost (budget), time (schedule), and performance (scope) of the project (see Figure 4.1). The interrelationship among these criteria varies. For example, sometimes it is necessary to compromise the performance and scope of the project to get the project done quickly or less expensively. Often the longer a project takes, the more expensive it becomes. However, a positive correlation between cost and schedule may not always be true. Other times project costs can be reduced by using cheaper, less efficient labor or equipment that extends

FIGURE 4.1
Project Management Trade-offs

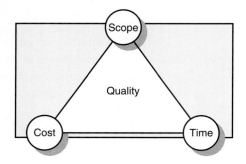

the duration of the project. Likewise, as will be seen in Chapter 9, project managers are often forced to expedite or "crash" certain key activities by adding additional labor, thereby raising the original cost of the project.

One of the primary jobs of a project manager is to manage the trade-offs among time, cost, and performance. To do so, project managers must define and understand the nature of the priorities of the project. They need to have a candid discussion with the project customer and upper management to establish the relative importance of each criterion. For example, what happens when the customer keeps adding requirements? Or if, midway through the project, a trade-off must be made between cost and expediting, which criterion has priority?

One technique found in practice that is useful for this purpose is completing a priority matrix for the project to identify which criterion is constrained, which should be enhanced, and which can be accepted:

Constrain. The original parameter is fixed. The project must meet the completion date, specifications and scope of the project, or budget.

Enhance. Given the scope of the project, which criterion should be optimized? In the case of time and cost, this usually means taking advantage of opportunities to either reduce costs or shorten the schedule. Conversely, with regard to performance, enhancing means adding value to the project.

Accept. For which criterion is it tolerable not to meet the original parameters? When trade-offs have to be made, is it permissible for the schedule to slip, to reduce the scope and performance of the project, or to go over budget?

Figure 4.2 displays the priority matrix for the development of a new cable modem. Because *time* to market is important to sales, the project manager is instructed to take advantage of

FIGURE 4.2
Project Priority Matrix

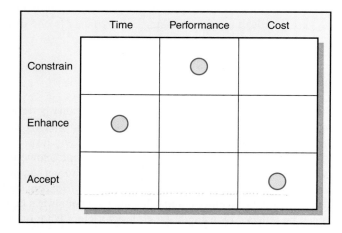

every opportunity to reduce completion time. In doing so, going over *budget* is acceptable though not desirable. At the same time, the original *performance* specifications for the modem as well as reliability standards cannot be compromised.

Priorities vary from project to project. For example, for many software projects time to market is critical, and companies like Microsoft may defer original scope requirements to later versions in order to get to the market first. Alternatively, for special event projects (conferences, parades, tournaments) time is constrained once the date has been announced, and if the budget is tight, the project manager will compromise the scope of the project in order to complete the project on time.

Some would argue that all three criteria are always constrained and that good project managers should seek to optimize each criterion. If everything goes well on a project and no major problems or setbacks are encountered, their argument may be valid. However, this situation is rare, and project managers are often forced to make tough decisions that benefit one criterion while compromising the other two. The purpose of this exercise is to define and agree on what the priorities and constraints of the project are so that when "push comes to shove," the right decisions can be made.

There are likely to be natural limits to the extent managers can constrain, optimize, or accept any one criterion. It may be acceptable for the project to slip one month behind schedule but no further or to exceed the planned budget by as much as $20,000. Likewise, it may be desirable to finish a project a month early, but after that cost conservation should be the primary goal. Some project managers document these limits as part of creating the priority matrix.

In summary, developing a decision priority matrix for a project before the project begins is a useful exercise. It provides a forum for clearly establishing priorities with customers and top management so as to create shared expectations and avoid misunderstandings. The priority information is essential to the planning process, where adjustments can be made in the scope, schedule, and budget allocation. Finally, the matrix is useful midway in the project for approaching a problem that must be solved.

One caveat must be mentioned; during the course of a project, priorities may change. The customer may suddenly need the project completed one month sooner, or new directives from top management may emphasize cost saving initiatives. The project manager needs to be vigilant in order to anticipate and confirm changes in priorities and make appropriate adjustments.

Step 3: Creating the Work Breakdown Structure

Major Groupings Found in a WBS

Once the scope and deliverables have been identified, the work of the project can be successively subdivided into smaller and smaller work elements. The outcome of this hierarchical process is called the work breakdown structure (WBS). The WBS is a map of the project. Use of WBS helps to assure project managers that all products and work elements are identified, to integrate the project with the current organization, and to establish a basis for control. Basically, the WBS is an outline of the project with different levels of detail.

Figure 4.3 on page 100 shows the major groupings commonly used in the field to develop a hierarchical WBS. The WBS begins with the project as the final deliverable. Major project work deliverables/systems are identified first; then the subdeliverables necessary to accomplish the larger deliverables are defined. The process is repeated until the subdeliverable detail is small enough to be manageable and where one person can be responsible. This subdeliverable is further divided into work packages. Because the lowest

AP/Wide World.

subdeliverable usually includes several work packages, the work packages are grouped by type of work—for example, hardware, programming, testing. These groupings within a subdeliverable are called cost accounts. This grouping facilitates a system for monitoring project progress by work, cost, and responsibility.

How WBS Helps the Project Manager

The WBS defines all the elements of the project in a hierarchical framework and establishes their relationships to the project end item(s). Think of the project as a large work package that is successively broken down into smaller work packages; the total project is the summation of all the smaller work packages. This hierarchical structure facilitates evaluation of cost, time, and technical performance at all levels in the organization over the life of the project. The WBS also provides management with information appropriate to each level. For example, top management deals primarily with major deliverables, while first-line supervisors deal with smaller subdeliverables and work packages.

Each item in the WBS needs a time and cost estimate. With this information it is possible to plan, schedule, and budget your project. The WBS also serves as a framework for tracking cost and work performance.

In the realm of event project management, the Olympic Games rank as one of the premier achievements.

PROJECT DEFINITION

Objective: To stage the Year 2004 Summer Olympic Games at specified locations in Greece beginning August 13 at a cost of $5.2 billion.

Client: Activities are underwritten by the Greek government. Many stakeholders and customers, e.g., citizens of Athens, local and national governments, the Greek people, the International Olympic Organization, the international community as a whole, the athletes, and Greek and international business communities.

Scope: Organizing all Games and ceremonies. Putting in place all technology and resources required to stage the Games. Handling public relations and fundraising.

Criteria for success: Trouble-free performance of Games. Level of public enthusiasm and enjoyment. Economic activity generated within Athens and Greece. Continued interest in future Olympic Games.

Project team: Athens Organizing Committee Olympic Games (AOCOG) was appointed as the project managers by legislation. Other organizations directly contributing to the success of the Games, such as the International Olympic Committee, Greek Olympic Committee, Athens City Council, and Olympic Coordination Authority (Greek government) have been made party to the Host City Contract. Olympic Coordination Authority is responsible for all the infrastructure projects, most of which are either already under way or are being reprogrammed to accommodate the Games. Completion of these projects on time is vital to the success of the Olympic Games.

WBS: The work breakdown structure for the project includes the following major areas: events; venues and facilities including accommodation; transport; media facilities and coordination; telecommunications; security arrangements; medical care; human resources including volunteers; cultural olympiad; pre-games training; information technology projects; opening and closing ceremonies; public relations; financing; test games and trial events; and sponsorship management and control of ambush marketing. Each of these items could be treated as a project in its own right. Precision coordination will be necessary to ensure that these, and therefore the entire Games project, are delivered on time.

Time, obviously, is the most critical dimension of the Athens 2004 Olympic Games project. Early on initial delays and confusion caused the International Olympic Committee (IOC) to consider moving the Olympics to a different city. This threat galvanized the Greek efforts. At the end of a three year, around the clock construction blitz, Olympic organizers finally silenced critics with all the venues ready for the August 13 opening ceremony. As in the past, Olympics cost was the dimension sacrificed with the projected cost doubling to the $8 to 12 billion range. The Greeks were also forced to scale back the scope of construction and compromise on quality. While the glass roof centerpiece for the Olympic Stadium was preserved, delays caused cancellation of a similar roof for the aquatic center. Secondary projects designed to spruce up the city had to be scaled back or cut. Unfinished work was hidden behind huge banners. Ribbons and flags were used to divert attention from sidewalks that were never smoothed out or the dreary concrete buildings that didn't get fresh paint.

As the WBS is developed, organizational units and individuals are assigned responsibility for executing work packages. This integrates the work and the organization. In practice, this process is sometimes called the organization breakdown structure (OBS), which will be further discussed later in the chapter.

Use of the WBS provides the opportunity to "roll up" (sum) the budget and actual costs of the smaller work packages into larger work elements so that performance can be measured by organizational units and work accomplishment.

The WBS can also be used to define communication channels and assist in understanding and coordinating many parts of the project. The structure shows the work and organizational units responsible and suggests where written communication should be directed. Problems can be quickly addressed and coordinated because the structure integrates work and responsibility.

WBS Development

Figure 4.4 on page 101 shows a simplified WBS for development of a new personal computer project. At the top of the chart (level 1) is the project end item—a deliverable product or service. Note how the levels of the structure can represent information for different levels

FIGURE 4.3
Hierarchical
Breakdown
of the WBS

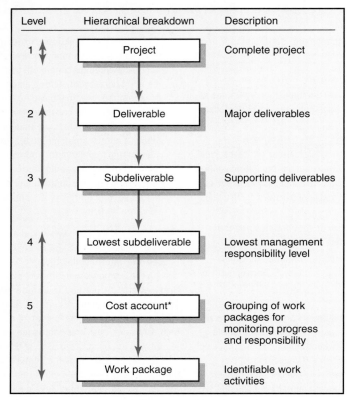

Level	Hierarchical breakdown	Description
1	Project	Complete project
2	Deliverable	Major deliverables
3	Subdeliverable	Supporting deliverables
4	Lowest subdeliverable	Lowest management responsibility level
5	Cost account*	Grouping of work packages for monitoring progress and responsibility
	Work package	Identifiable work activities

* This breakdown groups work packages by type of work within a deliverable and allows assignment of responsibility to an organizational unit. This extra step facilitates a system for monitoring project progress (discussed in Chapter 13).

of management. For example, level 1 information represents the total project objective and is useful to top management; levels 2, 3, and 4 are suitable for middle management; and level 5 is for first-line managers.

Level 2 shows a partial list of deliverables necessary to develop the personal computer. One deliverable is the disk storage unit (shaded), which is made up of three subdeliverables—external USB, optical, and hard disks. Finally, the hard disk requires four subdeliverables—motor, circuit board, chassis frame, and read/write head. These subdeliverables represent the lowest manageable elements of the project. Each subdeliverable requires work packages that will be completed by an assigned organizational unit. Each deliverable will be successively divided in this manner. It is not necessary to divide all elements of the WBS to the same level.

The lowest level of the WBS is called a *work package*. Work packages are short-duration tasks that have a definite start and stop point, consume resources, and represent cost. Each work package is a control point. A work package manager is responsible for seeing that the package is completed on time, within budget, and according to technical specifications. Practice suggests a work package should not exceed 10 workdays or one reporting period. If a work package has a duration exceeding 10 days, check or monitoring points should be established within the duration, say, every three to five days, so progress and problems can be identified before too much time has passed. Each work package of the WBS should be as independent of other packages of the project as possible. No work package is described in more than one subdeliverable of the WBS.

FIGURE 4.4 **Work Breakdown Structure**

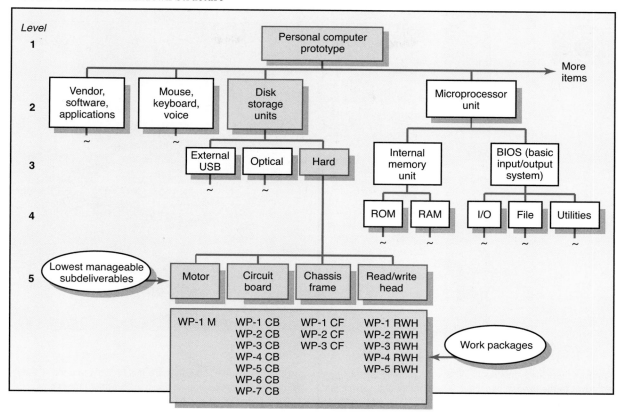

There is an important difference from start to finish between the last work breakdown subdeliverable and a work package. Typically, a work breakdown subdeliverable includes the outcomes of more than one work package from perhaps two or three departments. Therefore, the subdeliverable does not have a duration of its own and does not consume resources or cost money directly. (In a sense, of course, a duration for a particular work breakdown element can be derived from identifying which work package must start first [earliest] and which package will be the latest to finish; the difference from start to finish becomes the duration for the subdeliverable.) The higher elements are used to identify deliverables at different phases in the project and to develop status reports during the execution stage of the project life cycle. Thus, the work package is the basic unit used for planning, scheduling, and controlling the project.

To review, each work package in the WBS

1. Defines work (what).
2. Identifies time to complete a work package (how long).
3. Identifies a time-phased budget to complete a work package (cost).
4. Identifies resources needed to complete a work package (how much).
5. Identifies a single person responsible for units of work (who).
6. Identifies monitoring points for measuring progress (how well).

Figure 4.4 represents the classic WBS in which the project is broken down to the lowest manageable deliverable and subsequent work packages. Many situations do not require this level of detail. This begs the questions of how far you should break down the work.

There is no set answer to this question. However, here are some tips given by project managers:

Break down the work until you can do an estimate that is accurate enough for your purposes. If you are doing a ball-park estimate to see if the project is worthy of serious consideration, you probably do not need to break it down beyond major deliverables. On the other hand, if you are pricing a project to submit a competitive bid, then you are likely to go down to the work package level.

The WBS should conform to how you are going to schedule work. For example, if assignments are made in terms of days, then tasks should be limited as best as possible to one day or more to complete. Conversely, if hours are the smallest unit for scheduling, then work can be broken down to one-hour increments.

Final activities should have clearly defined start/end events. Avoid open-ended tasks like "research" or "market analysis." Take it down to the next level in which deliverables/outcomes are more clearly defined. Instead of ending with market analysis include items such as identify market share, list user requirements, or write a problem statement.

If accountability and control are important, then break the work down so that one individual is clearly responsible for the work. For example, instead of stopping at product design, take it to the next level and identify specific components of the design (i.e., electrical schematics, power source, etc.) that different individuals will be responsible for creating.

The bottom line is that the WBS should provide the level of detail needed to manage the specific project successfully.

Creating a WBS from scratch can be a daunting task. Project managers should take advantage of relevant examples from previous projects to begin the process.

WBSs are products of group efforts. If the project is small, the entire project team may be involved breaking down the project into its components. For large, complex projects, the people responsible for the major deliverables are likely to meet to establish the first two levels of deliverables. In turn, further detail would be delegated to the people responsible for the specific work. Collectively this information would be gathered

and integrated into a formal WBS by a project support person. The final version would be reviewed by the inner echelon of the project team. Relevant stakeholders (most notably customers) would be consulted to confirm agreement and revise when appropriate.

Project teams developing their first WBS frequently forget that the structure should be end-item, output oriented. First attempts often result in a WBS that follows the organization structure—design, marketing, production, finance. If a WBS follows the organization structure, the focus will be on the organization function and processes rather than the project output or deliverables. In addition, a WBS with a process focus will become an accounting tool that records costs by function rather than a tool for "output" management. Every effort should be made to develop a WBS that is output oriented in order to concentrate on concrete deliverables. See Snapshot from Practice: Creating a WBS for more advice on creating a WBS. This process is discussed next.

Step 4: Integrating the WBS with the Organization

The WBS is used to link the organizational units responsible for performing the work. In practice, the outcome of this process is the organization breakdown structure (OBS). The OBS depicts how the firm has organized to discharge work responsibility. The purposes of the OBS are to provide a framework to summarize organization unit work performance, identify organization units responsible for work packages, and tie the organizational unit to cost control accounts. Recall, cost accounts group similar work packages (usually under the purview of a department). The OBS defines the organization subdeliverables in a hierarchical pattern in successively smaller and smaller units. Frequently, the traditional organization structure can be used. Even if the project is completely performed by a team, it is necessary to break down the team structure for assigning responsibility for budgets, time, and technical performance.

As in the WBS, the OBS assigns the lowest organizational unit the responsibility for work packages within a cost account. Herein lies one major strength of using WBS and OBS; they can be *integrated* as shown in Figure 4.5. The intersection of work packages and the organizational unit creates a project control point (cost account) that integrates work and responsibility. The intersection of the WBS and OBS represents the set of work packages necessary to complete the subdeliverable located immediately above and the organizational unit on the left responsible for accomplishing the packages at the intersection. Later we will use the intersection as a cost account for management control of projects. For example, the circuit board element requires completion of work packages whose primary responsibility will include the design, production, test, and software departments. Control can be checked from two directions—outcomes and responsibility. In the execution phase of the project, progress can be tracked vertically on deliverables (client's interest) and tracked horizontally by organization responsibility (management's interest).

Step 5: Coding the WBS for the Information System

Gaining the maximum usefulness of a breakdown structure depends on a coding system. The codes are used to define levels and elements in the WBS, organization elements, work packages, and budget and cost information. The codes allow reports to be consolidated at any level in the structure. The most commonly used scheme in practice is numeric indention.

FIGURE 4.5 Integration of WBS and OBS

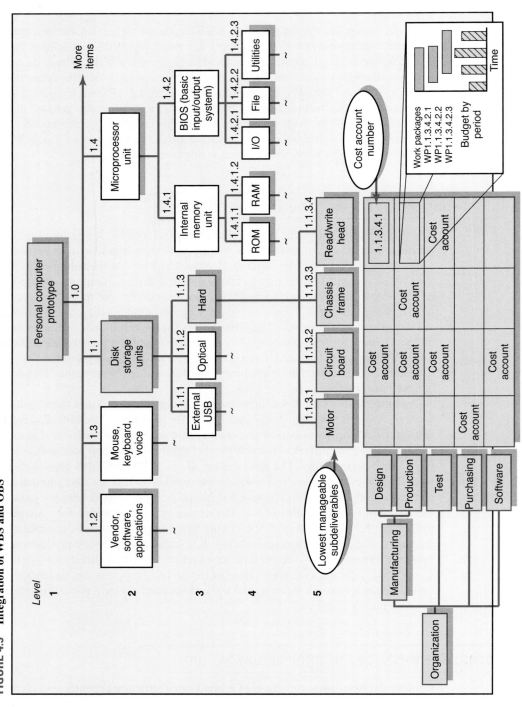

An example for the new computer project and the "Disk storage units" in Figure 4.5 is presented here:

1.0 Computer project
 1.1 Disk storage units
 1.1.1 External USB
 1.1.2 Optical
 1.1.3 Hard
 1.1.3.1 Motor
 1.1.3.1.1 Sourcing work package
 ·
 ·

 1.1.3.4 Read/write head
 1.1.3.4.1 Cost account
 1.1.3.4.2 Cost account
 1.1.3.4.2.1 WP
 1.1.3.4.2.2 WP
 1.1.3.4.2.3 WP
 1.1.3.4.3 Cost account
 ·
 ·
 ·

 etc.

Note the project identification is 1.0. Each successive indention represents a lower element or work package. Ultimately the numeric scheme reaches down to the work package level, and all tasks and elements in the structure have an identification code. The "cost account" is the focal point because all budgets, work assignments, time, cost, and technical performance come together at this point.

 This coding system can be extended to cover large projects. Additional schemes can be added for special reports. For example, adding a "–3" after the code could indicate a site location, an elevation, or a special account such as labor. Some letters can be used as special identifiers such as "M" for materials or "E" for engineers. You are not limited to only 10 subdivisions (0–9); you can extend each subdivision to large numbers—for example, .1–.99 or .1–.9999. If the project is small, you can use whole numbers. The following example is from a large, complex project:

$$3R–237A–P2–33.61$$

where 3R identifies the facility, 237A represents elevation and the area, P2 represents pipe two inches wide, and 33.6 represents the work package number. In practice most organizations are creative in combining letters and numbers to minimize the length of WBS codes.

Process Breakdown Structure

The WBS is best suited for design and build projects that have tangible outcomes such as an off-shore mining facility or a new car prototype. The project can be decomposed or broken down into major deliverables, subdeliverables, further subdeliverables, and ultimately to work packages. It is more difficult to apply WBS to less tangible, *process-oriented*

projects in which the final outcome is a product of a series of steps or phases. Here, the big difference is that the project evolves over time with each phase affecting the next phase. Information systems projects typically fall in this category—for example, creating an extranet Web site or an internal software database system. Process projects are driven by performance requirements, not by plans/blueprints. Some practitioners choose to utilize what we refer to as a process breakdown structure (PBS) instead of the classic WBS.

Figure 4.6 provides an example of a PBS for a software development project. Instead of being organized around deliverables, the project is organized around phases. Each of the five major phases can be broken down into more specific activities until a sufficient level of detail is achieved to communicate what needs to be done to complete that phase. People can be assigned to specific activities, and a complementary OBS can be created just as is done for the WBS. Deliverables are not ignored but are defined as outputs required to move to the next phase.

Checklists that contain the phase exit requirements are developed to manage project progress. These checklists provide the means to support phase walk-throughs and reviews. Checklists vary depending upon the project and activities involved but typically include the following details:

- Deliverables needed to exit a phase and begin a new one.
- Quality checkpoints to ensure that deliverables are complete and accurate.
- Sign-offs by all responsible stakeholders to indicate that the phase has been successfully completed and that the project should move on to the next phase.

As long as exit requirements are firmly established and deliverables for each phase are well defined, the PBS provides a suitable alternative to the standard WBS for projects that involve extensive development work.

FIGURE 4.6 PBS for Software Development Project

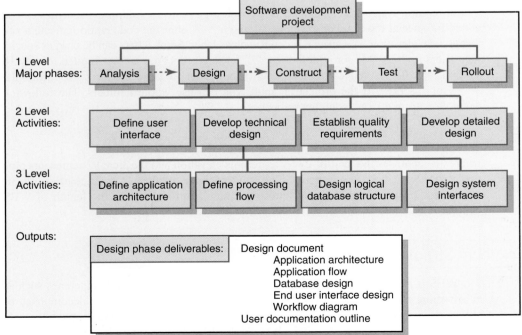

Responsibility Matrices

In many cases, the size and scope of the project do not warrant an elaborate WBS or OBS. One tool that is widely used by project managers and task force leaders of small projects is the *responsibility matrix* (RM). The RM (sometimes called a linear responsibility chart) summarizes the tasks to be accomplished and who is responsible for what on a project. In its simplest form an RM consists of a chart listing all the project activities and the participants responsible for each activity. For example, Figure 4.7 illustrates an RM for a market research study. In this matrix the R is used to identify the committee member who is responsible for coordinating the efforts of other team members assigned to the task and making sure that the task is completed. The S is used to identify members of the five-person team who will support and/or assist the individual responsible. Simple RMs like this one are useful not only for organizing and assigning responsibilities for small projects but also for subprojects of large, more complex projects.

More complex RMs not only identify individual responsibilities but also clarify critical interfaces between units and individuals that require coordination. For example, Figure 4.8 is an RM for a larger, more complex project to develop a new piece of test equipment. Notice that within each cell a numeric coding scheme is used to define the nature of involvement on that specific task. Such an RM extends the WBS/OBS and provides a clear and concise method for depicting responsibility, authority, and communication channels.

Responsibility matrices provide a means for all participants in a project to view their responsibilities and agree on their assignments. They also help clarify the extent or type of authority exercised by each participant in performing an activity in which two or more parties have overlapping involvement. By using an RM and by defining authority, responsibility, and communications within its framework, the relationship between different organizational units and the work content of the project is made clear.

FIGURE 4.7 Responsibility Matrix for a Market Research Project

Task	Richard	Dan	Dave	Linda	Elizabeth
		Project Team			
Identify target customers	R	S		S	
Develop draft questionnaire	R	S	S		
Pilot-test questionnaire		R		S	
Finalize questionnaire	R	S	S	S	
Print questionnaire					R
Prepare mailing labels					R
Mail questionnaires					R
Receive and monitor returned questionnaires				R	S
Input response data			R		
Analyze results		R	S	S	
Prepare draft of report	S	R	S	S	
Prepare final report	R		S		

R = Responsible
S = Supports/assists

FIGURE 4.8 Responsibility Matrix for the Conveyor Belt Project

Deliverables	Design	Development	Documentation	Assembly	Testing	Purchasing	Quality Assur.	Manufacturing
Architectural designs	1	2			2		3	3
Hardware specifications	2	1				2	3	
Kernel specifications	1	3						3
Utilities specifications	2	1			3			
Hardware design	1			3		3		3
Disk drivers	3	1	2					
Memory management	1	3			3			
Operating system documentation	2	2	1					3
Prototypes	5		4	1	3	3	3	4
Integrated acceptance test	5	2	2		1		5	5

Organization

1 Responsible
2 Support
3 Consult
4 Notification
5 Approval

Project Communication Plan

Once the project deliverables and work are clearly identified, following up with an internal communication plan is vital. Stories abound of poor communication as a major contributor to project failure. Having a robust communications plan can go a long way toward mitigating project problems and can ensure that customers, team members, and other stakeholders have the information to do their jobs.

The communication plan is usually created by the project manager and/or the project team in the early stage of project planning.

Communication is a key component in coordinating and tracking project schedules, issues, and action items. The plan maps out the flow of information to different stakeholders and becomes an integral part of the overall project plan. The purpose of a project communication plan is to express what, who, how, and when information will be transmitted to project stakeholders so schedules, issues, and action items can be tracked.

Project communication plans address the following core questions:

- What information needs to be collected and when?
- Who will receive the information?
- What methods will be used to gather and store information?
- What are the limits, if any, on who has access to certain kinds of information?
- When will the information be communicated?
- How will it be communicated?

Developing a communication plan that answers these questions usually entails the following basic steps:

1. **Stakeholder analysis.** Identify the target groups. Typical groups could be the customer, sponsor, project team, project office, or anyone who needs project information to make decisions and/or contribute to project progress.

2. **Information needs.** What information is pertinent to stakeholders who contribute to the project's progress? For example, top management needs to know how the project is progressing, whether it is encountering critical problems, and the extent to which project goals are being realized. This information is required so that they can make strategic decisions and manage the portfolio of projects. Project team members need to see schedules, task lists, specifications, and the like, so they know what needs to be done next. External groups need to know any changes in the schedule and performance requirements of the components they are providing. Frequent information needs found in communication plans are:

Project status reports	Deliverable issues
Changes in scope	Team status meetings
Gating decisions	Accepted request changes
Action items	Milestone reports

3. **Sources of information.** When the information needs are identified, the next step is to determine the sources of information. That is, where does the information reside? How will it be collected? For example, information relating to the milestone report, team meetings, and project status meetings would be found in the minutes and reports of various groups.

4. **Dissemination modes.** In today's world, traditional status report meetings are being supplemented by e-mail, teleconferencing, Lotus Notes, SharePoint, and a variety of database sharing programs to circulate information. In particular, many companies are

using the Web to create a "virtual project office" to store project information. Project management software feeds information directly to the Web site so that different people have immediate access to relevant project information. In some cases, appropriate information is routed automatically to key stakeholders. Backup paper hardcopy to specific stakeholders is still critical for many project changes and action items.

5. **Responsibility and timing.** Determine who will send out the information. For example, a common practice is to have secretaries of meetings forward the minutes or specific information to the appropriate stakeholders. In some cases the responsibility lies with the project manager or project office. Timing and frequency of distribution appropriate to the information need to be established.

The advantage of establishing a communication plan is that instead of responding to information requests, you are controlling the flow of information. This reduces confusion and unnecessary interruptions, and it can provide project managers greater autonomy. Why? By reporting on a regular basis how things are going and what is happening, you allow senior management to feel more comfortable about letting the team complete the project without interference. See Figure 4.9 for a sample Shale Oil Research Project Communication Plan.

The importance of establishing up-front a plan for communicating important project information cannot be overstated. Many of the problems that plague a project can be traced back to insufficient time devoted to establishing a well-grounded internal communication plan.

FIGURE 4.9 **Shale Oil Research Project Communication Plan**

What Information	Target Audience	When?	Method of Communication	Provider
Milestone report	Senior management and project manager	Bimonthly	E-mail and hardcopy	Project office
Project status reports & agendas	Staff and customer	Weekly	E-mail and hardcopy	Project manager
Team status reports	Project manager and project office	Weekly	E-mail	Team recorder
Issues report	Staff and customer	Weekly	E-mail	Team recorder
Escalation reports	Staff and customer	When needed	Meeting and hardcopy	Project manager
Outsourcing performance	Staff and customer	Bimonthly	Meeting	Project manager
Accepted change requests	Project office, senior mgmt., customer, staff, and project mgr.	Anytime	E-mail and hardcopy	Design department
Oversight gate decisions	Senior management and project manager	As required	E-mail meeting report	Oversight group or project office

Summary

The project scope definition, priorities, and breakdown structure are the keys to nearly every aspect of managing the project. The scope definition provides focus and emphasis on the end item(s) of the project. Establishing project priorities allows managers to make appropriate trade-off decisions. The structure helps ensure all tasks of the project are identified and provides two views of the project—one on deliverables and one on organization responsibility. The WBS avoids having the project driven by organization function or by a finance system. The structure forces attention to realistic requirements of personnel, hardware, and budgets. Use of the structure provides a powerful framework for project control that identifies deviations from plan, identifies responsibility, and spots areas for improved performance. No well-developed project plan or control system is possible without a disciplined, structured approach. The WBS, OBS, and cost account codes provide this discipline. The WBS will serve as the database for developing the project network which establishes the timing of work, people, equipment, and costs.

PBS is often used for process-based projects with ill-defined deliverables. In small projects responsibility matrices may be used to clarify individual responsibility.

Clearly defining your project is the first and most important step in planning. The absence of a clearly defined project plan consistently shows up as the major reason for project failures. Whether you use a WBS, PBS, or responsibility matrix will depend primarily on the size and nature of your project. Whatever method you use, definition of your project should be adequate to allow for good control as the project is being implemented. Follow-up with a clear communication plan for coordinating and tracking project progress will help keep important stakeholders informed and avoid some potential problems.

Key Terms

Cost account	Process breakdown	Work breakdown structure
Milestone	structure (PBS)	(WBS)
Organization breakdown	Responsibility matrix	Work package
structure (OBS)	Scope creep	
Priority matrix	Scope statement	

Review Questions

1. What are the six elements of a typical scope statement?
2. What questions does a project objective answer? What would be an example of a good project objective?
3. What does it mean if the priorities of a project include: Time-constrain, Scope-accept, and Cost-enhance?
4. What kinds of information are included in a work package?
5. When would it be appropriate to create a responsibility matrix rather than a full-blown WBS?
6. How does a communication plan benefit management of projects?

Exercises

1. You are in charge of organizing a dinner-dance concert for a local charity. You have reserved a hall that will seat 30 couples and have hired a jazz combo.
 a. Develop a scope statement for this project that contains examples of all the elements. Assume that the event will occur in 4 weeks and provide your best guess estimate of the dates for milestones.
 b. What would the priorities likely be for this project?

2. In small groups, identify real life examples of a project that would fit each of the following priority scenarios:

 a. Time-constrain, Scope-enhance, Cost-accept

 b. Time-accept, Scope-constrain, Cost-accept

 c. Time-constrain, Scope-accept, Cost-enhance

3. Develop a WBS for a project in which you are going to build a bicycle. Try to identify all of the major components and provide three levels of detail.

4. You are the father or mother of a family of four (kids ages 13 and 15) planning a weekend camping trip. Develop a responsibility matrix for the work that needs to be done prior to starting your trip.

5. Develop a WBS for a local stage play. Be sure to identify the deliverables and organizational units (people) responsible. How would you code your system? Give an example of the work packages in one of your cost accounts. Develop a corresponding OBS which identifies who is responsible for what.

6. Use an example of a project you are familiar with or are interested in. Identify the deliverables and organizational units (people) responsible. How would you code your system? Give an example of the work packages in one of your cost accounts.

7. Develop a communication plan for an airport security project. The project entails installing the hardware and software system that (1) scans a passenger's eyes, (2) fingerprints the passenger, and (3) transmits the information to a central location for evaluation.

8. Go to an Internet search engine (e.g., Google) and type in "project communication plan." Check three or four that have ".gov" as their source. How are they similar or dissimilar? What would be your conclusion concerning the importance of an internal communication plan?

References

Ashley, D. B., et al., "Determinants of Construction Project Success," *Project Management Journal,* 18 (2) June 1987, p. 72.

Chilmeran, A. H., "Keeping Costs on Track," *PM Network,* 19 (2) 2004, pp. 45–51.

Gobeli, D. H. and E. W. Larson, "Project Management Problems" *Engineering Management Journal, 2,* 1990, pp. 31–36.

Ingebretsen, M., "Taming the Beast," *PM Network,* July 2003, pp. 30–35.

Katz, D. M., "Case Study: Beware 'Scope Creep' on ERP Projects," *CFO.com,* March 27, 2001.

Kerzner, H., *Project Management: A Systems Approach to Planning,* 8th edition (New York: Van Nostrand Reinhold, 2003).

Lewis, J. P., *Project Planning, Scheduling and Controlling,* 3rd edition (Burr Ridge, IL: McGraw-Hill, 2000).

Luby, R. E., D. Peel, and W. Swahl, "Component-Based Work Breakdown Structure," *Project Management Journal,* 26 (2) December 1995, pp. 38–44.

Murch, R., *Project Management: Best Practices for IT Professionals* (Upper Darby, NJ: Prentice Hall, 2001).

Pinto, J. K. and D. P. Slevin, "Critical Success Factors Across the Project Life Cycle," *Project Management Journal,* 19 (3) June 1988, p. 72.

Pitagorsky, G., "Realistic Project Planning Promotes Success," *Engineer's Digest,* 29 (1) 2001.

PMI Standards Committee, *Guide to the Project Management Body of Knowledge* (Newton Square, PA: Project Management Institute, 2000).

Posner, B. Z., "What It Takes to Be a Good Project Manager," *Project Management Journal,* 18 (1) March 1987, p. 52.

Raz, T. and S. Globerson, "Effective Sizing and Content Definition of Work Packages," *Project Management Journal,* 29 (4) 1998, pp. 17–23.

Tate, K. and K. Hendrix, "Chartering IT Projects," *Proceedings, 30th Annual, Project Management Institute* (Philadelphia, PA. 1999), CD.

Zimmerman, E., "Preventing Scope Creep," *Manage,* February 2000.

Case

Manchester United Soccer Club

Nicolette Larson was loading the dishwasher with her husband, Kevin, and telling him about the first meeting of the Manchester United Tournament Organizing Committee. Nicolette, a self-confessed "soccer mom," had been elected tournament director and was responsible for organizing the club's first summer tournament.

Manchester United Soccer Club (MUSC) located in Manchester, New Hampshire, was formed in 1992 as a way of bringing recreational players to a higher level of competition and preparing them for the State Olympic Development Program and/or high school teams. The club currently has 24 boys and girls (ranging in age from under 9 to 16) on teams affiliated with the Hampshire Soccer Association and the Granite State Girls Soccer League. The club's board of directors decided in the fall to sponsor a summer invitational soccer tournament to generate revenue. Given the boom in youth soccer, hosting summer tournaments has become a popular method for raising funds. MUSC teams regularly compete in three to four tournaments each summer at different locales in New England. These tournaments have been reported to generate between $50,000 and $70,000 for the host club.

MUSC needs additional revenue to refurbish and expand the number of soccer fields at the Rock Rimmon soccer complex. Funds would also be used to augment the club's scholarship program, which provides financial aid to players who cannot afford the $450 annual club dues.

Nicolette gave her husband a blow-by-blow account of what transpired during the first tournament committee meeting that night. She started the meeting by having everyone introduce themselves and by proclaiming how excited she was that the club was going to sponsor its own tournament. She then suggested that the committee brainstorm what needed to be done to pull off the event; she would record their ideas on a flipchart.

What emerged was a free-for-all of ideas and suggestions. One member immediately stressed the importance of having qualified referees and spent several minutes describing in detail how his son's team was robbed in a poorly officiated championship game. This was followed by other stories of injustice on the soccer field. Another member suggested that they needed to quickly contact the local colleges to see if they could use their fields. The committee spent more than 30 minutes talking about how they should screen teams and how much they should charge as an entry fee. An argument broke out over whether they should reward the winning teams in each age bracket with medals or trophies. Many members felt that medals were too cheap, while others thought the trophies would be too expensive.

Someone suggested that they seek local corporate sponsors to help fund the tournament. The proposed sale of tournament T-shirts and sweatshirts was followed by a general critique of the different shirts parents had acquired at different tournaments. One member advocated that they recruit an artist he knew to develop a unique silk-screen design for the tournament. The meeting adjourned 30 minutes late with only half of the members remaining until the end. Nicolette drove home with seven sheets of ideas and a headache.

As Kevin poured a glass of water for the two aspirin Nicolette was about to take, he tried to comfort her by saying that organizing this tournament would be a big project not unlike the projects he works on at his engineering and design firm. He offered to sit down with her the next night and help her plan the project. He suggested that the first thing they needed to do was to develop a WBS for the project.

1. Make a list of the major deliverables for the project and use them to develop a draft of the work breakdown structure for the tournament that contains at least three levels of detail. What are the major deliverables associated with hosting an event such as a soccer tournament?
2. How would developing a WBS alleviate some of the problems that occurred during the first meeting and help Nicolette organize and plan the project?
3. Where can Nicolette find additional information to help her develop a WBS for the tournament?
4. How could Nicolette and her task force use the WBS to generate cost estimates for the tournament? Why would this be useful information?

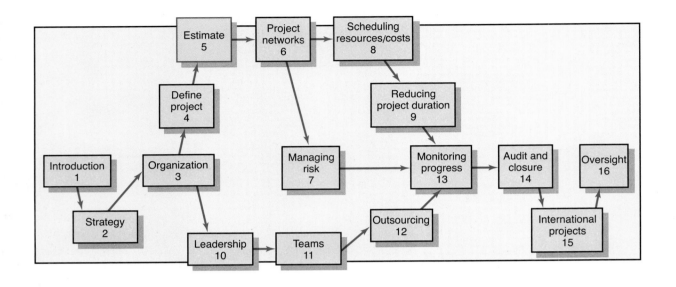

Estimating Project Times and Costs

Factors Influencing the Quality of Estimates

Estimating Guidelines for Times, Costs, and Resources

Top-Down versus Bottom-Up Estimating

Methods for Estimating Project Times and Costs

Level of Detail

Types of Costs

Refining Estimates

Creating a Database for Estimating

Summary

Appendix 5.1: Learning Curves for Estimating

Estimating Project Times and Costs

*Project estimation is indeed a yardstick for project cost control. And if the yardstick is faulty, you start on the "wrong foot." . . . we exhort you not to underestimate the estimate.**

Given the urgency to start work on the project, managers sometimes minimize or avoid the effort to follow through on estimating project time and cost. This attitude is a huge mistake and costly. There are important reasons to make the effort and incur the cost of estimating for your project. Exhibit 5.1 summarizes some key reasons.

Estimating is the process of forecasting or approximating the time and cost of completing project deliverables. Estimating processes are frequently classified as top-down and bottom-up. Top-down estimates are usually done by senior management. Management will often derive estimates from analogy, group consensus, or mathematical relationships. Bottom-up estimates are typically performed by the people who are doing the work. Their estimates are based on estimates of elements found in the work breakdown structure.

All project stakeholders prefer accurate cost and time estimates, but they also understand the inherent uncertainty in all projects. Inaccurate estimates lead to false expectations and consumer dissatisfaction. Accuracy is improved with greater effort, but is it worth the time and cost—estimating costs money! Project estimating becomes a trade-off, balancing the benefits of better accuracy against the costs for securing increased accuracy.

Cost, time, and budget estimates are the lifeline for control; they serve as the standard for comparison of actual and plan throughout the life of the project. Project status reports depend on reliable estimates as the major input for measuring variances and taking corrective action. Ideally, the project manager, and in most cases the customer, would prefer to have a database of detailed schedule and cost estimates for every work package in the project. Regrettably, such detailed data gathering is not always possible or practical and other methods are used to develop project estimates.

Factors Influencing the Quality of Estimates

A typical statement in the field is the desire to "have a 95 percent probability of meeting time and cost estimates." *Past experience* is a good starting point for developing time and cost estimates. But past experience estimates must almost always be refined by other considerations to reach the 95 percent probability level. Factors related to the

* O. P. Kharbanda and J. K. Pinto, *What Made Gertie Gallop: Learning from Project Failures* (New York: Von Nostrand Reinhold, 1996), p. 73.

- Estimates are needed to support good decisions.
- Estimates are needed to schedule work.
- Estimates are needed to determine how long the project should take and its cost.
- Estimates are needed to determine whether the project is worth doing.
- Estimates are needed to develop cash flow needs.
- Estimates are needed to determine how well the project is progressing.
- Estimates are needed to develop time-phased budgets and establish the project baseline.

uniqueness of the project will have a strong influence on the accuracy of estimates. Project, people, and external factors all need to be considered to improve quality of estimates for project times and costs.

Planning Horizon

The quality of the estimate depends on the *planning horizon;* estimates of current events are close to 100 percent accurate but are reduced for more distant events. The accuracy of time and cost estimates should improve as you move from the conceptual phase to the point where individual work packages are defined.

Project Duration

Time to implement new *technology* has a habit of expanding in an increasing, nonlinear fashion. Sometimes poorly written scope specifications for new technology result in errors in estimating times and costs. Long-duration projects increase the uncertainty in estimates.

People

The *people* factor can also introduce errors in estimating times and cost. For example, accuracy of estimates depends on the skills of the people making the estimates. A close match of people skills to the task will influence productivity and learning time. Similarly, whether members of the project team have worked together before on similar projects will influence the time it takes to coalesce into an effective team. Sometimes factors such as staff turnover can influence estimates. It should be noted that adding new people to a project increases time spent communicating. Typically, people have only five to six productive hours available for each working day; the other hours are taken up with indirect work, such as meetings, paperwork, answering e-mail.

Project Structure and Organization

Which *project structure* is chosen to manage the project will influence time and cost estimates. One of the major advantages of a dedicated project team discussed earlier is the speed gained from concentrated focus and localized project decisions. This speed comes at an additional cost of tying up personnel full time. Conversely, projects operating in a matrix environment may reduce costs by more efficiently sharing personnel across projects but may take longer to complete since attention is divided and coordination demands are higher.

Padding Estimates

In some cases people are inclined to *pad estimates.* For example, if you are asked how long it takes you to drive to the airport, you might give an average time of 30 minutes, assuming a 50/50 chance of getting there in 30 minutes. If you are asked the fastest you could possibly get there, you might reduce the driving time to 20 minutes. Finally, if you are asked how long the drive would take if you absolutely had to be there to meet with the president, it is likely you would increase the estimate to say 50 minutes to ensure not being late.

In work situations where you are asked for time and cost estimates, most of us are inclined to add a little padding to increase the probability and reduce the risk of being late. If everyone at all levels of the project adds a little padding to reduce risk, the project duration and cost are seriously overstated. This phenomenon causes some managers or owners to call for a 10–15 percent cut in time and/or cost for the project. Of course the next time the game is played, the person estimating cost and/or time will pad the estimate to 20 percent or more. Clearly such games defeat chances for realistic estimates, which is what is needed to be competitive.

Organization Culture

Organization culture can significantly influence project estimates. In some organizations padding estimates is tolerated and even privately encouraged. Other organizations place a premium on accuracy and strongly discourage estimating gamesmanship. Organizations vary in the importance they attach to estimates. The prevailing belief in some organizations is that detailed estimating takes too much time and is not worth the effort or that it's impossible to predict the future. Other organizations subscribe to the belief that accurate estimates are the bedrock of effective project management. Organization culture shapes every dimension of project management; estimating is not immune to this influence.

Other Factors

Finally, *nonproject factors* can impact time and cost estimates. For example, equipment downtime can alter time estimates. National holidays, vacations, and legal limits can influence project estimates. Project priority can influence resource assignment and impact time and cost.

Project estimating is a complex process. The quality of time and cost estimates can be improved when these variables are considered in making the estimates. Estimates of time and cost together allow the manager to develop a time-phased budget, which is imperative for project control. Before discussing macro and micro estimating methods for times and costs, a review of estimating guidelines will remind us of some of the important "rules of the game" that can improve estimating.

Estimating Guidelines for Times, Costs, and Resources

Managers recognize time, cost, and resource estimates must be accurate if project planning, scheduling, and controlling are to be effective. However, there is substantial evidence suggesting poor estimates are a major contributor to projects that have failed. Therefore, every effort should be made to see that initial estimates are as accurate as possible since the choice of no estimates leaves a great deal to luck and is not palatable to serious project managers. Even though a project has never been done before, a manager can follow seven guidelines to develop useful work package estimates.

1. **Responsibility.** At the work package level, estimates should be made by the person(s) most familiar with the task. Draw on their expertise! Except for supertechnical tasks, those responsible for getting the job done on schedule and within budget are usually first-line supervisors or technicians who are experienced and familiar with the type of work involved. These people will not have some preconceived, imposed duration for a deliverable in mind. They will give an estimate based on experience and best judgment. A secondary benefit of using those responsible is the hope they will "buy in" to seeing that the estimate materializes when they implement the work package. If those involved are not consulted, it will be difficult to hold them responsible for failure to achieve the estimated time. Finally, drawing on the expertise of team members who will be responsible helps to build communication channels early.

2. **Use several people to estimate.** It is well known that a cost or time estimate usually has a better chance of being reasonable and realistic when several people with relevant experience and/or knowledge of the task are used. True, people bring different biases based on their experience. But discussion of the individual differences in their estimate leads to consensus and tends to eliminate extreme estimate errors. This approach is similar to the Delphi estimating method, which can also be used.

3. **Normal conditions.** When task time, cost, and resource estimates are determined, they are based on certain assumptions. *Estimates should be based on normal conditions, efficient methods, and a normal level of resources.* Normal conditions are sometimes difficult to discern, but it is necessary to have a consensus in the organization as to what normal conditions mean in this project. If the normal workday is eight hours, the time estimate should be based on an eight-hour day. Similarly, if the normal workday is two shifts, the time estimate should be based on a two-shift workday. Any time estimate should reflect efficient methods for the resources normally available. The time estimate should represent the normal level of resources—people or equipment. For example, if three programmers are available for coding or two road graders are available for road construction, time and cost estimates should be based on these normal levels of resources unless it is anticipated the project will change what is currently viewed as "normal." In addition, possible conflicts in demand for resources on parallel or concurrent activities should not be considered at this stage. The need for adding resources will be examined when resource scheduling is discussed in a later chapter.

4. **Time units.** Specific time units to use should be selected early in the development phase of the project network. *All task time estimates need consistent time units.* Estimates of time must consider whether normal time is represented by calendar days, workdays, workweeks, person days, single shift, hours, minutes, etc. In practice the use of workdays is the dominant choice for expressing task duration. However, in projects such as a heart transplant operation, minutes probably would be more appropriate as a time unit. One such project that used minutes as the time unit was the movement of patients from an old hospital to an elegant new one across town. Since there were several life-endangering moves, minutes were used to ensure patient safety so proper emergency life-support systems would be available if needed. The point is, network analysis requires a standard unit of time. When computer programs allow more than one option, some notation should be made of any variance from the standard unit of time. If the standard unit of time is a five-day workweek and the estimated activity duration is in calendar days, it must be converted to the normal workweek.

5. **Independence.** Estimators should treat each task as independent of other tasks that might be integrated by the WBS. Use of first-line managers usually results in considering tasks independently; this is good. Top managers are prone to aggregate many tasks into one time estimate and then deductively make the individual task time estimates add to the total. If tasks are in a chain and performed by the same group or department, it is best not to ask for all the time estimates in the sequence at once to avoid the tendency for a planner or a supervisor to look at the whole path and try to adjust individual task times in the sequence to meet an arbitrary imposed schedule or some rough "guesstimate" of the total time for the whole path or segment of the project. This tendency does not reflect the uncertainties of individual activities and generally results in optimistic task time estimates. In summary, each task time estimate should be considered independently of other activities.

6. **Contingencies.** *Work package estimates should not include allowances for contingencies.* The estimate should assume normal or average conditions even though every work

package will not materialize as planned. For this reason top management needs to create an extra fund for contingencies that can be used to cover unforeseen events.

7. **Adding risk assessment to the estimate helps to avoid surprises to stakeholders.** It is obvious some tasks carry more time and cost risks than others. For example, a new technology usually carries more time and cost risks than a proven process. Simply identifying the degree of risk lets stakeholders consider alternative methods and alter process decisions. A simple breakdown by optimistic, most likely, and pessimistic for task time could provide valuable information regarding time and cost. See Chapter 7 for further discussion of project risk.

Where applicable, these guidelines will greatly help to avoid many of the pitfalls found so often in practice.

Top-Down versus Bottom-Up Estimating

Since estimating efforts cost money, the time and detail devoted to estimating is an important decision. Yet, when estimating is considered, you as a project manager may hear statements such as these:

> *Rough order of magnitude is good enough. Spending time on detailed estimating wastes money.*
>
> *Time is everything; our survival depends on getting there first! Time and cost accuracy is not an issue.*
>
> *The project is internal. We don't need to worry about cost.*
>
> *The project is so small, we don't need to bother with estimates. Just do it.*
>
> *We were burned once. I want a detailed estimate of every task by the people responsible.*

However, there are sound reasons for using top-down or bottom-up estimates. Table 5.1 depicts conditions that suggest when one approach is preferred over another.

Top-down estimates usually are derived from someone who uses experience and/or information to determine the project duration and total cost. These estimates are sometimes made by top managers who have very little knowledge of the processes used to complete the project. For example, a mayor of a major city making a speech noted that a new law building would be constructed at a cost of $23 million and would be ready for occupancy in two and one-half years. Although the mayor probably asked for an estimate from someone, the estimate could have come from a luncheon meeting with a local contractor who wrote an estimate (guesstimate) on a napkin. This is an extreme example, but in a relative sense this scenario is frequently played out in practice. See Snapshot from Practice: Council Fumes, for another example of this. But the question is, *do these estimates represent low-cost, efficient methods?* Do the top-down estimates of project time and cost become a self-fulfilling prophecy in terms of setting time and cost parameters?

TABLE 5.1
Conditions for Preferring Top-Down or Bottom-Up Time and Cost Estimates

Condition	Top-Down Estimates	Bottom-Up Estimates
Strategic decision making	X	
Cost and time important		X
High uncertainty	X	
Internal, small project	X	
Fixed-price contract		X
Customer wants details		X
Unstable scope	X	

Portland, Oregon's, Willamette riverfront development has exploded with seven condominium towers and a new health sciences center under construction. The health science complex is to be linked with Oregon Health Sciences University (OHSU), which is high on a nearby hill, with an aerial cable tram.

The aerial tram linking the waterfront district to OHSU is to support the university expansion, to increase biotechnology research, and to become Portland's icon equivalent to Seattle's Space Needle. All of the hype turned south when news from a hearing suggested that the real budget for the tram construction, originally estimated at $15 million, is going to be about $55–$60 million, nearly triple the original estimate. The estimate could even go higher. Commissioners want to find out why city staff knowingly relied on flawed estimates. Mike Lindberg, president of the nonprofit Aerial Transportation Inc., acknowledged "the $15 million number was not a good number. It was simply a guesstimate." Commissioner Erik Sten said, "Those numbers were presented as much more firm than they appear to have been. . . . It appears the actual design wasn't costed out. That's pretty shoddy."

** The Oregonian, January 13, 2006, by Frank Ryan, pages A1 and A14, and April 2, 2006, page A1.*

If possible and practical, you want to push the estimating process down to the work package level for bottom-up estimates that establish low-cost, efficient methods. This process can take place after the project has been defined in detail. Good sense suggests project estimates should come from the people most knowledgeable about the estimate needed. The use of several people with relevant experience with the task can improve the time and cost estimate. The bottom-up approach at the work package level can serve as a check on cost elements in the WBS by rolling up the work packages and associated cost accounts to major deliverables. Similarly, resource requirements can be checked. Later, the time, resource, and cost estimates from the work packages can be consolidated into time-phased networks, resource schedules, and budgets that are used for control.

The bottom-up approach also provides the customer with an opportunity to compare the low-cost, efficient method approach with any imposed restrictions. For example, if the project completion duration is imposed at two years and your bottom-up analysis tells you the project will take two and one-half years, the client can now consider the trade-off of the low-cost method versus compressing the project to two years—or in rare cases canceling the project. Similar trade-offs can be compared for different levels of resources or increases in technical performance. The assumption is any movement away from the low-cost, efficient method will increase costs—e.g., overtime. The preferred approach in defining the project is to make rough top-down estimates, develop the WBS/OBS, make bottom-up estimates, develop schedules and budgets, and reconcile differences between top-down and bottom-up estimates. Hopefully, these steps will be done *before* final negotiation with either an internal or external customer. In conclusion, the ideal approach is for the project manager to allow enough time for both the top-down and bottom-up estimates to be worked out so a complete plan based on reliable estimates can be offered to the customer. In this way false expectations are minimized for all stakeholders and negotiation is reduced.

Methods for Estimating Project Times and Costs

Top-Down Approaches for Estimating Project Times and Costs

At the strategic level top-down estimating methods are used to evaluate the project proposal. Sometimes much of the information needed to derive accurate time and cost estimates is not available in the initial phase of the project—for example, design is not finalized. In these situations top-down estimates are used until the tasks in the WBS are clearly defined.

Consensus Methods

This method simply uses the pooled experience of senior and/or middle managers to estimate the total project duration and cost. This typically involves a meeting where experts discuss, argue, and ultimately reach a decision as to their best guess estimate. Firms seeking greater rigor will use the Delphi method to make these macro estimates. See Snapshot from Practice: The Delphi Method.

It is important to recognize that these first top-down estimates are only a rough cut and typically occur in the "conceptual" stage of the project. The top-down estimates are helpful in initial development of a complete plan. However, such estimates are sometimes significantly off the mark because little detailed information is gathered. At this level individual work items are not identified. Or, in a few cases, the top-down estimates are not realistic because top management "wants the project." Nevertheless, the initial top-down estimates are helpful in determining whether the project warrants more formal planning, which would include more detailed estimates. Be careful that macro estimates made by senior managers are not dictated to lower level managers who might feel compelled to accept the estimates even if they believe resources are inadequate.

Although your authors prefer to avoid the top-down approach if possible, we have witnessed surprising accuracy in estimating project duration and cost in isolated cases. Some examples are building a manufacturing plant, building a distribution warehouse, developing air control for skyscraper buildings, and road construction. However, we have also witnessed some horrendous miscalculations, usually in areas where the technology is new and unproven. Top-down methods can be useful if experience and judgment have been accurate in the past.

Originally developed by the RAND Corporation in 1969 for technological forecasting, the *Delphi Method* is a group decision process about the likelihood that certain events will occur. The Delphi Method makes use of a panel of experts familiar with the kind of project in question. The notion is that well-informed individuals, calling on their insights and experience, are better equipped to estimate project costs/times than theoretical approaches or statistical methods. Their responses to estimate questionnaires are anonymous, and they are provided with a summary of opinions.

Experts are then encouraged to reconsider, and if appropriate to change their previous estimate in light of the replies of other experts. After two or three rounds it is believed that the group will converge toward the "best" response through this consensus process. The midpoint of responses is statistically categorized by the median score. In each succeeding round of questionnaires, the range of responses by the panelists will presumably decrease and the median will move toward what is deemed to be the "correct" estimate.

One distinct advantage of the Delphi Method is that the experts never need to be brought together physically. The process also does not require complete agreement by all panelists, since the majority opinion is represented by the median. Since the responses are anonymous, the pitfalls of ego, domineering personalities and the "bandwagon or halo effect" in responses are all avoided. On the other hand, future developments are not always predicted correctly by iterative consensus nor by experts, but at times by creative, "off the wall" thinking.

Ratio Methods

Top-down methods (sometimes called parametric) usually use ratios, or surrogates, to estimate project times or costs. Top-down approaches are often used in the concept or "need" phase of a project to get an initial duration and cost estimate for the project. For example, contractors frequently use number of square feet to estimate the cost and time to build a house; that is, a house of 2,700 square feet might cost $160 per square foot (2,700 feet \times $160 per foot equals $432,000). Likewise, knowing the square feet and dollars per square foot, experience suggests it should take approximately 100 days to complete. Two other common examples of top-down cost estimates are the cost for a new plant estimated by capacity size, or a software product estimated by features and complexity.

Apportion Methods

This method is an extension to the ratio method. Apportionment is used when projects closely follow past projects in features and costs. Given good historical data, estimates can be made quickly with little effort and reasonable accuracy. This method is very common in projects that are relatively standard but have some small variation or customization.

Anyone who has borrowed money from a bank to build a house has been exposed to this process. Given an estimated total cost for the house, banks and the FHA (Federal Housing Authority) authorize pay to the contractor by completion of specific segments of the house. For example, foundation might represent 3 percent of the total loan, framing 25 percent, electric, plumbing and heating 15 percent, etc. Payments are made as these items are completed. An analogous process is used by some companies that apportion costs to deliverables in the WBS—given average cost percentages from past projects. Figure 5.1 presents an example similar to one found in practice. Assuming the total project cost is estimated, using a top-down estimate, to be $500,000, the costs are apportioned as a percentage of the total cost. For example, the costs apportioned to the "Document" deliverable are 5 percent of the total, or $25,000. The subdeliverables "Doc-1 and Doc-2" are allocated 2 and 3 percent of the total—$10,000 and $15,000, respectively.

FIGURE 5.1 **Apportion Method of Allocating Project Costs Using the Work Breakdown Structure**

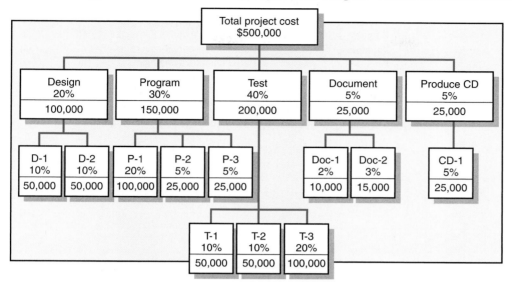

Function Point Methods for Software and System Projects

In the software industry, software development projects are frequently estimated using weighted macro variables called "function points" or major parameters such as number of inputs, number of outputs, number of inquiries, number of data files, and number of interfaces. These weighted variables are adjusted for a complexity factor and added. The total adjusted count provides the basis for estimating the labor effort and cost for a project (usually using a regression formula derived from data of past projects). This latter method assumes adequate historical data by type of software project for the industry—for example, MIS systems. In the U.S. software industry, one-person month represents on average five function points. A person working one month can generate on average (across all types of software projects) about five function points. Of course each organization needs to develop its own average for its specific type of work. Such historical data provide a basis for estimating the project duration. Variations of this top-down approach are used by companies such as IBM, Bank of America, Sears Roebuck, HP, AT & T, Ford Motors, GE, Du Pont and many others. See Table 5.2 and Table 5.3 for a simplified example of function point count methodology.

TABLE 5.2
Simplified Basic Function Point Count Process for a Prospective Project or Deliverable

Element	Complexity Weighting			Total
	Low	Average	High	
Number of *inputs*	_____ × 2 +	_____ × 3 +	_____ × 4	= _____
Number of *outputs*	_____ × 3 +	_____ × 6 +	_____ × 9	= _____
Number of *inquiries*	_____ × 2 +	_____ × 4 +	_____ × 6	= _____
Number of *files*	_____ × 5 +	_____ × 8 +	_____ × 12	= _____
Number of *interfaces*	_____ × 5 +	_____ × 10 +	_____ × 15	= _____

TABLE 5.3
Example: Function Point Count Method

Software Project 13: Patient Admitting and Billing			
15	Inputs	Rated complexity as low	(2)
5	Outputs	Rated complexity as average	(6)
10	Inquiries	Rated complexity as average	(4)
30	Files	Rated complexity as high	(12)
20	Interfaces	Rated complexity as average	(10)

Application of Complexity Factor					
Element	Count	Low	Average	High	Total
Inputs	15	× 2			= 30
Outputs	5		× 6		= 30
Inquiries	10		× 4		= 40
Files	30			× 12	= 360
Interfaces	20		× 10		= 200
				Total	660

From historical data the organization developed the weighting scheme for complexity found in Table 5.2. Function points are derived from multiplying the number of kinds of elements by weighted complexity.

Table 5.3 shows the data collected for a specific task or deliverable: Patient Admitting and Billing—the number of inputs, outputs, inquiries, files and interfaces along with the expected complexity rating. Finally, the application of the element count is applied and the function point count total is 660. Given this count and the fact that one person month has historically been equal to 5 function points, the job will require 132 person months (660/5 = 132). Assuming you have 10 programmers who can work on this task, the duration would be approximately 13 months. The cost is easily derived by multiplying the labor rate per month times 132 person months. For example, if the monthly programmer rate is $4,000, then the estimated cost would be $528,000 (132 × 4,000). Although function point metrics are useful, their accuracy depends on adequate historical data, currency of data, and relevancy of the project/deliverable to past averages.

Learning Curves

Some projects require that the same task, group of tasks, or product be repeated several times. Managers know intuitively that the time to perform a task improves with repetition. This phenomenon is especially true of tasks that are labor intensive. In these circumstances the pattern of improvement phenomenon can be used to predict the reduction in time to perform the task. From empirical evidence across *all* industries, the pattern of this improvement has been quantified in the *learning curve* (also known as improvement curve, experience curve, and industrial progress curve), which is described by the following relationship:

Each time the output quantity doubles, the unit labor hours are reduced at a constant rate.

In practice the improvement ratio may vary from 60 percent, representing very large improvement, to 100 percent, representing no improvement at all. Generally, as the difficulty of the work decreases the expected improvement also decreases and the improvement ratio that is used becomes greater. One significant factor to consider is the proportion of labor in the task in relation to machine-paced work. Obviously, a lower percentage of improvement can occur only in operations with high labor content. Appendix 5.1 at the end of the chapter provides a detailed example of how the improvement phenomenon can be used to estimate time and cost for repetitive tasks.

The main disadvantage of top-down approaches to estimating is simply that the time and cost for a specific task are not considered. Grouping many tasks into a common basket encourages errors of omission and the use of imposed times and costs.

Micro estimating methods are usually more accurate than macro methods. The bottom-up approach at the work package level can serve as a check on cost elements in the WBS by rolling up the work packages and associated cost accounts to major deliverables. Similarly, resource requirements can be checked. Later, the time, resource, and cost estimates from the work packages can be consolidated into time-phased networks, resource schedules, and budgets that are used for control.

Bottom-Up Approaches for Estimating Project Times and Costs

Template Methods

If the project is similar to past projects, the costs from past projects can be used as a starting point for the new project. Differences in the new project can be noted and past times and costs adjusted to reflect these differences. For example, a ship repair drydock firm has a set of standard repair projects (i.e., templates for overhaul, electrical, mechanical) that are used as starting points for estimating the cost and duration of any new project. Differences from the appropriate standardized project are noted (for times, costs, and resources) and changes are made. This approach enables the firm to develop a potential schedule, estimate costs, and develop a budget in a very short time span. Development of such templates in a database can quickly reduce estimate errors.

Parametric Procedures Applied to Specific Tasks

Just as parametric techniques such as cost per square foot can be the source of top-down estimates, the same technique can be applied to specific tasks. For example, as part of an MS Office conversion project, 36 different computer workstations needed to be converted. Based on past conversion projects, the project manager determined that on average one person could convert three workstations per day. Therefore the task of converting the 36 workstations would take three technicians four days [(36/3)/3]. Similarly, to estimate the wallpapering allowance on a house remodel, the contractor figured a cost of $5 per square yard of wallpaper and $2 per yard to install it, for a total cost of $7. By measuring the length and height of all the walls she was able to calculate the total area in square yards and multiply it by $7.

Detailed Estimates for the WBS Work Packages

Probably the most reliable method for estimating time and cost is to use the WBS and to ask the people responsible for the work package to make the estimates. They know from experience or know where to find the information to estimate work package durations—especially those that depend on labor hours and costs. When work packages have significant uncertainty associated with the time to complete, it is a prudent policy to require three time estimates—low, average, and high. Figure 5.2 presents a template training form using three time estimates for work packages by three different estimators. The form illustrates how this information can identify large differences among estimators and how the use of averages can give a more balanced time estimate. This time estimating approach gives the project manager and owner an opportunity to assess the risks associated with project times (and thus, costs). The approach helps to reduce surprises as the project progresses. The three-time estimate approach also provides a basis for assessing risk and determining the contingency fund. (See Chapter 7 for a discussion of contingency funds.)

3 estimates
- low
- average
- high

FIGURE 5.2 **SB45 Support Cost Estimate Worksheet**

		Estimator 1			Estimator 2			Estimator 3			Estimator Averages			Ratio*
		Low Est.	Aver. Est.	High Est.	Low Est.	Aver. Est.	High Est.	Low Est.	Aver. Est.	High Est.	Aver. Low	Aver.	Aver. High	Range/ Aver.
WBS ID	Description	Days	Days	Days	Days	Days	Days	Days	Days	Days	Days	Days	Days	
102	Engineering	95	100	105	97	100	103	93	96	100	95.0	98.7	102.7	0.08
103	Project Management	14	15	17	14	16	18	13	14	15	13.7	15.0	16.7	0.20
104	R/W Property Acceptances	44	48	52	45	50	52	43	46	49	44.0	48.0	51.0	0.15
105	Base Maps	36	38	40	36	37	39	35	36	37	35.7	37.0	38.7	0.08
106	Coordinate Utilities	7	8	9	7	8	9	8	9	10	7.3	8.3	9.3	0.24
107	EPA Acceptance	13	14	15	14	15	16	13	15	17	13.3	14.7	16.0	0.18
108	Alignment Surveys	32	35	38	32	35	37	32	34	35	32.0	34.7	36.7	0.14

Project Number: *17*
Project Description: *Road Diversion Project*

Project Manager: *Kathleen Walling*
Date: 5 - 07

* Note: = ABS (Average Low - Average High)/Average
This ratio indicates the degree of variability in the estimates.

A Hybrid: Phase Estimating

This approach begins with a top-down estimate for the project and then refines estimates for phases of the project as it is implemented. Some projects by their nature cannot be rigorously defined because of the uncertainty of design or the final product. Although rare, such projects do exist. These projects are often found in aerospace projects, IT projects, new technology projects, and construction projects where design is incomplete. In these projects, phase or life-cycle estimating is frequently used.

Phase estimating is used when an unusual amount of uncertainty surrounds a project and it is impractical to estimate times and costs for the entire project. Phase estimating uses a two-estimate system over the life of the project. A detailed estimate is developed for the immediate phase and a macro estimate is made for the remaining phases of the project. Figure 5.3 depicts the phases of a project and the progression of estimates over its life.

For example, when the project need is determined, a macro estimate of the project cost and duration is made so analysis and decisions can be made. Simultaneously a detailed estimate is made for deriving project specifications and a macro estimate for the remainder of the project. As the project progresses and specifications are solidified, a detailed estimate for design is made and a macro estimate for the remainder of the project is computed. Clearly, as the project progresses through its life cycle and more information is available, the reliability of the estimates should be improving.

Phase estimating is preferred by those working on projects where the final product is not known and the uncertainty is very large—for example, the integration of wireless phones and computers. The commitment to cost and schedule is only necessary over the next phase of the project and commitment to unrealistic future schedules and costs based

The smaller the element of a work package, the more accurate the overall estimate is likely to be. The extent of this improvement varies by type of project. The table below is developed to reflect this observation. For example, information technology projects that determine their time and cost estimates in the conceptual stage can expect their "actuals" to err up to 200 percent over cost and duration and, perhaps, as much as 30 percent under estimates. Conversely, estimates for buildings, roads, etc., made after the work packages are clearly defined, have a smaller error in actual costs and times of 15 percent over estimate and 5 percent less than estimate. Although these estimates vary by project, they can serve as ballpark numbers for project stakeholders selecting how project time and cost estimates will be derived.

Time and Cost Estimate Accuracy by Type of Project

	Bricks and Mortar	Information Technology
Conceptual stage	+60% to −30%	+200% to −30%
Deliverables defined	+30% to −15%	+100% to −15%
Work packages defined	+15% to −5%	+50% to −5%

on poor information is avoided. This progressive macro/micro method provides a stronger basis for using schedule and cost estimates to manage progress during the next phase.

Unfortunately your customer—internal or external—will want an accurate estimate of schedule and cost the moment the decision is made to implement the project. Additionally, the customer who is paying for the project often perceives phase estimating as a blank check because costs and schedules are not firm over most of the project life cycle. Even though the reasons for phase estimating are sound and legitimate, most customers have to be sold on its legitimacy. A major advantage for the customer is the opportunity to change features, re-evaluate, or even cancel the project in each new phase. In conclusion, phase estimating is very useful in projects that possess huge uncertainties concerning the final nature (shape, size, features) of the project.

See Figure 5.4 for a summary of the differences between top-down and bottom-up estimates.

Obtaining accurate estimates is a challenge. Committed organizations accept the challenge of coming up with meaningful estimates and invest heavily in developing their capacity to do so. Accurate estimates reduce uncertainty and support a discipline for effectively managing projects.

FIGURE 5.3
Phase Estimating over Project Life Cycle

Phase	Need 1	Specifications 2	Design 3	Produce 4	Deliver 5
1		Macro estimate			→
2		Detailed estimate →	Macro estimate		→
3			Detailed estimate →	Macro estimate	→
4				Detailed estimate →	Macro estimate →
5					Detailed estimate →

FIGURE 5.4
Top-Down and
Bottom-Up Estimates

Top-Down Estimates	Bottom-Up Estimates
Intended Use	**Intended Use**
Feasibility/conceptual phase Rough time/cost estimate Fund requirements Resource capacity planning	Budgeting Scheduling Resource requirements Fund timing
Preparation Cost	**Preparation Cost**
1/10 to 3/10 of a percent of total project cost	3/10 of a percent to 1.0 percent of total project cost
Accuracy	**Accuracy**
Minus 20%, to plus 60%	Minus 10%, to plus 30%
Method	**Method**
Consensus Ratio Apportion Function point Learning curves	Template Parametric WBS packages

Level of Detail

Level of detail is different for different levels of management. At any level the detail should be no more than is necessary and sufficient. Top management interests usually center on the total project and major milestone events that mark major accomplishments—e.g., "Build Oil Platform in the North Sea" or "Complete Prototype." Middle management might center on one segment of the project or one milestone. First-line managers' interests may be limited to one task or work package. One of the beauties of WBS is the ability to aggregate network information so each level of management can have the kind of information necessary to make decisions.

Getting the level of detail in the WBS to match management needs for effective implementation is crucial, but the delicate balance is difficult to find. See Snapshot from Practice: Level of Detail. The level of detail in the WBS varies with the complexity of the project; the need for control; the project size, cost, duration; and other factors. If the structure reflects excessive detail, there is a tendency to break the work effort into department assignments. This tendency can become a barrier to success, since the emphasis will be on departmental outcomes rather than on deliverable outcomes. Excessive detail also means more unproductive paperwork. Note that if the level of the WBS is increased by one, the number of cost accounts may increase geometrically. On the other hand, if the level of detail is not adequate, an organization unit may find the structure falls short of meeting its needs. Fortunately, the WBS has built-in flexibility. Participating organization units may expand their portion of the structure to meet their special needs. For example, the engineering department may wish to further break their work on a deliverable into smaller packages by electrical, civil, and mechanical. Similarly, the marketing department may wish to break their new product promotion into TV, radio, periodicals, and newspapers.

Practicing project managers advocate keeping the level of detail to a minimum. But there are limits to this suggestion. One of the most frequent errors of new project managers is to forget that the task time estimate will be used to control schedule and cost performance. A frequent rule of thumb used by practicing project managers says that a task duration should not exceed 5 workdays or at the most 10 workdays, if workdays are the time units used for the project. Such a rule probably will result in a more detailed network, but the additional detail pays off in controlling schedule and cost as the project progresses.

Suppose the task is "build prototype computer-controlled conveyor belt," the time estimate is 40 workdays, and the budget $300,000. It may be better to divide the task into seven or eight smaller tasks for control purposes. If one of the smaller tasks gets behind because of problems or a poor time estimate, it will be possible to take corrective action quickly and avoid delaying successive tasks and the project. If the single task of 40 workdays is used, it is possible that no corrective action would be taken until day 40, since many people have a tendency to "wait and see" or avoid admitting they are behind or passing on bad news; the result may mean far more than 5 days behind schedule.

The 5- to 10-day rule of thumb applies to cost and performance goals. If using the rule of thumb suggested above results in too many network tasks, an alternative is available, but it has conditions. The activity time can be extended beyond the 5- to 10-day rule only *IF* control monitoring checkpoints for segments of the task can be established so clear measures of progress can be identified by a specific percent complete.

This information is invaluable to the control process of measuring schedule and cost performance—for example, payments for contract work are paid on "percent complete" basis. Defining a task with clear definable start and end points and intermediate points enhances the chances of early detection of problems, corrective action, and on-time project completion.

Types of Costs

Assuming work packages are defined, detailed cost estimates can be made. Here are typical kinds of costs found in a project:

1. Direct costs
 a. Labor
 b. Materials
 c. Equipment
 d. Other
2. Project overhead costs
3. General and administrative (G&A) overhead costs

The total project cost estimate is broken down in this fashion to sharpen the control process and improve decision making.

Direct Costs

These costs are clearly chargeable to a specific work package. Direct costs can be influenced by the project manager, project team, and individuals implementing the work package. These costs represent real cash outflows and must be paid as the project progresses; therefore, direct costs are usually separated from overhead costs. Lower-level project rollups frequently include only direct costs.

Direct Overhead Costs

Direct overhead rates more closely pinpoint which resources of the organization are being used in the project. Direct overhead costs can be tied to project deliverables or work packages. Examples include the salary of the project manager and temporary rental space for the project team. Although overhead is not an immediate out-of-pocket expense, it is *real*

FIGURE 5.5
Contract Bid
Summary Costs

Direct costs	$80,000
Direct overhead	$20,000
Total direct costs	$100,000
G&A overhead (20%)	$20,000
Total costs	$120,000
Profit (20%)	$24,000
Total bid	$144,000

and must be covered in the long run if the firm is to remain viable. These rates are usually a ratio of the dollar value of the resources used—e.g., direct labor, materials, equipment. For example, a direct labor burden rate of 20 percent would add a direct overhead charge of 20 percent to the direct labor cost estimate. A direct charge rate of 50 percent for materials would carry an additional 50 percent charge to the material cost estimate. Selective direct overhead charges provide a more accurate project (job or work package) cost, rather than using a blanket overhead rate for the whole project.

General and Administrative (G&A) Overhead Costs

These represent organization costs that are not directly linked to a specific project. These costs are carried for the duration of the project. Examples include organization costs across all products and projects such as advertising, accounting, and senior management above the project level. Allocation of G&A costs varies from organization to organization. However, G&A costs are usually allocated as a percent of total direct cost, or a percent of the total of a specific direct cost such as labor, materials, or equipment.

Given the totals of direct and overhead costs for individual work packages, it is possible to cumulate the costs for any deliverable or for the entire project. A percentage can be added for profit if you are a contractor. A breakdown of costs for a proposed contract bid is presented in Figure 5.5.

Perceptions of costs and budgets vary depending on their users. The project manager must be very aware of these differences when setting up the project budget and when communicating these differences to others. Figure 5.6 depicts these different perceptions. The project manager can commit costs months before the resource is used. This information is

FIGURE 5.6
Three Views of Cost

O. P. Kharbanda in his book (co-authored with Jeffrey Pinto) *What Made Gertie Gallop: Learning from Project Failures* makes the important point that estimating is as much an art as a skill. For example, early in his career (1960s), he was involved with the fabrication of a nuclear reactor in India at a time when the local facilities were not geared for such sophisticated jobs. Having had no experience in building complex equipment with (almost) unheard of tolerances and precision, it was virtually impossible to create a reasonable advance estimate of the cost. The estimators did the best they could, then added a little more than normal margin before quoting a price to the client.

Soon after, O. P. happened to attend a week-long international nuclear power conference that included stalwarts in this field from all over the world. About midweek, he was fortunate to come face-to-face with the chief engineer of the company that had supplied the first reactor to India, identical in design to the one his company had recently bid on. This was the chance of a lifetime to finally get the inside information on accurate cost estimating. In fact, the expert confessed that his company lost "their shirt" on the Indian reactor. Then in reply to the innocent question, "How do you estimate a nuclear reactor?" the expert answered with cool confidence, "Do your normal cautious estimating, add more than normal margin and then after a short pause, double it!" O. P. confessed that in their ignorance, they had skipped the last vital step, but this short, casual conversation proved most valuable. "We were forewarned, we took it seriously, and got forearmed. It saved us several millions of dollars."

useful to the financial officer of the organization in forecasting future cash outflows. The project manager is interested in when the budgeted cost is expected to occur, and when the budgeted cost actually is charged (earned); the respective timings of these two cost figures are used to measure project schedule and cost variances.

Refining Estimates

As described earlier in Chapter 4, detailed work package estimates are aggregated and "rolled up" by deliverable to estimate the total direct cost of the project. Similarly, estimated durations are entered into the project network to establish the project schedule and determine the overall duration of the project. Experience tells us that for many projects the total estimates do not materialize and the actual costs and schedule of some projects significantly exceed original work package–based estimates. See Snapshot from Practice: How Do You Estimate the Cost of a Nuclear Power Plant? for a dramatic example of this. In order to compensate for the problem of actual cost and schedule exceeding estimates, some project managers adjust total costs by some multiplier (i.e., total estimated costs × 1.20).

The practice of adjusting original estimates by 20 or even 100 percent begs the question of why, after investing so much time and energy on detailed estimates, could the numbers be so far off? There are a number of reasons for this, most of which can be traced to the estimating process and the inherent uncertainty of predicting the future. Some of these reasons are discussed below.

- **Interaction costs are hidden in estimates.** According to the guidelines, each task estimate is supposed to be done independently. However, tasks are rarely completed in a vacuum. Work on one task is dependent upon prior tasks, and the hand-offs between tasks require time and attention. For example, people working on prototype development need to interact with design engineers after the design is completed, whether to simply ask clarifying questions or to make adjustments in the original design. Similarly, the time necessary to coordinate activities is typically not reflected in independent estimates. Coordination is reflected in meetings and briefings as well as time necessary to resolve disconnects between tasks. Time, and therefore cost, devoted to managing interactions rises exponentially as the number of people and different disciplines involved increases on a project.

- **Normal conditions do not apply.** Estimates are supposed to be based on normal conditions. While this is a good starting point, it rarely holds true in real life. This is especially true when it comes to the availability of resources. Resource shortages, whether in the form of people, equipment, or materials, can extend original estimates. For example, under normal conditions four bulldozers are typically used to clear a certain site size in five days, but the availability of only three bulldozers would extend the task duration to eight days. Similarly, the decision to outsource certain tasks can increase costs as well as extend task durations since time is added to acclimating outsiders to the particulars of the project and the culture of the organization.

- **Things go wrong on projects.** Design flaws are revealed after the fact, extreme weather conditions occur, accidents happen, and so forth. Although you shouldn't plan for these risks to happen when estimating a particular task, the likelihood and impact of such events need to be considered.

- **Changes in project scope and plans.** As one gets further and further into the project, a manager obtains a better understanding of what needs to be done to accomplish the project. This may lead to major changes in project plans and costs. Likewise, if the project is a commercial project, changes often have to be made midstream to respond to new demands by the customer and/or competition. Unstable project scopes are a major source of cost overruns. While every effort should be made up front to nail down the project scope, it is becoming increasingly difficult to do so in our rapidly changing world.

The reality is that for many projects not all of the information needed to make accurate estimates is available, and it is impossible to predict the future. The dilemma is that without solid estimates, the credibility of the project plan is eroded. Deadlines become meaningless, budgets become rubbery, and accountability becomes problematic.

Challenges similar to those described above will influence the final time and cost estimates. Even with the best estimating efforts, it may be necessary to revise estimates based on relevant information *prior* to establishing a baseline schedule and budget.

Effective organizations adjust estimates of specific tasks once risks, resources, and particulars of the situation have been more clearly defined. They recognize that the rolled up estimates generated from a detailed estimate based on the WBS are just the starting point. As they delve further into the project-planning process, they make appropriate revisions both in the time and cost of specific activities. They factor the final assignment of resources into the project budget and schedule. For example, when they realize that only three instead of four bulldozers are available to clear a site, they adjust both the time and cost of that activity. They adjust estimates to account for specific actions to mitigate potential risks on the project. For example, to reduce the chances of design code errors, they would add the cost of independent testers to the schedule and budget. Finally, organizations adjust estimates to take into account abnormal conditions. For example, if soil samples reveal excessive ground water, then they adjust foundation costs and times.

There will always be some mistakes, omissions, and adjustments that will require additional changes in estimates. Fortunately every project should have a change management system in place to accommodate these situations and any impact on the project baseline. Change management and contingency funds will be discussed later in Chapter 7.

Creating a Database for Estimating

The best way to improve estimates is to collect and archive data on past project estimates and actuals. Saving historical data—estimates and actuals—provides a knowledge base for improving project time and cost estimating. Creating an estimating database is a "best practice" among leading project management organizations.

FIGURE 5.7
Estimating Database Templates

Some organizations have large estimating departments of professional estimators—e.g., Boeing, Kodak, IBM—that have developed large time and cost databases. Others collect these data through the project office. This database approach allows the project estimator to select a specific work package item from the database for inclusion. The estimator then makes any necessary adjustments concerning the materials, labor, and equipment. Of course any items not found in the database can be added to the project—and ultimately to the database if desired. Again, the quality of the database estimates depends on the experience of the estimators, but over time the data quality should improve. Such structured databases serve as feedback for estimators and as benchmarks for cost and time for each project. In addition, comparison of estimate and actual for different projects can suggest the degree of risk inherent in estimates. See Figure 5.7 for the structure of a database similar to those found in practice.

Summary

Quality time and cost estimates are the bedrock of project control. Past experience is the best starting point for these estimates. The quality of estimates is influenced by other factors such as people, technology, and downtimes. The key for getting estimates that represent realistic average times and costs is to have an organization culture that allows errors in estimates without incriminations. If times represent average time, we should expect that 50 percent will be less than the estimate and 50 percent will exceed the estimate. The use of teams that are highly motivated can help in keeping task times and costs near the average. For this reason, it is crucial to get the team to buy into time and cost estimates.

Using top-down estimates is good for initial and strategic decision making or in situations where the costs associated with developing better estimates have little benefit. However, in most cases the bottom-up approach to estimating is preferred and more reliable because it assesses each work package, rather than the whole project, section, or deliverable of a project. Estimating time and costs for each work package facilitates development of the project schedule and a time-phased budget, which are needed to control the project as it

is implemented. Using the estimating guidelines will help eliminate many common mistakes made by those unacquainted with estimating times and costs for project control. Establishing a time and cost estimating database fits well with the learning organization philosophy.

The level of time and cost detail should follow the old saying of "no more than is necessary and sufficient." Managers must remember to differentiate between committed outlays, actual costs, and scheduled costs. It is well known that up-front efforts in clearly defining project objectives, scope, and specifications vastly improve time and cost estimate accuracy.

Finally, how estimates are gathered and how they are used can affect their usefulness for planning and control. The team climate, organization culture, and organization structure can strongly influence the importance attached to time and cost estimates and how they are used in managing projects.

Key Terms

Apportionment methods	Function points	Ratio methods
Bottom-up estimates	Learning curves	Template method
Contingency funds	Overhead costs	Time and cost databases
Delphi method	Padding estimates	Top-down estimates
Direct costs	Phase estimating	

Review Questions

1. Why are accurate estimates critical to effective project management?
2. How does the culture of an organization influence the quality of estimates?
3. What are the differences between bottom-up and top-down estimating approaches? Under what conditions would you prefer one over the other?
4. What are the major types of costs? Which costs are controllable by the project manager?

Exercises

1. Mrs. Tolstoy and her husband, Serge, are planning their dream house. The lot for the house sits high on a hill with a beautiful view of the Appalachian Mountains. The plans for the house show the size of the house to be 2,900 square feet. The average price for a lot and house similar to this one has been $120 per square foot. Fortunately, Serge is a retired plumber and feels he can save money by installing the plumbing himself. Mrs. Tolstoy feels she can take care of the interior decorating.

 The following average cost information is available from a local bank that makes loans to local contractors and disperses progress payments to contractors when specific tasks are verified as complete.

24%	Excavation and framing complete
8%	Roof and fireplace complete
3%	Wiring roughed in
6%	Plumbing roughed in
5%	Siding on
17%	Windows, insulation, walks, plaster, and garage complete
9%	Furnace installed
4%	Plumbing fixtures installed
10%	Exterior paint, light fixtures installed, finish hardware installed
6%	Carpet and trim installed
4%	Interior decorating
4%	Floors laid and finished

a. What is the estimated cost for the Tolstoy's house if they use contractors to complete all of the house?

b. Estimate what the cost of the house would be if the Tolstoys use their talents to do some of the work themselves.

2. Below is a project WBS with cost apportioned by percents. If the total project cost is estimated to be $600,000, what are the estimated costs for the following deliverables?

a. Design?

b. Programming?

c. In-house testing?

What weaknesses are inherent in this estimating approach?

EXERCISE 5.2

WBS Figure

3. Firewall Project XT. Using the "complexity weighting" scheme shown in Table 5.2 and the function point complexity weighted table shown below, estimate the total function point count. Assume historical data suggest five function points equal one person a month and six people can work on the project.

Complexity Weight Table		
Number of inputs	10	Rated complexity low
Number of outputs	20	Rated complexity average
Number of inquires	10	Rated complexity average
Number of files	30	Rated complexity high
Number of interfaces	50	Rated complexity high

a. What is the estimated project duration?

b. If 20 people are available for the project, what is the estimated project duration?

c. If the project must be completed in six months, how many people will be needed for the project?

References Dalkey, N. C., D. L. Rourke, R. Lewis, and D. Snyder, *Studies in the Quality of Life: Delphi and Decision Making* (Lexington, MA: Lexington Books, 1972).

Gray, N. S., "Secrets to Creating the Elusive 'Accurate Estimate,'" *PM Network,* 15 (8) August 2001, p. 56.

Jeffery, R., G. C. Low, and M. Barnes, "A Comparison of Function Point Counting Techniques," *IEEE Transactions on Software Engineering,* 19 (5) 1993, pp. 529–32.

Jones, C., *Applied Software Measurement* (New York: McGraw-Hill, 1991).

Jones, C., *Estimating Software Costs* (New York: McGraw-Hill, 1998).

Kharbanda, O. P., and J. K. Pinto, *What Made Gertie Gallop: Learning from Project Failures* (New York: Von Nostrand Reinhold, 1996).

Magne, E., K. Emhjellenm, and P. Osmundsen, "Cost Estimation Overruns in the North Sea," *Project Management Journal* 34 (1) 2003, pp. 23–29.

McLeod, G., and D. Smith, *Managing Information Technology Projects* (Cambridge, MA: Course Technology, 1996).

Milosevic, D. Z., *Project Management ToolBox* (Upper Saddle River, NJ: John Wiley, 2003), p. 229.

Pressman, R. S., *Software Engineering: A Practitioner's Approach, 4th edition* (New York: McGraw-Hill, 1997).

Symons, C. R., "Function Point Analysis: Difficulties and Improvements," *IEEE Transactions on Software Engineering,* 14 (1) 1988, pp. 2–11.

Case

Sharp Printing, AG

Three years ago the Sharp Printing (SP) strategic management group set a goal of having a color laser printer available for the consumer and small business market for less than $200. A few months later the senior management met off-site to discuss the new product. The results of this meeting were a set of general technical specifications along with major deliverables, a product launch date, and a cost estimate based on prior experience.

Shortly afterward, a meeting was arranged for middle management explaining the project goals, major responsibilities, the project start date, and importance of meeting the product launch date within the cost estimate. Members of all departments involved attended the meeting. Excitement was high. Although everyone saw the risks as high, the promised rewards for the company and the personnel were emblazoned in their minds. A few participants questioned the legitimacy of the project duration and cost estimates. A couple of R&D people were worried about the technology required to produce the high-quality product for less than $200. But given the excitement of the moment, everyone agreed the project was worth doing and doable. The color laser printer project was to have the highest project priority in the company.

Lauren was selected to be the project manager. She had 15 years of experience in printer design and manufacture, which included successful management of several projects related to printers for commercial markets. Since she was one of those uncomfortable with the project cost and time estimates, she felt getting good bottom-up time and cost estimates for the deliverables was her first concern. She quickly had a meeting with the significant stakeholders to create a WBS identifying the work packages and organizational unit responsible

for implementing the work packages. Lauren stressed she wanted time and cost estimates from those who would do the work or were the most knowledgeable, if possible. Getting estimates from more than one source was encouraged. Estimates were due in two weeks.

The compiled estimates were placed in the WBS/OBS. The corresponding cost estimate seemed to be in error. The cost estimate was $1,250,000 over the senior management estimate; this represents about a 20 percent overrun! The time estimate from the developed project network was only four months over the top management time estimate. Another meeting was scheduled with the significant stakeholders to check the estimates and to brainstorm for alternative solutions; the cost and time estimates appeared to be reasonable. Some of the suggestions for the brainstorming session are listed below.

- Change scope.
- Outsource technology design.
- Use the priority matrix (found in Chapter 4) to get top management to clarify their priorities.
- Partner with another organization or build a research consortium to share costs and to share the newly developed technology and production methods.
- Cancel the project.
- Commission a break-even study for the laser printer.

Very little in the way of concrete savings was identified, although there was consensus that time could be compressed to the market launch date, but at additional costs.

Lauren met with the marketing (Connor), production (Kim), and design (Gage) managers who yielded some ideas for cutting costs, but nothing significant enough to have a large impact. Gage remarked, "I wouldn't want to be the one to deliver the message to top management that their cost estimate is $1,250,000 off! Good luck, Lauren."

1. At this point, what would you do if you were the project manager?
2. Was top management acting correctly in developing an estimate?
3. What estimating techniques should be used for a mission critical project such as this?

Appendix 5.1

Learning Curves for Estimating

A forecast estimate of the time required to perform a work package or task is a basic necessity for scheduling the project. In some cases, the manager simply uses judgment and past experience to estimate work package time, or may use historical records of similar tasks.

Most managers and workers intuitively know that improvement in the amount of time required to perform a task or group of tasks occurs with repetition. A worker can perform a task better/quicker the second time and each succeeding time she/he performs it (without any technological change). It is this pattern of improvement that is important to the project manager and project scheduler.

This improvement from repetition generally results in a reduction of labor hours for the accomplishment of tasks and results in lowers project costs. From empirical evidence across *all* industries, the pattern of this improvement has been quantified in the *learning curve* (also known as improvement curve, experience curve, and industrial progress curve), which is described by the following relationship:

Each time the output quantity doubles, the unit labor hours are reduced at a constant rate.

For example, assume that a manufacturer has a new contract for 16 prototype units and a total of 800 labor hours were required for the first unit. Past experience has indicated that on similar types of units the improvement rate was 80 percent. This relationship of improvement in labor hours is shown below:

Unit		Labor Hours
1		800
2	800 × .80 =	640
4	640 × .80 =	512
8	512 × .80 =	410
16	410 × .80 =	328

By using Table A5.1 unit values, similar labor hours per unit can be determined. Looking across the 16 unit level and down the 80 percent column, we find a ratio of .4096. By multiplying this ratio times the labor hours for the first unit, we obtained the per unit value:

$$.4096 \times 800 = 328 \text{ hours or } 327.68$$

That is, the 16th unit should require close to 328 labor hours, assuming an 80 percent improvement ratio.

Obviously, a project manager may need more than a single unit value for estimating the time for some work packages. The cumulative values in Table A5.2 provide factors for computing the cumulative total labor hours of all units. In the previous example, for the first 16 units, the total labor hours required would be

$$800 \times 8.920 = 7,136 \text{ hours}$$

By dividing the total cumulative hours (7,136) by the units, the average unit labor hours can be obtained:

$$7,136 \text{ labor hours}/16 \text{ units} = 446 \text{ average labor hours per unit}$$

Note how the labor hours for the 16th unit (328) differs from average for all 16 units (446). The project manager, knowing the average labor costs and processing costs, could estimate the total prototype costs. (The mathematical derivation of factors found in Tables A5.1 and A5.2 can be found in Jelen, F. C. and J. H. Black, *Cost and Optimization Engineering,* 2nd ed. (New York: McGraw-Hill, 1983.)

FOLLOW-ON CONTRACT EXAMPLE

Assume the project manager gets a follow-on order of 74 units, how should she estimate labor hours and cost? Going to the cumulative Table A5.2 we find at the 80 percent ratio and 90 total units intersection—a 30.35 ratio.

800 × 30.35 =	24,280 labor hours for 90 units
Less previous 16 units =	7,136
Total follow-on order =	17,144 labor hours
17,144/74 equals 232 average labor hours per unit	

Labor hours for the 90th unit can be obtained from Table A5.1: .2349 × 800 = 187.9 labor hours. (For ratios between given values, simply estimate.)

TABLE A5.1
Learning Curves
Unit Values

Unit	60%	65%	70%	75%	80%	85%	90%	95%
1	1.0000	1.0000	1.0000	1.0000	1.0000	1.0000	1.0000	1.0000
2	.6000	.6500	.7000	.7500	.8000	.8500	.9000	.9500
3	.4450	.5052	.5682	.6338	.7021	.7729	.8462	.9219
4	.3600	.4225	.4900	.5625	.6400	.7225	.8100	.9025
5	.3054	.3678	.4368	.5127	.5956	.6857	.7830	.8877
6	.2670	.3284	.3977	.4754	.5617	.6570	.7616	.8758
7	.2383	.2984	.3674	.4459	.5345	.6337	.7439	.8659
8	.2160	.2746	.3430	.4219	.5120	.6141	.7290	.8574
9	.1980	.2552	.3228	.4017	.4930	.5974	.7161	.8499
10	.1832	.2391	.3058	.3846	.4765	.5828	.7047	.8433
12	.1602	.2135	.2784	.3565	.4493	.5584	.6854	.8320
14	.1430	.1940	.2572	.3344	.4276	.5386	.6696	.8226
16	.1296	.1785	.2401	.3164	.4096	.5220	.6561	.8145
18	.1188	.1659	.2260	.3013	.3944	.5078	.6445	.8074
20	.1099	.1554	.2141	.2884	.3812	.4954	.6342	.8012
22	.1025	.1465	.2038	.2772	.3697	.4844	.6251	.7955
24	.0961	.1387	.1949	.2674	.3595	.4747	.6169	.7904
25	.0933	.1353	.1908	.2629	.3548	.4701	.6131	.7880
30	.0815	.1208	.1737	.2437	.3346	.4505	.5963	.7775
35	.0728	.1097	.1605	.2286	.3184	.4345	.5825	.7687
40	.0660	.1010	.1498	.2163	.3050	.4211	.5708	.7611
45	.0605	.0939	.1410	.2060	.2936	.4096	.5607	.7545
50	.0560	.0879	.1336	.1972	.2838	.3996	.5518	.7486
60	.0489	.0785	.1216	.1828	.2676	.3829	.5367	.7386
70	.0437	.0713	.1123	.1715	.2547	.3693	.5243	.7302
80	.0396	.0657	.1049	.1622	.2440	.3579	.5137	.7231
90	.0363	.0610	.0987	.1545	.2349	.3482	.5046	.7168
100	.0336	.0572	.0935	.1479	.2271	.3397	.4966	.7112
120	.0294	.0510	.0851	.1371	.2141	.3255	.4830	.7017
140	.0262	.0464	.0786	.1287	.2038	.3139	.4718	.6937
160	.0237	.0427	.0734	.1217	.1952	.3042	.4623	.6869
180	.0218	.0397	.0691	.1159	.1879	.2959	.4541	.6809
200	.0201	.0371	.0655	.1109	.1816	.2887	.4469	.6757
250	.0171	.0323	.0584	.1011	.1691	.2740	.4320	.6646
300	.0149	.0289	.0531	.0937	.1594	.2625	.4202	.5557
350	.0133	.0262	.0491	.0879	.1517	.2532	.4105	.6482
400	.0121	.0241	.0458	.0832	.1453	.2454	.4022	.6419
450	.0111	.0224	.0431	.0792	.1399	.2387	.3951	.6363
500	.0103	.0210	.0408	.0758	.1352	.2329	.3888	.6314
600	.0090	.0188	.0372	.0703	.1275	.2232	.3782	.6229
700	.0080	.0171	.0344	.0659	.1214	.2152	.3694	.6158
800	.0073	.0157	.0321	.0624	.1163	.2086	.3620	.6098
900	.0067	.0146	.0302	.0594	.1119	.2029	.3556	.6045
1,000	.0062	.0137	.0286	.0569	.1082	.1980	.3499	.5998
1,200	.0054	.0122	.0260	.0527	.1020	.1897	.3404	.5918
1,400	.0048	.0111	.0240	.0495	.0971	.1830	.3325	.5850
1,600	.0044	.0102	.0225	.0468	.0930	.1773	.3258	.5793
1,800	.0040	.0095	.0211	.0446	.0895	.1725	.3200	.5743
2,000	.0037	.0089	.0200	.0427	.0866	.1683	.3149	.5698
2,500	.0031	.0077	.0178	.0389	.0606	.1597	.3044	.5605
3,000	.0027	.0069	.0162	.0360	.0760	.1530	.2961	.5530

TABLE A5.2
Learning Curves
Cumulative Values

Units	60%	65%	70%	75%	80%	85%	90%	95%
1	1.000	1.000	1.000	1.000	1.000	1.000	1.000	1.000
2	1.600	1.650	1.700	1.750	1.800	1.850	1.900	1.950
3	2.045	2.155	2.268	2.384	2.502	2.623	2.746	2.872
4	2.405	2.578	2.758	2.946	3.142	3.345	3.556	3.774
5	2.710	2.946	3.195	3.459	3.738	4.031	4.339	4.662
6	2.977	3.274	3.593	3.934	4.299	4.688	5.101	5.538
7	3.216	3.572	3.960	4.380	4.834	5.322	5.845	6.404
8	3.432	3.847	4.303	4.802	5.346	5.936	6.574	7.261
9	3.630	4.102	4.626	5.204	5.839	6.533	7.290	8.111
10	3.813	4.341	4.931	5.589	6.315	7.116	7.994	8.955
12	4.144	4.780	5.501	6.315	7.227	8.244	9.374	10.62
14	4.438	5.177	6.026	6.994	8.092	9.331	10.72	12.27
16	4.704	5.541	6.514	7.635	8.920	10.38	12.04	13.91
18	4.946	5.879	6.972	8.245	9.716	11.41	13.33	15.52
20	5.171	6.195	7.407	8.828	10.48	12.40	14.64	17.13
22	5.379	6.492	7.819	9.388	11.23	13.38	15.86	18.72
24	5.574	6.773	8.213	9.928	11.95	14.33	17.10	20.31
25	5.668	6.909	8.404	10.19	12.31	14.80	17.71	21.10
30	6.097	7.540	9.305	11.45	14.02	17.09	20.73	25.00
35	6.478	8.109	10.13	12.72	15.64	19.29	23.67	28.86
40	6.821	8.631	10.90	13.72	17.19	21.43	26.54	32.68
45	7.134	9.114	11.62	14.77	18.68	23.50	29.37	36.47
50	7.422	9.565	12.31	15.78	20.12	25.51	32.14	40.22
60	7.941	10.39	13.57	17.67	22.87	29.41	37.57	47.65
70	8.401	11.13	14.74	19.43	25.47	33.17	42.87	54.99
80	8.814	11.82	15.82	21.09	27.96	36.80	48.05	62.25
90	9.191	12.45	16.83	22.67	30.35	40.32	53.14	69.45
100	9.539	13.03	17.79	24.18	32.65	43.75	58.14	76.59
120	10.16	14.16	19.57	27.02	37.05	50.39	67.93	90.71
140	10.72	15.08	21.20	29.67	41.22	56.78	77.46	104.7
160	11.21	15.97	22.72	32.17	45.20	62.95	86.80	118.5
180	11.67	16.79	24.14	34.54	49.03	68.95	95.96	132.1
200	12.09	17.55	25.48	36.80	52.72	74.79	105.0	145.7
250	13.01	19.28	28.56	42.08	61.47	88.83	126.9	179.2
300	13.81	20.81	31.34	46.94	69.66	102.2	148.2	212.2
350	14.51	22.18	33.89	51.48	77.43	115.1	169.0	244.8
400	15.14	23.44	36.26	55.75	84.85	127.6	189.3	277.0
450	15.72	24.60	38.48	59.80	91.97	139.7	209.2	309.0
500	16.26	25.68	40.58	63.68	98.85	151.5	228.8	340.6
600	17.21	27.67	44.47	70.97	112.0	174.2	267.1	403.3
700	18.06	29.45	48.04	77.77	124.4	196.1	304.5	465.3
800	18.82	31.09	51.36	84.18	136.3	217.3	341.0	526.5
900	19.51	32.60	54.46	90.26	147.7	237.9	376.9	587.2
1,000	20.15	34.01	57.40	96.07	158.7	257.9	412.2	647.4
1,200	21.30	36.59	62.85	107.0	179.7	296.6	481.2	766.6
1,400	22.32	38.92	67.85	117.2	199.6	333.9	548.4	884.2
1,600	23.23	41.04	72.49	126.8	218.6	369.9	614.2	1001.
1,800	24.06	43.00	76.85	135.9	236.8	404.9	678.8	1116.
2,000	24.83	44.84	80.96	144.7	254.4	438.9	742.3	1230.
2,500	26.53	48.97	90.39	165.0	296.1	520.8	897.0	1513.
3,000	27.99	52.62	98.90	183.7	335.2	598.9	1047.	1791.

Exercise A5.1

<div align="center">

Norwegian Satellite Development Company
Cost estimates
for
World Satellite Telephone Exchange Project

</div>

NSDC has a contract to produce eight satellites to support a worldwide telephone system (for Alaska Telecom, Inc.) that allows individuals to use a single, portable telephone in any location on earth to call in and out. NSDC will develop and produce the eight units. NSDC has estimated that the R&D costs will be NOK (Norwegian Krone) 12,000,000. Material costs are expected to be NOK 6,000,000. They have estimated the design and production of the first satellite will require 100,000 labor hours and an 80 percent improvement curve is expected. Skilled labor cost is NOK 300 per hour. Desired profit for all projects is 25 percent of total costs.

A. How many labor hours should the eighth satellite require?
B. How many labor hours for the whole project of eight satellites?
C. What price would you ask for the project? Why?
D. Midway through the project your design and production people realize that a 75 percent improvement curve is more appropriate. What impact does this have on the project?
E. Near the end of the project Deutsch Telefon AG has requested a cost estimate for four satellites identical to those you have already produced. What price will you quote them? Justify your price.

Developing a Project Plan

I keep six honest serving-men (they taught me all I knew); their names are What and Why and When and How and Where and Who.
Rudyard Kipling

Developing the Project Network

The project network is the tool used for planning, scheduling, and monitoring project progress. The network is developed from the information collected for the WBS and is a graphic flow chart of the project job plan. The network depicts the project activities that must be completed, the logical sequences, the interdependencies of the activities to be completed, and in most cases the times for the activities to start and finish along with the longest path(s) through the network—the *critical path*. The network is the framework for the project information system that will be used by the project managers to make decisions concerning project time, cost, and performance.

Developing the project networks takes time for someone or some group to develop; therefore, they cost money! Are networks really worth the struggle? The answer is definitely yes, except in cases where the project is considered trivial or very short in duration. The network is easily understood by others because the network presents a graphic display of the flow and sequence of work through the project. Once the network is developed, it is very easy to modify or change when unexpected events occur as the project progresses. For example, if materials for an activity are delayed, the impact can be quickly assessed and the whole project revised in only a few minutes with the computer. These revisions can be communicated to all project participants quickly (for example, via e-mail or project Web site).

The project network provides other invaluable information and insights. It provides the basis for scheduling labor and equipment. It enhances communication that melds all managers and groups together in meeting the time, cost, and performance objectives of the project. It provides an estimate of project duration rather than picking a project completion date from a hat or someone's preferred date. The network gives the times when activities can start and finish and when they can be delayed. It provides the basis for budgeting the cash flow of the project. It identifies which activities are "critical" and, therefore, should not be delayed if the project is to be completed as planned. It highlights which activities to consider if the project needs to be compressed to meet a deadline.

There are other reasons project networks are worth their weight in gold. Basically, project networks minimize surprises by getting the plan out early and allowing corrective feedback. A commonly heard statement from practitioners is that the project

network represents three-quarters of the planning process. Perhaps this is an exaggeration, but it signals the perceived importance of the network to project managers in the field.

From Work Package to Network

Project networks are developed from the WBS. The project network is a visual flow diagram of the sequence, interrelationships, and dependencies of all the activities that must be accomplished to complete the project. *An activity is an element in the project that consumes time—for example, work or waiting.* Work packages from the WBS are used to build the activities found in the project network. An activity can include one or more work packages. The activities are placed in a sequence that provides for orderly completion of the project. Networks are built using nodes (boxes) and arrows (lines). The node depicts an activity, and the arrow shows dependency and project flow.

Integrating the work packages and the network represents a point where the management process often fails in practice. The primary explanations for this failure are that (1) different groups (people) are used to define work packages and activities and (2) the WBS is poorly constructed and not deliverable/output oriented. Integration of the WBS and project network is crucial to effective project management. The project manager must be careful to guarantee continuity by having some of the same people who defined the WBS and work packages develop the network activities.

Networks provide the project schedule by identifying dependencies, sequencing, and timing of activities, which the WBS is not designed to do. The primary inputs for developing a project network plan are work packages. Remember, a work package is defined independently of other work packages, has definite start and finish points, requires specific resources, includes technical specifications, and has cost estimates for the package. However, dependency, sequencing, and timing of each of these factors are not included in the work package. A network activity can include one or more work packages.

Figure 6.1 shows a segment of the WBS example from Chapter 4 and how the information is used to develop a project network. The lowest level deliverable in Figure 6.1 is "circuit board." The cost accounts (design, production, test, software) denote project work, organization unit responsible, and time-phased budgets for the work packages. Each cost account represents one or more work packages. For example, the design cost account has two work packages (D-1-1 and D-1-2)—specifications and documentation. The software and production accounts also have two work packages. Developing a network requires sequencing tasks from all work packages that have measurable work.

Figure 6.1 traces how work packages are used to develop a project network. You can trace the use of work packages by the coding scheme. For example, activity A uses work packages D-1-1 and D-1-2 (specifications and documentation), while activity C uses work package S-22-1. This methodology of selecting work packages to describe activities is used to develop the project network, which sequences and times project activities. Care must be taken to include all work packages. *The manager derives activity time estimates from the task times in the work package.* For example, activity B (proto 1) requires five weeks to complete; activity K (test) requires three weeks to complete. After computing the activity early and late times, the manager can schedule resources and time-phase budgets (with dates).

FIGURE 6.1
WBS/Work Packages to Network

Activity network for circuit board work packages

Constructing a Project Network

Terminology

Every field has its jargon that allows colleagues to communicate comfortably with each other about the techniques they use. Project managers are no exception. Here are some terms used in building project networks.

Activity. For project managers, an *activity* is an element of the project that requires time. It may or may not require resources. Typically an activity consumes time—either while people work or while people wait. Examples of the latter are time waiting for contracts to be signed, materials to arrive, drug approval by the government,

[handwritten margin note: activities → tasks } can include one or more → tasks]

budget clearance, etc. Activities usually represent one or more tasks from a work package. Descriptions of activities should use a verb/noun format: for example, develop product specifications.

Merge activity. This is an activity that has more than one activity immediately preceding it (more than one dependency arrow flowing to it).

Parallel activities. These are activities that can take place at the same time, if the manager wishes. However, the manager may choose to have parallel activities *not* occur simultaneously.

Path. A sequence of connected, dependent activities.

Critical path. When this term is used, it means the path(s) with the longest duration through the network; if an activity on the path is delayed, the project is delayed the same amount of time.

Event. This term is used to represent a point in time when an activity is started or completed. It does not consume time.

[handwritten margin note: an activity that triggers many activities ??]

Burst activity. This activity has more than one activity immediately following it (more than one dependency arrow flowing from it).

Two Approaches

The two approaches used to develop project networks are known as *activity-on-node (AON)* and *activity-on-arrow (AOA). Both methods use two building blocks—the arrow and the node.* Their names derive from the fact that the former uses a node to depict an activity, while the second uses an arrow to depict an activity. From the first use of these two approaches in the late 1950s, practitioners have offered many enhancements; however, the basic models have withstood the test of time and still prevail with only minor variations in form.

In practice, the activity-on-node (AON) method has come to dominate most projects. Hence, this text will deal primarily with AON. However, for those who find their organization using the activity-on-arrow (AOA) approach, the chapter includes an appendix demonstrating AOA methods (Appendix 6.1). There are good reasons for students of project management to be proficient in both methods. Different departments and organizations have their "favorite" approaches and are frequently loyal to software that is already purchased and being used. New employees or outsiders are seldom in a position to govern choice of method. If subcontractors are used, it is unreasonable to ask them to change their whole project management system to conform to the approach you are using. The point is, a project manager should feel comfortable moving among projects that use either AON or AOA.

Basic Rules to Follow in Developing Project Networks

The following eight rules apply in general when developing a project network:

1. Networks flow typically from left to right.
2. An activity cannot begin until all preceding connected activities have been completed.
3. Arrows on networks indicate precedence and flow. Arrows can cross over each other.
4. Each activity should have a unique identification number.
5. An activity identification number must be larger than that of any activities that precede it.
6. Looping is not allowed (in other words, recycling through a set of activities cannot take place).

7. Conditional statements are not allowed (that is, this type of statement should not appear: If successful, do something; if not, do nothing).

8. Experience suggests that when there are multiple starts, a common start node can be used to indicate a clear project beginning on the network. Similarly, a single project end node can be used to indicate a clear ending.

Read the Snapshot from Practice: The Yellow Sticky Approach (page 153) to see how these rules are used to create project networks.

Activity-on-Node (AON) Fundamentals

The wide availability of personal computers and graphics programs has served as an impetus for use of the activity-on-node (AON) method (sometimes called the *precedence diagram method*). Figure 6.2 shows a few typical uses of building blocks for the AON network construction. An **activity** is represented by a *node* (box). The node can take many forms, but in recent years the node represented as a rectangle (box) has dominated. The dependencies among activities are depicted by *arrows* between the rectangles (boxes) on the AON network. The arrows indicate how the activities are related and the sequence in which things must be accomplished. The length and slope of the arrow are arbitrary and set for

FIGURE 6.2

Activity-on-Node Network Fundamentals

convenience of drawing the network. The letters in the boxes serve here to identify the activities while you learn the fundamentals of network construction and analysis. In practice, activities have identification numbers and descriptions.

There are three basic relationships that must be established for activities included in a project network. The relationships can be found by answering the following three questions for each activity:

1. Which activities must be completed immediately *before* this activity? These activities are called *predecessor* activities.
2. Which activities must immediately *follow* this activity? These activities are called *successor* activities.
3. Which activities can occur *while* this activity is taking place? This is known as a *concurrent* or *parallel* relationship.

Sometimes a manager can use only questions 1 and 3 to establish relationships. This information allows the network analyst to construct a graphic flow chart of the sequence and logical interdependencies of project activities.

Figure 6.2A is analogous to a list of things to do where you complete the task at the top of the list first and then move to the second task, etc. This figure tells the project manager that activity A must be completed before activity B can begin, and activity B must be completed before activity C can begin.

Figure 6.2B tells us that activities Y and Z cannot begin until activity X is completed. This figure also indicates that activities Y and Z can occur concurrently or simultaneously if the project manager wishes; however, it is not a necessary condition. For example, pouring concrete driveway (activity Y) can take place while landscape planting (activity Z) is being accomplished, but land clearing (activity X) must be completed before activities Y and Z can start. Activities Y and Z are considered *parallel* activities. Parallel paths allow concurrent effort, which may shorten time to do a series of activities. Activity X is sometimes referred to as a *burst* activity because more than one arrow bursts from the node. The number of arrows indicates how many activities immediately follow activity X.

Figure 6.2C shows us activities J, K, and L can occur simultaneously if desired, and activity M cannot begin until activities J, K, and L are all completed. Activities J, K, and L are parallel activities. Activity M is called a *merge* activity because more than one activity must be completed before M can begin. Activity M could also be called a milestone.

In Figure 6.2D, activities X and Y are parallel activities that can take place at the same time; activities Z and AA are also parallel activities. But activities Z and AA cannot begin until activities X and Y are both completed.

Given these fundamentals of AON, we can practice developing a simple network. Remember, the arrows can cross over each other (e.g., Figure 6.2D), be bent, or be any length or slope. Neatness is not a criterion for a valid, useful network—only accurate inclusion of all project activities, their dependencies, and time estimates. Information for a simplified project network is given in Table 6.1. This project represents a new business center that is to be developed and the work and services the county engineering design department must provide as it coordinates with other groups—such as the business center owners and contractors.

Figure 6.3 shows the first steps in constructing the AON project network from the information in Table 6.1. We see that activity A (application approval) has nothing preceding it; therefore, it is the first node to be drawn. Next, we note that activities B, C, and D (construction plans, traffic study, and service availability check) are all preceded by

TABLE 6.1
Network Information

KOLL BUSINESS CENTER County Engineers Design Department		
Activity	**Description**	**Preceding Activity**
A	Application approval	None
B	Construction plans	A
C	Traffic study	A
D	Service availability check	A
E	Staff report	B, C
F	Commission approval	B, C, D
G	Wait for construction	F
H	Occupancy	E, G

activity A. We draw three arrows and connect them to activities B, C, and D. This segment shows the project manager that activity A must be completed before activities B, C, and D can begin. After A is completed, B, C, and D can go on concurrently, if desired. Figure 6.4 shows the completed network with all of the activities and precedences depicted.

At this point our project network presents us with a graphic map of the project activities with sequences and dependencies. This information is tremendously valuable to those managing the project. However, estimating the duration for each activity will further increase the value of the network. A realistic project plan and schedule require reliable time estimates for project activities. The addition of time to the network allows us to estimate how long the project will take. When activities can or must start, when resources must be available, which activities can be delayed, and when the project is estimated to be complete are all determined from the times assigned. Deriving an activity time estimate necessitates early assessment of resource needs in terms of material, equipment, and people. In essence the project network with activity time estimates links planning, scheduling, and controlling of projects.

FIGURE 6.3
Koll Business Center—Partial Network

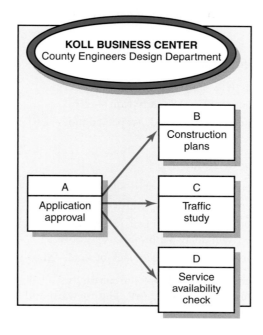

FIGURE 6.4 **Koll Business Center—Complete Network**

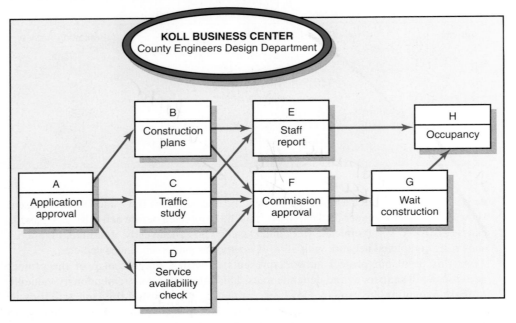

Network Computation Process

Drawing the project network places the activities in the right sequence for computing start and finish times of activities. Activity time estimates are taken from the task times in the work package and added to the network (review Figure 6.2). Performing a few simple computations allows the project manager to complete a process known as the forward and backward pass. Completion of the *forward and backward pass* will answer the following questions:

Forward Pass—Earliest Times

1. How soon can the activity start? (early start—ES)
2. How soon can the activity finish? (early finish—EF)
3. How soon can the project be finished? (expected time—TE)

Backward Pass—Latest Times

1. How late can the activity start? (late start—LS)
2. How late can the activity finish? (late finish—LF)
3. Which activities represent the critical path (CP)? This is the longest path in the network which, when delayed, will delay the project.
4. How long can the activity be delayed? (slack or float—SL)

The terms in parentheses represent the acronyms used in most texts and computer programs and by project managers. The forward and backward pass process is presented next.

In practice small project networks (25 to 100 activities) are frequently developed using yellow Post-it® stickers. The meeting requirements and process for the project team are described herein.

The following are the requirements for such a project:

1. Project team members and a facilitator.
2. One yellow sticker (3 × 4 inches or larger) for each activity with the description of the activity printed on the sticker.
3. Erasable whiteboard with marker pen (a long, 4-foot-wide piece of butcher paper can be used in place of the whiteboard).

All of the yellow stickers are placed in easy view of all team members. The team begins by identifying those activity stickers that have no predecessors. Each of these activity stickers is then attached to the whiteboard. A start node is drawn, and a dependency arrow is connected to each activity.

Given the initial network start activities, each activity is examined for immediate successor activities. These activities are attached to the whiteboard and dependency arrows drawn. This process is continued until all of the yellow stickers are attached to the whiteboard with dependency arrows. (Note: The process can be reversed, beginning with those activities that have no successor activities and connecting them to a project end node. The predecessor activities are selected for each activity and attached to the whiteboard with dependency arrows marked.)

When the process is complete, the dependencies are recorded in the project software, which develops a computer-designed network along with the critical path(s) and early, late, and slack times. This methodology sensitizes team members early to the interdependencies among activities of the project. But more importantly, the methodology empowers team members by giving them input to the important decisions that they must implement later.

Forward Pass—Earliest Times

The forward pass starts with the first project activity(ies) and traces each path (chain of sequential activities) through the network to the last project activity(ies). As you trace along the path, you *add* the activity times. The longest path denotes the project completion time for the plan and is called the critical path (CP). Table 6.2 lists the activity times in workdays for the Koll Business Center example we used for drawing a network.

TABLE 6.2
Network Information

	KOLL BUSINESS CENTER County Engineers Design Department		
Activity	Description	Preceding Activity	Activity Time
A	Application approval	None	5
B	Construction plans	A	15
C	Traffic study	A	10
D	Service availability check	A	5
E	Staff report	B, C	15
F	Commission approval	B, C, D	10
G	Wait for construction	F	170
H	Occupancy	E, G	35

Figure 6.5 shows the network with the activity time estimate found in the node (see "Dur" for duration in the legend). For example, activity A has an activity duration of 5 workdays, and activity G has a duration of 170 workdays. The forward pass begins with the project start time, which is usually time zero. (Note: Calendar times can be computed for the project later in the planning phase.) In our Koll Business Center example, the early start time for the first activity (activity A) is zero. This time is found in the upper left corner of the activity A node in Figure 6.6. The early finish for activity A is 5 (ES + Dur = EF or 0 + 5 = 5). Next, we see that activity A is the predecessor for activities B, C, and D. Therefore, the earliest these activities can begin is the instant in time when activity A is completed; this time is 5 workdays. You can now see in Figure 6.6 that

FIGURE 6.5 **Activity-on-Node Network**

FIGURE 6.6 **Activity-on-Node Network Forward Pass**

activities B, C, and D can all start the moment activity A is complete and, therefore, have an early start (ES) of 5. Using the formula ES + Dur = EF, the early finish (EF) times for activities B, C, and D are 20, 15, and 10. What is the ES for activity E, then, which is a merge activity? Is it 15 or 20? The answer is 20 because all activities immediately preceding activity E (B and C) must be completed before activity E can begin. Because activity B will take the longest to complete, it controls the ES of activity E. The same process is used for determining the ES for activity F. It is preceded by activities B, C, and D. The controlling early finish (EF) time is activity B, which has the longer early finish (20 versus 15 and 10) of the immediate predecessors (activities B, C, and D) of activity F. Stated differently, the forward pass assumes every activity will start the instant in time when the last of its predecessors is finished.

The forward pass requires that you remember just three things when computing early activity times:

1. You *add* activity times along each path in the network (ES + Dur = EF).
2. You carry the early finish (EF) to the next activity where it becomes its early start (ES), *unless*
3. The next succeeding activity is a *merge* activity. In this case you select the *largest* early finish number (EF) of *all* its immediate predecessor activities.

In our example in Figure 6.6, the EF for activity F (30) is carried to activity G, where it becomes its ES (30). We see activity H is a merge activity and therefore find the largest EF of its immediate predecessors (activities E and G). In this case, the choice is between the EF times of 35 and 200; the choice for the ES of activity H is 200. The EF for activity H (235) becomes the earliest the project can be expected to be completed (TE) under

normal conditions. The three questions derived from the forward pass have been answered; that is, early start (ES), early finish (EF), and the project duration (TE) times have been computed. The backward pass is the next process to learn.

Backward Pass—Latest Times

The backward pass starts with the last project activity(ies) on the network. You trace backward on each path *subtracting* activity times to find the late start (LS) and finish times (LF) for each activity. Before the backward pass can be computed, the late finish for the last project activity(ies) must be selected. In early planning stages, this time is usually set equal to the early finish (EF) of the last project activity (or in the case of multiple finish activities, the activity with the largest EF). In some cases an imposed project duration deadline exists, and this date will be used. Let us assume for planning purposes we can accept the EF project duration (TE) equal to 235 workdays. The LF for activity H becomes 235 workdays (EF = LF) (see Figure 6.7).

The backward pass is similar to the forward pass; you need to remember three things:

1. You *subtract* activity times along each path starting with the project end activity (LF − Dur = LS).
2. You carry the LS to the next preceding activity to establish its LF, *unless*
3. The next preceding activity is a *burst* activity; in this case you select the *smallest* LS of all its immediate successor activities to establish its LF.

Let's apply these rules to our Koll Business Center example. Beginning with activity H (occupancy) and an LF of 235 workdays, the LS for activity H is 200 workdays (LF − Dur = LS or 235 − 35 = 200). The LS for activity H becomes the LF for activities E and G. The LS

FIGURE 6.7 **Activity-on-Node Network Backward Pass**

for activities E and G becomes 185 (200 − 15 = 185) and 30 workdays (200 − 170 = 30), respectively. Next, the LS for activity G becomes the LF for activity F, and its LS becomes 20. At this point we see that activities B and C are *burst* activities that tie to activities E and F. The late finish for activity B is controlled by the LS of activities E and F. The LS for activity E is 185 days and for activity F, 20 days. Follow the arrows backward from activities E and F to activity B. Note that LS times for activities E and F have been placed to the right of the node so you can select the *smallest* time—20 days. The latest activity B can finish is 20 days, or activity F will be delayed and hence the project. The LF for activity C is identical to activity B because it is also controlled by the LS of activities E and F. Activity D simply picks up its LF from activity F. By computing the LS (LF − Dur = LS) for activities B, C, and D, we can determine the LF for activity A, which is a *burst* activity. You see that the finish of activity A is controlled by activity B, which has the smallest LS of activities B, C, and D. Because the LS for activity B is time period 5, the LF for activity A is 5, and its LS is time period zero. The backward pass is complete, and the latest activity times are known.

Determining Slack (or Float)

When the forward and backward passes have been computed, it is possible to determine which activities can be delayed by computing "slack" or "float." Total slack or float for an activity is simply the difference between the LS and ES (LS − ES = SL) or between LF and EF (LF − EF = SL). For example, the slack for activity C is 5 days, for activity D is 10 days, and for activity G is zero (see Figure 6.8). *Total slack* tells us the amount of time an activity can be delayed and yet not delay the project. If slack of one activity in a path is

FIGURE 6.8 **Activity-on-Node Network with Slack**

used, the ES for all activities that follow in the chain will be delayed and their slack reduced. Use of total slack must be coordinated with all participants in the activities that follow in the chain.

After slack for each activity is computed, the critical path(s) is (are) easily identified. When the LF = EF for the end project activity, the critical path can be identified as those activities that also have LF = EF or a slack of zero (LF − EF = 0 or LS − ES = 0). *The critical path is the network path(s) that has (have) the least slack in common.* This awkward arrangement of words is necessary because a problem arises when the project finish activity has an LF that differs from the EF found in the forward pass—for example, an imposed duration date. If this is the case, the slack on the critical path will *not* be zero; it will be the difference between the project EF and the imposed LF of the last project activity. For example, if the EF for the project is 235 days, but the imposed LF or target date is set at 220 days, all activities on the critical path would have a slack of minus 15 days. Of course, this would result in a late start of −15 days for the first project activity—a good trick if the project is to start now. Negative slack occurs in practice when the critical path is delayed.

In Figure 6.8 the critical path is marked with dashed arrows and nodes—activities A, B, F, G, and H. Delay of any of these activities will delay the total project by the same number of days. Critical activities typically represent about 10 percent of the activities of the project. Therefore, project managers pay close attention to the critical path activities to be sure they are not delayed. See Snapshot from Practice: The Critical Path.

We use the term sensitivity to reflect the likelihood the original critical path(s) will change once the project is initiated. Sensitivity is a function of the number of critical or near-critical paths. A network schedule that has only one critical path and noncritical activities that enjoy significant slack would be labeled insensitive. Conversely, a sensitive network would be one or more than critical paths and/or noncritical activities with very little slack. Under these circumstances the original critical path is much more likely to change once work gets under way on the project.

How sensitive is the Koll Business Center schedule? Not very, since there is only one critical path and each of the three noncritical activities have significant slack when compared to the estimated duration.

Projects managers assess the sensitivity of their network schedules to determine how much attention they should devote to managing the critical path.

Free Slack (Float)

Free slack is unique. It is the amount of time an activity can be delayed without delaying connected successor activities. Free slack can never be negative. Only activities that occur at the end of a chain of activities (usually where you have a merge activity) can have free slack. For example, if a single chain (path) of activities has 14 days slack, the last activity will have free slack, and the others will have none. Sometimes the chain is not very long; it can be only one activity. For example, in the Koll Business Center network (Figure 6.8), activity E is a chain of one and has free slack of 165 workdays (200 − 35 = 165). Activities C and D also have free slack of 5 and 10 days, respectively.

The beauty of free slack is that changes in start and finish times for the free slack activity require less coordination with other participants in the project and give the project manager more flexibility than total slack. Because the activity is the last in the chain, delaying the activity up to the slack amount will not influence any following activities. For example, assume a chain of 10 activities. Delaying any of the other nine activities in the chain requires notifying the managers of the remaining activities in the chain that you will be late, so they can adjust their schedules because the slack is not available to them.

The critical path method (CPM) has long been considered the "Holy Grail" of project management. Here are comments made by veteran project managers when asked about the significance of the critical path in managing projects:

- I try to make it a point whenever possible to put my best people on critical activities or on those activities that stand the greatest chance of becoming critical.

- I pay extra attention when doing risk assessment to identifying those risks that can impact the critical path, either directly or indirectly, by making a noncritical activity so late that it becomes critical. When I've got money to spend to reduce risks, it usually gets spent on critical tasks.

- I don't have time to monitor all the activities on a big project, but I make it a point to keep in touch with the people who are working on critical activities. When I have the time, they are the ones I visit to find out firsthand how things are going.

It's amazing how much more I can find out from talking to the rank and file who are doing the work and by reading the facial expressions of people—much more than I can gain from a number-driven status report.

- When I get calls from other managers asking to "borrow" people or equipment, I'm much more generous when it involves resources from working on noncritical activities. For example, if another project manager needs an electrical engineer who is assigned to a task with five days of slack, I'm willing to share that engineer with another project manager for two to three days.

- The most obvious reason the critical path is important is because these are the activities that impact completion time. If I suddenly get a call from above saying they need my project done two weeks earlier than planned, the critical path is where I schedule the overtime and add extra resources to get the project done more quickly. In the same way, if the project schedule begins to slip, it's the critical activities I focus on to get back on schedule.

Using the Forward and Backward Pass Information

What does a slack of 10 workdays for activity D (Service check) mean for the project manager? In this specific case it means activity D can be delayed 10 days. In a larger sense the project manager soon learns that slack is important because it allows flexibility in scheduling scarce project resources—personnel and equipment—that are used on more than one parallel activity or another project.

Knowing the four activity times of ES, LS, EF, and LF is invaluable for the planning, scheduling, and controlling phases of the project. The ES and LF tell the project manager the time interval in which the activity should be completed. For example, activity E (Staff report) must be completed within the time interval 20 and 200 workdays; the activity can start as early as day 20 or finish as late as day 200. Conversely, activity F (Commission approval), must start on day 20, or the project will be delayed.

When the critical path is known, it is possible to tightly manage the resources of the activities on the critical path so no mistakes are made that will result in delays. In addition, if for some reason the project must be expedited to meet an earlier date, it is possible to select those activities, or combination of activities, that will cost the least to shorten the project. Similarly, if the critical path is delayed and the time must be made up by shortening some activity or activities on the critical path to make up any negative slack, it is possible to identify the activities on the critical path that cost the least to shorten. If there are other paths with very little slack, it may be necessary to shorten activities on those paths also.

Level of Detail for Activities

Time-phasing work and budgets of the project mandate careful definition of the activities that make up the project network. Typically an activity represents one or more tasks from a work package. How many tasks you include in each activity sets the level

of detail. In some cases it is possible to end up with too much information to manage, and this can result in increased overhead costs. Managers of small projects have been able to minimize the level of detail by eliminating some of the preliminary steps to drawing networks. Larger firms also recognize the cost of information overload and are working to cut down the level of detail in networks and in most other dimensions of the project.

Practical Considerations

Network Logic Errors

Project network techniques have certain logic rules that must be followed. One rule is that conditional statements such as "if test successful build proto, if failure redesign" are not permitted. The network is not a decision tree; it is a project plan that we assume will materialize. If conditional statements were allowed, the forward and backward pass would make little sense. Although in reality a plan seldom materializes as we expect in every detail, it is a reasonable initial assumption. You shall see that once a network plan is developed, it is an easy step to make revisions to accommodate changes.

Another rule that defeats the project network and computation process is *looping*. Looping is an attempt by the planner to return to an earlier activity. Recall that the activity identification numbers should always be higher for the activities following an activity in question; this rule helps to avoid the illogical precedence relationships among the activities. An activity should only occur once; if it is to occur again, the activity should have a new name and identification number and should be placed in the right sequence on the network. Figure 6.9 shows an illogical loop. If this loop were allowed to exist, this path would perpetually repeat itself. Many computer programs catch this type of logic error.

Activity Numbering

Each activity needs a unique identification code—usually a number. In practice very elegant schemes exist. Most schemes number activities in ascending order, that is, each succeeding activity has a larger number so that the flow of the project activities is toward project completion. It is customary to leave gaps between numbers (1, 5, 10, 15 . . .). Gaps are desirable so you can add missing or new activities later. Because it is nearly impossible to draw a project network perfectly, numbering networks is frequently not done until after the network is complete.

In practice you will find computer programs that accept numeric, alphabetic, or a combination of activity designations. Combination designations are often used to identify cost, work skill, departments, and locations. As a general rule, activity numbering systems should be ascending and as simple as possible. The intent is to make it as easy as you can for project participants to follow work through the network and locate specific activities.

FIGURE 6.9
Illogical Loop

Use of Computers to Develop Networks

All of the tools and techniques discussed in this chapter can be used with computer software currently available. Two examples are shown in Figures 6.10 and 6.11. Figure 6.10 presents a generic AON computer output for the Air Control project. The critical path is identified by the unshaded nodes (activities 1, 4, 6, 7, and 8). The activity description is shown on the top line of the activity node. The activity identification and duration are found on the right side of the node. The early start and early finish are on the left side of the node. The project starts on January 1 and is planned to finish February 14.

Figure 6.11 presents an early start Gantt bar chart. Bar charts are popular because they present an easy-to-understand, clear picture on a time-scaled horizon. They are used during planning, resource scheduling, and status reporting. The format is a two-dimensional representation of the project schedule, with activities down the rows and time across the horizontal axis. In this computer output the gray bars represent the activity durations. The extended lines from the bars represent slack. For example, "software development" has a duration of 18 time units (shaded area of the bar) and 20 days slack (represented by the extended line). The bar also indicates the activity has an early start of January 3, would end January 20, but can finish as late as February 9 because it has 20 days of slack. When calendar dates are used on the time axis, Gantt charts provide a clear overview of the project schedule and can be often found posted on the walls of project offices. Unfortunately, when projects have many dependency relationships, the dependency lines soon become overwhelming and defeat the simplicity of the Gantt chart.

Project management software can be a tremendous help in the hands of those who understand and are familiar with the tools and techniques discussed in this text. However, there is nothing more dangerous than someone using the software with little or no knowledge of how the software derives its output. Mistakes in input are very common and require someone skilled in the concepts, tools, and information system to recognize that errors exist so false actions are avoided.

Calendar Dates

Ultimately you will want to assign calendar dates to your project activities. If a computer program is not used, dates are assigned manually. Lay out a calendar of workdays (exclude nonworkdays), and number them. Then relate the calendar workdays to the workdays on your project network. Most computer programs will assign calendar dates automatically after you identify start dates, time units, nonworkdays, and other information.

Multiple Starts and Multiple Projects

Some computer programs require a common start and finish event in the form of a node—usually a circle or rectangle—for a project network. Even if this is not a requirement, it is a good idea because it avoids "dangler" paths. Dangler paths give the impression that the project does not have a clear beginning or ending. If a project has more than one activity that can begin when the project is to start, each path is a dangler path. The same is true if a project network ends with more than one activity; these unconnected paths are also called danglers. Danglers can be avoided by tying dangler activities to a common project start or finish node.

When several projects are tied together in an organization, using a common start and end node helps to identify the total planning period of all projects. Use of pseudo or dummy wait activities from the common start node allows different start dates for each project.

FIGURE 6.10 Air Control Project—Network Diagram

Order review	
Start: 1/1	ID: 1
Finish: 1/2	Dur: 2 days
Res:	

Order vendor parts	
Start: 1/3	ID: 2
Finish: 1/17	Dur: 15 days
Res:	

Produce other standard par	
Start: 1/3	ID: 3
Finish: 1/12	Dur: 10 days
Res:	

Design custom parts	
Start: 1/3	ID: 4
Finish: 1/15	Dur: 13 days
Res:	

Software development	
Start: 1/3	ID: 5
Finish: 1/20	Dur: 18 days
Res:	

Manufacture custom hardware	
Start: 1/16	ID: 6
Finish: 1/30	Dur: 15 days
Res:	

Assemble	
Start: 1/31	ID: 7
Finish: 2/9	Dur: 10 days
Res:	

Test	
Start: 2/10	ID: 8
Finish: 2/14	Dur: 5 days
Res:	

FIGURE 6.11 Air Control Project—Gantt Chart

ID	Duration	Task Name	Start	Finish	Late Start	Late Finish	Free Slack	Total Slack
1	2 days	Order review	Tue 1/1	Wed 1/2	Tue 1/1	Wed 1/2	0 days	0 days
2	15 days	Order vendor parts	Thu 1/3	Thu 1/17	Wed 1/16	Wed 1/30	13 days	13 days
3	10 days	Produce other standard parts	Thu 1/3	Sat 1/12	Mon 1/21	Wed 1/30	18 days	18 days
4	13 days	Design custom parts	Thu 1/3	Tue 1/15	Thu 1/3	Tue 1/15	0 days	0 days
5	18 days	Software development	Thu 1/3	Sun 1/20	Wed 1/23	Sat 2/9	20 days	20 days
6	15 days	Manufacture custom hardware	Wed 1/16	Wed 1/30	Wed 1/16	Wed 1/30	0 days	0 days
7	10 days	Assemble	Thu 1/31	Sat 2/9	Thu 1/31	Sat 2/9	0 days	0 days
8	5 days	Test	Sun 2/10	Thu 2/14	Sun 2/10	Thu 2/14	0 days	0 days

Extended Network Techniques to Come Closer to Reality

The method for showing relationships among activities in the last section is called the finish-to-start relationship because it assumes all immediate preceding connected activities must be completed before the next activity can begin. In an effort to come closer to the realities of projects, some useful extensions have been added. The use of *laddering* was the first obvious extension practitioners found very useful.

Laddering

The assumption that all immediate preceding activities must be 100 percent complete is too restrictive for some situations found in practice. This restriction occurs most frequently when one activity overlaps the start of another and has a long duration. Under the standard finish-to-start relationship, when an activity has a long duration and will delay the start of an activity immediately following it, the activity can be broken into segments and the network drawn using a *laddering* approach so the following activity can begin sooner and not delay the work. This segmenting of the larger activity gives the appearance of steps on a ladder on the network, thus the name. The classic example used in many texts and articles is laying pipe, because it is easy to visualize. The trench must be dug, pipe laid, and the trench refilled. If the pipeline is one mile long, it is not necessary to dig one mile of trench before the laying of pipe can begin or to lay one mile of pipe before refill can begin. Figure 6.12 shows how these overlapping activities might appear in an AON network using the standard finish-to-start approach.

Use of Lags

The use of *lags* has been developed to offer greater flexibility in network construction. *A lag is the minimum amount of time a dependent activity must be delayed to begin or end.* The use of lags in project networks occurs for two primary reasons:

1. When activities of long duration delay the start or finish of successor activities, the network designer normally breaks the activity into smaller activities to avoid the long delay of the successor activity. Use of lags can avoid such delays and reduce network detail.
2. Lags can be used to constrain the start and finish of an activity.

The most commonly used relationship extensions are start-to-start, finish-to-finish, and combinations of these two. These relationship patterns are discussed in this section.

FIGURE 6.12 **Example of Laddering Using Finish-to-Start Relationship**

Finish-to-Start Relationship

The finish-to-start relationship represents the typical, generic network style used in the early part of the chapter. However, there are situations in which the next activity in a sequence must be delayed even when the preceding activity is complete. For example, removing concrete forms cannot begin until the poured cement has cured for two time units. Figure 6.13 shows this lag relationship for AON networks. Finish-to-start lags are frequently used when ordering materials. For example, it may take 1 day to place orders but take 19 days to receive the goods. The use of finish-to-start allows the activity duration to be only 1 day and the lag 19 days. This approach ensures the activity cost is tied to placing the order only rather than charging the activity for 20 days of work. This same finish-to-start lag relationship is useful to depict transportation, legal, and mail lags.

FIGURE 6.13
Finish-to-Start
Relationship

The use of finish-to-start lags should be carefully checked to ensure their validity. Conservative project managers or those responsible for completion of activities have been known to use lags as a means of building in a "slush" factor to reduce the risk of being late. A simple rule to follow is that the use of finish-to-start lags must be justified and approved by someone responsible for a large section of the project. The legitimacy of lags is not usually difficult to discern. The legitimate use of the additional relationship shown can greatly enhance the network by more closely representing the realities of the project.

Start-to-Start Relationship

An alternative to segmenting the activities as we did earlier is to use a start-to-start relationship. Typical start-to-start relationships are shown in Figure 6.14. Figure 6.14A shows the start-to-start relationship with zero lag, while Figure 6.14B shows the same relationship with a lag of five time units. It is important to note that the relationship may be used with or without a lag. If time is assigned, it is usually shown on the dependency arrow of an AON network.

FIGURE 6.14
Start-to-Start
Relationship

FIGURE 6.15
Use of Lags to
Reduce Detail

In Figure 6.14B, activity Q cannot begin until five time units after activity P begins. This type of relationship typically depicts a situation in which you can perform a portion of one activity and begin a following activity before completing the first. This relationship can be used on the pipe-laying project. Figure 6.15 shows the project using an AON network. The start-to-start relationship reduces network detail and project delays by using lag relationships.

It is possible to find compression opportunities by changing finish-to-start relations to start-to-start relationships. A review of finish-to-start critical activities may point out opportunities that can be revised to be parallel by using start-to-start relationships. For example, in place of a finish-to-start activity "design house, then build foundation," a start-to-start relationship could be used in which the foundation can be started, say, five days (lag) after design has started—assuming the design of the foundation is the first part of the total design activity. This start-to-start relationship with a small lag allows a sequential activity to be worked on in parallel and to compress the duration of the critical path. This same concept is frequently found in projects in which concurrent engineering is used to speed completion of a project. Concurrent engineering, which is highlighted in the Snapshot from Practice: Concurrent Engineering, basically breaks activities into smaller segments so that work can be done in parallel and the project expedited. Start-to-start relationships can depict the concurrent engineering conditions and reduce network detail. Of course, the same result can be accomplished by breaking an activity into small packages that can be implemented in parallel, but this latter approach increases the network and tracking detail significantly.

Finish-to-Finish Relationship

This relationship is found in Figure 6.17. The finish of one activity depends on the finish of another activity. For example, testing cannot be completed any earlier than four days after the prototype is complete. Note that this is not a finish-to-start relationship because the testing of subcomponents can begin before the prototype is completed, but four days of "system" testing is required after the prototype is finished.

Start-to-Finish Relationship

This relationship represents situations in which the finish of an activity depends on the start of another activity. For example, system documentation cannot end until three days

In the old days, when a new product development project was initiated by a firm, it would start its sequential journey in the research and development department. Concepts and ideas would be worked out and the results passed to the engineering department, which sometimes reworked the whole product. This result would be passed to manufacturing, where it might be reworked once more in order to ensure the product could be manufactured using existing machinery and operations. Quality improvements were initiated after the fact once defects and improvement opportunities were discovered during production. This sequential approach to product development required a great deal of time,

and it was not uncommon for the final product to be totally unrecognizable when compared to original specifications.

Given the emphasis on speed to the market, companies have abandoned the sequential approach to product development and have adopted a more holistic approach titled concurrent engineering. In a nutshell, *concurrent engineering* entails the active involvement of all the relevant specialty areas throughout the design and development process. The traditional chainlike sequence of finish-to-start relationships is replaced by a series of start-to-start lag relationships as soon as meaningful work can be initiated for the next phase. Figure 6.16 summarizes the dramatic gains in time to market achieved by this approach.

FIGURE 6.16 New Product Development Process

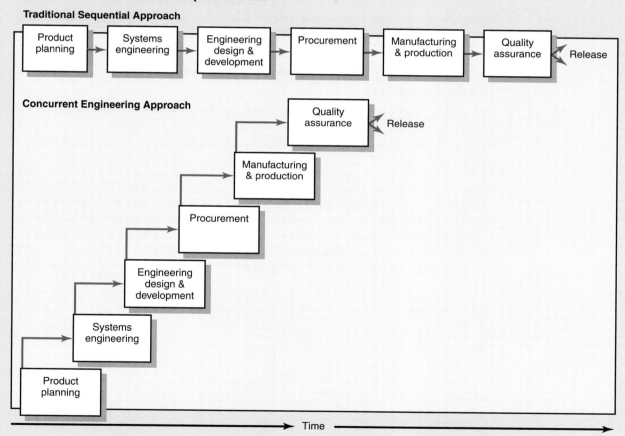

For example, this approach was used by Chrysler Corporation to design its new line of SC cars including the popular *Neon* sedan. From the very beginning specialists from marketing, engineering, design, manufacturing, quality assurance, and other relevant departments were involved in every stage of the project.

Not only did the project meet all of its objectives, it was completed six months ahead of schedule.

* O. Suris, "Competitors Blinded by Chrysler's Neon," *The Wall Street Journal,* January 10, 1994.

FIGURE 6.17
**Finish-to-Finish
Relationship**

after testing has started (see Figure 6.18). Here all the relevant information to complete the system documentation is produced after the first three days of testing.

Combinations of Lag Relationships

More than one lag relationship can be attached to an activity. These relationships are usually start-to-start and finish-to-finish combinations tied to two activities. For example, debug cannot begin until two time units after coding has started. Coding must be finished four days before debug can be finished (see Figure 6.19).

An Example Using Lag Relationships—The Forward and Backward Pass

The forward and backward pass procedures are the same as explained earlier in the chapter for finish-to-start relationships (without lags). The modifying technique lies in the need to check each new relationship to see if it alters the start or finish time of another activity.

An example of the outcome of the forward and backward pass is shown in Figure 6.20. Order hardware depends upon the design of the system (start-to-start). Three days into the design of the system (activity A), it is possible to order the required hardware (activity B). It takes four days after the order is placed (activity B) for the hardware to arrive so it can begin to be installed (activity C). After two days of installing the software system (activity D), the testing of the system can begin (activity E). System testing (activity E) can be completed two days after the software is installed (activity D). Preparing system documentation

FIGURE 6.18
**Start-to-Finish
Relationship**

FIGURE 6.19
**Combination
Relationships**

FIGURE 6.20 Network Using Lags

(activity F) can begin once the design is completed (activity A), but it cannot be completed until two days after testing the system (activity E). This final relationship is an example of a finish-to-finish lag.

Note how an activity can have a critical finish and/or start. Activities E and F have critical finishes (zero slack), but their activity starts have 4 and 12 days of slack. It is only the finish of activities E and F that are critical. Conversely, activity A has zero slack to start but has five days of slack to finish. The critical path follows activity start and finish constraints that occur due to the use of the additional relationships available and the imposed lags. You can identify the critical path in Figure 6.20 by following the dashed line on the network.

If a lag relationship exists, each activity must be checked to see if the start or finish is constrained. For example, in the forward pass the EF of activity E (test system) (18) is controlled by the finish of activity D (install software) and the lag of two time units (16 + lag 2 = 18). Finally, in the backward pass, the LS of activity A (design system) is controlled by activity B (order hardware) and the lag relationship to activity A (3 − 3 = 0).

Hammock Activities

Another of the extended techniques uses a *hammock activity*. This type of activity derives its name because it spans over a segment of a project. The hammock activity duration is determined *after* the network plan is drawn. The Snapshot from Practice: Hammock Activities describes how the hammock activity is used.

Hammock activities are frequently used to identify the use of fixed resources or costs over a segment of the project. Typical examples of hammock activities are inspection services, consultants, or construction management services. A hammock activity derives its duration from the time span between other activities. For example, a special color copy machine is needed for a segment of a tradeshow publication project. A hammock activity can be used to indicate the need for this resource and to apply costs over this segment of the project. This hammock is linked from the start of the first activity in the segment that uses the color copy machine to the end of the last activity that uses it. The hammock duration is simply the difference between the EF for the last activity and the ES of the first activity. The duration is computed after the forward pass and hence has no influence on other activity times. Figure 6.21 provides an example of a hammock activity used in a network. The duration for the hammock activity is derived from the early start of activity B and the early finish of activity F; that is, the difference between 13 and 5, or 8 time units. The hammock duration will change if any ES or EF in the chain-sequence changes. Hammock activities are very useful in assigning and controlling indirect project costs.

FIGURE 6.21 Hammock Activity Example

Another major use of hammock activities is to aggregate sections of a project. This is similar to developing a subnetwork, but the precedence is still preserved. This approach is sometimes used to present a "macro network" for upper management levels. Using a hammock activity to group activities can facilitate getting the right level of detail for specific sections of a project.

Summary

Many project managers feel the project network is their most valuable exercise and planning document. Project networks sequence and time-phase the project work, resources, and budgets. Work package tasks are used to develop activities for networks. Every project manager should feel comfortable working in an AON environment. The AON method uses nodes (boxes) for activities and arrows for dependencies. The forward and backward

passes establish early and late times for activities. Although most project managers use computers to generate networks and activity times, they find a keen understanding of network development and the ability to compute activity times is invaluable in the field. Computers break down; input errors give false information; some decisions must be made without computer "what if" analysis. Project managers who are well acquainted with network development and AON methods and who are able to compute activity times will encounter fewer problems than project managers less well acquainted. Project networks help to ensure there are no surprises.

Several extensions and modifications have been appended to the original AON method. Lags allow the project planner to more closely replicate the actual conditions found in practice. The use of lags can result in the start or finish of an activity becoming critical. Some computer software simply calls the whole activity critical rather than identifying the start or finish as being critical. Caution should be taken to ensure that lags are not used as a buffer for possible errors in estimating time. Finally, hammock activities are useful in tracking costs of resources used for a particular segment of a project. Hammock activities can also be used to reduce the size of a project network by grouping activities for simplification and clarity. All of the discussed refinements to the original AON methodology contribute toward better planning and control of projects.

Key Terms

Activity	Critical path	Merge activity
Activity-on-arrow (AOA)	Early and late times	Network sensitivity
Activity-on-node (AON)	Gantt chart	Parallel activity
Burst activity	Hammock activity	Slack/float—total and free
Concurrent engineering	Lag relationship	

Review Questions

1. How does the WBS differ from the project network?
2. How are WBS and project networks linked?
3. Why bother creating a WBS? Why not go straight to a project network and forget the WBS?
4. Why is slack important to the project manager?
5. What is the difference between free slack and total slack?
6. Why are lags used in developing project networks?
7. What is a hammock activity, and when is it used?

Exercises

Creating a Project Network

1. Here is a work breakdown structure for a wedding. Use the method described in the Snapshot from Practice: The Yellow Sticky Approach to create a network for this project.

Note: Do not include summary tasks in the network (i.e., 1.3, Ceremony, is a summary task; 1.2, Marriage license, is not a summary task). Do not consider who would be doing the task in building the network. For example, do not arrange "hiring a band" to occur after "florist" because the same person is responsible for doing both tasks. Focus only on technical dependencies between tasks.

Hint: Start with the last activity (wedding reception), and work your way back to the start of the project. Build the logical sequence of tasks by asking the following question: In

order to have or do this, what must be accomplished immediately before this? Once completed, check forward in time by asking this question: Is this task(s) the only thing that is needed immediately before the start of the next task?

Work Breakdown Structure

1. Wedding project

 1.1 Decide on date

 1.2 Marriage license

 1.3 Ceremony

 1.3.1 Rent church

 1.3.2 Florist

 1.3.3 Create/print programs

 1.3.4 Hire photographer

 1.3.5 Wedding ceremony

 1.4 Guests

 1.4.1 Develop guest list

 1.4.2 Order invitations

 1.4.3 Address and mail invitations

 1.4.4 Track RSVPs

 1.5 Reception

 1.5.1 Reserve reception hall

 1.5.2 Food and beverage

 1.5.2.1 Choose caterer

 1.5.2.2 Decide on menu

 1.5.2.3 Make final order

 1.5.3 Hire band

 1.5.4 Decorate reception hall

 1.5.5 Wedding reception

Drawing AON Networks

2. Draw a project network from the following information.

Activity	Predecessor
A	None
B	A
C	A
D	A, B, C
E	D
F	D, E

3. Given the following information, draw a project network.

Activity	Predecessor
A	None
B	A
C	A
D	A
E	B
F	C, D
G	E
H	G, F

4. Use the following information to draw a project network.

Activity	Predecessor
A	None
B	A
C	A
D	B
E	B
F	C
G	D, E
H	F
I	F
J	G, H
K	J, I

5. Draw an AON project network from the following information.

Activity	Predecessor
A	None
B	None
C	None
D	A, B
E	C
F	D, E
G	E
H	F, G
I	H

6. Use the following information to draw a project network.

Activity	Predecessor
A	None
B	None
C	A
D	B
E	C, D
F	E
G	E
H	E
I	F
J	G, H
K	H, I, J

AON Network Times

7. From the following information, develop an AON project network. Complete the forward and backward pass, compute the activity slack, and identify the critical path.

Activity	Predecessor	Time (weeks)
A	None	4
B	A	5
C	A	4
D	B	3
E	C, D	6
F	D	2
G	E, F	5

What is the critical path?

How many weeks to complete?

What is the slack for activity C? For activity F?

8. The marketing department of a bank is developing a new mortgage plan for housing contractors. Draw a project network given the information below. Complete the forward and backward pass, compute the activity slack, and identify the critical path.

Activity	Predecessor	Time (weeks)
A	None	3
B	None	4
C	A	2
D	C	5
E	B	7
F	D, E	1
G	D	4
H	F, G	5

What is the critical path?

How many weeks to complete?

What is the slack for activity F? For activity G?

9. The project information for the custom order project of the Air Control Company is presented here. Draw a project network for this project. Compute the early and late activity times and the slack times. Identify the critical path.

ID	Activity	Predecessor	Time
A	Order review	None	2
B	Order standard parts	A	15
C	Produce standard parts	A	10
D	Design custom parts	A	13
E	Software development	A	18
F	Manufacture custom hardware	C, D	15
G	Assemble	B, F	10
H	Test	E, G	5

10. J. Wold, project manager of Print Software, Inc., wants you to prepare a project network; compute the early, late, and slack activity times; determine the planned project duration; and identify the critical path. His assistant has collected the following information for the Color Printer Drivers Software Project:

ID	Description	Predecessor	Time
A	External specifications	None	8
B	Review design features	A	2
C	Document new features	A	3
D	Write software	A	60
E	Program and test	B	60
F	Edit and publish notes	C	2
G	Review manual	D	2
H	Alpha site	E, F	20
I	Print manual	G	10
J	Beta site	H, I	10
K	Manufacture	J	12
L	Release and ship	K	3

11. A large eastern city is requesting federal funding for a park-and-ride project. One of the requirements in the request application is a network plan for the design phase of the project. Catherine Walker, the chief engineer, wants you to develop a project network plan to meet this requirement. She has gathered the activity time estimates and their dependencies shown here. Show your project network with the activity early, late, and slack times. Mark the critical path.

ID	Description	Predecessor	Time
A	Survey	None	5
B	Soils report	A	20
C	Traffic design	A	30
D	Lot layout	A	5
E	Approve design	B, C, D	80
F	Illumination	E	15
G	Drainage	E	30
H	Landscape	E	25
I	Signing	E	20
J	Bid proposal	F, G, H, I	10

12. Given the project network that follows, complete a bar chart for the project. Use the timeline to align your bars. Be sure to show slack for noncritical activities.

13. Given the project network that follows, complete a bar chart for the project. Use the timeline to align your bars. Be sure to show slack for noncritical activities.

Computer Exercises

14. The planning department of an electronics firm has set up the activities for developing and production of a new CD Player. Given the information below, develop a project network using Microsoft Project. Assume a five-day workweek and the project starts on January 4, 2010.

Activity ID	Description	Activity Predecessor	Activity Time (weeks)
1	Staff	None	2
2	Develop market program	1	3
3	Select channels of distribution	1	8
4	Patent	1	12
5	Pilot production	1	4
6	Test market	5	4
7	Ad promotion	2	4
8	Set up for production	4, 6	16

The project team has requested that you create a network for the project, and determine if the project can be completed in 45 weeks.

15. Using Microsoft Project, set up the network and determine the critical path for Phase 1 of the project. The project workweek will be 5 days (M—F).

Whistler Ski Resort Project

Given the coming 2010 Winter Olympics in Vancouver and Whistler, BC, Canada, and the fact that the number of skiing visitors to Whistler has been increasing at an exciting rate, the Whistler Ski Association has been considering construction of another ski lodge and ski complex. The results of an economic feasibility study just completed by members of the staff show that a winter resort complex near the base of Whistler Mountain could be a very profitable venture. The area is accessible by car, bus, train, and air. The board of directors has voted to build the ten-million dollar complex recommended in the study. Unfortunately, due to the short summer season, the complex will have to be built in stages. The first stage (year 1) will contain a day lodge, chair lift, rope tow, generator house (for electricity), and a parking lot designed to accommodate 400 cars and 30 buses. The second and third stages will include a hotel, ice rink, pool, shops, two additional chair lifts, and other attractions. The board has decided that stage one should begin no later than April 1 and be completed by October 1, in time for the next skiing season. You have been assigned the task of project manager, and it is your job to coordinate the ordering of materials and construction activities to ensure the project's completion by the required date.

After looking into the possible sources of materials, you are confronted with the following time estimates. Materials for the chair lift and rope tow will take 30 days and 12 days, respectively, to arrive once the order is submitted. Lumber for the day lodge, generator hut, and foundations will take 9 days to arrive. The electrical and plumbing materials for the day lodge will take 12 days to arrive. The generator will take 12 days to arrive. Before actual construction can begin on the various facilities, a road to the site must be built; this will take 6 days. As soon as the road is in, clearing can begin concurrently on the sites of the day lodge, generator house, chair lift, and rope tow. It is estimated that the clearing task at each site will take 6 days, 3 days, 36 days, and 6 days, respectively. The clearing of the main ski slopes can begin after the area for the chair lift has been cleared; this will take 84 days.

The foundation for the day lodge will take 12 days to complete. Construction of the main framework will take an additional 18 days. After the framework is completed, electrical wiring

and plumbing can be installed concurrently. These should take 24 and 30 days, respectively. Finally, the finishing construction on the day lodge can begin; this will take 36 days.

Installation of the chair lift towers (67 days) can begin once the site is cleared, lumber delivered, and the foundation completed (6 days). Also, when the chair lift site has been cleared, construction of a permanent road to the upper towers can be started; this will take 24 days. While the towers are being installed, the electric motor to drive the chair lift can be installed; the motor can be installed in 24 days. Once the towers are completed and the motor installed, it will take 3 days to install the cable and an additional 12 days to install the chairs.

Installation of the towers for the rope tow can begin once the site is cleared and the foundation is built and poured; it takes 4 days to build the foundation, pour the concrete and let it cure, and 20 days to install the towers for the rope tow. While the towers are being erected, installation of the electric motor to drive the rope tow can begin; this activity will take 24 days. After the towers and motor are installed, the rope tow can be strung in 1 day. The parking lot can be cleared once the rope tow is finished; this task will take 18 days.

The foundation for the generator house can begin at the same time as the foundation for the lodge; this will take 6 days. The main framework for the generator house can begin once the foundation is completed; framing will take 12 days. After the house is framed, the diesel generator can be installed in 18 days. Finishing construction on the generator house can now begin and will take 12 more days.

Assignment:

1. Identify the critical path on your network.

2. Can the project be completed by October 1?

Optical Disk Preinstallation Project

16. The optical disk project team has started gathering the information necessary to develop the project network—predecessor activities and activity times in weeks. The results of their meeting are found in the following table.

Activity	Description	Duration	Predecessor
1	Define scope	6	None
2	Define customer problems	3	1
3	Define data records and relationships	5	1
4	Mass storage requirements	5	2, 3
5	Consultant needs analysis	10	2, 3
6	Prepare installation network	3	4, 5
7	Estimate costs and budget	2	4, 5
8	Design section "point" system	1	4, 5
9	Write request proposal	5	4, 5
10	Compile vendor list	3	4, 5
11	Prepare mgmt. control system	5	6, 7
12	Prepare comparison report	5	9, 10
13	Compare system "philosophies"	3	8, 12
14	Compare total installation	2	8, 12
15	Compare cost of support	3	8, 12
16	Compare customer satisfaction level	10	8, 12
17	Assign philosophies points	1	13
18	Assign installation cost	1	14
19	Assign support cost	1	15
20	Assign customer satisfaction points	1	16
21	Select best system	1	11, 17, 18, 19, 20
22	Order system	1	21

The project team has requested that you create a network for the project, and determine if the project can be completed in 45 weeks.

Lag Exercises

17. From the following information, draw the project network. Compute the early, late, and slack times for each activity. Identify the critical path. (Hint: Draw the finish-to-start relationships first.)

ID	Duration	Finish-to-Start Predecessor	Finish-to-Start Lag	Additional Lag Relationships	Lag
A	5	None	0	None	0
B	10	A	0	None	0
C	15	A	0	Start-finish C to D	20
D	5	B	5	Start-start D to E	5
				Finish-finish D to E	25
E	20	B	0	Finish-finish E to F	0
F	15	D	0	None	0
G	10	C	10	Finish-finish G to F	10
H	20	F	0	None	

18. Given the following information, draw the project network. Compute the early, late, and slack times for the project network. Which activities on the critical path have only the start or finish of the activity on the critical path?

ID	Duration	Finish-to-Start Predecessor	Finish-to-Start Lag	Additional Lag Relationships	Lag
A	2	None	0	None	0
B	4	A	0	None	0
C	6	A	0	Finish-finish C to F	7
D	8	A	0	None	0
E	18	B	0	Finish-finish E to G	9
		C	10		
F	2	D	0	None	
G	5	F	0	Start-start G to H	10
H	5	None	0	None	0
I	14	E	0	Finish-finish I to J	5
J	15	G, H	0	None	

19. Given the information in the following lag exercises, compute the early, late, and slack times for the project network. Which activities on the critical path have only the start or finish of the activity on the critical path?

20. Given the network below, compute the early, late, and slack time for each activity.

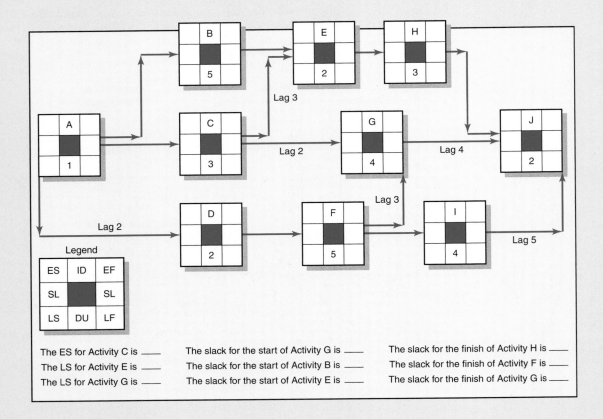

The ES for Activity C is ____
The LS for Activity E is ____
The LS for Activity G is ____

The slack for the start of Activity G is ____
The slack for the start of Activity B is ____
The slack for the start of Activity E is ____

The slack for the finish of Activity H is ____
The slack for the finish of Activity F is ____
The slack for the finish of Activity G is ____

CyClon Project

21. The CyClon project team has started gathering information necessary to develop a project network-predecessor activities and activity time in days. The results of their meeting are found in the following table:

Activity	Description	Duration	Predecessor
1	*Cyclon Project*		
2	Design	10	
3	Procure prototype parts	10	2
4	Fabricate parts	8	2
5	Assemble prototype	4	3, 4
6	Laboratory test	7	5
7	Field test	10	6
8	Adjust design	6	7
9	Order stock components	10	8
10	Order custom components	15	8
11	Assemble test production unit	10	9, 10
12	Test unit	5	11
13	Document results	3	12

Part A. Create a network based on the above information. How long will the project take? What is the critical path?

Part B. Upon further review the team recognizes that they missed three finish-to-start lags. Procure prototype parts will involve only 2 days of work but it will take 8 days for the parts to be delivered. Likewise, Order stock components will take 2 days of work and 8 days for delivery and Order custom components 2 days of work and 13 days for delivery.

Reconfigure the CyClon schedule by entering the three finish-to-start lags. What impact did these lags have on the original schedule? On the amount of work required to complete the project?

Part C. Management is still not happy with the schedule and wants the project completed as soon as possible. Unfortunately, they are not willing to approve additional resources. One team member pointed out that the network contained only finish-to-start relationships and that it might be possible to reduce project duration by creating start-to-start lags. After much deliberation the team concluded that the following relationships could be converted into start-to-start lags:

- Procure prototype parts could start 6 days after the start of Design.
- Fabricate parts could start 9 days after the start of Design.
- Laboratory test could begin 1 day after the start of Assemble prototype.
- Field test could start 5 days after the start of Laboratory test.
- Adjust design could begin 7 days after the start of Field test.
- Order stock and Order custom components could begin 5 days after Adjust design.
- Test unit could begin 9 days after the start of Assemble test production unit.
- Document results could start 3 days after the start of Test unit.

Reconfigure the CyClon schedule by entering all nine start-to-start lags. What impact did these lags have on the original schedule (Part A)? How long will the project take? Is there a change in the critical path? Is there a change in the sensitivity of the network? Why would management like this solution?

Case

Advantage Energy Technology Data Center Migration*

Brian Smith, network administrator at Advanced Energy Technology (AET), has been given the responsibility of implementing the migration of a large data center to a new office location. Careful planning is needed because AET operates in the highly competitive petroleum industry. AET is one of five national software companies which provide an accounting and business management package for oil jobbers and gasoline distributors. A few years ago, AET jumped into the "application service provider" world. Their large data center provides clients with remote access to AET's complete suite of application software systems. Traditionally, one of AET's primary competitive advantages has been the company's trademark IT reliability. Due to the complexity of this project, Brian will have to use a parallel method of implementation. Although this will increase project costs, a parallel approach is essential if reliability is not to be compromised.

Currently, AET's data center is located on the second floor of a renovated old bank building in downtown, Corvallis, Oregon. The company is moving to a new, one-level building located in the recently developed industrial complex at the Corvallis International Airport. On February 1, Brian is formally assigned the task by the Vice-President of Operations, Dan Whitmore, with the following guidelines:

- From start to finish, it is anticipated the entire project will take three to four months to complete.
- It is essential that AET's 235 clients suffer no downtime.

Whitmore advises Brian to come back to the Executive Committee on February 15, with a presentation on the scope of the project that includes costs, "first-cut" timeline, and proposed project team members.

Brian had some preliminary discussions with some of AET's managers and directors from each of the functional departments and then arranged for a full-day scope meeting on February 4 with a few of the managers and technical representatives from operations, systems, facilities, and applications. The scope team determined the following:

- Three to four months is a feasible project timeline and first-cut cost estimate is $80,000–$90,000 (this includes the infrastructure upgrade of the new site).
- Critical to the "no-downtime" requirement is the need to completely rely on AET's remote disaster recovery "hot" site for full functionality.
- Brian will serve as project manager of a team consisting of one team member each from facilities, operations/systems, operations/telecommunications, systems & applications, and customer service.

Brian's Executive Committee report was positively received and, after a few modifications and recommendations, he was formally charged with responsibility for the project. Brian recruited his team and scheduled their first team meeting (March 1) as the initial task of his project planning process.

Once the initial meeting is conducted Brian can hire the contractors to renovate the new data center. During this time Brian will figure out how to design the network. Brian estimates that screening and hiring a contractor will take about one week and that the network design will take about two weeks. The new center requires a new ventilation system. The

* Prepared by James Moran, a project management instructor at the College of Business, Oregon State University

manufacturer's requirements include an ambient temperature of 67 degrees to keep all of the data servers running at optimal speeds. The ventilation system has a lead time of three weeks. Brian will also need to order new racks to hold the servers, switches, and other network devices. The racks have a two-week delivery time.

The data center supervisor requested that Brian replace all of the old power supplies and data cables. Brian will need to order these as well. Because Brian has a great relationship with the vendor, they guarantee that it will take only one week lead time for the power supplies and the data cables. Once the new ventilation system and racks arrive, Brian can begin installing them. It will take one week to install the ventilation system and three weeks to install the racks. The renovation of the new data center can begin as soon as the contractors have been hired. The contractors tell Brian that construction will take 20 days. Once the construction begins and before Brian installs the ventilation system and racks, the city inspector must approve the construction of the raised floor.

The city inspector will take two days to approve the infrastructure. After the city inspection and after the new power supplies and cables have arrived, Brian can install the power supplies and run the cables. Brian estimates that it will take five days to install the power supplies and one week to run all of the data cables. Before Brian can assign an actual date for taking the network off line and switching to the hot remote site, he must get approval from the each of the functional units ("Switchover Approval"). Meetings with each of the functional units will require one week. During this time he can initiate a power check to ensure that each of the racks has sufficient voltage. This will require only one day.

Upon completion of the power check, he can take one week to install his test servers. The test servers will test all of the primary network functions and act as a safeguard before the network is taken off line. The batteries must be charged, ventilation installed, and test servers up and running before management can be assured that the new infrastructure is safe, which will take two days. Then they will sign off the Primary Systems check, taking one day of intense meetings. They will also set an official date for the network move.

Brian is happy that everything has gone well thus far and is convinced that the move will go just as smoothly. Now that an official date is set, the network will be shut down for a day. Brian must move all of the network components to the new data center. Brian will do the move over the weekend—two days—when user traffic is at low point.

Assignment

1. Generate a priority matrix for AET's system move.
2. Develop a WBS for Brian's project. Include duration (days) and predecessors.
3. Using a project planning tool, generate a network diagram for this project.

 (Note: Base your plan on the following guidelines: eight-hour days, seven-day weeks, no holiday breaks, March 1, 2010 is the project start date.)

Case

Greendale Stadium Case

The G&E Company is preparing a bid to build the new 47,000 seat Greendale baseball stadium. The construction must start July 1, 2006, and be completed in time for the start of the 2009 season. A penalty clause of $100,000 per day of delay beyond May 20, 2009, is written into the contract.

Ben Keith, the president of the company, expressed optimism at obtaining the contract and revealed that the company could net as much as $2 million on the project. He also said

TABLE 6.3
Greendale Stadium Case

ID	Activity	Duration	Predecessor(s)
1	*Baseball Stadium*		
2	Clear stadium site	70 days	—
3	Demolish building	30 days	2
4	Set up construction site	70 days	3
5	Drive support piling	120 days	2
6	Pour lower concrete bowl	120 days	5
7	Pour main concourse	120 days	3,6
8	Install playing field	90 days	3,6
9	Construct upper steel bowl	120 days	3,6
10	Install seats	140 days	7,9
11	Build luxury boxes	90 days	7,9
12	Install Jumbotron	30 days	7,9
13	Stadium infrastructure	120 days	7,9
14	Construct steel canopy	75 days	10
15	Light installation	30 days	14
16	Build roof supports	90 days	6
17	Construct roof	180 days	16
18	Install roof tracks	90 days	16
19	Install roof	90 days	17,18
20	Inspection	20 days	8,11,13,15,19

if they are successful, the prospects for future projects are quite good since there is a projected renaissance in building classic ball parks with modern luxury boxes.

Assignment

Given the information provided in Table 6.3, construct a network schedule for the stadium project and answer the following questions:

1. Will the project be able to be completed by the May 20 deadline? How long will it take?
2. What is the critical path for the project?
3. Based on the schedule would you recommend that G&E pursue this contact? Why? Include a one-page Gantt chart for the stadium schedule.

CASE APPENDIX: TECHNICAL DETAILS OF THE BASEBALL STADIUM

The baseball stadium is an outdoor structure with a retractable roof. The project begins with clearing the site, an activity that lasts 70 days. Once the site is clear, work can start simultaneously on the structure itself and demolishing an adjacent building site. This demolition is necessary to create a construction stage for storing materials and equipment. It will take 30 days to demolish the buildings and another 70 days to set up the construction site.

The work on the stadium begins by driving 160 support pilings, which will take 120 days. Next comes the pouring of the lower concrete bowl (120 days). Once this is done and the construction site has been set up, then the pouring of the main concourse (120 days), the installation of the playing field (90 days), and the construction of the upper steel bowl can occur (120 days).

Once the concourse and upper bowl are completed, work can start simultaneously on building the luxury boxes (90 days), installing the seats (140 days), installing the Jumbotron (30 days), and installing stadium infrastructure (120 days) which includes: bathrooms, lockers, restaurants, etc. Once the seats are installed then the steel canopy can be constructed (75 days) followed by the installation of the lights (30 days).

The retractable roof represents the most significant technical challenge to the project. Building the roof track supports (90 days) can begin after the lower concrete bowl is constructed. At this time the dimensions of the roof can be finalized and the construction of the roof at a separate site can begin (180 days). After the roof supports are completed then the roof tracks can be installed (90 days). Once the tracks and the roof are completed then the roof can be installed and made operational (90 days). Once all activities are completed it will take 20 days to inspect the stadium.

For purposes of this case assume the following:

1. The following holidays are observed: January 1, Memorial Day (last Monday in May), July 4th, Labor Day (first Monday in September), Thanksgiving Day (4th Thursday in November), December 25 and 26.
2. If a holiday falls on a Saturday then Friday will be given as an extra day off, and if it falls on a Sunday then Monday will be given as a day off.
3. The construction crew work Monday through Friday.

Appendix 6.1

Activity-on-Arrow Method

DESCRIPTION

The activity-on-arrow (AOA) approach also uses the arrow and node as network building blocks. However, in this approach *the arrow represents an individual project activity that requires time*. The length and slope of the arrow have no significance. *The node represents an event; it is usually presented as a small circle*. Events represent points in time but do not consume time. Each activity on the network has a start and end event node. For example, if the activity were "install software," the start event could be "start installing software" and the end event could be "finish software installation." Event nodes are numbered with the start node having a smaller number than the end event node (see Figure A6.1). These two numbers are used to identify the activity start node to finish node (79–80). As we shall see shortly, an event node can serve as a start or end node for one or more activities, and an end event node can serve as a start node for one or more activities that immediately follow.

FIGURE A6.1
AOA Network Building Blocks

FIGURE A6.2
Activity-on-Arrow
Network
Fundamentals

Figure A6.2 illustrates several methods for showing AOA activity relationships in a project network. Figure A6.2A simply tells the project manager that activity X must be completed before activity Y can begin. Activity X can also be identified as activity 10–11. Note that event 11 is the finish event for activity X and the start event for activity Y. All AOA networks use this method to link activities and establish dependencies among activities.

Figure A6.2B tells us that activities R, S, and T are parallel, that is, independent, and can occur concurrently if the project manager wishes; however, activities R, S, and T must all be completed before activity U can begin. Observe how event 20 is a common ending event for activities R, S, and T and the start event for activity U. Figure 6.2C shows that activity M must be completed before activities N and O can begin. When activity M is complete, activities N and O are considered independent and can occur simultaneously if you wish. Event 54 is called a burst event because more than one activity arrow leaves (bursts from) it. Figure A6.2D tells us activity E and F can go on together, but both must

TABLE A6.1
Network Information

KOLL BUSINESS CENTER
County Engineers Design Department

Activity	Description	Preceding Activity	Activity Time
A	Application approval	None	5
B	Construction plans	A	15
C	Traffic study	A	10
D	Service availability check	A	5
E	Staff report	B, C	15
F	Commission approval	B, C, D	10
G	Wait for construction	F	170
H	Occupancy	E, G	35

be completed before activities G and H can begin. Event 23 is both a merge event and a burst event. Theoretically, an event is unlimited in the number of activities (arrows) that can lead into (merge) or out of (burst from) it. Figure A6.2E illustrates parallel paths A–C and B–D. Activity A must precede activity C and B precede D. Paths A–C and B–D are independent of each other. Let us apply these fundamentals to the simple Koll Business Center project.

DESIGN OF AN AOA PROJECT NETWORK

You are now ready to use the information in Table A6.1 to draw an AOA network of the Koll Business Center. From the information given, the first four activities can be drawn as shown in Figure A6.3. Activity A (1–2) (Application approval) must be completed before activities B (2–4), C (2–3), and D (2–5) can begin.

At this point we run into a problem common in AOA networks. Activity E is preceded by activities B and C. The natural inclination is to draw your activity arrows for B and C from event 2 straight to event 4, which is the beginning event for activity E. However, the result would be that activities B and C would both have the same identification numbers (2–4). In cases like this where two or more activities are parallel and have the same start and finish nodes, a dummy activity is inserted to ensure each activity has its unique identification number. A dummy activity is depicted by a dashed arrow and its duration is zero. The dummy activity could be inserted before or after either activity B or C as shown in Figure A6.4 (see parts A through D). In Figure A6.4E we placed it after activity C with its own identification of X or 3–4.

FIGURE A6.3
Partial Koll Business Center AOA Network

FIGURE A6.4
Partial AOA Koll
Business Center
Network

Activity F in Figure A6.4E denotes another network problem in which activity dependencies exist but it is not convenient to connect the activities. In this case, the dummy activity can be used to maintain the logic of the network dependencies. Activity F is preceded by activities B, C, and D. Dummy activity Y (4–5) is necessary because activity B precedes both E and F. The dummy activity maintains the intended logic and sequence. Dummy activity 3–5 can be removed because it is redundant; that is, its removal does not change the intended relationships—the end event 4 precedes activity F. Typically, the first pass in drawing your network will include many dummy activities. After several passes forward and backward through the network, you will find ways to remove some of the dummy activities that are there solely to maintain logic. However, when two or more parallel activities have the same beginning and ending event nodes, dummy activities cannot be avoided. Figure A6.5 has a completed network for the Koll design project.

FIGURE A6.5 **Activity-on-Arrow Network**

In this simple project network no activity networks cross over each other, a situation which is very rare. Remember the length and slope of the arrows is arbitrary. The activity durations are included and found below the arrows, near the middle. You should work through the AOA network exercises before moving to the next section. Your familiarity with the activity/event approach will help your initial understanding of the forward and backward pass on an AOA network.

Forward Pass—Earliest Times

The forward pass in AOA uses the same concepts found in the AON procedure. The major difference lies in recognition and use of events to set early and late start and finish times for activities. Figure A6.6 shows the Koll design project with all the activity durations and early start and finish times. Also near each event is a box that will allow us to record event times and slack. In the field this box is sometimes called a "T-box" because the shape

FIGURE A6.6 **Activity-on-Arrow Network Forward Pass**

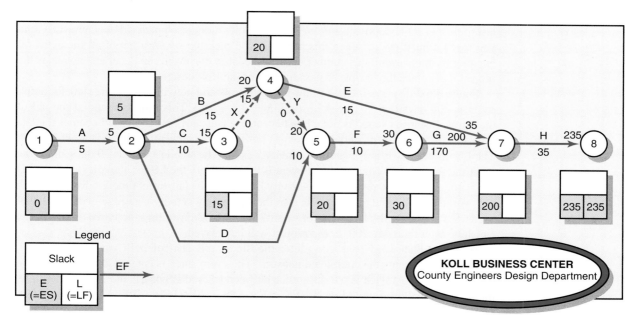

within the box forms the letter T. There are many variations of the T-box found in the field, but they all use the basic T format.

The forward pass starts with the first activity(ies) and traces each path through the network. As in AON, you *add* (cumulate) the activity times along the path. When you come to a merge event, you select the largest early finish (EF) of all the activities merging to that event. Let's work through Figure A6.6. Event 1 is the project start event; therefore, the earliest that event can occur is time zero. This early event time for event 1 is placed in the lower left side of the event box. The early event time is also the ES for any activity bursting from an event. Therefore, the zero in the box for event 1 is also the early start for activity A. The early finish for activity A is 5 workdays (ES + Dur = EF or 0 + 5 = 5). The EF for the activity is placed at the head of the arrow. The earliest event 2 can occur is the instant activity A is complete, which is 5 workdays; therefore, this time is placed in the lower left T-box of event 2. Again, note that the early event time is also the ES for any activity using the event as a start event. Hence, the ES for activities B, C, and D is 5 workdays. The EF for activity B is 20 (ES + Dur = EF), for activity C is 15, and for activity D is 10. (See the head of the arrow for each activity.) The ES for the dummy activity (3–4) is 15, and its EF is 15 (15 + 0 = 15). Although the dummy activity has zero duration, it must be included in the forward and backward pass computations.

At this point you must determine the early event times for events 4 and 5. Both are merge events that require selection among activities merging into these events. Event 4 has B and X, the dummy activity (3–4). The largest EF for these two activities (20 and 15) is 20, which controls the early event time for event 4. Similarly, event 5 is controlled by activities D and Y. Because activity Y has the largest early finish (20 versus 10 workdays for activity D), it establishes the early event time for event 5 and activity F. Times are cumulated until merge event 7. The EFs for activities E and G are 35 and 200 workdays, respectively. Thus, event 7 and activity H have early times of 200 workdays. The early finish for the project is 235 workdays. Assuming we accept this planned duration of 235 days for the project, the LF for event 8 becomes 235 days, and you are ready to compute the backward pass.

Backward Pass—Latest Times

The backward pass procedure is similar to that used in the AON procedure. You start with the last project event node(s) and *subtract* activity times along each path (LF − Dur = LS) until you reach a burst event. When this happens, you pick the *smallest* LS of all the activities bursting from the event; this number denotes the latest that event can occur and not delay the project. Let's trace the backward pass for part of the Koll design project.

Figure A6.7 displays the late times for the events and activities. The late start for activity H is 200 days (LF − Dur = LS or 235 − 35 = 200). This time is found at the tail of the arrow. Because event 7 is not a burst event, the late start for activity H becomes the late time for event 7. This procedure continues until you reach event 4, which is a burst event. The LS for activity E is 185 and for activity Y is 20. The smallest time is 20 days and is the late time for event 4. The next burst event is event 2. Here the LS for activities B, C, and D are 5, 10, and 15 days, respectively. Activity B controls the late event time for event 2, which is 5 workdays. The late event time is also the LF for any activity using the event as an end event. For example, the late time for event 7 is 200 workdays; thus, activities E and G can finish no later than day 200, or the project will be delayed.

With the backward pass complete, the slack and critical path can be identified. Figure A6.8 presents the completed network. The event slack is entered above the T in the event box. Activity slack is the difference between LS and ES or LF and EF. For example, the slack for activity E is 165 days—LS − ES (185 − 20 = 165) or LF − EF (200 − 35 = 165). What are the slack values for activities B, C, and D? The answers are zero workdays

FIGURE A6.7 **Activity-on-Arrow Network Backward Pass**

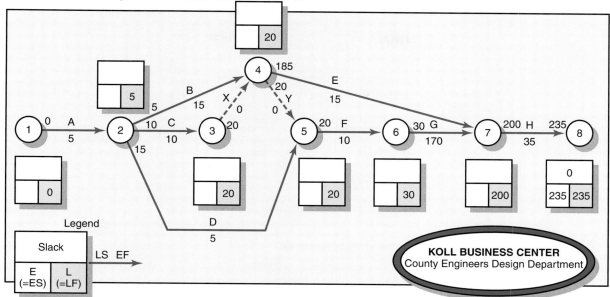

$(5 - 5 = 0$ or $20 - 20 = 0)$, 5 workdays $(10 - 5 = 5$ or $20 - 15 = 5)$, and 10 workdays $(15 - 5 = 10$ or $20 - 10 = 10)$, respectively. The critical path is A, B, Y, F, G, H.

Compare the networks found in Figure A6.8 and in chapter text Figure 6.8 to see the differences between the AOA and AON methods. As in the AON method, if the early and late time for the end project event are the same (L = E or LF = EF), the slack on the critical path will be zero. If the times are not the same, the slack on the critical path will equal the difference (L − E or LF − EF).

FIGURE A6.8 **Activity-on-Arrow Network Backward Pass, Forward Pass, and Slack**

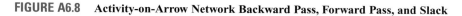

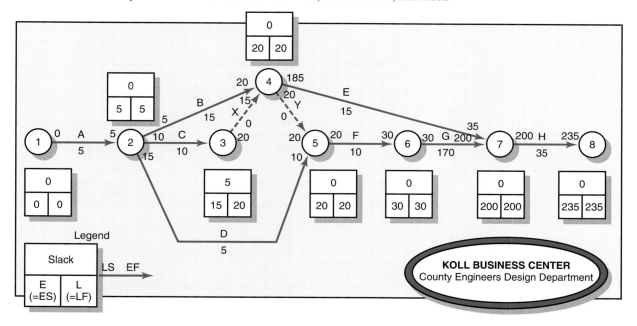

FIGURE A6.9 **Air Control, Inc. Custom Order Project—AOA Network Diagram**

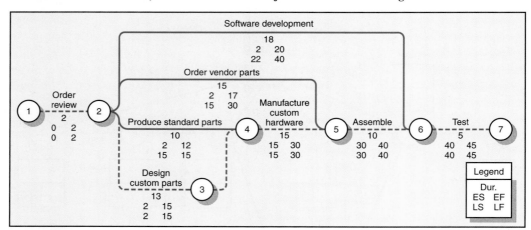

Computer-Generated Networks

Figure A6.9 presents a generic AOA computer output for the custom order project. AOA networks identify activities by the beginning and ending nodes—for example, the software development activity is identified as activity 2–6. Its duration is 18 time units; ES = 2; EF = 20; LS = 22; and LF = 40 time units. The critical path is 1-2-3-4-5-6-7. Compare the AOA computer output in Figure A6.9 with the AON computer output in chapter Figure 6.10. Bar charts are identical to those developed for AON networks; see chapter Figure 6.11.

CHOICE OF METHOD—AON OR AOA

Your choice of method depends on the importance of various advantages and disadvantages of each method. Table A6.2 will assist you in making your choice.

TABLE A6.2
Comparison of AON and AOA Methods

AON Method
Advantages
1. No dummy activities are used.
2. Events are not used.
3. AON is easy to draw if dependencies are not intense.
4. Activity emphasis is easily understood by first-level managers.
5. The CPM approach uses deterministic times to construct networks.
Disadvantages
1. Path tracing by activity number is difficult. If the network is not available, computer outputs must list the predecessor and successor activities for each activity.
2. Network drawing and understanding are more difficult when dependencies are numerous.
AOA Method
Advantages
1. Path tracing is simplified by activity/event numbering scheme.
2. AOA is easier to draw if dependencies are intense.
3. Key events or milestones can easily be flagged.
Disadvantages
1. Use of dummy activities increases data requirements.
2. Emphasis on events can detract from activities. Activity delays cause events and projects to be late.

SUMMARY

In AOA networks, dummy activities meet two needs. First, when two parallel activities have the same start and end nodes, a dummy must be inserted to give each activity a unique identification number (see activity X in Figure A6.8). Next, dummy activities can be used to clarify dependency relationships (see activity Y in Figure A6.8). Dummy activities are very useful when activity dependencies are far apart on the network. In AOA networks the early event time is the ES for any activity emanating from the event. Conversely, the late event time is the LF for any activity merging to the event. The major advantage of the AOA method is the avoidance of having to list all the predecessor and successor activities for each activity in the network so activity sequence and dependency can be traced when a network is not available or shows incomplete information. Computer output is reduced manyfold.

REVIEW QUESTIONS

1. How do the building blocks of AON and AOA differ?
2. What are the purposes of dummy or pseudo activities?
3. How do activities differ from events?

APPENDIX EXERCISES

1. Use the information found in the text exercises 3 and 4 (page 173) to draw AOA networks.
2. Use the information found in the text exercise 11 to draw an AOA network. Include the activity times and event nodes on the network as shown in Figure A6.5.
3. Given the project network that follows, compute the early, late, and slack times for the project. Be sure to show the early finish and late start times on your network.

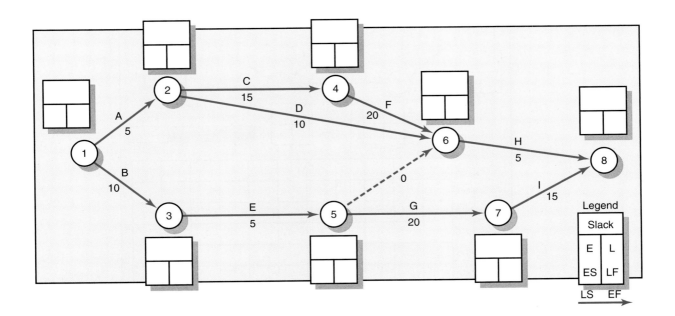

4. Given the project network that follows, compute the early, late, and slack times for the project. Be sure to show the early finish and late start times on your network.

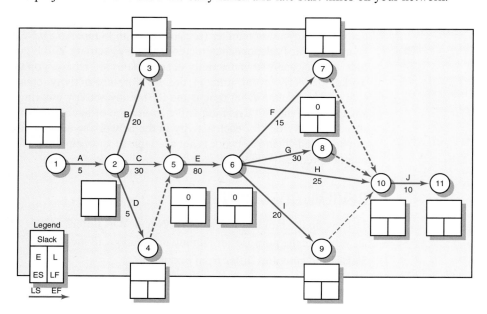

5. Given the project network that follows, complete the bar chart for this project. Use the time-line to align your bars. Be sure to use the legend to show slack for noncritical activities.

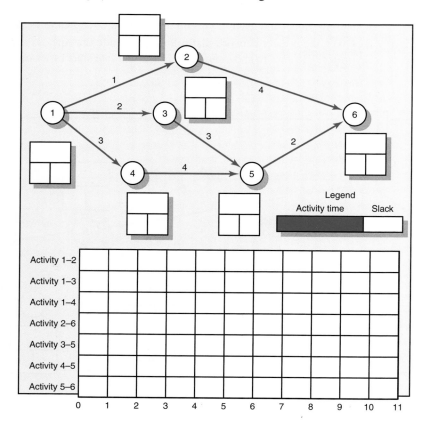

6. Given the project network that follows, draw a bar chart for this project. Use the timeline to align your bars. Be sure to show slack for noncritical activities.

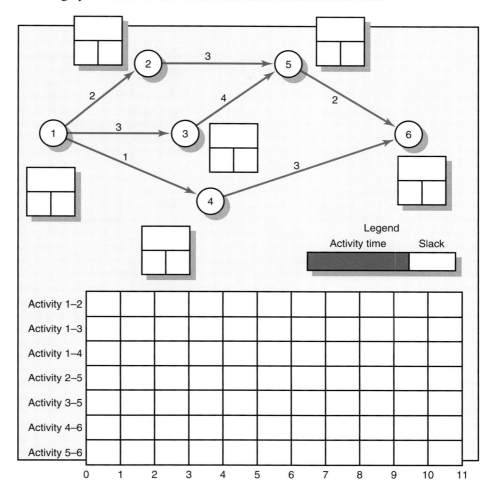

Managing Risk

Risk Management Process

Step 1: Risk Identification

Step 2: Risk Assessment

Step 3: Risk Response Development

Contingency Planning

Contingency Funding and Time Buffers

Step 4: Risk Response Control

Change Control Management

Summary

Appendix 7.1: PERT and PERT Simulation

Managing Risk

No great deed is done by falterers who ask for certainty.
George Eliot

Every project manager understands risks are inherent in projects. No amount of planning can overcome *risk,* or the inability to control chance events. In the context of projects, risk is an uncertain event or condition that, if it occurs, has a positive or negative effect on project objectives. A risk has a cause and, if it occurs, a consequence. For example, a cause may be a flu virus or change in scope requirements. The event is that team members get striken with the flu or the product has to be redesigned. If either of these uncertain events occurs, it will impact the cost, schedule, and quality of the project.

Some potential risk events can be identified before the project starts—such as equipment malfunction or change in technical requirements. Risks can be anticipated consequences, like schedule slippages or cost overruns. Risks can be beyond imagination like the September 11, 2001, attack on the Twin Towers in New York City.

While risks can have positive consequences such as unexpected price reduction in materials, the focus of this chapter is on what can go wrong and the risk management process.

Risk management attempts to recognize and manage potential and unforeseen trouble spots that may occur when the project is implemented. Risk management identifies as many risk events as possible (what can go wrong), minimizes their impact (what can be done about the event before the project begins), manages responses to those events that do materialize (contingency plans), and provides contingency funds to cover risk events that actually materialize.

For a humorous, but ultimately embarrassing example of poor risk management see Snapshot from Practice: Giant Popsicle Gone Wrong.

Risk Management Process

Figure 7.1 presents a graphic model of the risk management challenge. The chances of a risk event occurring (e.g., an error in time estimates, cost estimates, or design technology) are greatest in the concept, planning, and start-up phases of the project. The cost impact of a risk event in the project is less if the event occurs earlier rather than later. The early stages of the project represent the period when the opportunity for minimizing the impact or working around a potential risk exists. Conversely, as the project passes the halfway implementation mark, the cost of a risk event occurring increases rapidly. For example, the risk event of a design flaw occurring after a prototype has been made has a greater cost or time impact than if the event occurred in the start-up phase of the project. Clearly, identifying project risk events and deciding a response before the project begins is a more prudent approach than not attempting to manage risk.

The cost of mismanaged risk control early on in the project is magnified by the ill-fated 1999 NASA Mars Climate Orbiter. Investigations revealed that Lockheed Martin botched

An attempt to erect the world's largest Popsicle in New York City ended with a scene straight out of a disaster film, but much stickier.

The 25-foot-tall, 17½-ton treat of frozen juice melted faster than expected, flooding Union Square in downtown Manhattan with kiwi-strawberry–flavored fluid.

Bicyclists wiped out in the stream of goo. Pedestrians slipped. Traffic was, well, frozen. Firefighters closed off several streets and used hoses to wash away the thick, sweet slime.

The Snapple Company, a leading maker of soft beverages, had been trying to promote a new line of frozen treats by setting a record for the world's largest Popsicle, but called off the stunt before the frozen giant was pulled fully upright by a construction crane.

Authorities said they were worried the 2½-story popsicle would collapse.

Organizers were not sure why it melted so quickly. "We planned for it. We just didn't expect for it to happen so fast," said Snapple spokeswoman Lauren Radcliffe. She said the company would offer to pay the city for the clean-up costs.

* Associated Press, June 23, 2005.

the design of critical navigation software. While flight computers on the ground did calculations based on pounds of thrust per second, the spacecraft's computer software used metric units called newtons. A check to see if the values were compatible was never done.

"Our check and balances processes did not catch an error like this that should have been caught," said Ed Weiler, NASA's associate administrator for space science. "That is the bottom line. Processes that were in place were not followed." (*Orlando Sentinel*, 1999.) After the nine-month journey to the Red Planet the $125 million probe approached Mars at too low an altitude and burned up in the planet's atmosphere.

Risk management is a proactive approach rather than reactive. It is a preventive process designed to ensure that surprises are reduced and that negative consequences associated with undesirable events are minimized. It also prepares the project manager to take risk when a time, cost, and/or technical advantage is possible. Successful management of project risk

FIGURE 7.1
Risk Event Graph

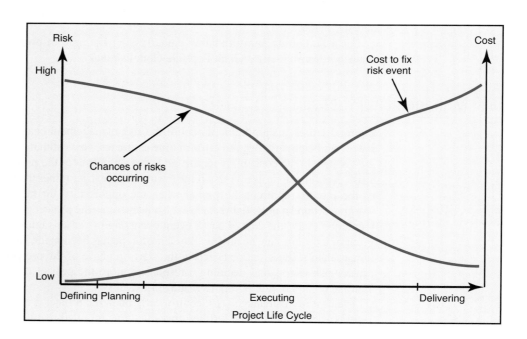

FIGURE 7.2
The Risk
Management Process

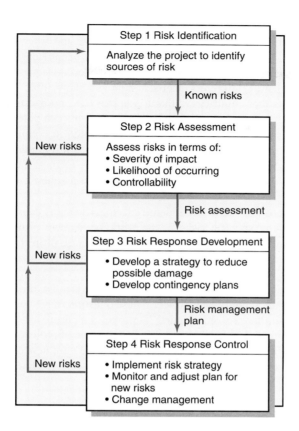

gives the project manager better control over the future and can significantly improve chances of reaching project objectives on time, within budget, and meeting required technical (functional) performance.

The sources of project risks are unlimited. There are sources external to the organization, such as inflation, market acceptance, exchange rates, and government regulations. In practice, these risk events are often referred to as "threats" to differentiate them from those that are not within the project manager's or team's responsibility area. (Later we will see budgets for such risk events are placed in a "management reserve" contingency budget.) Since such external risks are usually considered before the decision to go ahead with the project, they will be excluded from the discussion of project risks. However, external risks are extremely important and must be addressed.

The major components of the risk management process are depicted in Figure 7.2. Each step will be examined in more detail in the remainder of the chapter.

Step 1: Risk Identification

The risk management process begins by trying to generate a list of all the possible risks that could affect the project. Typically the project manager pulls together, during the planning phase, a risk management team consisting of core team members and other relevant stakeholders. The team uses brainstorming and other problem identifying techniques to identify potential problems. Participants are encouraged to keep an open mind and generate as many probable risks as possible. More than one project has been bushwhacked by

an event that members thought was preposterous in the beginning. Later during the assessment phase, participants will have a chance to analyze and filter out unreasonable risks.

One common mistake that is made early in the risk identification process is to focus on objectives and not on the events that could produce consequences. For example, team members may identify failing to meet schedule as a major risk. What they need to focus on are the events that could cause this to happen (i.e., poor estimates, adverse weather, shipping delays, etc.). Only by focusing on actual events can potential solutions be found.

Organizations use risk breakdown structures (RBSs) in conjunction with work breakdown structures (WBSs) to help management teams identify and eventually analyze risks. Figure 7.3 provides a generic example of an RBS. The focus at the beginning should be on risks that can affect the whole project as opposed to a specific section of the project or network.

After the macro risks have been identified, specific areas can be checked. An effective tool for identifying specific risks is the work breakdown structure. Use of the WBS reduces the chance a risk event will be missed. On large projects multiple risk teams are organized around specific deliverables and submit their risk management reports to the project manager.

A risk profile is another useful tool. A risk profile is a list of questions that address traditional areas of uncertainty on a project. These questions have been developed and refined from previous, similar projects. Figure 7.4 provides a partial example of a risk profile.

Good risk profiles, like RBSs, are tailored to the type of project in question. For example, building an information system is different from building a new car. They are organization specific. Risk profiles recognize the unique strengths and weaknesses of the firm. Finally,

FIGURE 7.3 **The Risk Breakdown Structure (RBS)**

FIGURE 7.4
Partial Risk Profile for Product Development Project

Technical Requirements	**Quality**
Are the requirements stable?	Are quality considerations built into the design?
Design	**Management**
Does the design depend on unrealistic or optimistic assumptions?	Do people know who has authority for what?
Testing	**Work Environment**
Will testing equipment be available when needed?	Do people work cooperatively across functional boundaries?
Development	**Staffing**
Is the development process supported by a compatible set of procedures, methods, and tools?	Is staff inexperienced or understaffed?
Schedule	**Customer**
Is the schedule dependent upon the completion of other projects?	Does the customer understand what it will take to complete the project?
Budget	**Contractors**
How reliable are the cost estimates?	Are there any ambiguities in contractor task definitions?

risk profiles address both technical and management risks. For example, the profile shown in Figure 7.4 asks questions about design *(Does the design depend upon unrealistic assumptions?)* and work environment *(Do people cooperate across functional boundaries?).*

Risk profiles are generated and maintained usually by personnel from the project office. They are updated and refined during the postproject audit (see Chapter 14). These profiles, when kept up to date, can be a powerful resource in the risk management process. The collective experience of the firm's past projects resides in their questions.

Historical records can complement or be used when formal risk profiles are not available. Project teams can investigate what happened on similar projects in the past to identify potential risks. For example, a project manager can check the on-time performance of selected vendors to gauge the threat of shipping delays. IT project managers can access "best practices" papers detailing other companies' experiences converting software systems. Inquiries should not be limited to recorded data. Savvy project managers tap the wisdom of others by seeking the advice of veteran project managers.

The risk identification process should not be limited to just the core team. Input from customers, sponsors, subcontractors, vendors, and other stakeholders should be solicited. Relevant stakeholders can be formally interviewed or included on the risk management team. Not only do these players have a valuable perspective, but by involving them in the risk management process they also become more committed to project success.

One of the keys to success in risk identification is attitude. While a "can do" attitude is essential during implementation, project managers have to encourage critical thinking when it comes to risk identification. The goal is to find potential problems before they happen.

The RBS and risk profiles are useful tools for making sure no stones are left unturned. At the same time, when done well the number of risks identified can be overwhelming and a bit discouraging. Initial optimism can be replaced with griping and cries of "what have we gotten ourselves into?" It is important that project managers set the right tone and complete the risk management process so members regain confidence in themselves and the project.

Step 2: Risk Assessment

Step 1 produces a list of potential risks. Not all of these risks deserve attention. Some are trivial and can be ignored, while others pose serious threats to the welfare of the project. Managers have to develop methods for sifting through the list of risks, eliminating inconsequential or redundant ones and stratifying worthy ones in terms of importance and need for attention.

Scenario analysis is the easiest and most commonly used technique for analyzing risks. Team members assess the significance of each risk event in terms of:

- Probability of the event.
- Impact of the event.

Simply stated, risks need to be evaluated in terms of the likelihood the event is going to occur and the impact or consequences of its occurrence. The risk of a project manager being struck by lightning at a work site would have major negative impact on the project, but the likelihood is so low it is not worthy of consideration. Conversely, people do change jobs, so an event like the loss of key project personnel would have not only an adverse impact but also a high likelihood of occurring in some organizations. If so, then it would be wise for that organization to be proactive and mitigate this risk by developing incentive schemes for retaining specialists and/or engaging in cross-training to reduce the impact of turnover.

The quality and credibility of the risk analysis process requires that different levels of risk probabilities and impacts be defined. These definitions vary and should be tailored to the specific nature and needs of the project. For example, a relatively simple scale ranging from "very unlikely" to "almost certainly" may suffice for one project, whereas another project may use more precise numerical probabilities (e.g., 0.1, 0.3, 0.5, . . .).

Impact scales can be a bit more problematic since adverse risks affect project objectives differently. For example, a component failure may cause only a slight delay in project schedule but a major increase in project cost. If controlling cost is a high priority, then the impact would be severe. If, on the other hand, time is more critical than cost, then the impact would be minor.

Because impact ultimately needs to be assessed in terms of project priorities, different kinds of impact scales are used. Some scales may simply use rank-order descriptors, such as "low," "moderate," "high," and "very high," whereas others use numeric weights (e.g., 1–10). Some may focus on the project in general while others focus on specific project objectives. The risk management team needs to establish up front what distinguishes a 1 from a 3 or "moderate" impact from "severe" impact. Figure 7.5 provides an example of how impact scales could be defined given the project objectives of cost, time, scope, and quality.

Documentation of scenario analyses can be seen in various risk assessment forms used by companies. Figure 7.6 is a partial example of a risk assessment form used on an IS project involving the upgrade from Windows Office XP to Windows Vista.

Notice that in addition to evaluating the severity and probablity of risk events the team also assesses when the event might occur and its detection difficulty. Detection difficulty is a measure of how easy it would be to detect that the event was going to occur in time to take mitigating action, that is, how much warning would we have?

Often organizations find it useful to categorize the severity of different risks into some form of risk assessment matrix. The matrix is typically structured around the impact and likelihood of the risk event. For example, the risk matrix presented in Figure 7.7 consists of a 5 × 5 array of elements with each element representing a different set of impact and likelihood values.

FIGURE 7.5 **Defined Conditions for Impact Scales of a Risk on Major Project Objectives (Examples for negative impacts only)**

Relative or Numerical Scale					
Project Objective	1 Very Low	2 Low	3 Moderate	4 High	5 Very High
Cost	Insignificant cost increase	< 10% cost increase	10–20% cost increase	20–40% cost increase	> 40% cost increase
Time	Insignificant time increase	< 5% time increase	5–10% time increase	10–20% time increase	> 20% time increase
Scope	Scope decrease barely noticeable	Minor areas of scope affected	Major areas of scope affected	Scope reduction unacceptable to sponsor	Project end item is effectively useless
Quality	Quality degradation barely noticeable	Only very demanding applications are affected	Quality reduction requires sponsor approval	Quality reduction unacceptable to sponsor	Project end item is effectively useless

The matrix is divided into red, yellow, and green zones representing major, moderate, and minor risks, respectively. The red zone is centered on the top right corner of the matrix (high impact/high likelihood), while the green zone is centered on the bottom left corner (low impact/low likelihood). The moderate risk, yellow zone extends down the middle of the matrix. Since impact is generally considered more important than likelihood (a 10 percent chance of losing $1,000,000 is usually considered a more severe risk than a 90 percent chance of losing $1,000), the red zone (major risk) extends farther down the high impact column.

Using the Windows Vista project again as an example, interface problems and system freezing would be placed in the red zone (major risk), while user backlash and hardware malfunctioning would be placed in the yellow zone (moderate risk).

FIGURE 7.6
Risk Assessment Form

Risk Event	Likelihood	Impact	Detection Difficulty	When
Interface problems	4	4	4	Conversion
System freezing	2	5	5	Start-up
User backlash	4	3	3	Postinstallation
Hardware malfunctioning	1	5	5	Installation

FIGURE 7.7
Risk Severity Matrix

The risk severity matrix provides a basis for prioritizing which risks to address. Red zone risks receive first priority followed by yellow zone risks. Green zone risks are typically considered inconsequential and ignored unless their status changes.

Failure Mode and Effects Analysis (FMEA) extends the risk severity matrix by including ease of detection in the equation:

$$\text{Impact} \times \text{Probability} \times \text{Detection} = \text{Risk Value}$$

Each of the three dimensions is rated according to a five-point scale. For example, detection is defined as the ability of the project team to discern that the risk event is imminent. A score of 1 would be given if even a chimpanzee could spot the risk coming. The highest detection score of 5 would be given to events that could only be discovered after it is too late (i.e., system freezing). Similar anchored scales would be applied for severity of impact and the probability of the event occurring. The weighting of the risks is then based on their overall score. For example, a risk with an impact in the "1" zone with a very low probability and an easy detection score might score a 1 ($1 \times 1 \times 1 = 1$). Conversely, a high-impact risk with a high probability and impossible to detect would score 125 ($5 \times 5 \times 5 = 125$). This broad range of numerical scores allows for easy stratification of risk according to overall significance.

No assessment scheme is absolutely foolproof. For example, the weakness of the FMEA approach is that a risk event rated Impact = 1, Probability = 5, and Detection = 5 would receive the same weighted score as an event rated Impact = 5, Probability = 5, and Detection = 1! This underscores the importance of *not* treating risk assessment as simply an exercise in mathematics. There is no substitute for thoughtful discussion of key risk events.

Probability Analysis

There are many statistical techniques available to the project manager that can assist in assessing project risk. Decision trees have been used to assess alternative courses of action using expected values. Statistical variations of net present value (NPV) have been used

to assess cash flow risks in projects. Correlations between past projects' cash flow and S-curves (cumulative project cost curve—baseline—over the life of the project) have been used to assess cash flow risks.

PERT (program evaluation and review technique) and PERT simulation can be used to review activity and project risk. PERT and related techniques take a more macro perspective by looking at overall cost and schedule risks. Here the focus is not on individual events but on the likelihood the project will be completed on time and within budget. These methods are useful in assessing the overall risk of the project and the need for such things as contingency funds, resources, and time. The use of PERT simulation is increasing because it uses the same data required for PERT, and software to perform the simulation is readily available.

Basically PERT simulation assumes a statistical distribution (range between optimistic and pessimistic) for each activity duration; it then simulates the network (perhaps over 1,000 simulations) using a random number generator. The outcome is the relative probability, called a criticality index, of an activity becoming critical under the many different, possible activity durations for each activity. PERT simulation also provides a list of potential critical paths and their respective probabilities of occurring. Having this information available can greatly facilitate identifying and assessing schedule risk. (See Appendix 7.1 at the end of this chapter for a more detailed description and discussion.)

Step 3: Risk Response Development

When a risk event is identified and assessed, a decision must be made concerning which response is appropriate for the specific event. Responses to risk can be classified as mitigating, avoiding, transferring, sharing, or retaining.

Mitigating Risk

Reducing risk is usually the first alternative considered. There are basically two strategies for mitigating risk: (1) reduce the likelihood that the event will occur and/or (2) reduce the impact that the adverse event would have on the project. Most risk teams focus first on reducing the likelihood of risk events since, if successful, this may eliminate the need to consider the potentially costly second strategy.

Testing and prototyping are frequently used to prevent problems from surfacing later in a project. An example of testing can be found in an information systems project. The project team was responsible for installing a new operating system in their parent company. Before implementing the project, the team tested the new system on a smaller isolated network. By doing so they discovered a variety of problems and were able to come up with solutions prior to implementation. The team still encountered problems with the installation but the number and severity were greatly reduced.

Often identifying the root causes of an event is useful. For example, the fear that a vendor will be unable to supply customized components on time may be attributable to (1) poor vendor relationships, (2) design miscommunication, and (3) lack of motivation. As a result of this analysis the project manager may decide to take his counterpart to lunch to clear the air, invite the vendor to attend design meetings, and restructure the contract to include incentives for on-time delivery.

Other examples of reducing the probability of risks occurring are scheduling outdoor work during the summer months, investing in up-front safety training, and choosing high-quality materials and equipment.

When the concerns are that duration and costs have been underestimated, managers will augment estimates to compensate for the uncertainties. It is common to use a ratio between

On March 26, 2000, the largest concrete domed structure in the world was reduced to a pile of rubble in a dramatic implosion lasting less than 20 seconds. According to Mark Loizeaux, whose Maryland-based Controlled Demolition Inc. was hired to bring the 24-year-old Seattle Kingdome down, "We don't blow things up. We use explosives as an engine, but gravity is the catalyst that will bring it down."

Destroying the Kingdome was the most complicated of the 7,000 demolitions Loizeaux's company has undertaken. Nearly three months of preparations were needed to implode the dome at a total cost of $9 million. The Kingdome was considered to be one of the strongest structures in the world containing over 25,000 tons of concrete with each of its 40 vaulted ribs incorporating seven lengths of two-and-one-quarter-inch reinforcing steel bar.

Strands of orange detonating cord—basically dynamite in a string that explodes at the lightning pace of 24,000 feet per second—connected six pielike divisions of the Kingdome to a nearby control center.

Throughout each section, Controlled Demolition workers drilled nearly 1,000 holes and packed them with high-velocity gelatin explosives the size of hot dogs. Large charges were placed about one-third of the way up each dome rib, smaller charges were put farther up the ribs. When the detonation button was pushed, blasting caps set off a chain reaction of explosions in each section reducing the stadium to rubble.

While the actual implosion was a technical tour-de-force, risk management was a critical part of the project's success.

To minimize damage to surrounding buildings, the explosive charges were wrapped in a layer of chain-link fencing covered with thick sheets of geotextile polypropylene fabric to contain flying concrete. Nearby buildings were protected in various manners depending on the structure and proximity to the Dome. Measures included sealing air-handling units, taping seams on doors and windows, covering floors and windows with plywood and draping reinforced polyethylene sheeting around the outside.

To help absorb the impact, air-conditioning units removed from the interior were stacked with other material to create a barrier around the perimeter of the work area.

Hundreds of police officers and security personnel were used to cordon off an area extending roughly 1,000 feet from the Dome from overzealous spectators. Traffic was closed for a larger area. Accommodations were provided for people and pets who lived within the restricted zone.

Eight water trucks, eight sweeper units, and more than 100 workers were deployed immediately after the blast to control dust and begin the cleanup.

As a side note, one-third of the concrete will be crushed and used in the foundation of a new $430 million outdoor football stadium which is being built in its place. The rest of the concrete will be carted away and used in roadbeds and foundations throughout the Seattle area.

*New York Times—Sunday Magazine (March 19, 2000); Seattle Times (March 27, 2000) Web site.

old and new project to adjust time or cost. The ratio typically serves as a constant. For example, if past projects have taken 10 minutes per line of computer code, a constant of 1.10 (which represents a 10 percent increase) would be used for the proposed project time estimates because the new project is more difficult than prior projects.

An alternative mitigation strategy is to reduce the impact of the risk if it occurs. For example, a bridge-building project illustrates risk reduction. A new bridge project for a coastal port was to use an innovative, continuous cement-pouring process developed by an Australian firm to save large sums of money and time. The major risk was that the continuous pouring process for each major section of the bridge could not be interrupted. Any interruption would require that the whole cement section (hundreds of cubic yards) be torn down and started over. An assessment of possible risks centered on delivery of the cement from the cement factory. Trucks could be delayed, or the factory could break down. Such risks would result in tremendous rework costs and delays. Risk was reduced by having two additional portable cement plants built nearby on different highways within 20 miles of the bridge project in case the main factory supply was interrupted. These two portable plants carried raw materials for a whole bridge section, and extra trucks were on immediate standby each time continuous pouring was required. Similar risk reduction scenarios are apparent in system and software development projects where parallel innovation processes are used in case one fails.

The Dome to Dust Snapshot from Practice details the steps Controlled Demolition took to minimize damage when they imploded the Seattle Kingdome.

Ellipsus Systems, AB, located in Vaxjo, Sweden, is a software design company whose products link corporate computer systems to mobile phones. Critical to the company's success is making the right technology decisions, especially around the standards and protocols its software uses. As wireless and mobile devices continue to take hold, there are two major emerging technical standards. One standard is WAP (Wireless Application Protocol). The second standard, Java, is based on Internet programming standards created by Sun Microsystems.

Rikard Kjellberg, one of Ellipsus's founders, was facing a conundrum: which standard to use? In one, Java was dominant; in the other, WAP was dominant. WAP was first to market. It generated huge excitement, and as Nokia prepared to launch the first wireless phone in late 1999, engineers across Europe left secure jobs to form WAP start-ups. At the same time some negative perceptions were developing about systems based on the WAP standard. Due to the slow response time, a Swedish newspaper ran a story titled "WAP is Crap." Java, on the other hand, had yet to establish itself with no commercial handsets available at the time.

Kjellberg's solution was to have projects in his company's portfolio based on both standards. Ellipsus built early prototypes of both systems and took them to a trade show, with both systems sitting side by side. "We knew within an hour which way to go," says Douglas Davies, the COO. Ellipsus began securing million dollar contracts to supply its Java-based system to leading U.S. operators.

* David Pringle, "How the U.S. took the wireless lead away from Europe," *The Wall Street Journal Europe,* 20 February 2002 http://www.network365 .com/news.jsp?id=145 (accessed 10, November 2003).

Avoiding Risk

Risk avoidance is changing the project plan to eliminate the risk or condition. Although it is impossible to eliminate all risk events, some specific risks may be avoided before you launch the project. For example, adopting proven technology instead of experimental technology can eliminate technical failure. Choosing an Australian supplier as opposed to an Indonesian supplier would virtually eliminate the chance that political unrest would disrupt the supply of critical materials. See the WAP versus JAVA Snapshot from Practice to see how Ellipsus Systems avoided a potentially critical technical risk.

Transferring Risk

Passing risk to another party is common; this transfer does not change risk. Passing risk to another party almost always results in paying a premium for this exemption. Fixed-price contracts are the classic example of transferring risk from an owner to a contractor. The contractor understands his or her firm will pay for any risk event that materializes; therefore, a monetary risk factor is added to the contract bid price. Before deciding to transfer risk, the owner should decide which party can best control activities that would lead to the risk occurring. Also, is the contractor capable of absorbing the risk? Clearly identifying and documenting responsibility for absorbing risk is imperative.

Another more obvious way to transfer risk is insurance. However, in most cases this is impractical because defining the project risk event and conditions to an insurance broker who is unfamiliar with the project is difficult and usually expensive. Of course, low-probability and high-consequence risk events such as acts of God are more easily defined and insured. Performance bonds, warranties, and guarantees are other financial instruments used to transfer risk.

Sharing Risk

Risk sharing allocates proportions of risk to different parties. An example of risk sharing was the Airbus A340. Research and development risks were allocated among European countries including Britain and France. Alternatively, the entertainment industry formed a

consortium to define a common operating format for Digital Video Disc (DVD) to ensure compatibility across products. Other forms of risk sharing are emerging.

On large, international construction projects like petrochemical plants and oil refineries, host countries are insisting on contracts that enforce Build-Own-Operate-Transfer (BOOT) provisions. Here the prime project organization is expected not only to build the facility, but also to take over ownership until its operation capacity has been proven and all the debugging has occurred before final transfer of ownership to the client. In such cases, the host country and project firm agree to share the financial risk of ownership until the project has been completed and capabilities proven.

Sharing risk has also been used to cut project costs and encourage innovation. Partnering (see Chapter 12) between an owner and contractors has prompted the development of continuous improvement procedures to encourage contractors to suggest innovative ways for project implementation. The new method will probably include additional start-up costs and the risk that the new process may not work. Usually the risk costs and benefits of the improved process are shared on a 50/50 basis between the owner and contracting firms.

Retaining Risk

In some cases a conscious decision is made to accept the risk of an event occurring. Some risks are so large it is not feasible to consider transferring or reducing the event (e.g., an earthquake or flood). The project owner assumes the risk because the chance of such an event occurring is slim. In other cases risks identified in the budget reserve can simply be absorbed if they materialize. The risk is retained by developing a contingency plan to implement if the risk materializes. In a few cases a risk event can be ignored and a cost overrun accepted should the risk event occur.

The more effort given to risk response before the project begins, the better the chances are for minimizing project surprises. Knowing that the response to a risk event will be retained, transferred, or shared greatly reduces stress and uncertainty when the risk event occurs. Again, control is possible with this structured approach.

Contingency Planning

A contingency plan is an alternative plan that will be used if a possible foreseen risk event becomes a reality. The contingency plan represents actions that will reduce or mitigate the negative impact of the risk event. Like all plans, the contingency plan answers the questions of what, where, when, and how much action will take place. The absence of a contingency plan, when a risk event occurs, can cause a manager to delay or postpone the decision to implement a remedy. This postponement can lead to panic, and acceptance of the first remedy suggested. Such after-the-event decision making under pressure can be potentially dangerous and costly. Contingency planning evaluates alternative remedies for possible foreseen events before the risk event occurs and selects the best plan among alternatives. This early contingency planning facilitates a smooth transition to the remedy or work-around plan. The availability of a contingency plan can significantly increase the chances for project success.

Conditions for activating the implementation of the contingency plan should be decided and clearly documented. The plan should include a cost estimate and identify the source of funding. All parties affected should agree to the contingency plan and have authority to make commitments. Because implementation of a contingency plan embodies disruption in the sequence of work, all contingency plans should be communicated to team members so that surprise and resistance are minimized.

Here is an example: A high-tech niche computer company intends to introduce a new "platform" product at a very specific target date. The project's 47 teams all agree delays will not be acceptable. Their contingency plans for two large component suppliers demonstrate how seriously risk management is viewed. One supplier's plant sits on the San Andreas Fault. The contingency plan has an alternative supplier, who is constantly updated, producing a replica of the component in another plant. Another supplier in Toronto, Canada, presents a delivery risk on their due date because of potential bad weather. This contingency plan calls for a chartered plane (already contracted to be on standby) if overland transportation presents a delay problem. To outsiders these plans must seem a bit extreme, but in high-tech industries where time to market is king, risks of identified events are taken seriously.

Risk response matrices such as the one shown in Figure 7.8 are useful for summarizing how the project team plans to manage risks that have been identified. Again, the Windows Vista project is used to illustrate this kind of matrix. The first step is to identify whether to reduce, share, transfer, or accept the risk. The team decided to reduce the chances of the system freezing by experimenting with a prototype of the system. Prototype experimentation not only allows them to identify and fix conversion "bugs" before the actual installation, but it also yields information that could be useful in enhancing acceptance by end-users. The project team is then able to identify and document changes between the old and new system that will be incorporated in the training the users receive. The risk of equipment malfunctioning is transferred by choosing a reliable supplier with a strong warranty program.

The next step is to identify contingency plans in case the risk still occurs. For example, if interface problems prove insurmountable, then the team would attempt a work-around until vendor experts arrived to help solve the problem. If the system freezes after installation, the team will first try to reinstall the software. If user dissatisfaction is high, then the IS department will provide more staff support. If the team is unable to get reliable equipment from the original supplier, then it will order a different brand from a second dealer. The team also needs to discuss and agree what would "trigger" implementation of the contingency plan. In the case of the system freezing, the trigger is not being able to unfreeze the system within one hour or, in the case of user backlash, an angry call from top management. Finally, the individual responsible for monitoring the potential risk and initiating the contingency plan needs to be assigned. Smart project managers establish protocols for contingency responses before they are needed. For an example of the importance of establishing protocols see the Risk Management at the Top of the World Snapshot from Practice on page 210.

Some of the most common methods for handling risk are discussed here.

FIGURE 7.8
Risk Response Matrix

Risk Event	Response	Contingency Plan	Trigger	Who Is Responsible
Interface problems	Reduce	Work around until help comes	Not solved within 24 hours	Nils
System freezing	Reduce	Reinstall OS	Still frozen after one hour	Emmylou
User backlash	Reduce	Increase staff support	Call from top management	Eddie
Equipment malfunctions	Transfer	Order different brand	Replacement doesn't work	Jim

Bobby Model/National Geographic Image Collection.

Into Thin Air, Jon Krakauer's gripping account of an ill-fated attempt to climb Mount Everest in which six climbers died, provides testimony to the risks of extreme mountain climbing. Thirteen days after the tragedy, David Breashears successfully led a film crew to the summit. Their footage can be seen in the spectacular IMAX film, *Everest.*

Accounts of Mount Everest expeditions provide insights into project risk management. First, most climbers spend more than three weeks acclimating their bodies to high-altitude conditions. Native Sherpas are used extensively to carry supplies and set up each of the four base camps that will be used during the final stages of the climb. To reduce the impact of hypoxia, lightheadness, and disorientation caused by shortage of oxygen, most climbers use oxygen masks and bottles during the final ascent. If lucky enough not to be one of the first expeditions of the season, the path to the summit should be staked out and roped by previous climbers. Climbing guides receive last-minute weather reports by radio to confirm whether the weather conditions warrant the risk. Finally, for added insurance, most climbers join their Sherpas in an elaborate *puja* ritual intended to summon the divine support of the gods before beginning their ascent.

All of these efforts pale next to the sheer physical and mental rigors of making the final climb from base camp IV to the summit.

This is what climbers refer to as the "death zone" because beyond 26,000 feet the mind and body begin to quickly deteriorate despite supplemental oxygen. Under fair conditions it takes around 18 hours to make the round-trip to the top and back to the base camp. Climbers leave as early as 1:00 A.M. in order to make it back before night falls and total exhaustion sets in.

The greatest danger in climbing Mount Everest is not reaching the summit but making it back to the base camp. One out of every five climbers who make it to the summit dies during their descent. The key is establishing a contingency plan in case the climbers encounter hard going or the weather changes. Guides establish a predetermined turnaround time (i.e., 2:00 P.M.) to ensure a safe return no matter how close the climbers are to the summit. Accepting the time takes tremendous discipline. One who was caught up by time was solo climber Goran Krupp. He turned back 1,000 feet from the top after bicycling 8,000 miles from Stockholm to Katmandu!

Many lives have been lost by failing to adhere to the turnback time and pushing forward to the summit. As one climber put it, "With enough determination, any bloody idiot can get up the hill. The trick is to get back down alive."

* Jon Krakauer, *Into Thin Air* (New York: Doubleday, 1997), p. 190; Broughton Coburn, *Everest: Mountain without Mercy* (New York: National Geographic Society, 1997).

Technical Risks

Technical risks are problematic; they can often be the kind that cause the project to be shut down. What if the system or process does not work? Contingency or backup plans are made for those possibilities that are foreseen. For example, Carrier Transicold was involved in developing a new Phoenix refrigeration unit for truck-trailer applications. This new unit was to use rounded panels made of bonded metals, which at the time was new technology for Transicold. Furthermore, one of its competitors had tried unsuccessfully to incorporate similar bonded metals in their products. The project team was eager to make the new technology work, but it wasn't until the very end of the project that they were able to get the new adhesives to bond adequately to complete the project. Throughout the project, the team maintained a welded-panel fabrication approach just in case they were unsuccessful. If this contingency approach had been needed, it would have increased production costs, but the project still would have been completed on time.

In addition to backup strategies, project managers need to develop methods to quickly assess whether technical uncertainties can be resolved. The use of sophisticated CAD programs has greatly helped resolve design problems. At the same time, Smith and Reinertsen, in their book *Developing Products in Half the Time,* argue that there is no substitute for making something and seeing how it works, feels, or looks. They suggest that one should first identify the high-risk technical areas, then build models or design experiments to resolve the risk as quickly as possible. By isolating and testing the key technical questions early on in a project, project feasibility can be quickly determined and necessary adjustments made such as reworking the process or in some cases closing down the project. Usually the owner and project manager make decisions concerning technical risks.

Schedule Risks

Often organizations will defer the threat of a project coming in late until it surfaces. Here contingency funds are set aside to expedite or "crash" the project to get it back on track. Crashing, or reducing project duration, is accomplished by shortening (compressing) one or more activities on the critical path. This comes with additional costs and risk. Techniques for managing this situation are discussed in Chapter 9. Some contingency plans can avoid costly procedures. For example, schedules can be altered by working activities in parallel or using start-to-start lag relationships. Also, using the best people for high-risk tasks can relieve or lessen the chance of some risk events occurring.

Cost Risks

Projects of long duration need some contingency for price changes—which are usually upward. The important point to remember when reviewing price is to avoid the trap of using one lump sum to cover price risks. For example, if inflation has been running about 3 percent, some managers add 3 percent for all resources used in the project. This lump-sum approach does not address exactly where price protection is needed and fails to provide for tracking and control. Price risks should be evaluated item by item. Some purchases and contracts will not change over the life of the project. Those that may change should be identified and estimates made of the magnitude of change. This approach ensures control of the contingency funds as the project is implemented.

Funding Risks

What if the funding for the project is cut by 25 percent or completion projections indicate that costs will greatly exceed available funds? What are the chances of the project being

canceled before completion? Seasoned project managers recognize that a complete risk assessment must include an evaluation of funding supply. This is especially true for publicly funded projects. Case in point was the ill-fated RAH-66 Comanche helicopter which was being developed for the U.S. Army by Sikorsky Aircraft Corp. and Boeing Co. Eight billion dollars had been invested to develop a new age combat and reconnaissance helicopter, when in February 2004, the Defense Department recommended that the project be canceled. The cancellation reflected a need to cut costs and a switch toward using unmanned aircraft for surveillance as well as attack missions.

Just as government projects are subject to changes in strategy and political agenda, business firms frequently undergo changes in priorities and top management. The pet projects of the new CEO replace the pet projects of the former CEO. Resources become tight and one way to fund new projects is to cancel other projects.

Severe budget cuts or lack of adequate funding can have a devastating effect on a project. Typically, when such a fate occurs, there is a need to scale back the scope of the project to what is possible. "All-or-nothing projects" are ripe targets to budget cutters. This was the case of the Comanche helicopter once the decision was made to move away from manned reconnaissance aircraft. Here the "chunkability" of the project can be an advantage. For example, freeway projects can fall short of the original intentions but still add value for each mile completed.

On a much smaller scale, similar funding risks may exist for more mundane projects. For example, a building contractor may find that due to a sudden downturn in the stock market the owners can no longer afford to build their dream house. Or an IS consulting firm may be left empty handed when a client files for bankruptcy. In the former case the contractor may have as a contingency selling the house on the open market, while unfortunately the consulting firm will have to join the long line of creditors.

Contingency Funding and Time Buffers

Contingency funds are established to cover project risks—identified and unknown. When, where, and how much money will be spent is not known until the risk event occurs. Project "owners" are often reluctant to set up project contingency funds that seem to imply the project plan might be a poor one. Some perceive the contingency fund as an add-on slush fund. Others say they will face the risk when it materializes. Usually such reluctance to establish contingency reserves can be overcome with documented risk identification, assessment, contingency plans, and plans for when and how funds will be disbursed.

The size and amount of contingency reserves depend on uncertainty inherent in the project. Uncertainty is reflected in the "newness" of the project, inaccurate time and cost estimates, technical unknowns, unstable scope, and problems not anticipated. In practice, contingencies run from 1 to 10 percent in projects similar to past projects. However, in unique and high-technology projects it is not uncommon to find contingencies running in the 20 to 60 percent range. Use and rate of consumption of reserves must be closely monitored and controlled. Simply picking a percentage of the baseline, say, 5 percent, and calling it the contingency reserve is not a sound approach. Also, adding up all the identified contingency allotments and throwing them into one pot is not conducive to sound control of the reserve fund.

In practice, the contingency reserve fund is typically divided into budget and management reserve funds for control purposes. Budget reserves are set up to cover identified risks; these reserves are those allocated to specific segments or deliverables of the

project. Management reserves are set up to cover unidentified risks and are allocated to risks associated with the total project. The risks are separated because their use requires approval from different levels of project authority. Because all risks are probabilistic, the reserves are not included in the baseline for each work package or activity; they are only activated when a risk occurs. If an identified risk does not occur and its chance of occurring is past, the fund allocated to the risk should be deducted from the budget reserve. (This removes the temptation to use budget reserves for other issues or problems.) Of course if the risk does occur, funds are removed from the reserve and added to the cost baseline.

It is important that contingency allowances be independent of the original time and cost estimates. These allowances need to be clearly distinguished to avoid time and budget game playing.

Budget Reserves

These reserves are identified for specific work packages or segments of a project found in the baseline budget or work breakdown structure. For example, a reserve amount might be added to "computer coding" to cover the risk of "testing" showing a coding problem. The reserve amount is determined by costing out the accepted contingency or recovery plan. The budget reserve should be communicated to the project team. This openness suggests trust and encourages good cost performance. However, distributing budget reserves should be the responsibility of both the project manager and the team members responsible for implementing the specific segment of the project. If the risk does not materialize, the funds are removed from the budget reserve. Thus, budget reserves decrease as the project progresses.

Management Reserves

These reserve funds are needed to cover major unforeseen risks and, hence, are applied to the total project. For example, a major scope change may appear necessary midway in the project. Because this change was not anticipated or identified, it is covered from the management reserve. Management reserves are established *after* budget reserves are identified and funds established. These reserves are independent of budget reserves and are controlled by the project manager and the "owner" of the project. The "owner" can be internal (top management) or external to the project organization. Most management reserves are set using historical data and judgments concerning the uniqueness and complexity of the project.

Placing technical contingencies in the management reserve is a special case. Identifying possible technical (functional) risks is often associated with a new, untried, innovative process or product. Because there is a chance the innovation may not work out, a fallback plan is necessary. This type of risk is beyond the control of the project manager. Hence, technical reserves are held in the management reserve and controlled by the owner or top management. The owner and project manager decide when the contingency plan will be implemented and the reserve funds used. It is assumed there is a high probability these funds will never be used.

Table 7.1 shows the development of a contingency fund estimate for a hypothetical project. Note how budget and management reserves are kept separate; control is easily tracked using this format.

Time Buffers

Just as contingency funds are established to absorb unplanned costs, managers use time buffers to cushion against potential delays in the project. And like contingency funds, the amount of time is dependent upon the inherent uncertainty of project. The more uncertain

TABLE 7.1
Contingency Fund Estimate (Thousands of Dollars)

Activity	Budget Baseline	Budget Reserve	Project Budget
Design	$500	$15	$515
Code	900	80	980
Test	20	2	22
Subtotal	$1,420	$97	$1,517
Management reserve	—	—	50
Total	$1,420	$97	$1,567

the project the more time should be reserved for the schedule. The strategy is to assign extra time at critical moments in the project. For example, buffers are added to

A. activities with severe risks.
B. merge activities that are prone to delays due to one or more preceding activities being late.
C. noncritical activities to reduce the likelihood that they will create another critical path.
D. activities that require scarce resources to ensure that the resources are available when needed.

In the face of overall schedule uncertainty, buffers are sometimes added to the end of the project. For example, a 300-working-day project may have a 30-day project buffer. While the extra 30 days would not appear on the schedule, it is available if needed. Like management reserves, this buffer typically requires the authorization of top management. A more systematic approach to buffer management is discussed in the Chapter 8 Appendix on critical chain project management.

Step 4: Risk Response Control

The last step in the risk management process is risk control—executing the risk response strategy, monitoring triggering events, initiating contingency plans, and watching for new risks. Establishing a change management system to deal with events that require formal changes in the scope, budget, and/or schedule of the project is an essential element of risk control.

Project managers need to monitor risks just like they track project progress. Risk assessment and updating needs to be part of every status meeting and progress report system. The project team needs to be on constant alert for new, unforeseen risks. Management needs to be sensitive that others may not be forthright in acknowledging new risks and problems. Admitting that there might be a bug in the design code or that different components are not compatible reflects poorly on individual performance. If the prevailing organizational culture is one where mistakes are punished severely, then it is only human nature to protect oneself. Similarly, if bad news is greeted harshly and there is a propensity to "kill the messenger," then participants will be reluctant to speak freely. The tendency to suppress bad news is compounded when individual responsibility is vague and the project team is under extreme pressure from top management to get the project done quickly.

Project managers need to establish an environment in which participants feel comfortable raising concerns and admitting mistakes. The norm should be that mistakes are acceptable, hiding mistakes is intolerable. Problems should be embraced not denied. Participants should

be encouraged to identify problems and new risks. Here a positive attitude by the project manager toward risks is a key.

On large, complex projects it may be prudent to repeat the risk identification/assessment exercise with fresh information. Risk profiles should be reviewed to test to see if the original responses held true. Relevant stakeholders should be brought into the discussion. While this may not be practical on an ongoing basis, project managers should touch base with them on a regular basis or hold special stakeholder meetings to review the status of risks on the project.

A second key for controlling the cost of risks is documenting responsibility. This can be problematic in projects involving multiple organizations and contractors. Responsibility for risk is frequently passed on to others with the statement, "That is not my worry." This mentality is dangerous. Each identified risk should be assigned (or shared) by mutual agreement of the owner, project manager, and the contractor or person having line responsibility for the work package or segment of the project. It is best to have the line person responsible approve the use of budget reserve funds and monitor their rate of usage. If management reserve funds are required, the line person should play an active role in estimating additional costs and funds needed to complete the project. Having line personnel participate in the process focuses attention on the management reserve, control of its rate of usage, and early warning of potential risk events. If risk management is not formalized, responsibility and responses to risk will be ignored—*it is not my area.*

The bottom line is that project managers and team members need to be vigilant in monitoring potential risks and identify new land mines that could derail a project. Risk assessment has to be part of the working agenda of status meetings and when new risks emerge they need to be analyzed and incorporated into the risk management process.

Change Control Management

A major element of the risk control process is change management. Every detail of a project plan will not materialize as expected. Coping with and controlling project changes present a formidable challenge for most project managers. Changes come from many sources such as the project customer, owner, project manager, team members, and occurrence of risk events. Most changes easily fall into three categories:

1. Scope changes in the form of design or additions represent big changes; for example, customer requests for a new feature or a redesign that will improve the product.
2. Implementation of contingency plans, when risk events occur, represent changes in baseline costs and schedules.
3. Improvement changes suggested by project team members represent another category.

Because change is inevitable, a well-defined change review and control process should be set up early in the project planning cycle.

Change control systems involve reporting, controlling, and recording changes to the project baseline. (Note: Some organizations consider change control systems part of configuration management.) In practice most change control systems are designed to accomplish the following:

1. Identify proposed changes.
2. List expected effects of proposed change(s) on schedule and budget.
3. Review, evaluate, and approve or disapprove changes formally.

FIGURE 7.9

Change Control Process

4. Negotiate and resolve conflicts of change, conditions, and cost.

5. Communicate changes to parties affected.

6. Assign responsibility for implementing change.

7. Adjust master schedule and budget.

8. Track all changes that are to be implemented.

As part of the project communication plan, stakeholders define up front the communication and decision-making process that will be used to evaluate and accept changes. The process can be captured in a flow diagram like the one presented in Figure 7.9. On small projects this process may simply entail approval of a small group of stakeholders. On larger projects more elaborate decision-making processes are established, with different processes being used for different kinds of change. For example, changes in performance requirements may require multiple sign-offs, including the project sponsor and client, while switching suppliers may be authorized by the project manager. Regardless of the nature of the project, the goal is to establish the process for introducing necessary changes in the project in a timely and effective manner.

Of particular importance is assessing the impact of the change on the project. Often solutions to immediate problems have adverse consequence on other aspects of a project. For example, in overcoming a problem with the exhaust system for a hybrid automobile, the design engineers contributed to the prototype exceeding weight parameters. It is important that the implications of changes are assessed by people with appropriate expertise and perspective. On construction projects this is often the responsibility of the architecture firm, while "software architects" perform a similar function on software development efforts.

Organizations use change request forms and logs to track proposed changes. An example of a simplified change request form is depicted in Figure 7.10. Typically change request forms include a description of the change, the impact of not approving the change, the impact of the change on project scope/schedule/cost, and defined signature paths for review as well as a tracking log number.

An abridged version of a change request log for a construction project is presented in Figure 7.11. These logs are used to monitor change requests. They typically summarize the status of all outstanding change requests and include such useful information as source and date of the change, document codes for related information, cost estimates, and the current status of the request.

Every approved change must be identified and integrated into the plan of record through changes in the project WBS and baseline schedule. The plan of record is the current official plan for the project in terms of scope, budget, and schedule. The plan of record serves as a change management benchmark for future change requests as well as the baseline for evaluating project progress.

If the change control system is not integrated with the WBS and baseline, project plans and control will soon self-destruct. Thus, one of the keys to a successful change control process is document, document, document! The benefits derived from change control systems are the following:

1. Inconsequential changes are discouraged by the formal process.

2. Costs of changes are maintained in a log.

3. Integrity of the WBS and performance measures is maintained.

4. Allocation and use of budget and management reserve funds are tracked.

5. Responsibility for implementation is clarified.

FIGURE 7.10
Sample Change Request

Project name *Irish/Chinese culture exchange* Project sponsor *Irish embassy*

Request number ___12___ Date *June 6, 2xxx*

Originator *Jennifer McDonald*

Change requested by *Chinese culture office*

Description of requested change

1. *Request river dancers to replace small Irish dance group.*
2. *Request one combination dance with river dancers and China ballet group.*

Reason for change

River dancers will enhance stature of event. The group is well known and loved by Chinese people.

Areas of impact of proposed change–describe each on separate sheet

[X] Scope [X] Cost [] Other _____

[] Schedule [] Risk

Disposition	Priority	Funding Source
[] Approve	[] Emergency	[] Mgmt. reserve
[X] Approve as amended	[X] Urgent	[] Budget reserve
[] Disapprove	[] Low	[X] Customer
[] Deferred		[] Other

Sign-off Approvals

Project manager *William O'Mally* Date *June 12, 2xxx*

Project sponsor *Kenneth Thompson* Date *June 13, 2xxx*

Project customer *Hong Lee* Date *June 18, 2xxx*

Other _____ Date _____

6. Effect of changes is visible to all parties involved.
7. Implementation of change is monitored.
8. Scope changes will be quickly reflected in baseline and performance measures.

Clearly, change control is important and requires that someone or some group be responsible for approving changes, keeping the process updated, and communicating changes to the project team and relevant stakeholders. Project control depends heavily on keeping the change control process current. This historical record can be used for satisfying customer inquiries, identifying problems in post-project audits, and estimating future project costs.

FIGURE 7.11 **Change Request Log**

	OWNER REQUESTED CHANGE STATUS REPORT—OPEN ITEMS						OSU—WEATHERFORD
		REFERENCE	DATES				
RC#	DESCRIPTION	DOCUMENT	DATE REC'D	DATE SUBMIT	AMOUNT	STATUS	COMMENTS
51	Sewer work offset				−188,129	OPEN	FUNDING FROM OTHER SOURCE
52	Stainless Plates at restroom Shower Valves	ASI 56	1/5/2008	3/30/2008	9,308	APPROVED	
53	Waterproofing Options	ASI 77	1/13/2008		169,386	OPEN	
54	Change Electrical floor box spec change	RFI 113	12/5/2008	3/29/2008	2,544	SUBMIT	
55	VE Option for Style and rail doors	Door samples	1/14/2008		−20,000	ROM	
56	Pressure Wash C tower	Owner request	3/15/2008	3/30/2008	14,861	SUBMIT	
57	Fire Lite glass in stairs	Owner request			8,000	QUOTE	ROM BASED ON FIRELITE NT
58	Cyber Café added tele/OFOI equipment	ASI 65	1/30/2008	3/29/2008	4,628	APPROVED	
59	Additional Dampers in C wing	ASI 68	2/4/2008	3/29/2008	1,085	SUBMIT	
60	Revise Corridor ceilings	ASI 72	2/13/2008	3/31/2008	−3,755	SUBMIT	

OPEN—Requires estimate SUBMIT—RC letter submitted ASI—Architect's supplemental instructions
ROM—Rough Order magnitde APPROVED—RC letter approved RFI—Request for information
QUOTE—Subcontractor quotes REVISE—RC letter to be reviewed

Summary

To put the processes discussed in this chapter in proper perspective one should recognize that the essence of project management is risk management. Every technique in this book is really a risk management technique. Each in its own way tries to prevent something bad from happening. Project selection systems try to reduce the likelihood that projects will not contribute to the mission of the firm. Project scope statements, among other things, are designed to avoid costly misunderstandings and reduce scope creep. Work breakdown structures reduce the likelihood that some vital part of the project will be omitted or that the budget estimates are unrealistic. Teambuilding reduces the likelihood of dysfunctional conflict and breakdowns in coordination. All of the techniques try to increase stakeholder satisfaction and increase the chances of project success.

From this perspective managers engage in risk management activities to compensate for the uncertainty inherent in project management and that things never go according to plan. Risk management is proactive not reactive. It reduces the number of surprises and leads to a better understanding of the most likely outcomes of negative events.

Although many managers believe that in the final analysis, risk assessment and contingency depend on subjective judgment, some standard method for identifying, assessing,

and responding to risks should be included in all projects. The very process of identifying project risks forces some discipline at all levels of project management and improves project performance.

Contingency plans increase the chance that the project can be completed on time and within budget. Contingency plans can be simple "work-arounds" or elaborate detailed plans. Responsibility for risks should be clearly identified and documented. It is desirable and prudent to keep a reserve as a hedge against project risks. Budget reserves are linked to the WBS and should be communicated to the project team. Control of management reserves should remain with the owner, project manager, and line person responsible. Use of contingency reserves should be closely monitored, controlled, and reviewed throughout the project life cycle.

Experience clearly indicates that using a formal, structured process to handle possible foreseen and unforeseen project risk events minimizes surprises, costs, delays, stress, and misunderstandings. Risk management is an iterative process that occurs throughout the lifespan of the project. When risk events occur or changes are necessary, using an effective change control process to quickly approve and record changes will facilitate measuring performance against schedule and cost. Ultimately successful risk management requires a culture in which threats are embraced not denied and problems are identified not hidden.

Key Terms

Avoiding risk	Mitigating risk	Scenario analysis
Budget reserve	Risk	Sharing risk
Change management system	Risk breakdown structure (RBS)	Time buffer
Contingency plan	Risk profile	Transferring risk
Management reserve	Risk severity matrix	

Review Questions

1. Project risks can/cannot be eliminated if the project is carefully planned. Explain.
2. The chances of risk events occurring and their respective costs increasing change over the project life cycle. What is the significance of this phenomenon to a project manager?
3. What is the difference between avoiding a risk and accepting a risk?
4. What is the difference between mitigating a risk and contingency planning?
5. Explain the difference between budget reserves and management reserves.
6. How are the work breakdown structure and change control connected?
7. What are the likely outcomes if a change control process is not used? Why?

Exercises

1. Gather a small team of students. Think of a project most students would understand; the kinds of tasks involved should also be familiar. Identify and assess major and minor risks inherent to the project. Decide on a response type. Develop a contingency plan for two to four identified risks. Estimate costs. Assign contingency reserves. How much reserve would your team estimate for the whole project? Justify your choices and estimates.
2. You have been assigned to a project risk team of five members. Because this is the first time your organization has formally set up a risk team for a project, it is hoped that your

team will develop a process that can be used on all future projects. Your first team meeting is next Monday morning. Each team member has been asked to prepare for the meeting by developing, in as much detail as possible, an outline that describes how you believe the team should proceed in handling project risks. Each team member will hand out their proposed outline at the beginning of the meeting. Your outline should include but not be limited to the following information:

a. Team objectives.

b. Process for handling risk events.

c. Team activities.

d. Team outputs.

3. The Manchester United Soccer Tournament project team (Review Manchester United case at the end of Chapter 4) has identified the following potential risks to their project:

a. Referees failing to show up at designated games.

b. Fighting between teams.

c. Pivotal error committed by a referee that determines the outcome of a game.

d. Abusive behavior along the sidelines by parents.

e. Inadequate parking.

f. Not enough teams sign up for different age brackets.

g. Serious injury.

How would you recommend that they respond (i.e., avoid, accept, . . .) to these risks and why?

4. Search the World Wide Web (WWW) using the key words: "best practices, project management." What did you find? How might this information be useful to a project manager?

References

Atkinson, W., "Beyond the Basics," *PM Network,* May 2003, pp. 38–43.

Baker, B., and R. Menon, "Politics and Project Performance: The Fourth Dimension of Project Management," *PM Network,* 9 (11) November 1995, pp. 16–21.

Carr, M. J., S. L. Konda, I. Monarch, F. C. Ulrich, and C. F. Walker, "Taxonomy-Based Risk Identification," *Technical Report CMU/SEI-93-TR 6, Software Engineering Institute,* Carnegie Mellon University, Pittsburgh, 1993.

Ford, E. C., J. Duncan, A. G. Bedeian, P. M. Ginter, M. D. Rousculp, and A. M. Adams, "Mitigating Risks, Visible Hands, Inevitable Disasters, and Soft Variables: Management Research that Matters to Managers," *Academy of Management Executive,* 19 (4) November 2005, pp. 24–38.

Graves, R., "Qualitative Risk Assessment," *PM Network,* 14 (10) October 2000, pp. 61–66.

Gray, C. F., and R. Reinman, "PERT Simulation: A Dynamic Approach to the PERT Technique," *Journal of Systems Management,* March 1969, pp. 18–23.

Hamburger, D. H., "The Project Manager: Risk Taker and Contingency Planner," *Project Management Journal,* 21 (4) 1990, pp. 11–16.

Hulett, D. T., "Project Schedule Risk Assessment," *Project Management Journal,* 26 (1) 1995, pp. 21–31.

Ingebretson, M., "In No Uncertain Terms," *PM Network,* 2002, pp. 28–32.

Levine, H. A., "Risk Management for Dummies: Managing Schedule, Cost and Technical Risk, and Contingency," *PM Network,* 9 (10) October 1995, pp. 31–33.

"Math Mistake Proved Fatal to Mars Orbiter," *The Orlando Sentinel,* November 23, 1999.

Pavlik, A., "Project Troubleshooting: Tiger Teams for Reactive Risk Management," *Project Management Journal,* 35 (4) December 2004, pp. 5–14.

Pinto, J. K., *Project Management: Achieving Competitive Advantage* (Upper Saddle River, NJ: Pearson, 2007).

Pritchard, C. L., "Advanced Risk-How Big Is Your Crystal Ball?" Proceedings of the 31st Annual Project Management Institute 2000 Seminars and Symposium, (Houston, TX, 2000) CD, pp. 933–36.

Project Management Body of Knowledge (Newton Square, PA: Project Management Institute, 2000), pp. 127–46.

Schuler, J. R., "Decision Analysis in Projects: Monte Carlo Simulation," *PM Network,* 7 (1) January 1994, pp. 30–36.

Smith, P. G., and G. M. Merritt, *Proactive Risk Management: Controlling Uncertainty in Product Development* (New York: Productivity Press, 2002).

Smith, P. G., and D. G. Reinertsen, *Developing Products in Half the Time* (New York: Van Nostrand Reinhold, 1995).

Case

Alaska Fly-Fishing Expedition*

You are sitting around the fire at a lodge in Dillingham, Alaska, discussing a fishing expedition you are planning with your colleagues at Great Alaska Adventures (GAA). Earlier in the day you received a fax from the president of BlueNote, Inc. The president wants to reward her top management team by taking them on an all-expense-paid fly-fishing adventure in Alaska. She would like GAA to organize and lead the expedition.

You have just finished a preliminary scope statement for the project (see below). You are now brainstorming potential risks associated with the project.

1. Brainstorm potential risks associated with this project. Try to come up with at least five different risks.
2. Use a risk assessment form similar to Figure 7.6 to analyze identified risks.
3. Develop a risk response matrix similar to Figure 7.8 to outline how you would deal with each of the risks.

PROJECT SCOPE STATEMENT

PROJECT OBJECTIVE

To organize and lead a five-day fly-fishing expedition down the Tikchik River system in Alaska from June 21 to 25 at a cost not to exceed $27,000.

* This case was prepared with the assistance of Stuart Morigeau.

DELIVERABLES

- Provide air transportation from Dillingham, Alaska, to Camp I and from Camp II back to Dillingham.
- Provide river transportation consisting of two eight-man drift boats with outboard motors.
- Provide three meals a day for the five days spent on the river.
- Provide four hours fly-fishing instruction.
- Provide overnight accommodations at the Dillingham lodge plus three four-man tents with cots, bedding, and lanterns.
- Provide four experienced river guides who are also fly fishermen.
- Provide fishing licenses for all guests.

MILESTONES

1. Contract signed January 22.
2. Guests arrive in Dillingham June 20.
3. Depart by plane to Base Camp I June 21.
4. Depart by plane from Base Camp II to Dillingham June 25.

TECHNICAL REQUIREMENTS

1. Fly in air transportation to and from base camps.
2. Boat transportation within the Tikchik River system.
3. Digital cellular communication devices.
4. Camps and fishing conform to state of Alaska requirements.

LIMITS AND EXCLUSIONS

1. Guests are responsible for travel arrangements to and from Dillingham, Alaska.
2. Guests are responsible for their own fly-fishing equipment and clothing.
3. Local air transportation to and from base camps will be outsourced.
4. Tour guides are not responsible for the number of King Salmon caught by guests.

CUSTOMER REVIEW

The president of BlueNote, Inc.

Case

Silver Fiddle Construction

You are the president of Silver Fiddle Construction (SFC), which specializes in building high-quality, customized homes in the Grand Junction, Colorado, area. You have just been hired by the Czopeks to build their dream home. You operate as a general contractor and employ only a part-time bookkeeper. You subcontract work to local trade professionals. Housing construction in Grand Junction is booming. You are tentatively scheduled to complete 11 houses this year. You have promised the Czopeks that the final costs will range from $450,000 to $500,000 and that it will take five months to complete the house once groundbreaking has begun. The Czopeks are willing to have the project delayed in order to save costs.

You have just finished a preliminary scope statement for the project (see below). You are now brainstorming potential risks associated with the project.

1. Identify potential risks associated with this project. Try to come up with at least five different risks.
2. Use a risk assessment form similar to Figure 7.6 to analyze identified risks.
3. Develop a risk response matrix similar to Figure 7.8 to outline how you would deal with each of the risks.

PROJECT SCOPE STATEMENT

PROJECT OBJECTIVE

To construct a high-quality, custom home within five months at a cost not to exceed $500,000.

DELIVERABLES

- A 2,500-square-foot, $2\frac{1}{2}$-bath, 3-bedroom, finished home.
- A finished garage, insulated and sheetrocked.
- Kitchen appliances to include range, oven, microwave, and dishwasher.
- High-efficiency gas furnace with programmable thermostat.

MILESTONES

1. Permits approved July 5.
2. Foundation poured July 12.
3. "Dry in"—framing, sheathing, plumbing, electrical, and mechanical inspections—passed September 25.
4. Final inspection November 7.

TECHNICAL REQUIREMENTS

1. Home must meet local building codes.
2. All windows and doors must pass NFRC class 40 energy ratings.
3. Exterior wall insulation must meet an "R" factor of 21.
4. Ceiling insulation must meet an "R" factor of 38.
5. Floor insulation must meet an "R" factor of 25.
6. Garage will accommodate two cars and one 28-foot-long Winnebago.
7. Structure must pass seismic stability codes.

LIMITS AND EXCLUSIONS

1. The home will be built to the specifications and design of the original blueprints provided by the customer.
2. Owner is responsible for landscaping.
3. Refrigerator is not included among kitchen appliances.
4. Air conditioning is not included, but house is prewired for it.
5. SFC reserves the right to contract out services.

CUSTOMER REVIEW

"Bolo" and Izabella Czopek.

Case

Peak LAN Project

Peak Systems is a small, information systems consulting firm located in Meridian, Louisiana. Peak has just been hired to design and install a local area network (LAN) for the city of Meridian's social welfare agency. You are the manager for the project, which includes one Peak professional and two interns from a local university. You have just finished a preliminary scope statement for the project (see below). You are now brainstorming potential risks associated with the project.

1. Identify potential risks associated with this project. Try to come up with at least five different risks.
2. Use a risk assessment form similar to Figure 7.6 to analyze identified risks.
3. Develop a risk response matrix similar to Figure 7.8 to outline how you would deal with each of the risks.

PROJECT SCOPE STATEMENT

PROJECT OBJECTIVE

To design and install a local area network (LAN) within one month with a budget not to exceed $90,000 for the Meridian Social Service Agency.

DELIVERABLES

- Twenty workstations and twenty laptop computers.
- Server with dual-core processors.
- Two color laser printers.
- Windows Vista server and workstation operating system.
- Four hours of introduction training for client's personnel.
- Sixteen hours of training for client network administrator.
- Fully operational LAN system.

MILESTONES

1. Hardware January 22.
2. Setting users' priority and authorization January 26.
3. In-house whole network test completed February 1.
4. Client site test completed February 2.
5. Training completed February 16.

TECHNICAL REQUIREMENTS

1. Workstations with 17-inch flat panel monitors, dual-core processors, 1 GB RAM, 8X DVD+RW, wireless card, Ethernet card, 80 GB hard drive.
2. Laptops with 12-inch display monitor, dual-core processors, 512 MB RAM, 8X DVD+RW, wireless card, Ethernet card, 60 GB hard drive and weigh less than $4\frac{1}{2}$ lbs.

3. Wireless network interface cards and Ethernet connections.
4. System must support Windows Vista platform.
5. System must provide secure external access for field workers.

LIMITS AND EXCLUSIONS

1. System maintenance and repair only up to one month after final inspection.
2. Warranties transferred to client.
3. Only responsible for installing software designated by the client two weeks before the start of the project.
4. Client will be billed for additional training beyond that prescribed in the contract.

CUSTOMER REVIEW

Director of the city of Meridian's Social Service Agency.

Case

XSU Spring Concert

You are a member of the X State University (XSU) student body entertainment committee. Your committee has agreed to sponsor a Spring concert. The motive behind this concert is to offer a safe alternative to Hasta Weekend. Hasta Weekend is a spring event in which students from XSU rent houseboats and engage in heavy partying. Traditionally this occurs during the last weekend in May. Unfortunately, the partying has a long history of getting out of hand, sometimes leading to fatal accidents. After one such tragedy last Spring, your committee wants to offer an alternative experience for those who are eager to celebrate the change in weather and the pending end of the school year.

You have just finished a preliminary scope statement for the project (see below). You are now brainstorming potential risks associated with the project.

1. Identify potential risks associated with this project. Try to come up with at least five different risks.
2. Use a risk assessment form similar to Figure 7.6 to analyze identified risks.
3. Develop a risk response matrix similar to Figure 7.8 to outline how you would deal with each of the risks.

PROJECT SCOPE STATEMENT

PROJECT OBJECTIVE

To organize and deliver an eight-hour concert at Wahoo Stadium at a cost not to exceed $50,000 on the last Saturday in May.

DELIVERABLES

- Local advertising.
- Concert security.
- Separate Beer Garden.
- Eight hours of music and entertainment.

- Food venues.
- Souvenir concert t-shirts.
- Secure all licenses and approvals.
- Secure sponsors.

MILESTONES

1. Secure all permissions and approvals by January 15.
2. Sign big-name artist by February 15.
3. Complete artist roster by April 1.
4. Secure vendor contracts by April 15.
5. Setup completed on May 27.
6. Concert on May 28.
7. Clean-up completed by May 31.

TECHNICAL REQUIREMENTS

1. Professional sound stage and system.
2. At least one big-name artist.
3. At least seven performing acts.
4. Restroom facilities for 10,000 people.
5. Parking available for 1,000 cars.
6. Compliance with XSU and city requirements/ordinances.

LIMITS AND EXCLUSIONS

1. Performers responsible for travel arrangements to and from XSU.
2. Vendors contribute a set percentage of sales.
3. Concert must be over by 11:30 P.M.

CUSTOMER REVIEW

The president of XSU student body.

Appendix 7.1

PERT and PERT Simulation

PERT—PROGRAM EVALUATION REVIEW TECHNIQUE

In 1958 the Special Office of the Navy and the Booze, Allen, and Hamilton consulting firm developed PERT (program evaluation and review technique) to schedule the more than 3,300 contractors of the Polaris submarine project and to cover uncertainty of activity time estimates.

PERT is almost identical to the critical path method (CPM) technique except it assumes each activity duration has a range that follows a statistical distribution. PERT uses three time estimates for each activity. Basically, this means each activity duration can range from an optimistic time to a pessimistic time, and a weighted average can be computed for each

activity. Because project activities usually represent work, and because work tends to stay behind once it gets behind, the PERT developers chose an approximation of the *beta distribution* to represent activity durations. This distribution is known to be flexible and can accommodate empirical data that do not follow a normal distribution. The activity durations can be skewed more toward the high or low end of the data range. Figure A7.1A depicts a *beta distribution* for activity durations that is skewed toward the right and is representative of work that tends to stay late once it is behind. The distribution for the project duration is represented by a normal (symmetrical) distribution shown in Figure A7.1B. The project distribution represents the sum of the weighted averages of the activities on the critical path(s).

Knowing the weighted average and variances for each activity allows the project planner to compute the probability of meeting different project durations. Follow the steps described in the hypothetical example given next. (The jargon is difficult for those not familiar with statistics, but the process is relatively simple after working through a couple of examples.)

The weighted average activity time is computed by the following formula:

$$t_e = \frac{a + 4m + b}{6} \tag{7.1}$$

where t_e = weighted average activity time

 a = optimistic activity time (1 chance in 100 of completing the activity earlier under *normal* conditions)

 b = pessimistic activity time (1 chance in 100 of completing the activity later under *normal* conditions)

 m = most likely activity time

When the three time estimates have been specified, this equation is used to compute the weighted average duration for each activity. The average (deterministic) value is placed on the project network as in the CPM method and the early, late, slack, and project completion times are computed as they are in the CPM method.

The variability in the activity time estimates is approximated by the following equations: Equation 7.2 represents the standard deviation for the *activity*. Equation 7.3 represents the standard deviation for the *project*. Note the standard deviation of the activity is

FIGURE A7.1 **Activity and Project Frequency Distributions**

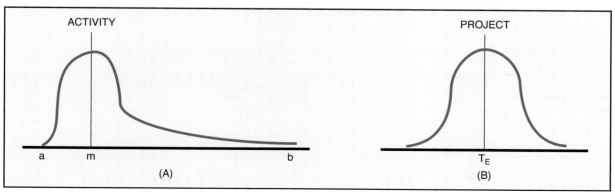

squared in this equation; this is also called variance. This sum includes only activities on the critical path(s) or path being reviewed.

$$\sigma_{t_e} = \left(\frac{b - a}{6} \right) \tag{7.2}$$

$$\sigma_{T_E} = \sqrt{\Sigma \sigma t_e^2} \tag{7.3}$$

Finally, the average project duration (T_E) is the sum of all the average activity times along the critical path (sum of t_e), and it follows a normal distribution.

Knowing the average project duration and the variances of activities allows the probability of completing the project (or segment of the project) by a specific time to be computed using standard statistical tables. The equation below (Equation 7.4) is used to compute the "Z" value found in statistical tables (Z = number of standard deviations from the mean), which, in turn, tells the probability of completing the project in the time specified.

$$Z = \frac{T_S - T_E}{\sqrt{\Sigma \sigma t_e^2}} \tag{7.4}$$

where T_E = critical path duration
 T_S = scheduled project duration
 Z = probability (of meeting scheduled duration) found in statistical
 Table A7.2

A HYPOTHETICAL EXAMPLE USING THE PERT TECHNIQUE

The activity times and variances are given in Table A7.1. The project network is presented in Figure A7.2. This figure shows the project network as AOA and AON. The AON network is presented as a reminder that PERT can use AON networks as well as AOA.

The expected project duration (T_E) is 64 time units; the critical path is 1, 2, 3, 5, 6. With this information, the probability of completing the project by a specific date can easily be computed using standard statistical methods. For example, what is the probability the project will be completed before a scheduled time (T_S) of 67? The normal curve for the project would appear as shown in Figure A7.3.

TABLE A7.1
Activity Times and Variances

Activity	a	m	b	t_e	$[(b - a)/6]^2$
1–2	17	29	47	30	25
2–3	6	12	24	13	9
2–4	16	19	28	20	4
3–5	13	16	19	16	1
4–5	2	5	14	6	4
5–6	2	5	8	5	1

Using the formula for the Z value, the probability can be computed as follows:

$$Z = \frac{T_S - T_E}{\sqrt{\Sigma \sigma_{t_e}^2}}$$

$$= \frac{67 - 64}{\sqrt{25 + 9 + 1 + 1}}$$

$$= \frac{+3}{\sqrt{36}}$$

$$= +0.50$$

$$P = 0.69$$

FIGURE A7.2
Hypothetical Network

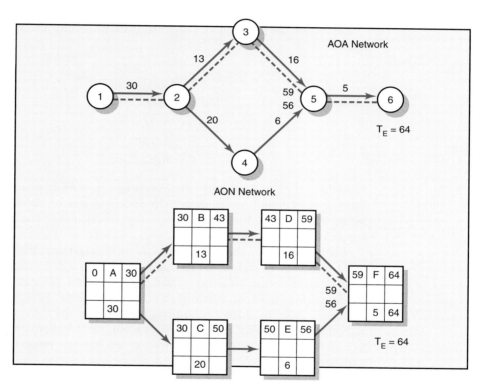

FIGURE A7.3
Possible Project Durations

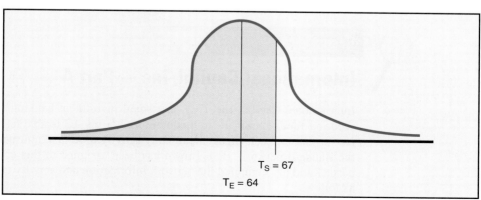

TABLE A7.2

Z Value	Probability	Z Value	Probability
−2.0	0.02	+2.0	0.98
−1.5	0.07	+1.5	0.93
−1.0	0.16	+1.0	0.84
−0.7	0.24	+0.7	0.76
−0.5	0.31	+0.5	0.69
−0.3	0.38	+0.3	0.62
−0.1	0.36	+0.1	0.54

Reading from Table A7.2, a *Z* value of +0.5 gives a probability of 0.69, which is interpreted to mean there is a 69 percent chance of completing the project on or before 67 time units.

Conversely, the probability of completing the project by time period 60 is computed as follows:

$$Z = \frac{60 - 64}{\sqrt{25 + 9 + 1 + 1}}$$
$$= \frac{-4}{\sqrt{36}}$$
$$= -0.67$$
$$P \approx 0.26$$

From Table A7.2, a *Z* value of −0.67 gives an approximate probability of 0.26, which is interpreted to mean there is about a 26 percent chance of completing the project on or before 60 time units. Note that this same type of calculation can be made for any path or segment of a path in the network.

When such probabilities are available to management, trade-off decisions can be made to accept or reduce the risk associated with a particular project duration. For example, if the project manager wishes to improve the chances of completing the project by 64 time units, at least two choices are available. First, management can spend money up front to change conditions that will reduce the duration of one or more activities on the critical path. A more prudent, second alternative would be to allocate money to a contingency fund and wait to see how the project is progressing as it is implemented.

Case

International Capital, Inc.—Part A

International Capital, Inc. (IC), is a small investment banking firm that specializes in securing funds for small- to medium-sized firms. IC is able to use a standardized project format for each engagement. Only activity times and unusual circumstances change the standard network. Beth Brown has been assigned to this client as project manager partner and has compiled the network information and activity times for the latest client as follows:

Activity	Description	Immediate Predecessor
A	Start story draft using template	—
B	Research client firm	—
C	Create "due diligence" rough draft	A, B
D	Coordinate needs proposal with client	C
E	Estimate future demand and cash flows	C
F	Draft future plans for client company	E
G	Create and approve legal documents	C
H	Integrate all drafts into first-draft proposal	D, F, G
I	Line up potential sources of capital	G, F
J	Check, approve, and print final legal proposal	H
K	Sign contracts and transfer funds	I, J

	Time in Workdays		
Activity	Optimistic	Most Likely	Pessimistic
A	4	7	10
B	2	4	8
C	2	5	8
D	16	19	28
E	6	9	24
F	1	7	13
G	4	10	28
H	2	5	14
I	5	8	17
J	2	5	8
K	17	29	45

MANAGERIAL REPORT

Brown and other broker partners have a policy of passing their plan through a project review committee of colleagues. This committee traditionally checks that all details are covered, times are realistic, and resources are available. Brown wishes you to develop a report that presents a planned schedule and expected project completion time in workdays. Include a project network in your report. The average duration for a sourcing capital project is 70 workdays. IC partners have agreed it is good business to set up projects with a 95 percent chance of attaining the plan. How does this project stack up with the average project? What would the average have to be to ensure a 95 percent chance of completing the project in 70 workdays?

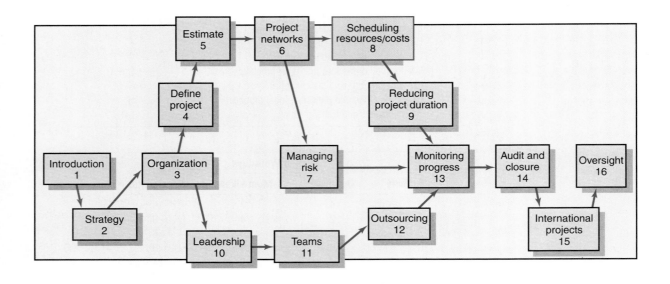

Scheduling Resources and Costs

Overview of the Resource Scheduling Problem

Types of Resource Constraints

Classification of a Scheduling Problem

Resource Allocation Methods

Computer Demonstration of Resource-Constrained Scheduling

Splitting Activities

Benefits of Scheduling Resources

Assigning Project Work

Multiproject Resource Schedules

Using the Resource Schedule to Develop a Project Cost Baseline

Summary

Appendix 8.1: The Critical-Chain Approach

Scheduling Resources and Costs

Project network times are not a schedule until resources have been assigned. Cost estimates are not a budget until they have been time-phased.

We have consistently stressed that up-front planning results in big payoffs. For those who have diligently worked through the earlier planning processes chapters, you are nearly ready to launch your project. This chapter completes the final two planning tasks that become the master plan for your project—resource and cost scheduling. (See Figure 8.1.) This process uses the resource schedule to assign *time-phased* costs that provide the project budget *baseline*. Given this time-phased baseline, comparisons can be made with actual and planned schedule and costs. This chapter first discusses the process for developing the project resource schedule. This resource schedule will be used to assign the time-phased budgeted values to create a project budget baseline.

There are always more project proposals than there are available resources. The priority system needs to select projects that best contribute to the organization's objectives, within the constraints of the resources available. If all projects and their respective resources are computer scheduled, the feasibility and impact of adding a new project to those in process can be quickly assessed. With this information the project priority team will add a new project only if resources are available to be formally committed to that specific project. This chapter examines methods of scheduling resources so the team can make realistic judgments of resource availability and project durations. The project manager uses the same schedule for implementing the project. If changes occur during project implementation, the computer schedule is easily updated and the effects easily assessed.

Overview of the Resource Scheduling Problem

After staff and other resources were assigned to her project, a project manager listed the following questions that still needed to be addressed:

- Will the assigned labor and/or equipment be adequate and available to deal with my project?
- Will outside contractors have to be used?
- Do unforeseen resource dependencies exist? Is there a new critical path?
- How much flexibility do we have in using resources?
- Is the original deadline realistic?

Clearly, this project director has a good understanding of the problems she is facing. Any project scheduling system should facilitate finding quick, easy answers to these questions.

FIGURE 8.1

Project Planning Process

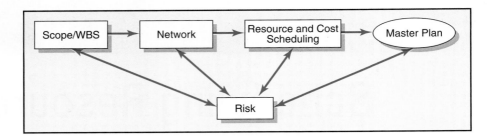

The planned network and activity project duration times found in previous chapters fail to deal with resource usage and availability. The time estimates for the work packages and network times were made independently with the implicit assumption that resources would be available. This may or may not be the case.

If resources are adequate but the demand varies widely over the life of the project, it may be desirable to even out resource demand by delaying noncritical activities (using slack) to lower peak demand and, thus, increase resource utilization. This process is called *resource leveling* or *smoothing.*

On the other hand, if resources are not adequate to meet peak demands, the late start of some activities must be delayed, and the duration of the project may be increased. This process is called *resource-constrained scheduling.* One research study by your author of more than 50 projects found that planned project network durations were increased 38 percent when resources were scheduled.

The consequences of failing to schedule limited resources are a costly activity and project delays usually manifest themselves midway in the project when quick corrective action is difficult. An additional consequence of failing to schedule resources is ignoring the peaks and valleys of resource usage over the duration of the project. Because project resources are usually overcommitted and because resources seldom line up by availability and need, procedures are needed to deal with these problems. This chapter addresses methods available to project managers for dealing with resource utilization and availability through resource leveling and resource-constrained scheduling.

Up to now the start and sequence of activities has been based solely on technical or logical considerations. For example, a project network for framing a house might show three activities in a sequence: (1) pour foundation, (2) build frame, and (3) cover roof. A network for a new software project could place the activities in the network, as a sequence of (1) design, (2) code, and (3) test. In other words, you cannot logically perform activity 2 until 1 is completed, and so on. The project network depicts technical constraints. (See Figure 8.2A). The network assumes the personnel and equipment are available to perform the required work. This is often not the case!

The absence or shortage of resources can drastically alter technical constraints. A project network planner may assume adequate resources and show activities occurring in parallel. However, parallel activities hold potential for resource conflicts. For example, assume you are planning a wedding reception that includes four activities—(1) plan, (2) hire band, (3) decorate hall, and (4) purchase refreshments. Each activity takes one day. Activities 2, 3, and 4 could be done in parallel by different people. There is no technical reason or dependency of one on another (see Figure 8.2B). However, if one person must perform all activities, the resource constraint requires the activities be performed in sequence or series. Clearly the consequence is a delay of these activities and a very different set of network relationships (see Figure 8.2C). Note that the

FIGURE 8.2
Constraint Examples

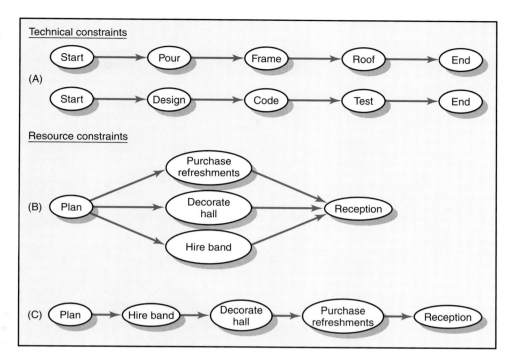

resource dependency takes priority over the technological dependency but *does not violate the technological dependency;* that is, hire, decorate, and purchase may now have to take place in sequence rather than concurrently, but they must all be completed before the reception can take place.

The interrelationships and interactions among time and resource constraints are complex for even small project networks. Some effort to examine these interactions before the project begins frequently uncovers surprising problems. Project managers who do not consider resource availability in moderately complex projects usually learn of the problem when it is too late to correct. A deficit of resources can significantly alter project dependency relationships, completion dates, and project costs. Project managers must be careful to schedule resources to ensure availability in the right quantities and at the right time. Fortunately, there are computer software programs that can identify resource problems during the early project planning phase when corrective changes can be considered. These programs only require activity resource needs and availability information to schedule resources.

See the Snapshot from Practice: Working in Tight Places for a third constraint that impinges on project schedules.

Types of Resource Constraints

Resources are people, equipment, and material that can be drawn on to accomplish something. In projects the availability or unavailability of resources will often influence the way projects are managed.

Digital Vision/Punchstock.

In rare situations, physical factors cause activities that would normally occur in parallel to be constrained by contractual or environmental conditions. For example, in theory the renovation of a sailboat compartment might involve four to five tasks that can be done independently. However, since space allows only one person to work at one time, all tasks have to be performed sequentially. Likewise, on a mining project it may be physically possible for only two miners to work in a shaft at a time. Another example would be the erection of a communication tower and nearby groundwork. For safety considerations, the contract prohibits groundwork within 2,000 feet of the tower construction.

The procedures for handling physical factors are similar to those used for resource constraints.

1. People This is the most obvious and important project resource. Human resources are usually classified by the skills they bring to the project—for example, programmer, mechanical engineer, welder, inspector, marketing director, supervisor. In rare cases some skills are interchangeable, but usually with a loss of productivity. The many differing skills of human resources add to the complexity of scheduling projects.

2. Materials Project materials cover a large spectrum: for example, chemicals for a scientific project, concrete for a road project, survey data for a marketing project.

Material availability and shortages have been blamed for the delay of many projects. When it is known that a lack of availability of materials is important and probable, materials should be included in the project network plan and schedule. For example, delivery and placement of an oil rig tower in a Siberian oil field has a very small time window during one summer month. Any delivery delay means a one-year, costly delay. Another example in which material was the major resource scheduled was the resurfacing and replacement of some structures on the Golden Gate Bridge in San Francisco. Work on the project was limited to the hours between midnight and 5:00 A.M. with a penalty of

$1,000 per minute for any work taking place after 5:00 A.M. Scheduling the arrival of replacement structures was an extremely important part of managing the five-hour work-time window of the project. Scheduling materials has also become important in developing products where time-to-market can result in loss of market share.

3. Equipment Equipment is usually presented by type, size, and quantity. In some cases equipment can be interchanged to improve schedules, but this is not typical. Equipment is often overlooked as a constraint. The most common oversight is to assume the resource pool is more than adequate for the project. For example, if a project needs one earth-moving tractor six months from now and the organization owns four, it is common to assume the resource will not delay the pending project. However, when the earth-moving tractor is due on-site in six months, all four machines in the pool might be occupied on other projects. In multiproject environments it is prudent to use a common resource pool for all projects. This approach forces a check of resource availability across all projects and reserves the equipment for specific project needs in the future. Recognition of equipment constraints before the project begins can avoid high crashing or delay costs.

Classification of a Scheduling Problem

Most of the scheduling methods available today require the project manager to classify the project as either *time constrained* or *resource constrained.* Project managers need to consult their priority matrix (see Figure 4.2) to determine which case fits their project. One simple test to determine if the project is time or resource constrained is to ask, "If the critical path is delayed, will resources be added to get back on schedule?" If the answer is yes, assume the project is time constrained; if no, assume the project is resource constrained.

A *time-constrained project* is one that must be completed by an imposed date. If required, resources can be added to ensure the project is completed by a specific date. Although time is the critical factor, resource usage should be no more than is necessary and sufficient.

A *resource-constrained project* is one that assumes the level of resources available cannot be exceeded. If the resources are inadequate, it will be acceptable to delay the project, but as little as possible.

In scheduling terms, time constrained means time (project duration) is fixed and resources are flexible, while resource constrained means resources are fixed and time is flexible. Methods for scheduling these projects are presented in the next section.

Resource Allocation Methods

Assumptions

Ease of demonstrating the allocation methods available requires some limiting assumptions to keep attention on the heart of the problem. The rest of the chapter depends entirely on the assumptions noted here. First, splitting activities will not be allowed. This means once an activity is placed in the schedule, assume it will be worked on continuously until it is finished; hence, an activity cannot be started, stopped for a period of time, and then finished. Second, the level of resources used for an activity cannot be changed. These limiting assumptions do not exist in practice, but simplify learning. It is easy for

new project managers to deal with the reality of splitting activities and changing the level of resources when they meet them on the job.

Time-Constrained Projects: Smoothing Resource Demand

Scheduling time-constrained projects focuses on resource *utilization*. When demand for a specific resource type is erratic, it is difficult to manage, and utilization may be very poor. Practitioners have attacked the utilization problem using resource leveling techniques that balance or smooth demand for a resource. Basically, all leveling techniques delay noncritical activities by using positive slack to reduce peak demand and fill in the valleys for the resources. An example will demonstrate the basic procedure for a time-constrained project. See Figure 8.3.

For the purpose of demonstration, the Botanical Garden project uses only one resource (backhoes); all backhoes are interchangeable. The top bar chart shows the activities on a time scale. The dependencies are shown with the vertical connecting arrows. The horizontal arrows following activities represent activity slack (for example, irrigation requires six days to complete and has six days slack). The number of backhoes needed for each task is shown in the shaded activity duration block (rectangle). After the land has been scarified and the plan laid out, work can begin on the walkways, irrigation, and fencing and retaining walls simultaneously. The middle chart shows the resource profile for the backhoes. For periods 4 through 10, four backhoes are needed.

Because this project is declared time constrained, the goal will be to reduce the peak requirement for the resource and thereby increase the utilization of the resource. A quick examination of the ES (early start) resource load chart suggests only two activities have slack that can be used to reduce the peak—fence and walls provide the best choice for smoothing the resource needs. Another choice could be irrigation, but it would result in an up and down resource profile. The choice will probably center on the activity that is perceived as having the least risk of being late. The smoothed resource loading chart shows the results of delaying the fence and walls activity. Note the differences in the resource profiles. The important point is the resources needed over the life of the project have been reduced from four to three (25 percent). In addition the profile has been smoothed, which should be easier to manage.

The Botanical Garden project schedule reached the three goals of smoothing:

- The peak of demand for the resource was reduced.
- Resources over the life of the project have been reduced.
- The fluctuations in resource demand were minimized.

The latter improves the utilization of resources. Backhoes are not easily moved from location to location. There are costs associated with changing the level of resources needed. The same analogy applies to the movement of people back and forth among projects. It is well known that people are more efficient if they can focus their effort on one project rather than multitasking their time among, say, three projects.

The downside of leveling is a loss of flexibility that occurs from reducing slack. The risk of activities delaying the project also increases because slack reduction can create more critical activities and/or near-critical activities. Pushing leveling too far for a perfectly level resource profile is risky. Every activity then becomes critical.

The Botanical Garden example gives a sense of the time-constrained problem and the smoothing approach. However, in practice the magnitude of the problem is very complex for even small projects. Manual solutions are not practical. Fortunately, the software packages

FIGURE 8.3 **Botanical Garden**

Leveling resources where there is slack. →

available today have very good routines for leveling project resources. Typically, they use activities that have the most slack to level project resources. The rationale is those activities with the most slack pose the least risk. Although this is generally true, other risk factors such as reduction of flexibility to use reassigned resources on other activities or the nature of the activity (easy, complex) are not addressed using such a simple rationale. It is easy to experiment with many alternatives to find the one that best fits your project and minimizes risk of delaying the project.

Resource-Constrained Projects

When the number of people and/or equipment is not adequate to meet peak demand requirements and it is impossible to obtain more, the project manager faces a resource-constrained problem. Something has to give. The trick is to prioritize and allocate resources to minimize project delay without exceeding the resource limit or altering the technical network relationships.

The resource scheduling problem is a large combinatorial one. This means even a modest-size project network with only a few resource types might have several thousand feasible solutions. A few researchers have demonstrated *optimum* mathematical solutions to the resource allocation problem but only for small networks and very few resource types. The massive data requirements for larger problems make pure mathematical solutions (e.g., linear programming) impractical. An alternative approach to the problem has been the use of heuristics (rules of thumb) to solve large combinatorial problems. These practical decision or priority rules have been in place for many years.

Heuristics do not always yield an optimal schedule, but they are very capable of yielding a "good" schedule for very complex networks with many types of resources. The efficiency of different rules and combinations of rules has been well documented. However, because each project is unique, it is wise to test several sets of heuristics on a network to determine the priority allocation rules that minimize project delay. The computer software available today makes it very easy for the project manager to create a good resource schedule for the project. A simple example of the heuristic approach is illustrated here.

Heuristics allocate resources to activities to minimize project delay; that is, heuristics prioritize which activities are allocated resources and which activities are delayed when resources are not adequate. The following scheduling heuristics have been found to consistently minimize project delay over a large variety of projects. Schedule activities using the following heuristic priority rules in the order presented:

1. Minimum slack.
2. Smallest duration.
3. Lowest activity identification number.

The parallel method is the most widely used approach to apply heuristics. The parallel method is an iterative process that starts at the first time period of the project and schedules period-by-period any activities eligible to start. In any period when two or more activities require the same resource, the priority rules are applied. For example, if in period 5 three activities are eligible to start (i.e., have the same ES) and require the same resource, the first activity placed in the schedule would be the activity with the least slack (rule 1). However, if all activities have the same slack, the next rule would be invoked (rule 2), and the activity with the smallest duration would be placed in the schedule first. In very rare cases, when all eligible activities have the same slack and the same duration, the tie is broken by the lowest activity identification number (rule 3), since each activity has a unique ID number.

When a resource limit has been reached, the early start (ES) for succeeding activities not yet in the schedule will be delayed (and all successor activities not having free slack) and their slack reduced. In subsequent periods the procedure is repeated until the project is scheduled. The procedure is demonstrated next, see Figure 8.4. The shaded areas in the resource loading chart represent the "scheduling interval" of the *time constrained* schedule (ES through LF). You can schedule the resource any place *within* the interval and not delay the project. Scheduling the activity beyond the LF will delay the project.

The programmers are limited to three. Follow the actions described in Figures 8.4 and 8.5. Note how the limit of three programmers starts to delay the project.

The Parallel Method:

Period	Action
0–1	Only activity 1 is eligible. It requires 2 programmers. Load activity 1 into schedule.
	See Figure 8.4
1–2	No activities are eligible to be scheduled.
2–3	Activities 2, 3, and 4 are eligible to be scheduled. Activity 3 has the least slack (0)—apply rule 1. Load Activity 3 into schedule. Activity 2 is next with slack of 2; however, activity 2 requires 2 programmers and only 1 is available. Delay activity 2. Update: ES = 3, slack = 1. The next eligible activity is activity 4, since it only requires 1 programmer. Load activity 4 into schedule.
	See Figure 8.5
3–4	Activity 2 is eligible but exceeds limit of 3 programmers in pool. Delay activity 2. Update: ES = 4, slack = 0.
4–5	Activity 2 is eligible but exceeds limit of 3 programmers in pool. Delay activity 2. Update: ES = 5, LF = 11, slack = –1. Delay activity 7. Update: ES = 11, LF = 13, slack = –1.
5–6	Activity 2 is eligible but exceeds limit of 3 programmers in pool. Delay activity 2. Update: ES = 6, LF = 12, slack = –2. Delay activity 7. Update: ES = 12, LF = 14, slack = –2.
6–7	Activities 2, 5, and 6 are eligible with slack of –2, 2, and 0, respectively. Load activity 2 into schedule (rule 1). Because activity 6 has 0 slack, it is the next eligible activity. Load activity 6 into schedule (rule 1). The programmer limit of 3 is reached. Delay activity 5. Update: ES = 7, slack = 1.
7–8	Limit is reached. No programmers available. Delay activity 5. Update: ES = 8, slack = 0.
8–9	Limit is reached. No programmers available. Delay activity 5. Update: ES = 9, LF = 11, slack = –1.
9–10	Limit is reached. No programmers available. Delay activity 5. Update: ES = 10, LF = 12, slack = –2.
10–11	Activity 5 is eligible. Load activity 5 into schedule. (Note: Activity 6 does not have slack because there are no programmers available—3 maximum.)
11–12	No eligible activities.
12–13	Activity 7 is eligible. Load activity 7 into schedule.

Observe how it is necessary to update each period to reflect changes in activity early start and slack times so the heuristics can reflect changing priorities. When using the parallel scheduling method, the network in Figure 8.5 on page 243 reflects the new schedule date of 14 time units, rather than the time-constrained project duration of 12 time units. The network has also been revised to reflect new start, finish, and slack times for each activity. Note that activity 6 is still critical and has a slack of 0 time units because no resources are available (they are being used on activities 2 and 5). Compare the slack for each activity found in Figures 8.4 and 8.5; slack has been reduced significantly. Note that activity 4 has only 2 units of slack rather than what appears to be 6 slack units. This

FIGURE 8.4 **Resource-Constrained Schedule through Period 2–3**

FIGURE 8.5 **Resource Constrained Schedule through Period 5–6**

Resource constrained schedule through period 5–6

ID	RES	DUR	ES	LF	SL	0	1	2	3	4	5	6	7	8	9	10	11	12	13	14	
1	2P	2	0	2	0	2	2														
2	2P	6	2 3 4 5 6	10 11 12	8 10 -1 -2			X	X	X	X										
3	2P	4	2	6	0			2	2	2	2										
4	1P	2	2	10	6			1	1												
5	1P	2	6	10	2																
6	1P	4	6	10	0																
7	1P	2	10 11 12	12 13 14	0 -1 -2												X	X			
	Total resource load					2P	2P	3P	3P	2P	2P										
	Resource available					3P	3P	3P	3P	3P	3P	3P	3P	3P	3P	3P	3P				

Final resource constrained schedule

ID	RES	DUR	ES	LF	SL	0	1	2	3	4	5	6	7	8	9	10	11	12	13	14	
1	2P	2	0	2	0	2	2														
2	2P	6	2 3 4 5 6	10 11 12	8 10 -1 -2			X	X	X	X	2	2	2	2	2	2				
3	2P	4	2	6	0			2	2	2	2										
4	1P	2	2	6	6 2			1	1	SL	SL										
5	1P	2	6 7 8 9 10	10 11 12	8 10 -1 -2								X	X	X	X	1	1			
6	1P	4	6	10	0								1	1	1	1					
7	1P	2	10 11 12	12 13 14	0 -1 -2												X	X	1	1	
	Total resource load					2P	2P	3P	3P	2P	2P	3P	3P	3P	3P	3P	3P	1P	1P		
	Resource available					3P	3P	3P	3P	3P	3P	3P	3P	3P	3P	3P	3P	3P	3P		

New, resource scheduled network

6	2	12
0	2P	0
6	6	12

10	5	12
0	1P	0
10	2	12

0	1	2
0	2P	0
0	2	2

2	3	6
0	2P	0
2	4	6

12	7	14
0	1P	0
12	2	14

6	6	10
0	1P	0
6	4	10

2	4	4
2	1P	2
4	2	6

Legend

ES	ID	EF
SL	RES	SL
LS	DUR	LF

occurs because only three programmers are available, and they are needed to satisfy the resource requirements of activities 2 and 5. Note that the number of critical activities (1, 2, 3, 5, 6, 7) has increased from four to six.

This small example demonstrates the scenario of scheduling resources in real projects and the resulting increase in the risk of being late. In practice this is not a trivial problem! Managers who fail to schedule resources usually encounter this scheduling risk when it is too late to work around the problem, resulting in a project delay.

Since manually using the parallel method is impractical on real-world projects because of size, project managers will depend on software programs to schedule project resources.

Computer Demonstration of Resource-Constrained Scheduling

Fortunately, project management software is capable of assessing and resolving complicated resource-constrained schedules using heuristics similar to what was described above. We will use the EMR project to demonstrate how this is done using MS Project. It is important to note that the software is not "managing" the project. The software is simply a tool the project manager uses to view the project from different perspectives and conditions. See the Snapshot from Practice on page 250 for more tips on assessing resource problems.

EMR is the name given to the development of a handheld electronic medical reference guide to be used by emergency medical technicians and paramedics. Figure 8.6 contains a time-limited network for the design phase of the project. For the purpose of this example, we assume that only design engineers are required for the tasks and that the design engineers are interchangeable. The number of engineers required to perform each task is noted in the network, where 500 percent means five design engineers are needed for the activity. For example, activity 5, feature specs, requires four design engineers (400 percent). The project begins January 1, and ends February 14, a duration of 45 workdays. The time-limited (constrained) bar chart for the project is shown in Figure 8.7. This bar chart incorporates the same information used to develop the project network, but presents the project in the form of a bar chart along a time line.

Finally, a resource usage chart is presented for a segment of the project—January 15 to January 23; see Figure 8.8A. Observe that the time-limited project requires 21 design engineers on January 18 and 19 (168 hrs/8 hrs per engineer = 21 engineers). This segment represents the peak requirement for design engineers for the project. However, due to the shortage of design engineers and commitments to other projects, only eight engineers can be assigned to the project. This creates overallocation problems more clearly detailed in Figure 8.8B, which is a resource loading chart for design engineers. Notice that the peak is 21 engineers and the limit of 8 engineers is shown by the gray shaded area.

To resolve this problem we use the "leveling" tool within the software and first try to solve the problem by leveling only within slack. This solution would preserve the original finish date. However, as expected, this does not solve all of the allocation problems. The next option is to allow the software to apply scheduling heuristics and level outside of slack. The new schedule is contained in the revised, resource-limited network chart presented in Figure 8.9. The resource-limited project network indicates the project duration has now been extended to 2/26, or 57 workdays (versus 45 days time limited). The critical path is now 2, 3, 9, 13.

Figure 8.10 presents the project bar chart and the results of leveling the project schedule to reflect the availability of only eight design engineers. The application of the heuristics can be seen in the scheduling of the internal, external, and feature specification activities. All three activities were originally scheduled to start immediately after activity 1, architectural decisions.

FIGURE 8.6 EMR Project Network View Schedule before Resources Leveled

Voice recognition SW	ID: 6		
Start:	1/18	Dur: 10 days	
Finish:	1/27		
Res: Design Engineers [400%]			

Case	ID: 7		
Start:	1/18	Dur: 4 days	
Finish:	1/21		
Res: Design Engineers [200%]			

Screen	ID: 8		
Start:	1/18	Dur: 2 days	
Finish:	1/19		
Res: Design Engineers [300%]			

Database	ID: 9		
Start:	1/16	Dur: 25 days	
Finish:	2/9		
Res: Design Engineers [400%]			

Microphone-soundcard	ID: 10		
Start:	1/16	Dur: 5 days	
Finish:	1/20		
Res: Design Engineers [200%]			

Digital devices	ID: 11		
Start:	1/16	Dur: 7 days	
Finish:	1/22		
Res: Design Engineers [300%]			

Computer I/O	ID: 12		
Start:	1/16	Dur: 5 days	
Finish:	1/20		
Res: Design Engineers [300%]			

Review design	ID: 13		
Start:	2/10	Dur: 5 days	
Finish:	2/14		
Res: Design Engineers [500%]			

Internal specs	ID: 3		
Start:	1/6	Dur: 12 days	
Finish:	1/17		
Res: Design Engineers [500%]			

External specs	ID: 4		
Start:	1/6	Dur: 7 days	
Finish:	1/12		
Res: Design Engineers [400%]			

Feature specs	ID: 5		
Start:	1/6	Dur: 10 days	
Finish:	1/15		
Res: Design Engineers [400%]			

Architectural decisions	ID: 2		
Start:	1/1	Dur: 5 days	
Finish:	1/5		
Res: Design Engineers [500%]			

EMR project	ID: 1		
Start:	1/1	Dur: 45 days	
Finish:	2/14		
Comp: 0%			

245

FIGURE 8.7 EMR Project before Resources Added

ID	Task Name	Start	Finish	Late Start	Late Finish	Free Slack	Total Slack
1	**EMR project**	**Tue 1/1**	**Thu 2/14**	**Tue 1/1**	**Thu 2/14**	**0 days**	**0 days**
2	Architectural decisions	Tue 1/1	Sat 1/5	Tue 1/1	Sat 1/5	0 days	0 days
3	Internal specs	Sun 1/6	Thu 1/17	Sat 1/19	Wed 1/30	0 days	13 days
4	External specs	Sun 1/6	Sat 1/12	Thu 1/24	Wed 1/30	5 days	18 days
5	Feature specs	Sun 1/6	Tue 1/15	Sun 1/6	Tue 1/15	0 days	0 days
6	Voice recognition SW	Fri 1/18	Sun 1/27	Thu 1/31	Sat 2/9	13 days	13 days
7	Case	Fri 1/18	Mon 1/21	Wed 2/6	Sat 2/9	19 days	19 days
8	Screen	Fri 1/18	Sat 1/19	Fri 2/8	Sat 2/9	21 days	21 days
9	Database	Wed 1/16	Sat 2/9	Wed 1/16	Sat 2/9	0 days	0 days
10	Microphone-soundcard	Wed 1/16	Sun 1/20	Tue 2/5	Sat 2/9	20 days	20 days
11	Digital devices	Wed 1/16	Tue 1/22	Sun 2/3	Sat 2/9	18 days	18 days
12	Computer I/O	Wed 1/16	Sun 1/20	Tue 2/5	Sat 2/9	20 days	20 days
13	Review design	Sun 2/10	Thu 2/14	Sun 2/10	Thu 2/14	0 days	0 days

FIGURE 8.8A **EMR Project—Time-Constrained Resource Usage View, January 15–23**

Resource Name	Work	Jan 15						Jan 21		
		T	W	T	F	S	S	M	T	W
Design engineers	**3,024 hrs**	72h	136h	136h	168h	168h	144h	104h	88h	64h
Architectural decisions	200 hrs									
Internal specs	480 hrs	40h	40h	40h						
External specs	224 hrs									
Feature specs	320 hrs	32h								
Voice recognition SW	320 hrs				32h	32h	32h	32h	32h	32h
Case	64 hrs				16h	16h	16h	16h		
Screen	48 hrs				24h	24h				
Database	800 hrs		32h	32h	32h	32h	32h	32h	32h	32h
Microphone-soundcard	80 hrs		16h	16h	16h	16h	16h			
Digital devices	168 hrs		24h	24h	24h	24h	24h	24h	24h	
Computer I/O	120 hrs		24h	24h	24h	24h	24h			
Review design	200 hrs									

FIGURE 8.8B
Resource Loading
Chart for
EMR Project,
January 15–23

| Peak Units | 900% | 1,700% | 1,700% | 2,100% | 2,100% | 1,800% | 1,300% | 1,100% | 800% |

Design Engineers Overallocated: ☐ Allocated: ▆

This is impossible, since the three activities collectively require 14 engineers. The software chooses to schedule activity 5 first because this activity is on the original critical path and has zero slack (heuristic # 1). Next, and concurrently, activity 4 is chosen over activity 3 because activity 4 has a shorter duration (heuristic # 2); internal specs, activity 3, is delayed due to the limitation of 8 design engineers. Notice that the original critical path no longer applies because of the resource dependencies created by having only eight design engineers.

Compare the bar chart in Figure 8.10 with the time-limited bar chart in Figure 8.7. For example, note the different start dates for activity 8 (screen). In the time-limited plan (Figure 8.7), the start date for activity 8 is 1/18, while the start date in the resource limited schedule (Figure 8.10) is 2/16, almost a month later!

While resource bar graphs are commonly used to illustrate overallocation problems, we prefer to view resource usage tables like the one presented in Figure 8.8A. This table tells you when you have an overallocation problem and identifies activities that are causing the overallocation.

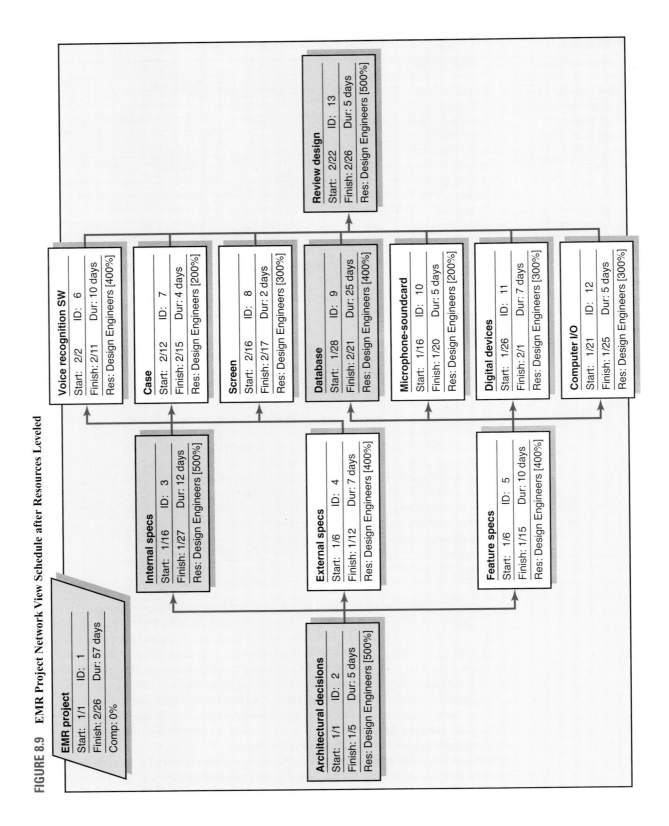

FIGURE 8.9 EMR Project Network View Schedule after Resources Leveled

EMR project
Start: 1/1	ID: 1
Finish: 2/26	Dur: 57 days
Comp: 0%	

Architectural decisions
Start: 1/1	ID: 2
Finish: 1/5	Dur: 5 days
Res: Design Engineers [500%]	

Internal specs
Start: 1/16	ID: 3
Finish: 1/27	Dur: 12 days
Res: Design Engineers [500%]	

External specs
Start: 1/6	ID: 4
Finish: 1/12	Dur: 7 days
Res: Design Engineers [400%]	

Feature specs
Start: 1/6	ID: 5
Finish: 1/15	Dur: 10 days
Res: Design Engineers [400%]	

Voice recognition SW
Start: 2/2	ID: 6
Finish: 2/11	Dur: 10 days
Res: Design Engineers [400%]	

Case
Start: 2/12	ID: 7
Finish: 2/15	Dur: 4 days
Res: Design Engineers [200%]	

Screen
Start: 2/16	ID: 8
Finish: 2/17	Dur: 2 days
Res: Design Engineers [300%]	

Database
Start: 1/28	ID: 9
Finish: 2/21	Dur: 25 days
Res: Design Engineers [400%]	

Microphone-soundcard
Start: 1/16	ID: 10
Finish: 1/20	Dur: 5 days
Res: Design Engineers [200%]	

Digital devices
Start: 1/26	ID: 11
Finish: 2/1	Dur: 7 days
Res: Design Engineers [300%]	

Computer I/O
Start: 1/21	ID: 12
Finish: 1/25	Dur: 5 days
Res: Design Engineers [300%]	

Review design
Start: 2/22	ID: 13
Finish: 2/26	Dur: 5 days
Res: Design Engineers [500%]	

FIGURE 8.10 EMR Project Resources Leveled

ID	Task Name	Start	Finish	Late Start	Late Finish	Free Slack	Total Slack
1	**EMR project**	**Tue 1/1**	**Thu 2/26**	**Tue 1/1**	**Tue 2/26**	**0 days**	**0 days**
2	Architectural decisions	Tue 1/1	Sat 1/5	Tue 1/1	Sat 1/5	0 days	0 days
3	Internal specs	Wed 1/16	Sun 1/27	Sun 1/20	Thu 1/31	15 days	4 days
4	External specs	Sun 1/6	Sat 1/12	Fri 1/25	Thu 1/31	19 days	19 days
5	Feature specs	Sun 1/6	Tue 1/15	Sun 1/6	Tue 1/15	0 days	0 days
6	Voice recognition SW	Sat 2/2	Mon 2/11	Tue 2/12	Thu 2/21	10 days	10 days
7	Case	Tue 2/12	Fri 2/15	Mon 2/18	Thu 2/21	6 days	6 days
8	Screen	Sat 2/16	Sun 2/17	Wed 2/20	Thu 2/21	4 days	4 days
9	Database	Mon 1/28	Thu 2/21	Mon 1/28	Thu 2/21	0 days	0 days
10	Microphone-soundcard	Wed 1/16	Sun 1/20	Sun 2/17	Thu 2/21	32 days	32 days
11	Digital devices	Sat 1/26	Fri 2/1	Fri 2/15	Thu 2/21	20 days	20 days
12	Computer I/O	Mon 1/21	Fri 1/25	Sun 2/17	Thu 2/21	27 days	27 days
13	Review design	Fri 2/22	Tue 2/26	Fri 2/22	Tue 2/26	0 days	0 days

249

The Impacts of Resource-Constrained Scheduling

Like leveling schedules, the limited resource schedule usually reduces slack, reduces flexibility by using slack to ensure delay is minimized, and increases the number of critical and near-critical activities. Scheduling complexity is increased because resource constraints are added to technical constraints; start times may now have two constraints. The traditional critical path concept of sequential activities from the start to the end of the project is no longer meaningful. The resource constraints can break the sequence and leave the network with a set of disjointed critical activities. Conversely, parallel activities can become sequential. Activities with slack on a time-constrained network can change from critical to noncritical.

Splitting Activities

Splitting tasks is a scheduling technique used to get a better project schedule and/or to increase resource utilization. A planner splits the continuous work included in an activity by interrupting the work and sending the resource to another activity for a period of time and then having the resource resume work on the original activity. Splitting can be a useful tool if the work involved does not include large start-up or shutdown costs—for example, moving equipment from one activity location to another. The most common error is to interrupt "people work," where there are high conceptual start-up and shutdown costs. For example, having a bridge designer take time off to work on the design problem of another project may cause this individual to lose four days shifting conceptual gears in and out of two activities. The cost may be hidden, but it is real. Figure 8.11 depicts the nature of the splitting problem. The original activity has been split into three

FIGURE 8.11
Splitting Activities

Activity duration without splitting

| Activity A | Activity B | Activity C |

Activity duration split into three segments—A, B, C

| Activity A | Activity B | Activity C |

Shutdown Start-up
Activity duration split with shutdown and start-up

separate activities: A, B, and C. The shutdown and start-up times lengthen the time for the original activity.

Some have argued that the propensity to deal with resource shortages by splitting is a major reason why projects fail to meet schedule. We agree. Planners should avoid the use of splitting as much as possible, except in situations where splitting costs are known to be small or when there is no alternative for resolving the resource problem. Computer software offers the splitting option for each activity; use it sparingly. See Snapshot from Practice: Assessing Resource Allocation.

Benefits of Scheduling Resources

It is important to remember that, if resources are truly limited and activity time estimates are accurate, the resource-constrained schedule *will* materialize as the project is implemented—*not* the time-constrained schedule! Therefore, failure to schedule limited resources can lead to serious problems for a project manager. The benefit of creating this schedule *before* the project begins leaves time for considering reasonable alternatives. If the scheduled delay is unacceptable or the risk of being delayed too high, the assumption of being resource constrained can be reassessed. Cost-time trade-offs can be considered. In some cases priorities may be changed. See Snapshot from Practice: U.S. Forest Service Resource Shortage.

Resource schedules provide the information needed to prepare time-phased work package budgets with dates. Once established, they provide a quick means for a project manager to gauge the impact of unforeseen events such as turnover, equipment breakdowns, or transfer of project personnel. Resource schedules also allow project managers to assess how much flexibility they have over certain resources. This is useful when they receive requests from other managers to borrow or share resources. Honoring such requests creates goodwill and an "IOU" that can be cashed in during a time of need.

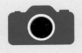

A major segment of work in managing U.S. Forest Service (USFS) forests is selling mature timber to logging companies that harvest the timber under contract conditions monitored by the Service. The proceeds are returned to the federal government. The budget allocated to each forest depends on the two-year plan submitted to the U.S. Department of Agriculture.

Olympic Forest headquarters in Olympia, Washington, was developing a two-year plan as a basis for funding. All of the districts in the forest submitted their timber sale projects (numbering more than 50) to headquarters, where they were compiled and aggregated into a project plan for the whole forest. The first computer run was reviewed by a small group of senior managers to determine if the plan was reasonable and "doable." Management was pleased and relieved to note all projects appeared to be doable in the two-year time frame until a question was raised concerning the computer printout. "Why are all the columns in these projects labeled 'RESOURCE' blank?" The response from an engineer was, "We don't use that part of the program."

The discussion that ensued recognized the importance of resources in completing the two-year plan and ended with a request to "try the program with resources included." The new output was startling. The two-year program turned into a three-and-a-half-year plan because of the shortage of specific labor skills such as road engineer and environmental impact specialist. Analysis showed that adding only three skilled people would allow the two-year plan to be completed on time. In addition, further analysis showed hiring only a few more skilled people, beyond the three, would allow an extra year of projects to also be compressed into the two-year plan. This would result in additional revenue of more than $3 million. The Department of Agriculture quickly approved the requested extra dollars for additional staff to generate the extra revenue.

Assigning Project Work

When making individual assignments, project managers should match, as best they can, the demands and requirements of specific work with the qualifications and experience of available participants. In doing so, there is a natural tendency to assign the best people the most difficult tasks. Project managers need to be careful not to overdo this. Over time these people may grow to resent the fact that they are always given the toughest assignments. At the same time, less experienced participants may resent the fact that they are never given the opportunity to expand their skill/knowledge base. Project managers need to balance task performance with the need to develop the talents of people assigned to the project.

Project managers not only need to decide who does what but who works with whom. A number of factors need to be considered in deciding who should work together. First, to minimize unnecessary tension, managers should pick people with compatible work habits and personalities but who complement each other (i.e., one person's weakness is the other person's strength). For example, one person may be brilliant at solving complex problems but sloppy at documenting his or her progress. It would be wise to pair this person with an individual who is good at paying attention to details. Experience is another factor. Veterans should be teamed up with new hires—not only so they can share their experience but also to help socialize the newcomers to the customs and norms of the organization. Finally, future needs should be considered. If managers have some people who have never worked together before but who have to later on in the project, they may be wise to take advantage of opportunities to have these people work together early on so that they can become familiar with each other. Finally, see the Snapshot in Practice: Managing Geeks for some interesting thoughts about how Novell, Inc., puts together teams.

Multiproject Resource Schedules

For clarity we have discussed key resource allocation issues within the context of a single project. In reality resource allocation generally occurs in a multiproject environment where the demands of one project have to be reconciled with the needs of other projects.

Eric Schmidt, after a successful career at Sun Microsystems, took over struggling Novell, Inc., and helped turn it around within two years. One of the keys to his success is his ability to manage the technical wizards who develop the sophisticated systems, hardware, and software that are the backbone of electronically driven companies. He uses the term "geek" (and he can, since he is one, with a Ph.D. in computer science) to describe this group of technologists who rule the cyberworld.

Schmidt has some interesting ideas about assigning geeks to projects. He believes that putting geeks together in project teams with other geeks creates productive peer pressure. Geeks care a great deal about how other geeks perceive them. They are good at judging the quality of technical work and are quick to praise as well as criticize each other's work. Some geeks can be unbearably arrogant, but Schmidt claims that having them work together on projects is the best way to control them—by letting them control each other.

At the same time, Schmidt argues that too many geeks spoil the soup. By this he means that, when there are too many geeks on a development team, there is a tendency for intense technical navel gazing. Members lose sight of deadlines, and delays are inevitable. To combat this tendency, he recommends using geeks only in small groups. He urges breaking up large projects into smaller, more manageable projects so that small teams of geeks can be assigned to them. This keeps the project on time and makes the teams responsible to each other.

* Mitchel Russ, "How to Manage Geeks," *Fast Company* (June 1999), pp. 175–80.

Organizations must develop and manage systems for efficiently allocating and scheduling resources across several projects with different priorities, resource requirements, sets of activities, and risks. The system must be dynamic and capable of accommodating new projects as well as reallocating resources once project work is completed. While the same resource issues and principles that apply to a single project also apply to this multiproject environment, application and solutions are more complex, given the interdependency among projects.

The following lists three of the more common problems encountered in managing multiproject resource schedules. Note that these are macro manifestations of single-project problems that are now magnified in a multiproject environment:

1. **Overall schedule slippage.** Because projects often share resources, delays in one project can have a ripple effect and delay other projects. For example, work on one software development project can grind to a halt because the coders scheduled for the next critical task are late in completing their work on another development project.

2. **Inefficient resource utilization.** Because projects have different schedules and requirements, there are peaks and valleys in overall resource demands. For example, a firm may have a staff of 10 electricians to meet peak demands when, under normal conditions, only 5 electricians are required.

3. **Resource bottlenecks.** Delays and schedules are extended as a result of shortages of critical resources that are required by multiple projects. For example, at one Lattice Semiconductor facility, project schedules were delayed because of competition over access to test equipment necessary to debug programs. Likewise, several projects at a U.S. forest area were extended because there was only one silviculturist on the staff.

To deal with these problems, more and more companies create project offices or departments to oversee the scheduling of resources across multiple projects. One approach to multiple project resource scheduling is to use a first come–first served rule. A project queue system is created in which projects currently underway take precedence over new projects. New project schedules are based on the projected availability of resources. This queuing tends to lead to more reliable completion estimates

The case for a central source to oversee project resource scheduling is well known by practitioners. Here is a synopsis of a conversation with one middle manager.

Interviewer: Congratulations on acceptance of your multi-project scheduling proposal. Everyone tells me you were very convincing.

Middle Manager: Thanks. Gaining acceptance was easy this time. The board quickly recognized we have no choice if we are to keep ahead of competition by placing our resources on the right projects.

Interviewer: Have you presented this to the board before?

Middle Manager: Yes, but not this company. I presented the same spiel to the firm I worked for two years ago. For their annual review meeting I was charged to present a proposal suggesting the need and benefits of central capacity resource planning for managing the projects of the firm.

I tried to build a case for bringing projects under one umbrella to standardize practices and to forecast and assign key people to mission critical projects. I explained how benefits such as resource demands will be aligned with mission critical projects, proactive resource planning, and a tool for catching resource bottlenecks and resolving conflicts.

Almost everyone agreed the idea was a good one. I felt good about the presentation and felt confident something was going to happen. But the idea never really got off the ground; it just faded into the sunset.

With hindsight, managers really did not trust colleagues in other departments, so they only gave half-hearted support to central resource planning. Managers wanted to protect their turf and ensure that they would not have to give up power. The culture there was simply too inflexible for the world we live in today. They are still struggling with constant conflicts among projects.

I'm glad I made the switch to this firm. The culture here is much more team-oriented. Management is committed to improving performance.

and is preferred on contracted projects that have stiff penalties for being late. The disadvantages of this deceptively simple approach are that it does not optimally utilize resources or take into account the priority of the project. See the Snapshot from Practice: Multiple Project Resource Scheduling.

Many companies utilize more elaborate processes for scheduling resources to increase the capacity of the organization to initiate projects. Most of these methods approach the problem by treating individual projects as part of one big project and adapting the scheduling heuristics previously introduced to this "megaproject." Project schedulers monitor resource usage and provide updated schedules based on progress and resource availability across all projects. One major improvement in project management software in recent years is the ability to prioritize resource allocation to specific projects. Projects can be prioritized in ascending order (e.g., 1, 2, 3, 4, . . .), and these priorities will override scheduling heuristics so that resources go to the project highest on the priority list. (Note: This improvement fits perfectly with organizations that use project priority models similar to those described in Chapter 2.) Centralized project scheduling also makes it easier to identify resource bottlenecks that stifle progress on projects. Once identified, the impact of the bottlenecks can be documented and used to justify acquiring additional equipment, recruiting critical personnel, or delaying the project.

Finally, many companies are using outsourcing as a means for dealing with their resource allocation problems. In some cases, a company will reduce the number of projects they have to manage internally to only core projects and outsource noncritical projects to contractors and consulting firms. In other cases, specific segments of projects are outsourced to overcome resource deficiencies and scheduling problems. Companies may hire temporary workers to expedite certain activities that are falling behind schedule or contract project work during peak periods when there are insufficient internal resources to meet the demands of all projects. The ability to more efficiently manage the ebbs and flows of project work is one of the major driving forces behind outsourcing today.

Using the Resource Schedule to Develop a Project Cost Baseline

Once resource assignments have been finalized we are able to develop a baseline budget schedule for the project. Using your project schedule, you can *time-phase* work packages and assign them to their respective scheduled activities to develop a budget schedule over the life of your project. Understanding the reason for time-phasing your budget is very important. Without a time-phased budget good project schedule and cost control are impossible.

Why a Time-Phased Budget Baseline Is Needed

The need for a time-phased budget baseline is demonstrated in the following scenario. The development of a new product is to be completed in 10 weeks at an estimated cost of $400,000 per week for a total cost of $4 million. Management wants a status report at the end of five weeks. The following information has been collected:

- Planned costs for the first five weeks are $2,000,000.
- Actual costs for the first five months are $2,400,000.

How are we doing? It would be easy to draw the conclusion there is a $400,000 cost overrun. But we really have no way of knowing. The $400,000 may represent money spent to move the project ahead of schedule. Assume another set of data at the end of five weeks:

- Planned costs for the first five weeks are $2,000,000.
- Actual costs for the first five weeks are $1,700,000.

Is the project costing $300,000 less than we expected? Perhaps. But the $300,000 may represent the fact that the project is behind schedule and work has not started. Could it be the project is behind schedule and over cost? We cannot tell from these data. The many systems found in the real world that use only planned funds (a constant burn rate) and actual costs can provide false and misleading information. There is no way to be certain how much of the physical work has been accomplished. *These systems do not measure how much work was accomplished for the money spent! Hence, without time-phasing cost to match your project schedule, it is impossible to have reliable information for control purposes.*

Creating a Time-Phased Budget

By using information from your WBS and resource schedule, you can create a time-phased cost baseline. Remember from the WBS for the PC Project in Chapters 4 and 5 we integrated the WBS and OBS organization breakdown structure so the work packages could be tracked by deliverable and organization responsible. See Figure 8.12 for an example of the PC Prototype Project arranged by deliverable and organization unit responsible. For each intersection point of the WBS/OBS matrix, you see work package budgets and the total cost. The total cost at each intersection is called a cost or control account. For example, at the intersection of the Read/write head deliverable and the Production department we see there are three work packages with a total budget of $200,000. The sum of all cost accounts in a column should represent the total costs for the deliverable. Conversely, the sum of the cost accounts in a row should represent the costs or budget for the organizational unit responsible to accomplish the work. You can continue to "roll up" costs on the WBS/OBS to total project costs. This WBS provides the information you can use to time

FIGURE 8.12 **Direct Labor Budget Rollup ($000)**

phase work packages and assign them to their respective scheduled activities over the life of the project.

Recall, from the development of your work breakdown structure for each work package, the following information needed to be developed:

1. Define work (what).
2. Identify time to complete a work package (how long).
3. Identify a time-phased budget to complete a work package (cost).
4. Identify resources needed to complete a work package (how much).
5. Identify a single person responsible for units of work (who).
6. Identify monitoring points for measuring progress (how well).

Number three, time-phasing the work package, is critical for the final step of creating your budget baseline. The process of time-phasing work packages, which is illustrated next, is demonstated in Figure 8.13. The work package has a duration of three weeks. Assuming labor, materials, and equipment are tracked separately, the work package costs for labor are distributed over the three weeks as they are expect to occur—$40,000, $30,000, and $50,000 for each week, respectively. When the three-week work package is placed in the network schedule, the costs are distributed to the time-phased budget for the same three scheduled weeks. Fortunately, most single WPs become an activity and the process of

FIGURE 8.13
Time-Phased Work Package Budget (labor cost only)

		Work Package Time-Phased Budget Labor cost only						

Work Package Description ___Test___ Page ___1___ of ___1___
Work Package ID ___1.1.3.2.3___ Project ___PC Protoype___
Deliverable ___Circuit board___ Date ___3/24/xx___
Responsible organization unit ___Test___ Estimator ___CEG___
Work Package Duration ___3___ weeks Total labor cost ___$120___

Time-Phased Labor Budget ($000)

Work Package	Resource	Labor rate	1	2	3	4	5	Total
			Work Periods--Weeks					
Code **1.1.3.2.3**	Quality testers	$xxxx/week	$40	$30	$50			$120

distributing costs is relatively simple. That is, the relationship is one-for-one. Such budget timing is directly from the work package to the activity.

In a few instances an activity will include more than one work package, where the packages are assigned to *one responsible person or department and deliverable*. In this case the work packages are consolidated into one activity. As seen in Figure 8.14, this activity includes two WPs. The first, WP-1.1.3.2.4.1 (Code), is distributed over the first three weeks. The second, WP-1.1.3.2.4.2 (Integration), is sequenced over weeks 3 and 4. The actvity duration is four weeks. When the activity is placed in the schedule, the costs are distributed starting with the schedule start—$20,000, $15,000, $75,000, and $70,000, respectively.

FIGURE 8.14 Two Time-Phased Work Packages (labor cost only)

Work Package Description ___Software___ Page ___1___ of ___1___
Work Package ID ___1.1.3.2.4.1 and 1.1.3.2.4.2___ Project ___PC Protoype___
Deliverable ___Circuit board___ Date ___3/24/xx___
Responsible organization unit ___Software___ Estimator ___LGG___
Work Package Duration ___4___ weeks Total labor cost ___$180___

Time-Phased Labor Budget ($000)

Work Package	Resource	Labor rate	1	2	3	4	5	Total
			Work Periods--Weeks					
Code **1.1.3.2.4.1**	Program'rs	$2,000/week	$20	$15	$15			$50
Integration **1.1.3.2.4.2**	System/program'rs	$2,500/week			$60	$70		$130
Total			$20	$15	$75	$70		$180

These time-phased budgets for work packages are lifted from your WBS and are placed in your project schedule as they are expected to occur over the life of the project. The outcome of these budget allocations is the project *cost* baseline (also called planned value—PV), which is used to determine cost and schedule variances as the project is implemented.

Figure 8.15 shows the Patient Entry Project network schedule, which is used to place the time-phased work packages' budgets in the baseline. Figure 8.16 presents the project time-phased budget for the Patient Entry Project and the cumulative graph of the project budget baseline. In this figure you can see how the time-phased work package costs were placed into the network and how the cumulative project budget graph for a project is developed. Notice that costs do not have to be distributed linearly, but the costs should be placed as you expect them to occur.

You have now developed complete time and cost plans for your project. These project baselines will be used to compare planned schedule and costs using an integrative system called *earned value*. The application and use of project baselines to measure performance are discussed in detail in Chapter 13. With your project budget baseline established, you are also able to generate cash flow statements for your project like the one presented in Figure 8.17. Such statements prepare the firm to cover costs over the lifespan of the project. Finally, with resource assignments finalized you are able to generate resource usage schedules for your project (see Figure 8.18). These schedules map out the full deployment of personnel and equipment and can be used to generate individual work schedules.

FIGURE 8.15 **Patient Entry Project Network**

FIGURE 8.16

Patient Entry Time-Phased Work Packages Assigned

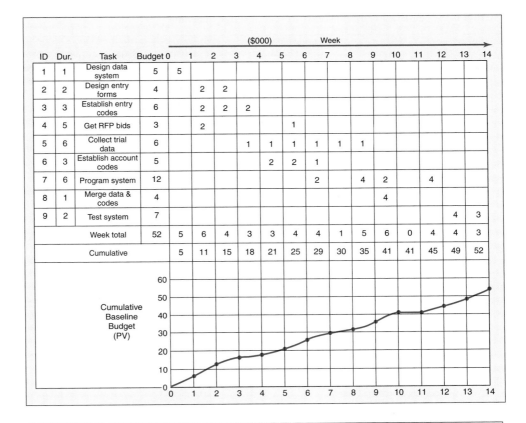

ID	Dur.	Task	Budget 0	1	2	3	4	5	6	7	8	9	10	11	12	13	14
1	1	Design data system	5	5													
2	2	Design entry forms	4		2	2											
3	3	Establish entry codes	6		2	2	2										
4	5	Get RFP bids	3		2				1								
5	6	Collect trial data	6				1	1	1	1	1	1					
6	3	Establish account codes	5					2	2	1							
7	6	Program system	12							2		4	2		4		
8	1	Merge data & codes	4									4					
9	2	Test system	7													4	3
		Week total	52	5	6	4	3	3	4	4	1	5	6	0	4	4	3
		Cumulative		5	11	15	18	21	25	29	30	35	41	41	45	49	52

FIGURE 8.17

CEBOO Project Monthly Cash Flow Statement

	January	February	March	April	May	June	July
CEBOO Project							
Hardware							
Hardware specifications	$11,480.00	$24,840.00	$3,360.00				
Hardware design			$23,120.00	$29,920.00	$14,960.00		
Hardware documentation					$14,080.00	$24,320.00	
Prototypes							
Order GXs							
Assemble preproduction models							
Operating system							
Kernel specifications	$5,320.00	$9,880.00					
Drivers							
OC drivers				$3,360.00	$12,320.00	$11,760.00	$12,880.00
Serial VO drivers							
Memory management							
Operating system documentation		$10,240.00	$21,760.00				
Network interface							
Utilities							
Utilities specifications				$8,400.00			
Routine utilities				$5,760.00	$21,120.00	$20,160.00	$10,560.00
Complex utilities							
Utilities documentation				$7,680.00	$17,920.00		
Shell							
System integration							
Architectural decisions	$20,400.00						
Integration first phase							
System H/S test							
Project documentation							
Integration acceptance test							
Total	$37,200.00	$44,960.00	$48,240.00	$55,120.00	$80,400.00	$56,240.00	$23,440.00

FIGURE 8.18 **CEBOO Project Weekly Resource Usage Schedule**

	12/30/07	1/6/08	1/13/08	1/20/08	1/27/08	2/03/08
I. Suzuki	24 hrs	40 hrs	40 hrs	40 hrs	40 hrs	40 hrs
Hardware specifications				24 hrs	40 hrs	40 hrs
Hardware design						
Hardware documentation						
Operating system documentation						
Utilities documentation						
Architectural decisions	24 hrs	40 hrs	40 hrs	16 hrs		
J. Lopez	24 hrs	40 hrs	40 hrs	40 hrs	40 hrs	40 hrs
Hardware specifications				12 hrs	20 hrs	20 hrs
Hardware design						
Prototypes						
Kernel specifications				12 hrs	20 hrs	20 hrs
Utilities specifications						
Architectural decisions	24 hrs	40 hrs	40 hrs	16 hrs		
Integration first phase						
J.J. Putz				24 hrs	40 hrs	40 hrs
Hardware documentation						
Kernel specifications				24 hrs	40 hrs	40 hrs
Operating system documentation						
Utilities documentetion						
Project documentation						
R. Sexon				24 hrs	40 hrs	40 hrs
Hardware specifications				24 hrs	40 hrs	40 hrs
Prototypes						
Assemble preproduction models						
OC drivers						
Complex utilities						
Integration first phase						
System H/S test						
Integration acceptance test						

Summary

Usage and availability of resources are major problem areas for project managers. Attention to these areas in developing a project schedule can point out resource bottlenecks before the project begins. Project managers should understand the ramifications of failing to schedule resources. The results of resource scheduling are frequently significantly different from the results of the standard CPM method.

With the rapid changes in technology and emphasis on time-to-market, catching resource usage and availability problems before the project starts can save the costs of crashing project activities later. Any resource deviations from plan and schedule that occur when the project is being implemented can be quickly recorded and the effect noted. Without this immediate update capability, the real negative effect of a change may not be known until it happens. Tying resource availability to a multiproject, multiresource system supports a project priority process that selects projects by their contribution to the organization's objectives and strategic plan.

Assignment of individuals to projects may not fit well with those assigned by computer software routines. In these cases overriding the computer solution to accommodate individual differences and skills is almost always the best choice.

The project resource schedule is important because it serves as your time baseline, which is used for measuring time differences between plan and actual. The resource schedule serves as the basis for developing your time-phased project cost budget baseline. The baseline (planned value, PV) is the sum of the cost accounts, and each cost account is the sum of the work packages in the cost account. Remember, if your budgeted costs are not time-phased, you really have no reliable way to measure performance. Although there are several types of project costs, the cost baseline is usually limited to direct costs (such as labor, materials, equipment) that are under the control of the project manager; other indirect costs can be added to project costs separately.

Key Terms

Heuristic
Leveling/smoothing
Planned value (PV)

Resource-constrained
 projects
Resource profile

Splitting
Time-constrained projects
Time-phased baseline

Review Questions

1. How does resource scheduling tie to project priority?
2. How does resource scheduling reduce flexibility in managing projects?
3. Present six reasons scheduling resources is an important task.
4. How can outsourcing project work alleviate the three most common problems associated with multiproject resource scheduling?
5. Explain the risks associated with leveling resources, compressing or crashing projects, and imposed durations or "catch-up" as the project is being implemented.
6. Why is it critical to develop a time-phased baseline?

Exercises

1. Given the network plan that follows, compute the early, late, and slack times. What is the project duration? Using any approach you wish (e.g., trial and error), develop a loading chart for resources, Electrical Engineers (EE), and resource, Mechanical Engineers (ME). Assume only one of each resource exists. Given your resource schedule, compute the

early, late, and slack times for your project. Which activities are now critical? What is the project duration now? Could something like this happen in real projects?

2. Given the network plan that follows, compute the early, late, and slack times. What is the project duration? Using any approach you wish (e.g., trial and error), develop a loading chart for resources Carpenters (C) and Electricians (E). Assume only one Carpenter is available and two Electricians are available. Given your resource schedule, compute the early, late, and slack times for your project. Which activities are now critical? What is the project duration now?

3. Compute the early, late, and slack times for the activities in the network that follows, assuming a time-constrained network. Which activities are critical? What is the time-constrained project duration?

Note: Recall, in the schedule resource load chart the *time-constrained* "scheduling interval (ES through LF) has been shaded. Any resource scheduled beyond the shaded area will delay the project.

Assume you have only three resources and you are using a computer that uses software that schedules projects by the parallel method and following heuristics. Schedule only one period at a time!

Minimum slack

Smallest duration

Lowest identification number

Keep a log of each activity change and update you make each period—e.g., period 0–1, 1–2, 2–3, etc. (Use a format similar to the one on page 241.) The log should include any changes or updates in ES and slack times each period, activities scheduled, and activities delayed. (Hint: Remember to maintain the technical dependencies of the network.) Use the resource load chart to assist you in scheduling (see pages 242–243).

List the order in which you scheduled the activities of the project. Which activities of your schedule are now critical?

Recompute your slack for each activity given your new schedule. What is the slack for activity 1? 4? 5?

4. Develop a resource schedule in the loading chart that follows. Use the parallel method and heuristics given. Be sure to update each period as the computer would do. Note: Activities 2, 3, 5, and 6 use two of the resource skills. Three of the resource skills are available.

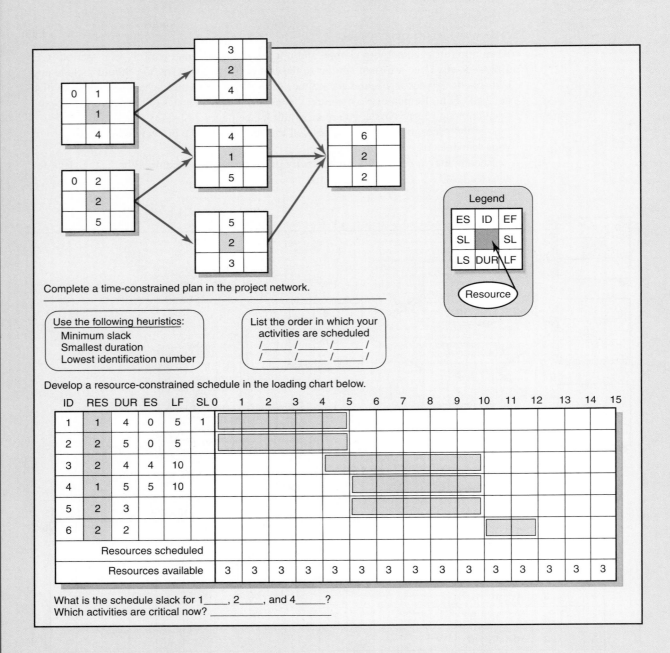

Complete a time-constrained plan in the project network.

Use the following heuristics:
Minimum slack
Smallest duration
Lowest identification number

List the order in which your activities are scheduled
/_____ /_____ /_____ /
/_____ /_____ /_____ /

Develop a resource-constrained schedule in the loading chart below.

ID	RES	DUR	ES	LF	SL	0	1	2	3	4	5	6	7	8	9	10	11	12	13	14	15
1	1	4	0	5	1																
2	2	5	0	5																	
3	2	4	4	10																	
4	1	5	5	10																	
5	2	3																			
6	2	2																			
Resources scheduled																					
Resources available					3	3	3	3	3	3	3	3	3	3	3	3	3	3	3	3	

What is the schedule slack for 1_____, 2_____, and 4_____?
Which activities are critical now? _____

5. You have prepared the following schedule for a project in which the key resource is a backhoe. This schedule is contingent on having 3 backhoes. You receive a call from your partner, Brooker, who desperately needs 1 of your backhoes. You tell Brooker you would be willing to let him have the backhoe if you are still able to complete your project in 11 months.

 Develop a resource schedule in the loading chart that follows to see if it is possible to complete the project in 11 months with only 2 backhoes. Be sure to record the order in which you schedule the activities using scheduling heuristics. Activities 5 and 6 require 2 backhoes, while activities 1, 2, 3, and 4 require 1 backhoe. No splitting of activities is possible. Can you say yes to Brooker's request?

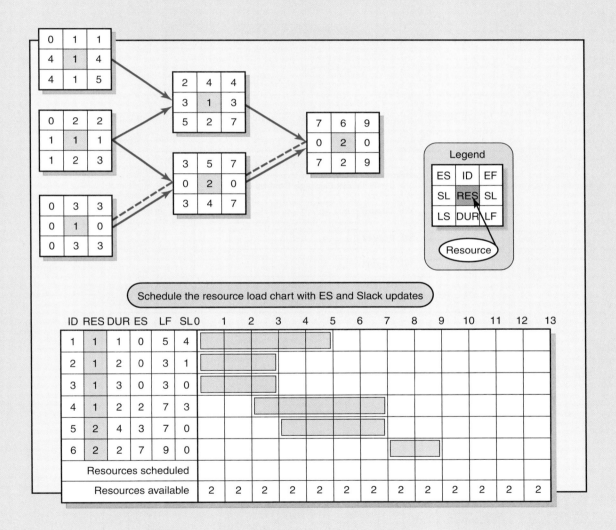

6. Given the time-phased work packages, complete the baseline budget form for the project.

Time-phased budget ($ 000)
Week

Task	Budget	0	1	2	3	4	5	6	7	8	9	10
Activity 1	4	4										
Activity 2	6		1	3	2							
Activity 3	10		2	4	2	2						
Activity 4	8							2	3	3		
Activity 5	3										2	1
Total	31											
Cumulative												

7. Given the time-phased work packages and network, complete the baseline budget form for the project.

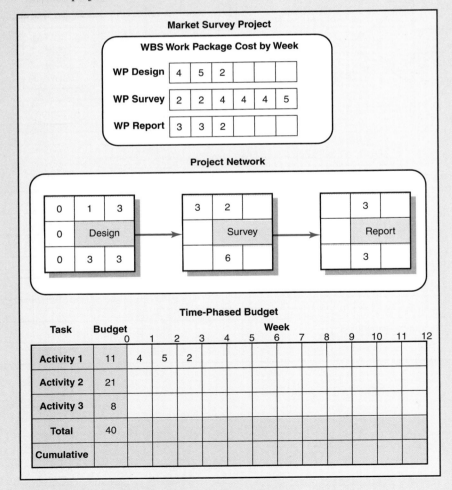

Market Survey Project

WBS Work Package Cost by Week

WP Design	4	5	2			
WP Survey	2	2	4	4	4	5
WP Report	3	3	2			

Project Network

0	1	3
0	Design	
0	3	3

3	2	
	Survey	
	6	

	3	
	Report	
	3	

Time-Phased Budget

Task	Budget	0	1	2	3	4	5	6	7	8	9	10	11	12
Activity 1	11	4	5	2										
Activity 2	21													
Activity 3	8													
Total	40													
Cumulative														

8. Given the time-phased work packages and network, complete the baseline budget form for the project.

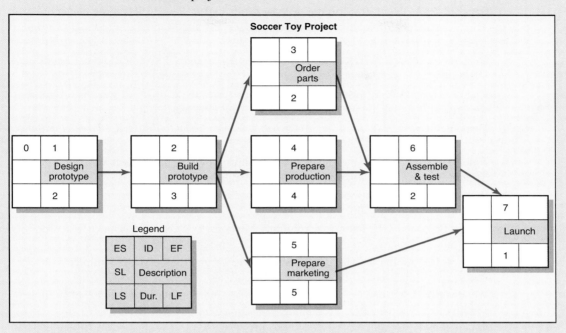

Soccer Toy Project

Cost by Week ($00)

	◄1	◄2	◄3	◄4	◄5
Design	12	12			
Build prototype	10	10	10		
Order parts	5	5			
Prepare production	16	10	22	16	
Prepare marketing	6	6	0	6	12
Assemble & test	18	18			
Launch	12				

Time-phased Budget ($000)

Week

	Budget	0	1	2	3	4	5	6	7	8	9	10	11	12
Design	24													
Build prototype	30													
Order parts	5													
Prepare prod'n	64													
Prepare market'g	30													
Assemble & test	36													
Launch	12													
Total	206													
Cumulative														

References

Arrow, K. J., and L. Hurowicz, *Studies in Resource Allocation Process* (New York: Cambridge University Press, 1997).

Brucker, P., A. Drexl, R. Mohring, L. Newmann, and E. Pesch, "Resource-constrained Project Scheduling: Notation, Classification, Models and Methods," *European Journal of Operational Research,* Vol. 112, 1999, pp. 3–42.

Burgess, A. R., and J. B. Kellebrew, "Variations in Activity Level on Cyclical Arrow Diagrams," *Journal of Industrial Engineering,* Vol. 13, March–April 1962, pp. 76–83.

Charnes, A., and W. W. Cooper, "A Network Interpretation and Direct Sub Dual Algorithm for Critical Path Scheduling," *Journal of Industrial Engineering,* July–August 1962.

Demeulemeester, E. L., and W. S. Herroelen, *Project Scheduling: A Research Handbook* (Norwell, Mass: Kluwer Academic Publishers, 2002).

Fendly, L. G., "Towards the Development of a Complete Multi Project Scheduling System," *Journal of Industrial Engineering,* Vol. 19, 1968, pp. 505–15.

Reinersten, D., "Is It Always a Bad Idea to Add Resources to a Late Project?" *Electric Design,* October 30, 2000, pp. 17–18.

Talbot, B. F., and J. H. Patterson, "Optimal Methods for Scheduling Under Resource Constraints," *Project Management Journal,* December 1979.

Wiest, J. D., "A Heuristic Model for Scheduling Large Projects with Unlimited Resources," *Management Science,* Vol. 18, February 1967, pp. 359–77.

Woodworth, B. M., and C. J. Willie, "A Heuristic Algorithm for Resource Leveling in Multiproject, Multiresource Scheduling," *Decision Sciences,* Vol. 6, July 1975, pp. 525–40.

Woodworth, B. M., and S. Shanahan, "Identifying the Critical Sequence in a Resource Constrained Project," *International Journal of Project Management,* Vol. 6, 1988, pp. 89–96.

Case

Power Train, Ltd.

We have smashing systems for reporting, tracking, and controlling costs on design projects. Our planning of projects is better than any I have seen at other companies. Our scheduling seemed to serve us well when we were small and we had only a few projects. Now that we have many more projects and schedule using multiproject software, there are too many occasions when the right people are not assigned to the projects deemed important to our success. This situation is costing us big money, headaches, and stress!

Claude Jones, VP, Design and Operations

HISTORY

Power Train, Ltd. (PT), was founded in 1960 by Daniel Gage, a skilled mechanical engineer and machinist. Prior to founding PT he worked for three years as design engineer for a company that designed and built transmissions for military tanks and trucks. It was a

natural transition for Dan to start a company designing and building power trains for farm tractor companies. Today, Dan is no longer active in the management of PT but is still revered as its founder. He and his family still own 25 percent of the company, which went public in 1988. PT has been growing at a 6 percent clip for the last five years but expects industry growth to level off as supply exceeds demand.

Today, PT continues its proud tradition of designing and building the best-quality power trains for manufacturers of farm tractors and equipment. The company employs 178 design engineers and has about 1,800 production and support staff. Contract design projects for tractor manufacturers represent a major portion of PT's revenue. At any given time, about 45 to 60 design projects are going on concurrently. A small portion of their design work is for military vehicles. PT only accepts military contracts that involve very advanced, new technology and are cost plus.

A new phenomenon has attracted management of PT to look into a larger market. Last year a large Swedish truck manufacturer approached PT to consider designing power trains for its trucks. As the industry consolidates, the opportunities for PT should increase because these large firms are moving to more outsourcing to cut infrastructure costs and stay very flexible. Only last week a PT design engineer spoke to a German truck manufacturing manager at a conference. The German manager was already exploring outsourcing of drive trains to Porsche and was very pleased to be reminded of PT's expertise in the area. A meeting is set up for next month.

CLAUDE JONES

Claude Jones joined PT in 1989 as a new MBA from the University of Edinburgh. He worked as a mechanical engineer for U.K. Hydraulics for five years prior to returning to school for the MBA. "I just wanted to be part of the management team and where the action is." Jones moved quickly through the ranks. Today he is the vice president of design and operations. Sitting at his desk, Jones is pondering the conflicts and confusion that seem to be increasing in scheduling people to projects. He gets a real rush at the thought of designing power trains for large trucks; however, given their current project scheduling problems, a large increase in business would only compound their problems. Somehow these conflicts in scheduling have to be resolved before any serious thought can be given to expanding into design of power transmissions for truck manufacturers.

Jones is thinking of the problems PT had in the last year. The MF project is the first to come to mind. The project was not terribly complex and did not require their best design engineers. Unfortunately, the scheduling software assigned one of the most creative and expensive engineers to the MF project. A similar situation, but reversed, happened on the Deer project. This project involved a big customer and new hydrostatic technology for small tractors. In this project the scheduling software assigned engineers who were not familiar with small tractor transmissions. Somehow, thinks Jones, the right people need to be scheduled to the right projects. Upon reflection, this problem with scheduling has been increasing since PT went to multiproject scheduling. Maybe a project office is needed to keep on top of these problems.

A meeting with the information technology team and software vendors was positive but not very helpful because these people are not really into detailed scheduling problems. The vendors provided all sorts of evidence suggesting the heuristics used—least slack, shortest duration, and identification number—are absolutely efficient in scheduling people and minimizing project delays. One project software vendor, Lauren, kept saying their software would allow PT to customize the scheduling of projects and people to almost any variation selected. Lauren repeated over and over, "If the standard heuristics do not meet your requirements, create your own heuristics that do." Lauren even volunteered to assist in setting up the system. But she is

not willing to spend time on the problem until PT can describe to her exactly what criteria will be used (and their sequence) to select and schedule people to projects.

WHAT NEXT?

Potential expansion into the truck power train business is not feasible until the confusion in project scheduling is solved or reduced significantly. Jones is ready to tackle this problem, but he is not sure where to start.

Appendix 8.1

The Critical-Chain Approach

In practice, project managers carefully manage slack on sensitive resource-limited projects. If possible, they will add slack at the end of the project by committing to a completion date that goes beyond the scheduled date. For example, the plans say the project should be completed on April 1, although the official completion date is May 1. Other managers take a more aggressive approach to managing slack within the schedule. They use an early start schedule and prohibit use of slack on any activity or work package to be used unless authorized by the project manager. Progress by percent complete and by remaining time are carefully monitored. Activities that are beating estimated completion times are reported so that succeeding activities can start ahead of schedule. This ensures that the time gained is used to start a succeeding activity earlier and time is not wasted. The overall intent is to create and save slack as a time buffer to complete the project early or to cover delay problems that may creep up on critical activities or paths.

Eliyahu Goldratt, who championed the "theory of constraints" in his popular book *The Goal,* advocates an alternative approach to managing slack. He has coined the term "critical-chain" to recognize that the project network may be constrained by both resource and technical dependencies. Each type of constraint can create task dependencies, and in the case of resource constraints, new task dependencies can be created! Remember how resource constrains shifted the critical path? If not, visit Figure 8.5 again. The critical chain refers to the longest string of dependencies that exist on the project. Chain is used instead of path, since the latter tends to be associated with just technical dependencies not resource dependencies. Goldratt uses the critical chain concept to develop strategies for accelerating the completion of projects. These strategies are based on his observations about time estimates of individual activities.

TIME ESTIMATES

Goldratt argues that there is a natural tendency for people to add safety (just-in-case) time to their estimations. It is believed that those who estimate activity times provide an estimate that has about an 80 to 90 percent chance of being completed on or before the estimated time. Hence, the median time (50/50 chance) is overestimated by approximately 30 to 40 percent. For example, a programmer may estimate that there is a 50/50 chance that he can complete an activity in six days. However, to ensure success and to protect against potential problems, he adds three days of safety time and reports that it will take nine days to complete the task. In this case the median (50/50) time is overestimated by approximately 50 percent. He now has a 50/50 chance of completing the project three days ahead

of the schedule. If this hidden contingency is pervasive across a project, then most activities in theory should be completed ahead of schedule.

Not only do workers add safety, but project managers like to add safety to ensure that they will be able to bring the project in ahead of schedule. They will add a month to a nine-month project to cover any delays or risks that might spring up. This situation raises an interesting paradox:

> *Why, if there is a tendency to overestimate activity durations, and add safety to the end of a project, do so many projects come in behind schedule?*

Critical Chain Project Management (CCPM) offers several explanations:

- *Parkinson's law:* Work fills the time available. Why hustle to complete a task today when it isn't due until tomorrow? Not only will the pace of work be dictated by deadline, but workers will take advantage of perceived free time to catch up on others things. This is especially true in matrix environments where workers will use this time to clear work backlog on other projects and duties.

- *Self-protection:* Participants fail to report early finishes out of fear that management will adjust their future standards and demand more next time. For example, if a team member estimates that a task will take seven days and delivers it in five, the next time he is asked for an estimate, the project manager may want to trim the estimate based on past performance. Peer pressure may also be a factor here: to avoid being labeled a "rate buster," members may not report early finishes.

- *Dropped baton:* Goldratt uses the metaphor of project as relay race to illustrate the impact of poor coordination. Just as a runner's time is lost if the next runner is not ready to receive the baton, so is the time gained from completing a task early lost if the next group of people are not ready to receive the project work. Poor communication and inflexible resource schedules prevent progress from occurring.

- *Excessive multitasking:* The norm in most organizations is to have project personnel work on several projects, activities, or assignments at the same time. This leads to costly interruptions and excessive task splitting. As pointed out on p. 250, this adds time to each activity. When looked at in isolation the time loss may seem minimal, but when taken as a whole the transition costs can be staggering.

- *Resource bottlenecks:* In multiproject organizations projects are frequently delayed because test equipment or other necessary resources are tied up on other project work.

- *Student syndrome (procrastination):* Goldratt asserts that just as students delay writing a term paper until the last minute, workers delay starting tasks when they perceive that they have more than enough time to complete the task. The problem with delaying the start of a task is that obstacles are often not detected until the task is under way. By postponing the start of the task, the opportunity to cope with these obstacles and complete the task on time is compromised.

CRITICAL-CHAIN IN ACTION

CCPM's solution to reducing project time overruns is to insist on people using the "true 50/50" activity time estimates (rather than estimates which have an 80 to 90 percent chance of being completed before the estimated time); the 50/50 estimates result in a project duration about one-half the low risk of 80 to 90 percent estimates. This requires a corporate culture which values accurate estimates and refrains from blaming people for not meeting deadlines. According to CCPM, using 50/50 estimates will discourage

Parkinson's law, the student syndrome, and self protection from coming into play because there is less "free time" available. Productivity will be increased as individuals try to meet tighter deadlines. Similarly, the compressed time schedule reduces the likelihood of the dropped baton effect.

CCPM recommends inserting time buffers into the schedule to act as "shock absorbers" to protect the project completion date against task durations taking longer than the 50/50 estimate. The rationale is that by using 50/50 estimates you are in essence taking out all of the "safety" in individual tasks. CCPM also recommends using portions of this collective safety strategically by inserting time buffers where potential problems are likely to occur. There are three kinds of buffers in CCPM:

- *Project buffer:* First, since all activities along the critical chain have inherent *uncertainty* that is difficult to predict, project duration is uncertain. Therefore, a project time buffer is added to the expected *project duration*. CCPM recommends using roughly 50 percent of the aggregate safety. For example, if the modified schedule reduces the project duration by 20 days from 50 to 30, then a 10-day project buffer would be used.
- *Feeder buffers:* Buffers are added to the network where noncritical paths merge with the critical chain. These buffers protect the critical chain from being delayed.
- *Resource buffers:* Time buffers are inserted where scarce resources are needed for an activity. Resource time buffers come in at least two forms. One form is a time buffer attached to a critical resource to ensure that the resource is on call and available when needed. This preserves the relay race. The second form of time buffer is added to activities preceding the work of a scarce resource. This kind of buffer protects against resource bottlenecks by increasing the likelihood that the preceding activity will be completed when the resource is available.

All buffers reduce the risk of the project duration being late and increase the chance of early project completion.

CRITICAL-CHAIN VERSUS TRADITIONAL SCHEDULING APPROACH

To illustrate how CCPM affects scheduling let's compare it with the traditional approach to project scheduling. We will first resolve resource problems the way described in Chapter 8 and then the CCPM method. Figure A8.1A shows the *planned* Air Control project network without any concern for resources. That is, activities are assumed to be independent and resources will be made available and/or are interchangeable. Figure A8.1B depicts the bar chart for the project. The blue bars represent the durations of critical activities; the clear bars represent the durations of noncritical activities; the light gray bars represent slack. Note that the duration is 45 days and the critical path is represented by activities 1, 4, 6, 7, and 8.

Parallel activities hold potential for resource conflicts. This is the case in this project. Ryan is the resource for activities 3 and 6. If you insert Ryan in the bar chart in Figure A8.1B for activities 3 and 6, you can see activity 3 overlaps activity 6 by five days—an impossible situation. Because Ryan cannot work two activities simultaneously and no other person can take his place, a resource dependency exists. The result is that two activities (3 and 6) that were assumed to be independent now become dependent. Something has to give! Figure A8.2A shows the Air Control project network with the resources included. A pseudo-dashed arrow has been added to the network to indicate the resource dependency. The bar chart in Figure A8.2B reflects the revised schedule resolving the overallocation of Ryan. Given the new schedule, slack for some activities has changed. More importantly, the critical path has changed. It is now 1, 3, 6, 7, 8. The resource schedule shows the new project duration to be 50 days rather than 45 days.

FIGURE A8.1A Air Control Project: Time Plan without Resources

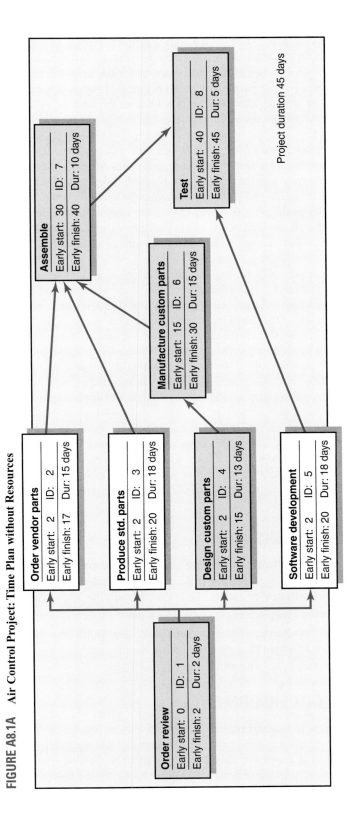

FIGURE A8.1B Air Control Project: Time Plan without Resources

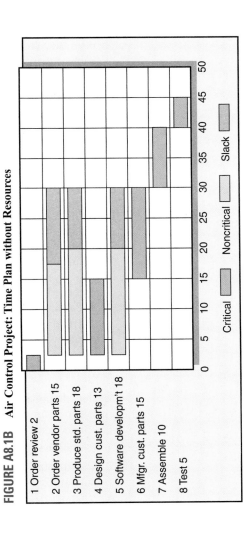

Now let's apply the CCPM approach to the Air Control project. Figure A8.3 details many of the changes. First, notice that task estimates now represent approximations of the 50/50 rule. Second, observe that not all of the activities on the critical-chain are technically linked. Manufacture custom parts is included because of previously defined resource dependency. Third, a project time buffer is added at the end of schedule. Finally, feeder buffers are inserted at each point where a noncritical activity merges with the critical chain.

The impact the CCPM approach has on the project schedule can best be seen in the Gantt chart presented in Figure A8.4. Notice first the late start times for each of the three noncritical activities. For example, under the critical path method, order vendor parts and software development would be scheduled to begin immediately after the order review. Instead they are scheduled later in the project. Three-day feeder buffers have been added to each of these activities to absorb any delays that might occur in these activities. Finally, instead of taking 50 days the project is now estimated to take only 27 days with a 10-day project buffer!

This example provides an opportunity for explaining the differences between buffers and slack. Slack is spare time inherent in the schedule of noncritical activities and can be determined by differences between the early start and late start of a specific activity. Buffers, on the other hand, are dedicated time blocks reserved to cover most likely contingencies and are monitored closely so, if they are not needed, subsequent activities can proceed on schedule. Buffers are needed in part because the estimates are based on 50/50 approximations, and therefore roughly half of the activities will take longer than planned. To protect against these extended activity durations, buffers are inserted to minimize the impact on the schedule. Buffers are not part of the project schedule and are used only when sound management dictates it.

While not depicted in the figures, an example of a resource buffer would be to add six days to Ryan's schedule (remember he is the critical resource that caused the schedule to be extended). This would ensure that he could continue to work on the project beyond the 18th day in case either produce standard parts and/or manufacture custom parts takes longer than planned. Progress on these two tasks would be monitored closely, and his schedule would be adjusted accordingly.

CCPM AND SPLITTING TASKS

Buffers do not address the insidious effects of pervasive task splitting, especially in a multiproject environment where workers are juggling different project assignments. CCPM has three recommendations that will help to reduce the impact of splitting activities:

1. Reduce the number of projects so people are not assigned to as many projects concurrently.
2. Control start dates of projects to accommodate resource shortages. Don't start projects until sufficient resources are available to work full time on the project.
3. Contract (lock in) for resources *before* the project begins.

MONITORING PROJECT PERFORMANCE

The CCPM method uses buffers to monitor project time performance. Remember that as shown in Figure A8.3 a project buffer is used to insulate the project against delays along the critical-chain. For monitoring purposes, this buffer is typically divided into three zones—OK, Watch and Plan, and Act, respectively (see Figure A8.5). As the buffer begins to decrease and moves into the second zone, alarms are set off to seek corrective action. To be truly effective, buffer management requires comparing buffer usage with actual

FIGURE A8.2A Air Control Project: Schedule with Resources Limited

Order review

Early start: 0	ID: 1	
Early finish: 2	Dur: 2 days	
Res: Ryan		

Order vendor parts

Early start: 2	ID: 2	
Early finish: 17	Dur: 15 days	
Res: Carly		

Produce std. parts

Early start: 2	ID: 3	
Early finish: 20	Dur: 18 days	
Res: Ryan		

Design custom parts

Early start: 2	ID: 4	
Early finish: 15	Dur: 13 days	
Res: Lauren		

Software development

Early start: 2	ID: 5	
Early finish: 20	Dur: 18 days	
Res: Connor		

Manufacture custom parts

Early start: 20	ID: 6	
Early finish: 35	Dur: 15 days	
Res: Ryan		

Assemble

Early start: 35	ID: 7	
Early finish: 45	Dur: 10 days	
Res: Dawn		

Test

Early start: 45	ID: 8	
Early finish: 50	Dur: 5 days	
Res: Kevin		

Project duration 50 days

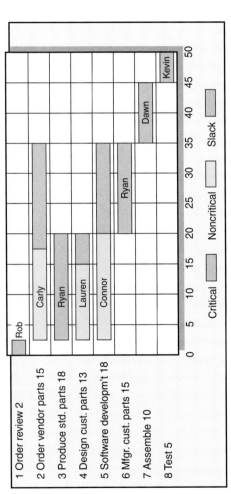

FIGURE A8.2B Air Control Project: Schedule with Resources Limited

1 Order review 2
2 Order vendor parts 15
3 Produce std. parts 18
4 Design cust. parts 13
5 Software developm't 18
6 Mfgr. cust. parts 15
7 Assemble 10
8 Test 5

Critical Noncritical Slack

275

FIGURE A8.3 Air Control Project: CCPM Network

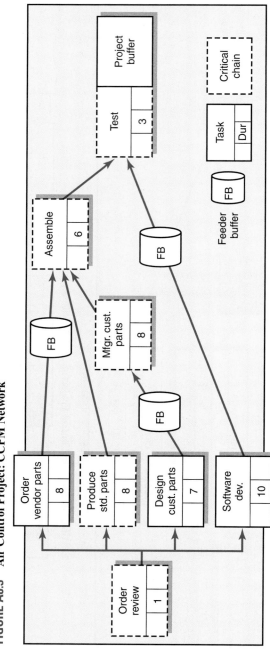

FIGURE A8.4
Air Control Project Gantt Chart: CCPM Network

Activity	DUR	LS	LF	Buffer
1. Order review	1	0	1	0
2. Order vendor parts	8	7	15	3
3. Produce std. parts	8	1	9	0
4. Design cust. parts	7	1	8	3
5. Software dev.	10	11	21	3
6. Mfgr. cust. parts	8	11	19	0
7. Assemble	6	18	24	0
8. Test	3	24	27	12

0 5 10 15 20 25 30 35 40

Activity ▭ Buffer ▭

FIGURE A8.5
Project Control— Buffer Management

Region III	Region II	Region I
OK	Watch & Plan	Act

100%
Full buffer
time left

0%
No buffer
time left

progress on the project. For example, if the project is 75 percent complete and you have only used 50 percent of the project buffer, then the project is in pretty good shape. Conversely, if the project is only 25 percent complete and 50 percent of the buffer has already been used, you are in trouble and corrective action is needed. A method for estimating percentage complete is described in Chapter 13.

THE CCPM METHOD TODAY

CCPM has generated considerable debate within the project management community. While sound in theory, support at this time is limited but growing. For example, Harris Semiconductor was able to build a new automated wafer fabrication facility within 13 months using CCPM methods when the industry standard for such a facility is 26–36 months. The Israeli aircraft industry has used CCPM techniques to reduce average maintenance work on aircraft from two months to two weeks. The U.S. Air Force and Navy as well as Boeing, Lucent Technologies, Intel, GM, and 3M are applying critical-chain principles to their multi-project environments.

CCPM is not without critics. First, CCPM does not address the biggest cause of project delays, which is an ill-defined and unstable project scope. Second, some critics challenge Goldratt's assumptions about human behavior. They question the tendency of experts to pad estimates and that employees act deliberately against the organization for their own interest and benefit. They also object to the insinuation that trained professionals would exhibit the student syndrome habits. Third, evidence of success is almost exclusively

anecdotal and based on single case studies. The lack of systematic evidence raises questions about generalizability of application. CCPM may prove to work best for only certain kinds of projects.

One of the keys to implementing CCPM is the culture of the organization. If the organization honors noble efforts that fail to meet estimates as it does efforts that do meet estimates, then greater acceptance will occur. Conversely, if management treats honest failure differently from success, then resistance will be high. Organizations adopting the CCPM approach have to invest significant energy to obtaining "buy-in" on the part of all participants to its core principles and allaying the fears that this system may generate.

APPENDIX SUMMARY

Regardless of where one stands in the debate, the CCPM approach deserves credit for bringing resource dependency to the forefront, highlighting the modern ills of multitasking, and forcing us to rethink conventional methods of project scheduling.

APPENDIX EXERCISES

1. Check out the Goldratt Institute's homepage at *http://www.goldratt.com* for current information on the application of critical-chain techniques to project management.
2. Apply critical-chain scheduling principles to the Print Software, Inc., project presented in Chapter 6 on page 175. Revise the estimated time durations by 50 percent except round up the odd time durations (i.e., 3 becomes 4). Draw a CCPM network diagram similar to the one contained in Figure A8.3 for the Print Software project as well as a Gantt chart similar to Figure A8.4. How would these diagrams differ from the ones generated using the traditional scheduling technique?

APPENDIX REFERENCES

Goldratt, *Critical Chain* (Great Barrington, MA: North River Press, 1997).

Herroelen, W., R. Leus, and E. Demeulemeester, "Critical Chain Project Scheduling: Do Not Oversimplify," *Project Management Journal,* Vol. 33 (4), 2002, pp. 48–60.

Leach, L. P., "Critical Chain Project Management," *Proceedings of 29th Annual Project Management Institute, 1998, Seminars and Symposium* (Newtown, PA: Project Management Institute, 1998), pp. 1239–44.

Levine, H. A., "Shared Contingency: Exploring the Critical Chain," *PM Network,* October 1999, pp. 35–38.

Newbold, R. C., *Project Management in the Fast Lane: Applying the Theory of Constraints* (Boca Raton, FL: St. Lucie Press, 1998).

Noreen, E., D. Smith, and J. Mackey, *The Theory of Constraints and Its Implication for Management Accounting* (Great Barrington, MA: North River Press, 1995).

Raz, T., R. Barnes, and D. Dvir, "A Critical Look at Critical Chain Project Management," *Project Management Journal,* December 2003, pp. 24–32.

Sood, S., "Taming Uncertainty: Critical-Chain Buffer Management Helps Minimize Risk in the Project Equation," *PM Network,* March 2003, pp. 57–59.

Zalmanson, E., "Readers Feedback," *PM Network,* Vol. 15 (1), 2001, p. 4.

Reducing Project Duration
Rationale for Reducing Project Duration
Options for Accelerating Project Completion
Project Cost–Duration Graph
Constructing a Project Cost–Duration Graph
Practical Considerations
What if Cost, Not Time, Is the Issue?
Summary

Reducing Project Duration

In skating over thin ice our safety is in our speed

—*Ralph Waldo Emerson*

Imagine the following scenarios:

—After finalizing your project schedule, you realize the estimated completion date is two months beyond what your boss publicly promised an important customer.

—Five months into the project, you realize that you are already three weeks behind the drop dead date for the project.

—Four months into a project top management changes its priorities and now tells you that money is not an issue. Complete the project ASAP!

What do you do?

This chapter addresses strategies for reducing project duration either prior to setting the baseline for the project or in the midst of project execution. Choice of options is based on the constraints surrounding the project. Here the project priority matrix introduced in Chapter 4 comes into play. For example, there are many more options available for reducing project time if you are not resource constrained than if you cannot spend more than your original budget. We will begin first by examining the reasons for reducing project duration followed by a discussion of different options for accelerating project completion. The chapter will conclude with the classic time-cost framework for selecting which activities to "crash." Crash is a term that has emerged in the Project Management lexicon for shortening the duration of an activity or project beyond when it can be normally done.

Rationale for Reducing Project Duration

There are few circumstances in which a project manager or owner would not wish to reduce the time to complete a project. Reducing the time of a critical activity in a project can be done but almost always results in a higher direct cost; thus, the manager faces a cost-time trade-off problem—is the reduction in time worth the additional cost? Cost-time situations focus on reducing the critical path that determines the project completion date.

There are many good reasons for attempting to reduce the duration of a project. One of the more important reasons today is time to market. Intense global competition and rapid technological advances have made speed a competitive advantage. To succeed, companies have to spot new opportunities, launch project teams, and bring new products or services to the marketplace in a flash. Perhaps in no industry does speed matter as much as in the electronics industry. For example, a rule of thumb for moderate- to high-technology firms is that a six-month delay in bringing a product to market can result in a gross profit loss of market share

© Lars A. Niki.

Speed has been critical in business ever since the California Gold Rush. The cell-phone industry is a good example of an intensely competitive business that places a premium on speed. In 2005 Motorola came out with the RAZR, its ultrathin cell phone with camera and music player. Samsung Group answered seven months later with the Blade . Then on February 1, 2006, Motorola released SLVR, a phone that is even more svelte than its predecessor. Nokia entered the fray with N80, which added Wi-Fi Web browsing to the product mix. "It's like having a popular night-club. You have to keep opening new ones. To stay cool, you have to

speed up," says Michael Greeson, president of market researcher Diffusion Group, Inc.

In order to survive, Motorola, Nokia, and other cell-phone manufacturers have become masters at project management. They have been able to cut the market release time of new phones from 12–18 months to 6–9 months. What is at stake is over 500 million in forecasted sales of new cell phones each year.

* Steve Hamm, "Is Your Company Fast Enough?" *BusinessWeek*, March 27, 2006, pp. 68–76.

David Butow/Corbis.

On January 17, 1994, a 6.8-magnitude earthquake struck the Los Angeles basin, near suburban Northridge, causing 60 deaths, thousands of injuries, and billions of dollars in property damage. Nowhere was the destructive power of nature more evident than in the collapsed sections of the freeway system that disrupted the daily commute of an estimated 1 million Los Angelenos. The Northridge earthquake posed one of the greatest challenges to the California Department of Transportation (CalTrans) in its nearly 100-year history. To expedite the recovery process, Governor Pete Wilson signed an emergency declaration allowing CalTrans to streamline contracting procedures and offer attractive incentives for completing work ahead of schedule. For each day that the schedule was beaten, a sizable bonus was to be awarded. Conversely, for each day over the deadline, the contractor would be penalized the same amount. The amount ($50,000 to $200,000) varied depending on the importance of the work.

The incentive scheme proved to be a powerful motivator for the freeway reconstruction contractors. C. C. Myers, Inc., of Rancho Cordova, California, won the contract for the reconstruction of the Interstate 10 bridges. Myers pulled out all stops to finish the project in a blistering 66 days—a whopping 74 days ahead of schedule—and earning a $14.8 million bonus! Myers took every opportunity to save time and streamline operations. They greatly expanded the workforce. For example, 134 ironworkers were employed instead of the normal 15. Special lighting equipment was set up so that work could be performed around the clock. Likewise, the sites were prepared and special materials were used so that work could continue despite inclement weather that would normally shut down construction. The work was scheduled much like an assembly line so that critical activities were followed by the next critical activity. A generous incentive scheme was devised to reward teamwork and reach milestones early. Carpenters and ironworkers competed as teams against each other to see who could finish first.

Although C. C. Myers received a substantial bonus for finishing early, they spent a lot of money on overtime, bonuses, special equipment, and other premiums to keep the job rolling along. CalTrans supported Myers's efforts. With reconstruction work going on 24 hours a day, including jackhammering and pile-driving, CalTrans temporarily housed many families in local motels. CalTrans even erected a temporary plastic soundwall to help reduce the construction noise traveling to a nearby apartment complex. The double-layer curtain, 450 feet long and 20 feet high, was designed to reduce construction noise by 10 decibels.

Despite the difficulties and expense incurred by around-the-clock freeway building, most of Los Angeles cheered CalTrans's quake recovery efforts. The Governor's Office of Planning and Research issued a report concluding that for every day the Santa Monica Freeway was closed, it cost the local economy more than $1 million.

* Jerry B. Baxter, "Responding to the Northridge Earthquake," *PM Network* (November 1994), pp. 13–22.

of about 35 percent. In these cases, high-technology firms typically assume that the time savings and avoidance of lost profits are worth any additional costs to reduce time without any formal analysis. See the Snapshot from Practice: Cell-Phone Wars for more on this.

Another common reason for reducing project time occurs when unforeseen delays—for example, adverse weather, design flaws, and equipment breakdown—cause substantial delays midway in the project. Getting back on schedule usually requires compressing the time on some of the remaining critical activities. The additional costs of getting back on schedule need to be compared with the consequences of being late. This is especially true when time is a top priority.

Incentive contracts can make reduction of project time rewarding—usually for both the project contractor and owner. For example, a contractor finished a bridge across a lake 18 months early and received more than $6 million for the early completion. The availability of the bridge to the surrounding community 18 months early to reduce traffic gridlock made the incentive cost to the community seem small to users. In another example, in a continuous improvement arrangement, the joint effort of the owner and contractor resulted in early completion of a river lock and a 50/50 split of the savings to the owner and contractor. See Snapshot from Practice: Northridge Earthquake for a situation in which a contractor went to great lengths to complete a project as quickly as possible

"Imposed deadlines" is another reason for accelerating project completion. For example, a politician makes a public statement that a new law building will be available in two years. Or the president of a software company remarks in a speech that new advanced software will be available in one year. Such statements too often become imposed project duration dates—without any consideration of the problems or cost of meeting such a date. The project duration time is set while the project is in its "concept" phase before or without any detailed scheduling of all the activities in the project. This phenomenon occurs very frequently in practice! Unfortunately, this practice almost always leads to a higher cost project than one that is planned using low-cost and detailed planning. In addition, quality is sometimes compromised to meet deadlines. More important, these increased costs of imposed duration dates are seldom recognized or noted by project participants.

Sometimes very high overhead costs are recognized before the project begins. In these cases it is prudent to examine the direct costs of shortening the critical path versus the overhead cost savings. Usually there are opportunities to shorten a few critical activities at less than the daily overhead rate. Under specific conditions (which are not rare), huge savings are possible with little risk.

Finally there are times when it is important to reassign key equipment and/or people to new projects. Under these circumstances, the cost of compressing the project can be compared with the costs of not releasing key equipment or people.

Options for Accelerating Project Completion

Managers have several effective methods for crashing specific project activities when resources are not constrained. Several of these are summarized below.

Options When Resources Are Not Constrained

Adding Resources

The most common method for shortening project time is to assign additional staff and equipment to activities. There are limits, however, as to how much speed can be gained by adding staff. Doubling the size of the workforce will not necessarily reduce completion time by half. The relationship would be correct only when tasks can be partitioned so

minimal communication is needed between workers, as in harvesting a crop by hand or repaving a highway. Most projects are not set up that way; additional workers increase the communication requirements to coordinate their efforts. For example, doubling a team by adding two workers requires six times as much pairwise intercommunication than is required in the original two-person team. Not only is more time needed to coordinate and manage a larger team; there is the additional delay of training the new people and getting them up to speed on the project. The end result is captured in Brooks' law: Adding manpower to a late software project makes it later.

Frederick Brooks formulated this principle based on his experience as a project manager for IBM's System/360 software project during the early 1960s. Subsequent research concluded that adding more people to a late project does not necessarily cause the project to be later. The key is whether the new staff is added early so there is sufficient time to make up for lost ground once the new members have been fully assimilated.

Outsourcing Project Work

A common method for shortening the project time is to subcontract an activity. The subcontractor may have access to superior technology or expertise that will accelerate the completion of the activity. For example, contracting for a backhoe can accomplish in two hours what it can take a team of laborers two days to do. Likewise, by hiring a consulting firm that specializes in ADSI programming, a firm may be able to cut in half the time it would take for less experienced, internal programmers to do the work. Subcontracting also frees up resources that can be assigned to a critical activity and will ideally result in a shorter project duration. See Snapshot from Practice: Outsourcing Bio-Tech. Outsourcing will be addressed more fully in Chapter 12.

Scheduling Overtime

The easiest way to add more labor to a project is not to add more people, but to schedule overtime. If a team works 50 hours a week instead of 40, it might accomplish 25 percent more. By scheduling overtime you avoid the additional costs of coordination and communication encountered when new people are added. If people involved are salaried workers, there may be no real additional cost for the extra work. Another advantage is that there are fewer distractions when people work outside normal hours.

Overtime has disadvantages. First, hourly workers are typically paid time and a half for overtime and double time for weekends and holidays. Sustained overtime work by salaried employees may incur intangible costs such as divorce, burnout, and turnover. The latter is a key organizational concern when there is a shortage of workers. Furthermore, it is an oversimplification to assume that, over an extended period of time, a person is as productive during his or her eleventh hour at work as during his or her third hour of work. There are natural limits to what is humanly possible, and extended overtime may actually lead to an overall decline in productivity when fatigue sets in.

Overtime and working longer hours is the preferred choice for accelerating project completion, especially when the project team is salaried. The key is to use overtime judiciously. Remember a project is a marathon not a sprint! You do not want to run out of energy before the finish line.

Establish a Core Project Team

As discussed in Chapter 3, one of the advantages of creating a dedicated core team to complete a project is speed. Assigning professionals full time to a project avoids the hidden cost of multitasking in which people are forced to juggle the demands of multiple projects. Professionals are allowed to devote their undivided attention to a specific project. This singular focus creates a shared goal that can bind a diverse set of professionals into a highly cohesive team capable of accelerating project completion. Factors that contribute to the emergence of high-performing project teams will be discussed in detail in Chapter 11.

Do It Twice—Fast and Correctly

If you are in a hurry, try building a "quick and dirty" short-term solution, then go back and do it the right way. For example, the Rose Garden stadium in Portland, Oregon, was supposed to be completely finished in time for the start of the 1995–1996 National Basketball Association (NBA) season. Delays made this impossible, so the construction crew set up temporary bleachers to accommodate the opening-night crowd. The additional costs of doing it twice are often more than compensated for by the benefits of satisfying the deadline.

Options When Resources Are Constrained

A project manager has fewer options for accelerating project completion when additional resources are either not available or the budget is severely constrained. This is especially true once the schedule has been established. Below are some of these options.

Fast-Tracking

Sometimes it is possible to rearrange the logic of the project network so that critical activities are done in parallel (concurrently) rather than sequentially. This alternative is a good one if the project situation is right. When this alternative is given serious attention, it is amazing to observe how creative project team members can be in finding ways to restructure sequential activities in parallel. As noted in Chapter 6, one of the most common methods for restructuring activities is to change a finish-to-start relationship to a start-to-start relationship. For example, instead of waiting for the final design to be approved, manufacturing engineers can begin building the production line as soon as key specifications have been established. Changing activities from sequential to parallel usually requires closer coordination among those responsible for the activities affected but can produce tremendous time savings.

Critical-Chain

Critical-chain project management (CCPM) is designed to accelerate project completion. As discussed in Chapter 8, the jury is still out in terms of its applicability. Still CCPM

AP/Wide World.

On March 13, 1999, Habitat for Humanity New Zealand built a fully operational, four-bedroom house in Auckland in 3 hours, 44 minutes, and 59 seconds from floor to roof complete with curtains, running showers, lawn, and fence. In doing so they became the fastest house builders in the world.

"We made a significant decimation of the record," said Habitat New Zealand's Chief Executive Graeme Lee. "The previous record of 4 hours, 39 minutes, 8 seconds, held by a Habitat chapter in Nashville, USA, was made with a three-bedroom home, and we built one with four bedrooms and used only 140 volunteers on the site." The rules provide for construction to commence from an established floor platform. The house is complete when it meets the local building code, and the family can move in.

The project took 14 months to plan. CCPM principles were applied using ProChain Software to finalize project schedule. The critical-chain was recalculated 150–200 times and then analyzed to optimize the resulting new sequence of operations. This reiterative process was used to progressively develop the fastest plan.

One of the keys to efficiency was the use of "Laserbilt" prefabricated walls made from 36mm particleboard using technology that had been invented by a company in New Zealand. Another time saver was the use of a crane which lowered the wooden roof frame (built on adjacent land) onto the four walls.

Once the roof was on the walls, roofing iron was put on. Meanwhile, the wall sheathing was attached to outside walls and windows fitted, with painters almost painting the face of the hammers as sheath nailing was completed. Inside, vinyl was laid first in the utility areas while painters started in the bedrooms. After the vinyl, the bathrooms were fitted and curtains hung. On the outside, while the roofing was being installed, decks and steps were constructed, a front path laid, mail box and clothesline installed, wooden fence constructed around the perimeter, three trees planted, and lawns leveled and seeded.

Post-project assessment revealed that even further time could have been gained. The management rule was to be "One tradesperson in one room at one time," but enthusiasm took over and people were doing whatever they could wherever they could, especially toward the end. The project manager estimated that if greater discipline had been exercised and if people moved out of the house as soon as they had completed their task, another 15 minutes would have been shaved from the record.

Habitat for Humanity is an international charitable organization that builds simple, affordable houses and sells them on a no-interest, no-profit basis to needy families.

*"A Four Bedroom House in Three Hours, 44 Minutes & 59 Seconds," Avraham Y. Goldratt Institute, *www.goldratt.com*. "Fastest House in the World," Habitat for Humanity International, *www.habitat.org*.

principles appear sound and worthy of experimentation if speed is essential. At the same time, it would be difficult to apply CCPM midstream in a project. CCPM requires considerable training and a shift in habits and perspectives that take time to adopt. Although there have been reports of immediate gains, especially in terms of completion times, a long-term management commitment is probably necessary to reap full benefits. See the Snapshot from Practice: The Fastest House in the World for an extreme example of CCPM application.

Reducing Project Scope

Probably the most common response for meeting unattainable deadlines is to reduce or scale back the scope of the project. This invariably leads to a reduction in the functionality of the project. For example, the new car will average only 25 mpg instead of 30, or the software product will have fewer features than originally planned. While scaling back the scope of the project can lead to big savings in both time and money, it may come at a cost of reducing the value of the project. If the car gets lower gas mileage, will it stand up to competitive models? Will customers still want the software minus the features?

The key to reducing a project scope without reducing value is to reassess the true specifications of the project. Often requirements are added under best-case, blue-sky scenarios and represent desirables, but not essentials. Here it is important to talk to the customer and/or project sponsors and explain the situation—you can get it your way but not until February. This may force them to accept an extension or to add money to expedite the project. If not, then a healthy discussion of what the essential requirements are and what items can be compromised in order to meet the deadline needs to take place. More intense re-examination of requirements may actually improve the value of the project by getting it done more quickly and for a lower cost.

Calculating the savings of reduced project scope begins with the work breakdown structure. Reducing functionality means certain tasks, deliverables, or requirements can be reduced or even eliminated. These tasks need to be found and the schedule adjusted. Focus should be on changes in activities on the critical path.

Compromise Quality

Reducing quality is always an option, but it is rarely acceptable or used. If quality is sacrificed, it may be possible to reduce the time of an activity on the critical path.

In practice the methods most commonly used to crash projects are scheduling overtime, outsourcing, and adding resources. Each of these maintains the essence of the original plan. Options that depart from the original project plan include do it twice and fast-tracking. Rethinking of project scope, customer needs, and timing become major considerations for these techniques.

Project Cost–Duration Graph

Nothing on the horizon suggests that the need to shorten project time will change. The challenge for the project manager is to use a quick, logical method to compare the benefits of reducing project time with the cost. When sound, logical methods are absent, it is difficult to isolate those activities that will have the greatest impact on reducing project time at least cost. This section describes a procedure for identifying the costs of reducing project time so that comparisons can be made with the benefits of getting the project completed sooner. The method requires gathering direct and indirect costs for specific project durations. Critical activities are searched to find the lowest direct-cost activities that will shorten the project duration. Total cost for specific project durations are computed and

FIGURE 9.1
Project Cost–
Duration Graph

then compared with the benefits of reducing project time—before the project begins or while it is in progress.

Explanation of Project Costs

The general nature of project costs is illustrated in Figure 9.1. The total cost for each duration is the sum of the indirect and direct costs. Indirect costs continue for the life of the project. Hence, any reduction in project duration means a reduction in indirect costs. Direct costs on the graph grow at an increasing rate as the project duration is reduced from its original planned duration. With the information from a graph such as this for a project, managers can quickly judge any alternative such as meeting a time-to-market deadline. Further discussion of indirect and direct costs is necessary before demonstrating a procedure for developing the information for a graph similar to the one depicted in Figure 9.1.

Project Indirect Costs

Indirect costs generally represent overhead costs such as supervision, administration, consultants, and interest. Indirect costs cannot be associated with any particular work package or activity, hence the term. Indirect costs vary directly with time. That is, any reduction in time should result in a reduction of indirect costs. For example, if the daily costs of supervision, administration, and consultants are $2,000, any reduction in project duration would represent a savings of $2,000 per day. If indirect costs are a significant percentage of total project costs, reductions in project time can represent very real savings (assuming the indirect resources can be utilized elsewhere).

Project Direct Costs

Direct costs commonly represent labor, materials, equipment, and sometimes subcontractors. Direct costs are assigned directly to a work package and activity, hence the term. The ideal assumption is that direct costs for an activity time represent normal costs, which typically mean low-cost, efficient methods for a normal time. When project durations are

imposed, direct costs may no longer represent low-cost, efficient methods. Costs for the imposed duration date will be higher than for a project duration developed from ideal normal times for activities. Because direct costs are assumed to be developed from normal methods and time, any reduction in activity time should add to the costs of the activity. The sum of the costs of all the work packages or activities represents the total direct costs for the project.

The major plight faced in creating the information for a graph similar to Figure 9.1 is computing the direct cost of shortening individual critical activities and then finding the total direct cost for each project duration as project time is compressed; the process requires selecting those critical activities that cost the least to shorten. (Note: The graph implies that there is always an optimum cost-time point. This is only true if shortening a schedule has incremental indirect cost savings exceeding the incremental direct cost incurred. However, in practice there are almost always several activities in which the direct costs of shortening are less than the indirect costs.)

Constructing a Project Cost–Duration Graph

There are three major steps required to construct a project cost–duration graph:

1. Find total direct costs for selected project durations.
2. Find total indirect costs for selected project durations.
3. Sum direct and indirect costs for these selected durations.

The graph is then used to compare additional cost alternatives for benefits. Details of these steps are presented here.

Determining the Activities to Shorten

The most difficult task in constructing a cost–duration graph is finding the total direct costs for specific project durations over a relevant range. The central concern is to decide which activities to shorten and how far to carry the shortening process. Basically, managers need to look for critical activities that can be shortened with the *smallest increase in cost per unit of time.* The rationale for selecting critical activities depends on identifying the activity's normal and crash times and corresponding costs. *Normal time* for an activity represents low-cost, realistic, efficient methods for completing the activity under normal conditions. Shortening an activity is called *crashing.* The shortest possible time an activity can realistically be completed in is called its *crash time.* The direct cost for completing an activity in its crash time is called *crash cost.* Both normal and crash times and costs are collected from personnel most familiar with completing the activity. Figure 9.2 depicts a hypothetical cost–duration graph for an activity.

The normal time for the activity is 10 time units, and the corresponding cost is $400. The crash time for the activity is five time units and $800. The intersection of the normal time and cost represents the original low-cost, early-start schedule. The crash point represents the maximum time an activity can be compressed. The heavy line connecting the normal and crash points represents the slope, which assumes the cost of reducing the time of the activity is constant *per unit of time.* The assumptions underlying the use of this graph are as follows:

1. The cost-time relationship is linear.
2. Normal time assumes low-cost, efficient methods to complete the activity.
3. Crash time represents a limit—the greatest time reduction possible under realistic conditions.

FIGURE 9.2
Activity Graph

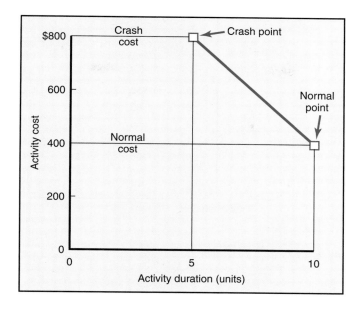

4. Slope represents cost per unit of time.

5. All accelerations must occur within the normal and crash times.

Knowing the slope of activities allows managers to compare which critical activities to shorten. The less steep the cost slope of an activity, the less it costs to shorten one time period; a steeper slope means it will cost more to shorten one time unit. The cost per unit of time or slope for any activity is computed by the following equation:

$$\text{Cost slope} = \frac{\text{Rise}}{\text{Run}} = \frac{\text{Crash cost} - \text{Normal cost}}{\text{Normal time} - \text{Crash time}}$$

$$= \frac{\text{CC} - \text{NC}}{\text{NT} - \text{CT}} = \frac{\$800 - \$400}{10 - 5}$$

$$= \frac{\$400}{5} = \$80 \text{ per unit of time}$$

In Figure 9.2 the rise is the y axis (cost) and the run is the x axis (duration). The slope of the cost line is $80 for each time unit the activity is reduced; the limit reduction of the activity time is five time units. Comparison of the slopes of all critical activities allows us to determine which activity(ies) to shorten to minimize total direct cost. Given the preliminary project schedule (or one in progress) with all activities set to their early-start times, the process of searching critical activities as candidates for reduction can begin. The total direct cost for each specific compressed project duration must be found.

A Simplified Example

Figure 9.3A presents normal and crash times and costs for each activity, the computed slope and time reduction limit, the total direct cost, and the project network with a duration of 25 time units. Note the total direct cost for the 25-period duration is $450. This is an anchor point to begin the procedure of shortening the critical path(s) and finding the total direct costs for each specific duration less than 25 time units. The maximum time reduction of an activity is simply the difference between the normal and crash times for an activity.

FIGURE 9.3
Cost–Duration
Trade-off Example

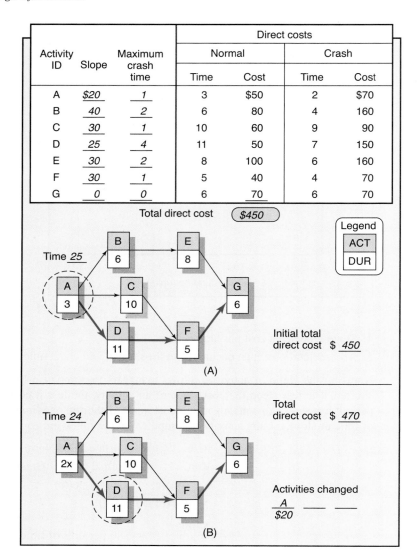

Activity ID	Slope	Maximum crash time	Direct costs			
			Normal		Crash	
			Time	Cost	Time	Cost
A	$20	1	3	$50	2	$70
B	40	2	6	80	4	160
C	30	1	10	60	9	90
D	25	4	11	50	7	150
E	30	2	8	100	6	160
F	30	1	5	40	4	70
G	0	0	6	70	6	70

Total direct cost $450

(A)

Time 25

Legend
ACT
DUR

Initial total direct cost $ 450

(B)

Time 24

Total direct cost $ 470

Activities changed
A
$20

For example, activity D can be reduced from a normal time of 11 time units to a crash time of 7 time units, or a maximum of 4 time units. The positive slope for activity D is computed as follows:

$$\text{Slope} = \frac{\text{Crash cost} - \text{Normal cost}}{\text{Normal time} - \text{Crash time}} = \frac{\$150 - \$50}{11 - 7}$$

$$= \frac{\$100}{4} = \$25 \text{ per period reduced}$$

The network shows the critical path to be activities A, D, F, G. Because it is impossible to shorten activity G, activity A is circled because it is the least-cost candidate; that is, its slope ($20) is less than the slopes for activities D and F ($25 and $30). Reducing activity A one time unit cuts the project duration to 24 time units but increases the total direct costs to $470 ($450 + $20 = $470). Figure 9.3B reflects these changes. The duration of activity

FIGURE 9.4
Cost–Duration
Trade-off Example
(continued)

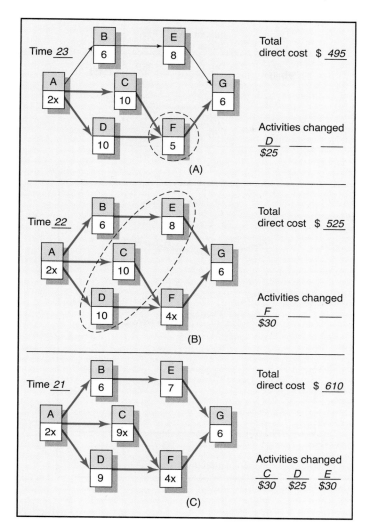

A has been reduced to two time units; the "x" indicates the activity cannot be reduced any further. Activity D is circled because it costs the least ($25) to shorten the project to 23 time units. Compare the cost of activity F. The total direct cost for a project duration of 23 time units is $495 (see Figure 9.4A).

Observe that the project network in Figure 9.4A now has two critical paths—A, C, F, G and A, D, F, G. Reducing the project to 22 time units will require that activity F be reduced; thus, it is circled. This change is reflected in Figure 9.4B. The total direct cost for 22 time units is $525. This reduction has created a third critical path—A, B, E, G; all activities are critical. The least-cost method for reducing the project duration to 21 time units is the combination of the circled activities C, D, E which cost $30, $25, $30, respectively, and increase total direct costs to $610. The results of these changes are depicted in Figure 9.4C. Although some activities can still be reduced (those without the "x" next to the activity time), no activity or combination of activities will result in a reduction in the project duration.

With the total direct costs for the array of specific project durations found, the next step is to collect the indirect costs for these same durations. These costs are typically a rate per

FIGURE 9.5
Summary Costs by Duration

Project duration	Direct costs	+	Indirect costs	=	Total costs
25	450		400		$850
24	470		350		820
23	495		300		795
22	525		250		775
21	610		200		810

FIGURE 9.6
Project Cost–Duration Graph

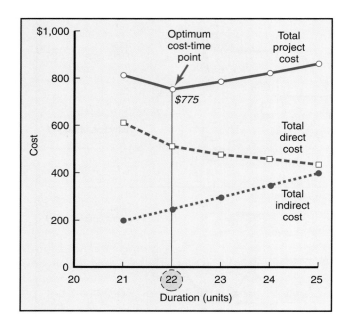

day and are easily obtained from the accounting department. Figure 9.5 presents the total direct costs, total indirect costs, and total project costs. These same costs are plotted in Figure 9.6. This graph shows that the optimum cost-time duration is 22 time units and $775. Assuming the project will actually materialize as planned, any movement away from this time duration will increase project costs. The movement from 25 to 22 time units occurs because, in this range, the absolute slopes of the indirect costs are greater than the direct cost slopes.

Practical Considerations

Using the Project Cost–Duration Graph

This graph, as presented in Figures 9.1 and 9.6, is valuable to compare any proposed alternative or change with the optimum cost and time. More importantly, the creation of such a graph keeps the importance of indirect costs in the forefront of decision making. Indirect costs are frequently forgotten in the field when the pressure for action is intense. Finally, such a graph can be used before the project begins or while the project is in progress. Creating the graph in the preproject planning phase without an imposed duration is the

first choice because normal time is more meaningful. Creating the graph in the project planning phase with an imposed duration is less desirable because normal time is made to fit the imposed date and is probably not low cost. Creating the graph after the project has started is the least desirable because some alternatives may be ruled out of the decision process. Managers may choose not to use the formal procedure demonstrated. However, regardless of the method used, the principles and concepts inherent in the formal procedure are highly applicable in practice and should be considered in any cost–duration trade-off decision.

Crash Times

Collecting crash times for even a moderate-size project can be difficult. The meaning of crash time is difficult to communicate. What is meant when you define crash time as "the shortest time you can realistically complete an activity"? Crash time is open to different interpretations and judgments. Some estimators feel very uncomfortable providing crash times. Regardless of the comfort level, the accuracy of crash times and costs is frequently rough at best, when compared with normal time and cost.

Linearity Assumption

Because the accuracy of compressed activity times and costs is questionable, the concern of some theorists—that the relationship between cost and time is not linear but curvilinear—is seldom a concern for practicing managers. Reasonable, quick comparisons can be made using the linear assumption. The simple approach is adequate for most projects. There are rare situations in which activities cannot be crashed by single time units. Instead, crashing is "all or nothing." For example, activity A will take 10 days (for say $1,000) or it will take 7 days (for say $1,500), but no options exist in which activity A will take 8 or 9 days to complete. In a few rare cases of very large, complex, long-duration projects, the use of present value techniques may be useful; such techniques are beyond the scope of this text.

Choice of Activities to Crash Revisited

The cost–time crashing method relies on choosing the cheapest method for reducing the duration of the project. There are other factors that should be assessed beyond simply cost. First, the inherent risks involved in crashing particular activities need to be considered. Some activities are riskier to crash than others. For example, accelerating the completion of a software design code may not be wise if it increases the likelihood of errors surfacing downstream. Conversely, crashing a more expensive activity may be wise if fewer inherent risks are involved.

Second, the timing of activities needs to be considered. Crashing a critical activity early in the project may result in wasted money if some other critical activity is finished early or some noncritical path becomes the new critical path. In such cases, the money spent early is gone and no benefit comes from early completion by crashing the activity. Conversely, it may be wise to crash an early critical activity when later activities are likely to be delayed and absorb the time gained. Then the manager would still have the option of crashing final activities to get back on schedule.

Finally, the impact crashing would have on the morale and motivation of the project team needs to be assessed. If the least-cost method repeatedly signals a subgroup to accelerate progress, fatigue and resentment may set in. Conversely, if overtime pay is involved, other team members may resent not having access to this benefit. This situation can lead to tension within the entire project team. Good project managers gauge the response that crashing activities will have on the entire project team. See Snapshot from Practice: I'll Bet You . . . for a novel approach to motivating employees to work faster.

Michael Newman/Photoedit.

The focus of this chapter has been on how project managers crash activities by typically assigning additional manpower and equipment to cut significant time off of scheduled tasks. Project managers often encounter situations in which they need to motivate individuals to accelerate the completion of a specific, critical task. Imagine the following scenario.

Brue Young just received a priority assignment from corporate headquarters. The preliminary engineering sketches that were due tomorrow need to be e-mailed to the West Coast by 4:00 P.M. today so that the model shop can begin construction of a prototype to present to top management. He approaches Danny Whitten, the draftsman responsible for the task, whose initial response is, "That's impossible!" While he agrees that it would be very difficult he does not believe that it is as impossible as Danny suggests or that Danny truly believes that. What should he do?

He tells Danny that he knows this is going to be a rush job, but he is confident that he can do it. When Danny balks, he responds, "I tell you what, I'll make a bet with you. If you are able to finish the design by 4:00, I'll make sure you get two of the company's tickets to tomorrow night's Celtics–Knicks basketball game." Danny accepts the challenge, works feverishly to complete the assignment, and is able to take his daughter to her first professional basketball game.

Conversations with project managers reveal that many use bets like this one to motivate extraordinary performance. These bets range from tickets to sporting and entertainment events to gift certificates at high-class restaurants to a well-deserved afternoon off. For bets to work they need to adhere to the principles of expectancy theory of motivation. Boiled down to simple terms, expectancy theory rests on three key questions:

1. Can I do it (Is it possible to meet the challenge)?
2. Will I get it (Can I demonstrate that I met the challenge and can I trust the project manager will deliver his/her end of the bargain)?
3. Is it worth it (Is the payoff of sufficient personal value to warrant the risk and extra effort)?

If in the mind of the participant the answer to any of these three questions is no, then the person is unlikely to accept the challenge. However, when the answers are affirmative, then the individual is likely to accept the bet and be motivated to meet the challenge.

Bets can be effective motivational tools and add an element of excitement and fun to project work. But, the following practical advice should be heeded:

1. The bet has greater significance if it also benefits family members or significant others. Being able to take a son or daughter to a professional basketball game allows that individual to "score points" at home through work. These bets also recognize and reward the support project members receive from their families and reinforces the importance of their work to loved ones.

2. Bets should be used sparingly; otherwise everything can become negotiable. They should be used only under special circumstances that require extraordinary effort.

3. Individual bets should involve clearly recognizable individual effort, otherwise others may become jealous and discord may occur within a group. As long as others see it as requiring truly remarkable, "beyond the call of duty" effort, they will consider it fair and warranted.

Time Reduction Decisions and Sensitivity

Should the project owner or project manager go for the optimum cost-time? The answer is, "It depends." Risk must be considered. Recall from our example that the optimum project time point represented a reduced project cost and was less than the original normal project time (review Figure 9.6). The project direct-cost line near the normal point is usually relatively flat. Because indirect costs for the project are usually greater in the same range, the optimum cost-time point is less than the normal time point. Logic of the cost-time procedure suggests managers should reduce the project duration to the lowest total cost point and duration.

How far to reduce the project time from the normal time toward the optimum depends on the *sensitivity* of the project network. A network is sensitive if it has several critical or near-critical paths. In our example project movement toward the optimum time requires spending money to reduce critical activities, resulting in slack reduction and/or more critical paths and activities. Slack reduction in a project with several near-critical paths increases the risk of being late. The practical outcome can be a higher total project cost if some near-critical activities are delayed and become critical; the money spent reducing activities on the original critical path would be wasted. Sensitive networks require careful analysis. The bottom line is that compression of projects with several near-critical paths reduces scheduling flexibility and increases the risk of delaying the project. The outcome of such analysis will probably suggest only a partial movement from the normal time toward the optimum time.

There is a positive situation where moving toward the optimum time can result in very real, large savings—this occurs when the network is *insensitive*. A project network is insensitive if it has a dominant critical path, that is, no near-critical paths. In this project circumstance, movement from the normal time point toward the optimum time will *not* create new or near-critical activities. The bottom line here is that the reduction of the slack of noncritical activities increases the risk of their becoming critical only slightly when compared with the effect in a sensitive network. Insensitive networks hold the greatest potential for real, sometimes large, savings in total project costs with a minimum risk of noncritical activities becoming critical.

Insensitive networks are not a rarity in practice; they occur in perhaps 25 percent of all projects. For example, a light rail project team observed from their network a dominant critical path and relatively high indirect costs. It soon became clear that by spending some dollars on a few critical activities, very large savings of indirect costs could be realized. Savings of several million dollars were spent extending the rail line and adding another station. The logic found in this example is just as applicable to small projects as large ones. Insensitive networks with high indirect costs can produce large savings.

Ultimately, deciding if and which activities to crash is a judgment call requiring careful consideration of the options available, the costs and risks involved, and the importance of meeting a deadline.

What if Cost, Not Time, Is the Issue?

In today's fast-paced world, there appears to be a greater emphasis on getting things done quickly. Still, organizations are always looking for ways to get things done cheaply. This is especially true for fixed-bid projects, where profit margin is derived from the difference between the bid and actual cost of the project. Every dollar saved is a dollar in your pocket. Sometimes, in order to secure a contract, bids are tight, which

puts added pressure on cost containment. In other cases, there are financial incentives tied to cost containment.

Even in situations where cost is transferred to customers there is pressure to reduce cost. Cost overruns make for unhappy customers and can damage future business opportunities. Budgets can be fixed or cut, and when contingency funds are exhausted, then cost overruns have to be made up with remaining activities.

As discussed earlier, shortening project duration may come at the expense of overtime, adding additional personnel, and using more expensive equipment and/or materials. Conversely, sometimes cost savings can be generated by extending the duration of a project. This may allow for a smaller workforce, less-skilled (expensive) labor, and even cheaper equipment and materials to be used. Below are some of the more commonly used options for cutting costs.

Reduce Project Scope

Just as scaling back the scope of the project can gain time, delivering less than what was originally planned also produces significant savings. Again, calculating the savings of a reduced project scope begins with the work breakdown structure. However, since time is not the issue, you do not need to focus on critical activities.

Have Owner Take on More Responsibility

One way of reducing project costs is identifying tasks that customers can do themselves. Homeowners frequently use this method to reduce costs on home improvement projects. For example, to reduce the cost of a bathroom remodel, a homeowner may agree to paint the room instead of paying the contractor to do it. On IS projects, a customer may agree to take on some of the responsibility for testing equipment or providing in-house training. Naturally, this arrangement is best negotiated before the project begins. Customers are less receptive to this idea if you suddenly spring it on them. An advantage of this method is that, while costs are lowered, the original scope is retained. Clearly this option is limited to areas in which the customer has expertise and the capability to pick up the tasks.

Outsourcing Project Activities or Even the Entire Project

When estimates exceed budget, it not only makes sense to re-examine the scope but also search for cheaper ways to complete the project. Perhaps instead of relying on internal resources, it would be more cost effective to outsource segments or even the entire project, opening up work to external price competition. Specialized subcontractors often enjoy unique advantages, such as material discounts for large quantities, as well as equipment that not only gets the work done more quickly but also less expensively. They may have lower overhead and labor costs. For example, to reduce costs of software projects, many American firms outsource work to firms operating in India where the salary of a software engineer is one-third that of an American software engineer. However, outsourcing means you have less control over the project and will need to have clearly definable deliverables.

Brainstorming Cost Savings Options

Just as project team members can be a rich source of ideas for accelerating project activities, they can offer tangible ways for reducing project costs. For example, one project manager reported that his team was able to come up with over $75,000 worth of cost saving

suggestions without jeopardizing the scope of the project. Project managers should not underestimate the value of simply asking if there is a cheaper, better way.

Summary

The need for reducing the project duration occurs for many reasons such as imposed duration dates, time-to-market considerations, incentive contracts, key resource needs, high overhead costs, or simply unforeseen delays. These situations are very common in practice and are known as cost-time trade-off decisions. This chapter presented a logical, formal process for assessing the implications of situations that involve shortening the project duration. Crashing the project duration increases the *risk* of being late. How far to reduce the project duration from the normal time toward the optimum depends on the *sensitivity* of the project network. A sensitive network is one that has several critical or near-critical paths. Great care should be taken when shortening sensitive networks to avoid increasing project risks. Conversely, insensitive networks represent opportunities for potentially large project cost savings by eliminating some overhead costs with little downside risk.

Alternative strategies for reducing project time were discussed within the context of whether or not the project is resource limited. Project acceleration typically comes at a cost of either spending money for more resources or compromising the scope of the project. If the latter is the case, then it is essential that all relevant stakeholders be consulted so that everyone accepts the changes that have to be made. One other key point is the difference in implementing time-reducing activities in the midst of project execution versus incorporating them into the project plan. You typically have far fewer options once the project is underway than before it begins. This is especially true if you want to take advantage of the new scheduling methodologies such as fast-tracking and critical-chain. Time spent up front considering alternatives and developing contingency plans will lead to time savings in the end.

Key Terms

Crash point	Fast-tracking	Project cost–duration
Crash time	Indirect costs	graph
Direct costs	Outsourcing	

Review Questions

1. What are five common reasons for crashing a project?
2. What are the advantages and disadvantages of reducing project scope to accelerate a project? What can be done to reduce the disadvantages?
3. Why is scheduling overtime a popular choice for getting projects back on schedule? What are the potential problems for relying on this option?
4. Identify four indirect costs you might find on a moderately complex project. Why are these costs classified as indirect?
5. How can a cost–duration graph be used by the project manager? Explain.
6. Reducing the project duration increases the risk of being late. Explain.
7. It is possible to shorten the critical path and save money. Explain how.

Exercises

1. Draw a project network from the following information.

Activity	Predecessor	Duration
A	None	2
B	A	4
C	A	3
D	A	2
E	B	3
F	C	6
G	C, D	5
H	E, F	6
I	G	5
J	H, I	5

Activities B and H can be shortened to a minimum of 2 weeks. Which activity would you shorten to reduce the project duration by 2 weeks? Why?

2. Assume the network and data that follow. Compute the total direct cost for each project duration. If the indirect costs for each project duration are $400 (19 time units), $350 (18), $300 (17), and $250 (16), compute the total project cost for each duration. Plot the total direct, indirect, and project costs for each of these durations on a cost-time graph. What is the optimum cost-time schedule for the project? What is this cost?

Act.	Crash Cost (Slope)	Maximum Crash Time	Normal Time	Normal Cost
A	20	1	3	50
B	60	2	5	60
C	40	1	3	70
D	0	0	10	50
E	50	3	6	100
F	100	3	7	90
G	70	1	5	50
				$470

3. Given the data and information that follow, compute the total direct cost for each project duration. If the indirect costs for each project duration are $90 (15 time units), $70 (14), $50 (13), $40 (12), and $30 (11), compute the total project cost for each duration. What is the optimum cost-time schedule for the project? What is this cost?

Act.	Crash Cost (Slope)	Maximum Crash Time	Normal Time	Normal Cost
A	20	1	5	50
B	60	2	3	60
C	0	0	4	70
D	10	1	2	50
E	60	3	5	100
F	100	1	2	90
G	30	1	5	50
H	40	0	2	60
I	200	1	3	200
				$730

Initial
project duration _15_

Total
direct cost $____

4. If the indirect costs for each duration are $1,200 for 16 weeks, $1,130 for 15 weeks, $1,000 for 14 weeks, $900 for 13 weeks, $860 for 12 weeks, $820 for 11 weeks and $790 for 10 weeks, compute the total costs for each duration. Plot these costs on a graph. What is the optimum cost-time schedule?

Act.	Crash Cost (Slope)	Maximum Crash Time	Normal Time	Normal Cost
A	10	1	4	30
B	70	2	7	60
C	0	0	1	80
D	20	2	4	40
E	50	3	5	110
F	200	3	5	90
G	30	1	2	60
H	40	1	2	70
I	0	0	2	140
				$680

Time unit=1 week

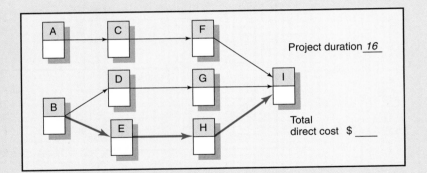

Project duration _16_

Total direct cost　$____

5. If the indirect costs for each duration are $300 for 27 weeks, $240 for 26 weeks, $180 for 25 weeks, $120 for 24 weeks, $60 for 23 weeks, and $50 for 22 weeks, compute the direct, indirect and total costs for each duration. What is the optimum cost-time schedule? The customer offers you $10 dollars for every week you shorten the project from your original network. Would you take it? If so for how many weeks?

Act.	Crash Cost (Slope)	Maximum Crash Time	Normal Time	Normal Cost
A	80	2	10	40
B	30	3	8	10
C	40	1	5	80
D	50	2	11	50
E	100	4	15	100
F	30	1	6	20
				$300

Time unit = 1 week

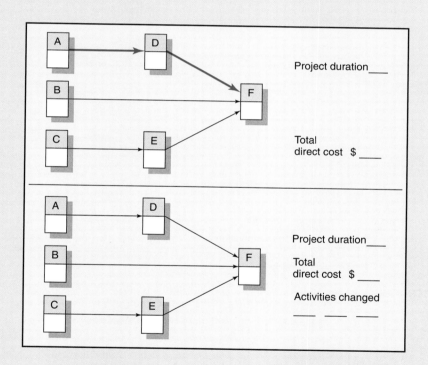

6. Use the information contained below to compress one time unit per move using the least cost method. Reduce the schedule until you reach the crash point of the network. For each move identify what activity(s) was crashed, the adjusted total cost, and explain your choice if you have to choose between activities that cost the same.

Note: Crash point of the network is the point in which the duration cannot be reduced any further.

Activity ID	Slope	Maximum Crash Time	Normal Time	Normal Cost	Crash Time	Crash Cost
A	—	0	4	$50	0	—
B	$40	3	5	70	2	$190
C	40	1	5	80	4	40
D	40	2	4	40	2	120
E	40	2	5	60	3	140
F	40	1	5	50	4	90
G	30	1	4	70	3	160
H	30	1	4	80	3	110
I	—	0	3	50	0	—

Total direct normal costs—$550

Completion time: _21_ Total cost $ _550_

References

Abdel-Hamid, T., and S. Madnick, *Software Project Dynamics: An Integrated Approach* (Englewood Cliffs, NJ: Prentice Hall, 1991).

Baker, B. M., "Cost/Time Trade-off Analysis for the Critical Path Method," *Journal of the Operational Research Society,* 48 (12), 1997, pp. 1241–44.

Brooks, F. P., Jr., *The Mythical Man-Month: Essays on Software Engineering Anniversary Edition* (Reading, MA: Addison-Wesley Longman, Inc., 1994), pp. 15–26.

DeMarco, T., *Slack: Getting Past Burnout, Busywork, and the Myth of Total Efficiency* (New York: Broadway, 2002).

Ibbs, C. W., S. A. Lee, and M. I. Li, "Fast-Tracking's Impact on Project Change," *Project Management Journal,* 29 (4), 1998, pp. 35–42.

Khang, D. B., and M. Yin, "Time, Cost, and Quality Tradeoff in Project Management," *International Journal of Project Management,* 17 (4), 1999, pp. 249–56.

Perrow, L. A., *Finding Time: How Corporations, Individuals, and Families Can Benefit From New Work Practices* (Ithaca, NY: Cornell University Press, 1997).

Roemer, T. R., R. Ahmadi, and R. Wang, "Time-Cost Trade-offs in Overlapped Product Development," *Operations Research,* 48 (6) 2000, pp. 858–65.

Smith, P. G., and D.G. Reinersten, *Developing Products in Half the Time* (New York: Van Nostrand Reinhold, 1995).

Verzuh, E., *The Fast Forward MBA in Project Management* (New York: John Wiley, 1999).

Vroom, V. H., *Work and Motivation* (New York: John Wiley & Sons, 1964).

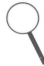

Case

International Capital, Inc.—Part B

Given the project network derived in Part A of the case from Chapter 7, Brown also wants to be prepared to answer any questions concerning compressing the project duration. This question will almost always be entertained by the accounting department, review committee, and the client. To be ready for the compression question, Brown has prepared the following data in case it is necessary to crash the project. (Use your weighted average times (t_e) computed in Part A of the International Capital case found in Chapter 7.)

Activity	Normal Cost	Maximum Crash Time	Crash Cost/Day
A	$ 3,000	3	$ 500
B	5,000	2	1000
C	6,000	0	—
D	20,000	3	3,000
E	10,000	2	1,000
F	7,000	1	1,000
G	20,000	2	3,000
H	8,000	1	2,000
I	5,000	1	2,000
J	7,000	1	1,000
K	12,000	6	1,000
Total normal costs = $103,000			

Using the data provided, determine the activity crashing decisions and best-time cost project duration. Given the information you have developed, what suggestions would you give Brown to ensure she is well prepared for the project review committee? Assume the overhead costs for this project are $700 per workday. Will this alter your suggestions?

Case

Whitbread World Sailboat Race

Each year countries enter their sailing vessels in the nine-month Round the World Whitbread Sailboat Race. In recent years, about 14 countries entered sailboats in the race. Each year's sailboat entries represent the latest technologies and human skills each country can muster.

Bjorn Ericksen has been selected as a project manager because of his past experience as a master helmsman and because of his recent fame as the "best designer of racing sailboats in the world." Bjorn is pleased and proud to have the opportunity to design, build, test, and train the crew for next year's Whitbread entry for his country. Bjorn has picked Karin Knutsen (as chief design engineer) and Trygve Wallvik (as master helmsman) to be team leaders responsible for getting next year's entry ready for the traditional parade of all entries on the Thames River in the United Kingdom, which signals the start of the race.

As Bjorn begins to think of a project plan, he sees two parallel paths running through the project—design and construction and crew training. Last year's boat will be used for training until the new entry can have the crew on board to learn maintenance tasks. Bjorn calls Karin and Trygve together to develop a project plan. All three agree the major goal is to have a winning boat and crew ready to compete in next year's competition at a cost of $3.2 million. A check of Bjorn's calendar indicates he has 45 weeks before next year's vessel must leave port for the United Kingdom to start the race.

THE KICKOFF MEETING

Bjorn asks Karin to begin by describing the major activities and the sequence required to design, construct, and test the boat. Karin starts by noting that design of the hull, deck, mast, and accessories should only take six weeks—given the design prints from past race entries and a few prints from other countries' entries. After the design is complete, the hull can be constructed, the mast ordered, sails ordered, and accessories ordered. The hull will require 12 weeks to complete. The mast can be ordered and will require a lead time of eight weeks; the seven sails can be ordered and will take six weeks to get; accessories can be ordered and will take 15 weeks to receive. As soon as the hull is finished, the ballast tanks can be installed, requiring two weeks. Then the deck can be built, which will require five weeks. Concurrently, the hull can be treated with special sealant and friction-resistance coating, taking three weeks. When the deck is completed and mast and accessories received, the mast and sails can be installed, requiring two weeks; the accessories can be installed, which will take six weeks. When all of these activities have been completed, the ship can be sea-tested, which should take five weeks. Karin believes she can have firm cost estimates for the boat in about two weeks.

Trygve believes he can start selecting the 12-man or woman crew and securing their housing immediately. He believes it will take six weeks to get a committed crew on-site and three weeks to secure housing for the crew members. Trygve reminds Bjorn that last year's vessel must be ready to use for training the moment the crew is on-site until the new vessel is ready for testing. Keeping the old vessel operating will cost $4,000 per week as long as it is used. Once the crew is on-site and housed, they can develop and implement a routine sailing and maintenance training program, which will take 15 weeks (using the old vessel). Also, once the crew is selected and on-site, crew equipment can be selected, taking only two weeks. Then crew equipment can be ordered; it will take five weeks to arrive. When the crew equipment and maintenance training program are complete, crew maintenance on the new vessel can begin; this should take 10 weeks. But crew maintenance on the new vessel cannot begin until the deck is complete and the mast, sails, and accessories have arrived. Once crew maintenance on the new vessel begins, the new vessel will cost $6,000 per week until sea training is complete. After the new ship maintenance is complete and while the boat is being tested, initial sailing training can be implemented; training should take seven weeks. Finally, after the boat is tested and initial training is complete, regular sea training can be implemented—weather permitting; regular sea training requires eight weeks. Trygve believes he can put the cost estimates together in a week, given last year's expenses.

Bjorn is pleased with the expertise displayed by his team leaders. But he believes they need to have someone develop one of those critical path networks to see if they can safely meet the start deadline for the race. Karin and Trygve agree. Karin suggests the cost estimates should also include crash costs for any activities that can be compressed and the resultant costs for crashing. Karin also suggests the team complete the following priority matrix for project decision making:

FIGURE C9.1
Project Priority
Matrix: Whitbread
Project

TWO WEEKS LATER

Karin and Trygve submit the following cost estimates for each activity and corresponding crash costs to Bjorn (costs are in thousands of dollars):

Activity		Normal Time	Normal Cost	Crash Time	Crash Cost
A	Design	6	$ 40	4	$ 160
B	Build hull	12	1,000	10	1,400
C	Install ballast tanks	2	100	2	100
D	Order mast	8	100	7	140
E	Order sails	6	40	6	40
F	Order accessories	15	600	13	800
G	Build deck	5	200	5	200
H	Coat hull	3	40	3	40
I	Install accessories	6	300	5	400
J	Install mast and sails	2	40	1	80
K	Test	5	60	4	100
L	Sea trials	8	200	7	450
M	Select crew	6	10	5	20
N	Secure housing	3	30	3	30
O	Select crew equipment	2	10	2	10
P	Order crew equipment	5	30	5	30
Q	Routine sail and maintenance	15	40	12	130
R	Crew maintenance training	10	100	9	340
S	Initial sail training	7	50	5	350

Bjorn reviews the materials and wonders if the project will come in within the budget of $3.2 million and in 45 weeks. Advise the Whitbread team of their situation.

Case

Nightingale Project—A

You are the assistant project manager to Rassy Brown, who is in charge of the Nightingale project. Nightingale was the code name given to the development of a handheld electronic medical reference guide. Nightingale would be designed for emergency medical technicians and paramedics who need a quick reference guide to use in emergency situations.

Rassy and her project team were developing a project plan aimed at producing 30 working models in time for MedCON, the biggest medical equipment trade show each year. Meeting the MedCON October 25 deadline was critical to success. All the major medical equipment manufacturers demonstrated and took orders for new products at MedCON. Rassy had also heard rumors that competitors were considering developing a similar product, and she knew that being first to market would have a significant sales advantage. Besides, top management made funding contingent upon developing a workable plan for meeting the MedCON deadline.

The project team spent the morning working on the schedule for Nightingale. They started with the WBS and developed the information for a network, adding activities when needed. Then the team added the time estimates they had collected for each activity. Following is the preliminary information for activities with duration time and predecessors:

Activity	Description	Duration	Predecessor
1	Architectural decisions	10	None
2	Internal specifications	20	1
3	External specifications	18	1
4	Feature specifications	15	1
5	Voice recognition	15	2,3
6	Case	4	2,3
7	Screen	2	2,3
8	Speaker output jacks	2	2,3
9	Tape mechanism	2	2,3
10	Database	40	4
11	Microphone/soundcard	5	4
12	Pager	4	4
13	Barcode reader	3	4
14	Alarm clock	4	4
15	Computer I/O	5	4
16	Review design	10	5,6,7,8,9,10,11,12,13,14,15
17	Price components	5	5,6,7,8,9,10,11,12,13,14,15
18	Integration	15	16,17
19	Document design	35	16
20	Procure prototype components	20	18
21	Assemble prototypes	10	20
22	Lab test prototypes	20	21
23	Field test prototypes	20	19,22
24	Adjust design	20	23
25	Order stock parts	15	24
26	Order custom parts	2	24
27	Assemble first production unit	10	25, FS—8 time units 26, FS—13 time units
28	Test unit	10	27
29	Produce 30 units	15	28
30	Train sales representatives	10	29

Use any project network computer program available to you to develop the schedule for activities (see Case Appendix for further instructions)—noting late and early times, the critical path, and estimated completion for the project.

Prepare a short memo that addresses the following questions:

1. Will the project as planned meet the October 25th deadline?
2. What activities lie on the critical path?
3. How sensitive is this network?

Case

Nightingale Project—B

Rassy and the team were concerned with the results of your analysis. They spent the afternoon brainstorming alternative ways for shortening the project duration. They rejected outsourcing activities because most of the work was developmental in nature and could only be done in-house. They considered altering the scope of the project by eliminating some of the proposed product features. After much debate, they felt they could not compromise any of the core features and be successful in the marketplace. They then turned their attention to accelerating the completion of activities through overtime and adding additional technical manpower. Rassy had built into her proposal a discretionary fund of $200,000. She was willing to invest up to half of this fund to accelerate the project, but wanted to hold onto at least $100,000 to deal with unexpected problems. After a lengthy discussion, her team concluded that the following activities could be reduced at the specified cost:

- Development of voice recognition system could be reduced from 15 days to 10 days at a cost of $15,000.
- Creation of database could be reduced from 40 days to 35 days at a cost of $35,000.
- Document design could be reduced from 35 days to 30 days at a cost of $25,000.
- External specifications could be reduced from 18 days to 12 days at a cost of $20,000.
- Procure prototype components could be reduced from 20 days to 15 days at a cost of $30,000.
- Order stock parts could be reduced from 15 days to 10 days at a cost of $20,000.

Ken Clark, a development engineer, pointed out that the network contained only finish-to-start relationships and that it might be possible to reduce project duration by creating start-to-start lags. For example, he said that his people would not have to wait for all of the field tests to be completed to begin making final adjustments in the design. They could start making adjustments after the first 15 days of testing. The project team spent the remainder of the day analyzing how they could introduce lags into the network to hopefully shorten the project. They concluded that the following finish-to-start relationships could be converted into lags:

- Document design could begin 5 days after the start of the review design.
- Adjust design could begin 15 days after the start of field test prototypes.
- Order stock parts could begin 5 days after the start of adjust design.
- Order custom parts could begin 5 days after the start of adjust design.
- Training sales representatives could begin 5 days after the start of test unit and completed 5 days after the production of 30 units.

As the meeting adjourns, Rassy turns to you and tells you to assess the options presented and try to develop a schedule that will meet the October 25th deadline. You are to prepare a report to be presented to the project team that answers the following questions:

1. Is it possible to meet the deadline?
2. If so, how would you recommend changing the original schedule (Part A) and why? Assess the relative impact of crashing activities versus introducing lags to shorten project duration.
3. What would the new schedule look like?
4. What other factors should be considered before finalizing the schedule?

CASE APPENDIX: TECHNICAL DETAILS

Create your project schedule and assess your options based on the following information:

1. The project will begin the first working day in January.
2. The following holidays are observed: January 1, Memorial Day (last Monday in May), July 4, Labor Day (first Monday in September), Thanksgiving Day (fourth Thursday in November), December 25 and 26.
3. If a holiday falls on a Saturday, then Friday will be given as an extra day off; if it falls on a Sunday, then Monday will be given as a day off.
4. The project team works Monday through Friday.
5. If you choose to reduce the duration of any one of the activities mentioned, then it must be for the specified time and cost (i.e., you cannot choose to reduce database to 37 days at a reduced cost; you can only reduce it to 35 days at a cost of $35,000).
6. You can only spend up to $100,000 to reduce project activities; lags do not contain any additional costs.

Case

The "Now" Wedding—Part A

On December 31 of last year, Lauren burst into the family living room and announced that she and Connor (her college boyfriend) were going to be married. After recovering from the shock, her mother hugged her and asked, "When?" The following conversation resulted:

Lauren:	January 21.
Mom:	What?
Dad:	The Now Wedding will be the social hit of the year. Wait a minute. Why so soon?
Lauren:	Because on January 30 Connor, who is in the National Guard, will be shipping out overseas. We want a week for a honeymoon.
Mom:	But Honey, we can't possibly finish all the things that need to be done by then. Remember all the details that were involved in your sister's wedding? Even if we start tomorrow, it takes a day to reserve the church and reception hall, and they need at least 14 days' notice. That has to be done before we can start decorating, which takes 3 days. An extra $200 on Sunday would probably cut that 14 day notice to 7 days, though.
Dad:	Oh, boy!

Lauren:	I want Jane Summers to be my maid of honor.
Dad:	But she's in the Peace Corps in Guatemala, isn't she? It would take her 10 days to get ready and drive up here.
Lauren:	But we could fly her up in 2 days and it would only cost $1,000.
Dad:	Oh, boy!
Mom:	And catering! It takes 2 days to choose the cake and decorations, and Jack's Catering wants at least 5 days' notice. Besides, we'd have to have those things before we could start decorating.
Lauren:	Can I wear your wedding dress, Mom?
Mother:	Well, we'd have to replace some lace, but you could wear it, yes. We could order the lace from New York when we order the material for the bridesmaids' dresses. It takes 8 days to order and receive the material. The pattern needs to be chosen first, and that would take 3 days.
Dad:	We could get the material here in 5 days if we paid an extra $20 to airfreight it. Oh, boy!
Lauren:	I want Mrs. Jacks to work on the dresses.
Mom:	But she charges $48 a day.
Dad:	Oh, boy!
Mom:	If we did all the sewing we could finish the dresses in 11 days. If Mrs. Jacks helped we could cut that down to 6 days at a cost of $48 for each day less than 11 days. She is very good too.
Lauren:	I don't want anyone but her.
Mom:	It would take another 2 days to do the final fitting and 2 more days to clean and press the dresses. They would have to be ready by rehearsal night. We must have rehearsal the night before the wedding.
Dad:	Everything should be ready rehearsal night.
Mom:	We've forgotten something. The invitations!
Dad:	We should order the invitations from Bob's Printing shop, and that usually takes 7 days. I'll bet he would do it in 6 days if we slipped him an extra $20!
Mom:	It would take us 2 days to choose the invitation style before we could order them and we want the envelopes printed with our return address.
Lauren:	Oh! That will be elegant.
Mom:	The invitations should go out at least 10 days before the wedding. If we let them go any later, some of the relatives would get theirs too late to come and that would make them mad. I'll bet that if we didn't get them out until 8 days before the wedding, Aunt Ethel couldn't make it and she would reduce her wedding gift by $200.
Dad:	Oh, boy!!
Mom:	We'll have to take them to the Post Office to mail them and that takes a day. Addressing would take 3 days unless we hired some part-time girls and we can't start until the printer is finished. If we hired the girls we could probably save 2 days by spending $40 for each day saved.
Lauren:	We need to get gifts for the bridesmaids. I could spend a day and do that.
Mom:	Before we can even start to write out those invitations we need a guest list. Heavens, that will take 4 days to get in order and only I can understand our address file.
Lauren:	Oh, Mom, I'm so excited. We can start each of the relatives on a different job.

* This case was adapted from a case originally written by Professor D. Clay Whybark, University of North Carolina, Chapel Hill, N.C.

> **Mom:** Honey, I don't see how we can do it. Why, I've got to choose the invitations and patterns and reserve the church and . . .
>
> **Dad:** Why don't you just take $3,000 and elope. Your sister's wedding cost me $2,400 and she didn't have to fly people up from Guatemala, hire extra girls and Mrs. Jacks, use airfreight, or anything like that.

1. Using a yellow sticky approach (see p. 153), develop a project network for the "Now" Wedding.
2. Create a schedule for the wedding using MS Project. Can you reach the deadline of January 21 for the Now Wedding? If you cannot, what would it cost to make the January 21 deadline and which activities would you change?

Case

The "Now" Wedding—Part B

Several complications arose during the course of trying to meet the deadline of January 20 for the Now Wedding rehearsal. Since Lauren was adamant on having the wedding on January 21 (as was Connor for obvious reasons), the implications of each of these complications had to be assessed.

1. On January 1 the chairman of the Vestry Committee of the church was left unimpressed by the added donation and said he wouldn't reduce the notice period from 14 to 7 days.
2. Mother comes down with the three-day flu as she starts work on the guest list January 2.
3. Bob's Printing Service's press was down for one day on January 5th in order to replace faulty brushes in the electric motor.
4. The lace and dress material are lost in transit. Notice of the loss is received on January 10.

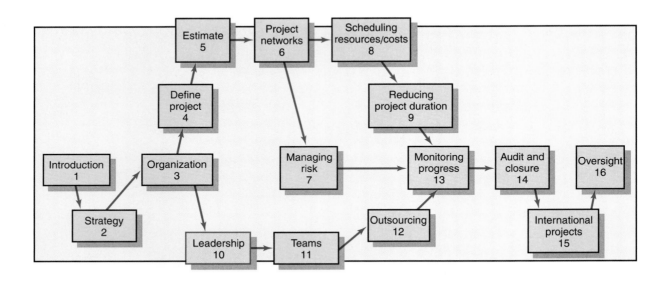

Leadership: Being an Effective Project Manager

I couldn't wait to be the manager of my own project and run the project the way I thought it should be done. Boy, did I have a lot to learn!

—*first-time project manager*

This chapter is based on the premise that one of the keys to being an effective project manager is building cooperative relationships among different groups of people to complete projects. Project success does not just depend on the performance of the project team. Success or failure often depends on the contributions of top management, functional managers, customers, suppliers, contractors, and others.

The chapter begins with a brief discussion of the differences between leading and managing a project. The importance of managing project stakeholders is then introduced. Managers require a broad influence base to be effective in this area. Different sources of influence are discussed and are used to describe how project managers build social capital. This management style necessitates constant interacting with different groups of people whom project managers depend on. Special attention is devoted to managing the critical relationship with top management and the importance of leading by example. The importance of gaining cooperation in ways that build and sustain the trust of others is emphasized. The chapter concludes by identifying personal attributes associated with being an effective project manager. Subsequent chapters will expand on these ideas in a discussion of managing the project team and working with people outside the organization.

Managing versus Leading a Project

In a perfect world, the project manager would simply implement the project plan and the project would be completed. The project manager would work with others to formulate a schedule, organize a project team, keep track of progress, and announce what needs to be done next, and then everyone would charge along. Of course no one lives in a perfect world, and rarely does everything go according to plan. Project participants get testy; they fail to complement each other; other departments are unable to fulfill their commitments; technical glitches arise; work takes longer than expected. The project manager's job is to get the project back on track. A manager expedites certain activities; figures out ways to solve technical problems; serves as peacemaker when tensions rise; and makes appropriate trade-offs among time, cost, and scope of the project.

However, project managers do more than put out fires and keep the project on track. They also innovate and adapt to ever-changing circumstances. They often have to deviate from what was planned and introduce significant changes in the project scope and schedule to respond to unforeseen threats or opportunities. For example, customers' needs may change, requiring significant design changes midway through the project. Competitors may release new products that dictate crashing project deadlines. Working relationships among project participants may break down, requiring a reformulation of the project team. Ultimately, what was planned or expected in the beginning may be very different from what was accomplished by the end of the project.

Project managers are responsible for integrating assigned resources to complete the project according to plan. At the same time they need to initiate changes in plans and schedules as persistent problems make plans unworkable. In other words, managers want to keep the project going while making necessary adjustments along the way. According to Kotter these two different activities represent the distinction between management and leadership. Management is about coping with complexity, while leadership is about coping with change.

Good management brings about order and stability by formulating plans and objectives, designing structures and procedures, monitoring results against plans, and taking corrective action when necessary. Leadership involves recognizing and articulating the need to significantly alter the direction and operation of the project, aligning people to the new direction, and motivating them to work together to overcome hurdles produced by the change and to realize new objectives.

Strong leadership, while usually desirable, is not always necessary to successfully complete a project. Well-defined projects that encounter no significant surprises require little leadership, as might be the case in constructing a conventional apartment building in which the project manager simply administrates the project plan. Conversely, the higher the degree of uncertainty encountered on a project—whether in terms of changes in project scope, technological stalemates, breakdowns in coordination between people, and so forth—the more leadership is required. For example, strong leadership would be needed for a software development project in which the parameters are always changing to meet developments in the industry.

It takes a special person to perform both roles well. Some individuals are great visionaries who are good at exciting people about change. Too often though, these same people lack the discipline or patience to deal with the day-to-day drudgeries of managing. Likewise, there are other individuals who are very well organized and methodical but lack the ability to inspire others.

Strong leaders can compensate for their managerial weaknesses by having trusted assistants who oversee and manage the details of the project. Conversely, a weak leader can complement his or her strengths by having assistants who are good at sensing the need to change and rallying project participants. Still, one of the things that makes good project managers so valuable to an organization is that they have the ability to both manage and lead a project. In doing so they recognize the need to manage project interfaces and build a social network that allows them to find out what needs to be done and obtain the cooperation necessary to achieve it.

Managing Project Stakeholders

First-time project managers are eager to implement their own ideas and manage their people to successfully complete their project. What they soon find out is that project success depends on the cooperation of a wide range of individuals, many of whom do not directly

report to them. For example, during the course of a system integration project, a project manager was surprised by how much time she was spending negotiating and working with vendors, consultants, technical specialists, and other functional managers:

> Instead of working with my people to complete the project, I found myself being constantly pulled and tugged by demands of different groups of people who were not directly involved in the project but had a vested interest in the outcome.

Too often when new project managers do find time to work directly on the project, they adopt a hands-on approach to managing the project. They choose this style not because they are power-hungry egomaniacs but because they are eager to achieve results. They become quickly frustrated by how slowly things operate, the number of people that have to be brought on board, and the difficulty of gaining cooperation. Unfortunately, as this frustration builds, the natural temptation is to exert more pressure and get more heavily involved in the project. These project managers quickly earn the reputation of "micro managing" and begin to lose sight of the real role they play on guiding a project.

Some new managers never break out of this vicious cycle. Others soon realize that authority does not equal influence and that being an effective project manager involves managing a much more complex and expansive set of interfaces than they had previously anticipated. They encounter a web of relationships that requires a much broader spectrum of influence than they felt was necessary or even possible.

For example, a significant project, whether it involves renovating a bridge, creating a new product, or installing a new information system, will likely involve in one way or another working with a number of different groups of stakeholders. First, there is the core group of specialists assigned to complete the project. This group is likely to be supplemented at different times by professionals who work on specific segments of the project. Second, there are the groups of people within the performing organization who are either directly or indirectly involved with the project. The most notable is top management, to whom the project manager is accountable. There are also other managers who provide resources and/or may be responsible for specific segments of the project, and administrative support services such as human resources, finance, etc. Depending on the nature of the project, there are a number of different groups outside the organization that influence the success of the project; the most important is the customer for which the project is designed (see Figure 10.1).

Each of these groups of individuals brings different expertise, standards, priorities, and agendas to the project. The sheer breadth and complexity of the relationships that need to be managed distinguishes project management from regular management. To be effective, a project manager must understand how these groups can affect the project and develop methods for managing the dependency. The nature of these dependencies is identified here:

- The **project team** manages and completes project work. Most participants want to do a good job, but they are also concerned with their other obligations and how their involvement on the project will contribute to their personal goals and aspirations.

- **Project managers** naturally compete with each other for resources and the support of top management. At the same time they often have to share resources and exchange information.

- **Administrative support** groups, such as human resources, information systems, purchasing agents, and maintenance, provide valuable support services. At the same time they impose constraints and requirements on the project such as the documentation of expenditures and the timely and accurate delivery of information.

FIGURE 10.1
Network of
Stakeholders

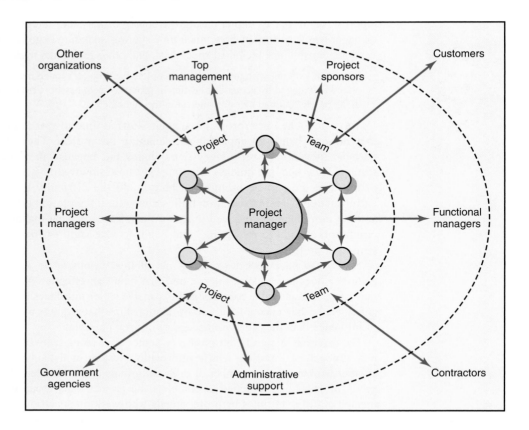

- **Functional managers,** depending on how the project is organized, can play a minor or major role toward project success. In matrix arrangements, they may be responsible for assigning project personnel, resolving technical dilemmas, and overseeing the completion of significant segments of the project work. Even in dedicated project teams, the technical input from functional managers may be useful, and acceptance of completed project work may be critical to in-house projects. Functional managers want to cooperate up to a point, but only up to a certain point. They are also concerned with preserving their status within the organization and minimizing the disruptions the project may have on their own operations.

- **Top management** approves funding of the project and establishes priorities within the organization. They define success and adjudicate rewards for accomplishments. Significant adjustments in budget, scope, and schedule typically need their approval. They have a natural vested interest in the success of the project, but at the same time have to be responsive to what is best for the entire organization.

- **Project sponsors** champion the project and use their influence to gain approval of the project. Their reputation is tied to the success of the project, and they need to be kept informed of any major developments. They defend the project when it comes under attack and are a key project ally.

- **Contractors** may do all the actual work, in some cases, with the project team merely coordinating their contributions. In other cases, they are responsible for ancillary segments of the project scope. Poor work and schedule slips can affect work of the core

Photodisc Green/Getty Images.

Metaphors convey meaning beyond words. For example, a meeting can be described as being difficult or "like wading through molasses." A popular metaphor for the role of a project manager is that of *conductor*. The conductor of an orchestra integrates the divergent sounds of different instruments to perform a given composition and make beautiful music. Similarly, the project manager integrates the talents and contributions of different specialists to complete the project. Both have to be good at understanding how the different players contribute to the performance of the whole. Both are almost entirely dependent upon the expertise and know-how of the players. The conductor does not have command of all the musical instruments. Likewise, the project manager usually possesses only a small proportion of the technical knowledge to make decisions. As such, the conductor and project

manager both facilitate the performance of others rather than actually perform.

Conductors use their arms, baton, and other nonverbal gestures to influence the pace, intensity, and involvement of different musicians. Likewise, project managers orchestrate the completion of the project by managing the involvement and attention of project members. Project managers balance time and process and induce participants to make the right decisions at the right time just as the conductor induces the wind instruments to perform at the right moment in a movement. Each controls the rhythm and intensity of work by managing the tempo and involvement of the players. Finally, each has a vision that transcends the music score or project plan. To be successful they must both earn the confidence, respect, and trust of their players.

project team. While contractors' reputations rest with doing good work, they must balance their contributions with their own profit margins and their commitments to other clients.

- **Government agencies** place constraints on project work. Permits need to be secured. Construction work has to be built to code. New drugs have to pass a rigorous battery of U.S. Food and Drug Administration tests. Other products have to meet safety standards, for example, Occupational Safety and Health Administration standards.

- **Other organizations,** depending on the nature of the project, may directly or indirectly affect the project. For example, suppliers provide necessary resources for completion of the project work. Delays, shortages, and poor quality can bring a project to a standstill. Public interest groups may apply pressure on government agencies. Customers often hire consultants and auditors to protect their interests on a project.

- **Customers** define the scope of the project, and ultimate project success rests in their satisfaction. Project managers need to be responsive to changing customer needs and requirements and to meeting their expectations. Customers are primarily concerned with getting a *good deal* and, as will be elaborated in Chapter 11, this naturally breeds tension with the project team.

These relationships are interdependent in that a project manager's ability to work effectively with one group will affect her ability to manage other groups. For example, functional managers are likely to be less cooperative if they perceive that top management's commitment to the project is waning. Conversely, the ability of the project manager to buffer the team from excessive interference from a client is likely to increase her standing with the project team.

The project management structure being used will influence the number and degree of external dependencies that will need to be managed. One advantage of creating a dedicated project team is that it reduces dependencies, especially within the organization, because most of the resources are assigned to the project. Conversely, a functional matrix structure increases dependencies, with the result that the project manager is much more reliant upon functional colleagues for work and staff.

The old-fashioned view of managing projects emphasized directing and controlling subordinates; the new perspective emphasizes managing project stakeholders and anticipating change as the most important jobs. Project managers need to be able to assuage concerns of customers, sustain support for the project at higher levels of the organization, quickly identify problems that threaten project work, while at the same time defend the integrity of the project and the interests of the project participants.

Within this web of relationships, the project manager must find out what needs to be done to achieve the goals of the project and build a cooperative network to accomplish it. Project managers must do so without the requisite authority to expect or demand cooperation. Doing so requires sound communication skills, political savvy, and a broad influence base. See the Snapshot from Practice: The Project Manager as Conductor for more on what makes project managers special.

Influence as Exchange

To successfully manage a project, a manager must adroitly build a cooperative network among divergent allies. Networks are mutually beneficial alliances that are generally governed by the law of reciprocity. The basic principle is that "one good deed deserves another, and likewise, one bad deed deserves another." The primary way to gain cooperation is to provide resources and services for others in exchange for future resources and services. This is the age-old maxim: "Quid pro quo (something for something)." Or in today's vernacular: "You scratch my back, I'll scratch yours."

Cohen and Bradford described the exchange view of influence as "currencies." If you want to do business in a given country, you have to be prepared to use the appropriate currency, and the exchange rates can change over time as conditions change. In the same way, what is valued by a marketing manager may be different from what is valued by a veteran project engineer, and you are likely to need to use different influence currency to obtain the cooperation of each individual. Although this analogy is a bit of an oversimplification,

TABLE 10.1
Commonly Traded Organizational Currencies

Source: Adapted from A. R. Cohen and David L. Bradford, *Influence without Authority* (New York: John Wiley & Sons, 1990). Reprinted by permission of John Wiley & Sons, Inc.

Task-related currencies	
Resources	Lending or giving money, budget increases, personnel, etc.
Assistance	Helping with existing projects or undertaking unwanted tasks.
Cooperation	Giving task support, providing quicker response time, or aiding implementation.
Information	Providing organizational as well as technical knowledge.
Position-related currencies	
Advancement	Giving a task or assignment that can result in promotion.
Recognition	Acknowledging effort, accomplishments, or abilities.
Visibility	Providing a chance to be known by higher-ups or significant others in the organization.
Network/contacts	Providing opportunities for linking with others.
Inspiration-related currencies	
Vision	Being involved in a task that has larger significance for the unit, organization, customer, or society.
Excellence	Having a chance to do important things really well.
Ethical correctness	Doing what is "right" by a higher standard than efficiency.
Relationship-related currencies	
Acceptance	Providing closeness and friendship.
Personal support	Giving personal and emotional backing.
Understanding	Listening to others' concerns and issues.
Personal-related currencies	
Challenge/learning	Sharing tasks that increase skills and abilities.
Ownership/involvement	Letting others have ownership and influence.
Gratitude	Expressing appreciation.

the key premise holds true that in the long run, "debit" and "credit" accounts must be balanced for cooperative relationships to work. Table 10.1 presents the commonly traded organizational currencies identified by Cohen and Bradford; they are then discussed in more detail in the following sections.

Task-Related Currencies

This form of influence comes directly from the project manager's ability to contribute to others' accomplishing their work. Probably the most significant form of this currency is the ability to respond to subordinates' requests for additional manpower, money, or time to complete a segment of a project. This kind of currency is also evident in sharing resources with another project manager who is in need. At a more personal level, it may simply mean providing direct assistance to a colleague in solving a technical problem.

Providing a good word for a colleague's proposal or recommendation is another form of this currency. Because most work of significance is likely to generate some form of opposition, the person who is trying to gain approval for a plan or proposal can be greatly aided by having a "friend in court."

Another form of this currency includes extraordinary effort. For example, fulfilling an emergency request to complete a design document in two days instead of the normal four days is likely to engender gratitude. Finally, sharing valuable information that would be useful to other managers is another form of this currency.

Position-Related Currencies

This form of influence stems from the manager's ability to enhance others' positions within their organization. A project manager can do this by giving someone a challenging assignment that can aid their advancement by developing their skills and abilities. Being given a chance to prove yourself naturally generates a strong sense of gratitude. Sharing the glory and bringing to the attention of higher-ups the efforts and accomplishments of others generate goodwill.

Project managers confide that a key strategy useful for gaining the cooperation of professionals in other departments and organizations is figuring out how to make these people look good to their bosses. For example, a project manager worked with a subcontractor whose organization was heavily committed to total quality management (TQM). The project manager made it a point in top-level briefing meetings to point out how quality improvement processes initiated by the contractor contributed to cost control and problem prevention.

Another variation of recognition is enhancing the reputation of others within the firm. "Good press" can pave the way for lots of opportunities, while "bad press" can quickly shut a person off and make it difficult to perform. This currency is also evident in helping to preserve someone's reputation by coming to the defense of someone unjustly blamed for project setbacks.

Finally, one of the strongest forms of this currency is sharing contacts with other people. Helping individuals expand their own networks by introducing them to key people naturally engenders gratitude. For example, suggesting to a functional manager that he should contact Sally X if he wants to find out what is really going on in that department or to get a request expedited is likely to engender a sense of indebtedness.

Inspiration-Related Currencies

Perhaps the most powerful form of influence is based on inspiration. Most sources of inspiration derive from people's burning desire to make a difference and add meaning to their lives. Creating an exciting, bold vision for a project can elicit extraordinary commitment. For example, many of the technological breakthroughs associated with the introduction of the original Macintosh computer were attributed to the feeling that the project members had a chance to change the way people approached computers. A variant form of vision is providing an opportunity to do something really well. Being able to take pride in your work often drives many people.

Often the very nature of the project provides a source of inspiration. Discovering a cure for a devastating disease, introducing a new social program that will help those in need, or simply building a bridge that will reduce a major traffic bottleneck can provide opportunities for people to feel good about what they are doing and that they are making a difference. Inspiration operates as a magnet—pulling people as opposed to pushing people toward doing something.

Relationship-Related Currencies

These currencies have more to do with strengthening the relationship with someone than directly accomplishing the project tasks. The essence of this form of influence is forming a relationship that transcends normal professional boundaries and extends into the realm of friendship. Such relationships develop by giving personal and emotional backing. Picking people up when they are feeling down, boosting their confidence, and providing encouragement naturally breed goodwill. Sharing a sense of humor and making difficult times fun is another form of this currency. Similarly, engaging in non-work-related activities such as sports and family outings is another way relationships are naturally enhanced.

Perhaps the most basic form of this currency is simply listening to other people. Psychologists suggest that most people have a strong desire to be understood and that relationships break down because the parties stop listening to each other. Sharing personal secrets/ ambitions and being a wise confidant also creates a special bond between individuals.

Personal-Related Currencies

This last form of currency deals with individual needs and an overriding sense of self-esteem. Some argue that self-esteem is a primary psychological need; the extent to which we can help others feel a sense of importance and personal worth will naturally generate goodwill. A project manager can enhance a colleague's sense of worth by sharing tasks that increase skills and abilities, delegating authority over work so that others experience ownership, and allowing individuals to feel comfortable stretching their abilities. This form of currency can also be seen in sincere expressions of gratitude for the contributions of others. Care, though, must be exercised in expressing gratitude since it is easily devalued when overused. That is, the first *thank you* is likely to be more valued than the twentieth.

The bottom line is that a project manager will be influential only insofar as she can offer something that others value. Furthermore, given the diverse cast of people a project manager depends on, it is important that she be able to acquire and exercise different influence currencies. The ability to do so will be constrained in part by the nature of the project and how it is organized. For example, a project manager who is in charge of a dedicated team has considerably more to offer team members than a manager who is given the responsibility of coordinating the activities of different professionals across different departments and organizations. In such cases, that manager will probably have to rely more heavily on personal and relational bases of influence to gain the cooperation of others.

Social Network Building

Mapping Dependencies

The first step to building a social network is identifying those on whom the project depends for success. The project manager and his or her key assistants need to ask the following questions:

- Whose cooperation will we need?
- Whose agreement or approval will we need?
- Whose opposition would keep us from accomplishing the project?

Many project managers find it helpful to draw a map of these dependencies. For example, Figure 10.2 contains the dependencies identified by a project manager responsible for installing a new financial software system in her company.

It is always better to overestimate rather than underestimate dependencies. All too often, otherwise talented and successful project managers have been derailed because they were blindsided by someone whose position or power they had not anticipated. After identifying whom you will depend on, you are ready to "step into their shoes" and see the project from their perspective:

- What differences exist between myself and the people on whom I depend (goals, values, pressures, working styles, risks)?
- How do these different people view the project (supporters, indifferents, antagonists)?

FIGURE 10.2
Dependencies for
Financial Software
Installation Project

- What is the current status of the relationship I have with the people I depend on?
- What sources of influence do I have relative to those on whom I depend?

Once you start this analysis you can begin to appreciate what others value and what currencies you might have to offer as a basis on which to build a working relationship. You begin to realize where potential problems lie—relationships in which you have a current debit or no convertible currency. Furthermore, diagnosing another's point of view as well as the basis for their positions will help you anticipate their reactions and feelings about your decisions and actions. This information is vital for selecting the appropriate influence strategy and tactics and conducting win/win negotiations.

For example, after mapping her dependency network, the project manager who was in charge of installing the software system realized that she was likely to have serious problems with the manager of the receipts department, who would be one of the primary users of the software. She had no previous history of working with this individual but had heard through the grapevine that the manager was upset with the choice of software and that he considered this project to be another unnecessary disruption of his department's operation. Prior to project initiation the project manager arranged to have lunch with the manager, where she sat patiently and listened to his concerns. She invested additional time and attention to educate him and his staff about the benefits of the new software. She tried to minimize the disruptions the transition would cause in his department. She altered the implementation schedule to accommodate his preferences as to when the actual software would be installed and the subsequent training would occur. In turn, the receipts manager and his people were much more accepting of the change, and the transition to the new software went more smoothly than anticipated.

Management by Wandering Around (MBWA)

The preceding example illustrates the next step in building a supportive social network. Once you have established who the key players are that will determine success, then you initiate contact and begin to build a relationship with those players. Building this relationship requires a management style employees at Hewlett-Packard refer to as "management by wandering around" (MBWA) to reflect that managers spend the majority of their time outside their offices. MBWA is somewhat of a misnomer in that there is a purpose/pattern behind the "wandering." Through face-to-face interactions, project managers are able to stay in touch with what is really going on in the project and build cooperation essential to project success.

Effective project managers initiate contact with key players to keep abreast of developments, anticipate potential problems, provide encouragement, and reinforce the objectives and vision of the project. They are able to intervene to resolve conflicts and prevent stalemates from occurring. In essence, they "manage" the project. By staying in touch with various aspects of the project they become the focal point for information on the project. Participants turn to them to obtain the most current and comprehensive information about the project which reinforces their central role as project manager.

We have also observed less-effective project managers who eschew MBWA and attempt to manage projects from their offices and computer terminals. Such managers proudly announce an open-door policy and encourage others to see them when a problem or an issue comes up. To them no news is good news. This allows their contacts to be determined by the relative aggressiveness of others. Those who take the initiative and seek out the project manager get too high a proportion of the project manager's attention. Those people less readily available (physically removed) or more passive get ignored. This behavior contributes to the adage, "Only the squeaky wheel gets greased," which breeds resentment within the project team.

Effective project managers also find the time to regularly interact with more distal stakeholders. They keep in touch with suppliers, vendors, top management, and other functional managers. In doing so they maintain familiarity with different parties, sustain friendships, discover opportunities to do favors, and understand the motives and needs of others. They remind people of commitments and champion the cause of their project. They also shape people's expectations (see Snapshot from Practice: Managing Expectations). Through frequent communication they alleviate people's concerns about the project, dispel rumors, warn people of potential problems, and lay the groundwork for dealing with setbacks in a more effective manner.

Unless project managers take the initiative to build a network of supportive relationships, they are likely to see a manager (or other stakeholder) only when there is bad news or when they need a favor (e.g., they don't have the data they promised or the project has slipped behind schedule). Without prior, frequent, easy give-and-take interactions around nondecisive issues, the encounter prompted by the problem is likely to provoke excess tension. The parties are more likely to act defensively, interrupt each other, and lose sight of the common problem.

Experienced project managers recognize the need to build relationships before they need them. They initiate contact with the key stakeholders at times when there are no outstanding issues or problems and therefore no anxieties and suspicions. On these social occasions, they engage in small talk and responsive banter. They respond to others' requests for aid, provide supportive counsel, and exchange information. In doing so they establish credit in that relationship, which will allow them to deal with more serious problems down the road. When one person views another as pleasant, credible, and helpful

Dorothy Kirk, a project management consultant and program manager with Financial Solutions Group of Mynd, offers several keen insights about the art of managing stakeholder expectations:

... expectations are hardy. All they need to take root is the absence of evidence to the contrary. Once rooted, the unspoken word encourages growth. They can develop and thrive without being grounded in reality. For this reason, project managers do daily battle with unrealistic expectations.

She goes on to offer several tips for managing expectations:

- The way you present information can either clarify or muddy expectations. For example, if you estimate that a task will take 317 hours, you are setting high expectations by your precision. The stakeholder is likely to be unhappy if it takes 323 hours. The stakeholder will not be unhappy with 323 hours if you quoted an estimate of 300–325 hours.

- Recognize that it is only human nature to interpret a situation in one's best interest. For example, if you tell someone it will be done by January, you are inclined to interpret it to your advantage and assume you have to the end of January, while the other person believes it will be done January 1st.

- Seize every opportunity to realign expectations with reality. Too often we avoid opportunities to adjust expectations because we hold onto a false hope that things will somehow work out.

- Do not ask for stakeholder suggestions for improvement if you do not intend to do something with their input. Asking for their input raises expectations.

- State the obvious. What is obvious to you may be obscure to others.

- Don't avoid delivering bad news. Communicate openly and in person. Expect some anger and frustration. Do not get defensive in return. Be prepared to explain the impact of the problems. For example, never say the project is going to be late without being able to give a new date. Explain what you are doing to see that this does not continue to happen.

All stakeholders have expectations about the schedule, cost, and project benefits. Project managers need to listen for, understand, and manage these expectations.

* D. Kirk, "Managing Expectations," *PM Network*, August 2000, pp. 59–62.

based on past contact, he or she is much more likely to be responsive to requests for help and less confrontational when problems arise.

Managing Upward Relations

Research consistently points out that project success is strongly affected by the degree to which a project has the support of top management. Such support is reflected in an appropriate budget, responsiveness to unexpected needs, and a clear signal to others in the organization of the importance of cooperation.

Visible top management support is not only critical for securing the support of other managers within an organization, but it also is a key factor in the project manager's ability to motivate the project team. Nothing establishes a manager's right to lead more than her ability to defend. To win the loyalty of team members, project managers have to be effective advocates for their projects. They have to be able to get top management to rescind unreasonable demands, provide additional resources, and recognize the accomplishments of team members. This is more easily said than done.

Working relationships with upper management is a common source of consternation. Laments like the following are often made by project managers about upper management:

They don't know how much it sets us back losing Neil to another project.

I would like to see them get this project done with the budget they gave us.

I just wish they would make up their minds as to what is really important.

While it may seem counterintuitive for a subordinate to "manage" a superior, smart project managers devote considerable time and attention to influencing and garnering the support of top management. Project managers have to accept profound differences in perspective and become skilled at the art of persuading superiors.

Ancona and Caldwell studied the performance of 45 new-product teams in five high-technology companies and produced some startling results. The most significant was that internal team dynamics were not related to performance. That is, high-performance teams were not distinguished by clearer goals, smoother workflow among members, or greater ability to satisfy the individual goals of team members. What related to team performance were level and intensity of external interactions between the project team and the rest of the organization. Ancona and Caldwell identified four key patterns of activity which contribute to creating a high-performance team:

1. *Ambassador* activities are aimed at representing the team to others and protecting the team from interference. The project manager typically takes on this responsibility, which involves buffering the team from political pressures and building support for the project within the hierarchy of the company.

2. *Task coordinator* activities are aimed at coordinating the team's efforts with other units and organizations. Unlike the ambassador role, which is focused upward, these are more lateral activities and involve negotiating and interacting with interested parties within the organization.

3. *Scouts* act as a scout on an expedition; that is, they go out from the team to bring back information about what is going on elsewhere in the organization. This is a much less focused task than task coordinator.

4. *Guard* activities differ from the other activities in that they are intended to keep information and resources inside the team, preventing drainage out of the group. A key guard activity is keeping necessary information secret until it is appropriate to share it.

Ancona and Caldwell found that the importance of these activities varies during the product development life cycle if the project team is to be successful. For example, scouting activities are more critical during the creation phase, when the product idea is being formulated and the team is being developed. Ambassador activities are especially critical during the development phase, when product specifications have been agreed upon and the major task is developing a prototype.

Ancona and Caldwell caution that their findings do not mean that teamwork and the internal operations of a project team are not important to project success. Effective team dynamics are necessary to successfully integrate information from outside sources and coordinate activities across groups. Their research supports the adage that problems and opportunities often lie at the borders of projects, and that one of the primary jobs of a project manager is to manage the interface between his or her team and the rest of the organization.

* D. G. Ancona and D. Caldwell, "Improving the Performance of New-Product Teams," *Research Technology Management,* Vol. 33, No. 2 (March–April 1990), pp. 25–29.

Many of the tensions that arise between upper management and project managers are a result of differences in perspective. Project managers become naturally absorbed with what is best for their project. To them the most important thing in the world is their project. Top management should have a different set of priorities. They are concerned with what is best for the entire organization. It is only natural for these two interests to conflict at times. For example, a project manager may lobby intensively for additional personnel only to be turned down because top management believes that the other departments cannot afford a reduction in staff. Although frequent communication can minimize differences, the project manager has to accept the fact that top management is inevitably going to see the world differently.

Once project managers accept that disagreements with superiors are more a question of perspective than substance, they can focus more of their energy on the art of persuading upper management. But before they can persuade superiors, they must first prove loyalty. Loyalty in this context simply means that most of the time project managers have to show that they consistently follow through on requests and adhere to the parameters established by top management without a great deal of grumbling or fuss. Once managers have proven loyalty to upper management, senior management is much more receptive to their challenges and requests.

Project managers have to cultivate strong ties with upper managers who are sponsoring the project. As noted earlier, these are high-ranking officials who championed approval

In 1914, the intrepid explorer Ernest Shackleton embarked on the *Endurance* with his team of seamen and scientists, intent upon crossing the unexplored Antarctic continent. What happened in the two years between their departure and their ultimate incredible rescue has rarely been matched in the annals of survival: a ship crushed by expanding ice pack . . . a crew stranded on the floes of the frozen Weddell Sea . . . two perilous treks in open boats across a raging Southern Ocean . . . a team marooned on the wild, forlorn Elephant Island, stretched to the limits of human endurance.

This adventure provided the basis for the book *Leading at the Edge: Leadership Lessons from the Extraordinary Saga of Shackleton's Antarctic Expedition* written by Dennis Perkins. Perkins provides numerous incidents of how Shackleton's personal example influenced the behavior of his beleaguered crew. For example, from the beginning of the Trans-Atlantic expedition to its end Shackleton consistently encouraged behavior that emphasized caring and respect:

> After the destruction of the *Endurance* Shackleton heated hot milk for the crew and went from tent to tent with the "life giving" drink. After the sail to the island of South Georgia, when the exhausted crew had landed, Shackleton took the first watch, which he kept for three hours instead of the usual one.

Crewmembers emulated the caring behaviors that Shackleton modeled. A good example of this occurred during one of the most dramatic moments in the *Endurance* saga. The food supply had dwindled to perilously low levels. Less than a week's supply remained, and the tiny ration of seal steak usually served at breakfast was eliminated. The waste meat generally used to feed the dogs was inspected for edible scraps.

Under these wretched conditions, and after a wet sleepless night, an argument broke out among some of the team members. Caught in the middle, one crew member (Greenstreet) spilled his tiny ration of powdered milk and shouted at the biologist (Clark). Alfred Lansing described what happened next:

> Greenstreet paused to get his breath, and in that instant his anger was spent and he suddenly fell silent. Everyone else in the tent became quiet, too, and looked at Greenstreet, shaggy-haired, bearded, and filthy with blubber soot, holding his empty

Topham/The Image Works.

mug in his hand and looking helplessly down into the snow that had thirstily soaked up his precious milk. The loss was so tragic he seemed almost on the point of weeping. Without speaking, Clark reached out and poured some milk into Greenstreet's mug. Then Worsely, then Macklin, and Rickerson and Kerr, Orde-Lees, and finally Blackborrow. They finished in silence.

* Adapted from Dennis N. T. Perkins, *Leading at the Edge: Leadership Lessons from the Extraordinary Saga of Shackleton's Antarctica Expedition* (New York: AMACOM Press, 2000), pp. 94–95; and Alfred Lansing, *Endurance: Shackleton's Incredible Voyage* (New York: Carroll & Graf, 1998), p. 127.

and funding of the project; as such, their reputations are aligned with the project. Sponsors are also the ones who defend the project when it is under attack in upper circles of management. They shelter the project from excessive interference (see Figure 10.3). Project managers should *always* keep such people informed of any problems that may cause embarrassment or disappointment. For example, if costs are beginning to outrun the budget or a technical glitch is threatening to delay the completion of the project, managers make sure that the sponsors are the first to know.

FIGURE 10.3
The Significance of a Project Sponsor

Timing is everything. Asking for additional budget the day after disappointing third-quarter earnings are reported is going to be much more difficult than making a similar request four weeks later. Good project managers pick the optimum time to appeal to top management. They enlist their project sponsors to lobby their cause. They also realize there are limits to top management's accommodations. Here, the Lone Ranger analogy is appropriate—you have only so many silver bullets, so use them wisely.

Project managers need to adapt their communication pattern to that of the senior group. For example, one project manager recognized that top management had a tendency to use sports metaphors to describe business situations, so she framed a recent slip in schedule by admitting that "we lost five yards, but we still have two plays to make a first down." Smart project managers learn the language of top management and use it to their advantage.

Finally, a few project managers admit ignoring chains of command. If they are confident that top management will reject an important request and that what they want to do will benefit the project, they do it without asking permission. While acknowledging that this is very risky, they claim that bosses typically won't argue with success.

Leading by Example

A highly visible, interactive management style is not only essential to building and sustaining cooperative relationships, it also allows project managers to utilize their most powerful leadership tool—their own behavior. Often, when faced with uncertainty, people look to others for cues as to how to respond and demonstrate a propensity to mimic the behavior of superiors. A project manager's behavior symbolizes how other people should work on the project. Through her behavior a project manager can influence how others act and respond to a variety of issues related to the project. (See Snapshot from Practice: Leading at the Edge for a dramatic example of this.)

To be effective, project managers must "walk the talk" (see Figure 10.4). Six aspects of leading by example are discussed next.

Priorities

Actions speak louder than words. Subordinates and others discern project managers' priorities by how they spend their time. If a project manager claims that this project is critical and then is perceived as devoting more time to other projects, then all his verbal

FIGURE 10.4
Leading by Example

reassurances are likely to fall on deaf ears. Conversely, a project manager who takes the time to observe a critical test instead of simply waiting for a report affirms the importance of the testers and their work. Likewise, the types of questions project managers pose communicate priorities. By repeatedly asking how specific issues relate to satisfying the customer, a project manager can reinforce the importance of customer satisfaction.

Urgency

Through their actions project managers can convey a sense of urgency, which can permeate project activities. This urgency in part can be conveyed through stringent deadlines, frequent status report meetings, and aggressive solutions for expediting the project. The project manager uses these tools like a metronome to pick up the beat of the project. At the same time, such devices will be ineffective if there is not also a corresponding change in the project manager's behavior. If they want others to work faster and solve problems quicker, then they need to work faster. They need to hasten the pace of their own behavior. They should accelerate the frequency of their interactions, talk and walk more quickly, get to work sooner, and leave work later. By simply increasing the pace of their daily interaction patterns, project managers can reinforce a sense of urgency in others.

Problem Solving

How project managers respond to problems sets the tone for how others tackle problems. If bad news is greeted by verbal attacks, then others will be reluctant to be forthcoming. If the project manager is more concerned with finding out who is to blame instead of how to prevent problems from happening again, then others will tend to cover their tracks and cast the blame elsewhere. If, on the other hand, project managers focus more on how they can turn a problem into an opportunity or what can be learned from a mistake, then others are more likely to adopt a more proactive approach to problem solving.

Cooperation

How project managers act toward outsiders influences how team members interact with outsiders. If a project manager makes disparaging remarks about the "idiots" in the marketing department, then this oftentimes becomes the shared view of the entire team. If project managers set the norm of treating outsiders with respect and being responsive to their needs, then others will more likely follow suit.

Standards of Performance

Veteran project managers recognize that if they want participants to exceed project expectations then they have to exceed others' expectations of a good project manager. They establish a high standard for project performance through the quality of their daily interactions. They respond quickly to the needs of others, carefully prepare and run crisp meetings, stay on top of all the critical issues, facilitate effective problem solving, and stand firm on important matters.

Ethics

How others respond to ethical dilemmas that arise in the course of a project will be influenced by how the project manager has responded to similar dilemmas. In many cases, team members base their actions on how they think the project manager would respond. If project managers deliberately distort or withhold vital information from customers or top management, then they are signaling to others that this kind of behavior is acceptable. Project management invariably creates a variety of ethical dilemmas; this would be an appropriate time to delve into this topic in more detail.

Ethics and Project Management

Questions of ethics have already arisen in previous chapters that discussed padding of cost and time estimations, exaggerating pay-offs of project proposals, and so forth. Ethical dilemmas involve situations where it is difficult to determine whether conduct is right or wrong. Is it acceptable to falsely assure customers that everything is on track when, in reality, you are only doing so to prevent them from panicking and making matters worse?

In a survey of project managers, 81 percent reported that they encounter ethical issues in their work. These dilemmas range from being pressured to alter status reports, backdate signatures, or shade documentation to mask the reality of project progress to falsifying cost accounts, compromising safety standards to accelerate progress, and approving shoddy work.

Project management is complicated work, and, as such, ethics invariably involve gray areas of judgment and interpretation. For example, it is difficult to distinguish deliberate falsification of estimates from genuine mistakes or the willful exaggeration of project payoffs from genuine optimism. It becomes problematic to determine whether unfulfilled promises were deliberate deception or an appropriate response to changing circumstances.

To provide greater clarity to business ethics, many companies and professional groups publish a code of conduct. Cynics see these documents as simply window dressing, while advocates argue that they are important, albeit limited, first steps. In practice, personal ethics do not lie in formal statutes but at the intersection of one's work, family, education, profession, religious beliefs, and daily interactions. Most project managers report that they rely on their own private sense of right and wrong—what one project manager called his "internal compass." One common rule of thumb for testing whether a response is ethical is to ask, "Imagine that whatever you did was going to be reported on the front page of your local newspaper. How would you like that? Would you be comfortable?"

Unfortunately, scandals at Enron, Worldcom, and Arthur Andersen have demonstrated the willingness of highly trained professionals to abdicate personal responsibility for illegal actions and to obey the directives of superiors (see Snapshot from Practice: The Collapse of Arthur Andersen). Top management and the culture of an organization play a decisive role in shaping members' beliefs of what is right and wrong. Many organizations encourage ethical transgressions by creating a "win at all cost" mentality. The pressures to succeed obscure consideration of whether the ends justify the means. Other organizations place a premium on "fair play" and command a market position by virtue of being trustworthy and reliable.

Many project managers claim that ethical behavior is its own reward. By following your own internal compass your behavior expresses your personal values. Others suggest that ethical behavior is doubly rewarding. You not only are able to fall asleep at night but you also develop a sound and admirable reputation. As will be explored in the next section, such a reputation is essential to establishing the trust necessary to exercise influence effectively.

Building Trust: The Key to Exercising Influence

We all know people who have influence but whom we do not trust; these individuals are often referred to as "political animals" or "jungle fighters." While these individuals are often very successful in the short run, the prevalent sense of mistrust prohibits long-term

"Think straight and talk straight" was the principle on which Arthur E. Andersen built his accounting firm in the early 1900s. It was a phrase his mother taught him and became the firm's motto. The commitment to integrity and a systematic, planned approach to work were instrumental in Arthur Andersen becoming one of the largest and best-known accounting firms in the world.

Working for Arthur Andersen was not for everyone. It could be a tough culture. It was much too hierarchical and top down for the more free spirited. Many people left after less than two years, believing the rewards did not warrant the demands that were made on them. Others learned to play by the rules and some even thrived. To remain in the firm, staff members were expected to work hard, respect authority of rank, and maintain a high level of conformity. In return they were rewarded with support, promotion, and the possibility of making partner. Those individuals who made a career with the firm grew old together, professionally and personally, and most had never worked anywhere else. To these survivors, Andersen was their second family, and they developed strong loyalties to the firm and its culture. (p. 133)

On October 23, 2001, David Duncan told his Enron project team that they needed to start complying with Andersen's new policy on handling audit documents. The policy had been instituted to make sure that the firm's extraneous paperwork could not be used in court cases. Although the document retention policy required that papers supporting the firm's opinions and audit be retained, it allowed a broad category of secondary documents to be destroyed. The team reacted with stunned silence to Duncan's directive. Then everyone got up and began racing to do what they had been told to do. No one asked Duncan to explain further. None asked whether what they were doing was wrong. No one questioned whether what he or she were doing might be illegal. Andersen's Houston staff just reacted, following orders without question.

On November 9, 2001, the day after the Securities Exchange Commission (SEC) issued a subpoena to Andersen, the shredding stopped. More than one ton of documents had been destroyed and 30,000 e-mails and Enron-related computer files erased. According to Andersen's legal defense team, the shredding was business as usual. The lawyers claimed that the shredding was standard practice for eliminating unnecessary files. To the SEC, it appeared to be the start of a deep cover-up operation. Subsequently one of the most respected accounting firms in the world closed its doors.

* Susan E. Squires, Cynthia J. Smith, Lorna McDougall, and William R. Yeak, *Inside Arthur Andersen: Shifting Values, Unexpected Consequences* (Upper Saddle, NJ: Prentice Hall, 2004).

efficacy. Successful project managers not only need to be influential, they also need to exercise influence in a manner that builds and sustains the trust of others.

The significance of trust can be discerned by its absence. Imagine how different a working relationship is when you distrust the other party as opposed to trusting them. When people distrust each other, they often spend inordinate amounts of time and energy attempting to discern hidden agendas and the true meaning of communications and then securing guarantees to promises. They are much more cautious with each other and hesitant to cooperate. Here is what one line manager had to say about how he reacted to a project manager he did not trust:

Whenever Jim approached me about something, I found myself trying to read between the lines to figure what was really going on. When he made a request, my initial reaction was "no" until he proved it.

Conversely, trust is the "lubricant" that maintains smooth and efficient interactions. When you trust, people are more likely to take your actions and intentions at face value when circumstances are ambiguous. For example, here is what a functional manager had to say about how he dealt with a project manager he trusted:

If Sally said she needed something, no questions were asked. I knew it was important or she wouldn't have asked.

Trust is an elusive concept. It is hard to nail down in precise terms why some project managers are trusted and others are not. One popular way to understand trust is to see it as

a function of character and competence. Character focuses on personal motives (i.e., does he or she want to do the right thing?), while competence focuses on skills necessary to realize motives (i.e., does he or she know the right things to do?).

Stephen Covey resurrected the significance of character in leadership literature in his best selling *Seven Habits of Highly Effective People.* Covey criticized popular management literature as focusing too much on shallow human relations skills and manipulative techniques, which he labeled the personality ethic. He argues that at the core of highly effective people is a character ethic that is deeply rooted in personal values and principles such as dignity, service, fairness, the pursuit of truth, and respect.

One of the distinguishing traits of character is consistency. When people are guided by a core set of principles, they are naturally more predictable because their actions are consistent with these principles. Another feature of character is openness. When people have a clear sense of who they are and what they value, they are more receptive to others. This trait provides them with the capacity to empathize and the talent to build consensus among divergent people. Finally, another quality of character is a sense of purpose. Managers with character are driven not only by personal ambitions but also for the common good. Their primary concern is what is best for their organization and the project, not what is best for themselves. This willingness to subordinate personal interests to a higher purpose garners the respect, loyalty, and trust of others.

The significance of character is summarized by the comments made by two team members about two very different project managers.

> At first everyone liked Joe and was excited about the project. But after a while, people became suspicious of his motives. He had a tendency to say different things to different people. People began to feel manipulated. He spent too much time with top management. People began to believe that he was only looking out for himself. It was HIS project. When the project began to slip he jumped ship and left someone else holding the bag. I'll never work for that guy again.

> My first impression of Jack was nothing special. He had a quiet, unassuming management style. Over time I learned to respect his judgment and his ability to get people to work together. When you went to him with a problem or a request, he always listened carefully. If he couldn't do what you wanted him to do, he would take the time to explain why. When disagreements arose he always thought of what was best for the project. He treated everyone by the same rules; no one got special treatment. I'd jump at the opportunity to work on a project with him again.

Character alone will not engender trust. We must also have confidence in the competency of individuals before we really trust them. We all know well-intended managers whom we like but do not trust because they have a history of coming up short on their promises. Although we may befriend these managers, we don't like to work with or for them.

Competence is reflected at a number of different levels. First, there is task-related knowledge and skills reflected in the ability to answer questions, solve technical problems, and excel in certain kinds of work. Second, there is competence at an interpersonal level demonstrated in being able to listen effectively, communicate clearly, resolve arguments, provide encouragement, and so forth. Finally, there is organizational competence. This includes being able to run effective meetings, set meaningful objectives, reduce inefficiencies, and build a social network. Too often there is a tendency for young engineers and other professionals to place too much value on task or technical competence. They underestimate the significance of organizational skills. Veteran professionals, on the other hand, recognize the importance of management and place a greater value on organizational and interpersonal skills.

One problem new project managers experience is that it takes time to establish a sense of character and competency. Character and competency are often demonstrated when they are tested, such as when a tough call has to be made or when difficult problems have to be solved. Veteran project managers have the advantage of reputation and an established track record of success. Although endorsements from credible sponsors can help a young project manager create a favorable first impression, ultimately he or she will have to demonstrate character and competence during the course of dealings with others in order to gain their trust.

So far this chapter has addressed the importance of building a network of relationships to complete the project based on trust and reciprocity. The next section examines the nature of project management work and the personal qualities needed to excel at it.

Qualities of an Effective Project Manager

Project management is, at first glance, a misleading discipline in that there is an inherent logic in the progression from formulating a project scope statement, creating a WBS, developing a network, adding resources, finalizing a plan, and reaching milestones. However, when it comes to actually implementing and completing projects, this logic quickly disappears, and project managers encounter a much messier world, filled with inconsistencies and paradoxes. Effective project managers have to be able to deal with the contradictory nature of their work. Some of those contradictions are listed here:

- **Innovate and maintain stability.** Project managers have to put out fires, restore order, and get the project back on track. At the same time they need to be innovative and develop new, better ways of doing things. Innovations unravel stable routines and spark new disturbances that have to be dealt with.

- **See the big picture while getting your hands dirty.** Project managers have to see the big picture and how their project fits within the larger strategy of their firm. There are also times when they must get deeply involved in project work and technology. If they don't worry about the details, who will?

- **Encourage individuals but stress the team.** Project managers have to motivate, cajole, and entice individual performers while at the same time maintaining teamwork. They have to be careful that they are considered fair and consistent in their treatment of team members while at the same time treating each member as a special individual.

- **Hands-off/Hands-on.** Project managers have to intervene, resolve stalemates, solve technical problems, and insist on different approaches. At the same time they have to recognize when it is appropriate to sit on the sidelines and let other people figure out what to do.

- **Flexible but firm.** Project managers have to be adaptable and responsive to events and outcomes that occur on the project. At the same time they have to hold the line at times and tough it out when everyone else wants to give up.

- **Team versus organizational loyalties.** Project managers need to forge a unified project team whose members stimulate one another to extraordinary performance. But at the same time they have to counter the excesses of cohesion and the team's resistance to outside ideas. They have to cultivate loyalties to both the team and the parent organization.

Managing these and other contradictions requires finesse and balance. Finesse involves the skillful movement back and forth between opposing behavioral patterns. For example, most of the time project managers actively involve others, move by increment, and seek

Emotional intelligence (EQ) describes the ability or skill to perceive, assess, and manage the emotions of one's self and others. Although the notion of EQ emerged in the 1920s, it was not until Daniel Goleman published his book *Emotional Intelligence* that the concept captured the attention of business people and public alike.

Goleman divided EQ into the following five emotional competences:

- **Self-awareness**—knowing your emotions, recognizing feelings as they occur, and understanding the link between your emotions and your behavior. Self-awareness is reflected in confidence, realistic assessment of personal strengths/weaknesses, and ability to make fun of oneself.

- **Self-regulation**—being able to control disruptive impulses and moods and respond appropriately to situations. Self-regulation is reflected in trustworthiness and openness to change.

- **Self-motivation**— being able to gather up your feelings and pursue goals with energy, passion, and persistence. The hallmarks of self-motivation include a strong desire to achieve and internal optimism.

- **Empathy**—being able to recognize the feelings of others and tuning into their verbal and nonverbal cues. Empathy is reflected in the ability to sustain relationships and in cross-cultural sensitivity.

- **Social skills**—being able to build social networks and rapport with different kinds of people. Social skills include being able to lead change, resolve conflicts, and build effective teams.

Not much imagination is needed to see how EQ would contribute to being an effective project manager.

In Goleman's view, these competences build on each other in a hierarchy. At the bottom of his hierarchy is self-awareness. Some level of self-awareness is needed to move to self-regulation. Ultimately, social skills requires all four of the other competences in order to begin to be proficient at leading others. Experts believe that most people can learn to significantly increase their EQ. Numerous training programs and materials have emerged to help individuals realize their EQ potential.

* T. Bradberry, and J. Graves, *The Emotional Intelligence Quick Book: How to Put Your EQ to Work* (New York: Simon & Schuster, 2005); J. Cabanis-Brewin, "The Human Task of a Project Leader: Daniel Goleman on the Value of High EQ," *PM Network*, November 1999, pp. 38–42.

consensus. There are other times when project managers must act as autocrats and take decisive, unilateral action. Balance involves recognizing the danger of extremes and that too much of a good thing invariably becomes harmful. For example, many managers have a tendency to always delegate the most stressful, difficult assignments to their best team members. This habit often breeds resentment among those chosen ("why am I always the one who gets the tough work?") and never allows the weaker members to develop their talents further.

There is no one management style or formula for being an effective project manager. The world of project management is too complicated for formulas. Successful project managers have a knack for adapting styles to specific circumstances of the situation.

So, what should one look for in an effective project manager? Many authors have addressed this question and have generated list after list of skills and attributes associated with being an effective manager. When reviewing these lists, one sometimes gets the impression that to be a successful project manager requires someone with superhuman powers. While we agree that not everyone has the right stuff to be an effective project manager, there are some core traits and skills that can be developed to successfully perform the job. Eight of these traits are noted below.

1. **Systems thinker.** Project managers must be able to take a holistic rather than a reductionist approach to projects. Instead of breaking up a project into individual pieces (planning, budget) and managing it by understanding each part, a systems perspective focuses on trying to understand how relevant project factors collectively interact to produce project outcomes. The key to success then becomes managing the interaction between different parts and not the parts themselves.

2. **Personal integrity.** Before you can lead and manage others, you have to be able to lead and manage yourself. Begin by establishing a firm sense of who you are, what you stand for, and how you should behave. This inner strength provides the buoyancy to endure the ups and downs of the project life cycle and the credibility essential to sustaining the trust of others.

3. **Proactive.** Good project managers take action before it is needed to prevent small concerns from escalating into major problems. They spend the majority of their time working within their sphere of influence to solve problems and not dwelling on things they have little control over. Project managers can't be whiners.

4. **High emotional intelligence (EQ).** Project management is not for the meek. Project managers have to have command of their emotions and be able to respond constructively to others when things get a bit out of control. See the Research Highlight: Emotional Intelligence to read more about this concept.

5. **General business perspective.** Because the primary role of a project manager is to integrate the contributions of different business and technical disciplines, it is important that a manager have a general grasp of business fundamentals and how the different functional disciplines interact to contribute to a successful business.

6. **Effective time management.** Time is a manager's scarcest resource. Project managers have to be able to budget their time wisely and quickly adjust their priorities. They need to balance their interactions so no one feels ignored.

7. **Skillful politician.** Project managers have to be able to deal effectively with a wide range of people and win their support and endorsement of their project. They need to be able to sell the virtues of their project without compromising the truth.

8. **Optimist.** Project managers have to display a can-do attitude. They have to be able to find rays of sunlight in a dismal day and keep people's attention positive. A good sense of humor and a playful attitude are often a project manager's greatest strength.

So how does one develop these traits? Workshops, self-study, and courses can upgrade one's general business perspective and capacity for systems thinking. Training programs can improve emotional intelligence and political skills. People can also be taught stress and time management techniques. However, we know of no workshop or magic potion that can transform a pessimist into an optimist or provide a sense of purpose when there is not one. These qualities get at the very soul or being of a person. Optimism, integrity, and even being proactive are not easily developed if there is not already a predisposition to display them.

Summary

To be successful, project managers must build a cooperative network among a diverse set of allies. They begin by identifying who the key stakeholders on a project are, followed by a diagnosis of the nature of the relationships, and the basis for exercising influence. Effective project managers are skilled at acquiring and exercising a wide range of influence. They use this influence and a highly interactive management style to monitor project performance and initiate appropriate changes in project plans and direction. They do so in a manner that generates trust, which is ultimately based on others' perceptions of their character and competence.

Project managers are encouraged to keep in mind the following suggestions:

- *Build relationships before you need them.* Identify key players and what you can do to help them before you need their assistance. It is always easier to receive a favor after you have granted one. This requires the project manager to see the project in systems

terms and to appreciate how it affects other activities and agendas inside and outside the organization. From this perspective they can identify opportunities to do good deeds and garner the support of others.

- *Trust is sustained through frequent face-to-face contact.* Trust withers through neglect. This is particularly true under conditions of rapid change and uncertainty that naturally engender doubt, suspicion, and even momentary bouts of paranoia. Project managers must maintain frequent contact with key stakeholders to keep abreast of developments, assuage concerns, engage in reality testing, and focus attention on the project. Frequent face-to-face interactions affirm mutual respect and trust in each other.

Ultimately, exercising influence in an effective and ethical manner begins and ends with how you view the other parties. Do you view them as potential partners or obstacles to your goals? If obstacles, then you wield your influence to manipulate and gain compliance and cooperation. If partners, you exercise influence to gain their commitment and support. People who view social network building as building partnerships see every interaction with two goals: resolving the immediate problem/concern and improving the working relationship so that next time it will be even more effective. Experienced project managers realize that "what goes around comes around" and try at all cost to avoid antagonizing players for quick success.

Key Terms

Emotional intelligence (EQ)
Law of reciprocity
Leading by example

Management by wandering around (MBWA)
Organizational currencies
Proactive

Project sponsor
Social network building
Stakeholder
Systems thinking

Review Questions

1. What is the difference between leading and managing a project?
2. Why is a conductor of an orchestra an appropriate metaphor for being a project manager? What aspects of project managing are not reflected by this metaphor? Can you think of other metaphors that would be appropriate?
3. What does the exchange model of influence suggest you do to build cooperative relationships to complete a project?
4. What differences would you expect to see between the kinds of influence currencies that a project manager in a functional matrix would use and the influence a project manager of a dedicated project team would use?
5. Why is it important to build a relationship before you need it?
6. Why is it critical to keep the project sponsor informed?
7. Why is trust a function of both character and competence?
8. Which of the eight traits/skills associated with being an effective project manager is the most important? The least important? Why?

Exercises

1. Do an Internet search for the Keirsey Temperament Sorter Questionnaire and find a site that appears to have a reputable self-assessment questionnaire. Respond to the questionnaire to identify your temperament type. Read supportive documents associated with your type. What does this material suggest are the kinds of projects that would best suit you? What does it suggest your strengths and weaknesses are as a project manager? How can you compensate for your weaknesses?

2. Access the Project Management Institute Web site and review the standards contained in PMI Member Ethical Standards section. How useful is the information for helping someone decide what behavior is appropriate and inappropriate?

3. You are organizing an AIDS benefit concert in your hometown that will feature local heavy metal rock groups and guest speakers. Draw a dependency map identifying the major groups of people that are likely to affect the success of this project. Who do you think will be most cooperative? Who do you think will be the least cooperative? Why?

4. You are the project manager responsible for the overall construction of a new international airport. Draw a dependency map identifying the major groups of people that are likely to affect the success of this project. Who do you think will be most cooperative? Who do you think will be the least cooperative? Why?

5. Identify an important relationship (co-worker, boss, friend) in which you are having trouble gaining cooperation. Assess this relationship in terms of the influence currency model. What kinds of influence currency have you been exchanging in this relationship? Is the "bank account" for this relationship in the "red" or the "black"? What kinds of influence would be appropriate for building a stronger relationship with that person?

6. Each of the following six mini-case scenarios involve ethical dilemmas associated with project management. How would you respond to each situation, and why?

Jack Nietzche

You returned from a project staffing meeting in which future project assignments were finalized. Despite your best efforts, you were unable to persuade the director of project management to promote one of your best assistants, Jack Nietzche, to a project manager position. You feel a bit guilty because you dangled the prospect of this promotion to motivate Jack. Jack responded by putting in extra hours to ensure that his segments of the project were completed on time. You wonder how Jack will react to this disappointment. More importantly, you wonder how his reaction might affect your project. You have five days remaining to meet a critical deadline for a very important customer. While it won't be easy, you believed you would be able to complete the project on time. Now you're not so sure. Jack is halfway through completing the documentation phase, which is the last critical activity. Jack can be pretty emotional at times, and you are worried that he will blow up once he finds he didn't get the promotion. As you return to your office, you wonder what you should do. Should you tell Jack that he isn't going to be promoted? What should you say if he asks about whether the new assignments were made?

Seaburst Construction Project

You are the project manager for the Seaburst construction project. So far the project is progressing ahead of schedule and below budget. You attribute this in part to the good working relationship you have with the carpenters, plumbers, electricians, and machine operators who work for your organization. More than once you have asked them to give 110 percent, and they have responded.

One Sunday afternoon you decide to drive by the site and show it to your son. As you point out various parts of the project to your son, you discover that several pieces of valuable equipment are missing from the storage shed. When you start work again on Monday you are about to discuss this matter with a supervisor when you realize that all the missing equipment is back in the shed. What should you do? Why?

The Project Status Report Meeting

You are driving to a project status report meeting with your client. You encountered a significant technical problem on the project that has put your project behind schedule. This is not good news because completion time is the number one priority for the project. You are confident that your team can solve the problem if they are free to give their undivided attention to it and that with hard work you can get back on schedule. You also believe if you tell the client about the problem, she will demand a meeting with your team to discuss the implications of the problem. You can also expect her to send some of her personnel to oversee the solution to the problem. These interruptions will likely further delay the project. What should you tell your client about the current status of the project?

Gold Star LAN project

You work for a large consulting firm and were assigned to the Gold Star LAN project. Work on the project is nearly completed and your clients at Gold Star appear to be pleased with your performance. During the course of the project, changes in the original scope had to be made to accommodate specific needs of managers at Gold Star. The costs of these changes were documented as well as overhead and submitted to the centralized accounting department. They processed the information and submitted a change order bill for your signature. You are surprised to see the bill is 10 percent higher than what you submitted. You contact Jim Messina in the accounting office and ask if a mistake has been made. He curtly replies that no mistake was made and that management adjusted the bill. He recommends that you sign the document. You talk to another project manager about this and she tells you off the record that overcharging clients on change orders is common practice in your firm. Would you sign the document? Why? Why not?

Cape Town Bio-Tech

You are responsible for installing the new Double E production line. Your team has collected estimates and used the WBS to generate a project schedule. You have confidence in the schedule and the work your team has done. You report to top management that you believe that the project will take 110 days and be completed by March 5. The news is greeted positively. In fact, the project sponsor confides that orders do not have to be shipped until April 1. You leave the meeting wondering whether you should share this information with the project team or not.

Ryman Pharmaceuticals

You are a test engineer on the Bridge project at Ryman Pharmaceuticals in Nashville, Tennessee. You have just completed conductivity tests of a new electrochemical compound. The results exceeded expectations. This new compound should revolutionize the industry. You are wondering whether to call your stockbroker and ask her to buy $20,000 worth of Ryman stock before everyone else finds out about the results. What would you do and why?

References

Ancona, D. G., and D. Caldwell, "Improving the Performance of New-Product Teams," *Research Technology Management,* 33 (2) March-April 1990, pp. 25–29.

Anand, V., B. E. Ashforth, and M. Joshi, "Business as Usual: The Acceptance and Perpetuation of Corruption in Organizations," *Academy of Management Executive,* 19 (4) 2005, pp. 9–23.

Badaracco, J. L. Jr., and A. P. Webb, "Business Ethics: A View from the Trenches," *California Management Review,* 37 (2) Winter 1995, pp. 8–28.

Baker, B., "Leadership and the Project Manager," *PM Network,* December 2002, p. 20.

Baker, W. E., *Network Smart: How to Build Relationships for Personal and Organizational Success* (New York: McGraw-Hill, 1994).

Bennis, W., *On Becoming a Leader* (Reading, MA: Addison-Wesley, 1989).

Bradberry, T., and J. Graves, *The Emotional Intelligence Quick Book: How to Put Your EQ to Work* (New York: Simon & Schuster, 2005).

Cabanis, J., "A Question of Ethics: The Issues Project Managers Face and How They Resolve Them," *PM Network,* December 1996, pp. 19–24.

Cabanis-Brewin, J., "The Human Task of a Project Leader: Daniel Goleman on the Value of High EQ," *PM Network,* November 1999, pp. 38–42.

Cohen, A. R., and D. L. Bradford, *Influence Without Authority* (New York: John Wiley & Sons, 1990).

Covey, S. R., *The Seven Habits of Highly Effective People* (New York: Simon & Schuster, 1989).

Dinsmore, P. C., "Will the Real Stakeholders Please Stand Up?" *PM Network,* December 1995, pp. 9–10.

Gabarro, S. J., *The Dynamics of Taking Charge* (Boston: Harvard Business School Press, 1987).

Hill, L. A., *Becoming A Manager: Mastery of a New Identity* (Boston: Harvard Business School Press, 1992).

Kaplan, R. E., "Trade Routes: The Manager's Network of Relationships," *Organizational Dynamics,* 12 (4) Spring 1984, pp. 37–52.

Kirk, D., "Managing Expectations," *PM Network,* August 2000, pp. 59–62.

Kotter, J. P., "What Leaders Really Do," *Harvard Business Review,* 68 (3) May–June 1990, pp. 103–11.

Kouzes, J. M., and B. Z. Posner, *The Leadership Challenge* (San Francisco: Jossey-Bass, 1987).

Kouzes, J. M., and B. Z. Posner, *Credibility: How Leaders Gain and Lose It. Why People Demand It* (San Francisco: Jossey-Bass, 1993).

Larson, E. W., and J. B. King, "The Systemic Distortion of Information: An Ongoing Management Challenge," *Organizational Dynamics,* 24 (3) Winter 1996, pp. 49–62.

Lewis, M. W., M. A. Welsh, G. E. Dehler, and S.G. Green, "Product Development Tensions: Exploring Contrasting Styles of Project Management," *Academy of Management Journal,* 45 (3) 2002, pp. 546–64.

Peters, L. H., "A Good Man in a Storm: An Interview with Tom West," *Academy of Management Executive,* 16 (4) 2002, pp. 53–63.

Peters, L. H., "Soulful Ramblings: An Interview with Tracy Kidder," *Academy of Management Executive,* 16 (4) 2002, pp. 45–52.

Peters, T., *Thriving on Chaos: Handbook For a Management Revolution* (New York: Alfred A. Knopf, 1988).

Pinto, J. K., and S. K. Mantel, "The Causes of Project Failure," *IEEE Transactions in Engineering Management,* 37 (4) 1990, pp. 269–76.

Pinto, J. K., and D. P. Sleven, "Critical Success Factors in Successful Project Implementation," *IEEE Transactions in Engineering Management,* 34 (1) 1987, pp. 22–27.

Posner, B. Z., "What It Takes to Be an Effective Project Manager," *Project Management Journal,* March 1987, pp. 51–55.

Project Management Institute, *Leadership in Project Management Annual* (Newton Square, PA: PMI Publishing, 2006).

Robb, D. J., "Ethics in Project Management: Issues, Practice, and Motive," *PM Network,* December 1996, pp. 13–18.

Sayles, L. R., *Leadership: Managing in Real Organizations* (New York: McGraw-Hill, 1989), pp. 70–78.

Sayles, L. R., *The Working Leader* (New York: Free Press, 1993).

Senge, P. M., *The Fifth Discipline* (New York: Doubleday, 1990).

Shenhar, A. J., and B. Nofziner, "A New Model for Training Project Managers," *Proceedings of the 28th Annual Project Management Institute Symposium,* 1997, pp. 301–6.

Shtub, A., J. F. Bard, and S. Globerson, *Project Management: Engineering, Technology, and Implementation* (Englewood Cliffs, NJ: Prentice Hall, 1994).

Case

Western Oceanography Institute

It was already 72 degrees when Astrid Young pulled into the parking lot at the Western Oceanography Institute (WOI). The radio announcer was reminding listeners to leave out extra water for their pets because the temperature was going to be in the high 90s for the third straight day. Young made a mental note to call her husband, Jon, when she got to her office and make sure that he left plenty of water outside for their cat, Figaro. Young was three-quarters of the way through the Microsoft NT conversion project. Yesterday had been a disaster, and she was determined to get back on top of things.

ASTRID YOUNG

Astrid Young was a 27-year-old graduate of Western State University (WSU) with a B.S. degree in management information systems. After graduation she worked for five years at Evergreen Systems in Seattle, Washington. While at WSU she worked part time for an oceanography professor, Ahmet Green, creating a customized database for a research project he was conducting. Green was recently appointed director of WOI, and Young was confident that this prior experience was instrumental in her getting the job as information services (IS) director at the Institute. Although she took a significant pay cut, she jumped at the opportunity to return to her alma mater. Her job at Evergreen Systems had been very demanding. The long hours and extensive traveling had created tension in her marriage. She was looking forward to a normal job with reasonable hours. Besides, Jon would be busy pursuing his MBA at Western State. While at Evergreen, Young worked on Y2000 projects and installed NT servers. She was confident that she had the requisite technical expertise to excel at her new job.

Western Oceanography Institute was an independently funded research facility aligned with Western State University. Approximately 60 full- and part-time staff worked at the Institute. They worked on research grants funded by the National Science Foundation (NSF) and the United Nations (UN), as well as research financed by private industry. There were typically 7 to 8 major research projects under way at any one time as well as 20 to 25

smaller projects. One-third of the Institute's scientists had part-time teaching assignments at WSU and used the Institute to conduct their own basic research.

FIRST FOUR MONTHS AT WOI

Young worked at the Institute for four months prior to initiating the NT conversion project. She made a point of introducing herself to the various groups of people upon her arrival at the Institute. Still, her contact with the staff had been limited. She spent most of her time becoming familiar with WOI's information system, training her staff, responding to unexpected problems, and planning the conversion project. Young suffered from food allergies and refrained from informal staff lunches at nearby restaurants. She stopped regularly attending the biweekly staff meetings in order to devote more time to her work. She now only attended the meetings when there was a specific agenda item regarding her operation.

Last month the system was corrupted by a virus introduced over the Internet. She devoted an entire weekend to restoring the system to operation. A recurring headache was one of the servers code named "Poncho" that would occasionally shut down for no apparent reason. Instead of replacing it, she decided to nurse Poncho along until it was replaced by the new NT system. Her work was frequently interrupted by frantic calls from staff researchers who needed immediate help on a variety of computer-related problems. She was shocked at how computer illiterate some of the researchers were and how she had to guide them through some of the basics of e-mail management and database configuration. She did find time to help Assistant Professor Amanda Johnson on a project. Johnson was the only researcher to respond to Young's e-mail announcing that the IS staff was available to help on projects. Young created a virtual project office on the Internet so that Johnson could collaborate with colleagues from institutes in Italy and Thailand on a UN research grant. She looked forward to the day when she could spend more time on fun projects like that.

Young had a part-time team of five student assistants from the computer science department. At first she was not sure how freely she could delegate work to the students, and she closely supervised their work. She quickly realized that they were all very bright, competent workers who were anxious to leverage this work experience into a lucrative career upon graduation. She admitted that she sometimes had a hard time relating to students who were preoccupied with fraternity bashes and X-games. She lost her temper only once, and that was at Samantha Eggerts for failing to set up an adequate virus screening system that would have prevented the Internet corruption that occurred. She kept a close eye on Eggerts's work after that, but in time, Eggert proved her worth. Young saw a lot of herself in Eggerts's work habits.

THE MICROSOFT NT CONVERSION PROJECT

Young laid the groundwork for the NT conversion project in her recruitment interview with the director by arguing that conversion was a critical skill she would bring to the position. Once hired she was able to sell the director and his immediate staff on the project, but not without some resistance. Some associate directors questioned whether it was necessary to go through another conversion so soon after the Windows 95 conversion 16 months ago. Some of the researchers lobbied that the money would be better spent on installing a centralized air-conditioning system at WOI. Ultimately, the director signed off on the project after Young assured him that the conversion would be relatively painless and the Institute would then have a state-of-the-art information system.

The conversion was scheduled to take eight weeks to complete and consisted of four major phases: server setup, network installation, data migration, and workstation conversion. The project would be completed during the summer so that the student assistants could work

full time on the project. Young and her student team would first need to purchase and set up seven new NT servers. They would then create a new local area network (LAN). Next they would migrate data to the new Oracle NT database. Finally, they would convert the existing 65 client computers into NT workstations capable of functioning on the new system. Young had been actively involved in four similar conversions when working at Evergreen Systems and was confident that she and her team could complete the project with a minimum of technical problems. She also believed that this conversion would not be traumatic to the staff at the Institute because the NT interface was very similar to the Windows 95 interface.

Young knew that in order for the project to be considered successful, there needed to be minimum disruption of daily staff functions. She held a staff briefing meeting to outline the scope of the project and the impact it would have on the Institute's operations. She was disappointed by the light attendance at the meeting. One problem was the irregular hours staff worked at WOI. Several of the researchers were night owls who preferred to work late into the night. Other staff traveled frequently. She ended up holding two other briefing meetings, including one in the evening. Still the attendance was less than desired.

The staff's major concerns were the amount of downtime that would occur and whether the software and databases they were currently using would work on the new system. Young assured them that most of the downtime would occur on the weekends and would be posted well in advance. The only disruption would be two hours necessary to convert their existing computer into a workstation. Young invested extra energy in researching the compatibility issue and sent an e-mail to everyone listing the software that was known to not work in the NT system. The only software problems involved specially written DOS v2.1 or older programs that would not function in the new NT operating environment. In one case, she assigned a student to rewrite and enhance the present program for a researcher. In the other case, she was able to persuade the staff member to use a newer, better program.

Young sent a second e-mail asking staff members to clean up their hard drives and get rid of old, obsolete files because the new NT software would take up considerably more space than the Windows 95 operating system. In some cases, she replaced existing hard drives with bigger drives so that this would not be a problem. She circulated a workstation conversion schedule by e-mail so that staff could pick a preferred time for when their computer would be down and when her assistants could upgrade the computer into a workstation. Seventy percent of the staff responded to the e-mail request, and she and her staff contacted the remaining staff by telephone to schedule the conversion.

The first six weeks of the project went relatively smoothly. The NT servers arrived on time and were installed and configured on schedule. The completion of the network was delayed three days when the fire marshal showed up earlier than planned to inspect the electrical wiring. Young had never met the marshal before and was surprised at how nitpicking he was. They failed the inspection, and it took three days to reschedule and pass inspection. Word about failing the fire inspection circulated the hallways at the Institute. One joker put a Smokey the Bear sign on the IS office door. Young later found out that as a result of a recent fire in town, the fire marshals had been instructed to be extra vigilant in their inspections.

Data migration to the new Oracle database took a little longer than planned because the new version was not as compatible with the old version as advertised. Still, this only added three days to the project. The project was entering the fourth and final phase—conversion of client computers into NT workstations. This phase involved her staff deleting the old operating system and installing new operating software in each computer at the Institute. Young had scheduled two hours per machine and had organized a daily workload of 10 computers so that adequate backup could be made just in case something went wrong.

Young chose to convert the director's office first and told Green that everything was going according to plan. Soon the project began to experience nagging problems. First,

some of the staff forgot when they were scheduled to be converted. The team had to wait for them to abandon what they were doing so they could convert the computer. Second, the drivers on some of the computers were not compatible, and the team had to devote extra time downloading new drivers off the Internet. Third, a few of the staff failed to create adequate hard drive space to accommodate the new NT software. In most cases, the team worked with the staff member to delete or compress unnecessary files. One time the staff member could not be found, and Young had to decide which files to delete. This wasn't a problem since the hard drive contained computer games and ancient Word Perfect files. To compound matters, midway through the third day, one of the student assistants, Steve Stills, was diagnosed with a moderate case of carpal tunnel and was told to take two weeks off from computer work.

After three days only 22 computers had been converted to NT stations. Young ended the day by sending an e-mail to the remaining users apologizing for the delays and posting a revised schedule for their system configuration.

THE CALL

Young and her staff were working diligently on converting computers into NT workstations when she received an urgent call from the director's secretary requesting that she drop everything and come downstairs to the staff meeting. The secretary's voice appeared tense, and Young wondered what was up. As she gathered her things, the student assistant, Eggerts, cleared her throat and confided that there may be problems with some of the Institute's Web sites. She discovered yesterday that some of the links in the Web pages created using Netscape weren't working in the Microsoft environment. Young demanded to know why she wasn't told about this sooner. Eggerts confessed that she thought she had fixed the problem last night. Young told her that they would talk about this when she got back and left.

Young entered the meeting room and immediately recognized that there were more than the usual faces in attendance. The director welcomed her by saying, "We're glad you could find the time to visit with us. My staff meeting has just erupted into a series of complaints about your NT conversion project. As it turns out Dr. Phillips over here can't access his documents because his Word Perfect file mysteriously disappeared. Dr. Simon's geothermal assessment program, which he has used for the past seven years, doesn't seem to work anymore. Now it appears that the Web site we use to coordinate our research with the Oslo Institute is a mess. Everyone is complaining about how the revised installation schedule is going to disrupt work. I want to know why I wasn't informed about these problems. These guys want to lynch me for approving your project!"

1. How would you respond to the director?
2. What mistakes did Young make that contributed to the problems at the end of the case?
3. How could she have managed the conversion project better?

Case

Tom Bray

Tom Bray was mulling over today's work schedule as he looked across the bay at the storm that was rolling in. It was the second official day of the Pegasus project and now the real work was about to begin.

Pegasus was a two-month renovation project for AtlantiCorp, a major financial institution headquartered in Boston, Massachusetts. Tom's group was responsible for installing

the furniture and equipment in the newly renovated accounts receivable department on the third floor. The Pegasus project was a dedicated project team formed out of AtlantiCorp facilities department with Tom as the project lead.

Tom was excited because this was his first *major league* project and he was looking forward to practicing a new management style—MBWA, aka management by wandering around. He had been exposed to MBWA in a business class in college, but it wasn't until he attended an AtlantiCorp leadership training seminar that he decided to change how he managed people. The trainer was devout MBWA champion ("You can't manage people from a computer!"). Furthermore, the testimonies from his peers reinforced the difference that MBWA can make when it comes to working on projects.

Tom had joined the facilities group at AtlantiCorp five years earlier after working for EDS for six years. He quickly demonstrated technical competences and good work habits. He was encouraged to take all the internal project management workshops offered by AtlantiCorp. On his last two projects he served as assistant project manager responsible for procurement and contract management.

He had read books about the soft side of project management and MBWA made sense—after all, people not tools get projects done. His boss had told him he needed to refine his people skills and work on developing rapport with team members. MBWA seemed like a perfect solution.

Tom reviewed the list of team member names; some of the foreign names were real tongue twisters. For example, one of his better workers was from Thailand and her name was Pinyarat Sirisomboonsuk. He practiced saying "Pin-ya-răt See-rē-som-boon-sook." He got up, tucked in his shirt, and walked out of his office and down to the floor where his team was busy unloading equipment.

Tom said "Hi" to the first few workers he met until he encountered Jack and three other workers. Jack was busy pulling hardware out of a box while his teammates were standing around talking. Tom blurted, "Come on guys, we've got work to do." They quickly separated and began unloading boxes.

The rest of the visit seemed to go well. He helped Shari unload a heavy box and managed to get an appreciative grin from Pinyarat when he almost correctly pronounced her name. Satisfied, Tom went back up to his office thinking that MBWA wouldn't be that tough to do.

After responding to e-mail and calling some vendors, Tom ventured back out to see how things were going downstairs. When he got there, the floor was weirdly quiet. People were busy doing their work and his attempts at generating conversation elicited stiff responses. He left thinking that maybe MBWA is going to be tougher than he thought.

1. What do you think is going on at the end of this case?
2. What should Tom do next and why?
3. What can be learned from this case?

Case

Cerberus Corporation*

Cerberus is a successful producer of specialty chemicals. It operates nine large campus sites in the United States, with a number of different business units on each site. These business units operate independently, with direct reporting to corporate headquarters. Site

* Courtesy of John Sloan, Oregon State University.

functions such as safety, environmental, and facilities management report to a host organization—typically the business unit that is the largest user of their services.

SUSAN STEELE

Susan Steele has worked in the Facilities group at the Cerberus Richmond site for the last two years. The Facilities manager, Tom Stern, reports to the General Manager of the largest business unit on site, the highly profitable Adhesives and Sealants Division. Susan started with Cerberus when she graduated with her business degree from Awsum University. She was excited about her new assignment—leading a project for the first time. She remembered Tom saying, "We've got office furniture dating back to the 80s. There are those ugly green-top desks that look like they came from military surplus! I'm especially concerned about computer workstation ergonomics—it's a major issue that we absolutely must fix! I want you to lead a project to transition our office furniture to the new corporate standard."

Susan assembled her project team: Jeff, the site safety/ergonomics engineer; Gretchen, the space planner; Cindy, the move coordinator; and Kari, the accounting liaison for Facilities. At their first meeting, everyone agreed that ergonomics was the most urgent concern. All five business units responded to a workstation survey that identified injury-causing ergonomics. The team was developing a plan to replace old desks with new, ergo-adjustable furniture by the end of the year. Susan asked Kari about the budget, and Kari responded, "Facilities should not pay for this. We want the individual business units to pay so that the costs will show where they are incurred."

Gretchen spoke up: "You know, we've got lots of department moves going on constantly. Everybody is always jockeying for space and location as their business needs change. Besides the ergonomics, could we say that only corporate standard furniture gets moved? That would force changing some of the stuff that's just plain ugly." Everyone agreed that this was a great idea.

Susan presented the project plan to Tom and got a green light to proceed.

JON WOOD

Jon Wood is a planning manager, with 22 years experience at Cerberus. His business unit, Photographic Chemicals Division (PCD), is losing money. Digital photography is continuing to reduce the size of the market, and PCD is having trouble matching the competition's relentless price-cutting. Jon recently transferred to Richmond from corporate headquarters, where he ran the economic forecasting group. He is considered a new broom, and he is determined to sweep clean.

One of Jon's early actions was to negotiate with his general manager for a department move. Money was tight, and the site facilities function charged an arm and a leg for moves (covering all their fixed overhead, the operations people groused). However, Jon felt it was important to move from Building 4, where they were next to Production, to Building 6, where they could be close to Marketing, Forecasting, and Accounting. His General Manager agreed, and there was lots of excitement in his team about their upcoming move. Jon assigned one of his planners, Richard, to work with the Facilities team on the layout and move plan for the group. Things seemed to be going fine—Jon saw Richard sitting down with the move coordinator, and they seemed to be on track.

The day before the move, Jon hung up the phone from a particularly tense teleconference with a Canadian subcontractor. Production was not going well, and product availability would be tight for the rest of the quarter. Clustered around his desk were Richard, Cindy, and a person he hadn't met yet, Susan. After hurried introductions, Susan told Jon that his filing cabinets could not be moved. The cabinets are large lateral files, five feet

wide and two feet deep, a combination of both filing cabinets and bookshelves. Jon brought them with him from Corporate because he thought they looked nice with their dark grey steel sides and wood veneer tops. Susan told him that he would have to replace them with new corporate standard cabinets, virtually the same size. Jon said, "You mean you want me to throw away perfectly good filing cabinets and spend another $2,000 on new ones, just so they match? I won't do it!"

Susan replied, "Then I won't authorize the movement of the old cabinets."

Jon said, "You're joking—these cabinets are grey, the new ones are grey—the only difference is the wood top! You'd throw away $2,000 for nothing?"

Susan replied stiffly, "I'm sorry, that's the policy."

Jon said, "I don't care what the policy is. If I have to move them myself, those cabinets are not going to the dump. My division is losing money and I'm not going to throw money away. If you don't like it, you're going to have to get your general manager to convince my general manager to make me do it. Now would you please leave so I can get some work done."

1. If you were Steele, what would you do?
2. What, if anything, could Steele have done differently to avoid this problem?
3. What could the management of Cerberus do to more effectively manage situations like this?

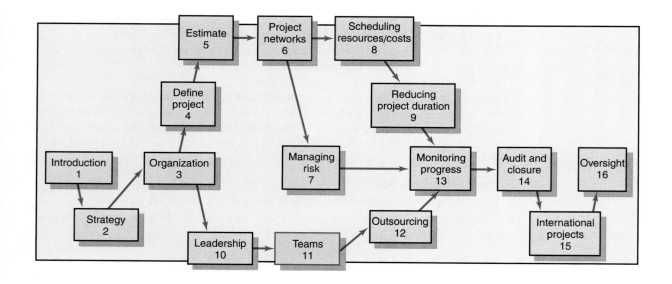

Managing Project Teams

The Five-Stage Team Development Model

Situational Factors Affecting Team Development

Building High-Performance Project Teams

Managing Virtual Project Teams

Project Team Pitfalls

Summary

Managing Project Teams

The difference in productivity between an average team and a turned-on, high-performing team is not 10 percent, 20 percent, or 30 percent, but 100 percent, 200 percent, even 500 percent!

—Tom Peters, management consultant and writer

The magic and power of teams is captured in the term "synergy," which is derived from the Greek word *sunergos:* "working together." There is positive and negative synergy. The essence of positive synergy can be found in the phrase "The whole is greater than the sum of the parts." Conversely, negative synergy occurs when the whole is less than the sum of the parts. Mathematically, these two states can be symbolized by the following equations:

$$\text{Positive Synergy } 1 + 1 + 1 + 1 + 1 = 10$$
$$\text{Negative Synergy } 1 + 1 + 1 + 1 + 1 = 2 \text{ (or even } -2)$$

Synergy perhaps can best be seen on a basketball court, a soccer pitch, or a baseball diamond. For example, in 2006 the Oregon State University (OSU) baseball team became the first team outside the sun belt in over 45 years to win the College World Series. The OSU Beaver baseball team, comprised mostly of local, small-town talent, with no top major league prospects, won a record six consecutive elimination games to be crowned champions. Positive synergy could be seen in how the Beavers executed sacrifice bunts, recorded stellar double plays, scratched out timely hits, and overcame adversity. "We played as one," first baseman Bill Rowe said, "When someone went down, somebody picked someone up." The newspaper headline perhaps captured the essence: "The Best Team Won."

Although less visible than in team sports, positive and negative synergy can also be observed and felt in the daily operations of project teams. Here is a description from one team member we interviewed:

> Instead of operating as one big team we fractionalized into a series of subgroups. The marketing people stuck together as well as the systems guys. A lot of time was wasted gossiping and complaining about each other. When the project started slipping behind schedule, everyone started covering their tracks and trying to pass the blame on to others. After a while we avoided direct conversation and resorted to e-mail. Management finally pulled the plug and brought in another team to salvage the project. It was one of the worst project management experiences in my life.

This same individual fortunately was also able to recount a more positive experience:

> There was a contagious excitement within the team. Sure we had our share of problems and setbacks, but we dealt with them straight on and, at times, were able to do the impossible. We all cared about the project and looked out for each other. At the same time we challenged each other to do better. It was one of the most exciting times in my life.

The following is a set of characteristics commonly associated with high-performing teams that exhibit positive synergy:

1. The team shares a sense of common purpose, and each member is willing to work toward achieving project objectives.

2. The team identifies individual talents and expertise and uses them, depending on the project's needs at any given time. At these times, the team willingly accepts the influence and leadership of the members whose skills are relevant to the immediate task.

3. Roles are balanced and shared to facilitate both the accomplishment of tasks and feelings of group cohesion and morale.

4. The team exerts energy toward problem solving rather than allowing itself to be drained by interpersonal issues or competitive struggles.

5. Differences of opinion are encouraged and freely expressed.

6. To encourage risk taking and creativity, mistakes are treated as opportunities for learning rather than reasons for punishment.

7. Members set high personal standards of performance and encourage each other to realize the objectives of the project.

8. Members identify with the team and consider it an important source of both professional and personal growth.

High-performing teams become champions, create breakthrough products, exceed customer expectations, and get projects done ahead of schedule and under budget. They are bonded together by mutual interdependency and a common goal or vision. They trust each other and exhibit a high level of collaboration.

The Five-Stage Team Development Model

Just as infants develop in certain ways during their first months of life, many experts argue that groups develop in a predictable manner. One of the most popular models identifies five stages (see Figure 11.1) through which groups develop into effective teams:

1. **Forming.** During this initial stage the members get acquainted with each other and understand the scope of the project. They begin to establish ground rules by trying to find out what behaviors are acceptable with respect to both the project (what role they will play, what performance expectations are) and interpersonal relations (who's really in charge). This stage is completed once members begin to think of themselves as part of a group.

2. **Storming.** As the name suggests, this stage is marked by a high degree of internal conflict. Members accept that they are part of a project group but resist the constraints that the project and group put on their individuality. There is conflict over who will control the group and how decisions will be made. As these conflicts are resolved, the project manager's leadership becomes accepted, and the group moves to the next stage.

3. **Norming.** The third stage is one in which close relationships develop and the group demonstrates cohesiveness. Feelings of camaraderie and shared responsibility for the project are heightened. The norming phase is complete when the group structure solidifies and the group establishes a common set of expectations about how members should work together.

4. **Performing.** The team operating structure at this point is fully functional and accepted. Group energy has moved from getting to know each other and how the group will work together to accomplishing the project goals.

FIGURE 11.1
The Five-Stage Team Development Model

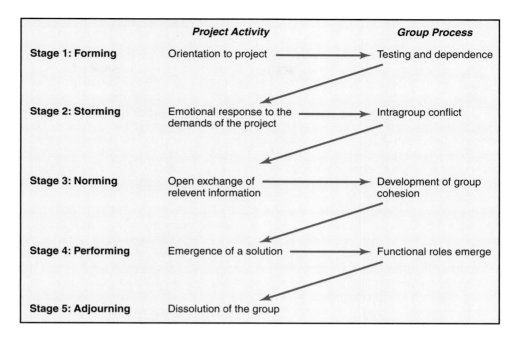

	Project Activity	Group Process
Stage 1: Forming	Orientation to project	Testing and dependence
Stage 2: Storming	Emotional response to the demands of the project	Intragroup conflict
Stage 3: Norming	Open exchange of relevent information	Development of group cohesion
Stage 4: Performing	Emergence of a solution	Functional roles emerge
Stage 5: Adjourning	Dissolution of the group	

5. **Adjourning.** For conventional work groups, performing is the last stage of their development. However, for project teams, there is a completion phase. During this stage, the team prepares for its own disbandment. High performance is no longer a top priority. Instead attention is devoted to wrapping up the project. Responses of members vary in this stage. Some members are upbeat, basking in the project team's accomplishments. Others may be depressed over loss of camaraderie and friendships gained during the project's life.

This model has several implications for those working on project teams. The first is that the model provides a framework for the group to understand its own development. Project managers have found it useful to share the model with their teams. It helps members accept the tensions of the storming phase, and it directs their focus to moving toward the more productive phases. Another implication is that it stresses the importance of the norming phase, which contributes significantly to the level of productivity experienced during the performing phase. Project managers, as we shall see, have to take an active role in shaping group norms that will contribute to ultimate project success. For an alternative model of group development see the Punctuated Equilibrium Research Highlight.

Situational Factors Affecting Team Development

Experience and research indicate that high-performance project teams are much more likely to develop under the following conditions:

- There are 10 or fewer members per team.
- Members volunteer to serve on the project team.
- Members serve on the project from beginning to end.
- Members are assigned to the project full time.
- Members are part of an organization culture that fosters cooperation and trust.
- Members report solely to the project manager.

Gersick's research suggests that groups don't develop in a universal sequence of stages as suggested by the five-phase model. Her research, which is based on the systems concept of *punctuated equilibrium,* found that the *timing* of when groups form and actually change the way they work is highly consistent. What makes this research appealing is that it is based on studies of more than a dozen field and laboratory task forces assigned to complete a specific project. This research reveals that each group begins with a unique approach to accomplishing its project that is set in its first meeting and includes the behavior and roles that dominate phase I. Phase I continues until one-half of the allotted time for project completion has expired (regardless of actual amount of time). At this midpoint, a major transition occurs that includes the dropping of the group's old norms and behavior patterns and the emergence of new behavior and working relationships that contribute to increased progress toward completing the project. The last meeting is marked by accelerated activity to complete the project. These findings are summarized in Figure 11.2.

The remarkable discovery in these studies was that each group experienced its transition at the same point in its calendar—precisely halfway between the first meeting and the completion deadline—despite the fact that some groups spent as little as an hour on their project while others spent six months. It was as if the groups universally experienced a midlife crisis at this point. The midpoint appeared to work like an alarm clock, heightening members' awareness that time was limited and they needed to get moving. Within the context of the five-stage model, it suggests that groups begin by combining the forming and norming stages, then go through a period of low performing, followed by storming, then a period of high performing, and finally adjourning.

Gersick's findings suggest that there are natural transition points during the life of teams in which the group is receptive to change and that such a moment naturally occurs at the scheduled midpoint of a project. However, a manager does not want to have to wait 6 months on a complicated 12-month project for a team to get its act together! Here it is important to note that Gersick's groups were working on relatively small-scale projects, i.e., a 4-person bank task force in charge of designing a new bank account in one month and a 12-person medical task force in charge of reorganizing two units of a treatment facility. In most cases no formal project plan was established. If anything, the results point to the importance of good project management and the need to establish deadlines and milestones. By imposing a series of deadlines associated with important milestones, it is possible to create multiple transition points for natural group development. For example, a 12-month construction project can be broken down into six to eight significant milestones with the challenge of meeting each deadline producing the prerequisite tension for elevating team performance.

* Connie J. Gersick, "Time and Transition in Work Teams: Toward a New Model of Group Development," *Academy of Management Journal,* Vol. 31, No. 1 (March 1988), pp. 9–41; and Connie J. Gersick, "Making Time Predictable Transitions in Task Groups," *Academy of Management Journal,* Vol. 32, No. 2 (June 1989), pp. 274–309.

FIGURE 11.2
The Punctuated Equilibrium Model of Group Development

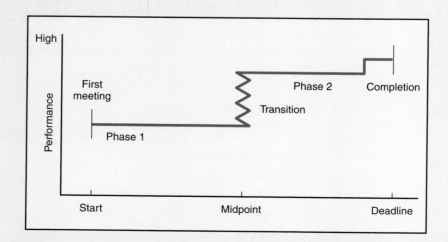

- All relevant functional areas are represented on the team.
- The project involves a compelling objective.
- Members are located within conversational distance of each other.

In reality, it is rare that a project manager is assigned a project that meets all of these conditions. For example, many projects' requirements dictate the active involvement of more than 10 members and may consist of a complex set of interlocking teams comprising more than 100 professionals. In many organizations, functional managers or central manpower offices assign project members with little input from the project manager. To optimize resource utilization, team member involvement may be part time, and/or participants may move in and out of the project team on an as-needed basis. In the case of ad hoc task forces, no member of the team works full time on the project. In many corporations an NIH (not invented here) culture exists that discourages collaboration across functional boundaries.

Team members often report to different managers, and, in some cases, the project manager will have no direct input over performance appraisals and advancement opportunities of team members. Key functional areas may not be represented during the entire duration of the project but may only be involved in a sequential manner. Not all projects have a compelling objective. It can be hard to get members excited about mundane projects such as a simple product extension or a conventional apartment complex. Finally, team members are often scattered across different corporate offices and buildings or, in the case of a virtual project, across the entire globe.

It is important for project managers and team members to recognize the situational constraints they are operating under and do the best they can. It would be naive to believe that every project team has the same potential to evolve into a high-performance team. Under less-than-ideal conditions, it may be a struggle just to meet project objectives. Ingenuity, discipline, and sensitivity to team dynamics are essential to maximizing the performance of a project team.

Building High-Performance Project Teams

Project managers play a key role in developing high-performance project teams. They recruit members, conduct meetings, establish a team identity, create a common sense of purpose or a shared vision, manage a reward system that encourages teamwork, orchestrate decision making, resolve conflicts that emerge within the team, and rejuvenate the team when energy wanes (see Figure 11.3). Project managers take advantage of situational factors that naturally contribute to team development while improvising around those factors that inhibit team development. In doing so they exhibit a highly interactive management style that exemplifies teamwork and, as discussed in the previous chapter, manage the interface between the team and the rest of the organization.

Recruiting Project Members

The process of selecting and recruiting project members will vary across organizations. Two important factors affecting recruitment are the importance of the project and the management structure being used to complete the project. Often for high-priority projects that are critical to the future of the organization, the project manager will be given virtual carte blanche to select whomever he or she deems necessary. For less significant projects, the project manager will have to persuade personnel from other areas within the organization to join the team.

FIGURE 11.3
Creating a High-Performance Project Team

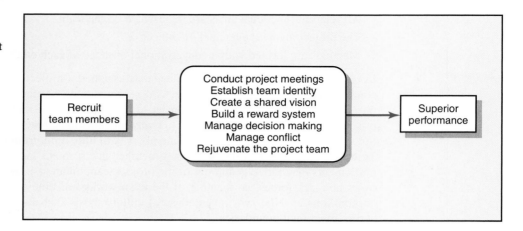

In many matrix structures, the functional manager controls who is assigned to the project; the project manager will have to work with the functional manager to obtain necessary personnel. Even in a project team where members are selected and assigned full time to the project, the project manager has to be sensitive to the needs of others. There is no better way to create enemies within an organization than to be perceived as unnecessarily robbing other departments of essential personnel.

Experienced project managers stress the importance of asking for volunteers. However, this desirable step oftentimes is outside the manager's control. Still, the value of having team members volunteer for the project as opposed to being assigned cannot be overlooked. Agreeing to work on the project is the first step toward building personal commitment to the project. Such commitment will be essential to maintain motivation when the project hits hard times and extra effort is required.

When selecting and recruiting team members, project managers naturally look for individuals with the necessary experience and knowledge/technical skills critical for project completion. At the same time, there are less obvious considerations that need to be factored into the recruitment process:

- *Problem-solving ability.* If the project is complex and fuzzy, then a manager wants people who are good at working under uncertainty and have strong problem identification and solving skills. These same people are likely to be bored and less productive working on straightforward projects that go by the book.
- *Availability.* Sometimes the people who are most available are not the ones wanted for the team. Conversely, if members recruited are already overcommitted, they may not be able to offer much.
- *Technological expertise.* Managers should be wary of people who know too much about a specific technology. They may be technology buffs who like to study but have a hard time settling down and doing the work.
- *Credibility.* The credibility of the project is enhanced by the reputation of the people involved in the project. Recruiting a sufficient number of "winners" lends confidence to the project.
- *Political connections.* Managers are wise to recruit individuals who already have a good working relationship with key stakeholders. This is particularly true for projects operating in a matrix environment in which a significant portion of the work will be under the domain of a specific functional department and not the core project team.
- *Ambition, initiative, and energy.* These qualities can make up for a lot of shortcomings in other areas and should not be underestimated.

After reviewing needed skills, the manager should try and find out through the corporate grapevine who is good, who is available, and who might want to work on the project. Some organizations may allow direct interviews. Often a manager will have to expend political capital to get highly prized people assigned to the project.

In matrix environments, the project manager will have to request appointments with functional managers to discuss project requirements for staffing. The following documents should be available at these discussions: an overall project scope statement, endorsements of top management, and a description of the tasks and general schedule that pertain to the people from their departments. Managers need to be precise as to what attributes they are seeking and why they are important.

Functional managers should be encouraged to suggest names of people within their departments as candidates. If the project manager is asked to suggest names, it might be wise to say, "Well, I would really like Pegi Young, but I know how critical her work is. How about Billy Talbot?" If the conversation goes this way, the project manager may be able to cut a deal then and there and will want to be sure to put the agreement in writing immediately after the meeting as a memorandum of understanding.

If, on the other hand, the functional manager balks at the suggestions and the meeting is not progressing, the project manager should adroitly terminate the conversation with an understanding that the matter will be discussed again in a few days. This technique demonstrates persistence and a desire to do what it takes to resolve the issue. Ultimately, of course, the project manager will have to settle on the best offer. Managers should exercise care not to reveal how different members of the team were selected. The project might be crippled at the start if reluctantly assigned members are identified and the team perceives differences in attitude and commitment.

Conducting Project Meetings

The First Project Team Meeting

Research on team development confirms what we have heard from project managers: The first project kick-off meeting is critical to the early functioning of the project team. According to one veteran project manager:

> The first team meeting sets the tone for how the team will work together. If it is disorganized, or becomes bogged down with little sense of closure, then this can often become a self-fulfilling prophecy for subsequent group work. On the other hand, if it is crisply run, focusing on real issues and concerns in an honest and straightforward manner, members come away excited about being part of the project team.

There are typically three objectives project managers try to achieve during the first meeting of the project team. The first is to provide an overview of the project, including the scope and objectives, the general schedule, method, and procedures. The second is to begin to address some of the interpersonal concerns captured in the team development model: Who are the other team members? How will I fit in? Will I be able to work with these people? The third and most important objective is to begin to model how the team is going to work together to complete the project. The project manager must recognize that first impressions are important; her behavior will be carefully monitored and interpreted by team members. This meeting should serve as an exemplary role model for subsequent meetings and reflect the leader's style.

The meeting itself comes in a variety of shapes and forms. It is not uncommon in major projects for the kick-off meeting to involve one or two days, often at a remote site away from interruptions. This retreat provides sufficient time for preliminary introduction, to begin to establish ground rules, and to define the structure of the project. One advantage of off-site kick-off meetings is that they provide ample opportunity for informal interaction

among members during breaks, meals, and evening activities; such informal interactions are critical to forming relationships.

However, many organizations do not have the luxury of holding elaborate retreats. In other cases the scope of project and level of involvement of different participants does not warrant such an investment of time. In these cases, the key operating principle should be KISS (keep it simple stupid!) Too often when constrained by time, project managers try to accomplish too much during the first meeting; in doing so, issues do not get fully resolved, and members come away with an information headache.

The primary goal is to run a productive meeting, and objectives should be realistic given the time available. If the meeting is only one hour, then the project manager should simply review the scope of the project, discuss how the team was formed, and provide an opportunity for members to introduce themselves to the team.

Establishing Ground Rules

Whether as part of an elaborate first meeting or during follow-up meetings, the project manager must quickly begin to establish operational ground rules for how the team will work together. These ground rules involve not only organizational and procedural issues but also normative issues on how the team will interact with each other. Although specific procedures will vary across organizations and projects, some of the major issues that need to be addressed include the following:

Planning Decisions

- How will the project plan be developed?
- What tools will be used to support the project?
- Will a specific project management software package be used? If so, which one?
- Who will enter the planning information?
- What are the specific roles and responsibilities of all the participants?
- Who needs to be informed of decisions? How will they be kept informed?
- What are the relative importance of cost, time, and performance?
- What are the deliverables of the project planning process?
- What format is appropriate for each deliverable?
- Who will approve and sign off at the completion of each deliverable?
- Who receives each deliverable?

Tracking Decisions

- How will progress be assessed?
- At what level of detail will the project be tracked?
- How will team members get data from each other?
- How often will they get this data?
- Who will generate and distribute reports?
- Who needs to be kept informed about project progress, and how will they be informed?
- What content/format is appropriate for each audience?
- Meetings
 - Where will meetings be located?
 - What kind of meetings will be held?
 - Who will "run" these meetings?
 - How will agendas be produced?
 - How will information be recorded?

Courtesy of NASA.

Donna Shirley's 35-year career as aerospace engineer reached a pinnacle in July 1997 when Sojourner—the solar-powered, self-guided, microwave-oven-sized rover—was seen exploring the Martian landscape in Pathfinder's spectacular images from the surface of the red planet. The event marked a milestone in space exploration: No vehicle had ever before roamed the surface of another planet. Shirley, a manager at the Jet Propulsion Laboratory's Mars Exploration Program, headed the mostly male team that designed and built Sojourner. In her insightful memoir, *Managing Martians*, written with Danelle Morton, she makes the following observation about managing creative teams:

> When you are managing really brilliant, creative people, at some point you find it's impossible to command or control them

because you can't understand what they are doing. Once they have gone beyond your ability to understand them, you have a choice to make as a manager. You can limit them and the project by your intelligence, which I think is the wrong way to do it. Or you can trust them and use your management skills to keep them focused on the goal.

A lot of bad managers get threatened when their "subordinates" know more than they do. They either hire people who are inferior to them so they can always feel in control or they bottleneck people who know something they don't so they can maintain control. The whole project suffers from the manager's insecurities.

* Donna Shirley and Danelle Morton, *Managing Martians* (New York: Broadway Books, 1998), pp. 88–89.

Managing Change Decisions
- How will changes be instituted?
- Who will have change approval authority?
- How will plan changes be documented and evaluated?

Relationship Decisions
- What department or organizations will the team need to interact with during the project?
- What are the roles and responsibilities of each organization (reviewer, approver, creator, user)?
- How will all involved parties be kept informed of deliverables, schedule dates, expectations, etc.?
- How will the team members communicate among themselves?
- What information will and won't be exchanged?

Checklists like these are only a guide; items should be added or deleted as needed. Many of these procedures will have already been established by precedent and will only have to be briefly reviewed. For example, *Microsoft Project* or *Primavera* may be the standard software tool for planning and tracking. Likewise, a specific firm is likely to have an established format for reporting status information. How to deal with other issues will have to be determined by the project team. When appropriate, the project manager should actively solicit input from the project team members and draw upon their experience and preferred work habits. This process also contributes to their buying into the operational decisions. Decisions should be recorded and circulated to all members.

During the course of establishing these operational procedures, the project manager, through word and deed, should begin working with members to establish the norms for team interaction. Below are examples of some of the norms researchers have found associated with high-performance teams.

- Confidentiality is maintained; no information is shared outside the team unless all agree to it.
- It is acceptable to be in trouble, but it is not acceptable to surprise others. Tell others immediately when deadlines or milestones will not be reached.
- There is zero tolerance for bulling a way through a problem or an issue.
- Agree to disagree, but when a decision has been made, regardless of personal feelings, move forward.
- Respect outsiders, and do not flaunt one's position on the project team.
- Hard work does not get in the way of having fun.

One way of making these norms more tangible is by creating a project team charter that goes beyond the scope statement of the project and states in explicit terms the norms and values of the team. This charter should be a collaborative effort on the part of the core team. Project managers can lead by proposing certain tenets, but they need to be open to suggestions from the team. Once there is general agreement to the rules of conduct, each member signs the final document to symbolize commitment to the principles it contains.

Unfortunately, in some cases charters become a meaningless ritual because the charter is signed and filed away, never to be discussed again. To have a lasting effect, the charter has to be a legitimate part of the project monitoring system. Just as the team reviews progress toward project objectives, the team assesses the extent to which members are adhering to the principles in the charter.

Project managers play a major role in establishing team norms through personal example. If they freely admit mistakes and share what they have learned from them, other team members will begin to do the same. At the same time, project managers need to intervene when they believe such norms are being violated. They should talk to offenders privately and clearly state their expectations. The amazing thing about groups is that once a group is cohesive, with well-established norms, the members will police themselves so that the manager doesn't have to be the heavy. For example, one project manager confided that his team had a practice of having a small bean bag present at every meeting. If any one member felt that a colleague was shooting hot air or shading the truth, he or she was obligated to toss the bean bag at the speaker.

Managing Subsequent Project Meetings

The project kick-off meeting is one of several kinds of meetings required to complete a project. Other meetings include status report meetings, problem-solving meetings, and audit meetings. Issues unique to these meetings will be discussed in subsequent chapters.

AP/Wide World.

Mattel is the largest toy manufacturing company in the world with product lines that include Barbie dolls, Fisher-Price toys, and Hot Wheels. Mattel stumbled when it missed out on the girl empowerment trend in the late 1990s. Vowing never to have this happen again, Mattel re-engineered its product development processes by instituting Project Platypus.

Project Platypus consists of people from a variety of functional areas who leave their regular jobs for three months and move out of Mattel headquarters to a separate location where they work collaboratively on new product ideas. Team members in Mattel's Project Platypus sometimes spend their days dropping eggs from a 14-foot ladder or throwing stuffed animals at each other. It is all part of team-building activities designed to get people to think differently and come up with creative ideas for new toys.

According to Ivy Ross, head of Mattel's girl design division, exercises such as devising a method to prevent an egg from breaking when dropped from 14 feet or throwing stuffed bunnies at a teammate to release inhibitions are ways to get people to think outside the box and discover consumer trends and market-place changes. "Other companies have skunk works," Ross says, "we have platypus. I looked up the definition and it said, 'an uncommon mix of different species.'"

The strength of the Platypus lies in its members' ability to build on one another's creative ideas. A key group norm is no one owns an idea. Everything belongs to the group, which helps eliminate competitiveness.

Project Platypus is also designed to encourage team bonding, so that people will continue to share ideas and collaborate once the creative ideas move further into product development and production. Previously, product development at Mattel involved a lot of "baton passing," as Ross puts it. Mattel now wants everyone to collaborate in a design and development process where there's a shared sense of ownership and achievement. Participants in the project work in a huge open space with no walls or cubicles. Desks are on wheels to encourage spontaneous sharing and collaboration. Project members can post their sketched ideas on the walls and invite others for suggestions.

The first Project Platypus effort is a new toy called Ello, a hybrid between a construction set and activity kit. Ello sets consist of interconnected pieces that allow children to explore their imagination to build anything from jewelry to buildings. Platypus project teams are continuing to work to develop two to three new product ideas a year.

* Chuck Salter, "Ivy Ross Is Not Playing Around," *Fast Company,* Issue 64, November 2002, p. 104.

For now, here are some general guidelines for running effective meetings. They speak directly to the person chairing the meeting:

- Start meetings on time regardless of whether everyone is present.
- Prepare and distribute an agenda prior to the meeting.
- Identify an adjournment time.
- Periodically take time to review how effective previous meetings have been.
- Solicit recommendations and implement changes.
- Assign good recordkeeping.
- Review the agenda before beginning, and tentatively allocate time for each item.
- Prioritize issues so that adjustments can be made given time constraints.
- Encourage active participation of all members by asking questions instead of making statements.
- Summarize decisions, and review assignments for the next meeting.
- Prepare and distribute a summary of the meeting to appropriate people.
- Recognize accomplishments and positive behavior.

Meetings are often considered an anathema to productivity, but this does not have to be the case. The most common complaint is that meetings last too long. Establishing an agenda and adjournment time helps participants budget discussion time and provides a basis for expediting the proceedings. Recordkeeping can be an unwelcome, tedious task. Utilizing laptop computers to record decisions and information in real time can facilitate the communication process. Careful preparation and consistent application of these guidelines can make meetings a vital part of projects.

Establishing a Team Identity

One of the challenges project managers often face in building a team is the lack of full-time involvement of team members. Specialists work on different phases of the project and spend the majority of their time and energy elsewhere. They are often members of multiple teams, each competing for their time and allegiance. Project expert David Frame points out that for many of these specialists a specific project is an abstraction; as a consequence their level of motivation suffers. Project managers need to try to make the project team as tangible as possible to the participants by developing a unique team identity to which participants can become emotionally attached. Team meetings, co-location of team members, team names, and team rituals are common vehicles for doing so.

- *Effective use of meetings.* Periodic project team meetings provide an important forum for communicating project information. A less obvious function of project meetings is to help establish a concrete team identity. During project meetings, members see that they are not working alone. They are part of a larger project team, and project success depends on the collective efforts of all the team members. Timely gatherings of all the project participants help define team membership and reinforce a collective identity.
- *Co-location of team members.* The most obvious way to make the project team tangible is to have members work together in a common space. This is not always possible in matrix environments where involvement is part time and members are working on other projects and activities. A worthwhile substitute for co-location is the creation of a project office, sometimes referred to as the project war room or clubhouse. Such rooms are the common meeting place and contain the most significant project documentation. Frequently, their walls are covered with Gantt charts, cost graphs, and other output associated with project planning and control. These rooms serve as a tangible sign of project effort.

Knight-Ridder's *Tallahassee Democrat,* like many American newspapers in the late 1980s, was struggling to survive in the face of declining revenues. Fred Mott, the general manager of the *Democrat,* was convinced that the key to the newspaper's future was becoming more customer-focused. Despite his best efforts, little progress was being made toward becoming a customer-driven newspaper. One area that was particularly problematic was advertising, where lost revenues due to errors could be as high as $10,000 a month.

Fred Mott decided to create a team of 12 of his best workers from all parts of the newspaper. They became known as the ELITE team because their mission was to "ELIminate The Errors." At first the team spent a lot of time pointing fingers at each other rather than coming to grips with the error problems at the newspaper. A key turning point came when one member produced what became known as "the rat tracks fax" and told the story behind it. It turns out a sloppily prepared ad arrived through a fax machine looking like "a rat had run across the page." Yet the ad passed through the hands of seven employees and probably would have been printed if it had not been totally unreadable. The introduction of this fax broke the ice, and the team started to

admit that everyone—not everyone else—was at fault. Then, recalls one member, "We had some pretty hard discussions. And there were tears at those meetings."

The emotional responses galvanized the group to the task at hand and bonded them to one another. The ELITE team looked carefully at the entire process by which an ad was sold, created, printed, and billed. When the process was examined, the team discovered patterns of errors, most of which could be attributed to bad communication, time pressures, and poor attitude. They made a series of recommendations that completely transformed the ad process at the *Democrat.* Under ELITE's leadership, advertising accuracy rose sharply and stayed above 99 percent. Lost revenues from errors dropped to near zero. Surveys showed a huge positive swing in advertiser satisfaction.

The impact of ELITE, however, went beyond numbers. The ELITE team's own brand of responsiveness to customer satisfaction spread to other parts of the newspaper. In effect this team of mostly frontline workers spearheaded a cultural transformation at the newspaper that emphasized a premium on customer service.

* Jon R. Katzenbach and Douglas K. Smith, *The Wisdom of Teams* (Boston: Harvard Business School Press, 1993), pp. 67–72. Copyright McKinsey & Co., Inc.

- *Creation of project team name.* The development of a team name such as the "A-Team" or "Casey's Crusaders" is a common device for making a team more tangible. Frequently an associated team logo is also created. Again the project manager should rely on the collective ingenuity of the team to come up with the appropriate name and logo. Such symbols then can be affixed to stationery, T-shirts, coffee mugs, etc., to help signify team membership.

- *Get the team to build or do something together early on.* Nothing reinforces a sense of a team more than working on something together. In the case of one international project, the manager simply hosted a potluck dinner where each member brought a dish his or her country was famous for.

- *Team rituals.* Just as corporate rituals help establish the unique identity of a firm, similar symbolic actions at the project level can contribute to a unique team subculture. For example, on one project members were given ties with stripes that corresponded to the number of milestones on the project. After reaching each milestone, members would gather and cut the next stripe off their ties to signify progress. Ralph Katz reports it was common practice for Digital Equipment's alpha chip design team to recognize people who found a bug in the design by giving them a phosphorescent toy roach. The bigger the bug that was discovered, the bigger the toy roach received. Such rituals help set project work apart from mainstream operations and reinforce a special status.

Creating a Shared Vision

Unlike project scope statements, which include specific cost, completion dates, and performance requirements, a *vision* involves the less tangible aspects of project performance. It refers to an image a project team holds in common about how the project will look upon

completion, how they will work together, and/or how customers will accept the project. At its simplest level, a shared vision is the answer to the question, "What do we want to create?" Not everyone will have the same vision, but the images should be similar. Visions come in a variety of shapes and forms; they can be captured in a slogan or a symbol or can be written as a formal vision statement.

What a vision is, is not as important as what it does. A vision inspires members to give their best effort. (See A Good Man in a Storm Snapshot.) Moreover, a shared vision unites professionals with different backgrounds and agendas to a common aspiration. It helps motivate members to subordinate their individual agendas and do what is best for the project. As psychologist Robert Fritz puts it, "In the presence of greatness, pettiness disappears." Visions also provide focus and help communicate less tangible priorities, helping members make appropriate judgment calls. Finally, a shared vision for a project fosters commitment to the long term and discourages expedient responses that collectively dilute the quality of the project.

Visions can be surprisingly simple. For example, the vision for a new car could be expressed as a "pocket rocket." Compare this vision with the more traditional product description—"a sports car in the midprice range." The "pocket rocket" vision provides a much clearer picture of what the final product should be. Design engineers would immediately understand that the car will be both small and fast and that the car should be quick at the getaway, nimble in the turns, and very fast in the straightaways. Obviously, many details would have to be worked out, but the vision would help establish a common framework for making decisions.

There appear to be four essential qualities of an effective vision (see Figure 11.4): First, its essential qualities must be able to be communicated. A vision is worthless if it only resides in someone's head. Second, visions have to be challenging but also realistic. For example, a task force directed at overhauling the curriculum at the college of business at a state university is likely to roll its eyes if the dean announces that their vision is to compete against the Harvard Business School. Conversely, developing the best undergraduate business program in that state may be a realistic vision for that task force. Third, the project manager has to believe in the vision. Passion for the vision is an essential element of an effective vision. Finally, it should be a source of inspiration to others.

Once a project manager accepts the importance of building a shared vision, the next question is how to get a vision for a particular project. First, project managers don't get visions. They act as catalysts and midwives for the formation of a shared vision of a

FIGURE 11.4
Requirements for an Effective Project Vision

project team. In many cases visions are inherent in the scope and objectives of the project. People get naturally excited about being the first ones to bring a new technology to the market or solving a problem that is threatening their organization. Even with mundane projects, there are often ample opportunities for establishing a compelling vision. One way is to talk to various people involved in the project and find out early on what gets them excited about the project. For some it may be doing a better job than on the last project or the satisfaction in the eyes of the customers when the project is over. Many visions evolve reactively in response to competition. For example, the Kodak team responsible for developing the single-use FunSaver camera was driven by the vision of beating a similar effort by Fuji to the market.

Some experts advocate engaging in formal vision-building meetings. These meetings generally involve several steps, beginning with members identifying different aspects of the project and generating ideal scenarios for each aspect. For example, on a construction project the scenarios may include "no accidents," "no lawsuits," "winning a prize," or "how we are going to spend our bonus for completing the project ahead of schedule." The group reviews and chooses the scenarios that are most appealing and translates them into vision statements for the project. The next step is to identify strategies for achieving the vision statements. For example, if one of the vision statements is that there will be no lawsuits, members will identify how they will have to work with the owner and subcontractors to avoid litigation. Next, members volunteer to be the keeper of the flame for each statement. The vision, strategies, and the name of the responsible team member are published and distributed to relevant stakeholders.

In more cases than not, shared visions emerge informally. Project managers collect information about what excites participants about the project. They test bits of their working vision in their conversations with team members to gauge the level of excitement the early ideas elicit in others. To some extent they engage in basic market research. They seize opportunities to galvanize the team, such as a disparaging remark by an executive that the project will never get done on time or the threat of a competing firm launching a similar project. Consensus in the beginning is not essential. What is essential is a core group of at least one-third of the project team that is genuinely committed to the vision. They will provide the critical mass to draw others aboard. Once the language has been formulated to communicate the vision, then the statement needs to be a staple part of every working agenda, and the project manager should be prepared to deliver a "stump" speech at a moment's notice. When problems or disagreements emerge, all responses should be consistent with the vision.

Much has been written about visions and leadership. Critics argue that vision is a glorified substitute for shared goals. Others argue that it is one of the things that separates leaders from managers. The key is discovering what excites people about a project, being able to articulate this source of excitement in an appealing manner, and finally protecting and nurturing this source of excitement throughout the duration of the project.

Managing Project Reward Systems

Project managers are responsible for managing the reward system that encourages team performance and extra effort. One advantage they have is that often project work is inherently satisfying, whether it is manifested in an inspiring vision or simple sense of accomplishment. Projects provide participants with a change in scenery, a chance to learn new skills, and an opportunity to break out of their departmental cocoon. Another inherent reward is what was referred to in *The Soul of the New Machine* as "pinball"—project success typically gives team members an option to play another exciting game.

Snapshot from Practice A Good Man in a Storm*

Once upon a time, back in 1976, Data General Corporation needed to come up quickly with a fast, reasonably priced 32-bit mini-computer to compete with Digital Equipment Corporation's VAX. Data General CEO Edson de Castro launched the Fountainhead Project and gave it the best people and ample resources to complete the 32-bit initiative. As a back-up to the Fountainhead project, Data General created the Eagle project within the Eclipse group under the leadership of Tom West. Work on both projects began in 1978.

In 1980 Data General announced its new computer, featuring simplicity, power, and low cost. This computer was not the Fountainhead from the well funded "best" DG group but the Eagle from Tom West's under-funded Eclipse team. Tracy Kidder saw all this happen and told the story in *The Soul of a New Machine,* which won a Pulitzer Prize in 1982. This book, which Kidder thought might be of interest to a handful of computer scientists, has become a project management classic.

In the beginning of his book, Kidder introduces the readers to the book's protagonist Tom West by telling the story of him sailing a yacht across rough seas off the coast of New England. Kidder's title for the prologue was "A Good Man in a Storm."

Twenty years after the Kidder's book was published Tom West was interviewed by Lawrence Peters for the *Academy of Management Executive.* Below are some excerpts that capture Tom's views on managing innovative projects:

On selecting team members:

> You explain to a guy what the challenge was, and then see if his eyes light up.

On motivating team members:

> . . . Challenge was everything. People, especially creative technical people who really want to make a difference, will do whatever is possible or whatever is necessary. I've done this more than once, and I've repeated it over and over. It seems to work.

On the importance of having a vision:

> . . . you've got to find a rallying cry. You need to have something that can be described very simply and has that sort of ring of truth to an engineer that says "yes that's the thing to be doing right now." Otherwise you're going to be rolling rocks up hill all the time.

On the role of being a project manager:

> You have to act as a cheerleader. You have to act as the instructor. You have to constantly bring to mind what the purpose is and what's moving the ball towards the goal post, and what's running sideways, and you have to take up a lot of battles for them. I mean you really don't want your design engineer arguing with the guy in the drafting shop about why he ought to do it the designer's way. I can do that, and I can pull rank too, and sometimes I did just that.

* Tracy Kidder, *The Soul of a New Machine* (New York: Avon Books, 1981); Lawrence H. Peters, "'A Good Man in a Storm': An Interview with Tom West," *Academy of Management Executive*, Vol. 16, No. 4, 2002, pp. 53–60.

Still, many projects are underappreciated, boring, interfere with other more significant priorities, and are considered an extra burden. In some of these cases, the biggest reward is finishing the project so that team members can go back to what they really enjoy doing and what will yield the biggest personal payoffs. Unfortunately, when this attitude is the primary incentive, project quality is likely to suffer. In these circumstances, external rewards play a more important role in motivating team performance.

Most project managers we talk to advocate the use of group rewards. Because most project work is a collaborative effort, it only makes sense that the reward system would encourage teamwork. Recognizing individual members regardless of their accomplishments can distract from team unity. Project work is highly interdependent, so it can become problematic to distinguish who truly deserves additional credit. Cash bonuses and incentives need to be linked to project priorities. It makes no sense to reward a team for completing their work early if controlling cost was the number one priority.

One of the limitations of lump-sum cash bonuses is that all too often they are consumed by the household budget to pay the dentist or mechanic. To have more value, rewards need to have lasting significance. Many companies convert cash into vacation rewards, sometimes with corresponding time off. For example, there is one firm that rewarded a project team for getting the job done ahead of schedule with a four-day, all-expenses-paid trip to

Walt Disney World for the members' entire families. That vacation not only will be remembered for years, but it also recognizes spouses and children who, in a sense, also contributed to the project's success. Similarly, other firms have been known to give members home computers and entertainment centers. Wise project managers negotiate a discretionary budget so that they can reward teams surpassing milestones with gift certificates to popular restaurants or tickets to sporting events. Impromptu pizza parties and barbecues are also used to celebrate key accomplishments.

Sometimes project managers have to use negative reinforcement to motivate project performance. For example, Ritti recounts the story of one project manager who was in charge of the construction of a new, state-of-the-art manufacturing plant. His project team was working with a number of different contracting firms. The project was slipping behind schedule, mostly because of a lack of cooperation among the different players. The project manager did not have direct authority over many key people, especially the contractors from the other companies. He did, however, have the freedom to convene meetings at his convenience. So the project manager instituted daily "coordination meetings," which were required of all the principals involved, at 6:30 A.M. The meetings continued for about two weeks until the project got back on schedule. At that time the project manager announced that the next meeting was canceled, and no further sunrise meetings were ever scheduled.

While project managers tend to focus on group rewards, there are times when they need to reward individual performance. This is done not only to compensate extraordinary effort but also to signal to the others what exemplary behavior is. More specifically, among the rewards they use to motivate and recognize individual contributions are the following:

- **Letters of commendation.** While project managers may not have responsibility for their team members' performance appraisals, they can write letters commending their project performance. These letters can be sent to the workers' supervisors to be placed in their personnel files.
- **Public recognition for outstanding work.** Superlative workers should be publicly recognized for their efforts. Some project managers begin each status review meeting with a brief mention of project workers who have exceeded their project goals.
- **Job assignments.** Good project managers recognize that, while they may not have much budgetary authority, they do have substantial control over who does what, with whom, when, and where. Good work should be rewarded with desirable job assignments. Managers should be aware of member preferences and, when appropriate, accommodate them.
- **Flexibility.** Being willing to make exceptions to rules, if done judiciously, can be a powerful reward. Allowing members to work at home when a child is sick or excusing a minor discretion can engender long-lasting loyalty.

We reiterate that individual rewards should be used judiciously, and the primary emphasis should be on group incentives. Nothing can undermine the cohesiveness of a team more than members beginning to feel that others are getting special treatment or that they are being treated unfairly. Camaraderie and collaboration can quickly vanish only to be replaced by bickering and obsessive preoccupation with group politics. Such distractions can absorb a tremendous amount of energy that otherwise would be directed toward completing the project. Individual rewards typically should be used only when everyone in the team recognizes that a member is deserving of special recognition.

Orchestrating the Decision-Making Process

Most decisions on a project do not require a formal meeting to discuss alternatives and determine solutions. Instead decisions are made in real time as part of the daily interaction patterns between project managers, stakeholders, and team members. For example, as a

result of routine "how's it going?" question, a project manager discovers that a mechanical engineer is stuck trying to meet the performance criteria for a prototype he is responsible for building. The project manager and engineer go down the hallway to talk to the designers, explain the problem, and ask what, if anything, can be done. The designers distinguish which criteria are essential and which ones they think can be compromised. The project manager then checks with the marketing group to make sure the modifications are acceptable. They agree with all but two of the modifications. The project manager goes back to the mechanical engineer and asks whether the proposed changes would help solve the problem. The engineer agrees. Before authorizing the changes he calls the project sponsor, reviews the events, and gets the sponsor to sign off on the changes. This is an example of how, by practicing MBWA (management by wandering around), project managers consult team members, solicit ideas, determine optimum solutions, and create a sense of involvement that builds trust and commitment to decisions.

Still, projects encounter problems and decisions that require the collective wisdom of team members as well as relevant stakeholders. Group decision making should be used when it will improve the quality of important decisions. This is often the case with complex problems that require the input of a variety of different specialists. Group decision making should also be used when strong commitment to the decision is needed and there is a low probability of acceptance if only one person makes the decision. Participation is used to reduce resistance and secure support for the decision. Group decision making would be called for with controversial problems which have a major impact on project activities or when trust is low within the project team. Guidelines for managing group decision making are provided below.

Facilitating Group Decision Making

Project managers play a pivotal role in guiding the group decision-making process. They must remind themselves that their job is not to make a decision but to facilitate the discussion within the group so that the team reaches a consensus on the best possible solution. Consensus within this context does not mean that everyone supports the decision 100 percent, but that they all agree what the best solution is under the circumstances. Facilitating group decision making essentially involves four major steps. Each step is briefly described next with suggestions for how to manage the process.

1. **Problem identification.** The project manager needs to be careful not to state the problem in terms of choices (e.g., should we do X or Y?). Rather the project manager should identify the underlying problem to which these alternatives and probably others are potential solutions. This allows group members to generate alternatives, not just choose among them. One useful way of defining problems is to consider the gap between where a project is (i.e., the present state) and where it should be (desired state). For example, the project may be four days behind schedule or the prototype weighs two pounds more than the specifications. Whether the gap is small or large, the purpose is to eliminate it. The group must find one or more courses of action that will change the existing state into the desired one.

 If one detects defensive posturing during the problem identification discussion, then it may be wise to postpone the problem-solving step if possible. This allows for emotions to subside and members to gain a fresh perspective on the issues involved.

2. **Generating alternatives.** Once there is general agreement as to the nature of the problem(s), then the next step is to generate alternative solutions. If the problem requires creativity, then brainstorming is commonly recommended. Here the team generates a list of possible solutions on a flipchart or blackboard. During that time the project manager establishes a moratorium on criticizing or evaluating ideas. Members are encouraged to

So far the discussion of team building has been directed primarily to significant projects that command the attention and involvement of assigned members. But what about projects that have low priority for team members: The perfunctory task forces that members begrudgingly join? The committee work people get assigned to do? The part-time projects that pull members away from the critical work they would rather be doing? Projects that cause members to privately question why they are doing this?

There is no magic wand available that transforms mildly interested, part-time project teams into high-performance teams. We interviewed several project managers about such project scenarios. They all agreed that these can be very difficult and frustrating assignments and that there are limits to what is possible. Still, they offered tips and advice for making the best of the situation. Most of these tips focus on building commitment to the project when it does not naturally exist.

One project manager advocated orchestrating a large "time" investment upfront on such projects—either in the form of a lengthy meeting or a significant early assignment. He viewed this as a form of down payment that members would forfeit if they didn't carry the project to completion.

Others emphasize interjecting as much fun into activities as possible. Here rituals discussed under building team identity come into play. People become committed because they enjoy working together on the project. One project manager even confided that the perfect attendance at her project meetings was due primarily to the quality of the doughnuts she provided.

Another strategy is to make the benefits of the project as real to the team members as possible. One project manager escalated commitment to a mandated accidents prevention task force by bringing accident victims to a project meeting. Another project manager brought the high-ranking project sponsor to recharge the team by reinforcing the importance of the project to the company.

Most project managers emphasized the importance of building a strong personal relationship with each of the team members. When this connection occurs, members work hard not so much because they really care about the project but because they don't want to let the project manager down. Although not couched in influence currency terms, these managers talked about getting to know each member, sharing contacts, offering encouragement, and extending a helping hand when needed.

Finally, all project managers cautioned that nothing should be taken for granted on low-priority projects. They recommend reminding people about meetings and bringing extra copies of materials to meetings for those who have forgotten them or can't find them. Project managers should remain in frequent contact with team members and remind them of their assignments. One manager summed it up best when he said, "Sometimes it all boils down to just being a good nag."

"piggyback" on other's ideas by extending them or combining ideas into a new idea. The object is to create as many alternatives as possible no matter how outlandish they may appear to be. Some project managers report that for really tough problems they have found it beneficial to conduct such sessions away from the normal work environment; the change in scenery stimulates creativity.

3. **Reaching a decision.** The next step is to evaluate and assess the merits of alternative solutions. During this phase it is useful to have a set of criteria for evaluating the merits of different solutions. In many cases the project manager can draw upon the priorities for the project and have the group assess each alternative in terms of its impact on cost, schedule, and performance as well as reducing the problem gap. For example, if time is critical, then the solution that solves the problem as quickly as possible would be chosen.

During the course of the discussion the project manager attempts to build consensus among the group. This can be a complicated process. Project managers need to provide periodic summaries to help the group keep track of its progress. They must protect those members who represent the minority view and ensure that such views get a fair hearing. They need to guarantee that everyone has an opportunity to share opinions and no one individual or group dominates the conversation. It may be useful to bring a two-minute timer to regulate the use of air time. When conflicts occur, managers need to apply some of the ideas and techniques discussed in the next section.

Project managers need to engage in consensus testing to determine what points the group agrees on and what are still sources of contention. They are careful not to interpret silence as agreement; they confirm agreement by asking questions. Ultimately, through thoughtful interaction, the team reaches a "meeting of the minds" as to what solution is best for the project.

4. **Follow-up.** Once the decision has been made and implemented, it is important for the team to find the time to evaluate the effectiveness of the decision. If the decision failed to provide the anticipated solution, then the reasons should be explored and the lessons learned added to the collective memory bank of the project team.

Managing Conflict within the Project

Disagreements and conflicts naturally emerge within a project team during the life of the project. Participants will disagree over priorities, allocation of resources, the quality of specific work, solutions to discovered problems, and so forth. Some conflicts support the goals of the group and improve project performance. For example, two members may be locked in a debate over a design trade-off decision involving different features of a product. They argue that their preferred feature is what the primary customer truly wants. This disagreement may force them to talk to or get more information from the customer, with the result that they realize neither feature is highly valued, but instead the customer wants something else. On the other hand, conflicts can also hinder group performance. Initial disagreements can escalate into heated arguments with both parties storming out of the room and refusing to work together.

Thamhain and Wilemon's research revealed that the sources of conflict change as projects progress along the project life cycle. Figure 11.5 summarizes the major sources of conflict in each phase.

FIGURE 11.5
Conflict Intensity over the Project Life Cycle

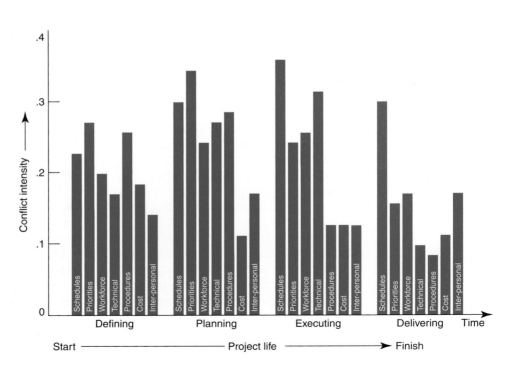

During project definition, the most significant sources of conflict are priorities, administrative procedures, schedule, and workforce. Disputes occur over the relative importance of the project compared with other activities, which project management structure to use (especially how much control the project manager should have), the personnel to be assigned, and the scheduling of the project into existing workloads.

During the planning phase, the chief source of conflict remains priorities, followed by schedules, procedures, and technical requirements. This is the phase where the project moves from a general concept to a detailed set of plans. Disagreements often emerge over the final schedule, the availability of resources, communication and decision making procedures, and technical requirements for the project.

During the execution phase, friction arises over schedule slippage, technical problems, and staff issues. Milestones become more difficult to meet because of accumulating schedule slippages. This leads to tension within the team as delays prevent others from starting or completing their work. Managing the trade-offs between time, cost, and performance becomes paramount. Project managers must decide between letting the schedule slip, investing additional funds to get back on track, or scaling back the scope of the project in order to save time. Technical problems involve finding solutions to unexpected problems and integrating the contributions of different people. The strain of the project may be expressed in interpersonal conflicts as well as pressures to use resources more effectively.

During the delivery phase, schedules continue as the biggest source of conflict as schedule slippages make it more difficult to meet target completion dates. Pressures to meet objectives coupled with growing anxiety over future assignments increases interpersonal tensions. Technical problems are rare since most of them have been worked out during the earlier phases.

Encouraging Functional Conflict

The demarcation between functional and dysfunctional conflict is neither clear nor precise. In one team, members may exchange a diatribe of four-letter expletives and eventually resolve their differences. Yet in another project team, such behavior would create irreconcilable divisions and would prohibit the parties from ever working together productively again. The distinguishing criterion is how the conflict affects project performance, not how individuals feel. Members can be upset and dissatisfied with the interchange, but as long as the disagreement furthers the objectives of the project, then the conflict is functional. Project managers should recognize that conflict is an inevitable and even a desirable part of project work; the key is to encourage functional conflict and manage dysfunctional conflict.

A shared vision can transcend the incongruities of a project and establish a common purpose to channel debate in a constructive manner. Without shared goals there is no common ground for working out differences. In the previous example involving the design trade-off decision, when both parties agreed that the primary goal was to satisfy the customer, there was a basis for more objectively resolving the dispute. Therefore, agreeing in advance which priority is most important—cost, schedule, or scope—can help a project team decide what response is most appropriate.

Sometimes it's not the presence of conflict, but the absence of conflict that is the problem. Oftentimes as a result of compressed time pressures, self-doubt, and the desire to preserve team harmony, members are reluctant to voice objections. This hesitation robs the team of useful information that might lead to better solutions and the avoidance of critical mistakes. Project managers need to encourage healthy dissent in order to improve problem solving and innovation. They can demonstrate this process by asking tough questions and

challenging the rationale behind recommendations. They can also orchestrate healthy conflict by bringing in people with different points of view to critical meetings.

Project managers can legitimize dissent within the team by designating someone to play the role of devil's advocate or by asking the group to take 15 minutes to come up with all the reasons the team should not pursue a course of action. Functional conflict plays a critical role in obtaining a deeper understanding of the issues and coming up with the best decisions possible.

One of the most important things project managers can do is model an appropriate response when someone disagrees or challenges their ideas. They need to avoid acting defensively and instead encourage critical debate. They should exhibit effective listening skills and summarize the key issues before responding. They should check to see if others agree with the opposing point of view. Finally, project managers should value and protect dissenters. Organizations have a tendency to create too many yes-men, and the emperor needs to be told when he doesn't have any clothes on.

Managing Dysfunctional Conflict

Managing dysfunctional conflict is a much more challenging task than encouraging functional conflict. First, dysfunctional conflict is hard to identify. A manager might have two highly talented professionals who hate each other's guts, but in the heat of competition they produce meritorious results. Is this a pleasant situation? No. Is it functional? Yes, as long as it contributes to project performance. Conversely, sometimes functional conflict degenerates into dysfunctional conflict. This change occurs when technical disagreements evolve into irrational personality clashes or when failure to resolve an issue causes unnecessary delays in critical project work.

The second major difficulty managers face is that there is often no easy solution to dysfunctional conflict. Project managers have to decide among a number of different strategies to manage it; here are five possibilities:

1. **Mediate the conflict.** The manager intervenes and tries to negotiate a resolution by using reasoning and persuasion, suggesting alternatives and the like. One of the keys is trying to find common ground. In some cases the project manager can make the argument that the win/lose interchange has escalated to the point that it has become lose/lose for everyone and now is the time to make concessions.

2. **Arbitrate the conflict.** The manager imposes a solution to the conflict after listening to each party. The goal is not to decide who wins but to have the project win. In doing so, it is important to seek a solution that allows each party to save face; otherwise the decision may provide only momentary relief. One project manager admits that she has had great success using a King Solomon approach to resolving conflict. She confided she announces a solution that neither party will like and gives the opponents two hours to come up with a better solution they can both agree on.

3. **Control the conflict.** Reducing the intensity of the conflict by smoothing over differences or interjecting humor is an effective strategy. If feelings are escalating, the manager can adjourn the interaction and hope cooler heads prevail the next day. If the conflict continues to escalate, project assignments may need to be rearranged if possible so that two parties don't have to work together.

4. **Accept it.** In some cases the conflict will outlive the life of the project and, though a distraction, it is one the manager has to live with.

5. **Eliminate the conflict.** Sometimes the conflict has escalated to the point that it is no longer tolerable. In this case the manager removes the members involved from the project. If there is a clear villain then only he or she should be removed. If, as is often the

case, both parties are at fault, then it would be wise if possible to eliminate both individuals. Their removal would give a clear signal to the others on the team that this kind of behavior is unacceptable.

In summary, project managers establish the foundation for functional conflict by establishing clear roles and responsibilities, developing common goals or a shared vision, and using group incentives that reward collaboration. Project managers have to be adroit at reading body language to identify unspoken disagreement. They also have to keep in touch with what is going on in a project to identify small problems that might escalate into big conflicts. Well-timed humor and redirecting the focus to what is best for the project can alleviate the interpersonal tensions that are likely to flare up on a project team.

Rejuvenating the Project Team

Over the course of a long project, a team sometimes drifts off course and loses momentum. The project manager needs to swing into action to realign the team with the project objectives and step on the pedal. There are both formal and informal ways of doing this. Informally, the project manager can institute new rituals like the "toy roaches" to reenergize a team. On one project that was experiencing rough going, the project manager stopped work and took the team bowling to relieve frustrations. On another project, a manager showed her team the movie *The Shawshank Redemption* to rekindle hope and commitment to success.

Another option is to have the project sponsor give a pep talk to the "troops." In other cases, a friendly challenge can reinvigorate a team. For example, one project sponsor offered to cook a five-course meal if the project got back on track and hit the next milestone.

Sometimes more formal action needs to be taken. The project manager may recognize the need for a team-building session devoted to improving the work processes of the team. This meeting is particularly appropriate if she senses that the team is approaching a transition point in its development. The goal of such a session is to improve the project team's effectiveness through better management of project demands and group processes. It is an inward look by the team at its own performance, behavior, and culture for the purpose of eliminating dysfunctional behaviors and strengthening functional ones. The project team critiques its performance, analyzes its way of doing things, and attempts to develop strategies to improve its operation.

Oftentimes an external consultant is hired, or an internal staff specialist is assigned to facilitate the session. This process brings a more objective, outside perspective to the table, frees the project manager to be part of the process, and provides a specialist trained in group dynamics. Furthermore, if preliminary information is to be collected, team members may be more candid and open to an outsider.

One caveat about using outside consultants is that too often managers resort to this as a method for dealing with a problem that they have been unable or unwilling to deal with. The marching order to the consultant is "fix my team for me." What the managers fail to recognize is that one of the keys to fixing the team is improving the working relationship between themselves and the remainder of the team. For such sessions to be effective, project managers have to be willing to have their own role scrutinized and be receptive to changing their own behavior and work habits based on the comments and suggestions of the project team.

Consultants use a wide variety of team-building techniques to elevate team performance. Here is a brief description of one of the more common approaches. The first step is to gather information and make a preliminary diagnosis of team performance. Whether through individual interviews or in a group forum, the consultant asks general questions about the project team performance, that is, what obstacles are getting in the

way of the team being able to perform better? This information is summarized in terms of themes. When everyone has understood the themes, the group ranks them in terms of both their importance and the extent the team has ownership over them. This last dimension is critical. *Ownership* refers to whether the team has direct influence over the issue. For example, a team probably has little influence over delivery of contracted supplies, but team members do control how quickly they inform each other of sudden changes in plans.

If the group becomes preoccupied with issues outside its control, the meeting can quickly evolve into a demoralizing gripe session. Therefore, the most important issues they have direct control over become the subjects of the agenda. During the course of the meeting, much interpersonal and group process information will be generated, and that is examined too. Thus, the group works on two sets of items: the agenda items and the items that emerge from the interaction of the participants. This is where the expertise of the external facilitator becomes critical for identifying interaction patterns and their implications for team performance.

As important problems are discussed, alternatives for action are developed. The team-building session concludes by deciding on specific action steps for remedying problems and setting target dates for who will do what, when. These assignments can be reviewed at project status meetings or at a special follow-up session.

It has become fashionable to link team-building activities with outdoor experiences. The outdoor experience—whether it is whitewater rafting down the Rogue River in Oregon or rock climbing in Colorado—places group members in a variety of physically challenging situations that must be mastered through teamwork, not individual effort. By having to work together to overcome difficult obstacles, team members are supposed to experience increased self-confidence, more respect for another's capabilities, and a greater commitment to teamwork. No empirical data are available to support such exotic endeavors other than the enthusiastic support of the participants. Such activities are likely to provide an intense common experience that may accelerate the social development of the team. Such an investment of time and money communicates the importance of teamwork and is considered by some a perk for being on the project. At the same time, unless the lessons from these experiences can be immediately transferred to actual project work, their significance is likely to vanish.

Managing Virtual Project Teams

Building a high-performance project team among a mixture of part-time and full-time members is a challenging task. Consider how much more challenging it is to build a team when members cannot engage in face-to-face interactions. Such would be the case for a virtual project team in which the team members are geographically situated so that they may seldom, if ever, meet face-to-face as a team. For example, Hewlett-Packard's integrated circuit business headquarters and a portion of the R&D facilities are located in Palo Alto, California; the two wafer fabrication operations are located in Corvallis, Oregon, and Fort Collins, Colorado; and the packaging assembly process is primarily in Singapore and Korea. It is not uncommon for professionals at each of these locations to be involved in the same project. When team members are spread across different time zones and continents, the opportunity for direct communication is severely limited. Electronic communication such as the Internet, e-mail, and teleconferencing takes on much more importance in virtual projects because this is the primary means of communication. See Snapshot from Practice: Managing Virtual Global Teams for an example of how this works.

Carl A. Singer, a senior program manager at IBM Global Services, described how global time zones were used to complete a time intensive project. The project required subject matter experts (SMEs) to document existing best practices in maintenance domain and to port these into a knowledge management tool. The most proficient SMEs available were on opposite sides of the globe—Australia and Scotland. Review and control of the project was from the United States.

Management realized that just working harder and smarter was not going to meet the time and quality targets. For this project they used the dimension of time to their benefit. Applying sound management principles as well as taking advantage of electronic communication systems, the team was able to create a virtual 24-hour workday for quick responses and accelerated reviews.

Each team consisted of veteran professionals familiar with the rigors of time-pressured consulting projects. A local point person was identified for each team and mutually agreed-upon targets, terminology, and processes were established.

An all-hands kick-off meeting was organized in which participants were able to socialize, understand local and projectwide constraints, and finalize an agreed-upon plan. The meeting was held at a corporate hotel with dining accommodations. The facility was considered an "assisted living community for IBM consultants." This hastened recovery from jet lag and provided an interruption-free work environment.

Upon returning to their home bases, each team created the majority of their deliverables independently with periodic three-way conference calls to maintain coordination. A project control book was established electronically so that all participants had access to the latest project documents.

The final phase of the project required intense interfacing and reviews between the teams. These reviews necessitated changes to deal with concerns, differences among subprojects, and other issues. It was here that the worldwide nature of the

project was leveraged. Using a "dry cleaning approach" (in by 5 P.M. out by 9 A.M.) team members in Australia and Scotland were able to address issues generated during the U.S.-based external reviews and provide concrete responses by the beginning of the next business day. Conference calls at 6:00 A.M. (U.S. EST) were used to coordinate responses and resolve issues. Conference calls at the end of the U.S. workday were used to finalize issues and assignments. Figure 11.6 (page 374) depicts the 24-hour clock used to align communication schedules.

Telephone conferencing was used instead of videoconferencing due to the setup lead time and because it would force participants to leave their offices. E-mail was used extensively for general communication. An electronic repository of project work was used to coordinate global involvement. In practice, a participant could draft a document and deposit it electronically only to wake up the next day to find the document annotated with suggested revisions. Likewise, one could start the day by checking an in-basket populated with documents to review and issues to address. Over time, "G'day" and "Cheers" crept into the U.S. speech—a clear indicator of team cohesion.

Singer identified a number of lessons learned from the project. These included:

* The all-hands kick-off meeting was critical for establishing goals and procedures as well as "rules of courtesy."

* Loosen the reins—establish clear deliverables and then step out of the way and let the professionals do their work.

* Establish and enforce agreed-upon quality standards and deliverable templates.

* Maintain a regular schedule of conference calls, even if only to say "Hello, we have nothing to talk about today." Conference calls should be guided by pre-established agendas, note-taking procedures, and reviews.

* Carl A. Singer, "Leveraging a Worldwide Project Team," *PM Network*, April 2001, pp. 36–40.

Two of the biggest challenges involved in managing a virtual project team are developing trust and effective patterns of communication. Trust is difficult to establish in virtual project management. Unlike working as a traditional team, where members can see whether someone has done what they say they have done, virtual team members depend on the word of distant members. At the same time, it can be difficult to trust someone whom you may have met only one or two times or not at all. Geographical separation also prohibits the informal social interactions that are often essential to building camaraderie among team members. As one virtual team member put it, "You can't have a beer together over the Internet."

So how can a project manager facilitate the development of trust within a virtual team? First, if it is impossible to hold a face-to-face meeting in the beginning, managers need to orchestrate the exchange of social information—who everyone is and some personal background information during the initial electronic interchange. Second, they need to set clear

FIGURE 11.6
24-Hour Global
Clock

United States (East Coast)	Australia	Scotland	Comments
12 midnight	2 PM	5 AM	
1 AM	3 PM	6 AM	
2 AM	4 PM	7 AM	
3 AM	5 PM	8 AM	
4 AM	6 PM	9 AM	Australia handoff for off-shift review
5 AM	7 PM	10 AM	
6 AM	8 PM	11 AM	3-way conferencing window (primary)
7 AM	9 PM	12 noon	3-way conferencing window (primary)
8 AM	10 PM	1 PM	3-way conferencing window (primary)
9 AM	11 PM	2 PM	
10 AM	12 midnight	3 PM	
11AM	1 AM	4 PM	
12 noon	2 AM	5 PM	Scotland handoff for off-shift review
1 PM	3 AM	6 PM	
2 PM	4 AM	7 PM	
3 PM	5 AM	8 PM	
4 PM	6 AM	9 PM	3-way conferencing window (secondary)
5 PM	7 AM	10 PM	3-way conferencing window (secondary)
6 PM	8 AM	11 PM	U.S. handoff for off-shift review
7 PM	9 AM	12 midnight	
8 PM	10 AM	1 AM	
9 PM	11 AM	2 AM	
10 PM	12 noon	3 AM	
11 PM	1 PM	4 AM	
12 midnight	2PM	5 AM	

☐ Prime time ☐ Secondary time ▨ Downtime

roles for each team member. Ideally, specific tasks should be assigned to each member so that they can make an immediate contribution to the project. Trust in virtual projects grows through team member reliability, consistency, and responsiveness. Finally, the project manager must consistently display enthusiasm and an action orientation in all messages; this spirit will hopefully spread to other team members.

The second major challenge for managing a virtual project team is to establish effective patterns of communication. E-mail and faxes are great for communicating facts—but not the feelings behind the facts; nor do they allow for real-time communication. Conference calls and project chat rooms can help, but they also have their limitations. Videoconferencing is a significant improvement over nonvisual electronic forms of communication. Still, it is a very expensive medium, and real-time interaction is available on only the most advanced and expensive systems. The maxim is match technology to the communication need. Here are some guidelines developed by 3M for use on their distributed projects:

- *When to e-mail.* To distribute important information and news in a one-to-one or one-to-many frame of reference.
- *When to use electronic bulletin boards.* To encourage discussion and flush out diversity of opinion on issues.
- *When to videoconference.* Videoconference when you need to see each other's face and expressions. This is important during the early phases of a project, when you are building relationships and developing a common understanding of what needs to be done. Use, again, when working on critical decisions and/or contentious issues.
- *When to use conference calls.* When people in different locations are working with common documents, presentations, sketches, and models. Use for status report meetings and to sustain social camaraderie.
- *When to fly.* Fly to build or repair trust. Use travel budget to get all key players together early on to instill commitment to the goals of the project and engage in team-building activities.

Even with the best communication system, managers have to overcome the problem of time zone differences, cultural nuances, and finding a convenient time for people to conference.

Below are some additional tips for alleviating communication problems and enhancing the performance of virtual teams:

1. **Keep team members informed on how the overall project is going.** Use shareware or develop a central access point such as either a Web site or LAN account to provide members with updated project schedules. Team members need to know where they fit in the big picture.
2. **Don't let team members vanish.** Virtual teams often experience problems getting in touch with each other. Use an Internet scheduling software to store members' calendars.
3. **Establish a code of conduct to avoid delays.** Team members need to agree not only on what, when, and how information will be shared but also on how and when they will respond to it. Develop a priority system to distinguish messages that require immediate response from those with longer time frames.
4. **Establish clear norms and protocols for surfacing assumptions and conflicts.** Because most communication is nonvisual, project managers cannot watch body language and facial expressions to develop a sense of what is going on. They need to probe deeper when communicating to force members to explain their viewpoints, actions, and concerns more clearly; they must double-check comprehension.
5. **Share the pain.** Do not require everyone to conform to your time zone and preferences. Rotate meeting times so that all team members have a turn working according to their clock.

To some extent managing a virtual project team is no different from managing a regular project team. The key is working within the constraints of the situation to develop effective ways for team members to interact and combine their talents to complete the project.

Project Team Pitfalls

High-performance project teams can produce dramatic results. However, like any good thing, there is a dark side to project teams that managers need to be aware of. We referred to this phenomenon as *projectitis* in Chapter 3. In this section we examine in more detail some of the pathologies that high-performance project teams can succumb to and highlight what project managers can do to reduce the likelihood of these problems occurring.

Groupthink

Janis first identified *groupthink* as a factor that influenced the misguided 1961 Bay of Pigs invasion of Cuba. His term refers to the tendency of members in highly cohesive groups to lose their critical evaluative capabilities. This malady appears when pressures for conformity are combined with an illusion of invincibility to suspend critical discussion of decisions. As a result decisions are made quickly with little consideration of alternatives; often the practice leads to fiascoes that, after the fact, appear totally improbable. Some of the symptoms of groupthink include the following:

- *Illusion of invulnerability.* The team feels invincible. It is marked by a high degree of esprit de corps, an implicit faith in its own wisdom, and an inordinate optimism that allows group members to feel complacent about the quality of their decisions.
- *Whitewash of critical thinking.* The group members discuss only a few solutions, ignoring alternatives; they fail to examine the adverse consequences that could follow their preferred course of action; and they too quickly dismiss any alternatives that, on the surface, appear to be unsatisfactory.
- *Negative stereotypes of outsiders.* "Good guy/bad guy" stereotypes emerge in which the group considers any outsiders who oppose their decisions as the bad guys, who are perceived as incompetent and malicious and whose points are unworthy of serious consideration.
- *Direct pressure.* When a team member does speak out or question the direction in which the team is headed, direct pressure is applied to the dissenter. He or she is reminded that speed is important and that the aim is agreement, not argument.

Bureaucratic Bypass Syndrome

Project teams are often licensed to get things done without having to go through normal protocols of the parent organization. Bypassing bureaucratic channels is appealing and invigorating. However, if bypassing becomes a way of life, it results in the rejection of bureaucratic policies and procedures, which provide the glue for the overall organization. A team that operates outside the organization may alienate other workers who are constrained by the norms and procedures of the organization; eventually, these outside bureaucrats will find ways to put up roadblocks and thwart the project team.

Team Spirit Becomes Team Infatuation

High-performance project teams can be a tremendous source of personal satisfaction. The excitement, chaos, and joy generated by working on a challenging project can be an invigorating experience. Leavitt and Lipman-Blumen even go so far as to say that team members behave like people in love. They become infatuated with the challenge of the project and the talent around them. This total preoccupation with the project and the project team, while contributing greatly to the remarkable success of the project, can leave in its wake a string of broken professional and personal relationships that contribute to burnout and disorientation upon completion of the project.

Going Native

Going native is a phrase first used by the British Foreign Service during colonial times to describe agents who assumed the customs, values, and prerogatives of their foreign country assignment. They did so to the point that they were no longer representing the best interests of the British government but rather those of the natives. This same phenomenon can occur within project teams working abroad or in those who become closely identified

GE Appliances, U.S. West, Marriott Corp., and Hewlett-Packard are among the many firms that use nominal group technique (NGT) to guide decisions on projects. The NGT begins by gathering project team members and/or stakeholders around a table and identifying the project problem at hand. Each member then writes his or her solutions. Next, each member presents his or her solution to the group, and the leader writes these solutions on a chart. No criticism is allowed. This process continues until all of the ideas have been expressed. Each solution then is discussed and clarified by the group. After all the ideas have been discussed, the group members privately rank-order their preferred solutions. The balloting is tallied to create a rank-ordering of each solution. These steps are repeated if necessary to refine the list further in order to get the most preferred solution.

NGT provides an orderly process for dealing with potentially inflammatory problems. It also prevents groupthink from occurring. NGT discourages any pressure to conform to the wishes of a high-status, powerful group member since all ideas are discussed and all preferences are expressed privately. Creativity should be enhanced since members are able to offer a solution based on their expertise and viewpoint. Finally, important decisions can be made in a relatively timely manner. NGT works best when there is a well-defined problem.

* Andrew Delbeeq, Andrew H. Van de Ven, and D. H. Gustafson, *Group Techniques for Program Planning* (Glenview, Il: Scott Foresman, 1975).

with their customers. In essence, the customer's interests take precedence over the parent organization's interests. This change in viewpoint can lead to excessive scope creep and open defiance of corporate policy and interests.

Dealing with these maladies is problematic because, in most cases, they are a distortion of a good thing, rather than a simple evil. Awareness is the first step for prevention. The next step is to take preemptive action to reduce the likelihood of these pitfalls occurring. For example, managers can reduce the isolation of the project team by creating work-related connections outside the project team. These interactions naturally occur in a matrix environment where members work on multiple projects and maintain ties to their home department. Likewise, the isolation of dedicated project teams can be reduced by the timely involvement of external specialists. In either case, the active involvement of relevant members of the parent organization at project status meetings can help maintain the link between the project and the rest of the organization. If the team appears to be suffering from groupthink, then the project manager can encourage functional conflict by playing a devil's advocate role to encourage dissent or using a structured problem-solving approach like the nominal group technique (see Snapshot). Finally, formal team-building sessions may reveal dysfunctional norms and refocus the attention of the team on project objectives.

Summary

Project managers must often work under less-than-ideal conditions to develop a cohesive team committed to working together and completing the project to the best of their abilities. They have to recruit personnel from other departments and manage the temporary involvement of team members. They have to bring strangers together and quickly establish a set of operational procedures that unite their efforts and contributions. They have to be skilled at managing meetings so that they do not become a burden but rather a vehicle for progress. Project managers need to forge a team identity and a shared vision, which command the attention and allegiance of participants. They need to use group incentives to encourage teamwork while recognizing when it is appropriate to single out individuals for special recognition. Project managers have to encourage functional conflict that contributes to superior solutions while being on guard against dysfunctional conflict that can break a team apart. In doing these things, they have to be careful not to do too good a job and avoid the pitfalls of excessive group cohesion.

While agendas, charters, visions, rewards, and so forth, are important tools and techniques, it has been emphasized both in this chapter and in Chapter 10 that the most important tool a project manager has to build an effective project team is his or her own behavior. Just as the founding members of an organization shape the culture of the organization, the project manager shapes and influences the internal culture of the project team. A positive example can define how team members respond to changes, how they handle new tasks, and how they relate to one another and the rest of the organization. There is no easy way to lead by example. It requires personal conviction, discipline, sensitivity to team dynamics, and a constant awareness of how personal actions are perceived by others.

Key Terms

Brainstorming	Nominal group technique	Project vision
Dysfunctional conflict	(NGT)	Team building
Functional conflict	Positive synergy	Team rituals
Groupthink	Project kick-off meeting	Virtual project team

Review Questions

1. What are the differences between the five stage model of team development and the punctuated equilibrium model?
2. What are the elements of an effective project vision? Why are they important?
3. Why should a project manager emphasize group rewards over individual rewards?
4. What is the difference between functional and dysfunctional conflict on a project?
5. When would it be appropriate to hold a formal team-building session on a project?
6. What are the unique challenges to managing a virtual project team?
7. What can a project manager do to avoid some of the pitfalls of a highly cohesive project team?

Exercises

1. The following activities are based on a recently completed group project that you have been involved in. This project may have been a student project, a work project, or an extracurricular project.
 a. Analyze the development of the team in terms of the five-phase model and the punctuated equilibrium model. Which model does the best job of describing how the team evolved?
 b. Analyze the group in terms of the nine situational factors that influence team development. What factors positively contributed to group performance? What factors negatively contributed to group performance? How did the group try to overcome the negative factors? What could you have done differently to overcome these negative factors?
 c. Analyze how effectively the group managed meetings. What did the group do well? What didn't the group do well? If the group were formed again, what specific recommendations would you make about how the group should manage meetings?
2. Assume that you have the following decision-making options: (1) make the decision on your own with available information, (2) consult others before making a decision, and (3) call a meeting and reach a consensus, seeking to arrive at a final decision everyone can agree on. Which approach would you use to make each of the following decisions and why?

a. You are the project leader for Casino Night on campus, a charitable event organized by your group to raise money for the homeless. The event was a big success, garnering a net profit of $3,500. Before the event your team researched nearby organizations that support the homeless and to whom the money could be given. You narrowed the choices to the "Chunk of Coal House" and "St. Mary's Soup Kitchen." Eventually your group decided that the funds be given to Chunk of Coal. You are about to write a check to its director when you read in the local newspaper that the Chunk of Coal House has terminated operations. What should you do with the money?

b. You are a golf course designer hired by Trysting Tree Golf Club to renovate their golf course. You have worked closely with the board of directors of the club to develop a new layout that is both challenging and aesthetically pleasing. Everyone is excited about the changes. The project is nearly 75 percent complete when you encounter problems on the 13th hole. The 13th hole at Trysting Tree is a 125-yard par three in which golfers have to hit their tee shots over a lake to a modulated green. During the construction of the new tee box, workers discovered that an underground spring runs beneath the box to the lake. You inspected the site and agreed with the construction supervisor that this could create serious problems, especially during the rainy winter months. After surveying the area, you believe the only viable option would be to extend the hole to 170 yards and create elevated tees on the adjacent hillside.

c. You are the leader of a new product development project. Your team has worked hard on developing a third-generation product that incorporates new technology and meets customer demands. The project is roughly 50 percent complete. You have just received a report from the marketing department detailing a similar product that is about to be released by a competitor. The product appears to utilize radical new design principles that expand the functionality of the product. This poses a serious threat to the success of your project. Top management is considering canceling your project and starting over again. They want you to make a recommendation.

3. The following activities are based on a current or recently completed group project that you have been involved in. This project may be a student project, a work project, or an extracurricular project.

a. How strong is the team identity on this project and why?

b. What could participants do to strengthen team identity?

c. What kind of informal activities could be used to rejuvenate the team? Why would these activities work?

References

Cleland, D. I., "Team Building: The New Strategic Weapon," *PM Network,* Vol. 11 (1) 1997.

Coutu, D. L., "Organization Trust in Virtual Teams," *Harvard Business Review,* Vol. 76 (3) 1998, pp. 20–21.

DeMarco, T., and T. Lister, *Peopleware: Productive Projects and Teams,* 2nd ed. (New York: Dorsett House, 1999).

Foti, R., "The Virtual Handshake," *PM Network,* March 2004, pp. 28–37.

Frame, J. D., *Managing Projects in Organizations* (San Francisco: Jossey-Bass, 1995).

Janis, I. L., *Groupthink* (Boston: Houghton Mifflin, 1982).

Katz, R., "How a Team at Digital Equipment Designed the 'Alpha' Chip," *The Human Side of Managing Technological Innovation,* 2nd ed. Ed. Ralph Katz (New York: Oxford University Press, 2004), pp. 121–33.

Katzenbach, J. R., and D. K. Smith, *The Wisdom of Teams* (Boston: Harvard Business School Press, 1993).

Kidder, T., *The Soul of a New Machine* (New York: Avon Books, 1981).

Kirkman, B. L., B. Rosen, C. B. Gibson, P. E. Tesluk, and S. O. McPherson, "Five Challenges to Virtual Team Success: Lessons From Sabre, INC.," *Academy of Management Executive,* 16 (2) 2002, pp. 67–79.

Leavitt, H. J., and J. Lipman-Blumen, "Hot Groups," *Harvard Business Review,* Vol. 73 1995, pp. 109–16.

Linetz, B. P., and K. P. Rea, *Project Management for the 21st Century* (San Diego: Academic Press, 2001).

Maier, N. R. F., *Problem Solving and Creativity in Individuals and Groups* (Belmont, CA: Brooks-Cole, 1970).

Maznevski, M. L., and K. M. Chudoba, "Bridging Space over Time: Global Virtual Team Dynamics and Effectiveness," *Organization Science*, Vol. 11 (5), September–October 2000, pp. 473–92.

Peters, T., *Thriving on Chaos: Handbook for a Management Revolution* (New York: Knopf, 1988).

Ritti, R. R., *The Ropes to Skip and the Ropes to Know: Studies in Organizational Behavior* (New York: Wiley, 1982).

Senge, P. M., *The Fifth Discipline* (New York: Doubleday, 1990).

Thamhain, H. J., and D. L. Wilemon, "Conflict Management in Project Life Cycle," *Sloan Management Review,* Vol. 16 (3) 1975, pp. 31–41.

Thoms, P., "Creating a Shared Vision With a Project Team," *PM Network,* January 1997, pp. 33–35.

3M, "Leading a Distributed Team," *www.3m.com/meetingnetwork/readingroom/ meetingguide_distribteam.html.* Accessed June 6, 2006.

Townsend, A. M., S. DeMarie, and A. R. Hendrickson, "Virtual Teams: Technology and the Workplace of the Future," *Academy of Management Executive,* Vol. 12 (3) 1998, pp. 17–29.

Tuchman, B. W., and M. C. Jensen, "Stages of Small Group Development Revisited," *Group and Organizational Studies,* Vol. 2 1997, pp. 419–27.

Vroom, V. H., and A. G. Jago, *The New Leadership* (Englewood Cliffs, NJ: Prentice Hall, 1988).

Case

Kerzner Office Equipment

Amber Briggs looked nervously at her watch as she sat at the front of a large table in the cafeteria at Kerzner Office Equipment. It was now 10 minutes after 3:00 and only 10 of the 14 members had arrived for the first meeting of the Kerzner anniversary task force. Just then two more members hurriedly sat down and mumbled apologies for being late. Briggs cleared her throat and started the meeting.

KERZNER OFFICE EQUIPMENT

Kerzner Office Equipment is located in Charleston, South Carolina. It specializes in the manufacture and sales of high-end office furniture and equipment. Kerzner enjoyed steady growth during its first five years of existence with a high-water employment mark of more than 1,400 workers. Then a national recession struck, forcing Kerzner to lay off 25 percent of its employees. This was a traumatic period for the company. Justin Tubbs was brought in as the new CEO, and things began to slowly turn around. Tubbs was committed to employee participation and redesigned operations around the concept of self-managing teams. The company soon introduced an innovative line of ergonomic furniture designed to reduce back strain and carpal tunnel. This line of equipment proved to be a resounding success, and Kerzner became known as a leader in the industry. The company currently employs 1,100 workers and has just been selected for the second straight time by the *Charleston Post and Courier* as one of the 10 best local firms to work for in South Carolina.

AMBER BRIGGS

Amber Briggs is a 42-year-old human resource specialist who has worked for Kerzner for the past five years. During this time she has performed a variety of activities involving recruitment, training, compensation, and team building. David Brown, vice president of human resources, assigned Briggs the responsibility for organizing Kerzner's 10th anniversary celebration. She was excited about the project because she would report directly to top management.

CEO Tubbs briefed her as to the purpose and objectives of the celebration. Tubbs stressed that this should be a memorable event and that it was important to celebrate Kerzner's success since the dark days of the layoffs. Moreover, he confided that he had just read a book on corporate cultures and believed that such events were important for conveying the values at Kerzner. He went on to say that he wanted this to be an employee celebration—not a celebration conjured up by top management. As such, she would be assigned a task force of 14 employees from each of the major departments to organize and plan the event. Her team was to present a preliminary plan and budget for the event to top management within three months. When discussing budgets, Tubbs revealed that he felt the total cost should be somewhere in the $150,000 range. He concluded the meeting by offering to help Briggs in any way he could to make the event a success.

Soon thereafter Briggs received the list of the names of the task force members, and she contacted them either by phone or e-mail to arrange today's meeting. She had to scramble to find a meeting place. Her cubicle in human resources was too small to accommodate such a group, and all the meeting rooms at Kerzner were booked or being refurbished. She settled on the cafeteria because it was usually deserted in the late afternoon. Prior to the meeting she posted the agenda on a flipchart (see Figure C11.1) adjacent to the table. Given everyone's busy schedules, the meeting was limited to just one hour.

FIGURE C11.1
Celebration Task Force

Agenda

3:00	Introductions
3:15	Project overview
3:30	Ground rules
3:45	Meeting times
4:00	Adjourn

THE FIRST MEETING

Briggs began the meeting by saying, "Greetings. For those who don't know me, I'm Amber Briggs from human resources and I've been assigned to manage the 10th anniversary celebration at Kerzner. Top management wants this to be special event—at the same time they want it to be our event. This is why you are here. Each of you represents one of the major departments, and together our job is to plan and organize the celebration." She then reviewed the agenda and asked each member to introduce him/herself. The tall, red-haired woman to the right of Briggs broke the momentary silence by saying, "Hi, I'm Cara Miller from Plastics. I guess my boss picked me for this task force because I have a reputation for throwing great parties."

In turn each member followed suit. Below is a sampling of their introductions:

"Hi, I'm Mike Wales from maintenance. I'm not sure why I'm here. Things have been a little slow in our department, so my boss told me to come to this meeting."

"I'm Megan Plinski from domestic sales. I actually volunteered for this assignment. I think it will be a lot of fun to plan a big party."

"Yo, my name is Nick Psias from accounting. My boss said one of us had to join this task force, and I guess it was my turn."

"Hi, I'm Rick Fennah. I'm the only one from purchasing who has been here since the beginning. We've been through some rough times, and I think it is important to take time and celebrate what we've accomplished."

"Hi, I'm Ingrid Hedstrom from international sales. I think this is a great idea, but I should warn you that I will be out of the country for most of the next month."

"I'm Abby Bell from engineering. Sorry for being late, but things are a bit crazy in my department."

Briggs circled the names of the two people who were absent and circulated a roster so that everyone could check to see if their phone numbers and e-mail addresses were correct. She then summarized her meeting with Tubbs and told the group that he expected them to make a formal presentation to top management within 10 weeks. She acknowledged that they were all busy people and that it was her job to manage the project as efficiently as possible. At the same time, she reiterated the importance of the project and that this would be a very public event: "If we screw up, everyone will know about it."

Briggs went over the ground rules and emphasized that from now on meetings would start on time and that she expected to be notified in advance if someone was going to be absent. She summarized the first part of the project as centering on five key questions: when, where, what, who, and how much? She created a stir in the group when she responded to a question about cost by informing them that top management was willing to pay up to $150,000 for the event. Megan quipped, "This is going to be one hell of a party."

Briggs then turned the group's attention to identifying a common meeting time. After jousting for 15 minutes, she terminated the discussion by requesting that each member submit a schedule of free time over the next month by Friday. She would use this information and a new planning software to identify optimal times. She ended the meeting by thanking the members for coming and asking them to begin soliciting ideas from co-workers about how this event should be celebrated. She announced that she would meet individually with each of them to discuss their role on the project. The meeting was adjourned at 4:00 P.M.

1. Critique Briggs's management of the first meeting. What, if anything, should she have done differently?
2. What barriers is she likely to encounter in completing this project?
3. What can she do to overcome these barriers?
4. What should she do between now and the next meeting?

Case

Ajax Project

Tran was taking his dog Callie on her evening walk as the sun began to set over the coastal range. He looked forward to this time of the day. It was an opportunity to enjoy some peace and quiet. It was also a time to review events on the Ajax project and plot his next moves.

Ajax is the code name given by CEBEX for a high-tech security system project funded by the U.S. Department of Defense (DOD). Tran is the project manager and his core team consisted of 30 full-time hardware and software engineers.

Tran and his family fled Cambodia when he was four years old. He joined the U.S. Air Force when he was 18 and used the education stipend to attend Washington State University. He joined CEBEX upon graduating with a dual degree in mechanical and electrical engineering. After working on a variety of projects for 10 years Tran decided he wanted to enter management. He went to night school at the University of Washington to earn an MBA.

Tran became a project manager for the money. He also thought he was good at it. He enjoyed working with people and making the right things happen. This was his fifth project and up to now he was batting .500, with half of his projects coming ahead of schedule. Tran was proud that he could now afford to send his oldest to Stanford University.

Ajax was one of many defense projects the CEBEX Corporation had under contract with DOD. CEBEX is a huge defense company with annual sales in excess of $30 billion and more than 120,000 employees worldwide. CEBEX's five major business areas are Aeronautics, Electronic Systems, Information & Technology Services, Integrated Systems & Solutions, and Space Systems. Ajax was one of several new projects sponsored by the Integrated Systems & Solutions division aimed at the homeland security business. CEBEX was confident that it could leverage its technical expertise and political connections to become a major player in this growing market. Ajax was one of several projects directed at designing, developing, and installing a security system at an important government installation.

Tran had two major concerns when he started the Ajax project. The first was the technical risks inherent in the project. In theory the design principles made sense and the project used proven technology. Still the technology had never been applied in the field in this matter. From past experience, Tran knew there was a big difference between the laboratory and the real world. He also knew that integrating the audio, optical, tactile, and laser subsystems would test the patience and ingenuity of his team.

The second concern involved his team. The team was pretty much split down the middle between hardware and electrical engineers. Not only did these engineers have different skill sets and tend to look at problems differently, but generational differences between the two groups were evident as well. The hardware engineers were almost all former military, family men with conservative attire and beliefs. The electrical engineers were a much motlier crew. They tended to be young, single, and at times very cocky. While the hardware engineers talked about the Seattle Mariners, raising teenagers, and going to Palm Desert to play golf, the software engineers talked about Vapor, the latest concert at the Gorge amphitheater, and going mountain biking in Peru.

To make matters worse, tension between these two groups within CEBEX festered around salary issues. Electrical engineers were at a premium, and the hardware engineers resented the new hires' salary packages, which were comparable to what they were earning after 20 years of working for CEBEX. Still the real money was to be made from the incentives associated with project performance. These were all contingent on meeting project milestones and the final completion date.

Before actual work started on the project, Tran arranged a two-day team-building retreat at a lodge on the Olympic peninsula for his entire team as well as key staff from the government installation. He used this time to go over the major objectives of the project and unveil the basic project plan. An internal consultant facilitated several team-building activities that made light of cross-generational issues. Tran felt a real sense of camaraderie within the team.

The good feelings generated from the retreat carried over to the beginning of the project. The entire team bought into the mission of the project and technical challenges it represented. Hardware and electrical engineers worked side by side to solve problems and build subsystems.

The project plan was built around a series of five tests, with each test being a more rigorous verification of total system performance. Passing each test represented a key milestone for the project. The team was excited about conducting the first alpha test one week early—only to be disappointed by a series of minor technical glitches that took two weeks of problem solving to resolve. The team worked extra hard to make up for the lost time. Tran was proud of the team and how hard members had worked together.

The Alpha II test was conducted on schedule, but once again the system failed to perform. This time three weeks of debugging was needed before the team received the green light to move to the next phase of the project. By this time, team goodwill had been tested, and emotions were a bit frayed. A cloud of disappointment descended over the team as hopes of bonuses disappeared with the project falling further behind schedule. This was augmented by cynics who felt that the original schedule was unfair and the deadlines were impossible to begin with.

Tran responded by starting each day with a status meeting where the team reviewed what they accomplished the previous day and set new objectives for that day. He believed these meetings were helpful in establishing positive momentum and reinforcing a team identity among the engineers. He also went out of his way to spend more time with the "troops," helping them solve problems, offering encouragement, and a sincere pat on the back when one was deserved.

He was cautiously optimistic when the time came to conduct the Alpha III test. It was the end of the day when the switch was turned on, but nothing happened. Within minutes the entire team heard the news. Screams could be heard down the hallway. Perhaps the most telling moment was when Tran looked down at the company's parking lot and saw most of his project team walking by themselves to their cars.

As Callie chased some wild bunnies, Tran pondered what he should do next.

1. How effective has Tran been as a project manager? Explain.
2. What problem(s) does Tran face?
3. How would you go about solving them? Why?

Case

Franklin Equipment, Ltd.*

Franklin Equipment, Ltd. (FEL), with headquarters and main fabrication facilities in Saint John, New Brunswick, was founded 75 years ago to fabricate custom-designed large machines for construction businesses in the Maritime Provinces. Over the years its product lines became strategically focused on creating rock-crushing equipment for dam and highway construction and for a few other markets that require the processing of aggregate. FEL now designs, fabricates, and assembles stationary and portable rock-crushing plants and services its own products and those of its competitors.

* Courtesy of John A. Drexler Jr., Oregon State University.

In the 1970s, FEL began to expand its market from the Maritime Provinces to the rest of Canada. FEL currently has several offices and fabrication facilities throughout the country. More recently, FEL has made a concerted effort to market its products internationally.

Last month, FEL signed a contract to design and fabricate a rock-crushing plant for a Middle East construction project, called Project Abu Dhabi. Charles Gatenby secured this contract and has been assigned as project manager. This project is viewed as a coup because FEL has wanted to open up markets in this area for a long time and has had difficulty getting prospective customers to realize that FEL is a Canadian firm and not from the United States. Somehow these customers view all North American vendors as the same and are reluctant to employ any of them because of international political considerations.

A project of this scope typically starts with the selection of a team of managers responsible for various aspects of the design, fabrication, delivery, and installation of the product. Manager selection is important because the product design and fabrication vary with the unique needs of each customer. For example, the terrain, rock characteristics, weather conditions, and logistical concerns create special problems for all phases of plant design and operations. In addition, environmental concerns and labor conditions vary from customer to customer and from region to region.

In addition to the project manager, all projects include a design engineer; an operations manager, who oversees fabrication and on-site assembly; and a cost accountant, who oversees all project financial and cost reporting matters. Each of these people must work closely together if a well-running plant is to be delivered on time and within cost constraints. Because international contracts often require FEL to employ host nationals for plant assembly and to train them for operations, a human resource manager is also assigned to the project team. In such cases, the human resource manager needs to understand the particulars of the plant specifications and then use this knowledge to design selection procedures and assess particular training needs. The human resource manager also needs to learn the relevant labor laws of the customer's country.

FEL assigns managers to project teams based on their expertise and their availability to work on a particular project given their other commitments. This typically means that managers without heavy current project commitments will be assigned to new projects. For instance, a manager finishing one project will likely be assigned a management position on a new project team. The project manager typically has little to say about who is assigned to his or her team.

Because he secured Project Abu Dhabi and has established positive working relationships with the Abu Dhabi customer, Gatenby was assigned to be project manager. Gatenby has successfully managed similar projects. The other managers assigned to Project Abu Dhabi are Bill Rankins, a brilliant design engineer, Rob Perry, operations manager with responsibility for fabrication and installation, Elaine Bruder, finance and cost accounting manager, and Sam Stonebreaker, human resource manager. Each of these managers has worked together on numerous past projects.

A few years ago, FEL began contracting for team facilitator services from several consulting firms to help new project teams operate effectively. Last month, FEL recruited Carl Jobe from one of these consulting firms to be a full-time internal consultant. A number of managers, including Gatenby, were so impressed with Jobe's skills that they convinced FEL top management of the need to hire a permanent internal facilitator; Jobe was the obvious choice.

Because Gatenby was instrumental in hiring Jobe at FEL, he was excited at the prospect of using Jobe to facilitate team building among Project Abu Dhabi team members. Gatenby was very proud of having secured this project and had expected to be appointed project manager. He knew that this project's success would be instrumental in advancing his own career.

Gatenby told Jobe, "This project is really important to FEL and to me personally. I really need for you to help us develop into a team that works well together to achieve the project's goals within budget. I've observed your success in developing teams on other projects, and I expect you'll do the same for Project Abu Dhabi. I'll take care of you if you help me make this work."

Jobe outlined for Gatenby how he would proceed. Jobe would begin by interviewing team members individually to learn their perceptions of each other and of the promises and pitfalls of being involved in this project. Meetings of the entire team would follow these interviews using the information he collected to help establish a team identity and a shared vision.

Jobe interviewed Bruder first. She expressed skepticism about whether the project could succeed. During the interview, Bruder appeared to be distant, and Jobe could not figure out why he had not established good rapport with her. Bruder intimated that she expected a lot of cost overruns and a lot of missed production deadlines. But not knowing Jobe well, Bruder was reluctant to identify any specific barriers to the project's success. While she would not directly say so, it was clear to Jobe that Bruder did not want to be a part of Project Abu Dhabi. Jobe left this interview confused and wondering what was going on.

Jobe's next interview was with Perry, the operations manager. Perry has worked at FEL for 15 years, and he immediately came to the point: "This project is not going to work. I cannot understand why upper management keeps assigning me to work on projects with Rankins. We simply cannot work together, and we don't get along. I've disliked him from day one. He keeps dropping the fact that he has earned all these advanced degrees from Purdue. And he keeps telling us how things are done there. I know he's better educated than I am, and he's really smart. But I'm smart too and am good at what I do. There's no need for Rankins to make me feel like an idiot because I don't have a degree. Jobe, I'll be honest with you. Rankins has only been here for five years, but I hold him personally responsible for my problem with alcohol, and for its resulting effect on my marriage. I got divorced last year, and it's Rankins's fault."

Jobe next talked with Rankins, who said, "I don't care what you do. Perry and I simply can't work closely together for the nine months it will take to get it done. One of us will kill the other. Ever since I arrived at FEL, Perry has hated my guts and does everything he can to sabotage my designs. We usually worry about customers creating change orders; here it's the fabrication and operations manager who is responsible for them. Perry second-guesses everything I do and makes design changes on his own, and these are always bad decisions. He is out of control. I swear he stays awake at nights thinking up ways to ruin my designs. I don't have this problem with any other manager."

Jobe left these interviews thoroughly discouraged and could not imagine what would come up in his interview with Stonebreaker. But Stonebreaker was quite positive: "I enjoy these international projects where I get to travel abroad and learn about different cultures. I can't wait to get started on this."

Jobe asked Stonebreaker about the ability of various team members to work together. Stonebreaker replied, "No problem! We've all worked together before and have had no problems. Sure, there have been ruffled feathers and hurt feelings between Rankins and Perry. Rankins can be arrogant and Perry stubborn, but it's never been anything that we can't work around. Besides, both of them are good at what they do—both professionals. They'll keep their heads on straight."

Jobe was even more bewildered. Gatenby says this project's success rides on Jobe's facilitation skills. The finance manager appears to want off this project team. The design engineer and operations manager admit they detest each other and cannot work together.

And the human resources manager, having worked on projects with Perry and Rankins before, expects a rosy working relationship and anticipates no problems.

Jobe had a second meeting with Gatenby. Before discussing the design of the team-building sessions, he asked questions to learn what Gatenby thought about the ability of team members to work together. Gatenby admitted that there has been very bad blood between Perry and Rankins, but added, "That's why we hired you. It's your job to make sure that the history between those two doesn't interfere with Project Abu Dhabi's success. It's your job to get them to work well together. Get it done."

Their dialogue toward the end of this meeting progressed as follows:

Jobe: "Why do you expect Rankins and Perry to work well together, given their history? What incentives do they have to do so?"

Gatenby: "As you should know, FEL requires formal goal setting between project managers and functional managers at the beginning of each project. I've already done this with Bruder, Stonebreaker, Perry, and Rankins. Perry and Rankins have explicit goals stating they must work well together and cooperate with each other."

Jobe: "What happens if they do not meet these goals?"

Gatenby: "I've already discussed this with top management. If it appears to me after two months that things are not working out between Perry and Rankins, FEL will fire Rankins."

Jobe: "Does Perry know this?"

Gatenby: "Yes."

1. Evaluate the criteria FEL uses to assign managers to project teams. What efficiencies do these criteria create? What are the resulting problems?
2. Why is it even more important that project team members work well together on international projects such as Project Abu Dhabi?
3. Discuss the dilemma that Jobe now faces.
4. What should Jobe recommend to Gatenby?

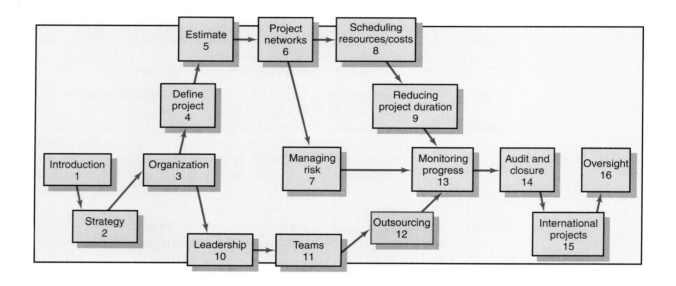

Outsourcing: Managing Interorganizational Relations

Outsourcing Project Work

Best Practices in Outsourcing Project Work

The Art of Negotiating

A Note on Managing Customer Relations

Summary

Appendix 12.1: Contract Management

Outsourcing: Managing Interorganizational Relations

. . . being a good partner has become a key corporate asset. I call it a company's collaborative advantage. In the global economy, a well-developed ability to create and sustain fruitful collaborations gives companies a significant competitive leg up.

—Rosabeth Moss Kanter, Harvard Business School professor

It is rare in today's flat world to find important projects that are being completed totally in-house. Outsourcing or contracting significant segments of project work to other companies is commonplace. For example, nine states attempting to unify the accounting of all their state agencies did not have the internal resources to implement such a large project. Hence, project teams were formed consisting of personnel from software, hardware, and accounting firms to implement the projects. Small high-tech firms outsource research to determine what features customers value in new products they are developing. Even industry giants such as Microsoft and Intel commonly hire independent firms to test new products they are developing.

Contracting project work has long been the norm in the construction industry, where firms hire general contractors who, in turn, hire and manage cadres of subcontractors to create new buildings and structures. For example, the Chunnel project, which created a transportation tunnel between France and England, involved more than 250 organizations. Contracting is not limited to large projects. For example, an insurance company worked with an outside contractor to develop an answering service that directs customers to specific departments and employees. The trend for the future suggests that more and more projects will involve working with people from different organizations.

This chapter extends the previous two chapters' discussion of building and managing relations by focusing specifically on issues surrounding working with people from other organizations to complete a project. First, the advantages and disadvantages of outsourcing project work are introduced. This is followed by a discussion of *best practices* used by firms to outsource and collaborate with each other on projects. The focus then shifts to the art of negotiating, which is at the heart of effective collaboration. Negotiating skills and techniques for resolving disagreements and reaching optimal solutions are then presented. The chapter closes with a brief note on managing customer relations. In addition, an appendix on contract management is included to augment our discussion of how organizations work together on projects.

Outsourcing Project Work

The term outsourcing has traditionally been applied to the transferring of business functions or processes (e.g., customer support, IT, accounting) to other, often foreign companies. For example, when you call your Internet provider to solve a technical problem you are likely to talk to a technician in Bangalore, India, or Bucharest, Romania. Outsourcing is now being applied to contracting significant chunks of project work. For example, HP and Dell work closely with hard drive manufacturers to develop next-generation laptops. Toyota and DaimlerChrysler collaborate with suppliers to develop new automobile platforms.

The shift toward outsourcing is readily apparent in the film industry. During the golden era of Hollywood, huge, vertically integrated corporations made movies. Studios such as MGM, Warner Brothers, and 20th Century–Fox owned large movie lots and employed thousands of full-time specialists—set designers, camera people, film editors, and directors. Star actors like Humphrey Bogart and Marilyn Monroe were signed to exclusive studio contracts for a set number of films (e.g., six films over three years). Today, most movies are made by a collection of individuals and small companies who come together to make films project-by-project. This structure allows each project to be staffed with the talent most suited to its demands rather than choosing from only those people the studio employs. This same approach is being applied to the creation of new products and services. For example, see Figure 12.1.

Figure 12.1 depicts a situation in which a zero-gravity reclining chair is being developed. The genesis for the chair comes from a mechanical engineer who developed the idea in her garage. The inventor negotiates a contract with a catalog firm to develop and manufacture the chair. The catalog company in turn creates a project team of manufacturers, suppliers, and marketing firms to create the new chair. Each participant adds requisite expertise to the project. The catalog firm brings its brand name and distribution channels

FIGURE 12.1
Reclining Chair Project

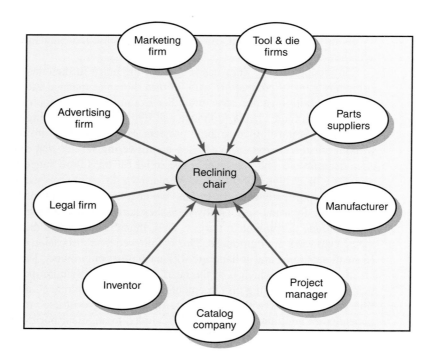

to the project. Tool and die firms provide customized parts which are delivered to a manufacturing firm that will produce the chair. Marketing firms refine the design, develop packaging, and test market potential names. A project manager is assigned by the catalog firm to work with the inventor and the other parties to complete the project.

Many outsourced projects operate in a virtual environment in which people are linked by computers, faxes, computer-aided design systems, and video teleconferencing. They rarely, if ever, see one another face-to-face. On other projects, participants from different organizations work closely together, for example, at a construction site or in shared office space. In either case, people come and go as services are needed, much as in a matrix structure, but they are not formal members of one organization, just technical experts who form a temporary alliance with an organization, fulfill their contractual obligations, and then move on to the next project.

The advantages of outsourcing project work are many:

1. *Cost reduction.* Companies can secure competitive prices for contracted services, especially if the work can be outsourced offshore. Furthermore, overhead costs are dramatically cut since the company no longer has to internally maintain the contracted services.

2. *Faster project completion.* Not only can work be done more cheaply, but it can also be done faster. Competitive pricing means more resources for the dollar. For example, you can hire three Indian software engineers for the price of one American software engineer. Furthermore, outsourcing can provide access to equipment that can accelerate completion of project tasks. For example, by contracting a backhoe operater you are able to accomplish in four hours what it would take landscaping crew four days to complete.

3. *High level of expertise.* A high level of expertise and technology can be brought to bear on the project. A company no longer has to keep up with technological advances. Instead, it can focus on developing its core competencies and hire firms with the know-how to work on relevant segments of the project.

4. *Flexibility.* Organizations are no longer constrained by their own resources but can pursue a wide range of projects by combining their resources with talents of other companies. Small companies can instantly go global by working with foreign partners.

The disadvantages of outsourcing project work are less well documented:

1. *Coordination breakdowns.* Coordination of professionals from different organizations can be challenging, especially if the project work requires close collaboration and mutual adjustment. Breakdowns are exacerbated by physical separation with people working in different buildings, different cities, if not different countries.

2. *Loss of control.* There is potential loss of control over the project. The core team depends on other organizations that they have no direct authority over. While long-term survival of participating organizations depends on performance, a project may falter when one partner fails to deliver.

3. *Conflict.* Projects are more prone to interpersonal conflict since the different participants do not share the same values, priorities, and culture. Trust, which is essential to project success, can be difficult to forge when interactions are limited and people come from different organizations.

4. *Internal morale issues.* Foreign outsourcing of work is a political hot potato. Employee morale is likely to suffer when project work that has normally been done in-house is being transferred to other companies.

Few people disagree that reducing costs is the primary motive behind outsourcing project work. However, recent industry polls indicate a shift away from simply nailing the best low-cost deal to securing services from companies that provide the best value in terms of

SATT Control (SC) is a Swedish electronics firm that sells electronic products and control systems worldwide. It has 550 employees in Sweden and about the same number abroad. So how does SC successfully bid against such electronic giants as ABB, Siemens, and Hewlett-Packard on major contracts for equipment that the company has never sold before? In the words of Hedberg and his coauthors, SC does so by acting as system integrator. In this role SC recruits a contracting syndicate by preparing a system description and dividing the system into various subsystems with each potential partner bidding for a part of the system. SC's ability to describe the system and divide it into subsystems that can be outsourced are two of its core competencies.

Another core competence at SC is project management. After the company has received an order for a project, one of the first actions taken is to work with the customer to develop clear specification of functions. While time consuming, this process is critical to be successful. The first step is to specify what the system is supposed to do, before deciding how it is to be done. This is commonly referred to as designing system architecture. It is crucial that the specifications are correct at the outset otherwise errors reappear all down the line. SC works hard at developing a common agreement among all the partners as to what the basic concept of the project is.

SC is also adroit at establishing a collaborative atmosphere among all the partners. The key is instilling a sense of "what is good for you is good for me." This comes from a history of treating each other with mutual respect and drafting contracts that share risks not isolate risks.

* B. Hedberg, G. Dahlgren, J. Hansson, and N-G. Olve, *Virtual Organizations and Beyond* (New York: Wiley, 1997), pp. 82–84.

both cost and performance. Performance is not limited to simply the quality of specific work but also ability to collaborate and work together. Companies are doing their homework to determine "Can we work with these people?"

Best Practices in Outsourcing Project Work

This section describes some of the best practices we have observed being used by firms that excel in project management (see Figure 12.2). Although the list is by no means comprehensive, it reflects strategies used by organizations with extensive outsourcing experience. These practices reveal an underlying theme in how firms approach contracted work on projects. Instead of the traditional master–slave relationship between owner and provider or buyer and seller, all parties work together as partners sharing the ultimate goal of a successful project. See the Snapshot from Practice: Competing against Giants for an example of how a small firm leverages this approach to succeed in a very competitive industry.

Differences between the traditional approach and the partnering approach to managing contracted relationships are summarized in Table 12.1. Partnering requires more than a simple hand-shake. It typically entails a significant commitment of time and energy to forge and sustain collaborative relations among all parties. This commitment is reflected in the seven best practices which will be discussed next.

FIGURE 12.2
Best Practices in Outsourcing Project Work

- Well-defined requirements and procedures.
- Extensive training and team-building activities.
- Well-established conflict management processes in place.
- Frequent review and status updates.
- Co-location when needed.
- Fair and incentive-laden contracts.
- Long-term outsourcing relationships.

TABLE 12.1

Key Differences Between Partnering and Traditional Approaches to Managing Contracted Relationships

Partnering Approach	Traditional Approach
Mutual trust forms the basis for strong working relationships.	Suspicion and distrust; each party is wary of the motives for actions by the other.
Shared goals and objectives ensure common direction.	Each party's goals and objectives, while similar, are geared to what is best for them.
Joint project team exists with high level of interaction.	Independent project teams; teams are spatially separated with managed interactions.
Open communications avoid misdirection and bolster effective working relationships.	Communications are structured and guarded.
Long-term commitment provides the opportunity to attain continuous improvement.	Single project contracting is normal.
Objective critique is geared to candid assessment of performance.	Objectivity is limited due to fear of reprisal and lack of continuous improvement opportunity.
Access to each other's organization resources is available.	Access is limited with structured procedures and self-preservation taking priority over total optimization.
Total company involvement requires commitment from CEO to team members.	Involvement is normally limited to project-level personnel.
Integration of administrative systems equipment takes place.	Duplication and/or translation takes place with attendant costs and delays.
Risk is shared jointly among the partners, which encourages innovation and continuous improvement.	Risk is transferred to the other party.

Well-Defined Requirements and Procedures

Convincing people from different professions, organizations, and cultures to work together is difficult. If expectations and requirements are fuzzy or open to debate, this is even harder. Successful firms are very careful in selecting the work to be outsourced. They often chose to contract only work with clearly defined deliverables with measurable outcomes. For example, contractors hire electric firms to install heating and air-conditioning systems, electronic firms use design firms to fabricate enclosures for their products, and software development teams outsource the testing of versions of their programs. In all of these cases, the technical requirements are spelled out in detail. Even so, communicating requirements can be troublesome, especially with foreign providers (see the Snapshot From Practice: Four Strategies for Communicating with Outsourcers) and extra care has to be taken to ensure that expectations are understood.

Not only do requirements have to be spelled out, but the different firms' project management systems need to be integrated. Common procedures and terminology need to be established so that different parties can work together. This can be problematic when you have firms with more advanced project management systems working with less developed organizations. Surprisingly, this often is the case when U.S. firms outsource software work to India. We have heard reports that Indian providers are shocked at how unsystematic their U.S. counterparts are in their approach to managing software projects.

The best companies address this issue up front instead of waiting for problems to emerge. First they assess "fit" between providers' project management methods and their own project management system. This is a prime consideration in choosing vendors.

Dr. Adam Kolawa offers four strategies for overcoming poor communication with offshore project partners.

STRATEGY 1: RECOGNIZE CULTURAL DIFFERENCES

Realize that not everyone you communicate with shares your assumptions. What is obvious to you is not necessarily obvious to your partner. This is especially true with foreign outsourcers. As an American, you likely assume that laws are generally obeyed. Believe it or not, that's generally not true in most of the world, where laws are guidelines that are not necessarily followed. This can lead to major communication problems! You think if you write a contract, everybody is going to adhere to it. For many people, a contract is merely a suggestion.

STRATEGY 2: CHOOSE THE RIGHT WORDS

When you explain your requirements to an outsourcer, word choice is critical. For many outsourcers, English is still a foreign language—even in India, where both outsourcing and the English language are common. No matter how prevalent English has become, your outsourcer might have a basic understanding of each word you utter yet be not completely clear on the exact meaning of the message you're trying to convey. This is why you should speak in a direct manner using short sentences made of basic, simple words.

STRATEGY 3: CONFIRM YOUR REQUIREMENTS

You should take the following steps to confirm that the outsourcer thoroughly understands your requirements:

1. *Document your requirements.* Follow up your conversations in writing. Commit your requirements to paper for the outsourcer.

Many people understand written language better than spoken language, probably because they have more time to process the message.

2. *Insist your outsourcer re-document your requirements.* Leave nothing to chance. Require outsourcers to write the requirements in their own words. If outsourcers cannot relay to you what you explained to them, then they didn't understand.

3. *Request a prototype.* After the requirements are written, ask the outsourcer to create a prototype for you. This is a safety net to ensure that your wants and needs are positively understood. Ask the provider to sketch what you want your final product to look like or build—a quick, simple program that reflects how the final product will look.

STRATEGY 4: SET DEADLINES

Another important cultural difference relates to schedules and deadlines. To most Americans, a deadline is a set completion date. In many other cultures, a deadline is a suggestion that maybe something will be finished by that indicated date. To ensure that outsourced work is completed on time it is imperative to add a penalty clause to your contract or enforce late fees.

Although these strategies were directed toward working with foreign outsourcers, you would be surprised to find how many project managers use them when working with their American counterparts!

* Adam Kolawa, "Four Strategies for Communicating with Outsourcers," *Enterprise Systems Journal* at www.esj.com, accessed September 13, 2005.

Work requirements and deliverables are spelled out in detail in the procurement process. They invest significant time and energy to establishing project communication systems to support effective collaboration.

Finally, whenever you work with other organizations on projects, security is an important issue. Security extends beyond competitive secrets and technology to include access to information systems. Firms have to establish robust safeguards to prevent information access and the introduction of viruses due to less secure provider systems. Information technology security is an additional cost and risk that needs to be addressed up front before outsourcing project work.

Extensive Training and Team-Building Activities

Too often managers become preoccupied with the plans and technical challenges of the project and assume that people issues will work themselves out over time. Smart firms recognize that people issues are as important, if not more important than technical issues. They train their personnel to work effectively with people from other organizations and countries. This training is pervasive. It is not limited to management but involves all the people, at all levels, who interact with and are dependent upon outsourcers. Whether in a general class on negotiation or a specific one on working with Chinese programmers, team

members are provided with a theoretical understanding of the barriers to collaboration as well as the skills and procedures to be successful.

The training is augmented by interorganizational team-building sessions designed to forge healthy relationships before the project begins. Team-building workshops involve the key players from the different firms, for example, engineers, architects, lawyers, specialists, and other staff. In many cases, firms find it useful to hire an outside consultant to design and facilitate the sessions. Such a consultant is typically well-versed in interorganizational team building and can provide an impartial perspective to the workshop.

The length and design of the team-building sessions will depend on the experience, commitment, and skill level of the participants. For example, one project, in which the owner and the contractors were relatively inexperienced at working together, utilized a three-day workshop. The first day was devoted to ice-breaking activities and establishing the rationale behind partnering. The conceptual foundation was supported by exercises and minilectures on teamwork, synergy, win/win, and constructive feedback. The second day began by examining the problems and barriers that prevented collaboration in the past. Representatives from the different organizations were separated and each asked the following:

- What actions do the other groups engage in that create problems for us?
- What actions do we engage in that we think create problems for them?
- What recommendations would we make to improve the situation?

The groups shared their responses and asked questions on points needing clarification. Agreements and disparities in the lists were noted and specific problems were identified. Once problem areas were noted, each group was assigned the task of identifying its specific interests and goals for the project. Goals were shared across groups, and special attention was devoted to establishing what goals they had in common. Recognition of shared goals is critical for transforming the different groups into a cohesive team.

The team-building sessions often culminate with the creation of a project charter signed by all of the participants. This charter states their common goals for the project as well as the procedures that will be used to achieve these goals (see Figure 12.3 for an example of the first page of a project charter).

Well-Established Conflict Management Processes in Place

Conflict is inevitable on a project and, as pointed out in the previous chapter, disagreements handled effectively can elevate performance. Dysfunctional conflict, however, can catch fire and severely undermine project success. Outsourced projects are susceptible to conflicts since people are unaccustomed to working together and have different values and perspectives. Successful firms invest significant time and energy up front in establishing the "rules of engagement" so that disagreements are handled constructively.

Escalation is the primary control mechanism for dealing with and resolving problems. The basic principle is that problems should be resolved at the lowest level within a set time limit (say, 24 hours), or they are "escalated" to the next level of management. If so, the principals have the same time limit to resolve the problem, or it gets passed on to the next higher level. No action is not an option. Nor can one participant force concessions from the other by simply delaying the decision. There is no shame in pushing significant problems up the hierarchy; at the same time, managers should be quick to point out to subordinates those problems or questions that they should have been able to resolve on their own.

If possible, key personnel from the respective organizations are brought together to discuss potential problems and responses. This is usually part of a coordinated series of team-building activities discussed earlier. Particular attention is devoted to establishing the change management control system where problems often erupt. People who are dependent

FIGURE 12.3 Project Partnering Charter

Partnering Charter

Edwards AFB — F-22 Fighter Building 1870

U.S. Air Force F-22 CTF, 411 FLTS ● **Edwards AFB** Civil Engineers
Computer Science Corporation ● **Lockheed Martin** ● **Telecom Solutions**
U.S. Army Corps of Engineers ● Valenzuela Engineering, Inc ● **VRR & Associates**

We, the partners of the F-22 design and construction team, recognizing the unique nature of this project, commit to creating an environment of trust and communication to design and build a quality project which meets or exceeds the customer's requirements. We commit to maintaining a positive and optimistic work environment in which all partners goals can be achieved.

● **Quality Project**
 - Meet program requirements for F-22 Support Systems.
● Complete on schedule and within cost constraints.
● Incorporate lessons learned from other F-22 projects.
● Create an environment for a fair and reasonable profit.
● Create an enjoyable work environment.

● **Safe Project**
 - Provide a safe environment.
 - With no lost-time accidents.
● Maintain positive, cooperative relationships
 - Clear and open communications through appropriate channels.
 - No surprises.
 - No hidden agendas.
 - Minimum delays of paperwork.
 - Resolve problems quickly at the lowest level.

The Partnering concept is a team relationship that promotes the achievement of mutually beneficial goals. This Partnering Charter does not create any legally enforceable rights or duties. Any changes to the contracts must be made by the contracting officers under the terms of the written contracts.

396

Before starting a bond-financed school construction project, Ohio does what a theater company does before opening night—it holds a dress rehearsal. Led by Cleveland-based Project Management Consultants, state and local school officials, construction managers, and architects get together before building begins to figure out how to talk to each other and how to handle problems.

Just as a theatrical dress rehearsal can allow a company to find and fix glitches before they ruin a show, preconstruction partnering can find early solutions to problems before they become lawsuits.

"This works because traditionally everyone does their own work on a project, behind their own walls," said Jeffrey Applebaum, a construction lawyer and managing director of Project Management Consultants, a wholly owned subsidiary of the law firm of Thompson, Hine, & Flory. "We're taking down the walls. This is more efficient."

"We couldn't be more pleased with this process," said Randy Fischer, executive director of the Ohio School Facilities Commission, which distributes state money to school construction projects. "We are currently administering $3 billion of construction, and we don't have any major disputes."

Crystal Canan, chief of contract administration for the commission, offered a medical metaphor, comparing partnering to a "flu shot" that will prevent the debilitating effects of litigation, work stoppages, and communication breakdowns. "Every building construction project is a candidate for the flu," Canan said. "We see partnering as a vaccination."

* Mary Wisneiski, "Partnering Used to Curb Costs in Ohio School Construction," *Bond Buyer*, 11/22/2000, 334 (31023) 3/4p, 2bw.

on each other try to identify potential problems that may occur and agree in advance how they should be resolved. See the Snapshot from Practice: "Partnering" a Flu Shot for Projects for the benefits of doing this.

Finally, principled negotiation is the norm for resolving problems and reaching agreements. This approach, which emphasizes collaborative problem solving, is discussed in detail later in this chapter.

Frequent Review and Status Updates

Project managers and other key personnel from all involved organizations meet on a regular basis to review and assess project performance. Collaborating as partners is considered a legitimate project priority which is assessed along with time, cost, and performance. Teamwork, communication, and timely problem resolution are evaluated. This provides a forum for identifying problems not only with the project but also with working relationships so that they can be resolved quickly and appropriately.

More and more companies are using online surveys to collect data from all project participants about the quality of working relations (see Figure 12.4 for a partial example). With this data one can gauge the "pulse" of the project and identify issues that need to be addressed. Comparison of survey responses period by period permits tracking areas of improvement and potential problems. In some cases, follow-up team-building sessions are used to focus on specific problems and recharge collaboration.

Finally, when the time to celebrate a significant milestone arrives, no matter who is responsible, all parties gather if possible to celebrate the success. This reinforces a common purpose and project identity. It also establishes positive momentum going into the next phase of the project.

Co-Location When Needed

One of the best ways to overcome interorganizational friction is to have people from each organization working side by side on the project. Smart companies rent or make available the necessary accommodations so that all key project personnel can work collectively together. This allows the high degree of face-to-face interaction needed to coordinate activities, solve difficult problems, and form a common bond. This is especially relevant for complex projects in which close collaboration from different parties is required to be

FIGURE 12.4
Sample Online Survey

Evaluation of partnering process: attitudes, teamwork, process.
(Collected separately from owner and contractor participants, compared, and aggregated.)

1. Communications between the owner/contractor personnel are

1	2	3	4	5
Difficult, guarded				Easy, open, up front

2. Top management support of partnering process is

1	2	3	4	5
Not evident or inconsistent				Obvious and consistent

3. Problems, issues, or concerns are

1	2	3	4	5
Ignored				Attacked promptly

4. Cooperation between owner and contractor personnel is

1	2	3	4	5
Cool, detached, unresponsive, removed				Genuine, unreserved, complete

5. Responses to problems, issues, or concerns frequently become

1	2	3	4	5
Personal issues				Treated as project problems

successful. For example, the U.S government provides housing and common office space for all key contractors responsible for developing disaster response plans.

Our experience tells us that co-location is critical and well worth the added expense and inconvenience. When creating this is not practically possible, the travel budget for the project should contain ample funds to support timely travel to different organizations.

Co-location is less relevant for independent work that does not require ongoing coordination between professionals from different organizations. This would be the case if you are outsourcing discrete, independent deliverables like beta testing or a marketing campaign. Here normal channels of communication can handle the coordination issues.

Fair and Incentive-Laden Contracts

When negotiating contracts the goal is to reach a fair deal for all involved. Managers recognize that cohesion and cooperation is undermined if one party feels he or she is being unfairly treated by others. They also realize that negotiating the best deal in terms of price can come back to haunt them with shoddy work and change order gouging.

Performance-based contracts, in which significant incentives are established based on priorities of the project, are becoming increasingly popular. For example, if time is critical, then contractors accrue payoffs for beating deadlines; if scope is critical, then bonuses are issued for exceeding performance expectations. At the same time contractors are held accountable with penalty clauses for failure to perform up to standard, meet deadlines, and/or control costs. More specific information about different types of contracts is presented in this chapter's appendix on contract management.

Photo by Sgt. Ken Hammond, U.S. Air Force.

As part of an effort to cut costs the United States Department of Defense (DoD) issues annual Value Engineering Awards. Value engineering is a systematic process to analyze functions to identify actions to reduce cost, increase quality, and improve mission capabilities across the entire spectrum of DoD systems, processes, and organizations. The Value Engineering Awards Program is an acknowledgment of outstanding achievements and encourages additional projects to improve in-house and contractor productivity.

In 2002 HBA Architecture, Engineering, and Interior Design, a Virginia Beach–based firm, was selected as the Outstanding Navy Contractor. HBA's work on three projects was cited in the award:

- Design Maintenance and Operations Facility for the 2nd Marine Division Reconnaissance Battalion in Camp Lejeune, NC. Unique to the project was a curved glass wall designed to prevent infiltration by conventional listening devices and an 80 foot tall parachute drying tower that will double as a reppelling platform for training.
- Renovation of an aircraft maintenance hangar originally constructed in 1954 at Cherry Point, NC. A major portion of

the work was devoted to the Under-Floor Aqueous Fire Fighting Foam (AFFF) Fire Suppression System throughout the hangar bays.

- Aircraft stripping facility addition at Naval Aviation Dept. in Cherry Point, NC. Designed a new PMB (Plastic Media Blasting) Hangar enclosure and training spaces to allow the Navy to strip aircraft as large as the V-22 (Ospry). PMB is a dry abrasive blasting process, designed to replace chemical stripping operations and conventional sand blasting.

HBA was recognized for using state-of-the-art electronic technologies to produce functional design alternatives and communicate project value improvement that could be evaluated efficiently by the client. These efforts saved $20 million in design costs and $1.6 million in life-cycle costs.

During fiscal 2001, more than 2,100 in-house value engineer proposals and contractor-initiated value engineering change proposals were accepted by the Department of Defense with projected savings in excess of $768 million.

* http://www.defenselink.mil/news/Nov2002/b11222002_bt596-02.html

Companies recognize that contracts can discourage continuous improvement and innovation. Instead of trying some new, promising technique that may reduce costs, contractors will avoid the risks and apply tried and true methods to meet contracted requirements. Companies that treat contractors as partners consider continuous improvement as a joint effort to eliminate waste and pursue opportunities for cost savings. Risks as well

as benefits are typically shared 50/50 between the principals, with the owner adhering to a fast-track review of proposed changes.

How the U.S. Department of Defense reaps the benefits of continuous improvement through value engineering is highlighted in the Snapshot from Practice: Value Engineering Awards.

Long-Term Outsourcing Relationships

Many companies recognize that major benefits can be enjoyed when outsourcing arrangements extend across multiple projects and are long term. For example, Corning and Toyota are among the many firms that have forged a network of long-term strategic partnerships with their suppliers. A recent study indicates that the average large corporation is involved in around 30 alliances today versus fewer than 3 in the early 1990s. Among the many advantages for establishing a long-term partnership are the following:

• **Reduced administrative costs**—The costs associated with bidding and selecting a contractor are eliminated. Contract administration costs are reduced as partners become knowledgeable of their counterpart's legal concerns.

• **More efficient utilization of resources**—Contractors have a known forecast of work while owners are able to concentrate their workforce on core businesses and avoid the demanding swings of project support.

• **Improved communication**—As partners gain experience with each other, they develop a common language and perspective, which reduces misunderstanding and enhances collaboration.

• **Improved innovation**—The partners are able to discuss innovation and associated risks in a more open manner and share risks and rewards fairly.

• **Improved performance**—Over time partners become more familiar with each other's standards and expectations and are able to apply lessons learned from previous projects to current projects.

Working as partners is a conscious effort on the part of management to form collaborative relationships with personnel from different organizations to complete a project. For outsourcing to work, the individuals involved need to be effective negotiators capable of merging interests and discovering solutions to problems that contribute to the project. The next section addresses some of the key skills and techniques associated with effective negotiation.

The Art of Negotiating

Effective negotiating is critical to successful collaboration. All it takes is one key problem to explode to convert a sense of "we" into "us versus them." At the same time, negotiating is pervasive through all aspects of project management work. Project managers must negotiate support and funding from top management. They must negotiate staff and technical input from functional managers. They must coordinate with other project managers and negotiate project priorities and commitments. They must negotiate within their project team to determine assignments, deadlines, standards, and priorities. Project managers must negotiate prices and standards with vendors and suppliers. A firm understanding of the negotiating process, skills, and tactics is essential to project success.

Many people approach negotiating as if it is a competitive contest. Each negotiator is out to win as much as he or she can for his or her side. Success is measured by how much is gained compared with the other party. While this may be applicable when negotiating the

sale of a house, it is not true for project management. *Project management is not a contest!* First, the people working on the project, whether they represent different companies or departments within the same organization, are not enemies or competitors but rather allies or partners. They have formed a temporary alliance to complete a project. For this alliance to work requires a certain degree of trust, cooperation, and honesty. Second, although the parties within this alliance may have different priorities and standards, they are bound by the success of the project. If conflicts escalate to the point where negotiations break down and the project comes to a halt, then everyone loses. Third, unlike bartering with a street vendor, the people involved on project work have to continue to work together. Therefore, it behooves them to resolve disagreements in a way that contributes to the long-term effectiveness of their working relationship. Finally, as pointed out in the previous chapter, conflict on a project can be good. When dealt with effectively it can lead to innovation, better decisions, and more creative problem solving.

Project managers accept this noncompetitive view of negotiation and realize that negotiation is essentially a two-part process: The first part deals with reaching an agreement; the second part is the implementation of that agreement. It is the implementation phase, not the agreement itself, that determines the success of negotiations. All too often, managers reach an agreement with someone only to find out later that they failed to do what they agreed to do or that their actual response fell far short of expectations. Experienced project managers recognize that implementation is based on satisfaction not only with the outcome but also with the process by which the agreement was reached. If someone feels bullied or tricked into doing something, this feeling will invariably be reflected by half-hearted compliance and passive resistance.

Veteran project managers do the best they can to merge individual interests with what is best for the project and come up with effective solutions to problems. Fisher and Ury from the Harvard Negotiation Project champion an approach to negotiating that embodies these goals. It emphasizes developing win/win solutions while protecting yourself against those who would take advantage of your forthrightness. Their approach is called *principled negotiation* and is based on four key points listed in Table 12.2 and discussed in the following sections.

Separate the People from the Problem

Too often personal relations become entangled with the substantive issues under consideration. Instead of attacking the problem(s), people attack each other. Once people feel attacked or threatened their energy naturally goes to defending themselves, and not to solving the problem. The key, then, is to focus on the problem—not the other person—during the negotiation. Avoid personalizing the negotiation and framing the negotiation as a contest. Instead, try to keep the focus on the problem to be resolved. In Fisher and Ury's words: *Be hard on the problem, soft on the people.*

By keeping the focus on the issues and not the personalities, negotiators are better able to let the other person blow off steam. On important problems it is not uncommon for people to become upset, frustrated, and angry. However, one angry attack produces an angry counterattack, and the discussion quickly escalates into a heated argument, an emotional chain reaction.

TABLE 12.2
Principled
Negotiation

1.	Separate the people from the problem
2.	Focus on interests, not positions
3.	Invent options for mutual gain
4.	When possible, use objective criteria

In some cases people use anger as a means of intimidating and forcing concessions because the other person wishes to preserve the relationship. When people become emotional, negotiators should keep a cool head and remember the old German proverb, "Let anger fly out the window." In other words, in the face of an emotional outburst, imagine opening a window and letting the heat of the anger out the window. Avoid taking things personally, and redirect personal attacks back to the question at hand. Don't react to the emotional outburst, but try to find the issues that triggered it. Skilled negotiators keep their cool under stressful times and, at the same time, build a bond with others by empathizing and acknowledging common sources of frustration and anger.

While it is important to separate the people from the problem during actual negotiations, it is beneficial to have a friendly rapport with the other person prior to negotiating. Friendly rapport is consistent with the social network tenet introduced in Chapter 10 of building a relationship before you need it. Reduce the likelihood of misunderstandings and getting off on the wrong foot by having a history of interacting in a friendly, responsive manner with the other person. If, in the past, the relationship has been marked by healthy give-and-take, in which both parties have demonstrated a willingness to accommodate the interests of the other, then neither individual is likely to adopt an immediate win/lose perspective. Furthermore, a positive relationship adds a common interest beyond the specific points of contention. Not only do both parties want to reach an agreement that suits their individual interests, but they also want to do so in a manner that preserves their relationship. Each is therefore more likely to seek solutions that are mutually beneficial.

Focus on Interests, Not Positions

Negotiations often stall when people focus on positions:

> I'm willing to pay $10,000. No, it will cost $15,000.
>
> I need it done by Monday. That's impossible, we can't have it ready until Wednesday.

While such interchanges are common during preliminary discussions, managers must prevent this initial posturing from becoming polarized. When such positions are stated, attacked, and then defended, each party figuratively begins to draw a line he or she will not cross. This line creates a win/lose scenario in which someone has to lose by crossing the line in order to reach an agreement. As such, the negotiations can become a war of wills, with concessions being seen as a loss of face.

The key is to focus on the interests behind your positions (what you are trying to achieve) and separate these goals from your ego as best you can. Not only should you be driven by your interests, but you should try to identify the interests of the other party. Ask why it will cost so much or why it can't be done by Monday. At the same time, make your own interests come alive. Don't just say that it is critical that it be done by Monday; explain what will happen if it isn't done by Monday.

Sometimes when the true interests of both parties are revealed, there is no basis for conflict. Take, for example, the Monday versus Wednesday argument. This argument could apply to a scenario involving a project manager and the production manager of a small, local firm that was contracted to produce prototypes of a new generation of computer mouse. The project manager needs the prototypes on Monday to demonstrate to a users' focus group. The production manager said it would be impossible. The project manager said this would be embarrassing because marketing had spent a lot of time and effort setting up this demonstration. The production manager again denied the request and added that he already had to schedule overtime to meet the Wednesday delivery date. However, when the project manager revealed that the purpose of the focus group was to gauge consumers' reactions to the color and shape of the new devices, not the finished

product, the conflict disappeared. The production manager told the project manager that she could pick up the samples today if she wanted because production had an excess supply of shells.

When focusing on interests, it is important to practice the communication habit: *Seek first to understand, then to be understood.* This involves what Stephen Covey calls empathetic listening, which allows a person to fully understand another person's frame of reference—not only what that person is saying but also how he or she feels. Covey asserts that people have an inherent need to be understood. He goes on to observe that satisfied needs do not motivate human behavior, only unsatisfied needs do. People try to go to sleep when they are tired, not when they are rested. The key point is that until people believe they are being understood, they will repeat their points and reformulate their arguments. If, on the other hand, you satisfy this need by seeking first to understand, then the other party is free to understand your interests and focus directly on the issues at hand. Seeking to understand requires discipline and compassion. Instead of responding to the other person by asserting your agenda, respond by summarizing both the facts and feelings behind what the other person has said and checking the accuracy of comprehension.

Invent Options for Mutual Gain

Once the individuals involved have identified their interests, then they can explore options for mutual gain. This is not easy. Stressful negotiations inhibit creativity and free exchange. What is required is collaborative brainstorming in which people work together to solve the problem in a way that will lead to a win/win scenario. The key to brainstorming is separating the inventing from the deciding. Begin by taking 15 minutes to generate as many options as possible. No matter how outlandish any option is, it should not be subject to criticism or immediate rejection. People should feed off the ideas of others to generate new ideas. When all the possible options are exhausted, then sort through the ideas that were generated to focus on those with the greatest possibilities.

Clarifying interests and exploring mutual options create the opportunity for dovetailing interests. Dovetailing means one person identifies options that are of low cost to them but of high interest to the other party. This is only possible if each party knows what the other's needs are. For example, in negotiating price with a parts supplier, a project manager learned from the discussion that the supplier was in a cash flow squeeze after purchasing a very expensive fabrication machine. Needed cash was the primary reason the supplier had taken such a rigid position on price. During the brainstorming session, one of the options presented was to prepay for the order instead of the usual payment on delivery arrangement. Both parties seized on this option and reached an amicable agreement in which the project manager would pay the supplier for the entire job in advance in exchange for a faster turnaround time and a significant price reduction. Such opportunities for win/win agreements are often overlooked because the negotiators become fixated on solving their problems and not on opportunities to solve the other person's problems.

When Possible, Use Objective Criteria

Most established industries and professions have developed standards and rules to help deal with common areas of dispute. Both buyers and sellers rely on the blue book to establish price parameters for a used car. The construction industry has building codes and fair practice policies to resolve proof of quality and safe work procedures. The legal profession uses precedents to adjudicate claims of wrongdoing.

Whenever possible, you should insist on using external, objective criteria to settle disagreements. For example, a disagreement arose between a regional airlines firm and the

independent accounting team entrusted with preparing the annual financial statement. The airline firm had made a significant investment by leasing several used airplanes from a larger airline. The dispute involved whether this lease should be classified as an operating or capital lease. This was important to the airline because if the purchase was classified as an operating lease, then the associated debt would not have to be recorded in the financial statement. However, if the purchase was classified as a capital lease, then the debt would be factored into the financial statement and the debt/equity ratio would be much less attractive to stockholders and would-be investors. The two parties resolved this dispute by deferring to formulas established by the Financial Accounting Standards Board. As it turns out the accounting team was correct, but, by deferring to objective standards, they were able to deflect the disappointment of the airline managers away from the accounting team and preserve a professional relationship with that firm.

Dealing with Unreasonable People

Most people working on projects realize that in the long run it is beneficial to work toward mutually satisfying solutions. Still, occasionally you encounter someone who has a dominant win/lose attitude about life and will be difficult to deal with. Fisher and Ury recommend that you use negotiation jujitsu when dealing with such a person. That is, when the other person begins to push, don't push back. As in the martial arts, avoid pitting your strengths against another's directly; instead use your skill to step aside and turn that person's strength to your ends. When someone adamantly sets forth a position, neither reject it nor accept it. Treat it as a possible option and then look for the interests behind it. Instead of defending your ideas, invite criticism and advice. Ask why it's a bad idea and discover the other's underlying interest.

Those who use negotiation jujitsu rely on two primary weapons. They ask questions instead of making statements. Questions allow for interests to surface and do not provide the opponent with something to attack. The second weapon is silence. If the other person makes an unreasonable proposal or attacks you personally, just sit there and don't say a word. Wait for the other party to break the stalemate by answering your question or coming up with a new suggestion.

The best defense against unreasonable, win/lose negotiators is having what Fisher and Ury call a strong BATNA (best alternative to a negotiated agreement). They point out that people try to reach an agreement to produce something better than the result of not negotiating with that person. What those results would be (BATNA) is the true benchmark for determining whether you should accept an agreement. A strong BATNA gives you the power to walk away and say, "No deal unless we work toward a win/win scenario."

Your BATNA reflects how dependent you are on the other party. If you are negotiating price and delivery dates and can choose from a number of reputable suppliers, then you have a strong BATNA. If on the other hand there is only one vendor who can supply you with specific, critical material on time, then you have a weak BATNA. Under these circumstances you may be forced to concede to the vendor's demands. At the same time, you should begin to explore ways of increasing your BATNA for future negotiations. This can be done by reducing your dependency on that supplier. Begin to find substitutable material or negotiate better lead times with other vendors.

Negotiating is an art. There are many intangibles involved. This section has reviewed some time-tested principles of effective negotiating based on the groundbreaking work of Fisher and Ury. Given the significance of negotiating, you are encouraged to read their book as well as others on negotiating. In addition, attending training workshops can provide an opportunity to practice these skills. You should also take advantage of day-to-day interactions to sharpen negotiating acumen.

A Note on Managing Customer Relations

In Chapter 4 it was emphasized that ultimate success is not determined by whether the project was completed on time, within budget, or according to specifications, but whether the customer is satisfied with what has been accomplished. Customer satisfaction is the bottom line. Bad news travels faster and farther than good news. For every happy customer who shares his satisfaction regarding a particular product or service with another person, a dissatisfied customer is likely to share her dissatisfaction with eight other people. Project managers need to cultivate positive working relations with clients to ensure success and preserve their reputations.

Customer satisfaction is a complex phenomenon. One simple but useful way of viewing customer satisfaction is in terms of met expectations. According to this model, customer satisfaction is a function of the extent to which perceived performance (or outcome) exceeds expectations. Mathematically, this relationship can be represented as the ratio between perceived performance and expected performance (see Figure 12.5). When performance falls short of expectations (ratio < 1), the customer is dissatisfied. If the performance matches expectations (ratio = 1), the customer is satisfied. If the performance exceeds expectations (ratio > 1), the customer is very satisfied or even delighted.

High customer satisfaction is the goal of most projects. However, profitability is another major concern. Exceeding expectations typically entails additional costs. For example, completing a construction project two weeks ahead of schedule may involve significant overtime expenses. Similarly, exceeding reliability requirements for a new electronic component may involve considerably more design and debugging effort. Under most circumstances, the most profitable arrangement occurs when the customer's expectations are only slightly exceeded. Returning to the mathematical model, with all other things being equal, one should strive for a satisfaction ratio of 1.05, not 1.5!

The met-expectations model of customer satisfaction highlights the point that whether a client is dissatisfied or delighted with a project is not based on hard facts and objective data but on perceptions and expectations. For example, a customer may be dissatisfied with a project that was completed ahead of schedule and under budget if he thought the work was poor quality and that his fears and concerns were not adequately addressed. Conversely, a customer may be very satisfied with a project that was over budget and behind schedule if she felt the project team protected her interests and did the best job possible under adverse circumstances.

Project managers must be skilled at managing customer expectations and perceptions. Too often they deal with these expectations after the fact when they try to alleviate a client's dissatisfaction by carefully explaining why the project cost more or took longer than planned. A more proactive approach is to begin to shape the proper expectations up front and accept that this is an ongoing process throughout the life of a project. Project managers need to direct their attention both to the customer's base expectations, the standard by which perceived performance will be evaluated, and to the customer's perceptions of actual performance. The ultimate goal is to educate clients so that they can make a valid judgment as to project performance.

FIGURE 12.5
The Met-Expectations Model of Customer Satisfaction

$$\underset{\text{Dissatisfied}}{0.90} = \frac{\text{Perceived performance}}{\text{Expected performance}} = \underset{\text{Very satisfied}}{1.10}$$

Webber and Torti studied the multiple roles project managers play on IT projects. Based on a comprehensive set of interviews with project managers and clients in three different information-technology service organizations, they identified five key roles critical to successfully implement IT projects in client organizations: entrepreneur, politician, friend, marketer, and coach. They are described in part in Table 12.3.

Webber and Torti observed that instead of maintaining a clearly defined relationship with the client, project managers become part of the client organization. They report that project managers attempt to "dress like the client, act like the client, and participate in the client organization's activities (i.e., social gatherings, blood drives, etc.)." They become such an integral part of their existence that many client employees, over the course of time, forget that the project manager is not an employee of the client organization. This helps establish a degree of trust essential to effective collaboration.

*S. S. Webber, and M. T. Torti, "Project Managers Doubling as Client Account Executives," *Academy of Management Executive,* Vol. 18, No. 1, pp. 60–71, 2004.

TABLE 12.3
Project Roles, Challenges, and Strategies

Project Manager Roles	Challenges	Strategies
Entrepreneur	Navigate unfamiliar surroundings	Use persuasion to influence others
Politician	Understand two diverse cultures (parent and client organization)	Align with the powerful individuals
Friend	Determine the important relationships to build and sustain outside the team itself	Identify common interests and experiences to bridge a friendship with the client
Marketer	Understand the strategic objectives of the client organization	Align new ideas/proposals with the strategic objectives of the client organization
Coach	Motivate client team members without formal authority	Provide challenging tasks to build the skills of the team members

Managing customer expectations begins during the preliminary project approval phase of negotiations. It is important to avoid the temptation to oversell the virtues of a project to win approval because this may create unrealistic expectations that may be too difficult, if not impossible, to achieve. At the same time, project proponents have been known to lower customer expectations by underselling projects. If the estimated completion time is 10 to 12 weeks, they will promise to have the project completed within 12 to 14 weeks, therefore increasing the chances of exceeding customer expectations by getting the project completed early.

Once the project is authorized, the project manager and team need to work closely with the client organization to develop a well-defined project scope statement that clearly states the objectives, parameters, and limits of the project work. The project scope statement is essential to establishing customer expectations regarding the project. It is critical that all parties are in agreement as to what is to be accomplished and that people are reading as best they can from the same page. It is also important to share significant risks that might disrupt project execution. Customers do not like surprises, and if they are aware in advance of potential problems they are much more likely to be accepting of the consequences.

Once the project is initiated it is important to keep customers abreast of project progress. The days when you would simply take orders from customers and tell them to return when the project is done are over. More and more organizations and their project managers are treating their customers as de facto members of the project team and are actively involving them in key aspects of project work. In the case of consulting assignments project managers sometimes *morph* into a member of the client organization (see Research Highlight: IT Project Managers).

Project managers need to keep customers informed of project developments so that customers can make adjustments in their own plans. When circumstances dictate changing the scope or priorities of the project, project managers need to be quick to spell out as best they can the implications of these changes to the customers so that they can make an informed choice. Active customer involvement allows customers to naturally adjust their expectations in accordance with the decisions and events that transpire on a project, while at the same time, the customer's presence keeps the project team focused on the customer's objectives for the project.

Active customer involvement also provides a firmer basis for assessing project performance. The customer not only sees the results of the project but also acquires glimpses of the effort and actions that produced those results. Naturally project managers want to make sure these glimpses reflect favorably on their project teams, so they exercise extra care that customer interactions are handled in a competent and professional manner. In some respects, customer perceptions of performance are shaped more by how well the project team deals with adversity than by actual performance. Project managers can impress customers with how diligently they deal with unexpected problems and setbacks. Likewise, industry analysts have noted that customer dissatisfaction can be transformed into customer satisfaction by quickly correcting mistakes and being extremely responsive to customer concerns.

Managing customer relations on a project is a broad topic; we have only highlighted some of the central issues involved. This brief segment concludes with two words of advice passed on by veteran project managers:

Speak with one voice. Nothing erodes confidence in a project more than for a customer to receive conflicting messages from different project members. The project manager should remind team members of this fact and work with them to ensure that appropriate information is shared with customers.

Speak the language of the customer. Too often project members respond to customer inquiries with technical jargon that exceeds the customer's vocabulary. Project managers and members need to describe problems, trade-offs, and solutions in ways that the customer can understand.

Summary

Outsourcing has become an integral part of project management. More and more companies are collaborating with each other on projects to compete in today's business world. The advantages of outsourcing include cost reduction, quicker completion times, greater flexibility, and higher level of expertise. Disadvantages include coordination problems, loss of control, conflicts, and declining morale.

A number of proactive best practices have emerged among firms that have mastered the outsourcing process. These practices include establishing well-defined requirements and procedures and utilizing fair and incentive-laden contracts. Team-building sessions are held before the project begins to forge relationships between personnel from different organizations. Escalation guidelines for resolving conflicts are established, as are provisions for process improvement and risk sharing. On highly critical work, arrangements are made so

that key personnel work together, face to face. Joint assessments of how well people are collaborating is the norm during status report briefings. Finally, many companies are realizing the benefits of forming long-term alliances with each other on projects. The ultimate goal is to work together as partners.

Effective negotiating skills are essential to working on projects as partners. People need to resolve differences at the lowest level possible in order to keep the project on track. Veteran project managers realize that negotiating is not a competitive game and work toward collaborative solutions to problems. They accomplish this by separating people from the problem, focusing on interests and not positions, inventing options for mutual gain, and relying on objective criteria whenever possible to resolve disagreements. They also recognize the importance of developing a strong BATNA, which provides them with the leverage necessary to seek collaborative solutions.

Customer satisfaction is the litmus test for project success. Project managers need to take a proactive approach to managing customer expectations and perceptions. They need to actively involve customers in key decisions and keep them abreast of important developments. Active customer involvement keeps the project team focused on the objectives of the project and reduces misunderstandings and dissatisfaction.

Key Terms			
	Best alternative to a negotiated agreement (BATNA)	Escalation	Outsourcing
		Met-expectations	Partnering charter
		model	Principled negotiation
	Co-location		

Review Questions

1. Why do firms outsource project work?
2. What are the best practices used by firms to outsource project work?
3. What does the term "escalate" refer to, and why is it essential to project success?
4. Why is the principled negotiation approach recommended for negotiating agreements on projects?
5. What does the acronym BATNA refer to, and why is it important to being a successful negotiator?
6. How can a project manager influence customer expectations and perceptions?

Exercises

1. Break into groups of four to five students. Assign half of the groups the role of Owner and the other half the role of Contractor.

 Owners: After saving for many years you are about to hire a contractor to build your "dream home." What are your objectives for this project? What concerns or issues do you have about working with a general contractor to build your home?

 Contractors: You specialize in building customized homes. You are about to meet with prospective owners to begin to negotiate a contract for building their "dream home." What are your objectives for this project? What concerns or issues do you have about working with the owners to build their home?

 Each Owner group meets with another Contractor group and shares their objectives, concerns, and issues.

 Identify what objectives, issues, and concerns you have in common and which ones are unique. Discuss how you could work together to realize your objectives. What would be the keys to working as partners on this project?

2. Enter "outsourcing" in an Internet search engine and browse different Web sites. Who appears to be interested in outsourcing? What are the advantages of outsourcing? What are the disadvantages? Does outsourcing mean the same thing to different people? What are future trends in outsourcing?

References

Cowan, C., C. F. Gray, and E. W. Larson, "Project Partnering," *Project Management Journal,* Vol. 12, No. 4, December 1992, pp. 5–15.

Covey, S. R., *The Seven Habits of Highly Effective People* (New York: Simon and Schuster, 1990).

DiDonato, L. S., "Contract Disputes: Alternatives for Dispute Resolution (Part 1)," *PM Network,* May 1993, pp. 19–23.

Drexler, J. A. and E. W. Larson, "Partnering: Why Project Owner-Contractor Relationships Change," *Journal of Construction Engineering and Management,* Vol. 126, No. 4, July/August 2000, pp. 293–397.

Dyer, S., *Partner Your Project* (Warwickshire, UK: Pendulum Pub., 1997).

Economy, P., *Business Negotiating Basics* (Burr Ridge, IL: Irwin Professional Publishing, 1994).

Fisher, R. and W. Ury, *Getting to Yes: Negotiating Agreement without Giving In,* 2nd ed. (New York: Penguin Books, 1991).

Hedberg, B., G. Dahlgren, J. Hansson, and N. Olve, *Virtual Organizations and Beyond* (New York: Wiley, 1997).

Hoang, H. and F. T. Rothaermel, "The Effect of General and Partner-Specific Alliance Experience on Joint R&D Project Performance," *Academy of Management Journal,* Vol. 48, No. 2, 2005, pp. 332–45.

Kanter, R. M., "Collaborative Advantage: The Art of Alliances," *Harvard Business Review,* July–August 1994, pp. 92–113.

Kezsbom, D. S., D. L. Schilling, and K. A. Edward, *Dynamic Project Management* (New York: Wiley, 1989).

Larson, E. W., "Project Partnering: Results of a Study of 280 Construction Projects," *Journal of Management Engineering,* Vol. 11, No. 2, March/April 1995, pp. 30–35.

Larson, E. W., "Partnering on Construction Projects: A Study of the Relationship between Partnering Activities and Project Success," *IEEE Transactions in Engineering Management,* Vol. 44, No. 2, May 1997, pp. 188–95.

Larson, E. W. and J. A. Drexler, "Barriers to Project Partnering: Report from the Firing Line," *Project Management Journal,* Vol. 28, No. 1, March 1997, pp. 46–52.

Magenau, J. M. and J. K. Pinto, "Power, Influence, and Negotiation in Project Management," in *The Wiley Guide to Managing Projects*, P. W. G. Morris and J. K. Pinto (Eds.), (New York: Wiley, 2004), pp. 1033–60.

Nambisan, S., "Designing Virtual Customer Environments for New Product Development: Toward a Theory," *Academy of Management Review,* Vol. 27, No. 3, 2002, pp. 392–413.

Nissen, M. E., "Procurement: Process Overview and Emerging Project Management Techniques," in *The Wiley Guide to Managing Projects*, P. W. G. Morris and J. K. Pinto (Eds.), (New York: Wiley, 2004), pp. 643–54.

Quinn, R. E., S. R. Faerman, M. P. Thompson, and M. R. McGrath, *Becoming a Master Manager: A Competency Framework* (New York: Wiley, 1990).

Schultzel, H. J. and V. P. Unruh, *Successful Partnering: Fundamentals for Project Owners and Contractors* (New York: Wiley, 1996).

Shell, G. R., *Bargaining for Advantage: Negotiation Strategies for Reasonable People* (New York: Penguin, 2000).

Case

The Accounting Software Installation Project

Sitting in her office, Karin Chung is reviewing the past four months of the large corporate accounting software installation project she has been managing. Everything seemed so well planned before the project started. Each company division had a task force that provided input into the proposed installation along with potential problems. All the different divisions had been trained and briefed on exactly how their division would interface and use the forthcoming accounting software. All six contractors, which included one of the Big Five consulting companies, assisted in developing the work breakdown structure—costs, specifications, time.

Karin hired a consultant to conduct a one-day "partnering" workshop attended by the major accounting heads, a member of each task force group, and key representatives from each of the contractors. During the workshop, several different team-building exercises were used to illustrate the importance of collaboration and effective communication. Everyone laughed when Karin fell into an imaginary acid pit during a human bridge-building exercise. The workshop ended on an upbeat note with everyone signing a partnering charter that expressed their commitment to working together as partners to complete the project.

TWO MONTHS LATER

One task force member came to Karin to complain that the contractor dealing with billing would not listen to his concerns about problems that could occur in the Virginia division when billings are consolidated. The contractor had told him, the task force member, he had bigger problems than consolidation of billing in the Virginia division. Karin replied, "You can settle the problem with the contractor. Go to her and explain how serious your problem is and that it will have to be settled before the project is completed."

Later in the week in the lunchroom she overheard one consulting contractor badmouthing the work of another— "never on time, interface coding not tested." In the hallway the same day an accounting department supervisor told her that tests showed the new software will never be compatible with the Georgia division's accounting practices.

While concerned, Karin considered these problems typical of the kind she had encountered on other smaller software projects.

FOUR MONTHS LATER

The project seemed to be falling apart. What happened to the positive attitude fostered at the team-building workshop? One contractor wrote a formal letter complaining that another contractor was sitting on a coding decision that was delaying their work. The letter went on: "We cannot be held responsible or liable for delays caused by others." The project was already two months behind, so problems were becoming very real and serious. Karin finally decided to call a meeting of all parties to the project and partnering agreement.

She began by asking for problems people were encountering while working on the project. Although participants were reluctant to be first for fear of being perceived as a complainer, it was not long before accusations and tempers flared out of control. It was always some group complaining about another group. Several participants complained that others were sitting on decisions that resulted in their work being held up. One consultant said, "It is impossible to tell who's in charge of what." Another participant complained that

although the group met separately on small problems, it never met as a total group to assess new risk situations that developed.

Karin felt the meeting had degenerated into an unrecoverable situation. Commitment to the project and partnering appeared to be waning. She quickly decided to stop the meeting and cool things down. She spoke to the project stakeholders: "It is clear that we have some serious problems, and the project is in jeopardy. The project must get back on track, and the backbiting must stop. I want each of us to come to a meeting Friday morning with concrete suggestions of what it will take to get the project back on track and specific actions of how we can make it happen. We need to recognize our mutual interdependence and bring our relationships with each other back to a win/win environment. When we do get things back on track, we need to figure out how to stay on track."

1. Why does this attempt at project partnering appear to be failing?
2. If you were Karin, what would you do to get this project back on track?
3. What action would you take to keep the project on track?

Case

Goldrush Electronics Negotiation Exercise

OBJECTIVE

The purpose of this case is to provide you with an opportunity to practice negotiations.

PROCEDURE

STEP 1

The class is divided into four groups, each comprising the project management group for one of four projects at Goldrush Electronics.

STEP 2

Read the Goldrush Electronics "Background Information" section given below. Then read the instructions for the project you represent. Soon you will meet with the management of the other projects to exchange personnel. Plan how you want to conduct those meetings.

BACKGROUND INFORMATION

Goldrush Electronics (GE) produces a range of electronic products. GE has a strong commitment to project management. GE operates as a projectized organization with each project organized as a fully dedicated team. The compensation system is based on a 40 + 30 + 30 formula. Forty percent is based on your base salary, 30 percent on your project performance, and 30 percent on overall performance of the firm.

Four new product development projects have been authorized. They are code named: Alpha, Beta, Theta, and Zeta. The preliminary assignment of personnel is listed below. You are assigned to represent the management of one of these projects.

The policy at GE is that once preliminary assignments are made project managers are free to exchange personnel as long as both parties agree to the transaction. You will have the opportunity to adjust your team by negotiating with other project managers.

Alpha Project		
Software Engineer	**Hardware Engineer**	**Design Engineer**
Jill	Cameron	Mitch
John	Chandra	Marsha

Beta Project		
Software Engineer	**Hardware Engineer**	**Design Engineer**
Jake	Casey	Mike
Jennifer	Craig	Maria

Theta Project		
Software Engineer	**Hardware Engineer**	**Design Engineer**
Jack	Chuck	Monika
Johan	Cheryl	Mark

Zeta Project		
Software Engineer	**Hardware Engineer**	**Design Engineer**
Jeff	Carlos	Max
Juwoo	Chad	Maile

Personnel may be traded for one or more other personnel.

STEP 3

Meet and negotiate with the other project managers.

STEP 4

Individual project scores are totaled and posted.

STEP 5

DISCUSSION QUESTIONS

1. What was your initial strategy before starting the actual negotiations? How did you view the other groups?
2. Did your initial strategy change once negotiations began? If so how and why?
3. What could top management at GE have done to make it easier to reach agreement with the other groups?

Appendix 12.1

Contract Management

Since most outsourced work on projects is contractual in nature, this appendix discusses the different kinds of contracts that are used, their strengths and weaknesses, and how contracts shape the motives and expectations of different participants. Contract management is a key element of any project procurement management system. It is beyond the scope of

this book to describe this system. However, the basic processes are listed here to put contract management and related topics like RFP (see Appendix 2.1) in perspective. Six main steps comprise procurement management:

- **Planning purchases and acquisitions** involves determining what to procure, when, and how. This entails the classic build-versus-buy analysis as well as determination of the type of contract to use.
- **Planning contracting** involves describing the requirements for products or services desired from outsourcing and identifying potential suppliers or sellers. Outputs include procurement documents such as a Request for Proposal (RFP) as well as selection criteria.
- **Requesting seller responses** involves obtaining information, quotes, bids, or proposals from sellers and providers. The main outputs of this process include a qualified sellers list and specific proposals.
- **Selecting sellers** involves choosing from potential suppliers through a process of evaluating potential providers and negotiating a contract.
- **Administering the contract** involves managing the relationship with the selected seller or provider.
- **Closing the contract** involves completion and settlement of the contract.

Most companies have purchasing departments that specialize in procurement. Often purchasing agents will be assigned to project teams and they work with other team members to come up with optimum solutions for the project. Even if project teams are not directly involved in contract negotiations and the decision to outsource project work, it is important that the team understand the procurement process and the nature of different kinds of contracts.

CONTRACTS

A contract is a formal agreement between two parties wherein one party (the contractor) obligates itself to perform a service and the other party (the client) obligates itself to do something in return, usually in the form of a payment to the contractor. For example, an insurance firm contracted with a consulting firm to reprogram segments of their information system to conform to MS Vista.

A contract is more than just an agreement between parties. A contract is a codification of the private law, which governs the relationship between the parties to it. It defines the responsibilities, spells out the conditions of its operations, defines the rights of the parties in relationship to each other, and grants remedies to a party if the other party breaches its obligations. A contract attempts to spell out in specific terms the transactional obligations of the parties involved as well as contingencies associated with the execution of the contract. An ambiguous or inconsistent contract is difficult to understand and enforce.

There are essentially two different kinds of contracts. The first is the "fixed-price" contract in which a price is agreed upon in advance and remains fixed as long as there are no changes to scope or provisions of the agreement. The second is a "cost-plus" contract in which the contractor is reimbursed for all or some of the expenses incurred during the performance of the contract. Unlike the fixed-price contract, the final price is not known until the project is completed. Within these two types of contracts, several variations exist.

FIXED-PRICE CONTRACTS

Under a fixed-price (FP) or lump-sum agreement, the contractor agrees to perform all work specified in the contract at a fixed price. Clients are able to get a minimum price by putting out the contract to competitive bid. Advertising an invitation for bid (IFB) that lists

customer requirements usually results in low bids. Prospective contractors can obtain IFB notices through various channels. In the case of large business organizations and government agencies, potential contractors can request to be included on the bidder's list in the area of interest. In other cases, IFBs can be found by scanning appropriate industry media such as newspapers, trade journals, and Web sites. In many cases, the owner can put restrictions on potential bidders, such as requiring that they be ISO 9000 certified.

With fixed-price contract bids, the contractor has to be very careful in estimating target cost and completion schedule because once agreed upon, the price cannot be adjusted. If contractors overestimate the target cost in the bidding stage, they may lose the contract to a lower-priced competitor; if the estimate is too low, they may win the job but make little or no profit.

Fixed-price contracts are preferred by both owners and contractors when the scope of the project is well defined with predictable costs and low implementation risks. Such might be the case for producing parts or components to specifications, executing training programs, or orchestrating a banquet. With fixed-price contracts, clients do not have to be concerned with project costs and can focus on monitoring work progress and performance specifications. Likewise, contractors prefer fixed-price contracts because the client is less likely to request changes or additions to the contract. Fewer potential changes reduce project uncertainty and allow the contractors to more efficiently manage their resources across multiple projects.

The disadvantage of a fixed-price contract for owners is that it is more difficult and more costly to prepare. To be effective, design specifications need to be spelled out in sufficient detail to leave little doubt as to what is to be achieved. Because the contractor's profit is determined by the difference between the bid and the actual costs, there is some incentive for contractors to use cheaper quality materials, perform marginal workmanship, or extend the completion date to reduce costs. The client can counteract these by stipulating rigid end-item specifications and completion date and by supervising work. In many cases, the client will hire a consultant who is an expert in the field to oversee the contractor's work and protect the client's interest.

The primary disadvantage of a fixed-price contract for contractors is that they run the risk of underestimating. If the project gets into serious trouble, cost overruns may make the project unprofitable, and, in some cases, may lead to bankruptcy. To avoid this, contractors have to invest significant time and money to ensure that their estimates are accurate.

Contracts with long lead times such as construction and production projects may include escalation provisions that protect the contractor against external cost increases in materials, labor rates, or overhead expenses. For example, the price may be tied to an inflation index, so it can be adjusted to sudden increases in labor and material prices, or it may be redetermined as costs become known. A variety of redetermination contracts are used. Some establish a ceiling price for a contract and permit only downward adjustments, others permit upward and downward adjustments; some establish one readjustment period at the end of the project, others use more than one period. Redetermination contracts are appropriate where engineering and design efforts are difficult to estimate or when final price cannot be estimated for lack of accurate cost data.

While, in principle, redetermination contracts are used to make appropriate adjustments in cost uncertainties, they are prone to abuse. A contractor may win an initial low bid contract, initiate the contracted work, and then "discover" that the costs are much higher than expected. The contractor can take advantage of redetermination provisions and a client's ignorance to justify increasing the actual cost of the contract. The contract evolves into a cost-plus contract.

To alleviate some of the disadvantages of a fixed-price contract while maintaining some certainty as to final cost, many fixed-price contracts contain incentive clauses

designed to motivate contractors to reduce costs and improve efficiency. For example, a contractor negotiates to perform the work for a target price based on target cost and a target profit. A maximum price and maximum profit are also established. If the total cost ends up being less than the target cost, the contractor makes a higher profit up to the profit maximum. If there is a cost overrun, the contractor absorbs some of the overrun until a profit floor is reached.

Profit is determined according to a formula based on a cost-sharing ratio (CSR). A CSR of 75/25, for example, indicates that for every dollar spent above target costs, the client pays 75 cents and the contractor pays 25 cents. This provision motivates contractors to keep costs low since they pay 25 cents on every dollar spent above the expected cost and earn 25 cents more on every dollar saved below the expected cost. Fixed-price incentive contracts tend to be used for long-duration projects with fairly predictable cost estimates. The key is being able to negotiate a reasonable target cost estimate. Unscrupulous contractors have been known to take advantage of the ignorance of the client to negotiate an unrealistically high target cost and use performance incentives to achieve excessive profits.

COST-PLUS CONTRACTS

Under a cost-plus contract the contractor is reimbursed for all direct allowable costs (materials, labor, travel) plus an additional fee to cover overhead and profit. This fee is negotiated in advance and usually involves a percentage of the total costs. On small projects this kind of contract comes under the rubric "time and materials contract" in which the client agrees to reimburse the contractor for labor cost and materials. Labor costs are based on an hourly or daily rate, which includes direct and indirect costs as well as profit. The contractor is responsible for documenting labor and materials costs.

Unlike fixed contracts, cost-plus contracts put the burden of risk on the client. The contract does not indicate what the project is going to cost until the end of the project. Contractors are supposed to make the best effort to fulfill the specific technical requirements of the contract but cannot be held liable, in spite of their best efforts, if the work is not produced within the estimated cost and time frame. These contracts are often criticized because there is little formal incentive for the contractors to control costs or finish on time because they get paid regardless of the final cost. The major factor motivating contractors to control costs and schedule is the effect overruns have on their reputation and their ability to secure future business.

The inherent weakness of cost-plus contracts has been compensated for by a variety of incentive clauses directed at providing incentives to contractors to control costs, maintain performance, and avoid schedule overruns. Contractors are reimbursed for costs, but instead of the fee being fixed, it is based on an incentive formula and subject to additional provisions. This is very similar to fixed-price incentive contracts, but instead of being based on a target cost, the fee is based on actual cost, using a cost-sharing formula.

Most contracts are concerned with the negotiated cost of the project. However, given the importance of speed and timing in today's business world, more and more contracts involve clauses concerning completion dates. To some extent schedule incentives provide some cost-control measures because schedule slippage typically but not always involves cost overruns. Schedule incentives/penalties are stipulated depending on the significance of time to completion for the owner. For example, the contract involving the construction of a new baseball stadium is likely to contain stiff penalties if the stadium is not ready for opening day of the season. Conversely, time-constrained projects in which the number one priority is getting the project completed as soon as possible are likely to include attractive incentives for completing the project early.

A good example of this can be seen in the Northridge Earthquake Snapshot from Practice (Chapter 9) in which the construction firm pulled out all the stops to restore the damaged highway system 74 days ahead of schedule. The firm received a $14.8 million bonus for these efforts!

Figure A12.1 summarizes the spectrum of risk to the buyer and supplier for different kinds of contracts. Buyers have the lowest risk with firm fixed-price contracts because they know exactly what they will need to pay the supplier. Buyers have the most risk with cost-plus percentage of cost contracts because they do not know in advance what the suppliers' costs will be and suppliers may be motivated to increase costs. From the suppliers' perspective, the cost-plus contract offers the least risk and the firm fixed-price contract entails the most risk.

CONTRACT CHANGE CONTROL SYSTEM

A contract change control system defines the process by which the contract may be modified. It includes the paperwork, tracking systems, dispute resolution procedures, and approval levels necessary for authorizing changes. There are a number of reasons a contract may need to be changed. Clients may wish to alter the original design or scope of the project once the project is initiated. This is quite common as the project moves from concept to reality. For example, an owner may wish to add windows after inspecting the partially completed homesite. Market changes may dictate adding new features or increasing the performance requirements of equipment. Declining financial resources may dictate that the owner cut back on the scope of the project. The contractor may initiate changes in the contract in response to unforeseen legitimate problems. A building contractor may need to renegotiate the contract in the face of excessive groundwater or the lack of availability of specified materials. In some cases, external forces may dictate contract changes, such as a need to comply with new safety standards mandated by the federal government.

There need to be formal, agreed-upon procedures for initiating changes in the original contract. Contract change orders are subject to abuse. Contractors sometimes take advantage of owners' ignorance to inflate the costs of changes to recoup profit lost from a low bid. Conversely, owners have been known to "get back" at contractors by delaying approval of contract changes, thus delaying project work and increasing the costs to the contractor.

FIGURE A12.1

Contract Type versus Risk

All parties need to agree upon the rules and procedures for initiating and making changes in the original terms of the contract in advance.

CONTRACT MANAGEMENT IN PERSPECTIVE

Contract management is not an exact science. For decades, the federal government has been trying to develop a more effective contract administration system. Despite their best efforts, abuses are repeatedly exposed in the news media. The situation is similar to trying to take a wrinkle out of an Oriental rug. Efforts to eliminate a wrinkle in one part of the rug invariably create a wrinkle in another part. Likewise, each new revision in government procurement procedures appears to generate a new loophole that can be exploited. There is no perfect contract management system. Given the inherent uncertainty involved in most project work, no contract can handle all the issues that emerge. Formal contracts cannot replace or eliminate the need to develop effective working relationships between the parties involved that are based on mutual goals, trust, and cooperation. For this reason, the earlier discussion of best practices, in outsourcing and effective negotiating is very important.

APPENDIX REVIEW QUESTIONS

1. What are the fundamental differences between fixed-price and cost-plus contracts?
2. For what kinds of projects would you recommend that a fixed-price contract be used? For what kinds of projects would you recommend that a cost-plus contract be used?

APPENDIX REFERENCES

Angus, R. B., N. A. Gundersen, and T. P. Cullinane, *Planning, Performing, and Controlling Projects* (Upper Saddle River, NJ: Prentice Hall, 2003).

Cavendish, J. and M. Martin, *Negotiating and Contracting for Project Management* (Upper Darby, PA: Project Management Institute, 1982).

Fleming, Q. W., *Project Procurement Management: Contracting, Subcontracting, Teaming* (Tustin, CA: FMC Press, 2003).

Fraser, J., *Professional Project Proposals* (Aldershot, U.K.: Gower/Ashgate, 1995).

Lowe, D., "Contract Management" in *The Wiley Guide to Managing Projects,* P. W. G. Morris and J. K. Pinto (Eds.), (New York: Wiley, 2004), pp. 678–707.

Schwalbe, K., *Information Technology Project Management,* 4th ed. (Boston: Thomson Course Technology, 2006).

Worthington, M. M. and L. P. Goldsman, *Contracting with the Federal Government,* 4th ed. (New York: Wiley, 1998).

Progress and Performance Measurement and Evaluation

Structure of a Project Monitoring Information System

The Project Control Process

Monitoring Time Performance

Development of an Earned Value Cost/Schedule System

Developing a Status Report: A Hypothetical Example

Indexes to Monitor Progress

Forecasting Final Project Cost

Other Control Issues

Summary

Appendix 13.1: The Application of Additional Earned Value Rules

Appendix 13.2: Obtaining Project Performance Information from MS Project

Progress and Performance Measurement and Evaluation

How does a project get one year late?
. . . One day at a time.
—Frederick P. Brooks, The Mythical Man Month, p. 153

Evaluation and control are part of every project manager's job. Control by "wandering around" and/or "involvement" can overcome most problems in small projects. But large projects need some form of formal control. Control holds people accountable, prevents small problems from mushrooming into large problems, and keeps focus. Except for accounting controls, project control is not performed well in most organizations. Control is one of the most neglected areas of project management. Unfortunately, it is not uncommon to find resistance to control processes. In essence, those who minimize the importance of control are passing up a great opportunity to be effective managers and, perhaps, allow the organization to gain a competitive edge. Neglecting control in organizations with multiple projects is even more serious. For effective control, the project manager needs a single information system to collect data and report progress on cost, schedule, and specifications. The general structure of such a system is discussed next.

Structure of a Project Monitoring Information System

A project monitoring system involves *determining what* data to collect; *how, when,* and *who* will collect the data; *analysis* of the data; and *reporting* current progress.

What Data Are Collected? Data collected are determined by *which* metrics will be used for project control. Typical key data collected are actual activity duration times, resource usage and rates, and actual costs, which are compared against planned times, resources, and budgets. Since a major portion of the monitoring system focuses on cost/schedule concerns, it is crucial to provide the project manager and stakeholders with data to answer questions such as:

- What is the current status of the project in terms of schedule and cost?
- How much will it cost to complete the project?
- When will the project be completed?
- Are there potential problems that need to be addressed now?
- What, who, and where are the causes for cost or schedule overruns?
- What did we get for the dollars spent?
- If there is a cost overrun midway in the project, can we forecast the overrun at completion?

The performance metrics you need to collect should support answering these questions. Examples of specific metrics and tools for collecting data will be discussed in detail later in this chapter.

Collecting Data and Analysis With the determination of what data are collected, the next step is to establish who, when, and how the data will be assembled. Will the data be collected by the project team, contractor, independent cost engineers, project manager? Or will the data be derived electronically from some form of surrogate data such as cash flow, machine hours, labor hours, or materials in place? Should the reporting period be one hour, one day, one week, or what? Is there a central repository for the data collected and is someone responsible for its dissemination?

Electronic means of collecting data have vastly improved data assembly, analysis, and dissemination. Numerous software vendors have programs and tools to analyze your customized collected data and present it in a form that facilitates monitoring the project, identifying sources of problems, and updating your plan.

Reports and Reporting First, who gets the progress reports? We have already suggested that different stakeholders and levels of management need different kinds of project information. Senior management's major interest is usually, "Are we on time and within budget? If not what corrective action is taking place?" Likewise, an IT manager working on the project is concerned primarily about her deliverable and specific work packages. The reports should be designed for the right audience.

Typically, project progress reports are designed and communicated in written or oral form. A common topic format for progress reports follows:

- Progress since last report
- Current status of project

 1. Schedule
 2. Cost
 3. Scope
- Cumulative trends
- Problems and issues since last report

 1. Actions and resolution of earlier problems
 2. New variances and problems identified
- Corrective action planned

Given the structure of your information system and the nature of its outputs, we can use the system to interface and facilitate the project control process. These interfaces need to be relevant and seamless if control is to be effective.

Project Control Process

The Project Control Process

Control is the process of comparing actual performance against plan to identify deviations, evaluate possible alternative courses of actions, and take appropriate corrective action. The project control steps for measuring and evaluating project performance are presented below.

1. Setting a baseline plan.
2. Measuring progress and performance.
3. Comparing plan against actual.
4. Taking action.

Each of the control steps is described in the following paragraphs.

Step 1: Setting a Baseline Plan

The baseline plan provides us with the elements for measuring performance. The baseline is derived from the cost and duration information found in the work breakdown structure (WBS) database and time-sequence data from the network and resource scheduling decisions. From the WBS the project resource schedule is used to time-phase all work, resources, and budgets into a baseline plan. See Chapter 8.

Step 2: Measuring Progress and Performance

Time and budgets are quantitative measures of performance that readily fit into the integrated information system. Qualitative measures such as meeting customer technical specifications and product function are most frequently determined by on-site inspection or actual use. This chapter is limited to quantitative measures of time and budget. Measurement of time performance is relatively easy and obvious. That is, is the critical path early, on schedule, or late; is the slack of near-critical paths decreasing to cause new critical activities? Measuring performance against budget (e.g., money, units in place, labor hours) is more difficult and is *not* simply a case of comparing actual versus budget. Earned value is necessary to provide a realistic estimate of performance against a time-phased budget. Earned value (EV) is defined as the budgeted cost of the work performed.

Step 3: Comparing Plan against Actual

Because plans seldom materialize as expected, it becomes imperative to measure deviations from plan to determine if action is necessary. Periodic monitoring and measuring the status of the project allow for comparisons of actual versus expected plans. It is crucial that the timing of status reports be frequent enough to allow for early detection of variations from plan and early correction of causes. Usually status reports should take place every one to four weeks to be useful and allow for proactive correction.

Step 4: Taking Action

If deviations from plans are significant, corrective action will be needed to bring the project back in line with the original or revised plan. In some cases, conditions or scope can change, which, in turn, will require a change in the baseline plan to recognize new information.

The remainder of this chapter describes and illustrates monitoring systems, tools, and components to support managing and controlling projects. Several of the tools you developed in the planning and scheduling chapters now serve as input to your information system for monitoring performance. Monitoring time performance is discussed first, followed by cost performance.

Monitoring Time Performance

A major goal of progress reporting is to catch any negative variances from plan as early as possible to determine if corrective action is necessary. Fortunately, monitoring schedule performance is relatively easy. The project network schedule, derived from the WBS/OBS, serves as the baseline to compare against actual performance.

Gantt charts (bar charts) and control charts are the typical tools used for communicating project schedule status. As suggested in Chapter 6, the Gantt chart is the most favored, used, and understandable. This kind of chart is commonly referred to as a tracking Gantt chart. Gantt and control charts serve well as a means for tracking and trending schedule performance. Their easy-to-understand visual formats make them favorite tools for communicating project schedule status—especially to top management, who do not usually have time for details. Adding actual and revised time estimates to the Gantt chart gives a quick overview of project status on the report date.

Tracking Gantt Chart

Figure 13.1 presents a baseline Gantt chart and a tracking Gantt chart for a project at the end of period 6. The solid bar below the original schedule bar represents the actual start and finish times for completed activities or any portion of an activity completed (see activities A, B, C, D, and E). For example, the actual start time for activity C is period 2; the actual finish time is period 5; the actual duration is three time units, rather than four scheduled time periods. Activities in process show the actual start time until the present; the extended bar represents the remaining scheduled duration (see activities D and E). The remaining expected duration for activities D and E are shown with the hatched bar. Activity F, which has not started, shows a revised estimated actual start (9) and finish time (13).

FIGURE 13.1
Baseline Gantt Chart

Note how activities can have durations that differ from the original schedule, as in activities C, D, and E. Either the activity is complete and the actual is known, or new information suggests the estimate of time be revised and reflected in the status report. In activity D the revised duration is expected to be four time units, which is one time period longer than the original schedule. Although sometimes the Gantt chart does not show dependencies, when it is used with a network, the dependencies are easily identified if tracing is needed.

Control Chart

This chart is another tool used to monitor past project schedule performance and current performance and to estimate future schedule trends. Figure 13.2 depicts a project control chart. The chart is used to plot the difference between the scheduled time on the critical path at the report date with the actual point on the critical path. Although Figure 13.2 shows the project was behind early in the project, the plot suggests corrective action brought the project back on track. If the trend is sustained, the project will come in ahead of schedule. Because the activity scheduled times represent average durations, four observations trending in one direction indicate there is a very high probability that there is an identifiable cause. The cause should be located and action taken if necessary. Control chart trends are very useful for giving warning of potential problems so appropriate action can be taken if necessary.

Control charts are also frequently used to monitor progress toward milestones, which mark events and as such have zero duration. Milestones are significant project events that mark major accomplishments. To be effective, milestones need to be concrete, specific, measurable events. Milestones must be easily identifiable by all project stakeholders—for example, product testing complete. Critical merge activities are good candidates for milestones. Control charts very similar to the example shown in Figure 13.2 are often used to record and communicate project progress toward a milestone.

Schedule slippage of one day seldom receives a great deal of attention. However, one day here and another there soon add up to large delay problems. It is well known that once work gets behind, it has a tendency to stay behind because it is difficult to make up. Examples of causes of schedule slippage are unreliable time estimates, minor redesign, scope creep, and unavailable resources. Using slack early in a path may create a problem for someone

FIGURE 13.2
Project Schedule Control Chart

At Microsoft each software product has a corresponding project status report. Project teams send these reports each month to Bill Gates and other top executives as well as to the managers of all related projects. The status reports are brief and have a standard format. Gates can read most of them quickly and still spot potential project delays or changes he does not want. He especially looks for schedule slips, cutting too many product features, or the need to change a specification. Gates usually responds to the relevant managers or developers directly by electronic mail. Status reports are an important mechanism for communicating between top management and projects. As Gates explains:

"I get all the status reports. Right now there might be a hundred active projects. . . . [The status reports] contain the schedule, including milestones dates, and any change in spec, and any comments about 'Hey, we can't hire enough people,' or 'Jeez, if this OLE (Object Linking and Embedding) 2 Mac release isn't done, we're just going to have to totally slip.'. . . They know [their report] goes up to all the people who manage all the other groups that they have dependencies with. So if they don't raise it in the status report and then two months later they say something, that's a breakdown in communication. . . . The internal group is totally copied on those things, so it's sort of the consensus of the group."

*From *Microsoft Secrets: The World's Most Powerful Software Company Creates Technology.* Copyright © 1995 by Michael A. Cusumano and Richard W. Selby.

responsible for a later activity; flexibility and potential opportunities are reduced. For these reasons, having frequent and clearly defined monitoring points for work packages can significantly improve the chances of catching schedule slippage early. Early detection reduces the chance of small delays growing to large ones and thereby reducing opportunities for corrective action to get back on schedule. See Snapshot from Practice: Status Reports at Microsoft.

Development of An Earned Value Cost/Schedule System

Earned value is not new; although its initial use was in military contracts, in recent years the private sector has come to depend on the system for managing multiple and large projects.

The original earned value cost/schedule system was pioneered by the U.S. Department of Defense (DOD) in the 1960s. It is probably safe to say project managers in every major country are using some form of the system. The system is being used on internal projects in the manufacturing, pharmaceutical, and high-tech industries. For example, organizations such as EDS, NCR, Levi Strauss, Tektronics, and Disney have used earned value systems to track projects. The basic framework of the earned value system is withstanding the test of time. Most project management software includes the original framework; many systems have added industry-specific variations to more precisely track progress and costs. This chapter presents the "generic" core of an integrated cost/schedule information system.

The earned value system starts with the time-phased costs that provide the project budget *baseline,* which is called the planned budgeted value of the work scheduled (PV). Given this time-phased baseline, comparisons are made with actual and planned schedule and costs using earned value. The earned value approach provides the missing links not found in conventional cost-budget systems. At any point in time, a status report can be developed for the project.

The earned value cost/schedule system uses several acronyms and equations for analysis. Table 13.1 presents a glossary of these acronyms. You will need this glossary as a reference. In recent years acronyms have been shortened to be more phonetically friendly. This movement is reflected in material from the Project Management Institute, in project management software, and by most practitioners. This text edition follows the recent trend. The acronyms found in brackets represent the older acronyms, which are often found in software programs. To the uninitiated, the terms used in practice appear horrendous and intimidating. However, once a few basic terms are understood, the intimidation index will evaporate.

TABLE 13.1
Glossary of Terms

EV	Earned value for a task is simply the percent complete times its original budget. Stated differently, EV is the percent of the original budget that has been earned by actual work completed. [The older acronym for this value was BCWP—budgeted cost of the work performed.]
PV	The planned time-phased baseline of the value of the work scheduled. An approved cost estimate of the resources scheduled in a time-phased cumulative baseline [BCWS—budgeted cost of the work scheduled].
AC	Actual cost of the work completed. The sum of the costs incurred in accomplishing work. [ACWP—actual cost of the work performed].
CV	Cost variance is the difference between the earned value and the actual costs for the work completed to date where $CV = EV - AC$.
SV	Schedule variance is the difference between the earned value and the baseline line to date where $SV = EV - PV$.
BAC	Budgeted cost at completion. The total budgeted cost of the baseline or project cost accounts.
EAC	Estimated cost at completion.
ETC	Estimated cost to complete remaining work.
VAC	Cost variance at completion. VAC indicates expected actual over- or underrun cost at completion.

Following five careful steps ensures that the cost/schedule system is integrated. These steps are outlined here. Steps 1, 2, and 3 are accomplished in the planning stage. Steps 4 and 5 are sequentially accomplished during the execution stage of the project.

1. Define the work using a WBS. This step involves developing documents that include the following information (see Chapters 4 and 5):
 a. Scope.
 b. Work packages.
 c. Deliverables.
 d. Organization units.
 e. Resources.
 f. Budgets for each work package.
2. Develop work and resource schedule.
 a. Schedule resources to activities (see Chapter 8).
 b. Time-phase work packages into a network.
3. Develop a time-phase budget using work packages included in an activity. The cumulative values of these budgets will become the baseline and will be called the planned budgeted cost of the work scheduled (PV). The sum should equal the budgeted amounts for all the work packages in the cost accounts (See Chapter 8).
4. At the work package level, collect the actual costs for the work performed. These costs will be called the actual cost of the work completed (AC). Collect percent complete and multiply this times the original budget amount for the value of the work actually completed. These values will be called earned value (EV).
5. Compute the schedule variance ($SV = EV - PV$) and cost variance ($CV = EV - AC$). Prepare hierarchical status reports for each level of management—from work package manager to customer or project manager. The reports should also include project rollups by organization unit and deliverables. In addition, actual time performance should be checked against the project network schedule.

FIGURE 13.3
**Project Management
Information System
Overview**

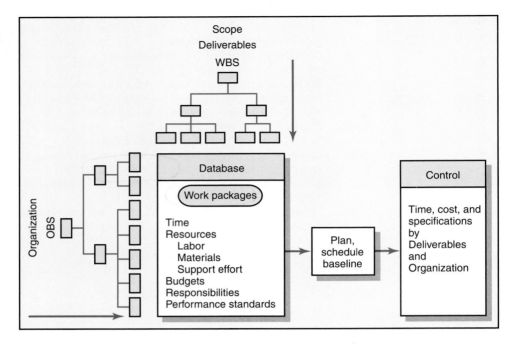

Figure 13.3 presents a schematic overview of the integrated information system, which includes the techniques and systems presented in earlier chapters. Those who have tenaciously labored through the early chapters can smile! Steps 1 and 2 are already carefully developed. Observe that control data can be traced backward to specific deliverables and organization unit responsible.

The major reasons for creating a baseline are to monitor and report progress and to estimate cash flow. Therefore, it is crucial to integrate the baseline with the performance measurement system. Costs are placed (time-phased) in the baseline exactly as managers expect them to be "earned." This approach facilitates tracking costs to their point of origin. In practice, the integration is accomplished by using the same rules in assigning costs to the baseline as those used to measure progress using earned value. You may find several rules in practice, but percent complete is the workhorse most commonly used. Someone familiar with each task estimates what percent of the task has been completed or how much of the task remains.

Percent Complete Rule

This rule is the heart of any earned value system. The best method for assigning costs to the baseline under this rule is to establish frequent checkpoints over the duration of the work package and assign completion percentages in dollar terms. For example, units completed could be used to assign baseline costs and later to measure progress. Units might be lines of code, hours, drawings completed, cubic yards of concrete in place, workdays, prototypes complete, etc. This approach to percent complete adds "objectivity" to the subjective observation approaches often used. When measuring percent complete in the monitoring phase of the project, it is common to limit the amount earned to 80 or 90 percent until the work package is 100 percent complete.

What Costs Are Included in Baselines?

The baseline (PV) is the sum of the cost accounts, and each cost account is the sum of the work packages in the cost account. Three direct costs are typically included in

baselines—labor, equipment, and materials. The reason: these are direct costs the project manager can control. Overhead costs and profit are typically added later by accounting processes. Most work packages should be discrete, of short time span, and have measurable outputs. If materials and/or equipment are a significant portion of the cost of work packages, they can be budgeted in separate work packages and cost accounts.

Methods of Variance Analysis

Generally the method for measuring accomplishments centers on two key computations:

1. Comparing earned value with the expected schedule value.
2. Comparing earned value with the actual costs.

These comparisons can be made at the project level or down to the cost account level. Project status can be determined for the latest period, all periods to date, and estimated to the end of the project.

Assessing the current status of a project using the earned value cost/schedule system requires three data elements—planned cost of the work scheduled (PV), budgeted cost of the work completed (EV), and actual cost of the work completed (AC). From these data the schedule variance (SV) and cost variance (CV) are computed each reporting period. *A positive variance indicates a desirable condition, while a negative variance suggests problems or changes that have taken place.*

Cost variance tells us if the work accomplished costs more or less than was planned at any point over the life of the project. If labor and materials have not been separated, cost variance should be reviewed carefully to isolate the cause to either labor or materials—or to both.

Schedule variance presents an overall assessment of *all* work packages in the project scheduled to date. It is important to note schedule variance contains *no* critical path information. Schedule variance measures progress in dollars rather than time units. Therefore, it is unlikely that any translation of dollars to time will yield accurate information telling if any milestone or critical path is early, on time, or late (even if the project occurs exactly as planned). *The only accurate method for determining the true time progress of the project is to compare the project network schedule against the actual network schedule to measure if the project is on time* (refer to Figure 13.1). However, SV is very useful in assessing the direction all the work in the project is taking—after 20 or more percent of the project has been completed.

Figure 13.4 presents a sample cost/schedule graph with variances identified for a project at the current status report date. Note the graph also focuses on what remains to be accomplished and any favorable or unfavorable trends. The "today" label marks the report date (time period 25) of where the project has been and where it is going. Because our system is hierarchical, graphs of the same form can be developed for different levels of management. In Figure 13.4 the top line represents the actual costs (AC) incurred for the project work to date. The middle line is the baseline (PV) and ends at the scheduled project duration (45). The bottom line is the budgeted value of the work actually completed to date (EV) or the earned value. The dotted line extending the actual costs from the report date to the new estimated completion date represents revised estimates of *expected* actual costs; that is, additional information suggests the costs at completion of the project will differ from what was planned. Note that the project duration has been extended and the variance at completion (VAC) is negative (BAC − EAC).

Another interpretation of the graph uses percentages. At the end of period 25, 75 percent of the work was scheduled to be accomplished. At the end of period 25, the value of the

FIGURE 13.4
Cost/Schedule Graph

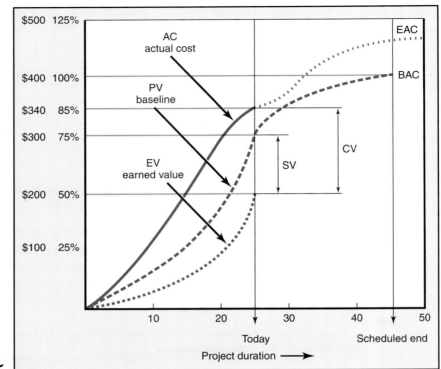

SV–
scheduled
variance

cV–
cost variance

work accomplished is 50 percent. The actual cost of the work completed to date is $340, or 85 percent of the total project budget. The graph suggests the project will have about a 18 percent cost overrun and be five time units late. The current status of the project shows the cost variance (CV) to be over budget by $140 (EV − AC = 200 − 340 = −140). The schedule variance (SV) is negative $100 (EV − PV = 200 − 300 = −100), which suggests the project is behind schedule. Before moving to an example, consult Figure 13.5 to practice interpreting the outcomes of cost/schedule graphs. Remember, PV is your baseline and anchor point.

FIGURE 13.5
Earned-Value Review Exercise

benchmark

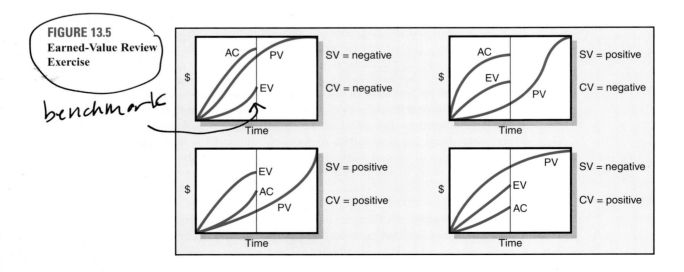

Developing a Status Report: A Hypothetical Example

Working through an example demonstrates how the baseline serves as the anchor from which the project can be monitored using earned value techniques.

Assumptions

Because the process becomes geometrically complex with the addition of project detail, some simplifying assumptions are made in the example to more easily demonstrate the process:

1. Assume each cost account has only one work package, and each cost account will be represented as an activity on the network.
2. The project network early start times will serve as the basis for assigning the baseline values.
3. From the moment work on an activity task begins, some actual costs will be incurred each period until the activity is completed.

Baseline Development

Figure 13.6 (Work Breakdown Structure with Cost Accounts) depicts a simple work breakdown structure (WBS/OBS) for the Digital Camera example. There are six deliverables (Design Specifications, Shell & Power, Memory/Software, Zoom System, Assemble, and Test), and five responsible departments (Design, Shell, Storage, Zoom, and Assembly). The total for all the cost accounts (CA) is $320,000, which represents the total project cost. Figure 13.7, derived from the WBS, presents a planning Gantt chart for the Digital Camera

FIGURE 13.6 **Work Breakdown Structure with Cost Accounts**

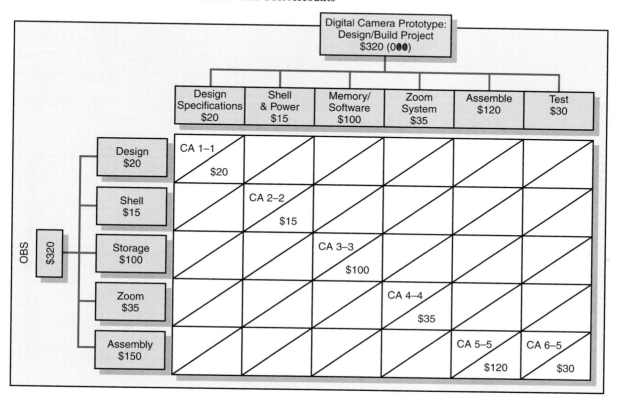

FIGURE 13.7
Digital Camera Prototype Project Baseline Gantt Chart

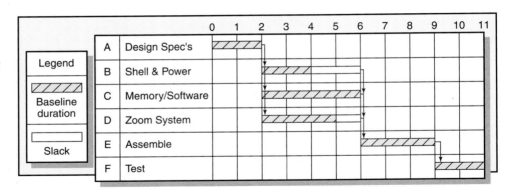

project. The planned project duration is 11 time units. This project information is used to time-phase the project budget baseline. Figure 13.8 (Project Baseline Budget) presents a worksheet with an early start baseline developed with costs assigned. They are assigned "exactly" as managers plan to monitor and measure schedule and cost performance.

Development of the Status Report

A status report is analogous to a camera snapshot of a project at a specific point in time. The status report uses earned value to measure schedule and cost performance. Measuring earned value begins at the work package level. Work packages are in one of three conditions on a report date:

1. Not yet started.
2. Finished.
3. In-process or partially complete.

Earned values for the first two conditions present no difficulties. Work packages that are not yet started earn zero percent of the PV (budget). Packages that are completed earn 100 percent of their PV. In-process packages apply the percent complete rule to the PV baseline to measure earned value (EV). In our camera example we will only use the percent complete rule to measure progress.

Table 13.2 presents the completed, separate status reports of the Digital Camera Prototype project for periods 1 through 7. Each period percent complete and actual cost

FIGURE 13.8
Digital Camera Prototype Project Baseline Budget ($000)

ACT/ WP	DUR	ES	LF	SL	Total PV	0	1	2	3	4	5	6	7	8	9	10	11
		Schedule information								Baseline budget needs							
											Time period						
A	2	0	2	0	20	10	10										
B	2	2	6	2	15			5	10								
C	4	2	6	0	100			20	30	30	20						
D	3	2	6	1	35			15	10	10							
E	3	6	9	0	120								30	40	50		
F	2	9	11	0	30											10	20
Total PV by period						10	10	40	50	40	20	30	40	50	10	20	
Cumulative PV by period						10	20	60	110	150	170	200	240	290	300	320	

TABLE 13.2
Digital Camera Prototype Status Reports: Periods 1–7

Cost Variance $CV = EV - AC$
Schedule Variance $SV = EV - PV$

Status Report: Ending Period 1

Task	%Complete	EV	AC	PV	CV	SV
A	50%	10	10	10	0	0
Cumulative Totals		**10**	**10**	**10**	**0**	**0**

Status Report: Ending Period 2

Task	%Complete	EV	AC	PV	CV	SV
A	Finished	20	30	20	−10	0
Cumulative Totals		**20**	**30**	**20**	**−10**	**0**

Status Report: Ending Period 3

Task	%Complete	EV	AC	PV	CV	SV
A	Finished	20	30	20	−10	0
B	33%	5	10	5	−5	0
C	20%	20	30	20	−10	0
D	60%	21	20	15	+1	+6
Cumulative Totals		**66**	**90**	**60**	**−24**	**+6**

Status Report: Ending Period 4

Task	%Complete	EV	AC	PV	CV	SV
A	Finished	20	30	20	−10	0
B	Finished	15	20	15	−5	0
C	50%	50	70	50	−20	0
D	80%	28	30	25	−2	+3
Cumulative Totals		**113**	**150**	**110**	**−37**	**+3**

Status Report: Ending Period 5

Task	%Complete	EV	AC	PV	CV	SV
A	Finished	20	30	20	−10	0
B	Finished	15	20	15	−5	0
C	60%	60	100	80	−40	−20
D	80%	28	50	35	−22	−7
Cumulative Totals		**123**	**200**	**150**	**−77**	**−27**

Status Report: Ending Period 6

Task	%Complete	EV	AC	PV	CV	SV
A	Finished	20	30	20	−10	0
B	Finished	15	20	15	−5	0
C	80%	80	110	100	−30	−20
D	Finished	35	60	35	−25	0
Cumulative Totals		**150**	**220**	**170**	**−70**	**−20**

Status Report: Ending Period 7

Task	%Complete	EV	AC	PV	CV	SV
A	Finished	20	30	20	−10	0
B	Finished	15	20	15	−5	0
C	90%	90	120	100	−30	−10
D	Finished	35	60	35	−25	0
E	0%	0	0	30	0	−30
F	0%	0	0	0	0	0
Cumulative Totals		**160**	**230**	**200**	**−70**	**−40**

were gathered for each task from staff in the field. The schedule and cost variance are computed for each task and the project to date. For example, the status in period 1 shows only Task A (Design Specifications) is in process and it is 50 percent complete and actual cost for the task is 10. The planned value at the end of period 1 for Task A is 10 (See Figure 13.8). The cost and schedule variance are both zero, which indicates the project is on budget and schedule. By the end of period 3, Task A is finished. Task B (Shell & Power) is 33 percent complete and AC is 10; Task C is 20 percent complete and AC is 30; and D is 60 percent complete and AC is 20. Again, from Figure 13.8 *at the end of period 3,* we can see that the PV for Task A is 20 (10 + 10 = 20), for task B is 5, for Task C is 20, and for Task D is 15. At the end of period 3 it is becoming clear the actual cost (AC) is exceeding the value of the work completed (EV). The cost variance (see Table 13.2) for the project at the end of period 3 is negative 24. Schedule variance is positive 6, which suggests the project may be ahead of schedule.

It is important to note that since earned values are computed from costs (or sometimes labor hours or other metrics), the relationship of costs to time is not one-for-one. For example, it is possible to have a negative SV variance when the project is actually ahead on the critical path. Therefore, it is important to remember, SV is in dollars and is not an accurate measure of time; however, it is a fairly good indicator of the status of the whole project in terms of being ahead or behind schedule after the project is over 20 percent complete. Only the project network, or Tracking Gantt chart, and actual work completed can give an accurate assessment of schedule performance down to the work package level.

By studying the separate status reports for periods 5 through 7, you can see the project will be over budget and behind schedule. By period 7 tasks A, B, and D are finished, but all are over budget—negative 10, 5, and 25. Task C (Memory/Software) is 90 percent complete. Task E is late and hasn't started because Task C is not yet completed. The result is that, at the end of period 7, the digital camera project is over budget $70,000, with a schedule budget over $40,000.

Figure 13.9 shows the graphed results of all the status reports through period 7. This graph represents the data from Table 13.2. The cumulative actual costs (AC) to date and the earned value budgeted costs to date (EV) are plotted against the original project baseline (PV). The cumulative AC to date is $230; the cumulative EV to date is $160. Given these cumulative values, the cost variance (CV = EV − AC) is negative $70 (160 − 230 = −70).

FIGURE 13.9
Digital Camera Prototype Summary Graph ($000)

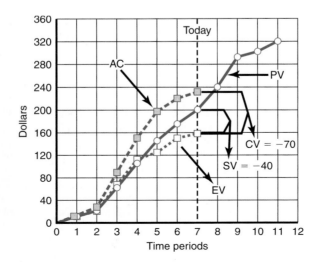

The schedule variance (SV = EV − PV) is negative $40 (160 − 200 = −40). Again, recall that only the project network or Tracking Gantt chart can give an accurate assessment of schedule performance down to the work package level.

A Tracking Gantt bar chart for the Digital Camera Prototype is shown in Figure 13.10. From this figure you can see Task C (Memory/Software), which had an original duration of 4 time units, now is expected to require 6 time units. This delay of 2 time units for Task C will also delay Tasks E and F two time units and result in the project being late 2 time periods.

Figure 13.11 shows an oversimplified project rollup at the end of period 7. The rollup is by deliverables and organization units. For example, the Memory/Software deliverable has an SV of $ −10 and a CV of −30. The responsible "Storage" department should have an explanation for these variances. Similarly, the assembly department, which is responsible for the Assemble and Test deliverables, has an SV of $ −30 due to the delay of Task C (see Figure 13.10). Most deliverables look unfavorable on schedule and cost variance.

In more complex projects, the crosstabs of cost accounts by deliverables and organization units can be very revealing and more profound. This example contains the basics for developing a status report, baseline development, and measuring schedule and cost variance. In our example, performance analysis had only one level above the cost account level. Because all data are derived from the detailed database, it is relatively easy to determine progress status at all levels of the work and organization breakdown structures. Fortunately, this same current database can provide additional views of the current status of the project and forecast costs at the completion of the project. Approaches for deriving additional information from the database are presented next.

To the uninitiated, a caveat is in order. In practice budgets may not be expressed in total dollars for an activity. Frequently, budgets are time-phased for materials and labor separately for more effective control over costs. Another common approach used in practice is to use labor hours in place of dollars in the earned value system. Later, labor hours are converted to dollars. The use of labor hours in the earned value system is the *modus operandi* for most construction work. Labor hours are easy to understand and are often the way many time and cost estimates are developed. Most earned value software easily accommodates the use of labor hours for development of cost estimates.

FIGURE 13.10
Digital Camera Project-Tracking Gantt Chart Showing Status—Through Period 7

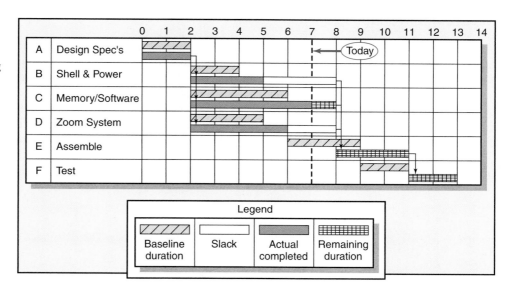

FIGURE 13.11 **Project Rollup End Period 7 ($000)**

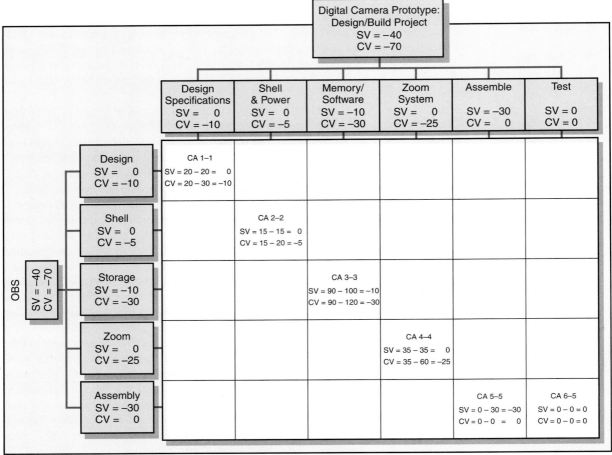

Indexes to Monitor Progress

Practitioners sometimes prefer to use schedule and cost indexes over the absolute values of SV and CV, because indexes can be considered efficiency ratios. Graphed indexes over the project life cycle can be very illuminating and useful. The trends are easily identified for deliverables and the whole project.

Indexes are typically used at the cost account level and above. In practice, the database is also used to develop indexes that allow the project manager and customer to view progress from several angles. An index of 1.00 (100 percent) indicates progress is as planned. An index greater than 1.00 shows progress is better than expected. An index less than 1.00 suggests progress is poorer than planned and deserves attention. Table 13.3 presents the interpretation of the indexes.

Performance Indexes

There are two indexes of performance efficiency. The first index measures *cost* efficiency of the work accomplished to date:

$$\text{Cost performance index (CPI)} = \text{EV/AC} = 160/230 = .696 \text{ or } .70$$

TABLE 13.3
Interpretation
of Indexes

Index	Cost (CPI)	Schedule (SPI)
>1.00	Under cost	Ahead of schedule
=1.00	On cost	On schedule
<1.00	Over cost	Behind schedule

The CPI of .696 shows that $.70 worth of work planned to date has been completed for each $1.00 actually spent—an unfavorable situation indeed. The CPI is the most accepted and used index. It has been tested over time and found to be the most accurate, reliable, and stable.

The second index is a measure of scheduling efficiency to date:

$$\text{Scheduling performance index (SPI)} = \text{EV/PV} = 160/200 = .80$$

The schedule index indicates $.80 worth of work has been accomplished for each $1.00 worth of scheduled work to date. Figure 13.12 shows the indexes plotted for our example project through period 7. This figure is another example of graphs used in practice.

Project Percent Complete Indexes

Two project percent complete indexes are used, depending on your judgment of which one is most representative of your project. The first index assumes the original budget of work complete is the most reliable information to measure project percent complete. The second index assumes the actual costs-to-date and expected cost at completion are the most reliable for measuring project percent complete. These indexes compare the to-date progress to the end of the project. The implications underlying use of these indexes are that conditions will not change, no improvement or action will be taken, and the information in the database is accurate. The first index looks at percent complete in terms of *budget* amounts:

$$\text{Percent complete index PCIB} = \text{EV/BAC} = 160/320 = .50 \ (50\%)$$

FIGURE 13.12
Indexes Periods 1–7

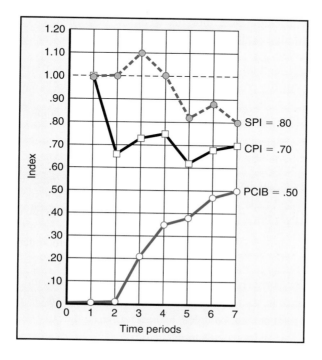

This PCIB indicates the work accomplished represents 50 percent of the total budgeted (BAC) dollars to date. Observe that this calculation does not include actual costs incurred. Because actual dollars spent do not guarantee project progress, this index is favored by many project managers when there is a high level of confidence in the original budget estimates.

The second index views percent complete in terms of *actual* dollars spent to accomplish the work to date and the actual expected dollars for the completed project (EAC). For example, at the end of period 7 the staff re-estimates that the EAC will be 575 instead of 320. The application of this view is written as

$$\text{Percent complete index PCIC} = AC/EAC = 230/575 = .40 \ (40\%)$$

Some managers favor this index because it contains actual and revised estimates that include newer, more complete information.

These two views of percent complete present alternative views of the "real" percent complete. These percents may be quite different as shown above. (Note: The PCIC index was not plotted in Figure 13.12. The new figures for EAC would be derived each period by estimators in the field.)

Technical Performance Measurement

Measuring technical performance is as important as measuring schedule and cost performance. Although technical performance is often assumed, the opposite can be true. The ramifications of poor technical performance frequently are more profound—something works or it doesn't if technical specifications are not adhered to.

Assessing technical performance of a system, facility, or product is often accomplished by examining the documents found in the scope statement and/or work package documentation. These documents should specify criteria and tolerance limits against which performance can be measured. For example, the technical performance of a software project suffered because the feature of "drag and drop" was deleted in the final product. Conversely, the prototype of an experimental car exceeded the miles per gallon technical specification and, thus, its technical performance. Frequently tests are conducted on different performance dimensions. These tests become an integral part of the project schedule.

It is very difficult to specify how to measure technical performance because it depends on the nature of the project. Suffice it to say, measuring technical performance must be done. Technical performance is frequently where quality control processes are needed and used. Project managers must be creative in finding ways to control this very important area.

Software for Project Cost/Schedule Systems

Software developers have created sophisticated schedule/cost systems for projects that track and report budget, actual, earned, committed, and index values. These values can be labor hours, materials, and/or dollars. This information supports cost and schedule progress, performance measurements, and cash flow management. Recall from Chapter 5 that budget, actual, and committed dollars usually run in different time frames (see Figure 5.6). A typical computer-generated status report includes the following information outputs:

1. Schedule variance (EV − PV) by cost account and WBS and OBS.
2. Cost variance (EV − AC) by cost account and WBS and OBS.
3. Indexes—total percent complete and performance index.
4. Cumulative actual total cost to date (AC).

5. Expected costs at completion (EAC).
6. Paid and unpaid commitments.

The variety of software packages, with their features and constant updating, is too extensive for inclusion in this text. Software developers and vendors have done a superb job of providing software to meet the information needs of most project managers. Differences among software in the last decade have centered on improving "friendliness" and output that is clear and easy to understand. Anyone who understands the concepts and tools presented in Chapters 4, 5, 6, 8, and 13 should have little trouble understanding the output of any of the popular project management software packages.

Additional Earned Value Rules

Although the percent complete rule is the most-used method of assigning budgets to baselines and for cost control, there are additional rules that are very useful for reducing the overhead costs of collecting detailed data on percent complete of individual work packages. (An additional advantage of these rules, of course, is that they remove the often subjective judgments of the contractors or estimators as to how much work has actually been completed.) The first two rules are typically used for short-duration activities and/or small-cost activities. The third rule uses gates before the total budgeted value of an activity can be claimed.

- **0/100 rule.** This rule assumes credit is earned for having performed the work once it is completed. Hence, 100 percent of the budget is earned when the work package is completed. This rule is used for work packages having very short durations.
- **50/50 rule.** This approach allows 50 percent of the value of the work package budget to be earned when it is started and 50 percent to be earned when the package is completed. This rule is popular for work packages of short duration and small total costs.
- **Percent complete with weighted monitoring gates.** This more recent rule uses subjective estimated percent complete in combination with hard, tangible monitoring points. This method works well on long-duration activities that can be broken into short, discrete work packages of no more than one or two report periods. These discrete packages limit the subjective estimated values. For example, assume a long-duration activity with a total budget of $500. The activity is cut into three sequentially discrete packages with monitoring gates representing 30, 50, and 100 percent of the total budget. The earned amount at each monitoring gate cannot exceed $150, $250, and $500. These hard monitoring points serve as a check on overly optimistic estimates.

Notice the only information needed for the first two rules is that the work package has started and the package has been completed. For those who wish to explore the application of these two rules, or who are studying for certification, Appendix 13.1 presents two exercises that apply these rules along with the percent complete rule.

The third rule is frequently used to authorize progress payments to contractors. This rule supports careful tracking and control of payments; it discourages payment to contractors for work not yet completed. (See Fleming and Koppelman for an excellent discussion of applying earned value rules.)

Forecasting Final Project Cost

There are basically two methods used to revise estimates of future project costs. In many cases both methods are used on specific segments of the project. The result is confusion of terms in texts, in software, and among practitioners in the field. We have chosen to note the differences between the methods.

The first method allows experts in the field to change original baseline durations and costs because new information tells them the original estimates are not accurate. We have used EAC_{re} to represent revisions made by experts and practitioners associated with the project. The revisions from project experts are almost always used on smaller projects.

The equation for calculating revised estimated cost at completion (EAC_{re}) is as follows:

$$EAC_{re} = AC + ETC_{re}$$

where EAC_{re} = revised estimated cost at completion.
 AC = cumulative actual cost of work completed to date.
 ETC_{re} = revised estimated cost to complete remaining work.

A second method is used in large projects where the original budget is less reliable. This method uses the actual costs to date plus an efficiency index ($CPI = EV/AC$) applied to the remaining project work. When the estimate for completion uses the CPI as the basis for forecasting cost at completion, we use the acronym EAC_f. The equation is presented here.

The equation for this forecasting model (EAC_f) is as follows:

$$EAC_f = ETC + AC$$

$$ETC = \frac{\text{Work remaining}}{CPI} = \frac{BAC - EV}{EV/AC}$$

where EAC_f = estimated total cost at completion.
 ETC = estimated cost to complete remaining work.
 AC = cumulative actual cost of work completed to date.
 CPI = cumulative cost index to date.
 BAC = total budget of the baseline.
 EV = cumulative budgeted cost of work completed to date.

The following information is available from our earlier example; the estimate cost at completion (EAC_f) is computed as follows:

Total baseline budget (BAC) for the project	$320
Cumulative earned value (EV) to date	$160
Cumulative actual cost (AC) to date	$230

$$EAC_f = \frac{320 - 160}{160/230} + 230 = \frac{160}{.7} + 230 = 229 + 230$$

$$EAC_f = 459$$

The final project projected cost forecast is $459,000 versus $320,000 originally planned.

Another popular index is the To Complete Performance Index (TCPI), which is useful as a supplement to the estimate at complete (EAC_f) computation. This ratio measures the amount of value each *remaining* dollar in the budget must earn to stay within the budget. The index is computed for the Digital Camera project at the end of period 7.

$$TCPI = \frac{BAC - EV}{BAC - AC} = \frac{320 - 160}{320 - 230} = \frac{160}{90} = 1.78$$

The index of 1.78 indicates that each remaining dollar in the budget must earn $1.78 in value. There is more work to be done than there is budget left. Clearly, it would be tough to increase productivity that much to make budget. The work to be done will have to be reduced or you will have to accept running over budget. If the TCPI is less than 1.00, you should be able to complete the project without using all of the remaining budget. A ratio of less than 1.00 opens the possibility of other opportunities such as improving quality, increasing profit, or expanding scope.

Research data indicate that on large projects that are more than 15 percent complete, the model performs well with an error of less than 10 percent. This model can also be used for WBS and OBS cost accounts that have been used to forecast remaining and total costs. It is important to note that this model assumes conditions will not change, the cost database is reliable, EV and AC are cumulative, and past project progress is representative of future progress. This objective forecast represents a good starting point or benchmark that management can use to compare other forecasts that include other conditions and subjective judgments.

Exhibit 13.1 presents an abridged monthly status report similar to one used by a project organization. The form is used for all projects in their project portfolio. (Note that the schedule variance of −$22,176 does not translate directly to days. The 25 days were derived from the network schedule.)

Another summary report is shown in the Snapshot from Practice: Trojan Decommissioning Project. Compare the differences in format.

EXHIBIT 13.1
Monthly Status Report

Project number: 163 **Project manager:** Connor Gage
Project priority now: 4
Status as of: April 1, 2007
Earned value figures:

PV	EV	AC	SV	CV	BAC
588,240	566,064	596,800	−22,176	−30,736	1,051,200
EAC	**VAC**	**EAC$_f$**	**CPI**	**PCIB**	**PCIC**
1,090,640	−39,440	1,107,469	.95	.538	.547

Project description: A computer-controlled conveyor belt that will move and position items on the belt with accuracy of less than one millimeter.

Status summary: The project is approximately 25 days behind schedule. The project has a cost variance of ($30,736).

Explanations: The schedule variance has moved from noncritical activities to those on the critical path. Integration first phase, scheduled to start 3/26, is now expected to start 4/19, which means it is approximately 25 days behind schedule. This delay is traced to the loss of the second design team which made it impossible to start utilities documentation on 2/27 as planned. This loss illustrates the effect of losing valuable resources on the project. The cost variance to date is largely due to a design change that cost $21,000.

Major changes since last report: The major change was loss of one design team to the project.

Total cost of approved design changes: $21,000. Most of this amount is attributed to the improved design of the serial I/O drivers.

Projected cost at completion: EAC$_f$ is estimated to be $1,107,469. This represents an overrun of −$56,269, given a CPI of .95. The CPI of .95 causes the forecast to be greater than the VAC −$39,440.

Risk watch: Nothing suggests the risk level of any segments has changed.

Brendan McDermid/EPA/Landov.

Portland General Electric Company has been charged with decommissioning the Trojan Nuclear Plant. This is a long and complex project extending over two decades. The first segment of the project of moving the used reactors to a storage location is complete and was awarded the Project of the Year, 2000, by the Project Management Institute (PMI). The remainder of the project—decontamination of the remaining structures and waste—is ongoing.

The figure on page 442 shows their earned value status report through December 2000. This report measures schedule and cost performance for monitoring the project. The report also serves as a basis for funding for rate filings with the Public Utilities Commission.

The SPI (0.94) suggests the project schedule is falling behind. Resolving issues with a major vendor and solutions for technical problems should solve these delay problems. The CPI (1.14) for the project is positive. Some of this good cost performance is attributed to partnering and incentive arrangements with vendors and labor unions.

Interview with Michael B. Lackey, general manager, Trojan, PGE (September 2001).

Other Control Issues

Scope Creep

Large changes in scope are easily identified. It is the "minor refinements" that eventually build to be major scope changes that can cause problems. These small refinements are known in the field as *scope creep*. For example, the customer of a software developer requested small changes in the development of a custom accounting software package. After several minor refinements, it became apparent the changes represented a significant enlargement of the original project scope. The result was an unhappy customer and a development firm that lost money and reputation.

Although scope changes are usually viewed negatively, there are situations when scope changes result in positive rewards. Scope changes can represent significant opportunities. In product development environments, adding a small feature to a product can result in a huge competitive advantage. A small change in the production process may get the product to market one month early or reduce product cost.

Scope creep is common early in projects—especially in new-product development projects. Customer requirements for additional features, new technology, poor design assumptions, etc., all manifest pressures for scope changes. Frequently these changes are small and go unnoticed until time delays or cost overruns are observed. Scope creep affects the organization, project team, and project suppliers. Scope changes alter the organization's cash flow requirements in the form of fewer or additional resources, which may also affect other projects. Frequent changes eventually wear down team motivation and cohesiveness. Clear team goals are altered, become less focused, and cease being the focal point for team action. Starting over again is annoying and demoralizing to the project team because it disrupts project rhythm and lowers productivity. Project suppliers resent frequent changes because they represent higher costs and have the same effect on their team as on the project team.

The key to managing scope creep is change management. One project manager of an architectural firm related that scope creep was the biggest risk his firm faced in projects. The best defense against scope creep is a well-defined scope statement. Poor scope statements are one of the major causes of scope creep.

A second defense against scope creep is stating what the project is not, which can avoid misinterpretations later. (Chapter 7 discusses the process. See Figure 7.9 to review key variables to document in project changes.) First, the original baseline must be well defined and agreed upon with the project customer. Before the project begins, it is imperative that clear procedures be in place for authorizing and documenting scope changes by the customer or project team. If a scope change is necessary, the impact on the baseline should be clearly documented—for example, cost, time, dependencies, specifications, responsibilities, etc. Finally, the scope change must be quickly added to the original baseline to reflect the change in budget and schedule; these changes and their impacts need to be communicated to all project stakeholders.

Baseline Changes

Changes during the life cycle of projects are inevitable and will occur. Some changes can be very beneficial to project outcomes; changes having a negative impact are the ones we wish to avoid. Careful project definition can minimize the need for changes. The price for poor project definition can be changes that result in cost overruns, late schedules, low morale, and loss of control. Change comes from external sources or from within. Externally, for example, the customer may request changes that were not included in the original scope statement and that will require significant changes to the project and thus to the baseline. Or the government may render requirements that were not a part of the original plan and that require a revision of the project scope. Internally, stakeholders may identify unforeseen problems or improvements that change the scope of the project. In rare cases scope changes can come from several sources. For example, the Denver International Airport automatic baggage handling system was an afterthought supported by several project stakeholders that included the Denver city government, consultants, and at least one airline customer. The additional $2 billion in costs were staggering, and the airport opening was delayed 16 months. If this automatic baggage scope change had been in the original plan, costs would have been only a fraction of the overrun costs, and delays would have been reduced significantly. Any changes in scope or the baseline should be recorded by the change control system that was set in place during risk control planning. (See Chapter 7.)

Generally, project managers monitor scope changes very carefully. They should allow scope changes only if it is clear that the project will fail without the change, the project will be improved significantly with the change, or the customer wants it and will pay for it. This statement is an exaggeration, but it sets the tone for approaching baseline changes. The effect of the change on the scope and baseline should be accepted and signed off by

Cost/Budget Performance — Decommissioning Cumulative Costs — Nominal Year Dollars

Portland General Electric Co.-Trojan Nuclear Plant Report Run: 23-Jan-01 8:13 A.M. Report Number: DECT005

Description	Dec 2000			Year-to-Date			YTD Variance EV-AC	2000 PV	CPI EV/AC	SPI EV/PV
	PV	EV	AC	PV	EV	AC				
ISFSI	193,014	182,573	162,579	3,655,677	3,586,411	3,263,995	322,416	3,655,677	1.10	0.98
RVAIR	0	0	0	0	0	399	(399)	0	0.00	0.00
Equip removal—AB/FB	79,083	79,649	73,899	497,197	504,975	308,461	196,514	497,197	1.64	1.02
Equip removal—other	0	0	0	0	(36,822)	519	(37,341)	0	0.00	0.00
Embed piping—AB/FB	3,884	0	2,118	532,275	540,232	515,235	24,997	532,275	1.05	1.01
Embed piping—other	0	0	3,439	175,401	210,875	79,235	131,640	175,401	2.66	1.20
Surface decon—AB/FB	29,935	23,274	21,456	1,266,685	1,293,315	1,171,712	121,603	1,266,665	1.10	1.02
Surface decon—other	2,875	2	11,005	308,085	199,853	251,265	(51,412)	308,085	0.80	0.65
Surface decon—containment	680,502	435,657	474,427	5,271,889	4,950,528	4,823,338	127,190	5,271,889	1.03	0.94
Radwaste disposal	884,873	453,032	(28,675)	10,680,118	8,276,616	10,807,916	(2,531,300)	10,880,118	0.77	0.77
Final survey	58,238	57,985	27,091	780,990	780,990	700,942	80,048	780,990	1.11	1.00
Nonradiological areas	92,837	91,956	58,538	2,471,281	2,376,123	834,643	1,541,480	2,471,281	2.85	0.96
Staffing	714,806	714,509	468,858	9,947,775	9,947,775	8,241,383	1,706,392	9,947,775	1.21	1.00
ISFSI—Long-term ops	85,026	85,028	19,173	2,004,398	2,004,398	337,206	1,667,192	2,004,398	5.94	1.00
Labor loadings	258,289	258,289	240,229	3,216,194	3,216,194	2,755,604	460,590	3,216,194	1.17	1.00
Material loadings	17,910	17,910	(95,128)	211,454	211,454	136,973	74,481	211,454	1.54	1.00
Corporate governance	153,689	228,499	228,521	1,814,523	1,814,523	1,814,520	3	1,814,523	1.00	1.00
Undistributable costs	431,840	401,720	242,724	5,541,679	5,575,879	4,007,732	1,567,947	5,541,679	1.39	1.01
Total decommissioning	3,688,481	3,008,081	1,905,084	48,375,399	45,453,119	40,051,079	5,402,040	48,375,399	1.13	0.94
Total (less ISFSI and RVAIR)	3,493,467	2,845,508	1,743,485	44,719,720	41,886,710	36,788,680	5,080,024	44,719,720	1.14	0.94

the project customer. Figure 13.13 depicts the cost impact of a scope change on the baseline at a point in time—"today." Line A represents a scope change that results in an increase in cost. Line B represents a scope change that decreases cost. Quickly recording scope changes to the baseline keeps the computed earned values valid. Failure to do so results in misleading cost and schedule variances.

Care should be taken to not use baseline changes to disguise poor performance on past or current work. A common signal of this type of baseline change is a constantly revised baseline that seems to match results. Practitioners call this a "rubber baseline" because it stretches to match results. Most changes will not result in serious scope changes and should be absorbed as positive or negative variances. Retroactive changes for work already accomplished should not be allowed. Transfer of money among cost accounts should not be allowed after the work is complete. Unforeseen changes can be handled through the contingency reserve. The project manager typically makes this decision. In some large projects, a partnering "change review team," made up of members of the project and customer teams, makes all decisions on project changes.

The Costs and Problems of Data Acquisition

Data acquisition is time consuming and costly. The Snapshot from Practice: A Pseudo-Earned Value Percent Complete Approach captures some of the frequent issues surrounding resistance to data collection of percent complete for earned value systems. Similar pseudo-percent complete systems have been used by others. Such pseudo-percent complete approaches appear to work well in multiproject environments that include several small and medium-sized projects. Assuming a one-week reporting period, care needs to be taken to develop work packages with a duration of about one week long so problems are identified quickly. For large projects, there is no substitute for using a percent complete system that depends on data collected through observation at clearly defined monitoring points.

In some cases data exist but are not sent to the stakeholders who need information relating to project progress. Clearly, if the information does not reach the right people in a timely manner, you can expect serious problems. Your communication plan developed in

FIGURE 13.13
Scope Changes to a Baseline

A consultant for the U.S. Forest Service suggested the use of earned value to monitor the 50-plus timber sale projects taking place concurrently in the district. As projects were completed, new ones were started. Earned value was tried for approximately nine months. After a nine-month trial, the process was to be reviewed by a task force. The task force concluded the earned value system provided good information for monitoring and forecasting project progress; however, the costs and problems of collecting timely percent complete data were unacceptable because there were no funds available to collect such data.

The level of detail dilemma was discussed, but no suggestions satisfied the problem. The discussion recognized that too little data fail to offer good control, while excessive reporting requires paperwork and people, which are costly. The task force concluded progress and performance could be measured using a pseudo-version of percent complete while not giving up much

accuracy for the total project. This modified approach to percent complete required that very large work packages (about 3 to 5 percent of all work packages in a project) be divided into smaller work packages for closer control and identification of problems sooner. It was decided work packages of about a week's duration would be ideal. The pseudo-version required only a telephone call and "yes/no" answers to one of the following questions to assign percent complete:

Has work on the work package started?	No = 0%
Working on the package?	Yes = 50%
Is the work package completed?	Yes = 100%

Data for the pseudo-earned value percent complete system was collected for all 50-plus projects by an intern working fewer than eight hours each week.

the project planning stage can greatly mitigate this problem by mapping out the flow of information and keeping stakeholders informed on all aspects of project progress and issues. See Figure 13.14 for an internal communication plan for a WiFi Project. The information developed in this chapter contributes significant data to support your communication plan and ensures correct dissemination of the data.

FIGURE 13.14
Conference Center WiFi Project Communication Plan

What Information	When?	Mode?	Responsible?	Recipient?
Milestone report	Bimonthly	E-mail	Project office	Senior management
Time/cost report	Weekly	E-mail	Project office	Staff and customer
Risk report	Weekly	E-mail	Project office	Staff and customer
Issues	Weekly	E-mail	Anyone	Staff and customer
Team meeting times	Weekly	Meeting	Project manager	Staff and customer
Outsourcing performance	Bimonthly	Meeting	Project manager	Project office, staff, and customer
Change requests	Anytime	Document	Project manager, customer, design	Project office, staff, and customer
Stage gate decisions	Monthly	Meeting	Project office	Senior management

Summary

The best information system does not result in good control. Control requires the project manager to *use* information to steer the project through rough waters. Control and Gantt charts are useful vehicles for monitoring time performance. The cost/schedule system allows the manager to have a positive influence on cost and schedule in a timely manner. The ability to influence cost decreases with time; therefore, timely reports identifying adverse cost trends can greatly assist the project manager in getting back on budget and schedule. The integrated cost/schedule model provides the project manager and other stakeholders with a snapshot of the current and future status of the project. The benefits of the cost/schedule model are as follows:

1. Measures accomplishments against plan and deliverables.
2. Provides a method for tracking directly to a problem work package and organization unit responsible.
3. Alerts all stakeholders to early identification of problems, and allows for quick, proactive corrective action.
4. Improves communication because all stakeholders are using the same database.
5. Keeps customer informed of progress, and encourages customer confidence that the money spent is resulting in the expected progress.
6. Provides for accountability over individual portions of the overall budget for each organizational unit.

With your information system in place, you need to use your communication plan to keep stakeholders informed so timely decisions can be made to ensure the project is managed effectively.

Key Terms

Baseline budget	Estimated cost at	Scope creep
Control chart	completion (EAC)	To complete performace
Cost performance index	Percent complete index	index (TCPI)
(CPI)	Schedule performance	Tracking Gantt chart
Cost variance (CV)	index (SPI)	Variance at completion
Earned value (EV)	Schedule variance (SV)	(VAC)

Review Questions

1. How does a Tracking Gantt chart help communicate project progress?
2. How does earned value give a clearer picture of project schedule and cost status than a simple plan versus actual system?
3. Schedule variance (SV) is in dollars and does not directly represent time. Why is it still useful?
4. How would a project manager use the CPI?
5. What are the differences between BAC and EAC?
6. Why is it important for project managers to resist changes to the project baseline? Under what conditions would a project manager make changes to a baseline? When would a project manager not allow changes to a baseline?

Exercises

1. In month 9 the following project information is available: actual cost is $2,000, earned value is $2,100, and planned cost is $2,400. Compute the SV and CV for the project.
2. On day 51 a project has an earned value of $600, an actual cost of $650, and a planned cost of $560. Compute the SV, CV, and CPI for the project. What is your assessment of the project on day 51?

3. Given the project network and baseline information below, complete the form to develop a status report for the project at the end of period 4 and the end of period 8. From the data you have collected and computed for periods 4 and 8, what information are you prepared to tell the customer about the status of the project at the end of period 8?

Task	Dur.	ES	LF	Slack	Budget (PV)	0	1	2	3	4	5	6	7	8	9	10	11	12	13	14	15
					Project baseline (PV) (in $)																
A	2	0	2	0	400	200	200														
B	6	2	8	0	2400			200	600	200	600	200	600								
C	5	2	9	2	1500			200	400	500	100	300									
D	4	8	12	0	1600										400	400	400	400			
E	3	7	12	2	900									300	400	200					
F	3	12	15	0	600														200	100	300
Period PV total						200	200	400	1000	700	700	500	900	800	600	400	400	200	100	300	
Cumulative PV total						200	400	800	1800	2500	3200	3700	4600	5400	6000	6400	6800	7000	7100	7400	

End of Peroid 4

Task	Actual % Complete	EV	AC	PV	CV	SV
A	Finished	——	300	400	——	——
B	50%	——	1000	800	——	——
C	33%	——	500	600	——	——
D	0	——	0	——	——	——
E	0	——	0	——	——	——
Cumulative Totals		——	——	——	——	——

End of Peroid 8

Task	Actual % Complete	EV	AC	PV	CV	SV
A	Finished	——	300	400	——	——
B	Finished	——	2200	2400	——	——
C	Finished	——	1500	1500	——	——
D	25%	——	300	0	——	——
E	33%	——	300	——	——	——
F	0	——	0	——	——	——
Cumulative Totals		——	——	——	——	——

4. Given the following project network, baseline, and status information, develop status reports for periods 1–4 and complete the project summary graph (or a similar one). Report the final SV, CV, CPI, and PCIB. Based on your data, what is your assessment of the current status of the project? At completion?

	Schedule information					Baseline budget needs ($ 000)						
ACT/WP	DUR	ES	LF	SL	Total PV	Time period						
						0	1	2	3	4	5	6
1	2	0	3	1	12	4	8					
2	3	0	3	0	15	3	7	5				
3	2	0	2	0	8	4	4					
4	2	2	5	1	6			3	3			
5	2	3	5	0	10				6	4		
6	3	2	5	0	9			3	3	3		
7	1	5	6	0	5							5
	Total PV by period					11	19	11	12	7	5	
	Cumulative PV by period					11	30	41	53	60	65	

Status Report: Ending Period 1

Task	%Complete	EV	AC	PV	CV	SV
1	50%	——	6	4	——	——
2	40%	——	8	3	——	——
3	25%	——	3		——	——
Cumulative Totals		——	17		——	——

Status Report: Ending Period 2

Task	%Complete	EV	AC	PV	CV	SV
1	Finished	——	13	——	——	——
2	80%	——	14	——	——	——
3	75%	——	8	——	——	——
Cumulative Totals		——	**35**	——	——	——

Status Report: Ending Period 3

Task	%Complete	EV	AC	PV	CV	SV
1	Finished	12	13	——	——	——
2	80%	——	15	——	——	——
3	Finished	——	10	——	——	——
4	50%	——	4	——	——	——
5	0%	——	0	——	——	——
6	33.3%	——	4	——	——	——
Cumulative Totals		——	——	——	——	——

Status Report: Ending Period 4

Task	%Complete	EV	AC	PV	CV	SV
1	Finished	12	13	——	——	——
2	Finished	15	18	——	——	——
3	Finished	——	10	——	——	——
4	Finished	——	8	——	——	——
5	30%	——	3	——	——	——
6	66.7%	——	8	——	——	——
7	0%	——	0	——	——	——
Cumulative Totals		——	——	——	——	——

Summary Graph

5. The following labor hours data have been collected for a nanotechnology project for periods 1 through 6. Compute the SV, CV, SPI, and CPI for each period. Plot the EV and the AC on the summary graph provided (or a similar one). Plot the SPI, CPI, and PCIB on the index graph provided (or a similar one). What is your assessment of the project at the end of period 6?

	Schedule information					Baseline budget needs–labor hours (00)														
ACT/WP	DUR	ES	LF	SL	Total PV								Time period							
						0	1	2	3	4	5	6	7	8	9	10	11	12	13	14
1	2	0	2	0	20	10	10													
2	2	2	7	3	24			16	8											
3	6	2	11	3	30			5	5	10	3	2	5							
4	5	2	7	0	25			10	10	2	2	1								
5	4	4	11	3	16					4	4	4	4							
6	4	7	11	0	20								5	5	6	4				
7	2	11	13	0	10													5	5	
				Total PV by period		10	10	31	23	16	9	7	14	5	6	4	5	5		
				Cumulative PV by period		10	20	51	74	90	99	106	120	125	131	135	140	145		

Status Report: Ending Period 1

Task	%Complete	EV	AC	PV	CV	SV
1	50%	——	500	1000	——	——
Cumulative Totals		——	**500**	**1000**	——	——

Status Report: Ending Period 2

Task	%Complete	EV	AC	PV	CV	SV
1	Finished	——	1500	2000	——	——
Cumulative totals		——	**1500**	**2000**	——	——

Status Report: Ending Period 3

Task	%Complete	EV	AC	PV	CV	SV
1	Finished	2000	1500	2000	——	——
2	0%	——	0		——	——
3	10%	——	200		——	——
4	20%	——	500		——	——
Cumulative Totals		——	**2200**		——	——

Status Report: Ending Period 4

Task	%Complete	EV	AC	PV	CV	SV
1	Finished	2000	1500	2000	——	——
2	50%	——	1000		——	——
3	30%	——	800		——	——
4	40%	——	1500		——	——
Cumulative Totals		——	**4800**		——	——

Status Report: Ending Period 5

Task	%Complete	EV	AC	PV	CV	SV
1	Finished	2000	1500	2000	——	——
2	Finished	——	2000		——	——
3	50%	——	800		——	——
4	60%	——	1500		——	——
5	25%	——	400		——	——
Cumulative Totals		——	**6200**		——	——

Status Report: Ending Period 6

Task	%Complete	EV	AC	PV	CV	SV
1	Finished	2000	1500	2000	——	——
2	Finished	——	2000		——	——
3	80%	——	2100		——	——
4	80%	——	1800		——	——
5	50%	——	600		——	——
Cumulative Totals		——	**8000**		——	——

Period	SPI	CPI	PCIB
1	——	——	——
2	——	——	——
3	——	——	——
4	——	——	——
5	——	——	——
6	——	——	——

$$SPI = EV/PV$$
$$CPI = EV/AC$$
$$PCIB = EV/BAC$$

Summary Graph

Indexes Periods 1–6

6. The following data have been collected for a British health care IT project for two-week reporting periods 2 through 12. Compute the SV, CV, SPI, and CPI for each period. Plot the EV and the AC on the summary graph provided. Plot the SPI, CPI, and PCIB on the index graph provided. (You may use your own graphs.) What is your assessment of the project at the end of period 12?

					Baseline (PV) ($00)												
Task	Dur.	ES	LF	Slack	PV ($00)	0	2	4	6	8	10	12	14	16	18	20	22
1	4	0	4	0	8	4	4										
2	8	4	14	2	40			10	10	10	10						
3	6	4	10	0	30			10	15	5							
4	4	4	10	2	20			10	10								
5	4	10	14	0	40						20	20					
6	8	8	18	2	60					20	20	10	10				
7	4	14	18	0	20								10	10			
8	4	18	22	0	30											20	10
			Period PV total			4	4	30	35	35	50	30	20	10	20	10	
			Cumulative PV total			4	8	38	73	108	158	188	208	218	238	248	

Status Report: Ending Period 2

Task	%Complete	EV	AC	PV	CV	SV
1	50%	——	4	——	——	——
Cumulative totals		——	**4**	——	——	——

Status Report: Ending Period 4

Task	%Complete	EV	AC	PV	CV	SV
1	Finished	——	10	——	——	——
Cumulative Totals		——	**10**	——	——	——

Status Report: Ending Period 6

Task	%Complete	EV	AC	PV	CV	SV
1	Finished	——	10	——	——	——
2	25%	——	15	——	——	——
3	33%	——	12	——	——	——
4	0%	——	0	——	——	——
Cumulative Totals		——	**37**	——	——	——

Status Report: Ending Period 8

Task	%Complete	EV	AC	PV	CV	SV
1	Finished	——	10	——	——	——
2	30%	——	20	——	——	——
3	60%	——	25	——	——	——
4	0%	——	0	——	——	——
Cumulative Totals		——	**55**	——	——	——

Status Report: Ending Period 10

Task	%Complete	EV	AC	PV	CV	SV
1	Finished	——	10	——	——	——
2	60%	——	30	——	——	——
3	Finished	——	40	——	——	——
4	50%	——	20	——	——	——
5	0%	——	0	——	——	——
6	30%	——	24	——	——	——
Cumulative Totals		——	**124**	——	——	——

Status Report: Ending Period 12

Task	%Complete	EV	AC	PV	CV	SV
1	Finished	——	10	——	——	——
2	Finished	——	50	——	——	——
3	Finished	——	40	——	——	——
4	Finished	——	40	——	——	——
5	50%	——	30	——	——	——
6	50%	——	40	——	——	——
Cumulative Totals		——	**210**	——	——	——

Period	SPI	CPI	PCIB
2	___	___	___
4	___	___	___
6	___	___	___
8	___	___	___
10	___	___	___
12	___	___	___

SPI = EV/PV
CPI = EV/AC
PCIB = EV/BAC

Summary Graph

Indexes Periods 2–12

References

Abramovici, A. "Controlling Scope Creep," *PM Network,* Vol. 14, No. 1, January 2000, pp. 44–48.

Anbari, F. T., "Earned Value Project Management Method and Extensions," *Project Management Journal,* Vol. 34, No. 4, December 2003, pp. 12–22.

Brandon, D. M. Jr., "Implementing Earned Value Easily and Effectively," *Project Management Journal,* Vol. 29, No. 3, June 1998, pp. 11–17.

Fleming, Q. and Joel M. Koppelman, *Earned Value Project Management,* 3rd ed. (Project Management Institute, Newton Square, PA, 2006).

Kerzner, H. "Strategic Planning for a Project Office," *Project Management Journal,* Vol. 34, No. 2, June 2003, pp. 13–25.

Webb, A. *Using Earned Value: A Project Manager's Guide,* (Gower Publishing Co., Aldershot, UK, 2003).

Case

Scanner Project

You have been serving as Electroscan's project manager and are now well along in the project. Develop a narrative status report for the board of directors of the chain store that discusses the status of the project to date and at completion. Be as specific as you can using numbers given and those you might develop. Remember, your audience is not familiar with the jargon used by project managers and computer software personnel; therefore, some explanation may be necessary. Your report will be evaluated on your detailed use of the data, your total perspective of the current status and future status of the project, and your recommended changes (if any).

Electroscan, Inc.
555 Acorn Street, Suite 5
Boston, Massachusetts

29 In-store Scanner Project
(thousands of dollars)
Actual Progress as of January 1

Name	PV	EV	AC	SV	CV	BAC	EAC_f
Scanner project	420	395	476	−25	−81	915	1103
H 1.0 Hardware	92	88	72	−4	16	260	213
H 1.1 Hardware specifications (DS)	20	20	15	0	5	20	15
H 1.2 Hardware design (DS)	30	30	25	0	5	30	25
H 1.3 Hardware documentation (DOC)	10	6	5	−4	1	10	8
H 1.4 Prototypes (PD)	2	2	2	0	0	40	40
H 1.5 Test prototypes (T)	0	0	0	0	0	30	30
H 1.6 Order circuit boards (PD)	30	30	25	0	5	30	25
H 1.7 Preproduction models (PD)	0	0	0	0	0	100	100
OP 1.0 Operating system	195	150	196	−45	−46	330	431
OP 1.1 Kernel specifications (DS)	20	20	15	0	5	20	15
OP 1.2 Drivers	45	55	76	10	−21	70	97
OP 1.2.1 Disk drivers (DEV)	25	30	45	5	−15	40	60
OP 1.2.2 I/O drivers (DEV)	20	25	31	5	−6	30	37
OP 1.3 Code software	130	75	105	−55	−30	240	336
OP 1.3.1 Code software (C)	30	20	40	−10	−20	100	200
OP 1.3.2 Document software (DOC)	45	30	25	−15	5	50	42
OP 1.3.3 Code interfaces (C)	55	25	40	−30	−15	60	96
OP 1.3.4 Beta test software (T)	0	0	0	0	0	30	30
U 1.0 Utilities	87	108	148	21	−40	200	274
U 1.1 Utilities specifications (DS)	20	20	15	0	5	20	15
U 1.2 Routine utilities (DEV)	20	20	35	0	−15	20	35
U 1.3 Complex utilities (DEV)	30	60	90	30	−30	100	150
U 1.4 Utilities documentation (DOC)	17	8	8	−9	0	20	20
U 1.5 Beta test utilities (T)	0	0	0	0	0	40	40
S 1.0 System integration	46	49	60	3	−11	125	153
S 1.1 Architecture decisions (DS)	9	9	7	0	2	10	8
S 1.2 Integration hard/soft (DEV)	25	30	45	5	−15	50	75
S 1.3 System hard/software test (T)	0	0	0	0	0	20	20
S 1.4 Project documentation (DOC)	12	10	8	−2	2	15	12
S 1.5 Integration acceptance testing (T)	0	0	0	0	0	30	30

Appendix 13.1

The Application of Additional Earned Value Rules

The following example and exercises are designed to provide practice in applying the following three earned value rules:

- Percent complete rule
- 0/100 rule
- 50/50 rule

See the chapter for an explanation of each of these rules.

SIMPLIFYING ASSUMPTIONS

The same simplifying assumptions used for the chapter example and exercises will be also used here.

1. Assume each cost account has only one work package, and each cost account will be represented as an activity on the network.
2. The project network early start times will serve as the basis for assigning the baseline values.
3. Except when the 0/100 rule or 50/50 rule is used, baseline values will be assigned linearly, unless stated differently. (Note: In practice estimated costs should be applied "exactly" as they are expected to occur so measures of schedule and cost performance are useful and reliable.)
4. For purposes of demonstrating the examples, from the moment work on an activity begins, some actual costs will be incurred each period until the activity is completed.
5. When the 0/100 rule is used, the total cost for the activity is placed in the baseline on the early finish date.
6. When the 50/50 rule is used, 50 percent of the total cost is placed in the baseline on the early start date and 50 percent on the early finish date.

APPENDIX EXERCISES

1. Given the information provided for development of a product warranty project for periods 1 through 7, compute the SV, CV, SPI, and CPI for each period. Plot the EV and the AC on the PV graph provided. Explain to the owner your assessment of the project at the end of period 7 and the future expected status of the project at completion. Figure A13.1.1A presents the project network. Figure A13.1.1B presents the project baseline noting those activities using the 0/100 (rule 3) and 50/50 (rule 2) rules. For example, activity 1 uses rule 3, the 0/100 rule. Although the early start time is period 0, the budget is not placed in the time-phased baseline until period 2 when the activity is planned to be finished (EF). This same procedure has been used to assign costs for activities 2 and 7. Activities 2 and 7 use the 50/50 rule. Thus, 50 percent of the budget for each activity is assigned on its respective early start date (time period 2 for activity 2 and period 11 for activity 7) and 50 percent for their respective finish dates. Remember, when assigning earned value as the project is being implemented, if an activity actually starts early or late, the earned values must shift with the actual times. For example, if activity 7 actually starts in period 12 rather than 11, the 50 percent is not earned until period 12.

FIGURE A13.1.1A

FIGURE A13.1.1B

	Schedule information						Baseline budget needs															
EV Rule	ACT/ WP	DUR	ES	LF	SL	Total PV	Time period															
							0	1	2	3	4	5	6	7	8	9	10	11	12	13	14	
③	1	2	0	2	0	6		6														
②	2	3	2	11	6	20			10		10											
①	3	5	2	7	0	30			9	6	6	6	3									
①	4	4	2	7	1	20			8	2	5	5										
①	5	4	7	11	0	16									4	4	4	4				
①	6	2	6	11	3	18									9	9						
②	7	3	11	14	0	8													4			4
	Total PV by period						0	6	27	8	21	11	12	13	4	4	4	4	0	4		
	Cumulative PV by period						0	6	33	41	62	73	85	98	102	106	110	114	114	118		

Rule
1 = %complete
2 = 50/50
3 = 0/100

Status Report: Ending Period 1

Task	%Complete	EV	AC	PV	CV	SV
1	0%	——	3	0	——	——
Cumulative Totals		——	**3**	**0**	——	——

Status Report: Ending Period 2

Task	%Complete	EV	AC	PV	CV	SV
1	Finished	6	5	——	——	——
Cumulative Totals		**6**	**5**	——	——	——

Status Report: Ending Period 3

Task	%Complete	EV	AC	PV	CV	SV
1	Finished	6	5	——	——	——
2	0%	——	5	——	——	——
3	30%	——	7	——	——	——
4	25%	——	5	——	——	——
Cumulative Totals		——	**22**	——	——	——

Status Report: Ending Period 4

Task	%Complete	EV	AC	PV	CV	SV
1	Finished	6	5	——	——	——
2	0%	——	7	——	——	——
3	50%	——	10	——	——	——
4	50%	——	8	——	——	——
Cumulative Totals		——	**30**	——	——	——

Status Report: Ending Period 5

Task	%Complete	EV	AC	PV	CV	SV
1	Finished	6	5	——	——	——
2	50%	——	8	——	——	——
3	60%	——	12	——	——	——
4	70%	——	10	——	——	——
Cumulative Totals		——	**35**	——	——	——

Status Report: Ending Period 6

Task	%Complete	EV	AC	PV	CV	SV
1	Finished	6	5	——	——	——
2	50%	——	10	——	——	——
3	80%	——	16	——	——	——
4	Finished	——	15	——	——	——
Cumulative Totals		——	**46**	——	——	——

Status Report: Ending Period 7

Task	%Complete	EV	AC	PV	CV	SV
1	Finished	6	5	——	——	——
2	Finished	——	14	——	——	——
3	Finished	——	20	——	——	——
4	Finished	——	15	——	——	——
5	0%	——	0	——	——	——
6	50%	——	9	——	——	——
Cumulative Totals		——	**63**	——	——	——

Period	SPI	CPI	PCIB
1	——	——	——
2	——	——	——
3	——	——	——
4	——	——	——
5	——	——	——
6	——	——	——
7	——	——	——

$$SPI = EV/PV$$
$$CPI = EV/AC$$
$$PCIB = EV/BAC$$

FIGURE A13.1.1C

FIGURE A13.1.1D

2. Given the information provided for development of a catalog product return process for periods 1 through 5, assign the PV values (using the rules) to develop a baseline for the project. Compute the SV, CV, SPI, and CPI for each period. Explain to the owner your assessment of the project at the end of period 5 and the future expected status of the project at the completion.

FIGURE A13.1.2A

FIGURE A13.1.2B

Schedule information							Baseline budget needs											
EV Rule	ACT/ WP	DUR	ES	LF	SL	Total PV	Time period											
							0	1	2	3	4	5	6	7	8	9	10	
②	1	3	0	5	2	30												
③	2	2	0	3	1	20												
②	3	4	0	4	0	30												
③	4	2	3	7	2	10												
②	5	4	2	7	1	40												
①	6	3	4	7	0	30												
①	7	3	7	10	0	60												
Total PV by period																		
Cumulative PV by period																		

Rule
1 = %complete
2 = 50/50
3 = 0/100

Status Report: Ending Period 1

Task	%Complete	EV	AC	PV	CV	SV
1	40%	——	8	——	——	——
2	0%	——	12	——	——	——
3	30%	——	10	——	——	——
Cumulative Totals		——	**30**	——	——	——

Status Report: Ending Period 2

Task	%Complete	EV	AC	PV	CV	SV
1	80%	——	20	——	——	——
2	Finished	——	18	——	——	——
3	50%	——	12	——	——	——
Cumulative Totals		——	**50**	——	——	——

Status Report: Ending Period 3

Task	%Complete	EV	AC	PV	CV	SV
1	Finished	——	27	——	——	——
2	Finished	——	18	——	——	——
3	70%	——	15	——	——	——
4	0%	——	5	——	——	——
5	30%	——	8	——	——	——
Cumulative Totals		——	**73**	——	——	——

Status Report: Ending Period 4

Task	%Complete	EV	AC	PV	CV	SV
1	Finished	——	27	——	——	——
2	Finished	——	18	——	——	——
3	Finished	——	22	——	——	——
4	0%	——	7	——	——	——
5	60%	——	22	——	——	——
Cumulative Totals		——	**96**	——	——	——

Status Report: Ending Period 5

Task	%Complete	EV	AC	PV	CV	SV
1	Finished	——	27	——	——	——
2	Finished	——	18	——	——	——
3	Finished	——	22	——	——	——
4	Finished	——	8	——	——	——
5	70%	——	24	——	——	——
6	30%	——	10	——	——	——
Cumulative Totals		——	**109**	——	——	——

Period	SPI	CPI	PCIB
1	——	——	——
2	——	——	——
3	——	——	——
4	——	——	——
5	——	——	——

$$SPI = EV/PV$$
$$CPI = EV/AC$$
$$PCIB = EV/BAC$$

FIGURE A13.1.2C

Appendix 13.2

Obtaining Project Performance Information from MS Project

The objective of this appendix is to illustrate how one can obtain the performance information discussed in Chapter 13 from MS Project. One of the great strengths of MS Project is its flexibility. The software provides numerous options for entering, calculating, and presenting project information. Flexibility is also the software's greatest weakness in that there are so many options that working with the software can be frustrating and confusing. The intent here is to keep it simple and present basic steps for obtaining performance information. Students with more ambitious agendas are advised to work with the software tutorial or consult one of many instructional books on the market.

For purposes of this exercise we will use the Digital Camera project, which was introduced in Chapter 13. In this scenario the project started as planned on March 1 and today's date is March 7. We have received the following information on the work completed to date:

Design Spec.s took 2 days to complete at a total cost of $20.

Shell & Power took 3 days to complete at a total cost of $25.

Memory/Software is in progress with 4 days completed and two days remaining. Cost to date is $100.

Zoom System took 2 days to complete at a cost of $25.

All tasks started on time.

STEP 1 ENTERING PROGRESS INFORMATION

We enter this progress information in the TRACKING TABLE from the GANTT CHART VIEW ▶ TABLE:

TABLE A13.2A **Tracking Table**

ID	Task Name	Act. Start	Act. Finish	% Comp.	Act. Dur.	Rem. Dur.	Act. Cost	Act. Work
1	**Digital Camera Prototype**	3/1	NA	61%	6.72 days	4.28 days	$170.00	272 hrs
2	Design Spec.s	3/1	3/2	100%	2 days	0 days	$20.00	32 hrs
3	Shell & Power	3/3	3/7	100%	3 days	0 days	$25.00	40 hrs
4	Memory/Software	3/3	NA	67%	4 days	2 days	$100.00	160 hrs
5	Zoom System	3/3	3/4	100%	2 days	0 days	$25.00	40 hrs
6	Assemble	NA	NA	0%	0 days	3 days	$0.00	0 hrs
7	Test	NA	NA	0%	0 days	2 days	$0.00	0 hrs

Note that the software automatically calculates the percent complete and actual finish, cost, and work. In some cases you will have to override these calculations if they are inconsistent with what actually happened. **Be sure to check** to make sure the information in this table is displayed the way you want it to be.

The final step is to enter the current status date (March 7). You do so by clicking PROJECT ▶ PROJECT INFORMATION and inserting the date into the status date window.

STEP 2 ACCESSING PROGRESS INFORMATION

MS Project provides a number of different options for obtaining progress information. The most basic information can be obtained from VIEW ▶ REPORTS ▶ COSTS ▶ EARNED VALUE.

TABLE A13.2B **Earned Value Table**

ID	Task Name	PV	EV	AC	SV	CV	EAC	BAC	VAC
2	Design Spec.s	$20.00	$20.00	$20.00	$0.00	$0.00	$20.00	$20.00	$0.00
3	Shell & Power	$15.00	$15.00	$25.00	$0.00	($10.00)	$25.00	$15.00	($10.00)
4	Memory/Software	$100.00	$70.00	$100.00	($30.00)	($30.00)	$153.85	$100.00	($53.85)
5	Zoom System	$35.00	$35.00	$25.00	$0.00	$10.00	$25.00	$35.00	$10.00
6	Assemble	$0.00	$0.00	$0.00	$0.00	$0.00	$120.00	$120.00	$0.00
7	Test	$0.00	$0.00	$0.00	$0.00	$0.00	$30.00	$30.00	$0.00
		$170.00	$140.00	$170.00	($30.00)	($30.00)	$373.85	$320.00	($53.85)

When you scale this table to 80 percent you can obtain all the basic CV, SV and VAC information on one convenient page.

Note: Older versions of MS Project use the old acronyms:

BCWS = PV

BCWP = EV

ACWP = AC

and the EAC is calculated using the CPI and is what the text refers to as EAC_f.

STEP 3 ACCESSING CPI INFORMATION

To obtain additional cost information such as CPI and TCPI click from the GANTT CHART view click TABLE ▶ MORE TABLES ▶ EARNED VALUE COST INDICATORS, which will display the following information:

TABLE A13.2C Earned Value Cost Indicators Table

ID	Task Name	PV	EV	CV	CV%	CPI	BAC	EAC	VAC	TCPI
1	**Digital Camera Prototype**	$170.00	$140.00	($30.00)	−21%	0.82	$320.00	$373.85	($53.85)	1.2
2	Design Spec.s	$20.00	$20.00	$0.00	0%	1	$20.00	$20.00	$0.00	
3	Shell & Power	$15.00	$15.00	($10.00)	−66%	0.6	$15.00	$25.00	($10.00)	
4	Memory/Software	$100.00	$70.00	($30.00)	−42%	0.7	$100.00	$153.85	($53.85)	
5	Zoom System	$35.00	$35.00	$10.00	28%	1.4	$35.00	$25.00	$10.00	
6	Assemble	$0.00	$0.00	$0.00	0%	0	$120.00	$120.00	$0.00	
7	Test	$0.00	$0.00	$0.00	0%	0	$30.00	$30.00	$0.00	

STEP 4 ACCESSING SPI INFORMATION

To obtain additional schedule information such as SPI from the GANTT CHART view, click TABLE ▶ MORE TABLES ▶ EARNED VALUE SCHEDULE INDICATORS, which will display the following information:

**TABLE 13.2D
Earned Value
Schedule Indicators
Table**

ID	Task Name	PV	EV	SV	SV%	SPI
1	**Digital Camera Prototype**	$170.00	$140.00	($30.00)	−18%	0.82
2	Design Spec.s	$20.00	$20.00	$0.00	0%	1
3	Shell & Power	$15.00	$15.00	$0.00	0%	1
4	Memory/Software	$100.00	$70.00	($30.00)	−30%	0.7
5	Zoom System	$35.00	$35.00	$0.00	0%	1
6	Assemble	$0.00	$0.00	$0.00	0%	0
7	Test	$0.00	$0.00	$0.00	0%	0

STEP 5 CREATING A TRACKING GANTT CHART

You can create a Tracking Gantt Chart like the one presented on page 465 by simply clicking VIEW ▶ TRACKING GANTT

FIGURE 13.2E **Tracking Gantt Chart**

Project Audit and Closure

Project Audits

The Project Audit Process

Project Closure

Team, Team Members, and Project Manager Evaluations

Summary

Appendix 14.1: Project Closeout Checklist

Project Audit and Closure

A project is complete when it starts working for you, rather than you working for it.

— Scott Allen

Mistakes are made; the unexpected happens; conditions change. In organizations that have several projects going on concurrently, it is prudent to have periodic reality checks on current and recently completed projects and their role in the organization's future. The project audit includes three major tasks:

1. Evaluate if the project delivered the expected benefits to all stakeholders. Was the project managed well? Was the customer satisfied?
2. Assess what was done wrong and what contributed to successes.
3. Identify changes to improve the delivery of future projects.

The project audit and report are instruments for supporting continuous improvement and quality management. We learn from past mistakes and what we did right.

Unfortunately, it is estimated that about 90 percent of all projects are not seriously reviewed or audited. The most common reason given is "we're too busy to stop and assess how well we manage projects." This is a big mistake. Without reflective assessment, valuable lessons learned are forgotten and mistakes are repeated. Sadly, those projects that are audited tend to be major failures or disasters. This is another big mistake. One tends to learn only what *not* to do from failures, not what to do. By examining both successes and failures, better practices can be incorporated into the project management system of an organization.

We have observed that organizations that seriously audit their projects are leaders in their fields. These organizations are vigorously committed to continuous improvement and organizational learning.

This chapter begins by discussing different kinds of project audits as well as the audit process. The emergence of maturity models to benchmark the evolution of project management practices is addressed next, followed by issues related to project closure. The chapter concludes by discussing the evaluation of team and individual performance on a project.

Project Audits

Project audits are more than the status reports suggested in Chapter 13, which check on project performance. Project audits do use performance measures and forecast data. But project audits are more inclusive. Project audits review why the project was selected. Project audits include a reassessment of the project's role in the organization's priorities.

Project audits include a check on the organizational culture to ensure it facilitates the type of project being implemented. Project audits assess if the project team is functioning well and is appropriately staffed. Audits of projects in process should include a check on external factors that might change where the project is heading or its importance—for example, technology, government laws, competitive products. Project audits include a review of all factors relevant to the project and to managing future projects.

Project audits can be performed while a project is in process and after a project is completed. There are only a few minor differences between these audits.

- **In-process project audits.** Project audits early in projects allow for corrective changes, if they are needed, on the audited project or others in progress. In-process project audits concentrate on project progress and performance and check if conditions have changed. For example, have priorities changed? Is the project mission still relevant? In rare cases, the audit report may recommend closure of a project that is in process.
- **Postproject audits.** These audits tend to include more detail and depth than in-process project audits. Project audits of completed projects emphasize improving the management of future projects. These audits are more long-term oriented than in-process audits. Postproject audits do check on project performance, but the audit represents a broader view of the project's role in the organization; for example, were the strategic benefits claimed actually delivered?

TABLE 14.1
Factors Influencing Audit Depth and Detail

- Organization size
- Project importance
- Project type
- Project risk
- Project size
- Project problems

The depth and detail of the project audit depend on many factors. Some are listed in Table 14.1. Because audits cost time and money, they should include no more time or resources than are necessary and sufficient. Early in-process project audits tend to be perfunctory unless serious problems or concerns are identified. Then, of course, the audit would be carried out in more detail. Because in-process project audits can be worrisome and destructive to the project team, care needs to be taken to protect project team morale. The audit should be carried out quickly, and the report should be as positive and constructive as possible. Postproject audits are more detailed and inclusive and contain more project team input.

In summary, plan the audit, and limit the time for the audit. For example, in post-project audits, for all but very large projects, a one-week limit is a good benchmark. Beyond this time, the marginal return of additional information diminishes quickly. Small projects may require only one or two days and one or two people to conduct an audit.

The priority team functions well in selecting projects and monitoring performance—cost and time. However, reviewing and evaluating projects and the process of managing projects is usually delegated to independent audit groups. Each audit group is charged with evaluating and reviewing *all* factors relevant to the project and to managing future projects. The outcome of the project audit is a report.

The Project Audit Process

Below are guidelines that should be noted before you conduct a project audit. The guidelines below will improve your chances for a successful audit.

Guidelines for Conducting a Project Audit

1. First and foremost, the philosophy must be that the project audit is not a witch hunt.
2. Comments about individuals or groups participating in the project are no-nos. Keep to project issues, not what happened or by whom.
3. Audit activities should be intensely sensitive to human emotions and reactions. The inherent threat to those being evaluated should be reduced as much as possible.

4. Accuracy of data should be verifiable or noted as subjective, judgmental, or hearsay.

5. Senior management should announce support for the project audit and see that the audit group has access to all information, project participants, and (in most cases) project customers.

6. The attitude toward a project audit and its aftermath depends on the modus operandi of the audit leadership and group. The objective is not to prosecute. The objective is to learn and conserve valuable organization resources where mistakes have been made. Friendliness, empathy, and objectivity encourage cooperation and reduce anxiety.

7. The audit should be completed as quickly as is reasonable.

8. The audit leader should be given access to senior management above the project manager.

With these guidelines in mind, the process of the project audit is conveniently divided into three steps: initiation and staffing, data collection and analysis, and reporting. Each step is discussed next.

Step 1: Initiating and Staffing

Initiation of the audit process depends primarily on organization size and project size along with other factors. However, every effort should be made to make the project audit a normal process rather than a surprise notice. In small organizations and projects where face-to-face contact at all levels is prevalent, an audit may be informal and only represent another staff meeting. But even in these environments the content of a formal project audit should be examined and covered with notes made of the lessons learned. In medium-sized organizations that have several projects occurring simultaneously, initiation can come from a formal project review group, from the project priority team, or be automatic. For example, in the latter case, all projects are audited at specific stages in the project life cycle—perhaps when a project is 10 to 20 percent complete in time or money, 50 percent complete, and after completion. The automatic process works well because it removes the perceptions that a project has been singled out for evaluation and that someone might be on a witch hunt. In large projects, the audit may be planned for major milestones.

There are rare circumstances that require an unplanned project audit, but they should be few and far between. For example, in a project that involved the development of a very large computer accounting system for multiple locations, one major consulting firm (of many) gave notice of withdrawal from the project, with no apparent reason. The project customer became alarmed that perhaps there was a serious fundamental problem in the project that caused the large consulting firm to drop out. A project audit identified the problem. The problem was one of sexual harassment by members of a small consulting firm toward members of the larger consulting firm. The small consulting firm engagement was terminated and replaced with a firm of similar expertise. The larger firm agreed to remain with the project.

A major tenet of the project audit is that the outcome must represent an independent, outside view of the project. Maintaining independence and an objective view is difficult, given that audits are frequently viewed as negative by project stakeholders. Careers and reputations can be tarnished even in organizations that tolerate mistakes. In less forgiving organizations, mistakes can lead to termination or exile to less significant regions of an organization. Of course, if the result of an audit is favorable, careers and reputations can be enhanced. Given that project audits are susceptible to internal politics, some organizations rely on outside consulting firms to conduct the audits.

Step 2: Data Collection and Analysis

Each organization and project is unique. Therefore, the specific kinds of information that will be collected will depend on the industry, project size, newness of technology, and project experience. These factors can influence the nature of the audit. However, information and data are gathered to answer questions similar to those suggested next.

Organization View

1. Was the organizational culture supportive and correct for this type of project? Why? Why not?
2. Was senior management's support adequate?
3. Did the project accomplish its intended purpose?
 a. Is there a clear link to organizational strategy and objectives?
 b. Does the priority system reflect importance to the future of the organization?
 c. Has the environment (internal or external) changed the need for the project's completion (if project is still in process)?
4. Were the risks for the project appropriately identified and assessed? Were contingency plans used? Were they realistic? Have risk events occurred that have an impact greater than anticipated?
5. Were the right people and talents assigned to this project?
6. If the project was completed, have staff been fairly assigned to new projects?
7. What does evaluation from outside contractors suggest?
8. Were the project start-up and hand-off successful? Why? Was the customer satisfied?

Project Team View

1. Were the project planning and control systems appropriate for this type of project? Should all similar size and type of projects use these systems? Why? Why not?
2. Did the project conform to plan? Was the project over or under budget and schedule? Why?
3. Were interfaces and communications with project stakeholders adequate and effective?
4. If the project is completed, have staff been fairly assigned to new projects?
5. Did the team have adequate access to organizational resources—people, budget, support groups, equipment? Were there resource conflicts with other ongoing projects? Was the team managed well?
6. What does evaluation from outside contractors suggest?

The audit group should not be limited to these questions. The audit group should include other questions related to their organization and project type—e.g., research and development, marketing, information systems, construction, facilities. The generic questions above, although overlapping, represent a good starting point and will go a long way toward identifying project problem and success patterns.

Step 3: Reporting

The major goal of the audit report is to improve the way future projects are managed. Succinctly, the report attempts to capture needed changes and lessons learned from a current or finished project. The report serves as a training instrument for project managers of future projects.

Audit reports need to be tailored to the specific project and organizational environment. Nevertheless, a generic format for all audits facilitates development of an audit

database and a common outline for those who prepare audit reports and the managers who read and act on their content. A very general outline common to those found in practice is as follows.

Classification

The classification of projects by characteristics allows prospective readers and project managers to be selective in the use of the report content. Typical classification categories include the following:

* Project type—e.g., development, marketing, systems, construction.
* Size—monetary.
* Number of staff.
* Technology level—low, medium, high, new.
* Strategic or support.

Other classifications relevant to the organization should be included.

Analysis

The analysis section includes succinct, factual review statements of the project. For example,

* Project mission and objectives.
* Procedures and systems used.
* Organization resources used.

Recommendations

Usually audit recommendations represent major corrective actions that should take place. See, for example, Snapshot from Practice: Post Katrina: New Orleans Announces New Evacuation Plan for 2006 Hurricane Season. However, it is equally important to recommend positive successes that should be continued and used in future projects. Postproject audits may be the place to give credit to the project team for an outstanding contribution.

Lessons Learned

These do not have to be in the form of recommendations. Lessons learned serve as reminders of mistakes easily avoided and actions easily taken to ensure success. In practice, new project teams reviewing audits of past projects similar to the one they are about to start have found audit reports very useful. Team members will frequently remark later, "The recommendations were good, but the 'lessons learned' section really helped us avoid many pitfalls and made our project implementation smoother."

Appendix

The appendix may include backup data or details of analysis that would allow others to follow up if they wished. It should not be a dumping ground used for filler; only critical pertinent information should be attached.

Project Closure

Every project comes to an end, eventually. On some projects the end may not be as clear as would be hoped. Although the scope statement may define a clear ending for a project, the actual ending may or may not correspond. Fortunately, a majority of projects are blessed with a well-defined ending. Regular project audits and a priority team will identify those projects that should have endings different from those planned.

On August 29, 2005, Hurricane Katrina, a category 4 hurricane with winds greater than 145 miles per hour, hit the Gulf Coast with devastating effect. The next day two levees in New Orleans broke and water poured in, covering 80 percent of the city and rising to 20 feet in some areas. Many people climbed onto roofs to escape. The storm ended up killing more than 1,300 people in Louisiana and Mississippi.

While investigations into local, state, and federal responses will continue, the City of New Orleans unveiled a new plan based on lessons learned from Katrina for the forthcoming 2006 hurricane season.

"The Superdome and Morial Convention Center became a scene of misery for days after the August 29 hurricane as thousands of evacuees, many of them ill or elderly, languished with shortages in food and water. In the future, [Mayor Ray] Nagin said, the Convention Center will be a staging point not a shelter." The city negotiated a deal with Homeland Security so that AMTRAK trains would be used to supplement buses in mandatory evacuation of citizens.

"The new plan will take effect for any storms stronger than a Category 2, which have sustained winds of 111 miles per hour or higher."

The plan also addresses specific problems that arose during Katrina, such as tourists being stranded in hotels and looters raiding stores and damaging property.

"By default, whether we like it or not, we are the most experienced in this [disaster] in the United States," New Orleans homeland security director Terry Ebbert said.

Ebbert said the emergency plan calls for a central hotel guest processing center with the aim of ensuring those with return plane tickets can rebook earlier departures.

People with special medical needs and the elderly would be picked up by city, school, and church buses and taken to the train station or evacuated by bus to shelters farther north.

For security, 3,000 National Guard troops could be stationed with local police throughout the city prior to a storm, and a dusk-to-dawn curfew would be in place once the evacuation was over, Police Superintendent Warren Riley said.

"It will be an overwhelming force." Riley said. "When citizens leave, they will have no doubt their property is protected. Obviously, it is far beyond what we have done in the past."

"The new evacuation plan applies to a city that now has a vastly reduced population, less than half its pre-storm number of about 455,000."

* Bret Martel, Associated Press, "New Orleans Evacuation Plan for 2006 Hurricane Season: More Buses, No Superdome Shelter," *The San Diego Union Tribune*, May 2, 2006.

Conditions for Project Closure

Normal

The most common circumstance for project closure is simply a completed project. In the case of "turnkey" projects, such as building a new manufacturing facility or creating a customized information system, the finish is marked by the transfer of ownership to the customer. For many development projects, the end involves handing off the final design to production and the creation of a new product or service line. For other internal projects, such as system upgrades or creation of new inventory control systems, the end occurs when the output is incorporated into ongoing operations. Some modifications in scope, cost, and schedule probably occurred during implementation.

Premature

For a few projects, the project may be completed early with some parts of the project eliminated. For example, in a new-product development project, a marketing manager may insist on production models before testing:

> Give the new product to me now, the way it is. Early entry into the market will mean big profits! I know we can sell a bizzillion of these. If we don't do it now, the opportunity is lost!

The pressure is on to finish the project and send it to production. Before succumbing to this form of pressure, the implications and risks associated with this decision should be

carefully reviewed and assessed by senior management and all stakeholders. Too frequently, the benefits are illusory, dangerous, and carry large risks. Why have the original project scope and objectives changed? If early project closure occurs, it should have the support of all project stakeholders. This decision should be left to the audit group, project priority team, or senior management.

Perpetual

Some projects never seem to end. That is, the project appears to develop a life of its own. Although these projects are plagued with delays, they are viewed as desirable when they finally are completed. The major characteristic of this kind of project is constant "add-ons." The owner or others continuously require more small changes that will improve the project outcome—product or service. These changes typically represent "extras" perceived as being part of the original project intent. Examples are adding features to software, to product design, to systems, or to construction projects. Constant add-on changes suggest a poorly conceived project scope. More care in upfront definition of the project scope and limitations will reduce the add-on phenomenon.

At some point the project manager or audit group needs to call the project design locked to bring closure. Although these projects are exhibiting scope, cost, and schedule creep, facing the fact that the project should be brought to an end is not an easy chore. An interesting study by Isabelle Royer chronicles "perpetual" projects of two French companies that lasted well over a decade. Essilor, maker of "progressive" lenses that correct for nearsightedness, and Lafarge, maker of building materials, each had projects that started with much fanfare only to fail to make significant progress. Signs of problems were ignored and allowed the doomed projects to drag on for over 10 years before being killed. Both companies absorbed millions of dollars of lost investment.

Project managers or audit/priority groups have several alternatives available for projects displaying characteristics of being perpetual. They can redefine the project end or scope so that closure is forced. They can limit budget or resources. They can set a time limit. All alternatives should be designed to bring the project to an end as quickly as possible to limit additional costs and still gain the positive benefits of a completed project. The audit group should recommend methods for bringing final closure to this type of project. Failed projects are usually easy to identify and easy for an audit group to close down. However, every effort should be made to communicate the technical reasons for termination of the project; project participants should not be left with an embarrassing stigma of working on a project that failed.

Failed Project

In rare circumstances projects simply fail—for a variety of reasons. For example, developing a prototype of a new technology product may show the original concept to be unworkable. Or in the development of a new pharmaceutical drug, the project may need to be abandoned because side effects of the drug are deemed unacceptable. See Snapshot from Practice: Project Canceled.

Changed Priority

The priority team continuously revises project selection priorities to reflect changes in organizational direction. Normally these changes are small over a period of time, but periodically major shifts in organization require dramatic shifts in priorities. In this transition period, projects in process may need to be altered or canceled. Thus, a project may start with a high priority but see its rank erode or crash during its project life cycle as conditions change. For example, a computer game company found their major competitor

Germany is the major crossroad for Europe's international commercial trucks. The German government felt the need to have international trucks (over 12 tons) using their road infrastructure assist in paying for the road maintenance and additional new infrastructure. The project objectives were clear—a new electronic truck toll-collection system that ensures accurate charges and easy fee collection across German, Swiss, and Austrian highways by August 31, 2003. The technology relied on global positioning systems (GPS), telecommunications, and software to record miles and charges, without using toll booths along the highways.

Several problems sabotaged the project. Time-to-market deadlines were impossible to meet. Delayed launch dates were caused by technical problems with truck tracking units and software that failed to function as expected. Interface communication with public and private stakeholders failed. As a result, the

August 2003 deadline was never met. The revised November 2003 deadline was not met. Finally, in March 2004 the German government pulled the plug and canceled the project.

The cancellation of the project had serious impacts on other governmental programs. The shortfall of not receiving the revenue from the new toll system is estimated at $1.6 billion. Some of those revenues were destined for a high-speed maglev train in Munich and other infrastructure projects.

Lessons learned reveal that lack of project management knowledge was evident. More importantly, failure to identify and assess the impact of schedule and complex technology risks resulted in the death of the project. Perhaps a simpler, cheaper microwave system recommended by the Swiss and Austrians to be operational by 2005 would have sufficed.

* "Case Analysis: Taking a Toll," *PM Network*, Vol. 18, No. 3, March, 2004, p. 1.

placed a 64-bit, 3-D game on the market while their product development projects still centered on 32-bit games. From that moment on, 32-bit game projects were considered obsolete and met sudden deaths. The priority team of this company revised organization priorities. Audit groups found it easy to recommend closure for many projects, but those on the margin or in "gray areas" still presented formidable analysis and difficult decisions.

In some cases the original importance of the project was misjudged; in some the needs have changed. In other situations implementation of the project is impractical or impossible. Because the audit group and priority team are periodically reviewing a project, the changed perception of the project's role (priority) in the total scheme of things becomes apparent quickly. If the project no longer contributes significantly to organization strategy, the audit group or priority team needs to recommend the project be terminated. In many termination situations, these projects are integrated into related projects or routine daily operations.

Termination of "changed priority" projects is no easy task. The project team's perception may be that the project priority is still high in relation to other projects. Egos and, in some cases perhaps, jobs are on the line. Individuals or teams feel success is just over the horizon. Giving up is tantamount to failure. Normally, rewards are given for staying with a project when the chips are down, not giving up. Such emotional issues make project termination difficult.

There is little advantage to placing blame on individuals. Other modes should be used to "justify" early project closure or to identify a project problem—for example, customer needs or tastes have changed, technology is ahead of this project, or competition has a better, more advanced product or service. These examples are external to the organization and perceived as beyond anyone's control. Another approach that weakens close team loyalty is changing team members or the project manager. This approach tends to minimize team commitment and makes closing the project easier, but it should only be used as a last resort. Minimizing embarrassment should be a primary goal for a project review group closing down an unfinished project.

Signals for Continuing or Early Project Closure

Persons who are preparing to join a project audit group for the first time would find it rewarding to read a few studies that identify barriers to project success and the antithesis, factors that contribute to success. Knowledge of these factors will suggest areas to review in an audit. These factors signal where problems or success patterns might exist. In rare cases their existence may signal problems and the need for an in-process project to be terminated early.

A number of studies have examined this area. There is surprising conformity among these studies. For example, all of these studies (and others) rank poor project definition (scope) as a major barrier to project success. There is no evidence these factors have changed over the years, although some differences in relative importance have been noted in different industries. See Research Highlight—Chaos: Software Projects. Table 14.2 presents the barriers identified by 1,654 participating project managers in a survey by Gobeli and Larson. The signals noted in Table 14.2 can be useful to audit groups in their preliminary review of in-process projects or even in postproject audits.

The Closure Decision

For an incomplete project, the decision to continue or close down the project is fundamentally an organizational resource allocation decision. Should the organization commit additional resources to complete the project and realize the project objectives? This is a complex decision. The rationale for closing or proceeding is often based on many cost factors that are primarily subjective and judgmental. Thus, care needs to be taken to avoid

TABLE 14.2
Barriers to Project Success

Activity*	Barrier	Incidence(%)
Planning 32%	Unclear definition	16%
	Poor decision making	9
	Bad information	3
	Changes	4
Scheduling 12%	Tight schedule	4
	Not meeting schedule	5
	Not managing schedule	3
Organizing 11%	Lack of responsibility or accountability	5
	Weak project manager	5
	Top management interference	1
Staffing 12%	Inadequate personnel	5
	Incompetent project manager	4
	Project member turnover	2
	Poor staffing process	1
Directing 26%	Poor coordination	9
	Poor communication	6
	Poor leadership	5
	Low commitment	6
Controlling 7%	Poor follow-up	3
	Poor monitoring	2
	No control system	1
	No recognition of problems	1

* To interpret the table, note that 32 percent of the 1,654 participants reported the barriers under "Planning," 12 percent reported the barriers under "Scheduling," and so on.

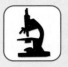

The Standish Group International is a market research and advisory firm specializing in mission-critical software and electronic commerce. They have conducted and published extensive research on the success and failure of software development/application projects. Their research, code name "Chaos," shows that a staggering 31 percent of software projects will be canceled before they are ever completed. In addition, 53 percent of projects will cost 189 percent of their original estimates. In terms of success, on the average only 16 percent of software projects are completed on time and within budget. In larger companies, the success rate is much worse—9 percent. The Standish Group estimated that in 1995 American companies and government agencies spent $81 billion for canceled software projects.

The Chaos research is based on "key findings" from research surveys and personal interviews. The respondents were information technology (IT) executive managers. The sample included large, medium, and small companies across major industry segments, for example, banking; securities; manufacturing; retail; wholesale; health care; insurance service; and local, state, and federal organizations. The total sample size was 365 respondents and represented 8,380 projects.

Based on an in-depth comparison of successful versus unsuccessful software projects, the Standish Group created a success potential chart that identifies key factors associated with project success. The success criteria were weighted based on the input from the surveyed IT managers. The most important criterion, "user involvement," was given 19 success points, while the least important, "hard-working, focused staff," was given 3 success points. The following chart lists the criteria in order of importance:

* Used by permission of the Standish Group International, Inc., 196 Old Town House Rd., West Yarmouth, MA 02673. The CHAOS report was updated in 2001. Although improvement was noted (e.g., cost overruns were reduced to 145 percent), the magnitude of the core problems remains the same.

Success Criteria	Points
1. User involvement	19
2. Executive management support	16
3. Clear statement of requirements	15
4. Proper planning	11
5. Realistic expectations	10
6. Smaller project milestones	9
7. Competent staff	8
8. Project team ownership	6
9. Clear vision and objectives	3
10. Hard-working, focused staff	3
Total	100

inferences concerning groups or individuals. The audit report needs to focus on organizational goals, changing conditions, and changing priorities requiring reallocation of scarce organizational resources.

When the audit group or priority team suggests closure, the announcement may need to come from a CEO position if the effect is large or if key egos are involved. But, in most cases, the closure decision is left to the audit group or priority team. Prior to announcement of closure, a plan for future assignment of the project team members should be in place.

Project Closure Process

As the project nears the end of its life cycle, people and equipment are directed to other activities or projects. Carefully managing the closure phase is as important as any other phase of the project. The major challenges for the project manager and team members are

over. Getting the project manager and team members to wrap up the odds and ends of closing down the project is sometimes difficult. For example, accounting for equipment and completing final reports are perceived as boring by project professionals who are action-oriented individuals. They are looking forward to new opportunities and challenges. The major activities found in project terminations are developing a plan, staffing, communicating the plan, and implementing the plan.

The typical close-out plan includes answers to questions similar to these:

- What tasks are required to close the project?
- Who will be responsible for these tasks?
- When will closure begin and end?
- How will the project be delivered?

Staffing is usually not a significant issue if the termination is not a sudden hatchet job. If the project is suddenly canceled early, before completion, it may be judicious to seek someone other than the project manager to close out the project. In successful, completed projects, the project manager is the likely choice for closing down the project. In this case it is best to have the project manager's next assignment known; this will serve as an inducement to terminate the project as quickly as possible and move on to new challenges.

Communicating the termination plan and schedule early allows the project team to (1) accept the psychological fact the project will end and (2) prepare to move on. The ideal scenario is to have the team member's next assignment ready when the termination is announced. Conversely, a major dilemma in the termination phase is that project participants are looking forward to future projects or other opportunities. The project manager's challenge is to keep the project team focused on the project activities and delivery to the customer until the project is complete. Project managers need to be careful to maintain their enthusiasm for completing the project and hold people accountable to deadlines, which are prone to slip during the waning stages of the project.

Implementing the closedown plan includes several wrap-up activities. Many organizations develop lengthy lists for closing projects as they gain experience. These are very helpful and ensure nothing is overlooked. Implementing closedown includes the following five major activities:

1. Getting delivery acceptance from the customer.
2. Shutting down resources and releasing to new uses.
3. Reassigning project team members.
4. Closing accounts and seeing all bills are paid.
5. Evaluating the project team, project team members, and the project manager.

Figure 14.1 depicts a partial closedown checklist for the Euro Conversion Project for a space company. See Appendix 14.1 for another example used by the state of Virginia.

Orchestrating the closure of a project can be a difficult task. Implementing closure usually takes place in an emotionally charged web of happiness from successful completion of the project and sadness that newly forged friendships are now being severed as individuals go their separate ways. It is customary in organizations to arrange a celebration of the completion of the project; this could range from an informal pizza party after work to a more formal banquet including speeches and awards or certificates of recognition for participants. Such a festivity provides a sense of closure and emotional release for the participants as they bid farewell to each other. For less successful projects, this ending can take the form of a ceremonial wake; even though the atmosphere

FIGURE 14.1 **Euro Conversion—Project Closure Checklist**

Project _____ *Euro Conversion* _____ Customer _____ *Finance Department* _____

Project manager _____ *Hans Kramer* _____ Completion date _____ *12 December XX* _____

	Due date	Person responsible	Notes
1. Document finance department acceptance	16/12	Hans	
2. Customer training in Euro software	28/12	Joan	Train all departments before conversion
3. Archive all			
Schedules/actuals	31/12	Maeyke	
Budgets/actual costs	31/12	Maeyke	
Changes	31/12	Maeyke	
4. Close out all accounts with vendors	31/12	Guido	
5. Close out all work orders	31/12	Mayo	
6. Close out partner accounts	31/12	Guido	
7. Reassign project staff	16/12	Sophie	
8. Evaluation of			
Vendors	31/12	Mayo	Use standard questionnaire for vendors
Staff members	31/12	Sophie	Have HR department develop and administer
9. Final report and lessons learned meeting	4/1	Hans	Send notice to all stakeholders
10. Lessons learned archive to database	10/1	Maeyke	Contact IS department
...tribute awards		Sophie	Notify all stakeholders

may be less than festive, such an event can also provide a sense of closure and help people move on with their lives.

It is important to remember that dragging out the project closure process can also drag out costs that continue for the life of the project. If the project is not completed and earning the benefits promised, the interest costs of the money spent for the project continue, along with other continuing costs. Not only that, but for contracted projects final payment is not received until after the closeout.

Team, Team Members, and Project Manager Evaluations

Auditing includes performance evaluations of the project team, individual team members, and the project manager. See Research Highlight: Measures of Team Performance. Evaluation of performance is essential to encourage changes in behavior and to support

If team evaluation is not done well in practice, how bad is it? Joseph Fusco surveyed 1,667 project managers representing 134 different projects. Fifty-two percent of the respondents indicated their team received no collective evaluation of their team performance. Of the 22 percent who indicated their team was evaluated, further probing found their evaluation was informal, lasting little more than 20 minutes. This apparent lack of team evaluation practices may be sending the wrong signal. Individual team members can slough off poor team performance by relying on the old saying, "I did my job." Strong team evaluation practices need to emphasize team members are "in this together," while minimizing individual performance. Nearly every company in Fusco's survey lacked an effective project management reward system.

*Joseph Fusco, "Better Policies Provide the Key to Implementing Project Management," *Project Management Journal*, Vol. 28, No. 3, September 1997, p. 38.

individual career development and continuous improvement through organization learning. Evaluation implies measurement against specific criteria. Experience corroborates that before commencement of the project the stage must be set so all expectations, standards, supportive organization culture, and constraints are in place; if not, the effectiveness of the evaluation process will suffer.

In a macro sense, the evidence today suggests that performance evaluation in each of these realms is not done well. The major reasons cited by practitioners are twofold:

1. Evaluations of individuals are still left to supervisors of the team member's home department.
2. Typical measures of team performance center on time, cost, and specifications.

Most organizations do not go beyond these measures, although they are important and critical. Organizations should consider evaluating the team-building process, effectiveness of group decision and problem-solving processes, group cohesion, trust among team members, and quality of information exchanged. Addressing evaluation of teams, team members, and project managers is extremely complex and project dependent. The discussion that follows touches on some of the major issues and approaches found in practice.

Team Evaluation

Before an auditing of the project team can be effective and useful, a minimum core of conditions needs to be in place before the project begins (see Chapter 11). Some conditions are listed here in the form of questions:

1. Do standards for measuring performance exist? (You can't manage what you can't measure.) Are the goals clear for the team and individuals? Challenging? Attainable? Lead to positive consequences?
2. Are individual and team responsibilities and performance standards known by all team members?
3. Are team rewards adequate? Do they send a clear signal that senior management believes the synergy of teams is important?
4. Is a clear career path for successful project managers in place?
5. Does the team have discretionary authority to manage short-term difficulties?
6. Is there a relatively high level of trust emanating from the organization culture?
7. Team evaluation should go beyond time, cost, and specifications. Are there criteria beyond these triple threat criteria? The "characteristics of highly effective teams" from Chapter 11 can easily be adapted as measurements of team effectiveness.

TABLE 14.3
Sample Team
Evaluation and
Feedback Survey

	Disagree				Agree
Using the scale below, assess each statement.					
1. The team shared a sense of common purpose, and each member was willing to work toward achieving project objectives.	1	2	3	4	5
2. Respect was shown for other points of view. Differences of opinion were encouraged and freely expressed.	1	2	3	4	5
3. All interaction among team members occurred in a comfortable, supportive atmosphere.	1	2	3	4	5

These "in-place conditions" will support any evaluation approach for teams and their members.

In practice, the actual team evaluation process takes many forms—especially when evaluation goes beyond time, budget, and specifications. The typical mechanism for evaluation of teams is a survey administered by a consultant, a staff member from the human resources department, or through computer e-mail. The survey is normally restricted to team members, but, in some cases, other project stakeholders interacting with the team may be included in the survey. When the results are tabulated, the team meets with senior management, and the results are reviewed. An example of a partial survey is found in Table 14.3.

This session is comparable to the team-building sessions described in Chapter 11 except that the focus is on using the survey results to assess the development of the team, its strengths and weaknesses, and the lessons that can be applied to future project work. The results of team evaluation surveys are helpful in changing behavior, stressing the importance of supporting the team approach, and continuous improvement.

Individual Team Member and Project Manager Evaluation

Team evaluation is crucial, but at some point a project manager is likely to be asked to evaluate the performance of individual members. Such an evaluation will typically be required as part of the closure process and will then be incorporated in the annual performance appraisal system of the organization. These evaluations constitute a major element of an individual's personnel file and often form the basis for making decisions about promotions, future job assignments, merit pay increases, and other rewards.

Organizations vary in the extent to which project managers are actively involved in performing the appraisal process. In organizations where projects are managed within a functional organization or functional matrix, the individual's area manager, not the project manager, is responsible for assessing performance. The area manager may solicit the project manager's opinion of the individual's performance on a specific project; this will be factored into the individual's overall performance. In a balanced matrix, the project manager and the area manager jointly evaluate an individual's performance. In project matrix and project organizations in which the lion's share of the individual's work is project related, the project manager is responsible for appraising individual performance. One new process, which appears to be gaining wider acceptance, is the multirater appraisal or "360-degree feedback," which involves soliciting feedback concerning team members' performance from all the people their work affects. This would include not only project and area

managers, but also peers, subordinates, and even customers. See Snapshot from Practice: The 360-Degree Feedback.

Performance appraisals generally fulfill two important functions. The first is developmental in nature; the focus is on identifying individual strengths and weaknesses and developing action plans for improving performance. The second is evaluative and involves assessing how well the person has performed in order to determine salary or merit adjustments. These two functions are not compatible. Employees, in their eagerness to find out how much pay they will receive, tend to tune out constructive feedback on how they can improve their performance. Likewise, managers tend to be more concerned with justifying their decision than engaging in a meaningful discussion on how the employee can improve his or her performance. It is difficult to be both a coach and a judge. As a result, several experts on performance appraisal systems recommend that organizations separate performance reviews, which focus on individual improvement, and pay reviews, which allocate the distribution of rewards.

In some matrix organizations, project managers conduct the performance reviews, while area managers are responsible for pay reviews. In other cases, performance reviews are part of the project closure process, and pay reviews are the primary objective of the annual performance appraisal. Other organizations avoid this dilemma by allocating only group rewards for project work. The remaining discussion is directed at reviews designed to improve performance because pay reviews are often outside the jurisdiction of the project manager.

Performance Review

Organizations employ a wide range of methods to review individual performance on a project. In general, all review methods of individual performance center on the technical and social skills brought to the project and team. Some organizations rely simply on an informal discussion between the project manager and the project member. Other organizations require project managers to submit written essays that describe and assess an individual's performance on a project. Many organizations use rating scales similar to the team evaluation survey in which the project manager rates the individual according to a certain scale (i.e., from 1 to 5) on a number of relevant performance dimensions (i.e., teamwork, customer relations). Some organizations augment these rating schemes with behaviorally anchored descriptions of what constitutes a 1 rating, a 2 rating, and so forth. Each method has its strengths and weaknesses, and, unfortunately, in many organizations the appraisal systems were designed to support mainstream operations and not unique project work. The bottom line is that project managers have to use the performance review system mandated by their organization as best they can.

Regardless of the method, the project manager needs to sit down with each team member and discuss his or her performance. Here are some general tips for conducting performance reviews:

- Always begin the process by asking the individual to evaluate his or her own performance. First, this approach may yield valuable information that you were not aware of. Second, the approach may provide an early warning for situations in which there is disparity in assessments. Finally, this method reduces the judgmental nature of the discussion.
- Avoid, when possible, drawing comparisons with other team members; rather, assess the individual in terms of established standards and expectations. Comparisons tend to undermine cohesion and divert attention away from what the individual needs to do to improve performance.

More and more companies are discarding the traditional superior-subordinate performance feedback process and replacing it with 360-degree feedback systems. The 360-degree feedback approach gathers behavioral observations from many sources within the organization and includes employee self-assessment. The individual completes the same structured evaluation process that superiors, project team members, peers and, in many cases, external customers use to evaluate a performance. Survey questionnaires, augmented by a few open-ended questions, are typically used to gather information.

Summary results are compared against organizational strategies, values, and business objectives. The feedback is communicated to the individual with the assistance of the company's human resource department or an outside consultant. The technique is used by a growing number of firms including General Electric, AT&T, Mobil Oil, Nabisco, Hewlett-Packard, and Warner-Lambert.

The objective of the 360-degree process is to identify areas for individual improvement. When anonymous feedback solicited from others is compared with the individual's self-evaluations, the individual may form a more realistic picture of her strengths and weaknesses. This may prompt behavioral change if the weaknesses identified were previously unknown to the individual. Such

appears to be the case for Jerry Wallace, an up-and-coming manager at General Motors. "The strongest message I got was that I need to delegate more," he says, "I thought I'd been doing it. But I need to do it more and sooner. My people are saying, 'Turn me loose.'"

Many firms obtain feedback from internal and external project customers. For example, a client may evaluate a project manager or member of the project team according to, "How effectively does the individual get things done without creating unnecessary adversarial relationships?" Incorporating customer feedback in the evaluation process underscores collaboration and the importance of client expectations in determining project success.

William J. Miller, a program director at Du Pont, helped install a 360-degree feedback system for 80 scientists and support people. "A high or low score didn't predict a scientist's ability to invent Teflon," says Miller. "But what feedback did was really improve the ability of people to work in teams. Their regard for others and behaviors that were damaging and self-centered are what changed."

* Brian O'Reilly, "360 Feedback Can Change Your Life," *Fortune,* October, 17, 1994, pp. 93–100; Robert Hoffman, "Ten Reasons You Should Be Using 360 Degree Feedback," *HR Magazine,* April 1995, pp. 82–85; Dick Cochran, "Finally, a Way to Completely Measure Project Manager Performance," *PM Network,* September 2000, pp. 75–80.

- When you have to be critical, focus the criticism on specific examples of behavior rather than on the individual personally. Describe in specific terms how the behavior affected the project.
- Be consistent and fair in your treatment of all team members. Nothing breeds resentment more than if, through the grapevine, individuals feel that they are being held to a different standard than are other project members.
- Treat the review as only one point in an ongoing process. Use it to reach an agreement as to how the individual can improve his or her performance.

Both managers and subordinates may dread a formal performance review. Neither side feels comfortable with the evaluative nature of the discussion and the potential for misunderstanding and hurt feelings. Much of this anxiety can be alleviated if the project manager is doing her job well. Project managers should be constantly giving team members feedback throughout the project so that individual team members can have a pretty good idea how well they have performed and how the manager feels before the formal meeting.

While in many cases the same process that is applied to reviewing the performance of team members is applied to evaluating the project manager, many organizations augment this process, given the importance of the position to their organization. This is where conducting the 360-degree review is becoming more popular. In project-driven organizations, directors or vice presidents of project management will be responsible for collecting information on a specific project manager from customers, vendors, team members, peers, and other managers. This approach has tremendous promise for developing more effective project managers.

Summary

Project audits enhance individual and organizational change and improvement. In this chapter processes for conducting project audits and developing the report were examined. Project closures and the importance of conducting team and individual evaluations were also reviewed. Key points of the chapter include the following:

- It is better to have automatic times or points when audits will take place. Surprises should be avoided.
- Audits of projects (especially those in process) need to be conducted carefully and with sensitivity to human reactions. The audit should focus on issues, problems, and successes and avoid references to groups or individuals.
- The audit is best staffed with individuals independent of the project.
- Audit reports need to be used and accessible.
- Audits support an organizational culture that vigorously promotes continuous improvement and organizational learning.
- Project closures should be planned and orderly regardless of the type of closure.
- Certain "core conditions" should be in place to support team and individual evaluation.
- Both individual and team evaluations should be conducted, and performance reviews should be separated from pay or merit reviews.

Competitive conditions appear to be forcing more organizations to adopt continuous improvement and organizational learning. Regular use of project audits has yielded dramatic improvements in the way projects are managed. As more members of these organizations are learning from project mistakes and what is contributing to project successes, the process of managing projects is continuously improving in their respective organizations. The major instrument for implementing this philosophy will be the project audit and report.

Since the purpose of the audit it to improve performance, the project maturity model is a good approach for checking project management performance and improvement for the organization over the long haul. Using the model as a starting benchmark, improvements can easily be tracked to higher levels.

Key Terms

In-process project audit
Performance review
Postproject audit

Project audit report
Project closure

Team evaluation
360-degree review

Review Questions

1. How does the project audit differ from the performance measurement control system discussed in Chapter 13?
2. What major information would you expect to find in a project audit?
3. Why is it difficult to perform a truly independent, objective audit?
4. What are the five major activities for closing a project?
5. Comment on the following statement: "We cannot afford to terminate the project now. We have already spent more than 50 percent of the project budget."
6. Why should you separate performance reviews from pay reviews? How?

Exercises

1. Consider a course that you recently completed. Perform an audit of the course (the course represents a project and the course syllabus represents the project plan). Summarize the results of the audit as a report organized in accordance with the outline in the section "Step 3: Reporting."

2. Imagine you are conducting an audit of the International Space Station project. Research press coverage and the Internet to collect information on the current status of the project. What are the successes and failures to date? What forecasts would you make about the completion of the project, and why? What recommendations would you make to top management of the program, and why?

3. Interview a project manager who works for an organization that implements multiple projects. Ask the manager what kind of closeout procedures are used to complete a project and whether projects are audited.

References

Cochran, D., "Finally, a Way to Completely Measure Project Manager Performance," *PM Network,* September 2000, pp. 75–80.

Fincher, A. and G. Levin, "Project Management Maturity Model," *Proceedings of the 28th Annual PMI Symposium* (Newtown Square, PA: PMI, 1997), pp. 1028–35.

Fretty, P., "Why Do Projects Really Fail?" *PM Network,* March 2006, pp. 45–48.

Gobeli, D. and E. W. Larson, "Barriers Affecting Project Success," in *1986 Proceedings Project Management Institute: Measuring Success* (Upper Darby, PA: Project Management Institute, 1986), pp. 22–29.

Hoffman, R., "Ten Reasons You Should Be Using 360 Degree Feedback," *HRMagazine,* April 1995, pp. 82–85.

Ibbs, W. C. and Y. H. Kwak, "Assessing Project Maturity," *Project Management Journal,* Vol. 31, No. 1, March 2000, pp. 32–43.

Kwak, Y. H. and C. W. Ibbs, "Calculating Project Management's Return on Investment," *Project Management Journal,* Vol. 31, No. 2, March 2000, pp. 38–47.

Pippett, D. D. and J. F. Peters, "Team Building and Project Management: How Are We Doing?" *Project Management Journal,* Vol. 26, No. 4, December 1995, pp. 29–37.

Royer, I., "Why Bad Projects Are So Hard to Kill," *Harvard Business Review,* February 2003, pp. 49–56.

Software Engineering Institute (SEI). (See website at http://www.sei.cmu/edu/activities/sema/profile.html.)

Stewart, W. E., "Balanced Scorecard for Projects" (2000 International Student Paper Award Winner), *Project Management Journal,* Vol. 32, No. 1, March 2001, pp. 38–47.

Wheatly, M., "Over the Bar," *PM Network,* Vol. 17, No. 1, January, 2003, pp. 40–45.

Yates, J. K. and S. Aniftos, "ISO 9000 Series of Quality Standards and the E/C Industry," *Project Management Journal,* Vol. 28, No. 2, June 1997, pp. 21–31.

Appendix 14.1

Project Closeout Checklist

Section 5: Project Closeout

Project Closeout Transition Checklist

Provide basic information about the project including: Project Title—The proper name used to identify this project; Project Working Title—The working name or acronym that will be used for the project; Proponent Secretary—The Secretary to whom the proponent agency is assigned or

the Secretary that is sponsoring an enterprise project; Proponent Agency—The agency that will be responsible for the management of the project; Prepared by—The person(s) preparing this document; Date/Control Number—The date the checklist is finalized and the change or configuration item control number assigned.

Project Title: _____ **Project Working Title:** _____
Proponent Secretary: _____ **Proponent Agency:** _____
Prepared by: _____ **Date/Control Number:** _____

Complete the Status and Comments columns. In the Status column indicate: Yes, if the item has been addressed and completed; No, if the item has not been addressed, or is incomplete; N/A, if the item is not applicable to this project. Provide comments or describe the plan to resolve the item in the last column.

	Item	Status	Comments/Plan to Resolve
1	Have all the product or service deliverables been accepted by the customer?		
1.1	Are there contingencies or conditions related to the acceptance? If so, describe in the Comments.		
2	Has the project been evaluated against each performance goal established in the project performance plan?		
3	Has the actual cost of the project been tallied and compared to the approved cost baseline?		
3.1	Have all approved changes to the cost baseline been identified and their impact on the project documented?		
4	Have the actual milestone completion dates been compared to the approved schedule?		
4.1	Have all approved changes to the schedule baseline been identified and their impact on the project documented?		
5	Have all approved changes to the project scope been identified and their impact on the performance, cost, and schedule baselines documented?		

(continued)

	Item	Status	Comments/Plan to Resolve
6	Has operations management formally accepted responsibility for operating and maintaining the product(s) or service(s) delivered by the project?		
6.1	Has the documentation relating to operation and maintenance of the product(s) or service(s) been delivered to, and accepted by, operations management?		
6.2	Has training and knowledge transfer of the operations organization been completed?		
6.3	Does the projected annual cost to operate and maintain the product(s) or service(s) differ from the estimate provided in the project proposal? If so, note and explain the difference in the Comments column.		
7	Have the resources used by the project been transferred to other units within the organization?		
8	Has the project documentation been archived or otherwise disposed as described in the project plan?		
9	Have the lessons learned been documented in accordance with the Commonwealth Project Management guideline?		
10	Has the date for the post implementation review been set?		
10.1	Has the person or unit responsible for conducting the post implementation review been identified?		

Signatures

The Signatures of the people below relay an understanding that the key elements within the Closeout Phase section are complete and the project has been formally closed.

Position/Title	Name	Date	Phone Number

Source: http://www.vita.virginia.gov/projects/cpm/cpmDocs/CPMG-SEC5-Final.pdf

Case

Maximum Megahertz Project

Olaf Gundersen, the CEO of Wireless Telecom Company, is in a quandary. Last year he accepted the Maximum Megahertz Project suggested by six up-and-coming young R&D corporate stars. Although Olaf did not truly understand the technical importance of the project, the creators of the project needed only $600,000, so it seemed like a good risk. Now the group is asking for $800,000 more and a six-month extension on a project that is already four months behind. However, the team feels confident they can turn things around. The project manager and project team feel that if they hang in there a little longer they will be able to overcome the roadblocks they are encountering—especially those that reduce power, increase speed, and use a new technology battery. Other managers familiar with the project hint that the power pack problem might be solved, but "the battery problem will never be solved." Olaf believes he is locked into this project; his gut feeling tells him the project will never materialize, and he should get out. John, his human resource manager, suggested bringing in a consultant to axe the project. Olaf is thinking maybe he should do that on this project if it needs to be terminated.

Olaf decided to call his friend Dawn O'Connor, the CEO of an accounting software company. He asked her, "What do you do when project costs and deadlines escalate drastically? How do you handle doubtful projects?" Her response was, "Let another project manager look at the project. Ask: 'If you took over this project tomorrow, could you bring the project in on time and within budget with the extended time and additional money?' If the answer is no, I call my top management team together and have them review the doubtful project in relation to other projects in our project portfolio." Olaf feels this is good advice.

Unfortunately, the Maximum Megahertz Project is not an isolated example. Over the last five years there have been three projects that were never completed. "We just seemed to pour more money into them, even though we had a pretty good idea the projects were dying. The cost of those projects was high; those resources could have been better used on other projects." Olaf wonders, "Do we ever learn from our mistakes? How can we develop a process that catches errant projects early? More importantly, how do we ease a project manager and team off an errant project without embarrassment?" Olaf certainly does not want to lose the six bright stars on the Maximum Megahertz Project.

Olaf is contemplating how his growing telecommunications company should deal with the problem of identifying projects that should be terminated early, how to allow good managers to make mistakes without public embarrassment, and how they all can learn from their mistakes.

Give Olaf a plan of action for the future that attacks the problem. Be specific and provide examples that relate to Wireless Telecom Company.

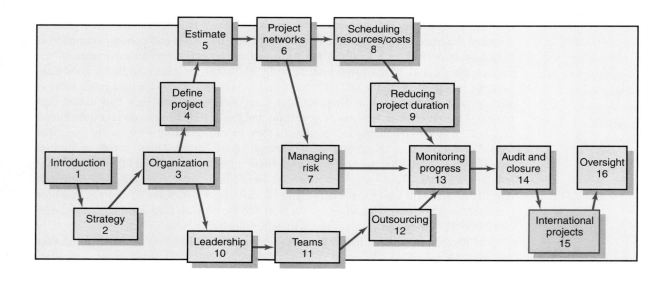

International Projects
International Projects
Environmental Factors
Project Site Selection
Cross-Cultural Considerations: A Closer Look
Selection and Training for International Projects
Summary

International Projects

The principal benefit of living abroad is that it enables us to get glimpses of ourselves as others see us and to realize that others' views are more accurate than ours. Progress begins with grasping the truth about ourselves, however unpleasant it may be.

—Russel Ackoff, The Wharton School, University of Pennsylvania

Projects are frequently classified as domestic, overseas, foreign, or global. A domestic project is one performed in its native country for a resident firm (a construction firm building a bridge in its state). An overseas project is one executed in a foreign country for a native firm (a Swedish company building a truck factory in the United States for their native company). A foreign project is executed in a foreign country for a foreign firm (a U.S. firm developing an information system in Malaysia for Malaysian banks). A global project consists of teams formed from professionals spanning multiple countries, continents, and cultures with their work integrated for the entire enterprise (e.g., multinational enterprise developing a global distribution system). Global teams are a crisscross of functions, work locale, markets, culture, and products. Today, these distinctions become blurred as the world economy and organizations become more integrated.

This chapter targets the international project manager who must resettle in a foreign environment to manage the project. The chapter also includes useful information for project professionals working overseas as well as those working on virtual projects involving colleagues from different countries.

There is no generally accepted framework or road map for project managers given international assignments. These project managers typically face a difficult set of problems—for example, absence from home, friends, and sometimes family; personal risks; missed career opportunities; foreign language, culture, and laws; adverse conditions. Of course there are positives—for example, increased income, increased responsibilities, career opportunities, foreign travel, new lifetime friends. How the international project manager adapts and approaches problems encountered in the host country often determines the success or failure of a project.

This chapter focuses on four major issues surrounding the management of international projects. First, major environmental factors that impact project selection and implementation are briefly highlighted. Second, an example of how organizations decide where to expand globally is provided. Third, the challenge of working in a strange and foreign culture is addressed. Finally, how companies select and train professionals for international projects is discussed. Although by no means comprehensive, this chapter attempts to provide a solid understanding of the major issues and challenges confronting the international project manager.

Environmental Factors

The major challenge international project managers face is the reality that what works at home may not work in a foreign environment. Too often project managers impose practices, assumed to be superior, from their home country on host-country nationals without questioning applicability to the new environment. Although there are similarities between domestic and international projects, it is a fact that good management practices vary across nations and cultures. It is these differences that can turn an international project into a nightmare. If potential international project managers have a keen awareness of differences in the host country's environment from their own domestic environment, dangers and obstacles of the global project can be reduced or avoided. There are several basic factors in the host country's environment that may alter how projects will be implemented: legal/political, security, geographical, economic, infrastructure, and culture (see Figure 15.1).

Legal/Political

Expatriate project managers should operate within the laws and regulations of the host country. Political stability and local laws strongly influence how projects will be implemented. Typically, these laws favor protection of local workers, suppliers, and environment. For example, how much control will be imposed from government agencies? What is the attitude of federal and state bureaucracies toward regulations and approval policies that can cause project delays? How much government interference or support can one expect? For example, an expatriate project manager based in Ho Chi Minh City observed:

> There is a common saying among the barflies about doing business in Vietnam: "The government interprets the law for its friends, and applies the law to strangers." Vietnam is no place for strangers to do business. The foreign investment law is tailored to approve investments based on the government's view of how a company and its project will further certain economic and social objectives.

The constraints imposed by national and local laws need to be identified and adhered to. Are local ecological laws restrictive? Will manufacturing a new product in a computer chip plant require exporting toxic waste materials? What are the pollution standards? How will labor laws affect the use of indigenous workers to complete the project?

FIGURE 15.1
Environmental Factors Affecting International Projects

Given laws that affect business vary widely across countries, qualified legal assistance is essential.

Government corruption is a very real part of international business. In China various forms of obligatory "profit sharing" with city officials in the Hainan province have been reported. Employment of relatives, donations, and other "favors" are an expected cost of doing business in that region. The *Wall Street Journal* reports that Russia has become a nation in which corruption is both pervasive and arbitrary: "Without the structure the Communist Party provided, people did not know whom to pay and many anarchistic bribe collectors stepped up with their hands out."

Political stability is another key factor in deciding to implement a project in a foreign country. What are the chances that there will be a change in the party in power during the project? Are the tax provisions and government regulations stable or subject to change with the winds of political change? How are laws made, and what is the past record of fairness? How are labor unions treated in the political realm? Does labor unrest exist? Is there a chance for a coup d'état? Contingency plans need to be established to respond to emergencies.

Security

International terrorism is a fact of life in today's world. Tim Daniel, chief operating officer of International SOS Assistance, Inc., reported that the number of his firm's clients doubled after September 11th. SOS is a security firm that specializes in evacuating expatriates from dangerous situations around the world. The company cites PricewaterhouseCoopers, Nortel Networks Corp., and Citigroup among its clients.

While the 9/11 attacks magnified the fact that Americans are vulnerable to terrorism at home, they also heightened security concerns for working abroad. For example, after September 11th, several American firms canceled or scaled back projects in potential hotspots such as Pakistan and the Philippines. Others reported increased pressures from expatriates who wanted to return home with their families. On June 3, 2004, the Nobel Peace Prize-winning relief agency *Médecins Sans Frontières* (Doctors Without Borders) suspended all Afghan projects after five of its aid workers were killed in an ambush claimed by the former Taliban regime.

Crime is another factor. The growing presence of the Russian Mafia has discouraged many foreign firms from setting up operations in the former Soviet Union. Kidnapping of American professionals is also a very real threat in many parts of the world.

Security nationally involves the capacity of a country's military and police forces to prevent and respond to attacks. In many foreign countries, American firms will have to augment the countries' security system. For example, it is common practice to hire tribal bodyguards in such places as Angola and Uzbekistan.

Another real cost associated with international terrorism is the ease of commerce across borders. Heightened security measures have created border congestions that have expanded the time and cost of moving personnel, materials, and equipment across countries. These constraints need to be factored into the budget and schedule of projects.

Risk management is always a vital part of project management. It plays an even bigger role in managing projects overseas. For example, Strohl Systems Group, a global leader in recovery-planning software and services, includes the following among the questions it uses to evaluate vulnerability to terrorism: Have you included possible terrorist targets (facilities and personnel) in your hazard and vulnerability analysis? Have you conducted a counterterrorism exercise complete with law enforcement, fire, medical, and emergency management participation? What should your organization's policy be on negotiating with a person threatening a terrorist act?

Managing projects in a dangerous world is a tough assignment. Security precautions are major cost considerations not only in dollars and cents, but also in the psychological well-being of personnel sent abroad. Effective risk management is critical to success.

Geography

One factor that is often underestimated until project personnel actually arrive at a foreign destination is the geography of the country. Imagine what it is like to deplane from a modern aircraft and encounter the 105-degree heat and 90 percent humidity of Jakarta, Indonesia, or three feet of fresh snow and 225-degree temperatures in Kokkla, Finland. Whether it is the wind, the rain, the heat, the jungle, or the desert, more than one project manager has asserted that their greatest challenge was overcoming the "elements." Mother Nature cannot be ignored.

The planning and implementation of a project must take into account the impact the country's geography will have on the project. For example, a salvage operation off the coast of Greenland can only be scheduled one month out of the year because the waterway is frozen over during the remainder of the year. Construction projects in Southeast Asia have to accommodate the monsoon season when rainfall can be as high as 50 inches per month. Geography does not just affect outdoor projects. It can have an indirect effect on "indoor" projects. For example, one information systems specialist reported that his performance on a project in northern Sweden declined due to sleep deprivation. He attributed his problems to the 20 hours of daylight this part of the world experiences during summer months. Finally, extreme weather conditions can make extraordinary demands on equipment. Projects can grind to a halt because of equipment breakdown under the brunt of the elements. Working under extreme conditions typically requires special equipment, which increases the costs and complexity of the project.

Before beginning a project in a foreign land, project planners and managers need to study carefully the unique characteristics of the geography of that country. They need to factor into project plans and schedules such items as climate, seasons, altitude, and natural geographical obstacles. See the Snapshot from Practice: The Filming of *Apocalypse Now* for an example of a poorly planned endeavor in the Phillipines.

Economic

How business is conducted in the host country can influence project success. Basic economic factors in foreign countries and regions influence choices of site selection and how business will be conducted for potential projects. The gross domestic product (GDP) of a country suggests the level of development of a country. A faltering economy may indicate fewer sources of capital funding. For example, changes in protectionist strategies of a host country, such as import quotas and tariffs, can quickly alter the viability of projects. Other factors such as balance of payments, currency fluctuations, hyperinflation, population growth, education level of workforce, and market size can influence project choices and operations. For example, the economic downturn in Southeast Asia during the late 1990s saw local economies in Thailand, Malaysia, and Indonesia being devastated by inflation rates in excess of 60 percent. A company can protect against currency fluctuations by hedging or tying costs to a strong currency such as the U.S. dollar, British pound, or Euro. Still, the social upheaval caused by such dramatic economic events cannot be underestimated.

Bartering is a form of compensation that is still used by some countries and organizations. For example, one project in Africa was paid in goat skins. The goat skins were eventually sold to an Italian manufacturer of gloves. Another project along the Caspian Sea was paid for in oil. There is a small group of firms that specialize in bartering for project

In February 1976, Francis Ford Coppola took his Hollywood film crew to the Philippines to shoot *Apocalypse Now,* a film adaptation of Joseph Conrad's *Heart of Darkness* within the context of the Vietnam conflict. The Philippines was chosen because the terrain was similar to Vietnam's, and the government was willing to rent its helicopter force for the movie. At the time, the U.S. military was unwilling to cooperate on a film about Vietnam. An additional advantage was cheap labor. Coppola was able to hire more than 300 laborers at $1 to $3 per day to construct elaborate production sets, including an impressive Cambodian temple. *Apocalypse Now* was scheduled for 16 weeks of shooting at a budget of $12 to $14 million.

Months earlier, George Lucas, of *Star Wars* fame, warned Coppola against filming the movie in the Philippines. He said, "It's one thing to go over there for three weeks with five people and scrounge some footage with the Filipino Army, but if you go over there with a big Hollywood production, the longer you stay the more in danger you are of getting sucked into the swamp." His words turned out to be prophetic.

A civil war was going on between government forces and communist rebels. Shooting was repeatedly interrupted because the Philippine military ordered their helicopter pilots to leave the set and fly to the mountains to fight the rebels.

In May 1976, a typhoon struck the Philippine Islands, destroying most of the movie sets. The film team was forced to shut down production and returned to the United States for two months.

The lead character was played by Martin Sheen, who suffered a serious heart attack under the stress and heat of the filming and had to return to the United States. Coppola scrambled to film the scenes that did not require Sheen, but eventually production came to a standstill until Sheen's return nine weeks later.

The entire project proved to be a traumatic experience for Coppola, who had enjoyed Academy Award success with his previous *Godfather* movies, "There were times when I thought I was going to die, literally, from the inability to move the problems I had. I would go to bed at four in the morning in a cold sweat."

Film production ended in May 1977 after more than 200 days of shooting. The final cost was about $30 million. To date, *Apocalypse Now* has earned more than $150 million throughout the world.

* *Hearts of Darkness: A Filmmaker's Apocalypse* (Paramount Pictures, 1991).

contractors. These intermediaries charge a commission to sell the bartered goods (e.g., oil) for the contractor. However, dealing with commodities can be a risky enterprise.

Skills, educational level, and labor supply prevalent in a host country can determine the choice of a project site. Is project selection driven by low wage levels or availability of technically skilled talent? For example, you can hire three computer programmers in India for the price of one programmer in the United States. Conversely, many high-tech companies are willing to endure the additional expense of setting up joint projects in Switzerland and Germany to take advantage of their engineering prowess.

Infrastructure

Infrastructure refers to a country or community's ability to provide the services required for a project. Infrastructure needs for a project could be communication, transportation, power, technology, and education systems. For example, developing an electric steel plant to be near a major market requires a reliable supply of electric power. If reliable power is not sufficient, other alternatives need to be considered. Software projects across borders are common today; however, they depend on reliable telecommunication networks. These networks simplify and facilitate project coordination and management among project stakeholders in different locations. If the project depends on a high ratio of vendor suppliers, good roads, and other transportation modes such as air and seaports, a good infrastructure will be imperative.

An example of a project that failed to take into account the needs and infrastructure of the host nation involved a U.S. company that was awarded the contract for building a hospital in an African nation. The local African officials wanted a "low-tech" health care facility that would take local traditions into consideration. Because their relatives generally accompanied patients, space had to be provided for them, too. Electricity was not reliably

supplied, and it was doubtful whether well-educated doctors would want to spend careers away from the city. Therefore, the locals wanted a hospital for basic care with minimum technology. The construction company doing the building, on the other hand, had a preconceived notion of what a hospital should be and was not going to be accused of building a second-rate facility. It built a modern hospital that could have stood in any U.S. city. The building was completed; however, even after several years it was not used because the electricity was not sufficient, the air-conditioning could not be used, and doctors refused to live in the rural area.

Organizations need to consider the needs of the families of personnel they send overseas. Will the facilities and living conditions for the expatriate families place an undue hardship on families? Will schooling for children be available? The welfare and comfort of expatriate families play an important role in retaining good project managers and promoting their peak performance.

Culture

Visiting project managers must accept and respect the customs, values, philosophies, and social standards of their host country. Global managers recognize that if the customs and social cultural dimensions of the host country are not accommodated, projects will not succeed. Too many project audits and final reports of international projects reflect challenges and problems linked to cultural differences.

For most project managers, the biggest difference in managing an international project is operating in a national culture where things are done differently. For example, most developed nations use the same project management techniques (CPM, risk analysis, trade-off analysis). However, how activity work is performed can be very different in the host country.

Will English be the operating language, or will the project manager need to be fluent in the foreign language? Will translation services be available and sufficient? Communication problems—because of language differences—often become a major problem in carrying out even simple tasks. Although the use of translators can help tremendously, their use does not solve the communication problem completely because something is lost in translation. For example, consider the disastrous consequences of differences in interpretations and expectations between the Brazilians and Americans highlighted in the Snapshot from Practice: River of Doubt.

Will religious factors influence the project? For example, religious factors touched the spouse of a Scandinavian project manager responsible for building a water desalination plant from sea water in a Middle East country. She was restricted to the living compound for families of foreign guest workers. Going outside the compound to a nearby city meant covering her head, arms, and legs and being accompanied by another woman or, preferably, a man. A physical altercation in the city concerning her clothing was traumatic for her. She left the country and returned home. Her husband requested a transfer back home three months later. The loss of the original project manager from the project required the assigned project manager to establish relationships with the project team and host country's nationals to get the project moving smoothly again.

Not only do project managers have to adapt to the culture of the host country, but oftentimes overseas projects require working with people from different countries. For example, on a light rail project in the Philippines, an American firm was hired to oversee the interests of local real estate companies who were funding the project. The American project manager had to work with Czech representatives who were providing the rail equipment, Japanese engineers responsible for building the rail, Australian bankers who were providing additional financing, an Indian firm that were the principal architects, as well as the native Filipinos.

Snapshot from Practice River of Doubt*

After his crushing election defeat in 1912 as a third-party candidate, former president Theodore ("Teddy") Roosevelt set his sights on a grand adventure, the first descent of an unmapped rapids-choked tributary of the Amazon aptly titled the "River of Doubt." Together with Brazil's most famous explorer, Candido Mariano da Silva Rondon, Roosevelt accomplished a feat that belongs in the annals of great expeditions.

Along the way, Roosevelt and his men faced an unbelievable series of hardships, losing their canoes and supplies to crushing whitewater rapids, and enduring starvation, Indian attacks, disease, drowning, and even murder within their ranks. Candice Millard brings alive these extraordinary events in her nonfiction thriller *The River of Doubt*. While her account details the ill-fated journey it also reveals insights into international project management as it describes the collaboration between the American and Brazilian cohorts. While each party ultimately earned the respect and admiration of the other, friction between the two parties simmered from the outset.

One source of consternation was the amount of supplies and luggage that the Americans required for the journey. Warned that the luggage requirements of the former president and his party would be extensive, the Brazilian commodore Rondon ordered 110 mules and 17 pack oxen to be used for the expedition's overland journey across the Brazilian highland to the great river. Surely, he felt, this would be more than necessary for such a trip.

The Brazilians were astounded by the sheer volume of baggage that was unloaded from Roosevelt's ship, the *Vandycks*.

There were mountains of crates: guns and ammunition, chairs and tables, tents and cots, equipment for collecting preserving specimens, surveying the river, and cooking meals. An exhausted stevedore elicited a roar of laughter from the onlooking crowd when he announced, "Nothing lacking but the piano!"

Rather than risk embarrassment by telling Roosevelt that they were not prepared to take so much luggage, Rondon scrambled to find additional animals. Extra oxen and mules were located, but they were far from tame. Loaded with supplies, the oxen would buck and throw off the packs. The expedition was delayed as gauchos (South American cowboys) endeavored to "break" the animals as quickly as possible.

Within days of finally setting off across the vast highlands, Roosevelt and his men began to experience the harsh realities that were to plague the expedition. After crossing a bone-strewn graveyard of oxen and mules that had starved to death or been eaten during previous expeditions, they were stunned by the sight of unopened supply crates, all clearly marked "Roosevelt South American Expedition." The pack animals, still making their weary away across the plateau ahead of the them, had begun bucking off their heavy loads!

As the officers rode slowly past the boxes, they wondered what they were leaving behind and how precious it might become in the months ahead. Little did they know how true those fears would be.

* Candice Millard, *The River of Doubt* (New York: Doubleday), 2005.

Of all the factors, working within a multicultural environment is most often the greatest challenge for project managers. It will be dealt with in detail later in this chapter.

Project Site Selection

As the project manager studies the factors contributing to site selection, he will see that inherent in all of these factors is the risk level senior management and directors are willing to accept for the potential rewards of a successful international project. One approach for the project manager to digest, clarify, and understand the factors leading to the selection of a specific project is to use a risk matrix similar to those found in Chapter 7. The major difference lies in the selection of the risk factors for different project sites.

Figure 15.2 presents a truncated matrix for project site selection of the construction of a laser printer factory in Singapore, India, or Ireland. In this example, political stability, worker skill and supply, culture compatibility, infrastructure, government support, and product-to-market advantage were the major assessment factors. Each project site is compared against each factor. Figure 15.3 depicts a further breakdown of the infrastructure evaluation factor. In this example, transportation, educated workforce, utilities, telecommunications, and vendor suppliers are considered important to evaluating the infrastructure for each site.

FIGURE 15.2
Assessment Matrix
Project Site Selection

Score legend
5 = excellent
3 = acceptable
1 = poor

	Political stability	Worker skill, supply	Culture compatibility	Infrastructure	Government support	Product-to-market advantage
Singapore	5	4	4	4	4	3
India	3	4	3	3	3	3
Ireland	5	4	5	5	5	5

FIGURE 15.3
Evaluation Matrix
Breakdown for
Infrastructure

Score legend
5 = excellent
3 = acceptable
1 = poor

	Transportation	Educated workforce	Utilities	Telecommunications	Vendor suppliers
Singapore	5	4	5	5	4
India	3	4	4	4	2
Ireland	5	4	5	5	5

The scores given in Figure 15.3 are used to assign values to the infrastructure factor of the assessment matrix, Figure 15.2. In this project, Ireland was the choice. Clearly, Singapore and Ireland were very close in terms of infrastructure and several other factors. However, the major assessment factor of using Ireland to access the EEC (product-to-market advantage) turned the decision.

Given the macro economic factors, the firm's strategic posture toward global projects, and the major considerations for selecting this project, it is imperative the project manager quickly become sensitized to the foreign cultural factors that can spell project success or failure.

Cross-Cultural Considerations: A Closer Look

The concept of culture was introduced in Chapter 3 as referring to the unique personality of a particular firm. More specifically, culture was defined as a system of shared norms, beliefs, values, and customs that bind people together, creating shared meaning and a unique identity. *Culture* is a concept created for descriptive purposes and depends on the group that is the focus of attention. For example, within a global context culture can refer to certain regions (i.e., Europeans, Arabs), to specific nations (i.e., French, Thai), or to certain ethnic or religious groups (i.e., Kurds, African-Americans). This chapter looks at national cultures; we freely recognize that many cultural characteristics are borderless and that there is considerable variation within any one country. Still, national cultures provide a useful anchor for understanding different habits, customs, and values around the world.

Right or wrong, Americans have a reputation for not being able to work effectively in foreign cultures. (When we use the term "American," we are referring to people from the United States; we apologize to our friends in Canada and Central and South America.) In the 1960s, the term "Ugly American" encapsulated the apparent indifference of Americans to native cultures when working or traveling abroad. Americans are often criticized for being parochial; that is, they view the world solely through their own eyes and perspectives. People with a parochial perspective do not recognize that other people have different ways of living and working effectively. American parochial attitudes probably reflect the huge domestic market of the United States, the geographic isolation of the United States, and the reality that English is becoming the international business language in many parts of the world.

It is important that Americans working on international projects anticipate cultural differences. Take, for example, a project manager from a large North American construction company who was given responsibility to select a site for the design and construction of a large fish-processing plant in a West African country. The manager assessed potential sites according to the availability of reliable power, closeness to transportation, nearness to the river for access of fishing boats from the Atlantic Ocean, proximity to main markets, and availability of housing and people for employment. After evaluating alternative sites, the project manager chose the optimum location. Just prior to requesting bids from local contractors for some of the site preparation, the manager discovered, in talking to the contractors, that the site was located on ground considered sacred by the local people, who believed this site was the place where their gods resided. None of the local people upon whom the project manager was depending for staff would ever consider working there! The project manager quickly revised his choice and relocated the site. In this case, he was lucky that the cultural gaffe was discovered prior to construction. Too often these errors are realized only after a project is completed.

Some argue that Americans have become less parochial. International travel, immigration, movies, and the popularity of such international events as the Olympics have made more Americans sensitive to cultural differences. While Americans may be more worldly, there is still a tendency for them to believe that American cultural values and ways of doing things are superior to all others. This ethnocentric perspective is reflected in wanting to

Anthropologists Kluckhohn and Strodtbeck assert that cultural variations reflect how different societies have responded to common issues or problems throughout time (see Figure 15.4). Five of the issues featured in their comparative framework are discussed here.

- *Relation to nature*—This issue reflects how people relate to the natural world around them and to the supernatural. Should people dominate their environment, live in harmony with it, or be subjugated to it? North Americans generally strive to harness nature's forces and change them as they need. Other societies, as in India, strive to live in harmony with nature. Still other societies see themselves at the mercy of physical forces and/or subject to the will of a supreme being. Life in this context is viewed as predetermined, preordained, or an exercise in chance.

- *Time orientation*—Does the culture focus on the past, present, or future? For example, many European countries focus on the past and emphasize maintaining tradition. North Americans, on the other hand, are less concerned with tradition and tend to focus on the present and near future. Paradoxically, Japanese society, while rich with tradition, has a much longer time horizon.

- *Activity orientation*—This issue refers to a desirable focus of behavior. Some cultures emphasize "being" or living in the moment. This orientation stresses experiencing life and seeking immediate gratification. Other cultures emphasize "doing" and emphasize postponing immediate gratification for greater accomplishment. A third alternative is the "control" orientation, where people restrain their desires by detaching themselves from objects. The activity dimension affects how people approach work and leisure and the extent to which work-related concerns pervade their lives. It is reflected in the age-old question, "Do we live to work or work to live?"

- *Basic nature of people*—Does a culture view people as good, evil, or some mix of these two? In many Third World countries, people see themselves as basically honest and trustworthy. Conversely, some Mediterranean cultures have been characterized as taking a rather evil view of human nature. North Americans are somewhere in between. They see people as basically good but stay on guard so as not to be taken advantage of.

- *Relationships among people*—This issue concerns the responsibility one has for others. Americans, for instance, tend to be highly individualistic and believe everyone should take care of him- or herself. In contrast, many Asian societies emphasize concern for the group or community he or she is a member of. A third variation is hierarchical, which is similar to the group except that in these societies groups are hierarchically ranked, and membership is essentially stable over time. This is a characteristic of aristocratic societies and caste systems.

The Kluckhohn and Strodtbeck framework provides a basis for a deeper understanding of cultural differences. At the same time, they warn that not all members of a culture practice the same behavior all the time, and, as in the United States, there is likely to be considerable variation within a given culture.

* F. Kluckhohn and F. L. Strodtbeck, *Variations in Value Orientations* (Evanston, IL: Row, Peterson, 1961).

FIGURE 15.4
Kluckhohn-Strodtbeck's Cross-Cultural Framework

Note: The line indicates where the United States tends to fall along these issues.

Cultural issue	Variations		
Relationship to nature	Domination	Harmony	Subjugation
Time orientation	Past	Present	Future
Activity orientation	Being	Doing	Controlling
Nature of people	Good	Evil	Mixed
Relationships among people	Individualist	Group	Hierarchical

The Hofstede framework grew from a study of 88,000 people working in IBM subsidiaries in 50 countries and 3 multicountry regions. Based on responses to a 32-item questionnaire, Dutch social scientist Geert Hofstede developed different dimensions for examining cultures:

1. Individualism versus collectivism. Identifies whether a culture holds individuals or the group responsible for each member's welfare.

2. Power distance. Describes the degree to which a culture accepts status and power differences among its members.

3. Uncertainty avoidance. Identifies a culture's willingness to accept uncertainty and ambiguity about the future.

4. Masculinity-femininity. Describes the degree to which the culture emphasizes competitive and achievement-oriented behavior or displays concerns for relationships.

Figure 15.5 shows how he ranked selected countries according to collectivism-individualism and power distance. Wealth appears to influence both factors. Power distance is correlated with income inequality in a country while individualism is correlated with national wealth (Per Capita Gross National Product). As a result high power distance and collectivism are often found together, as are low power distance and individualism. This can affect decision making on project teams. For example, while the high collectivism may lead a project team in Thailand to operate consensually, the high power distance may cause decisions to be heavily influenced by the desires of the project manager. Conversely, a similar team operating in more individualistic and low power distance such as Great Britain or America might make decisions with more open debate including challenging the preferences of the project manager.

*Culture's Consequences: Comparing Values, Behaviors, Institutions and Organizations Across Nations, 2nd Edition. (Thousand Oaks, CA: Sage Publications, 2001). http://www.geerthofstede.nl

FIGURE 15.5

Sample Country Clusters on Hofstede's Dimensions of Individualism-Collectivism and Power Distance

Collectivism		Columbia, Peru, Thailand, Singapore, Mexico, Turkey, Indonesia
Individualism	Israel, Finland, Germany, Ireland, New Zealand, Canada, Great Britain, United States	Spain, South Africa, France, Italy, Belgium
	Low power distance	High power distance

conduct business only on their terms and stereotyping other countries as lazy, corrupt, or inefficient. Americans need to make a serious effort to appreciate other ways of approaching work and problems in other countries.

Finally, American project managers have earned a reputation abroad for being very good at understanding technology but not good at understanding people. As one Indonesian engineer put it, "Americans are great at solving technical problems, but they tend to ignore the people factor." For example, Americans tend to underestimate the importance that relationship building plays in conducting business in other countries. Americans have a tendency to want to get down to work and let friendships evolve in the course of their work. In most other cultures just the opposite is true. Before a foreigner works with you, he wants to get to know you as a person. Trust is not established by credentials but rather evolves from personal interaction. Business deals often require a lengthy and elaborate courtship. For example, it may take five to eight meetings before Arab managers are even willing to discuss business details.

Adjustments

Two of the biggest adjustments Americans typically have to make in working abroad are adapting to the general pace of life and the punctuality of people. In America "time is money," and a premium is placed on working quickly. Other cultures do not share Americans' sense of urgency and are accustomed to a much slower pace of life. They can't understand why Americans are always in such a hurry. Punctuality varies across cultures. For example, Americans will generally tolerate someone being 5 to 10 minutes late. In contrast, among Peruvians, the period before an apology or explanation for being late is expected might be 45 minutes to an hour!

While working on multicultural projects, managers sometimes encounter ethical dilemmas that are culturally bound. For example, the 1999 Olympic site selection scandal featured the sordid details of committee members peddling their votes for a wide range of gifts (i.e., university scholarships for their children, extravagant trips). In many societies such "bribes" or "tributes" are expected and the only way to conduct meaningful business. Moreover, many cultures will not grant a female project manager the same respect they will a male project manager. Should U.S. management increase project risk or violate its own sex-discrimination policy?

These cultural differences are just the tip of the iceberg. There are numerous "How to Do Business in . . ." books written by people who have traveled and worked abroad. Although these books may lack rigor, they typically do a good job of identifying local customs and common mistakes made by outsiders. On the other hand, anthropologists have made significant contributions to our understanding of why and how the cultures of societies are different (see the accompanying Research Highlights). Students of international project management are encouraged to study these works to gain a deeper understanding of the root causes of cultural diversity.

So what can be said to prepare people to work on international projects? The world is too diverse to do justice in one chapter to all the cultural variations managers are likely to encounter when working on international projects. Instead, a sample of some of these differences will be highlighted by discussing working on projects in four different countries: Mexico, France, Saudi Arabia, and China. We apologize to our readers outside the United States because briefings are presented from the viewpoint of a U.S. project manager working in these countries. Still, in an effort not to be too ethnocentric, we present a fifth scenario for foreign project managers assigned to working in the United States. Although by no means exhaustive, these briefings provide a taste of what it is like to work in and with people from these countries.

Working in Mexico

America developed historically in an environment where it was important for strangers to be able to get along, interact, and do business. On the American frontier almost everyone was a stranger, and people had to both cooperate and keep their distance. The New England Yankee sentiment that "Good fences make good neighbors" expresses this American cultural value well. Conversely, Mexico developed historically in an environment where the only people to trust were family and close friends—and by extension, people who were known to those whom you knew well. As a consequence, personal relationships dominate all aspects of Mexican business. While Americans are generally taught not to do business with friends, Mexicans and other Latin Americans are taught to do business with no one but friends.

The significance of personal relationships has created a *compadre* system in which Mexicans are obligated to give preference to relatives and friends when hiring, contracting, procuring, and sharing business opportunities. North Americans often complain that such

practices contribute to inefficiency in Mexican firms. While this may or may not be the case, efficiency is prized by Americans, while Mexicans place a higher value on friendship.

Mexicans tend to perceive Americans as being "cold." They also believe that most Americans look down on them. Among the most effective things an American can do to prevent being seen as a typical *Gringo* is to take the time and effort in the beginning of a working relationship to really get to know Mexican counterparts. Because family is all-important to Mexicans, a good way for developing a personal relationship is exchanging information about each other's family. Mexicans will often gauge people's trustworthiness by the loyalty and attention they devote to their family.

The *mañana* syndrome reflects another cultural difference between Americans and Mexicans. Mexicans have a different concept of time than Americans do. Mexicans feel confined and pressured when given deadlines; they prefer open-ended schedules. They generally consider individuals to be more important than sticking to a schedule. If a friend drops in at work, most Mexicans will stop and talk, regardless of how long it takes, and even if chatting makes their work late. This sometimes contributes to the erroneous perception that Mexicans lack a work ethic. Quite the contrary; given a minimal incentive, Mexicans can be quite industrious and ambitious.

Finally, as in many other cultures, Mexicans do not share Americans' confidence that they control their own destiny. While Americans are taught, "When the going gets tough, the tough get going," Mexicans are taught, "Taking action without knowing what is expected or wanted can have dangerous consequences." Mexicans tend to be more cautious and want to spend more time discussing risks and potential problems that Americans might dismiss as improbable or irrelevant.

Other useful guidelines for working with Mexicans on projects include the following:

1. Americans tend to be impersonal and practical when making arguments; Mexicans can be very passionate and emotional when arguing. They enjoy a lively debate.
2. Where Americans tend to use meetings as the place to work things out publicly, Mexicans tend to see meetings as the place where persons with authority ratify what has been decided during informal private discussions.
3. While Mexicans can be emotional, they tend to shy away from any sort of direct confrontation or criticism. A long silence often indicates displeasure or disagreement.
4. Speech in Mexico is often indirect. People rarely say no directly but are more likely to respond by saying maybe *(quizas),* or by saying "I will think about it" or changing the subject. Yes *(si)* is more likely to mean "I understand you" than "yes."
5. Titles are extremely important in Mexico and are always used when a person is introducing him- or herself or being introduced. Pay as much attention to remembering a person's title as to remembering his or her name.

Today, with NAFTA and increased international business activity in Mexico, old traditions are disappearing. American managers report that cultural differences are less evident in northern Mexico where many multinational firms operate. Here *hora americana* (American time) rather than *hora mexicana* tends to be used when dealing with foreigners. Project managers should devote up-front effort to understanding how much older mores of Mexican culture apply to their project.

Working in France

Some Americans consider the French the most difficult to work with among Europeans. This feeling probably stems from a reflection of the French culture, which is quite different from that in the United States.

In France, one's social class is very important. Social interactions are constrained by class standing, and during their lifetimes most French people do not encounter much change in social status. Unlike an American, who through hard work and success can move from the lowest economic stratum to the highest, a successful French person might, at best, climb one or two rungs up the social ladder. Additionally, the French are very status conscious and like to provide signs of this status, such as knowledge of literature and arts; a well-designed, tastefully decorated house; and a high level of education.

The French tend to admire or be fascinated with people who disagree with them; in contrast, Americans are more attracted to those who agree with them. As a result, the French are accustomed to conflict and, during negotiations, accept the fact that some positions are irreconcilable and must be accepted as such. Americans, on the other hand, tend to believe that conflicts can be resolved if both parties make an extra effort and are willing to compromise. Also, the French often determine a person's trustworthiness based on their first-hand, personal evaluation of the individual's character. Americans, in contrast, tend to evaluate a person's trustworthiness on the basis of past achievements and other people's evaluations.

The French are often accused of lacking an intense work ethic. For example, many French workers frown on overtime and on average they have one of the longest vacations in the world (four to five weeks annually). On the other hand, the French enjoy a reputation for productive work, a result of the French tradition of craftsmanship. This tradition places a greater premium on quality rather than on getting things accomplished quickly.

Most French organizations tend to be highly centralized with rigid structures. As a result, it usually takes longer to carry out decisions. Because this arrangement is quite different from the more decentralized organizations in the United States, many U.S. project managers find the bureaucratic red tape a source of considerable frustration.

In countries like the United States, a great deal of motivation is derived from professional accomplishments. The French do not tend to share this same view of work. While they admire American industriousness, they believe that quality of life is what really matters. As a result they attach much greater importance to leisure time, and many are unwilling to sacrifice the enjoyment of life for a dedication to project work.

Cautions to remember with the French include these:

1. The French value punctuality. It is very important to be on time for meetings and social occasions.

2. Great importance is placed on neatness and taste. When interacting with French businesspeople, pay close attention to your own professional appearance and appear cultured and sophisticated.

3. The French can be very difficult to negotiate with. Often, they ignore facts, no matter how convincing they may be. They can be quite secretive about their position. It is difficult to obtain information from them, even in support for their position. Patience is essential for negotiating with them.

4. French managers tend to see their work as an intellectual exercise. They do not share the American view of management as an interpersonally demanding exercise, where plans have to be constantly "sold" upward and downward using personal skills.

5. The French generally consider managers to be experts. They expect managers to give precise answers to work-related questions. To preserve their reputation, some French managers act as if they know the answers to questions even when they don't.

Working in Saudi Arabia

Project management has a long tradition in Saudi Arabia and other Arab countries. Financed by oil money, European and American firms have contributed greatly to the modernization of Arab countries. Despite this tradition, foreigners often find it very hard to work on projects in Saudi Arabia. A number of cultural differences can be cited for this difficulty.

One is the Arabian view of time. In North America, it is common to use the cliché, "The early bird gets the worm." In Saudi Arabia, a favorite expression is, "Bukra insha Allah," which means, "Tomorrow if God wills," an expression that reflects the Saudis' approach to time. Unlike Westerners, who believe they control their own time, Arabs believe that Allah controls time. As a result, when Saudis commit themselves to a date in the future and fail to show up, there is no guilt or concern on their part because they have no control over time in the first place. In planning future events with Arabs, it pays to hold lead time to a week or less, because other factors may intervene or take precedence.

An associated cultural belief is that destiny depends more on the will of a supreme being than on the behavior of individuals. A higher power dictates the outcome of important events, so individual action is of little consequence. As a result, progress or the lack of progress on a project is considered more a question of fate than effort. This leads Saudis to rely less on detailed plans and schedules to complete projects than Americans do.

Another important cultural contrast between Saudi Arabians and Americans is emotion and logic. Saudis often act on the basis of emotion; in contrast, those in an Anglo culture are taught to act on logic. During negotiations, it is important not only to share the facts but also to make emotional appeals that demonstrate your suggestion is the right thing to do.

Saudis also make use of elaborate and ritualized forms of greetings and leave-takings. A businessperson may wait far past the assigned meeting time before being admitted to a Saudi office. Once there, the individual may find a host of others present; one-on-one meetings are rare. Moreover, during the meeting there may be continuous interruptions. Visitors arrive and begin talking to the host, and messengers may come in and go out on a regular basis. The businessperson is expected to take all this activity as perfectly normal and to remain composed and ready to continue discussions as soon as the host is prepared to do so.

Initial meetings are typically used to get to know the other party. Business-related discussions may not occur until the third or fourth meeting. Business meetings typically conclude with an offer of coffee or tea. This is a sign that the meeting is over and that future meetings, if there are to be any, should now be arranged.

Saudis attach a great deal of importance to status and rank. When meeting with them, defer to the senior person. It is also important never to criticize or berate anyone publicly. This causes the individual to lose face; the same is true for the person who makes these comments. Mutual respect is expected at all times.

Other useful guidelines for working in an Arab culture such as Saudi Arabia include the following:

1. It is important never to display feelings of superiority because this makes the other party feel inferior. No matter how well someone does something, the individual should let the action speak for itself and not brag or draw attention to himself.

2. A lot of what gets done is a result of going through administrative channels in the country. It is often difficult to sidestep a lot of this red tape, and efforts to do so can be regarded as disrespect for legal and governmental institutions.

3. Connections are extremely important in conducting business. More important people get fast service from less important people. Close relatives take absolute priority; non-relatives are kept waiting.

4. Patience is critical to the success of business negotiations. Time for deliberations should be built into all negotiations to prevent a person from giving away too much in an effort to reach a quick settlement.

5. Important decisions are usually made in person and not by correspondence or telephone. While Saudis seek counsel from many people, the ultimate power to make a decision rests with the person at the top, and this individual relies heavily on personal impressions, trust, and rapport.

Working in China

In recent years the People's Republic of China (PRC, or China, for short) has moved away from isolation to encourage more business with the rest of the world. While China holds tremendous promise, many Western firms have found working on projects in China to be a long, grueling process that often results in failure. One of the primary reasons for problems is the failure to appreciate Chinese culture.

Chinese society, like those of Japan and Korea, is influenced by the teachings of Confucius (551–478 B.C.). Unlike America, which relies on legal institutions to regulate behavior, in Confucian societies the primary deterrent against improper or illegal behavior is shame or loss of face. Face is more than simply reputation. There is a Chinese saying that, "Face is like the bark of a tree; without its bark, the tree dies." Loss of face not only brings shame to individuals but also to family members. A member's actions can cause shame for the entire family, hampering that family from working effectively in Chinese society.

In China, "whom you know is more important than what you know." The term *guanxi* refers to personal connections with appropriate authorities or individuals. China observers argue that *guanxi* is critical for working with the Chinese. Chinese are raised to distrust strangers, especially foreigners. Trust is transmitted via *guanxi.* That is, a trusted business associate of yours must pass you along to his trusted business associates. Many outsiders criticize *guanxi,* considering it to be like nepotism where decisions are made regarding contracts or problems based on family ties or connections instead of an objective assessment of ability.

Many believe that the quickest way to build *guanxi* relationships is through tendering favors. Gift-giving, entertainment at lavish banquets, questionable payments, and overseas trips are common. While Westerners see this as nothing short of bribery, the Chinese consider it essential for good business. Another common method for outsiders to acquire *guanxi* is by hiring local intermediaries, who use their connections to create contacts with Chinese officials and businesspeople.

In dealing with the Chinese, you must realize they are a collective society in which people pride themselves on being a member of a group. For this reason, you should never single out a Chinese for specific praise because this is likely to embarrass the individual in front of his peers. At the same time, you should avoid the use of "I" because it conveys that the speaker is drawing attention to himself or herself.

Chinese do not appreciate loud, boisterous behavior, and when speaking to each other they maintain a greater physical distance than is typical in America. Other cautions include the following:

1. Once the Chinese decide who and what is best, they tend to stick to their decisions. So while they may be slow in formulating a plan, once they get started they make good progress.

2. Reciprocity is important in negotiations. If Chinese give concessions, they expect some in return.

Americans tend to discount the significance of luck and believe that good fortune is generally a result of hard work. In other cultures, luck takes on greater significance and has supernatural ramifications. For example, in many Asian cultures certain numbers are considered lucky, while others are unlucky. In Hong Kong the numbers 7, 3, and especially 8 (which sounds like the word for prosperity) are considered lucky, while the number 4 is considered unlucky (because it is pronounced like the word "death"). Hong Kong businesspeople go to great lengths to avoid the number 4. For example, there is no fourth floor in office and hotel buildings. Business executives have been known to reject ideal sites in heavily congested Hong Kong because the address would contain the number 4. They pay premium prices for suitable sites containing addresses with the lucky numbers. Likewise, Hong Kong business managers avoid scheduling important events on the fourth day of each month and prefer to arrange critical meetings on the eighth day.

Hong Kong is also a place where the ancient art of *Feng shui* (literally "wind water") is practiced. This involves making sure a site and buildings are aligned in harmony with the earth's energy forces so that the location will be propitious. Feng shui practitioners are often called in on construction projects to make sure that the building is aligned correctly on the site. In some cases, the technical design of the building is changed to conform to the recommendations of such experts. Similarly, Feng shui experts have been known to be called in when projects are experiencing problems. Their recommendations may include repositioning the project manager's desk or hanging up mirrors to deflect the flow of unharmonious influences away from the building or site of the project.

Rob Brimson/Taxi/Getty Images.

In cultures where luck is believed to play a role in business, people who discount luck may not only insult the luck seekers, they may risk being thought negligent in not paying enough attention to what is viewed as a legitimate business concern.

3. The Chinese tend to be less animated than Americans. They avoid open displays of affection and physical contact; they are more reticent and reserved than Americans.

4. The Chinese place less value on the significance of time and often get Americans to concede concessions by stalling.

5. In Confucian societies those in position of power and authority are obligated to assist the disadvantaged. In return they gain face and a good reputation.

For more insights on Chinese culture see the Snapshot from Practice: Project Management X-Files.

Working in the United States

In the world of international projects, professionals from other countries will come to the United States to manage projects. To them, the United States is a foreign assignment. They will have to adapt their management style to the new environment they find in the States.

Immigration has made the United States a melting pot of diverse cultures. While many are quick to point out the differences between North and South, Silicon Valley and Wall Street, social anthropologists have identified certain cultural characteristics that shape how many Americans conduct business and manage projects.

Mainstream Americans are motivated by achievement and accomplishment. Their identity and, to a certain extent, their self-worth are measured by what they have achieved. Foreigners are often astounded by the material wealth accumulated by Americans and the modern conveniences most Americans enjoy. They are also quick to point out that Americans appear too busy to truly enjoy what they have achieved.

Americans tend to idolize the self-made person who rises from poverty and adversity to become rich and successful. Most Americans have a strong belief that they can influence and create their future, that with hard work and initiative, they can achieve whatever they set out to do. Self-determination and pragmatism dominate their approach to business.

Although Americans like to set precise objectives, they view planning as a means and not an end. They value flexibility and are willing to deviate from plans and improvise if they believe change will lead to accomplishment. Obstacles on a project are to be overcome, not worked around. Americans think they can accomplish just about anything, given time, money, and technology.

Americans fought a revolution and subsequent wars to preserve their concept of democracy, so they resent too much control or interference, especially by governments. While more an ideal than practice, there is deep-rooted belief in American management philosophy that those people who will be affected by decisions should be involved in making decisions. Many foreign businesspeople are surprised at the amount of autonomy and decision-making authority granted to subordinates. Foreign personnel have to learn to interact with American professionals below their rank in their own organizations.

Businesspeople from different African, Asian, and Latin American countries are amazed and often somewhat distressed at the rapid pace of America. "Getting things done" is an American characteristic. Americans are very time-conscious and efficient. They expect meetings to start on time. They tinker with gadgets and technological systems, always searching for easier, better, more efficient ways of accomplishing things. American professionals are often relentless in pursuing project objectives and expect that behavior of others also.

Americans in play or business generally are quite competitive, reflecting their desire to achieve and succeed. Although the American culture contains contradictory messages about the importance of success (i.e., "It's not whether you win or lose but how you play the game" versus "nice guys finish last"), winning and being number one are clearly valued in American society. Foreigners are often surprised at how aggressively Americans approach business with adversarial attitudes toward competitors and a desire to not just meet but to exceed project goals and objectives.

Other guidelines and cautions for working with Americans on projects include:

1. More than half of U.S. women work outside the home; females have considerable opportunity for personal and professional growth, guaranteed by law. It is not uncommon to find women in key project positions. Female professionals expect to be treated as equals. Behavior tolerated in other countries would be subject to harassment laws in the States.

2. In the United States, gifts are rarely brought by visitors in a business situation.

3. Americans tend to be quite friendly and open when first meeting someone. Foreigners often mistake this strong "come-on" for the beginning of a strong reciprocal friendship. This is in contrast to many other cultures where there is more initial reserve in interpersonal relations, especially with strangers. For many foreigners, the American comes on too strong, too soon, and then fails to follow up with the implicitly promised friendship.

4. Although in comparison to the rest of the world Americans tend to be informal in greeting and dress, they are a noncontact culture (e.g., they avoid embracing in public usually)

Will corruption influence the project? Bribes are illegal in the United States, but in some countries they are the usual way to do business. For example, one American project manager in a foreign country requested that a shipment of critical project equipment be sent "overnight rush." Two days later, inquiries to the sender confirmed the materials had been delivered to the nearby airport. Further inquiries to the port found the shipment "waiting to pass customs." Locals quickly informed the American that money paid to the chief customs inspector would expedite clearance. The American project manager's response

was, "I will not be held hostage. Bribes are illegal!" Two more days of calling government officials did not move the shipment from customs. The manager related his problem to a friendly businessman of the host nation at a social affair. The local businessman said he would see if he could help. The shipment arrived the next morning at 10:00 A.M. The American called his local business friend and thanked him profusely. "I owe you one." "No," replied the local. "You owe me a $50 dinner when I visit you in the States." The use of an intermediary in such situations may be the only avenue available to a manager to reduce the stress and personal conflict with the U.S. value system.

and Americans maintain certain physical/psychological distance with others (e.g., about two feet) in conversations.

5. American decision making is results oriented. Decisions tend to be based on facts and expected outcomes, not social impact.

Summary Comments about Working in Different Cultures

These briefings underscore the complexity of working on international projects. It is common practice to rely on intermediaries—often natives who are foreign educated—to bridge the gap between cultures. These intermediaries perform a variety of functions. They act as translators. They use their social connections to expedite transactions and protect the project against undue interference. They are used to sidestep the touchy bribery/gift dilemma (see the accompanying Snapshot from Practice). They serve as cultural guides, helping outsiders understand and interpret the foreign culture. In today's world, there are a growing number of consulting firms that perform these functions by helping foreign clients work on projects in their country.

The international briefings also highlight the importance of project managers doing their homework and becoming familiar with the customs and habits of the host country they are going to be working in. As far as possible, the project should be managed in such a way that local-country norms and customs are honored. However, there are limits to the extent to which you should accommodate foreign cultures. *Going native* is generally not an alternative. After all, it took a Russian his entire life to learn how to be a Russian. It would be foolish to think an outsider could learn to be one in six months, two years, or perhaps ever.

The remainder of this chapter focuses on the selection and training of project personnel for international projects. But before these issues are discussed, this section concludes with a discussion of the phenomenon of culture shock, which can have a profound effect on a foreigner's performance on a project in a strange culture.

Culture Shock

My first few weeks in Chiang Mai [Thailand] were filled with excitement. I was excited about the challenge of building a waste treatment plant in a foreign country. I was fascinated with Thai customs and traditions, the smells and sights of the night market. Soon I noticed a distinct change in my attitude and behavior. I started having problems sleeping and lacked energy. I became irritable at work, frustrated by how long things took to accomplish, and how I couldn't seem to get anything accomplished. I started staying up late at night watching CNN in my hotel room.

Stages of culture shock

FIGURE 15.6
Culture Shock Cycle

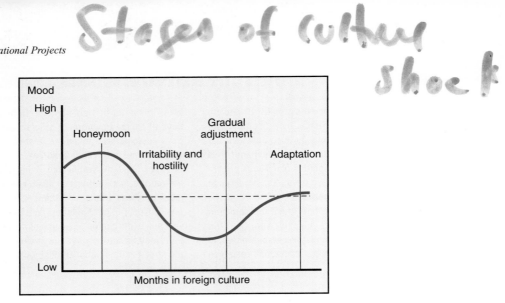

This engineer is experiencing what many would call "culture shock." *Culture shock* is a natural psychological disorientation that most people suffer when they move into a culture different from their own. The culture shock cycle has four stages (see Figure 15.6):

1. *Honeymoon*—You start your overseas assignment with a sense of excitement. The new and the unusual are welcomed. At first it is amusing not to understand or be understood. Soon a sense of frustration begins to set in.

2. *Irritability and hostility*—Your initial enthusiasm is exhausted, and you begin to notice that differences are greater than you first imagined. You become frustrated by your inability to get things done as you are accustomed to. You begin to lose confidence in your abilities to communicate and work effectively in the different culture.

3. *Gradual adjustment*—You begin to overcome your sense of isolation and figure out how to get things done in the new culture. You acquire a new perspective of what is possible and regain confidence in your ability to work in the culture.

4. *Adaptation*—You recover from your sense of psychological disorientation and begin to function and communicate in the new culture.

Culture shock is not a disease but a natural response to immersing yourself in a new environment. Culture shock results from a breakdown in your selective perception and effective interpretation system. At a subliminal level, your senses are being bombarded by a wide variety of strange sounds, sights, and smells. At the same time, the normal assumptions you are accustomed to using in your home culture to interpret perceptions and to communicate intentions no longer apply. When this happens, whether in a business context or in normal attempts to socialize, confusion and frustration set in. The natives' behavior does not seem to make sense, and, even more importantly, your behavior does not produce expected results. Frustration occurs because you are used to being competent in such situations and now find you are unable to operate effectively.

Culture shock is generally considered a positive sign that the professional is becoming involved in the new culture instead of remaining isolated in an expatriate ghetto. The significant question is how best to manage culture shock, not how to avoid it. The key appears to be managing the stress associated with culture shock.

Stress-related culture shock takes many forms: disappointment, frustration, withdrawal, anxiety, and physiological responses such as fatigue, sleeplessness, and headaches. Stress is induced by the senses being overwhelmed by foreign stimuli and the inability to function effectively in a strange land. Stress is exacerbated when one encounters disturbing situations

that, as a foreigner, are neither understood nor condoned. For example, many North Americans are appalled by the poverty and hunger in many underdeveloped countries.

Coping with Culture Shock

There are a wide range of stress management techniques for coping with culture shock. One method does not necessarily work any better than another; success depends on the particular individual and situation involved. Some people engage in regular physical exercise programs, some practice meditation and relaxation exercises, and others find it healthy to keep a journal.

Many effective international managers create "stability zones." They spend most of their time immersed in the foreign culture but then briefly retreat into an environment—a stability zone—that closely recreates home. For example, when one of the authors was living in Kraków, Poland, with his family, they would routinely go to the Polish movie houses to see American movies with Polish subtitles. The two hours spent hearing English and seeing a familiar environment on the screen had a soothing effect on everyone.

On the project, managers can reduce the stress caused by culture shock by recognizing it and modifying their expectations and behavior accordingly. They can redefine priorities and develop more realistic expectations as to what is possible. They can focus their limited energy on only the most important tasks and relish small accomplishments.

After three to six months, depending on the individual and assignment, most people come up from their culture shock "low" and begin living a more normal life in the foreign country. They talk to acquaintances from the host country and experienced outsiders from their own culture to find out how to behave and what to expect. Little by little they learn how to make sense of the new environment. They figure out when "yes" means "yes" and when it means "maybe" and when it means "no." They begin to master the language so that they can make themselves understood in day-to-day conversations.

The vast majority of people eventually make the adjustment, although for some people it can take much longer than three to six months. A smaller number never recover, and their international experience turns into a nightmare. Some exhibit severe stress symptoms (e.g., alcoholism, drug abuse, nervous breakdown) and must return home before finishing their assignment.

Professionals can use project work as a bridge until they adjust to their new environment. Unfortunately, spouses who do not work do not have this advantage. When spouses are left to cope with the strange environment on their own, they often have a much more difficult time overcoming culture shock. The effect on spouses cannot be underestimated. The number one reason expatriate managers return home is that their spouses failed to adjust to the new environment.

Project professionals working overseas accept that they are in a difficult situation and that they will not act as effectively as they did at home, especially in the initial stages. They recognize the need for good stress management techniques, including stability zones. They also recognize that it is not an individual problem and invest extra time and energy to help their spouses and families manage the transition. At the same time, they appreciate that their colleagues are experiencing similar problems and are sensitive to their needs. They work together to manage the stress and pull out of a culture shock low as quickly as possible.

It is somewhat ironic, but people who work on projects overseas experience culture shock twice. Many professionals experience the same kind of disorientation and stress when they return home, although it is usually less severe. For some, their current job has less responsibility and is boring compared with the challenge of their overseas assignment. For others, they have problems adjusting to changes made in the home organization while they were gone. This can be compounded by financial shock when the salary and fringe benefits they became accustomed to in the foreign assignment are now lost, and adjusting to a lower standard of living is difficult. It typically takes six months to a year before managers operate again at full effectiveness after a lengthy foreign assignment.

Selection and Training for International Projects

When professionals are selected for overseas projects and they do not work out, the overall costs can be staggering. Not only does the project experience a serious setback, but the reputation of the firm is damaged in the region. This is why many firms have developed formal screening procedures to help ensure the careful selection of personnel for international projects. Organizations examine a number of characteristics to determine whether an individual is suitable for overseas work. They may look for work experience with cultures other than one's own, previous overseas travel, good physical and emotional health, a knowledge of a host nation's language, and even recent immigration background or heritage. Prospective candidates and their family members are often interviewed by trained psychologists, who assess their ability to adapt and function in the new culture.

While there is growing appreciation for screening people for foreign assignments, the number one reason for selection is that the personnel assigned are the best people available for the technical challenges of the project. Technical know-how takes precedence over cross-cultural sensitivity or experience. As a consequence, training is critical to fill in the cultural gaps and prepare individuals to work in a foreign land.

Training varies widely, depending on the individual, company, nature of the project, and cultures to work with. Project professionals assigned to foreign countries should have a minimal understanding of the following areas:

- Religion.
- Dress codes.
- Education system.
- Holidays—national and religious.
- Daily eating patterns.
- Family life.
- Business protocols.
- Social etiquette.
- Equal opportunity.

An example of a short-term training program is the one developed by Underwriter Laboratories, Inc., to train staff who travel to Japan to work with clients on projects. The program is designed around a series of mini-lectures that cover topics ranging from how to handle introductions to the proper way to exchange gifts to the correct way of interpreting Japanese social and business behavior. The two-day program consists of lectures, case studies, role plays, language practice, and a short test on cultural terminology; it concludes with a 90-minute question-and-answer period. At the end of the program, participants have a fundamental understanding of how to communicate with the Japanese. More importantly, they know the types of information they lack and how to go about learning more to become effective intercultural communicators.

Other training programs are more extensive. For example, Peace Corps volunteers undergo an intense two- to four-month training program in their country of service. The training includes classes on the history and traditions of the country, intensive language instruction, and cross-cultural training as well as home-stays with local families. Many companies outsource training to one of the many firms specializing in overseas and intercultural training.

Figure 15.7 attempts to link the length and type of training with the cultural fluency required to successfully complete the project. Three different learning approaches are highlighted:

1. The "information-giving" approach—the learning of information or skills from a lecture-type orientation.

Culture Training

FIGURE 15.7
Relationship between Length and Rigor of Training and Cultural Fluency Required

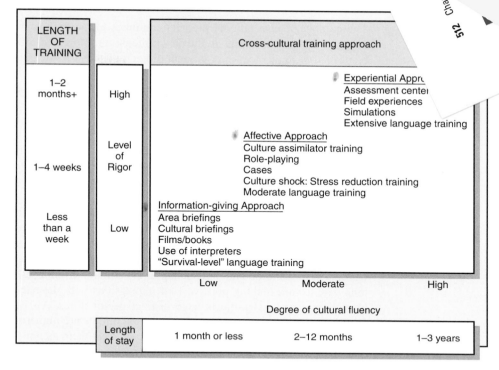

2. The "affective" approach—the learning of information/skills that raise the affective responses on the part of the trainee and result in cultural insights.

3. The "behavioral/experiential" approach—variant of the affective approach technique that provides the trainee with realistic simulations or scenarios.

According to this framework, the length and level of training would depend on the degree of cultural fluency required to be successful. In general, the longer the person is expected to work in the foreign country, the more intensive the training should be. Length of stay should not be the only consideration; high levels of cultural fluency, and therefore more extensive training, may be required to perform short-term, intense projects. In addition, location is important. Working in Australia will likely require less cultural fluency than working on a project in Pakistan.

While English is rapidly becoming the international language for business in many parts of the world, you should not underestimate the value of being able to speak the language of the host country. At a minimum you should be able to exchange basic pleasantries in the native tongue. Most foreigners consider this a sign of respect, and even if you stumble they appreciate the effort.

In many situations translators are used to facilitate communication. While time-consuming, this is the only way to communicate with non-English-speaking personnel. Be careful in the selection of translators, and do not just assume they are competent. For example, one of the authors enlisted the help of a Polish translator to conduct a meeting with some Polish managers. After the meeting the translator, who taught English at a local university, asked if the author "had good time." I responded that I felt things went well. The translator repeated her question. Puzzled, I reaffirmed that I felt things went well. After the interchange was repeated several times, the translator finally grabbed my wrist, pointed at my watch, and asked again if I "had good time?" Doubts arose concerning the accuracy of the meeting translation!

Summary

The number of international projects continues to increase, and nothing on the horizon suggests things will change in the new millennium. More and more project managers will be needed to implement international projects. There are few guidelines for the fledgling international project manager. Preparing for international projects can be enhanced through training. As a general background, potential international project managers can benefit from a basic international business course that sensitizes them to the forces of change in the global economy and to cultural differences. Learning a foreign language is also strongly recommended.

Further training specific to the host country is a very useful preproject endeavor. The length and type of training usually depend on the duration of the project manager's assignment. Review Figure 15.7. Still, self-learning, on-the-job training, and experience are the best teachers for international project managers.

Preparing for a specific international project requires serious preproject homework. Understanding the motivation of the firm in selecting the project and its site provides important insights. What basic political, geographic, economic, and infrastructure factors were key considerations? How will they impact the implementation of the project?

Finally, preparation and understanding the cultural differences of the host country go a long way toward making positive first impressions with the nationals and managing the project. International projects have distinct personalities. All people are not the same. Differences within and among countries and cultures are numerous and complex. Project managers need to accept these differences and treat them as real—or live with the consequences. What works at home may not work in the foreign country. Americans are regarded as friendly by our neighbors in the global village, but Americans are also noted to be insensitive to differences in local cultures and customs and awkward in our use of languages other than English. Although most attention in foreign projects is focused on technical efforts and their cost, the project must be carried out within the environment of the country's social customs, work practices, government controls, and religious beliefs. In most cultures, sincerity and flexibility will pay off.

Key Terms

Cross-cultural orientations	Culture shock	International projects
Culture	Infrastructure	

Review Questions

1. How do environmental factors affect project implementation?
2. What role do local intermediaries play in helping an outsider complete a project?
3. Why is it important to honor the customs and traditions of a country when working on an international project?
4. What is culture shock? What can you do to reduce the negative effects of culture shock?
5. How should you go about preparing yourself for an international project?

Exercises

1. Interview someone who has worked or lived in a foreign country for more than six months.
 a. What was his experience with culture shock?
 b. What did he learn about the culture of the country he lived in?
 c. What advice would he give to someone who would be working on a project in that country?

2. Try as best you can to apply the Kluckhohn-Strodtbeck cross-cultural framework to the four countries discussed in this chapter: Mexico, France, Saudi Arabia, and China. Where do you think these countries lie on each of the cultural issues?

3. Place in order the following countries in terms of what you would think would be the least to most corrupt:

> United States, Finland, Saudi Arabia, Russia, Australia, Hong Kong, Brazil, China, Kenya, Indonesia, Germany, Chile.

Use an Internet search engine to find the most recent International Corruptions Perceptions Index (CPI) released by the Berlin-based organization Transparency International.

a. Check your predictions with the Index.

b. How well did you do? What countries surprised you? Why?

References

Ackoff, R. L., *Ackoff's Fables: Irreverent Reflections on Business and Bureaucracy* (New York: Wiley, 1991), p. 221.

Alder, N., *International Dimensions of Organizational Behavior,* 2nd ed. (Boston: PWS-Kent Publishing, 1991).

Borsuk, R., "In Indonesia, a Twist on Spreading the Wealth: Decentralization of Power Multiplies Opportunities for Bribery, Corruption," *The Wall Street Journal,* January 29, 2003, p. A16.

Contingency Planning and Management.com, "Strohl Systems Offers Terrorism Readiness Questionnaire," September 24, 2001.

Deneire, M. and M. Segalla, "Mr. Christian Pierret, Secretary of State for Industry (1997–2002), on French Perspectives on Organizational Leadership and Management," *Academy of Management Executive,* 16 (4), November 2002, pp. 25–30.

Doh, J. P., P. Rodriguez, K. Uhlenbruck, J. Collins, and L. Eden, "Coping with Corruption in Foreign Markets," *Academy of Management Executive,* 17 (3) August 2003, pp. 114–127.

Graham, J. L. and N. M. Lam, "The Chinese Negotiation," *Harvard Business Review,* October 1, 2003, pp. 82–91.

Graham, S., "Relief Agency Suspends Afghan Operations," *www.guardian.co.uk,* June 3, 2004.

Hallowell, R., D. Bowen, and C-I. Knoop, "Four Seasons Goes to Paris," *Academy of Management Executive,* 16 (4), November 2002, pp. 7–24.

Henry, W. L. and J. J. DiStefano, *International Project Management,* 2nd ed. (Boston: PWS-Kent Publishing, 1992).

Hodgetts, R. M. and F. Luthans, *International Management: Culture, Strategy, and Behavior,* 5th ed. (Boston: McGraw-Hill/Irwin, 2003).

Hofstede, G., *Cultures Consequences: International Difference in Work-Related Values* (Beverly Hills, CA: Sage Publishing, 1980).

Hooker, J., *Working across Cultures* (Stanford, CA: Stanford Business Books, 2003).

Kluckhohn, F. and F. L. Strodtbeck, *Variations in Value Orientations* (Evanston, IL: Row, Peterson, 1961).

Krane, J., "Intelligence Companies Help Overseas Business Travelers," *The Cincinnati Enquirer,* April 2, 2002, website.

Kras, E., *Management in Two Cultures: Bridging the Gap between U.S. and Mexican Managers,* rev. ed. (Yarmouth, ME: Intercultural Press, 1995).

Lieberthal, K. and G. Lieberthal, "The Great Transition," *Harvard Business Review,* October 1, 2003, pp. 71–81.

Mendenhall, M. E., E. Dunbar, and G. R. Oddou, "Expatriate Selection, Training, and Career-Pathing: A Review and Critique," *Human Resource Management,* 26 (3), Fall 1987, pp. 331–45.

Milosevic, D. Z., "Echoes of the Silent Language of Project Management," *Project Management Journal,* 30 (1), March 1999, pp. 27–39.

Ricks, D. A., *Blunders in International Business* (London: Blackwell, 2000).

Saunders, C., C. Van Slyke, and D. R. Vogel "My Time or Yours? Managing Time Visions in Global Virtual Teams," *Academy of Management Executive,* 18 (1), 2004, pp. 19–31.

Scown, M. J., "Managers Journal: Barstool Advice for the Vietnam Investor," *Asian Wall Street Journal,* July 15, 1993.

Tung, R. L., "Expatriate Assignments: Enhancing Success and Minimizing Failure," *Academy of Management Executive,* 1 (2) 1987, pp. 117–26.

Yeung I. and R. L. Tung, "Achieving Business Success in Confucian Societies: The Importance of Guanxi (Connections)," *Organizational Dynamics,* 25 (2), Autumn 1996, pp. 54–65.

Case

AMEX, Hungary

Michael Thomas shouted, "Sasha, Tor-Tor, we've got to go! Our driver is waiting for us." Thomas's two daughters were fighting over who would get the last orange for lunch that day. Victoria ("Tor-Tor") prevailed as she grabbed the orange and ran out the door to the Mercedes Benz waiting for them. The fighting continued in the back seat as they drove toward the city of Budapest, Hungary. Thomas finally turned around and grabbed the orange and proclaimed that he would have it for lunch. The back seat became deadly silent as they made their way to the American International School of Budapest.

After dropping the girls off at the school, Thomas was driven to his office in the Belvéros area of Budapest. Thomas worked for AMEX Petroleum and had been sent to Budapest four months earlier to set up business operations in central Hungary. His job was to establish 10 to 14 gas stations in the region by purchasing existing stations, building new ones, or negotiating franchise arrangements with existing owners of stations. Thomas jumped at this project. He realized that his career at AMEX was going nowhere in the United States, and if he were going to realize his ambitions, it would be in the "wild, wild east" of the former Soviet empire. Besides, Thomas's mother was Hungarian, and he could speak the language. At least he thought he could until he arrived in Budapest and realized that he had greatly exaggerated his competence.

As he entered the partially refurbished offices of AMEX, he noticed that only three of his staff were present. No one knew where Miklos was, while Margit reported that she would not be at work today because she had to stay at home to take care of her sick mother. Thomas asked Béla why the workmen weren't present to work on finishing the office. Béla informed him that the work had to be halted until they received approval from the city historian. Budapest, anxious to preserve its historical heritage, required that all building

renovations be approved by the city historian. When Thomas asked Béla how long it would take, Béla responded, "Who knows—days, weeks, maybe even months." Thomas muttered "great" to himself and turned his attention to the morning business. He was scheduled to interview prospective employees who would act as station managers and staff personnel.

The interview with Ferenc Erkel was typical of the many interviews he held that morning. Erkel was a neatly dressed, 42-year-old, unemployed professional who could speak limited English. He had a masters degree in international economics and had worked for 12 years in the state-owned Institute for Foreign Trade. Since being laid off two years ago, he has been working as a taxicab driver. When asked about his work at the Institute, Erkel smiled sheepishly and said that he pushed paper and spent most of the time playing cards with his colleagues.

To date Thomas had hired 16 employees. Four quit within three days on the job, and six were let go after a trial period for being absent from work, failing to perform duties, or showing a lack of initiative. Thomas thought that at this rate it would take him over a year just to hire his staff.

Thomas took a break from the interview schedule to scan the *Budapest Business Journal,* an English newspaper that covered business news in Hungary. Two items caught his eye. One article was on the growing threat of the Ukrainian Mafia in Hungary, which detailed extortion attempts in Budapest. The second story was that inflation had risen to 32 percent. This last item disturbed Thomas because at the time only one out of every five Hungarian families owned a car. AMEX's strategy in Hungary depended on a boom in first-time car owners.

Thomas collected his things and popped a few aspirin for the headache he was developing. He walked several blocks to the Kispipa restaurant where he had a supper meeting with Hungarian businessman Zoltán Kodaly. He had met Kodaly briefly at a reception sponsored by the U.S. consulate for American and Hungarian businesspeople. Kodaly reportedly owned three gas stations that Thomas was interested in.

Thomas waited, sipping bottled water for 25 minutes. Kodaly appeared with a young lady who could not have been older than 19. As it turned out Kodaly had brought his daughter Annia, who was a university student, to act as translator. While Thomas made an attempt to speak in Hungarian at first, Kodaly insisted that they use Annia to translate.

After ordering the house specialty, *szekelygulas,* Thomas immediately got down to business. He told Kodaly that AMEX was willing to make two offers to him. They would like to either purchase two of his stations at a price of $150,000 each, or they could work out a franchise agreement. Thomas said AMEX was not interested in the third station located near Klinikak because it would be too expensive to modernize the equipment. Annia translated, and as far as Thomas could tell she was doing a pretty good job. At first Kodaly did not respond and simply engaged in side conversations with Annia and exchanged pleasantries with people who came by. Thomas became frustrated and reiterated his offer. Eventually Kodaly asked what he meant by franchising, and Thomas tried to use the local McDonald's as an example of how it worked. He mentioned that Kodaly would still own the stations, but he would have to pay a franchisee fee, share profits with AMEX, and adhere to AMEX procedures and practices. In exchange, AMEX would provide petroleum and funds to renovate the stations to meet AMEX standards.

Toward the end of the meal Kodaly asked what would happen to the people who worked at the stations. Thomas asserted that according to his calculation the stations were overstaffed by 70 percent and that to make a profit, at least 15 workers would have to be let go. This statement was greeted with silence. Kodaly then turned the conversation to soccer and asked Thomas if it was true that in America girls play "football." Thomas said that both of his daughters played AYSO soccer in America and hoped to play in Hungary. Kodaly said

girls don't play football in Hungary and that Annia was an accomplished volleyball player. Thomas pressed Kodaly for a response to his offer, but Kodaly rose and thanked Thomas for the meal. He said he would think about his offer and get back in touch with him.

Thomas left the Kispipa wondering if he would ever see Kodaly again. He returned to his office where an urgent message was waiting from Tibor. Tibor was responsible for retrofitting the first station Thomas had purchased for AMEX. The new tanks had not arrived from Vienna, and the construction crew had spent the day doing nothing. After several phone calls he found out that the tanks were being held at the border by customs. This irritated him because he had been assured by local officials that everything had been taken care of. He asked his secretary to schedule an appointment with the Hungarian trade office as soon as possible.

At the end of the day he checked his e-mail from the States. There was a message from headquarters asking about the status of the project. By this time he had hoped to have his office staffed and up and running and at least three stations secured. So far he had only one-third of his staff, his office was in shambles, and only one station was being retrofitted. Thomas decided to wait until tomorrow to respond to the e-mail.

Before returning home Thomas stopped off at the English Pub, a favorite hangout for expats in Budapest. There he met Jan Krovert, who worked for a Dutch company that was building a large discount retail store on the outskirts of Badapest. Thomas and Krovert often talked about being "strangers in a strange land" at the pub. Thomas talked about the interviews and how he could just see in their eyes that they didn't have the drive or initiative to be successful. Krovert responded that Hungary has high unemployment but a shortage of motivated workers. Krovert confided that he no longer interviewed anyone over the age of 30, claiming that what fire they had in their bellies was burned out after years of working in state-run companies.

1. What are the issues confronting Thomas in this case?
2. How well is Thomas dealing with these issues?
3. What suggestions would you have for Thomas in managing this project?

Case

Ghost Stories

On December 26, 2004, an earthquake reaching 9.1 on the Richter scale triggered a series of devastating tsunamis off the coast of Indonesia. They spread throughout the Indian Ocean, killing large numbers of people and inundating coastal communities across South and Southeast Asia, including parts of Indonesia, Sri Lanka, India, and Thailand. The 2004 Asian tsunami was one of the deadliest catastrophes in modern history, with more than 220,000 lives lost.

Nils Lofgrin, who had managed several construction projects in Australia and New Guinea, was sent by his construction firm to restore a five-star resort along the Andaman coast in southern Thailand that had been ravaged by this tsunami. Casualties at the resort included 12 staff and 37 guests. This was Nils's first assignment in Thailand.

Nils flew down and toured the site. His assessment of the damage was that it was not as severe as feared. The basic infrastructure was intact but debris needed to be cleared and the resort refurbished. He reported back to headquarters that with a bit of luck he should have the resort up and running in matter of months. Little did he realize how soon he would regret making such a promise.

The problems began immediately when he was unable to recruit workers to help clean up the mess at the resort. The Burmese migrant workers who comprised a significant portion of the workforce in this region had fled into the hills out of growing fears of being arrested and deported. Even when he offered double wages he was not able to recruit many Thais. At first he attributed their reluctance to the shock caused by the devastation of the tsunami. Everyone he met seemed to know someone who had died or even worse had just disappeared. But he soon realized there was more going on than just shock.

Nils was at a restaurant having a lunch with a Thai friend when an animated discussion broke out among some Thai patrons nearby. He asked his friend what was going on. The friend said someone was telling the story of a local taxi driver who had picked up three foreign tourists and was driving them to Kata Beach when he looked around and found his cab empty. Another told the story of a local family whose telephone rings constantly through the day and night. When answered, the voices of missing friends and relatives cry out for help.

Nils sank in his chair when he began to realize that no one wanted to work for him because prospective workers believed that the region and his resort are haunted by ghosts.

1. What options are available to Nils?
2. What would you do and why?

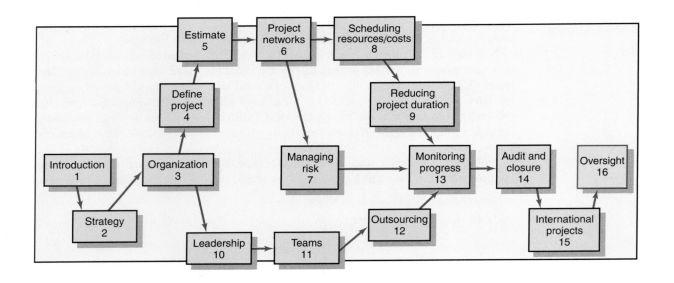

Estimate 5	Project networks 6	Scheduling resources/costs 8			
Define project 4		Reducing project duration 9			
Introduction 1	Organization 3	Managing risk 7	Monitoring progress 13	Audit and closure 14	Oversight 16
Strategy 2	Leadership 10	Teams 11	Outsourcing 12	International projects 15	

Oversight

Project Oversight

Unresolved Issues

Career Issues and Paths

Summary

Conclusions

Oversight

Without continual growth and progress, such words as achievement and success have no meaning.

—Benjamin Franklin

Up to now this text has primarily been devoted to tools and techniques for successfully managing specific projects. It is important now to stop and look at the big picture to see how these methodologies fit within an organization's ability to manage projects to achieve strategic objectives. *Oversight* is the term that has emerged to reflect how organizations oversee their project management systems.

This chapter identifies some current oversight practices and efforts to improve the management of projects over the long haul. Unresolved issues confronting the field are also identified and discussed. Because the premise is that project management has a bright future, the chapter appropriately concludes with suggestions on how to pursue a career in project management.

Project Oversight

In the last few years the paradigm shift to project oversight/governance has been profound. Project oversight can be defined as *a set of principles and processes to guide and improve the management of projects.* The intent is to ensure projects meet the needs of the *organization* through standards, procedures, accountability, efficient allocation of resources, and continuous improvement in the management of projects. A second purpose is to support the project manager. We estimate over 95 percent of project-driven organizations have been implementing some form of oversight for several years. Progress has been rapid and steady. The typical activities of project oversight cover two dimensions: organization and project. Here are some of the major oversight activities used in practice:

At the Organization Level

- Project selection.
- Portfolio management.
- Improving the way all projects are managed over time.
- Assessing and elevating the maturity level of the organization's project management system.
- Using the balanced scorecard approach to review progress on strategic priorities.

At the Project Level

- Review projects' objectives.
- Decide on issues raised by the project manager such as resource needs and escalation.

- Track and assist the project to resolve bottlenecks.
- Review status reports from the project manager.
- Audit and review lessons learned.
- Authorize any major deviations from the original scope.
- Cancel the project.

All of these activities are designed to bring consistency, structure, accountability, and improvement to the management of projects. Today, project oversight, through an executive committee, oversight group, or a project office, covers every aspect of managing projects in the organization.

Importance of Oversight to the Project Manager

What does this solid paradigm shift mean to a project manager who is normally in charge of only one or two projects? Four things. First, in almost all cases oversight is interested in supporting and helping the project manager where needed. This is an improvement over the past. Second, the oversight function determines the environment in which the project manager will implement his or her project. This can affect the management of a project in a positive or negative manner. Third, depending on the size and complexity of the project, methods used to hold the project manager responsible and accountable will influence how performance is measured. Finally, the project manager, who is responsible for day-to-day management, will probably be reporting to this oversight group at predetermined phases in the project. In short, project oversight supports project management at the organization and project levels.

As a project manager you need to be aware of how these oversight activities can and will influence management of your projects. A short description of each of these oversight activities follows.

Portfolio Project Management

When project effort moves from tactical to strategic, project selection, project processes, and resources are brought under one system known as portfolio project management. Remember from Chapter 2 that portfolio management integrates projects with current priorities, strategic thrust, and overall allocation of scarce organization resources. Here is a typical definition:

> *Portfolio project management* is the centralized management of projects to ensure that the allocation of resources to projects is directed toward projects that contribute the greatest value to organization goals.

 Project portfolio management supports management of multiple projects in a coordinated way to obtain the benefits not available from managing them individually. The development of portfolio project management is complemented by the movement to use project management offices.

Project Office

Most project-driven organizations have set up project offices. The appearance of a project office frequently follows the implementation of project portfolio management efforts. The project office is now used as the vehicle to support and manage oversight activities. Here is one definition:

> The *project office (PO)* is the unit responsible for the continued support of consistent application of selection criteria, standards, and processes; training of and general assistance to project managers; and continued improvement and use of best practices.

The project office frequently includes project portfolio management. Project portfolios and project offices both result in an integration function for planning and control. The PO

As more and more companies embrace project management as a critical vehicle for realizing corporate objectives, they are creating centralized project offices (POs) to oversee and improve the management of projects. PO functions vary widely by organization and need. In some cases, they serve as a simple clearinghouse for project management information. In other cases, they recruit, train, and assign managers to specific projects. As POs mature and evolve over time, they become full-service providers of project management expertise within a firm. The different services POs may provide include the following:

- Creating and maintaining the internal project management information system.
- Recruiting and selecting project managers both within and outside the organization.
- Establishing standardized project planning and reporting methodologies.
- Training personnel in project management techniques and tools.
- Auditing ongoing and recently completed projects.
- Developing comprehensive risk management programs.
- Providing in-house project management consulting and mentoring services.

- Maintaining an internal project management library containing critical documents, including project plans, funding papers, test plans, audit reports, and so forth.
- Establishing and benchmarking best practices in project management.
- Maintaining and tracking the portfolio of projects within an organization.

A good example of how project offices evolve is the global project office (GPO) at Citibank's Global Corporate Bank. GPO originated at the grassroots level within the small world of Operations and Technology for Global Cash Management. Committed to bringing order to the chaos of managing projects, GPO instituted training programs and professional project management practices on a very small scale. Soon the success of GPO-supported projects caught the eye of upper management. Within three years the department was expanded to offer a full range of PO services across Citibank's entire banking operation. GPO's mission is to establish project management as a core competency throughout the entire Citibank organization.

* T. R. Block, and J. D. Frame, "Today's Project Office: Gauging Attitudes," *PM Network,* August, 2001; W. Gradante, and D. Gardner, "Managing Projects from the Future, Not from the Past," *Proceedings of the 29th Annual Project Management Institute 1998 Seminars and Symposium* (Newtown Square, PA: Project Management Institute, 1998), pp. 289–94.

FIGURE 16.1 **Project Portfolio Cost Summary Report for Top Management**

Location	Project ID	Description	PV	EV	AC	CPI	SPI	PCIB	BAC	EAC	VAC
Summary	**All**	**Portfolio**							$18,120		
United States									$10,500		
○	01-003	Digitize Fingerprints-FBI	3,000	3,500	3,230	1.08	1.17	97.2%	3,600	3,322	278
◐	01-011	Encryption	270	250	250	1.00	0.93	71.4%	350	350	0
◐	01-002	Internet Protocol--CIA						0.0%	950		
○	01-009	Supply Chain Partners	90	90	90	1.00	1.00	16.7%	540	540	0
	01-012	Bonus Mileage Awards						0.0%	630		
●	01-005	E-sales Claims	150	140	150	0.93	0.93	35.0%	400	429	-29
●	01-011	Procurement Net	400	340	380	0.89	0.85	27.6%	1,230	1,375	-145
○	01-008	Smart Tag Tracking	850	900	900	1.00	1.06	32.1%	2,800	2,800	0
Asia/Pacific									$2,800		
◐	02-007	Currency Conversion	125	120	120	1.00	0.96	80.0%	150	150	0
◐	02-002	Billing System	280	280	280	1.00	1.00	70.0%	400	400	0
○	02-005	Web-Based Cash Flow	210	220	200	1.10	1.05	73.3%	300	273	27
	02-004	Olympic Simulation						0.0%	1,950		
EEC									$4,820		
●	03-008	Smart Card	145	110	140	0.79	0.76	18.3%	600	764	-164
	03-003	Warranty						0.0%	70		
	03-004	Simulation--ESA						0.0%	800		
●	03-005	Air Reservation Net	510	490	520	0.94	0.96	35.0%	1,400	1,486	-86
●	03-007	Pilot Internet Log Syst.	540	490	550	0.89	0.91	57.6%	850	954	-104
◐	03-006	Internet Telephone Syst.	850	850	860	0.99	1.00	77.3%	1,100	1,113	-13

Net Services, Inc. View Cost Project Portfolio Cost Summary ($ 000) Date:

Gantt · Network · Resource · Status · WBS · Sponsor · Team · Priority · Issues

LEGEND
○ Under Budget
◐ On Budget
● Over Budget

also supports the integration of the processes of managing projects within the social/cultural environment of the organization. High-tech firms such as Hewlett-Packard (HP), International Business Machines (IBM), and Dell all use project offices to coordinate projects and to ensure best practices are being used to manage projects. For example, HP has project offices in Europe/Middle East, Americas, Asia Pacific, and Japan with several others planned. Because projects are used to implement strategy, HP has created a new position—vice president of project offices. Project offices ensure a consistent approach to all projects in all locations. See Snapshot from Practice: The Project Office.

Figures 16.1 and 16.2 provide an example of a report the project office provides senior management of an international organization. Note that such a report requires a standard format for all projects. Figure 16.1 depicts a project portfolio cost summary report developed for top management. Figure 16.2 presents the same summary for project schedules. Additional detailed information for any specific highlighted project—such as the project schedule, cost status report, project team—is only a double click away. For example, the Smart Card project in the European Economic Community (EEC) appears to be behind schedule. The cause can be identified by "drilling down" to the project schedule, WBS, resources, or issues. Standard project formats such as these provide a wealth of information in multiproject organizations.

Project offices are known to result in positive benefits such as the following:

- They serve as a bridge between senior management and project managers.
- They support integration of all project management processes from selection through project closure and lessons learned.

Benefits of the PMO.

FIGURE 16.2 **Project Portfolio Schedule Summary Report for Project Schedules**

- Through training they support the movement of the organization to a higher level of project management maturity.

The growth in the application of portfolio project management and project offices will continue. Portfolio management and project offices strongly influence how a project manager will manage his or her respective project. A more recent oversight activity has been the quick implementation of phase gate reviews.

Phase Gate Methodology

Following the emergence of the project office and project portfolios came the use of phase gate methodology. It provides an in-depth review of individual projects at *specific phases* in the project life cycle. These reviews cover assessments to continue or kill the project, reassess resource allocation, reassess prioritization, and evaluate execution progress, as well as strategic alignment decisions. The phase review process serves the organization by having gatekeepers (usually selected from several areas of the firm) perform the review. The phase gate process is also designed to support the project manager on decisions and other issues such as escalation and resource needs. The idea of phase gate methodology fits effortlessly into the oversight function of the project office. Phase gate methodology was originally developed for product development, but the application of the methodology has grown beyond new-product development to include all projects in the portfolio. One study by Morris and Jamieson showed 85 percent of those surveyed use phase review gates, while 85 percent who did not thought they should.

The original *Stage-Gate™* model was pioneered by Robert G. Cooper several decades ago to improve management of new-product development. The original model incorporates

[margin note: original 5 stages of Phase-gate technology.]

five stages: preliminary investigation, detailed investigation, development, testing and validation, and full production and market launch. Stages precede gates and represent information developed to enable gatekeepers to make the right decision at the next gate. These decision points at each gate are known as go, kill, hold, or recycle decisions. Given the information developed for each stage, the gatekeepers (the oversight team) can decide to continue with the project, abort the project, or revise/recycle.

Today, variations of the original model are being used across all industries to help manage project portfolios. These variations are not limited to new-product development. The number of stages and gates varies. But the idea of oversight review several times throughout the project life cycle appears in all models. Each gate check will always, at a minimum, check the project against alignment with current strategic goals.

Phase gate methodology has appeal because it provides a clean-cut, structured process that can be consistently applied across all projects in the portfolio. Distinct review stages and go/kill gates comprise this oversight function. The major goals for phase gating are to ensure oversight and support for the project manager and the project team, to direct organization resources toward strategic goals, and to reduce the number of projects that do not support the forward direction of the organization. A multiproject organization having employees spread across many time zones that does not use some form of phase review methodology is rare. For example, companies such as 3M, General Motors, Northern Telecom, DuPont, Intel, Hewlett-Packard, and Dell all use some form of phase gating to manage projects.

[margin note: definition of stage-gate]

The phase gate review process can be defined as a *structured process to review, evaluate, and document outcomes in each project phase and to provide management with information to guide resource deployment toward strategic goals.* This oversight activity begins with project selection and tracking the project life cycle through closure and lessons learned. Phase gates need to occur at consistent points in the project life cycle so each project encounters similar gates at predefined authorization points.

The phase review process may appear similar to the project audit discussed in an earlier chapter. Some overlap does occur, but the focus here is more integrated and holistic. Individual projects are reviewed as part of a total portfolio. For example, have strategic priorities changed the importance of the project? If the priorities of the organization have changed, a project that is executing on time, on budget, and meeting the project goals may have to be "killed." Phase review takes place at each phase from project selection through lessons learned as opposed to the audit, which often takes place at the end of the project. Phase gating provides a larger perspective to managing multiple projects in a project portfolio. Gatekeepers first focus on organization needs, with individual project needs second.

Figure 16.3 is a flow diagram of an abridged, generic variation of phase gate methodology that has application across all types of projects.

The decision gates focus on go/kill decisions based on major questions such as those shown in Gates 1 and 2 below (see the "Pull the Plug" reference). At a minimum each gate should include three components:

[margin note: Gate parameters/ criteria]

1. Required deliverables (e.g., project goals, progress, variances).
2. Gate criteria and specific outputs (e.g., adjusting project scope, schedule).
3. A clear yes/no decision on whether to go ahead.

The criteria for all of the gates during the project are selected *before* the start of the project.

The value of phase gating methods rests firmly on having enough information to support the gate decision. Significant amounts of support data must be gathered to answer critical gate questions. Fortunately, you can readily discern that following the best practices shown in earlier chapters will prepare you to easily answer critical gate questions. Frequent questions from practice for each gate are presented here.

FIGURE 16.3
Abridged Generic Phase Gate Process Diagram

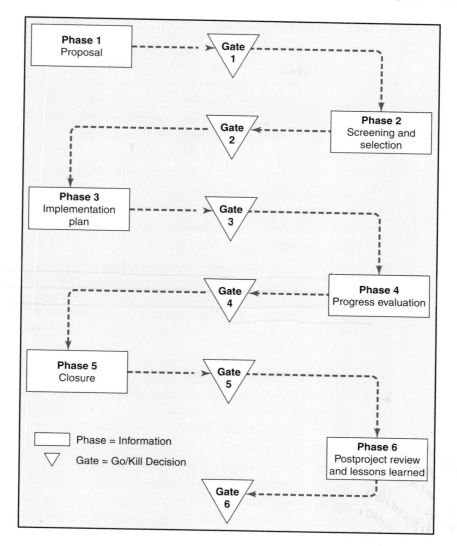

Gate 1: Proposal Decision

- What business problem does the proposed project solve?
- Does this project align with our strategic direction?
- What type of project is this? Strategic, organization maintenance, "must," etc.?
- Should the project be considered?

This *proposal* phase answers a fundamental question: Is the project a good idea and does it solve a business problem or issue? Basically, anyone can propose a project. However, the proposal should provide enough key information to allow an oversight team to decide if the proposal should be considered further. For example, the information might include the business problem the proposed project will solve, the urgency of the project, and clear, relevant project objectives. Gate 1 provides information at a minimal expenditure of cost and resources and in a short time, so the project can be reevaluated more thoroughly if it is perceived to have merits.

Gate 2: Selection Decision

- Is the sponsor identified and supportive?
- Should this project be selected and implemented?
- How does the project support the organization strategy and goals?
- Is it important to implement this project now? Why?
- What is the impact or risk of not doing this project?
- What are the project's ROI and/or nonfinancial benefits?
- How does the project fit our skills and culture?
- What metrics will be used to measure progress? Success?
- What are the major risks for this project?
- Will this project be implemented internally or outsourced?
- Will our business culture support this project?
- How long and how large is this project?

The *selection* review includes a thorough analysis based on selection criteria. The gating group uses weighted scoring model criteria, which typically include project risks, costs, resource needs, urgency, financial analysis, benefits, identified sponsor, and other criteria found in selection models. Many information requirements for Gate 2 are discussed in detail in Chapter 2 (see project selection section) and should answer most of the decision criteria for this phase review.

Gate 3: Implementation Plan Decision

- Are the project scope, tasks, milestones and deliverables, and gates established and acceptable?
- Are the resources needed identified and available?
- Are tasks sequenced and is a time-phased budget established?
- Are appropriate performance metrics in place for tracking the project?
- Are project risks identified and is how they will be managed clearly stated?
- Are all stakeholders identified?
- Is the stakeholder communication plan complete and appropriate?
- Is a formal change management system in place?
- Are accountability metrics in place and is responsibility assigned?

The *implementation plan* review information should include the planning document developed in earlier chapters. For example, what are the specific goals for the project and what are the major deliverables (scope)? What tasks will be performed to complete the deliverables (WBS)? How are tasks sequenced (network)? When will the tasks be performed (schedule)? What resources are needed to complete the tasks (resource schedule)? What are the estimated costs for the tasks (time-phased budget)? What and how will performance be measured (variance metrics)? How will information be collected and distributed (communication plan)? What and how will project risks be identified and handled (risk plan)? What vendors will be used for procurement?

Gate 4: Progress Evaluation Decision

- Is the project still aligned with business requirements?
- Are activities completed according to the project plan?
- Are the technical requirements of the project being met?

- Are contractors meeting defined performance requirements?
- Are there urgent corrective actions that must be done quickly?
- Are time, costs, and scope performances within acceptable limits?
- Have the project objectives changed?
- What risks can be retired?

tracking and risk management

Your *progress evaluation* review covers the control activities of tracking progress, identifying variances from your plan, and taking corrective action. A major chunk of the data requirements for the phase review are simply measures against the project plan. Tracking progress and identifying variances against scope, time, budget, and control of changes and identified risks are easily accomplished using available software (see Chapters 7 and 13). For example, if the project is not going according to plan, your risk assessment plan may help you decide an action to be taken. Beyond these quantitative measures, there are always "issues" that deserve attention. Moreover, project priority must be checked against strategy to determine whether this measure is still valid. If not, a change in scope or killing the project may be necessary. Don Kingsberry, director of HP's Global Program Management Office, describes HP's progress phase review succinctly: We have "42 health checks on current projects. We look at risks, issues, critical path analysis, resource analysis, sponsorship, alignment with strategy, earned value metrics, dependency, and other factors impacting the triple constraints of project management: time, cost, and scope." (See Boyer for more on HP's efforts.)

Gate 5: Closure

- Did the project deliver the business outcomes? Were the metrics and benefits used to justify the project met?
- Were project scope objectives met?
- Were project cost and schedule met?
- Are contracts closed out?
- Are the end users satisfied?
- Have staff been recognized and reassigned?
- Was the organization culture right for this type of project?
- Was senior management support adequate?
- Were the right people assigned to the project?
- Were project risks identified and assessed realistically?
- Did technology overextend our competencies?
- How will the project be delivered?

Lessons learned

The *closure* and lessons learned activities closely follow the closure activities found in the audit chapter. Some organizations have wrapped phases 5 and 6—closure and lessons learned—into a single gate.

Gate 6: Lessons Learned

- Have we identified what went wrong and what contributed to success?
- Have changes to improve delivery of future projects been communicated and archived?
- What hindered or contributed to delivering the expected ROI or business outcomes?
- Can others learn from this experience?
- What changes in scope or quality were made?
- Who will be responsible for archiving the lessons learned?

One manager from a high-tech firm related to your authors that "phase-gating is the best thing that has ever happened to [his] firm—better than apple pie. We rotate middle managers to serve on the project oversight committee to give them as much exposure as possible." Serving on the oversight committee has great rewards for the organization and individual. The following relates the core of his conversation:

First, the process itself gets everyone on the same menu. Everyone is constantly reminded of the strategic vision of the firm and how the project supports the vision. Second, serving on a review or oversight committee provides a more holistic insight that creates more understanding and tolerance of changes that need to occur. Serving on the oversight committee is the cheapest, most rewarding training vehicle we have ever had. Best of all, the training lasts and the learned holistic view is transferred to others. The cost of serving on the oversight committee is near zero. Members are more likely to support and help see a project through to a speedy, successful completion. Next, using the phased approach limits scope creep, which has been a constant issue in all our projects. Finally, the bottom line is that the number of useless projects has practically disappeared—pet projects are out in the open, resources are used more efficiently, and most projects come in on time and within budget. Phase gating has changed the whole culture of our firm and the way projects are managed.

The questions shown above for each phase only touch the surface of those found in practice. Some are formalized, others very porous and less structured, but all phase review models are designed to check management of a project from selection to lessons learned. Key benefits of using phase gating are:

Benefits of the phase gating:

- Provides excellent training for functional staff who serve on oversight review groups.
- Encourages a larger perspective and role of projects within the organization.
- Is a clear-cut process, easily understood, and applicable to all projects in a portfolio.
- Provides a structured process for a project office to follow on all projects.
- Eliminates poor value projects.
- Supports faster decision making with predefined deliverables for each gate.

See Snapshot from Practice: Phase Gate Side Benefits for a project manager's opinion on the benefits of phase gating.

✳ Another key oversight function is benchmarking your project management maturity against others in your industry.

Organization Project Management Maturity

Individual audits and phase gate reviews can yield valuable lessons that team members can apply to future project work. A more encompassing look, from an organizationwide point of view, uses a project maturity model that strives for a never-ending goal to continuously improve the management of projects. It is well established that project-driven companies with higher maturity levels are more successful in managing projects than those lacking project maturity programs. Project maturity has become a competitive edge. Companies are increasingly using outsourcing or external contractors and RFPs (Request for proposals) to look for contractors that have reached high maturity levels. Harold Kerzner, a project management consultant and professor, eloquently states why a company should pursue maturity:

> Given the fact that many executives today view their company as a stream of projects, project management permeates the entire organization, mandating that maturity is necessary. So only those companies that want to stay in business and remain competitive should pursue maturity. The alternative is rather unpleasant. (Quoted in Mueller.)

The purposes of all maturity models, and many are available, are to enable organizations to assess their progress in implementing the best practices in their industry and

FIGURE 16.4
Project Management Maturity Model

continuously move to improvement. It is important to understand that the model does not ensure success; it serves only as a measuring stick and an indicator of progress.

The term *maturity model* was coined in the late 1980s from a research study by the United States government and the Software Engineering Institute (SEI) at Carnegie Mellon University. The government wanted a tool to predict successful software development by contractors. The outcome of this research was the Capability Maturity Model (CMM). The model focuses on guiding and assessing organizations in implementing concrete best practices of managing software development projects. Since its development, the model is used across all industries.

One newer model has received a great deal of publicity. In January 2004, after eight years of development, the Project Management Institute (PMI) rolled out its second version of the Organizational Project Maturity Model. The latest version is called OPM3 (See *www.pmi.org/opm3*). Typically, these models are divided into a continuum of growth levels: initial, repeatable, defined, managed, and optimized. Figure 16.4 presents our version, which borrows liberally from other models.

Level 1: Ad Hoc Project Management No consistent project management process is in place. How a project is managed depends upon the individuals involved. Characteristics of this level include

- No formal project selection system exists—projects are done because people decide to use them or because a high-ranking manager orders them done.
- How any one project is managed varies by individual and thus is unpredictable.
- No investment is made in project management training.
- Working on projects is a struggle because it goes against the grain of established policies and procedures.

Level 2: Formal Application of Project Management The organization applies established project management procedures and techniques. This level is often marked by tension between project managers and line managers who need to redefine their roles. Features of this level include

- Standard approaches to managing projects, including scope statements, WBS, and activity lists, are used.

- Quality emphasis is on the product or outcome of the project and is inspected instead of built in.
- The organization is moving in the direction of a stronger matrix with project managers and line managers working out their respective roles.
- Recognition of the need for cost control, not just scope and time management, is growing.
- No formal project priority selection system is established.
- Limited training in project management is provided.

Level 3: Institutionalization of Project Management An organizationwide project management system, tailored to specific needs of the organization with the flexibility to adapt the process to unique characteristics of the project, is established. Characteristics of this level include

- An established process for managing projects is evident by planning templates, status report systems, and checklists for each stage of the project life cycle.
- Formal criteria are used to select projects.
- Project management is integrated with quality management and concurrent engineering.
- Project teams try to build in quality, not simply inspect it.
- The organization is moving toward a team-based reward system to recognize project execution.
- Risk assessment derived from WBS and technical analyses and customer input is in place.
- The organization offers expanded training in project management.
- Time-phased budgets are used to measure and monitor performance based on earned value analysis.
- A specific change control system for requirements, cost, and schedule is developed for each project, and a work authorization system is in place.
- Project audits tend to be performed only when a project fails.

EVA

Level 4: Management of Project Management System The organization develops a system for managing multiple projects that are aligned with strategic goals of the organization. Characteristics of this level include

- Portfolio project management is practiced; projects are selected based on resource capacity and contribution to strategic goals.
- A project priority system is established.
- Project work is integrated with ongoing operations.
- Quality improvement initiatives are designed to improve both the quality of the project management process and the quality of specific products and services.
- Benchmarking is used to identify opportunities for improvement.
- The organization has established a Project Management Office or Center for Excellence.
- Project audits are performed on all significant projects and lessons learned are recorded and used on subsequent projects.
- An integrative information system is established for tracking resource usage and performance of all significant projects. See Snapshot from Practice: Acer Attacks Costly Delays.

PMO exists / center of excellence

Level 5: Optimization of Project Management System The focus is on continuous improvement through incremental advancements of existing practices and by innovations using new technologies and methods. Features include

- A project management information system is fine-tuned: specific and aggregate information is provided to different stakeholders.

Tom Wagner/Corbis.

In today's rapidly changing world, the risk of failing to develop new products for the market on time is the difference between success and failure. The Mobile Systems Unit (MSU) of Taiwan computer maker Acer, which produces computer notebooks, operates under extreme time-to-market pressures. By 1998 MSU development cycles had shrunk to eight months. Still, missing the market introduction window by only one month on any given model eliminated the unit's profit potential for that model.

MSU did a companywide analysis into the causes of costly delays in their projects. They discovered that schedule variance was a function of multiple causes. Vendors would occasionally not deliver sufficient volumes of a promised new component on time. Major customers such as IBM would change their requirements. Design problems with the motherboard would cause additional design loops. Negotiations among multiple parties might change internal specifications. Administrative pressure on engineers and insufficiently documented procedures led to shortcuts in testing, causing major rework at a more costly stage.

Acer attacked the multiple causes on multiple fronts. First, MSU management created resource buffers in the form of slack capacity by canceling two projects that were already delayed. This wasn't easy, because one was to be a showpiece, top-of-the-line model, and the decision to kill it was hotly contested. MSU then concentrated on improving documentation of operating procedures in order to increase testing coverage and facilitate the training of young engineers. Those steps reduced the number of correction loops during product development and improved the quality of the company's manufacturing ramp-up. Acer also concentrated the responsibility of product specifications in one group, thereby reducing negotiation loops and internally caused specification changes. Over the next two years, MSU more than doubled its sales and gained significant market share.

* B. Einhorn, "Acer's About Face," *BusinessWeek (International Edition)*, April 23, 2000.

- An informal culture that values improvement drives the organization, not policies and procedures.
- There is greater flexibility in adapting the project management process to demands of a specific project.

Progress from one level to the next will not occur overnight. The Software Engineering Institute estimates the following median times for movement:

- Maturity level 1 to 2 is 22 months.
- Maturity level 2 to 3 is 29 months.
- Maturity level 3 to 4 is 25 months.
- Maturity level 4 to 5 is 13 months.

Why does it take so long? One reason is simply organizational inertia. It is difficult for social organizations to institute significant changes while at the same time maintaining business efficacy. "How do we find time to change when we are so busy just keeping our heads above water?"

A second significant reason is that one cannot leapfrog past any one level. Just as a child cannot avoid the trials and tribulations of being a teenager, people within an organization have to work through the unique challenges and problems of each level to get to the next level. Learning of this magnitude naturally takes time and cannot be avoided by using quick fixes or simple remedies.

Our best-guess estimates are that most companies are in the throes of moving from level 2 to level 3 and that fewer than 10 percent of those firms that actively practice project management are at either level 4 or 5. Remember, project maturity is not an end; project maturity is a never-ending process of continuous improvement. An additional view of the success of the projects you have selected over time is discussed next.

Assessing the Effectiveness of the Project Selection over the Long Haul: The Balanced Scorecard Model

Project priority selection models select which actions (projects) best support organizational strategy. The balanced scorecard model differs from selection models by reviewing projects over a longer horizon—5 to 10 years after the project is implemented. It is more "macro" in perspective than project selection models. This model measures the results of major activities taken to support the overall vision, mission, and goals of the organization. It helps answer two questions: Did we select the right projects? Did the projects contribute to long-range strategic direction of the firm? American Express, the U.S. Department of Transportation, ExxonMobil, Kaiser Permanente, National Semiconductor, and others are known to be using their own customized models of the balanced scorecard. (See Kaplan and Norton.)

The scorecard model limits measures of performance to goals in four main areas: *customer, internal, innovation and learning, and financial measures.* For example, a performance measure for a customer might be industry ranking for sales, quality, or on-time projects. Internal measures that influence employees' actions could mean time to market or reduction of design time to final product. Innovation and learning measures frequently deal with process and product innovation and improvement. For example, the percentage of sales or profit from new products is often used as a performance goal and measure. Project improvement savings from partnering agreements are another example of an innovation and learning measure. Finally, financial measures such as ROI, cash flow, and projects on budget reflect improvement and actions that contribute value to the bottom line.

These four perspectives and performance measures keep vision and strategy at the forefront of employees' actions. The basic assumption underlying the balanced scorecard model is that people will take the necessary actions to improve the performance of the organization on the given measures and goals. The balanced scorecard model and priority selection models should never conflict with each other. If a conflict exists, both models should be reviewed and conflicts eliminated. When both models are used in project-driven organizations, focus on vision, strategy, and implementation are reinforced. Both models encourage employees to determine the actions needed to improve performance.

In summary, all oversight practices are directed to improving the way the organization manages all projects. How projects are managed in your organization will depend heavily on the level of project oversight and maturity. As oversight continues to evolve, you will need to view your job as a project manager from a broader, top-down view of project management in your organization and even in the total field of project management.

Unresolved Issues

While we are fairly confident in our observations and resulting inferences, there are still some unresolved issues confronting project management. Two of these are virtual project management and the management of projects under high levels of uncertainty:

- How far can virtual project management evolve?

In Chapter 11 we introduced the subject of virtual project teams in which members primarily interact electronically. Today, most project communication is limited to e-mail, teleconferencing, faxes, and, in some cases, videoconferencing. As telecommunication systems become more reliable worldwide and videoconferencing with high-definition resolution becomes readily available, project teams will be able to hold meetings in which geographically separated members visually interact with each other; e-mail will be augmented by video messages. Similarly, telephone conversations will be replaced by direct video interaction using PCs.

Some companies with access to the latest technology are experimenting with 24-hour product design teams. These teams have members scattered across the time zones so that work on a project is nonstop. For example, team members work on the project during normal hours in New York and then electronically pass their work to members in Hawaii, who are beginning their workday when the New York team is about to go home. The Hawaiian team passes their work to a team in Bangkok, Thailand, which, in turn, passes their work to a team situated in Copenhagen, Denmark. The Danish team passes their work to the New York team, and the cycle is repeated. Although it is too early to say how successful this tag-team approach to project management will be, it exemplifies the potential that exists given the information technology that is available today.

Clearly in the world of the future, project professionals will have access to technology to reduce the barriers of distance and time and improve their ability to interact in a virtual domain. The question is, what are the limits to virtual project management? What kinds of projects and under what circumstances will virtual project management best work? Or not work? Will different skill sets and personal characteristics be required to work in a virtual environment? What protocols, habits, and procedures need to be developed to successfully manage a virtual project team? Will visual, video interaction enhance the development of trust among physically separated team members? Conversely, new technology often produces unintended side effects (smog in the case of the gasoline engine; carpal tunnel in the case of PCs). What are the potential negative physical and psychological side effects of working in a virtual environment? How will workers respond if their sleep is periodically interrupted by urgent calls from Krakow, Poland, or if they have to make sure they are home from the movies at 11:00 P.M. so they can participate in a video project meeting?

Answers to these questions and others will emerge as organizations experiment with virtual project management.

- How do we manage projects under high levels of uncertainty?

Research on project success and failure consistently points to poor planning as a major reason behind project failures. The general recommendation is that more time and attention should be devoted to clearly defining the scope of the project and developing the project plan. However, poor planning may not simply be a result of a lack of effort but rather due to the inherent difficulty of planning a project under conditions of high uncertainty. For example, software development projects are notorious for being completed significantly over budget and behind schedule. Is this a result of poor planning? Or an innate characteristic of project work that involves tightly coupled activities, trial-and-error problem solving, and shifting design parameters?

Modern project management planning tools and techniques are well suited to accomplish projects in which the scope is well defined. They are less well suited to manage projects with vaguely defined or unstable scope. Purists would argue that this is a moot point because, by definition, project management involves only endeavors with well-defined objectives. While this is a neat "academic" solution to the problem, it does not mirror the reality of project management today. More and more people are engaged in projects in which, by intent, the initial scope is broadly defined or subject to significant change. Customers' needs change. Top management strategies and priorities change. Innovations create the impossible. Competitors change the playing field. In today's business world, certainty is a luxury, and a premium is placed on flexibility.

The key question is how to effectively manage projects with loosely defined or *unstable scope* accompanied by high levels of *uncertainty*. How do managers plan a project for which they are not sure what the final outcome will be? How do they develop a project control system that is both flexible and responsive yet, at the same time, ensures accountability and yields reliable projections? How do they avoid paralysis through overanalysis yet, at the same time, engage in prudent risk management? How do they know when it is appropriate to freeze the scope or design of the project and begin formal implementation? Conversely, using uncertainty as an excuse for not planning and flying into the wind by the seat of the pants is an invitation for disaster.

The next decade should see a whirlwind of attention to the problem of managing projects with ill-defined project scopes and project uncertainties. Answers to the problem are not obvious. Some of the ideas and techniques will be short-term fads. Others will withstand the test of time and make significant contributions to the project management body of knowledge.

Career Issues and Paths

Career Paths

There is no set career path for becoming a project manager. Career avenues vary from industry to industry, organization to organization, and from profession to profession. What can be said is that advancement occurs incrementally. You don't simply graduate and become a project manager. As in other careers you have to work your way up to the position. For example, in project-based organizations such as construction firms, you may begin by working on several projects as an assistant engineer, then take an assignment as a project analyst. From there you are promoted to principal engineer, advance to assistant project manager, assume the role of project manager over a small project, and then continue to bigger, riskier projects. In other organizations, project management careers run parallel with functional advancement with many crossovers. For example, at Intel a management information systems (MIS) specialist might start his career as a designer, then take an assignment as a project specialist, later work as a project manager, and then return to a functional position as head of a department or as a product manager.

Other people find that their project management responsibilities expand as they move up the organization's hierarchy. For example, a former marketing student began her career as an assistant buyer for a large retail company. She then became area sales manager at a specific store and became involved on a part-time basis in a series of projects acting as a facilitator of focus groups. She was promoted to buyer and eventually became a store manager. In her current position she coordinates a variety of projects ranging from improving the sales acumen of her salesforce to altering the physical layout of the store. Although the title of project manager does not appear in her job description, more than 50 percent of her work involves managing projects.

Temporary Assignments

One aspect of project managing that is unique is the temporary nature of assignments. With line appointments, promotions are for the most part permanent and there is a natural, hierarchical progression to positions with greater authority and responsibility. In the example of the former marketing student, she progressed from assistant buyer to sales manager to buyer to store manager. Only under very unusual circumstances would she regress to being a buyer. Conversely, tenure is rarely granted to project managers. Once the project is completed, the manager may return to his previous department, even to a lesser position. Or, depending on the projects available, he may be assigned to manage a more or less significant project. Future work depends on what projects are available at the time the individual is available and how well the last project went. A promising career can be derailed by one unsuccessful project.

Pursuing a Career

If you are considering pursuing a career in project management, you should first find out what specific project job opportunities exist in your company. You should talk to people in project management positions and find out how they got to where they are and what advice they can give you. Because career paths, as noted earlier, vary from organization to organization, you need to be attuned to the unique pathways within your company. For example, retail companies naturally assign marketing managers to projects.

Once you have concluded that you wish to pursue a career in project management, or see project management as an avenue for advancement, you need to share your aspirations with your immediate superior. Your superior can champion your ambitions, sanction additional training in project management, and assign immediate work that will contribute to your project skill base.

Professional Training and Certification

Most project managers have never received formal training in project management. They mastered the job through on-the-job training, buttressed by occasional workshops on specific project topics such as project scheduling or negotiating contracts. It wasn't until recently that universities started offering courses on project management outside of schools of engineering; to date there are only a handful of degree programs in project management. Regardless of your level of training you will likely need to supplement your education. Many large companies have in-house training programs on project management. For example, Hewlett-Packard has more than 32 training modules in its project management curriculum, which is organized around five levels of experience: project team, new project manager, project manager, experienced project manager, and manager of project managers. Take advantage of professional workshops, which can cover a range of specific project management tools and topics. Continued education should not be restricted to project management. Many technical professionals return to universities to complete an MBA or take night classes in management to expand their general business background.

Many professionals find it beneficial to join the Project Management Institute (PMI). Membership entitles you to subscriptions to PMI publications including the academic *Project Management Journal* and the *PM Network,* a trade magazine. PMI sponsors workshops and national forums on project management. When you join PMI you also become a member of one of the more than 200 local chapters across North America. These chapters meet on a monthly basis and provide project managers with opportunities to network and learn from each other. In addition, PMI, as part of its effort to advance the profession, certifies mastery of project manager competency through a formal examination that covers the entire body of knowledge of project management. Passing the exam and being certified as a project management professional (PMP) or certified associate in project management (CAPM) is a clearly visible way to signal your competence and interest.

Gaining Visibility

As you accumulate knowledge and techniques, you need to apply them to your immediate job situation. Most people's jobs entail some form of project, whether realizing a mandated objective or simply figuring out ways to improve the quality of performance. Gantt charts, responsibility matrixes, CPM networks, and other project management tools can be used to plan and implement these endeavors. It may also be wise to look outside the workplace for opportunities to develop project management skills. Active involvement in your local community can provide numerous opportunities to manage projects. Organizing a local soccer tournament, managing a charitable fund-raising event, or coordinating the renovation of the neighborhood park can allow you to practice project management. Furthermore, given the volunteer nature of most of these projects, they can provide you with an excellent training ground to sharpen your ability to exercise influence without formal authority.

Regardless of how competent and worthy you are, your project management skills must be visible to others for them to be recognized. Many project managers' careers began by volunteering for task forces and small projects. Ideally you should select task forces and projects that allow you access to higher-ups and other departments within your organization, providing you with opportunities to develop contacts.

This was certainly true for a former student of ours named Bob who escaped the trenches of a large corporation by volunteering to lead the organization's annual United Way campaign. While an important cause, directing the United Way campaign was generally given to someone who was expendable. This was true for Bob, whose career had

bottomed out. Bob took advantage of the United Way task force to show off his project management skills. Through recruiting key participants, establishing a shared vision, managing milestones, and contagious enthusiasm the campaign was a resounding success, shattering previous records. Bob's efforts caught the attention of top management and he was rewarded with more project work.

Mentors

In pursuing your ambition you should continually be on the lookout for a mentor. Most fast-track managers acknowledge that mentors played a significant role in their advancement. Mentors are typically superiors who take a special interest in you and your career. They use their clout to champion your ambitions and act as a personal coach, teaching you "the ropes to skip and the ropes to know." This special treatment does not come without a price. Mentors typically require fervent loyalty and superior performance; after all, the mentor's reputation rests on your performance. How do you find a mentor? Most people say it just happens. But it doesn't happen to everyone. Mentors typically seek A+ workers, not C workers, and you must make your abilities known to others.

Many organizations have instituted formal mentoring programs in which experienced project managers are assigned to promising young managers. Although the relationship may not evolve to the personal level experienced with an informal mentor, designated mentors play a very similar role in coaching and championing one's professional progress. You should take advantage of this opportunity to learn as much as you can from these seasoned veterans.

Since much project work is temporary and contractual in nature, it is important to develop professional contacts that may lead to future work. Attending conferences, trade fairs, and workshops provides good opportunities to "network" and develop social connections that might precipitate project assignments. These social/professional networks can provide a safety net for project work during times of downsizing and layoffs.

Success in Key Projects

Ultimately your goal is to accumulate a portfolio of project management experiences that broaden your skill base and reputation. Early on you should choose, when possible, projects with the greatest learning opportunities. Pick projects more for the quality of the people working on them than for the scope of the projects. There is no better way to learn how to be an effective project manager than by watching one at work. Keep a diary of your observations and review and refine lessons learned. Later, as your confidence and competency grow, you should try to get involved in projects that will enhance your reputation within the firm. Remember the comments about customer satisfaction. You want to exceed your superior's expectations. Avoid run-of-the-mill projects or assignments. Seek high-profile projects that have some risks and tangible payoffs. At the same time, be careful to be involved in projects commensurate with your abilities.

Finally, despite your efforts you may find that you are not making satisfactory progress toward your career goals. If this is your appraisal, you may wish to seriously consider moving to a different company or even a different industry that might provide more project management opportunities. Hopefully you have managed to accumulate sufficient project management experience to aid in your job search. One advantage of project work over general management is that it is typically easier to highlight and "sell" your accomplishments. A second advantage is that project management is a portable skill set, applicable to a wide range of industries and situations.

Summary

The twenty-first century should be the Golden Age for project management. Not only will there be an increased demand for project management skills and know-how, but organizations will continue to evolve and change to support more effective project management. Project oversight will be a driving force behind these changes. Instead of trying to get projects done despite everything else, the organization's culture, structure, reward system, and administrative systems will be reengineered to support successful project management. Organization mastery of the process of managing projects will be critical to business growth and survival.

The project manager of the new millennium will be a businessperson with responsibilities that encompass the total organization. The past 30 years have seen the transition from a technically oriented project manager to one skilled in all aspects of business. Worldwide competition will direct projects toward technology transfer, infrastructure, consumer goods, environment/ecological recovery, defense, and fundamental needs. The future project manager will be comfortable in foreign or domestic settings and will understand the needs of people in all social settings. The project-driven organization will recognize the project manager as an agent of change and, from their ranks, select the senior managers of tomorrow.

Twenty years from now career paths in project management should be more clearly defined. Until then, people wishing to pursue a career in project management should take advantage of the transition and improvise within the constraints of their situation to develop their project management skills. They should volunteer to work on task forces, take advantage of training opportunities, and apply project management tools and techniques to their work. They should signal to their superiors their interest in project management and garner project assignments. Over time they should accumulate a portfolio of project management experiences that establishes their skill base and reputation as someone who gets things done quickly and done right.

Conclusions

By studying this text you have been exposed to the major elements of the process of managing projects. When you apply these ideas and techniques to real project situations, we offer two suggestions.

1. Maintain a sense of the big picture. Engage regularly in what some have called "helicopter management," which means expand your perspective beyond immediate concerns and assess how the project fits in the larger scheme of things. Project managers need to constantly assess how the project fulfills the mission and strategy of the firm, how the project is affecting the rest of the organization, whether the expectations of stakeholders are changing, and what key project interfaces have to be managed.

2. Remember that successful project management is essentially a balancing act. Project managers need to balance the soft (people) side of project management with the hard (technical) side, the demands of top management with the needs of team members, short-term gain with long-term need, and so forth.

Key Terms

Balanced scorecard	Phase gating	Project management
Mentor	Portfolio management	maturity
Oversight		Project office (PO)

Review Questions

1. What are the major economic forces that serve as an impetus for using oversight/governance tools and processes?

2. The Super Web Design president asked you to justify present and future oversight activities. Answer her request.

3. What are the three major advantages to an organization using a maturity model?

4. "We aren't big enough to have a project office, but we need the discipline of project management methods and standards." What advice would you give the CEO of this organization? Justify.

5. How can a mentor advance someone's career in project management?

6. Experts predict that most people will undergo at least three major career changes in their working life. If so, then why is project management an important skill set to master?

Exercises

1. Reread the "Day in a Life" case in Chapter 1. How would you assess her effectiveness now that you have studied project management? What part of Rachel's experience contributes to her success?

2. Access the Project Management Institute's home page at *www.pmi.org*. Review the qualifications necessary to earn certification as a project management professional and certified associate in project management. If possible, take the practice exam. How well did you do?

References

Baker, B., "The Nominees Are . . . ," *PM Network,* Vol. 18, No. 6, June 2004, p. 23.

Boyer, C., "Make Profit Your Priority," *PM Network,* Vol. 17, No. 10, October, 2003, p. 40.

Cochran, D., "Finally, A Way to Completely Measure Project Manager Performance," *PM Network,* Vol. 14, No. 9, September 2000, pp. 75–80.

Cooper, R. G., *Winning at New Products: Accelerating the Idea from Idea to Launch* (Cambridge, MA: Perseus Publishing, 2001).

Cooper, R. G., *Product Leadership: Creating and Launching Superior New Products* (Cambridge, MA: Perseus Publishing, 2000).

Cooper, R. G., S.J. Edgett, and E. J. Kleinschmidt, *Portfolio Management for New Products* (Reading, MA: Addison-Wesley, 1998).

Dinsmore, P. C., "Toward a Corporate Project Management Culture: Fast Tracking into the Future," *Proceedings of the Project Management Institute 28th Annual Seminars and Symposium* (Newton Square, PA: Project Management Institute, 1997).

Ibbs, C. W. and Y. H. Kwak, "Assessing Project Maturity," *Project Management Journal,* Vol. 31, No. 1, March 2000, pp. 32–43.

Kaplan, R. S. and D. Norton, "The Balanced Scorecard—Measures that Drive Performance," *Harvard Business Review,* January–February 1992, pp. 73–79. Note: A CD simulation is available from Harvard Customer Service, Product 8387. This interactive simulation provides hands-on experience for learning more about the method.

Lientz, B. P. and K. P. Rea, *Project Management for the 21st Century* (San Diego: Academic Press, 1995).

Mackay, H., *Dig Your Well before You're Thirsty* (New York: Doubleday, 1997).

Martin, P. and K. Tate, *Getting Started in Project Management* (New York: Wiley, 2004).

Morris, P. W. and A. Jamieson, "Moving from Corporate Strategy to Project Strategy," *Project Management Journal,* Vol. 36, No. 4. December 2005, pp. 5–18.

Mueller, E., "Maturity, Do or Die?" *PM Network,* Vol. 20, No. 2, February 2006, p. 32.

Norrie, J. and D. H. T. Walker, "A Balanced Scorecard Approach to Project Management Leadership," *Project Management Journal,* Vol. 35, No. 4, December 2004, pp. 47–56.

"Pull the Plug," *PM Network,* Vol. 20, No. 6, June 2006, pp. 39–42.

Rover, I., "Why Bad Projects Are So Hard to Kill," *Harvard Business Review,* February 2003, pp. 49–56.

Stewart, W. E., "Balanced Scorecard for Projects," *Project Management Journal,* Vol. 32, No. 1, March 2001, pp. 38–47. (2000 International Student Paper Award Winner.)

Case

Don't Tell Me What You Have Done. Tell Me What You Are Going to Do

The firm has been merged with a larger firm carrying a similar product line of information technology consumer and industry products. One major goal of the merger was to save costs by eliminating duplication and improving management. Weeks before the merger, Lauren (not her real name) had just been promoted to project office director of the smaller firm. She assumed her position would be absorbed into the project office of the large firm. Mentally, Lauren was prepared to start job hunting. Maybe she should change careers and go back to a job that used her bachelor's degree in political science. Two weeks after the merger was finalized, others, including herself, received a letter to report for an interview with the new company senior management "conversion" vice president. Lauren spent three days gathering materials to substantiate all of her past accomplishments, to demonstrate her management skills, and to show her potential value to the new firm. When the big day came, Lauren entered the office of the interviewer with approximately nine inches of substantiating material. She was prepared!

The first few minutes were spent explaining her past roles in the firm, the new project office, and other niceties. She explained to the VP she had all of the materials with her to back up her statements and he could take them if he wished. He replied, "I am not as interested in your past accomplishments as I am in your possible future accomplishments. Here is the need. Projects eat up about 40 percent of our yearly expenses. We need to cut 10 million off those expenses. In five minutes tell me how you will do it and how it will be verified."

Her last statement at the end of four minutes was: "I can give you five million within the next year. Ten million is too big a stretch."

His retort was, "Lauren, can you get five in six months?"

(Gulp.) "I'm pretty sure I can."

"Congratulations, Lauren, you are now the new project office director of this continental division."

In 500 words or less, write what you believe Lauren could have used as key points to get the position.

SimProject Experiential Exercises*

In this section, experiential exercises for SimProject are introduced. The simulation scenario will be different for every class. The use of a computer simulation, specifically SimProject, in your class is a unique method of learning the fundamentals as well as the intricacies of project management.

Simulation is not a new pedagogy but one that has been in existence for many years. Both you and your instructor may use a simulation either passively or actively. The Simulation Experiential Exercises in this section allow you to use SimProject actively by getting you involved in the operation of a project from the acquisition of people to the management of a team's process and content throughout the project.

The Simulation Experiential Exercises (SEEs) that follow are designed to coordinate with your textbook and are numbered by chapter for you to follow along easily. The computer simulation will provide specific details about the actual scenario in which you find yourself. SEEs may give you additional information from the chapter and the simulation that will help you complete the experiential exercise.

Two teams are involved in this project: the *project* team and your *class* team. The *project* team consists of the virtual set of individuals selected from the "pool" of resources available to you in the simulation. The simulation will give descriptions. The decisions you and your *class* team make in the simulation are made on behalf of the *project* team and the *simulated* project. Your *class* team will consist of real people within your class with whom you form your team.

The instructor will select SEEs and will be specific as to whether you should use the *project* team or your *class* team.

After reading the text, applying the principles to the *simulation project* through the Simulation Experiential Exercises, and participating in SimProject, you should be prepared to apply your skills to a real world situation.

Notes to Instructors

The key to the successful pedagogical use of computer simulations is to integrate them into the "fabric" of the class. The simulation is a source of exercises and problems to apply the principles in the text and lecture, thus bringing home the application of the tools and techniques of project management. This series of exercises is linked with both the text and the simulation to help you to use the simulation effectively and efficiently in your class.

You may select as many of the Simulation Experiential Exercises as you wish. Each has specific learning objectives and is tied to a specific chapter (noted by the first number in the numbering scheme).

* Prepared by Diane Parente, Penn State–Erie.

Simulation Experiential Exercises

Simulation Experiential Exercise 1-1: Defining a Project

Purpose

To provide the opportunity to identify how the simulation project exercise qualifies as a project. *{Project Team}*

Instructions

Use the description of the project provided by the simulation setup and identify the five major characteristics of this project.

Deliverable

Short description of your project, followed by the details of the five major characteristics of this project.

Simulation Experiential Exercise 1-2: Project Life Cycle

Purpose

To provide the vehicle for the team to look ahead and anticipate some of the activities in the various stages of the project life cycle (PLC). *{Project Team}*

Instructions

Review the four stages of the project life cycle. Adapt the tasks in each stage to reflect your simulation project. Identify the category of resource (i.e., engineer, programmer, carpenter) that is appropriate for each of the major activities.

Deliverable

The document should include the PLC stages, component activities, and the resource type that is planned.

Simulation Experiential Exercise 2-1: Project Fit

Purpose

The intent of this exercise is to describe the project "fit" with the organization's mission. *{Project Team}*

Instructions

Step 1: Identify the project stakeholders and describe the interests of each stakeholder group. (i.e., what are the project team members' interests in the success of the project?) Step 2: Use the organization's mission provided in the description of your simulation scenario (or one you develop) and discuss the consistencies and inconsistencies between the organization's mission and the stakeholders' interests.

Deliverable

Short narrative including mission statement, list of stakeholders and corresponding stakeholder interests, and discussion of consistencies and inconsistencies.

Simulation Experiential Exercise 2-2: Writing Objectives

Purpose

To practice writing "good" goals. *{Project Team or Class Team}*

Instructions

Write three goals for either your *Project Team* or *Class Team* (as directed by your instructor). Be sure that the goals are in SMARTc3 format.

Note: Specific, Measurable, Achievable, Relevant, Timed, caveat or limitation, 3 levels eg. Increase sales by 10% within the next year without decreasing price. (satisfactory = 10%; good = 13%; outstanding = 15%)

Deliverable

Three goals in SMARTc3 format.

Simulation Experiential Exercise 2-3: SWOT Analysis

Purpose

To learn to do a SWOT analysis. *{Project Team or Class Team}*

Instructions

Identify at least three each strengths, weaknesses, opportunities, or threats for your project.

Deliverable

List of three strengths, three weaknesses, three opportunities, and three threats for your project.

Simulation Experiential Exercise 2-4: Project Financial Assessment

Purpose

To determine the payback period and NPV of the project. *{Project Team}*

Instructions

Identify the costs and benefits of your simulated project over the life of the project. Calculate the payback period and NPV of the project. Is this an acceptable project? What are the criteria for determining feasibility?

Deliverable

Costs, benefits, cash flow, payback, and NPV calculation. Includes a paragraph describing project feasibility.

Simulation Experiential Exercise 2-5: Project Proposals

Purpose

To prepare a project proposal. *{Project Team}*

Instructions

Based on the information available from SimProject, prepare a Project Proposal in the format of Figure 2.4A.

Deliverable

Project Proposal for your simulation project.

Simulation Experiential Exercise 2-6: Risk and Risk Response

Purpose

To appropriately identify risk and develop plans for response. *{Project Team}*

Instructions

Identify the sources of possible risk for your simulation project. Use the technique shown in Figure 2.4B in your text to develop a Risk Assessment Matrix and a response to Risk Matrix.

Deliverable

Risk Analysis Document.

Simulation Experiential Exercise 3-1: Project Organization Structure

Purpose

To analyze the project organization structure. *{Project Team}*

Instructions

Based on the information available from SimProject, prepare a recommendation to management on the most appropriate organizational structure for your *project team*. Diagram your proposed structure and discuss the strengths and weaknesses and potential issues with your recommended structure.

Deliverable

Formal recommendation to management regarding project organization structure including cover letter, project structure diagram, and explanation.

Simulation Experiential Exercise 3-2: Project Organizational Culture

Purpose

To understand the elements of organizational culture in a project team. *{Class Team}*

Instructions

Using the primary characteristics of organizational culture described in your text, assess your *Class Team* on each of the dimensions and place your assessment on a chart (Figure 3.6). Your text also gives you ideas on how to identify these cultural characteristics. Prepare a Culture Diagnosis Worksheet (Figure 3.7). Chart the results of your cultural assessment and compare to the chart in Figure 3.8 for an organization supportive of project management. Discuss the differences and potential adjustments that your team might make.

Deliverable

Assessment of cultural dimensions, bar chart, organizational culture diagnosis, and comparison discussion—all based on *Class Team*.

Simulation Experiential Exercise 4-1: Project Scope

Purpose

To write a project scope statement. *{Project Team}*

Instructions

Using the instructions and the examples in your text, write a Project Scope Statement for your simulation. As in a real project, you will need to extrapolate some of the information

(i.e., requirements and limitations) and use the project scope statement to obtain clarification from the customer and preproject approval.

Deliverable

Project Scope Statement including objectives, deliverables, milestones, technical requirements, limits and exclusions, and customer review as appropriate.

Simulation Experiential Exercise 4-2: Project Costs

Purpose

To identify the cost of project deliverables and the total project. *{Project Team}*

Instructions

Identify each of the project deliverables and develop the total cost for each one. Compute the total project cost and compare to your budget. Identify actions that you might take to correct any problems identified.

Deliverable

Budgeted vs. outlook cost comparison by deliverable. Action plan for deficiencies.

Note: Outlook costs are those that will be incurred given the current plan. This typically includes project to date plus anticipated expenses to project completion.

Simulation Experiential Exercise 4-3: Project Responsibility Matrix

Purpose

To create a Project Responsibility Matrix. *{Class Team* or *Project Team}*

Instructions

Identify the project tasks for your *Class Team* or *Project Team.* Create a Responsibility Matrix for your project for the semester. Be sure to assign primary and supporting responsibilities.

Deliverable

Project Responsibility Matrix for your *Class Project* or SimProject.

Simulation Experiential Exercise 4-4: Project Priority Matrix

Purpose

To understand the relative priorities of a project. *{Project Team}*

Instructions

Project success in your simulated organization will be based on competing priorities. Based on the information available to you concerning your project to date, how would you rate the relative importance of time, cost, functionality, and quality (stakeholder satisfaction).

Complete a Project Priority Matrix for your simulation project. Divide 100 points between the above four competing priorities. Briefly discuss the rationale for your point assignment.

Deliverable

Project Priority Matrix. Also, each of the four components (time, cost, functionality, and stakeholder satisfaction) will have a point assignment and a brief statement of the reason for the assignment.

Simulation Experiential Exercise 5-1: Project Budget

Purpose

To create a detailed project budget and compare to the macro-level budget. *{Project Team}*

Instructions

Based on the information in your simulation scenario, create a detailed project budget. Compare to the deliverable from SEE 4-2 and reconcile the differences. Define your action plan to resolve the top-down vs. bottom-up approaches to project estimation. Which is better?

Deliverable

Bottom-up project estimate and comparison to top-down approach. Action plan to resolve differences and short discussion of choice of approaches.

Simulation Experiential Exercise 5-2: Apportion Method of Allocating Project Costs

Purpose

To understand apportioning of project costs. *{Project Team}*

Instructions

Prepare a chart of major components of the WBS for your SimProject scenario (as shown in Figure 5.1).

Deliverable

Allocation of project costs in WBS chart.

Simulation Experiential Exercise 6-1: Project Network Analysis

Purpose

To prepare and analyze the project network. *{Project Team}*

Instructions

After assigning personnel and estimating the task times, develop and print out the project network for your simulation project. Identify areas of potential problems that you can see as a result of examining the project network.

Deliverable

Project network diagram and list of issues regarding the plan.

Simulation Experiential Exercise 6-2: Project Network vs. Gantt Chart Comparison

Purpose

To compare the value of the Gantt chart and the project network. *{Project Team}*

Instructions

Prepare a Gantt chart for your simulation project. Compare it with the output from SEE 6-1 and discuss the advantages and disadvantages of each.

Deliverable

Gantt chart and discussion of comparison between Gantt chart and project network.

Simulation Experiential Exercise 7-1: Risk Management

Purpose

To understand and manage project risk. *{Project Team* or *Class Team}*

Instructions

Prepare a list of potential risk events and develop a Risk Assessment Form (Figure 7.6). Also, prepare a Risk Severity Matrix (Figure 7.7). Prepare a Failure Mode and Effects Assessment to stratify the risks.

Deliverable

Risk Assessment, Risk Severity Matrix, and FMEA.

Simulation Experiential Exercise 7-2: Risk Response and Mitigation

Purpose

To understand risk response.

Instructions

Prepare a Risk Response Matrix as shown in Figure 7.8.

Deliverable

Risk Response Matrix.

Simulation Experiential Exercise 7-3: Change Control Management

Purpose

To reinforce the importance of change control management. *{Project Team}*

Instructions

Design a process and the appropriate documentation for Change Control in your simulation project.

Deliverable

Procedure for Change Control including forms, screens, responsibilities, and step-by-step directions for how change is initiated, approved, and implemented.

Simulation Experiential Exercise 8-1: Resource Limitations

Purpose

To understand resource limitations. *{Project Team}*

Instructions

Once you have reviewed the Resource Pool and bid for services initially, you will find that you have accomplished the "hiring" of the resource in some cases and not "hired" them in others. Answer the following questions about the process:

1. What was your strategy for resource selection?

2. What are the implications of not achieving your hiring objectives in terms of time, cost, functionality, and stakeholder satisfaction?

3. What are your contingency plans?

Deliverable

A written evaluation of the resource selection process.

Simulation Experiential Exercise 8-2: Unplanned Time Constraints

Purpose

To evaluate how to respond to an unplanned time constraint. *{Project Team}*

Instructions

Your simulation has demonstrated a special event in which there is now a time constraint. Identify and implement your action plan to deal with this constraint.

Deliverable

Description of the time impact on the simulated project and a plan to address the issue.

Simulation Experiential Exercise 8-3: Unplanned Resource Constraints

Purpose

To evaluate how to respond to an unplanned resource constraint. *{Project Team}*

Instructions

Your simulation has demonstrated that there is a resource constraint. Identify and implement your action plan to deal with this constraint.

Deliverable

Description of the resource impact on the simulated project and a plan to address the issue.

Simulation Experiential Exercise 9-1: Crashing the Project

Purpose

To understand the impact of "crashing." *{Project Team}*

Instructions

Your simulation due date has been moved forward. Make the appropriate changes in your project plan to accomplish the required schedule reduction. Discuss the areas of the project that are most likely to be impacted by the "crashing."

Deliverable

New project plan and list of actions to be taken. Assessment of the potential results of actions.

Simulation Experiential Exercise 9-2: Results of Project Crashing

Purpose

To evaluate the results of project crashing. *{Project Team}*

Instructions

The time reduction in SEE 9-1 has resulted in several outcomes. Evaluate the various project issues that have arisen as a result of your actions. Include time, cost, money, team cohesiveness, stakeholder satisfaction, and functionality.

Deliverable

Written review of the impact of project crashing.

Simulation Experiential Exercise 10-1: Project Stakeholders

Purpose

To understand the relationship between the various stakeholders on the project. *{Project Team}*

Instructions

Draw the network of stakeholders for your simulation project. Identify whether the potential impact of the stakeholder on the project success is direct or indirect.

Deliverable

Diagram of network with stakeholders identified as direct or indirect impact to the project.

Simulation Experiential Exercise 10-2: Organizational Currencies

Purpose

To identify and understand organizational currencies. *{Class Team}*

Instructions

Prepare specific examples of each of the organizational currencies in Table 10.1.

Deliverable

Organizational currency chart.

Simulation Experiential Exercise 10-3: Social Networks

Purpose

To understand how to build and use a social network. *{Project Team or Class Team}*

Instructions

Draw a map of dependencies such as the one in Figure 10.2. Answer the questions about the dependencies as shown after the graphic. Design a plan to deal with your social network.

Deliverable

Social network diagram with discussion.

Simulation Experiential Exercise 11-1: Team Development Model

Purpose

To apply two models of team development. *{Class Team}*

Instructions

Discuss your class team within the framework of the Five-Stage Model and also the Punctuated Equilibrium Model. Be specific in identifying the characteristics and timing of each stage through which the team passed as well as the final performance of the team on the project. Discuss where improvements should have been made to facilitate the team-building process.

Deliverable

Written review of the Team Development.

Simulation Experiential Exercise 11-2: Conflict

Purpose

To debrief conflict in the team. *{Class Team}*

Instructions

Discuss an instance of functional and dysfunctional conflict within your team. Identify your method of dealing with each type of conflict within your team.

Deliverable

Short written report debriefing the conflict.

Simulation Experiential Exercise 11-3: Virtual Team Assessment

Purpose

To debrief the operation of a virtual class team. *{Class Team}*

Instructions

If your class team has been a virtual one, review the mechanisms used for effectively (or ineffectively) managing and communicating with your class team.

Deliverable

Short written report debriefing the operation of the virtual class team.

Simulation Experiential Exercise 12-1: Project Outsourcing

Purpose

To assess potential project outsourcing. *{Class Team* or *Project Team}*

Instructions

Identify areas of your simulation project in which you could have outsourced to another organization. Write a formal proposal to management requesting approval for an outsourcing arrangement. Discuss the terms that you propose for the arrangement and assess the benefits and risks of your proposal.

Deliverable

Formal business proposal including memo to management and cost benefit analysis of the proposal.

Simulation Experiential Exercise 13-1: Cost vs. Time Comparison

Purpose

To estimate the cost vs. time expenditures. *{Project Team}*

Instructions

Build a graph of the budgeted cost of work scheduled (PV) vs. the project periods. Discuss any obvious issues you find with the project as it is planned.

Deliverable

PV vs. time chart and short discussion of issues.

Simulation Experiential Exercise 13-2: Project Status Report

Purpose

To create a project status report. *{Project Team}*

Instructions

Develop a project status report for your simulation project such as the one that is in Figure 13.10. Include an earned value chart and a Tracking Gantt chart. Be sure to include a report that reports on actual costs, variance from budget, and explanations for the variances.

Deliverable

Complete formal project status report.

Simulation Experiential Exercise 13-3: Monthly Status Report

Purpose

To learn how to do a monthly status report. *{Project Team}*

Instructions

Develop the monthly status report for your simulation project as shown in Exhibit 13.1. Be sure to forecast remaining costs and time as well as to provide explanations and plans for getting back on budget in time or cost or both.

Deliverable

Formal monthly status report including variance analysis and explanations.

Simulation Experiential Exercise 14-1: Project Audit Report

Purpose

To prepare a project audit report. *{Class Team* or *Project Team}*

Instructions

Your instructor will determine whether you will use your *class team* or the *project team* in the simulation to complete this exercise. Using the guidelines in the chapter, prepare a project audit report. Be sure to include project classification, analysis of information gathered, recommendations, and lessons learned. You may also include an appendix of appropriate documentation.

Deliverable

Final project report discussing all phases of the project.

Simulation Experiential Exercise 14-2: Individual Performance Appraisal System

Purpose

To implement a performance appraisal process. *{Class Team}*

Instructions

Using the process developed in SEE 2-3, conduct individual performance appraisals on all team members. Write a short debrief on the effectiveness of the process.

Deliverable

Individual performance appraisals for each team member and brief evaluation of the process.

Computer Project Exercises

In developing the exercises, trade-offs had to be made to enrich the learning experience. One of the major problems students initially encounter is data and detail overload. This reduces their ability to identify project and data problems and to compare alternatives. Although the project found in the exercises is real, it has been reduced and detail has been eliminated many times to concentrate on applying project management principles and understanding linkages. In addition, other simplifying assumptions have been made so that students and instructors can trace problems and discuss outcomes. These assumptions detract from reality, but they keep the focus on the objectives of the exercises and reduce student frustration with software intricacies. Moving from these exercises to real projects is primarily one of increasing detail. The simplifying assumptions are given below (make sure they are included in "default," "preferences," and/or "options" sections of the software used):

Blue Zuma Project

The ARC Company specializes in developing and selling a wide range of high-quality scooters. Sales representatives report that there is a growing demand for racing scooters. ARC's president, Robin Lane, is excited about the possibilities and predicts that one day these kinds of razor scooters will be featured in X-Game events. ARC is a small company and uses a strong matrix to optimally utilize limited manpower.

The Project Priority Matrix for the Blue Zuma Project is:

	Time	Scope	Cost
Constrain		X	
Enhance	X		
Accept			X

Part 1

You are a member of a project team assigned to develop the new razor scooter code named "Blue Zuma." Table A2.1 contains the information necessary to create a project schedule. For the purpose of this case assume the following:

1. The project begins January 2, 2008.
2. The following holidays are observed: January 1, Memorial Day (last Monday in May), July 4th, Labor Day (first Monday in September), Thanksgiving Day (4th Thursday in November), December 25 and 26.

TABLE A2.1 Blue Zuma Project

ID	Task Name	Duration	Predecessors	Resources
1	Product development project			
2	Market analysis	25 days		Marketing (4)
3	Product design	40 days	2	Marketing (1) Design (4) Development (2) Industrial (1) Purchasing (1)
4	Manufacturing study	20 days	2	Industrial (4) Development (2)
5	Product design selection	10 days	3,4	Marketing (2) Design (3) Development (2) Industrial (2) Purchasing (.25)
6	Detailed marketing plan	15 days	5	Marketing (4)
7	Manufacturing process	30 days	5	Design (1) Development (2) Industrial (4)
8	Detailed product design	50 days	5	Marketing (2) Design (4) Development (2) Industrial (2) Purchasing (.25)
9	Test prototype	10 days	8	Design (3) Development (2)
10	Finalized product design	25 days	7,9	Marketing (2) Design (3) Development (3) Industrial (2)
11	Order components	7 days	10	Purchasing (1)
12	Order production equipment	14 days	10	Purchasing (1)
13	Install production equipment	35 days	11F-S + 20 days, 12F-S + 40 days	Development (3) Industrial (4) Design (1)
14	Celebrate	1 day	6,13	Development (4) Industrial (4) Design (4) Marketing (4) Purchasing (1)

3. If a holiday falls on a Saturday, then Friday will be given as an extra day off, and if it falls on a Sunday, then Monday will be given as a day off.

4. The project team works eight-hour days, Monday through Friday.

Construct a network schedule for this project and prepare a memo that answers the following questions:

1. When is the project estimated to be completed? How long will the project take?

2. What is the critical path for the project?

3. Which activity has the greatest amount of slack?

4. How sensitive is this network?

5. Identify two sensible milestones and explain your choices.

6. Compare the advantages/disadvantages of displaying the schedule as a network versus a Gantt chart.

Include the following printouts:

- A Gantt chart.
- A network diagram highlighting the critical path.
- A schedule table reporting ES, LS, EF, LF, and slack for each activity.

Part 2

The following personnel have been assigned to the Blue Zuma project team:

- 4 marketing specialists
- 4 design engineers

TABLE A2.2
Blue Zuma Project Resources

Resource	$/hour	Number Available
Marketing specialist	$60	4
Design engineer	$90	4
Development engineer	$80	4
Industrial engineer	$70	4
Purchasing agent	$50	1

- 4 development engineers
- 4 industrial engineers
- 1 purchasing agent

Use the file from Part 1 and the information contained in Tables A2.1 and A2.2 to assign resources to the project schedule.

Part A

Prepare a memo that addresses the following questions:

1. Which if any of the resources are overallocated?
2. Which activities involve overallocated resources?
3. Assume that the project is time constrained and try to resolve any overallocation problems by leveling within slack. What happens?
4. What is the impact of leveling within slack on the sensitivity of the network?

Include a Gantt chart with the schedule table after leveling within slack.

Part B

Prepare a memo that addresses the following questions:

1. Assume that the project is resource constrained and no additional personnel are available. How long will the project take given the resources assigned? (Hint: Undo leveling performed in Part A before answering this question.)

Note: No splitting of activities is allowed.

2. How does the new duration compare with the estimated completion date generated from Part 1? What does this tell you about the impact resources can have on a schedule?

Include a Gantt chart with a schedule table depicting the resource-constrained schedule.

Part 3

Top management is not happy with the resource-constrained schedule generated at the end of Part 2. Robin Lane, the president, has promised retailers that production of the new scooters would start on February 1, 2009.

1. What options are available to meet this new deadline if the project is not resource constrained?
2. What options are available to meet this deadline if the project is resource constrained?

Dewey Martin, director of product development, has managed to make the following personnel available to work on specific activities on the project. Since there is an acute shortage of personnel at ARC he requests that you only use additional manpower that will help meet the new deadline. Your objective is to develop a schedule which will satisfy the deadline with minimum additional resource usage. The available personnel and impact on activity duration are presented in Table A2.3.

TABLE A2.3
Blue Zuma Project Crashing Options

Activity	Additional Resources	Revised Duration Estimates
Detailed marketing plan	Marketing (2)	10 days
Detailed product design	Design (1) Development (1)	42 days
Install production equipment	Industrial (1) Development (1)	27 days

Pay rates for additional personnel: Marketing, $70/hour; Design, $100/hour; Development, $90/hour; and Industrial, $80/hour.

Prepare a memo that addresses the following questions:

1. Which additional personnel assignments would you choose to complete the project within the original deadline? Explain your choices as well as the reasons for not choosing other options.
2. How have these changes affected the sensitivity of the network?

Include a Gantt chart with a schedule table presenting the new schedule.

Note: You cannot go back and relevel resources. These new resources are only available for the stated specific tasks according to the schedule created at the end of Part 2.

Part 4

Robin Lane and top management have approved the schedule generated at the end of Part 3. Save the file containing this schedule as a baseline schedule.

Prepare a memo that addresses the following questions:

1. How much is the project estimated to cost?
2. What activity is estimated to cost the most to complete?
3. What resource commands the greatest total cost?
4. During which month of the project are the highest and lowest costs expected to occur? What are those costs?
5. What likely costs are not contained in this budget?

Include a table containing the estimated costs for each activity and a cash flow schedule for each month of the project.

Part 5

Today's date is August 16, 2008. Table A2.4 summarizes the information regarding activities accomplished to date.

Robin Lane has requested a written status report for the Blue Zuma project.

1. Your status report should include a table containing the PV, EV, AC, BAC, EAC, SV, CV, and CPI for each activity and the whole project. The report should also address the following questions:

TABLE A2.4
Blue Zuma Project Update

Activity	Start Date	Finish Date	Actual Duration	Remaining Duration
Market analysis	1/2/08	2/1/08	23	
Product design	2/4/08	3/20/08	34	
Manufacturing study	3/21/08	4/22/08	23	
Product design selection	4/23/08	5/13/08	15	
Manufacturing process	8/1/08		11	25
Detailed product design	5/14/08	7/31/08	55	
Test prototype	8/1/08	8/15/08	11	

a. How is the project progressing in terms of cost and schedule?
b. What activities have gone well? What activities have not gone well?
c. What do the PCIB and PCIC indicate in terms of how much of the project has been accomplished to date?
d. What is the forecasted cost at completion (EAC$_F$)? What is the predicted VAC$_f$?
e. Report and interpret the TCPI for the project at this point in time.
f. What is the estimated date of completion?
g. How well is the project doing in terms of its priorities?

Try to present the above information in a form worthy of consideration by top management. Include a tracking Gantt chart with your report.
Note: Enter August 15 as the status report date since you are preparing your report on the 16th.

2. While preparing your report you receive a phone call from Jim Keltner, a fellow project manager. He is calling to see if one of the industrial engineers assigned to your project would be available to work on his project from August 22 to 27, 2008. What would you tell him?

Part 6

Robin Lane has authorized using Management Reserves to expedite the shipping of components at an additional cost of $50,000. She has asked you to update completion and cost estimates for the Blue Zuma project. Table A2.5 presents the revised estimates generated by the Zuma project team.

Based on this new information prepare a memo that answers the following questions:

1. When will the project be completed? How does this compare with the baseline completion date?
2. What is the new estimated cost at completion (EAC)? What is the new VAC? How does this compare with VAC based on the EAC$_F$ generated in Part 5? Which of the two VACs would you have the greatest confidence in and why?
3. How do you think Robin will react given the priorities for this project?

Include a tracking Gantt with a cost table for the estimated completion schedule.

TABLE A2.5
Blue Zuma Project Revised Estimates to Completion

Activity	Start Date	Finish Date	Actual Duration
Market analysis	1/2/08	2/1/08	23
Product design	2/4/08	3/20/08	34
Manufacturing study	3/21/08	4/22/08	23
Product design selection	4/23/08	5/13/08	15
Detailed marketing plan	10/28/08	11/24/08	20
Manufacturing process	8/1/08	9/18/06	34
Detailed product design	5/14/08	7/31/08	55
Test prototype	8/1/08	8/15/08	11
Finalized product design	9/19/08	10/16/08	20
Order components	10/31/08	11/6/08	5
Order production equipment *	10/17/08	11/3/08	12
Install production equipment	12/9/08	1/22/09	30
Celebrate	1/23/09	1/23/09	1

* Add $50,000 expediting costs.

Conveyor Belt Project

Part 1

Project Description

The new computer-controlled conveyor belt is an exciting project that moves and positions items on the conveyor belt within <1 millimeter. The project will produce a new system for future installations, and for replacement of those in the field, at a low cost. The computer-controlled conveyor belt has the potential to be a critical unit in 30 percent of the systems installed in factories. The new system is also easier to update with future technologies.

The Project Priority Matrix for the Conveyor Belt Project (CBP) is:

	Time	Scope	Cost
Constrain	X		
Enhance		X	
Accept			X

Table A2.6 has been developed for you to use in completing the project exercises.

Assignment

Develop the WBS outline using the software available to you.

TABLE A2.6
Conveyor Belt Project; WBS

Conveyor Belt Project	
Hardware	Hardware specifications
	Hardware design
	Hardware documentation
	Prototypes
	Order circuit boards
	Assemble preproduction models
Operating system	Kernel specifications
	Drivers
	Disk drivers
	Serial I/O drivers
	Memory management
	Operating system documentation
	Network interface
Utilities	Utilities specifications
	Routine utilities
	Complex utilities
	Utilities documentation
	Shell
System integration	Architectural decisions
	Integration first phase
	System hard/software test
	Project documentation
	Integration acceptance testing

Question

Does this information (WBS) allow you to define any milestones of the project? Why or why not? What are they?

Remember: Save your file for future exercises!

Part 2

Use your file from Part 1 and the information provided below to complete this exercise. (See Table A2.7.)

1. Each work package will represent an activity.
2. The project begins January 4, 2010.
3. The following holidays are observed: January 1, Memorial Day (last Monday in May), July 4th, Labor Day (first Monday in September), Thanksgiving Day (4th Thursday in November), December 25 and 26.
4. If a holiday falls on a Saturday then Friday will be given as an extra day off, and if it falls on a Sunday, then Monday will be given as a day off.
5. The project team work eight-hour days, Monday through Friday.

Warning: Experience has taught students to frequently make separate backup files for each exercise. The software is never as friendly as users expect!

Construct a network schedule for the conveyor belt project and prepare a memo that addresses the following questions:

1. When is the project estimated to be completed? How long will the project take?
2. What is the critical path(s) for the project?
3. Which activity has the greatest amount of slack?

TABLE A2.7 Conveyor Belt Project; Schedule

Activity	Description	Resource	Duration (days)	Preceding Activity
1	Architectural decisions	Design	25	—
2	Hardware specifications	Development, design	50	1
3	Kernel specifications	Design	20	1
4	Utilities specifications	Development, design	15	1
5	Hardware design	Design, development	70	2
6	Disk drivers	Assembly, development	100	3
7	Memory management	Development	90	3
8	Operating system documentation	Design, documentation	25	3
9	Routine utilities	Development	60	4
10	Complex utilities	Development	80	4
11	Utilities documentation	Documentation, design	20	4
12	Hardware documentation	Documentation, design	30	5
13	Integration first phase	Assembly, development	50	6,7,8,9,10,11,12
14	Prototypes	Assembly, development	80	13
15	Serial I/O drivers	Development	130	13
16	System hard/software test	Assembly	25	14,15
17	Order circuit boards	Purchasing	5	16
18	Network interface	Development	90	16
19	Shell	Development	60	16
20	Project documentation	Documentation, development	50	16
21	Assemble preproduction models	Assembly, development	30	17F-S, lag 50 days
22	Integrated acceptance testing	Assembly, development	60	18,19,20,21

4. How sensitive is this network?
5. Identify two sensible milestones and explain your choices.
6. Compare the advantages/disadvantages of displaying the schedule as a network versus a Gantt chart.

Include the following printouts:

• A Gantt chart.
• A network diagram highlighting the critical path.
• A schedule table reporting. ES, LS, EF, LF, and slack for each activity.

Hint: the project should be completed in 530 days.
Remember: Save your file for future exercises!

Part 3

Remember the old saying, "A project plan is not a schedule until resources are committed." This exercise illustrates this subtle, but very important, difference.

Part A

Using your files from Part 2 input resources and their costs if you have not already done so. All information is found in Tables A2.7 and A2.8.
Prepare a memo that addresses the following questions:

1. Which if any of the resources are overallocated?
2. Assume that the project is time constrained and try to resolve any overallocation problems by leveling within slack. What happens?
3. What is the impact of leveling within slack on the sensitivity of the network?

Include a Gantt chart with the schedule table after leveling within slack.

4. Assume the project is resource constrained and resolve any overallocation problems by leveling outside of slack. What happens? What are the managerial implications?
5. What options are available at this point in time?

Include a Gantt chart with the schedule table after leveling outside of slack.

Note: No splitting of activities is allowed.
Note: No partial assignments (i.e., 50 percent). All resources must be assigned 100 percent.

Part B

When you show the resource-constrained network to top management, they are visibly shaken. After some explanation and negotiation they make the following compromise with you:

• The project must be completed no later than February 2, 2012 (530 days).
• You may assign two additional development teams.

TABLE A2.8
Organization Resources

Name	Group	Cost ($/hr)
Design	R&D (2 teams)	$100
Development	R&D (2 teams)	70
Documentation	R&D (1 team)	60
Assembly/test	R&D (1 team)	70
Purchasing	Procurement (1 team)	40

- If this does not suffice, you may hire other development teams from the outside. Hire as few external teams as possible because they cost $50 more per hour than your inside development people.

Internal Development

Add as many development units (teams) as needed to stay within the 530 days. If you need more than the two units, examine all possibilities. Select the cheapest possibilities! Change as few activities as possible. It is recommended you keep work packages which require cooperation of several organizational units inside your company. You decide how best to do this.

Hint: Undo leveling prior to adding new resources.

Once you have obtained a schedule that meets the time and resource constraints, prepare a memo that addresses the following questions:

1. What changes did you make and why?
2. How long will the project take?
3. How did these changes affect the sensitivity of the network?

Include a Gantt chart with a schedule table presenting the new schedule.

Part 4

Based on the file created at the end of Part 3, prepare a memo that addresses the following questions:

1. How much will the project cost?
2. What does the cash flow statement tell you about how costs are distributed over the lifespan of the project?

Include a monthly cash flow and a cost table for the project.

Once you are confident that you have the final schedule, save the file as a baseline.
Hint: Save a backup file just in case without baseline!

Part 5

Prepare status reports for each of the first four quarters of the project given the information provided here. This requires saving your resource schedule as a baseline and inserting the appropriate status report date in the program. Assume that no work has been completed on the day of the status report.

Your status report should include a table containing the PV, EV, AC, BAC, EAC, SV, CV, and CPI for each activity and the whole project. The report should also address the following questions:

1. How is the project progressing in terms of cost and schedule?
2. What activities have gone well? What activities have not gone well?
3. What do the PCIB and PCIC indicate in terms of how much of the project has been accomplished to date?
4. What is the forecasted cost at completion (EAC_f)? What is the predicted VAC_f?
5. Report and interpret the TCPI for the project at this point in time.
6. What is the estimated date of completion?
7. How well is the project doing in terms of its priorities?

TABLE A2.9
April 1, 2010

Activity	Start Date	Finish Date	Actual Duration	Remaining Duration
Hardware specifications	2/9/10		37	8
Kernel specifications	2/8/10	3/12/10	25	0
Disk drivers	3/15/10		13	87
Memory management	3/15/10		13	77
Op. systems documentation	3/15/10		13	7
Utilities specifications	3/8/10	3/29/10	16	0
Complex utilities	3/30/10		2	85
Architectural decisions	1/4/10	2/5/10	25	0

Try to present the above information in a form worthy of consideration by top management. Include a Tracking Gantt chart with each report.

First Quarter, April 1, 2010

Table A2.9 summarizes the information regarding activities accomplished to date.
Be sure to save your file after each quarterly report and use it to build the next report!

Second Quarter, July 1, 2010

Table A2.10 summarizes the information regarding activities accomplished since the last report.

Third Quarter, October 1, 2010

Table A2.11 summarizes the information regarding activities accomplished since the last report.

Fourth Quarter, January 1, 2011

Table A2.12 summarizes the information regarding activities accomplished since the last report.

TABLE A2.10
July 1, 2010

Activity	Start Date	Finish Date	Actual Duration	Remaining Duration
Hardware specifications	2/9/10	4/12/10	45	0
Hardware design	4/13/10		56	11
Kernel specifications	2/8/10	3/12/10	25	0
Disk drivers	3/15/10		77	33
Memory management	3/15/10		77	19
Op. systems documentation	3/15/10	4/16/10	25	0
Utilities specifications	3/8/10	3/29/10	16	0
Routine utilities*	4/26/10		47	18
Complex utilities	3/30/10		66	25
Utilities documentation	5/3/10	6/2/10	22	0
Architectural decisions	1/4/10	2/5/10	25	0

* The project manager for the external development team that was hired to perform routine utilities reported that due to commitments to other clients they would be able to start on that activity 4/26/10.

TABLE A2.11
October 1, 2010

Activity	Start Date	Finish Date	Actual Duration	Remaining Duration
Hardware specifications	2/9/10	4/12/10	45	0
Hardware design	4/13/10	7/16/10	67	0
Hardware documentation	7/19/10	8/24/10	27	0
Kernel specifications	2/8/10	3/12/10	25	0
Disk drivers	3/15/10	8/17/10	110	0
Memory management	3/15/10	7/30/10	98	0
Op. systems documentation	3/15/10	4/16/10	25	0
Utilities specifications	3/8/10	3/29/10	16	0
Routine utilities	4/26/10	7/27/10	65	0
Complex utilities	3/30/10	8/11/10	95	0
Utilities documentation	5/3/10	6/2/10	22	0
Architectural decisions	1/4/10	2/5/10	25	0
Integration 1st phase	8/25/10		26	24

TABLE A2.12
January 1, 2011

Activity	Start Date	Finish Date	Actual Duration	Remaining Duration
Hardware specifications	2/9/10	4/12/10	45	0
Hardware design	4/13/10	7/16/10	67	0
Hardware documentation	7/19/10	8/24/10	27	0
Prototypes	11/11/10		34	44
Kernel specifications	2/8/10	3/12/10	25	0
Disk drivers	3/15/10	8/17/10	110	0
Serial I/O drivers	11/11/10		34	119
Memory management	3/15/10	7/30/10	98	0
Op. systems documentation	3/15/10	4/16/10	25	0
Utilities specifications	3/8/10	3/29/10	16	0
Routine utilities	4/26/10	7/27/10	65	0
Complex utilities	3/30/10	8/11/10	95	0
Utilities documentation	5/3/10	6/2/10	22	0
Architectural decisions	1/4/10	2/5/10	25	0
Integration 1st phase	8/25/10	11/10/10	55	0

Part 6

You have received revised estimates for the remaining activities at the end of the fourth quarter:

- Prototypes will be completed on 3/8/11.
- Serial I/O drivers will be completed on 6/30/11.
- System hardware/software test will start on 7/1/11 and take 25 days.
- Order circuit boards will start on 8/8/11 and take 5 days.
- Assemble preproduction model will begin on 10/14/11 and take 18 days.
- Project documentation is expected to start on 8/8/11 and will take 55 days.
- Network interface is expected to start on 8/8/11 and will take 99 days.

- Shell is expected to start on 8/8/11 and will take 55 days.
- Integrated acceptance testing is expected to start on 12/29/11 and will take 54 days.

Prepare a memo that addresses the following questions:

1. What is the new EAC for the project? How long should the project take given these revised estimates?
2. How happy will top management be with these forecasts given the priorities of the project?
3. What recommendations would you make?

Include a revised schedule, a Tracking Gantt chart, and cost table with your memo.

A

activity Task(s) of the project that consumes time while people/equipment either work or wait.

activity duration Estimate of time (hours, days, weeks, months, etc.) necessary to complete a project task.

actual cost of the work completed (AC) The sum of the cost incurred in accomplishing work. Previously this was called the actual cost of the work performed (ACWP).

actual cost of the work performed (ACWP) Actual cost of the work performed in a given time period. The sum of the costs incurred in accomplishing work.

AOA Activity-on-arrow method for drawing project networks. The activity is shown as an arrow.

AON Activity-on-node method for drawing project networks. The activity is on the node (rectangle).

apportionment method Costs allocated to a specific segment of a project by using a percentage of planned total cost—for example, framing a house might use 25 percent of the total cost, or coding a teaching module 40 percent of total cost.

avoiding risk Elimination of the risk cause before the project begins.

B

backward pass The method used to compute the late start and finish times for each activity in the project network.

balanced matrix A matrix structure in which the project manager and functional managers share roughly equal authority over the project. The project manager decides what needs to be done; functional managers are concerned with how it will be accomplished.

balanced scorecard method Model that measures the long-run results of major program activities in four areas—customer, internal, innovation and learning, and financial.

bar chart A graphic presentation of project activities depicted as a time-scaled bar line (also called a Gantt chart).

baseline A concrete document and commitment; it represents the first real plan with cost, schedule, and resource allocation. The planned cost and schedule performance are used to measure actual cost and schedule performance. Serves as an anchor point for measuring performance.

BATNA Best alternative to a negotiated agreement. Strong or weak BATNA indicates your power to negotiate with the other party.

bottom-up estimates Detailed estimates of work packages usually made by those who are most familiar with the the task (also called micro estimates).

brainstorming Generating as many ideas/solutions as possible without critical judgment.

budget at completion (BAC) Budgeted cost at completion. The total budgeted cost of the baseline or project cost accounts.

budget reserve Reserve setup to cover identified risks that may occur and influence baseline tasks or costs. These reserves are typically controlled by the project manager and the project team. See management reserve.

budgeted cost of the work performed (BCWP) The value for completed work measured in terms of the planned budget for the work. The earned value or original budgeted cost for work actually completed.

build-own-operate-transfer (BOOT) A risk management provision in which the prime contractor not only builds the facility, but also takes over ownership until its operation capacity has been proven before final transfer of ownership to the client.

burst activity An activity that has more than one activity immediately following it.

C

capability maturity model (CMM) A framework which describes the evolutionary stages of project management systems.

change control The process of documenting, reviewing, accepting or rejecting change, and documenting any change to the project baseline.

change management system A defined process for authorizing and documenting changes in the scope of a project.

chart of accounts A hierarchical numbering system used to identify tasks, deliverables, and organizational responsibility in the work breakdown structure.

co-location A situation in which project members including those from different organizations work together in the same location.

communication plan A plan that defines information to be collected and distributed to stakeholders based on their requirements.

concurrent engineering or simultaneous engineering
Cross-functional teamwork in new-product development projects that provides product design, quality engineering, and manufacturing process engineering all at the same time.

consensus decision making Reaching a decision that all involved parties basically agree with and support.

contingency fund See contingency reserve.

contingency plan A plan that covers possible identified project risks that may materialize over the life of the project.

contingency reserve Usually an amount of money or time set aside to cover identified and unforeseen project risks.

contract A formal agreement between two parties wherein one party (the contractor) obligates itself to perform a service and the other party (the client) obligates itself to do something in return, usually in the form of a payment to the contractor.

cost account A control point of one or more work packages used to plan, schedule, and control the project. The sum of all the project cost accounts represents the total cost of the project.

cost performance index (CPI) The ratio of work performed to actual costs (EV/AC).

cost-plus contract A contract in which the contractor is reimbursed for all direct allowable costs (materials, labor, travel) plus an additional fee to cover overhead and profit.

cost variance (CV) The difference between EV and AC (CV = EV − AC). Tells if the work accomplished cost more or less than was planned at any point over the life of the project.

crash point The most a project activity time can realistically be compressed with the resources available to the organization.

crash time The shortest time an activity can be completed (assuming a reasonable level of resources).

critical path The longest activity path(s) through the network. The critical path can be distinguished by identifying the collection of activities that all have the same minimum slack.

critical path method (CPM) A scheduling method based on the estimates of time required to complete activities on the critical path. The method computes early, late, and slack times for each activity in the network. It establishes a planned project duration, if one is not imposed on the project.

culture The totality of socially transmitted behavior patterns, beliefs, institutions, and all other products of human work and thought characteristic of a community or country.

culture shock A natural psychological disorientation that most people suffer when they move to a culture different from their own.

D

dedicated project team An organizational structure in which all of the resources needed to accomplish a project are assigned full time to the project.

deliverable A major product or result that must be finished to complete the project.

Delphi Technique A group method to predict future events—e.g., time, cost.

direct costs Costs that are clearly charged to a specific work package—usually labor, materials, or equipment.

dummy activity An activity that does not consume time; it is represented on the AOA network as a dashed line. A dummy activity is used to ensure a unique identification number for parallel activities and used to maintain dependencies among activities on the project network.

duration (DUR) The time needed to complete an activity, a path, or a project.

dysfunctional conflict Disagreement that does not improve project performance.

E

early finish (EF) The earliest an activity can finish if all its preceding activities are finished by their early finish times (EF = ES + DUR).

early start (ES) The earliest an activity can start. It is the largest early finish of all its immediate predecessors (ES = EF − DUR).

earned value (EV) The physical work accomplished plus the authorized budget for this work. Previously this was called the budgeted cost of work performed (BCWP).

emotional intelligence (EQ) The ability or skill to perceive, assess, and manage the emotions of one's self and others.

escalation A control mechanism for resolving problems in which people at the lowest appropriate level attempt to resolve a problem within a set time limit or the problem is "escalated" to the next level of management.

estimated cost at completion (EAC) The sum of actual costs to date plus revised estimated costs for the work remaining in the WBS. The text uses EAC$_{re}$ to represent revisions made by experts and practitioners associated with the project.

A second method is used in large projects where the original budget is less reliable. This method uses the actual costs to date plus an efficiency index (CPI = EV/AC) applied to the remaining project work. When the estimate for completion uses the CPI as the basis for forecasting cost at completion, we use the acronym EAC_f, where $\mathbf{EAC_f}$ = estimated costs at completion. Includes costs to date plus revised estimated costs for the work remaining. (Uses formula to complute EAC.)

$\mathbf{ETC_f}$ Estimated cost to complete (uses formula to compute estimates).

$\mathbf{ETC_{re}}$ Estimated cost to complete (uses expert estimates).

event A point in time when an activity(s) is started or completed. It does not consume time.

F

failure mode and effects analysis (FMEA) Each potential risk is assessed in terms of severity of impact, probability of the event occurring, and ease of detection.

fast-tracking Accelerating project completion typically by rearranging the network schedule and using start-to-start lags.

fixed-price or "lump sum" contract A contract in which the contractor agrees to perform all the work specified in the contract at a predetermined, fixed price.

float See slack.

forecast at completion (FAC) The forecasted cost at completion—using forecast equation.

forward pass The method for determining the early start and finish times for each activity in the project network.

free slack The maximum amount of time an activity can be delayed from its early start (ES) without affecting the early start (ES) of any activity immediately following it.

function points Points derived from past software projects to estimate project time and cost, given specific features of the project.

functional conflict Disagreement that contributes to the objectives of the project.

functional manager A manager responsible for activities in a specialized department or function (e.g., engineering, marketing, finance).

functional organization A hierarchical organizational structure in which departments represent individual disciplines such as engineering, marketing, purchasing.

G

Gantt chart See bar chart.

going native Adopting the customs, values, and prerogatives of a foreign culture.

Golden Rule Do unto others as you would wish them to do unto you.

groupthink A tendency of members in highly cohesive groups to lose their critical evaluative capabilities.

H

hammock activity A special-purpose, aggregate activity that identifies the use of fixed resources or costs over a segment of the project—e.g., a consultant. Derives its duration from the time span between other activities.

heuristic A rule of thumb used to make decisions. Frequently found in scheduling projects. For example, schedule critical activities first, then schedule activities with the shortest duration.

I

implementation gap The lack of consensus between the goals set by top management and those independently set by lower levels of management. This lack of consensus leads to confusion and poor allocation of organization resources.

indirect costs Costs that cannot be traced to a particular project or work package.

infrastructure Basic services (i.e., communication, transportation, power) needed to support project completion.

in-process project audit Project audits early in projects that allow for corrective changes if they are needed on the audited project or others in progress.

insensitive network A network in which the critical path is likely to remain stable during the life of the project.

international project A project that includes tasks that will be completed in different countries.

ISO 9000 A set of standards governing the requirements for documentation of a quality program.

J

joint evaluation A process in which different parties involved in a project evaluate how well they work together.

L

lag The amount of time between the end of one activity and the start of another. A duration assigned to the activity dependency. The minimum amount of time a dependent activity must be delayed to begin or end.

lag relationship The relationship between the start and/or finish of a project activity and the start and/or finish of another activity. The most common lag relationships are (1) finish-to-start, (2) finish-to-finish, (3) start-to-start, and (4) start-to-finish.

late finish (LF) The latest an activity can finish and not delay a following activity (LF = LS + DUR).

late start (LS) The latest an activity can start and not delay a following activity. It is the largest late finish (LF) of all activities immediately preceding it (LS = LF − DUR).

law of reciprocity People are obligated to grant a favor comparable to the one they received.

leading by example Exhibiting the behaviors you want to see in others.

learning curves A mathematical curve used to predict a pattern of time reduction as a task is performed over and over.

leveling (smoothing) A technique used to lower the maximum demand for a resource by using slack to realign resource.

M

management by wandering around (MBWA) A management style in which managers spend the majority of their time outside their offices interacting with key people.

management reserve A percentage of the total project budget reserved for contingencies. The fund exists to cover unforeseen, new problems—not unnecessary overruns. The reserve is designed to reduce the risk of project delays. Management reserves are typically controlled by the project owner or project manager. See budget reserve.

matrix Any organizational structure in which the project manager shares responsibility with the functional managers for assigning priorities and for directing the work of individuals assigned to the project.

maturity model A model used to assess project management practices against others in the same industry and to guide and continuously strive to improve the management of projects. Most maturity models recognize levels of maturity so organizations can gauge their relative maturity against others in their industry.

mentor Typically a more experienced manager who acts as a personal coach and champions a person's ambitions.

merge activity An activity that has more than one activity immediately preceding it.

met-expectations model Customer satisfaction is a function of the extent to which perceived performance exceeds expectations.

milestone An event that represents significant, identifiable accomplishment toward the project's completion.

mitigating risk Action taken to either reduce the likelihood that a risk will occur and/or the impact the risk will have on the project.

Monte Carlo simulation A method of simulating project activity durations using probabilities. The method identifies the percentage of times, activities, and paths that are critical over thousands of simulations.

N

negative reinforcement A motivational technique in which negative stimuli are removed once desired behavior is exhibited.

net present value (NPV) A minimum desired rate of return discount (e.g., 15 percent) is used to compute present value of all future cash inflows and outflows.

network A logic diagram arranged in a prescribed format (e.g., AOA or AON) consisting of activities, sequences, interrelationships, and dependencies.

network organization An alliance of several organizations created for the purpose of creating products and services for customers.

network sensitivity The likelihood that the critical path will change on a project.

nominal group technique (NGT) A structured problem-solving process in which members privately rank-order preferred solutions.

O

objective An end you seek to create or acquire. Should be specific, measurable, realistic, assignable, and include a time frame for accomplishment.

organization breakdown structure (OBS) A structure used to assign responsibility for work packages.

organizational culture A system of shared norms, beliefs, values, and assumptions held by an organization's members.

organizational currencies A set of currencies used as a medium of exchange within organizations to influence behavior.

organizational politics Actions by individuals or groups of individuals to acquire, develop, and use power and other resources to obtain preferred outcomes when there is uncertainty or disagreement over choices.

outsourcing Contracting for the use of external sources (skills) to assist in implementing a project.

overhead costs Typically organization costs that are not directly linked to a specific project. These costs cover general expenses such as upper management, legal, market promotion, and accounting. Overhead costs are usually charged per unit of time or as a percentage of labor or material costs.

oversight A set of principles and processes to guide and improve the management of projects. The intent is to ensure projects meet the needs of the organization through standards, procedures, accountability, efficient allocation of resources, and continuous improvement in the management of projects.

P

padding estimates Adding a safety factor to a time or cost estimate to ensure the estimate is met when the project is executed.

parallel activity One or more activities that can be carried on concurrently or simultaneously.

partnering See project partnering.

partnering charter A formal document that states common goals as well as cooperative procedures used to achieved these goals which is signed by all parties working on a project.

path A sequence of connected activities.

payback method The time it takes to pay back the project investment (investment/net annual savings). The method does not consider the time value of money or the life of the investment.

performance review In general, all review methods of individual performance center on the technical and social skills brought to the project and team. These reviews stress personal improvement and are frequently used for salary and promotion decisions.

phase estimating This estimating method begins with a macro estimate for the project and then refines estimates for phases of the project as it is implemented.

phase gating A structured process to review, evaluate, and document outcomes at each project phase and to provide

management with information to guide resource deployment toward strategic goals.

phase project delivery Delivering useful parts of a project in phases instead of when the project is entirely completed.

planned value (PV) The planned time-phased baseline of the value of the work scheduled. Previously this was called budgeted cost of work scheduled (BCWS).

plan of record The current official plan for the project in terms of scope, budget, and schedule.

portfolio management Centralized selection and management of a portfolio of projects to ensure that allocation of resources is directed and balanced toward the strategic focus of the organization.

positive synergy A characteristic of high-performance teams in which group performance is greater than the sum of individual contributions.

precedence diagram method A method used to construct a project network that uses nodes (e.g., a rectangle) to represent activities and connecting arrows to indicate dependencies.

principled negotiation A process of negotiation that aims to achieve win/win results.

priority matrix A matrix that is set up before the project begins that establishes which criterion among cost, time, and scope will be enhanced, constrained, or accepted.

priority system The process used to select projects. The system uses selected criteria for evaluating and selecting projects that are strongly linked to higher-level strategies and objectives.

priority team The group (sometimes the project office) responsible for selecting, overseeing, and updating project priority selection criteria.

proactive Working within your sphere of influence to accomplish something.

process breakdown structure (PBS) A phase-oriented grouping of project activities that defines the total scope of the project. Each descending level represents an increasingly detailed description of project work.

project A complex, nonroutine, one-time effort to create a product or service limited by time, budget, and specifications.

project audit report A report that includes classification of the project, analysis of information gathered, recommendations, lessons learned, and an appendix of backup information.

project cost—duration graph A graph that plots project cost against time; it includes direct, indirect, and total cost for a project over a relevant range of time.

project interfaces The intersections between a project and other groups of people both within and outside the organization.

projectitis A social phenomenon in which project members exhibit inappropriately intense loyalty to the project.

project kick off meeting Typically the first meeting of the project team.

project life cycle The stages found in all projects—definition, planning, execution, and delivery.

project management The application of knowledge, skills, tools, and techniques to project activities to meet the project requirements.

Project Management Professional (PMP) An individual who has met specific education and experience requirements set forth by the Project Management Institute, has agreed to adhere to a code of professional conduct, and has passed an examination designed to objectively assess and measure project management knowledge. In addition, a PMP must satisfy continuing certification requirements or lose the certification.

project office (PO) A centralized unit within an organization or department that oversees and improves the management of projects.

project oversight See oversight.

project manager The individual responsible for managing a project.

project organization An organizational structure in which core work is accomplished by project teams.

project partnering A nonbinding method of transforming contractual relationships into a cohesive, cooperative project team with a single set of goals and established procedures for resolving disputes in a timely manner.

project portfolio Group of projects that have been selected for implementation balanced by project type, risk, and ranking by selected criteria.

project screening matrix A matrix used to assess and compare the relative value of projects being considered for implementation.

project sponsor Typically a high-ranking manager who champions and supports a project.

project vision An image of what the project will accomplish.

R

ratio (parametric) methods Uses the ratio of past actual costs for similar work to estimate the cost for a potential project. This macro method of forecasting cost does not provide a sound basis for project cost control since it does not recognize differences among projects.

resource Any person, groups, skill, equipment or material used to accomplish a task, work package, or activity.

resource-constrained project A project that assumes resources are limited (fixed) and therefore time is variable.

resource profile A chart showing the usage of a resource in a project over time. It is common to try to reduce the peak of the resource usage by leveling or smoothing, thereby improving the utilization of the resource.

responsibility matrix A matrix whose intersection point shows the relationship between an activity (work package) and the person/group responsible for its completion.

risk The chance that an undesirable project event will occur and the consequences of all its possible outcomes.

risk breakdown structure (RBS) A hierarchical depiction of the identified project risks arranged by risk category and subcategory that identifies the various areas and causes of potential risks.

risk profile A list of questions that addresses traditional areas of uncertainty on a project.

risk severity matrix A tool used to assess the impact of risks on a project.

S

"sacred cow" A project that is a favorite of a powerful management figure who is usually the champion for the project.

scenario analysis A process in which potential risk events are identified and analyzed.

schedule performance index (SPI) The ratio of work performed to work scheduled (EV/PV).

schedule variance (SV) The difference between the planned dollar value of the work actually completed and the value of the work scheduled to be completed at a given point in time ($SV = EV - PV$). Schedule variance contains no critical path information.

scope creep The tendency for the scope of a project to expand once it has started.

scope statement A definition of the end result or mission of a project. Scope statements typically include project objectives, deliverables, milestones, specifications, and limits and exclusions.

sensitivity of a network The likelihood that the critical path(s) will change once the project begins to be implemented.

sharing risk Allocating proportions of risk to different parties.

slack (SL) Time an activity can be delayed before it becomes critical.

social network building The process of identifying and building cooperative relationships with key people.

sociotechnical perspective A focus on the interaction between tools/methods and people.

splitting A scheduling technique in which work is interrupted on one activity and the resource is assigned to another activity for a period of time, then reassigned to work on the original activity.

stakeholders Individuals and organizations that are actively involved in the project, or whose interests may be positively or negatively affected as a result of project execution or completion. They may also exert influence over the project and its results.

strong matrix A matrix structure in which the project manager has primary control over project activities and functional managers support project work.

systems thinking A holistic approach to viewing problems that emphasizes understanding the interactions among different problem factors.

T

task See activity.

team-building A process designed to improve the performance of a team.

team evaluation Evaluating the performance of the project team using a minimum core of conditions in place before the project began. Evaluation practices should emphasize the team as a whole, while minimizing individual performance.

team rituals Ceremonial actions that reinforce team identity and values.

template method Use of a prepared form to develop project networks, costs, and time estimates.

360-degree feedback A multirater appraisal system based on performance information that is gathered from multiple sources (superiors, peers, subordinates, customers).

time and cost databases Collection of actual versus estimated times and costs of work packages over many projects that are used for estimating new project tasks and their expected possible error.

time buffer A contingency amount of time for an activity to cover uncertainty—for example, availability of a key resource or merge event.

time-constrained project A project that assumes time is fixed and, if resources are needed, they will be added.

time-phased baseline A cost baseline that is derived from the WBS and project schedule. The budgeted costs are distributed to mirror the project schedule.

time-phased budgets Planned costs that are broken down by distinct time periods (e.g., $5,000 per week) for a work package, as opposed to a budget for a whole job/project (6 months for a total of $130,000). Time phasing allows better cost control by measuring the actual rate of expenditure versus the planned expenditure rate over small pieces of the project.

total slack (TS) The amount of time an activity can be delayed and not affect the project duration ($TS = LS - ES$ or $LF - EF$).

Tracking Gantt A Gantt chart that compares planned versus actual schedule information.

transferring risk Shifting responsibility for a risk to another party.

triple constraint The competing demands of time, cost, and scope. These constraints frequently represent trade-off decisions to be dealt with by the project manager and/or sponsor.

top-down estimates Rough estimates that use surrogates to estimate project time and cost (also called macro estimates).

V

variance at completion (VAC) Indicates expected actual cost over- or underrun at completion ($VAC = BAC - EAC$).

virtual project team Spatially separated project team whose members are unable to communicate face to face. Communication is usually by electronic means.

W

weak matrix A matrix structure in which functional managers have primary control over project activities and the project manager coordinates project work.

work breakdown structure (WBS) A hierarchical method that successively subdivides the work of the project into smaller detail.

work package A task at the lowest level of the WBS. Responsibility for the package should be assigned to one person and, if possible, limited to 80 hours of work.

AC	Actual cost of work completed	**KISS**	Keep it simple, stupid
ACWP	Actual cost of work performed	**LF**	Late finish
AOA	Activity-on-arrow	**LS**	Late start
AON	Activity-on-node	**MBWA**	Management by wandering around
BAC	Budget at completion	**NIH**	Not invented here
BATNA	Best alternative to a negotiated agreement	**NPV**	Net present value
BCWP	Budgeted cost of work performed	**OBS**	Organization breakdown structure
BCWS	Budgeted cost of work scheduled	**PBS**	Process breakdown structure
BOOT	Build-own-operate-transfer	**PCI**	Percent complete index
CAPM	Certified Associate in Project Management	**PCIB**	Percent complete index—budget costs
CCPM	Critical-chain approach to project planning and management	**PCIC**	Percent complete index—actual costs
CPI	Cost performance index	**PDM**	Precedence diagramming method
CPM	Critical path method	**PERT**	Project evaluation review technique
CV	Cost variance	**PO**	Project office
DUR	Duration	**PMP**	Project Management Professional
EAC	Estimate at completion (with revised cost estimates)	**PV**	Planned value of work scheduled
EF	Early finish	**RBS**	Risk breakdown structure
EQ	Emotional intelligence	**RM**	Responsibility matrix
ES	Early start	**SL**	Slack
ETC	Estimate to complete	**SPI**	Schedule performance index
EV	Earned value	**SV**	Schedule variance
FAC	Forecast at completion	**TCPI**	To complete performance index
FF	Free float	**VAC**	Variance at completion
IFB	Invitation for bid	**WBS**	Work breakdown structure

PROJECT MANAGEMENT EQUATIONS

$$PCIB = \frac{EV}{BAC}$$

$$CV = EV - AC$$

$$CPI = \frac{EV}{AC}$$

$$EAC_f = \frac{(BAC - EV)}{\left(\frac{EV}{AC}\right)} + AC$$

$$EAC_{re} = AC + ETC_{re}$$

$$t_e = \frac{a + 4m + b}{6}$$

$$\sigma_{te} = \left(\frac{b - a}{6}\right)$$

$$TCPI = \frac{(BAC - EV)}{(BAC - AC)}$$

$$PCIC = \frac{AC}{EAC}$$

$$SV = EV - PV$$

$$SPI = \frac{EV}{PV}$$

$$VAC_f = BAC - EAC_f$$

$$VAC_{re} = BAC - EAC_{re}$$

$$\sigma_{T_E} = \sqrt{\sum \sigma_{te}^2}$$

$$Z = \frac{T_S - T_E}{\sqrt{\sum \sigma_{te}^2}}$$

Index